Readings for

CULTURE
AND VALUES

Readings for

CULTURE AND VALUES

A SURVEY OF THE HUMANITIES

SEVENTH EDITION

LAWRENCE S. CUNNINGHAM
John A. O'Brien Professor of Theology
University of Notre Dame

JOHN J. REICH
Syracuse University
Florence, Italy

WADSWORTH
CENGAGE Learning

Australia • Brazil • Japan • Korea • Mexico • Singapore • Spain • United Kingdom • United States

ISBN-13: 978-0-495-57070-7
ISBN-10: 0-495-57070-2

Wadsworth
20 Channel Center Street
Boston, MA 02210
USA

Cengage Learning products are represented in Canada by Nelson Education, Ltd.

For your course and learning solutions, visit **www.cengage.com**

Purchase any of our products at your local college store or at our preferred online store **www.ichapters.com**

Printed in Canada
1 2 3 4 5 6 7 12 11 10 09

Contents

21

22

CHAPTER 1

READING 1

from THE EPIC OF GILGAMESH (C. 2000 BCE)

The following excerpts from THE EPIC OF GILGAMESH *describe the exploits of the Sumerian ruler Gilgamesh and his friend Enkidu. In the course of the poem, Enkidu dies of an illness sent by the gods and Gilgamesh goes on a journey in search of the meaning of existence. Toward the end he meets Utnapishtim, the only mortal to whom the gods have given eternal life, and tries to learn from him the secret of immortality. The futility of his quest is expressed by his inability even to stay awake.*

At the end of the epic, like all mortals he dies, and the poet points out the lesson: "O Gilgamesh, you were given the kingship, such was your destiny, everlasting life was not your destiny."

The Flood

With the first light of dawn a black cloud came from the horizon; it thundered within where Adad, lord of the storm, was riding. In front over hill and plain Shullat and Hanish, heralds of the storm, led on. Then the gods of the abyss rose up; Nergal pulled out the dams of the nether waters, Ninurta the warlord threw down the dykes, and the seven judges of hell, the Annunaki, raised their torches, lighting the land with their livid flame. A stupor of despair went up to heaven when the god of the storm turned daylight to darkness, when he smashed the land like a cup. One whole day the tempest raged gathering fury as it went, it poured over the people like the tides of battle; a man could not see his brother nor the people be seen from heaven. Even the gods were terrified at the flood, they fled to the highest heaven, the firmament of Anu; they crouched against the walls, cowering like curs. Then Ishtar the sweet-voiced Queen of Heaven cried out like a woman in travail:

"Alas the days of old are turned to dust because I commanded evil; why did I command this evil in the council of all the gods? I commanded wars to destroy the people, but are they not my people, for I brought them forth? Now like the spawn of fish they float in the ocean." The great gods of heaven and of hell wept, they covered their mouths.

The Afterlife

Enkidu slept alone in his sickness and he poured out his heart to Gilgamesh, "Last night I dreamed again, my friend. The heavens moaned and the earth replied; I stood alone before an awful being; his face was somber like the black bird of the storm. He fell upon me with the talons of an eagle and he held me fast, pinioned with his claw, till I smothered; then he transformed me so that my arms became wings covered with feathers. He turned his stare towards me, and he led me away to the palace of Irkalla, the Queen of Darkness, to the house from which none who enters ever returns, down the road from which there is no coming back.

"There is the house whose people sit in darkness; dust is their food and clay their meat. They are clothed like birds with wings for covering, they see no light, they sit in darkness. I entered the house of dust and I saw the kings of the earth, their crowns put away for ever; rulers and princes, all those who once wore kingly crowns and ruled the world in the days of old. They who had stood in the place of the gods, like Anu and Enlil, stood now like servants to fetch baked meats in the house of dust, to carry cooked meat and cold water from the water-skin. In the house of dust which I entered were high-priests and acolytes, priests of the incantation and of ecstasy; there were servers of the temple, and there was Etana, that king of Kish whom the eagle carried to heaven in the days of old. I saw also Samuqan, god of cattle, and there was Ereshkigal the Queen of the Underworld; and Belit-Sheri squatted in front of her, she who is recorder of the gods and keeps the book of death.

She held a tablet from which she read. She raised her head, she saw me and spoke: 'Who has brought this one here?' Then I awoke like a man drained of blood who wanders alone in a waste of rushes; like one whom the bailiff has seized and his heart pounds with terror. O my brother, let some great prince, some other, come when I am dead, or let some god stand at your gate, let him obliterate my name and write his own instead."

The Return of Gilgamesh

Utnapishtim said, "As for you, Gilgamesh, who will assemble the gods for your sake, so that you may find that life for which you are searching? But if you wish, come and put it to the test: only prevail against sleep for six days and seven nights." But while Gilgamesh sat there resting on his haunches, a mist of sleep like soft wool teased from the fleece drifted over him, and Utnapishtim said to his wife, "Look at him now, the strong man who would have everlasting life, even now the mists of sleep are drifting over him." His wife replied, "Touch the man to wake him, so that he may return to his own land in peace, going back through the gate by which he came." Utnapishtim said to his wife, "All men are deceivers, even you he will attempt to deceive; therefore bake loaves of bread, each day one loaf, and put it beside his head; and make a mark on the wall to number the days he has slept."

So she baked loaves of bread, each day one loaf, and put it beside his head, and she marked on the wall the days that he slept; and there came a day when the first loaf was hard, the second loaf was like leather, the third loaf was soggy, the crust of the fourth had mould, the fifth was mildewed, the sixth was fresh, and the seventh was still on the embers. Then Utnapishtim touched him and he woke. Gilgamesh said to Utnapishtim the Faraway, "I hardly slept when you touched and roused me." But Utnapishtim said, "Count these loaves and learn how many days you slept, for your first is hard, your second is like leather, your third is soggy, the crust of your fourth has mould, your fifth is mildewed, your sixth is fresh, and your seventh was still over the glowing embers when I touched and woke you." Gilgamesh said, "What shall I do, O Utnapishtim, where shall I go? Already the thief in the night has hold of my limbs, death inhabits my room; wherever my foot rests, there I find death."

Then Utnapishtim spoke to Urshanabi the ferryman: "Woe to you Urshanabi, now and for ever more you have become hateful to this harborage; it is not for you, nor for you are the

crossings of this sea. Go now, banished from the shore. But this man before whom you walked, bringing him here, whose body is covered with foulness and the grace of whose limbs has been spoiled by wild skins, take him to the washing-place. There he shall wash his long hair clean as snow in the water, he shall throw off his skins and let the sea carry them away, and the beauty of his body shall be shown, the fillet on his forehead shall be renewed, and he shall be given clothes to cover his nakedness. Till he reaches his own city and his journey is accomplished, these clothes will show no sign of age, they will wear like a new garment." So Urshanabi took Gilgamesh and led him to the washing-place, he washed his long hair as clean as snow in the water, he threw off his skins, which the sea carried away, and showed the beauty of his body. He renewed the fillet on his forehead, and to cover his nakedness gave him clothes which would show no sign of age, but would wear like a new garment till he reached his own city, and his journey was accomplished. Then Gilgamesh and Urshanabi launched the boat on to the water and boarded it, and they made ready to sail away; but the wife of Utnapishtim the Far-away said to him, "Gilgamesh came here wearied out, he is worn out; what will you give him to carry him back to his own country?" So Utnapishtim spoke, and Gilgamesh took a pole and brought the boat in to the bank. "Gilgamesh, you came here, a man wearied out, you have worn yourself out; what shall I give you to carry you back to your own country? Gilgamesh, I shall reveal a secret thing, it is a mystery of the gods that I am telling you. There is a plant that grows under the water, it has a prickle like a thorn, like a rose; it will wound your hands, but if you succeed in taking it, then your hands will hold that which restores his lost youth to a man."

When Gilgamesh heard this he opened the sluices so that a sweet-water current might carry him out to the deepest channel; he tied heavy stones to his feet and they dragged him down to the water-bed. There he saw the plant growing; although it pricked him he took it in his hands; then he cut the heavy stones from his feet, and the sea carried him and threw him on to the shore. Gilgamesh said to Urshanabi the ferryman, "Come here, and see this marvelous plant. By its virtue a man may win back all his former strength. I will take it to Uruk of the strong walls; there I will give it to the old men to eat. Its name shall be 'The Old Men Are Young Again'; and at last I shall eat it myself and have back all my lost youth." So Gilgamesh returned by the gate through which he had come, Gilgamesh and Urshanabi went together. They traveled their twenty leagues and then they broke their fast; after thirty leagues they stopped for the night.

Gilgamesh saw a well of cool water and he went down and bathed; but deep in the pool there was lying a serpent, and the serpent sensed the sweetness of the flower. It rose out of the water and snatched it away, and immediately it sloughed its skin and returned to the well. Then Gilgamesh sat down and wept, the tears ran down his face, and he took the hand of Urshanabi; "O Urshanabi, was it for this that I toiled with my hands, is it for this I have wrung out my heart's blood? For myself I have gained nothing; not I, but the beast of the earth has joy of it now.

Already the stream has carried it twenty leagues back to the channels where I found it. I found a sign and now I have lost it. Let us leave the boat on the bank and go." After twenty leagues they broke their fast, after thirty leagues they stopped for the night; in three days they had walked as much as a journey of a month and fifteen days. When the journey was accomplished they arrived at Uruk, the strong-walled city.

Gilgamesh spoke to him, to Urshanabi the ferryman, "Urshanabi, climb up on to the wall of Uruk, inspect its foundation terrace, and examine well the brickwork; see if it is not of burnt bricks; and did not the seven wise men lay these foundations? One third of the whole is city, one third is garden, and one third is field, with the precinct of the goddess Ishtar. These parts and the precinct are all Uruk."

This too was the work of Gilgamesh, the king, who knew the countries of the world. He was wise, he saw mysteries and knew secret things, he brought us a tale of the days before the flood. He went a long journey, was weary, worn out with labor, and returning engraved on a stone the whole story.

The Death of Gilgamesh

The destiny was fulfilled which the father of the gods, Enlil of the mountain, had decreed for Gilgamesh: "In nether-earth the darkness will show him a light; of mankind, all that are known, none will leave a monument for generations to come to compare with his. The heroes, the wise men, like the new moon have their waxing and waning. Men will say, 'Who has ever ruled with might and with power like him?' As in the dark month, the month of shadows, so without him there is no light. O Gilgamesh, this was the meaning of your dream. You were given the kingship, such was your destiny, everlasting life was not your destiny. Because of this do not be sad at heart, do not be grieved or oppressed; he has given you power to bind and to loose, to be the darkness and the light of mankind. He has given unexampled supremacy over the people, victory in battle from which no fugitive returns, in forays and assaults from which there is no going back. But do not abuse this power, deal justly with your servants in the palace, deal justly before the face of the Sun."

> The king has laid himself down and will not rise again,
> The Lord of Kullab will not rise again;
> He overcame evil, he will not come again;
> Though he was strong of arm he will not rise again;
> He had wisdom and a comely face, he will not come again;
> He is gone into the mountain, he will not come again;
> On the bed of fate he lies, he will not rise again,
> From the couch of many colors he will not come again.

The people of the city, great and small, are not silent; they lift up the lament, all men of flesh and blood lift up the lament. Fate has spoken; like a hooked fish he lies stretched on the bed, like a gazelle that is caught in a noose. Inhuman Namtar is heavy upon him, Namtar that has neither hand nor foot, that drinks no water and eats no meat. For Gilgamesh, son of Ninsun, they weighed out their offerings; his dear wife, his son, his concubine, his musicians, his jester, and all his household; his servants, his stewards, all who lived in the palace weighed out their offerings for Gilgamesh the son of Ninsun, the heart of Uruk. They weighed out their offerings to Ereshkigal, the Queen of Death, and to all the gods of the dead. To Namtar, who is fate, they weighed out the offering. Bread for Neti the Keeper of the Gate, bread for Ningizzida the god of the serpent, the lord of the Tree of Life; for Dumuzi also, the young shepherd, for Enki and Ninki, for Endukugga and Nindukugga, for Enmul and Ninmul, all the ancestral gods, forbears of Enlil. A feast for Shulpae, the god of feasting. For Samuqan, god of the herds, for the mother Ninhursag, and the gods of creation in the place of creation, for the host of heaven, priest and priestess weighed out the offering of the dead. Gilgamesh, the son of Ninsun, lies in the tomb. At the place of offerings he weighed the bread-offering, at the place of libation he poured out the wine. In those days the lord Gilgamesh departed, the son of Ninsun, the king, peerless, without an equal among men, who did not neglect Enlil his master. O Gilgamesh, lord of Kullab, great is thy praise.

From *The Epic of Gilgamesh*, trans. N. K. Sandars (Penguin Classics 1960, Third Edition 1972), copyright © N. K. Sandars, 1960, 1964, 1972. Reproduced by permission of Penguin Books, Ltd.

CHAPTER 2

READING 2

from HOMER, THE ILIAD (C. 900–700 BCE)

*The action of the ILIAD takes place during the final year of the Greeks'
siege of Troy, or Ilium. Its principal theme is stated in the opening lines of
Book I that establish the tragic mood of the work: "Sing, goddess, of the
anger of Peleus' son Achilles, which disastrously inflicted countless suffer-
ings on the Greeks, sending the strong souls of many heroes to Hades and
leaving their bodies to be devoured by dogs and all birds." The subject of
the ILIAD, then, is the anger of Achilles and its consequences. The ILIAD's
message is a direct one: we are responsible for our actions and when
we act wrongly we will cause suffering both for ourselves and, perhaps
more important, for those we love. Told in a simple and direct narrative,
the story of Achilles' disastrous mistake begins with a quarrel between
Agamemnon, commander-in-chief of the Greek forces, and Achilles, his
powerful ally, who resents Agamemnon's overbearing assertion of author-
ity. After a public argument, Achilles decides to punish Agamemnon by
withdrawing his military support and retiring to his tent, in the hope
that without his aid the Greeks will be unable to overcome the Trojans.
In the battles that follow he is proved correct; the Trojans inflict a series
of defeats on the Greeks, killing many of their leading warriors. We pick
up the story in Book XV.*

from Book XV

*The following long extract contains the crucial battle around the Greek
ships, in which the Trojan prince Hector (Hektor) plays a decisive part.
With Achilles still refusing to fight, despite Agamemnon's attempt to
patch up their quarrel, the Trojans seem on the point of finally gaining
the upper hand. Time after time, Hector leads his men within reach of the
Greek ships, ready to set them on fire, and only mighty Greek counterat-
tacks block his way. As casualties mount, the epic reaches its pivotal point.
In the passage's last lines, only the stubborn courage of "great-hearted"
Aias (Ajax) holds back the destruction of the entire Greek fleet. At the
beginning of the next Book, Achilles' dearest friend Patroclus rushes to
Achilles' tent in a desperate attempt to persuade him to reenter the fight-
ing. Achilles' only concession is to lend Patroclus his own armor, and
to send him into battle to give the impression that Achilles himself has
returned. When Patroclus is in turn slain by Hector, Achilles—driven
by rage and grief—hurls himself into the fighting and defeats Hector in
single combat.*

The Achaians stood steady against the Trojan attack, but
 they could not
beat the enemy, fewer as they were, away from their
 vessels,
nor again had the Trojans strength to break the battalions
 of the Danaans, and force their way into the ships
 and the shelters.
But as a chalkline straightens the cutting of a ship's
 timber 410
in the hands of an expert carpenter, who by Athene's
inspiration is well versed in all his craft's subtlety,
so the battles fought by both sides were pulled fast
 and even.
Now by the ships others fought in their various places
but Hektor made straight for glorious Aias. These two
were fighting hard for a single ship, and neither was able,
Hektor to drive Aias off the ship, and set fire to it,
nor Aias to beat Hektor back, since the divinity
drove him. Shining Aias struck with the spear Kaletor,
Klytios' son, in the chest as he brought fire to the vessel 420
He fell, thunderously, and the torch dropped from his
 hand. Then

Hektor, when his eyes were aware of his cousin fallen
in the dust in front of the black ship, uplifting
his voice in a great cry called to the Trojans and Lykians:
"Trojans, Lykians, Dardanians who fight at close quarters,
do not anywhere in this narrow place give way from the
 fighting
but stand by the son of Klytios, do not let the Achaians
strip the armor from him, fallen where the ships are
 assembled."
So he spoke, and made a cast at Aias with the shining
spear, but missed him and struck the son of Mastor,
 Lykophron, 430
henchman of Aias from Kythera who had been living
with him; for he had killed a man in sacred Kythera.
Hektor struck him in the head above the ear with the
 sharp bronze
as he stood next to Aias, so that Lykophron sprawling
dropped from the ship's stern to the ground, and his
 strength was broken.
And Aias shuddered at the sight, and spoke to his
 brother:
"See, dear Teukros, our true companion, the son of Mastor,
is killed, who came to us from Kythera and in our
 household
was one we honored as we honored our beloved parents.
Now great-hearted Hektor has killed him. Where are
 your arrows 440
of sudden death, and the bow that Phoibos Apollo
 gave you?"
He spoke, and Teukros heard and came running to stand
 beside him
holding in his hand the backstrung bow and the quiver
to hold arrows, and let go his hard shots against the
 Trojans.
First he struck down Kleitos, the glorious son of Peisenor
and companion of Poulydamas, proud son of Panthoös.
Now Kleitos held the reins, and gave all his care to the
 horses,
driving them into that place where the most battalions
 were shaken,
for the favor of Hektor and the Trojans, but the
 sudden evil
came to him, and none for all their desire could
 defend him, 450
for the painful arrow was driven into his neck from
 behind him.
He fell out of the chariot, and the fast-footed horses
shied away, rattling the empty car; but Poulydamas
their master saw it at once, and ran first to the heads of
 the horses.
He gave them into the hands of Astynoös, Protiaon's
son, with many orders to be watchful and hold the
 horses
close; then himself went back into the ranks of the
 champions.
But Teukros picked up another arrow for bronze-helmed
Hektor, and would have stopped his fighting by the ships
 of the Achaians
had he hit him during his bravery and torn the life
 from him; 460
but he was not hidden from the close purpose of Zeus,
 who was guarding
Hektor, and denied that glory to Telamonian Teukros;
who broke in the unfaulted bow the close-twisted sinew
as Teukros drew it against him, so the bronze-
 weighted arrow
went, as the bow dropped out of his hands, driven crazily
 sidewise.

And Teukros shuddered at the sight, and spoke to his
 brother:
"See now, how hard the divinity cuts across the intention
in all our battle, who struck the bow out of my hand,
 who has broken
the fresh-twisted sinew of the bowstring I bound on
this morning, so it would stand the succession of
 springing arrows." 470
Then in turn huge Telamonian Aias answered him:
"Dear brother, then let your bow and your showering
 arrows
lie, now that the god begrudging the Danaans
 wrecked them.
But take a long spear in your hands, a shield on your
 shoulder,
and close with the Trojans, and drive on the rest of your
 people.
Let them not, though they have beaten us, easily capture
our strong-benched ships. We must remember the frenzy
 of fighting."
He spoke, and Teukros put away the bow in his shelter
and threw across his shoulders the shield of the fourfold
 ox-hide.
Over his mighty head he set the well-fashioned
 helmet 480
with the horse-hair crest, and the plumes nodded
 terribly above it.
Then he caught up a powerful spear, edged with sharp
 bronze,
and went on his way, running fast, and stood beside Aias.
But Hektor, when he saw how the arrows of Teukros
 were baffled,
lifted his voice in a great cry to the Trojans and Lykians:
"Trojans, Lykians, Dardanians who fight at close quarters,
be men now, dear friends, remember your furious valor
along the hollow ships, since I have seen with my
 own eyes
how by the hand of Zeus their bravest man's arrows
 were baffled.
Easily seen is the strength that is given from Zeus to
 mortals 490
either in those into whose hands he gives the surpassing
glory, or those he diminishes and will not defend them
as now he diminishes the strength of the Argives, and
 helps us.
Fight on then by the ships together. He who among you
finds by spear thrown or spear thrust his death and
 destiny,
let him die. He has no dishonor when he dies defending
his country, for then his wife shall be saved and his
 children afterwards,
and his house and property shall not be damaged, if the
 Achaians
must go away with their ships to the beloved land of
 their fathers."
So he spoke, and stirred the spirit and strength in
 each man. 500
But Aias on the other side called to his companions:
"Shame, you Argives; here is the time of decision,
 whether
we die, or live on still and beat back ruin from our
 vessels.
Do you expect, if our ships fall to helm-shining
 Hektor,
you will walk each of you back dryshod to the land of
 your fathers?
Do you not hear how Hektor is stirring up all his people,
how he is raging to set fire to our ships? He is not

inviting you to come to a dance. He invites you to battle.
For us there can be no design, no purpose, better than
 this one,
to close in and fight with the strength of our hands at
 close quarters. 510
Better to take in a single time our chances of dying
or living, than go on being squeezed in the stark
 encounter
right up against our ships, as now, by men worse than
 we are."
So he spoke, and stirred the spirit and strength in
 each man.
There Hektor killed the son of Perimedes, Schedios,
lord of the men of Phokis; but Aias killed Laodamas,
leader of the foot-soldiers, and shining son of Antenor.
Then Poulydamas stripped Otos of Kyllene, companion
to Meges, Phyleus' son, and a lord among the great-
 hearted
Epeians. Meges seeing it lunged at him, but Poulydamas 520
bent down and away, so that Meges missed him. Apollo
would not let Panthoös' son go down among the front
 fighters,
but Meges stabbed with the spear the middle of the chest
 of Kroismos.
He fell, thunderously, and Meges was stripping
 the armor
from his shoulders, but meanwhile Dolops lunged at
 him, Lampos'
son, a man crafty with the spear and strongest of the
 sons born
to Lampos, Laomedon's son, one skilled in furious fighting.
He from close up stabbed with his spear at the shield
 of Phyleides
in the middle, but the corselet he wore defended
 him, solid
and built with curving plates of metal, which in days
 past Phyleus 530
had taken home from Ephyra and the river Seleëis.
A guest and friend had given him it, lord of men,
 Euphetes,
to carry into the fighting and beat off the attack of the
 enemy,
and now it guarded the body of his son from destruction.
But Meges stabbed with the sharp spear at the uttermost
 summit
of the brazen helmet thick with horse-hair, and tore off
the mane of horse-hair from the helmet, so that it toppled
groundward and lay in the dust in all its new shining of
 purple.
Yet Dolops stood his ground and fought on, in hope still
 of winning,
but meanwhile warlike Menelaos came to stand
 beside Meges, 540
and came from the side and unobserved with his spear,
 and from behind
threw at his shoulder, so the spear tore through his chest
 in its fury
to drive on, so that Dolops reeled and went down, face
 forward.
The two of them swept in to strip away from his
 shoulders
the bronze armor, but Hektor called aloud to his brothers,
the whole lot, but first scolded the son of Hiketaon,
strong Melanippos. He in Perkote had tended his lumbering
cattle, in the days before when the enemy were still
 far off;
but when the oarswept ships of the Danaans came, then
he returned to Ilion, and was a great man among the Trojans, 550

and lived with Priam, who honored him as he honored
 his children.
Now Hektor spoke a word and called him by name
 and scolded him:
"Shall we give way so, Melanippos? Does it mean
 nothing
even to you in the inward heart that your cousin is
 fallen?
Do you not see how they are busied over the armor
 of Dolops?
Come on, then; no longer can we stand far off and
 fight with
the Argives. Sooner we must kill them, or else sheer Ilion
 be stormed utterly by them, and her citizens be
 killed."
He spoke, and led the way, and the other followed, a
 mortal
godlike. But huge Telamonian Aias stirred on the
 Argives: 560
"Dear friends, be men; let shame be in your hearts, and
 discipline,
and have consideration for each other in the strong
 encounters,
since more come through alive when men consider each
 other,
and there is no glory when they give way, nor warcraft
 either."
He spoke, and they likewise grew furious in their defense,
and put his word away in their hearts, and fenced in
 their vessels
in a circle of bronze, but Zeus against them wakened the
 Trojans.
Then Menelaos of the great war cry stirred on
 Antilochos:
"Antilochos, no other Achaian is younger than you are,
nor faster on his feet, nor strong as you are in
 fighting. 570
You could make an outrush and strike down some man
 of the Trojans."
So speaking, he hastened back but stirred Antilochos
 onward,
and he sprang forth from the champions and hefted the
 shining javelin,
glaring round about him, and the Trojans gave way in
 the face
of the man throwing with the spear. And he made no
 vain cast
but struck Hiketaon's son, Melanippos the high-hearted,
in the chest next to the nipple as he swept into the
 fighting.
He fell, thunderously, and darkness closed over
 both eyes.
Antilochos sprang forth against him, as a hound rushes
 against a stricken fawn that as he broke from his
 covert 580
a hunter has shot at, and hit, and broken his limbs'
 strength.
So Antilochos stubborn in battle sprang, Melanippos,
at you, to strip your armor, but did not escape brilliant
 Hektor's
notice, who came on the run through the fighting
 against him.
Antilochus did not hold his ground, although a swift
 fighter,
but fled away like a wild beast who has done some bad
 thing,
one who has killed a hound or an ox-herd tending his
 cattle

and escapes, before a gang of men has assembled
 against him;
so Nestor's son ran away, and after him the Trojans and
 Hektor
with unearthly clamor showered their groaning weapons
 against him. 590
He turned and stood when he got into the swarm of his
 own companions.
But the Trojans in the likeness of ravening lions swept
 on against the ships, and were bringing to accom-
 plishment Zeus' orders,
who wakened always the huge strength in them, dazed
 the courage
of the Argives, and denied their glory, and stirred on the
 others.
Zeus' desire was to give glory to the son of Priam,
Hektor, that he might throw on the curved ships the
 inhuman
weariless strength of fire, and so make completely
 accomplished
the prayer of Thetis. Therefore Zeus of the counsels
 waited
the sight before his eyes of the are, when a single ship
 burned. 600
From thereon he would make the attack of the Trojans
surge back again from the ships, and give the Danaans
 glory.
With this in mind he drove on against the hollow ships
 Hektor,
Priam's son, though Hektor without the god was in fury
and raged, as when destructive fire or spear-shaking Ares
rages among the mountains and dense places of the deep
 forest.
A slaver came out around his mouth, and under the
 lowering
brows his eyes were glittering, the helm on his temples
was shaken and thundered horribly to the fighting of
 Hektor.
Out of the bright sky Zeus himself was working to
 help him 610
and among men so numerous he honored this one man
and glorified him, since Hektor was to have only a
 short life
and already the day of his death was being driven
 upon him
by Pallas Athene through the strength of Achilleus.
 And now
he was probing the ranks of men, and trying to
 smash them,
and made for where there were most men together, and
 the best armor.
But even so he could not break them, for all his fury,
for they closed into a wall and held him, like some towering
huge sea-cliff that lies close along the grey salt water
and stands up against the screaming winds and their
 sudden directions 620
and against the waves that grow to bigness and burst
 up against it.
So the Danaans stood steady against the Trojans, nor
 gave way.
But he, lit about with flame on all sides, charged on
 their numbers
and descended upon them as descends on a fast ship the
 battering
wave storm-bred from beneath the clouds, and the ship
 goes utterly
hidden under the foam, and the dangerous blast of the
 hurricane

thunders against the sail, and the hearts of the seamen
 are shaken
with fear, as they are carried only a little way out of
 death's reach.
So the heart in the breast of each Achaian was troubled.
Hektor came on against them, as a murderous lion on
 cattle 630
who in the low-lying meadow of a great marsh
 pasture
by hundreds, and among them a herdsman who does
 not quite know
how to fight a wild beast off from killing a horn-curved
ox, and keeps pace with the first and the last of the cattle
always, but the lion making his spring at the middle
eats an ox as the rest stampede; so now the Achaians
fled in unearthly terror before father Zeus and Hektor,
all, but he got one only, Periphetes of Mykenai,
beloved son of Kopreus, who for the lord Eurystheus
had gone often with messages to powerful
 Herakles. 640
To him, a meaner father, was born a son who was better
for all talents, in the speed of his feet and in battle
and for intelligence counted among the first in Mykenai.
Thereby now higher was the glory he granted to Hektor.
For as he whirled about to get back, he fell over the
 out-rim
of the shield he carried, which reached to his feet to keep
 the spears from him.
Stumbling on this he went over on his back, and the
 helmet
that circled his temples clashed horribly as he
 went down.
Hektor saw it sharply, and ran up and stood beside him,
and stuck the spear into his chest and killed him before
 the eyes 650
of his dear friends, who for all their sorrowing could do
 nothing
to help their companion, being themselves afraid of
 great Hektor.
Now they had got among the ships, and the ends were
 about them
of the ships hauled up in the first line, but the Trojans
 swarmed
on them. The Argives under force gave back from the
 first line
of their ships, but along the actual shelters they rallied
in a group, and did not scatter along the encampment.
 Shame held them
and fear. They kept up a continuous call to each other,
and beyond others Gerenian Nestor, the Achaians'
 watcher,
supplicated each man by the knees for the sake of his
 parents. 660
"Dear friends, be men; let shame be in your hearts and
 discipline
in the sight of other men, and each one of you remember
his children and his wife, his property and his parents,
whether a man's father and mother live or have died.
 Here now
I supplicate your knees for the sake of those who are
 absent
to stand strongly and not be turned to the terror of
 panic."
So he spoke, and stirred the spirit and heart in each man,
and from their eyes Athene pushed the darkness
 immortal
of mist, and the light came out hard against them
 on both sides

whether they looked from the ships or from the closing of
 battle. 670
They knew Hektor of the great war cry, they knew his
 companions
whether they stood away behind and out of the fighting
 or whether alongside the fast ships they fought in
 the battle.
Nor did it still please great-hearted Aias to stand back
where the other sons of the Achaians had taken position;
 but he went in huge strides up and down the
 decks of the vessels.
He wielded in his hands a great pike for sea fighting,
twenty-two cubits long and joined together by clinchers.
And as a man who is an expert rider of horses
who when he has chosen and coupled four horses out
 of many 680
makes his way over the plain galloping toward a great city
along the travelled road, and many turn to admire him,
men or women, while he steadily and never slipping
jumps and shifts his stance from one to another as they
 gallop;
so Aias ranged crossing from deck to deck of the
 fast ships
taking huge strides, and his voice went always up to
 the bright sky
as he kept up a terrible bellow and urged on the Danaans
 to defend their ships and their shelters, while on
 the other side Hektor
would not stay back among the mass of close-armored
 Trojans,
but as a flashing eagle makes his plunge upon other 690
flying birds as these feed in a swarm by a river,
whether these be geese or cranes or swans long-throated,
 so Hektor steered the course of his outrush
 straight for a vessel
with dark prows, and from behind Zeus was pushing
 him onward
hard with his big hand, and stirred on his people be-
 side him.
Now once again a grim battle was fought by the vessels;
 you would say that they faced each other un-
 bruised, unwearied
in the fighting, from the speed in which they went for
 each other.
This was the thought in each as they struggled on: the
 Achaians
thought they could not get clear of the evil, but must
 perish, 700
while the heart inside each one of the Trojans was
 hopeful
to set Fire to the ships and kill the fighting men of Achaia.
 With such thoughts in mind they stood up to fight
 with each other.
Hektor caught hold of the stern of a grand, fast-running,
 seafaring ship, that once had carried Protesilaos
to Troy, and did not take him back to the land of his
 fathers.
It was around his ship that now Achaians and Trojans cut
 each other down at close quarters, nor any longer
 had patience for the volleys exchanged from bows
 and javelins
but stood up close against each other, matching their
 fury, 710
and fought their battle with sharp hatchets and axes,
 with great swords
and with leaf-headed pikes, and many magnificent
swords were scattered along the ground, black-thonged,
 heavy-hilted,

sometimes dropping from the hands, some glancing from
 shoulders
of men as they fought, so the ground ran black with
 blood. Hektor
would not let go of the stern of a ship where he had
 caught hold of it
but gripped the sternpost in his hands and called to the
 Trojans:
"Bring Fire, and give single voice to the clamor of battle.
 Now Zeus has given us a day worth all the rest of
 them: the ships' capture, the ships that came here
 in spite of the gods' will 720
and have visited much pain on us, by our counsellors'
 cowardice
who would not let me fight by the grounded ships,
 though I wanted to,
but held me back in restraint, and curbed in our fighters.
 But Zeus of the wide brows, though then he fouled
 our intentions,
comes now himself to urge us on and give us encouragement."
He spoke, and they thereby came on harder against the
 Argives.
Their volleys were too much for Aias, who could hold no
 longer
his place, but had to give back a little, expecting to die
 there,
back to the seven-foot midship, and gave up the high
 deck of the balanced
ship. There he stood and waited for them, and with his
 pike always 730
beat off any Trojan who carried persistent fire from the
 vessels.
He kept up a terrible bellowing, and urged on the
 Danaans:
"Friends and fighting men of the Danaans, henchmen
 of Ares,
be men now, dear friends, remember your furious valor.
Do we think there are others who stand behind us to
 help us?
Have we some stronger wall that can rescue men from
 perdition?
We have no city built strong with towers lying near us,
 within which
we could defend ourselves and hold off this host that
 matches us.
We hold position in this plain of the close-armored Trojans,
bent back against the sea, and far from the land of our
 fathers. 740
Salvation's light is in our hands' work, not the mercy of
 battle."
He spoke, and came forward with his sharp spear, raging
 for battle.
And whenever some Trojan crashed against the hollow ships
with burning fire, who sought to wake the favor of Hektor,
Aias would wait for him and then stab with the long pike
and so from close up wounded twelve in front of the vessels.

from Book XXIII

*Book XXIII describes the funeral of Patroclus, and the games held to
commemorate the event. In the following passage, the "painful" box-
ing and wrestling contests give Homer a chance to use vivid similes to
describe the action. In lines 692–693, he compares one of the boxers to
a fish jumping in the water; note the extra touch of atmosphere provided
by the description of the water as "roughened by the north wind." The
two wrestlers, with their arms interlocked, are likened to the rafters of a
high house.*

Peleides went back among the great numbers
of Achaians assembled, when he had listened to all the
 praise spoken
by Neleus' son, and set forth the prizes for the painful
 boxing.
He led out into the field and tethered there a hard-working
six-year-old unbroken jenny, the kind that is hardest
to break; and for the loser set out a two-handled goblet.
 He stood upright and spoke his word out among
 the Argives:
"Son of Atreus, and all you other strong-greaved
 Achaians,
we invite two men, the best among you, to contend for
 these prizes
with their hands up for the blows of boxing. He whom
 Apollo 660
grants to outlast the other, and all the Achaians witness it,
let him lead away the hard-working jenny to his own
 shelter.
The beaten man shall take away the two-handled goblet."
He spoke, and a man huge and powerful, well skilled in
 boxing,
rose up among them; the son of Panopeus, Epeios.
He laid his hand on the hard-working jenny, and
 spoke out:
"Let the man come up who will carry off the two-handled
 goblet.
I say no other of the Achaians will beat me at boxing
and lead off the jenny. I claim I am the champion. Is it
not enough that I fall short in battle? Since it could
 not be 670
ever, that a man could be a master in every endeavor.
For I tell you this straight out, and it will be a thing
 accomplished.
I will smash his skin apart and break his bones on each
 other.
Let those who care for him wait nearby in a huddle
 about him
to carry him out, after my fists have beaten him under."
So he spoke, and all of them stayed stricken to silence.
 Alone Euryalos stood up to face him, a godlike
man, son of lord Mekisteus of the seed of Talaos;
of him who came once to Thebes and the tomb of
 Oidipous after
his downfall, and there in boxing defeated all the
 Kadmeians. 680
The spear-famed son of Tydeus was his second, and
 talked to him
in encouragement, and much desired the victory for him.
First he pulled on the boxing belt about his waist,
 and then
gave him the thongs carefully cut from the hide of a ranging
ox. The two men, girt up, strode into the midst of the
 circle
and faced each other, and put up their ponderous hands
 at the same time
and closed, so that their heavy arms were crossing each
 other,
and there was a fierce grinding of teeth, the sweat began
 to run
everywhere from their bodies. Great Epeios came in, and
 hit him
as he peered out from his guard, on the cheek, and he
 could no longer 690
keep his feet, but where he stood the glorious limbs gave.
As in the water roughened by the north wind a fish jumps
in the weeds of the beach-break, then the dark water
 closes above him,

so Euryalos left the ground from the blow, but great-
hearted Epeios
took him in his arms and set him upright, and his true
companions
stood about him, and led him out of the circle, feet dragging
as he spat up the thick blood and rolled his head over on
one side.
He was dizzy when they brought him back and set him
among them.
But they themselves went and carried off the two-
handled goblet.
Now Peleides set forth the prizes for the third contest,
for the painful wrestling, at once, and displayed them
before the Danaans.
There was a great tripod, to set over fire, for the winner.
The Achaians among themselves valued it at the
worth of twelve oxen.
But for the beaten man he set in their midst a woman
skilled in much work of her hands, and they rated
her at four oxen.
He stood upright and spoke his word out among the
Argives:
"Rise up, two who would endeavor this prize." So
he spoke
and presently there rose up huge Telamonian Aias,
and resourceful Odysseus rose, who was versed in every
advantage.
The two men, girt up, strode out into the midst of the
circle,
and grappled each other in the hook of their heavy arms,
as when
rafters lock, when a renowned architect has fitted them
in the roof of a high house to keep out the force of the
winds' spite.
Their backs creaked under stress of violent hands that
tugged them
stubbornly, and the running sweat broke out, and raw
places
frequent all along their ribs and their shoulders broke out
bright red with blood, as both of them kept up their hard
efforts
for success and the prize of the wrought tripod. Neither
Odysseus
was able to bring Aias down or throw him to the
ground, nor
could Aias, but the great strength of Odysseus held out
against him. 720
But now as they made the strong-greaved Achaians begin
to be restless,
at last great Telamonian Aias said to the other:
"Son of Laertes and seed of Zeus, resourceful Odysseus:
lift me, or I will lift you. All success shall be as
Zeus gives it."
He spoke, and heaved; but not forgetting his craft Odysseus
caught him with a stroke behind the hollow of the knee,
and unnerved
the tendons, and threw him over backward, so that
Odysseus
fell on his chest as the people gazed upon them and
wondered.
Next, brilliant much-enduring Odysseus endeavored to
lift him
and budged him a little from the ground, but still could
not raise him 730
clear, then hooked a knee behind, so that both of them
went down
together to the ground, and lay close, and were soiled in
the dust. Then

they would have sprung to their feet once more and
wrestled a third fall,
had not Achilleus himself stood up and spoken to
stop them:
"Wrestle no more now; do not wear yourselves out and
get hurt.
You have both won. Therefore take the prizes in equal
division
and retire, so the rest of the Achaians can have their
contests."

 700

from Book XXIV

This extract from Book XXIV of the Iliad *comprises the last great
episode in the work, the confrontation between Priam, king of Troy, and
the Greek hero Achilles over the body of Priam's son Hector. Throughout
the long scene, Homer maintains the heroic dignity of his characters while
allowing us to identify with them as human beings. After the pathos of
Priam's appeal, Achilles' immediate reaction is as perfectly appropriate
as it is unexpected. His own changing moods, veering from philosophical
resignation to sudden anger to tenderness, seem to run the gamut of emo-
tional response. How typical it is, too, of a Homeric hero to be practical
enough after such an intense encounter to think of dinner and supervise
its serving.*

[Priam] made straight for the dwelling
where Achilleus the beloved of Zeus was sitting. He
found him
inside, and his companions were sitting apart, as
two only, 710
Automedon the hero and Alkimos, scion of Ares,
were busy beside him. He had just now got through with
his dinner,
with eating and drinking, and the table still stood by. Tall
Priam
came in unseen by the other men and stood close be-
side him
and caught the knees of Achilleus in his arms, and kissed
the hands
that were dangerous and manslaughtering and had killed
so many
of his sons. As when dense disaster closes on one who
has murdered 480
a man in his own land, and he comes to the country of
others,
to a man of substance, and wonder seizes on those who
behold him,
so Achilleus wondered as he looked on Priam, a godlike
man, and the rest of them wondered also, and looked at
each other.
But now Priam spoke to him in the words of a suppliant:
"Achilleus like the gods, remember your father, one who
is of years like mine, and on the door-sill of sorrowful
old age.
And they who dwell nearby encompass him and af-
flict him,
nor is there any to defend him against the wrath, the
destruction.
Yet surely he, when he hears of you and that you are still
living, 490
is gladdened within his heart and all his days he is
hopeful
that he will see his beloved son come home from the
Troad.
But for me, my destiny was evil. I have had the noblest
of sons in Troy, but I say not one of them is left to me.
Fifty were my sons, when the sons of the Achaians
came here.

Nineteen were born to me from the womb of a single
 mother,
and other women bore the rest in my palace; and of these
violent Ares broke the strength in the knees of most
 of them,
but one was left me who guarded my city and people,
 that one
you killed a few days since as he fought in defense of his
 country, 500
Hektor; for whose sake I come now to the ships of the
 Achaians
to win him back from you, and I bring you gifts beyond
 number.
Honor then the gods, Achilleus, and take pity upon me
remembering your father, yet I am still more pitiful;
I have gone through what no other mortal on earth has
 gone through;
I put my lips to the hands of the man who has killed my
 children.''

So he spoke, and stirred in the other a passion of grieving
for his own father. He took the old man's hand and
 pushed him
gently away, and the two remembered, as Priam sat
 huddled
at the feet of Achilleus and wept close for manslaughter-
 ing Hektor 510
and Achilleus wept now for his own father, now again
for Patroklos. The sound of their mourning moved in the
 house. Then
when great Achilleus had taken full satisfaction in sorrow
and the passion for it had gone from his mind and body,
 thereafter
he rose from his chair, and took the old man by the hand,
 and set him
on his feet again, in pity for the grey head and the grey
 beard,
and spoke to him and addressed him in winged words:
 "Ah, unlucky,
surely you have had much evil to endure in your spirit.
How could you dare to come alone to the ships of the
 Achaians
and before my eyes, when I am one who have killed in
 such numbers 520
such brave sons of yours? The heart in you is iron.
 Come, then,
and sit down upon this chair, and you and I will even let
our sorrows lie still in the heart for all our grieving. There
 is not
any advantage to be won from grim lamentation.
Such is the way the gods spun life for unfortunate
 mortals,
that we live in unhappiness, but the gods themselves
 have no sorrows.
There are two urns that stand on the door-sill of Zeus.
 They are unlike
for the gifts they bestow: an urn of evils, an urn of
 blessings.
If Zeus who delights in thunder mingles these and be-
 stows them
on man, he shifts, and moves now in evil, again in good
 fortune. 530
But when Zeus bestows from the urn of sorrows, he
 makes a failure
of man, and the evil hunger drives him over the shining
earth, and he wanders respected neither of gods nor
 mortals.
Such were the shining gifts given by the gods to Peleus

from his birth, who outshone all men beside for his riches
and pride of possession, and was lord over the
 Myrmidons. Thereto
the gods bestowed an immortal wife on him, who was
 mortal.
But even on him the god piled evil also. There was not
any generation of strong sons born to him in his
 great house
but a single all-untimely child he had, and I give him 540
no care as he grows old, since far from the land of my
 fathers
I sit here in Troy, and bring nothing but sorrow to you
 and your children.
And you, old sir, we are told you prospered once; for
 as much
as Lesbos, Makar's hold, confines to the north above it
and Phrygia from the north confines, and enormous
 Hellespont,
of these, old sir, you were lord once in your wealth and
 your children.
But now the Uranian gods brought us, an affliction
 upon you,
forever there is fighting about your city, and men killed.
But bear up, nor mourn endlessly in your heart, for there
 is not
anything to be gained from grief for your son; you
 will never 550
bring him back; sooner you must go through yet another
 sorrow.''

In answer to him again spoke aged Priam the godlike:
"Do not, beloved of Zeus, make me sit on a chair while
 Hektor
lies yet forlorn among the shelters; rather with all speed
give him back, so my eyes may behold him, and accept
 the ransom
we bring you, which is great. You may have joy of it, and
 go back
to the land of your own fathers, since once you have
 permitted me
to go on living myself and continue to look on the
 sunlight.''

Then looking darkly at him spoke swift-footed Achilleus:
"No longer stir me up, old sir. I myself am minded 560
to give Hektor back to you. A messenger came to me
 from Zeus,
my mother, she who bore me, the daughter of the sea's
 ancient.
I know you, Priam, in my heart, and it does not
 escape me
that some god led you to the running ships of the
 Achaians.
For no mortal would dare come to our encampment,
 not even
one strong in youth. He could not get by the pickets, he
 could not
lightly unbar the bolt that secures our gateway. Therefore
you must not further make my spirit move in my
 sorrows,
for fear, old sir, I might not let you alone in my shelter,
suppliant as you are; and be guilty before the god's
 orders.'' 570
He spoke, and the old man was frightened and did as he
 told him.
The son of Peleus bounded to the door of the house like
 a lion,
nor went alone, but the two henchmen followed
 attending,

the hero Automedon and Alkimos, those whom Achilleus
honored beyond all companions after Patroklos dead.
 These two
now set free from under the yoke the mules and the horses,
and led inside the herald, the old king's crier, and
 gave him
a chair to sit in, then from the smooth-polished
 mule wagon
lifted out the innumerable spoils for the head of Hektor
but left inside it two great cloaks and a finespun tunic 580
to shroud the corpse in when they carried him home.
 Then Achilleus
called out to his serving-maids to wash the body and
 anoint it
all over; but take it first aside, since otherwise Priam
might see his son and in the heart's sorrow not hold in
 his anger
at the sight, and the deep heart in Achilleus be shaken to
 anger;
that he might not kill Priam and be guilty before the
 god's orders.
Then when the serving-maids had washed the corpse and
 anointed it
with olive oil, they threw a fair great cloak and a tunic
about him, and Achilleus himself lifted him and laid him
on a litter, and his friends helped him lift it to the smooth-
 polished 590
mule wagon. He groaned then, and called by name on his be-
 loved companion:
"Be not angry with me, Patroklos, if you discover,
though you be in the house of Hades, that I gave back
 great Hektor
to his loved father, for the ransom he gave me was not
 unworthy.
I will give you your share of the spoils, as much as is fitting."
So spoke great Achilleus and went back into the shelter
and sat down on the elaborate couch from which he had
 risen,
against the inward wall, and now spoke his word to
 Priam:
"Your son is given back to you, aged sir, as you asked it.
He lies on a bier. When dawn shows you yourself shall
 see him 600
as you take him away. Now you and I must remember
 our supper.
For even Niobe, she of the lovely tresses, remembered
to eat, whose twelve children were destroyed in her
 palace,
six daughters, and six sons in the pride of their youth,
 whom Apollo
killed with arrows from his silver bow, being angered
with Niobe, and shaft-showering Artemis killed the
 daughters;
because Niobe likened herself to Leto of the fair coloring
and said Leto had borne only two, she herself had
 borne many;
but the two, though they were only two, destroyed all
 those others.
Nine days long they lay in their blood, nor was there
 anyone 610
to bury them, for the son of Kronos made stones out of
the people; but on the tenth day the Uranian gods
 buried them.
But she remembered to eat when she was worn out with
 weeping.
And now somewhere among the rocks, in the lonely
 mountains,
in Sipylos, where they say is the resting place of the
 goddesses

who are nymphs, and dance beside the waters of Acheloios,
there, stone still, she broods on the sorrows that the gods
 gave her.
Come then, we also, aged magnificent sir, must
 remember
to eat, and afterwards you may take your beloved
 son back
to Ilion, and mourn for him; and he will be much
 lamented." 620
So spoke fleet Achilleus and sprang to his feet and
 slaughtered
a gleaming sheep, and his friends skinned it and
 butchered it fairly,
and cut up the meat expertly into small pieces, and
 spitted them,
and roasted all carefully and took off the pieces.
Automedon took the bread and set it out on the table
in fair baskets, while Achilleus served the meats. And
 thereon
they put their hands to the good things that lay ready
 before them.
But when they had put aside their desire for eating and
 drinking,
Priam, son of Dardanos, gazed upon Achilleus,
 wondering
at his size and beauty, for he seemed like an outright vision 630
of gods. Achilleus in turn gazed on Dardanian Priam
and wondered, as he saw his brave looks and listened to
 him talking.
But when they had taken their fill of gazing one on the
 other,
first of the two to speak was the aged man, Priam the
 godlike:
"Give me, beloved of Zeus, a place to sleep presently,
 so that
we may even go to bed and take the pleasure of sweet
 sleep.
For my eyes have not closed underneath my lids since
 that time
when my son lost his life beneath your hands, but
 always
I have been grieving and brooding over my numberless
 sorrows
and wallowed in the muck about my courtyard's
 enclosure. 640
Now I have tasted food again and have let the gleaming
wine go down my throat. Before, I had tasted nothing."
He spoke, and Achilleus ordered his serving-maids and
 companions
to make a bed in the porch's shelter and to lay upon it
fine underbedding of purple, and spread blankets above it
and fleecy robes to be an over-all covering. The maid-
 servants
went forth from the main house, and in their hands held
 torches
and set to work, and presently had two beds made.
 Achilleus
of the swift feet now looked at Priam and said, sarcastic:
"Sleep outside, aged sire and good friend, for fear some
 Achaian 650
might come in here on a matter of counsel, since they keep
 coming
and sitting by me and making plans; as they are sup-
 posed to.
But if one of these come through the fleeting black night
 should notice you,
he would go straight and tell Agamemnon, shepherd of
 the people,
and there would be delay in the ransoming of the body.

But come, tell me this and count off for me exactly
how many days you intend for the burial of great Hektor.
Tell me, so I myself shall stay still and hold back the
people.”
In answer to him again spoke aged Priam the godlike:
“If you are willing that we accomplish a complete
funeral 660
for great Hektor, this, Achilleus, is what you could do
and give
me pleasure. For you know surely how we are penned in
our city,
and wood is far to bring in from the hills, and the Trojans
are frightened
badly. Nine days we would keep him in our palace and
mourn him,
and bury him on the tenth day, and the people feast
by him,
and on the eleventh day we would make the grave-
barrow for him,
and on the twelfth day fight again; if so we must do.”

Then in turn swift-footed brilliant Achilleus
answered him:
“Then all this, aged Priam, shall be done as you ask it.
I will hold off our attack for as much time as you
bid me.” 670

So he spoke, and took the aged king by the right hand
at the wrist, so that his heart might have no fear. Then
these two,
Priam and the herald who were both men of close counsel,
slept in the place outside the house, in the porch’s shelter;
but Achilleus slept in the inward corner of the strong-
built shelter,
and at his side lay Briseis of the fair coloring.

Excerpt from *The Iliad* by Homer, translated by Richard Lattimore, copyright 1951 from Books XVIII, XXIII, XV, XXIV. Copyright 1951, University of Chicago Press. Reprinted by permission.

READING 3
from SAPPHO (C. 612–570 BCE)

The chief subject of Sappho’s poetry is love, but her work also gives voice to the contrasting and equally painful agonies of loneliness and passionate commitment. Perhaps her greatest quality is her ability to probe the depths of her own responses and by describing them to understand them. Poems such as these reveal a reluctant resignation that comes only from profound self-understanding.

“Alone”

The moon and Pleiades
are set. Midnight,
and time spins away.
I lie in bed, alone.

“Seizure”

To me he seems like a god
as he sits facing you and
hears you near as you speak
softly and laugh
in a sweet echo that jolts
the heart in my ribs. For now
as I look at you my voice
is empty and
can say nothing as my tongue
cracks and slender fire is quick 10

under my skin. My eyes are dead
to light, my ears
pound, and sweat pours over me.
I convulse, paler than grass,
and feel my mind slip as I
go close to death.

“To Eros”

From all the offspring
of the earth and heaven
love is the most precious.

“The Virgin”

Like a sweet apple reddening on the high
tip of the topmost branch and forgotten
by the pickers—no, beyond their reach.
Like a hyacinth crushed in the mountains
by shepherds; lying trampled on the earth
yet blooming purple.

“Age and Light”

Here are fine gifts, children,
O friend, singer on the clear tortoise lyre,
all my flesh is wrinkled with age,
my black hair has faded to white,
my legs can no longer carry me,
once nimble as a fawn’s,
but what can I do?
It cannot be undone,
No more than can pink-armed Dawn
not end in darkness on earth, 10
or keep her love for Tithonos,
who must waste away;
yet I love refinement, and beauty and light
are for me the same as desire for the sun.

Excerpt from *Sappho and the Greek Lyric Poets*, translated by Willis Barnstone, copyright © 1962, 1967, 1988 by Willis Barnstone. Used by permission of Schocken Books, a division of Random House, Inc.

READING 4
from HERACLITUS OF EPHESUS (C. 535–475 BCE)

The following fragments consist of observations and teachings of the Presocratic philosopher Heraclitus, many of which must have been passed down orally by his pupils.

This world . . . was created by no god or man; it was, it is, and it always will be an undying fire which kindles and extinguishes itself in a regular pattern. All things change place with fire and fire with all things, as money does with goods and goods with money.

Heraclitus says that everything is in motion, nothing stands fast. Comparing things to the flow of a river, he says that you cannot step twice into the same stream . . . for new water is always flowing down. By the violence and swiftness of its change, it tears itself away, yet renews itself again. It has no past and no future; it is in advance and in retreat at the same time. . . . The way up and the way down are the same. [Both have the same beginning and end.]

Know that conflict is universal, that justice is strife; through strife all things arise and disappear. Men do not realize that a thing which thrusts out in opposite directions is at unity with itself; harmony is a matter of opposing tensions, like those in a bow or a lyre. . . . Conflict is the father and ruler of all.

READING 5

from Parmenides of Elea (c. 510 bce)

Parmenides set out his ideas in a poem divided into three parts: the Prologue, the Way of Truth, and the Way of Opinion. A collection of lines from this work has survived and we reproduce here excerpts from the Way of Truth. The second extract is one of the longest of all Presocratic fragments in existence.

Now I shall show you—do you listen well and mark my words—the only roads of inquiry which lead to knowledge. The first is that of him who says, "That which exists is real; that it should not exist is impossible." This is the reasonable road, for Truth herself makes it straight. The other road is his who says, "There are, of necessity, things which do not exist,"—and this, I tell you, is a fantastic and impossible path. For how could you know about something which does not exist? a sheer impossibility. You could not even talk about it, for thought and existence are the same.

There remains only to tell of the way of him who maintains that Being does exist; and on this road there are many signs that Being is without beginning or end. It is the only thing that is; it is all-inclusive and immoveable, without an end. It has no past and no future; its only time is *now*, for it is one continuous whole. What sort of creation could you find for it? From what could it have grown, and how? I cannot let you say or think that it came from nothing, for we cannot say or think that something which does not exist actually does so [i.e., if we say that Being comes from Not-being, we imply that Not-being exists, which is self-contradictory]. What necessity could have roused up existence from nothingness? And, if it had done so, why at one time rather than at another? No; we must either admit that Being exists completely, or that it does not exist at all. Moreover, the force of my argument makes us grant that nothing can arise from Being except Being. Thus iron Law does not relax to allow creation and destruction, but holds all things firm in her grasp.

Excerpt from *The Classics in Translation*, Volume I, edited by Paul L. Mac-Kendrick and Herbert M. Howe, copyright 1952. Reprinted by permission of The University of Wisconsin Press.

READING 6

from Herodotus (484–420 bce), History of the Persian Wars, Book VIII

In Book VIII of his History *Herodotus describes Xerxes' invasion of Greece in 480 bce. In the course of their journey southward toward Athens, the Persian troops arrive at the narrow mountain pass of Thermopylae in central Greece. There a small band of Greek soldiers blocks the road and threatens to hold up the entire Persian army. In his justly famous account of the battle Herodotus summons up a world of meaning through carefully chosen details depicting the Spartan soldiers preparing for battle. As the fighting intensifies, so does the tension of the account. With simplicity and dignity Herodotus leads us to the final desperate struggle over the body of the dead Greek commander, one of the first great prose passages in Western literature.*

The Persian army was now close to the pass, and the Greeks, suddenly doubting their power to resist, held a conference to consider the advisability of retreat. It was proposed by the Peloponnesians generally that the army should fall back upon the Peloponnese and hold the Isthmus; but when the Phocians and Locrians expressed their indignation at this suggestion, Leonidas gave his voice for staying where they were and sending, at the same time, an appeal for reinforcements to the various states of the confederacy, as their numbers were inadequate to cope with the Persians.

During the conference Xerxes sent a man on horseback to ascertain the strength of the Greek force and to observe what the troops were doing. He had heard before he left Thessaly that a small force was concentrated here, led by the Lacedaemonians under Leonidas of the house of Heracles. The Persian rider approached the camp and took a thorough survey of all he could see—which was not, however, the whole Greek army; for the men on the further side of the wall which, after its reconstruction, was now guarded, were out of sight. He did, nonetheless, carefully observe the troops who were stationed on the outside of the wall. At that moment these happened to be the Spartans, and some of them were stripped for exercise, while others were combing their hair. The Persian spy watched them in astonishment; nevertheless he made sure of their numbers, and of everything else he needed to know, as accurately as he could, and then rode quietly off. No one attempted to catch him, or took the least notice of him.

Back in his own camp he told Xerxes what he had seen. Xerxes was bewildered; the truth, namely that the Spartans were preparing themselves to kill and to be killed according to their strength, was beyond his comprehension, and what they were doing seemed to him merely absurd. Accordingly he sent for Demaratus, the son of Ariston, who had come with the army, and questioned him about the spy's report, in the hope of finding out what the unaccountable behavior of the Spartans might mean. "Once before," Demaratus said, "when we began our march against Greece, you heard me speak of these men. I told you then how I saw this enterprise would turn out, and you laughed at me. I strive for nothing, my lord, more earnestly than to observe the truth in your presence; so hear me once more. These men have come to fight us for possession of the pass, and for that struggle they are preparing. It is the common practice of the Spartans to pay careful attention to their hair when they are about to risk their lives. But I assure you that if you can defeat these men and the rest of the Spartans who are still at home, there is no other people in the world who will dare to stand firm or lift a hand against you. You have now to deal with the finest kingdom in Greece, and with the bravest men."

Xerxes, unable to believe what Demaratus said, asked further how it was possible that so small a force could fight with his army. "My lord," Demaratus replied, "treat me as a liar, if what I have foretold does not take place." But still Xerxes was unconvinced.

For four days Xerxes waited, in constant expectation that the Greeks would make good their escape; then, on the fifth, when still they had made no move and their continued presence seemed mere impudent and reckless folly, he was seized with rage and sent forward the Medes and Cissians with orders to take them alive and bring them into his presence. The Medes charged, and in the struggle which ensued many fell; but others took their places, and in spite of terrible losses refused to be beaten off. They made it plain enough to anyone, and not least to the king himself, that he had in his army many men, indeed, but few soldiers. All day the battle continued; the Medes, after their rough handling, were at length withdrawn and their place was taken by Hydarnes and his picked Persian troops—the King's—Immortals who advanced to the attack in full confidence of bringing the business to a quick and easy end. But, once engaged, they were no more successful than the Medes had been; all went as before, the two armies fighting in a confined space, the Persians using shorter spears than the Greeks and having no advantage from their numbers.

On the Spartan side it was a memorable fight; they were men who understood war pitted against an inexperienced enemy, and amongst the feints they employed was to turn

their backs in a body and pretend to be retreating in confusion, whereupon the enemy would come on with a great clatter and roar, supposing the battle won; but the Spartans, just as the Persians were on them, would wheel and face them and inflict in the new struggle innumerable casualties. The Spartans had their losses too, but not many. At last the Persians, finding that their assaults upon the pass, whether by divisions or by any other way they could think of, were all useless, broke off the engagement and withdrew. Xerxes was watching the battle from where he sat; and it is said that in the course of the attacks three times, in terror for his army, he leapt to his feet.

Next day the fighting began again, but with no better success for the Persians, who renewed their onslaught in the hope that the Greeks, being so few in number, might be badly enough disabled by wounds to prevent further resistance. But the Greeks never slackened; their troops were ordered in divisions corresponding to the states from which they came, and each division took its turn in the line except the Phocian, which had been posted to guard the track over the mountains. So when the Persians found that things were no better for them than on the previous day, they once more withdrew.

How to deal with the situation Xerxes had no idea; but while he was still wondering what his next move should be, a man from Malis got himself admitted to his presence. This was Ephialtes, the son of Eurydemus, and he had come, in hope of a rich reward, to tell the king about the track which led over the hills to Thermopylae—and the information he gave was to prove the death of the Greeks who held the pass.

Later on, Ephialtes, in fear of the Spartans, fled to Thessaly, and during his exile there a price was put upon his head at an assembly of the Amphictyons at Pylae. Some time afterwards he returned to Anticyra, where he was killed by Athenades of Trachis. In point of fact, Athenades killed him not for his treachery but for another reason, which I will explain further on; but the Spartans honored him nonetheless on that account. According to another story, which I do not at all believe, it was Onetes, the son of Phanagoras, a native of Carystus, and Corydallus of Anticyra who spoke to Xerxes and showed the Persians the way round by the mountain track; but one may judge which account is the true one, first by the fact that the Amphictyons, who must surely have known everything about it, set a price not upon Onetes and Corydallus but upon Ephialtes of Trachis, and, secondly, by the fact that there is no doubt that the accusation of treachery was the reason for Ephialtes' flight. Certainly Onetes, even though he was not a native of Malis, might have known about the track, if he had spent much time in the neighborhood—but it was Ephialtes, and no one else, who showed the Persians the way, and I leave his name on record as the guilty one.

Xerxes found Ephialtes' offer most satisfactory. He was delighted with it, and promptly gave orders to Hydarnes to carry out the movement with the troops under his command. They left camp about the time the lamps are lit.

The track was originally discovered by the Malians of the neighborhood; they afterwards used it to help the Thessalians, taking them over it to attack Phocis at the time when the Phocians were protected from invasion by the wall which they had built across the pass. That was a long time ago, and no good ever came of it since. The track begins at the Asopus, the stream which flows through the narrow gorge, and, running along the ridge of the mountain—which, like the track itself, is called Anopaea—ends at Alpenus, the first Locrian settlement as one comes from Malis, near the rock known as Black-Buttocks' Stone and the seats of the Cercopes. Just here is the narrowest part of the pass.

This then, was the mountain track which the Persians took, after crossing the Asopus. They marched throughout the night, with the mountains of Oeta on their right hand and those of Trachis on their left. By early dawn they were at the summit of the ridge, near the spot where the Phocians, as I mentioned before, stood on guard with a thousand men, to watch the track and protect their country. The Phocians were ready enough to undertake this service, and had, indeed, volunteered for it to Leonidas, knowing that the pass at Thermopylae was held as I have already described.

The ascent of the Persians had been concealed by the oak-woods which cover this part of the mountain range, and it was only when they reached the top that the Phocians became aware of their approach; for there was not a breath of wind, and the marching feet made a loud swishing and rustling in the fallen leaves. Leaping to their feet, the Phocians were in the act of arming themselves when the enemy was upon them. The Persians were surprised at the sight of troops preparing to resist; they had not expected any opposition—yet here was a body of men barring their way. Hydarnes asked Ephialtes who they were, for his first uncomfortable thought was that they might be Spartans; but on learning the truth he prepared to engage them. The Persian arrows flew thick and fast, and the Phocians, supposing themselves to be the main object of the attack, hurriedly withdrew to the highest point of the mountain, where they made ready to face destruction. The Persians, however, with Ephialtes and Hydarnes paid no further attention to them, but passed on along the descending track with all possible speed.

The Greeks at Thermopylae had their first warning of the death that was coming with the dawn from the seer Megistias, who read their doom in the victims of sacrifice; deserters, too, had begun to come in during the night with news of the Persian movement to take them in the rear, and, just as day was breaking, the look-out men had come running from the hills. At once a conference was held, and opinions were divided, some urging that they must on no account abandon their post, others taking the opposite view. The result was that the army split; some dispersed, the men returning to their various homes, and others made ready to stand by Leonidas.

There is another account which says that Leonidas himself dismissed a part of his force, to spare their lives, but thought it unbecoming for the Spartans under his command to desert the post which they had originally come to guard. I myself am inclined to think that he dismissed them when he realized that they had no heart for the fight and were unwilling to take their share of the danger; at the same time honor forbade that he himself should go. And indeed by remaining at his post he left a great name behind him, and Sparta did not lose her prosperity, as might otherwise have happened; for right at the outset of the war the Spartans had been told by the oracle, when they asked for advice, that either their city must be laid waste by the foreigner or one of their kings be killed. The prophecy was in hexameter verse and ran as follows:

Hear your fate, O dwellers in Sparta of the wide spaces;
Either your famed, great town must be sacked by Perseus'
 sons.
Or, if that be not, the whole land of Lacedaemon
Shall mourn the death of a king of the house of Heracles,
For not the strength of lions or of bulls shall hold him,
Strength against strength; for he has the power of Zeus,
And will not be checked till one of these two he has
 consumed.

I believe it was the thought of this oracle, combined with his wish to lay up for the Spartans a treasure of fame in which no other city should share, that made Leonidas dismiss those troops; I do not think that they deserted, or went off without orders, because of a difference of opinion. Moreover, I am strongly supported in this view by the case of Megistias, the seer from Acarnania who foretold the coming doom by his

inspection of the sacrificial victims: this man—he was said to be descended from Melampus—was with the army, and quite plainly received orders from Leonidas to quit Thermopylae, to save him from sharing the army's fate. But he refused to go, sending away instead an only son of his, who was serving with the forces.

Thus it was that the confederate troops, by Leonidas' orders, abandoned their posts and left the pass, all except the Thespians and the Thebans who remained with the Spartans. The Thebans were detained by Leonidas as hostages very much against their will—unlike the loyal Thespians, who refused to desert Leonidas and his men, but stayed, and died with them. They were under the command of Demophilus the son of Diadromes.

In the morning Xerxes poured a libation to the rising sun, and then waited till about the time of the filling of the marketplace, when he began to move forward. This was according to Ephialtes' instructions, for the way down from the ridge is much shorter and more direct than the long and circuitous ascent. As the Persian army advanced to the assault, the Greeks under Leonidas, knowing that the fight would be their last, pressed forward into the wider part of the pass much farther than they had done before; in the previous days' fighting they had been holding the wall and making sorties from behind it into the narrow neck, but now they left the confined space and battle was joined on more open ground. Many of the invaders fell; behind them the company commanders plied their whips, driving the men remorselessly on. Many fell into the sea and were drowned, and still more were trampled to death by their friends. No one could count the number of the dead. The Greeks, who knew that the enemy were on their way round by the mountain track and that death was inevitable, fought with reckless desperation, exerting every ounce of strength that was in them against the invader. By this time most of their spears were broken, and they were killing Persians with their swords.

In the course of that fight Leonidas fell, having fought like a man indeed. Many distinguished Spartans were killed at his side—their names, like the names of all the three hundred, I have made myself acquainted with, because they deserve to be remembered. Amongst the Persian dead, too, were many men of high distinction—for instance, two brothers of Xerxes, Habrocomes and Hyperanthes, both of them sons of Darius by Artanes' daughter Phratagune.

There was a bitter struggle over the body of Leonidas; four times the Greeks drove the enemy off, and at last by their valor succeeded in dragging it away. So it went on, until the fresh troops with Ephialtes were close at hand; and then, when the Greeks knew that they had come, the character of the fighting changed. They withdrew again into the narrow neck of the pass, behind the walls, and took up a position in a single compact body—all except the Thebans—on the little hill at the entrance to the pass, where the stone lion in memory of Leonidas stands today. Here they resisted to the last, with their swords, if they had them, and, if not, with their hands and teeth, until the Persians, coming on from the front over the ruins of the wall and closing in from behind, finally overwhelmed them.

Of all the Spartans and Thespians who fought so valiantly on that day, the most signal proof of courage was given by the Spartan Dieneces. It is said that before the battle he was told by a native of Trachis that, when the Persians shot their arrows, there were so many of them that they hid the sun. Dieneces, however, quite unmoved by the thought of the terrible strength of the Persian army, merely remarked: "This is pleasant news that the stranger from Trachis brings us: for if the Persians hide the sun, we shall have our battle in the shade." He is said to have left on record other sayings, too, of a similar kind, by which he will be remembered. After Dieneces the greatest distinction was won by the two Spartan brothers, Alpheus and

Maron, the sons of Orsiphantus; and of the Thespians the man to gain the highest glory was a certain Dithyrambus, the son of Harmatides.

The dead were buried where they fell, and with them the men who had been killed before those dismissed by Leonidas left the pass. Over them is this inscription, in honor of the whole force:

> Four thousand here from Pelops' land
> Against three million once did stand.

The Spartans have a special epitaph; it runs:

> Go tell the Spartans, you who read:
> We took their orders, and are dead.

For the seer Megistias there is the following:

> I was Megistias once, who died
> When the Mede passed Spercheius' tide.
> I knew death near, yet would not save
> Myself, but share the Spartans' grave.

CHAPTER 3

READING 7
SOPHOCLES (496–406 BCE), OEDIPUS THE KING (429 BCE)

Sophocles' famous play, which we reproduce in its entirety, recounts the tragic downfall of Oedipus, king of Thebes, fated even before birth to kill his father and marry his mother. In the course of the action he is transformed from the confident ruler of the first scene to the self-blinded helpless beggar of the play's conclusion. The inexorable drive of the action is accomplished in a series of dramatic encounters: Oedipus with the Thebans; Oedipus and Teiresias; Oedipus and Creon; Oedipus and his wife Jocasta; the arrival of the first messenger with news that Jocasta understands only too well; the arrival of the second messenger, the old servant, who finally opens Oedipus's eyes to the truth.

When at last all is clear, by a powerful stroke of Sophoclean irony, Oedipus blinds himself. The entire play is, in fact, marked by the use of what is called dramatic irony. The term is used to describe situations or speeches that have one meaning for the characters in the play but a very different one for the audience. Thus when in the opening scene Oedipus tells the chorus "None there is among you as sick as I," unknown to him his statement has a terrible truth. Similarly, in the central scene of the play Jocasta pours scorn on the warnings of oracles and prophets; we know, although she does not, that her own words contradict themselves and that everything she claims to be false is in fact true.

The end of the play is a gradual unwinding of the tension. As the broken king prepares to go into exile, the chorus reminds us of the instability of success and happiness, leaving us to interpret for ourselves the moral of Oedipus's fate.

CHARACTERS

OEDIPUS, *king of Thebes*
A PRIEST
CREON, *brother-in-law of Oedipus*
CHORUS *of Theban elders*
TEIRESIAS, *a prophet*

JOCASTA, *sister of Creon, wife of Oedipus*
MESSENGER
SERVANT of Laius, *father of Oedipus*
SECOND MESSENGER
(silent) ANTIGONE and ISMENE, *daughters of Oedipus*

SCENE. *Before the palace of Oedipus at Thebes. In front of the large central doors, an altar; and an altar near each of the two side doors. On the altar steps are seated suppliants—old men, youths, and young boys—dressed in white tunics and cloaks, their hair bound with white fillets. They have laid on the altars olive branches wreathed with wool-fillets.*

The old PRIEST OF ZEUS *stands alone facing the central doors of the palace. The doors open, and* OEDIPUS, *followed by two attendants who stand at either door, enters and looks about.*

OEDIPUS O children, last born stock of ancient
 Cadmus,
 What petitions are these you bring to me
 With garlands on your suppliant olive branches?
 The whole city teems with incense fumes,
 Teems with prayers for healing and with groans.
 Thinking it best, children, to hear all this
 Not from some messenger, I came myself,
 The world renowned and glorious Oedipus.
 But tell me, aged priest, since you are fit
 To speak before these men, how stand you here, 10
 In fear or want? Tell me, as I desire
 To do my all; hard hearted I would be
 To feel no sympathy for such a prayer.
PRIEST O Oedipus, ruler of my land, you see
 How old we are who stand in supplication
 Before your altars here, some not yet strong
 For lengthy flight, some heavy with age,
 Priests, as I of Zeus, and choice young men.
 The rest of the tribe sits with wreathed branches,
 In market places, at Pallas' two temples, 20
 And at prophetic embers by the river.
 The city, as you see, now shakes too greatly
 And cannot raise her head out of the depths
 Above the gory swell. She wastes in blight,
 Blight on earth's fruitful blooms and grazing flocks,
 And on the barren birth pangs of the women.
 The fever god has fallen on the city,
 And drives it, a most hated pestilence
 Through whom the home of Cadmus is made empty.
 Black Hades is enriched with wails and groans. 30
 Not that we think you equal to the gods
 These boys and I sit suppliant at your hearth,
 But judging you first of men in the trials of life,
 And in the human intercourse with spirits:—
 You are the one who came to Cadmus' city
 And freed us from the tribute which we paid
 To the harsh-singing Sphinx. And that you did
 Knowing nothing else, unschooled by us.
 But people say and think it was some god
 That helped you to set our life upright. 40
 Now Oedipus, most powerful of all,
 We all are turned here toward you, we beseech you,
 Find us some strength, whether from one of the gods
 You hear an omen, or know one from a man.
 For the experienced I see will best
 Make good plans grow from evil circumstance.
 Come, best of mortal men, raise up the state.
 Come, prove your fame, since now this land of ours
 Calls you savior for your previous zeal.
 O never let our memory of your reign 50
 Be that we first stood straight and later fell,

 But to security raise up this state.
 With favoring omen once you gave us luck;
 Be now as good again; for if henceforth
 You rule as now, you will be this country's king,
 Better it is to rule men than a desert,
 Since nothing is either ship or fortress tower
 Bare of men who together dwell within.
OEDIPUS O piteous children, I am not ignorant
 Of what you come desiring. Well I know 60
 You are all sick, and in your sickness none
 There is among you as sick as I,
 For your pain comes to one man alone,
 To him and to none other, but my soul
 Groans for the state, for myself, and for you.
 You do not wake a man who is sunk in sleep;
 Know that already I have shed many tears,
 And travelled many wandering roads of thought.
 Well have I sought, and found one remedy;
 And this I did: the son of Menoeceus, 70
 Creon, my brother-in-law, I sent away
 Unto Apollo's Pythian halls to find
 What I might do or say to save the state.
 The days are measured out that he is gone;
 It troubles me how he fares. Longer than usual
 He has been away, more than the fitting time.
 But when he comes, then evil I shall be,
 If all the god reveals I fail to do.
PRIEST You speak at the right time. These men just now
 Signal to me that Creon is approaching. 80
OEDIPUS O Lord Apollo, grant that he may come
 In saving fortune shining as in eye.
PRIEST Glad news he brings, it seems, or else his head
 Would not be crowned with leafy, berried bay.
OEDIPUS We will soon know. He is close enough to hear.—
 Prince, my kinsman, son of Menoeceus,
 What oracle do you bring us from the god?
CREON A good one. For I say that even burdens
 If they chance to turn out right, will all be well.
OEDIPUS Yet what is the oracle? Your present word 90
 Makes me neither bold nor apprehensive.
CREON If you wish to hear in front of this crowd
 I am ready to speak, or we can go within.
OEDIPUS Speak forth to all. The sorrow that I bear
 Is greater for these men than for my life.
CREON May I tell you what I heard from the god?
 Lord Phoebus clearly bids us to drive out,
 And not to leave uncured within this country,
 A pollution we have nourished in our land.
OEDIPUS With what purgation? What kind of
 misfortune? 100
CREON Banish the man, or quit slaughter with slaughter
 In cleansing, since this blood rains on the state.
OEDIPUS Who is this man whose fate the god reveals?
CREON Laius, my lord, was formerly the guide
 Of this our land before you steered this city.
OEDIPUS I know him by hearsay, but I never saw him.
CREON Since he was slain, the god now plainly bids us
 To punish his murderers, whoever they may be.
OEDIPUS Where are they on the earth? How shall we find
 This indiscernible track of ancient guilt? 110
CREON In this land, said Apollo. What is sought
 Can be apprehended; the unobserved escapes.
OEDIPUS Did Laius fall at home on this bloody end?
 Or in the fields, or in some foreign land?
CREON As a pilgrim, the god said, he left his tribe
 And once away from home, returned no more.
OEDIPUS Was there no messenger, no fellow wayfarer
 Who saw, from whom an inquirer might get aid?

CREON They are all dead, save one, who fled in fear
 And he knows only one thing sure to tell. 120
OEDIPUS What is that? We may learn many facts from one
 If we might take for hope a short beginning.
CREON Robbers, Apollo said, met there and killed him
 Not by the strength of one, but many hands.
OEDIPUS How did the robber unless something from here
 Was at work with silver, reach this point of daring?
CREON These facts are all conjecture. Laius dead,
 There rose in evils no avenger for him.
OEDIPUS But when the king had fallen slain, what
 trouble
 Prevented you from finding all this out? 130
CREON The subtle-singing Sphinx made us let go
 What was unclear to search at our own feet.
OEDIPUS Well then, I will make this clear afresh
 From the start. Phoebus was right, you were right
 To take this present interest in the dead.
 Justly it is you see me as your ally
 Avenging alike this country and the god.
 Not for the sake of some distant friends,
 But for myself I will disperse this filth.
 Whoever it was who killed that man 140
 With the same hand may wish to do vengeance on me.
 And so assisting Laius I aid myself.
 But hurry quickly, children, stand up now
 From the altar steps, raising these suppliant boughs.
 Let someone gather Cadmus' people here
 To learn that I will do all, whether at last
 With Phoebus' help we are shown saved or fallen.
PRIEST Come, children, let us stand. We came here
 First for the sake of what this man proclaims.
 Phoebus it was who sent these prophecies 150
 And he will come to save us from the plague.
CHORUS

Strophe A

O sweet-tongued voice of Zeus, in what spirit do you come
From Pytho rich in gold
To glorious Thebes? I am torn on the rack, dread shakes
 my fearful mind,
Apollo of Delos, hail!
As I stand in awe of you, what need, either new
Do you bring to the full for me, or old in the turning
 times of the year?
Tell me, O child of golden Hope, undying
Voice!

Antistrophe A

First on you do I call, daughter of Zeus, undying Athene 160
And your sister who guards our land,
Artemis, seated upon the throne renowned of our circled Place,
And Phoebus who darts afar;
Shine forth to me, thrice warder-off of death;
If ever in time before when ruin rushed upon the state,
The flame of sorrow you drove beyond our bounds, come
 also now.

Strophe B

O woe! Unnumbered that I bear
The sorrows are! My whole host is sick, nor is there a
 sword of thought
To ward off pain. The growing fruits
Of glorious earth wax not, nor women 170
Withstand in childbirth shrieking pangs.
Life on life you may see, which, like the well-
 winged bird,

Faster than stubborn fire, speed
To the strand of the evening god.

Antistrophe B

Unnumbered of the city die.
 Unpitied babies bearing death lie unmoaned on the
 ground.
Grey-haired mothers and young wives
From all sides at the altar's edge
Lift up a wail beseeching, for their mournful woes.
The prayer for healing shines blent with a grieving cry; 180
Wherefore, O golden daughter of Zeus,
Send us your succor with its beaming face.

Strophe C

Grant that fiery Ares, who now with no brazen shield
Flames round me in shouting attack
May turn his back in running flight from our land,
May be borne with fair wind
To Amphitrite's great chamber
Or to the hostile port
Of the Thracian surge.
For even if night leaves any ill undone 190
It is brought to pass and comes to be in the day.
O Zeus who bear the fire
And rule the lightning's might,
Strike him beneath your thunderbolt with death!

Antistrophe C

O lord Apollo, would that you might come and scat-
 ter forth
Untamed darts from your twirling golden bow;
Bring succor from the plague; may the flashing
Beams come of Artemis,
With which she glances through the Lycian hills.
Also on him I call whose hair is held in gold, 200
Who gives a name to this land,
Bacchus of winy face, whom maidens hail!
Draw near with your flaming Maenad band
And the aid of your gladsome torch
Against the plague, dishonored among the gods.

OEDIPUS You pray; if for what you pray you would be
 willing
 To hear and take my words, to nurse the plague,
 You may get succor and relief from evils.
 A stranger to this tale I now speak forth,
 A stranger to the deed, for not alone 210
 Could I have tracked it far without some clue,
 But now that I am enrolled a citizen
 Latest among the citizens of Thebes
 To all you sons of Cadmus I proclaim
 Whoever of you knows at what man's hand
 Laius, the son of Labdacus, met his death,
 I order him to tell me all, and even
 If he fears, to clear the charge and he will suffer
 No injury, but leave the land unharmed.
 If someone knows the murderer to be an alien 220
 From foreign soil, let him not be silent;
 I will give him a reward, my thanks besides.
 But if you stay in silence and from fear
 For self or friend thrust aside my command,
 Hear now from me what I shall do for this;
 I charge that none who dwell within this land
 Whereof I hold the power and the throne
 Give this man shelter whoever he may be,
 Or speak to him, or share with him in prayer

Or sacrifice, or serve him lustral rites, 230
But drive him, all, out of your homes, for he
Is this pollution on us, as Apollo
Revealed to me just now in oracle.
I am therefore the ally of the god
And of the murdered man. And now I pray
That the murderer, whether he hides alone
Or with his partners, may, evil coward,
Wear out in luckless ills his wretched life.
I further pray, that, if at my own hearth
He dwells known to me in my own home, 240
I may suffer myself the curse I just now uttered.
And you I charge to bring all this to pass
For me, and for the god, and for our land
Which now lies fruitless, godless, and corrupt.
Even if Phoebus had not urged this affair,
Not rightly did you let it go unpurged
When one both noble and a king was murdered!
You should have sought it out. Since now I reign
Holding the power which he had held before me,
Having the selfsame wife and marriage bed— 250
And if his seed had not met barren fortune
We should be linked by offspring from one mother;
But as it was, fate leapt upon his head.
Therefore in this, as if for my own father
I fight for him, and shall attempt all
Searching to seize the hand which shed that blood,
For Labdacus' son, before him Polydorus,
And ancient Cadmus, and Agenor of old.
And those who fail to do this, I pray the gods
May give them neither harvest from their earth 260
Nor children from their wives, but may they be
Destroyed by a fate like this one, or a worse.
You other Thebans, who cherish these commands,
May Justice, the ally of a righteous cause,
And all the gods be always on your side.
CHORUS By the oath you laid on me, my king, I speak.
I killed not Laius, nor can show who killed him.
Phoebus it was who sent this question to us,
And he should answer who has done the deed.
OEDIPUS Your words are just, but to compel the gods 270
In what they do not wish, no man can do.
CHORUS I would tell what seems to me our second course.
OEDIPUS If there is a third, fail not to tell it too.
CHORUS Lord Teiresias I know, who sees this best
Like lord Apollo; in surveying this,
One might, my lord, find out from him most clearly.
OEDIPUS Even this I did not neglect; I have done it already.
At Creon's word I twice sent messengers.
It is a wonder he has been gone so long.
CHORUS And also there are rumors, faint and old. 280
OEDIPUS What are they? I must search out every tale.
CHORUS They say there were some travellers who
killed him.
OEDIPUS So I have heard, but no one sees a witness.
CHORUS If his mind knows a particle of fear
He will not long withstand such curse as yours.
OEDIPUS He fears no speech who fears not such a deed.
CHORUS But here is the man who will convict the guilty.
Here are these men leading the divine prophet
In whom alone of men the truth is born.
OEDIPUS O you who ponder all, Teiresias, 290
Both what is taught and what cannot be spoken,
What is of heaven and what trod on the earth,
Even if you are blind, you know what plague
Clings to the state, and, master, you alone
We find as her protector and her savior.
Apollo, if the messengers have not told you,

Answered our question, that release would come
From this disease only if we make sure
Of Laius' slayers and slay them in return
Or drive them out as exiles from the land. 300
But you now, grudge us neither voice of birds
Nor any way you have of prophecy.
Save yourself and the state; save me as well.
Save everything polluted by the dead.
We are in your hands; it is the noblest task
To help a man with all your means and powers.
TEIRESIAS Alas! Alas! How terrible to be wise,
Where it does the seer no good. Too well I know
And have forgot this, or would not have come here.
OEDIPUS What is this? How fainthearted you have come! 310
TEIRESIAS Let me go home; it is best for you to bear
Your burden, and I mine, if you will heed me.
OEDIPUS You speak what is lawless, and hateful to the state
Which raised you, when you deprive her of your answer.
TEIRESIAS And I see that your speech does not proceed
In season; I shall not undergo the same.
OEDIPUS Don't by the gods turn back when you are wise,
When all we suppliants lie prostrate before you.
TEIRESIAS And all unwise; I never shall reveal
My evils, so that I may not tell yours. 320
OEDIPUS What do you say? You know, but will not speak?
Would you betray us and destroy the state?
TEIRESIAS I will not hurt you or me. Why in vain
Do you probe this? You will not find out from me.
OEDIPUS Worst of evil men, you would enrage
A stone itself. Will you never speak,
But stay so untouched and so inconclusive?
TEIRESIAS You blame my anger and do not see that
With which you live in common, but upbraid me.
OEDIPUS Who would not be enraged to hear these words 330
By which you now dishonor this our city?
TEIRESIAS Of itself this will come, though I hide it in silence.
OEDIPUS Then you should tell me what it is will come.
TEIRESIAS I shall speak no more. If further you desire,
Rage on in wildest anger of your soul.
OEDIPUS I shall omit nothing I understand
I am so angry. Know that you seem to me
Creator of the deed and worker too
In all short of the slaughter; if you were not blind,
I would say this crime was your work alone. 340
TEIRESIAS Really? Abide yourself by the decree
You just proclaimed, I tell you! From this day
Henceforth address neither these men nor me.
You are the godless defiler of this land.
OEDIPUS You push so bold and taunting in your speech;
And how do you think to get away with this?
TEIRESIAS I have got away. I nurse my strength in truth.
OEDIPUS Who taught you this? Not from your art you
got it.
TEIRESIAS From you. You had me speak against my will.
OEDIPUS What word? Say again, so I may better learn. 350
TEIRESIAS Didn't you get it before? Or do you bait me?
OEDIPUS I don't remember it. Speak forth again.
TEIRESIAS You are the slayer whom you seek, I say.
OEDIPUS Not twice you speak such bitter words
unpunished.
TEIRESIAS Shall I speak more to make you angrier still?
OEDIPUS Do what you will, your words will be in vain.
TEIRESIAS I say you have forgot that you are joined
With those most dear to you in deepest shame
And do not see where you are in sin.
OEDIPUS Do you think you will always say such things
in joy? 360
TEIRESIAS Surely, if strength abides in what is true.

OEDIPUS It does, for all but you, this not for you
Because your ears and mind and eyes are blind.
TEIRESIAS Wretched you are to make such taunts, for soon
All men will cast the selfsame taunts on you.
OEDIPUS You live in entire night, could do no harm
To me or any man who sees the day.
TEIRESIAS Not at my hands will it be your fate to fall.
Apollo suffices, whose concern it is to do this.
OEDIPUS Are these devices yours, or are they Creon's? 370
TEIRESIAS Creon is not your trouble; you are yourself.
OEDIPUS O riches, empire, skill surpassing skill
In all the numerous rivalries of life,
How great a grudge there is stored up against you
If for this kingship, which the city gave,
Their gift, not my request, into my hands—
For this, the trusted Creon, my friend from the start
Desires to creep by stealth and cast me out
Taking a seer like this, a weaver of wiles,
A crooked swindler who has got his eyes 380
On gain alone, but in his art is blind.
Come, tell us, in what clearly are you a prophet?
How is it, when the weave-songed bitch was here
You uttered no salvation for these people?
Surely the riddle then could not be solved
By some chance comer; it needed prophecy.
You did not clarify that with birds
Or knowledge from a god; but when I came,
The ignorant Oedipus, I silenced her,
Not taught by birds, but winning by my wits, 390
Whom you are now attempting to depose,
Thinking to minister near Creon's throne.
I think that to your woe you and that plotter
Will purge the land, and if you were not old
Punishment would teach you what you plot.
CHORUS It seems to us, O Oedipus our king,
Both this man's words and yours were said in anger.
Such is not our need, but to find out
How best we shall discharge Apollo's orders.
TEIRESIAS Even if you are king, the right to answer 400
Should be free to all; of that I too am king.
I live not as your slave, but as Apollo's.
And not with Creon's wards shall I be counted.
I say, since you have taunted even my blindness,
You have eyes, but see not where in evil you are
Nor where you dwell, nor whom you are living with.
Do you know from whom you spring? And you forget
You are an enemy to your own kin
Both those beneath and those above the earth.
Your mother's and father's curse, with double goad 410
And dreaded foot shall drive you from this land.
You who now see straight shall then be blind,
And there shall be no harbor for your cry
With which all Mount Cithaeron soon shall ring,
When you have learned the wedding where you sailed
At home, into no port, by voyage fair.
A throng of other ills you do not know
Shall equal you to yourself and to your children.
Throw mud on this, on Creon, on my voice—
Yet there shall never be a mortal man 420
Eradicated more wretchedly than you.
OEDIPUS Shall these unbearable words be heard from him?
Go to perdition! Hurry! Off, away,
Turn back again and from this house depart.
TEIRESIAS If you had not called me, I should not
have come.
OEDIPUS I did not know that you would speak such folly
Or I would not soon have brought you to my house.
TEIRESIAS And such a fool I am, as it seems to you.

But to the parents who bore you I seem wise.
OEDIPUS What parents? Wait! What mortals gave me birth? 430
TEIRESIAS This day shall be your birth and your
destruction.
OEDIPUS All things you say in riddles and unclear.
TEIRESIAS Are you not he who best can search this out?
OEDIPUS Mock, if you wish, the skill that made me great.
TEIRESIAS This is the very fortune that destroyed you.
OEDIPUS Well, if I saved the city, I do not care.
TEIRESIAS I am going now. You, boy, be my guide.
OEDIPUS Yes, let him guide you. Here you are in the way.
When you are gone you will give no more trouble.
TEIRESIAS I go when I have said what I came to say 440
Without fear of your frown; you cannot destroy me.
I say, the very man whom you long seek
With threats and announcements about Laius' murder—
This man is here. He seems an alien stranger,
But soon he shall be revealed of Theban birth,
Nor at this circumstance shall he be pleased.
He shall be blind who sees, shall be a beggar
Who now is rich, shall make his way abroad
Feeling the ground before him with a staff.
He shall be revealed at once as brother 450
And father to his own children, husband and son
To his mother, his father's kin and murderer.
Go in and ponder that. If I am wrong,
Say then that I know nothing of prophecy.

CHORUS
Strophe A

Who is the man the Delphic rock said with oracular voice
Unspeakable crimes performed with his gory hands?
It is time for him now to speed
His foot in flight, more strong
Than horses swift as the storm.
For girt in arms upon him springs 460
With fire and lightning, Zeus' son
And behind him, terrible,
Come the unerring Fates.

Antistrophe A

From snowy Parnassus just now the word flashed clear
To track the obscure man by every way,
For he wanders under the wild
Forest, and into caves
And cliff rocks, like a bull,
Reft on his way, with care on care
Trying to shun the prophecy 470
Come from the earth's mid-navel;
But about him flutters the ever living doom.

Strophe B

Terrible, terrible things the wise bird-augur stirs.
I neither approve nor deny, at a loss for what to say,
I flutter in hopes and fears, see neither here nor ahead;
For what strife has lain
On Labdacus' sons or Polybus' that I have found ever
before
Or now, whereby I may run for the sons of Labdacus
In sure proof against Oedipus' public fame
As avenger for dark death? 480

Antistrophe B

Zeus and Apollo surely understand and know
The affairs of mortal men, but that a mortal seer
Knows more than I, there is no proof. Though a man

May surpass a man in knowledge,
Never shall I agree, till I see the word true, when men
 blame Oedipus,
For there came upon him once clear the winged maiden
And wise he was seen, by sure test sweet for the state.
So never shall my mind judge him evil guilt.

CREON Men of our city, I have heard dread words
 That Oedipus our king accuses me. 490
 I am here indignant. If in the present troubles
 He thinks that he has suffered at my hands
 One word or deed tending to injury
 I do not crave the long-spanned age of life
 To bear this rumor, for it is no simple wrong
 The damage of this accusation brings me;
 It brings the greatest, if I am called a traitor
 To you and my friends, a traitor to the state.
CHORUS Come now, for this reproach perhaps was forced
 By anger, rather than considered thought. 500
CREON And was the idea voiced that my advice
 Persuaded the prophet to give false accounts?
CHORUS Such was said. I know not to what intent.
CREON Was this accusation laid against me
 From straightforward eyes and straightforward mind?
CHORUS I do not know. I see not what my masters do;
 But here he is now, coming from the house.
OEDIPUS How dare you come here? Do you own a face
 So bold that you can come before my house
 When you are clearly the murderer of this man 510
 And manifestly pirate of my throne?
 Come, say before the gods, did you see in me
 A coward or a fool, that you plotted this?
 Or did you think I would not see your wiles
 Creeping upon me, or knowing, would not ward off?
 Surely your machination is absurd
 Without a crowd of friends to hunt a throne
 Which is captured only by wealth and many men.
CREON Do you know what you do? Hear answer to
 your charges
 On the other side. Judge only what you know. 520
OEDIPUS Your speech is clever, but I learn it ill
 Since I have found you harsh and grievous toward me.
CREON This very matter hear me first explain.
OEDIPUS Tell me not this one thing: you are not false.
CREON If you think stubbornness a good possession
 Apart from judgment, you do not think right.
OEDIPUS If you think you can do a kinsman evil
 Without the penalty, you have no sense.
CREON I agree with you. What you have said is just.
 Tell me what you say you have suffered from me. 530
OEDIPUS Did you, or did you not, advise my need
 Was summoning that prophet person here?
CREON And still is. I hold still the same opinion.
OEDIPUS How long a time now has it been since Laius—
CREON Performed what deed? I do not understand.
OEDIPUS —Disappeared to his ruin at deadly hands.
CREON Far in the past the count of years would run.
OEDIPUS Was this same seer at that time practicing?
CREON As wise as now, and equally respected.
OEDIPUS At that time did he ever mention me? 540
CREON Never when I stood near enough to hear.
OEDIPUS But did you not make inquiry of the murder?
CREON We did, of course, and got no information.
OEDIPUS How is it that this seer did not utter this then?
CREON When I don't know, as now, I would keep still.
OEDIPUS This much you know full well, and so should
 speak:—
CREON What is that? If I know, I will not refuse.

OEDIPUS This: If he had not first conferred with you
 He never would have said that I killed Laius.
CREON If he says this, you know yourself, I think; 550
 I learn as much from you as you from me.
OEDIPUS Learn then: I never shall be found a slayer.
CREON What then, are you the husband of my sister?
OEDIPUS What you have asked is plain beyond denial.
CREON Do you rule this land with her in equal sway?
OEDIPUS All she desires she obtains from me.
CREON Am I with you two not an equal third?
OEDIPUS In just that do you prove a treacherous friend.
CREON No, if, like me, you reason with yourself.
 Consider this fact first: would any man 560
 Choose, do you think, to have his rule in fear
 Rather than doze unharmed with the same power?
 For my part I have never been desirous
 Of being king instead of acting king.
 Nor any other man has, wise and prudent.
 For now I obtain all from you without fear.
 If I were king, I would do much unwilling.
 How then, could kingship sweeter be for me
 Than rule and power devoid of any pain?
 I am not yet so much deceived to want 570
 Goods besides those I profitably enjoy.
 Now I am hailed and gladdened by all men.
 Now those who want from you speak out to me,
 Since all their chances' outcome dwells therein.
 How then would I relinquish what I have
 To get those gains? My mind runs not so bad.
 I am prudent yet, no lover of such plots,
 Nor would I ever endure others' treason.
 And first as proof of this go on to Pytho;
 See if I told you truly the oracle. 580
 Next proof: see if I plotted with the seer;
 If you find so at all, put me to death
 With my vote for my guilt as well as yours.
 Do not convict me just on unclear conjecture.
 It is not right to think capriciously
 The good are bad, nor that the bad are good.
 It is the same to cast out a noble friend,
 I say, as one's own life, which best he loves.
 The facts, though, you will safely know in time,
 Since time alone can show the just man just, 590
 But you can know a criminal in one day.
CHORUS A cautious man would say he has spoken well.
 O king, the quick to think are never sure.
OEDIPUS When the plotter, swift, approaches me in
 stealth
 I too in counterplot must be as swift.
 If I wait in repose, the plotter's ends
 Are brought to pass and mine will then have erred.
CREON What do you want then? To cast me from the land?
OEDIPUS Least of all that. My wish is you should die,
 Not flee to exemplify what envy is. 600
CREON Do you say this? Will you neither trust nor yield?
OEDIPUS [No, for I think that you deserve no trust.]
CREON You seem not wise to me.
OEDIPUS I am for me.
CREON You should be for me too.
OEDIUPUS No, you are evil.
CREON Yes, if you understand nothing.
OEDIPUS Yet I must rule.
CREON Not when you rule badly.
OEDIPUS O city, city! 610
CREON It is my city too, not yours alone.
CHORUS Stop, princes. I see Jocasta coming
 Out of the house at the right time for you.
 With her you must settle the dispute at hand.

JOCASTA O wretched men, what unconsidered feud
　　Of tongues have you aroused? Are you not ashamed,
　　The state so sick, to stir up private ills?
　　Are you not going home? And you as well?
　　Will you turn a small pain into a great?
CREON My blood sister, Oedipus your husband　　　　620
　　Claims he will judge against me two dread ills:
　　Thrust me from the fatherland or take and kill me.
OEDIPUS I will, my wife; I caught him in the act
　　Doing evil to my person with evil skill.
CREON Now may I not rejoice but die accursed
　　If ever I did any of what you accuse me.
JOCASTA O, by the gods, believe him, Oedipus.
　　First, in reverence for his oath to the gods,
　　Next, for my sake and theirs who stand before you.
CHORUS Hear my entreaty, lord. Consider and consent.　630
OEDIPUS What wish should I then grant?
CHORUS Respect the man, no fool before, who now in oath
　　　is strong.
OEDIPUS You know what you desire?
CHORUS I know.
OEDIPUS Say what you mean.
CHORUS Your friend who has sworn do not dishonor
　　By casting guilt for dark report.
OEDIPUS Know well that when you ask this grant from me,
　　You ask my death or exile from the land.
CHORUS No, by the god foremost among the gods,　　　640
　　The Sun, may I perish by the utmost doom
　　Godless and friendless, if I have this in mind.
　　But ah, the withering earth wears down
　　My wretched soul, if to these ills
　　Of old are added ills from both of you.
OEDIPUS Then let him go, though surely I must die
　　Or be thrust dishonored from this land by force.
　　Your grievous voice I pity, not that man's;
　　Wherever he may be, he will be hated.
CREON Sullen you are to yield, as you are heavy　　　650
　　When you exceed in wrath. Natures like these
　　Are justly sorest for themselves to bear.
OEDIPUS Will you not go and leave me?
CREON I am on my way.
　　You know me not, but these men see me just.
CHORUS O queen, why do you delay to bring this man
　　　indoors?
JOCASTA I want to learn what happened here.
CHORUS Unknown suspicion rose from talk, and the unjust
　　　devours.
JOCASTA In both of them?
CHORUS Just so.　　　　　　　　　　　　　　　　660
JOCASTA What was the talk?
CHORUS Enough, enough! When the land is pained
　　It seems to me at this point we should stop.
OEDIPUS Do you see where you have come?
　　　Though your intent
　　Is good, you slacken off and blunt my heart
CHORUS O lord, I have said not once alone,
　　Know that I clearly would be mad
　　And wandering in mind, to turn away
　　You who steered along the right,　　　　　　　　670
　　When she was torn with trouble, our beloved state.
　　O may you now become in health her guide.
JOCASTA By the gods, lord, tell me on what account
　　You have set yourself in so great an anger.
OEDIPUS I shall tell you, wife; I respect you more than
　　　these men.
　　Because of Creon, since he has plotted against me.
JOCASTA Say clearly, if you can; how started the
　　　quarrel?
OEDIPUS He says that I stand as the murderer of Laius.

JOCASTA He knows himself, or learned from someone else?
OEDIPUS No, but he sent a rascal prophet here.　　　680
　　He keeps his own mouth clean in what concerns him.
JOCASTA Now free yourself of what you said, and listen.
　　Learn from me, no mortal man exists
　　Who knows prophetic art for your affairs,
　　And I shall briefly show you proof of this:
　　An oracle came once to Laius. I do not say
　　From Phoebus himself, but from his ministers
　　That his fate would be at his son's hand to die—
　　A child, who would be born from him and me.
　　And yet, as the rumor says, they were strangers,　690
　　Robbers who killed him where three highways meet.
　　But three days had not passed from the child's birth
　　When Laius pierced and tied together his ankles,
　　And cast him by others' hands on a pathless mountain.
　　Therein Apollo did not bring to pass
　　That the child murder his father, nor for Laius
　　The dread he feared, to die at his son's hand.
　　Such did prophetic oracles determine.
　　Pay no attention to them. For the god
　　Will easily make clear the need he seeks.　　　　700
OEDIPUS What wandering of soul, what stirring of mind
　　Holds me, my wife, in what I have just heard!
JOCASTA What care has turned you back that you say this?
OEDIPUS I thought I heard you mention this, that Laius
　　Was slaughtered at the place where three highways meet.
JOCASTA That was the talk. The rumor has not ceased.
OEDIPUS Where is this place where such a sorrow was?
JOCASTA The country's name is Phocis. A split road
　　Leads to one place from Delphi and Daulia.
OEDIPUS And how much time has passed since these
　　　events?　　　　　　　　　　　　　　　　　710
JOCASTA The news was heralded in the city scarcely
　　A little while before you came to rule.
OEDIPUS O Zeus, what have you planned to do to me?
JOCASTA What passion is this in you, Oedipus?
OEDIPUS Don't ask me that yet. Tell me about Laius.
　　What did he look like? How old was he when murdered?
JOCASTA A tall man, with his hair just brushed with white.
　　His shape and form differed not far from yours.
OEDIPUS Alas! Alas! I think unwittingly
　　I have just laid dread curses on my head.　　　　720
JOCASTA What are you saying? I shrink to behold you, lord.
OEDIPUS I am terribly afraid the seer can see.
　　That will be clearer if you say one thing more.
JOCASTA Though I shrink, if I know what you ask, I will
　　　answer.
OEDIPUS Did he set forth with few attendants then,
　　Or many soldiers, since he was a king?
JOCASTA They were five altogether among them. One was
　　　a herald. One chariot bore Laius.
OEDIPUS Alas! All this is clear now. Tell me, my wife,
　　Who was the man who told these stories to you?
JOCASTA One servant, who alone escaped, returned.　　730
OEDIPUS Is he by chance now present in our house?
JOCASTA Not now. Right from the time when he returned
　　To see you ruling and Laius dead,
　　Touching my hand in suppliance, he implored me
　　To send him to fields and to pastures of sheep
　　That he might be farthest from the sight of this city.
　　So I sent him away, since he was worthy
　　For a slave, to bear a greater grant than this.
OEDIPUS How then could he return to us with speed?
JOCASTA It can be done. But why would you order this?　740
OEDIPUS O lady, I fear I have said too much.
　　On this account I now desire to see him.
JOCASTA Then he shall come. But I myself deserve
　　To learn what it is that troubles you, my lord.

OEDIPUS And you shall not be prevented, since my fears
 Have come to such a point. For who is closer
 That I may speak to in this fate than you?
 Polybus of Corinth was my father,
 My mother, Dorian Merope. I was held there
 Chief citizen of all, till such a fate 750
 Befell me—as it is, worthy of wonder,
 But surely not deserving my excitement.
 A man at a banquet overdrunk with wine
 Said in drink I was a false son to my father.
 The weight I held that day I scarcely bore,
 But on the next day I went home and asked
 My father and mother of it. In bitter anger
 They took the reproach from him who had let it fly.
 I was pleased at their actions; nevertheless
 The rumor always rankled; and spread abroad. 760
 In secret from mother and father I set out
 Toward Delphi. Phoebus sent me away ungraced
 In what I came for, but other wretched things
 Terrible and grievous, he revealed in answer;
 That I must wed my mother and produce
 An unendurable race for men to see,
 That I should kill the father who begot me.
 When I heard this response, Corinth I fled
 Henceforth to measure her land by stars alone.
 I went where I should never see the disgrace 770
 Of my evil oracles be brought to pass,
 And on my journey to that place I came
 At which you say this king had met his death.
 My wife, I shall speak the truth to you. My way
 Led to a place close by the triple road.
 There a herald met me, and a man
 Seated on colt-drawn chariot, as you said.
 There both the guide and the old man himself
 Thrust me with driving force out of the path.
 And I in anger struck the one who pushed me, 780
 The driver. Then the old man, when he saw me,
 Watched when I passed, and from his chariot
 Struck me full on the head with double goad.
 I paid him back and more. From this very hand
 A swift blow of my staff rolled him right out
 Of the middle of his seat onto his back.
 I killed them all. But if relationship
 Existed between this stranger and Laius,
 What man now is wretcheder than I?
 What man is cursed by a more evil fate? 790
 No stranger or citizen could now receive me
 Within his home, or even speak to me,
 But thrust me out; and no one but myself
 Brought down these curses on my head.
 The bed of the slain man I now defile
 With hands that killed him. Am I evil by birth?
 Am I not utterly vile if I must flee
 And cannot see my family in my flight
 Nor tread my homeland soil, or else be joined
 In marriage to my mother, kill my father, 800
 Polybus, who sired me and brought me up?
 Would not a man judge right to say of me
 That this was sent on me by some cruel spirit?
 O never, holy reverence of the gods,
 May I behold that day, but may I go
 Away from mortal men, before I see
 Such a stain of circumstance come to me.
CHORUS My lord, for us these facts are full of dread.
 Until you hear the witness, stay in hope.
OEDIPUS And just so much is all I have of hope, 810
 Only to wait until the shepherd comes.
JOCASTA What, then, do you desire to hear him speak?
OEDIPUS I will tell you, if his story is found to be

The same as yours, I would escape the sorrow.
JOCASTA What unusual word did you hear from me?
OEDIPUS You said he said that they were highway robbers
 Who murdered him. Now, if he still says
 The selfsame number, I could not have killed him,
 Since one man does not equal many men.
 But if he speaks of a single lonely traveller, 820
 The scale of guilt now clearly falls to me.
JOCASTA However, know the word was set forth thus
 And it is not in him now to take it back;
 This tale the city heard, not I alone.
 But if he diverges from his previous story,
 Even then, my lord, he could not show Laius' murder
 To have been fulfilled properly. Apollo
 Said he would die at the hands of my own son.
 Surely that wretched child could not have killed him,
 But he himself met death some time before. 830
 Therefore, in any prophecy henceforth
 I would not look to this side or to that.
OEDIPUS Your thoughts ring true, but still let someone go
 To summon the peasant. Do not neglect this.
JOCASTA I shall send without delay. But let us enter.
 I would do nothing that did not please you.

CHORUS
Strophe A

 May fate come on me as I bear
 Holy pureness in all word and deed,
 For which the lofty striding laws were set down,
 Born through the heavenly air, 840
 Whereof the Olympian sky alone the father was;
 No mortal spawn of mankind gave them birth,
 Nor may oblivion ever lull them down;
 Mighty in them the god is, and he does not age.

Antistrophe A

 Pride breeds the tyrant.
 Pride, once overfilled with many things in vain,
 Neither in season nor fit for man,
 Scaling the sheerest height
 Hurls to a dire fate
 Where no foothold is found. 850
 I pray the god may never stop the rivalry
 That works well for the state.
 The god as my protector I shall never cease to hold.

Strophe B

 But if a man goes forth haughty in word or deed
 With no fear of the Right
 Nor pious to the spirits' shrines,
 May evil doom seize him
 For his ill-fated pride,
 If he does not fairly win his gain
 Or works unholy deeds, 860
 Or, in bold folly lays on the sacred profane hands.
 For when such acts occur, what man may boast
 Ever to ward off from his life darts of the gods?
 If practices like these are in respect,
 Why then must I dance the sacred dance?

Antistrophe B

 Never again in worship shall I go
 To Delphi, holy navel of the earth,
 Nor to the temple at Abae,
 Nor to Olympia,
 If these prophecies do not become 870
 Examples for all men.

O Zeus, our king, if so you are rightly called,
Ruler of all things, may they not escape
You and your forever deathless power.
Men now hold light the fading oracles
Told about Laius long ago
And nowhere is Apollo clearly honored;
Things divine are going down to ruin.

JOCASTA Lords of this land, the thought has come to me
 To visit the spirits' shrines, bearing in hand 880
 These suppliant boughs and offerings of incense.
 For Oedipus raises his soul too high
 With all distresses; nor, as a sane man should,
 Does he confirm the new by things of old,
 But stands at the speaker's will if he speaks terrors.
 And so, because my advice can do no more,
 To you, Lycian Apollo—for you are nearest—
 A suppliant, I have come here with these prayers,
 That you may find some pure deliverance for us:
 We all now shrink to see him struck in fear, 890
 That man who is the pilot of our ship.
MESSENGER Strangers, could I learn from one of you
 Where is the house of Oedipus the king?
 Or best, if you know, say where he is himself.
CHORUS This is his house, stranger; he dwells inside;
 This woman is the mother of his children.
MESSENGER May she be always blessed among the blest,
 Since she is the fruitful wife of Oedipus.
JOCASTA So may you, stranger, also be. You deserve
 As much for your graceful greeting. But tell me 900
 What you have come to search for or to show.
MESSENGER Good news for your house and your husband,
 lady.
JOCASTA What is it then? And from whom have you come?
MESSENGER From Corinth. And the message I will tell
 Will surely gladden you and vex you, perhaps.
JOCASTA What is it? What is this double force it holds?
MESSENGER The men who dwell in the Isthmian country
 Have spoken to establish him their king.
JOCASTA What is that? Is not old Polybus still ruling?
MESSENGER Not he. For death now holds him in the tomb. 910
JOCASTA What do you say, old man? Is Polybus dead?
MESSENGER If I speak not the truth, I am ready to die.
JOCASTA O handmaid, go right away and tell your master
 The news. Where are you, prophecies of the gods?
 For this man Oedipus has trembled long,
 And shunned him lest he kill him. Now the man
 Is killed by fate and not by Oedipus.
OEDIPUS O Jocasta, my most beloved wife,
 Why have you sent for me within the house?
JOCASTA Listen to this man, and while you hear him, think 920
 To what have come Apollo's holy prophecies.
OEDIPUS Who is this man? Why would he speak to me?
JOCASTA From Corinth he has come, to announce that your
 father
 Polybus no longer lives, but is dead.
OEDIPUS What do you say, stranger? Tell me this yourself.
MESSENGER If I must first announce my message clearly,
 Know surely that the man is dead and gone.
OEDIPUS Did he die by treachery or chance disease?
MESSENGER A slight scale tilt can lull the old to rest.
OEDIPUS The poor man, it seems, died by disease. 930
MESSENGER And by the full measure of lengthy time.
OEDIPUS Alas, alas! Why then do any seek
 Pytho's prophetic art, my wife, or hear
 The shrieking birds on high, by whose report
 I was to slay my father? Now he lies
 Dead beneath the earth, and here am I
 Who have not touched the blade. Unless in longing

For me he died, and in this sense was killed by me.
Polybus has packed away these oracles
In his rest in Hades. They are now worth nothing. 940
JOCASTA Did I not tell you that some time ago?
OEDIPUS You did, but I was led astray by fear.
JOCASTA Henceforth put nothing of this on your heart.
OEDIPUS Why must I not still shrink from my
 mother's bed?
JOCASTA What should man fear, whose life is ruled by fate,
 For whom there is clear foreknowledge of nothing?
 It is best to live by chance, however you can.
 Be not afraid of marriage with your mother;
 Already many mortals in their dreams
 Have shared their mother's bed. But he who counts 950
 This dream as nothing, easiest bears his life.
OEDIPUS All that you say would be indeed propitious,
 If my mother were not alive. But since she is,
 I still must shrink, however well you speak.
JOCASTA And yet your father's tomb is a great eye.
OEDIPUS A great eye indeed. But I fear her who lives.
MESSENGER Who is this woman that you are afraid of?
OEDIUPUS Merope, old man, with whom Polybus lived.
MESSENGER What is it in her that moves you to fear?
OEDIPUS A dread oracle, stranger, sent by the god. 960
MESSENGER Can it be told, or must no other know?
OEDIPUS It surely can. Apollo told me once
 That I must join in intercourse with my mother
 And shed with my own hands my father's blood.
 Because of this, long since I have kept far
 Away from Corinth—and happily—but yet
 It would be most sweet to see my parents' faces.
MESSENGER Was this your fear in shunning your own city?
OEDIPUS I wished, too, old man, not to slay my father.
MESSENGER Why then have I not freed you from this fear, 970
 Since I have come with friendly mind, my lord?
OEDIPUS Yes, and take thanks from me, which you deserve.
MESSENGER And this is just the thing for which I came,
 That when you got back home I might fare well.
OEDIPUS Never shall I go where my parents are.
MESSENGER My son, you clearly know not what you do.
OEDIPUS How is that, old man? By the gods, let me know.
MESSENGER If for these tales you shrink from going home.
OEDIPUS I tremble lest what Phoebus said comes true.
MESSENGER Lest you incur pollution from your parents? 980
OEDIPUS That is the thing, old man, that always
 haunts me.
MESSENGER Well, do you know that surely you fear
 nothing?
OEDIPUS How so? If I am the son of those who bore me.
MESSENGER Since Polybus was no relation to you.
OEDIPUS What do you say? Was Polybus not my father?
MESSENGER No more than this man here but just so much.
OEDIPUS How does he who begot me equal nothing?
MESSENGER That man was not your father, any more
 than I am.
OEDIPUS Well then, why was it he called me his son?
MESSENGER Long ago he got you as a gift from me. 990
OEDIPUS Though from another's hand, yet so much he
 loved me!
MESSENGER His previous childlessness led him to that.
OEDIPUS Had you bought or found me when you gave me
 to him?
MESSENGER I found you in Cithaeron's folds and glens.
OEDIPUS Why were you travelling in those regions?
MESSENGER I guarded there a flock of mountain sheep.
OEDIPUS Were you a shepherd, wandering for pay?
MESSENGER Yes, and your savior too, child, at that time.
OEDIPUS What pain gripped me, that you took me in
 your arms?

MESSENGER The ankles of your feet will tell you that. 1000

OEDIPUS Alas, why do you mention that old trouble?

MESSENGER I freed you when your ankles were pierced
 together.

OEDIPUS A terrible shame from my swaddling
 clothes I got.

MESSENGER Your very name you got from this misfortune.

OEDIPUS By the gods, did my mother or father do it?
 Speak.

MESSENGER I know not. He who gave you knows better
 than I.

OEDIPUS You didn't find me, but took me from another?

MESSENGER That's right. Another shepherd gave
 you to me.

OEDIPUS Who was he? Can you tell me who he was?

MESSENGER Surely. He belonged to the household of
 Laius. 1010

OEDIPUS The man who ruled this land once long ago?

MESSENGER Just so. He was a herd in that man's service.

OEDIPUS Is this man still alive, so I could see him?

MESSENGER You dwellers in this country should
 know best.

OEDIPUS Is there any one of you who stand before me
 Who knows the shepherd of whom this man speaks?
 If you have seen him in the fields or here,
 Speak forth; the time has come to find this out.

CHORUS I think the man you seek is no one else
 Than the shepherd you were so eager to see before. 1020
 Jocasta here might best inform us that.

OEDIPUS My wife, do you know the man we just ordered
 To come here? Is it of him that this man speaks?

JOCASTA Why ask of whom he spoke? Think nothing of it.
 Brood not in vain on what has just been said.

OEDIPUS It could not be that when I have got such clues,
 I should not shed clear light upon my birth.

JOCASTA Don't, by the gods, investigate this more
 If you care for your own life. I am sick enough.

OEDIPUS Take courage. Even if I am found a slave 1030
 For three generations, your birth will not be base.

JOCASTA Still, I beseech you, hear me. Don't do this.

OEDIPUS I will hear of nothing but finding out the truth.

JOCASTA I know full well and tell you what is best.

OEDIPUS Well, then, this best, for some time now, has given
 me pain.

JOCASTA O ill-fated man, may you never know who
 you are.

OEDIPUS Will someone bring the shepherd to me here?
 And let this lady rejoice in her opulent birth.

JOCASTA Alas, alas, hapless man. I have this alone
 To tell you, and nothing else forevermore. 1040

CHORUS O Oedipus, where has the woman gone
 In the rush of her wild grief? I am afraid
 Evil will break forth out of this silence.

OEDIPUS Let whatever will break forth. I plan to see
 The seed of my descent, however small.
 My wife, perhaps, because a noblewoman
 Looks down with shame upon my lowly birth.
 I would not be dishonored to call myself
 The son of Fortune, giver of the good.
 She is my mother. The years, her other children, 1050
 Have marked me sometimes small and sometimes great.
 Such was I born! I shall prove no other man,
 Nor shall I cease to search out my descent.

CHORUS

Strophe

 If I am a prophet and can know in mind,
 Cithaeron, by tomorrow's full moon

 You shall not fail, by mount Olympus,
 To find that Oedipus, as a native of your land,
 Shall honor you for nurse and mother.
 And to you we dance in choral song because you bring
 Fair gifts to him our king. 1060
 Hail, Phoebus, may all this please you.

Antistrophe

 Who, child, who bore you in the lengthy span of years?
 One close to Pan who roams the mountain woods,
 One of Apollo's bedfellows?
 For all wild pastures in mountain glens to him are dear.
 Was Hermes your father, who Cyllene sways,
 Or did Bacchus, dwelling on the mountain peaks,
 Take you a foundling from some nymph
 Of those by springs of Helicon, with whom he sports
 the most?

OEDIPUS If I may guess, although I never met him, 1070
 I think, elders, I see that shepherd coming
 Whom we have long sought, as in the measure
 Of lengthy age he accords with him we wait for.
 Besides, the men who lead him I recognize
 As servants of my house. You may perhaps
 Know better than I if you have seen him before.

CHORUS Be assured, I know him as a shepherd
 As trusted as any other in Laius' service.

OEDIPUS Stranger from Corinth, I will ask you first,
 Is this the man you said? 1080

MESSENGER You are looking at him.

OEDIPUS You there, old man, look here and answer me
 What I shall ask you. Were you ever with Laius?

SERVANT I was a slave, not bought but reared at home.

OEDIPUS What work concerned you? What was your way
 of life?

SERVANT Most of my life I spent among the flocks.

OEDIPUS In what place most of all was your usual pasture?

SERVANT Sometimes Cithaeron, or the ground nearby.

OEDIPUS Do you know this man before you here at all?

SERVANT Doing what? And of what man do you speak? 1090

OEDIPUS The one before you. Have you ever had congress
 with him?

SERVANT Not to say so at once from memory.

MESSENGER That is no wonder, master, but I shall re-
 mind him,
 Clearly, who knows me not; yet will I know
 That he knew once the region of Cithaeron.
 He with a double flock and I with one
 Dwelt there in company for three whole years
 During the six months' time from spring to fall.
 When winter came, I drove into my fold
 My flock, and he drove his to Laius' pens. 1100
 Do I speak right, or did it not happen so?

SERVANT You speak the truth, though it was long ago.

MESSENGER Come now, do you recall you gave me then
 A child for me to rear as my own son?

SERVANT What is that? Why do you ask me this?

MESSENGER This is the man, my friend, who then was
 young.

SERVANT Go to destruction! Will you not be quiet?

OEDIPUS Come, scold him not, old man. These words
 of yours
 Deserve a scolding more than this man's do.

SERVANT In what, most noble master, do I wrong? 1110

OEDIPUS Not to tell of the child he asks about.

SERVANT He speaks in ignorance, he toils in vain.

OEDIPUS If you will not speak freely, you will under
 torture.

SERVANT Don't, by the gods, outrage an old man like me.
OEDIPUS Will someone quickly twist back this fel-
 low's arms?
SERVANT Alas, what for? What do you want to know?
OEDIPUS Did you give this man the child of whom he asks?
SERVANT I did. Would I had perished on that day!
OEDIPUS You will come to that unless you tell the truth.
SERVANT I come to far greater ruin if I speak. 1120
OEDIPUS This man, it seems, is trying to delay.
SERVANT Not I. I said before I gave it to him.
OEDIPUS Where did you get it? At home or from some-
 one else?
SERVANT It was not mine. I got him from a man.
OEDIPUS Which of these citizens? Where did he live?
SERVANT O master, by the gods, ask me no more.
OEDIPUS You are done for if I ask you this again.
SERVANT Well then, he was born of the house of Laius.
OEDIPUS One of his slaves, or born of his own race?
SERVANT Alas, to speak I am on the brink of horror. 1130
OEDIPUS And I to hear. But still it must be heard.
SERVANT Well, then, they say it was his child.
 Your wife
 Who dwells within could best say how this stands.
OEDIPUS Was it she who gave him to you?
SERVANT Yes, my lord.
OEDIPUS For what intent?
SERVANT So I could put it away.
OEDIPUS When she bore him, the wretch.
SERVANT She feared bad oracles. 1140
OEDIPUS What were they?
SERVANT They said he should kill his father.
OEDIPUS Why did you give him up to this old man?
SERVANT I pitied him, master, and thought he would take
 him away
 To another land, the one from which he came.
 But he saved him for greatest woe. If you are he
 Whom this man speaks of, you were born curst by fate.
OEDIPUS Alas, alas! All things are now come true.
 O light, for the last time now I look upon you;
 I am shown to be born from those I ought not to
 have been. 1150
 I married the woman I should not have married,
 I killed the man whom I should not have killed.

CHORUS

Strophe A

 Alas, generations of mortal men!
 How equal to nothing do I number you in life!
 Who, O who, is the man
 Who bears more of bliss
 Than just the seeming so,
 And then, like a waning sun, to fall away?
 When I know your example,
 Your guiding spirit, yours, wretched Oedipus, 1160
 I call no mortal blest.

Antistrophe A

 He is the one, O Zeus,
 Who peerless shot his bow and won well-fated bliss,
 Who destroyed the hook-clawed maiden,
 The oracle-singing Sphinx,
 And stood a tower for our land from death;
 For this you are called our king,
 Oedipus, are highest-honored here,
 And over great Thebes hold sway.

Strophe B

 And now who is more wretched for men to hear, 1170
 Who so lives in wild plagues, who dwells in pains,
 In utter change of life?
 Alas for glorious Oedipus!
 The selfsame port of rest
 Was gained by bridegroom father and his son,
 How, O how did your father's furrows ever bear you,
 suffering man?
 How have they endured silence for so long?

Antistrophe B

 You are found out, unwilling, by all seeing Time.
 It judges your unmarried marriage where for long
 Begetter and begot have been the same. 1180
 Alas, child of Laius,
 Would I had never seen you.
 As one who pours from his mouth a dirge I wail,
 To speak the truth, through you I breathed new life,
 And now through you I lulled my eye to sleep.

SECOND MESSENGER O men most honored always of
 this land
 What deeds you shall hear, what shall you behold!
 What grief shall stir you up, if by your kinship
 You are still concerned for the house of Labdacus!
 I think neither Danube nor any other river 1190
 Could wash this palace clean, so many ills
 Lie hidden there which now will come to light.
 They were done by will, not fate; and sorrows hurt
 The most when we ourselves appear to choose them.
CHORUS What we heard before causes no little sorrow.
 What can you say which adds to that a burden?
SECOND MESSENGER This is the fastest way to tell
 the tale;
 Hear it: Jocasta, your divine queen, is dead.
CHORUS O sorrowful woman! From what cause did
 she die?
SECOND MESSENGER By her own hand. The most painful
 of the action 1200
 Occurred away, not for your eyes to see.
 But still, so far as I have memory
 You shall learn the sufferings of that wretched woman:
 How she passed on through the door enraged
 And rushed straight forward to her nuptial bed,
 Clutching her hair's ends with both her hands.
 Once inside the doors she shut herself in
 And called on Laius, who has long been dead,
 Having remembrance of their seed of old
 By which he died himself and left her a mother 1210
 To bear an evil brood to his own son.
 She moaned the bed on which by double curse
 She bore husband to husband, children to child.
 How thereafter she perished I do not know,
 For Oedipus burst in on her with a shriek,
 And because of him we could not see her woe.
 We looked on him alone as he rushed around.
 Pacing about, he asked us to give him a sword,
 Asked where he might find the wife no wife,
 A mother whose plowfield bore him and his children. 1220
 Some spirit was guiding him in his frenzy,
 For none of the men who are close at hand did so.
 With a horrible shout, as if led on by someone,
 He leapt on the double doors, from their sockets
 Broke hollow bolts aside, and dashed within.
 There we beheld his wife hung by her neck

From twisted cords, swinging to and fro.
When he saw her, wretched man, he terribly groaned
And slackened the hanging noose. When the
 poor woman
Lay on the ground, what happened was dread to see. 1230
He tore the golden brooch pins from her clothes,
And raised them up, and struck his own eyeballs,
Shouting such words as these "No more shall you
Behold the evils I have suffered and done.
Be dark from now on, since you saw before
What you should not, and knew not what you should."
Moaning such cries, not once but many times
He raised and struck his eyes. The bloody pupils
Bedewed his beard. The gore oozed not in drops,
But poured in a black shower, a hail of blood. 1240
From both of them these woes have broken out,
Not for just one, but man and wife together.
The bliss of old that formerly prevailed
Was bliss indeed, but now upon this day
Lamentation, madness, death, and shame—
No evil that can be named is not at hand.
CHORUS Is the wretched man in any rest now from pain?
SECOND MESSENGER He shouts for someone to open up
 the doors
And show to all Cadmeans his father's slayer,
His mother's—I should not speak the unholy word. 1250
He says he will hurl himself from the land, no more
To dwell cursed in the house by his own curse.
Yet he needs strength and someone who will guide him.
His sickness is too great to bear. He will show it to you
For the fastenings of the doors are opening up,
And such a spectacle you will soon behold
As would make even one who abhors it take pity.
CHORUS O terrible suffering for men to see,
Most terrible of all that I
Have ever come upon. O wretched man, 1260
What madness overcame you, what springing
 daimon
Greater than the greatest for men
Has caused your evil-daimoned fate?
Alas, alas, grievous one,
But I cannot bear to behold you, though I desire
To ask you much, much to find out,
Much to see,
You make me shudder so!
OEDIPUS Alas, alas, I am grieved!
Where on earth, so wretched, shall I go? 1270
Where does my voice fly through the air,
O Fate, where have you bounded?
CHORUS To dreadful end, not to be heard or seen.

Strophe A

OEDIPUS O cloud of dark
That shrouds me off, has come to pass, unspeakable,
Invincible, that blows no favoring blast.
Woe,
O woe again, the goad that pierces me,
Of the sting of evil now, and memory of before.
CHORUS No wonder it is that among so many pains 1280
You should both mourn and bear a double evil.

Antistrophe A

OEDIPUS Ah, friend,
You are my steadfast servant still,
You still remain to care for me, blind.
Alas! Alas!

You are not hid from me; I know you clearly,
And though in darkness, still I hear your voice.
CHORUS O dreadful doer, how did you so endure
To quench your eyes? What daimon drove you on?

Strophe B

OEDIPUS Apollo it was, Apollo, friends 1290
Who brought to pass these evil, evil woes of mine.
The hand of no one struck my eyes but wretched me.
For why should I see,
When nothing sweet there is to see with sight?
CHORUS This is just as you say.
OEDIPUS What more is there for me to see,
My friends, what to love,
What joy to hear a greeting?
Lead me at once away from here,
Lead me away, friends, wretched as I am, 1300
Accursed, and hated most
Of mortals to the gods.
CHORUS Wretched alike in mind and in your fortune,
How I wish that I had never known you.

Antistrophe B

OEDIPUS May he perish, whoever freed me
From fierce bonds on my feet,
Snatched me from death and saved me, doing me no joy
For if then I had died, I should not be
So great a grief to friends and to myself.
CHORUS This also is my wish. 1310
OEDIPUS I would not have come to murder my father,
Nor have been called among men
The bridegroom of her from whom I was born.
But as it is I am godless, child of unholiness,
Wretched sire in common with my father.
And if there is any evil older than evil left,
It is the lot of Oedipus.
CHORUS I know not how I could give you good advice,
For you would be better dead than living blind.
OEDIPUS That how things are was not done for the best— 1320
Teach me not this, or give me more advice.
If I had sight, I know not with what eyes
I could ever face my father among the dead,
Or my wretched mother. What I have done to them
Is too great for a noose to expiate.
Do you think the sight of my children would be a joy
For me to see, born as they were to me?
No, never for these eyes of mine to see.
Nor the city, nor the tower, nor the sacred
Statues of gods; of these I deprive myself, 1330
Noblest among the Thebans, born and bred,
Now suffering everything. I tell you all
To exile me as impious, shown by the gods
Untouchable and of the race of Laius.
When I uncovered such a stain on me,
Could I look with steady eyes upon the people?
No, No! And if there were a way to block
The spring of hearing, I would not forbear
To lock up wholly this my wretched body.
I should be blind and deaf.—For it is sweet 1340
When thought can dwell outside our evils.
Alas, Cithaeron, why did you shelter me?
Why did you not take and kill me at once, so I
Might never reveal to men whence I was born?
O Polybus, O Corinth, O my father's halls,
Ancient in fable, what an outer fairness,
A festering of evils, you raised in me.

For now I am evil found, and born of evil.
O the three paths! Alas the hidden glen,
The grove of oak, the narrow triple roads 1350
That drank from my own hands my father's blood.
Do you remember any of the deeds
I did before you then on my way here
And what I after did? O wedlock, wedlock!
You gave me birth, and then spawned in return
Issue from the selfsame seed; you revealed
Father, brother, children, in blood relation,
The bride both wife and mother, and whatever
Actions are done most shameful among men.
But it is wrong to speak what is not good to do. 1360
By the gods, hide me at once outside our land,
Or murder me, or hurl me in the sea
Where you shall never look on me again.
Come, venture to lay your hands on this wretched man.
Do it. Be not afraid. No mortal man
There is, except myself, to bear my evils.
CHORUS Here is Creon, just in time for what you ask
To work and to advise, for he alone
Is left in place of you to guard the land.
OEDIPUS Alas, what word, then, shall I tell this man? 1370
What righteous ground of trust is clear in me,
As in the past in all I have done him evil?
CREON Oedipus, I have not come to laugh at you,
Nor to reproach you for your former wrongs.

(TO THE ATTENDANTS)

If you defer no longer to mortal offspring,
Respect at least the all-nourishing flame
Of Apollo, lord of the sun. Fear to display
So great a pestilence, which neither earth
Nor holy rain nor light will well receive. 1380
But you, conduct him to the house at once.
It is most pious for the kin alone
To hear and to behold the family sins.
OEDIPUS By the gods, since you have plucked me from
my fear,
Most noble, facing this most vile man,
Hear me one word—I will speak for you, not me.
CREON What desire do you so persist to get?
OEDIPUS As soon as you can, hurl me from this land
To where no mortal man will ever greet me.
CREON I would do all this, be sure. But I want first 1390
To find out from the god what must be done.
OEDIPUS His oracle, at least, is wholly clear;
Leave me to ruin, an impious parricide.
CREON Thus spake the oracle. Still, as we stand
It is better to find out sure what we should do.
OEDIPUS Will you inquire about so wretched a man?
CREON Yes. You will surely put trust in the god.
OEDIPUS I order you and beg you, give the woman
Now in the house such burial as you yourself
Would want. Do last rites justly for your kin. 1400
But may this city never be condemned—
My father's realm—because I live within.
Let me live in the mountains where Cithaeron
Yonder has fame of me, which father and mother
When they were alive established as my tomb.
There I may die by those who sought to kill me.
And yet this much I know, neither a sickness
Nor anything else can kill me. I would not
Be saved from death, except for some dread evil.
Well, let my fate go wherever it may. 1410
As for my sons, Creon, assume no trouble;
They are men and will have no difficulty

Of living wherever they may be.
O my poor grievous daughters, who never knew
Their dinner table set apart from me,
But always shared in everything I touched—
Take care of them for me, and first of all
Allow me to touch them and bemoan our ills.
Grant it, lord,
Grant it, noble. If with my hand I touch them 1420
I would think I had them just as when I could see.

(CREON'S ATTENDANTS BRING IN ANTIGONE AND ISMENE.)

What's that?
By the gods, can it be I hear my dear ones weeping?
And have you taken pity on me, Creon?
Have you had my darling children sent to me?
Do I speak right?
CREON You do. For it was I who brought them here,
Knowing this present joy your joy of old.
OEDIPUS May you fare well. For their coming may the
spirit 1430
That watches over you be better than mine.
My children, where are you? Come to me, come
Into your brother's hands, that brought about
Your father's eyes, once bright, to see like this.
Your father, children, who, seeing and knowing
nothing,
Became a father whence he was got himself.
I weep also for you—I cannot see you—
To think of the bitter life in days to come
Which you will have to lead among mankind.
What citizens' gatherings will you approach? 1440
What festivals attend, where you will not cry
When you go home, instead of gay rejoicing?
And when you arrive at marriageable age,
What man, my daughters, will there be to chance you,
Incurring such reproaches on his head,
Disgraceful to my children and to yours?
What evil will be absent, when your father
Killed his own father, sowed seed in her who bore him,
From whom he was born himself, and equally
Has fathered you whence he himself was born. 1450
Such will be the reproaches. Who then will wed you?
My children, there is no one for you. Clearly
You must decay in barrenness, unwed.
Son of Menoeceus—since you are alone
Left as a father to them, for we who produced them
Are both in ruin—see that you never let
These girls wander as beggars without husbands,
Let them not fall into such woes as mine.
But pity them, seeing how young they are
To be bereft of all except your aid. 1460
Grant this, my noble friend, with a touch of your hand.
My children, if your minds were now mature,
I would give you much advice. But, pray this for me,
To live as the time allows, to find a life
Better than that your siring father had.
CREON You have wept enough here, come, and go inside
the house.
OEDIPUS I must obey, though nothing sweet.
CREON All things are good in their time.
OEDIPUS Do you know in what way I go?
CREON Tell me, I'll know when I hear. 1470
OEDIPUS Send me outside the land.
CREON You ask what the god will do.
OEDIPUS But to the gods I am hated.
CREON Still, it will soon be done.
OEDIPUS Then you agree?

CREON What I think not I would not say in vain.

OEDIPUS Now lead me away.

CREON Come then, but let the children go.

OEDIPUS Do not take them from me.

CREON Wish not to govern all,

 For what you ruled will not follow you through life.

CHORUS Dwellers in native Thebes, behold this Oedipus

 Who solved the famous riddle, was your mightiest man.

 What citizen on his lot did not with envy gaze?

 See to how great a surge of dread fate he has come!

 So I would say a mortal man, while he is watching

 To see the final day, can have no happiness

 Till he pass the bound of life, nor be relieved of pain.

1480

Albert Cook, translation of "Oedipus Rex" in *Oedipus Rex: A Mirror for Greek Drama*, Wadsworth Publishing Co., 1963. With permission of Carol Cook.

READING 8

from PLATO (428–347 BCE), THE DIALOGUES

In the DIALOGUES, Plato claims to record the teachings of Socrates. In almost all of them Socrates appears, arguing with his opponents and presenting his own ideas. How much of Plato's picture of Socrates is historical truth and how much is Plato's invention, however, is debatable. In general, modern opinion supports the view that in the early DIALOGUES Plato tried to preserve something of his master's views and methods, whereas in the later ones he used Socrates as the spokesman for his own ideas.

from the Apology

Plato was present at the trial of Socrates, whose speech in his own defense Plato records in the APOLOGY, one of three works that describe Socrates' last days. After ironic compliments to his accusers on their cleverness, Socrates begs to use his customary plain style; he will merely tell the truth, first explaining the causes of his present predicament.

[Socrates is speaking.] First, then, I ought to reply to the earlier charges against me and my earlier accusers, and then to the later ones. For there have been many accusers for many years, though their charges have been false; and I am more afraid of them than of Anytus and his associates, though they, too, are formidable. But the earlier are still more formidable, since they began when most of you were children to persuade you by false accusations that there is one Socrates, a wise man, who speculates about the heavens above and investigates what is beneath the earth, and who makes the worse appear to be the better case. They who have broadcast this rumor are my really formidable accusers; for their hearers suppose that those who investigate these matters do not believe in the existence of the gods. Then, too, these accusers are many and have been at work for a long time during your most credulous years, when you were children or young men, and when there was no one to answer them. And what makes it hardest of all is that I do not know and cannot name any of them—unless perhaps it be some comic poet. All who by envy and malice persuaded you, some of them actually themselves persuaded, are most difficult to deal with; for I cannot put any of them up here for cross-examination, but must engage in shadow-fighting in my defense, and must ask questions when there is no one to answer me. . . .

Well, then, I must defend myself, and I must try in a short time to clear away a slander that you have accepted for a long time. I hope I may succeed, if success is for your welfare as well as mine. But I think, indeed I know, it will be difficult. Yet God's will be done; and I must make my defense in obedience to the law.

Let us begin at the beginning. What is the accusation that lies behind the slander against me, relying on which Meletus has brought this charge against me? Well, what do the slanderers say? I may phrase their charge as follows: "Socrates is guilty of busying himself with inquiries about subterranean and celestial matters and of making the worse appear the better case and of teaching these matters to others." There, that's the sort of charge; and you yourselves have seen it embodied in the comedy of Aristophanes, in which "Socrates" is presented as suspended aloft and proclaiming that he is "treading on air" and talking a lot of other nonsense about which I understand nothing either great or small. Not that I disprize such knowledge on the part of any one who really knows about such matters; I hope I may not have to defend myself against Meletus on such a charge. But the fact is that I have nothing to do with such matters. I appeal to most of you as witnesses of this fact, and I beg you to speak up to one another, as many as have ever heard me discoursing; tell one another whether any of you have ever heard me talking about such matters in brief or at length. You see; and from their response to this question you will judge that the rest of the gossip about me is of the same cloth.

[And it is not true that Socrates, like the Sophists, undertakes formal instruction and charges fees.]

Perhaps, then, some one of you may ask: "Well, Socrates, what is this occupation of yours? How have these slanders against you arisen? Surely all this talk would not have sprung up if you had not been busying yourself with something out of the ordinary. Tell us then what it is, so that we may not judge you arbitrarily."

Fair enough; and I'll try to show you what has given me this reputation and this slander. Listen. Perhaps I shall seem to some of you to be speaking in jest; but I am going to tell you the whole truth. I got this reputation wholly because of a kind of wisdom. What sort of wisdom? Well, perhaps it is such wisdom as man can make his own; I rather think I have that kind of wisdom. The gentlemen whom I mentioned a moment ago may have a superhuman wisdom, or I don't know what to call it; I don't understand it, and any one who says I do speaks falsely in order to slander me. Now, gentlemen, don't make a disturbance even if I seem to say something extravagant; for the point that I am going to make is not mine, but I am going to refer you to a witness as to my wisdom and its nature who is deserving of your credence: the god of Delphi.

You must have known Chaerephon; he was a boyhood friend of mine, and as your friend he shared in the recent exile of the people and returned with you. And you know what manner of man he was—very impetuous in all his undertakings. Well, he went to Delphi and had the audacity to ask the oracle—now, as I was saying, please don't make a disturbance, gentlemen—he asked the oracle if there was any one wiser than I. And the Pythian priestess answered that there was no one wiser. Since Chaerephon is dead, his brother here will vouch for this statement.

Consider now why I tell you this; I am going to explain to you the source of the slander against me. When I had heard the answer of the oracle, I said to myself: "What in the world does the god mean, and what is this riddle? For I realize that I am wise in nothing, great or small; what then does he mean by saying that I am the wisest? Surely, he does not lie; that is not in keeping with his nature." For a long time I was perplexed; then I resorted to this method of inquiry. I went to one of those men who were reputed to be wise, with the idea of disproving the oracle and of showing it: "Here is one wiser than I; but you said that I was the wisest." Well, after observing and talking with him (I don't need to mention his name; but he was a politician), I had this experience: the man seemed in the opinions of many other men, and especially of himself, to be wise; but he really wasn't. And

then I tried to show him that he thought he was wise, but really wasn't; so I found myself disliked by him and by many of those present. So I left him, and said to myself: "Well, I am wiser than this man. Probably neither of us knows anything noble; but he thinks he knows, whereas he doesn't, while I neither know nor think I know. So I seem to have this slight advantage over him, that I don't think I know what I don't know." Next I went to another man who was reputed to be even wiser, and in my opinion the result was the same; and I got myself disliked by him and by many others.

After that I went to other men in turn, aware of the dislike that I incurred, and regretting and fearing it; yet I felt that God's word must come first, so that I must go to all who had the reputation of knowing anything, as I inquired into the meaning of the oracle. And by the Dog! gentlemen, for I must tell you the truth, this is what happened to me in my quest: those who were in greatest repute were just about the most lacking, while others in less repute were better off in respect to wisdom. I really must expound to you my wanderings, my Herculean labors to test the oracle. After the politicians, I went to the poets, tragic, dithyrambic, and the rest, with the expectation that there I should be caught less wise than they. So picking up those of their poems which seemed to me to be particularly elaborated, I asked them what they meant, so that at the same time I might learn something from them. Now I am ashamed to tell you the truth, but it must be spoken; almost every one present could have talked better about the poems than their authors. So presently I came to know that the poets, too, like the seers and the soothsayers, do what they do not through wisdom but through a sort of genius and inspiration; for the poets, like them, say many fine things without understanding what they are saying. And I noticed also that they supposed because of their poetry that they were wisest of men in other matters in which they were not wise. So I left them, too, believing that I had the same advantage over them that I had over the politicians.

Finally I went to the craftsmen; for I knew that I knew hardly anything, but that I should find them knowing many fine things. And I was not deceived in this; they knew things that I did not know, and in this way they were wiser than I. But even good craftsmen seemed to me to have the same failing as the poets; because of his skill in his craft each one supposed that he excelled also in other matters of the greatest importance; and this lapse obscured their wisdom. So I asked myself whether I would prefer to be as I was, without their wisdom and without their ignorance, or to have both their wisdom and their ignorance; and I answered myself and the oracle that I was better off just as I was.

From this inquiry many enmities have arisen against me, both violent and grievous, as well as many slanders and my reputation of being "wise." For those who are present on each occasion suppose that I have the wisdom that I find wanting in others; but the truth is that only God is wise, and that by that oracle he means to show that human wisdom is worth little or nothing. And by speaking of "Socrates" he appears to use me and my name merely as an example, just as if he were to say, "Mortals, he of you is wisest who, like Socrates, knows that in truth his wisdom is worth nothing." That is why I go about even now, questioning and examining in God's name any man, citizen or stranger, whom I suppose to be wise. And whenever I find that he is not wise, then in vindication of the divine oracle I show him that he is not wise. And by reason of this preoccupation I have no leisure to accomplish any public business worth mentioning or any private business, but I am in extreme poverty because of my service to the god.

Besides this, the young men who follow me about of their own accord, well-to-do and with plenty of leisure, take delight in hearing men put to the test, and often imitate me and put others to test; and then, I believe, they find no lack of men who suppose they know something but who know little or nothing. Then the people who are quizzed by them are angry with me, not with themselves, and say, "There is one Socrates who is a rascal and who corrupts the young." And when any one asks them what this Socrates does or teaches, they don't know and have nothing to say, but so as not to seem to be at a loss they repeat the ready-made charges made against all philosophers, about things celestial and things subterranean, and not believing in gods, and making the worse appear the better case. They wouldn't like to admit the truth, I suppose, which is that they have been shown up as pretenders to knowledge that they do not possess. Now since they are ambitious and energetic and numerous, and are well marshalled and persuasive, they have filled your ears with vehement and oft-repeated slander.

[Turning now to the immediate charges, Socrates has no difficulty in showing their shallowness and insincerity. But he has no illusions about the deep and dangerous prejudice that lies behind them, though he will not therefore abandon his divine and philosophic mission, even to save his life. "For I go about doing nothing but persuading you all, young and old, not to care for your bodies or for money more than for the excellence of your souls, saying that virtue does not come from money, but that it is from virtue that money comes and every other good of man, both private and public."]

Socrates the Gadfly

Now therefore, Athenians, I am far from arguing merely in self-defense, as one might suppose; I am arguing on your behalf, to prevent you from sinning against God by condemning me who am his gift to you. For if you put me to death you will not easily find another like me, one attached by God to the state, which (if I may use a rather ludicrous figure) is like a great and noble steed, but a sluggish one by reason of his bulk and in need of being roused by a gadfly. I am the gadfly, I think, which God has attached to the state; all day and in all places I always light on you, rousing you and persuading you and reproaching each one of you. Another like me you will not easily find, and if you will take my advice you will spare me. But perhaps you may be annoyed by me, like people who are roused from slumber, and may slap at me and kill me, as Anytus advises; and then you would doze through the rest of your lives—unless God in his mercy should send you another gadfly. . . .

Socrates Has Been Deterred by His Inner Voice from Entering Politics

It may seem strange that I go about busying myself with private advice but do not venture to enter public life and advise the state. Well, the reason for this is what you have often and in many places heard me mention: that divine warning, or voice, which has come to me from childhood, and which Meletus ridiculed in his indictment. When it speaks, it always diverts me from something that I am going to do, but never eggs me on; and it is this that opposes my entering politics. And quite rightly, I think; for rest assured, gentlemen, that if I had tried to engage in politics I should have perished long ago without benefiting either you or myself. Now don't be angry at me for telling you the truth; for the fact is that no man who honestly opposes you or any other crowd, trying to prevent the many unjust and lawless deeds that are done in the state, will save his life. He who fights effectively for what is just, if he wants to save his life for even a brief time, must remain a private citizen and not engage in public life.

[After a few further arguments, and a dignified refusal to indulge in emotional appeals to the jury (or judges), Socrates rests his case. He is condemned by a narrow margin; to the

accuser's proposal of death as penalty he is tempted to propose as counter-penalty that he be honored by the support of the state, but is persuaded by friends to offer instead a fine of money, which they will guarantee. By a larger margin, he is condemned to death. The rest of his speech is addressed, first to the judges who voted against him, then to those who voted to acquit him.]

A Prophecy of Judgment

And now, you who have voted to condemn me, I wish to proclaim to you a prophecy; for I am now approaching death, and it is when men are about to die that they are most given to prophecy. I tell you who have brought about my death that immediately after my death there will come upon you a punishment far more grievous, by Zeus, than the punishment that you have inflicted on me. You have voted in the belief that you would rid yourselves of the need of giving an account of your lives; I tell you that the very opposite will befall you. Your accusers will be more numerous, men whom I restrained though you were not aware of them, fiercer because younger; and you will smart the more. If you think that by killing men you are going to prevent any one from reproaching you for not living well, you are not well advised; for that riddance is neither possible nor noble. The noblest and the easiest means of relief is not to cut short the lives of others but to reform your own lives. That, then, is the prophecy that I give to those who have condemned me, before I depart.

To those who voted to acquit me I would gladly talk about what has befallen, while the magistrates are busy and I am not yet on my way to the place where I must die. Do remain, gentlemen, just these few minutes, for nothing prevents our discoursing while it is permitted. For I should like to show you, friends as you are, the meaning of what has happened to me. Why, judges (you I may rightly call judges), something wonderful has befallen me. That customary divine warning of mine has frequently prevented me in time past from acting wrongly, even in trifling matters; but on this occasion, when what would generally be regarded as the worst of evils befell me, it did not oppose me when I was leaving my house in the morning, or when I was on my way hither, or at any point in my speech, though it has often checked me in the midst of other speeches. This time, it has opposed no deed or word of mine in the whole affair. What then am I to suppose to be the explanation? I will tell you: I am inclined to believe that what has happened is a good, and that they are mistaken who suppose death to be an evil. A great token of this has been given me; for my customary sign would have opposed me if I had not been going to fare well.

Let us consider another argument for there being great reason to hope that death is a good. There are two possibilities: either death is nothingness and utter lack of consciousness, or as men say it is a change and migration of the soul from this world to another place. Now if there be no consciousness, but something like a dreamless sleep, death would be a wondrous boon. For if one were to select that night during which he had thus slept without a dream, and were to compare with it all the other nights and days of his life, and were to tell us how many days and nights he has spent in the course of his life, better and more pleasantly than this one, I think that any private citizen, and even the great king, would not find many such days or nights. If then death be of such a nature, I say that it is a boon; for all eternity in this case appears to be only a single night.

But if death is a journey to another place, and if, as men say, it is true that all the dead abide there, what greater good could there be than this? [Socrates pictures his arrival there and his discourse with the great men of old.] Above all, it would be pleasant to spend my time examining the men there, as I have those here, and discovering who among them is wise and who thinks he is but is not. What would one not give to examine the leader of the great expedition against Troy, or Odysseus, or Sisyphus, or countless others, both men and women? It would be an indescribable delight to converse with them, and associate with them, and examine them. For surely they don't put men to death there for asking questions; those who dwell there, besides being happier than men here are in general, are immortal, if what is said is true.

So, my judges, you must be of good cheer about death and be assured of this one truth, that no evil can befall a good man, in life or in death, and his estate is not neglected by the gods; nor have my affairs been determined by chance, but it is clear to me that for me to die and to take my leave of troubles is now for the best. That is why my sign did not divert me, and why I am not really angry with those who condemned me or with my accusers. To be sure, they acted not with the intent of helping me, but thinking to hurt me; for this I have a right to find fault with them.

I have nevertheless this request to beg of them: when my sons are grown up, punish them, gentlemen, and trouble them just as I troubled you, if they seem to be more concerned about money or about anything else than virtue; and if they pretend to be something when they are really nothing, reproach them as I reproached you for wrong concerns and false pretensions. If you do this, my sons and I shall have received justice from you.

But now it is time to depart, for me to die, for you to live. Which of us goes to the better state, God only knows.

Excerpt from *The Classics in Translation*, Volume I, edited by Paul L. MacKendrick and Herbert M. Howe, copyright 1952. Reprinted by permission of The University of Wisconsin Press.

from the Phaedo

The PHAEDO describes Socrates' last hours, spent discussing with his friends the immortality of the soul, and ends with his death. A number of ideas Plato developed further in later works appear in this section. Belief in the immortal nature of the soul is reinforced by a conviction that during life the soul is trapped in the body and thereby prevented from attaining its full powers. This emphasis on the superiority of spiritual to material values had a great appeal for later Christian philosophers.

[Socrates is speaking.] "Now then, I want to give the proof at once, to you as my judges, why I think it likely that one who has spent his life in philosophy should be confident when he is going to die, and have good hopes that he will win the greatest blessings in the next world when he has ended: so Simmias and Cebes my judges, I will try to show how this could be true.

"The fact is, those who tackle philosophy aright are simply and solely practicing dying, practicing death, all the time, but nobody sees it. If this is true, then it would surely be unreasonable that they should earnestly do this and nothing else all their lives, yet when death comes they should object to what they had been so long earnestly practicing."

Simmias laughed at this, and said, "I don't feel like laughing just now, Socrates, but you have made me laugh. I think the many if they heard that would say, 'That's a good one for the philosophers!' And other people in my city would heartily agree that philosophers are really suffering from a wish to die, and now they have found them out, that they richly deserve it!"

"That would be true, Simmias," said Socrates, "except the words 'found out.' For they have not found out in what sense the real philosophers wish to die and deserve to die, and what kind of death it is. Let us say good-bye to them," he went on, "and ask ourselves: Do we think there is such a thing as death?"

"Certainly," Simmias put in.

"Is it anything more than the separation of the soul from the body?" said Socrates. "Death is, that the body separates from the soul, and remains by itself apart from the soul, and the soul, separated from the body, exists by itself apart from the body. Is death anything but that?"

"No," he said, "that is what death is."

"Then consider, my good friend, if you agree with me here, for I think this is the best way to understand the question we are examining. Do you think it the part of a philosopher to be earnestly concerned with what are called pleasures, such as these— eating and drinking, for example?"

"Not at all," said Simmias.

"The pleasures of love, then?"

"Oh no."

"Well, do you suppose a man like that regards the other bodily indulgences as precious? Getting fine clothes and shoes and other bodily adornments—ought he to price them high or low, beyond whatever share of them it is absolutely necessary to have?"

"Low, I think," he said, "if he is a true philosopher."

"Then in general," he said, "do you think that such a man's concern is not for the body, but as far as he can he stands aloof from that and turns towards the soul?"

"I do."

"Then firstly, is it not clear that in such things the philosopher as much as possible sets free the soul from communion with the body, more than other men?"

"So it appears."

"And I suppose, Simmias, it must seem to most men that he who has no pleasure in such things and takes no share in them does not deserve to live, but he is getting pretty close to death if he does not care about pleasures which he has by means of the body."

"Quite true, indeed."

"Well then, what about the actual getting of wisdom? Is the body in the way or not, if a man takes it with him as companion in the search? I mean, for example, is there any truth for men in their sight and hearing? Or as poets are forever dinning into our ears, do we hear nothing and see nothing exactly? Yet if these of our bodily senses are not exact and clear, the others will hardly be, for they are all inferior to these, don't you think so?"

"Certainly," he said.

"Then," said he, "when does the soul get hold of the truth? For whenever the soul tries to examine anything in company with the body, it is plain that it is deceived by it."

"Quite true."

"Then is it not clear that in reasoning, if anywhere, something of the realities becomes visible to it?"

"Yes."

"And I suppose it reasons best when none of these senses disturbs it, hearing or sight, or pain, or pleasure indeed, but when it is completely by itself and says good-bye to the body, and so far as possible has no dealings with it, when it reaches out and grasps that which really is."

"That is true."

"And is it not then that the philosopher's soul chiefly holds the body cheap and escapes from it, while it seeks to be by itself?"

"So it seems."

"Let us pass on, Simmias. Do we say there is such a thing as justice by itself, or not?"

"We do say so, certainly!"

"Such a thing as the good and beautiful?"

"Of course!"

"And did you ever see one of them with your eyes?"

"Never," said he.

"By any other sense of those the body has did you ever grasp them? I mean all such things, greatness, health, strength, in short everything that really is the nature of things whatever they are: Is it through the body that the real truth is perceived? Or is this better—whoever of us prepares himself most completely and most exactly to comprehend each thing which he examines would come nearest to knowing each one?"

"Certainly."

"And would he do that most purely who should approach each with his intelligence alone, not adding sight to intelligence, or dragging in any other sense along with reasoning, but using the intelligence uncontaminated alone by itself, while he tries to hunt out each essence uncontaminated, keeping clear of eyes and ears and, one might say, of the whole body, because he thinks the body disturbs him and hinders the soul from getting possession of truth and wisdom when body and soul are companions—is not this the man, Simmias, if anyone, who will hit reality?"

"Nothing could be more true, Socrates," said Simmias.

"Then from all this," said Socrates, "genuine philosophers must come to some such opinion as follows, so as to make to one another statements such as these: 'A sort of direct path, so to speak, seems to take us to the conclusion that so long as we have the body with us in our enquiry, and our soul is mixed up with so great an evil, we shall never attain sufficiently what we desire, and that, we say, is the truth. For the body provides thousands of busy distractions because of its necessary food; besides, if diseases fall upon us, they hinder us from the pursuit of the real. With loves and desires and fears and all kinds of fancies and much rubbish, it infects us, and really and truly makes us, as they say, unable to think one little bit about anything at any time. Indeed, wars and factions and battles all come from the body and its desires, and from nothing else. For the desire of getting wealth causes all wars, and we are compelled to desire wealth by the body, being slaves to its culture; therefore we have no leisure for philosophy, from all these reasons. Chief of all is that if we do have some leisure, and turn away from the body to speculate on something, in our searches it is everywhere interfering, it causes confusion and disturbance, and dazzles us so that it will not let us see the truth; so in fact we see that if we are ever to know anything purely we must get rid of it, and examine the real things by the soul alone; and then, it seems, after we are dead, as the reasoning shows, not while we live, we shall possess that which we desire, lovers of which we say we are, namely wisdom. For if it is impossible in company with the body to know anything purely, one thing of two follows: either knowledge is possible nowhere, or only after death; for then alone the soul will be quite by itself apart from the body, but not before. And while we are alive, we shall be nearest to knowing, as it seems, if as far as possible we have no commerce or communion with the body which is not absolutely necessary, and if we are not infected with its nature, but keep ourselves pure from it, until God himself shall set us free. And so, pure and rid of the body's foolishness, we shall probably be in the company of those like ourselves, and shall know through our own selves complete incontamination, and that is perhaps the truth. But for the impure to grasp the pure is not, it seems, allowed.' So we must think, Simmias, and so we must say to one another, all who are rightly lovers of learning; don't you agree?"

"Assuredly, Socrates."

"Then," said Socrates, "if this is true, my comrade, there is great hope that when I arrive where I am travelling, there if anywhere I shall sufficiently possess that for which all our study has been pursued in this past life. So the journey which has been commanded for me is made with good hope, and the same for any other man who believes he has got his mind purified, as I may call it."

"Certainly," replied Simmias.

"And is not purification really that which has been mentioned so often in our discussion, to separate as far as possible

the soul from the body, and to accustom it to collect itself together out of the body in every part, and to dwell alone by itself as far as it can, both at this present and in the future, being freed from the body as if from a prison?"

"By all means," said he.

"Then is not this called death—a freeing and separation of soul from body?"

"Not a doubt of that," said he.

"But to set it free, as we say, is the chief endeavor of those who rightly love wisdom, nay of those alone, and the very care and practice of the philosophers is nothing but the freeing and separation of soul from body, don't you think so?"

"It appears to be so."

"Then, as I said at first, it would be absurd for a man preparing himself in his life to be as near as possible to death, so to live, and then when death came, to object?"

"Of course."

"Then in fact, Simmias," he said, "those who rightly love wisdom are practicing dying, and death to them is the least terrible thing in the world. Look at it in this way: If they are everywhere at enmity with the body, and desire the soul to be alone by itself, and if, when this very thing happens, they shall fear and object—would not that be wholly unreasonable? Should they not willingly go to a place where there is good hope of finding what they were in love with all through life (and they loved wisdom), and of ridding themselves of the companion which they hated? When human favorites and wives and sons have died, many have been willing to go down to the grave, drawn by the hope of seeing there those they used to desire, and of being with them; but one who is really in love with wisdom and holds firm to this same hope, that he will find it in the grave, and nowhere else worth speaking of—will he then fret at dying and not go thither rejoicing? We must surely think, my comrade, that he will go rejoicing, if he is really a philosopher; he will surely believe that he will find wisdom in its purity there and there alone. If this is true, would it not be most unreasonable, as I said just now, if such a one feared death?"

"Unreasonable, I do declare," said he.

The PHAEDO ends with one of the most famous of all passages in Greek literature, the description of Socrates' death. His last words have been interpreted in many different ways. Asclepius was the god of healing, and Socrates may perhaps be reminding his friends that death, by releasing the soul, is the final cure for bodily ills.

. . . [He] got up and retired into another room for the bath, and Criton went after him, telling us to wait. So we waited discussing and talking together about what had been said, or sometimes speaking of the great misfortune which had befallen us, for we felt really as if we had lost a father and had to spend the rest of our lives as orphans. When he had bathed, and his children had been brought to see him—for he had two little sons, and one big—and when the women of his family had come, he talked to them before Criton and gave what instructions he wished. Then he asked the women and children to go, and came back to us. It was now near sunset, for he had spent a long time within. He came and sat down after his bath, and he had not talked long after this when the servant of the Eleven came in, and standing by him said, "O Socrates! I have not to complain of you as I do of others, that they are angry with me, and curse me, because I bring them word to drink their potion, which my officers make me do! But I have always found you in this time most generous and gentle, and the best man who ever came here. And now too, I know well you are not angry with me, for you know who are responsible, and you keep it for them. Now you know what I came to tell you, so farewell, and try to bear as well as you can what can't be helped."

Then he turned and was going out, with tears running down his cheeks. And Socrates looked up at him and said, "Farewell to you also, I will do so." Then, at the same time turning to us, "What a nice fellow!" he said. "All the time he has been coming and talking to me, a real good sort, and now how generously he sheds tears for me! Come along, Criton, let's obey him. Someone bring the potion, if the stuff has been ground; if not, let the fellow grind it."

Then Criton said, "But, Socrates, I think the sun is still over the hills, it has not set yet. Yes, and I know of others who, having been told to drink the poison, have done it very late; they had dinner first and a good one, and some enjoyed the company of any they wanted. Please don't be in a hurry, there is time to spare."

But Socrates said, "Those you speak of have very good reason for doing that, for they think they will gain by doing it; and I have good reasons why I won't do it. For I think I shall gain nothing by drinking a little later, only that I shall think myself a fool for clinging to life and sparing when the cask's empty. Come along," he said, "do what I tell you, if you please."

And Criton, hearing this, nodded to the boy who stood near. The boy went out, and after spending a long time, came in with the man who was to give the poison carrying it ground ready in a cup. Socrates caught sight of the man and said, "Here, my good man, you know about these things; what must I do?"

"Just drink it," he said, "and walk about till your legs get heavy, then lie down. In that way the drug will act of itself."

At the same time, he held out the cup to Socrates, and he took it quite cheerfully, Echecrates, not a tremble, not a change in color or looks; but looking full at the man under his brows, as he used to do, he asked him, "What do you say about this drink? What of a libation to someone? Is that allowed, or not?"

He said, "We only grind so much as we think enough for a moderate potion."

"I understand," he said, "but at least, I suppose, it is allowed to offer a prayer to the gods and that must be done, for good luck in the migration from here to there. Then that is my prayer, and so may it be!"

With these words he put the cup to his lips and, quite easy and contented, drank it up. So far most of us had been able to hold back our tears pretty well; but when we saw him begin drinking and end drinking, we could no longer. I burst into a flood of tears for all I could do, so I wrapped up my face and cried myself out; not for him indeed, but for my own misfortune in losing such a man and such a comrade. Criton had got up and gone out even before I did, for he could not hold the tears in. Apollodoros had never ceased weeping all this time, and now he burst out into loud sobs, and by his weeping and lamentations completely broke down every man there except Socrates himself. He only said, "What a scene! You amaze me. That's just why I sent the women away, to keep them from making a scene like this. I've heard that one ought to make an end in decent silence. Quiet yourselves and endure."

When we heard him we felt ashamed and restrained our tears. He walked about, and when he said that his legs were feeling heavy, he lay down on his back, as the man told him to do; at the same time the one who gave him the potion felt him, and after a while examined his feet and legs; then pinching a foot hard, he asked if he felt anything; he said no. After this, again, he pressed the shins; and, moving up like this, he showed us that he was growing cold and stiff. Again he felt him, and told us that when it came to his heart, he would be gone. Already the cold had come nearly as far as the abdomen, when Socrates threw off the covering from his face—for he had covered it over—and said, the last words he uttered, "Criton," he said, "we owe a cock to Asclepios; pay it without fail."

"That indeed shall be done," said Criton. "Have you anything more to say?"

When Criton had asked this, Socrates gave no further answer, but after a little time, he stirred, and the man uncovered him, and his eyes were still. Criton, seeing this, closed the mouth and eyelids.

This was the end of our comrade, Echecrates, a man, as we would say, of all then living we had ever met, the noblest and the wisest and most just.

READING 9

from PLATO (428–347 BCE), THE REPUBLIC, BOOK VII

In THE REPUBLIC *Plato describes his version of the ideal society. Using an elaborate metaphor—the Allegory of the Cave—Plato defines the role of education and the function of the philosopher. We are to imagine a group of people who live, as it were, chained to the ground in an underground cave in such a way that they can see only shadows of reality projected onto the inner wall of the cave by firelight behind them. Since they have been accustomed to seeing nothing but shadows all their lives they have no way of comprehending the real world outside the cave. It is therefore the task of the philosopher, who is already free from the chains of misconception, to liberate the others and educate them in such a way as to set them free from the imprisonment of the senses.*

The Allegory of the Cave

"Next, then," I said, "take the following parable of education and ignorance as a picture of the condition of our nature. Imagine mankind as dwelling in an underground cave with a long entrance open to the light across the whole width of the cave; in this they have been from childhood, with necks and legs fettered, so they have to stay where they are. They cannot move their heads round because of the fetters, and they can only look forward, but light comes to them from fire burning behind them higher up at a distance. Between the fire and the prisoners is a road above their level, and along it imagine a low wall has been built, as puppet showmen have screens in front of their people over which they work their puppets."

"I see," he said.

"See, then, bearers carrying along this wall all sorts of articles which they hold projecting above the wall, statues of men and other living things, made of stone or wood and all kinds of stuff, some of the bearers speaking and some silent, as you might expect."

"What a remarkable image," he said, "and what remarkable prisoners!"

"Just like ourselves," I said. "For, first of all, tell me this: What do you think such people would have seen of themselves and each other except their shadows, which the fire cast on the opposite wall of the cave?"

"I don't see how they could see anything else," said he, "if they were compelled to keep their heads unmoving all their lives!"

"Very well, what of the things being carried along? Would not this be the same?"

"Of course it would."

"Suppose the prisoners were able to talk together, don't you think that when they named the shadows which they saw passing they would believe they were naming things?"

"Necessarily."

"Then if their prison had an echo from the opposite wall, whenever one of the passing bearers uttered a sound, would they not suppose that the passing shadow must be making the sound? Don't you think so?"

"Indeed I do," he said.

"If so," said I, "such persons would certainly believe that there were no realities except those shadows of handmade things."

"So it must be," said he.

"Now consider," said I, "what their release would be like, and their cure from these fetters and their folly; let us imagine whether it might naturally be something like this. One might be released, and compelled suddenly to stand up and turn his neck round, and to walk and look towards the firelight; all this would hurt him, and he would be too much dazzled to see distinctly those things whose shadows he had seen before. What do you think he would say, if someone told him that what he saw before was foolery, but now he saw more rightly, being a bit nearer reality and turned towards what was a little more real? What if he were shown each of the passing things, and compelled by questions to answer what each one was? Don't you think he would be puzzled, and believe what he saw before was more true than what was shown to him now?"

"Far more," he said.

"Then suppose he were compelled to look toward the real light, it would hurt his eyes, and he would escape by turning them away to the things which he was able to look at, and these he would believe to be clearer than what was being shown to him."

"Just so," said he.

"Suppose, now," said I, "that someone should drag him thence by force, up the rough ascent, the steep way up, and never stop until he could drag him out into the light of the sun, would he not be distressed and furious at being dragged; and when he came into the light, the brilliance would fill his eyes and he would not be able to see even one of the things now called real?"

"That he would not," said he, "all of a sudden."

"He would have to get used to it, surely, I think, if he is to see the things above. First he would most easily look at shadows, after that images of mankind and the rest in water, lastly the things themselves. After this he would find it easier to survey by night the heavens themselves and all that is in them, gazing at the light of the stars and moon, rather than by day the sun and the sun's light."

"Of course."

"Last of all, I suppose, the sun; he could look on the sun itself by itself in its own place, and see what it is like, not reflections of it in water or as it appears in some alien setting."

"Necessarily," said he.

"And only after all this he might reason about it, how this is he who provides seasons and years, and is set over all there is in the visible region, and he is in a manner the cause of all things which they saw."

"Yes, it is clear," said he, "that after all that, he would come to this last."

"Very good. Let him be reminded of his first habitation, and what was wisdom in that place, and of his fellow-prisoners there; don't you think he would bless himself for the change, and pity them?"

"Yes, indeed."

"And if there were honors and praises among them and prizes for the one who saw the passing things most sharply and remembered best which of them used to come before and which after and which together, and from these was best able to prophesy accordingly what was going to come—do you believe he would set his desire on that, and envy those who were honored men or potentates among them? Would he not feel as Homer says, and heartily desire rather to be serf of some

landless man on earth and to endure anything in the world, rather than to opine as they did and to live in that way?"

"Yes indeed," said he, "he would rather accept anything than live like that."

"Then again," I said, "just consider; if such a one should go down again and sit on his old seat, would he not get his eyes full of darkness coming in suddenly out of the sun?"

"Very much so," said he.

"And if he should have to compete with those who had been always prisoners, by laying down the law about those shadows while he was blinking before his eyes were settled down—and it would take a good long time to get used to things—wouldn't they all laugh at him and say he had spoiled his eyesight by going up there, and it was not worthwhile so much as to try to go up? And would they not kill anyone who tried to release them and take them up, if they could somehow lay hands on him and kill him?"

"That they would!" said he.

"Then we must apply this image, my dear Glaucon," said I, "to all we have been saying. The world of our sight is like the habitation in prison, the firelight there to the sunlight here, the ascent and the view of the upper world is the rising of the soul into the world of mind; put it so and you will not be far from my own surmise, since that is what you want to hear; but God knows if it is really true. At least, what appears to me is, that in the world of the known, last of all, is the idea of the good, and with what toil to be seen! And seen, this must be inferred to be the cause of all right and beautiful things for all, which gives birth to light and the king of light in the world of sight, and, in the world of mind, herself the queen produces truth and reason; and she must be seen by one who is to act with reason publicly or privately."

"I believe as you do," he said, "insofar as I am able."

"Then believe also, as I do," said I, "and do not be surprised, that those who come thither are not willing to have part in the affairs of men, but their souls ever strive to remain above; for that surely may be expected if our parable fits the case."

"Quite so," he said.

"Well then," said I, "do you think it surprising if one leaving divine contemplations and passing to the evils of men is awkward and appears to be a great fool, while he is still blinking—not yet accustomed to the darkness around him, but compelled to struggle in law courts or elsewhere about shadows of justice, or the images which make the shadows, and to quarrel about notions of justice in those who have never seen justice itself?"

"Not surprising at all," said he.

"But any man of sense," I said, "would remember that the eyes are doubly confused from two different causes, both in passing from light to darkness and from darkness to light; and believing that the same things happen with regard to the soul also, whenever he sees a soul confused and unable to discern anything he would not just laugh carelessly; he would examine whether it had come out of a more brilliant life, and if it were darkened by the strangeness; or whether it had come out of greater ignorance into a more brilliant light, and if it were dazzled with the brighter illumination. Then only would he congratulate the one soul upon its happy experience and way of life, and pity the other; but if he must laugh, his laugh would be a less downright laugh than his laughter at the soul which came out of the light above."

READING 10
from ARISTOTLE (384–322 BCE), NICOMACHEAN ETHICS, BOOK I

I. The End, or the Good, in Practical Activities
Every activity aims at some end.

[1]Every art and every inquiry, and in the same way every action and choice, seem to aim at some good; so that people have well defined the good as that at which all things aim. [2]But there appears to be a certain difference among ends; some are activities, and others certain products distinct from these; and in cases where there are ends aside from the actions, the products are better than the activities. [3]Since there are many actions and arts and sciences, there are also many ends: of medicine, health; of ship-building, a ship; of military science, victory; of household management, wealth. [4]But as many of these as come under some one faculty, as the art of bridle-making and the others concerned with the trappings of a horse come under horsemanship, and the latter as well as every other action concerned with war under military science, and other arts under different faculties in the same way—in all of them the ends of all the leading arts are more choiceworthy than those beneath them, for the latter are pursued for the sake of the former. [5]And it makes no difference whether the activities themselves are the ends of action or something else aside from them, as in the sciences mentioned.

II. The Highest Good, That of Politics
The highest good, or end, is one chosen for its own sake. Its knowledge is of great practical value.

[1]If then there is some end of action which we desire for its own sake, and other things for its sake, and if we do not choose everything for the sake of something else (for this would lead us into an infinite series, so that all desire would be ineffectual and vain), it is clear that this would be the good, and indeed the highest good. [2]Now does the knowledge of this not have a great influence in the conduct of life, and if we knew it would we not, like archers who have a mark to shoot at, be more likely to attain what is required?

It belongs to the leading art of politics.

[3]If so, we must try to define in rough outline what it is and to which of the sciences or faculties it belongs. [4]It would seem to belong to that which is most authoritative, most eminently a leading art, [5]and this seems to be that of politics. [6]This art determines which of the sciences is to exist in each city and which each person is to learn, and to what extent. We perceive, too, that the most honored of the arts come under politics, such as military science, household management, and rhetoric. [7]Since it uses the rest of the sciences and decrees what one must do and refrain from doing, its end would include those of the others, so that it would be the good for man. [8]Even though the end be the same for an individual and a city, that of the city seems to be greater and more perfect, both to achieve and to preserve. It is worth while even for a single individual, but fairer and more divine for a people or a city. This is what our inquiry aims at, being political in nature.

III. Method in Politics and Ethics
The study of politics and ethics is not an exact science.

[1]Our account will be adequate if it is worked out clearly as far as the subject matter at hand allows. The same degree of accuracy

is not to be expected in every philosophical discussion, any more than in every product of handicraft. [2]There is much difference and fluctuation of opinion about what is noble and what is just, which are the subject matter of politics, so that some believe they are so only by custom and not by nature. [3]The same sort of fluctuation exists in the case of what is good, because harm has come to many persons through good things—some have been destroyed by wealth, others by courage. [4]Now for us, since we are speaking on matters of this sort and with principles of this sort, it will be satisfactory to indicate the truth roughly and in outline, and since we are speaking about things which are generally true, it will suffice for our conclusions to be of the same nature. What we say should of course be received in the same spirit, for it is the part of an educated person to seek accuracy in each kind of subject matter to the extent which its nature admits. It seems equally absurd to accept probable arguments from a mathematician and to demand demonstration of an orator. [5]Each man judges capably the things which he knows, and of them he is a good judge—in each particular field, the man who is educated in it, and in general, the man who is generally educated.

Since it depends on experience and on a disposition to follow reason, it is not a suitable study for the young.

This is why a young person is not a proper student of political science, for he is without experience in the activities of life, and theories are derived from these and concerned with them. [6]Furthermore, since he is inclined to follow emotion, it will be vain and unprofitable for him to listen to instruction, because the end is not knowledge but action. [7]It makes no difference whether one is young in age or merely youthful in character, for the defect lies not in age but in the fact of living and pursuing one's desires according to emotion. For such people knowledge is of no benefit, any more than for the incontinent. For those whose desires and actions are governed by reason, however, knowledge of these matters would be very useful.

[8]Let this be our prologue on the student, on how the discussion is to be understood, and on what we propose to discuss.

IV. Happiness, the End of Politics

All agree that the end which politics pursues is happiness, but what does this mean? There are several different ideas current.

[1]Now resuming our argument, since every investigation and choice aims at some good, let us say what it is that we affirm politics aims at and what is the highest of all the goods of action. [2]As far as the name is concerned there is almost universal agreement, for both the many and the refined call it happiness, and consider living well and doing well to be the same thing as being happy. But they disagree about the definition of happiness, and the many do not account for it in the same way as the wise. [3]Some regard happiness as something manifest and obvious, like pleasure or wealth or honor, others as something different—and frequently the same person will contradict himself, in sickness calling it health, in poverty wealth. Realizing their own ignorance, people admire those who say something grand and above their comprehension. Again, some used to suppose that alongside these many good things there is something else independent which is the cause of their being good. [4]It would doubtless be unprofitable to examine every opinion; it will be enough to consider those which are most prevalent or which seem to have some reason in them.

We must begin with the known facts and proceed from them to generalizations.

[5]Let us not forget that there is a difference between arguments from first principles and those to first principles. Plato did well

in raising this difficulty and inquiring whether the path is from or toward the first principles, as in a race track it may be from the judges to the goal or the reverse. We must begin with the known, but this has two senses: to us, and absolutely. We at least must begin, it seems, with what is known to us. [6]Therefore one who is to be a competent student of the noble and just, and of politics generally, must be trained in good habits. [7]This is so because the starting point is in the facts, and if these are sufficiently established there will be no difficulty about the cause. A person like this either possesses already or can easily grasp the principles. Let him to whom neither of these applies hear the words of Hesiod: "Best of all is he who knows all things, good also he who obeys good counsel. But he who neither knows nor, listening to another, takes his words to heart he is a worthless man. . . ."

VII. The Nature of Happiness

The highest good of action is an activity chosen always for its own sake.

[1]Now let us return to the good we are seeking, and its nature. It seems to be different in different actions and arts; it is one thing in medicine, another in military science, and so on for the rest. Now what is the good of each art? That for whose sake everything else is done? In medicine this is health; in military science, victory; in household management, the household—in each art something different; but in every action and every exercise of choice it is the end, for it is on account of the end that people do everything. Thus, if some one thing is the end of all actions, it would be the good of action, or if there is more than one, they would be.

[2]By a gradual advance our argument has come round again to the same conclusion; but we must try to clarify this still further. [3]Since ends are plural, and we choose some of them for the sake of something else, like wealth and flutes and instruments generally, it is clear that all of them are not perfect. But the highest good is obviously something perfect, so that if there is some one thing which alone is perfect, this would be what we are seeking, and if there is more than one, the most perfect of these. [4]We call that which is sought for its own sake more perfect than what is sought for the sake of something else, and that which is never chosen for the sake of something else more perfect than things chosen both for its sake and for their own, and we call absolutely perfect that which is always chosen for its own sake and never because of anything else.

Happiness fits this definition; it is completely self-sufficient.

[5]Happiness certainly seems to be something of this nature, for we always choose it for itself and never for something else, whereas we choose honor and pleasure and intelligence both for their own sake (even if nothing further resulted from them we should choose them) and also for the sake of happiness, in the belief that through them we are going to live happily. But happiness no one chooses for the sake of these things, nor generally for the sake of anything but itself.

[6]The same result seems to follow also from consideration of its self-sufficiency. (The perfect good surely is something self-sufficient.) By self-sufficient we mean not only what suffices for a person himself, leading a solitary life, but also for his parents and children and wife and generally his friends and fellow citizens, since man is by nature a political being. [7]But there must be some end to this list, for if we extend it to the ancestors and descendants and friends' friends we could go on to infinity. This matter may be taken up again later; at present we shall consider self-sufficient that which taken by itself alone makes a life desirable and lacking in nothing; and this is the sort of thing we commonly judge happiness to be. [8]Moreover, it is the most

choiceworthy of all good things, not as though it were counted as one of them, for it is clear that if it were counted as one of them it would become more choiceworthy with the addition of even the least of good things; for what is added is the measure of superiority among goods, and the greater good is always the more choiceworthy. Happiness, then, is perfect and self-sufficient, the end of action.

The nature of happiness is connected with the function of man.

[9]No doubt, however, to say that happiness is the greatest good seems merely obvious, and what is wanted is a still clearer statement of what it is. [10]It may be possible to achieve this by considering the function of man. As with a flute player or sculptor or any artisan, or generally those who have a function and an activity, the good and good performance seem to lie in the performance of function, so it would appear to be with a man, if there is any function of man. [11]Are there actions and a function peculiar to a carpenter and a shoemaker, but not to man? Is he functionless? Or as there appears to be a function of the eye and the foot and generally of every part of him, could one also posit some function of man aside from all these? [12]What would this be? Life he shares even with plants, so that we must leave out the life of nourishment and growth. The next in order would be a kind of sentient life, but this seems to be shared by horse and cow and all the animals. [13]There remains an active life of a being with reason. This can be understood in two senses: as pertaining to obedience to reason and as pertaining to the possession of reason and the use of intelligence; and since the latter as well is spoken of in two senses, we must take the one which has to do with action, for this seems to be regarded as higher.

[14]If the function of man is an activity of the soul according to reason or not without reason, and we say that the function of a thing and of a good thing are generically the same, as of a lyre-player and a good lyre-player, and the same way with all other cases, the superiority of virtue being attributed to the function—that of a lyre-player being to play, that of a good one being to play well—[15]if this is so, the good for man becomes an activity of the soul in accordance with virtue, and if there are more virtues than one, in accordance with the best and most perfect. [16]And further, in a complete life; for one swallow does not make it spring, nor one day, and so a single day or a short time does not make a man blessed and happy.

Ethics is not an exact science.

[17]Let this be our account of the good. It seems desirable to make a sketch first, and then later to fill it in. It would be easy for anyone to develop and work out in detail that which is well outlined, and time could be a discoverer and co-worker in such matters. This is the way the arts, too, make progress; for it is easy for anyone to add what is missing. [18]We must remember also what was said before, and not ask for the same precision in everything, but only that which is proper to the material at hand and to an extent suitable to the type of investigation. [19]Both a carpenter and a geometer aspire toward a straight line, but in different ways—the one to the extent to which it is useful in his work, the other endeavoring to discover what it is or what sort of thing, being an investigator of the truth. One should do the same in other fields as well, that subsidiary tasks may not crowd out the main ones. [20]Not even the cause is to be asked for in the same sense in all investigations, but in some it is good enough for the fact to be demonstrated, as with first principles: facts and first principles are primary. [21]Of principles some are apprehended by induction, some by sense perception, some by a certain habituation, and others in other ways. [22]But we must try to investigate each in accordance with its nature and be zealous that each be defined

well;[23] they give a great impetus towards discovery of the rest. For the principle—the beginning—seems to be more than half of the whole, and many objects of inquiry become obvious as soon as it is discovered. . . .

READING 11
from ARISTOTLE (384–322 BCE),
POLITICS, BOOK V

Aristotle defined political community as the city (perhaps reflecting the Greek political divisions of city-states). This urban community is an organism, none of whose parts can live without the other, and whose parts work together "for the sake of noble actions, not for the sake of living together." Out of the city arises the family and out of the family arises the individual. It was Aristotle who said, "man is by nature a political animal."

I. General Causes of Revolution

[1]We have dealt with about all the topics we previously proposed; our next task, after what has been said, is to consider what are the causes of revolution in constitutions, and how many they are and of what nature, and what kinds are likely to change into what other kinds, and further, what are the means of preserving them (both the means common to all and those peculiar to each single type), and also what are the particular means by which each of them is most likely to be preserved.

Recapitulation: strife arises because people wish to extend equally or inequality in one field to all others.

[2]First we must take as our starting point that there have come into existence many forms of government in spite of the fact that everyone agrees on the nature of justice [that is, proportionate equality], because they understand its meaning wrongly, as we said before. Democracy rose from the assumption that those who were equal in any respect were absolutely equal: since all alike are free they believe that all are equal absolutely. But oligarchy rose from the supposition that persons unequal [i.e., superior] in some one respect were generally unequal [superior]: being unequal in property they suppose they are absolutely unequal. [3]Then the one group think that, being equal, they should share equally in every thing, and the others, since they are unequal, seek a greater share, since superiority means inequality. Each constitution has an element of justice, but each is, from an absolute point of view, faulty. And it is for this reason, when they do not have shares in the constitution corresponding to the beliefs which each group happens to hold, that they engage in party strife. The ones who would be most justified of all in entering the struggle, but who do it least, are those who excel in virtue. In their case alone is it reasonable to consider them absolutely unequal [superior]. There are some who, being superior in birth, think of themselves as worth more than equality because of this inequality, for they believe that to be well born is to have the wealth and virtue of one's ancestors. [4]These are the beginnings and as it were the fountainheads of party strife.

Revolutions usually aim either to change the form of government or to transfer power from one group to another, within the same form.

Thus it is that revolutions are of two kinds: one kind is against the constitution, that they may set up another in place of the existing one, as an oligarchy instead of a democracy or a democracy instead of an oligarchy or a "polity" or aristocracy in

place of either of these, or vice versa. Sometimes a revolution is not against the constitution, when people want the same constitutional arrangement but want it in their power, for example in an oligarchy or monarchy.

They may also aim at a general tightening or loosening of the existing type or at partial revision of some kind.

⁵Or a revolution may be concerned with the more or less, for example that an existing oligarchy may be more or less oligarchical, or that an existing democracy may be more or less democratic, and the same way with the other constitutions, that they may be either tightened or loosened. Again, it may be intended to change a certain part of the constitution, for example, to establish or remove a certain office, as some say Lysander tried to destroy the monarchy in Lacedaemon and King Pausanias the ephorate. ⁶In Epidamnus, too, the constitution suffered a partial change, for they set up a council in place of the conclave of tribe leaders, and of the citizens it is still compulsory for the magistrates alone to attend the meeting of the assembly when some office is being voted on; and another oligarchical feature is the election of a single archon.

People confuse arithmetical and proportionate equality.

Everywhere party strife is due to inequality, where the unequal are not treated according to proportion (a perpetual monarchy is unequal, if it exists among equals). Generally party conflict is a struggle for equality. ⁷Equality is of two kinds, the arithmetical and that according to merit. By arithmetical I mean that which is the same or equal in number or size, by "according to merit" that which is proportionate. For example, 3 exceeds 2 and 2 exceeds 1 by an equal amount, arithmetically, but according to proportion 4 exceeds 2 as 2 exceeds 1, since 2 is the same part of 4 as 1 is of 2, namely half. But while they agree that the absolutely just is in accordance with worth, people develop differences, as was said before, some because, if they are equal in one respect, they think they are generally equal, and others because if they are unequal in one respect they think themselves worthy of inequality [superiority] in everything.

Democracy and oligarchy are the most common forms of government, because there are always rich and poor.

⁸This is the reason why there are two principal forms of government, democracy and oligarchy; good birth and virtue are restricted to a few, but the qualifications of these governments exist in a larger number. Nowhere are there as many as a hundred well born and virtuous, but there are many rich and poor everywhere. It is wrong, though, for the government to be organized simply and in all respects according to either idea of equality. This is clear from the consequences, for no government of this kind is stable. The cause of this is that it is impossible, starting from an original error in principle, to avoid some evil in the outcome. Some matters, therefore, must be handled according to arithmetical equality and some according to the equality based on merit.

Democracy is more stable than oligarchy, and is closer to the "polity."

⁹All the same, however, democracy is safer and freer from party strife than oligarchy. In oligarchies there are two kinds of strife, that among members of the ruling class and that against the people, whereas in democracies there is only that against the oligarchs, and factional strife of the people against itself does not occur often enough to mention. Further, the "polity," based on the middle classes, comes closer to the people than to the few, and is the safest constitution of this type. . . .

IV. Causes of Revolution in Democracies

The main cause is the reckless wickedness of popular leaders. This can be seen from many examples.

¹We must now consider what happens in each form of government, taking them one by one.

Democracies are overthrown mainly through the wanton license of popular leaders. Sometimes they cause the men of property to unite by their private persecutions (a common fear brings even the bitterest enemies together), and sometimes by publicly leading the populace against them. In many instances one can see that things have turned out in this way. ²For example, in Cos the democracy was overthrown when unscrupulous popular leaders arose and the nobles united against them; and in Rhodes, when the popular leaders introduced payment and prevented the trierarchs from being paid what was owing them, so that the latter were compelled, when suits were brought against them, to dissolve the democracy. The democracy in Heraclea was also dissolved, immediately after the foundation of the colony, because of the popular leaders; the nobles, being unjustly treated by them, went into exile, and then the exiles, joining together and coming back, destroyed the democracy. ³The democracy in Megara, too, was overthrown in a similar manner; the popular leaders, in order to have property to confiscate, banished many of the nobles, until they produced a large body of exiles, who returned, defeated the populace in battle, and established an oligarchy. The same thing also happened in Cyme to the democracy which Thrasymachus destroyed. And in practically every other case, if one looks closely, he can see that the revolution has had this cause. For sometimes in a quest for popular favor, popular leaders have driven the nobles to unite by treating them unjustly, either dividing up their property or crippling their revenues by the imposition of public burdens; sometimes they have done this by slandering them, in order to be able to confiscate the property of the rich.

Formerly democracies often changed into tyrannies, because the popular leaders were military men.

⁴In ancient times, when the same man used to be popular leader and general, they would change from democracy to tyranny, for most of the ancient tyrants developed out of popular leaders. The reason that this happened then but does not do so now, is that at that time popular leaders were chosen from the military leaders (people were not yet clever at public speaking). Now, on the other hand, since the art of oratory has burgeoned, those who are good at speaking become popular leaders, but because of their inexperience have no aspirations toward military leadership, though there may be some exceptions to this.

⁵Another reason why tyrannies were more common formerly than now is in the important offices which fell to some individuals, like that which developed out of the prytany (Presidents of the Assembly) in Miletus, where the prytany had charge of many important matters. Furthermore, since the cities were not then large, and the populace, living in the country, was busy with its work, the leaders of the populace, when they had military experience, had the opportunity to establish tyrannies. They all did this on the basis of popular confidence, and this confidence lay in hatred for the rich. In Athens, for example, Pisistratus became tyrant by leading a party struggle against the "party of the plain"; and Theagenes in Megara by slaughtering the herds of the wealthy when he found them grazing along the river; and Dionysius, having brought accusations against Daphnaeus and the wealthy, was thought worthy to be tyrant, establishing confidence, by his hatred, in his democratic sentiments.

Sometimes there is simply a change within the democratic form.

⁶Changes also take place from "ancestral" democracies to the latest type; for wherever the offices are elective, but not on the basis of a property qualification, and the populace does the electing, those who are eager for office, using the arts of demagoguery, bring things to a point where the populace even has power over the laws. A remedy which will do away with this defect, or at least render it less severe, is for the tribes to provide the magistrates, and not the whole populace.

These are the causes of practically all revolutions in democracies. . . .

VIII. Characteristics of Monarchy

Two types of monarchy distinguished: kingship (closer to aristocracy) and tyranny (closer to democracy).

¹It remains to consider monarchy, and the causes by which it is naturally destroyed and preserved. What has been said about other constitutional forms is practically the same as what happens with kingships and tyrannies; for kingship is like aristocracy, and tyranny is a compound of extreme oligarchy and democracy—this is why it is the most harmful to the subjects, being compounded of two bad forms and having the deviations and flaws of both these forms.

²The origins of the two monarchical forms are from directly opposite causes. Kingship arose to assist the better classes against the populace, and a king is established by the upper classes because of preeminence in virtue or the deeds which arise from virtue, or the preeminence of a family of this sort. The tyrant, on the other hand, is set up by the people and the multitude against the nobles, that the populace may not suffer injustice at their hands.

Origins of tyranny

³The majority of tyrants have developed out of popular leaders, so to speak, gaining credit by slander of the nobles. Some tyrannies came about in this way after the cities were already well grown; and others, earlier, from kings who violated ancestral customs and strove for a more absolute rule; a third group from those elected to authoritative positions (in former times democracies used to give officers and magistrates a long tenure); and still others from oligarchies when they chose one man with authority over the highest magistracies. ⁴In these ways it was easy for them to accomplish their purpose, if only they had the will, because they had power in advance—some that of the position of king, others that of higher office. Thus Pheidon of Argos and others became tyrants under a kingship, Phalaris and those of Ionia from other offices, while Panaetius of Leontini, Cypselus of Corinth, Pisistratus of Athens, Dionysius of Syracuse, and others, came to power in the same way after being popular leaders.

Origins of kingship

⁵Now as we said, kingship is classified with aristocracy, since it is based on worth, either the virtue of an individual or a family, or benefactions, or these along with ability. All who have attained this office have done so by conferring benefits, or being able to do so, upon cities or nations—some, by war, saving them from slavery, like Codrus, others setting them free, like Cyrus, or settling or acquiring territory, like the kings of the Lacedaemonians, Macedonians, and Molossians.

⁶It is the intention of a king to be a guardian, that those who have acquired property may suffer no injustice, and that the populace may suffer no violence; tyranny, however, as has been said many times, does not regard the public interest unless for the sake of private advantage. The criterion of goodness for a tyrant is the pleasant, for a king, the noble. Thus, too, of the kinds of greed, that for money is characteristic of a tyrant, that for honor of a king; and the guard of a king will be composed of citizens, that of a tyrant of foreigners.

Tyranny has the bad points of both democracy and oligarchy.

⁷It is clear that tyranny has the evils of both democracy and oligarchy. From oligarchy comes the fact that its end is wealth (for it is by this alone that the tyrant's guard and his luxury can be maintained), and the fact that it does not allow trust in the multitude. This is why tyrants take away the people's arms; and oligarchy and tyranny are alike in oppressing the common people, driving them from the city into the country, and dispersing them. From democracy it gets its habit of warring against the nobles, destroying them secretly and openly, and banishing them for being rivals and hindrances to its power. This is the cause of conspiracies, too, since some want to hold power themselves, others not to be slaves. And from this came the advice of Periander to Thrasybulus, to cut off the ears of grain which project above the rest—meaning always to remove the outstanding citizens.

CHAPTER 4

READING 12
from CATULLUS (C. 80–54 BCE)

Many of Catullus's short poems trace the course of his relationship with a woman given the pseudonym of Lesbia; her real name was Clodia, and she was the sister of Cicero's archenemy Publius Clodius Pulcher. The poems written in the early days of their affair express Catullus's joy in language of almost musical beauty. The contentment was not to last. Lesbia lost interest, even as Catullus continued to protest his love. Driven to desperation by the hopelessness of his cause, he described in later poems his vain attempts to cure himself of the "fever" of his passion, until finally he could take no more: The last of the Lesbia poems expresses bitterness and hatred.

This short sequence follows their affair from rapturous beginning to hostile breakup; the reader inclined to sympathize with Catullus's pain should, of course, remember that Lesbia's (that is Clodia's) side of the story remains untold.

V

My darling, let us live
And love for ever.
They with no love to give,
Who feel no fever,
Who have no tale to tell
But one of warning—
The pack of them might sell
For half a farthing.
The sunset's dying ray
Has its returning,
But fires of our brief day
Shall end their burning
In night where joy and pain
Are past recalling—
So kiss me, kiss again—
The night is falling.

10

Kiss me and kiss again,
Nor spare thy kisses.
Let thousand kisses rain
A thousand blisses. 20
Then, when ten thousand more
Their strength have wasted,
Let's wipe out all the score
Of what we've tasted:
Lest we should count our bliss
To our undoing,
Or others grudge the kiss
On kiss accruing.

.
.
.

LXXXVII

None could ever say that she,
Lesbia! was so loved by me.
Never all the world around
Faith so true as mine was found:
If no longer it endures
(Would it did!) the fault is yours.
I can never think again
Well of you: I try in vain:
But—be false—do what you will—
Lesbia! I must love you still. 10

.
.
.

LXXV

The office of my heart is still to love
When I would hate.
Time and again your faithlessness I prove
Proven too late.
Your ways might mend, yet my contempt could never
Be now undone.
Yet crimes repeated cannot stop this fever
From burning on.

.
.
.

LVIII

She that I loved, that face,
Those hands, that hair,
Dearer than all my race,
As dear as fair—
See her where throngs parade
Th' imperial route,
Plying her skill unpaid—
Rome's prostitute.

Poems V, LXXXVII, LXXV, LVIII by Catullus, from *The Lyric Genius of Catullus*, translated by Eric Alfred Havelock, 1939.

READING 13
from VIRGIL (70–19 BCE), AENEID

The AENEID, *one of the great poems of the world, is divided into twelve books. Its hero is a Trojan prince, Aeneas, who flees from the ruins of burning Troy and sails west to Italy to found a new city, the predecessor of Rome. Virgil's choice was significant: Aeneas's Trojan birth establishes connections with the world of Homer; his arrival in Italy involves the origins*

of Rome; and the theme of a fresh beginning born, as it were, out of the ashes of the past corresponds perfectly to the Augustan mood of revival.

from Book I

The opening of the epic invokes the poem's central theme: the destiny that will bring Aeneas to Italy and lead to the foundation of Rome. Thereafter we first meet Aeneas and his men as they struggle through a storm blown up by Aeolus, god of the winds, at the request of Juno; the goddess's implacable hostility to the Trojans goes back to Paris' failure to award her the golden apple in the beauty contest between Juno, Minerva, and Venus. Aeneas emerges as resolute and determined, a good leader, although Virgil shows us his hidden anxiety—very much that of a modern rather than Homeric hero. When Venus, Aeneas's mother, appeals to Jupiter for mercy, the father of gods and men comforts her with a description of the future glories of Rome.

I tell about war and the hero who first from Troy's frontier,
Displaced by destiny, came to the Lavinian shores,
To Italy—a man much travailed on sea and land
By the powers above, because of the brooding anger of Juno
Suffering much in war until he could found a city
And march his gods into Latium, whence rose the
 Latin race,
The royal line of Alba and the high walls of Rome.
Where lay the cause of it all? How was her godhead
 injured?
What grievance made the queen of heaven so harry a man
Renowned for piety, through such toils, such a cycle
 of calamity? 10
Can a divine being be so persevering in anger?
There was a town of old—men from Tyre colonized it—
Over against Italy and Tiber mouth, but afar off,
Carthage, rich in resources, fiercely efficient in warfare.
This town, they say, was Juno's favorite dwelling,
 preferred
To all lands, even Samos: here were her arms, her chariot:
And even from the long-ago time she cherished the aim
 that this
Should be, if fate allowed, the metropolis of all nations.
Nevertheless, she had heard a future race was forming
Of Trojan blood, which one day would topple that Tyrian
 stronghold— 20
A people arrogant in war, born to be everywhere rulers
And root up her Libyan empire—so the Destiny-
 Spinners planned.
Juno, afraid of this, and remembering well the old war
Wherein she had championed the Greeks whom she
 loved against the Trojans—
Besides, she has other reasons for rage, bitter affronts
Unblotted as yet from her heart: deep in her mind
 rankle
The judgment of Paris, the insult of having her beauty
 scorned,
Her hate for Troy's origin, Ganymede taken and made a
 favorite—
Furious at these things too, she tossed all over the sea
The Trojans, the few that the Greeks and relentless
 Achilles had left, 30
And rode them off from their goal, Latium.
Many years
They were wandering round the seven seas, moved on
 by destiny.
So massive a task it was to found the Roman race.
They were only just out of sight of Sicily, towards deep
 water
Joyfully crowding on sail and driving the foam-flocks
 before them,
When Juno, who under her heart nursed that inveterate wound,

Soliloquized thus:—
 Shall I give up? own myself beaten?
Impotent now to foil the Trojan lord from Italy?
Fate forbids me, indeed! Did not Athene burn 40
The Argive fleet and drown the crews, because
 one man
Had given offence? because of the criminal madness
 of Ajax?
Why, she herself flung down Jove's firebolt from the
 clouds,
Blasted that navy and capsized the sea with a storm;
And Ajax, gasping flame out of his cloven breast,
She whisked up in the whirlwind, impaled him on a crag.
But I, who walk in majesty, queen of heaven, Jove's
Sister and consort, I must feud with a single nation
For all these years. Does anyone worship my divinity
After this, or pay my altar a suppliant's homage? 50
Such were the thoughts milling round in her angry heart
 as the goddess
Came to the storm-cloud country, the womb-land of
 brawling siroccos,
Aeolia. Here in a huge cavern King Aeolus
Keeps curbed and stalled, chained up in durance to his
 own will,
The heaving winds and far-reverberating tempests.
Behind the bars they bellow, mightily fretting: the
 mountain is
One immense murmur, Aeolus, aloft on his throne
 of power,
Scepter in hand, gentles and disciplines their fierce
 spirits.
Otherwise, they'd be bolting off with the earth and
 the ocean
And the deep sky—yes, brushing them all away into
 space. 60
But to guard against this the Father of heaven put
 the winds
In a dark cavern and laid a heap of mountains
 upon them,
And gave them an overlord who was bound by a firm
 contract
To rein them in or give them their head, as he was
 ordered.
Him Juno now petitioned. Here are the words she
 used:—
 Aeolus, the king of gods and men has granted
You the rule of the winds, to lull the waves or lift them.
A breed I have no love for now sails the Tyrrhene sea,
Transporting Troy's defeated gods to Italy.
Lash fury into your winds! Whelm those ships and
 sink them! 70
Flail the crews apart! Litter the sea with their fragments!
Fourteen nymphs I have—their charms are quite out of
 the common—
Of whom the fairest in form, Deiopea, I'll join
To you in lasting marriage and seal her yours for ever,
A reward for this great favor I ask, to live out all
The years with you, and make you the father of hand-
 some children.
 Aeolus answered thus:—
 O queen, it is for you to
Be fully aware what you ask: my duty is but to obey.
Through you I hold this kingdom, for what it's worth,
 as Jove's 80
Viceroy; you grant the right to sit at the gods' table;
You are the one who makes me grand master of cloud and
 storm.
 Thus he spoke, and pointing his spear at the hollow
 mountain,

Pushed at its flank: and the winds, as it were in a solid mass,
Hurl themselves through the gates and sweep the land
 with tornadoes.
They have fallen upon the sea, they are heaving it up
 from its deepest
Abysses, the whole sea—East wind, South, Sou'wester
Thick with squalls—and bowling great billows at the
 shore.
There follows a shouting of men, a shrilling of stays and
 halyards.
All of a sudden the storm-clouds are snatching the
 heavens, the daylight 90
From the eyes of the Trojans; night, black night is fallen
 on the sea.
The welkin explodes, the firmament flickers with thick-
 and-fast lightning,
And everything is threatening the instant death of men.
At once a mortal chill went through Aeneas and
 sapped him;
He groaned, and stretching out his two hands toward
 the stars,
Uttered these words:—
 Oh, thrice and four times blessèd you
Whose luck it was to fall before your father's eyes
Under Troy's battlements! O Diomed, the bravest
Of the Greek kind, why could not I have fallen to death 100
On Ilium's plains and shed my soul upon your sword?
Fallen where Hector lies, whom Achilles slew, and tall
Sarpedon fell, and Simois our river rolls so many
Helmets and shields and heroes together down its stream?
 Even as he cried out thus, a howling gust from
 the North
Hit the front of the sail, and a wave climbed the sky.
Oars snapped; then the ship yawed, wallowing broad-
 side on
To the seas: and then, piled up there, a precipice of
 sea hung.
One vessel was poised on a wave crest; for another the
 waters, collapsing,
Showed sea-bottom in the trough: the tide-race boiled
 with sand. 110
Three times did the South wind spin them towards an
 ambush of rocks
(Those sea-girt rocks which Italians call by the name of
 "The Altars"),
Rocks like a giant spine on the sea: three times did the
 East wind
Drive them in to the Syrtes shoal, a piteous spectacle—
Hammering them on the shallows and hemming them
 round with sandbanks.
One ship, which carried in her the Lycians and faithful
 Orontes,
Before Aeneas' eyes is caught by an avalanche wave
And pooped: her helmsman is flicked from off the deck
 and headlong
Sent flying; but three times the vessel is twirled around
By the wave ere the waters open and greedily gulp
 her down. 120
A man or two can be seen swimming the huge
 maelstrom,
With weapons and planks and Trojan treasure spilt on
 the sea.
Now Ilioneus' strong ship, now the ship of valiant Achates,
And the ships that carry Abás and aged Aletes go
Down to the gale; the ships have all sprung leaks and are
 letting
The enemy pour in through the loosened joints of their hulls,
 Meanwhile Neptune has felt how greatly the sea is
 in turmoil,

Felt the unbridled storm disturbing the water even
Down to the sea-bed, and sorely troubled has broken
 surface;
He gazes forth on the deep with a pacific mien. 130
He sees the fleet of Aeneas all over the main, dis-
 membered,
The Trojans crushed by waves and the sky in ribbons
 about them:
Juno's vindictive stratagems do not escape her brother.
He summons the East and the West winds, and then
 proceeds to say:—
 Does family pride tempt you to such impertinence?
Do you really dare, you Winds, without my divine assent
To confound earth and sky, and raise this riot of water?
You, whom I—! Well, you have made the storm, I must
 lay it.
Next time, I shall not let you so lightly redeem your sins.
Now leave, and quickly leave, and tell your overlord
 this— 140
Not to him but to me was allotted the stern trident,
Dominion over the seas. His domain is the mountain
 of rock,
Your domicile, O East wind. Let Aeolus be king of
That castle and let him keep the winds locked up in its
 dungeon.
 He spoke; and before he had finished, the insurgent
 sea was calmed,
The mob of cloud dispersed and the sun restored to power.
Nereid and Triton heaving together pushed the ships off
From the sharp rock, while Neptune levered them up
 with his trident,
And channelled a way through the sandbanks, and made
 the sea lie down—
Then lightly charioted off over the face of the waters. 150
Just as so often it happens, when a crowd collects, and
 violence
Brews up, and the mass mind boils nastily over, and the
 next thing
Firebrands and brickbats are flying (hysteria soon finds a
 missile),
That then, if they see some man whose goodness of heart
 and conduct
Have won their respect, they fall silent and stand still,
 ready to hear him;
And he can change their temper and calm their thoughts
 with a speech:
So now the crash of the seas died down, when Neptune
 gazed forth
Over their face, and the sky cleared, and the Father of
 ocean,
Turning his horses, wheeled away on an easy course.
 Aeneas' men, worn out, with a last effort, make
 for 160
The nearest landing place; somewhere on the coast of
 Libya.
A spot there is in a deep inlet, a natural harbor
Formed by an island's flanks upon which the swell from
 the deep sea
Breaks and dividing runs into the land's recesses.
At either end of the lofty cliffs a peak towers up
Formidably to heaven, and under these twin summits
The bay lies still and sheltered: a curtain of overhanging
Woods with their shifting light and shadow forms the
 backdrop;
At the seaward foot of the cliffs there's a cave of
 stalactites
Fresh water within, and seats which nature has hewn
 from the stone— 170

A home of the nymphs. Here, then, tired ships could lie,
 and need
No cable nor the hooking teeth of an anchor to hold them.
Here, with seven ships mustered, all that was left of his
 convoy,
Aeneas now put in: and the Trojans, aching for dry land,
Tumbled out of their ships onto the sands they craved so,
And laid their limbs, crusted with brine, upon the shore.
Then first of all Achates struck a spark from flint,
Nursed the spark to a flame on tinder, gave it to feed on
Dry fuel packed around it and made the flame blaze up
 there.
Sick of mischance, the men got ready the gifts and gear of 180
Ceres, setting themselves to roast on the fire and grind,
Though tainted it was with the salt water, what grain
 they had salvaged.
While this was going forward, Aeneas scaled a crag
To get an extensive view of the sea, hoping to sight
Some Trojan ship—Antheus perhaps, safe from the storm,
Or Capys, or the tall ship displaying the shield of
 Caicus.
Ship there was none in view; but on the shore three stags
Caught his eye as they wandered with a whole herd be-
 hind them,
A straggling drove of deer which browsed along the
 valley.
Aeneas, where he stood, snatched up the bow and
 arrows— 190
The weapons he had borrowed just now from faithful
 Achates—
And aiming first at the leaders of the herd, which carried
 their heads high
With branching antlers, he laid them low; then shot at
 the herd,
And his arrows sent it dodging all over the leafy
 woods.
Nor would he stop shooting until triumphantly
He had brought down seven beasts, one for each of his
 ships.
Then he returned to the harbor and shared them among
 his comrades.
And then he shared out the wine which good Acestes
 had casked
In Sicily and given them—a generous parting present,
And spoke these words of comfort to his sad-hearted
 friends:— 200
 Comrades, we're well acquainted with evils, then
 and now.
Worse than this you have suffered. God will end all
 this too.
You, who have risked the mad bitch, Scylla, risked the
 cliffs
So cavernously resounding, and the stony land of the
 Cyclops,
Take heart again, oh, put your dismal fears away!
One day—who knows?—even these will be grand
 things to look back on.
Through chance and change, through hosts of dangers,
 our road still
Leads on to Latium: there, destiny offers a home
And peace; there duty tells us to build the second Troy.
Hold on, and find salvation in the hope of better things! 210
 Thus spoke Aeneas; and though his heart was sick
 with anxiety,
He wore a confident look and kept his troubles to
 himself.
The Trojans set to work, preparing the game for a
 banquet;

Hacked the chines apart from the ribs, and exposed
 the guts:
Some sliced the meat into steaks which they spitted with
 trembling fingers,
Some set down cooking pots on the beach, and fed
 the fires,
Then they restored their strength with the food, and
 sprawling at ease
On the grass they took their fill of the wine and the rich
 venison.
Afterwards, hunger appeased and the meal cleared away,
 for a long time
They talked of their missing friends, longing to have
 them back, 220
Half-way between hope and fear, not knowing whether
 to deem them
Alive or utterly perished and far beyond human call.
True-hearted Aeneas grieved especially for the fate of
Ardent Orontes, and Amycus, and the cruel fate of
 Lycus,
Grieved for Gyas the brave and for the brave Cloanthus.
 At last they made an end. Jupiter from high
 heaven
Looked down at the flights of sails on the sea, and the
 earth beneath him,
Its shores and its far-flung peoples: so, at the top of the
 morning
He stood, and presently focused his gaze on the Libyan
 realm.
Now, as he deeply pondered the troubles there, came
 Venus, 230
Sadder than is her wont, her eyes shining with tears,
And spoke to him:—
 Sir, you govern the affairs of gods and men
By law unto eternity, you are terrible in the lightning:
Tell me, what wrong could my Aeneas or his Trojans
Have done you, so unforgivable that, after all these
 deaths,
To stop them reaching Italy they are locked out from the
 whole world?
Verily you had promised that hence, as the years
 rolled on,
Troy's renaissance would come, would spring the Roman
 people
And rule as sovereigns absolute over earth and sea. 240
You promised it. Oh, my father, why have you changed
 your mind?
That knowledge once consoled me for the sad fall of Troy:
I could balance fate against fate, past ills with luck
 to come.
But still the same ill fortune dogs my disaster-ridden
Heroes. Oh when, great king, will you let their or-
 deal end?
Antenor, slipping away through the Greek army, could
 safely
Sail right up the Illyrian gulf, pass by the remote
Liburnians, and pass the source of river Timavus
Where tidal water, roaring aloud below rock, spouts up
Through nine mouths, and the fields are hemmed with
 a sound of the sea. 250
He was allowed to found Padua, make a home for
Trojans there—could give his people a name, and nail up
His arms, could settle down to enjoy peace and quiet.
But we, your seed, for whom you sanction a place in
 heaven—
Our ships damnably sunk—because of one being's
 anger
We are cheated, and fenced afar from Italy.

Is this the reward for being true? Is it thus you restore
 a king?
 The begetter of gods and men inclined towards her
 the smiling
Countenance which calms the sky and makes fair weather,
Gently kissed his daughter's mouth, and began to
 speak:— 260
 Fear no more, Cytherea. Take comfort, for your
 people's
Destiny is unaltered; you shall behold the promised
City walls of Lavinium, and exalt great-hearted Aeneas
Even to the starry skies. I have not changed my mind.
I say it now—for I know these cares constantly
 gnaw you—
And show you further into the secret book of fate:
Aeneas, mightily warring in Italy, shall crush
Proud tribes, to establish city walls and a way of life,
Till a third summer has seen him reigning in Latium
And winter thrice passed over his camp in the con-
 quered land. 270
His son Ascanius, whose surname is now Iulus—. . .
Ilus it was, before the realm of Ilium fell—
Ascanius for his reign shall have full thirty years
With all their wheeling mouths; shall move the king-
 dom from
Lavinium and make Long Alba his sure stronghold.
Here for three hundred years shall rule the dynasty
Of Hector, until a priestess and queen of Trojan blood,
With child by Mars, shall presently give birth to twin sons.
Romulus, then, gay in the coat of the tawny she-wolf
Which suckled him, shall succeed to power and found
 the city 280
Of Mars and with his own name endow the Roman
 nation.
To these I set no bounds, either in space or time;
Unlimited power I give them. Even the spiteful Juno,
Who in her fear now troubles the earth, the sea and
 the sky,
Shall think better of this and join me in fostering
The cause of the Romans, the lords of creation, the togaed
 people.
Thus it is written. An age shall come, as the years
 glide by,
When the children of Troy shall enslave the children of
 Agamemnon,
Of Diomed and Achilles, and rule in conquered Argos.
From the fair seed of Troy there shall be born a Caesar— 290
Julius, his name derived from great Iulus—whose empire
Shall reach to the ocean's limits, whose fame shall end in
 the stars.
He shall hold the East in fee; one day, cares ended,
 you shall
Receive him into heaven; him also will mortals pray to.
Then shall the age of violence be mellowing into peace:
Venerable Faith, and the Home, with Romulus and
 Remus,
Shall make the laws; the grim, steel-welded gates of War
Be locked; and within, on a heap of armaments, a
 hundred
Bronzen knots tying his hands behind him, shall sit
Growling and bloody-mouthed the godless spirit of
 Discord. 300
 So Jupiter spoke, and sent Mercury down from on
 high
To see that the land and the new-built towers of Carthage
 offered
Asylum to the Trojans, for otherwise might queen Dido,
Blind to destiny, turn them away.

from Book IV

*The bitter confrontation between Dido and Aeneas in Book IV of the
AENEID forms the emotional heart of the epic's first half. The scene be-
gins as Aeneas has received the divine message to leave Carthage and
continue on his journey. He says nothing to Dido for the moment and
makes his preparations for departure. The queen cannot be fooled so eas-
ily; in a frenzy of grief and rage, she accuses him of deserting her. Aeneas's
response seems cold and indicates the sacrifice of personal feelings his mis-
sion requires. His appeal to common sense and the will of the gods only
enrages Dido further; she dismisses him with words of furious contempt.
Yet, at the end of the scene, Virgil leaves no doubt as to Aeneas's terrible
dilemma. Faced with the choice between love and duty he has chosen
duty, but only at the price of personal anguish.*

But who can ever hoodwink a woman in love? The queen,
Apprehensive even when things went well, now sensed
 his deception,
Got wind of what was going to happen. That mis-
 chievous Rumor,
Whispering the fleet was preparing to sail, put her in a
 frenzy.
Distraught, she witlessly wandered about the city, raving
Like some Bacchante driven wild, when the emblems of
 sanctity
Stir, by the shouts of "Hail, Bacchus!" and drawn to
 Cithaeron
At night by the din of revellers, at the triennial orgies.
Finding Aeneas at last, she cried, before he could
 speak:—
 Unfaithful man, did you think you could do such
 a dreadful thing 10
And keep it dark? yes, skulk from my land without
 one word?
Our love, the vows you made me—do these not give you
 pause,
Nor even the thought of Dido meeting a painful death?
Now, in the dead of winter, to be getting your ships ready
And hurrying to set sail when northerly gales are
 blowing,
You heartless one! Suppose the fields were not foreign,
 the home was
Not strange that you are bound for, suppose Troy stood
 as of old,
Would you be sailing for Troy, now, in this stormy
 weather?
Am I your reason for going? By these tears, by the hand
 you gave me—
They are all I have left, to-day, in my misery—I im-
 plore you, 20
And by our union of hearts, by our marriage hardly
 begun,
If I have ever helped you at all, if anything
About me pleased you, be sad for our broken
 home, forgo
Your purpose, I beg you, unless it's too late for prayers
 of mine!
Because of you, the Libyan tribes and the Nomad
 chieftains
Hate me, the Tyrians are hostile: because of you I
 have lost
My old reputation for faithfulness—the one thing that
 could have made me
Immortal. Oh, I am dying! To what, my guest, are you
 leaving me?
"Guest"—that is all I may call you now, who have called
 you husband.
Why do I linger here? Shall I wait till my brother,
 Pygmalion, 30

Destroys this place, or Iarbas leads me away captive?
If even I might have conceived a child by you before
You went away, a little Aeneas to play in the palace
And, in spite of all this, to remind me of you by his looks,
 oh then
I should not feel so utterly finished and desolate.
 She had spoken. Aeneas, mindful of Jove's words,
 kept his eyes
Unyielding, and with a great effort repressed his feeling
 for her.
In the end he managed to answer:—
 Dido, I'll never pretend
You have not been good to me, deserving of everything 40
You can claim. I shall not regret my memories of Elissa
As long as I breathe, as long as I remember my own self.
For my conduct—this, briefly: I did not look to make off
 from here
In secret—do not suppose it; nor did I offer you marriage
At any time or consent to be bound by a marriage contract.
If fate allowed me to be my own master, and gave me
Free will to choose my way of life, to solve my problems,
Old Troy would be my first choice: I would restore it,
 and honor
My people's relics—the high halls of Priam perpetuated,
Troy given back to its conquered sons, a renaissant city 50
Had been my task. But now Apollo and the Lycian
Oracle have told me that Italy is our bourne.
There lies my heart, my homeland. You, a Phoenician, are held
 by
These Carthaginian towers, by the charm of your
 Libyan city:
So can you grudge us Trojans our vision of settling down
In Italy? We too may seek a kingdom abroad.
Often as night envelops the earth in dewy darkness,
Often as star-rise, the troubled ghost of my father, Anchises,
Comes to me in my dreams, warns me and frightens me.
I am disturbed no less by the wrong I am doing
 Ascanius, 60
Defrauding him of his destined realm in Hesperia.
What's more, just now the courier of heaven, sent
 by Jupiter—
I swear it on your life and mine—conveyed to me,
 swiftly flying,
His orders: I saw the god, as clear as day, with my
 own eyes,
Entering the city, and these ears drank in the words he
 uttered.
No more reproaches, then—they only torture us both.
God's will, not mine, says "Italy."
 All the while he was speaking she gazed at him
 askance,
Her glances flickering over him, eyes exploring the
 whole man
In deadly silence. Now, furiously, she burst out:— 70
 Faithless and false! No goddess mothered you, no
 Dardanus
Your ancestor! I believe harsh Caucasus begat you
On a flint-hearted rock and Hyrcanian tigers suckled you.
Why should I hide my feelings? What worse can there be
 to keep them for?
Not one sigh from him when I wept! Not a softer glance!
Did he yield an inch, or a tear, in pity for her who
 loves him?
I don't know what to say first. It has come to this,—
 not Juno,
Not Jove himself can view my plight with the eye of
 justice.
Nowhere is it safe to be trustful. I took him, a castaway,

A pauper, and shared my kingdom with him—I must
 have been mad— 80
Rescued his lost fleet, rescued his friends from death.
Oh, I'm on fire and drifting! And now Apollo's
 prophecies,
Lycian oracles, couriers of heaven sent by Jupiter
With stern commands—all these order you to betray me.
Oh, of course this is just the sort of transaction that
 troubles the calm of
The gods. I'll not keep you, nor probe the dishonesty of
 your words,
Chase your Italy, then! Go, sail to your realm overseas!
I only hope that, if the just spirits have any power,
Marooned on some mid-sea rock you may drink the full
 cup of agony
And often cry out for Dido. I'll dog you, from far, with
 the death-fires; 90
And when cold death has parted my soul from my body,
 my specter
Will be wherever you are. You shall pay for the evil
 you've done me.
The tale of your punishment will come to me down in
 the shades.
 With these words Dido suddenly ended, and sick
 at heart
Turned from him, tore herself away from his eyes, ran
 indoors,
While he hung back in dread of a still worse scene,
 although
He had much to say. Her maids bore up the fainting queen
Into her marble chamber and laid her down on the bed.
 But the god-fearing Aeneas, much as he longed to
 soothe
Her anguish with consolation, with words that would
 end her troubles, 100
Heavily sighing, his heart melting from love of her,
Nevertheless obeyed the gods and went off to his fleet.

from Book VI

In Book VI of the Aeneid, *Aeneas travels to the underworld led by his
guide, the Sibyl of Cumae, to learn of the future destiny both of himself
and of Rome. The opening lines of this passage evoke the melancholy
gloom of the scene; as Aeneas comes to the river of the dead, the poet em-
phasizes by a string of pathetic images the sadness of those trying to cross
it. Aeneas's journey is necessary because he has to confront his past and
come to terms with it before he can move on to his future heroic destiny.*

 *As the Sibyl leads him through the ranks of the dead he meets Palin-
urus, the helmsman of Aeneas's ship who had fallen overboard just before
reaching Troy and drowned. The most emotional encounter, however, is
the one that concludes this episode—Aeneas's meeting with Dido. Now
it is Aeneas who weeps and pleads, while Dido neither looks at him nor
speaks.*

You gods who rule the kingdom of souls!
You soundless shades!
Chaos, and Phlegethon! O mute wide leagues of
 Nightland!—
Grant me to tell what I have heard! With your assent
May I reveal what lies deep in the gloom of the
 Underworld!
 Dimly through the shadows and dark solitudes they
 wended,
Through the void domiciles of Dis, the bodiless regions:
Just as, through fitful moonbeams, under the moon's thin light,
A path lies in a forest, when Jove has palled the sky
With gloom, and the night's blackness has bled the world
 of color. 10

See! At the very porch and entrance way to Orcus
Grief and ever-haunting Anxiety make their bed:
Here dwell pallid Diseases, here morose Old Age,
With Fear, ill-prompting Hunger, and squalid Indigence,
Shapes horrible to look at, Death and Agony;
Sleep, too, which is the cousin of Death; and Guilty Joys,
And there, against the threshold, War, the bringer of
 Death:
Here are the iron cells of the Furies, and lunatic Strife
Whose viperine hair is caught up with a headband
 soaked in blood.
 In the open a huge dark elm tree spreads wide its
 immemorial 20
Branches like arms, whereon, according to old wives'
 tales,
Roost the unsolid Dreams, clinging everywhere under its
 foliage.
Besides, many varieties of monsters can be found
Stabled here at the doors—Centaurs and freakish Scyllas,
Briareus with his hundred hands, the Lernaean Hydra
That hisses terribly and the flame-throwing Chimaera,
Gorgons and Harpies, and the ghost of three-bodied
 Geryon.
Now did Aeneas shake with a spasm of fear, and
 drawing
His sword, offered its edge against the creatures' onset:
Had not his learned guide assured him they were but
 incorporeal 30
Existences floating there, forms with no substance be-
 hind them,
He'd have attacked them, and wildly winnowed with
 steel mere shadows.
 From here is the road that leads to the dismal
 waters of Acheron.
Here a whirlpool boils with mud and immense swirlings
Of water, spouting up all the slimy sand of Cocytus.
A dreadful ferryman looks after the river crossing,
Charon: Appallingly filthy he is, with a bush of unkempt
White beard upon his chin, with eyes like jets of fire;
And a dirty cloak draggles down, knotted about his
 shoulders.
He poles the boat, he looks after the sails, he is all
 the crew 40
Of the rust-colored wherry which takes the dead
 across—
An ancient now, but a god's old age is green and sappy.
This way came fast and streaming up to the bank the
 whole throng:
Matrons and men were there, and there were great-heart
 heroes
Finished with earthly life, boys and unmarried maidens,
Young men laid on the pyre before their parents' eyes;
Multitudinous as the leaves that fall in a forest
At the first frost of autumn, or the birds that out of the
 deep sea
Fly to land in migrant flocks, when the cold of the year
Has sent them overseas in search of a warmer climate. 50
So they all stood, each begging to be ferried across first,
Their hands stretched out in longing for the shore beyond
 the river.
But the surly ferryman embarks now this, now that
 group,
While others he keeps away at a distance from the
 shingle.
Aeneas, being astonished and moved by the great stir,
 said:—
 Tell me, O Sibyl, what means this rendezvous at the
 river?

What purpose have these souls? By what distinction
 are some
Turned back, while other souls sweep over the wan
 water?
To which the long-lived Sibyl uttered this brief
 reply:—
 O son of Anchises' loins and true-born offspring of
 heaven, 60
What you see is the mere of Cocytus, the Stygian marsh
By whose mystery even the gods, having sworn, are
 afraid to be forsworn.
All this crowd you see are the helpless ones, the
 unburied:
That ferryman is Charon: the ones he conveys have had
 burial.
None may be taken across from bank to awesome
 bank of
That harsh-voiced river until his bones are laid to rest.
Otherwise, he must haunt this place for a hundred years
Before he's allowed to revisit the longed-for stream at last.
 The son of Anchises paused and stood stock still,
 in deep
Meditation, pierced to the heart by pity for their hard
 fortune. 70
He saw there, sorrowing because deprived of death's
 fulfilment,
Leucaspis and Orontes, the commodore of the Lycian
Squadron, who had gone down, their ship being lost with
 all hands
In a squall, sailing with him the stormy seas from Troy.
 And look! yonder was roaming the helmsman,
 Palinurus,
Who, on their recent voyage, while watching the stars,
 had fallen
From the afterdeck, thrown off the ship there in mid-
 passage.
A somber form in the deep shadows, Aeneas barely
Recognized him; then accosted:—
 Which of the gods, Palinurus, 80
Snatched you away from us and made you drown in the
 midsea?
Oh, tell me! For Apollo, whom never before had I found
Untruthful, did delude my mind with this one answer,
Foretelling that you would make your passage to Italy
Unharmed by sea. Is it thus he fulfils a sacred promise?
 Palinurus replied:—
 The oracle of Phoebus has not tricked you,
My captain, son of Anchises; nor was I drowned by
 a god.
It was an accident: I slipped, and the violent shock
Of my fall broke off the tiller to which I was holding
 firmly 90
As helmsman, and steering the ship. By the wild seas
 I swear
That not on my own account was I frightened nearly
 so much as
Lest your ship, thus crippled, its helmsman overboard,
Lose steerage-way and founder amid the mountainous
 waves.
Three stormy nights did the South wind furiously drive
 me along
Over the limitless waters: on the fourth day I just
Caught sight of Italy, being lifted high on a wave crest.
Little by little I swam to the shore. I was all but safe,
When, as I clung to the rough-edged cliff top, my fingers
 crooked
And my soaking garments weighing me down, some
 barbarous natives 100

Attacked me with swords, in their ignorance thinking
 that I was a rich prize.
Now the waves have me, the winds keep tossing me up
 on the shore again.
So now, by the sweet light and breath of heaven above
I implore you, and by your father, by your hopes for
 growing Ascanius
Redeem me from this doom, unconquered one! Please
 sprinkle
Dust on my corpse—you can do it and quickly get back
 to port Velia:
Or else, if way there is, some way that your heavenly
 mother
Is showing you (not, for sure, without the assent of deity
Would you be going to cross the swampy Stygian stream),
Give poor Palinurus your hand, take me with you across
 the water 110
So that at least I may rest in the quiet place, in death.
 Thus did the phantom speak, and the Sibyl began to
 speak thus:—
 This longing of yours, Palinurus, has carried you
 quite away.
Shall you, unburied, view the Styx, the austere river
Of the Infernal gods, or come to its bank unbidden?
Give up this hope that the course of fate can be swerved
 by prayer.
But hear and remember my words, to console you in
 your hard fortune.
I say that the neighboring peoples, compelled by portents
 from heaven
Occurring in every township, shall expiate your death,
Shall give you burial and offer the solemn dues to your
 grave, 120
And the place shall keep the name of Palinurus
 forever.
 Her sayings eased for a while the anguish of his sad
 heart;
He forgot his cares in the joy of giving his name to a region.
 So they resumed their interrupted journey, and drew
 near
The river. Now when the ferryman, from out on the Styx,
 espied them
Threading the soundless wood and making fast for the bank,
He hailed them, aggressively shouting at them before
 they could speak:—
 Whoever you are that approaches my river, carrying
 a weapon,
Halt there! Keep your distance, and tell me why you are
 come!
This is the land of ghosts, of sleep and somnolent night: 130
The living are not permitted to use the Stygian ferry.
Not with impunity did I take Hercules,
When he came, upon this water, nor Theseus, nor
 Pirithous,
Though their stock was divine and their powers were
 irresistible.
Hercules wished to drag off on a leash the watch-dog
 of Hades,
Even from our monarch's throne, and dragged it away
 trembling:
The others essayed to kidnap our queen from her lord's
 bedchamber.
 The priestess of Apollo answered him shortly, thus:—
There is no such duplicity here, so set your mind at rest;
These weapons offer no violence: the huge watch-dog in
 his kennel 140
May go on barking for ever and scaring the blood-
 less dead,

Prosperpine keep her uncle's house, unthreatened in
　　chastity.
Trojan Aeneas, renowned for war and a duteous heart,
Comes down to meet his father in the shades of the
　　Underworld.
If you are quite unmoved by the spectacle of such great
　　faith,
This you must recognize—
　　　　And here she disclosed the golden
Bough which was hid in her robe. His angry mood
　　calms down.
No more is said. Charon is struck with awe to see
After so long that magic gift, the bough fate-given;　　150
He turns his sombre boat and poles it towards the
　　bank.
Then, displacing the souls who were seated along its
　　benches
And clearing the gangways, to make room for the big
　　frame of Aeneas,
He takes him on board. The ramshackle craft creaked
　　under his weight
And let in through its seams great swashes of muddy
　　water.
At last, getting the Sibyl and the hero safe across,
He landed them amidst wan reeds on a dreary mud flat.
　　Huge Cerberus, monstrously couched in a cave con-
　　fronting them,
Made the whole region echo with his three-throated
　　barking.
The Sibyl, seeing the snakes bristling upon his neck now,　　160
Threw him for bait a cake of honey and wheat in-
　　fused with
Sedative drugs. The creature, crazy with hunger, opened
Its three mouths, gobbled the bait; then its huge body
　　relaxed
And lay, sprawled out on the ground, the whole length of
　　its cave kennel.
Aeneas, passing its entrance, the watch-dog neutralized,
Strode rapidly from the bank of that river of no return.
　　At once were voices heard, a sound of mewling and
　　wailing,
Ghosts of infants sobbing there at the threshold, infants
From whom a dark day stole their share of delicious life,
Snatched them away from the breast, gave them sour
　　death to drink.　　170
Next to them were those condemned to death on a false
　　charge.
Yet every place is duly allotted and judgment is given.
Minos, as president, summons a jury of the dead:
　　he hears
Every charge, examines the record of each; he shakes
　　the urn.
Next again are located the sorrowful ones who killed
Themselves, throwing their lives away, not driven
　　by guilt
But because they loathed living: how they would like to be
In the world above now, enduring poverty and hard trials!
God's law forbids: that unlovely fen with its gloom-
　　ing water
Corrals them there, the nine rings of Styx corral them in.　　180
Not far from here can be seen, extending in all
　　directions,
The vale of mourning—such is the name it bears: a
　　region
Where those consumed by the wasting torments of
　　merciless love
Haunt the sequestered alleys and myrtle groves that
　　give them

Cover; death itself cannot cure them of love's disease.
Here Aeneas descried Phaedra and Procris, sad
　　Eriphyle displaying the wounds her heartless son
　　once dealt her,
Evadne and Pasiphae; with them goes Laodamia;
Here too is Caeneus, once a young man, but next
　　a woman
And now changed back by fate to his original sex.　　190
Amongst them, with her death-wound still bleeding,
　　through the deep wood
Was straying Phoenician Dido. Now when the Trojan
　　leader
Found himself near her and knew that the form he
　　glimpsed through the shadows
Was hers—as early in the month one sees, or imagines
　　he sees,
Through a wrack of cloud the new moon rising and
　　glimmering—
He shed some tears, and addressed her in tender, loving
　　tones:—
　　Poor, unhappy Dido, so the message was true that
　　came to me
Saying you'd put an end to your life with the sword and
　　were dead?
Oh god! was it death I brought you, then? I swear by
　　the stars,
By the powers above, by whatever is sacred in the
　　Underworld,　　200
It was not of my own will, Dido, I left your land.
Heaven's commands, which now force me to traverse
　　the shades,
This sour and derelict region, this pit of darkness, drove me
Imperiously from your side. I did not, could not imagine
My going would ever bring such terrible agony on you.
Don't move away! Oh, let me see you a little longer!
To fly from me, when this is the last word fate allows us!
　　Thus did Aeneas speak, trying to soften the
　　wild-eyed,
Passionate-hearted ghost, and brought the tears to his
　　own eyes.
She would not turn to him; she kept her gaze on the
　　ground,　　210
And her countenance remained as stubborn to his appeal
As if it were carved from recalcitrant flint or a crag of
　　marble.
At last she flung away, hating him still, and vanished
Into the shadowy wood where her first husband,
　　Sychaeus,
Understands her unhappiness and gives her an
　　equal love.
Nonetheless did Aeneas, hard hit by her piteous fate,
Weep after her from afar, as she went, with tears of
　　compassion.

. . . .

*Toward the end of Book VI, Aeneas meets his father, Anchises. After
an emotional greeting, Anchises describes many of the future heroes of
Roman history, and in a famous passage, beginning at line 96, evokes
Rome's destined rise to world ruler and peacemaker. Yet after Virgil's ring-
ing description of the glorious future, he ends the episode ambiguously.
There are two gates out of the underworld, one of horn for true dreams,
and one of ivory—bright and shining—for false dreams. Anchises sends
his son back into the world through the gate of ivory.*

When Anchises had finished, he drew his son and the Sibyl
Into the thick of the murmuring concourse assembled there
And took his stand on an eminence from which he could
　　scan the long files

Over against him, and mark the features of those who
 passed
 Listen, for I will show you your destiny, setting forth
The fame that from now shall attend the seed of
 Dardanus
The posterity that awaits you from an Italian marriage—
Illustrious souls, one day to come in for our Trojan name.
That young man there—do you see him? who leans on
 an untipped spear,
Has been allotted the next passage to life, and first of 10
All these will ascend to earth, with Italian blood in
 his veins;
He is Silvius, an Alban name, and destined to be your
 last child,
The child of your late old age by a wife, Lavinia,
 who shall
Bear him in sylvan surroundings, a king and the father
 of kings
Through whom our lineage shall rule in Alba Longa.
Next to him stands Procas, a glory to the Trojan line;
Then Capys and Numitor, and one who'll revive your
 own name—
Silvius Aeneas, outstanding alike for moral rectitude
And prowess in warfare, if ever he comes to the Alban
 throne.
What fine young men they are! Look at their stalwart
 bearing, 20
The oak leaves that shade their brows—decorations for
 saving life!
These shall found your Nomentum, Gabii and Fidenae,
These shall rear on the hills Collatia's citadel,
Pometii, and the Fort of Inuus, Bola and Cora—
All nameless sites at present, but then they shall have
 these names.
Further, a child of Mars shall go to join his grandsire—
Romulus, born of the stock of Assarcus by his mother,
Ilia. Look at the twin plumes upon his helmet's crest,
Mars' cognizance, which marks him out for the world
 of earth!
His are the auguries, my son, whereby great Rome 30
Shall rule to the ends of the earth, shall aspire to the
 highest achievement,
Shall ring the seven hills with a wall to make one city,
Blessed in her breed of men: as Cybele, wearing her
 turreted
Crown, is charioted round the Phrygian cities, proud of
Her brood of gods, embracing a hundred of her
 children's children—
Heaven-dwellers all, tenants of the realm above.
Now bend your gaze this way, look at that people there!
They are your Romans. Caesar is there and all
 Ascanius'
Posterity, who shall pass beneath the arch of day.
And here, here is the man, the promised one you
 know of— 40
Caesar Augustus, son of a god, destined to rule
Where Saturn ruled of old in Latium, and there
Bring back the age of gold: his empire shall expand
Past Garamants and Indians to a land beyond the zodiac
And the sun's yearly path, where Atlas the sky-bearer pivots
The wheeling heavens, embossed with fiery stars, on his
 shoulder.
Even now the Caspian realm, the Crimean country
Tremble at oracles of the gods predicting his advent,
And the seven mouths of the Nile are in a lather of fright.
Not even Hercules roved so far and wide over earth, 50
Although he shot the bronze-footed deer, brought peace
 to the woods of

Erymanthus, subdued Lerna with the terror of his bow;
Nor Bacchus, triumphantly driving his team with vines
 for reins,
His team of tigers down from Mount Nysa, travelled
 so far.
Do we still hesitate, then, to enlarge our courage by action?
Shrink from occupying the territory of Ausonia?
Who is that in the distance, bearing the hallows,
 crowned with
A wreath of olive? I recognize—grey hair and
 hoary chin—
That Roman king who, called to high power from
 humble Cures,
A town in a poor area, shall found our system of law 60
And thus refound our city. The successor of Numa,
 destined
To shake our land out of its indolence, stirring men up
 to fight
Who have grown unadventurous and lost the habit of
 victory,
Is Tullus. After him shall reign the too boastful Ancus,
Already over-fond of the breath of popular favor.
Would you see the Tarquin kings, and arrogant as they,
 Brutus
The avenger, with the symbols of civic freedom he
 won back?
He shall be first to receive consular rank and its
 power of
Life and death: when his sons awake the dormant conflict,
Their father, a tragic figure, shall call them to pay the
 extreme 70
Penalty, for fair freedom's sake. However posterity
Look on that deed, patriotism shall prevail and love of
Honor. See over there the Decii, the Drusi, Torquatus
With merciless axe, Camillus with the standards he
 recovered.
See those twin souls, resplendent in duplicate
 armor: now
They're of one mind, and shall be as long as the Under-
 world holds them;
But oh, if ever they reach the world above, what
 warfare,
What battles and what carnage will they create
 between them—
Caesar descending from Alpine strongholds, the fort of
 Monoceus,
His son-in-law Pompey lined up with an Eastern army
 against him. 80
Lads, do not harden yourselves to face such terrible
 wars!
Turn not your country's hand against your country's
 heart!
You, be the first to renounce it, my son of heavenly
 lineage,
You be the first to bury the hatchet! . . .
That one shall ride in triumph to the lofty Capitol,
The conqueror of Corinth, renowned for the Greeks he
 has slain.
That one shall wipe out Argos and Agamemnon's
 Mycenae,
Destroying an heir of Aeacus, the seed of warrior
 Achilles,
Avenging his Trojan sires and the sacrilege done to
 Minerva.
Who could leave unnoticed the glorious Cato, Cossus, 90
The family of the Gracchi, the two Scipios—
 thunderbolts
In war and death to Libya; Fabricius, who had plenty

In poverty; Serranus, sowing his furrowed fields?
Fabii, where do you lead my lagging steps? O Fabius,
The greatest, you the preserver of Rome by delaying
 tactics!
Yet others fashion from bronze more lifelike, breathing
 images—
For so they shall—and evoke living faces from marble;
Others excel as orators, others track with their
 instruments
The planets circling in heaven and predict when stars
 will appear.
But, Romans, never forget that government is your
 medium! 100
Be this your art:—to practice men in the habit of peace,
Generosity to the conquered, and firmness against
 aggressors.
 They marvelled at Anchises' words, and he went
 on:—
 Look how Marcellus comes all glorious with the
 highest
Of trophies, a victor over-topping all other men!
He shall buttress the Roman cause when a great war
 shakes it,
Shatter the Carthaginian and rebel Gaul with his cavalry,
Give to Quirinus the third set of arms won in single
 combat.
 Aeneas interposed, seeing beside Marcellus 110
A youth of fine appearance, in glittering accoutrements,
But his face was far from cheerful and downcast were
 his eyes:—
 Father, who is he that walks with Marcellus there?
His son? Or one of the noble line of his children's
 children?
How the retinue murmurs around him! How fine is the
 young man's presence!
Yet is his head haloed by somber shade of night.
 Then father Anchises began, tears welling up in his
 eyes:—
 My son, do not probe into the sorrows of your kin.
Fate shall allow the earth one glimpse of this
 young man—
One glimpse, no more. Too puissant had been Rome's
 stock, ye gods,
In your sight, had such gifts been granted it to keep. 120
What lamentations of men shall the Campus Martius echo
To Mars' great city! O Tiber, what obsequies you shall see
One day as you glide past the new-built mausoleum!
No lad of the Trojan line shall with such hopeful
 promise
Exalt his Latin forebears, nor shall the land of Romulus
Ever again be so proud of one she has given birth to.
Alas for the sense of duty, the old-time honor! Alas for
The hand unvanquished in war! Him would no foe
 have met
In battle and not rued it, whether he charged on foot
Or drove his lathering steed with spurs against the
 enemy. 130
Alas, poor youth! If only you could escape your harsh
 fate!
Marcellus you shall be. Give me armfuls of lilies
That I may scatter their shining blooms and shower
 these gifts
At least upon the dear soul, all to no purpose though
Such kindness be.
 So far and wide, surveying all,
They wandered through that region, those broad and
 hazy plains.
After Anchises had shown his son over the whole place

And fired his heart with passion for the great things
 to come,
He told the hero of wars he would have to fight one day, 140
Told of the Laurentines and the city of Latinus,
And how to evade, or endure, each crisis upon his way.
 There are two gates of Sleep: the one is made of horn,
They say, and affords the outlet for genuine apparitions:
The other's gate of brightly-shining ivory; this way
The Shades send up to earth false dreams that impose
 upon us.
Talking, then, of such matters, Anchises escorted his son
And the Sibyl as far as the ivory gate and sent them
 through it.
Aeneas made his way back to the ships and his friends
 with all speed,
Then coasted along direct to the harbor of Caieta. 150
The ships, anchored by the bows, line the shore with
 their sterns.

From Book I, Book IV, Book VI of "The Georgics of Vergil," translated by
C. Day Lewis. Copyright 1953 by C. Day Lewis. Reprinted by permission
of Sll/Sterling Lord Literistic, Inc.

READING 14
from HORACE (65–8 BCE), CARMINUM LIBER I–III

*Horace's poetry addresses a wide range of subjects: love; friendship; the
inevitable approach of old age; political issues of his times; famous epi-
sodes in Roman history. The five odes below, drawn from and numbered
by collection and sequence, illustrate a number of these topics.*

*The first (I-X) evokes various pleasures: the beauty of nature, com-
panionable drinking, romantic assignations. The wistful note of the uncer-
tainty of life and the all-too-certain coming of old age, is utterly character-
istic of Horace's view of the world. The second (I-XX) invites Maecenas,
his friend and patron, to dinner. Maecenas, who oversaw Augustus's cul-
tural program, had just recovered from an illness. The opening line of the
third (II-III) expresses another familiar Horatian theme, while the next
poem (II-XIV) shows Horace at his most despondent. Yet, as the last
(III-XXX) reminds us, the poet may die but his poems will live on. Few
have described art's ability to transcend death more gloriously.*

I-X

Look how the snow lies deeply on glittering
Soracte. White woods groan and protestingly
 Let fall their branch-loads. Bitter frost has
 Paralyzed rivers: the ice is solid.

Unfreeze the cold! Pile plenty of logs in the
Fireplace! And you, dear friend Thaliarchus, come,
 Bring out the Sabine wine-jar four years
 Old and be generous. Let the good gods

Take care of all else. Later, as soon as they've
Calmed down this contestation of winds upon 10
 Churned seas, the old ash-trees can rest in
 Peace and the cypresses stand unshaken.

Try not to guess what lies in the future, but,
As Fortune deals days, enter them into your
 Life's book as windfalls, credit items,
 Gratefully. Now that you're young, and peevish

Grey hairs are still far distant, attend to the
Dance-floor, the heart's sweet longings; for now is the
 Right time for midnight assignations,
 Whispers and murmurs in Rome's piazzas 20

And fields, and soft, low laughter that gives away
The girl who plays love's games in a hiding-place—
 Off comes a ring coaxed down an arm or
 Pulled from a faintly resisting finger.

I-XX

My dear Maecenas, noble knight,
You'll drink cheap Sabine here tonight
From common cups. Yet I myself
Sealed it and stored it on the shelf
In a Greek jar that day the applause
Broke out in your recovery's cause,
So that the compliment resounded
Through the full theater and rebounded
From your own Tiber's banks until
The echo laughed on Vatican hill. 10
At your house you enjoy the best—
Caecuban or the grape that's pressed
At Cales. But whoever hopes
My cups will taste of Formian slopes
Or of the true Falernian
Must leave a disappointed man.

II-III

Maintain an unmoved poise in adversity;
Likewise in luck one free of extravagant
 Joy. Bear in mind my admonition,
 Dellius. Whether you pass a lifetime

Prostrate with gloom, or whether you celebrate
Feast-days with choice old brands of Falernian
 Stretched out in some green, unfrequented
 Meadow, remember your death is certain.

For whom but us do silvery poplar and
Tall pine conspire such welcome with shadowy 10
 Laced boughs? Why else should eager water
 Bustle and fret in its zigzag channel?

Come, bid them bring wine, perfume and beautiful
Rose-blooms that die too swiftly: be quick while the
 Dark threads the three grim Sisters weave still
 Hold and your years and the times allow it.

Soon farewell town house, country estate by the
Brown Tiber washed, chain-acres of pasture-land,
 Farewell the sky-high piles of treasure
 Left with the rest for an heir's enjoyment. 20

Rich man or poor man, scion of Inachus
Or beggar wretch lodged naked and suffering
 God's skies—it's all one. You and I are
 Victims of never-relenting Orcus,

Sheep driven deathward. Sooner or later Fate's
Urn shakes, the lot comes leaping for each of us
 And books a one-way berth in Charon's
 Boat on the journey to endless exile.

II-XIV

Ah, how they glide by, Postumus, Postumus,
The years, the swift years! Wrinkles and imminent
 Old age and death, whom no one conquers—
 Piety cannot delay their onward

March; no, my friend, not were you to sacrifice
Three hundred bulls each day to inflexible
 Pluto, whose grim moat holds the triple
 Geryon jailed with his fellow Giants—

Death's lake that all we sons of mortality
Who have the good earth's fruits for the picking are 10
 Foredoomed to cross, no matter whether
 Rulers of kingdoms or needy peasants.

In vain we stay unscratched by the bloody wars,
In vain escape tumultuous Hadria's
 Storm-waves, in vain each autumn dread the
 Southern sirocco, our health's destroyer.

We must at last set eyes on the scenery
Of Hell: the ill-famed daughters of Danaus,
 Cocytus' dark, slow, winding river,
 Sisyphus damned to his endless labor. 20

Farewell to lands, home, dear and affectionate
Wife then. Of all those trees that you tended well
 Not one, a true friend, save the hated
 Cypress shall follow its short-lived master.

An heir shall drain those cellars of Caecuban
You treble-locked (indeed he deserves it more)
 And drench the stone-flagged floor with prouder
 Wine than is drunk at the pontiffs' banquet.

III-XXX

More durable than bronze, higher than Pharaoh's
Pyramids is the monument I have made,
A shape that angry wind or hungry rain
Cannot demolish, nor the innumerable
Ranks of the years that march in centuries.
I shall not wholly die: some part of me
Will cheat the goddess of death, for while High Priest
And Vestal climb our Capitol in a hush,
My reputation shall keep green and growing.
Where Aufidus growls torrentially, where once, 10
Lord of a dry kingdom, Daunus ruled
His rustic people, I shall be renowned
As one who, poor-born, rose and pioneered
A way to fit Greek rhythms to our tongue.
Be proud, Melpomene, for you deserve
What praise I have, and unreluctantly
Garland my forehead with Apollo's laurel.

From *The Odes of Horace* by Horace, translated by James Michie. Translation copyright © 1965 by James Michie. Used by permission of Viking Penguin, a division of Penguin Group (USA), Inc.

READING 15

from Juvenal (c. 60–130), Satire III

Juvenal tells us at the beginning of his first Satire that he turned to writing out of fierce outrage at the corruption and decadence of his day. In Satire III he takes on Rome itself and the inconveniences (to say the least) of urban life. An imaginary friend has decided that he no longer can stand life in the big city and, as he leaves for the country (symbolized in the first lines of this passage by small towns such as Praeneste and Gabii), he catalogues some of the reasons for his departure.

"Who, in Praeneste's cool, or the wooded Volsinian
 uplands,
Who, on Tivoli's heights, or a small town like Gabii, say,
Fears the collapse of his house? But Rome is supported
 on pipestems,
Matchsticks; it's cheaper, so, for the landlord to shore up
 his ruins,
Patch up the old cracked walls, and notify all the tenants

They can sleep secure, though the beams are in ruins
 above them.
No, the place to live is out there, where no cry of *Fire!*
Sounds the alarm of the night, with a neighbor yelling
 for water,
Moving his chattels and goods, and the whole third story
 is smoking.
This you'll never know: for if the ground floor is scared
 first, 10
You are the last to burn, up there where the eaves of
 the attic
Keep off the rain, and the doves are brooding their nest
 eggs. . . .
 "Here in town the sick die from insomnia mostly.
Undigested food, on a stomach burning with ulcers,
Brings on listlessness, but who can sleep in a flophouse?
Who but the rich can afford sleep and a garden
 apartment?
That's the source of infection. The wheels creak by on the
 narrow
Streets of the wards, the drivers squabble and brawl
 when they're stopped,
More than enough to frustrate the drowsiest son of a
 sea cow.
When his business calls, the crowd makes way, as the
 rich man, 20
Carried high in his car, rides over them, reading or
 writing,
Even taking a snooze, perhaps, for the motion's
 composing.
Still, he gets where he wants before we do; for all of
 our hurry
Traffic gets in our way, in front, around and behind us.
Somebody gives me a shove with an elbow, or two-by-
 four scantling.
One clunks my head with a beam, another cracks down
 with a beer keg.
Mud is thick on my shins, I am trampled by somebody's
 big feet.
Now what?—a soldier grinds his hobnails into my toes.
 "Don't you see the mob rushing along to the
 handout?
There are a hundred guests, each one with his kitchen
 servant. 30
Even Samson himself could hardly carry those burdens,
Pots and pans some poor little slave tries to keep on his
 head, while he hurries
Hoping to keep the fire alive by the wind of his running.
Tunics, new-darned, are ripped to shreds; there's the
 flash of a fir beam
Huge on some great dray, and another carries a pine tree,
Nodding above our heads and threatening death to the
 people.
What will be left of the mob, if that cart of Ligurian marble
Breaks its axle down and dumps its load on these
 swarms?
Who will identify limbs or bones? The poor man's cadaver,
Crushed, disappears like his breath. And meanwhile, at
 home, his household 40
Washes the dishes, and puffs up the fire, with all kinds of
 clatter
Over the smeared flesh-scrapers, the asks of oil, and the
 towels.
So the boys rush around, while their late master is sitting,
Newly come to the bank of the Styx, afraid of the filthy
Ferryman there, since he has no fare, not even a copper
In his dead mouth to pay for the ride through that
 muddy whirlpool.

"Look at other things, the various dangers of
 nighttime.
How high it is to the cornice that breaks, and a chunk
 beats my brains out,
Or some slob heaves a jar, broken or cracked, from a
 window.
Bang! It comes down with a crash and proves its weight
 on the sidewalk. 50
You are a thoughtless fool, unmindful of sudden disaster,
If you don't make your will before you go out to have
 dinner.
There are as many deaths in the night as there are open
 windows
Where you pass by; if you're wise, you will pray, in your
 wretched devotions,
People may be content with no more than emptying
 slop jars."

From "The Third Satire" by Juvenal in *The Satires of Juvenal,* translated by Rolfe Humphries, © 1958 Indiana University Press. Reprinted by permission.

READING 16

Marcus Aurelius Antoninus (121–180), The Meditations, Book II

The Meditations of Marcus Aurelius, written in Greek, consist of a philosophical journal or diary, in which the emperor recorded his reflections and observations. Some parts were carefully composed; elsewhere he jotted down a few words or a quotation. Ideas were recorded in no logical order and Marcus Aurelius contradicted himself in places—or at least changed his mind. The chief theme of the Meditations is that of self-examination and the search for spiritual happiness, inspired by the teachings of Stoicism.

The tone of Book II, which we reproduce here in its entirety, is not a happy one, and in places the emperor seems to come close to despair. Yet it is inspiring to share the thoughts of a man of high responsibilities and even higher ideals. Furthermore, on page after page we find observations that transcend Marcus Aurelius's historical period and remind us of the universality of human experience by their relevance to our own lives.

1. Say to yourself in the morning: I shall meet people who are interfering, ungracious, insolent, full of guile, deceitful and antisocial; they have all become like that because they have no understanding of good and evil. But I who have contemplated the essential beauty of good and the essential ugliness of evil, who know that the nature of the wrong-doer is of one kin with mine—not indeed of the same blood or seed but sharing the same mind, the same portion of the divine—I cannot be harmed by any one of them, and no one can involve me in shame. I cannot feel anger against him who is of my kin, nor hate him. We were born to labor together, like the feet, the hands, the eyes, and the rows of upper and lower teeth. To work against one another is therefore contrary to nature, and to be angry against a man or turn one's back on him is to work against him.

2. Whatever it is which I am, it is flesh, breath of life, and directing mind. The flesh you should despise: blood, bones and a network woven of nerves, veins and arteries. Consider too the nature of the life-breath: wind, never the same, but disgorged and then again gulped in, continually. The third part is the directing mind. Throw away your books, be no longer anxious: that was not your given role. Rather reflect thus as if death were now before you: "You are an old man, let this third part be enslaved no longer,

nor be a mere puppet on the strings of selfish desire; no longer let it be vexed by your past or present lot, or peer suspiciously into the future."

3. The works of the gods are full of Providence. The works of Chance are not divorced from Nature or from the spinning and weaving together of those things which are governed by Providence. Thence everything flows. There is also Necessity and what is beneficial to the whole ordered universe of which you are a part. That which is brought by the nature of the Whole, and preserves it, is good for every part. As do changes in the elements, so changes in their compounds preserve the ordered universe. That should be enough for you, these should ever be your beliefs. Cast out the thirst for books that you may not die growling, but with true graciousness, and grateful to the gods from the heart.

4. Remember how long you delayed, how often the gods have appointed the day of your redemption and you have let it pass. Now, if ever, you must realize of what kind of ordered universe you are a part, of what kind of governor of that universe you are an emanation, that a time limit has now been set for you and that if you do not use it to come out into the light, it will be lost, and you will be lost, and there will be no further opportunity.

5. Firmly, as a Roman and a man should, think at all times how you can perform the task at hand with precise and genuine dignity, sympathy, independence, and justice, making yourself free from all other preoccupations. This you will achieve if you perform every action as if it was the last of your life, if you rid yourself of all aimless thoughts, of all emotional opposition to the dictates of reason, of all pretense, selfishness and displeasure with your lot. You see how few are the things a man must overcome to enable him to live a smoothly flowing and godly life; for even the gods will require nothing further from the man who keeps to these beliefs.

6. You shame yourself, my soul, you shame yourself, and you will have no further opportunity to respect yourself; the life of every man is short and yours is almost finished while you do not respect yourself but allow your happiness to depend upon the souls of others.

7. Do external circumstances to some extent distract you? Give yourself leisure to acquire some further good knowledge and cease to wander aimlessly. Then one must guard against another kind of wandering, for those who are exhausted by life, and have no aim at which to direct every impulse and generally every impression, are foolish in their deeds as well as in their words.

8. A man is not easily found to be unhappy because he takes no thought for what happens in the soul of another; it is those who do not attend to the disturbances of their own soul who are inevitably in a state of unhappiness.

9. Always keep this thought in mind: what is the essential nature of the universe and what is my own essential nature? How is the one related to the other, being so small a part of so great a Whole? And remember that no one can prevent your deeds and your words being in accord with nature.

10. Theophrastus speaks as a philosopher when, in comparing sins as a man commonly might, he states that offenses due to desire are worse than those due to anger, for the angry man appears to be in the grip of pain and hidden pangs when he discards Reason, whereas he who sins through desire, being overcome by pleasure, seems more licentious and more effeminate in his wrongdoing. So Theophrastus is right, and speaks in a manner worthy of philosophy, when he says that one who sins through pleasure deserves more blame than one who sins through pain. The latter is more like a man who was wronged first and compelled by pain to anger; the former starts on the path to sin of his own accord, driven to action by desire.

11. It is possible to depart from life at this moment. Have this thought in mind whenever you act, speak, or think. There is nothing terrible in leaving the company of men, if the gods exist, for they would not involve you in evil. If, on the other hand, they do not exist or do not concern themselves with human affairs, then what is life to me in a universe devoid of gods or of Providence? But they do exist and do care for humanity, and have put it altogether within a man's power not to fall into real evils. And if anything else were evil they would have seen to it that it be in every man's power not to fall into it. As for that which does not make a man worse, how could it make the life of man worse?

Neither through ignorance nor with knowledge could the nature of the Whole have neglected to guard against this or correct it; nor through lack of power or skill could it have committed so great a wrong, namely that good and evil should come to the good and the evil alike, and at random. True, death and life, good and ill repute, toil and pleasure, wealth and poverty, being neither good nor bad, come to the good and the bad equally. They are therefore neither blessings nor evils.

12. How swiftly all things vanish; in the universe the bodies themselves, and in time the memories of them. Of what kind are all the objects of sense, especially those which entice us by means of pleasure, frighten us by means of pain, or are shouted about in vainglory; how cheap they are, how contemptible, sordid, corruptible and dead—upon this our intellectual faculty should fix its attention. Who are these men whose voice and judgment make or break reputations? What is the nature of death? When a man examines it in itself, and with his share of intelligence dissolves the imaginings which cling to it, he conceives it to be no other than a function of nature, and to fear a natural function is to be only a child. Death is not only a function of nature but beneficial to it.

How does man reach god, with what part of himself, and in what condition must that part be?

13. Nothing is more wretched than the man who runs around in circles busying himself with all kinds of things—investigating things below the earth, as the saying goes—always looking for signs of what his neighbors are feeling and thinking. He does not realize that it is enough to be concerned with the spirit within oneself and genuinely to serve it. This service consists in keeping it free from passions, aimlessness, and discontent with its fate at the hands of gods and men. What comes from the gods must be revered because of their goodness; what comes from men must be welcomed because of our kinship, although sometimes these things are also pitiful in a sense, because of men's ignorance of good and evil, which is no less a disability than to be unable to distinguish between black and white.

14. Even if you were to live three thousand years or three times ten thousand, remember nevertheless that no one can shed another life than this which he is living, nor live another life than this which he is shedding, so that the longest and the shortest life come to the same thing. The present is equal for all, and that which is being lost is equal, and that which is being shed is thus shown to be but a moment. No one can shed that which is past, nor what is still to come; for how could he be deprived of what he does not possess?

Therefore remember these two things always: first, that all things as they come round again have been the same from eternity, and it makes no difference whether you see the same things for a hundred years, or for two hundred years, or for an infinite time; second, that the

longest-lived or the shortest-lived sheds the same thing at death, for it is the present moment only of which he will be deprived, if indeed only the present moment is his, and no man can discard what he does not have.

15. "All is but thinking so." The retort to the saying of Monimus the Cynic is obvious, but the usefulness of the saying is also obvious, if one accepts the essential meaning of it insofar as it is true.

16. The human soul violates itself most of all when it becomes, as far as it can, a separate tumor or growth upon the universe; for to be discontented with anything that happens is to rebel against that Nature which embraces, in some part of itself, all other natures. The soul violates itself also whenever it turns away from a man and opposes him to do him harm, as do the souls of angry men; thirdly, whenever it is overcome by pleasure or pain; fourthly, whenever it acts a part and does or says anything falsely and hypocritically; fifthly, when it fails to direct any action or impulse to a goal, but acts at random, without purpose, whereas even the most trifling actions must be directed toward the end; and this end, for reasonable creatures, is to follow the reason and the law of the most honored commonwealth and constitution.

17. In human life time is but a point, reality a flux, perception indistinct, the composition of the body subject to easy corruption, the soul a spinning top, fortune hard to make out, fame confused. To put it briefly: physical things are but a flowing stream, things of the soul dreams and vanity; life is but a struggle and the visit to a strange land, posthumous fame but a forgetting.

What then can help us on our way? One thing only: philosophy. This consists in guarding our inner spirit inviolate and unharmed, stronger than pleasures and pains, never acting aimlessly, falsely or hypocritically, independent of the actions or inaction of others, accepting all that happens or is given as coming from whence one came oneself, and at all times awaiting death with contented mind as being only the release of the elements of which every creature is composed. If it is nothing fearful for the elements themselves that one should continually change into another, why should anyone look with suspicion upon the change and dissolution of all things? For this is in accord with nature, and nothing evil is in accord with nature.

CHAPTER 5

READING 17

from THE RIG VEDA (C. 1200–900 BCE)

Characteristic of Aryan culture, with its elaborate religious system that placed enormous emphasis on ritual sacrifice to a pantheon of gods, the RIG VEDA *represents the oldest strain of Indian religious literature. The collection of over 1000 hymns addressed to various deities and intended to be chanted at rituals, is organized into ten hymn books, or mandalas. The hymns are still chanted by Hindus at all important moments in Indian religious life: at birth, naming ceremonies, rites of passage to adulthood, in sickness, and at death. Mandalas 1 and 10 are the longest and most recent collections with 191 hymns each, four of which we reproduce here, numbered as is usual by their book number, sequence, and stanza. Agni is the god of sacrificial fire and one of the chief gods to whom the* RIG VEDIC *hymns are addressed.*

1.1 I Pray to Agni

Appropriately placed at the very beginning of the *Rig Veda,* this hymn invites Agni, the divine priest, to come to the sacrifice.

1. I pray to Agni, the household priest who is the god of the sacrifice, the one who changes and invokes and brings most treasure.
2. Agni earned the prayers of the ancient sages, and of those of the present, too; he will bring the gods here.
3. Through Agni one may win wealth, and growth from day to day, glorious and most abounding in heroic sons.
4. Agni, the sacrificial ritual that you encompass on all sides—only that one goes to the gods.
5. Agni, the priest with the sharp sight of a poet, the true and most brilliant, the god will come with the gods.
6. Whatever good you wish to do for the one who worships you, Agni, through you, O Angiras [the Angirases were an ancient family of priests, often identified with Vedic gods such as Agni and Indra], that comes true.
7. To you Agni, who shine upon darkness, we come day after day, bringing our thoughts and homage.
8. To you, the kind over sacrifices, the shining guarding of the Order, growing in your own house.
9. Be easy for us to reach, like a father to his son. Abide with us, Agni, for our happiness.

1.26 Agni and the Gods

This hymn emphasizes the close symbiosis between the sacrificer and Agni, on the one hand, and the sacrificer and the gods on the other.

1. Now get dressed in your robes,[1] lord of powers and master of the sacrificial food, and offer this sacrifice for us.
2. Young Agni, take your place as our favorite priest with inspirations and shining speech.
3. The father sacrifices for his son, the comrade for his comrade, the favorite friend for his friend.[2]
4. May Varuna, Mitra and Aryaman, proud of their powers, sit upon our sacred grass, as upon Manu's.[3]
5. You who were the first to invoke, rejoice in our friendship and hear only these songs.
6. When we offer sacrifice to this god or that god, in the full line of order, it is to you alone that the oblation is offered.
7. Let him be a beloved lord of tribes for us, a favorite, kindly invoker; let us have a good fire and be beloved.
8. For when the gods have a good fire, they bring us what we wish for. Let us pray with a good fire.
9. So let praises flow back and forth between the two, between us who are mortals and you, the immortal.[4]
10. Agni, young spawn of strength, with all the fires take pleasure in this sacrifice and in this speech.

[1] When Agni becomes the priest, his robes are both the flames and the prayers.

[2] Many gods are asked to behave like friends or fathers; here, it is also suggested that one person might sacrifice on behalf of another, and Agni is asked to do this on behalf of the worshipper.

[3] A reference to the primeval sacrifice offered by Manu, ancestor of mankind.

[4] The verse, which is elliptic, implies both that Agni and the worshipper should enjoy a mutuality of praise and that, through that link, the other gods and the worshippers should enjoy such a mutuality.

2.35 The Child of the Waters
(*Apām Napāt*)

The Child of the Waters is often identified with Agni, as the form of fire that appears as the lightning born of the clouds. But he is a deity in his own right, who appears in the Avesta as a spirit who lives deep in the waters, surrounded by females, driving swift horses. As the embodiment of the dialectic conjunction of fire and water, the child of the waters is a symbol central to Vedic and later Hindu cosmology. This hymn, the only one dedicated entirely to him, plays upon the simultaneous unity and nonunity of the eartly and celestial forms of Agni and the Child of the Waters.

1. Striving for the victory prize, I have set free my eloquence; let the god of the rivers gladly accept my songs. Surely the child of the waters, urging on his swift horses, will adorn my songs,[1] for he enjoys them.
2. We would sing to him this prayer well-fashioned from the heart; surely he will recognize it. With his divine[2] energy, the child of the waters has created all noble creatures.
3. Some flow together, while others flow toward the sea, but the rivers fill the same hollow cavern.[3] The pure waters surrounded this pure, radiant child of the waters.
4. The young women, the waters, flow around the young god, making him shine and gazing solemnly upon him. With his clear, strong flames he shines riches upon us, wearing his farment of butter, blazing without fuel in the waters.
5. Three women, goddesses,[4] wish to give food[5] to the god so that he will not weaken. He has stretched forth in the waters; he sucks the new milk of those who have given birth for the first time.[6]
6. The firth of the horse is here[7] and in the sun. Guard our patrons from falling prey to malice or injury. When far away in fortresses of unbaked bricks,[8] hatred and falsehoods shall not reach him.
7. In his own house he keeps the cow who yields good milk; he makes his vital force swell as he eats the nourishing food. Fathering strength in the waters, the child of the waters shines forth to give riches to his worshipper.
8. True and inexhaustible, he shines forth in the waters with pure divinity.[9] Other creatures and plants, his branches, are reborn with their progeny.[10]

9. Clothed in lightning, the upright child of the waters has climbed into the lap of the waters as they lie down. The golden-hued young women[11] flow around him, bearing with them his supreme energy.
10. Golden is his form, like gold to look upon; and gold in color is this child of the waters. Seated away from his golden womb,[12] the givers of gold give him food.
11. His face and the lovely secret name of the child of the waters grow when the young women[13] kindle him thus. Golden-hued butter is his food.
12. To him, the closest friend among many,[14] we would offer worship with sacrifices, obeisance, and oblations. I rub his back;[15] I bring him shavings; I give him food; I praise him with verses.
13. Being a bull, he engendered that embryo in the females;[16] being a child, he sucks them, and they lick him. The child of the waters, whose color never fades, seems to enter the body of another here.[17]
14. He shines forever, with undarkened flames, remaining in this highest place. The young waters, bringing butter as food to their child, themselves enfold him with robes.
15. O Agni, I have given a good dwelling place to the people; I have given a good hymn to the generous patron. All this is blessed, that the gods love. Let us speak great words as men of power in the sacrificial gathering.

10.18 Burial Hymn

This evocative hymn contains several references to symbolic gestures that may well have been accompanied by rituals similar to those know to us from later Vedic literature. But the human concerns of the hymn are vividly accessible to us, whatever the ritual may have been.

1. Go away, death, by another path that is your own, different from the road of the gods. I say to you who have eyes, who have ears: do not injure our children or our men.
2. When you have gone, wiping away the footprint of death, stretching farther your own lengthening span of life, become pure and clean and worthy of sacrifice, swollen with offspring and wealth.
3. These who are alive have now parted from those who are dead. Our invitation to the gods has become auspicious today. We have gone forward to dance and laugh, stretching farther our own lengthening span of life.
4. I set up this wall for the living, so that no one else among them will reach this point. Let them live a hundred full autumns and bury death in this hill.
5. As days follow days in regular succession, as seasons come after seasons in proper order, in the same way order their

[1] Either he will make them beautiful, or he will reward them.
[2] As a form of Agni, the child of the waters is an Asura, a high divinity.
[3] That is, the ocean.
[4] The three mothers of Agni, the waters of the three worlds.
[5] Soma or butter.
[6] The waters are *primaparas* or *primagravitas,* as the child of the waters is their first child.
[7] Agni is often depicted as a horse, who is in turn identified with the sun; the micro-macrocosmic parallel is enriched by Agni's simultaneous terrestrial and celestial forms, and those of the waters ("here"). Moreover, the sun, like the child of the waters, is born in the waters.
[8] The sacrificer asks to be protected by Agni, who is safe even when among enemies who do not control fire and so do not fire their bricks, or who (as the sun) is safe from his enemies when he is in his own "natural" citadels not make of baked bricks, i.e., the clouds.
[9] Here the Child of the Waters is a god (*deva*).
[10] Other fires on earth are regarded as branches of Agni, who also appears in plants; on another level, Agni causes all creatures and plants to be reborn.
[11] The waters of heaven or earth.

[12] The construction is loose, and may imply either that it is Agni who is seated away from his gold womb or that the sacrificers are seated around him.
[13] Here the young women are the ten fingers, not the waters. The fingers kindle the earthly fire, that grows in the waters (the clouds) secretly and then is fed with butter at the sacrifice.
[14] Literally, the lowest, that is the most intimate friend of men among the many gods, and therefore enjoying intimate services as described in the rest of this verse.
[15] That is, the fire-altar.
[16] The child of the waters engenders himself. He is father and son, pervading a body that belongs to someone who merely *seems* to be other.
[17] That is, on earth. This is an explicit statement of the identity of the Child of the Waters with Agni as the sacrificial fire: the former enters the body of the latter.

life-spans, O Arranger, so that the young do not abandon the old.

6. Climb on to old age, choosing a long life-span, and follow in regular succession, as many as you are. May Tvastr who presides over births be persuaded to give you a long life-span to live.

7. These women who are not widows, who have good husbands—let them take their places, using butter to anoint their eyes. Without tears, without sickness, well dressed let them first climb into the marriage bed.

8. Rise up, woman, into the world of the living. Come here; you are lying beside a man whose life's breath has gone. You were the wife of this man who took your hand and desired to have you.

9. I take the bow from the hand of the dead man, to be our supremacy and glory and power, and I say, 'You are there; we are here. Let us as great heroes conquer all envious attacks.'

10. Creep away to this broad, vast earth, the mother that is kind and gentle. She is a young girl, soft as wool to anyone who makes offerings; let her guard you from the lap of Destruction.

11. Open up, earth; do not crush him. Be easy for him to enter and to burrow in. Earth, wrap him up as a mother wraps a son in the edge of her skirt.

12. Let the earth as she opens up stay firm, for a thousand pillars must be set up. Let them be houses dripping with butter for him, and let them be a refuge for him here for all his days.

13. I shore up the earth all around you; let me not injure you as I lay down this clod of earth. Let the fathers hold up this pillar for you; let Yama build a house for you here.

14. On a day that will come, they will lay me in the earth, like the feather of an arrow. I hold back speech that goes against the grain, as one would restrain a horse with a bridle.

From *The Rig Veda*, translated by Wendy Doniger O'Flaherty (Penguin Classics, 1981). Copyright © Wendy Doniger O'Flaherty, 1981. Reprinted by permission of Penguin Books, Ltd.

READING 18

from THE BRIHAD-ARANYAKA UPANISHAD (8TH–7TH CENTURIES BCE), THE SUPREME TEACHING

This selection from one of the oldest Hindu scriptures earned its title by capturing some of the most fundamental truths found in the UPANISHADS.

The Supreme Teaching—Prologue

To Janaka King of Videha came once Yajñavalkya meaning to keep in silence the supreme secret wisdom. But once, when Janaka and Yajñavalkya had been holding a discussion at the offering of the sacred fire, Yajñavalkya promised to grant the kind any wish and the king chose to ask questions according to his desire. Therefore Janaka, king of Videha, began and asked this question:

Yajñavalkya, what is the light of man?

The sun is his light, O king, he answered. It is by the light of the sun that a man rests, goes forth, does his work, and returns.

This is so in truth, Yajñavalkya. And when the sun is set, what is then the light of man?

The moon then becomes his light, he replied. It is by the light of the moon that a man rests, goes forth, does his work, and returns.

This is so in truth, Yajñavalkya. And when the sun and the moon are set, what is then the light of man?

Fire then becomes his light. It is by the light of fire that a man rests, goes forth, does his work, and returns.

And when the sun and the moon are set, Yajñavalkya, and the fire has sunk down, what is then the light of man?

Voice then becomes his light; and by the voice as his light he rests, goes forth, does his work and returns. Therefore in truth, O king, when a man cannot see even his own hand, if he hears a voice after that he wends his way.

This is so in truth, Yajñavalkya. And when the sun is set, Yajñavalkya, and the moon is also set, and the fire has sunk down, and the voice is silent, what is then the light of man?

The Soul then becomes his light; and by the light of the Soul he rests, goes forth, does his work, and returns.

What is the Soul? asked the kind of Videha.

Waking and Dreaming

Yajñavalkya spoke:

It is the consciousness of life. It is the light of the heart. Forever remaining the same, the Spirit of man wanders in the world of waking life and also in the world of dreams. He seems to wander in thought. He seems to wander in joy.

But in the rest of deep sleep he goes beyond this world and beyond its fleeting forms.

For in truth when the Spirit of man comes to life and takes a body, then he is joined with moral evils; but when at death he goes beyond, then he leaves evil behind.

The Spirit of man has two dwellings: this world and the world beyond. There is also a third dwelling place: the land of sleep and dreams. Resting in this borderland the Spirit of man can behold his dwelling in this world and in the other world afar, and wandering in this borderland he beholds behind him the sorrows of this world and in front of him he seeks the joys of the beyond.

Dreams

When the Spirit of man retires to rest, he takes with him materials from this all-containing world, and he creates and destroys in his own glory and radiance. Then the Spirit of man shines in his own light.

In that land there are no chariots, no teams of horses, nor roads; but he creates his own chariots, his teams of horses, and roads. There are no joys in that region, and no pleasures nor delights; but he creates his own joys, his own pleasures and delights. In that land there are no lakes, no lotus ponds, nor streams; but he creates his own lakes, his lotus ponds, and streams. For the Spirit of man is Creator.

It was said in these verses:

Abandoning his body by the gate of dreams, the Spirit beholds in awaking his senses sleeping. Then he takes his own light and returns to his home, this Spirit of golden radiance, the wandering swan everlasting.

Leaving his nest below in charge of the breath of life, the immortal Spirit soars afar from his nest. He moves in all regions wherever he loves, this Spirit of golden radiance, the wandering swan everlasting.

And in the region of dreams, wandering above and below, the Spirit makes for himself innumerable subtle creations. Sometimes he seems to rejoice in the love of fairy beauties, sometimes he laughs or beholds awe-inspiring terrible visions.

People see his field of pleasure; but he can never be seen.

So they say that one should not wake up a person suddenly, for hard to heal would he be if the Spirit did not return. They say also that dreams are like the waking state, for what is seen

when awake is seen again in a dream. What is true is that the Spirit shines in his own light.

"I give you a thousand gifts," said then the king of Videha, "but tell me of the higher wisdom that leads to liberation."

When the Spirit of man has had his joy in the land of dreams, and his wanderings there has beholden good and evil, he then returns to this world of waking. But whatever he has seen does not return with him, for the Spirit of man is free.

And when he has had his joy in this world of waking and in his wanderings here has beholden good and evil, he returns by the same path again to the land of dreams.

Even as a great fish swims along the two banks of a river, first along the eastern bank and then the western bank, in the same way the Spirit of man moves along beside his two dwellings: this waking world and the land of sleep and dreams.

Deep Sleep

Even as a falcon or an eagle, after soaring in the sky, folds his wings for he is weary, and flies down to his nest, even so the Spirit of man hastens to that place of rest where the soul has no desires and the Spirit sees no dreams.

What was seen in a dream, all the fears of waking, such as being slain or oppressed, pursued by an elephant or falling into an abyss, is seen to be a delusion. But when like a king or a god of the Spirit feels "I am all," then he is in the highest world. It is the world of the Spirit, where there are no desires, all evil has vanished, and there is no fear.

As a man in the arms of the woman beloved feels only peace all around, even so the Soul in the embrace of Atman, the Spirit of vision, feels only peace all around. All desires are attained, since the Spirit that is all has been attained, no desires are there, and there is no sorrow.

There a father is a father no more, nor is a mother there a mother; the worlds are no longer worlds, nor the gods are gods any longer. There the *Vedas* disappear; and a thief is not a thief, nor is a slayer a slayer; the outcast is not an outcast, nor the base-born a base-born; the pilgrim is not a pilgrim and the hermit is not a hermit; because the Spirit of man has crossed the lands of good and evil, and has passed beyond the sorrows of the heart.

There the Spirit sees not, but though seeing not he sees. How could the Spirit not see if he is the All? But there is no duality there, nothing apart for him to see.

There the Spirit feels no perfumes, yet feeling no perfumes he feels them. How could the Spirit feel no perfumes if he is the All? But there is no duality there, no perfumes, apart for him to feel.

There the Spirit tastes not, yet tasting not he tastes. How could the Spirit not taste if he is the All? But there is no duality there, nothing apart for him to taste.

There the Spirit speaks not, yet speaking not he speaks. How could the Spirit not speak if he is the All? But there is no duality there, nothing apart for him to speak to.

There the Spirit hears not, yet hearing not he hears. How could the Spirit not hear if he is the All? But there is no duality there, nothing apart for him to hear.

• There the Spirit thinks not, yet thinking not he thinks. How could the Spirit not think if he is the All? But there is no duality there, nothing apart for him to think.

There the Spirit touches not, yet touching not he touches. How could the Spirit not touch if he is the All? But there is no duality there, nothing apart for him to touch.

There the Spirit knows not, yet knowing not he knows. How could the Spirit not know if he is the All? But there is no duality there, nothing apart for him to know.

For only where there seems to be a duality, there one sees another, one feels another's perfume, one tastes another, one speaks to another, one listens to another, one touches another and one knows another.

But in the ocean of Spirit the seer is alone beholding his own immensity.

This is the world of Brahman, O king. This is the path supreme. This is the supreme treasure. This is the world supreme. This is the supreme joy. On a portion of that joy all other beings live.

He who in this world attains success and wealth, who is Lord of men and enjoys all human pleasures, has reached the supreme human joy.

But a hundred times greater than the human joy is the joy of those who have attained the heaven of the ancestors.

A hundred times greater than the joy of the heaven of the ancestors is the joy of the heaven of the celestial beings.

A hundred times greater than the joy of the heaven of the celestial beings is the joy of the gods who have attained divinity through holy works.

A hundred times greater than the joy of the gods who have attained divinity through holy works is the joy of the gods who were born divine, and of him who has sacred wisdom, who is pure and free from desire.

A hundred times greater than the joy of the gods who were born divine is the joy of the world of the Lord of Creation, and of him who has sacred wisdom, who is pure and free from desire.

And a hundred times greater than the joy of the Lord of Creation is the joy of the world of Brahman, and of him who has sacred wisdom, who is pure and free from desire.

This is the joy supreme, this is the world of the Spirit, O king.

"I give you a thousand gifts," said then the kind of Videha: "but tell me of the higher wisdom that leads to liberation."

And Yajñavalkya was afraid and thought: Intelligent is the kind. He has cut me off from all retreat.

When the Spirit of man has had his joy in the land of dreams, and in his wanderings there has beholden good and evil, he returns once again to this the world of waking.

Death

Even as a heavy-laden cart moves on groaning, even so the cart of the human body, wherein lives the Spirit, moves on groaning when a man is giving up the breath of life.

When the body falls into weakness on account of old age or disease, even as a mango-fruit, or the fruit of the holy fig tree, is loosened from its stem, so the Spirit of man is loosened from the human body and returns by the same way to Life, wherefrom he came.

As when a king is coming, the nobles and officers, the charioteers and heads of the village prepare for him food and drink and royal lodgings, saying "The king is coming, the king is approaching," in the same way all the powers of life wait for him who knows this and say: "The Spirit is coming, the Spirit is approaching."

And as when a king is going to depart, the nobles and officers, the charioteers and the heads of the village assemble around him, even so all the powers of life gather about the soul when a man is giving up the breath of life.

When the human soul falls into weakness and into seeming unconsciousness all the powers of life assemble around. The soul gathers these elements of life-fire and enters into the heart. And when the Spirit that lives in the eye has returned to his own source, then the soul knows no more forms.

Then a person's power of life become one and people say: "he sees no more." His powers of life become one and people say: "he feels perfumes no more." His powers of life become one and people say: "he tastes no more." His powers of life

become one and people say: "he speaks no more." His powers of life become one and people say: "he hears no more." His powers of life become one and people say: "he thinks no more." His powers of life become one and people say: "he touches no more." His powers of life become one and people say: "he knows no more."

Then at the point of the heart a light shines, and this light illumines the soul on its way afar. When departing, by the head, or by the eye or other parts of the body, life arises and follows the soul, and the powers of life follow life. The soul becomes conscious and enters into Consciousness. His wisdom and works take him by the hand, and the knowledge known of old.

Even as a caterpillar, when coming to the end of a blade of grass, reaches out to another blade of grass and draws itself over to it, in the same way the Soul, leaving the body and unwisdom behind, reaches out to another body and draws itself over to it.

And even as a worker in gold, taking an old ornament, molds it into a form newer and fairer, even so the Soul, leaving the body and unwisdom behind, goes into a form newer and fairer: a form like that of the ancestors in heaven, or of the celestial beings, or of the gods of light, or of the Lord of Creation, or of Brahma the Creator supreme, or a form of other beings.

The Soul is Brahman, the Eternal.

It is made of consciousness and mind: it is made of life and vision. It is made of the earth and the waters: it is made of air and space. It is made of light and darkness: it is made of desire and peace. It is made of anger and love: it is made of virtue and vice. It is made of all that is near: it is made of all that is afar. It is made of all.

Karma

According as a man acts and walks in the path of life, so he becomes. He that does good becomes good; he that does evil becomes evil. By pure actions he becomes pure; by evil actions he becomes evil.

And they say in truth that a man is made of desire. As his desire is, so is his faith. As his faith is, so are his works. As his works are, so he becomes. It was said in this verse:

A man comes with his actions to the end of his determination.

Reaching the end of the journey begun by his works on earth, from that world a man returns to this world of human action.

Thus far for the man who lives under desire.

Liberation

Now as to the man who is free from desire.

He who is free from desire, whose desire finds fulfillment, since the Spirit is his desire, the powrs of life leave him not. He becomes one with Brahman, the Spirit, and enters into the Spirit. there is a verse that says:

When all desires that cling to the heart disappear, then a mortal becomes immortal, and even in this life attains liberation.

As the slough of a snake lies dead upon an ant-hill, even so the mortal body; but the incorporeal immortal Spirit is life and light and Eternity.

Concerning this are these verses:

I have found the small path known of old that stretches far away. By it the sages who know the Spirit arise to the regions of heaven and thence beyond to liberation.

It is adorned with white and blue, yellow and green and red. This is the path of the seers of Brahman, of those whose actions are pure and who have inner fire and light.

Into deep darkness fall those who follow action. Into deeper darkness fall those who follow knowledge.

There are worlds of no joy, regions of utter darkness. To those worlds go after death those who in their unwisdom have not wakened up to light.

When awake to the vision of the Atman, our own Self, when a man in truth can say: "I am He," what desires could lead him to grieve in fever for the body?

He who in the mystery of life has found the Atman, the Spirit, and has awakened to his light, to him as creator belongs the world of the Spirit, for he is this world.

While we are here in this life we may reach the light of wisdom; and if we reach it not, how deep is the darkness. Those who see the light enter life eternal: those who live in darkness enter into sorrow.

When a man sees the Atman, the Self in him, God himself, the Lord of what was and of what shall be, he fears no more.

Before whom the years roll and all the days of the years, him the gods adore as the Light of all lights, as Life immortal;

In whom the five hosts of beings rest and the vastness of space, him I know as Atman immortal, him I know as eternal Brahman.

Those who know him who is the eye of the eye, the ear of the ear, the mind of the mind and the life of life, they know Brahman from the beginning of time.

Even by the mind this truth must be seen: there are not many but only One. Who sees variety and not the Unity wanders on from death to death.

Behold then as One the infinite and eternal One who is in radiance beyond space, the everlasting Soul never born.

Knowing this, let the lover of Brahman follow wisdom. Let him not ponder on many words, for many words are weariness.

Yajñavalkya went on:

This is the great Atman, the Spirit never born, the consciousness of life. He dwells in our own hearts as ruler of all, master of all, lord of all. His greatness becomes no greater by good actions no less great by evil actions. He is the Lord supreme, sovereign and protector of all beings, the bridge that keeps the worlds apart that they fall not into confusion.

The lovers of Brahman seeks him through the sacred Vedas, through holy sacrifices, charity, penance and abstinence. He who knows him becomes a Muni, a sage. Pilgrims follow their life of wandering in their longing for his kingdom.

Knowing this, the sages of old desired not offspring. "What shall we do with offspring," said they, "we who possess the Spirit, the wold world?" Rising above the desire of sons, wealth, and the world they followed the life of the pilgrim. For the desire of sons and wealth is the desire of the world. And this desire is vanity.

But the Spirit is not this, is not this. He is incomprehensible, for he cannot be comprehended. He is imperishable, for he cannot pass away. He has no bonds of attachment, for he is free; and free from all bonds he is beyond suffering and fear.

A man who knows this is not moved by grief or exultation on account of the evil or good he has done. He goes beyond both. What is done or left undone grieves him not.

This was said in this sacred verse:

The everlasting greatness of the seer of Brahman is not greater or less great by actions. Let man find the path of the Spirit: who has found this path becomes free from the bonds of evil.

Who knows this and has found peace, he is the lord of himself, his is a calm endurance, and calm concentration. In himself he sees the Spirit, and he sees the Spirit as all.

He is not moved by evil: he removes evil. He is not burned by sin: he burns all sin. And he goes beyond evil, beyond passion, and beyond doubts, for he sees the Eternal.

This is the world of the Spirit, O king. Thus spoke Yajñavalkya.

O Master. Yours is my kingdom and I am yours, said then the king of Vedeha.

Epilogue

This is the great never-born Spirit of man, enjoyer of the food of life, and giver of treasure. He finds this treasure who knows this.

This is the great never-born Spirit of man, never old and immortal. This is the Spirit of the universe, a refuge from all fear.

From *The Upanishads*, translated by Juan Mascaro (Penguin Classics, 1965). Copyright © Juan Mascaro, 1965. Reprinted by permission of Penguin Books, Ltd.

READING 19

from SIDDARTHA GAUTAMA, THE BUDDHA (C. 563–483 BCE)

These selections are ancient Buddhist texts. BUDDHA'S PITY is an early hymn of praise. THE FIRST SERMON, considered the Buddha's most famous sermon on the Middle Way, reproduces Buddha's sermon at Sarnath outside Benares. In the well-known FIRE SERMON, Buddha urges his followers to free themselves from the fires of life's passions.

Buddha's Pity

My children,

The Enlightened One, because he saw Mankind drowning in the Great Sea of Birth, Death and Sorrow, and longed to save them,

For this he was moved to pity.

Because he saw the men of the world straying in false paths, and none to guide them,

For this he was moved to pity.

Because he say that they lay wallowing in the mire of the Five Lusts, in dissolute abandonment,

For this he was moved to pity.

Because he saw them still fettered to their wealth, their wives and their children, knowing not to how to cast them aside,

For this he was moved to pity.

Because he saw them doing evil with hand, heart and tongue, and many times receiving the bitter fruits of sin, yet ever yielding to their desires,

For this he was moved to pity.

Because he saw that they slaked the thirst of the Five Lusts as it were with brackish water,

For this he was moved to pity.

Because he saw that though they longed for happiness, they made for themselves no karma of happiness; and though they hated pain, yet willingly made for themselves a karma of pain: a though they coveted the joys of Heaven, would not follow his commandments on earth,

For this he was moved to pity.

Because he saw them afraid of birth, old age and death, yet still pursuing the works that lead to birth, old age and death,

For this he was moved to pity.

Because he saw them consumed by the fires of pain and sorrow, yet knowing not where to seek the still waters of Samadhi [Enlightenment],

For this he was moved to pity.

Because he saw them living in an evil time, subjected to tyrannous kinds and suffering many ills, yet heedlessly following after pleasure,

For this he was moved to pity.

Because he saw them living in a time of wars, killing and wounding on another: and knew that for the riotous hatred that had flourished in their hearts they were doomed to pay an endless retribution,

For this he was moved to pity.

Because many born at the time of his incarnation had heard him preach the Holy Law, yet could not receive it,

For this he was moved to pity.

Because some had great riches which they could not bear to give away,

For this he was moved to pity.

Because he saw the men of the world ploughing their fields, sowing the seed, trafficking, huckstering, buying and selling: and at the end winning nothing but bitterness,

For this he was moved to pity.

Buddha's Teaching

Cease to do evil;
Learn to do good;
Cleanse your own heart;
This is the teaching of the Buddhas.

The First Sermon

Thus have I heard: once the Exalted One was dwelling near Benares, at Isipatana, in the Deer-Park.

Then the Exalted One thus spake unto the company of five monks. "Monks, these two extremes should not be followed by one who has gone forth as a wandered. What two?

"Devotion to the pleasures of sense, a low practice of villagers, a practice unworthy, unprofitable, the way of the world (on the one hand); and (on the other) devotion to self-mortification, which is painful, unworthy and unprofitable.

"By avoiding these two extremes the Tathagata [another name for Buddha] has gained knowledge of that middle path which giveth vision, which giveth knowledge, which causeth calm, special knowledge, enlightenment, Nirvana.

"An what, monks, is that middle path which giveth vision . . . Nirvana?

"Verily it is this Ariyan eightfold way, to wit: Right view, right aim, right speech, right action, right living, right effort, right mindfulness, right concentration. This, monks, is that middle path which giveth vision, which giveth knowledge, which causeth calm, special knowledge, enlightenment, Nirvana.

"Now this, monks, is the Ariyan truth about Ill:

"Birth is Ill, decay is Ill, sickness is Ill, death is Ill: likewise sorrow and grief, woe, lamentation and despair. To be conjoined with things which we dislike: to be separated from things which we like,—that also is Ill. Not to get what one wants—that also is Ill. In a word, this body, this fivefold mass which is based on grasping—that is ill.

"Now this, monks, is the Ariyan truth about the arising of Ill:

"It is that craving that leads back to birth, along with the lure and the lust that lingers longingly now here, now there: namely, the craving for sensual pleasure, the craving to be born again, the craving for existence to end. Such, monks, is the Ariyan truth about the arising of Ill.

"And this, monks, is the Ariyan truth about the ceasing of Ill:

"Verily it is the utter passionless cessation of, the giving up, the forsaking, the release from, the absence of longing for this craving.

"Now this, monks, is the Ariyan truth about the practice that leads to the ceasing of Ill:

"Verily it is this Ariyan eightfold way, to wit: Right views, right aim, right speech, right action, right living, right effort, right mindfulness, right concentration.

"Monks, at the thought of this Ariyan truth of ill, concerning things unlearnt before, there arose in me vision, insight, understanding: there arose in me wisdom, there arose in me light.

"Monks, at the thought: This Ariyan truth about Ill is to be understood—concerning things unlearnt before, there arose in me vision, insight, understanding: there arose in me wisdom, there arose in me light.

"Monks, at the thought: This Ariyan truth about Ill has been understood (by me)—concerning things unlearnt before, there arose in me vision, insight, understanding: there arose in me wisdom, there arose in me light.

"Again, monks, at the thought of this Ariyan truth about the arising of Ill, concerning things unlearnt before, there arose in me vision, insight, understanding: there arose in me wisdom, there arose in me light.

"At the thought: This arising of Ill is to be put away—concerning things unlearnt before . . . there arose in me light.

"At the thought: This arising of Ill has been put away—concerning things unlearnt before . . . there arose in me light.

"Again, monks, at the thought of this Ariyan truth about the ceasing of Ill, concerning things unlearnt before . . . there arose in me light.

"At the thought: This ceasing of Ill must be realized—concerning things unlearnt before . . . there arose in me light.

"At the thought: This Ariyan truth about the ceasing of Ill has been realized—concerning things unlearnt before . . . there arose in me light.

"Again, monks, at the thought of this Ariyan truth about the practice leading to the ceasing of Ill, concerning things unlearnt before . . . there arose in me light.

"At the thought: This Ariyan truth about the practice leading to the ceasing of Ill must be cultivated—concerning things unlearnt before . . . there arose in me light.

"At the thought: This Ariyan truth about the practice leading to the ceasing of Ill has been cultivated—concerning things unlearnt before there arose in me vision, insight, understanding: there arose in me wisdom, there arose in me light.

"Now, monks, so long as my knowledge and insight of these thrice revolved twelvefold Ariyan truths, in their essential nature, was not quite purified—so long was I not sure that in this world there was one enlightenment with supreme enlightenment.

"But, monks, so soon as my knowledge and insight of these thrice revolved twelvefold Ariyan truths, in their essential nature, was quite purified, then, monks, was I assured what it is to be enlightened with supreme enlightenment. Now knowledge and insight have arisen in me so that I know. Sure is my heart's release. This is my last birth. There is no more becoming for me."

The Fire Sermon

All things, O monks, are on fire.

The eye, O monks, is on fire; forms are on fire; eye-consciousness is on fire; impressions received by the eye are on fire; and whatever sensation, pleasant, unpleasant or indifferent, originates in dependence on impressions received by the eye, that also is on fire.

And with what are these on fire?

With the fire of passion, with the fire of hatred, with the fire of infatuation; with birth, old age, death, sorrow, lamentation misery, grief and despair are they on fire.

The ear is on fire; sounds are on fire . . . the nose is on fire, odors are on fire; . . . the tongue is on fire; tastes are

on fire; . . . mind-consciousness is on fire; impressions received by the mind are on fire; and whatever sensation, pleasant, unpleasant or indifferent, originates in dependence on impressions received by the mind, that also is on fire.

And with what are these on fire?

With the fire of passion, with the fire of hatred, with the fire of infatuation; with birth, old age, sorrow, lamentation, misery, grief and despair are they on fire.

Perceiving this, O monks, the learned and noble disciple conceives an aversion for the eye, for forms, for eye-consciousness, for the impressions received by the eye; and whatever sensation, pleasant, unpleasant or indifferent, originates in dependence on impressions received by the eye, for that also he conceives an aversion . . . And in conceiving this aversion, he becomes divested of passion, and by the absence of passion he becomes free, and when he is free he becomes aware that he is free; and he knows that rebirth is exhausted, that he has lived the holy life, that he has done what it behoved him to do, and that he is no more for this world.

From *The Wisdom of Buddhism,* trans. Christmas Humphries, pp. 36–37, 42–45.

READING 20
from Li Po (701–762)

Even during his lifetime, Li Po was recognized as one of the greatest Chinese poets, and posterity has confirmed his status. Although most of his works deal with traditional themes—the beauties of nature, the search for spiritual peace, the pleasures of wine—he brought to them a unique sense of fantasy and eloquence. About a thousand of his poems survive; those reproduced below are among his most popular.

"Bring the Wine!"

Have you never seen
the Yellow River waters descending from the sky,
racing restless toward the ocean, never to return?
Have you never seen
bright mirrors in high halls, the white-haired ones
　　　lamenting,
their black silk of morning by evening turned to snow?
If life is to have meaning, seize every joy you can;
do not let the golden cask sit idle in the moonlight!
Heaven gave me talents, and meant them to be used;
gold scattered by the thousand comes home to me again.
Boil the mutton, roast the ox—we will be merry,
at one bout no less that three hundred cups.
Master Ts'en!
Scholar Tan-ch'iu!
Bring the wine and no delay!
For you I'll sing a song—
be pleased to bend your ears and hear.
Bells and drums, food as rare as jade—these aren't worth
　　　prizing;
all I ask is to be drunk for ever, never to sober up!
Sages and worthies from antiquity—all gone into silence;
only the great drinkers have left a name behind.
The Prince of Ch'en once feasted in the Hall of Calm
　　　Delight;
wine, ten thousand coins a cask, flowed for his revelers' joy.
Why does my host tell me the money has run out?
Buy more wine at once—my friends have cups to be refilled!
My dapple mount,
my furs worth a thousand—
call the boy, have him take them and barter for fine wine!
Together we'll wash away ten thousand years of care.

"Autumn Cove"

At Autumn Cove, so many white monkeys
bounding, leaping up like snowflakes in flight!
They coax and pull their young ones down from the branches
to drink and frolic with the water-borne moon.

"Viewing the Waterfall at Mount Lu"

Sunlight streaming on Incense Stone kindles violet smoke;
far off I watch the waterfall plunge to the long river,
flying waters descending straight three thousand feet,
till I think the Milky Way has tumbled from the ninth height of
 Heaven.

"Seeing a Friend Off"

Green hills sloping from the northern wall,
white water rounding the eastern city;
once parted from this place
the lone weed tumbles ten thousand miles.
Drifting clouds—a traveler's thoughts;
setting sun—an old friend's heart.
Wave hands and let us take leave now,
hsiao-hsiao our hesitant horses neighing.

"Still Night Thoughts"

Moonlight in front of my bed—
I took it for frost on the ground!
I lift my eyes to watch the mountain moon,
lower them and dream of home.

From *The Columbia Book of Chinese Poetry: From Early Times to the Thirteenth Century*, trans. and edited by Burton Watson, pp. 207–210, 212, © 1984 Columbia University Press. Reprinted by permission.

CHAPTER 6

READING 21

from the Bible, Old Testament

The English word bible *comes from the Greek name for the ancient city of Byblos, from which the papyrus reed used to make books was exported. The Bible is a collection of books that took its present shape over a long period. The list of books contained in the modern Bible was not established until 90 CE, when an assembly of rabbis drew up the list, or canon, even though its main outline had been known for centuries.*

from the Book of Genesis

The selections from the BOOK OF GENESIS *are the classic Hebrew accounts of creation; the first runs from 1:1 to 2:4a and the second to the end of the second chapter.*

1 In the beginning God created the heavens and the earth. ²The earth was without form and void, and darkness was upon the face of the deep; and the Spirit of God was moving over the face of the waters.

³And God said, "Let there be light"; and there was light. ⁴And God saw that the light was good; and God separated the light from the darkness. ⁵God called the light Day, and the darkness he called Night. And there was evening and there was morning, one day.

⁶And God said, "Let there be a firmament in the midst of the waters, and let it separate the waters from the waters." ⁷And God made the firmament and separated the waters which were under the firmament from the waters which were above the firmament. And it was so. ⁸And God called the firmament Heaven. And there was evening and there was morning, a second day.

⁹And God said, "Let the waters under the heavens be gathered together into one place, and let the dry land appear." And it was so. ¹⁰God called the dry land Earth, and the waters that were gathered together he called Seas. And God saw that it was good. ¹¹And God said, "Let the earth put forth vegetation, plants yielding seed, and fruit trees bearing fruit in which is their seed, each according to its kind, upon the earth." And it was so. ¹²The earth brought forth vegetation, plants yielding seed according to their own kinds, and trees bearing fruit in which is their seed, each according to its kind. And God saw that it was good. ¹³And there was evening and there was morning, a third day.

¹⁴And God said, "Let there be lights in the firmament of the heavens to separate the day from the night; and let them be for signs and for seasons and for days and years, ¹⁵and let them be lights in the firmament of the heavens to give light upon the earth." And it was so. ¹⁶And God made the two great lights, the greater light to rule the day, and the lesser light to rule the night; he made the stars also. ¹⁷And God set them in the firmament of the heavens to give light upon the earth, ¹⁸to rule over the day and over the night, and to separate the light from the darkness. And God saw that it was good. ¹⁹And there was evening and there was morning, a fourth day.

²⁰And God said, "Let the waters bring forth swarms of living creatures, and let birds fly above the earth across the firmament of the heavens." ²¹So God created the great sea monsters and every living creature that moves, with which the waters swarm according to their kinds, and every winged bird according to its kind. And God saw that it was good. ²²And God blessed them, saying, "Be fruitful and multiply and fill the waters in the seas, and let birds multiply on the earth." ²³And there was evening and there was morning, a fifth day.

²⁴And God said, "Let the earth bring forth living creatures according to their kinds: cattle and creeping things and beasts of the earth according to their kinds." And it was so. ²⁵And God made the beasts of the earth according to their kinds and the cattle according to their kinds, and everything that creeps upon the ground according to its kind. And God saw that it was good.

²⁶Then God said, "Let us make man in our image, after our likeness; and let them have dominion over the fish of the sea, and over the birds of the air, and over the cattle, and over all the earth, and over every creeping thing that creeps upon the earth." ²⁷So God created man in his own image, in the image of God he created him; male and female he created them. ²⁸And God blessed them, and God said to them, "Be fruitful and multiply, and fill the earth and subdue it; and have dominion over the fish of the sea and over the birds of the air and over every living thing that moves upon the earth." ²⁹And God said, "Behold, I have given you every plant yielding seed which is upon the face of all the earth, and every tree with seed in its fruit; you shall have them for food. ³⁰And to every beast of the earth, and to every bird of the air, and to everything that creeps on the earth, everything that has the breath of life, I have given every green plant for food." And it was so. ³¹And God saw everything that he had made, and behold, it was very good. And there was evening and there was morning, a sixth day.

2Thus the heavens and the earth were finished, and all the host of them. [2]And on the seventh day God finished his work which he had done, and he rested on the seventh day from all his work which he had done. [3]So God blessed the seventh day and hallowed it, because on it God rested from all his work which he had done in creation.

[4]These are the generations of the heavens and the earth when they were created.

In the day that the LORD God made the earth and the heavens, [5]when no plant of the field was yet in the earth and no herb of the field had yet sprung up, for the LORD God had not caused it to rain upon the earth, and there was no man to till the ground; [6]but a mist went up from the earth and watered the whole face of the ground—[7]then the LORD God formed man of dust from the ground, and breathed into his nostrils the breath of life; and man became a living being. [8]And the LORD God planted a garden in Eden, in the east; and there he put the man whom he had formed. [9]And out of the ground the LORD God made to grow every tree that is pleasant to the sight and good for food, the tree of life also in the midst of the garden, and the tree of the knowledge of good and evil.

[10]A river flowed out of Eden to water the garden, and there it divided and became four rivers. [11]The name of the first is Pishon; it is the one which flows around the whole land of Hav′i-lah, where there is gold; [12]and the gold of that land is good; bdellium and onyx stone are there. [13]The name of the second river is Gihon; it is the one which flows around the whole land of Cush. [14]And the name of the third river is Hid′de-kel, which flows east of Assyria. And the fourth river is the Eu-phra′tes.

[15]The LORD God took the man and put him in the garden of Eden to till it and keep it. [16]And the LORD God commanded the man, saying, "You may freely eat of every tree of the garden; [17]but of the tree of the knowledge of good and evil you shall not eat, for in the day that you eat of it you shall die."

[18]Then the LORD God said, "It is not good that the man should be alone; I will make him a helper fit for him." [19]So out of the ground the LORD God formed every beast of the field and every bird of the air, and brought them to the man to see what he would call them; and whatever the man called every living creature, that was its name. [20]The man gave names to all cattle, and to the birds of the air, and to every beast of the field; but for the man there was not found a helper fit for him. [21]So the LORD God caused a deep sleep to fall upon the man, and while he slept took one of his ribs and closed up its place with flesh; [22]and the rib which the LORD God had taken from the man he made into a woman and brought her to the man. [23]Then the man said, "This at last is bone of my bones and flesh of my flesh; she shall be called Woman, because she was taken out of Man."

[24]Therefore a man leaves his father and his mother and cleaves to his wife, and they become one flesh. [25]And the man and his wife were both naked, and were not ashamed.

from the Book of Job

The selections from the BOOK OF JOB *constitute one of the finest poetic sections in the whole of the Bible. In answer to Job's questions about human sufferings God, speaking from a "whirlwind," catalogues the mystery of life itself. In essence, God says that the mystery of human suffering (the theme of* JOB*) is paltry in the face of the wonders of creation. By a curious twist, God "answers" Job's questions not with an answer but by pointing to the deeper mysteries of existence itself.*

37"At this also my heart trembles, and leaps out of its place.
[2]Hearken to the thunder of his voice and the rumbling that comes from his mouth.

[3]Under the whole heaven he lets it go, and his lightning to the corners of the earth.
[4]After it his voice roars; he thunders with his majestic voice and he does not restrain the lightnings when his voice is heard.
[5]God thunders wondrously with his voice; he does great things which we cannot comprehend.
[6]For to the snow he says, 'Fall on the earth'; and to the shower and the rain, 'Be strong.'
[7]He seals up the hand of every man, that all men may know his work.
[8]Then the beasts go into their lairs, and remain in their dens.
[9]From its chamber comes the whirlwind, cold from the scattering winds.
[10]By the breath of God ice is given, and the broad waters are frozen fast.
[11]He loads the thick cloud with moisture; the clouds scatter his lightning.
[12]They turn round and round by his guidance, to accomplish all that he commands them on the face of the habitable world.
[13]Whether for correction, or for his land, or for love, he causes it to happen.

[14]"Hear this, O Job; stop and consider the wondrous works of God.
[15]Do you know how God lays his command upon them, and causes the lightning of his cloud to shine?
[16]Do you know the balancings of the clouds, the wondrous works of him who is perfect in knowledge,
[17]you whose garments are hot when the earth is still because of the south wind?
[18]Can you, like him, spread out the skies, hard as a molten mirror?
[19]Teach us what we shall say to him; we cannot draw up our case because of darkness.
[20]Shall it be told him that I would speak? Did a man ever wish that he would be swallowed up?

[21]"And now men cannot look on the light when it is bright in the skies, when the wind has passed and cleared them.
[22]Out of the north comes golden splendor; God is clothed with terrible majesty.
[23]The Almighty—we cannot find him; he is great in power and justice, and abundant righteousness he will not violate.
[24]Therefore men fear him; he does not regard any who are wise in their own conceit."

38Then the LORD answered Job out of the whirlwind:
[2]"Who is this that darkens counsel by words without knowledge?
[3]Gird up your loins like a man. I will question you, and you shall declare to me.

[4]"Where were you when I laid the foundation of the earth? Tell me, if you have understanding.
[5]Who determined its measurements—surely you know! Or who stretched the line upon it?
[6]On what were its bases sunk, or who laid its cornerstone,
[7]when the morning stars sang together, and all the sons of God shouted for joy?
[8]"Or who shut in the sea with doors, when it burst forth from the womb;
[9]when I made clouds its garment, and thick darkness its swaddling band,
[10]and prescribed bounds for it, and set bars and doors,
[11]and said, 'Thus far shall you come, and no farther, and here shall your proud waves be stayed'?

¹²"Have you commanded the morning since your days
begun,
and caused the dawn to know its place,
¹³that it might take hold of the skirts of the earth, and the
wicked be shaken out of it?
¹⁴It is changed like clay under the seal, and it is dyed like a
garment.
¹⁵From the wicked their light is withheld, and their uplifted
arm is broken.

¹⁶"Have you entered into the springs of the sea, or walked in
the recesses of the deep?
¹⁷Have the gates of death been revealed to you, or have you
seen the gates of deep darkness?
¹⁸Have you comprehended the expanse of the earth?
Declare, if you know all this.

¹⁹"Where is the way to the dwelling of light, and where is the
place of darkness,
²⁰that you may take it to its territory and that you may discern
the paths to its home?
²¹You know, for you were born then, and the number of your
days is great!

²²"Have you entered the storehouses of the snow, or have you
seen the storehouses of the hail,
²³which I have reserved for the time of trouble, for the day of
battle and war?
²⁴What is the way to the place where the light is distributed,
or where the east wind is scattered upon the earth?

²⁵"Who has cleft a channel for the torrents of rain,
and a way for the thunderbolt,
²⁶to bring rain on a land where no man is, on the desert in
which there is no man;
²⁷to satisfy the waste and desolate land, and to make the ground
put forth grass?

²⁸"Has the rain a father, or who has begotten the drops
of dew?
²⁹From whose womb did the ice come forth, and who has
given birth to the hoarfrost of heaven?
³⁰The waters become hard like stone, and the face of the deep
is frozen.
³¹"Can you bind the chains of the Plei'ades, or loose the cords
of Orion?
³²Can you lead forth the Maz'zaroth in their season, or can you
guide the Bear with its children?
³³Do you know the ordinances of the heavens? Can you estab-
lish their rule on the earth?

³⁴"Can you lift up your voice to the clouds, that a flood of
waters may cover you?
³⁵Can you send forth lightnings, that they may go and say to
you, 'Here we are'?
³⁶Who has put wisdom in the clouds, or given understanding to
the mists?
³⁷Who can number the clouds by wisdom? Or who can tilt the
waterskins of the heavens,
³⁸when the dust runs into a mass and the clods cleave fast
together?
³⁹"Can you hunt the prey for the lion, or satisfy the appetite of
the young lions,
⁴⁰when they crouch in their dens, or lie in wait in their covert?
⁴¹Who provides for the raven its prey, when its young ones cry
to God, and wander about for lack of food?

39 "Do you know when the mountain goats
bring forth?
Do you observe the calving of the hinds?
²Can you number the months that they fulfil, and do you know
the time when they bring forth,
³when they crouch, bring forth their offspring, and are deliv-
ered of their young?
⁴Their young ones become strong, they grow up in the open;
they go forth, and do not return to them.

⁵"Who has let the wild ass go free? Who has loosed the bonds
of the swift ass,
⁶to whom I have given the steppe for his home, and the salt
land for his dwelling place?
⁷He scorns the tumult of the city; he hears not the shouts of the
driver.
⁸He ranges the mountains as his pasture, and he searches after
every green thing.
⁹"Is the wild ox willing to serve you? Will he spend the night
at your crib?
¹⁰Can you bind him in the furrow with ropes, or will he har-
row the valleys after you?
¹¹Will you depend on him because his strength is great, and
will you leave to him your labor?
¹²Do you have faith in him that he will return, and bring your
grain to your threshing floor?
¹³"The wings of the ostrich wave proudly; but are they the pin-
ions and plumage of love?
¹⁴For she leaves her eggs to the earth, and lets them be warmed
on the ground,
¹⁵forgetting that a foot may crush them, and that the wild beast
may trample them.
¹⁶She deals cruelly with her young, as if they were not hers;
though her labor be in vain, yet she has no fear;
¹⁷because God has made her forget wisdom, and given her no
share in understanding.
¹⁸When she rouses herself to flee, she laughs at the horse and
his rider.

¹⁹"Do you give the horse his might? Do you clothe his neck
with strength?
²⁰Do you make him leap like the locust? His majestic snorting
is terrible.
²¹He paws in the valley, and exults in his strength; he goes out
to meet the weapons.
²²He laughs at fear, and is not dismayed; he does not turn back
from the sword.
²³Upon him rattle the quiver, the flashing spear and the javelin.
²⁴With fierceness and rage he swallows the ground;
he cannot stand still at the sound of the trumpet.
²⁵When the trumpet sounds, he says 'Aha!' He smells the battle
from afar, the thunder of the captains, and the
shouting.

²⁶"Is it by your wisdom that the hawk soars, and spreads his
wings toward the south?
²⁷Is it at your command that the eagle mounts up and makes
the nest on high?
²⁸On the rock he dwells and makes his home in the fastness of
the rocky crag.
²⁹Thence he spies out the prey; his eyes behold it afar off.
³⁰His young ones suck up blood; and where the slain are, there
is he."

40 And the LORD said to Job:
²"Shall a faultfinder contend with the Almighty?
He who argues with God, let him answer it."

³Then Job answered the LORD:

⁴"Behold, I am of small account; what shall I answer thee?
I lay my hand on my mouth.

⁵I have spoken once, and I will not answer; twice, but I will
proceed no further."

⁶Then God answered Job out of the whirlwind:

⁷"Gird up your loins like a man; I will question you, and you
declare to me.

⁸Will you even put me in the wrong? Will you condemn me
that you may be justified?

⁹Have you an arm like God, and can you thunder with a voice
like his?

¹⁰"Deck yourself with majesty and dignity; clothe yourself with
glory and splendor.

¹¹Pour forth the overflowings of your anger, and look on every
one that is proud, and abase him.

¹²Look on every one that is proud, and bring him low;
and tread down the wicked where they stand.

¹³Hide them all in the dust together; bind their faces in the
world below.

¹⁴Then will I also acknowledge to you, that your own right
hand can give you victory.

¹⁵"Behold, Be´hemoth, which I made as I made you; he eats
grass like an ox.

¹⁶Behold, his strength in his loins, and his power in the muscles
of his belly.

¹⁷He makes his tail stiff like a cedar; the sinews of his thighs are
knit together.

¹⁸His bones are tubes of bronze, his limbs like bars of iron.

¹⁹"He is the first of the works of God; let him who made him
bring near his sword!

²⁰For the mountains yield food for him where all the wild
beasts play.

²¹Under the lotus plants he lies, in the covert of the reeds and
in the marsh.

²²For his shade the lotus trees cover him; the willows of the
brook surround him.

²³Behold, if the river is turbulent he is not frightened;
he is confident though Jordan rushes against his mouth.

²⁴Can one take him with hooks, or pierce his nose with a
snare?"

from the Book of Exodus

This selection from the BOOK OF EXODUS *recounts the appearance of
God (a theophany; a "showing forth" of God) and the giving of the Ten
Commandments, which became the central core of the moral code of the
Bible. When reading this passage note all the ways in which the author
emphasizes the power and otherness of God in order to emphasize the
awful solemnity of the events being described.*

19 On the third new moon after the people of Israel had
gone forth out of the land of Egypt, on that day they
came into the wilderness of Sinai. ²And when they set out
from Reph´idim and came into the wilderness of Sinai, they
encamped in the wilderness; and there Israel encamped before
the mountain. ³And Moses went up to God, and the LORD
called him out of the mountain, saying, "Thus you shall say to
the house of Jacob, and tell the people of Israel: ⁴"You have
seen what I did to the Egyptians, and how I bore you on eagles'
wings and brought you to myself. ⁵Now therefore, if you will
obey my voice and keep my covenant, you shall be my own
possession among all peoples; for all the earth is mine, ⁶and you

shall be to me a kingdom of priests and a holy nation.' These
are the words which you shall speak to the children of Israel."

⁷So Moses came and called the elders of the people, and set
before them all these words which the LORD had commanded
him. ⁸And all the people answered together and said, "All that
the LORD has spoken we will do." And Moses reported the
words of the people to the LORD. ⁹And the LORD said to Moses,
"Lo, I am coming to you in a thick cloud, that the people
may hear when I speak with you, and may also believe you for
ever."

Then Moses told the words of the people to the LORD.
¹⁰And the LORD said to Moses, "Go to the people and conse-
crate them today and tomorrow, and let them wash their gar-
ments, ¹¹and be ready by the third day; for on the third day
the LORD will come down upon Mount Sinai in the sight of
all the people. ¹²And you shall set bounds for the people
round about, saying, 'Take heed that you do not go up into
the mountain or touch the border of it; whoever touches the
mountain shall be put to death; ¹³no hand shall touch him,
but he shall be stoned or shot; whether beast or man, he shall
not live.' When the trumpet sounds a long blast, they shall
come up to the mountain." ¹⁴So Moses went down from
the mountain to the people, and consecrated the people;
and they washed their garments. ¹⁵And he said to the people,
"Be ready by the third day; do not go near a woman."

¹⁶On the morning of the third day there were thunders
and lightnings, and a thick cloud upon the mountain, and
a very loud trumpet blast, so that all the people who were in
the camp trembled. ¹⁷Then Moses brought the people out of
the camp to meet God; and they took their stand at the foot
of the mountain. ¹⁸And Mount Sinai was wrapped in smoke,
because the LORD descended upon it in fire; and the smoke of
it went up like the smoke of a kiln, and the whole mountain
quaked greatly. ¹⁹And as the sound of the trumpet grew louder
and louder, Moses spoke, and God answered him in thunder.
²⁰And the LORD came down upon Mount Sinai, to the top of
the mountain; and the LORD called Moses to the top of the
mountain, and Moses went up. ²¹And the LORD said to Moses,
"Go down and warn the people, lest they break through to
the LORD to gaze and many of them perish. ²²And also let the
priests who come near to the LORD consecrate themselves, lest
the LORD break out upon them," ²³And Moses said to the LORD,
"The people cannot come up to Mount Sinai; for thou thyself
didst charge us, saying, 'Set bounds about the mountain, and con-
secrate it.' " ²⁴And the LORD said to him, "Go down, and come up
bringing Aaron with you; but do not let the priests and the people
break through to come up to the LORD, lest he break out against
them." ²⁵So Moses went down to the people and told them.

20 And God spoke all these words, saying, ²"I am the LORD
your God, who brought you out of the land of Egypt,
out of the house of bondage.

³"You shall have no other gods before me.

⁴"You shall not make yourself a graven image, or any like-
ness of anything that is in heaven above, or that is in the earth
beneath, or that is in the water under the earth; ⁵you shall not
bow down to them or serve them; for I the LORD your God am
a jealous God, visiting the iniquity of the fathers upon the chil-
dren to the third and the fourth generation of those who hate
me, ⁶but showing steadfast love to thousands of those who love
me and keep my commandments.

⁷"You shall not take the name of the LORD your God in
vain; for the LORD will not hold him guiltless who takes his
name in vain.

⁸"Remember the sabbath day, to keep it holy. ⁹Six days you
shall labor, and do all your work; ¹⁰but the seventh day is a sab-
bath to the LORD your God; in it you shall not do any work,

you, or your son, or your daughter, your manservant, or your maidservant, or your cattle, or the sojourner who is within your gates; [11]for in six days the LORD made heaven and earth, the sea, and all that is in them, and rested the seventh day; therefore the LORD blessed the sabbath day and hallowed it.

[12]"Honor your father and your mother, that your days may be long in the land which the LORD your God gives you.

[13]"You shall not kill.

[14]"You shall not commit adultery.

[15]"You shall not steal.

[16]"You shall not bear false witness against your neighbor.

[17]"You shall not covet your neighbor's house; you shall not covet your neighbor's wife, or his manservant, or his maidservant, or his ox, or his ass, or anything that is your neighbor's."

[18]Now when all the people perceived the thunderings and the lightnings and the sound of the trumpet and the mountain smoking, the people were afraid and trembled; and they stood afar off, [19]and said to Moses, "You speak to us, and we will hear; but let not God speak to us, lest we die." [20]And Moses said to the people, "Do not fear; for God has come to prove you, and that the fear of him may be before your eyes, that you may not sin."

[21]And the people stood afar off, while Moses drew near to the thick cloud where God was. [22]And the LORD said to Moses, "Thus you shall say to the people of Israel: 'You have seen for yourselves that I have talked with you from heaven. [23]You shall not make gods of silver to be with me, nor shall you make for yourselves gods of gold. [24]An altar of earth you shall make for me and sacrifice on it your burnt offerings and your peace offerings, your sheep and your oxen; in every place where I cause my name to be remembered I will come to you and bless you. [25]And if you make me an altar of stone, you shall not build it of hewn stones; for if you wield your tool upon it you profane it. [26]And you shall not go up by steps to my altar, that your nakedness be not exposed on it.'"

from the Book of Amos

Amos, an eighth-century prophet, reflects many of the characteristics of classical biblical prophetism: the prophet who speaks in the name of God: the warnings against social injustice; the demand for a pure worship of God and fidelity to the biblical covenant; the judgment against neighboring people.

3 Hear this word that the LORD has spoken against you, O people of Israel, against the whole family which I brought up out of the land of Egypt:

[2]"You only have I known of all the families of the earth;
therefore I will punish you for all your iniquities.

[3]"Do two walk together, unless they have made an
appointment?
[4]Does a lion roar in the forest, when he has no prey?
Does a young lion cry out from his den, if he has taken
nothing?
[5]Does a bird fall in a snare on the earth, when there is no trap
for it?
Does a snare spring up from the ground, when it has taken
nothing?
[6]Is a trumpet blown in a city, and the people are not afraid?
Does evil befall a city, unless the LORD has done it?
[7]Surely the LORD God does nothing, without revealing his
secret to his servants the prophets.
[8]The lion has roared; who will not fear?
The LORD God has spoken; who can but prophesy?"

[9]Proclaim to the strongholds in Assyria and to the strongholds
in the land of Egypt,

and say, "Assemble yourselves upon the mountains of Samar'ia,
and see the great tumults within her, and the oppressions in her
midst."
[10]"They do not know how to do right," says the LORD,
"those who store up violence and robbery in their
strongholds."
[11]Therefore thus says the LORD God: "An adversary shall sur-
round the land,
and bring down your defenses from you, and your strongholds
shall be plundered."

[12]Thus says the LORD: "As the shepherd rescues from the
mouth of the lion two legs, or a piece of an ear, so shall the
people of Israel who dwell in Samar'ia be rescued, with the
corner of a couch and part of a bed.

[13]"Hear, and testify against the house of Jacob," says the LORD
God, the God of hosts,
[14]that on the day I punish Israel for his transgressions
I will punish the altars of Bethel, and the horns of the altar shall
be cut off and fall to the ground.
[15]I will smite the winter house with the summer house;
and the houses of ivory shall perish, and the great houses shall
come to an end,"

says the LORD.

4 "Hear this word, you cows of Bashan,
who are in the mountain of Samar'ia,
who oppress the poor, who crush the needy, who say to their
husbands, 'Bring, that we may drink!'
[2]The LORD God has sworn by his holiness that, behold, the
days are coming upon you, when they shall take you away
with hooks, even the last of you with fishhooks.
[3]And you shall go out through the breaches, every one straight
before her; and you shall be cast forth into Harmon,"

says the LORD.

[4]"Come to Bethel, and transgress; to Gilgal, and multiply
transgression;
bring your sacrifices every morning, your tithes every
three days;
[5]offer a sacrifice of thanksgiving of that which is leavened, and
proclaim freewill offerings, publish them; for so you love to
do, O people of Israel!"

says the LORD God.

[6]"I gave you cleanness of teeth in all your cities, and lack of
bread in all your places,
yet you did not return to me,"

says the LORD.

[7]"And I also withheld the rain from you when there were yet
three months to the harvest;
I would send rain upon one city, and send no rain upon
another city;
one field would be rained upon, and the field on which it did
not rain withered;
[8]so two or three cities wandered to one city to drink water, and
were not satisfied;
yet you did not return to me,"

says the LORD.

[9]"I smote you with blight and mildew; I laid waste your gar-
dens and your vineyards; your fig trees and your olive trees
the locust devoured;
yet you did not return to me,"

says the LORD.

¹⁰"I sent among you a pestilence after the manner of Egypt;
I slew your young men with the sword;
I carried away your horses; and I made the stench of your camp
 go up into your nostrils;
yet you did not return to me,"

 says the LORD.

¹¹"I overthrew some of you, as when God overthrew Sodom
 and Gomor´rah,
and you were as a brand plucked out of the burning;
yet you did not return to me,"

 says the LORD.

¹²"Therefore thus I will do to you, O Israel; because I will do
 this to you, prepare to meet your God, O Israel!"

¹³For lo, he who forms the mountains, and creates the wind,
and declares to man what is his thought; who makes the morn-
 ing darkness, and treads on the heights of the earth—
the LORD, the God of hosts, is his name!

5 Hear this word which I take up over you in lamentation, O
house of Israel:
²"Fallen, no more to rise, is the virgin Israel;
forsaken on her land, with none to raise her up."

³"For thus says the LORD God: "The city that went forth a
 thousand shall have a hundred left,
and that which went forth a hundred shall have ten left to the
 house of Israel."

⁴For thus says the LORD to the house of Israel: "Seek me
 and live;
⁵but do not seek Bethel, and do not enter into Gilgal or cross
 over to Beer-sheba;
for Gilgal shall surely go into exile, and Bethel shall come to
 nought."

⁶Seek the LORD and live, lest he break out like fire in the house
 of Joseph, and it devour, with none to quench it for Bethel,
⁷O you who turn justice to wormwood, and cast down righ-
 teousness to the earth!

⁸He who made the Pleiades and Orion, and turns deep darkness
 into the morning, and darkens the day into night,
who calls for the waters of the sea, and pours them out upon
 the surface of the earth,
the LORD is his name,
⁹who makes destruction flash forth against the strong, so that
 destruction comes upon the fortress.
¹⁰They hate him who reproves in the gate, and they abhor him
 who speaks the truth.
¹¹Therefore because you trample upon the poor and take from
 him exactions of wheat,
you have built houses of hewn stone, but you shall not dwell
 in them;
you have planted pleasant vineyards, but you shall not drink
 their wine.
¹²For I know how many are your transgressions, and how great
 are your sins—
you who afflict the righteous, who take a bribe, and turn aside
 the needy in the gate.
¹³Therefore he who is prudent will keep silent in such a time;
 for it is an evil time.

¹⁴Seek good, and not evil, that you may live;
and so the LORD, the God of hosts, will be with you, as you
 have said.
¹⁵Hate evil, and love good, and establish justice in the gate;
it may be that the LORD, the God of hosts, will be gracious to
 the remnant of Joseph.

¹⁶Therefore thus says the LORD, the God of hosts, the Lord:
"In all the squares there shall be wailing; and in all the streets
 they shall say, 'Alas! alas!'
They shall call the farmers to mourning and to wailing those
 who are skilled in lamentation,
¹⁷and in all vineyards there shall be wailing, for I will pass
 through the midst of you,"

 says the LORD.

¹⁸Woe to you who desire the day of the LORD! Why would you
 have the day of the LORD?
It is darkness, and not light; ¹⁹as if a man fled from a lion, and a
 bear met him;
or went into the house and leaned with his hand against the
 wall, and a serpent bit him.
²⁰Is not the day of the LORD darkness, and not light, and gloom
 with no brightness in it?

²¹"I hate, I despise your feasts, and I take no delight in your
 solemn assemblies.
²²Even though you offer me your burnt offerings and cereal
 offerings,
I will not accept them, and the peace offerings of your fatted
 beasts I will not look upon.
²³Take away from me the noise of your songs; to the melody of
 your harps I will not listen.
²⁴But let justice roll down like waters, and righteousness like an
 everflowing stream.

25 "Did you bring to me sacrifices and offerings the forty years
in the wilderness, O house of Israel? ²⁶You shall take up Sak-
kuth your king, and Kaiwan your star-god, your images, which
you made for yourselves; ²⁷therefore I will take you into exile
beyond Damascus," says the LORD, whose name is the God of
hosts.

6 "Woe to those who are at ease in Zion,
and to those who feel secure on the mountain of
Samar´ia.
the notable men of the first of the nations, to whom the house
 of Israel come!
²Pass over to Calneh, and see; and thence go to Hamath the
 great; then go down to Gath of the Philistines.
Are they better than these kingdoms? Or is their territory
 greater than your territory,
³O you put far away the evil day, and bring near the seat of
 violence?

⁴Woe to those who lie upon beds of ivory, and stretch them-
 selves upon their couches,
and eat lambs from the flock, and calves from the midst of the
 stall;
⁵who sing idle songs to the sound of the harp, and like David
 invent for themselves instruments of music;
⁶who drink wine in bowls, and anoint themselves with the fin-
 est oils, but are not grieved over the ruin of Joseph!
⁷Therefore they shall now be the first of those to go into exile,
and the revelry of those who stretch themselves shall pass
 away."

⁸The LORD God has sworn by himself says the LORD, the God
 of hosts: "I abhor the pride of Jacob, and hate his strongholds;
 and I will deliver up the city and all that is in it."

⁹And if ten men remain in one house, they shall die. ¹⁰And
when a man's kinsman, he who burns him, shall take him up
to bring the bones out of the house, and shall say to him who is
in the innermost parts of the house, "Is there still any one with
you?" he shall say, "No"; and he shall say, "Hush! We must
not mention the name of the LORD."

[11]For behold, the LORD commands and the great house shall be
 smitten into fragments,
and the little house into bits.

READING 22

from THE BIBLE, NEW TESTAMENT

In forming what we know as the Christian Scriptures of the NEW TES-
TAMENT, Christians accepted the Hebrew canon of the OLD TESTAMENT
and added twenty-seven new books.

from the Gospel of Matthew

These sayings of Jesus, taken from the GOSPEL OF MATTHEW, reflect
the core of the teachings of Jesus. In these sayings one finds not only
the Beatitudes but also a prayer that is said to reflect perfectly the es-
sential relationship of Jesus to Abba (the familiar Aramaic word for
"Father," which Jesus used to describe God). Note too the demand
Jesus makes to go beyond the mere observance of law. In asking for an
interior conversion beyond law, Jesus stands in the tradition of the great
Jewish prophets.

5 Seeing the crowds, he went up on the mountain, and when he sat down his disciples came to him.

[2]And he opened his mouth and taught them, saying:

[3]"Blessed are the poor in spirit, for theirs is the kingdom of heaven.

[4]"Blessed are those who mourn, for they shall be comforted.

[5]"Blessed are the meek, for they shall inherit the earth.

[6]"Blessed are those who hunger and thirst for righteousness, for they shall be satisfied.

[7]"Blessed are the merciful, for they shall obtain mercy.

[8]"Blessed are the pure in heart, for they shall see God.

[9]"Blessed are the peacemakers, for they shall be called sons of God.

[10]"Blessed are those who are persecuted for righteousness' sake, for theirs is the kingdom of heaven.

[11]"Blessed are you when men revile you and persecute you and utter all kinds of evil against you falsely on my account. [12]Rejoice and be glad, for your reward is great in heaven, for so men persecuted the prophets who were before you.

[13]"You are the salt of the earth; but if salt has lost its taste, how shall its saltness be restored? It is no longer good for anything except to be thrown out and trodden under foot by men.

[14]"You are the light of the world. A city set on a hill cannot be hid. [15]Nor do men light a lamp and put it under a bushel, but on a stand, and it gives light to all in the house. [16]Let your light so shine before men, that they may see your good works and give glory to your Father who is in heaven.

[17]"Think not that I have come to abolish the law and the prophets; I have come not to abolish them but to fulfil them. [18]For truly, I say to you, till heaven and earth pass away, not an iota, not a dot, will pass from the law until all is accomplished. [19]Whoever then relaxes one of the least of these commandments and teaches men so, shall be called least in the kingdom of heaven; but he who does them and teaches them shall be called great in the kingdom of heaven. [20]For I tell you, unless your righteousness exceeds that of the scribes and Pharisees, you will never enter the kingdom of heaven.

[21]"You have heard that it was said to the men of old, 'You shall not kill; and whoever kills shall be liable to judgment.' [22]But I say to you that every one who is angry with his brother shall be liable to judgment; whoever insults his brother shall be liable to the council, and whoever says, 'You fool!' shall be liable to the hell of fire.

[23]So if you are offering your gift at the altar, and there remember that your brother has something against you, [24]leave your gift there before the altar and go; first be reconciled to your brother, and then come and offer your gift. [25]Make friends quickly with your accuser, while you are going with him to court, lest your accuser hand you over to the judge, and the judge to the guard, and you be put in prison; [26]truly, I say to you, you will never get out till you have paid the last penny.

[27]"You have heard that it was said, 'You shall not commit adultery.' [28]But I say to you that every one who looks at a woman lustfully has already committed adultery with her in his heart. [29]If your right eye causes you to sin, pluck it out and throw it away; it is better that you lose one of your members than that your whole body be thrown into hell. [30]And if your right hand causes you to sin, cut it off and throw it away; it is better that you lose one of your members than that your whole body go into hell.

[31]"It was also said, 'Whoever divorces his wife, let him give her a certificate of divorce.' [32]But I say to you that every one who divorces his wife, except on the ground of unchastity, makes her an adulteress; and whoever marries a divorced woman commits adultery.

[33]"Again you have heard that it was said to the men of old, 'You shall not swear falsely, but shall perform to the Lord what you have sworn.' [34]But I say to you, Do not swear at all, either by heaven, for it is the throne of God, [35]or by the earth, for it is his footstool, or by Jerusalem, for it is the city of the great King. [36]And do not swear by your head, for you cannot make one hair white or black. [37]Let what you say be simply 'Yes' or 'No'; anything more than this comes from evil.

[38]"You have heard that it was said, 'An eye for an eye and a tooth for a tooth.' [39]But I say to you, Do not resist one who is evil. But if any one strikes you on the right cheek, turn to him the other also; [40]and if any one would sue you and take your coat, let him have your cloak as well; [41]and if any one forces you to go one mile, go with him two miles. [42]Give to him who begs from you, and do not refuse him who would borrow from you.

[43]"You have heard that it was said, 'You shall love your neighbor and hate your enemy.' [44]But I say to you, Love your enemies and pray for those who persecute you, [45]so that you may be sons of your Father who is in heaven; for he makes his sun rise on the evil and on the good, and sends rain on the just and on the unjust. [46]For if you love those who love you, what reward have you? Do not even the tax collectors do the same? [47]And if you salute only your brethren, what more are you doing than others? Do not even the Gentiles do the same? [48]You, therefore, must be perfect, as your heavenly Father is perfect.

6 "Beware of practicing your piety before men in order to be seen by them; for then you will have no reward from your Father who is in heaven.

[2]"Thus, when you give alms, sound no trumpet before you, as the hypocrites do in the synagogues and in the streets, that they may be praised by men. Truly, I say to you, they have their reward. [3]But when you give alms, do not let your left hand know what your right hand is doing, [4]so that your alms may be in secret; and your Father who sees in secret will reward you.

[5]"And when you pray, you must not be like the hypocrites; for they love to stand and pray in the synagogues and at the street corners, that they may be seen by men. Truly, I say to you, they have their reward. [6]But when you pray, go into your room and shut the door and pray to your Father who is in secret; and your Father who sees in secret will reward you.

[7]"And in praying do not heap up empty phrases as the Gentiles do; for they think that they will be heard for their many words. [8]Do not be like them, for your Father knows what you need before you ask him. [9]Pray then like this:

> Our Father who art in heaven,
> Hallowed be thy name.
> [10]Thy kingdom come,
> Thy will be done,
> On earth as it is in heaven.
> [11]Give us this day our daily bread;
> [12]And forgive us our debts,
> As we also have forgiven our debtors;
> [13]And lead us not into temptation.
> But deliver us from evil.

[14]For if you forgive men their trespasses, your heavenly Father also will forgive you; [15]but if you do not forgive men their trespasses, neither will your Father forgive your trespasses.

[16]"And when you fast, do not look dismal, like the hypocrites, for they disfigure their faces that their fasting may be seen by men. Truly, I say to you, they have their reward. [17]But when you fast, anoint your head and wash your face, [18]that your fasting may not be seen by men but by your Father who is in secret; and your Father who sees in secret will reward you.

[19]"Do not lay up for yourselves treasures on earth, where moth and rust consume and where thieves break in and steal, [20]but lay up for yourselves treasures in heaven, where neither moth nor rust consumes and where thieves do not break in and steal. [21]For where your treasure is, there will your heart be also.

[22]"The eye is the lamp of the body. So, if your eye is sound, your whole body will be full of light; [23]but if your eye is not sound, your whole body will be full of darkness. If then the light in you is darkness, how great is the darkness!

[24]"No one can serve two masters; for either he will hate the one and love the other, or he will be devoted to the one and despise the other. You cannot serve God and mammon.

[25]"Therefore I tell you, do not be anxious about your life, what you shall eat or what you shall drink, nor about your body, what you shall put on. Is not life more than food, and the body more than clothing? [26]Look at the birds of the air: they neither sow nor reap nor gather into barns, and yet your heavenly Father feeds them. Are you not of more value than they? [27]And which of you by being anxious can add one cubit to his span of life?

[28]And why are you anxious about clothing? Consider the lilies of the field, how they grow; they neither toil nor spin; [29]yet I tell you, even Solomon in all his glory was not arrayed like one of these. [30]But if God so clothes the grass of the field, which today is alive and tomorrow is thrown into the oven, will he not much more clothe you, O men of little faith? [31]Therefore do not be anxious, saying, 'What shall we eat?' or 'What shall we drink?' or 'What shall we wear?' [32]For the Gentiles seek all these things; and your heavenly Father knows that you need them all. [33]But seek first his kingdom and his righteousness, and all these things shall be yours as well.

[34]"Therefore do not be anxious about tomorrow, for tomorrow will be anxious for itself. Let the day's own trouble be sufficient for the day.

7 "Judge not, that you be not judged. [2]For with the judgment you pronounce you will be judged, and the measure you give will be the measure you get. [3]Why do you see the speck that is in your brother's eye, but do not notice the log that is in your own eye? [4]Or how can you say to your brother, 'Let me take the speck out of your eye,' when there is the log in your own eye? [5]You hypocrite, first take the log out of your own eye, and then you will see clearly to take the speck out of your brother's eye.

[6]"Do not give dogs what is holy; and do not throw your pearls before swine, lest they trample them underfoot and turn to attack you.

[7]"Ask, and it will be given you; seek and you will find; knock, and it will be opened to you. [8]For every one who asks receives, and he who seeks finds, and to him who knocks it will be opened. [9]Or what man of you, if his son asks him for a loaf, will give him a stone? [10]Or if he asks for a fish, will give him a serpent? [11]If you then, who are evil, know how to give good gifts to your children, how much more will your Father who is in heaven give good things to those who ask him? [12]So whatever you wish that men would do to you, do so to them; for this is the law and the prophets.

[13]"Enter by the narrow gate; for the gate is wide and the way is easy, that leads to destruction, and those who enter by it are many. [14]For the gate is narrow and the way is hard, that leads to life, and those who find it are few.

[15]"Beware of false prophets, who come to you in sheep's clothing but inwardly are ravenous wolves. [16]You will know them by their fruits. Are grapes gathered from thorns, or figs from thistles? [17]So, every sound tree bears good fruit, but the bad tree bears evil fruit. [18]A sound tree cannot bear evil fruit, nor can a bad tree bear good fruit. [19]Every tree that does not bear good fruit is cut down and thrown into the fire. [20]Thus you will know them by their fruits.

[21]"Not every one who says to me, 'Lord, Lord,' shall enter the kingdom of heaven, but he who does the will of my Father who is in heaven. [22]On that day many will say to me, 'Lord, Lord, did we not prophesy in your name, and cast out demons in your name, and do many mighty works in your name?' [23]And then will I declare to them, 'I never knew you; depart from me, you evildoers.'

[24]"Every one then who hears these words of mine and does them will be like a wise man who built his house upon the rock; [25]and the rain fell, and the floods came, and the winds blew and beat upon that house, but it did not fall, because it had been founded on the rock. [26]And every one who hears these words of mine and does not do them will be like a foolish man who built his house upon the sand; [27]and the rain fell, and the floods came, and the winds blew and beat against that house, and it fell; and great was the fall of it."

[28]And when Jesus finished these sayings, the crowds were astonished at his teaching, [29]for he taught them as one who had authority, and not as their scribes.

from Acts 17

Paul's speech in Athens is a good example of Christianity's attempt to speak to the pagan world it encountered in its attempt to spread its message.

[14]Then the brethren immediately sent Paul off on his way to the sea, but Silas and Timothy remained there. [15]Those who conducted Paul brought him as far as Athens; and receiving a command for Silas and Timothy to come to him as soon as possible, they departed.

[16]Now while Paul was waiting for them at Athens, his spirit was provoked within him as he saw that the city was full of idols. [17]So he argued in the synagogue with the Jews and the devout persons, and in the market place every day with those who chanced to be there. [18]Some also of the Epicurean and Stoic philosophers met him. And some said, "What would this babbler say?" Others said, "He seems to be a preacher of foreign divinities"—because he preached Jesus and the resurrection.

[19]And they took hold of him, and brought him to the Areop´agus, saying, "May we know what this new teaching is which you present? [20]For you bring some strange things to our ears; we wish to know therefore what these things mean." [21]Now all the Athenians and the foreigners who lived there spent their time in nothing except telling or hearing something new.

[22]So Paul, standing in the middle of the Areop´agus, said: "Men of Athens, I perceive that in every way you are very

religious. ²³For as I passed along, and observed the objects of your worship, I found also an altar with this inscription, 'To an unknown god.' What therefore you worship as unknown, this I proclaim to you. ²⁴The God who made the world and everything in it, being Lord of heaven and earth, does not live in shrines made by man, ²⁵nor is he served by human hands, as though he needed anything, since he himself gives to all men life and breath and everything. ²⁶And he made from one every nation of men to live on all the face of the earth, having determined allotted periods and the boundaries of their habitation, ²⁷that they should seek God, in the hope that they might feel after him and find him. Yet he is not far from each one of us, ²⁸for 'In him we live and move and have our being'; as even some of your poets have said, 'For we are indeed his offspring.'

²⁹Being then God's offspring, we ought not to think that the Deity is like gold, or silver, or stone, a representation by the art and imagination of man. ³⁰The times of ignorance God overlooked, but now he commands all men everywhere to repent, ³¹because he has fixed a day on which he will judge the world in righteousness by a man whom he has appointed, and of this he has given assurance to all men by raising him from the dead."

³²Now when they heard of the resurrection of the dead, some mocked; but others said, "We will hear you again about this." ³³So Paul went out from among them. ³⁴But some men joined him and believed, among them Dionys´ius the Are-op´agite and a woman named Dam´aris and others with them.

from I Corinthians

This passage from Paul's letters gives us an example of the powerful message he could articulate.

And I will show you a still more excellent way.

13If I speak in the tongues of men and of angels, but have not love, I am a noisy gong or a clanging cymbal. ²And if I have prophetic powers, and understand all mysteries and all knowledge, and if I have all faith, so as to remove mountains, but have not love, I am nothing. ³If I give away all I have, and if I deliver my body to be burned, but have not love, I gain nothing.

⁴Love is patient and kind; love is not jealous or boastful; ⁵it is not arrogant or rude. Love does not insist on its own way; it is not irritable or resentful; ⁶it does not rejoice at wrong, but rejoices in the right. ⁷Love bears all things, believes all things, hopes all things, endures all things.

⁸Love never ends; as for prophecy, it will pass away; as for tongues, they will cease; as for knowledge, it will pass away. ⁹For our knowledge is imperfect and our prophecy is imperfect; ¹⁰but when the perfect comes, the imperfect will pass away. ¹¹When I was a child, I spoke like a child, I thought like a child, I reasoned like a child; when I became a man, I gave up childish ways. ¹²For now we see in a mirror dimly, but then face to face. Now I know in part; then I shall understand fully, even as I have been fully understood. ¹³So faith, hope, love abide, these three; but the greatest of these is love.

from II Corinthians

Here, Paul gives us a glimpse of his own life as an early missionary of the infant Christian Church.

11I wish you would bear with me in a little foolishness. Do bear with me! ²I feel a divine jealousy for you, for I betrothed you to Christ to present you as a pure bride to her one husband. ³But I am afraid that as the serpent deceived Eve by his cunning, your thoughts will be led astray from a sincere and pure devotion to Christ. ⁴For if some one comes and preaches another Jesus than the one we preached, or if you receive a different spirit from the one you received, or if you accept a different gospel from the one you accepted, you submit to it readily enough. ⁵I think that I am not in the least inferior to these superlative apostles. ⁶Even if I am unskilled in speaking, I am not in knowledge; in every way we have made this plain to you in all things.

⁷Did I commit a sin in abasing myself so that you might be exalted, because I preached God's gospel without cost to you? ⁸I robbed other churches by accepting support from them in order to serve you. ⁹And when I was with you and was in want, I did not burden any one, for my needs were supplied by the brethren who came from Macedo´nia. So I refrained and will refrain from burdening you in any way. ¹⁰As the truth of Christ is in me, this boast of mine shall not be silenced in the regions of Acha´ia. ¹¹And why? Because I do not love you? God knows I do!

¹²And what I do I will continue to do, in order to undermine the claim of those who would like to claim that in their boasted mission they work on the same terms as we do. ¹³For such men are false apostles, deceitful workmen, disguising themselves as apostles of Christ. ¹⁴And no wonder, for even Satan disguises himself as an angel of light. ¹⁵So it is not strange if his servants also disguise themselves as servants of righteousness. Their end will correspond to their deeds.

¹⁶I repeat, let no one think me foolish; but even if you do, accept me as a fool, so that I too may boast a little. ¹⁷(What I am saying I say not with the Lord's authority but as a fool, in this boastful confidence; ¹⁸since many boast of worldly things, I too will boast.) ¹⁹For you gladly bear with fools, being wise yourselves! ²⁰For you bear it if a man makes slaves of you, or preys upon you, or takes advantage of you, or puts on airs, or strikes you in the face. ²¹To my shame, I must say, we were too weak for that!

But whatever any one dares to boast of—I am speaking as a fool—I also dare to boast of that. ²²Are they Hebrews? So am I. Are they Israelites? So am I. Are they descendants of Abraham? So am I. ²³Are they servants of Christ? I am a better one—I am talking like a madman—with far greater labors, far more imprisonments, with countless beatings, and often near death. ²⁴Five times I have received at the hands of the Jews the forty lashes less one. ²⁵Three times I have been beaten with rods; once I was stoned. Three times I have been shipwrecked; a night and a day I have been adrift at sea; ²⁶on frequent journeys, in danger from rivers, danger from robbers, danger from my own people, danger from Gentiles, danger in the city, danger in the wilderness, danger at sea, danger from false brethren; ²⁷in toil and hardship, through many a sleepless night, in hunger and thirst, often without food, in cold and exposure. ²⁸And, apart from things, there is the daily pressure upon me of my anxiety for all the churches. ²⁹Who is weak, and I am not weak? Who is made to fall, and I am not indignant?

³⁰If I must boast, I will boast of the things that show my weakness. ³¹The God and Father of the Lord Jesus, he who is blessed for ever, knows that I do not lie. ³²At Damascus, the governor under King Ar´etas guarded the city of Damascus in order to seize me, ³³but I was let down in a basket through a window in the wall, and escaped his hands.

12I must boast; there is nothing to be gained by it, but I will go on to visions and revelations of the Lord. ²I know a man in Christ who fourteen years ago was caught up to the third heaven—whether in the body or out of the body I do not know, God knows. ³And I know that this man was caught up into Paradise—whether in the body or out of the body I do not know, God knows—⁴and he heard things that cannot be told, which man may not utter. ⁵On behalf of this man I will boast, but on my own behalf I will not boast, except of my weaknesses. ⁶Though if I wish to boast, I shall not be a fool, for I shall be speaking the truth. But I refrain from it,

so that no one may think more of me than he sees in me or hears from me. [7]And to keep me from being too elated by the abundance of revelations, a thorn was given me in the flesh, a messenger of Satan, to harass me, to keep me from being too elated. [8]Three times I besought the Lord about this, that it should leave me; [9]but he said to me, "My grace is sufficient for you, for my power is made perfect in weakness." I will all the more gladly boast of my weaknesses, that the power of Christ may rest upon me. [10]For the sake of Christ, then, I am content with weaknesses, insults, hardships, persecutions, and calamities; for when I am weak, then I am strong.

[11]I have been a fool! You forced me to it, for I ought to have been commended by you. For I am not at all inferior to these superlative apostles, even though I am nothing. [12]The signs of a true apostle were performed among you in all patience, with signs and wonders and mighty works. [13]For in what were you less favored than the rest of the churches, except that I myself did not burden you? Forgive me this wrong!

[14]Here for the third time I am ready to come to you. And I will not be a burden, for I seek not what is yours but you; for children ought not to lay up for their parents, but parents for their children. [15]I will most gladly spend and be spent for your souls. If I love you the more, am I to be loved less? [16]But granting that I myself did not burden you, I was crafty, you say, and got the better of you by guile. [17]Did I take advantage of you through any of those whom I sent to you? [18]I urged Titus to go, and sent the brother with him. Did Titus take advantage of you? Did we not act in the same spirit? Did we not take the same steps?

[19]Have you been thinking all along that we have been defending ourselves before you? It is in the sight of God that we have been speaking in Christ, and all for your upbuilding, beloved. [20]For I fear that perhaps I may come and find you not what I wish, and that you may find me not what you wish; that perhaps there may be quarreling, jealousy, anger, selfishness, slander, gossip, conceit, and disorder. [21]I fear that when I come again my God may humble me before you, and I may have to mourn over many of those who sinned before and have not repented of the impurity, immorality, and licentiousness which they have practiced.

READING 23

from JUSTIN MARTYR, FIRST APOLOGY (150–155)

Addressed by Justin Martyr, one of the early Christian apologists, to the Roman Emperor Antoninus Pius, these selections from Justin's FIRST APOLOGY are interesting because they are the earliest detailed description we possess of how early Christians worshiped. Justin probably gave this description as an antidote to rumors that Christians did immoral or criminal things at their meetings for worship. The selections below give us insight both into early baptismal practice as well as an outline of what Christian worship looked like on a typical Sunday.

Chapter 61

Lest we be judged unfair in this exposition, we will not fail to explain[1] how we consecrated ourselves to God when we were

[1] In this chapter, and again in chapters 65, 66, and 67, Justin ignored the Disciplina arcani to explain some Christian practices. This was unusual at that time.

regenerated through Christ. Those who are convinced and believe what we say and teach is the truth, and pledge themselves to be able to live accordingly, are taught in prayer and fasting to ask God to forgive their past sins, while we pray and fast with them. Then we lead them to a place where there is water, and they are regenerated in the same manner in which we ourselves were regenerated. In the name of God, the Father and Lord of all, and of our Savior, Jesus Christ, and of the Holy Ghost,[2] they then receive the washing with water. For Christ said: "Unless you be born again, you shall not enter into the kingdom of heaven."[3] Now, it is clear to everyone how impossible it is for those who have been born once to enter their mothers' wombs again. Isaias the Prophet explained, as we already stated, how those who have sinned and then repented shall be freed of their sins. These are his words: "Wash yourselves, be clean, banish sin from your souls; learn to do well: judge for the fatherless and defend the widow; and then come and let us reason together," saith the Lord. "And if your sins be as scarlet, I will make them white as wool; and if they be red as crimson, I will make them white as snow. But if you will not hear me, the sword shall devour you: for the mouth of the Lord hath spoken it."[4] And this is the reason, taught to us by the Apostles, why we baptize the way we do. We were totally unaware of our first birth, and were born of necessity from fluid seed through the mutual union of our parents, and were trained in wicked and sinful customs. In order that we do not continue as children of necessity and ignorance, but of deliberate choice and knowledge, and in order to obtain in the water the forgiveness of past sins, there is invoked over the one who wishes to be regenerated, and who is repentant of his sins, the name of God, the Father and Lord of all; he who leads the person to be baptized to the laver calls him by this name only. For, no one is permitted to utter the name of the ineffable God, and if anyone ventures to affirm that His name can be pronounced, such a person is hopelessly mad. This washing is called illumination,[5] since they who learn these things become illuminated intellectually. Furthermore, the illuminated one is also baptized in the name of the Holy Spirit, who predicted through the Prophets everything concerning Jesus.

Chapter 62

After hearing of this baptism which the Prophet Isaiah announced, the demons prompted those who enter their temples and come to them with libations and burnt offerings to sprinkle themselves also with water; furthermore, they cause them to wash their whole persons, as they approach the place of sacrifice, before they go to the shrines where their [the demons'] statues are located. And the order given by the priests to those who enter and worship in the temples, to take off their shoes, was imitated by the demons after they learned what happened to Moses, the above-mentioned Prophet. For at this time, when Moses was ordered to go down into Egypt and bring out the Israelites who were there, and while he was tending the sheep of his mother's brother in the land of Arabia, our Christ talked with him in the shape of fire from a bush. Indeed, He said: "Put off thy shoes, and draw near and hear."[1] When he had taken off his shoes, he approached the burning bush and heard that he was to go down into Egypt and bring out the people of Israel who were in that land; and he received great power

[2] The Trinitarian formula; cf. Matt. 28:19.
[3] John 3:3. Justin did know St. John's Gospel.
[4] Isa. 1:16–20.
[5] *Photismós:* illumination, commonly used in ancient times as a synonym for baptism.

[1] Exod. 3:5.

from Christ who spoke to him under the form of fire, and he went down and brought out the people after he performed great and wondrous deeds. If you wish to know about these deeds you may learn them clearly from his writings.

Chapter 63

Even now, all Jews teach that the ineffable God spoke to Moses. Wherefore, the Prophetic Spirit, censuring the Jews through Isaias, the above-mentioned Prophet, said: "The ox knoweth his owner, and the ass his master's crib; but Israel hath not known Me, and My people hath not understood Me."[1] Because the Jews did not know the nature of the Father and the Son, Jesus Christ likewise upbraided them, saying: "No one knows the Father except the Son; nor does anyone know the Son except the Father, and those to whom the Son will reveal Him."[2] Now, the Word of God is His Son, as we have already stated, and He is called Angel and Apostle; for, as Angel He announces all that we must know, and [as Apostle] He is sent forth to inform us of what has been revealed, as our Lord Himself says: "He that heareth Me, heareth Him that sent Me."[3] This will be further clarified from the following words of Moses: "And the Angel of God spoke to Moses in a flame of fire out of the midst of a bush and said, 'I AM WHO I AM, the God of Abraham, the God of Isaac, and the God of Jacob, the God of your fathers; go down into Egypt, and bring forth My people.'"[4] If you are curious to know what happened after this, you can find out by consulting these same Mosaic writings, for it is impossible to recount everything in this work. What has been written has been here set down to prove that Jesus Christ is the Son of God and His Apostle, being of old the Word, appearing at one time in the form of fire, at another under the guise of incorporeal beings [i.e., as an angel], but now, at the will of God, after becoming man for mankind, He bore all the torments which the demons prompted the rabid Jews to wreak upon Him. Although it is explicitly stated in the Mosaic writings: "And the Angel of God spoke to Moses in a flame of fire out of the midst of a bush and said, 'I AM WHO I AM, the God of Abraham, the God of Isaac, and the God of Jacob,'"[5] the Jews assert that it was the Father and Maker of all things who spoke thus. Hence, the Prophetic Spirit reproaches them, saying: "Israel hath not known Me, and My people hath not understood Me."[6] And again, as we have already shown, Jesus, while still in their midst, said: "No one knows the Father except the Son, nor does anyone know the Son except the Father, and those to whom the Son will reveal Him."[7] The Jews, therefore, always of the opinion that the Universal Father spoke to Moses, while in fact it was the very Son of God, who is styled both Angel and Apostle, were justly reproached by both the Prophetic Spirit and by Christ Himself, since they knew neither the Father nor the Son. For, they who claim that the Son is the Father are reproached for knowing neither the Father nor that the Father of all has a Son, who, as the First-born Word of God, is also God. He once appeared to Moses and the other prophets in the form of fire and in the guise of an angel, but now in the time of your reign, after He became man by a virgin, as we already stated, by the design of God the Father, to effect the salvation of those believing in Him, He permitted Himself to be an object of contempt and to suffer pain, so that by dying and arising from the dead He might con-

quer death. But what was proclaimed to Moses from the bush: "I AM WHO I AM, the God of Abraham, and the God of Isaac, and the God of your fathers,"[8] meant that those who had died were still in existence, and belonged to Christ Himself. For they were the first of all to occupy themselves in searching for God; Abraham being the father of Isaac, and Isaac the father of Jacob, as was written by Moses.

Chapter 64

From what has already been stated you can readily perceive how the demons, imitating what Moses said, instigated men to erect at the fountain-heads a statue of her who was called Kore,[1] and claimed that she was the daughter of Jupiter. For, as we stated previously, Moses said: "In the beginning God created heaven and earth. And the earth was invisible and empty, and the Spirit of God moved over the waters."[2] In imitation of the Spirit of God who was said to be borne over the waters, therefore, they [the demons] said that Kore was the daughter of Jupiter. They likewise viciously affirmed that Minerva was the daughter of Jupiter, not by sexual union, but, well knowing that God conceived and created the world by the Word, they state that Minerva was the first conception; which we consider most ridiculous, to present the female form as the image of conception. Their deeds likewise condemn the others who are called sons of Jupiter.

Chapter 65

After thus baptizing the one who has believed and given his assent, we escort him to the place where are assembled those whom we call brethren, to offer up sincere prayers in common for ourselves, for the baptized person, and for all other persons wherever they may be, in order that, since we have found the truth, we may be deemed fit through our actions to be esteemed as good citizens and observers of the law, and thus attain eternal salvation. At the conclusion of the prayers we greet one another with a kiss.[1] Then, bread and a chalice containing wine mixed with water[2] are presented to the one presiding over the brethren. He takes them and offers praise and glory to the Father of all, through the name of the Son and of the Holy Spirit, and he recites lengthy prayers of thanksgiving to God in the name of those to whom He granted such favors. At the end of these prayers and thanksgiving, all present express their approval by saying "Amen." This Hebrew word, "Amen," means "So be it." And when he who presides has celebrated the Eucharist, they whom we call deacons permit each one present to partake of the Eucharistic bread, and wine and water; and they carry it also to the absentees.

Chapter 66

We call this food the Eucharist, of which only he can partake who has acknowledged the truth of our teachings, who has been cleansed by baptism for the remission of his sins and for his regeneration, and who regulates his life upon the principles laid down by Christ. Not as ordinary bread or as ordinary drink do we partake of them, but just as, through the word of God, our Savior

[1] Isa. 1:3.
[2] Matt. 11:27.
[3] Luke 10:16.
[4] Exod. 3:14–15.
[5] Exod. 3:14–15.
[6] Isa. 1:3.
[7] Matt. 11:27.

[8] Exod. 3:14–15.

[1] *Cora,* maiden or daughter; i.e., Proserpine.
[2] Gen. 1:1–3.

[1] The pagans, who misinterpreted the kiss of peace, must not have realized that it was a form of greeting confined to persons of the same sex.
[2] *Potérion húdatos kaì krámatos,* a chalice of wine mixed with water. It seems, however, that *kráma* is used here as a synonym for wine.

Jesus Christ became Incarnate and took upon Himself flesh and blood for our salvation, so, we have been taught, the food which has been made the Eucharist by the prayer of His word,[1] and which nourishes our flesh and blood by assimilation, is both the flesh and blood of that Jesus who was made flesh. The Apostles in their memoirs, which are called Gospels, have handed down what Jesus ordered them to do; that He took bread and, after giving thanks, said: "Do this in remembrance of Me; this is My body." In like manner, He took also the chalice, gave thanks, and said: "This is My blood";[2] and to them only did He give it. The evil demons, in imitation of this, ordered the same thing to be performed in the Mithraic mysteries.[3] For, as you know or may easily learn, bread and a cup of water, together with certain incantations, are used in their mystic initiation rites.

Chapter 67

Henceforward, we constantly remind one another of these things. The rich among us come to the aid of the poor, and we always stay together. For all the favors we enjoy we bless the Creator of all, through His Son Jesus Christ and through the Holy Spirit. On the day which is called Sunday we have a common assembly of all who live in the cities or in the outlying districts, and the memoirs of the Apostles or the writings of the Prophets are read, as long as there is time. Then, when the reader has finished, the president of the assembly verbally admonishes and invites all to imitate such examples of virtue. Then we all stand up together and offer up our prayers, and, as we said before, after we finish our prayers, bread and wine and water are presented. He who presides likewise offers up prayers and thanksgivings, to the best of his ability, and the people express their approval by saying "Amen." The Eucharistic elements are distributed and consumed by those present, and to those who are absent they are sent through the deacons. The wealthy, if they wish, contribute whatever they desire, and the collection is placed in the custody of the president. [With it] he helps the orphans and widows, those who are needy because of sickness or any other reason, and the captives and strangers in our midst; in short, he takes care of all those in need. Sunday, indeed, is the day on which we all hold our common assembly because it is the first day on which God, transforming the darkness and [prime] matter, created the world; and our Savior Jesus Christ arose from the dead on the same day. For they crucified Him on the day before that of Saturn, and on the day after, which is Sunday, He appeared to His Apostles and disciples, and taught them the things which we have passed on to you also for consideration.

From "The First Apology" by Justin Martyr from *Writings of Saint Justin Martyr*, translated by Thomas Falls. Copyright © Catholic University Press of America. Reprinted by permission of Catholic University of America Press, Washington, DC.

READING 24

from THE PASSION OF PERPETUA AND FELICITY

This famous account (slightly edited) of martyrdom, compiled from the memoirs of a noblewoman named Perpetua by an unknown third-century North African Christian (possibly the great author Tertullian), recounts

[1] *Dí euchés lógou toù par' autoù:* by the prayer of His word. The word *lógou* does not refer to the Word of God, but to the words of Christ—the words of consecration: "This is My Body; this is My Blood." Indeed, Justin quotes these words of Christ to prove to the pagans why Christians believe that the bread and wine become the Body and Blood of Christ.

the death of Perpetua, her maid Felicity, and some catechumens (persons inscribed for baptism in the church) in the arena of Carthage c. 203. Fleshed out with vision narratives, it became an immensely influential work that profoundly shaped later accounts of martyrdom. It is of great significance because it is one of the few early Christian treatises that come to us from the hand of a woman before the time of Constantine. The deepest core of the account is to be seen in the fact that the mere confession "I am a Christian" was sufficient for the penalty of death to be imposed.

. . . [2]There were apprehended the young catechumens, Revocatus and Felicity his fellow-servant, Saturninus and Secundulus. With them also was Vibia Perpetua, nobly born, reared in a liberal manner, wedded honorably; having a father and mother and two brothers, one of them a catechumen likewise, and a son, a child at the breast; and she herself was about twenty-two years of age. What follows here she shall tell herself; the whole order of her martyrdom as she left it written with her own hand and in her own words.

[3]When, saith she, we were yet with our sureties and my father was fain to vex me with his words and continually strove to hurt my faith because of his love: Father, said I, seest thou (for example's sake) this vessel lying, a pitcher or whatsoever it may be? And he said, I see it. And I said to him, Can it be called by any other name than that which it is? And he answered, No. So can I call myself nought other than that which I am, a Christian? Then my father moved with this word came upon me to tear out my eyes; but he vexed me only, and he departed vanquished, he and the arguments of the devil. Then because I was without my father for a few days I gave thanks unto the Lord; and I was comforted because of his absence. In this same space of a few days we were baptized, and the Spirit declared to me, I must pray for nothing else after that water save only endurance of the flesh. A few days after we were taken into prison, and I was much afraid because I had never known such darkness. O bitter day! There was a great heat because of the press, there was cruel handling of the soldiers. Lastly I was tormented there by care for the child. Then Tertius and Pomponius, the blessed deacons who ministered to us, obtained with money that for a few hours we should be taken forth to a better part of the prison and be refreshed. Then all of them going out from the dungeon took their pleasure; I suckled my child that was now faint with hunger. And being careful for him, I spoke to my mother and strengthened my brother and commended my son unto them. I pined because I saw they pined for my sake. Such cares I suffered for many days; and I obtained that the child should abide with me in prison; and straightway I became well, and was lightened of my labor and care for the child; and suddenly the prison was made a palace for me, so that I would sooner be there than anywhere else.

[4]Then said my brother to me: Lady my sister, thou art now in high honor, even such that thou mightest ask for a vision; and it should be shown thee whether this be a passion or else a deliverance. And I, as knowing that I conversed with the Lord, for Whose sake I had suffered such things, did promise him, nothing doubting; and I said: To-morrow I will tell thee. And I asked, and this was shown me.

I beheld a ladder of bronze, marvelously great, reaching up to heaven; and it was narrow, so that not more than one might go up at one time. And in the sides of the ladder were planted all manner of things of iron. There were swords there, spears, hooks, and knives; so that if any that went up took not good heed or looked not upward, he would be torn and his flesh cling to the iron. And there was right at the ladder's foot a serpent lying, marvelously great, which lay in wait for those that would go up, and frightened them that they might not go up. Now Saturus went up first (who afterwards had of his own

will given up himself for our sakes, because it was he who had edified us; and when we were taken he had not been there). And he came to the ladder's head; and he turned and said: Perpetua, I await thee; but see that serpent bite thee not. And I said: It shall not hurt me, in the name of Jesus Christ. And from beneath the ladder, as though it feared me, it softly put forth its head; and as though I trod on the first step I trod on its head. And I went up, and I saw a very great space of garden, and in the midst a man sitting, white-headed, in shepherd's clothing, tall, milking his sheep; and standing around in white were many thousands. And he raised his head and beheld me and said to me: Welcome, child. And he cried to me, and from the curd he had from the milk he gave me as it were a morsel; and I took it with joined hands and ate it up; and all that stood around said, Amen. And at the sound of that word I awoke, yet eating I know not what of sweet.

And forthwith I told my brother, and we knew it should be a passion; and we began to have no hope any longer in this world.

[5]A few days after, the report went abroad that we were to be tried. Also my father returned from the city spent with weariness; and he came up to me to cast down my faith, saying: Have pity, daughter, on my grey hairs; have pity on thy father, if I am worthy to be called father by thee; if with these hands I have brought thee unto this flower of youth—and I have preferred thee before all thy brothers; give me not over to the reproach of men. Look upon thy brothers; look upon thy mother and mother's sister; look upon thy son, who will not endure to live after thee. Forbear thy resolution; destroy us not all together; for none of us will speak openly among men again if thou sufferest aught. This he said fatherwise in his love, kissing my hands and groveling at my feet; and with tears he named me, not daughter, but lady. And I was grieved for my father's case because he only would not rejoice at my passion out of all my kin; and I comforted him, saying: That shall be done at this tribunal, whatsoever God shall please; for know that we are not stablished in our own power, but in God's. And he went from me very sorrowful.

[6]Another day as we were at meat we were suddenly snatched away to be tried; and we came to the forum. Therewith a report spread abroad through the parts near to the forum, and a very great multitude gathered together. We went up to the tribunal. The others being asked, confessed. So they came to me. And my father appeared there also, with my son, and would draw me from the step, saying: Sacrifice; have mercy on the child. And Hilarianus the procurator—he that after the death of Minucius Timinian the proconsul had received in his room the right and power of the sword—Spare, said he, thy father's grey hairs; spare the infancy of the boy. Make sacrifice for the Emperors' prosperity. And I answered: I will not sacrifice. Then said Hilarianus: Art thou a Christian? And I answered: I am a Christian. And when my father stood by me yet to cast down my faith, he was bidden by Hilarianus to be cast down and was smitten with a rod. And I sorrowed for my father's harm as though I had been smitten myself; so sorrowed I for his unhappy old age. Then Hilarianus passed sentence upon us all and condemned us to the beasts; and cheerfully we went down to the dungeon. Then because my child had been wont to take suck of me and to abide with me in the prison, straightway I sent Pomponius the deacon to my father, asking for the child. But my father would not give him. And as God willed, neither is he fain to be suckled any more, nor did I take fever; that I might not be tormented by care for the child and by the pain of my breasts.

[7]A few days after, while we were all praying, suddenly in the midst of the prayer I uttered a word and named Dinocrates; and I was amazed because he had never come into my mind save then; and I sorrowed, remembering his fate. And straightway I knew that I was worthy, and that I ought to ask for him.

And I began to pray for him long, and to groan unto the Lord. Forthwith the same night, this was shown me.

I beheld Dinocrates coming forth from a dark place, where were many others also; being both hot and thirsty, his raiment foul, his color pale; and the wound on his face which he had when he died. This Dinocrates had been my brother in the flesh, seven years old, who being diseased with ulcers of the face had come to a horrible death, so that his death was abominated of all men. For him therefore I had made my prayer; and between him and me was a great gulf, so that either might not go to other. There was moreover, in the same place where Dinocrates was, a font full of water, having its edge higher than was the boy's stature; and Dinocrates stretched up as though to drink. I was sorry that the font had water in it, and yet for the height of the edge he might not drink.

And I awoke, and I knew that my brother was in travail. Yet I was confident I should ease his travail; and I prayed for him every day till we passed over into the camp prison. . . . And I made supplication for him day and night with groans and tears, that he might be given me.

[8]On the day when we abode in the stocks, this was shown me.

I saw that place which I had before seen, and Dinocrates clean of body, finely clothed, in comfort; and the font I had seen before, the edge of it being drawn down to the boy's navel; and he drew water thence which flowed without ceasing. And on the edge was a golden cup full of water; and Dinocrates came up and began to drink therefrom; which cup failed not. And being satisfied he departed away from the water and began to play as children will, joyfully.

And I awoke. Then I understood that he was translated from his pains.

[9]Then a few days after, Pudens the adjutant, in whose charge the prison was, who also began to magnify us because he understood that there was much grace in us, let in many to us that both we and they in turn might be comforted. Now when the day of the games drew near, there came in my father unto me, spent with weariness, and began to pluck out his beard and throw it on the ground and to fall upon his face cursing his years and saying such words as might move all creation. I was grieved for his unhappy old age.

[10]The day before we fought, I saw in a vision that Pomponius the deacon had come hither to the door of the prison, and knocked hard upon it. And I went out to him and opened to him; he was clothed in a white robe ungirdled, having shoes curiously wrought. And he said to me: Perpetua, we await thee; come. And he took my hand, and we began to go through rugged and winding places. At last with much breathing hard we came to the amphitheater, and he led me into the midst of the arena. And he said to me: Be not afraid; I am here with thee and labor together with thee. And he went away. And I saw much people watching closely. And because I knew that I was condemned to the beasts I marveled that beasts were not sent out against me. And there came out against me a certain ill-favored Egyptian with his helpers, to fight with me. Also there came to me comely young men, my helpers and aiders. And I was stripped, and I became a man. And my helpers began to rub me with oil as their custom is for a contest; and over against me I saw that Egyptian wallowing in the dust. And there came forth a man of very great stature, so that he overpassed the very top of the amphitheater, wearing a robe ungirdled, and beneath it between the two stripes over the breast a robe of purple; having also shoes curiously wrought in gold and silver; bearing a rod like a master of gladiators, and a green branch whereon were golden apples. And he besought silence and said: The Egyptian, if he shall conquer this woman, shall slay her with the sword; and if she shall conquer him, she shall receive this branch. And he went away. And we came nigh to each other,

and began to buffet one another. He was fain to trip up my feet, but I with my heels smote upon his face. And I rose up into the air and began so to smite him as though I trod not the earth. But when I saw that there was yet delay, I joined my hands, setting finger against finger of them. And I caught his head, and he fell upon his face; and I trod upon his head. And the people began to shout, and my helpers began to sing. And I went up to the master of gladiators and received the branch. And he kissed me and said to me: Daughter, peace be with thee. And I began to go with glory to the gate called the Gate of Life.

And I awoke; and I understood that I should fight, not with beasts but against the devil; but I knew that mine was the victory.

Thus far have I written this, till the day before the games; but the deed of the games themselves let him write who will.

[11]And blessed Saturus too delivered this vision which he himself wrote down.

We had suffered, saith he, and we passed out of the flesh, and we began to be carried towards the east by four angels whose hand touched us not. And we went not as though turned upwards upon our backs, but as though we went up an easy hill. And passing over the world's edge we saw a very great light; and I said to Perpetua (for she was at my side): This is that which the Lord promised us; we have received His promise. And while we were being carried by these same four angels, a great space opened before us, as it had been a pleasure garden, having rose-trees and all kinds of flowers. The height of the trees was after the manner of the cypress, and their leaves sang without ceasing. And there in the garden were four other angels, more glorious than the rest; who when they saw us gave us honor and said to the other angels: Lo, here are they, here are they: and marveled. And the four angels who bore us set us down trembling; and we passed on foot by a broad way over a plain. There we found Jocundus and Saturninus and Artaxius who in the same persecution had suffered and had been burned alive; and Quintus, a martyr also, who in prison had departed this life; and we asked of them where were the rest. The other angels said to us: Come first, go in, and salute the Lord.

[12]And we came near to a place, of which place the walls were such, they seemed built of light; and before the door of that place stood four angels who clothed us when we went in with white raiment. And we went in, and we heard as it were one voice crying [Holy, Holy, Holy] without any end. And we saw sitting in that same place as it were a man, white-headed, having hair like snow, youthful of countenance; whose feet we saw not. And on his right hand and on his left, four elders; and behind them stood many other elders. And we went in with wonder and stood before the throne; and the four angels raised us up; and we kissed him, and with his hand he passed over our faces. And the other elders said to us: Stand ye. And we stood, and gave the kiss of peace. And the elders said to us: Go ye and play. And I said to Perpetua: Thou hast that which thou desirest. And she said to me: Yea, God be thanked; so that I that was glad in the flesh am now more glad.

[13]And we went out, and we saw before the doors, on the right Optatus the bishop, and on the left Aspasius the priest and teacher, being apart and sorrowful. And they cast themselves at our feet and said: Make peace between us, because ye went forth and left us thus. And we said to them: Art not thou our Father, and thou our priest, that ye should throw yourselves at our feet? And we were moved, and embraced them. And Perpetua began to talk with them in Greek; and we set them apart in the pleasure garden beneath a rose tree. And while we yet spoke with them, the angels said to them: Let these go and be refreshed; and whatsoever dissensions ye have between you, put them away from you each for each. And they made them to be confounded. And they said to Optatus: Correct thy people; for they come to thee as those that return from the games and wrangle concerning the parties there. And it seemed to us as though they would shut the gates. And we began to know many brothers there, martyrs also. And we were all sustained there with a savor inexpressible which satisfied us. Then in joy I awoke.

[14]These were the glorious visions of those martyrs themselves, the most blessed Saturus and Perpetua, which they themselves wrote down. But Secundulus by an earlier end God called from this world while he was yet in prison; not without grace, that he should escape the beasts. Yet if not his soul, his flesh at least knew the sword.

[15]As for Felicity, she too received this grace of the Lord. For because she was now gone eight months (being indeed with child when she was taken) she was very sorrowful as the day of the games drew near, fearing lest for this cause she should be kept back (for it is not lawful for women that are with child to be brought forth for torment) and lest she should shed her holy and innocent blood after the rest, among strangers and malefactors. Also her fellow martyrs were much afflicted lest they should leave behind them so good a friend and as it were their fellow-traveler on the road of the same hope. Wherefore with joint and united groaning they poured out their prayer to the Lord, three days before the games. Incontinently after their prayer her pains came upon her. And when by reason of the natural difficulty of the eighth month she was oppressed with her travail and made complaint, there said to her one of the servants of the keepers of the door: Thou that thus makest complaint now, what wilt thou do when thou art thrown to the beasts, which thou didst condemn when thou wouldst not sacrifice? And she answered, I myself now suffer that which I suffer, but there another shall be in me who shall suffer for me, because I am to suffer for him. So she was delivered of a daughter, whom a sister reared up to be her own daughter.

[16]Since therefore the Holy Spirit has suffered, and suffering has willed, that the order of the games also should be written; though we are unworthy to finish the recounting of so great glory, yet we accomplish the will of the most holy Perpetua, nay rather her sacred trust, adding one testimony more of her own steadfastness and height of spirit. When they were being more cruelly handled by the tribune because through advice of certain most despicable men he feared lest by magic charms they might be withdrawn secretly from the prisonhouse, Perpetua answered him to his face: Why dost thou not suffer us to take some comfort, seeing we are victims most noble, namely Caesar's, and on his feast day we are to fight? Or is it not thy glory that we should be taken out thither fatter of flesh? The tribune trembled and blushed, and gave order they should be more gently handled, granting that her brothers and the rest should come in and rest with them. Also the adjutant of the prison now believed. . . .

[18]Now dawned the day of their victory, and they went forth from the prison into the amphitheatre as it were into heaven, cheerful and bright of countenance; if they trembled at all, it was for joy, not for fear. Perpetua followed behind, glorious of presence, as a true spouse of Christ and darling of God; at whose piercing look all cast down their eyes. Felicity likewise, rejoicing that she had borne a child in safety, that she might fight with the beasts, came now from blood to blood, from the midwife to the gladiator, to wash after her travail in a second baptism. And when they had been brought to the gate and were being compelled to put on, the men the dress of the priests of Saturn, the women the dress of the priestesses of Ceres, the noble Perpetua remained of like firmness to the end, and would not. For she said: For this cause came we willingly unto this, that our liberty might not be obscured. For this cause have we devoted our lives, that we might do no such thing as this; this we agreed with you. Injustice acknowledged justice; the

tribune suffered that they should be brought forth as they were, without more ado. Perpetua began to sing, as already treading on the Egyptian's head. Revocatus and Saturninus and Saturus threatened the people as they gazed. Then when they came into Hilarianus's sight, they began to say to Hilarianus, stretching forth their hands and nodding their heads: Thou judgest us, said they, and God thee. At this the people being enraged besought that they should be vexed with scourges before the line of gladiators (those namely who fought with beasts). Then truly they gave thanks because they had received somewhat of the sufferings of the Lord.

[19]But He Who had said *Ask, and ye shall receive* gave to them asking that end which each had desired. For whenever they spoke together of their desire in their martyrdom, Saturninus for his part would declare that he wished to be thrown to every kind of beast, that so indeed he might wear the more glorious crown. At the beginning of the spectacle therefore himself with Revocatus first had ado with a leopard and was afterwards torn by a bear also upon a raised bridge. Now Saturus detested nothing more than a bear, but was confident already he should die by one bite of a leopard. Therefore when he was being given to a boar, the gladiator instead who had bound him to the boar was torn asunder by the same beast and died after the days of the games; nor was Saturus more than dragged. Moreover when he had been tied on the bridge to be assaulted by a bear, the bear would not come forth from its den. So Saturus was called back unharmed a second time.

[20]But for the women the devil had made ready a most savage cow, prepared for this purpose against all custom; for even in this beast he would mock their sex. They were stripped therefore and made to put on nets; and so they were brought forth. The people shuddered, seeing one a tender girl, the other her breasts yet dropping from her late childbearing. So they were called back and clothed in loose robes. Perpetua was first thrown, and fell upon her loins. And when she had sat upright, her robe being rent at the side, she drew it over to cover her thigh, mindful rather of modesty than of pain. Next, looking for a pin, she likewise pinned up her disheveled hair; for it was not meet that a martyr should suffer with hair disheveled, lest she should seem to grieve in her glory. So she stood up; and when she saw Felicity smitten down, she went up and gave her her hand and raised her up. And both of them stood up together and (the hardness of the people being now subdued) were called back to the Gate of Life. There Perpetua being received by one named Rusticus, then a catechumen, who stood close at her side, and as now awakening from sleep (so much was she in the Spirit and in ecstasy) began first to look about her; and then (which amazed all there), When, forsooth, quoth she, are we to be thrown to the cow? And when she heard that this had been done already, she would not believe till she perceived some marks of mauling on her body and on her dress. Thereupon she called her brother to her, and that catechumen, and spoke to them, saying: Stand fast in the faith, and love ye all one another; and be not offended because of our passion.

[21]Saturus also at another gate exhorted Pudens the soldier, saying: So then indeed, as I trusted and foretold, I have felt no assault of beasts, until now. And now believe with all thy heart. Behold, I go out thither and shall perish by one bite of the leopard. And forthwith at the end of the spectacle, the leopard being released, with one bite of his he was covered with so much blood that the people (in witness to his second baptism) cried out to him returning: Well washed, well washed. Truly it was well with him who had washed in this wise. Then said he to Pudens the soldier: Farewell; remember the faith and me; and let not these things trouble thee, but strengthen thee. And therewith he took from Pudens' finger a little ring, and dipping it in his wound gave it him back again for an heirloom, leaving

him a pledge and memorial of his blood. Then as the breath left him he was cast down with the rest in the accustomed place for his throat to be cut. And when the people besought that they should be brought forward, that when the sword pierced through their bodies their eyes might be joined thereto as witnesses to the slaughter, they rose of themselves and moved whither the people willed them, first kissing one another, that they might accomplish their martyrdom with the rites of peace. The rest not moving and in silence received the sword; Saturus much earlier gave up the ghost; for he had gone up earlier also, and now he waited for Perpetua likewise. But Perpetua, that she might have some taste of pain, was pierced between the bones and shrieked out; and when the swordsman's hand wandered still (for he was a novice), herself set it upon her own neck. Perchance so great a woman could not else have been slain (being feared of the unclean spirit) had she not herself so willed it.

O most valiant and blessed martyrs! O truly called and elected unto the glory of Our Lord Jesus Christ! Which glory he that magnifies, honors and adores, ought to read these witnesses likewise, as being no less than the old, unto the Church's edification; that these new wonders also may testify that one and the same Holy Spirit works ever until now, and with Him God the Father Almighty, and His Son Jesus Christ Our Lord, to Whom is glory and power unending for ever and ever. Amen.

From *The Passion of Saints Perpetua and Felicity,* translated by W. H. Shewing (London: Steed and Ward, 1931).

CHAPTER 7

READING 25
from Saint Augustine (354–430), Confessions

These selections from the Confessions *recount Augustine's conversion experience in his garden in Milan, Italy, and his subsequent conversation with his mother Monica as they await a ship at the Roman port of Ostia to take them back to their native North Africa. Monica dies before their departure, which adds a sad note to the great religious conversation the two had as they looked out over the port itself.*

from Book VIII

11

This was the nature of my sickness. I was in torment, reproaching myself more bitterly than ever as I twisted and turned in my chain. I hoped that my chain might be broken once and for all, because it was only a small thing that held me now. All the same it held me. And you, O Lord, never ceased to watch over my secret heart. In your stern mercy you lashed me with the twin scourge of fear and shame in case I should give way once more and the worn and slender remnant of my chain should not be broken but gain new strength and bind me all the faster. In my heart I kept saying "Let it be now, let it be now!," and merely by saying this I was on the point of making the resolution. I was on the point of making it, but I did not succeed. Yet I did not fall back into my old state. I stood on the brink of resolution, waiting to take fresh breath. I tried again and came a little nearer to my goal, and then a little nearer still, so that I could almost reach out and grasp it. But I did not reach it. I could

not reach out to it or grasp it, because I held back from the step by which I should die to death and become alive to life. My lower instincts, which had taken firm hold of me, were stronger than the higher, which were untried. And the closer I came to the moment which was to mark the great change in me, the more I shrank from it in horror. But it did not drive me back or turn me from my purpose: it merely left me hanging in suspense.

I was held back by mere trifles, the most paltry inanities, all my old attachments. They plucked at my garment of flesh and whispered, "Are you going to dismiss us? From this moment we shall never be with you again, for ever and ever. From this moment you will never again be allowed to do this thing or that, for evermore." What was it, my God, that they meant when they whispered "this thing or that"? Things so sordid and so shameful that I beg you in your mercy to keep the soul of your servant free from them! These voices, as I heard them, seemed less than half as loud as they had been before. They no longer barred my way, blatantly contradictory, but their mutterings seemed to reach me from behind, as though they were stealthily plucking at my back, trying to make me turn my head when I wanted to go forward. Yet, in my state of indecision, they kept me from tearing myself away, from shaking myself free of them and leaping across the barrier to the other side, where you were calling me. Habit was too strong for me when it asked, "Do you think you can live without these things?"

But by now the voice of habit was very faint. I had turned my eyes elsewhere, and while I stood trembling at the barrier, on the other side I could see the chaste beauty of Continence in all her serene, unsullied joy, as she modestly beckoned me to cross over and to hesitate no more. She stretched out loving hands to welcome and embrace me, holding up a host of good examples to my sight. With her were countless boys and girls, great numbers of the young and people of all ages, staid widows and women still virgins in old age. And in their midst was Continence herself, not barren but a fruitful mother of children, of joys born of you, O Lord, her Spouse. She smiled at me to give me courage, as though she were saying, "Can you not do what these men and these women do? Do you think they find the strength to do it in themselves and not in the Lord their God? It was the Lord their God who gave me to them. Why do you try to stand in your own strength and fail? Cast yourself upon God and have no fear. He will not shrink away and let you fall. Cast yourself upon him without fear, for he will welcome you and cure you of your ills." I was overcome with shame, because I was still listening to the futile mutterings of my lower self and I was still hanging in suspense. And again Continence seemed to say, "Close your ears to the unclean whispers of your body, so that it may be mortified. It tells you of things that delight you, but not such things as the law of the Lord your God has to tell."

In this way I wrangled with myself, in my own heart, about my own self. And all the while Alypius stayed at my side, silently awaiting the outcome of this agitation that was new in me.

12

I probed the hidden depths of my soul and wrung its pitiful secrets from it, and when I mustered them all before the eyes of my heart, a great storm broke within me, bringing with it a great deluge of tears. I stood up and left Alypius so that I might weep and cry to my heart's content, for it occurred to me that tears were best shed in solitude. I moved away far enough to avoid being embarrassed even by his presence. He must have realized what my feelings were, for I suppose I had said something and he had known from the sound of my voice that I was ready to burst into tears. So I stood up and left him where we had been sitting, utterly bewildered. Somehow I flung myself down beneath a fig tree and gave way to the tears which now streamed from my eyes, the sacrifice that is acceptable to you. I

had much to say to you, my God, not in these very words but in this strain: *Lord, will you never be content? Must we always taste your vengeance? Forget the long record of our sins.* For I felt that I was still the captive of my sins, and in my misery I kept crying "How long shall I go on saying 'tomorrow, tomorrow'? Why not now? Why not make an end of my ugly sins at this moment?"

I was asking myself these questions, weeping all the while with the most bitter sorrow in my heart, when all at once I heard the sing-song voice of a child in a nearby house. Whether it was the voice of a boy or a girl I cannot say, but again and again it repeated the refrain "Take it and read, take it and read." At this I looked up, thinking hard whether there was any kind of game in which children used to chant words like these, but I could not remember ever hearing them before. I stemmed my flood of tears and stood up, telling myself that this could only be a divine command to open my book of Scripture and read the first passage on which my eyes should fall. For I had heard the story of Antony, and I remembered how he had happened to go into a church while the Gospel was being read and had taken it as a counsel addressed to himself when he heard the words *Go home and sell all that belongs to you. Give it to the poor, and so the treasure you shall have shall be in heaven; then come back and follow me.* By this divine pronouncement he had at once been converted to you.

So I hurried back to the place where Alypius was sitting, for when I stood up to move away I had put down the book containing Paul's Epistles. I seized it and opened it, and in silence I read the first passage on which my eyes fell: *Not in reveling and drunkenness, not in lust and wantonness, not in quarrels and rivalries. Rather, arm yourselves with the Lord Jesus Christ; spend no more thought on nature and nature's appetites.* I had no wish to read more and no need to do so. For in an instant, as I came to the end of the sentence, it was as though the light of confidence flooded into my heart and all the darkness of doubt was dispelled.

I marked the place with my finger or by some other sign and closed the book. My looks now were quite calm as I told Alypius what had happened to me. He too told me what he had been feeling, which of course I did not know. He asked to see what I had read. I showed it to him and he read on beyond the text which I had read. I did not know what followed, but it was this: *Find room among you for a man of over delicate conscience.* Alypius applied this to himself and told me so. This admonition was enough to give him strength, and without suffering the distress of hesitation he made his resolution and took this good purpose to himself. And it very well suited his moral character, which had long been far, far better than my own.

Then we went in and told my mother, who was overjoyed. And when we went on to describe how it had all happened, she was jubilant with triumph and glorified you, *who are powerful enough, and more than powerful enough, to carry out your purpose beyond all our hopes and dreams.* For she saw that you had granted her far more than she used to ask in her tearful prayers and plaintive lamentations. You converted me to yourself, so that I no longer desired a wife or placed any hope in this world but stood firmly upon the rule of faith, where you had shown me to her in a dream so many years before. And you turned her sadness into rejoicing, into joy far fuller than her dearest wish, far sweeter and more chaste than any she had hoped to find in children begotten of my flesh.

from Book IX

10

Not long before the day on which she was to leave this life— you knew which day it was to be, O Lord, though we did

not—my mother and I were alone, leaning from a window which overlooked the garden in the courtyard of the house where we were staying at Ostia. We were waiting there after our long and tiring journey, away from the crowd, to refresh ourselves before our sea voyage. I believe that what I am going to tell you happened through the secret working of your providence. For we were talking alone together and our conversation was serene and joyful. *We had forgotten what we had left behind and were intent on what lay before us.* In the presence of Truth, which is yourself, we were wondering what the eternal life of the saints would be like, that life which *no eye has seen, no ear has heard, no human heart conceived.* But we laid the lips of our hearts to the heavenly stream that flows from your fountain, *the source of all life* which is *in you,* so that as far as it was in our power to do so we might be sprinkled with its waters and in some sense reach an understanding of this great mystery.

Our conversation led us to the conclusion that no bodily pleasure, however great it might be and whatever earthly light might shed luster upon it, was worthy of comparison, or even of mention, beside the happiness of the life of the saints. As the flame of love burned stronger in us and raised us higher towards the eternal God, our thoughts ranged over the whole compass of material things in their various degrees, up to the heavens themselves, from which the sun and the moon and the stars shine down upon the earth. Higher still we climbed, thinking and speaking all the while in wonder at all that you have made. At length we came to our own souls and passed beyond them to that place of everlasting plenty, where you feed Israel for ever with the food of truth. There life is that Wisdom by which all these things that we know are made, all things that ever have been and all that are yet to be. But that Wisdom is not made: it is as it has always been and as it will be for ever—or, rather, I should not say that *it has been or will be,* for it simply *is,* because eternity is not in the past or in the future. And while we spoke of the eternal Wisdom, longing for it and straining for it with all the strength of our hearts, for one fleeting instant we reached out and touched it. Then with a sigh, leaving *our spiritual harvest* bound to it, we returned to the sound of our own speech, in which each word has a beginning and an ending—far, far different from your Word, our Lord, who abides in himself for ever, yet never grows old and gives new life to all things.

And so our discussion went on. Suppose, we said, that the tumult of a man's flesh were to cease and all that his thoughts can conceive, of earth, of water, and of air, should no longer speak to him; suppose that the heavens and even his own soul were silent, no longer thinking of itself but passing beyond; suppose that his dreams and the visions of his imagination spoke no more and that every tongue and every sign and all that is transient grew silent—for all these things have the same message to tell, if only we can hear it, and their message is this: We did not make ourselves, but he who abides for ever made us. Suppose, we said, that after giving us this message and bidding us listen to him who made them, they fell silent and he alone should speak to us, not through them but in his own voice, so that we should hear him speaking, not by any tongue of the flesh or by an angel's voice, not in the sound of thunder or in some veiled parable, but in his own voice, the voice of the one whom we love in all these created things; suppose that we heard him himself, with none of these things between ourselves and him, just as in that brief moment my mother and I had reached out in thought and touched the eternal wisdom which abides over all things; suppose that this state were to continue and all other visions of things inferior were to be removed, so that this single vision entranced and absorbed the one who beheld it and enveloped him in inward joys in such a way that for him life was eternally the same as that instant of understanding for which we had longed so much—would not this be what we are to understand by the words *Come and share the joy of your Lord?* But when is it to be? Is it to be when *we all rise again, but not all of us will undergo the change?*

This was the purport of our talk, though we did not speak in these precise words or exactly as I have reported them. Yet you know, O Lord, that as we talked that day, the world, for all its pleasures, seemed a paltry place compared with the life that we spoke of. And then my mother said, "My son, for my part I find no further pleasure in this life. What I am still to do or why I am here in the world, I do not know, for I have no more to hope for on this earth. There was one reason, and one alone, why I wished to remain a little longer in this life, and that was to see you a Catholic Christian before I died. God has granted my wish and more besides, for I now see you as his servant, spurning such happiness as the world can give. What is left for me to do in this world?"

11

I scarcely remember what answer I gave her. It was about five days after this, or not much more, that she took to her bed with a fever. One day during her illness she had a fainting fit and lost consciousness for a short time. We hurried to her bedside, but she soon regained consciousness and looked up at my brother and me as we stood beside her. With a puzzled look she asked, "Where was I?" Then watching us closely as we stood there speechless with grief, she said, "You will bury your mother here." I said nothing, trying hard to hold back my tears, but my brother said something to the effect that he wished for her sake that she would die in her own country, not abroad. When she heard this, she looked at him anxiously and her eyes reproached him for his worldly thoughts. She turned to me and said, "See how he talks!" and then, speaking to both of us, she went on, "It does not matter where you bury my body. Do not let that worry you! All I ask of you is that, wherever you may be, you should remember me at the altar of the Lord."

Although she hardly had the strength to speak, she managed to make us understand her wishes and then fell silent, for her illness was becoming worse and she was in great pain. But I was thinking of your gifts, O God. Unseen by us you plant them like seeds in the hearts of your faithful and they grow to bear wonderful fruits. This thought filled me with joy and I thanked you for your gifts, for I had always known, and well remembered now, my mother's great anxiety to be buried beside her husband's body in the grave which she had provided and prepared for herself. Because they had lived in the greatest harmony, she had always wanted this extra happiness. She had wanted it to be said of them that, after her journey across the sea, it had been granted to her that the earthly remains of husband and wife should be joined as one and covered by the same earth. How little the human mind can understand God's purpose! I did not know when it was that your good gifts had borne their full fruit and her heart had begun to renounce this vain desire, but I was both surprised and pleased to find that it was so. And yet, when we talked at the window and she asked, "What is left for me to do in this world?" it was clear that she had no desire to die in her own country. Afterwards I also heard that one day during our stay at Ostia, when I was absent, she had talked in a motherly way to some of my friends and had spoken to them of the contempt of this life and the blessings of death. They were astonished to find such courage in a woman—it was your gift to her, O Lord—and asked whether she was not frightened at the thought of leaving her body so far from her own country. "Nothing is far from God," she replied, "and I need have no fear that he will not know where to find me when he comes to raise me to life at the end of the world."

And so on the ninth day of her illness, when she was fifty-six and I was thirty-three, her pious and devoted soul was set free from the body.

From Book VIII and Book IX of *Confessions of Saint Augustine*, translated by R.S. Pine-Coffin (Penguin Classics, 1961). Copyright © R.S. Pine-Coffin, 1961. Reprinted by permission of Penguin Books, Ltd.

READING 26
from Saint Augustine (354–430), The City of God, Book XIX

In this selection from Augustine's massive meditation on history Augustine ponders a perennial subject for all people: the character of peace in both its personal and social context. This great reflection on peace is all the more compelling because it was written by Augustine against the background of the Barbarian invasions of Europe and Roman North Africa as well as his own shock at the sack of the city of Rome, the occasion for his writing this book in the first place.

7. Human society divided by differences of language. The misery of war, even when just

After the city or town comes the world, which the philosophers reckon as the third level of human society. They begin with the household, proceed to the city, and then arrive at the world. Now the world, being like a confluence of waters, is obviously more full of danger than the other communities by reason of its greater size. To begin with, on this level the diversity of languages separates man from man. For if two men meet, and are forced by some compelling reason not to pass on but to stay in company, then if neither knows the other's language, it is easier for dumb animals, even of different kinds, to associate together than these men, although both are human beings. For when men cannot communicate their thoughts to each other, simply because of difference of language, all the similarity of their common human nature is of no avail to unite them in fellowship. So true is this that a man would be more cheerful with his dog for company than with a foreigner. I shall be told that the Imperial City has been at pains to impose on conquered peoples not only her yoke but her language also, as a bond of peace and fellowship, so that there should be no lack of interpreters but even a profusion of them. True; but think of the cost of this achievement! Consider the scale of those wars, with all that slaughter of human beings, all the human blood that was shed!

Those wars are now past history; and yet the misery of these evils is not yet ended. For although there has been, and still is, no lack of enemies among foreign nations, against whom wars have always been waged, and are still being waged, yet the very extent of the Empire has given rise to wars of a worse kind, namely, social and civil wars, by which mankind is more lamentably disquieted either when fighting is going on in the hope of bringing hostilities eventually to a peaceful end, or when there are fears that hostilities will break out again. If I were to try to describe, with an eloquence worthy of the subject, the many and multifarious disasters, the dour and dire necessities, I could not possibly be adequate to the theme, and there would be no end to this protracted discussion. But the wise man, they say, will wage just wars. Surely, if he remembers that he is a human being, he will rather lament the fact that he is faced with the necessity of waging just wars; for if they were not just, he would not have to engage in them, and consequently there would be no wars for a wise man. For it is the injustice of the opposing side that lays on the wise man the duty of waging wars; and this injustice is assuredly to be deplored by a human being, since it is the injustice of human beings, even though no necessity for war should arise from it. And so everyone who reflects with sorrow on such grievous evils, in all their horror and cruelty, must acknowledge the misery of them. And yet a man who experiences such evils, or even thinks about them, without heartfelt grief, is assuredly in a far more pitiable condition, if he thinks himself happy simply because he has lost all human feeling.

8. The friendship of good men can never be carefree, because of this life's dangers

If we are spared that kind of ignorance, akin to madness, which is a common affliction in the wretched condition of this life, an ignorance which leads men to believe an enemy to be a friend, or a friend an enemy, what consolation have we in this human society, so replete with mistaken notions and distressing anxieties, except the unfeigned faith and mutual affections of genuine, loyal friends? Yet the more friends we have and the more dispersed they are in different places, the further and more widely extend our fears that some evil may befall them from among all the mass of evils of this present world. For not only are we troubled and anxious because they may be afflicted by famine, war, disease, or captivity, fearing that in slavery they may suffer evils beyond our powers of imagination; there is the much more bitter fear, that their friendship be changed into treachery, malice and baseness. And when such things do happen (and the more numerous our friends, the more often they happen) and the news is brought to our ears, who, except one who has this experience, can be aware of the burning sorrow that ravages our hearts? Certainly we would rather hear that our friends were dead, although this also we could not hear without grief.

For if their life brought us the consoling delights of friendship, how could it be that their death should bring us no sadness? Anyone who forbids such sadness must forbid, if he can, all friendly conversation, must lay a ban on all friendly feeling or put a stop to it, must with a ruthless insensibility break the ties of all human relationships, or else decree that they must only be engaged upon so long as they inspire no delight in a man's soul. But if this is beyond all possibility, how can it be that a man's death should not be bitter if his life is sweet to us? For this is why the grief of a heart that has not lost human feeling is a thing like some wound or ulcer, and our friendly words of consolation are the healing application. And it does not follow that there is nothing to be healed simply because the nobler a man's spirit the quicker and easier the cure.

It is true, then, that the life of mortals is afflicted, sometimes more gently, sometimes more harshly, by the death of those most dear to us, and especially the death of those whose functions are necessary for human society; and yet we should prefer to hear, or even to witness, the death of those we love, than to become aware that they have fallen from faith or from moral conflict—that is, that they have died in their very soul. The earth is full of this vast mass of evils; that is why we find this in Scripture: "Is man's life on earth anything but temptation?" And why the Lord himself says, "Alas for the world, because of these obstacles"; and again, "Because iniquity will increase beyond measure, the love of many will grow cold." The result of this situation is that when good men die who are our friends we rejoice for them; and though their death brings us sadness, we find our surer consolation in this, that they have been spared those evils by which in this life even good men are crushed or corrupted, or at least are in danger of both these disasters.

9. The friendship of the holy angels, obscured by the deceit of demons

Our relationship with the society of the holy angels is quite another matter. Those philosophers, we observe, who insisted

that the gods are our friends placed this angelic fellowship on the fourth level, as they proceeded in their scheme from the earth to the universe, intending by this method to include, in some fashion, even heaven itself. Now, with regard to the angels, we have, it is true, no manner of fear that such friends may bring us sorrow, either by their death or by their degradation. But they do not mix with us on the same familiar footing as do men—and this in itself is one of the disappointments involved in this life—and Satan, as Scripture tells us, transforms himself at times to masquerade as an angel of light, to tempt those men who are in need of this kind of training, or men who deserve to be thus deluded. Hence God's great mercy is needed to prevent anyone from supposing that he is enjoying the friendship of good angels when in fact it is evil demons that he has as his false friends, and when he thus suffers from the enmity of those whose harmfulness is in proportion to their cunning and deceit. In fact, where is God's great mercy needed if not by men in their most pitiable state, where they are so weighed down by ignorance that they are readily deluded by the pretences of those spirits? Now those philosophers in the ungodly city alleged that the gods were their friends; but it is quite certain that they had fallen in with these malignant demons, the powers to whom that city itself is wholly subjected, and in whose company it will suffer everlasting punishment. This is made quite clear by those beings who are worshipped in that city. It is revealed unmistakably by the sacred, or rather sacrilegious, rites by which the pagans think it right to worship them, and by the filthy shows by which they think those demons must be propitiated; and it is the demons themselves who suggest, and indeed demand, the performance of such vile obscenities.

10. The reward of victory over temptation

However, not even the saints and the faithful worshippers of the one true and supreme God enjoy exemption from the deceptions of the demons and from their multifarious temptations. In fact, in this situation of weakness and in these times of evil such anxiety is even not without its use in leading them to seek, with more fervent longing, that state of serenity where peace is utterly complete and assured. For there the gifts of nature, that is, the gifts bestowed on our nature by the Creator of all natures, will be not only good but also everlasting; and this applies not only to the spirit, which is healed by the wisdom, but also to the body, which will be renewed by resurrection. There the virtues will not be engaged in conflict with any kind of vice or evil; they will be possessed of the reward of victory, the everlasting peace which no adversary can disturb. This is indeed the ultimate bliss, the end of ultimate fulfillment that knows no destructive end. Here in this world we are called blessed, it is true, when we enjoy peace, however little may be the peace—the peace of a good life—which can be enjoyed here. And yet such blessedness as this life affords proves to be utter misery when compared with that final bliss. And so, when we enjoy here, if we live rightly, such peace as can be the portion of mortal men under the conditions of mortality, virtue rightly uses the blessings of peace, and even when we do not possess that peace, virtue turns to a good use even the ills that man endures. But virtue is truly virtue when it refers all the good things of which it makes good use, all its achievements in making good use of good things and evil things, and when it refers itself also, to that end where our peace shall be so perfect and so great as to admit of neither improvement nor increase.

11. The bliss of everlasting peace, which is the fulfillment of the saints

It follows that we could say of peace, as we have said of eternal life, that it is the final fulfillment of all our goods; especially in view of what is said in a holy psalm about the City of God, the subject of this laborious discussion. These are the words: "Praise the Lord, O Jerusalem; praise your God, O Sion: for he has strengthened the bolts of your gates; he has blessed your sons within your walls; he has made your frontiers peace." Now when the bolts of her gates have been strengthened, that means that no one will any more enter or leave that City. And this implies that we must take her "frontiers" (or "ends") to stand here for the peace whose finality I am trying to establish. In fact, the name of the City itself has a mystic significance, for "Jerusalem," as I have said already, means "vision of peace."

But the word *peace* is freely used in application to the events of this mortal state, where there is certainly no eternal life; and so I have preferred to use the term "eternal life" instead of "peace" in describing the end of this City, where its Ultimate Good will be found. About this end the Apostle says, "But now you have been set free from sin and have become the servants of God; and so you have your profit, a profit leading to sanctification, and the end is everlasting life." On the other hand, the life of the wicked may also be taken to be eternal life by those who have no familiarity with the holy Scriptures. They may follow some of the philosophers in thinking in terms of the immortality of the soul, or they may be influenced by our Christian belief in the endless punishment of the ungodly, who obviously cannot be tortured for ever without also living for ever. Consequently, in order to make it easier for everyone to understand our meaning, we have to say that the end of this City, whereby it will possess its Supreme Good, may be called either "peace in life everlasting" or "life everlasting in peace." For peace is so great a good that even in relation to the affairs of earth and of our mortal state no word ever falls more gratefully upon the ear, nothing is desired with greater longing, in fact, nothing better can be found. So if I decide to discourse about it at somewhat greater length, I shall not, I think, impose a burden on my readers, not only because I shall be speaking of the end of the City which is the subject of this work, but also because of the delightfulness of peace, which is dear to the heart of all mankind.

12. Peace is the instinctive aim of all creatures, and is even the ultimate purpose of war

Anyone who joins me in an examination, however slight, of human affairs, and the human nature we all share, recognizes that just as there is no man who does not wish for joy, so there is no man who does not wish for peace. Indeed, even when men choose war, their only wish is for victory; which shows that their desire in fighting is for peace with glory. For what is victory but the conquest of the opposing side? And when this is achieved, there will be peace. Even wars, then, are waged with peace as their object, even when they are waged by those who are concerned to exercise their warlike prowess, either in command or in the actual fighting. Hence it is an established fact that peace is the desired end of war. For every man is in quest of peace, even in waging war, whereas no one is in quest of war when making peace. In fact, even when men wish a present state of peace to be disturbed they do so not because they hate peace, but because they desire the present peace to be exchanged for one that suits their wishes. Thus their desire is not that there should not be peace but that it should be the kind of peace they wish for. Even in the extreme case when they have separated themselves from others by sedition, they cannot achieve their aim unless they maintain some sort of semblance of peace with their confederates in conspiracy. Moreover, even robbers, to ensure greater efficiency and security in their assaults on the peace of the rest of mankind, desire to preserve peace with their associates.

Indeed, one robber may be so unequalled in strength and so wary of having anyone to share his plans that he does not trust

any associate, but plots his crimes and achieves his successes by himself, carrying off his booty after overcoming and dispatching such as he can; yet even so he maintains some kind of shadow of peace, at least with those whom he cannot kill, and from whom he wishes to conceal his activities. At the same time, he is anxious, of course, to be at peace in his own home, with his wife and children and any others members of his household; without doubt he is delighted to have them obedient to his beck and call. For if this does not happen, he is indignant; he scolds and punishes; and, if need be, he employs savage measures to impose on his household a peace which, he feels, cannot exist unless all the other elements in the same domestic society are subject to one head; and this head, in his own home, is himself. Thus, if he were offered the servitude of a larger number, of a city, maybe, or a whole nation, on the condition that they should all show the same subservience he had demanded from his household, then he would no longer lurk like a brigand in his hide-out; he would raise himself on high as a king for all to see—although the same greed and malignity would persist in him.

We see, then, that all men desire to be at peace with their own people, while wishing to impose their will upon those people's lives. For even when they wage war on others, their wish is to make those opponents their own people, if they can—to subject them, and to impose on them their own conditions of peace.

Let us, however, suppose such a man as is described in the verse of epic legends, a creature so unsociable and savage that they perhaps preferred to call him a semi-human rather than a human being. Now although his kingdom was the solitude of a dreadful cavern, and although he was so unequalled in wickedness that a name was found for him derived from that quality (he was called Cacus, and *kakos* is the Greek word for "wicked"); although he had no wife with whom to exchange endearments, no children to play with when little or to give orders to when they were a little bigger, no friends with whom to enjoy a chat, not even his father, Vulcan (he was happier than his father only in this important respect—that he did not beget another such monster as himself); although he never gave anything to anyone, but took what he wanted from anyone he could and removed, when he could, anyone he wished to remove; despite all this, in the very solitude of his cave, the floor of which, in the poet's description

reeked ever with the blood of recent slaughter

his only desire was for a peace in which no one should disturb him, and no man's violence, or the dread of it, should trouble his repose. Above all, he desired to be at peace with his own body; and in so far as he achieved this, all was well with him. He gave the orders and his limbs obeyed. But his mortal nature rebelled against him because of its insatiable desires, and stirred up the civil strife of hunger, intending to dissociate the soul from the body and to exclude it; and then he sought with all possible haste to pacify that mortal nature, and to that end he ravished, murdered, and devoured. And thus, for all his monstrous savagery, his aim was still to ensure peace, for the preservation of his life, by these monstrous and savage methods. Accordingly, if he had been willing to maintain, in relation to others also, the peace he was so busily concerned to preserve in his own case and in himself, he would not have been called wicked, or a monster, or semi-human. Or if it was his outward appearance and his belching of murky flames that frightened away human companions, it may be that it was not lust for inflicting injury but the necessity of preserving his life that made him so savage. Perhaps, after all, he never existed or, more probably, he was not like the description given by poetic fantasy; for if Cacus had not been excessively blamed, Hercules would have received inadequate praise. And therefore the exis-

tence of such a man, or rather semi-human, is discredited, as are many similar poetical fictions.

We observe, then, that even the most savage beasts, from whom Cacus derived the wild-beast side of his nature (he was in fact also called a semi-beast), safeguard their own species by a kind of peace, by coition, by begetting and bearing young, by cherishing them and rearing them; even though most of them are not gregarious but solitary—not, that is, like sheep, deer, doves, starlings, and bees, but like lions, wolves, foxes, eagles and owls. What tigress does not gently purr over her cubs, and subdue her fierceness to caress them? What kite, however solitary as he hovers over his prey, does not find a mate, build a nest, help to hatch the eggs, rear the young birds, and, as we may say, preserve with the mother of his family a domestic society as peaceful as he can make it? How much more strongly is a human being drawn by the laws of his nature, so to speak, to enter upon a fellowship with all his fellow-men and to keep peace with them, as far as lies in him. For even the wicked when they go to war do so to defend the peace of their own people, and desire to make all men their own people, if they can, so that all men and all things might together be subservient to one master. And how could that happen, unless they should consent to a peace of his dictation either through love or through fear? Thus pride is a perverted imitation of God. For pride hates a fellowship of equality under God, and seeks to impose its own dominion on fellow men, in place of God's rule. This means that it hates the just peace of God, and loves its own peace of injustice. And yet it cannot help loving peace of some kind or other. For no creature's perversion is so contrary to nature as to destroy the very last vestiges of its nature.

It comes to this, then; a man who has learnt to prefer right to wrong and the rightly ordered to the perverted, sees that the peace of the unjust, compared with the peace of the just, is not worthy even of the name of peace. Yet even what is perverted must of necessity be in, or derived from, or associated with—that is, in a sense, at peace with—some part of the order of things among which it has its being or of which it consists. Otherwise it would not exist at all. For instance if anyone were to hang upside-down, this position of the body and arrangement of the limbs is undoubtedly perverted, because what should be on top, according to the dictates of nature, is underneath, and what nature intends to be underneath is on top. This perverted attitude disturbs the peace of the flesh, and causes distress for that reason. For all that, the breath is at peace with its body and is busily engaged for its preservation; that is why there is something to endure the pain. And even if the breath is finally driven from the body by its distresses, still, as long as the framework of the limbs holds together, what remains retains a kind of peace among the bodily parts; hence there is still something to hang there. And in that the earthly body pulls towards the earth, and pulls against the binding rope that holds it suspended, it tends towards the position of its own peace, and by what might be called the appeal of its weight, it demands a place where it may rest. And so even when it is by now lifeless and devoid of all sensation it does not depart from the peace of its natural position, either while possessed of it or while tending toward it. Again, if treatment with embalming fluids is applied to prevent the dissolution and disintegration of the corpse in its present shape, a kind of peace still connects the parts with one another and keeps the whole mass fixed in its earthly condition, an appropriate, and therefore a peaceable state.

On the other hand, if no preservative treatment is given, and the body is left for nature to take its course, there is for a time a kind of tumult in the corpse of exhalations disagreeable and offensive to our senses (for that is what we smell in putrefaction), which lasts until the body unites with the elements of the world as, little by little, and particle by particle, it vanishes into their peace. Nevertheless, nothing is in any way

removed, in this process, from the control of the laws of the supreme Creator and Ruler who directs the peace of the whole scheme of things. For although minute animals are produced in the corpse of a larger animal, those little bodies, each and all of them, by the same law of their Creator, are subservient to their little souls in the peace that preserves their lives. And even if the flesh of dead animals is devoured by other animals, in whatever direction it is taken, with whatever substances it is united, into whatever substances it is converted and transformed, it still finds itself subject to the same laws which are diffused throughout the whole of matter for the preservation of every mortal species, establishing peace by a harmony of congruous elements.

13. The peace of the universe maintained through all disturbances by a law of nature: The individual attains, by God's ordinance, to the state he has deserved by his free choice

The peace of the body, we conclude, is a tempering of the component parts in duly ordered proportion; the peace of the irrational soul is a duly ordered repose of the appetites; the peace of the rational soul is the duly ordered agreement of cognition and action. The peace of body and soul is the duly ordered life and health of a living creature; peace between mortal man and God is an ordered obedience, in faith, in subjection to an everlasting law; peace between men is an ordered agreement of mind with mind; the peace of a home is the ordered agreement among those who live together about giving and obeying orders; the peace of the Heavenly City is a perfectly ordered and perfectly harmonious fellowship in the enjoyment of God, and a mutual fellowship in God; the peace of the whole universe is the tranquility of order—and order is the arrangement of things equal and unequal in a pattern which assigns to each its proper position.

It follows that the wretched, since, in so far as they are wretched, they are obviously not in a state of peace, lack the tranquillity of order, a state in which there is no disturbance of mind. In spite of that, because their wretchedness is deserved and just, they cannot be outside the scope of order. They are not, indeed, united with the blessed; yet it is by the law of order that they are sundered from them. And when they are free from disturbance of mind, they are adjusted to their situation, with however small a degree of harmony. Thus they have amongst them some tranquillity of order, and therefore some peace. But they are still wretched just because, although they enjoy some degree of serenity and freedom from suffering, they are not in a condition where they have the right to be serene and free from pain. They are yet more wretched, however, if they are not at peace with the law by which the natural order is governed. Now when they suffer, their peace is disturbed in the part where they suffer; and yet peace still continues in the part which feels no burning pain, and where the natural frame is not broken up. Just as there is life, then, without pain, whereas there can be no pain when there is no life, so there is peace without any war, but no war without some degree of peace. This is not a consequence of war as such, but of the fact that war is waged by or within persons who are in some sense natural beings—for they could have no kind of existence without some kind of peace as the condition of their being.

There exists, then, a nature in which there is no evil, in which, indeed, no evil can exist; but there cannot exist a nature in which there is no good. Hence not even the nature of the Devil himself is evil, in so far as it is a nature; it is perversion that makes it evil. And so the Devil did not stand firm in the truth, and yet he did not escape the judgement of the truth. He did not continue in the tranquillity of order; but that did not mean that he escaped from the power of the imposer of order. The good that God imparts, which the Devil has in his nature, does not withdraw him from God's justice by which his punishment is ordained. But God, in punishing, does not chastise the good which he created, but the evil which the Devil has committed. And God does not take away all that he gave to that nature; he takes something, and yet he leaves something, so that there may be some being left to feel pain at the deprivation.

Now this pain is in itself evidence of the good that was taken away and the good that was left. In fact, if no good has been left there could have been no grief for lost good. For a sinner is in a worse state if he rejoices in the loss of righteousness; but a sinner who feels anguish, though he may gain no good from his anguish, is at least grieving at the loss of salvation. And since righteousness and salvation are both good, and the loss of any good calls for grief rather than for joy (assuming that there is no compensation for the loss in the shape of a higher good—for example, righteousness of character is a higher good than health of body), the unrighteous man's grief in his punishment is more appropriate than his rejoicing in sin. Hence, just as delight in the abandonment of good, when a man sins, is evidence of a bad will, so grief at the loss of good, when a man is punished, is evidence of a good nature. For when a man grieves at the loss of the peace of his nature, his grief arises from some remnants of that peace, which ensure that his nature is still on friendly terms with itself. Moreover, it is entirely right that in the last punishment the wicked and ungodly should bewail in their agonies the loss of their "natural" goods, and realize that he who divested them of these goods with perfect justice is God, whom they despised when with supreme generosity he bestowed them.

God then, created all things in supreme wisdom and ordered them in perfect justice; and in establishing the mortal race of mankind as the greatest ornament of earthly things, he has given to mankind certain good things suitable to this life. These are: temporal peace, in proportion to the short span of a mortal life—the peace that consists in bodily health and soundness, and in fellowship with one's kind; and everything necessary to safeguard or recover this peace—those things, for example, which are appropriate and accessible to our senses: light, speech, air to breathe, water to drink, and whatever is suitable for the feeding and clothing of the body, for the care of the body and the adornment of the person. And all this is granted under the most equitable condition: that every mortal who uses aright such goods, goods designed to serve the peace of mortal men, shall receive goods greater in degree and superior in kind, namely, the peace of immortality, and the glory and honor appropriate to it in a life which is eternal for the enjoyment of God and of one's neighbor in God, whereas he who wrongly uses those mortal goods shall lose them, and shall not receive the blessings of eternal life.

14. The order and law, earthly or heavenly, by which government serves the interests of human society

We see, then, that all man's use of temporal things is related to the enjoyment of earthly peace in the earthly city; whereas in the Heavenly City it is related to the enjoyment of eternal peace. Thus, if we were irrational animals, our only aim would be the adjustment of the parts of the body in due proportion, and the quieting of the appetites—only, that is, the repose of the flesh, and an adequate supply of pleasures, so that bodily peace might promote the peace of the soul. For if bodily peace is lacking, the peace of the irrational soul is also hindered, because it cannot achieve the quieting of its appetites. But the two together promote that peace which is a mutual concord between soul and body, the peace of an ordered life and of health. For living creatures show their love of bodily peace by their avoidance of pain, and by their pursuit of pleasure to sat-

isfy the demands of their appetites they demonstrate their love of peace of soul. In just the same way, by shunning death they indicate quite clearly how great is their love of the peace in which soul and body are harmoniously united.

But because there is in man a rational soul, he subordinates to the peace of the rational soul all that part of his nature which he shares with the beasts, so that he may engage in deliberate thought and act in accordance with this thought, so that he may thus exhibit that ordered agreement of cognition and action which we called the peace of the rational soul. For with this end in view he ought to wish to be spared the distress of pain and grief, the disturbances of desire, the dissolution of death, so that he may come to some profitable knowledge and may order his life and his moral standards in accordance with this knowledge. But he needs divine direction, which he may obey with resolution, and divine assistance that he may obey it freely, to prevent him from falling, in his enthusiasm for knowledge, a victim to some fatal error, through the weakness of the human mind. And so long as he is in this mortal body, he is a pilgrim in a foreign land, away from God; therefore he walks by faith, not by sight. That is why he views all peace, of body or of soul, or of both, in relation to that peace which exists between mortal man and immortal God, so that he may exhibit an ordered obedience in faith in subjection to the everlasting Law.

Now God, our master, teaches two chief precepts, love of God and love of neighbor; and in them man finds three objects for his love: God, himself, and his neighbor; and a man who loves God is not wrong in loving himself. It follows, therefore, that he will be concerned also that his neighbor should love God, since he is told to love his neighbor as himself; and the same is true of his concern for his wife, his children, for the members of his household, and for all other men, so far as is possible. And, for the same end, he will wish his neighbor to be concerned for him, if he happens to need that concern. For this reason he will be at peace, as far as lies in him, with all men, in that peace among men, that ordered harmony; and the basis of this order is the observance of two rules: first, to do no harm to anyone, and, secondly, to help everyone whenever possible. To begin with, therefore, a man has a responsibility for his own household—obviously, both in the order of nature and in the framework of human society, he has easier and more immediate contact with them; he can exercise his concern for them. That is why the Apostle says, "Anyone who does not take care of his own people, especially those in his own household, is worse than an unbeliever—he is a renegade." This is where domestic peace starts, the ordered harmony about giving and obeying orders among those who live in the same house. For the orders are given by those who are concerned for the interests of others; thus the husband gives orders to the wife, parents to children, masters to servants. While those who are the objects of this concern obey orders; for example, wives obey husbands, the children obey their parents, the servants their masters. But in the household of the just man who "lives on the basis of faith" and who is still on pilgrimage, far from that Heavenly City, even those who give orders are the servants of those whom they appear to command. For they do not give orders because of a lust for domination but from a dutiful concern for the interests of others, not with pride in taking precedence over others, but with compassion in taking care of others.

15. Man's natural freedom; and the slavery caused by sin

This relationship is prescribed by the order of nature, and it is in this situation that God created man. For he says, "Let him have lordship over the fish of the sea, the birds of the sky . . . and all the reptiles that crawl on the earth." He did not wish the rational being, made in his own image, to have dominion over any but irrational creatures, not man over man, but man over beasts. Hence the first just men were set up as shepherds of flocks, rather than as kings of men, so that in this way also God might convey the message of what was required by the order of nature, and what was demanded by the deserts of sinners—for it is understood, of course, that the condition of slavery is justly imposed on the sinner. That is why we do not hear of a slave anywhere in the Scriptures until Noah, the just man, punished his son's sin with this word; and so that son deserved this name because of his misdeed, not because of his nature. The origin of the Latin word for slave, *servus,* is believed to be derived from the fact that those who by the laws of war could rightly be put to death by the conquerors, became *servi,* slaves, when they were preserved, receiving this name from their preservation. But even this enslavement could not have happened, if it were not for the deserts of sin. For even when a just war is fought it is in defense of his sin that the other side is contending; and victory, even when the victory falls to the wicked, is a humiliation visited on the conquered by divine judgement, either to correct or to punish their sins. We have a witness to this in Daniel, a man of God, who in captivity confesses to God his own sins and the sins of his people, and in devout grief testifies that they are the cause of that captivity. The first cause of slavery, then, is sin, whereby man was subjected to man in the condition of bondage; and this can only happen by the judgment of God, with whom there is no injustice, and who knows how to allot different punishments according to the deserts of the offenders.

Now, as our Lord above says, "Everyone who commits sin is sin's slave," and that is why, though many devout men are slaves to unrighteous masters, yet the masters they serve are not themselves free men; "for when a man is conquered by another he is also bound as a slave to his conqueror." And obviously it is a happier lot to be slave to a human being than to a lust; and, in fact, the most pitiless domination that devastates the hearts of men, is that exercised by this very lust for domination, to mention no others. However, in that order of peace in which men are subordinate to other men, humility is as salutary for the servants as pride is harmful to the masters. And yet by nature, in the condition in which God created man, no man is the slave either of man or of sin. But it remains true that slavery as a punishment is also ordained by that law which enjoins the preservation of the order of nature, and forbids its disturbance; in fact, if nothing had been done to contravene that law, there would have been nothing to require the discipline of slavery as a punishment. That explains also the Apostle's admonition to slaves, that they should be subject to their masters, and serve them loyally and willingly. What he means is that if they cannot be set free by their masters, they themselves may thus make their slavery, in a sense, free, by serving not with the slyness of fear, but with the fidelity of affection, until all injustice disappears and all human lordship and power is annihilated, and God is all in all.

16. Equity in the relation of master and slave

This being so, even though our righteous fathers had slaves, they so managed the peace of their households as to make a distinction between the situation of children and the condition of slaves in respect of the temporal goods of this life; and yet in the matter of the worship of God—in whom we must place our hope of everlasting goods—they were concerned, with equal affection, for all the members of their household. This is what the order of nature prescribes, so that this is the source of the name *paterfamilias,* a name that has become so generally used that even those who exercise unjust rule rejoice to be called by this title. On the other hand, those who are genuine

"fathers of their household" are concerned for the welfare of all in their households in respect of the worship and service of God, as if they were all their children, longing and praying that they may come to the heavenly home, where it will not be a necessary duty to give orders to men, because it will no longer be a necessary duty to be concerned for the welfare of those who are already in the felicity of that immortal state. But until that home is reached, the fathers have an obligation to exercise the authority of masters greater than the duty of slaves to put up with their condition as servants.

However, if anyone in the household is, through his disobedience, an enemy to the domestic peace, he is reproved by a word, or by a blow, or any other kind of punishment that is just and legitimate, to the extent allowed by human society; but this is for the benefit of the offender, intended to readjust him to the domestic peace from which he had broken away. For just as it is not an act of kindness to help a man, when the effect of the help is to make him lose a greater good, so it is not a blameless act to spare a man, when by so doing you let him fall into a greater sin. Hence the duty of anyone who would be blameless includes not only doing no harm to anyone but also restraining a man from sin or punishing his sin, so that either the man who is chastised may be corrected by his experience, or others may be deterred by his example. Now a man's house ought to be the beginning, or rather a small component part of the city, and every beginning is directed to some end of its own kind, and every component part contributes to the completeness of the whole of which it forms a part. The implication is quite apparent, that domestic peace contributes to the peace of the city—that is, the ordered harmony of those who live together in a house in the matter of giving and obeying orders, contributes to the ordered harmony concerning authority and obedience obtaining among the citizens. Consequently it is fitting that the father of a household should take his rules from the law of the city, and govern his household in such a way that it fits in with the peace of the city.

17. The origin of peace between the heavenly society and the earthly city, and of discord between them

But a household of human beings whose life is not based on faith is in pursuit of an earthly peace based on the things belonging to this temporal life, and on its advantages, whereas a household of human beings whose life is based on faith looks forward to the blessings which are promised as eternal in the future, making use of earthly and temporal things like a pilgrim in a foreign land, who does not let himself be taken in by them or distracted from his course toward God, but rather treats them as supports which help him more easily to bear the burdens of "the corruptible body which weighs heavy on the soul"; they must on no account be allowed to increase the load. Thus both kinds of men and both kinds of households alike make use of the things essential for this mortal life: but each has its own very different end in making use of them. So also the earthly city, whose life is not based on faith, aims at an earthly peace, and it limits the harmonious agreement of citizens concerning the giving and obeying of orders to the establishment of a kind of compromise between human wills about the things relevant to mortal life. In contrast, the Heavenly City—or rather that part of it which is on pilgrimage in this condition of mortality, and which lives on the basis of faith—must needs make use of this peace also, until this mortal state, for which this kind of peace is essential, passes away. And therefore, it leads what we may call a life of captivity in this earthly city as in a foreign land, although it has already received the promise of redemption, and the gift of the Spirit as a kind of pledge of it; and yet it does not hesitate to obey the laws of the earthly city by which those things which are designed for the support of this mortal life are regulated; and the purpose of this obedience is that, since this mortal condition is shared by both cities, a harmony may be preserved between them in things that are relevant to this condition.

But this earthly city has had some philosophers belonging to it whose theories are rejected by the teaching inspired by God. Either led astray by their own speculation or deluded by demons, these thinkers reached the belief that there are many gods who must be won over to serve human ends, and also that they have, as it were, different departments with different responsibilities attached. Thus the body is the department of one god, the mind that of another; and within the body itself, one god is in charge of the head, another of the neck and so on with each of the separate members. Similarly, within the mind, one is responsible for natural ability, another for learning, another for anger, another for lust; and in the accessories of life there are separate gods over the departments of flocks, grain, wine, oil, forests, coinage, navigation, war and victory, marriage, birth, fertility, and so on. The Heavenly City, in contrast, knows only one God as the object of worship, and decrees, with faithful devotion, that he only is to be served with that service which the Greeks call *latreia*, which is due to God alone. And the result of this difference has been that the Heavenly City could not have laws of religion common with the earthly city, and in defense of her religious laws she was bound to dissent from those who thought differently and to prove a burdensome nuisance to them. Thus she had to endure their anger and hatred, and the assaults of persecution; until at length that City shattered the morale of her adversaries by the terror inspired by her numbers, and by the help she continually received from God.

While this Heavenly City, therefore, is on pilgrimage in this world, she calls out citizens from all nations and so collects a society of aliens, speaking all languages. She takes no account of any difference in customs, laws, and institutions, by which earthly peace is achieved and preserved—not that she annuls or abolishes any of those, rather, she maintains them and follows them (for whatever divergences there are among the diverse nations, those institutions have one single aim—earthly peace), provided that no hindrance is presented thereby to the religion which teaches that the one supreme and true God is to be worshipped. Thus even the Heavenly City in her pilgrimage here on earth makes use of the earthly peace and defends and seeks the compromise between human wills in respect of the provisions relevant to the mortal nature of man, so far as may be permitted without detriment to true religion and piety. In fact, that City relates the earthly peace to the heavenly peace, which is so truly peaceful that it should be regarded as the only peace deserving the name, at least in respect of the rational creation; for this peace is the perfectly ordered and completely harmonious fellowship in the enjoyment of God, and of each other in God. When we arrive at that state of peace, there will be no longer a life that ends in death, but a life that is life in sure and sober truth; there will be no animal body to "weigh down the soul" in its process of corruption; there will be a spiritual body with no cravings, a body subdued in every part to the will. This peace the Heavenly City possesses in faith while on its pilgrimage, and it lives a life of righteousness, based on this faith, having the attainment of that peace in view in every good action it performs in relation to God, and in relation to a neighbor, since the life of a city is inevitably a social life.

From Book XIX of *Concerning the City of God: Against the Pagans* by Saint Augustine, translated by Henry Bettenson (Penguin Classics, 1972). Translation copyright © Henry Bettenson, 1972. Reprinted by permission of Penguin Books, Ltd.

CHAPTER 8

READING 27
from THE QUR´AN (COMPILED C. 632–656)

These selections—complete sûrahs or chapters—are taken from a translation by a Muslim scholar who called his work an "explanatory translation" because no human can "translate" the very words of God spoken to the prophet Mohammed. A careful reading will reveal Islamic attitudes toward both Judaism and Christianity, why Muslims revere Jerusalem as a holy place, and something of their own devotional customs—such as washing before prayer.

Sûrah I The Opening

Revealed at Mecca

In the name of Allah, the Beneficent, the Merciful.

1. Praise be to Allah, Lord of the Worlds,
2. The Beneficent, the Merciful.
3. Owner of the Day of Judgment,
4. Thee (alone) we worship; Thee (alone) we ask for help.
5. Show us the straight path,
6. The path of those whom Thou has favored;
7. Not (the path) of those who earn Thine anger nor of those who go astray.

Sûrah V The Table Spread

Revealed at Al-Madînah

In the name of Allah, the Beneficent, the Merciful.

1. O ye who believe! Fulfill your undertakings. The beast of cattle is made lawful unto you (for food) except that which is announced unto you (herein), game being unlawful when ye are on the pilgrimage. Lo! Allah ordaineth that which pleaseth Him.
2. O ye who believe! Profane not Allah's monuments nor the Sacred Month nor the offerings nor the garlands, nor those repairing to the Sacred House,[1] seeking the grace and pleasure of Allah. But when ye have left the sacred territory, then go hunting (if ye will). And let not your hatred of a folk who (once) stopped your going to the Inviolable Place of Worship seduce you to transgress; but help ye one another unto righteousness and pious duty. Help not one another unto sin and transgression, but keep your duty to Allah. Lo! Allah is severe in punishment.
3. Forbidden unto you (for food) are carrion and blood and swine-flesh, and that which hath been dedicated unto any other than Allah, and the strangled, and the dead through beating, and the dead through falling from a height, and that which hath been killed by (the gorging of) horns, and the devoured of wild beasts, saving that which ye make lawful (by the deathstroke), and that which hath been immolated unto Idols. And (forbidden is it) that ye swear by the divining arrows. This is an abomination. This day are those who disbelieve in despair of (ever harming) your religion; so fear them not, fear Me! This day I have perfected your religion for you and completed My favor onto you, and have chosen for you as religion AL-ISLAM.[2] Whoso is forced by hunger, not by will, to sin: (for him) lo! Allah is Forgiving, Merciful.

4. They ask thee (O Muhammad) what is made lawful for them. Say: (all) good things are made lawful for you. And those beasts and birds of prey which ye have trained as hounds are trained, ye teach them that which Allah taught you; so eat of that which they catch for you and mention Allah's name upon it, and observe your duty to Allah. Lo! Allah is swift to take account.
5. This day are (all) good things made lawful for you. The food of those who have received the Scripture is lawful for you, and your food is lawful for them. And so are the virtuous women of the believers and the virtuous women of those who received the Scripture before you (lawful for you) when ye give them their marriage portions and live with them in honor, not in fornication, nor taking them as secret concubines. Whoso denieth the faith, his work is vain and he will be among the losers in the Hereafter.
6. O ye who believe! When ye rise up for prayer, wash your faces, and your hands up to the elbows, and lightly rub your heads and (wash) your feet up to the ankles. And if ye are unclean, purify yourselves. And if ye are sick or on a journey, or one of you cometh from the closet, or ye have had contact with women, and ye find not water, then go to clean, high ground and rub your faces and your hands with some of it. Allah would not place a burden on you, but He would purify you and would perfect His grace upon you, that ye may give thanks.
7. Remember Allah's grace upon you and His covenant by which He bound you when ye said: We hear and we obey; and keep your duty to Allah. Lo! Allah knoweth what is in the breasts (of men).
8. O ye who believe! Be steadfast witnesses for Allah in equity, and let not hatred of any people seduce you that ye deal not justly. Deal justly, that is nearer to your duty. Observe your duty to Allah. Lo! Allah is Informed of what ye do.
9. Allah hath promised who believe and do good works: Theirs will be forgiveness and immense reward.
10. And they who disbelieve and deny Our revelations, such are rightful owners of hell.
11. O ye who believe! Remember Allah's favor unto you, how a people were minded to stretch out their hands against you but He withheld their hands from you; and keep your duty to Allah. In Allah let believers put their trust.
12. Allah made a covenant of old with the Children of Israel and We raised among them twelve chieftains, and Allah said: Lo! I am with you. If ye establish worship and pay the poor-due, and believe in My messengers and support them, and lend unto Allah a kindly loan,[3] surely I shall remit your sins, and surely I shall bring you into gardens underneath which rivers flow. Whoso among you disbelieve after this will go astray from a plain road.
13. And because of their breaking their covenant, We have cursed them and made hard their hearts. They change words from their context and forget a part of that whereof they were admonished. Thou wilt not cease to discover treachery from all save a few of them. But bear with them and pardon them. Lo! Allah loveth the kindly.

[1] I.e., the Ka´bah at Mecca.

[2] I.e., "The Surrender" to Allah. Thus solemnly the religion which the Prophet had established received its name.

[3] I.e., a loan without interest or thought of gain

14. And with those who say: "Lo! We are Christians," We made a covenant, but they forgot a part of that whereof they were admonished. Therefore We have stirred up enmity and hatred among them till the Day of Resurrection, when Allah will inform them of their handiwork.

15. O People of the Scripture! Now hath Our messenger come unto you, expounding unto you much of that which ye used to hide in the Scripture, and forgiving much. Now hath come unto you light from Allah and a plain Scripture.

16. Whereby Allah guideth him who seeketh His good pleasure unto paths of peace. He bringeth them out of darkness unto light by His decree, and guideth them unto a straight path.

17. They indeed have disbelieved who say: Lo! Allah is the Messiah, son of Mary. Say: Who then can do aught against Allah, if He had willed to destroy the Messiah, son of Mary, and his mother and everyone on earth? Allah's is the sovereignty of the heavens and the earth and all that is between them. He createth what He will. And Allah is Able to do all things.

18. The Jews and Christians say: We are sons of Allah and His loved ones. Say: Why then doth He chastise you for your sins? Nay, ye are but mortals of His creating. He forgiveth whom He will, and chastiseth whom He will. Allah's is the Sovereignty of the heavens and the earth and all that is between them, and unto Him is the journeying.

19. O people of the Scripture! Now hath Our messenger come unto you to make things plain after an interval (of cessation) of the messengers, lest ye should say: There came not unto us a messenger of cheer nor any warner. Now hath a messenger of cheer and a warner come unto you. Allah is Able to do all things.

20. And (remember) when Moses said unto his people: O my people! Remember Allah's favor unto you, how He placed among you Prophets, and He made you kings, and gave you that (which) He gave not to any (other) of (His) creatures.

21. O my people! Go into the holy land which Allah hath ordained for you. Turn not in flight, for surely ye turn back as losers.

22. They said: O Moses! Lo! a giant people (dwell) therein, and lo! we go not in till they go forth from thence. When they go forth, then we will enter (not till then).

23. Then outspake two of those who feared (their Lord, men) unto whom Allah had been gracious: Enter in upon them by the gate, for if ye enter by it, lo! ye will be victorious. So put your trust (in Allah) if ye are indeed believers.

24. They said: O Moses! We will never enter (the land) while they are in it. So go thou and they Lord and fight! We will sit here.

25. He said: My lord! I have control of none but myself and my brother, so distinguish between us and the wrongdoing folk.

26. (Their Lord) said: For this the land will surely be forbidden them for forth years that they will wander in the earth, bewildered. So grieve not over the wrongdoing folk.

27. But recite unto them with truth the tale of the two sons of Adam, how they offered each a sacrifice, and it was accepted from the one of them and it was not accepted from the other. (The one) said: I will surely kill thee. (The other) answered: Allah accepteth only from those who ward off (evil).

28. Even if you stretch out they hand against me to kill me, I shall not stretch out my hand against thee to kill thee, lo! I fear Allah, the Lord of the Worlds.

29. Lo! I would rather thou shouldst bear the punishment of the sin against me and thine own sin and become one of the owners of the Fire. That is the reward of evil-doers.

30. But (the others) mind imposed on him the killing of his brother, so he slew him and became one of the losers.

31. Then Allah sent a raven scratching up the ground, to show him how to hide his brother's naked corpse. He said: Woe unto me! Am I not able to be as this raven and so hide my brother's naked corpse? And he became repentant.

32. For that cause We decreed for the Children of Israel that whosoever killeth a human being for other than manslaughter or corruption on earth, it shall be as if he had killed all mankind, and whoso saveth the life of one, it shall be as if he had saved the life of all mankind. Our messengers came unto them of old with clear proofs (of Allah's sovereignty), but afterwards lo! many of them became prodigals in the earth.

33. The only reward of those who make war upon Allah and His messenger and strive after corruption in the land will be that they will be killed or crucified, or have their hands and feet on alternate sides cut off, or will be expelled out of the land. Such will be their degradation in the world, and in the Hereafter theirs will be an awful doom.

34. Save those who repent before ye overpower them. For know that Allah is forgiving, Merciful.

35. O ye who believe! Be mindful of your duty to Allah, and seek the way of approach unto Him, and strive in His way in order that ye may succeed.

36. As for those who disbelieve, lo! If all that is in the earth were theirs, and as much again therewith, to ransom them from the doom on the Day of Resurrection, it would not be accepted from them. Theirs will be a painful doom.

37. They will wish to come forth from the Fire, but they will not come forth from it. Theirs will be a lasting doom.

38. As for the thief, both male and female, cut off their hands. It is the reward of their own deeds, an exemplary punishment from Allah. Allah is Mighty, Wise.

39. But whoso repenteth after his wrongdoing and amendeth, lo! Allah will relent toward him. Lo! Allah is Forgiving, Merciful.

40. Knowest thou not that unto Allah belongeth the Sovereignty of the heavens and the earth? He punisheth whom He will, and forgiveth whom He will. Allah is Able to do all things.

41. O Messenger! Let not them grieve thee who vie one with another in the race to disbelief, of such as say with their mouths: "We believe," but their hearts believe not, and of the Jews: listeners for the sake of falsehood, listeners on behalf of other folk who come not unto thee, changing words from their context and saying: If this be given unto you, receive it, but if this be not given unto you, then beware! He whom Allah doometh unto sin, thou (by thine efforts) wilt avail him naught against Allah. Those are they for whom the will of Allah is that He cleanse not their hearts. Theirs in the world will be ignominy, and in the Hereafter an awful doom.

42. Listeners for the sake of falsehood! Greedy for illicit gain! If then they have recourse unto thee (Muhammad) judge between them or disclaim jurisdiction. If thou disclaimest jurisdiction, then they cannot harm thee at all. But if thou judgest, judge between them with equity. Lo! Allah loveth the equitable.

43. How come they unto thee for judgment when they have the Torah, wherein Allah hath delivered judgment (for them)? Yet even after that they turn away. Such (folk) are not believers.

44. Lo! We did reveal the Torah, wherein is guidance and a light, by which the Prophets who surrendered (unto Allah) judged the Jews, and the rabbis and the priests (judged) by such of Allah's Scripture as they were bidden to observe, and thereunto were they witnesses. So fear not mankind, but fear Me. And barter not My revelations for a little gain. Whoso judgeth not by that which Allah hath revealed: such are disbelievers.

45. And We prescribed for them therein: The life for the life, and the eye for the eye, and the nose for the nose, and the ear for the ear, and the tooth for the tooth, and for wounds retaliation. But whoso forgoeth it (in the way of charity) it shall be expiation for him. Whoso judgeth not by that which Allah hath revealed: such are wrong-doers.

46. And We caused Jesus, son of Mary, to follow in their footsteps, confirming that which was (revealed) before him, and We bestowed on him the Gospel wherein is guidance and a light, confirming that which was (revealed) before it in the Torah—a guidance and an admonition unto those who ward off (evil).

47. Let the People of the Gospel judge by that which Allah hath revealed therein. Whoso judgeth not by that which Allah hath revealed; such are evil-livers.

48. And unto thee have We revealed the Scripture with the truth, confirming whatever Scripture was before it, and a watcher over it. So judge between them by that which Allah hath revealed, and follow not their desires away from the truth which hath come unto thee. For each We have appointed a divine law and a traced-out way. Had Allah willed He could have made you one community. But that He may try you by that which He hath given you (He hath made you as ye are). So vie one with another in good works. Unto Allah ye will all return, and He will then inform you of that wherein ye differ.

49. So judge between them by that which Allah hath revealed, and follow not their desires, but beware of them lest they seduce thee from some part of that which Allah hath revealed unto thee. And if they turn away, then know that Allah's will is to smite them for some sin of theirs. Lo! many of mankind are evil-livers.

50. It is a judgment of the time of (pagan) ignorance that they are seeking? Who is better than Allah for judgment to a people who have certainty (in their belief)?

51. O ye who believe! Take not the Jews and the Christians for friends. They are friends one to another. He among you who taketh them for friends if (one) of them. Lo! Allah guideth not wrongdoing folk.

52. And thou seest those in whose heart is a disease race toward them, saying: We fear lest a change of fortune befall us. And it may happen that Allah will vouchsafe (unto thee) the victory, or a commandment from His presence. Then will they repent them of their secret thoughts.

53. Then will the believers say (unto the people of the Scripture): Are these they who swore by Allah their most binding oaths that they were surely with you? Their works have failed, and they have become the losers.

54. O ye who believe! Whoso of you becometh a renegade from his religion (know that in his stead), Allah will bring a people whom He loveth and who love Him, humble toward believers, stern toward disbelievers, striving in the way of Allah, and fearing not the blame of any blamer. Such is the grace of Allah which He giveth unto whom He will. Allah is all-Embracing, all-Knowing.

55. Your friend can be only Allah; and His messenger and those who believe, who establish worship and pay the poor-due, and bow down (in prayer).

56. And whoso taketh Allah and His messenger and those who believe for friend (will know that), lo! the party of Allah, they are the victorious.

57. O ye who believe! Choose not for friends such as those who received the Scripture before you, and of the disbelievers, as make a jest and sport of your religion. But keep your duty to Allah if ye are true believers.

58. And when ye call to prayer they take it for a jest and sport. That is because they are a folk who understand not.

59. Say: O, People of the Scripture! Do ye blame us for aught else than that we believe in Allah and that which is revealed unto us and that which was revealed aforetime, and because most of you are evil-livers?

60. Shall I tell thee of a worse (case) than theirs for retribution with Allah? Worse (is the case of him) whom Allah hath cursed, him on whom His wrath hath fallen! Worse is he of whose sort Allah hath turned some to apes and swine, and who serveth idols. Such are in worse plight and further stray from the plain road.

61. When they come unto you (Muslims), they say: We believe; but came in unbelief and they went out the same; and Allah knoweth best what they were hiding.

62. And thou seest many of them vying one with another in sin and transgression and their devouring of illicit gain. Verily evil is what they do.

63. Why do not the rabbis and the priests forbid their evil-speaking and their devouring of illicit gain? Verily evil is their handiwork.

64. The Jews say: Allah's hand is fettered. Their hands are fettered and they are accursed for saying so. Nay, but both His hands are spread out wide in bounty. He bestoweth as He will. That which hath been revealed unto thee from they Lord is certain to increase the contumacy and disbelief of many of them, and We have cast among them enmity and hatred till the Day of Resurrection. As often as they light a fire for war, Allah extinguisheth it. Their effort is for corruption in the land, and Allah loveth not corrupters.

65. If only the People of the Scripture would believe and ward off (evil), surely We should remit their sins from them and surely We should bring them into Gardens of Delight.

66. If they had observed the Torah and the Gospel and that which was revealed unto them from their Lord, they would surely have been nourished from above them and from beneath their feet. Among them there are people who are moderate, but many of them are of evil conduct.

67. O messenger! Make known that which hath been revealed unto thee from thy Lord, for if thou do it, thou will not have conveyed His message. Allah will protect thee from mankind. Lo! Allah guideth not the disbelieving folk.

68. Say: O People of the Scripture! Ye have naught (of guidance) till ye observe the Torah and the Gospel and that which was revealed unto you from your Lord. That which is revealed unto thee (Muhammad) from thy Lord is certain to increase the contumacy and disbelief of many of them. But grieve not for the disbelieving folk.

69. Lo! those who believe, and those who are Jews, and Sabaeans, and Christians—whosoever believeth in Allah and the Last Day and doeth right—then shall no fear come upon them neither shall they grieve.[4]

70. We made a covenant of old with the Children of Israel and We sent unto them messengers. As often as a messen-

[4] Almost identical with Sûrah II, v. 62.

ger came unto them with that which their souls desired not (they became rebellious). Some (of them) they denied and some they slew.

71. They thought no harm would come of it, so they were willfully blind and deaf. And afterward Allah turned (in mercy) toward them. Now (even after that) are many of them willfully blind and deaf. Allah is Seer of what they do.

72. They surely disbelieve who say: Lo! Allah is the Messiah, son of Mary. The Messiah (himself) said: O Children of Israel, worship Allah, my Lord and your Lord. Lo! whoso ascribeth partners unto Allah, for him Allah hath forbidden Paradise. His abode is the Fire. For evil-doers there will be no helpers.

73. They surely disbelieve who say: Lo! Allah is the third of three; when there is no God save the One God. If they desist not from so saying a painful doom will fall on those of them who disbelieve.

74. Will they not rather turn unto Allah and seek forgiveness of Him? For Allah is Forgiving, Merciful.

75. The Messiah, son of Mary, was no other than a messenger, messengers (the like of whom) had passed away before him. And his mother was a saintly woman. And they both used to eat (earthly) food. See how we make the revelations clear for them, and see how they are turned away!

76. Say: Serve ye in place of Allah that which possesseth for you neither hurt nor use? Allah it is Who is the Hearer, the Knower.

77. Say: O People of the Scripture! Stress not in your religion other than the truth, and follow not the vain desires of folk who erred of old and led many astray, and erred from a plain road.

78. Those of the Children of Israel who went astray were cursed by the tongue of David, and of Jesus, son of Mary. That was because they rebelled and used to transgress.

79. They restrained not one another from the wickedness they did. Verily evil was that they used to do!

80. Thou seest many of them making friends with those who disbelieve. Surely ill for them is that which they themselves send on before them: that Allah will be wroth with them and in the doom they will abide.

81. If they believed in Allah and the Prophet and that which is revealed unto him, they would not choose them for their friends. But many of them are of evil conduct.

82. Thou wilt find the most vehement of mankind in hostility to those who believe (to be) the Jews and the idolaters. And thou wilt find the nearest of them in affection to those who believe (to be) those who say: Lo! We are Christians. That is because there are among them priests and monks,[5] and because they are not proud.

83. When they listen to that which hath been revealed unto the messenger, thou seest their eyes overflow with tears because of their recognition of the Truth. They say: Our Lord, we believe. Inscribe us as among the witnesses.

84. How should we not believe in Allah and that which hath come unto us of the Truth. And (how should we not) hope that our Lord will bring us in along with righteous folk.

85. Allah hath rewarded them for that their saying— Gardens underneath which rivers flow, wherein they will abide forever. That is the reward of the good.

86. But those who disbelieve and deny Our revelations, they are owners of hell-fire.

87. O ye who believe! Forbid not the good things which Allah hath made lawful for you, and transgress not. Lo! Allah loveth not transgressors.

88. Eat of that which Allah hath bestowed on you as food lawful and good, and keep your duty to Allah in Whom ye are believers.

89. Allah will not take you to task for that which is unintentional in your oaths, but He will take you to task for the oaths which ye swear in earnest. The expiation thereof is the feeding of ten of the needy with the average of that wherewith ye feed your own folk, or the clothing of them, or the liberation of a slave, and for him who findeth not (the wherewithal to do so) then a three-days' fast. This is the expiation of your oaths when ye have sworn; and keep your oaths. Thus Allah expoundeth unto you His revelations in order that ye may give thanks.

90. O ye who believe! Strong drink and games of chance and idols and divining arrows are only an infamy of Satan's handiwork. Leave it aside in order that ye may succeed.

91. Satan seeketh only to cast among you enmity and hatred by means of strong drink and games of chance, and to turn you from remembrance of Allah and from (His) worship. Will ye then have done?

92. Obey Allah and obey the messenger, and beware! But if ye turn away, then know that the duty of Our messenger is only plain conveyance (of the messenger).

93. There shall be no sin (imputed) unto those who believe and do good works for what they may have eaten (in the past). So be mindful of your duty (to Allah), and do good works; and again: be mindful of your duty, and believe; and once again: be mindful of your duty, and do right. Allah loveth the good.

94. O ye who believe! Allah will surely try you somewhat (in the matter) of the game which ye take with your hands and your spears, that Allah may know him who feareth Him in secret. Whoso transgresseth after this, for him there is a painful doom.

95. O ye who believe! Kill no wild game while ye are on the pilgrimage. Whoso of you killeth it of set purpose he shall pay its forfeit in the equivalent of that which he hath killed, of domestic animals, the judge to be two men among you known for justice, (the forfeit) to be brought as an offering to the Ka´bah; or, for expiation, he shall feed poor persons, or the equivalent thereof in fasting, that he may taste the evil consequences of his deed. Allah forgiveth whatever (of this kind) may have happened in the past, but whoso relapseth, Allah will take retribution from him. Allah is Mighty, Able to Requite (the wrong).

96. To hunt and to eat the fish of the sea is made lawful for you, a provision for you and for seafarers; but to hunt on land is forbidden you so long as ye are on the pilgrimage. Be mindful of your duty to Allah, unto Whom ye will be gathered.

97. Allah hath appointed the Ka´bah, the Sacred Month and the offerings and the garlands. That is so that ye may know that Allah knoweth whatsoever is in the heavens and whatsoever is in the earth, and that Allah is Knower of all things.

98. Know that Allah is severe in punishment, but that Allah (also) is Forgiving, Merciful.

99. The duty of the messenger is only to convey (the message). Allah knoweth what ye proclaim and what ye hide.

100. Say: The evil and the good are not alike even though the plenty of the evil attract thee. So be mindful of your duty to Allah, O men of understanding, that ye may succeed.

101. O ye who believe! Ask not of things which, if they were made known unto you, would trouble you; but if ye ask of them when the Qur´an is being revealed, they will be

[5] I.e., persons entirely devoted to the service of God, as were the Muslims.

made known unto you. Allah pardoneth this, for Allah is Forgiving, Clement.

102. A folk before you asked (for such disclosures) and then disbelieved therein.

103. Allah hath not appointed anything in the nature of a Bahîrah or a Sâʾbah or a Wasîlah or a Hâmi,[6] but those who disbelieve invent a lie against Allah. Most of them have no sense.

104. And when it is said unto them: Come unto that which Allah hath revealed and unto the messenger, they say: Enough for us is that wherein we found our fathers. What! Even though their fathers had no knowledge whatsoever, and no guidance?

105. O ye who believe! Ye have charge of your own souls. He who erreth cannot injure you if ye are rightly guided. Unto Allah ye will all return; and then He will inform you of what ye used to do.

106. O ye who believe! Let there be witnesses between you when death draweth nigh unto one of you, at the time of bequest—two witnesses, just men among you, or two others from another tribe, in case ye are campaigning in the land and the calamity of death befall you. Ye shall empanel them both after the prayer, and, if ye doubt, they shall be made to swear by Allah (saying): We will not take a bribe, even though it were (on behalf of) a near kinsman nor will we hide the testimony of Allah, for then indeed we should be of the sinful.

107. But then, if it is afterwards ascertained that both of them merit (the suspicion of) sin, let two others take the place of those nearly concerned, and let them swear by Allah, (saying): Verily our testimony is truer than their testimony and we have not transgressed (the bounds of duty), for then indeed we shall be of the evil-doers.

108. Thus it is more likely that they will bear true witness of fear that after their oath the oath (of others) will be taken. So be mindful of your duty (to Allah) and hearken. Allah guideth not the forward folk.

109. In the day when Allah gathereth together the messengers, and saith: What was your response (from mankind)? they say: We have no knowledge. Lo! Thou, only Thou art the Knower of Things Hidden.

110. When Allah saith: O Jesus, son of Mary! Remember My favor unto thee and unto they mother; how I strengthened thee with the holy Spirit, so that thou spakest unto mankind in the cradle as in maturity; and how I taught thee the Scripture and Wisdom and the Torah and the Gospel; and how thou didst shape of clay as it were the likeness of a bird by My permission, and didst blow upon it and it was a bird by My permission, and how they didst heal him who was born blind and the leper by My permission; and how thou didst raise the dead, by My permission; and how I restrained the Children of Israel from (harming) thee when thou camest unto them with clear proofs, and those of them who disbelieved exclaimed: This is naught else than mere magic.

111. And when I inspired the disciples, (saying): Believe in Me and in My messenger, they said: We believe. Bear witness that we have surrendered[7] (unto Thee).

112. When the disciples said: O Jesus, son of Mary! Is thy Lord able to send down for us a table spread with food from heaven? He said: Observe your duty to Allah, if ye are true believers.

113. (They said): We wish to eat thereof, that we may satisfy our hearts and know that thou hast spoken truth to us, and that thereof we may be witnesses.

114. Jesus, son of Mary, said: O Allah, Lord of us! Send down for us a table spread with food from heaven; that it may be a feast for us, for the first of us and for the last of us, and a sign from Thee. Give us sustenance, for Thou art the Best of Sustainers.

115. Allah said: Lo! I send it down for you. And whoso disbelieveth of you afterward, him surely will I punish with a punishment wherewith I have not punished any of (My) creatures.

116. And when Allah saith: O Jesus, son of Mary! Didst thou say unto mankind: Take me and my mother for two gods beside Allah? he saith: Be glorified! It was not mine to utter that to which I had no right. If I used to say it, then Thou knewest it. Thou knowest what is in my mind, and I know not what is in Thy Mind. Lo! Thou, only Thou are the Knower of Things Hidden.

117. I spake unto them only that which Thou commandedest of me, (saying): Worship Allah, my Lord and your Lord. I was a witness of them while I dwelt among them, and when Thou tookest me Thou wast the Watcher over them. Thou are Witness over all things.

118. If Thou punish them, lo! they are Thy slaves, and if Thou forgive them (lo! They are Thy slaves). Lo! Thou, only Thou are the Mighty, the Wise.

119. Allah saith: This is a day in which their truthfulness profiteth the truthful, for theirs are [the] Gardens underneath which rivers flow, wherein they are secure forever, Allah taking pleasure in them and they in Him. That is the great triumph.

120. Unto Allah belongeth the Sovereignty of the heavens and the earth and whatsoever is therein, and He is Able to do all things.

Sûrah XVII The Children of Israel

"The Children of Israel"(Banî Isrâîl) begins and ends with references to the Israelites. Verse 1 describes the Prophet's vision in which he was carried by night to the Temple of Jerusalem and ushered into the very presence of God.

Revealed at Mecca

In the name of Allah, the Beneficent, the Merciful.

1. Glorified by He Who carried His servant by night from the Inviolable Place of Worship[1] to the Far Distant Place of Worship[2] the neighborhood whereof We have blessed, that We might show him of Our tokens! Lo! He, only He, is the Hearer, the Seer.

2. We gave unto Moses the Scripture, and We appointed it a guidance for the Children of Israel, saying: Choose no guardian beside Me.

3. (They were) the seed of those whom We carried (in the ship) along with Noah. Lo! he was a grateful slave.

4. And We decreed for the Children of Israel in the Scripture: Ye verily will work corruption in the earth twice, and ye will become great tyrants.

[7] Or "are Muslims."

[6] Different classes of cattle liberated in honor of idols and reverenced by the pagan Arabs.

[1] Mecca.
[2] Jerusalem.

5. So when the time for the first of the two came, We roused against you slaves of Ours of great might who ravaged (your) country, and it was a threat performed.

6. Then We gave you once again your turn against them, and We aided you with wealth and children and made you more in soldiery,

7. (saying): If ye do good, ye do good for your own souls, and if ye do evil, it is for them (in like manner). So, when the time for the second (of the judgments) came (We roused against you others of Our slaves) to ravage you, and to enter the Temple even as they entered it the first time, and to lay waste all that they conquered with an utter wasting.

8. It may be that your Lord will have mercy on you, but if ye repeat (the crime) We shall repeat (the punishment), and We have appointed hell a dungeon for the disbelievers.

9. Lo! this Qur´an guideth unto that which is straightest, and giveth tidings unto the believers who do good works that theirs will be a great reward.

10. And that those who believe not in the Hereafter, for them We have prepared a painful doom.

11. Man prayeth for evil as he prayeth for good; for man was ever hasty.

12. And We appoint the night and the day two portents. Then We make dark the portent of the night, and We make the portent of the day sight-giving, that ye may seek bounty from your Lord, and that ye may know the computation of the years, and the reckoning; and everything have We expounded with a clear expounding.

13. And every man's augury have We fastened to his own neck, and We shall bring forth for him on the Day of Resurrection a book which he will find open.

14. (And it will be said unto him): Read thy book. Thy soul sufficeth as reckoner against thee this day.

15. Whosoever goeth right, it is only for (the good of) his own soul that he goeth right, and whosoever erreth, erreth only to its hurt. No laden soul can bear another's load. We never punish until We have sent a messenger.

16. And when We would destroy a township We send commandment to its folk who live at ease, and afterward they commit abomination therein, and so the Word (of doom) hath effect for it, and We annihilate it with complete annihilation.

17. How many generations have We destroyed since Noah! And Allah sufficeth as Knower and Beholder of the sins of His slaves.

18. Whoso desireth that (life) which hasteneth away, We hasten for him therein that We will for whom We please. And afterward We have appointed for him hell; he will endure the heat thereof, condemned, rejected.

19. And whoso desireth the Hereafter and striveth for it with the effort necessary, being a believer; for such, their effort findeth favor (with their Lord).

20. Each do We supply, both these and those from the bounty of thy Lord. And the bounty of thy Lord can never be walled up.

21. See how We prefer one above another, and verily the Hereafter will be greater in degrees and greater in preferment.

22. Set not up with Allah any other god (O man) lest thou sit down reproved, forsaken.

23. Thy Lord hath decreed, that ye worship none save Him, and (that ye show) kindness to parents. If one of them or both of them attain old age with thee, say not "Fie" unto them nor repulse them, but speak unto them a gracious word.

24. And lower unto them the wing of submission through mercy, and say: My Lord! Have mercy on them both as they did care for me when I was little.

25. Your Lord is best aware of what is in your minds. If ye are righteous, then lo! He was ever Forgiving unto those who turn (unto Him).

26. Give the kinsman his due, and the needy, and the wayfarer, and squander not (thy wealth) in wantonness.

27. Lo! the squanderers were ever brothers of the devils, and the devil was ever an ingrate to his Lord.

28. But if thou turn away from them, seeking mercy from Lord, for which thou hopest, then speak unto them a reasonable word.

29. And let not thy hand be chained to thy neck nor open it with a complete opening, lest thou sit down rebuked, denuded.

30. Lo! thy Lord enlargeth the provision for whom He will, and straighteneth (it for whom He will). Lo, He was ever Knower, Seer of His slaves.

31. Slay not your children, fearing a fall to poverty, We shall provide for them and for you. Lo! the slaying of them is great sin.

32. And come not near unto adultery. Lo! it is an abomination and an evil way.

33. And slay not the life which Allah hath forbidden save with right. Whoso is slain wrongfully, We have given power unto his heir, but let him not commit excess in slaying. Lo! he will be helped.

34. Come not near the wealth of the orphan save with that which is better till he come to strength; and keep the covenant. Lo! of the covenant it will be asked.

35. Fill the measure when ye measure, and weigh with a right balance; that is meet, and better in the end.

36. (O man), follow not that whereof thou hast no knowledge. Lo! the hearing and the sight and the heart—of each of these it will be asked.

37. And walk not in the earth exultant. Lo! thou canst not rend the earth, nor canst thou stretch to the height of the hills.

38. The evil of all that is hateful in the sight of thy Lord.

39. This is (part) of that wisdom wherewith thy Lord hath inspired thee (O Muhammad). And set not up with Allah any other god, lest thou be cast into hell, reproved, abandoned.

40. Hath your Lord then distinguished you (O men of Mecca) by giving you sons, and hath chosen for Himself females from among the angels? Lo! verily ye speak an awful word!

41. We verily have displayed (Our warnings) in this Qur´an that they may take heed, but increaseth them in naught save aversion.

42. Say (O Muhammad, to the disbelievers): If there were other gods along with Him, as they say, then had they sought a way against the Lord of the Throne.

43. Glorified is He, and High Exalted above what they say!

44. The seven heavens and the earth and all that is therein praise Him, and there is not a thing but hymneth his praise; but ye understand not their priase. Lo! He is ever Clement, Forgiving.

45. And when thou recitest the Qur´an We place between thee and those who believe not in the Hereafter a hidden barrier.

46. And We place upon their hearts veils lest they should understand it, and in their ears a deafness; and when thou makest mention of thy Lord alone in the Qur´an, they turn their backs in aversion.

47. We are best aware of what they wish to hear when they give ear to thee and when they take secret counsel, when the evil-doers say: Ye follow but a man bewitched.

48. See what similitudes they coin for thee, and thus are all astray, and cannot find a road!

49. And they say: When we are bones and fragments, shall we, forsooth, be raised up as a new creation?

50. Say: Be ye stones or iron,

51. Or some created thing that is yet greater in your thoughts! Then they will say: Who shall bring us back (to life). Say: he who created you at the first. Then will they shake their heads at thee, and say: When will it be? Say: It will perhaps be soon.

52. A day when He will call you and ye will answer with His praise, and ye will think that ye have tarried but a little while.

53. Tell My bondmen to speak that which is kindlier. Lo! the devil soweth discord among them. Lo! the devil is for man an open foe.

54. Your Lord is best aware of you. If He will, He will have mercy on you, or if He will, He will punish you. We have not sent thee (O Muhammad) as a warden over them.

55. And thy Lord is best aware of all who are in the heavens and the earth. And We preferred some of the Prophets above others, and unto David We gave the Psalms.

56. Say: Cry unto those (saints and angels) whom ye assume (to be gods) beside Him, yet they have no power to rid you of misfortune nor to change.

57. Those unto whom they cry seek the way of approach to their Lord, which of them shall be the nearest; they hope for His mercy and they fear His doom. Lo! the doom of thy Lord is to be shunned.

58. There is not a township[3] but We shall destroy it ere the Day of Resurrection, or punish it with dire punishment. That is set forth in the Book (of Our decrees).

59. Naught hindereth Us from sending portents save that the folk of old denied them. And We gave Thamûd the she-camel—a clear portent—but they did wrong in respect of her. We send not portents save to warn.

60. And (it was a warning) when We told thee: Lo! thy Lord encompasseth mankind, and We appointed the vision[4] which We showed thee as an ordeal for mankind, and (likewise) the Accursed Tree in the Qur´an.[5] We warn them, but it increaseth them in naught save gross impiety.

61. And when We said unto the angels: Fall down prostrate before Adam and they fell prostrate all save Iblîs, he said: Shall I fall prostrate before that which Thou has created of clay?

62. He said: Seest Thou this (creature) whom Thou has honored above me, if Thou give me grace until the Day of Resurrection I verily will seize his seed, save but a few.

63. He said: Go, and whosoever of them followeth thee—lo! hell will be your payment, ample payment.

64. And excite any of them who thou canst with thy voice, and urge thy horse and foot against them, and be a partner in their wealth and children, and promise them. Satan promiseth them only to deceive.

65. Lo! My (faithful) bondmen—over them thou hast no power, and thy Lord sufficeth as (their) guardian.

66. (O mankind), your Lord is He Who driveth for you the ship upon the sea that ye may seek of His bounty. Lo! He was ever Merciful toward you.

67. And when harm toucheth you upon the sea, all unto whom ye cry (for succor) fail save Him (alone), but when He bringeth you safe to land, ye turn away, for man was ever thankless.

68. Feel ye then secure that He will not cause a slope of the land to engulf you, or send a sand-storm upon you, and then ye will find that ye have no protector?

69. Or feel ye secure that He will not return you to that (plight) a second time, and send against you a hurricane of wind and drown you for your thanklessness, and then ye will not find therein that ye have any avenger against Us?

70. Verily We have honored the children of Adam. We carry them on the land and the sea, and have made provision of good things for them, and have preferred them above many of those whom We created with a marked preferment.

71. On the day when We shall summon all men with their record, whoso is given his book in his right hand—such will read their book and they will not be wronged a shred.

72. Whoso is blind here will be blind in the Hereafter, and yet further from the road.

73. And they indeed strove hard to beguile thee (Muhammad) away from that wherewith We have inspired thee, that thou shouldst invent other than it against Us; and then would they have accepted thee as a friend.[6]

74. And if We had not made thee wholly firm thou mightest almost have inclined unto them a little.

75. Then had We made thee taste a double (punishment) of living and a double (punishment) of dying, then hadst thou found no helper against us.

76. And they indeed wished to scare thee from the land they might drive thee forth from thence, and then they would have stayed (there) but a little after thee.[7]

77. (Such was Our) method in the case of these whom We sent before thee (to mankind) and thou wilt not find for Our method aught of power to change.

78. Establish worship at the going down of the sun until the dark of night, and (the recital of) the Qur´an at dawn. Lo! (the recital of) the Qur´an at dawn is ever witnessed.

79. And some part of the night awake for it, a largess for thee. It may be that thy Lord will raise thee to a praised estate.

80. And say: My Lord! Cause me to come in with a firm incoming and to go out with a firm outgoing. And give me from They presence a sustaining Power.

81. And say: Truth hath come and falsehood hath vanished away. Lo! falsehood is ever bound to banish.[8]

82. And We reveal of the Qur´an that which is a healing and a mercy for believers though it increase the evil-doers in naught save ruin.

83. And when We make life pleasant unto man, he turneth away and is averse; and when ill toucheth him he is in despair.

84. Say: Each one doth according to his rule of conduct, and thy Lord is best aware of him whose way is right.

85. They will ask thee concerning the Spirit. Say: The Spirit is by command of my Lord, and of knowledge ye have been vouchsafed but little.

86. And if We willed We could withdraw that which We have revealed unto thee, then wouldst thou find no guardian for thee against Us in respect thereof.

87. (It is naught) save mercy from thy Lord. Lo! His kindness unto thee was ever great.[9]

88. Say: Verily, though mankind and the Jinn should assemble to produce the like of this Qur´an, they could not produce the like thereof though they were helpers one of another.

[3] Or *community*.

[4] The Prophet's vision of his ascent through the seven heavens.

[5] See Svrah XLIV, vv. 43–49.

[6] The idolaters more than once offered to compromise with the Prophet.

[7] If, as the Jalâleyn declare, vv. 76–82 were revealed at Al-Madînah the reference here is to the plotting of the Jews and Hypocrites.

[8] These words were recited by the Prophet when he witnessed the destruction of the idols around the Ka´bah after the conquest of Mecca.

[9] Vv. 85, 86, and 87 are said to have been revealed in answer to the third question, which some Jewish rabbis prompted the idolaters to ask, the first two questions being answered in the following Sûrah.

89. And verily We have displayed for mankind in this Qur'an all kinds of similitudes, but most of mankind refuse aught save disbelief.

90. And they say: We will not put faith in thee till thou cause a spring to gush forth from the earth for us;

91. Or thou have a garden of date-palms and grapes, and cause rivers to gush forth therein abundantly;

92. Or thou cause the heaven to fall upon us piecemeal, as thou has pretended, or bring Allah and the angels as a warrant;

93. Or thou have a house of gold; or thou ascend up into heaven, and even then we will put no faith in thine ascension till thou bring down for us a book that we can read. Say (O Muhammad): My Lord be glorified! Am I aught save a mortal messenger?

94. And naught prevented mankind from believing when the guidance came unto them save that they said: Hath Allah sent a mortal as (His) messenger?

95. Say: If there were in the earth angels walking secure, We had sent down for them from heaven an angel as messenger.

96. Say: Allah sufficeth for a witness between me and you. Lo! He is knower, Seer of His slaves.

97. And he whom Allah guideth, he is led aright; while, as for him whom He sendeth astray, for them thou wilt find no protecting friends beside Him, and We shall assemble them on the Day of Resurrection on their faces, blind, dumb and deaf; their habitation will be hell; whenever it abateth, We increase the flame for them.

98. That is their reward because they disbelieved Our revelations and said: When we are bones and fragments shall we, forsooth, be raised up as a new creation?

99. Have they not seen that Allah Who created the heavens and the earth is Able to create the like of them, and hath appointed for them an end whereof there is no doubt? But the wrong-doers refuse aught save disbelief.

100. Say (unto them): If ye possessed the treasures of the mercy of my Lord, ye would surely hold them back for fear of spending, for man was every grudging.

101. And verily We gave unto Moses nine tokens, clear proofs (of Allah's Sovereignty). Do but ask the Children of Israel how he came unto them, then Pharaoh said unto him: Lo! I deem thee one bewitched, O Moses.

102. He said: In truth thou knowest that none sent down these (portents) save the Lord of the heavens and the earth as proofs, and lo! (for my part) I deem thee lost, O Pharaoh.

103. And he wished to scare them from the land, but We drowned him and those with him, all together.

104. And We said unto the Children of Israel after him: Dwell in the land; but when the promise of the Hereafter cometh to pass we shall bring you as a crowd gathered out of various nations.[10]

105. With truth have We sent it down, and with truth hath it descended. And We have sent thee as naught else save a bearer of good tidings and a warner.

106. And (it is) a Qur'an that We have divided, that thou mayest recite it unto mankind at intervals, and We have revealed it by (successive) revelation.

107. Say: Believe therein or believe not, lo! those who were given knowledge before it, when it is read unto them, fall down prostrate on their faces, adoring,

108. Saying: Glory to our Lord! Verily the promise of our Lord must be fulfilled.

109. They fall down on their faces, weeping, and it increaseth humility in them.

110. Say (unto mankind): Cry unto Allah, or cry unto the Beneficent,[11] unto whichsoever ye cry (it is the same). His are the most beautiful names. And thou (Muhammad), be no loud voiced in they worship nor yet silent therein, but follow a way between.

111. And say: Praise be to Allah, Who hath not taken unto Himself a son, and Who hath no partner in the Sovereignty, nor hath He any protecting friend through dependence. And magnify Him with all magnificence.

Sûrah C The Coursers

Revealed at Mecca

In the name of Allah, the Beneficent, the Merciful.

1. By the snorting coursers,
2. Striking sparks of fire
3. And scouring to the raid at dawn,
4. Then, therewith, their trail of dust,
5. Cleaving, as one the center (of the foe),[1]
6. Lo! man is an ingrate unto his Lord
7. And lo! he is a witness unto that;
8. And lo! in the love of wealth he is violent.
9. Knoweth he not that, when the contents of the graves are poured forth.
10. And the secrets of the breasts are made known.
11. On that day will their Lord be perfectly informed concerning them.

Sûrah CXII The Unity

Revealed at Mecca

In the name of Allah, the Beneficent, the Merciful.

1. Say: He is Allah, the One!
2. Allah, the eternally Besought of all!
3. He begeteth not nor was begotten.
4. And there is none comparable unto Him.

From "The Opening," "The Table Spread," "The Children of Israel," "The Coursers," "The Unity," from *The Meaning of Glorious Koran*, translated by Mohammed Marmaduke Pickthall, 1930, George Allen & Unwin, an imprint of HarperCollins Publishers, Ltd., 1930.

READING 28

from Rābi'a al-'Adawiyya al-Qaysiyya (717–801)

Rābi'a al-'Adawiyya was an early female ascetic and Sufi mystic who introduced her religious community to the concept of divine love: to love God joyously not out of fear but for God's own sake. The following selections, taken down by her disciples, reveal her thinking.

[11] The idolaters had a peculiar objection to the name *Al-Rahmân*, "The Beneficent," in the Qur'an. They said: "We do not know this Rahmân." Some of them thought that Ar-Rahmân was a man living in Yamâmah.

[10] A reference to the dispersal of the Jews as a consequence of their own deeds after God had established them in the land.

[1] The meaning of the first five verses is by no means clear. The above is a probable rendering.

5

One day Rabiʿa was seen carrying fire in one hand and water in the other and she was running with speed. They asked her what was the meaning of her action and where she was going. She replied: "I am going to light a fire in Paradise and pour water onto Hell, so that both veils[1] may completely disappear from the pilgrims, and their purpose may be sure, and the servants of God may see Him, without any object of hope or motive of fear. What if the hope of Paradise and the fear of Hell did not exist? Not one could worship his Lord or obey Him."

6

The best thing for the servant, who desires to be near his Lord, is to possess nothing in this world or the next, save Him. I have not served God from fear of Hell, for I should be like a wretched hireling, if I did it from fear: nor from love of Paradise, for I should be a bad servant if I served for the sake of what was given, but I have served Him only for the love of Him and out of desire for Him.

The Neighbor first and then the house: is it not enough for me that I am given leave to worship him? Even if Heaven and Hell were not, does it not behoove us to obey Him? He is worthy of worship without any intermediate motive.

O my Lord, if I worship Thee from fear of Hell, burn me in Hell; and if I worship Thee from hope of Paradise, exclude me thence; but if I worship Thee for Thine own sake, then withhold not from me Thine Eternal Beauty.

7

The groaning and the yearning of the lover of God will not be satisfied until it is satisfied in the Beloved,

I have made Thee the Companion of my heart,
But my body is available for those who desire its company.
And my body is friendly toward its guests,
But the beloved of my heart is the Guest of my soul.

My peace is in solitude, but my Beloved is always with me. Nothing can take the place of His love and it is the test for me among mortal beings. Whenever I contemplate His Beauty, He is my mihrāb,[2] toward Him is my qibla[3]— O Healer of souls, the heart feeds upon its desire and it is the striving toward union with Thee that has healed my soul. Thou are my Joy and my Life to eternity. Thou wast the source of my life, from Thee came my ecstasy. I have separated myself from all created beings: my hope is for union with Thee, for that is the goal of my quest.

From *Readings from the Mystics of Islam* translated by Margaret Smith, 1950.

READING 29

from MOWLANA JALALADDUN RUMI (1207–1273)

Perhaps the most famous of the Sufi mystic poets was the thirteenth-century writer known as Rumi. Born in what is now Afghanistan, Rumi moved with his family to what is present-day Turkey. A prolific writer of religious verse in a form that used rhyming couplets developed by earlier Sufis, Rumi, writing in the Persian language, composed more than three thousand poems while also leaving behind seventy long discourses on mystical experience. Reproduced here are two of his poems and several mediations that reflect Rumi's deep awareness of God as well as his capacity to observe ordinary things and turn them into mystic reflections.

"The Night Air"

A man on his deathbed left instructions for dividing up his
 goods among his three sons.
He had devoted his entire spirit to those sons.
They stood like cypress trees around him, quiet and strong.

He told the town judge,
"Whichever of my sons is *laziest*, give him *all* the
 inheritance."

Then he died, and the judge turned to the three,
"Each of you must give some account of your laziness, so I
 can understand just *how* you are lazy."

Mystics are experts in laziness. They rely on it, because they
 continuously see God working all around them.
The harvest keeps coming in, yet they never even did the
 plowing!

"Come on. Say something about the ways you are lazy."

Every spoken word is a covering for the inner self.
A little curtain-flick no wider than a slice of roast meat can
 reveal hundreds of exploding suns.
Even if what is being said is trivial and wrong, the listener
 hears the source. One breeze comes from across a
 garden. Another from across the ash-heap.
Think how different the voices of the fox and the lion, and
 what they tell you!

Hearing someone is lifting the lid off the cooking pot.
You learn what's for supple. Though some people can
 know just by the smell, a sweet stew from a sour
 soup cooked with vinegar.

A man taps a clay pot before he buys it to know by the
 sound if it has a crack.

The eldest of the three brothers told the judge,
"I can know a man by his voice, and if he won't speak,
I wait three days, and then I know him intuitively."

The second brother, "I know him when he speaks, and
 if he won't talk, I strike up a conversation."

"But what if he knows the trick?" asked the judge.

Which reminds me of the mother who tells her child,
"When you're walking through the graveyard at night and
 you see a boogeman, run *at* it, and it will go away."

"But what," replies the child, "if the boogeyman's mother
 has told it to do the same thing?
Boogeymen have mothers too."

The second brother had no answer.

The judge then asked the youngest brother,
"What if a man cannot be made to say anything?
How do you learn his hidden nature?"

"I sit in front of him in silence, and set up a ladder made
 of patience, and if in his presence a language from
 beyond joy and beyond grief begins to pour from
 my chest,
I know that his soul is as deep and bright as the star
 Canopus rising over Yemen.

[1] I.e., hindrances to the true vision of God.
[2] A niche in the mosque, facing toward Mecca.
[3] The part toward which the congregation direct their prayers.

And so when I start speaking a powerful right arm of words
sweeping down, I know *him* from what I say, and
how I say it, because there's a window open between
us, mixing the night air of our beings."

The youngest was, obviously, the laziest. He won.

"Only Breath"

Not Christian or Jew or Muslim, not Hindu, Buddhist, sufi,
or zen. Not any religion

or cultural system. I am not from the East or the West, not
out of the ocean or up

from the ground, not natural or ethereal, not composed of
elements at all. I do not exist,

am not an entity in this world or the next, did not descend
from Adam or Eve or any

origin story. My place is placeless, a trace of the traceless.
Neither body or soul.

belong to the beloved, have seen the two worlds as one and
that one call to and know,

first, last, outer, inner, only that breath breathing human
being.

There is a way between voice and presence where
information flows.

In disciplined silence it opens.
With wandering talk it closes.

from Meditations

114

By love bitter things are made sweet: copper turns to gold. By
love, the sediment becomes clear: by love torment is removed.
By love the dead is made to live; by love the sovereign is made
a slave. This love also is the fruit of knowledge: when did folly
sit on a throne like this?—The faith of love is separated from
all religion; for lovers the faith and the religion is God. O spirit,
in striving and seeking, becoming like running water: O reason,
at all times be ready to give up mortality for the sake of immor-
tality. Remember God always, that self may be forgotten, so
that your self my be effaced in the One to Whom you pray,
without care for who is praying, or the prayer. . . .

116

Each night Thou dost set the spirits free from the net of the
body! Thou dost erase the tablets of memory. The spirits escape
each night from this cage, set free from control and from speech
and from the tales of men. At night prisoners are unaware of
the prison, at night rulers forget their power. there is no anxi-
ety, no thought of profit or loss, no consideration of this one or
that. This is the state of the gnostic,[1] even when awake. God
said: "They are asleep," though they may seem to be awake.
Be not afraid of this statement. He, that is, the gnostic, is asleep
in regard to this world of affairs, both by day and night, like the
pen which is moved by the hand of God. That one who does
not see the hand, which is writing, thinks that the movement

[1] *Gnostic:* one who has spiritual hidden understanding.

is due to the pen. A little of this state of the gnostic has been
shown to us, since all creatures are subject to the sleep of the
senses. Their souls have gone forth into the mysterious wastes;
their spirits are at rest with their bodies. Thou callest them back
into the net and bringest them all to justice and their judge. He
Who created the dawn, like Isrāfil, brings them all back from
those spiritual regions into the material world. He has made the
spirits to be like a horse free of its harness, this is the secret of
"sleep is the brother of death."

117

We were, once, one substance, like the Sun: flawless we were
and pure as water is pure. Purify yourself, therefore from the
qualities of self, so that you may see your essence, perfect and
pure. If you seek for a parable of the knowledge which is hid-
den, hear the story of the Greeks and the Chinese.

The Chinese said: "We are the better artists," and the
Greeks rejoined: "We have more skill than you and more sense
of beauty." So the king, in whose presence they were speaking,
said to them: "I will test you in this, to see which of you is jus-
tified in your claim."

The Chinese then said: "Give us a room for ourselves and
let there be a room for the Greeks." There were two rooms,
with doors opposite each other; the Chinese took one room
and the Greeks the other. The Chinese asked the king for a
hundred different colors: the king opened his treasure-house
for them to take what they would. Each morning the Chinese
took from the treasure-house some of his gift of colors. But
the Greeks said: "No colors or paints are needed for our work,
which is only to remove the rust." They shut themselves in and
polished continuously, until all was pure and clear like the sky.
From many colors there is a way to freedom from color: color
is like cloud, and freedom from color like the moon. Whatever
radiance and light you see in the cloud, know that it comes
from the stars and the moon, and the sun.

When the Chinese had finished their work, they rejoiced
and began to beat drums. The king came in and looked at
the pictures which were there and when he saw them he was
dumbfounded. Then after that, he came to the Greeks: one
of them raised the curtain that was between the rooms. The
reflection of those paintings and the work the Chinese had
done, fell upon those polished walls. All that the king had seen
there, seemed more lovely here: the wonder of it made his eyes
start from their sockets.

The Greeks are the Sufis, who dispense with study and
books and learning, but they have purified their hearts, making
them free from desire and greed and avarice and malice; that
spotless mirror is undoubtedly the heart which receives images
without number. Those who are purified have left behind them
fragrance and color; each moment they see Beauty without
hindrance: they have left behind the form and the externals of
knowledge, they have raised the standard of certainty. Thought
has gone from them and they have found light, they have found
the river and then the sea of gnosis. For the Sufis, there are a
hundred signs from the Empyrean and the sphere above and
the empty spaces, and what are these but the very Vision of
God Himself?

118

O lovers, the time has come to depart from the world; the
drum is sounding in the ear of my spirit, calling us to the jour-
ney. Behold, the camel-driver has bestirred himself and set his
camels in their ranks and desires us to let him start. Why are
you still sleeping, O travelers? These sounds which we hear
from before and behind betoken travel, for they are the camel-
bells. Each moment that passes, a soul is passing out of life and
starting for the Divine world. From these gleaming stars and

from these blue curtains of the heavens, have come forth a wondrous people, so that marvelous things of mystery may be made known. From these revolving orbs came a heavy sleep to you: beware of this so-transient life, have a care of this heavy sleep. O heart, depart toward the Beloved, O friend, go to your Friend. O watchman, keep awake, for sleep is not becoming to a watchman.

Excerpt from *Essential Rumi*, translated by Coleman Barks and John Moyne. © 1955 Coleman Barks. Reprinted by permission.

C H A P T E R 9

READING 30
from HILDEGARD OF BINGEN (1098–1179), SCIVIAS (THE WAY TO KNOWLEDGE)

This passage from the SCIVIAS begins with Hildegard's introduction to the book and, following on that, the first vision. Hildegard always begins by describing her vision and then commenting on its meaning. She had so powerful a reputation that Pope Eugene requested a copy of her work.

DECLARATION

These Are True Visions Flowing from God

And behold! In the forty-third year of my earthly course, as I was gazing with great fear and trembling attention at a heavenly vision, I saw a great splendor in which resounded a voice from Heaven, saying to me, "O fragile human, ashes of ashes, and filth of filth! Say and write what you see and hear. But since you are timid in speaking, and simple in expounding, and untaught in writing, speak and write these things not by a human mouth, and not by the understanding of human invention, and not by the requirements of human composition, but as you see and hear them on high in the heavenly places in the wonders of God. Explain these things in such a way that the hearer, receiving the words of his instructor, may expound them in those words, according to that will, vision and instruction. Thus therefore, O human, speak these things that you see and hear. And write them not by yourself or any other human being, but by the will of Him Who knows, sees and disposes all things in the secrets of His mysteries."

And again I heard the voice from Heaven saying to me, "Speak therefore of these wonders, and, being so taught, write them and speak."

It happened that, in the eleven hundred and forty-first year of the Incarnation of the Son of God, Jesus Christ, when I was forty-two years and seven months old, Heaven was opened and a fiery light of exceeding brilliance came and permeated my whole brain, and inflamed my whole heart and my whole breast, not like a burning but like a warming flame, as the sun warms anything its rays touch. And immediately I knew the meaning of the exposition of the Scriptures, namely the Psalter, the Gospel and the other catholic volumes of both the Old and the New Testaments, though I did not have the interpretation of the words of their texts or the division of the syllables or the knowledge of cases or tenses. But I had sensed in myself wonderfully the power and mystery of secret and admirable visions from my childhood—that is, from the age of five—up to that time, as I do now. This, however, I showed to no one except a few religious persons who were living in the same manner as I; but meanwhile, until the time when God by His grace wished it to be manifested, I concealed it in quiet silence. But the visions I saw I did not perceive in dreams, or sleep, or delirium, or by the eyes of the body, or by the ears of the outer self, or in hidden places; but I received them while awake and seeing with a pure mind and the eyes and ears of the inner self, in open places, as God willed it. How this might be is hard for mortal flesh to understand.

But when I had passed out of childhood and had reached the age of full maturity mentioned above, I heard a voice from Heaven saying, "I am the Living Light, Who illuminates the darkness. The person [Hildegard] whom I have chosen and whom I have miraculously stricken as I willed, I have placed among great wonders, beyond the measure of the ancient people who saw in Me many secrets; but I have laid her low on the earth, that she might not set herself up in arrogance of mind. The world has had in her no joy or lewdness or use in worldly things, for I have withdrawn her from impudent boldness, and she feels fear and is timid in her works. For she suffers in her inmost being and in the veins of her flesh; she is distressed in mind and sense and endures great pain of body, because no security has dwelt in her, but in all her undertakings she has judged herself guilty. For I have closed up the cracks in her heart that her mind may not exalt itself in pride or vainglory, but may feel fear and grief rather than joy and wantonness. Hence in My love she searched in her mind as to where she could find someone who would run in the path of salvation. And she found such a one and loved him [the monk Volmar of Disibodenberg], knowing that he was a faithful man, working like herself on another part of the work that leads to Me. And, holding fast to him, she worked with him in great zeal so that My hidden miracles might be revealed. And she did not seek to exalt herself above herself but with many sighs bowed to him whom she found in the ascent of humility and the intention of good will.

"O human, who receives these things meant to manifest what is hidden not in the disquiet of deception but in the purity of simplicity, write, therefore, the things you see and hear."

But I, though I saw and heard these things, refused to write for a long time through doubt and bad opinion and the diversity of human words, not the stubbornness but in the exercise of humility, until, laid low by the scourge of God, I fell upon a bed of sickness; then, compelled at last by many illnesses, and by the witness of a certain noble maiden of good conduct [the nun Richardis of Stade] and of that man whom I had secretly sought and found, as mentioned above, I set my hand to the writing. While I was doing it, I sensed, as I mentioned before, the deep profundity of scriptural exposition; and, raising myself from illness by the strength I received, I brought this work to a close—though just barely—in ten years.

These visions took place and these words were written in the days of Henry, Archbishop of Mainz, and of Conrad, King of the Romans, and of Cuno, Abbot of Disibodenberg, under Pope Eugenius.

And I spoke and wrote these things not by the invention of my heart or that of any other person, but as by the secret mysteries of God I heard and received them in the heavenly places.

And again I heard a voice from Heaven saying to me, "Cry out therefore, and write thus!"

VISION ONE

God Enthroned Shows Himself to Hildegard

I saw a great mountain the color of iron, and enthroned on it One of such great glory that it blinded my sight. On each side of him there extended a soft shadow, like a wing of wondrous breadth and length. Before him, at the foot of the mountain, stood an image full of eyes on all sides, in which, because of those eyes, I could discern no human form. In front of this image stood another, a child wearing a tunic of subdued color but white shoes, upon whose head such glory descended from the

One enthroned upon that mountain that I could not look at its face. But from the One who sat enthroned upon that mountain many living sparks sprang forth, which flew very sweetly around the images. Also, I perceived in this mountain many little windows, in which appeared human heads, some of subdued colors and some white.

And behold, He Who was enthroned upon that mountain cried out in a strong, loud voice saying, "O human, who are fragile dust of the earth and ashes of ashes! Cry out and speak of the origin of pure salvation until those people are instructed, who, though they see the inmost contents of the Scriptures, do not wish to tell them or preach them, because they are luke-warm and sluggish in serving God's justice. Unlock for them the enclosure of mysteries that they, timid as they are, conceal in a hidden and fruitless field. Burst forth into a fountain of abundance and overflow with mystical knowledge, until they who now think you contemptible because of Eve's transgression are stirred up by the flood of your irrigation. For you have received your profound insight not from humans, but from the lofty and tremendous Judge on high, where this calmness will shine strongly with glorious light among the shining ones.

"Arise therefore, cry out and tell what is shown to you by the strong power of God's help, for He Who rules every creature in might and kindness floods those who fear Him and serve Him in sweet love and humility with the glory of heavenly enlightenment and leads those who persevere in the way of justice to the joys of the Eternal Vision."

1 The strength and stability of God's eternal Kingdom

As you see, therefore, *the great mountain the color of iron* symbolizes the strength and stability of the eternal Kingdom of God, which no fluctuation of mutability can destroy; and *the One enthroned upon it of such great glory that it blinds your sight* is the One in the kingdom of beatitude Who rules the whole world with celestial divinity in the brilliance of unfading serenity, but is incomprehensible to human minds. But that *on each side of him there extends a soft shadow like a wing of wonderful breadth and length* shows that both in admonition and in punishment ineffable justice displays sweet and gentle protection and perseveres in true equity.

2 Concerning fear of the Lord

And before him at the foot of the mountain stands an image full of eyes on all sides. For the Fear of the Lord stands in God's presence with humility and gazes on the Kingdom of God, surrounded by the clarity of a good and just intention, exercising her zeal and stability among humans. And thus *you can discern no human form in her on account of those eyes.* For by the acute sight of her contemplation she counters all forgetfulness of God's justice, which people often feel in their mental tedium, so no inquiry by weak mortals eludes her vigilance.

3 Concerning those who are poor in spirit

And so *before this image appears another image, that of a child, wearing a tunic of subdued color but white shoes.* For when the Fear of the Lord leads, they who are poor in spirit follow; for the Fear of the Lord holds fast in humble devotion to the blessedness of poverty of spirit, which does not seek boasting or elation of heart, but loves simplicity and sobriety of mind, attributing its just works not to itself but to God in pale subjection, wearing, as it were, a tunic of subdued color and faithfully following the serene footsteps of the Son of God. *Upon her head descends such glory from the One enthroned upon that mountain that you cannot look at her face;* because He Who rules every created being imparts the power and strength of this blessedness by the great clarity of His visitation, and weak, mortal thought cannot grasp His pur-

pose, since He Who possesses celestial riches submitted himself humbly to poverty.

4 They who fear God and love poverty of spirit are the guardians of virtues

But *from the One Who is enthroned upon that mountain many living sparks go forth, which fly about those images with great sweetness.* This means that many exceedingly strong virtues come forth from Almighty God, darting fire in divine glory; these ardently embrace and captivate those who truly fear God and who faithfully love poverty of spirit, surrounding them with their help and protection.

5 The aims of human acts cannot be hidden from God's knowledge

Wherefore *in this mountain you see many little windows, in which appear human heads, some of subdued color and some white.* For in the most high and profound and perspicuous knowledge of God the aims of human acts cannot be concealed or hidden. Most often they display both lukewarmness and purity, since people now slumber in guilt, weary in their hearts and in their deeds, and now awaken and keep watch in honor. Solomon bears witness to this for Me, saying:

6 Solomon on this subject

"The slothful hand has brought about poverty, but the hand of the industrious man prepares riches" [Proverbs 10:4]; which means, a person makes himself weak and poor when he will not work justice, or avoid wickedness, or pay a debt, remaining idle in the face of the wonders of the works of beatitude. But one who does strong works of salvation, running in the way of truth, obtains the upwelling fountain of glory, by which he prepares himself most precious riches on earth and in Heaven.

Therefore, whoever has knowledge in the Holy Spirit and wings of faith, let this one not ignore My admonition but taste it, embrace it and receive it in his soul.

This selection from the Causae et Curae *of Hildegard of Bingen reflects what most medievals thought about human conception. Hildegard, though she is a nun, treats these matters with openness and without any of the antiwoman rhetoric common at the time. Her discussion of the "humors" was a commonplace derived from ancient Greek and Roman medicine.*

READING 31
from HILDEGARD OF BINGEN (1098–1179)
CAUSAE ET CURAE (*CAUSES AND CURES*) (C. 1155)

WOMEN'S PHYSIOLOGY

On Intercourse

When a woman is making love with a man, a sense of heat in her brain, which brings forth with it sensual delight, communicates the taste of that delight during the act and summons forth the emission of the man's seed. And when the seed has fallen into its place, that vehement heat descending from her brain

draws the seed to itself and holds it, and soon the woman's sexual organs contract and all the parts that are ready to open up during the time of menstruation now close, in the same way as a strong man can hold something enclosed in his fist.

When God created Adam, Adam experienced a sense of great love in the sleep that God instilled in him. And God gave a form to that love of the man, and so woman is the man's love. And as soon as woman was formed God gave man the power of creating, that through his love—which is woman—he might procreate children. When Adam gazed at Eve, he was entirely filled with wisdom, for he saw in her the mother of the children to come. And when she gazed at Adam, it was as if she were gazing into heaven, or as the human soul strives upwards, longing for heavenly things—for her hope was fixed in him. And so there will be and must be one and the same love in man and woman, and no other.

The man's love, compared with the woman's is a heat of ardor like a fire on blazing mountains which can hardly be put out, while hers is a wood-fire that is easily quenched; but the woman's love, compared with the man's is like a sweet warmth proceeding from the sun, which brings forth fruits. . . .

But the great love that was in Adam when Eve came forth from him, and the sweetness of the sleep with which he then slept, were turned in his transgression into a contrary mode of sweetness. And so, because a man still feels this great sweetness in himself, and like a stag thirsting for the fountain, he races swiftly to the woman and she to him—she like a threshing-floor pounded by his many strokes and brought to heat when the grains are threshed inside her.

Conceiving Male and Female Children

When the man approaches the woman, releasing powerful semen and in a true cherishing love for the woman, and she too has a true love for the man in that same hour, then a male child is conceived, for so it was ordained by God. Nor can it be otherwise, because Adam was formed of clay which is a stronger material than flesh. And this male child will be prudent and virtuous. . . .

But if the woman's love is lacking in that hour . . . and if the man's semen is strong, a male child will still be born, because the man's cherishing love predominates. But that male child will be feeble and not virtuous. . . . If the man's semen is thin, and yet he cherishes the woman lovingly and she him, then a virtuous female child is procreated. . . . If the man's semen is powerful but neither the man nor the woman cherish each other lovingly, a male child is procreated . . . but he will bitter with his parents' bitterness; and if the man's semen is thin and there is no cherishing love on either side in that hour, a girl of bitter temperament is born.

The blood in every human being increases and diminishes according to the waxing and waning of the moon . . . when, as the moon waxes, the blood in human beings is increased, then both men and women are fertile for bearing fruit—for generating children—since then the man's semen is powerful and robust; and in the waning of the moon, when human blood also wanes, the man's semen is feeble and without strength, like dregs. . . . If a woman conceives a child then, whether boy or girl, it will be infirm and feeble and not virtuous.

The Temperaments of Women: *De sanguinea* (About Sanguine Women)

Some women are inclined to plumpness, and have soft and delectable flesh and slender veins, and well-constituted blood free from impurities. . . . And these have a clear and light coloring, and in love's embraces are themselves lovable; they are subtle in arts, and show self-restraint in their disposition. At menstruation they suffer only a modest loss of blood, and their womb is well developed for childbearing, so they are fertile and can take in the man's seed. Yet they do not bear many children, and if they are without husbands so that they remain childless, they easily have physical pains; but if they have husbands, they are well.

De flecmatica (About Phlegmatic Women)

There are other women whose flesh does not develop as much, because they have thick veins and healthy, whitish blood (though it does contain a little impurity, which is the source of its light color). They have severe features, and are darkish in coloring; they are vigorous and practical, and have a somewhat mannish disposition. At menstruation their menstrual blood flows neither too little nor too abundantly. And because they have thick veins they are very fertile and conceive easily, for the womb and all their inner organs, too, are well developed. They attract men and make men pursue them, and so men love them well. If they want to stay away from men, they can do so without being affected by it badly, though they are slightly affected. However, if they do avoid making love with men they will become difficult and unpleasant in their behavior. But if they go with men and do not wish to avoid men's love-making, they will be unbridled and over-lascivious, according to men's report. And because they are to some extent mannish on account of the vital force (*viriditas,* lit. greenness) within them, a little down sometimes grows on their chin.

De colerica (About Choleric Women)

There are other women who have slender flesh but big bones, moderately sized veins and dense red blood. They are pallid in coloring, prudent and benevolent, and men show them reverence and are afraid of them. They suffer much loss of blood in menstruation; their womb is well developed and they are fertile. And men like their conduct, yet flee from them and avoid them to some extent, for they can interest men but not make men desire them. If they do get married, they are chaste, they remain loyal wives and live healthily with their husbands; and if they are unmarried, they tend to be ailing—as much because they do not know to what man they might pledge their womanly loyalty as because they lack a husband. . . .

De melancolica (About Melancholic Women)

But there are other women who have gaunt flesh and thick veins and moderately sized bones; their blood is more lead-colored than sanguine, and their coloring is as it were blended with grey and black. They are changeable and free-roaming in their thoughts, and wearisomely wasted away in affliction; they also have little power of resistance, so that at times they are worn out by melancholy. They suffer much loss of blood in menstruation, and they are sterile, because they have a weak and fragile womb. So they cannot lodge or retain or warm a man's seed, and thus they are also healthier, stronger and happier without husbands than with them—especially because, if they lie with their husbands, they will tend to feel weak afterwards. But men turn away from them and shun them because they do not speak to men affectionately, and love them only a little. If for some hour they experience sexual joy, it quickly passes in them. Yet some such women, if they unite with robust and sanguine husbands, can at times, when they reach a fair age, such as fifty, bear at least one child. . . . If their menopause comes before the just age, they will sometimes suffer gout or swellings of the legs, or will incur an insanity which their melancholy arouses, or else backache or a kidney ailment. . . . If they are not helped in

their illness, so that they are not freed from it either by God's help or by medicine, they will quickly die.

READING 32

from Hroswitha (died c. 1000),
The Conversion of the Harlot Thaïs

The German nun–poet Hroswitha (or Roswitha; the name is spelled variously), who lived at the aristocratic court of Gandersheim, left us both a collection of legends written in Latin and six plays. What is interesting about this well-educated woman is the broad range of her learning and her mastery of classical Latin in an age that did not put a high premium on the education of females. That her plays do not have a finished dramatic quality underscores the fact that she was the first dramatist writing in Germany (as well as Germany's first female poet). The plays are heavily moralistic, typically involving a religious conversion or steadfastness in faith during a time of persecution. Her stylistic model was the ancient drama of Rome, particularly the playwright Terence, but her intention was to use that style to educate and convert. She was a direct heir of the humane learning that developed in the Carolingian and Ottonian periods.

The story of Thaïs is a very old one that Hroswitha adapts from the legends of the saints. (The same story was turned into an opera titled Thaïs *by Jules Massenet in 1894.) Like many of Hroswitha's plays, it deals with a woman who triumphs in the life of virtue. Given the very rudimentary stage directions it is easy to imagine this play being read aloud by a small circle of literate people (the nuns of Hroswitha's convent, perhaps) for their mutual edification and instruction. We reproduce here the second half of the play.*

PAFNUTIUS A certain shameless woman dwells in this land./
DISCIPLES For all citizens a grave peril at hand./
PAFNUTIUS She shines forth in wondrous beauty, but threatens men with foul shame./
DISCIPLES How misfortunate. What is her name?/
PAFNUTIUS Thaïs.
DISCIPLES Thaïs, the whore?/
PAFNUTIUS That is her name./
DISCIPLES No one is unaware of her sordid fame./
PAFNUTIUS No wonder, because she is not satisfied with leading only a few men to damnation/but is ready to ensnare all men with the allurement of her beauty and drag them along with her to eternal perdition./
DISCIPLES A doleful situation./
PAFNUTIUS And not only frivolous youths dissipate their family's few possessions on her,/ but even respected men waste their costly treasures by lavishing gifts on her./ Thus they harm themselves.
DISCIPLES We are horrified to hear./
PAFNUTIUS Crowds of lovers flock to her, wishing to be near./
DISCIPLES Damning themselves in the process.
PAFNUTIUS These fools that come to her are blind in their hearts; they contend and quarrel and fight each other./
DISCIPLES One vice gives birth to another./
PAFNUTIUS Then, when the fight has started they fracture each other's faces and noses with their fists; they attack each other with their weapons and drench the threshold of the brothel with their blood gushing forth./
DISCIPLES What detestible wrong!/
PAFNUTIUS This is the injury to our Maker which I bewail./ This is the cause of my grief and ail./

DISCIPLES Justifiably you grieve thereof, and doubtlessly the citizens of heaven grieve with you.
PAFNUTIUS What if I visit her, disguised as a lover, to see if perchance she might be recovered from her worthless and frivolous life?
DISCIPLES He who instilled the desire for this undertaking in you,/ may He make this worthy desire come true./
PAFNUTIUS Stand by me with your constant prayers all the while/ so that I won't be overcome by the vicious serpent's guile./
DISCIPLES He who overcame the prince of the dark, may He grant you triumph over the fiend.
PAFNUTIUS Here I see some young men in the forum. First I will go to them and ask, where I may find her whom I seek./
YOUNG MEN Hm, a stranger approaches, let's enquire what he wants.
PAFNUTIUS Young men, who are you?/
YOUNG MEN Citizens of this town.
PAFNUTIUS Greetings to you./
YOUNG MEN Greetings to you whether you are from these parts or stranger./
PAFNUTIUS I just arrived. I am a stranger./
YOUNG MEN Why did you come? What do you seek?/
PAFNUTIUS Of that, I cannot speak./
YOUNG MEN Why not?
PAFNUTIUS Because that is my secret.
YOUNG MEN It would be better if you told us,/ because as you are not one of us, you will find it very difficult to accomplish your business without the inhabitants' advice.
PAFNUTIUS What if I told you and by telling an obstacle for myself procured?
YOUNG MEN Not from us—rest assured!/
PAFNUTIUS Then, trusting in your promise I will yield,/ and my secret no longer shield./
YOUNG MEN We will not betray our promise; we will not lay an obstacle in your way./
PAFNUTIUS Rumors reached my ear/ that a certain woman lives here/ which surpasses all in amiability,/ surpasses all in affability:/
YOUNG MEN Do you know her name?/
PAFNUTIUS I do.
YOUNG MEN What is her name?/
PAFNUTIUS Thaïs.
YOUNG MEN For her, we too are aflame./
PAFNUTIUS They say she is the most beautiful woman on earth,/ greater than all in delight and mirth./
YOUNG MEN Whoever told you that, did not tell a lie./
PAFNUTIUS It was for her sake that I decided to make this arduous journey; I came to see her today./
YOUNG MEN There are no obstacles in your way./
PAFNUTIUS Where does she stay?/
YOUNG MEN In that house, quite near./
PAFNUTIUS The one you are pointing out to me here?/
YOUNG MEN Yes.
PAFNUTIUS I will go there.
YOUNG MEN If you like, we'll go along./
PAFNUTIUS No, I'd rather go alone./
YOUNG MEN As you wish.

PAFNUTIUS Are you inside, Thaïs, whom I'm seeking?/
THAÏS Who is the stranger speaking?/
PAFNUTIUS One who loves you.
THAÏS Whoever seeks me in love/ finds me returning his love./
PAFNUTIUS Oh Thaïs, Thaïs, what an arduous journey I took to come to this place/ in order to speak with you and to behold your face./

THAÏS I do not deny you the sight of my face nor my conversation./

PAFNUTIUS The secret nature of our conversation/ necessitates the solitude of a secret location./

THAÏS Look, here is a room well furnished for a pleasant stay./

PAFNUTIUS Isn't there another room, where we can converse more privately, one that is hidden away?/

THAÏS There is one so hidden, so secret, that no one besides me knows its inside except for God./

PAFNUTIUS What God?/

THAÏS The true God./

PAFNUTIUS Do you believe He knows what we do?/

THAÏS I know that nothing is hidden from His view./

PAFNUTIUS Do you believe that He overlooks the deeds of the wicked or that He metes out justice as its due?/

THAÏS I believe that He weighs the merits of each person justly in His scale/ and that, each according to his deserts receives reward or travail./

PAFNUTIUS Oh Christ, how wondrous is the patience, of Thy great mercy! Thou seest that some sin with full cognition,/ yet Thou delay their deserved perdition./

THAÏS Why do you tremble? Why the change of color? Why all these tears?

PAFNUTIUS I shudder at your presumption,/ I bewail your sure perdition/ because you know all this so well,/ and yet you sent many a man's soul to Hell./

THAÏS Woe is me, wretched woman!

PAFNUTIUS You deserve to be damned even more,/ as you offended the Divine Majesty haughtily, knowing of Him before./

THAÏS Alas, alas, what do you do? What calamity do you sketch?/ Why do you threaten me, unfortunate wretch?/

PAFNUTIUS Punishment awaits you in Hell/ if you continue in sin to dwell./

THAÏS Your severe reproach's dart/ pierces the inmost recesses of my heart./

PAFNUTIUS Oh, how I wish you were pierced through all your flesh with pain/ so that you wouldn't dare to give yourself to perilous lust again./

THAÏS How can there be place now for appalling lust in my heart when it is filled entirely with the bitter pangs of sorrow/and the new awareness of guilt, fear, and woe?/

PAFNUTIUS I hope that when the thorns of your vice are destroyed at the root,/ the winestock of penitence may then bring forth fruit./

THAÏS If only you believed/ and the hope conceived/ that I who am so stained,/ with thousands and thousands of sins enchained,/ could expiate my sins or could perform due penance to gain forgiveness!

PAFNUTIUS Show contempt for the world, and flee the company of your lascivious lovers' crew./

THAÏS And then, what am I to do?/

PAFNUTIUS Withdraw yourself to a secret place,/ where you may reflect upon yourself and your former ways/ and lament the enormity of your sins.

THAÏS If you have hopes that I will succeed,/ then I will begin with all due speed./

PAFNUTIUS I have no doubt that you will reap benefits.

THAÏS Give me just a short time to gather what I long saved:/ my wealth, ill-gotten and depraved./

PAFNUTIUS Have no concern for your treasure,/ there'll be those who will use them for pleasure./

THAÏS I was not planning on saving it for myself not giving it to friends. I don't even wish to give it to the poor because I don't think that the prize of sin is fit for good.

PAFNUTIUS You are right. But how do you plan to dispose of your treasure and cash?/

THAÏS To feed all to the fire, until it is turned to ash./

PAFNUTIUS Why?

THAÏS So that nothing is left of what I acquired through sin,/ wronging the world's Maker therein./

PAFNUTIUS Oh how you have changed from your prior condition/ when you burned with illicit passions/ and were inflamed with greed for possessions./

THAÏS Perhaps, God willing,/ I'll be changed into a better being./

PAFNUTIUS It is not difficult for Him, Himself unchangeable, to change things according to His will./

THAÏS I will now leave and what I planned fulfill./

PAFNUTIUS Go forth in peace and return quickly.

THAÏS Come, hurry along,/ my worthless lovers' throng!/

LOVERS The voice of Thaïs calls us, let us hurry, let us go/ so that we don't offend her by being slow./

THAÏS Be quick, come here, and don't delay,/ there is something I wish to say./

LOVERS Oh Thaïs, Thaïs, what do you intend to do with this pile, why did you gather all these riches around the pyre yonder?/

THAÏS Do you wonder?

LOVERS We are much surprised./

THAÏS You'll be soon apprised./

LOVERS That's what we hope for.

THAÏS Then watch me!

LOVERS Stop it Thaïs; refrain!/ What are you doing? Are you insane?/

THAÏS I am not insane, but savoring good health again./

LOVERS But why this destruction of four-hundred pounds of gold,/ and of these treasures manifold?/

THAÏS All that I extorted from you unjustly, I now wish to burn,/ so that no spark of hope is left that I will ever again return/ and give in to your lust.

LOVERS Wait for a minute, wait,/ and the cause of your distress relate!

THAÏS I will not stay,/ for I have nothing more to say./

LOVERS Why do you dismiss us in obvious disgust?/ Do you accuse any one of us of breaking trust?/ Have we not always satisfied your every desire,/ and yet you reward us with hate and with ire!/

THAÏS Go away, depart!/ Don't tear my robe apart./ It's enough that I sinned with you in the past;/ this is the end of my sinful life, it is time to part at last./

LOVERS Whereto are you bound?/

THAÏS Where I never can be found./

LOVERS What incredible plight/ . . . that Thaïs, our only delight,/ the same Thaïs who was always eager to accumulate wealth, who always had lascivious things on her mind,/ and who abandoned herself entirely to voluptuousness of every kind,/ has now destroyed her jewels and her gold and all of a sudden scorns us,/ and wants to leave us./

THAÏS Here I come, father Pafnutius, eager to follow you.

PAFNUTIUS You took so long to arrive here,/ that I was tortured by grave fear/ that you may have become involved once again in worldly things.

THAÏS Do not fear; I had different things planned namely to dispose of my possessions according to my wish and to renounce my lovers publicly.

PAFNUTIUS Since you have abandoned those/ you may now make your avowals/ to the Heavenly Bridegroom.

THAÏS It is up to you to tell me what I ought to do. Chart my course as if drawing a circle.

PAFNUTIUS Then, come along./

THAÏS I shall follow you, I'm coming along:/ Oh, how I wish to avoid all wrong,/ and imitate your deeds!

PAFNUTIUS Here is the cloister where the noble company of holy virgins stays./ Here I want you to spend your days/ performing your penance.

THAÏS I will not contradict you.

PAFNUTIUS I will enter and ask the abbess, the virgins' leader, to receive you./

THAÏS In the meantime, what shall I do?

PAFNUTIUS Come with me./

THAÏS As you command, it shall be./

PAFNUTIUS But look, the abbess approaches. I wonder who told her so promptly of our arrival./

THAÏS Some rumor, bound by no hindrance and in speed without a rival./

PAFNUTIUS Noble abbess, Providence brings you,/ for I came to seek you./

ABBESS Honored father Pafnutius, our most welcome guest,/ your arrival, beloved of God, is manifoldly blest./

PAFNUTIUS May the felicity of eternal bliss/ grant you the Almighty's grace and benefice./

ABBESS For what reason does your holiness deign to visit my humble abode?/

PAFNUTIUS I ask for your aid; in a situation of need I took to the road./

ABBESS Give me only a hint of what you wish me to do, and I will fulfill it forthright./ I will try to satisfy your wish with all my might.

PAFNUTIUS I have brought you a half-dead little she-goat, recently snatched from the teeth of wolves. I hope that by your compassion its shelter will be ensured,/ and that by your care, it will be cured,/ until, having cast aside the rough pelt of a goat, she will be clothed with the soft wool of the lamb.

ABBESS Please, explain it more./

PAFNUTIUS She whom you see before you, led the life of a whore./

ABBESS What a wretched life she bore!/

PAFNUTIUS She gave herself entirely to vice./

ABBESS At the cost of her salvation's sacrifice!/

PAFNUTIUS But now urged by me and helped by Christ, she renounced her former frivolous way of life and seeks to embrace chastity./

ABBESS Thanks be to the Lord for the change./

PAFNUTIUS But because the sickness of both body and soul must be cured by the medicine of contraries, it follows that she must be sequestered from the tumult of the world,/ obscured in a small cell, so that she may contemplate her sins undisturbed./

ABBESS That cure will work very well./

PAFNUTIUS Then have them build such a cell./

ABBESS It will be completed promptly./

PAFNUTIUS Make sure it has no entry and no exit, only a tiny window through which she may receive some modest food on certain days at set hours and in small quantity./

ABBESS I fear that the softness of her delicate disposition/ will find it difficult to suffer such harsh conditions./

PAFNUTIUS Do not fear; such a grave offense certainly requires a strong remedy./

ABBESS That is quite plain./

PAFNUTIUS I am loath to delay any longer, because I fear she might be seduced by visitors again./

ABBESS Why do you worry? Why don't you hurry/ and enclose her? Look, the cell you ordered is built./

PAFNUTIUS Well done. Enter, Thaïs, your tiny cell, just

right for deploring your sins and guilt./

THAÏS How narrow, how dark is the room!/ For a tender woman's dwelling, how full of gloom!/

PAFNUTIUS Why do you complain about the place?/ Why do you shudder and your steps retrace?/ It is only proper that you who for so long were wandering unrestrained/ in a solitary place should be detained./

THAÏS A mind used to comfort and luxury,/ is rarely able to bear such austerity./

PAFNUTIUS All the more reason to restrain it by the reins of discipline, until it desist from rebellion.

THAÏS Whatever your fatherly concern prescribes for my reform,/ my wretched self does not refuse to perform;/ but in this dwelling there is one unsuitable thing however/ which would be difficult for my weak nature to bear./

PAFNUTIUS What is this cause of care?/

THAÏS I am embarrassed to speak./

PAFNUTIUS Don't be embarrassed, but speak!/

THAÏS What could be more unsuitable/ what could be more uncomfortable,/ than that I would have to perform all necessary functions of the body in the very same room? I am sure that it will soon be uninhabitable because of the stench.

PAFNUTIUS Fear rather the eternal tortures of Hell,/ and not the transitory inconveniences of your cell./

THAÏS My frailty makes me afraid.

PAFNUTIUS It is only right/ that you expiate the evil sweetness of alluring delight/ by enduring this terrible smell./

THAÏS And so I shall./ I, filthy myself, do not refuse to dwell/ in a filthy befouled cell/ —that is my just due./ But it pains me deeply that there is no spot left dignified and pure,/ where I could invoke the name of God's majesty.

PAFNUTIUS And how can you have such great confidence that you would presume to utter the name of the unpolluted Divinity with your polluted lips?

THAÏS But how can I hope for grace, how can I be saved by His mercy if I am not allowed to invoke Him, against Whom alone I sinned, and to Whom alone I should offer my devotion and prayer?

PAFNUTIUS Clearly you should pray not with words but with tears; not with your tinkling voice's melodious art/ but with the bursting of your penitent heart./

THAÏS But if I am prohibited from praying with words, how can I ever hope for forgiveness?/

PAFNUTIUS The more perfectly you humiliate yourself, the faster you will earn forgiveness./ Say only: Thou Who created me,/ have mercy upon me!/

THAÏS I will need His mercy not to be overcome in this uncertain struggle.

PAFNUTIUS Struggle manfully so that you may gloriously attain your triumph.

THAÏS You must pray for me so that I may deserve the palm of victory./

PAFNUTIUS No need to admonish me./

THAÏS I hope so.

PAFNUTIUS Now it is time that I return to my longed-for retreat and visit my dear disciples. Noble abbess,/ I commit my charge to your care and kindness,/ so that you may nourish her delicate body with a few necessities occasionally/ and nourish her soul with profitable admonitions frequently./

ABBESS Don't worry about her, because I will look after her, and my maternal affections will never cease./

PAFNUTIUS I will then leave.

ABBESS Go forth in peace!/

DISCIPLES Who knocks at the door?

PAFNUTIUS Hello!/

DISCIPLES Our father's, Pafnutius' voice!/

PAFNUTIUS Unlock the door!/

DISCIPLES Oh father, greetings to you!/

PAFNUTIUS Greetings to you, too./

DISCIPLES We were worried about your long stay./

PAFNUTIUS It was good that I went away./

DISCIPLES What happened with Thaïs?/

PAFNUTIUS Just the event for which I was praying./

DISCIPLES Where is she now staying?/

PAFNUTIUS She is bewailing her sins in a tiny cell, quite nigh./

DISCIPLES Praise be to the Trinity on High./

PAFNUTIUS And blessed be His formidable name, now and forever.

DISCIPLES Amen.

PAFNUTIUS Behold, three years of Thaïs' penitence have passed and I don't know whether or not her penance was deemed acceptable. I will rise and go to my brother Antonius, so that through his intercession I may find out.

ANTONIUS What unexpected pleasure, what surprising delight:/ it is my brother and co-hermit Pafnutius whom I sight!/ He is coming near./

PAFNUTIUS I am here./

ANTONIUS How good of you to come, brother, your arrival gives me great joy.

PAFNUTIUS I am as delighted in seeing you as you are with my visit.

ANTONIUS And what happy and for both of us welcome cause brings you here away from your solitary domain?/

PAFNUTIUS I will explain./

ANTONIUS I'd like to know./

PAFNUTIUS Three years ago/ a certain whore/ by the name of Thaïs lived in this land/ who not only damned herself but dragged many a man to his miserable end./

ANTONIUS What an abominable way one's life to spend!/

PAFNUTIUS I visited her, disguised as a lover, secretly/ and won over her lascivious mind first with kind admonitions and flattery,/ then I frightened her with harsh threats.

ANTONIUS A proper measure,/ necessary for this whore of pleasure./

PAFNUTIUS Finally she yielded,/ scorning the reprehensible way of life she formerly wielded/ and she chose a life of chastity consenting to be enclosed in a narrow cell./

ANTONIUS I am delighted to hear what you tell/ so much so that my veins are bursting, and my heart beats with joy.

PAFNUTIUS That becomes your saintliness, and while I am overjoyed by her change of heart,/ I am still disturbed by a decision on my part:/ I fear that her frailty/ can bear the long penance only with great difficulty./

ANTONIUS Where true affection reigns,/ kind compassion never wanes./

PAFNUTIUS Therefore I'd like to implore you that you and your disciples pray together with me until Heaven reveals to our sight or ears/ whether or not Divine Mercy has been moved to forgiveness by the penitent's tears./

ANTONIUS We are happy to comply with your request./

PAFNUTIUS I have no doubt that God will listen and grant your behest./

ANTONIUS Look, the Gospel's promise is fulfilled in us.

PAFNUTIUS What promise?

ANTONIUS The one that promises that communal prayer can achieve all./

PAFNUTIUS What did befall?/

ANTONIUS A vision was granted to my disciple, Paul./

PAFNUTIUS Call him!/

ANTONIUS Come hither, Paul, and tell Pafnutius what you saw.

PAUL In my vision of Heaven, I saw a bed/ with white linen beautifully spread/ surrounded by four resplendent maidens who stood as if guarding the bed./ And when I beheld the beauty of this marvelous brightness I said to myself: This glory belongs to no one more than to my father and my lord Antonius.

ANTONIUS I am not worthy so such beautitude to soar./

PAUL After I spoke, a Divine voice spoke: "This glory is not as you hope for Antonius, but is meant for Thaïs the whore."/

PAFNUTIUS Praised be Thy sweet mercy, Oh Christ, only begotten Son of God, for Thou hast designed to deliver me from my sadness' plight./

ANTONIUS To praise Him is meet and right./

PAFNUTIUS I shall go and visit my prisoner.

ANTONIUS It is proper to give her hope for forgiveness without further remiss,/ and assure her of the comfort of Heavenly bliss./

PAFNUTIUS Thaïs, my adoptive daughter, open your window so I may see you and rejoice./

THAÏS Who speaks? Whose is this voice?

PAFNUTIUS It is Pafnutius, your father.

THAÏS To what do I owe the bliss of such great joy that you deign to visit me, poor sinful soul?/

PAFNUTIUS Even though I was absent in body for three years, yet I was constantly concerned about how you would achieve your goal./

THAÏS I do not doubt that at all./

PAFNUTIUS Tell me of these past three years' course,/ and how you practiced your remorse./

THAÏS This is all I can tell:/ I have done nothing worthy of God, and that I know full well./

PAFNUTIUS If God would consider our sins only/ no one would stand up to scrutiny./

THAÏS But if you wish to know how I spent my time, in my conscience I enumerated my manifold sins and wickedness and gathered them as in a bundle of crime./ Then I continuously went over them in my mind,/ so that just as the nauseating smell here never left my nostrils, so the fear of Hell never departed from my heart's eyes.

PAFNUTIUS Because you punished yourself with such compunction/ you have earned forgiveness' unction./

THAÏS Oh, how I wish I did!

PAFNUTIUS Give me your hand so I can lead you out.

THAÏS Venerable Father, do not take me, stained and foul wretch, from this filth; let me remain in this place/ appropriate for my sinful ways./

PAFNUTIUS It is time for you to lessen your fear./ and to begin to have hopeful cheer./

THAÏS All angels sing His praise and His kindness, because He never scorns the humility of a contrite soul.

PAFNUTIUS Remain steadfast in fearing God, and continue to love Him forever. After fifteen days you will leave your human body/ and, having completed your happy journey,/ by the favor of Heavenly grace you will reach the stars.

THAÏS Oh, how I desire to avoid Hell's tortures, or rather how I aspire/ to suffer by some less cruel fire!/ For my merits do not suffice/ to secure me the bliss of paradise./

PAFNUTIUS Grace is God's gift and a free award,/ and not human merit's reward;/ because if it were simply a payment for merits, it wouldn't be called grace.

THAÏS Therefore praise Him all the company of heaven, and on earth the least little sprout or bush,/ not only all living creatures but even the waterfall's crush/ because He not only suffers men to live in sinful ways/ but rewards the penitent with the gift of grace./

PAFNUTIUS This has been His custom from time immemorial, to have mercy on sinners rather than to slay them.

THAÏS Do not leave, venerable father, but stand by me with consolation in my hour of death.

PAFNUTIUS I am not leaving,/ I am staying/ until your soul rejoices in Heaven's gains/ and I bury your earthly remains./

THAÏS Death is near./

PAFNUTIUS Then we must begin our prayer./

THAÏS Thou Who made me, Have mercy upon me/ and grant that my soul which Thou breathed into me,/ may return happily to Thee.

PAFNUTIUS Thou Who art created by no one, Thou only art truly without material form, one God in Unity of Substance,/ Thou Who created man, unlike Thee, to consist of diverse substances;/ grant that the dissolving, diverse parts of this human being/ may happily return to the source of their original being; that the soul, divinely imparted, live on in heavenly bliss,/ and that the body, may rest in peace/ in the soft lap of earth, from which it came,/ until ashes and dirt combine again/ and breath animates the revived members; that Thaïs be resurrected exactly as she was,/ a human being, and joining the white lambs may enter eternal joys./ Thou Who alone art what Thou art, one God in the Unity of the Trinity who reigns and is glorified, world without end.

"The Conversion of the Harlot Thaïs" by Hrosvit von Gandersheim from *The Plays of Hrostvit von Gandersheim,* translated by Katharina Wilson. Reprinted by permission of the author.

READING 33
The Life of Saint Bertilla, Abbess of Chelles (9th century)

This brief biography—typical of biographies of the saints written in the Middle Ages—is an account of a seventh-century female monastic who was the first abbess of Chelles (modern Meaux in France), a Benedictine monastery that would continue in existence until the French Revolution. Notice the emphasis on the austerity of monastic life, which, as the text itself notes, was considered a form of martyrdom. The miraculous element was typical of this kind of literature since it was widely considered that miraculous powers were a sign of God's favor. It is also worth noting the relationship between the monastery and its royal patrons. Many of the nuns would have come from the aristocracy although provisions for members of the lower classes to enter religious life were not lacking.

1. The brighter the religious life of holy virgins shines in merit, the more it is celebrated by word of mouth and praised in the tongues of all people. For as long as it presents an example of good behavior to others, it should move every voice to praise. Blessed Bertilla, a virgin native to the province of Soissons, sprang from parents of the highest nobility. As worthy seed gives birth to yet worthier children, she amplified the honors she received from her birth by the merits of her blessed life when Christ chose to be glorified in her and to make her glitter so that many would imitate her. From the beginnings of her earliest youth, she showed so much fervor in the faith that she willingly relinquished her parents for love of Christ, though as long as she was a child she always yielded swiftly to their desires. As soon as she reached her adolescence, the age of understanding, she desired Christ the Lord and planned, with a heart full of love, to enter His service. When questioned by the most faithful man Dado, called Ouen, as to whether she wished to serve Christ, she answered with thankful spirit that she had been devoted to Him from infancy when she had sworn to gain Christ, the Son of God, for her spouse. But she had not dared to announce this publicly for she knew that her parents were strongly opposed and would rather impede her with their prohibitions than give her their consent. But while she was still of tender age, she astutely followed divine counsel and secretly begged help most assiduously from God that her piety might produce profits and He might ordain that she be led into a suitable consortium of holy women or one of their communities. Considering her devotion, Divine Piety Which never fails those who place their hope in It, soon sent divine grace to her aid. At last, she gained her parents' consent and her devoted brothers and sisters encouraged her to persist in holy devotion and consecrate herself as an intact virgin to God. By the Lord's inspiration, they freely gave her encouragement and soon brought her, according to her vow, to a nearby monastery of women called Jouarre. She arrived there and was commended to the Lady Abbess Theudechild, who received her with honor among the holy women.

2. Thus the noble maiden Bertilla gave many thanks to Christ, whose piety guided her from the tempest of the world to the snug harbor of the community. And from that day, in that same place, she set herself to be pleasing to God with so much humility of soul that, except for the honorable way she behaved, she took no pride in the nobility of her stock. For sprung from free people at birth, she voluntarily consented to become a slave. In the holy community, she behaved herself so admirably and praiseworthily under the norms of the holy rule, that she soon achieved senior status in holy obedience. She hastened devoutly with fervent mind to prayers and to the divine office. She behaved properly with all gravity, gentleness and temperance, winning the admiration of the holy congregation. She kept the fear of God always before her eyes, walking with a heart perfected by the purity of confession. Humble and obedient, she was always pleasant to her seniors and served her elders in every way, as the mother ordered her. She strove to do everything most faithfully with a willing spirit, trusting in the consolation of divine grace and did all that was enjoined upon her without a murmur. Thus she profited, making daily advances in her exercises. She rose steadily above herself, not simply to surpass the others in merits but to triumph in taming her own body. Who now can recollect or tell all that there was to tell of what Christ's servant Bertilla did in that time? She was foremost in the stringency of her fasting and readier in love of vigils, more laudable in assiduity of prayer, more lavish in charity, more careful in reading Holy Scripture and more remarkable in works of mercy. Despite her youth, she was an elder in her habits of obedience and so mature in the treading down of vice that, in her juvenile inexperience, she was an example of understanding to her seniors, a solace to her companions and a model of the saints' ways to her juniors. While she lived, she wished to be wholly in Christ and with Christ. Not voluptuous in her gaze nor wanton of ear, not turning her mind to pleasure, but always restraining herself with the anchor of gravity, she so worked within the monastery walls that, in many useful matters, she resembled the spiritual mother. Considering her most faithful ministry, the abbess enjoined more and heavier duties upon her than others below her. Thus, while she was trained in many holy and religious ways she behaved with pious solicitude to other sisters under the mother's direction.

The care of the sick, of children and even guests was frequently entrusted to her. All of this, she performed most blessedly with a spirit of grace and equanimity, as though under divine guidance. She was chosen by the Lord for all the offices of the monastery and held the chief office second only to the mother abbess.

She discharged all with flawless obedience for the love of God. She always maintained sobriety and peace with an untroubled mind so that no provocation ever moved her spirit to scandal. And more, if she discerned any commotion or heard any sisters murmuring, for zeal of piety she strove to soothe and pacify them, to curb malicious whispers so that she might administer charity and piety by divine grace to their hearts.

3. So that the great merit in Christ's servant, Bertilla, might be shown to others, a great miracle was done through her. For once, when one of her sisters, whose spirit was troubled, spoke wrathful words to her, she called down divine judgment upon her. Although, as was seemly, the fault was mutually forgiven, Lady Bertilla continued to be fearful about the divine judgment she had summoned. Then the sister who had angered her died unexpectedly, choked by asthma. Hearing the signal, the rest of the sisters gathered for the funeral, to perform the customary prayers for the soul that had been taken from them so that the Lord might decree a warm welcome for her into His perpetual peace. Not having been told, God's servant Bertilla asked what caused the resounding chorus of psalms. One sister answered her; "Did you not know that the tones are ringing out because that sister's soul has left her body?" Hearing that, she trembled greatly because of the words they had had between them. She ran speedily, hurrying with great faith, to the place where the little body of the defunct sister lay lifeless. Entering, she immediately laid her right hand on the breast of the deceased adjuring her receding soul through Jesus Christ, the Son of God, not to leave but, before she spoke with Him, to forgive her anger against her. God permitting, at her commanding voice, the spirit which had left the body returned to the corpse and to the stupefaction of all, the revived cadaver drew breath. Looking at the servant of God, she said: "What have you done, sister? Why did you retrieve me from the way of light?" To which God's servant Bertilla said humbly: "I beg you sister to give me words of forgiveness, for once I cursed you with a troubled spirit." To which she said: "May God forgive you. I harbor no resentment in my heart against you now. Nay, rather, I hold you in fullest love. I pray that you will entreat God for me and permit me to go in peace nor cause me delay. For I am ready for the bright road and now I cannot start without your permission." And to that she said: "Go then in the peace of Christ and pray for me, sweet and lovable sister." How great was the faith in God that permitted her to recall a soul when she wished and return it when she pleased! From that miraculous deed, let us recognize how much constancy of faith God's servant had that enabled her, strengthened inwardly by the gift of celestial piety, to recall a soul indubitably gone from the body, to reanimate a cadaver. She spoke with her as she wished. And when the talk was ended, she permitted the soul to leave. Thus in the blessed Bertilla was the scripture fulfilled: "All things are possible to him that believeth" (Mark 9:23). For nothing is impossible to one who confides in God with all her heart, as this miracle makes clear.

4. Now this was in the time after the decease of Lord Clovis the King. Queen Balthild, his most noble wife, with her little son Clothar, governed the Kingdom of the Franks without reproach. All the bishops and nobles and even the commoners of the kingdom were compelled by her merits to love her with wonderful affection. For she was religious and much devoted to God and took care of paupers and churches. With great strength of soul, she governed the palace manfully. She took counsel with pontiffs and primates of the people and proposed to build

a monastery of maidens at a royal villa called Chelles. For she announced that she had made up her mind that when her son, the said Lord Clothar, reached his majority and could rule for himself, she would enter that monastery under religious orders, leaving royal cares behind. And because she loved everyone with wondrous affection and everyone loved her, her counsel pleased the company and they all gave their assent to it. And, prudent and wise as she was, she ordered the monastery to be built with all haste. Foreseeing the future needs of God's handmaids, she provided the necessary substance. Then, with the convent diligently prepared, she resolved in her mind to seek a woman of worthy merits and honesty and maidenly behavior to whom she could entrust a flock of holy virgins gathered there under the rule of holy religion. Rumors of the blessed holy maid Bertilla were on many tongues and, through many tales told by the faithful, came at last to the ears of the royal lady Balthild, the most glorious and Christian Queen. She rejoiced at the news of her sanctity and took counsel on the spot and decreed that [Bertilla] should be constituted mother over the holy women whom she had gathered for the love of Christ and reverence of holy Mary in the above-named convent. This, by God's dispensation, she afterwards brought to pass. With great devotion and humility she entreated the lady abbess Theudechild to designate some servants of God from her monastery to govern her community. After long urging, she could not deny the queen's supplication and freely granted the glorious lady's petition. She ordered the Lady Bertilla with several holy maidens to proceed to the convent at Chelles, to the spiritual mother Lady Balthild with the greatest care and fitting honor. As is proper, through the great priest Genesius, the whole congregation was commended to her as spiritual mother and he presently relayed to the Lady Queen his confidence in her religion and modest manners. Accordingly, the glorious queen, Balthild, received her as a heavenly gift, with great honor and, by mandate of Lady Theudechild, imposed the burden of ruling the whole convent upon her and ordered her to be its abbess.

5. Now truly I cannot express with what prudence and utter blamelessness the venerable servant of God Bertilla prepared herself to take up the cares of governance. She was not puffed up by the honor she had assumed or the abundant wealth or the surrounding crowd of servants of both sexes. She continued to remain in herself what she had been before: humble, pious, benignant, modest, virginal and, what supercedes everything, charitable. Assiduously, with complete faith, she prayed God, Who had consoled her in all things since her infancy, to help her and give her both strength and astute counsel to govern her holy community so that it would please Him Who had deigned to call her to this dignity. With the help of divine piety, she was able, through priestly counsel, to govern the community manfully with the highest sanctity and religion and guide it wonderfully under the holy rule so that she was pleasing to God and to the holy queen in all things. For she loved each of her sons and daughters like a mother and all returned that love. So she was loved when she was angry and feared when she laughed. She fortified her daughters and others under her governance against the devil's insidiousness and used spiritual arts as precautions to lead them to good deeds. She showed herself as a shining example in every good work and provided abundantly for their physical needs. Her sober and beneficent demeanor attracted many women and even men whose hearts were faithful. As the holy woman's fame spread, even more men and women hastened to her, not only from neighboring provinces but even from across the seas, leaving parents and fatherland with love's strongest desire. And with pious affection, God's servant Bertilla received them all as a mother to her darling little ones and cared for them lovingly, instructing them with holy lessons to live justly and piously that they might be pleasing to Christ the King.

6. Now, through her continence and fullest love, blessed Bertilla was an example and model of piety to all. She carefully taught religious customs to her subjects not only through holy speech but even more through her own sanctity, so that they might love one another in charitable affection and behave purely, soberly and chastely in all things and be ever ready for offices and prayers and to take care of guests and the poor with fond concern and to love their neighbors. Through holy communion, she drew the monastic household and its near neighbors to do the penance given for their sins in confession. Thus she gained the improvement of many and gained much profit for their souls and rewards for herself. Christ's servant Bertilla had the highest devotion and diligence for the adornment of churches and altars for Christ. She ordered her priests daily to offer their sacred hosts to God for the salvation of the souls of the faithful and the right state of God's Holy Church. She was always assiduous in vigils and prayers and abstinence from food and above all it was wonderful how little she drank. And in constancy of faith, she kept her unswerving mind always on the Lord Jesus Christ. And when she carried out these and other most honest customs, her holy example was edifying to the Christianity of her brothers and sisters; meanwhile paupers and pilgrims were comforted by her munificent largesse. Through her, the Lord collected such great fruits for the salvation of souls that even from over the seas, the faithful kings of the Saxons, through trusted messengers, asked her to send some of her disciples for the learning and holy instruction they heard were wonderful in her, that they might build convents of men and nuns in their land. She did not deny these religious requests which would speed the salvation of souls. In a thankful spirit, taking counsel with her elders and heeding her brothers' exhortations, with great diligence and the protection of the saints, she sent many volumes of books to them. That the harvest of souls in that nation might increase through her and be multiplied by God's grace, she sent chosen women and devout men. And we trust that this has been fulfilled to the praise of God and Lady Bertilla.

7. Meanwhile the glorious servant of God, Queen Balthild, who had been bound to government service and the care of the affairs of the principality, felt love of Christ and devotion to religion possess her mind, even as she labored under the heavy burden. With the consent of his optimates, she abandoned care of the royal palace to her adult son Lord Clothar and enlisted as a soldier of the Lord Christ in the monastery which she had built. There, as we wrote above, she submitted herself in obedience to the abbess Lady Bertilla. Received by her and by the whole flock of holy maidens, with great veneration, as was right and proper, she determined to remain in holy religion even to her dying day. By common counsel and dual example of sanctity, [the two women] adorned the conventual buildings and offices. They shone like two of the brightest lights placed on a candlestick for the clear edification of many. By apostolic custom, through the grace of the Holy Spirit, they were one heart and one soul, and their minds were always ready to act for the good. It was wonderful what delight and charity there was between them all their days. They mutually exhorted one another, that their rewards might increase in abundance. And after Lady Balthild the Queen had completed her devotions in all ways and migrated in peace to Christ, her body was placed with honors in the grave. Then the servant of Christ, Lady Bertilla, a few of whose many deeds we here commemorate, continued to occupy her office according to God, working in this convent while forty-six years ran their cycle. More and more, she grew in good works and progressed from strength to strength even to the day of her perfect death.

8. Blessed Bertilla would gladly have bowed her neck to gratify her great desire for martyrdom, had there been a skilled executioner ready for the task. But we believe that even though that passion was not fulfilled, yet she completed her martyrdom through mortification of her own body and blood. For when she had reached an advanced age, she drove her weary and senescent members to spiritual service. She did not follow the common custom and modify her life in old age or seek for better diet. As she had begun, she went on ever more strongly never taking enough of anything but barely sustaining her aged body, lest she might weaken from within. She indulged in a modicum of food and drink to force her weakening limbs into their nightly vigils. You yourselves have seen the many admirable deeds she performed which you will remember in full. So it is fitting that we proclaim them, though with our poor little words we could never tell you how much she loved you. And when Divine Piety had determined to reward her for so many merits, her body was stricken with a slight illness and she lay feverish on her cot. So confined to her bed of sickness, she strove to give thanks to God in psalms, hymns, and spiritual canticles admonishing those standing by to sing to God. Without being too much troubled by bodily illness, she happily scaled the heights of beatitude, with eyes raised up and holy hands stretched to heaven. The soul so dear to God was torn from the world and released in Heaven, living with Christ while the angels applauded. Then there was sorrow in the whole convent among Christ's servants. What a multitude of mourning brethren arrived immediately, their lamenting voices choked up with welling tears! It is impossible for us to tell and only those who were there in person will believe what happened. Plangent sounds reverberated, as though thunder struck the place. Nothing could be heard among the bitter sighs except everyone clamoring: "Pious nurse, noble mother! Why do you desert us and why do you leave us behind whom you have nurtured so long a time with sweet and maternal affection? Why make us derelict today, orphaned and pitiable? In your death, all of us have died too." For three days, these and similar complaints went on without intermission. On the fourth day, with fitting honors, they conducted her blessed little body, anointed with balsam, to the grave. There by the Lord's grace, for the salvation of human kind, she proved worthy to perform many miracles. Daily the prayers of the faithful are heard demanding her intercession and a variety of illnesses and infirmities are cured.

9. Therefore, for the edification of the faithful, we have been pleased to write here a few of the many deeds in the life of the servant of God, Bertilla of blessed memory. Then anyone who likes may carefully consider and imitate, as in a clear mirror, those examples of virtue, particularly humility which is the mother of virtues and the fullest loving charity, the sharpest abstinence and the prudence of astute counsel and fortitude of faith and piety of generous mercy and, the reward of integrity, holy modesty of virginity with most devout insistence on prayer and wondrous peace and fervor of holy zeal which far surpasses every beauty. Almighty God chose whatever might be pleasing from these most brilliant gems to adorn the spirit of his servant Bertilla. As He well might, He desired to conserve her, with Christ presiding, to be a participant in the rewards of the just. For this evangelical virgin of Christ could claim a hundred-fold reward and life eternal. We have no doubt that she has achieved eternal life associated in eternal glory for her holy and splendid labors. She ran first in the race with the help of Christ and happily finished it and received the reward of the crown of eternal life in the flock of the just where she remains from everlasting to everlasting. Amen.

From "Saint Bertilla, Abbess of Chelles" in *Sainted Women of the Dark Ages*, edited and translated by Jo Ann McNamara and John E. Harlborg. © 1992, Duke University Press. Reprinted by permission. All rights reserved.

READING 34

from THE SONG OF ROLAND (LATE 11TH CENTURY), THE DEATH OF ROLAND

The selection from the SONG OF ROLAND *reproduced here recounts the death of Roland, Olivier (Lord Olivier), Archbishop Turpin, and their loyal followers and the return of Charlemagne to take up the battle against the pagans. Pay particular attention to the epic qualities of the narrative: the stark distinction between the battling forces; the bravery of the combatants in the face of death; the sacred nature of weapons and horses (indicated by their being named); and, peculiar to post-classical epic poetry, the blending of martial and biblical language. To get the full force of the poem, read some of the stanzas aloud in a declamatory fashion—the way they were originally meant to be "read." The phrase AOI appended to the end of many of the stanzas is of uncertain meaning. It may have been a ritual shout, but scholars do not agree.*

128

Count Roland sees the slaughter of his men.
He calls aside Olivier, his comrade:
"Fair lord, dear comrade, in the name of God, what now?
You see what good men lie here on the ground.
We well may mourn sweet France the Beautiful,
to be deprived of barons such as these.
Oh king, my friend—if only you were here!
Olivier, my brother, what can we do?
By what means can we get this news to him?"
"I have no notion," says Olivier, 10
"but I'd rather die than have us vilified." AOI

129

Then Roland says: "I'll sound the oliphant,
and Charles, who's moving through the pass, will hear it.
I promise you the Franks will then return."
Olivier says: "That would bring great shame
and reprobation down on all your kin,
and this disgrace would last throughout their lives!
You wouldn't do a thing when I implored you,
so don't act now to win my gratitude.
No courage is involved in sounding it; 20
already you have bloodied both your arms."
The count replies: "I've struck some lovely blows!" AOI

130

Then Roland says: "Our fight is getting rough:
I'll sound my horn—King Charles is sure to hear it."
Olivier says: "That would not be knightly.
You didn't deign to, comrade, when I asked you,
and were the king here now, we'd be unharmed.
The men out yonder shouldn't take the blame."
Olivier says: "By this beard of mine,
if I should see my lovely sister Alde, 30
then *you* shall never lie in her embrace." AOI

131

Then Roland says: "You're angry with me—why?"
And he replies: "Companion, you're to blame,
for bravery in no sense is bravado,
and prudence is worth more than recklessness.
Those French are dead because of your caprice;
King Charles will have our services no more.
My lord would be here now, if you'd believed me,
and we'd have put an end to this affray;
Marsilla would be dead or taken captive. 40
But we were doomed to see your prowess, Roland;

now Charlemagne will get no help from us
(there'll be no man like him until God judges)
and you shall die, and France shall be disgraced.
Today our loyal comradeship will end:
before the evening falls we'll part in grief." AOI

132

The archbishop overhears them quarreling:
he rakes his horse with spurs of beaten gold,
comes over, and begins to reprimand them:
"Lord Roland, you too, Lord Olivier, 50
I beg of you, for God's sake do not quarrel!
A horn blast cannot save us any more,
but nonetheless it would be well to sound it;
the king will come, and then he can avenge us—
the men from Spain will not depart in joy.
Our Frenchmen will dismount here, and on foot
they'll come upon us, dead and hacked to pieces,
and lift us up in coffins onto pack-mules,
and weep for us in pity and in grief.
They'll bury us beneath the aisles of churches, 60
where wolves and pigs and dogs won't gnaw on us."
"You've spoken very well, sire," answers
Roland. AOI

133

Count Roland brought the horn up to his mouth:
he sets it firmly, blows with all his might.
The peaks are high, the horn's voice carries far;
they hear it echo thirty leagues away.
Charles hears it, too, and all his company:
the king says then: "Our men are in a fight."
And Ganelon replies contentiously:
"Had someone else said that, he'd seem a liar."
AOI 70

134

Count Roland, racked with agony and pain
and great chagrin, now sounds his ivory horn:
bright blood leaps in a torrent from his mouth:
the temple has been ruptured in his brain.
The horn he holds emits a piercing blast:
Charles hears it as he crosses through the pass;
Duke Naimes has heard it, too; the Franks give ear.
The king announces: "I hear Roland's horn!
He'd never sound it if he weren't embattled."
Says Ganelon: "There isn't any battle! 80
You're getting old, your hair is streaked and white;
such speeches make you sound just like a child.
You're well aware of Roland's great conceit;
it's strange that God has suffered him so long.
Without your orders he once captured Naples:
the Saracens inside came riding out
and then engaged that worthy vassal Roland,
who later flushed the gory field with water—
he did all this to keep it out of sight.
He'll blow that horn all day for just one hare. 90
He's showing off today before his peers—
no army under heaven dares to fight him.
So keep on riding!—Why do you stop here?
For Tere Majur lies far ahead of us." AOI

135

Count Roland's mouth is filling up with blood;
the temple has been ruptured in his brain.
In grief and pain he sounds the oliphant;

Charles hears it, and his Frenchmen listen, too.
The king says then, "That horn is long of wind."
Duke Naimes replies, "The baron is attacking! 100
A fight is taking place, of that I'm sure.
This man who tries to stall you has betrayed them.
Take up your arms, sing out your battle cry,
and then go save your noble retinue:
you've listened long enough to Roland's plaint!"

136

The emperor has let his horns be sounded:
the French dismount, and then they arm themselves
with hauberks and with casques and gilded swords.
Their shields are trim, their lances long and stout,
their battle pennants crimson, white, and blue. 110
The barons of the army mount their chargers
and spur them briskly, all down through the passes.
There is not one who fails to tell his neighbor:
"If we see Roland prior to his death,
we'll stand there with him, striking mighty blows."
But what's the use?—for they've delayed too long.

137

The afternoon and evening are clear:
the armor coruscates against the sun,
those casques and hauberks throw a dazzling glare,
as do those shields, ornate with painted flowers, 120
those spears, those battle flags of gold brocade.
Impelled by rage, the emperor rides on,
together with the French, chagrined and grieved.
No man there fails to weep with bitterness,
and they are much afraid for Roland's sake.
The king has had Count Ganelon arrested,
and turns him over to his household cooks.
He tells Besgun, the leader of them all:
"Keep watch on him, like any common thug,
for he's betrayed the members of my house." 130
He turned him over to a hundred comrades,
the best and worst together, from the kitchen.
These men plucked out his beard and his moustache,
and each one hit him four times with his fist;
they whipped him thoroughly with sticks and clubs,
and then they put a chain around his neck
and chained him up exactly like a bear;
in ridicule, they set him on a pack-horse.
They'll guard him this way until Charles returns.

138

The hills are high and shadowy and large, 140
the valleys deep, with swiftly running streams.
The trumpets ring out to the front and rear,
all racketing reply to the oliphant.
The emperor rides on, impelled by rage,
as do the Franks, chagrined and furious:
no man among them fails to weep and mourn
and pray to God that He may safeguard Roland
until they all arrive upon the field.
Together with him there, they'll really fight.
But what's the use? They cannot be of help; 150
they stayed too long; they can't get there in time. AOI

139

Impelled by rage, King Charles keeps riding on,
his full white beard spreads out upon his byrnie.
The Frankish barons all have used their spurs;
not one of them but bitterly regrets
that he is not beside the captain Roland,

now fighting with the Saracens from Spain,
and injured so, I fear his soul won't stay.
But, God—the sixty in his company!
No king or captain his commanded better. AOI 160

140

Count Roland scans the mountains and the hills:
he sees so many dead French lying there,
and like a noble king he weeps for them.
"My lords and barons, God be merciful,
deliver all your souls to Paradise
and let them lie among the blessed flowers!
I've never seen more worthy knights than you—
you all have served me long and faithfully,
and conquered such great lands for Charles's sake!
The emperor has raised you, all for naught. 170
My land of France, how very sweet you are—
today laid waste by terrible disaster!
French lords, because of me I see you dying—
I can't reprieve you now, nor save your lives.
May God, who never lied, come to your aid!
Olivier, I won't fail *you*, my brother;
if no one kills me, I shall die of grief.
My lord companion, let's attack once more."

141

Count Roland now goes back into the field,
with Durendal in hand, fights gallantly: 180
he then has cut Faldrun of Pui in two,
as well as twenty-four among their best;
no man will ever want revenge so badly.
Just as the stag will run before the hounds,
the pagans break and run away from Roland.
The archbishop says: "You're doing rather well!
Such gallantry a chevalier should have,
if he's to carry arms and ride a horse.
He must be fierce and powerful in combat—
if not, he isn't worth four deniers— 190
should be instead a monastery monk
and pray the livelong day for all our sins."
"Lay on, don't spare them!" Roland says in answer,
and at these words the Franks attack again.
The Christians suffered very heavy losses.

142

The man who knows no captives will be taken,
in such a fight puts up a stout defense:
because of this, the Franks are fierce as lions.
Now see Marsilla make a gallant show.
He sits astride the horse he calls Gaignon; 200
he spurs him briskly, then attacks Bevon
(this man was lord of Beaune and of Dijon).
He breaks his shield and smashes through his hauberk
and drops him dead without a *coup de grâce*.
And then he killed Ivon and Ivorie,
together with Gerard of Roussillon.
Count Roland isn't very far away;
he tells the pagan: "May the Lord God damn you!
So wrongfully you've slaughtered my companions;
before we separate, you'll take a stroke, 210
and from my sword today you'll learn its name."
He goes to strike him with a gallant show:
the count swings down and cuts his right hand off,
then takes the head of Jurfaleu the Blond
(this pagan was the son of King Marsilla).
The pagans raise the cry: "Help us, Mohammed!
And you, our gods, give us revenge on Charles.
He's sent such villains to us in this land—

they'd rather die than leave the battlefield."
One tells another: "Let's get out of here!" 220
And at that word a hundred thousand run.
No matter who may call, they won't come back. AOI

145

The pagans, when they see the French are few,
feel proud and reassured among themselves:
"The emperor is wrong," one tells another.
Astride a sorrel horse sits Marganice;
he rakes him briskly with his golden spurs
and strikes Olivier on the back,
lays bare the flesh beneath the shining hauberk
and shoves his lance entirely through his chest, 230
and then he says: "You took a mortal blow!
Great Charles should not have left you at the pass,
he's done us wrong, he has no right to boast;
through you alone, our side is well avenged."

146

Olivier feels wounded unto death,
but gripping Halteclere, whose blade was polished,
strikes Marganice's high-peaked golden casque;
he smashes downward through fleurons and gems
and splits the skull wide open to the teeth.
He wrenches free and lets the dead man fall, 240
and afterward he tells him: "Damn you, pagan!
I do not say that Charles has had no loss,
but neither to your wife nor any woman
you've seen back where you came from shall you brag
you took a denier of loot from me,
or injured me or anybody else."
Then afterward he calls for help to Roland. AOI

147

Olivier feels injured unto death,
yet he will never have his fill of vengeance:
he battles in the thick crowd like a baron, 250
still shearing through those shafts of spears, those
 bucklers,
and feet and wrists and shoulder-bones and ribs.
Whoever saw him maiming Saracens
and piling dead men one upon the other
would be reminded of a worthy knight.
Not wanting Charles's battle cry forgotten,
he sings out in a loud, clear voice: "Monjoy!"
He calls to him his friend and peer, Count Roland:
"My lord companion, come fight here by me;
today in bitter anguish we shall part." AOI 260

148

Count Roland contemplates Olivier:
his face is gray and bloodless, wan and pale,
and from his trunk bright blood is surging out
and dripping down in pools upon the ground.
The count says: "God, I don't know what to do.
Your valor was for naught, my lord companion—
there'll never be another one like you.
Sweet France, today you're going to be robbed
of loyal men, defeated and destroyed:
all this will do the emperor great harm." 270
And at this word he faints, still on his horse.
AOI

149

See Roland, who has fainted on his horse,
and, wounded unto death, Olivier,

his vision so impaired by loss of blood
that, whether near or far, he cannot see
enough to recognize a living man;
and so, when he encounters his companion,
he hits him on his jeweled golden casque
and splits it wide apart from crown to nasal,
but doesn't cut into his head at all. 280
On being struck so, Roland studied him,
then asked him in a soft and gentle voice:
"My lord companion, did you mean to do that?
It's Roland, who has been your friend so long:
you gave no sign that you had challenged me."
Olivier says: "Now I hear you speak.
Since I can't see you, God keep you in sight!
I hit you, and I beg you to forgive me."
And Roland says: "I've not been hurt at all,
and here before the Lord I pardon you." 290
And with these words, they bowed to one another:
in friendship such as this you see them part.

150

Olivier feels death-pangs coming on;
his eyes have both rolled back into his head,
and his sight and hearing are completely gone.
Dismounting, he lies down upon the ground,
and then confesses all his sins aloud,
with both hands clasped and lifted up toward heaven.
He prays that God may grant him Paradise
and give His blessing to sweet France and Charles 300
and, most of all, to his companion Roland.
His heart fails; his helmet tumbles down;
his body lies outstretched upon the ground.
The count is dead—he could endure no more.
The baron Roland weeps for him and mourns:
on earth you'll never hear a sadder man.

151

Now Roland, when he sees his friend is dead
and lying there face down upon the ground,
quite softly starts to say farewell to him:
"Your valor was for naught, my lord companion! 310
We've been together through the days and years,
and never have you wronged me, nor I you;
since you are dead, it saddens me to live."
And having said these words, the marquis faints
upon his horse, whose name is Veillantif;
but his stirrups of fine gold still hold him on:
whichever way he leans, he cannot fall.

153

Now, Roland, grown embittered in his pain,
goes slashing through the middle of the crowd;
he throws down lifeless twenty men from Spain, 320
while Gautier kills six, and Turpin five.
The pagans say: "These men are infamous;
don't let them get away alive, my lords:
whoever fails to rush them is a traitor,
who lets them save themselves, a renegade."
So once more they renew the hue and cry;
from every side they go to the attack. AOI

154

Count Roland is a noble man-at-arms.
Gautier of Hum a splendid chevalier,
the archbishop an experienced campaigner: 330
no one of them will ever leave the others.
Engulfed within the crowd, they cut down pagans.

A thousand Saracens get down on foot,
and forty thousand stay upon their horses:
they do not dare come closer, that I know,
but they hurl at them their javelins and spears
and darts and wigars, mizraks, and agers.
The first barrage has killed Count Gautier;
Turpin of Reims—his shield is pierced clear through,
his helmet broken, injuring his head, 340
his hauberk torn apart and stripped of mail;
his body has been wounded by four spears;
they kill his destrier from under him.
Great sorrow comes as the archbishop falls. AOI

155

Turpin of Reims, when he sees that he's been downed
by four spears driven deep into his body,
the brave man leaps back quickly to his feet
and looks toward Roland, then runs up to him
and says this word: "By no means am I beaten;
no loyal man gives up while still alive." 350
He draws Almace, his sword of polished steel;
in the crowd he strikes a thousand blows or more.
Charles later on will say he spared no one—
he found about four hundred, all around him,
some only wounded, some who'd been run through,
and others who had had their heads cut off.
Thus says the *geste* and he who was afield,
the noble Giles, for whom God brought forth wonders.
At the minister of Laon he wrote the charter;
whoever doesn't know that much knows little. 360

156

Count Roland keeps on fighting skillfully,
although his body's hot and drenched with sweat:
he feels great pain and torment in his head,
since, when he blew his horn, his temple burst.
Yet he has to know if Charles is coming back:
he draws the ivory horn and sounds it feebly.
The emperor pulled up so he might listen:
"My lords," he says, "it's very bad for us;
today my nephew Roland will be lost.
From his horn blast I can tell he's barely living; 370
whoever wants to get there must ride fast.
So sound your trumpets, all this army has!"
And sixty thousand of them blare so loud,
the mountains ring, the valleys echo back.
The pagans hear it, take it as no joke.
One tells another: "Now we'll have King Charles."

157

The pagans say: "The emperor's returning; AOI
just listen to the Frenchmen's trumpets blare!
If Charles comes, it will be the ruin of us—
if Roland lives, our war will start again, 380
and we'll have forfeited our land of Spain."
About four hundred, wearing casques, assemble—
and launch one brutal, grim assault on Roland.
This time the count has got his work cut out. AOI

158

Count Roland, when he sees them drawing near,
becomes so strong and bold and vigilant!
As long as he's alive, he'll never yield.
He sits astride the horse called Veillantif
and rakes him briskly with his fine gold spurs
and wades into the crowd to fight them all, 390
accompanied by Turpin, the archbishop.
One tells another: "Friend, get out of here!
We've heard the trumpets of the men from France;
now Charles, the mighty king, is coming back."

159

Count Roland never cared much for a coward
nor a swaggerer nor evil-minded man
nor a knight, if he were not a worthy vassal.
He called out then to Turpin, the archbishop:
"My lord, you are on foot and I am mounted;
for love of you I'll make my stand right here. 400
Together we shall take the good and bad;
no mortal man shall ever make me leave you.
Today, in this assault, the Saracens
shall learn the names Almace and Durendal."
The archbishop says: "Damn him who won't fight hard!
When Charles comes back here, he'll avenge us well."

160

The pagans cry out: "We were doomed at birth;
a bitter day has dawned for us today!
We've been bereft of all our lords and peers,
the gallant Charles is coming with his host, 410
we hear the clear-voiced trumpets of the French
and the uproar of the battle cry 'Monjoy.'
So great is the ferocity of Roland,
no mortal man will ever vanquish him;
so let us lance at him, then let him be."
They hurl at him a multitude of darts,
befeathered mizraks, wigars, lances, spears—
they burst and penetrated Roland's shield
and ripped his hauberk, shearing off its mail,
but not a one went through into his body. 420
They wounded Veillantif in thirty places
and killed him out from underneath the count.
The pagans take fiight then and let him be:
Count Roland is still there upon his feet. AOI

161

The pagans, galled and furious, take flight
and head for Spain, as fast as they can go.
Count Roland is unable to pursue them,
for he has lost his charger Veillantif
and now, despite himself, is left on foot.
He went to give Archbishop Turpin help, 430
unlaced his gilded helmet from his head,
then pulled away his gleaming, lightweight hauberk
and cut his under-tunic all to shreds
and stuffed the strips into his gaping wounds.
This done, he took him up against his chest
and on the green grass gently laid him down.
Most softly Roland made him this request:
"Oh noble lord, if you will give me leave—
all our companions, whom we held so dear,
are dead now; we should not abandon them. 440
I want to seek them out, identify them,
and lay them out before you, side by side."
The archbishop tells him: "Go and then return;
this field is yours, I thank God, yours and mine."

162

Now Roland leaves and walks the field alone:
he searches valleys, searches mountain slopes.
He found there Gerier, his friend Gerin,
and then he found Aton and Berenger,

and there he found Sanson and Anseïs;
he found Gerard the Old of Roussillon. 450
The baron picked them up then, pair by pair,
and brought them every one to the archbishop
and placed them in a row before his knees.
The archbishop cannot help himself; he weeps,
then lifts his hand and makes his benediction,
and says thereafter: "Lords, you had no chance;
may God the Glorious bring all your souls
to Paradise among the blessed flowers!
My own death causes me great pain, for I
shall see the mighty emperor no more." 460

163

Now Roland leaves, goes searching through the field:
he came upon Olivier, his comrade,
and holding him up tight against his chest
returned as best he could to the archbishop.
He laid him on a shield beside the others;
the archbishop blessed him, gave him absolution.
Then all at once despair and pain well up,
and Roland says: "Olivier, fair comrade,
you were the son of wealthy Duke Renier,
who ruled the frontier valley of Runers. 470
To break a lance-shaft or to pierce a shield,
to overcome and terrify the proud,
to counsel and sustain the valorous,
to overcome and terrify the gluttons,
no country ever had a better knight."

164

Count Roland, looking on his lifeless peers
and Olivier, whom he had cared for so,
is seized with tenderness, begins to weep.
The color has all vanished from his face;
he cannot stand, the pain is so intense; 480
despite himself, he falls to earth unconscious.
The archbishop says: "Brave lord, you've come to grief."

165

The archbishop, upon seeing Roland faint,
feels sorrow such as he has never felt,
extends his hand and takes the ivory horn.
At Roncesvals there is a running stream;
he wants to fetch some water there for Roland;
with little, stumbling steps he turns away,
but can't go any farther—he's too weak
and has no strength, has lost far too much blood. 490
Before a man could walk across an acre,
his heart fails, and he falls upon his face.
With dreadful anguish death comes over him.

166

Count Roland, now regaining consciousness,
gets on his feet, in spite of dreadful pain,
and scans the valleys, scans the mountainsides,
across the green grass, out beyond his comrades.
He sees the noble baron lying there—
the archbishop, sent by God in His own name.
Confessing all his sins, with eyes upraised
and both hands clasped and lifted up toward Heaven, 500
he prays that God may grant him Paradise.
Now Turpin, Charles's warrior, is dead:
in mighty battles and in moving sermons
he always took the lead against the pagans.
May God bestow on him His holy blessing! AOI

167

Count Roland sees the archbishop on the ground:
he sees the entrails bulging from his body.
His brains are boiling out upon his forehead.
Upon his chest, between the collarbones, 510
he laid crosswise his beautiful white hands,
lamenting him, as was his country's custom:
"Oh noble vassal, well-born chevalier,
I now commend you to celestial Glory.
No man will ever serve Him with such zeal;
no prophet since the days of the Apostles
so kept the laws and drew the hearts of men.
Now may your soul endure no suffering;
may Heaven's gate be opened up for you!"

168

Count Roland realizes death is near: 520
his brains begin to ooze out through his ears.
He prays to God to summon all his peers,
and to the angel Gabriel, himself.
Eschewing blame, he takes the horn in hand
and in the other Durendal, his sword,
and farther than a crossbow fires a bolt,
heads out across a fallow field toward Spain
and climbs a rise. Beneath two lovely trees
stand four enormous marble monoliths.
Upon the green grass he has fallen backward 530
and fainted, for his death is near at hand.

169

The hills are high, and very high the trees;
four massive blocks are there, of gleaming marble;
upon green grass Count Roland lies unconscious.
And all the while a Saracen is watching:
he lies among the others, feigning death;
he smeared his body and his face with blood.
He rises to his feet and starts to run—
a strong, courageous, handsome man he was;
through pride he enters into mortal folly— 540
and pinning Roland's arms against his chest,
he cries out: "Charles's nephew has been vanquished;
I'll take this sword back to Arabia."
And as he pulls, the count revives somewhat.

170

Now Roland feels his sword is being taken
and, opening his eyes, he says to him:
"I know for certain you're not one of us!"
He takes the horn he didn't want to leave
and strikes him on his jeweled golden casque;
he smashes through the steel and skull and bones, 550
and bursting both his eyeballs from his head,
he tumbles him down lifeless at his feet
and says to him: "How dared you, heathen coward,
lay hands on me, by fair means or by foul?
Whoever hears of this will think you mad.
My ivory horn is split across the bell,
and the crystals and the gold are broken off."

171

Now Roland feels his vision leaving him,
gets to his feet, exerting all his strength;
the color has all vanished from his face. 560
In front of him there is a dull gray stone;
ten times he strikes it, bitter and dismayed:

the steel edge grates, but does not break or nick.
"Oh holy Mary, help me!" says the count,
"Oh Durendal, good sword, you've come to grief!
When I am dead, you won't be in my care.
I've won with you on many battlefields
and subjugated many spacious lands
now ruled by Charles, whose beard is shot with gray.
No man who flees another should possess you! 570
A loyal knight has held you many years;
your equal holy France will never see."

172

Roland strikes the great carnelian stone:
the steel edge grides, but does not break or chip.
And when he sees that he cannot destroy it,
he makes this lamentation to himself:
"Oh Durendal, how dazzling bright you are—
you blaze with light and shimmer in the sun!
King Charles was in the Vales of Moriane
when God in Heaven had His angel tell him 580
that he should give you to a captain-count:
the great and noble king then girded me.
With this I won Anjou and Brittany,
and then I won him both Poitou and Maine.
with this I won him Normandy the Proud,
and then I won Provence and Aquitaine,
and Lombardy, as well as all Romagna.
With this I won Bavaria, all Flanders,
and Burgundy, the Poliani lands,
Constantinople, where they did him homage— 590
in Saxony they do what he commands.
With this I won him Scotland, Ireland too,
and England, which he held as his demesne.
With this I've won so many lands and countries
which now are held by Charles, whose beard is white.
I'm full of pain and sorrow for this sword;
I'd rather die than leave it to the pagans.
Oh God, my Father, don't let France be shamed!"

173

Roland hammers on a dull gray stone
and breaks off more of it than I can say: 600
the sword grates, but it neither snaps nor splits,
and only bounces back into the air.
The count, on seeing he will never break it,
laments it very softly to himself:
"Oh Durendal, so beautiful and sacred,
within your golden hilt are many relics—
Saint Peter's tooth, some of Saint Basil's blood,
some hair belonging to my lord, Saint Denis,
a remnant, too, of holy Mary's dress.
It isn't right that pagans should possess you; 610
you ought to be attended on by Christians.
You never should be held by one who cowers!
With you I've conquered many spacious lands
now held by Charles, whose beard is streaked with
 white;
through them the emperor is rich and strong."

174

Now Roland feels death coming over him,
descending from his head down to his heart.
He goes beneath a pine tree at a run
and on the green grass stretches out, face down.
He puts his sword and ivory horn beneath him 620
and turns his head to face the pagan host.
He did these things in order to be sure
that Charles, as well as all his men, would say:

"This noble count has died a conqueror."
Repeatedly he goes through his confession,
and for his sins he proffers God his glove. AOI

175

Now Roland is aware his time is up:
he lies upon a steep hill, facing Spain,
and with one hand he beats upon his chest:
"Oh God, against Thy power I have sinned, 630
because of my transgressions, great and small,
committed since the hour I was born
until this day when I have been struck down!"
He lifted up his right-hand glove to God:
from Heaven angels came to him down there. AOI

176

Count Roland lay down underneath a pine,
his face turned so that it would point toward Spain:
he was caught up in the memory of things—
of many lands he'd valiantly subdued,
of sweet France, of the members of his line, 640
of Charlemagne, his lord, who brought him up;
he cannot help but weep and sigh for these.
But he does not intend to slight himself;
confessing all his sins, he begs God's mercy:
"True Father, Who hath never told a lie,
Who resurrected Lazarus from the dead,
and Who protected Daniel from the lions,
protect the soul in me from every peril
brought on by wrongs I've done throughout my
 life!"
He offered up his right-hand glove to God: 650
Saint Gabriel removed it from his hand.
And with his head inclined upon his arm,
hands clasped together, he has met his end.
Then God sent down his angel Cherubin
and Saint Michael of the Sea and of the Peril;
together with Saint Gabriel they came
and took the count's soul into Paradise.

177

Roland is dead, his soul with God in Heaven.
The emperor arrives at Roncesvals.
There's not a single trace nor footpath there, 660
nor ell, nor even foot of vacant ground,
on which there's not a pagan or a Frank.
"Fair nephew," Charles cries loudly, "where are you?
Where's the archbishop, and Count Olivier?
Where is Gerin, and his comrade Gerier?
Where is Anton? and where's Count Berenger?
Ivon and Ivorie, I held so dear?
What's happened to the Gascon, Engelier?
and Duke Sanson? and gallant Anseïs?
and where is Old Gerard of Roussillon? 670
—the twelve peers I permitted to remain?"
But what's the use, when none of them reply?
The king says: "God! I've cause enough to grieve
that I was not here when the battle started!"
He tugs upon his beard like one enraged;
the eyes of all his noble knights shed tears,
and twenty thousand fall down in a faint.
Duke Naimes profoundly pities all of them.

178

There's not a chevalier or baron there
who fails to shed embittered tears of grief; 680
they mourn their sons, their brothers, and their nephews,

together with their liege-lords and their friends;
and many fall unconscious to the ground.
Duke Naimes displayed this courage through all this,
for he was first to tell the emperor:
"Look up ahead of us, two leagues away—
along the main road you can see the dust,
so many of the pagan host are there.
So ride! Take vengeance for this massacre!"
"Oh God!" says Charles, "already they're so far! 690
Permit me what is mine by right and honor;
they've robbed me of the flower of sweet France."
The king gives orders to Geboin, Oton,
Thibaud of Reims, and to the count Milon:
"You guard the field—the valleys and the hills.
Leave all the dead exactly as they lie,
make sure no lion or other beast comes near,
and let no groom or serving-man come near.
Prohibit any man from coming near them
till God grants our return upon this field." 700
In fond, soft-spoken tones these men reply:
"Dear lord and rightful emperor, we'll do it!"
They keep with them a thousand chevaliers. AOI

179

The emperor has had his trumpets sounded;
then, with his mighty host, the brave lord rides.
The men from Spain have turned their backs to them;
they all ride out together in pursuit.
The king, on seeing dusk begin to fall,
dismounts upon the green grass in a field,
prostrates himself, and prays Almighty God 710
that He will make the sun stand still for him,
hold back the night, and let the day go on.
An angel he had spoken with before
came instantly and gave him this command:
"Ride on, Charles, for the light shall not desert you.
God knows that you have lost the flower of France;
you may take vengeance on the guilty race."
And at these words, the emperor remounts. AOI

180

For Charlemagne God worked a miracle,
because the sun is standing motionless. 720
The pagans flee, the Franks pursue them hard,
and overtake them at Val-Tenebrus.
They fight them on the run toward Saragossa;
with mighty blows they kill them as they go;
they cut them off from the main roads and the lanes.
The river Ebro lies in front of them,
a deep, swift-running, terrifying stream;
there's not a barge or boat or dromond there.
The pagans call on Termagant, their god,
and then leap in, but nothing will protect them. 730
The men in armor are the heaviest,
and numbers of them plummet to the bottom;
the other men go floating off downstream.
The best equipped thus get their fill to drink;
they all are drowned in dreadful agony.
The Frenchmen cry out: "You were luckless,
 Roland!" AOI

181

As soon as Charles sees all the pagans dead
(some killed, a greater number of them drowned)
and rich spoils taken off them by his knights,
the noble king then climbs down to his feet, 740
prostrates himself, and offers thanks to God.

When he gets up again, the sun has set.
"It's time to pitch camp," says the emperor.
"It's too late to go back to Roncesvals.
Our horses are fatigued and ridden down;
unsaddle them and then unbridle them
and turn them out to cool off in this field."
The Franks reply: "Sire, you have spoken well." AOI

182

The emperor has picked a place to camp.
The French dismount upon the open land 750
and pull the saddles off their destriers
and take the gold-trimmed bridles from their heads;
then turn them out to graze the thick green grass;
there's nothing else that they can do for them.
The tiredest go to sleep right on the ground:
that night they post no sentinels at all.

183

The emperor has lain down in a meadow.
The brave lord sets his great lance at his head—
tonight he does not wish to be unarmed—
keeps on his shiny, saffron-yellow hauberk, 760
and his jeweled golden helmet, still laced up,
and at his waist Joyeuse, which has no peer:
its brilliance alters thirty times a day.
We've heard a great deal spoken of the lance
with which Our Lord was wounded on the cross;
that lance's head is owned by Charles, thank God;
he had its tip inletted in the pommel.
Because of this distinction and this grace,
the name "Joyeuse" was given to the sword.
The Frankish lords will not forget this fact:
they take from it their battle cry, "Monjoy."
Because of this, no race can stand against them.

From *Song of Roland*, translated by Robert Harrison. Copyright © 1970 by Robert Harrison. Used by permission of Dutton Signet, a division of Penguin Group (USA), Inc.

READING 35
EVERYMAN (15TH CENTURY)

Written in rhyming couplets, EVERYMAN is a good example of the transitional play that forms a link between the earlier liturgical drama and the more secular drama that was to come at the end of the English medieval period. The subject of EVERYMAN is one dear to the medieval heart—the struggle for the soul—and the plot is quickly summarized by the Messenger who opens the play: Everyman must face God in final judgment after death. None of the aids and friends of this life will support Everyman, as the speeches of the allegorical figures of Fellowship and others make clear. The strengths for Everyman come from the aiding virtues of Confession, Good Deeds, and Knowledge. The story, however, is not the central core of this play; the themes that run through the entire play are what should engage our attention. First is the common medieval notion of life as a pilgrimage, which surfaces repeatedly. Second, the notion of the inevitability of death as the defining action of human life is omnipresent in medieval culture. EVERYMAN has an intense memento mori motif—"Keep death before your eyes!" Finally, medieval theology places great emphasis on the will of the human being in the attainment of salvation. It is not faith (this virtue is presumed) that will save Everyman; his or her willingness to learn (Knowledge), act (Good Deeds), and convert (Confession) will make the difference between salvation and damnation.

MESSENGER I pray you all give your audience,
 And hear this matter with reverence,

By figure° a moral play: *in form*
The *Summoning of Everyman* called it is,
That of our lives and ending shows 5
How transitory we be all day. ° *always*
This matter is wondrous precious,
But the intent of it is more gracious,
And sweet to bear away.
The story saith: Man, in the beginning 10
Look well, and take good heed to the ending,
Be you never so gay!
Ye think sin in the beginning full sweet,
Which in the end causeth the soul to weep,
When the body lieth in clay. 15
Here shall you see how Fellowship and Jollity,
Both Strength, Pleasure, and Beauty,
Will fade from thee as flower in May;
For ye shall hear how our Heaven King
Calleth Everyman to a general reckoning: 20
Give audience, and hear what he doth say.

[EXIT]

[GOD *SPEAKETH*]

GOD I perceive, here in my majesty,
How that all creatures be to me unkind,° *ungrateful*
Living without dread in worldly prosperity:
Of ghostly sight the people be so blind, 25
Drowned in sin, they know me not for
 their God;
In worldly riches is all their mind,
They fear not my righteousness, the
 sharp rod.
My law that I showed, when I for them died,
They forget clean, and shedding of my
 blood red; 30
I hanged between two, it cannot be denied;
To get them life I suffered to be dead;
I healed their feet, with thorns hurt was
 my head.
I could do no more than I did, truly;
And now I see the people do clean for-
 sake me: 35
They use the seven deadly sins damnable,
As pride, covetise, wrath, and lechery° *covetousness*
Now in the world be made commendable;
And thus they leave of angels the heavenly
 company.
Every man liveth so after his own pleasure, 40
And yet of their life they be nothing sure:
I see the more that I them forbear
The worse they be from year to year.
All that liveth appaireth° fast; *degenerates*
Therefore I will, in all the haste, 45
Have a reckoning of every man's person;
For, and° I leave the people thus alone *if*
In their life and wicked tempests,° *tumults*
Verily they will become much worse than
 beasts;
For now one would by envy another up eat; 50
Charity they do all clean forget.
I hoped well that every man
In my glory should make his mansion,
And thereto I had them all elect;
But now I see, like traitors deject,° *abject*
They thank me not for the pleasure that I to° *for*
 them meant
Nor yet for their being that I them have lent.
I proffered the people great multitude of
 mercy,

And few there be that asketh it heartily.° *earnestly*
They be so cumbered with worldly riches 60
That needs on them I must do justice,
On every man living without fear.
Where art thou, Death, thou mighty messenger?

[*ENTER* DEATH]

DEATH Almighty God, I am here at your will,
Your commandment to fulfil. 65
GOD Go thou to Everyman,
And show him, in my name,
A pilgrimage he must on him take,
Which he in no wise may escape;
And that he bring with him a sure reckoning 70
Without delay or any tarrying.

[GOD *WITHDRAWS*]

DEATH Lord, I will in the world go run
 overall,° *everywhere*
And cruelly outsearch both great and small;
Every man will I beset that liveth beastly
Out of God's laws, and dreadeth not folly. 75
He that loveth riches I will strike with
 my dart,
His sight to blind, and from heaven to
 depart°— *separate*
Except that alms be his good friend—
In hell for to dwell, world without end.
Lo, yonder I see Everyman walking. 80
Full little he thinketh on my coming;
His mind is on fleshly lusts and his treasure,
And great pain it shall cause him to endure
Before the Lord, Heaven King.

[*ENTER* EVERYMAN]

EVERYMAN, stand still! Whither art
 thou going 85
Thus gaily? Hast thou thy Maker forget?
EVERYMAN Why askest thou?
Wouldest thou wit?° *know*
DEATH Yea, sir; I will show you:
In great haste I am sent to thee 90
From God out of his majesty.
EVERYMAN What, sent to me?
DEATH Yea, certainly.
Though thou have forget him here,
He thinketh on thee in the heavenly sphere, 95
As, ere we depart, thou shalt know.
EVERYMAN What desireth God of me?
DEATH That shall I show thee:
A reckoning he will needs have
Without any longer respite. 100
EVERYMAN To give a reckoning longer leisure
 I crave;
This blind° matter troubleth my wit. *obscure*
DEATH On thee thou must take a long
 journey;
Therefore thy book of count° with thee thou *account*
 bring,
For turn again° thou cannot by no way. *return*
And look thou be sure of thy reckoning,
For before God thou shalt answer, and show
Thy many bad deeds, and good but a few;
How thou hast spent thy life, and in
 what wise,
Before the chief Lord of paradise. 110
Have ado that we were in that way,
For, wit thou well, thou shalt make none attorney.

EVERYMAN Full unready I am such reckoning
 to give.
 I know thee not. What messenger art thou?
DEATH I am Death, that no man dreadeth, 115
 For every man I rest,° and no man spareth; *arrest*
 For it is God's commandment
 That all to me should be obedient.
EVERYMAN O Death, thou comest when I had
 thee least in mind!
 In thy power it lieth me to save; 120
 Yet of my good° will I give thee, if thou will *goods*
 be kind:
 Yea, a thousand pound shalt thou have,
 And defer this matter till another day.
DEATH Everyman, it may not be, by no way.
 I set not by° gold, silver, nor riches *care not for*
 Ne by pope, emperor, king, duke, ne princes;
 For, and° I would receive gifts great, *if*
 All the world I might get;
 But my custom is clean contrary.
 I give thee no respite. Come hence, and not
 tarry. 130
EVERYMAN Alas, shall I have no longer
 respite?
 I may say Death giveth no warning!
 To think on thee, it maketh my heart sick,
 For all unready is my book of reckoning.
 But twelve year and I might have abiding, 135
 My counting-book I would make so clear
 That my reckoning I should not need to fear.
 Wherefore, Death, I pray thee, for God's
 mercy,
 Spare me till I be provided of remedy.
DEATH Thee availeth not to cry, weep,
 and pray; 140
 But haste thee lightly that thou were gone
 that journey,
 And prove thy friends if thou can;
 For, wit thou well, the tide° abideth no man, *time*
 And in the world each living creature
 For Adam's sin must die of nature. 145
EVERYMAN Death, if I should this pilgrim-
 age take,
 And my reckoning surely make,
 Show me, for saint charity,
 Should I not come again shortly?
DEATH No, Everyman; and thou be once there, 150
 Thou mayst never more come here,
 Trust me verily.
EVERYMAN O gracious God in the high seat
 celestial.
 Have mercy on me in this most need!
 Shall I have no company from this vale
 terrestrial 155
 Of mine acquaintance, that way me to lead?
DEATH Yea, if any be so hardy
 That would go with thee and bear thee
 company.
 Hie thee that thou were gone to God's
 magnificence,
 Thy reckoning to give before his presence. 160
 What, weenest° thou thy life is given thee, *suppose*
 And thy worldly goods also?
EVERYMAN I had wend° so, verily. *supposed*
DEATH Nay, nay; it was but lent thee;
 For as soon as thou art go,° *gone*
 Another a while shall have it, and then go
 therefro,° *from it*

Even as thou hast done.
 Everyman, thou art mad! Thou hast thy
 wits five,
 And here on earth will not amend thy life;
 For suddenly I do come. 170
EVERYMAN O wretched caitiff, whither shall
 I flee,
 That I might scape this endless sorrow?
 Now, gentle Death, spare me till tomorrow,
 That I may amend me
 With good advisement.° *reflection*
DEATH Nay, thereto I will not consent,
 Nor no man will I respite;
 But to the heart suddenly I shall smite
 Without any advisement.
 And now out of thy sight I will me hie; 180
 See thou make thee ready shortly,
 For thou mayst say this is the day
 That no man living may scape away.

[*EXIT* DEATH]

EVERYMAN Alas, I may well weep with
 sighs deep!
 Now have I no manner of company 185
 To help me in my journey, and me to keep;° *guard*
 And also my writing is full unready.
 How shall I do now for to excuse me?
 I would to God I had never be get!° *been born*
 To my soul a full great profit it had be; 190
 For now I fear pains huge and great.
 The time passeth. Lord, help, that all wrought!
 For though I mourn it availeth nought.
 The day passeth, and is almost ago;° *gone*
 I wot not well what for to do. 195
 To whom were I best my complaint
 to make?
 What and° I to Fellowship thereof spake, *if*
 And showed him of this sudden chance?
 For in him is all mine affiance;° *trust*
 We have in the world so many a day 200
 Be good friends in sport and play.
 I see him yonder, certainly.
 I trust that he will bear me company;
 Therefore to him will I speak to ease my
 sorrow.
 Well met, good Fellowship, and good
 morrow! 205

[FELLOWSHIP *SPEAKETH*]

FELLOWSHIP Everyman, good morrow, by
 this day!
 Sir, why lookest thou so piteously?
 If any thing be amiss, I pray thee me say,
 That I may help to remedy.
EVERYMAN Yea, good Fellowship, yea; 210
 I am in great jeopardy.
FELLOWSHIP My true friend, show to me
 your mind;
 I will not forsake thee to my life's end,
 In the way of good company.
EVERYMAN That was well spoken, and
 lovingly. 215
FELLOWSHIP Sir, I must needs know your
 heaviness;° *sorrow*
 I have pity to see you in any distress.
 If any have you wronged, ye shall revenged be,
 Though I on the ground be slain for thee—

Though that I know before that I should die. 220
EVERYMAN Verily, Fellowship, gramercy.
FELLOWSHIP Tush! by thy thanks I set not a
 straw.
 Show me your grief, and say no more.
EVERYMAN If I my heart should to you break,° *open*
 And then you to turn your mind from me, 225
 And would not me comfort when ye hear me
 speak,
 Then should I ten times sorrier be.
FELLOWSHIP Sir, I say as I will do indeed.
EVERYMAN Then be you a good friend at need:
 I have found you true herebefore. 230
FELLOWSHIP And so ye shall evermore;
 For, in faith, and thou go to hell,
 I will not forsake thee by the way.
EVERYMAN Ye speak like a good friend; I
 believe you well.
 I shall deserve° it, and I may. *repay*
FELLOWSHIP I speak of no deserving, by
 this day!
 For he that will say, and nothing do,
 Is not worthy with good company to go;
 Therefore show me the grief of your mind,
 As to your friend most loving and kind. 240
EVERYMAN I shall show you how it is:
 Commanded I am to go a journey,
 A long way, hard and dangerous,
 And give a strait count,° without delay, *strict account*
 Before the high Judge, Adonai. 245
 Wherefore, I pray you, bear me company,
 As ye have promised, in this journey.
FELLOWSHIP That is matter indeed. Promise
 is duty;
 But, and I should take such a voyage on me,
 I know it well, it should be to my pain; 250
 Also it maketh me afeard, certain.
 But let us take counsel here as well as
 we can,
 For your words would fear° a strong man *frighten*
EVERYMAN Why, ye said if I had need
 Ye would me never forsake, quick ne dead, 255
 Though it were to hell, truly.
FELLOWSHIP So I said, certainly,
 But such pleasures be set aside, the sooth
 to say;
 And also, if we took such a journey,
 When should we come again? 260
EVERYMAN Nay, never again, till the day
 of doom.
FELLOWSHIP In faith, then will not I come
 there!
 Who hath you these tidings brought?
EVERYMAN Indeed, Death was with me here.
FELLOWSHIP Now, by God 265
 that all hath bought,° *redeemed*
 If Death were the messenger,
 For no man that is living to-day
 I will not go that loath° journey— *loathsome*
 Not for the father that begat me!
EVERYMAN Ye promised otherwise, pardie.° *by God*
FELLOWSHIP I wot well I said so, truly;
 And yet if thou wilt eat, drink, and make
 good cheer,
 Or haunt to women the lusty company,
 I would not forsake you while the day is
 clear,
 Trust me verily. 275

EVERYMAN Yea, thereto ye would be ready!
 To go to mirth, solace, and play,
 Your mind will sooner apply,° *attend*
 Than to bear me company in my long
 journey.
FELLOWSHIP Now, in good faith, I will not
 that way. 280
 But and thou will murder, or any man kill,
 In that I will help thee with a good will.
EVERYMAN O, that is a simple advice indeed.
 Gentle fellow, help me in my necessity!
 We have loved long, and now I need; 285
 And now, gentle Fellowship, remember me.
FELLOWSHIP Whether ye have loved
 me or no,
 By Saint John, I will not with thee go.
EVERYMAN Yet, I pray thee, take the labour,
 and do so much for me
 To bring me forward,° for saint charity, *'escort me*
 And comfort me till I come without
 the town.
FELLOWSHIP Nay, and thou would give me a
 new gown,
 I will not a foot with thee go;
 But, and thou had tarried, I would not have
 left thee so.
 And as now God speed thee in thy journey, 295
 For from thee I will depart as fast as I may.
EVERYMAN Whither away, Fellowship? Will
 thou forsake me?
FELLOWSHIP Yea, by my fay°! To God I *faith*
 betake° thee. *commend*
EVERYMAN Farewell, good Fellowship; for
 thee my heart is sore.
 Adieu for ever! I shall see thee no more. 300
FELLOWSHIP In faith, Everyman, farewell
 now at the ending;
 For you I will remember that parting is
 mourning.

 [*EXIT* FELLOWSHIP]

EVERYMAN Alack! shall we thus depart° *part*
 indeed—
 Ah, Lady, help!—without any more
 comfort?
 Lo, Fellowship forsaketh me in my
 most need. 305
 For help in this world whither shall I resort?
 Fellowship herebefore with me would
 merry make,
 And now little sorrow for me doth he take.
 It is said, "In prosperity men friends may find,
 Which in adversity be full unkind." 310
 Now whither for succour shall I flee,
 Sith° that Fellowship hath forsaken me? *since*
 To my kinsmen I will, truly,
 Praying them to help me in my necessity;
 I believe that they will do so, 315
 For kind will creep where it may not go.
 I will go say,° for yonder I see them. *essay, try*
 Where be ye now, my friends and kinsmen?

 [*ENTER* KINDRED *AND* COUSIN]

KINDRED Here be we now at your com-
 mandment.
 Cousin, I pray you show us your intent 320
 In any wise, and do not spare.
COUSIN Yea, Everyman, and to us declare

If ye be disposed to go anywhither;° *anywhere*
For, wit you well, we will live and die
 together.
KINDRED In wealth and woe 325
 we will with you hold,° *side*
For over his kin a man may be bold.
EVERYMAN Gramercy, my friends and kins-
 men kind.
 Now shall I show you the grief of my mind:
 I was commanded by a messenger,
 That is a high king's chief officer; 330
 He bade me go a pilgrimage, to my pain,
 And I know well I shall never come again;
 Also I must give a reckoning strait,
 For I have a great enemy that hath me in wait,
 Which intendeth me for to hinder. 335
KINDRED What account is that which ye must
 render?
 That would I know.
EVERYMAN Of all my works I must show
 How I have lived and my days spent;
 Also of ill deeds that I have used° *practiced*
 In my time, sith life was me lent;
 And of all virtues that I have refused.
 Therefore, I pray you, go thither with me
 To help to make mine account, for saint
 charity.
COUSIN What, to go thither? Is that the matter? 345
 Nay, Everyman, I had liefer fast bread
 and water
 All this five year and more.
EVERYMAN Alas, that ever I was bore!° *born*
 For now shall I never be merry,
 If that you forsake me. 350
KINDRED Ah, sir, what ye be a merry man!
 Take good heart to you, and make no moan.
 But one thing I warn you, by Saint Anne—
 As for me, ye shall go alone.
EVERYMAN My Cousin, will you not
 with me go? 355
COUSIN No, by our Lady! I have the cramp in
 my toe.
 Trust not to me, for, so God me speed,
 I will deceive you in your most need.
KINDRED It availeth not us to tice.
 Ye shall have my maid with all my heart; 360
 She loveth to go to feasts, there to be nice,° *wanton*
 And to dance, and abroad to start:
 I will give her leave to help you in that
 journey,
 If that you and she may agree.
EVERYMAN Now show me the very 365
 effect° of your mind: *tenor*
 Will you go with me, or abide behind?
KINDRED Abide behind? Yea, that will I, and
 I may!
 Therefore farewell till another day.

[EXIT KINDRED]

EVERYMAN How should I be merry or glad?
 For fair promises men to me make, 370
 But when I have most need they me forsake.
 I am deceived; that maketh me sad.
COUSIN Cousin Everyman, farewell now,
 For verily I will not go with you.
 Also of mine own an unready reckoning 375
 I have to account; therefore I make tarrying.
 Now God keep thee, for now I go.

[EXIT COUSIN]

EVERYMAN Ah, Jesus, is all come hereto?
 Lo, fair words maketh fools fain;
 They promise, and nothing will do, certain. 380
 My kinsmen promised me faithfully
 For to abide with me steadfastly,
 And now fast away do they flee:
 Even so Fellowship promised me.
 What friend were best me of to provide? 385
 I lose my time here longer to abide.
 Yet in my mind a thing there is:
 All my life I have loved riches;
 If that my Good° now help me might, *Goods*
 He would make my heart full light. 390
 I will speak to him in this distress—
 Where art thou, my Goods and riches?

[GOODS *SPEAKS FROM A CORNER*]

GOODS Who calleth me? Everyman? What!
 hast thou haste?
 I lie here in corners, trussed and piled
 so high,
 And in chests I am locked so fast, 395
 Also sacked in bags. Thou mayst see with
 thine eye
 I cannot stir; in packs low I lie.
 What would you have? Lightly° me say *quickly*
EVERYMAN Come hither, Good, in all the
 haste thou may,
 For of counsel I must desire thee. 400
GOODS Sir, and ye in the world have sorrow
 or adversity,
 That can I help you to remedy shortly.
EVERYMAN It is another disease° that *trouble*
 grieveth me;
 In this world it is not, I tell thee so.
 I am sent for, another way to go, 405
 To give a strait count general
 Before the highest Jupiter of all;
 And all my life I have had joy and pleasure in thee,
 Therefore, I pray thee, go with me;
 For, peradventure, thou mayst before God
 Almighty 410
 My reckoning help to clean and purify;
 For it is said ever among
 That money maketh all right that is wrong.
GOODS Nay, Everyman, I sing another song.
 I follow no man in such voyages; 415
 For, and I went with thee,
 Thou shouldst fare much the worse for me;
 For because on me thou did set thy mind,
 Thy reckoning I have made blotted° and *obscure*
 blind,
 That thine account thou cannot make truly; 420
 And that hast thou for the love of me.
EVERYMAN That would grieve me full sore,
 When I should come to that fearful answer.
 Up, let us go thither together.
GOODS Nay, not so! I am too brittle, I may not
 endure; 425
 I will follow no man one foot, be ye sure.
EVERYMAN Alas, I have thee loved, and had
 great pleasure
 All my life-days on good and treasure.
GOODS That is to thy damnation, without
 leasing,
 For my love is contrary to the love everlasting; 430

But if thou had me loved moderately during,
As to the poor to give part of me,
Then shouldst thou not in this dolour° be, *distress*
Nor in this great sorrow and care.
EVERYMAN Lo, now was I deceived 435
 ere I was ware,° *aware*
And all I may write misspending of time.
GOODS What, weenest thou that I am thine?
EVERYMAN I had wend° so. *supposed*
GOODS Nay, Everyman, I say no.
 As for a while I was lent thee; 440
A season thou hast had me in prosperity.
My condition° is man's soul to kill; *nature*
If I save one, a thousand I do spill.° *ruin*
Weenest thou that I will follow thee?
 Nay, not from this world, verily. 445
EVERYMAN I had wend otherwise.
GOODS Therefore to thy soul Good is a thief;
For when thou art dead, this is my guise°— *practice*
 Another to deceive in this same wise
As I have done thee, 450
 and all to his soul's reprief.°— *shame*
EVERYMAN O false Good, cursed may
 thou be,
Thou traitor to God, that hast deceived me
And caught me in thy snare!
GOODS Marry, thou brought thyself in care,
 Whereof I am glad; 455
I must needs laugh, I cannot be sad.
EVERYMAN Ah, Good, thou hast had long my
 heartly° love; *heartfelt*
I gave thee that which should be the Lord's
 above.
But wilt thou not go with me indeed?
I pray thee truth to say. 460
GOODS No, so God me speed!
 Therefore farewell, and have good day.

[*EXIT* GOODS]

EVERYMAN O, to whom shall I make my moan
For to go with me in that heavy journey?
First Fellowship said he would 465
 with me gone;° *go*
His words were very pleasant and gay,
But afterward he left me alone.
Then spake I to my kinsmen, all in despair,
And also they gave me words fair;
They lacked no fair speaking, 470
But all forsook me in the ending.
Then went I to my Goods, that I loved best,
In hope to have comfort, but there had I least;
For my Goods sharply did me tell
That he bringeth many into hell. 475
Then of myself I was ashamed,
And so I am worthy to be blamed;
Thus may I well myself hate.
Of whom shall I now counsel take?
I think that I shall never speed 480
Till that I go to my Good Deed.
But, alas, she is so weak
That she can neither go° nor speak; *walk*
Yet will I venture° on her now. *gamble*
My Good Deeds, where be you? 485

[GOOD DEEDS *SPEAKS FROM THE GROUND*]

GOOD DEEDS Here I lie, cold in the ground;
Thy sins hath me sore bound,
That I cannot stir.

EVERYMAN O Good Deeds, I stand in fear!
I must you pray of counsel, 490
For help now should come right well.
GOOD DEEDS Everyman, I have under-
 standing
That ye be summoned account to make
Before Messias, of Jerusalem King;
And you do by me, that journey with you
 will I take. 495
EVERYMAN Therefore I come to you, my
 moan to make;
GOOD DEEDS I would full fain, but I cannot
 stand, verily.
EVERYMAN Why, is there anything on you fall°? *befallen*
GOOD DEEDS Yea, sir, I may thank you of° all; *for*
If ye had perfectly cheered me,
Your book of count full ready had be.
Look, the books of your works and
 deeds eke°! *also*
Behold how they lie under the feet,
To your soul's heaviness. 505
EVERYMAN Our Lord Jesus help me!
For one letter here I cannot see.
GOOD DEEDS There is a blind reckoning in
 time of distress.
EVERYMAN Good Deeds, I pray you help me
 in this need,
Or else I am for ever damned indeed; 510
Therefore help me to make reckoning
Before the Redeemer of all thing,
That King is, and was, and ever shall.
GOOD DEEDS Everyman, I am sorry of
 your fall,
And fain would I help you, and I were able. 515
EVERYMAN Good Deeds, your counsel I pray
 you give me.
GOOD DEEDS That shall I do verily;
Though that on my feet I may not go,
I have a sister that shall with you also,
Called Knowledge, which shall with you
 abide, 520
To help you to make that dreadful
 reckoning.

[*ENTER* KNOWLEDGE]

KNOWLEDGE Everyman, I will go with thee,
 and be thy guide,
In thy most need to go by thy side.
EVERYMAN In good condition I am now in
 every thing,
And am wholly content with this good thing 525
Thanked be God my creator.
GOOD DEEDS And when she hath brought
 you there
Where thou shalt heal thee of thy smart,° *pain*
Then go you with your reckoning and your
 Good Deeds together,
For to make you joyful at heart 530
Before the blessed Trinity.
EVERYMAN My Good Deeds, gramercy!
I am well content, certainly,
With your words sweet.
KNOWLEDGE Now go we together lovingly 535
To Confession, that cleansing river.
EVERYMAN For joy I weep; I would we were
 there!
But, I pray you, give me cognition° *knowledge*
Where dwelleth that holy man, Confession.

KNOWLEDGE In the house of salvation: 540
 We shall find him in that place,
 That shall us comfort, by God's grace.

 [KNOWLEDGE *TAKES* EVERYMAN *TO* CONFESSION]

 Lo, this is Confession. Kneel down and ask
 mercy,
 For he is in good conceit° with God *esteem*
 Almighty.
EVERYMAN O glorious fountain, that all
 uncleanness doth clarify, 545
 Wash from me the spots of vice unclean,
 That on me no sin may be seen.
 I come with Knowledge for my redemption,
 Redempt with heart and full contrition;
 For I am commanded a pilgrimage to take, 550
 And great accounts before God to make.
 Now I pray you, Shrift,° mother of salvation *confession*
 Help my Good Deeds for my piteous
 exclamation.
CONFESSION I know your sorrow well,
 Everyman.
 Because with Knowledge ye come to me, 555
 I will you comfort as well as I can,
 And a precious jewel I will give thee,
 Called penance, voider° of adversity; *expeller*
 Therewith shall your body chastised be,
 With abstinence and perseverance in God's service. 560
 Here shall you receive that scourge of me,
 Which is penance strong that ye must
 endure,
 To remember thy Saviour was scourged
 for thee
 With sharp scourges, and suffered it patiently;
 So must thou, ere thou scape that painful
 pilgrimage. 565
 Knowledge, keep him in this voyage,
 And by that time Good Deeds will be
 with thee.
 But in any wise be siker° of mercy, *sure*
 For your time draweth fast; and° ye will *if*
 saved be,
 Ask God mercy, and he will grant truly. 570
 When with the scourge of penance man doth
 him° bind, *himself*
 The oil of forgiveness then shall he find.
EVERYMAN Thanked be God for his
 gracious work!
 For now I will my penance begin; 575
 This hath rejoiced and lighted° my heart *lightened*
 Though the knots be painful and hard
 within.
KNOWLEDGE Everyman, look your penance
 that ye fulfil,
 What pain that ever it to you be;
 And Knowledge shall give you counsel
 at will
 How your account ye shall make clearly. 580
EVERYMAN O eternal God, O heavenly figure,
 O way of righteousness, O goodly vision,
 Which descended down in a virgin pure
 Because he would every man redeem,
 Which Adam forfeited by his disobedience: 585
 O blessed Godhead, elect and high divine,° *divinity*
 Forgive my grievous offence;
 Here I cry thee mercy in this presence.
 O ghostly treasure, O ransomer and
 redeemer,

 Of all the world hope and conductor, 590
 Mirror of joy, and founder of mercy,
 Which enlumineth heaven and earth
 thereby,° *besides*
 Hear my clamorous complaint, though it
 late be;
 Receive my prayers, of thy benignity;
 Though I be a sinner most abominable, 595
 Yet let my name be written in Moses' table.
 O Mary, pray to the Maker of all thing,
 Me for to help at my ending;
 And save me from the power of my enemy,
 For Death assaileth me strongly. 600
 And, Lady, that I may by mean of thy prayer
 Of your Son's glory to be partner,
 By the means of his passion, I it crave;
 I beseech you help my soul to save.
 Knowledge, give me the scourge of penance; 605
 My flesh therewith shall give acquittance;
 I will now begin, if God give me grace.
KNOWLEDGE Everyman, God give you time
 and space!° *opportunity*
 Thus I bequeath you in the hands of our
 Saviour;
 Now may you make your reckoning sure. 610
EVERYMAN In the name of the Holy Trinity,
 My body sore punished shall be:
 Take this, body, for the sin of the flesh!

 [*SCOURGES HIMSELF*]

 Also° thou delightest to go gay and fresh, *as*
 And in the way of damnation thou did me
 bring, 615
 Therefore suffer now strokes and punishing.
 Now of penance I will wade the water clear,
 To save me from purgatory, that sharp fire.

 [GOOD DEEDS *RISES FROM THE GROUND*]

GOOD DEEDS I thank God, now I can walk
 and go,
 And am delivered of my sickness and woe. 620
 Therefore with Everyman I will go, and not
 spare;
 His good works I will help him to declare.
KNOWLEDGE Now, Everyman, be merry
 and glad!
 Your Good Deeds whole and sound, 625
 Going upright upon the ground.
EVERYMAN My heart is light, and shall be
 evermore;
 Now will I smite faster than I did before.
GOOD DEEDS Everyman, pilgrim, my special
 friend,
 Blessed be thou without end; 630
 For thee is preparate° the eternal glory. *prepared*
 Ye have me made whole and sound,
 Therefore I will bide by thee in every stound.° *trial*
EVERYMAN Welcome, my Good Deeds; now I
 hear thy voice,
 I weep for very sweetness of love. 635
KNOWLEDGE Be no more sad, but ever
 rejoice;
 God seeth thy living in his throne above.
 Put on this garment to thy behoof,° *advantage*
 Which is wet with your tears,
 Or else before God you may it miss, 640
 When ye to your journey's end come shall.

EVERYMAN Gentle Knowledge, what do ye
 it call?
KNOWLEDGE It is a garment of sorrow:
 From pain it will you borrow;° *release*
 contrition it is, 645
 That geteth forgiveness;
 It pleaseth God passing° well. *exceedingly*
GOOD DEEDS Everyman, will you wear it
 for your heal?° *salvation*
EVERYMAN Now blessed be Jesu, Mary's Son,
 For now have I on true contrition. 650
 And let us go now without tarrying;
 Good Deeds, have we clear our reckoning?
GOOD DEEDS Yea, indeed, I have it here.
EVERYMAN Then I trust we need not fear;
 Now, friends, let us not part in twain. 655
KNOWLEDGE Nay, Everyman, that will we
 not, certain.
GOOD DEEDS Yet must thou lead with thee
 Three persons of great might.
EVERYMAN Who should they be?
GOOD DEEDS Discretion and Strength they 660
 hight,° *are called*
 And thy Beauty may not abide behind.
KNOWLEDGE Also ye must call to mind
 Your Five Wits° as for your counsellors. *senses*
GOOD DEEDS You must have them ready at
 all hours.
EVERYMAN How shall I get them hither? 665
KNOWLEDGE You must call them all together,
 And they will hear you incontinent.° *immediately*
EVERYMAN My friends, come hither and be
 present,
 Discretion, Strength, my Five Wits, and
 Beauty.

[*ENTER* BEAUTY, STRENGTH, DISCRETION,
AND FIVE WITS]

BEAUTY Here at your will we be all ready. 670
 What will ye that we should do?
GOOD DEEDS That ye would with everyman go,
 And help him in his pilgrimage.
 Advise° you, will ye with him or not in that *consider*
 voyage?
STRENGTH We will bring him all thither, 675
 To his help and comfort, ye may believe me.
DISCRETION So will we go with him all together.
EVERYMAN Almighty God, lofed° may *praised*
 thou be!
 I give thee laud that I have hither brought
 Strength, Discretion, Beauty, and Five Wits.
 Lack I nought. 680
 And my Good Deeds, with Knowledge clear,
 All be in my company at my will here;
 I desire no more to° my business. *for*
STRENGTH And I, Strength, will by you stand
 in distress,
 Though thou would in battle fight on the
 ground. 685
FIVE WITS And though it were through the
 world round,
 We will not depart for sweet ne sour.
BEAUTY No more will I unto° death's hour, *until*
 Whatsoever thereof befall.
DISCRETION Everyman, advise you first of all; 690
 Go with a good advisement° and *reflection*
 deliberation.

We all give you virtuous monition° *forewarning*
 That all shall be well.
EVERYMAN My friends, harken what I
 will tell:
 I pray God reward you in his heavenly
 sphere. 695
 Now harken, all that be here,
 For I will make my testament
 Here before you all present:
 In alms half my good I will give with my
 hands twain
 In the way of charity, with good intent, 700
 And the other half still shall remain
 In queth,° to be returned *bequest*
 there° it ought to be. *where*
 This I do in despite of the fiend of hell,
 To go quit out of his peril
 Ever after and this day. 705
KNOWLEDGE Everyman, harken what I say:
 Go to priesthood, I you advise,
 And receive of him in any wise° *without fail*
 The holy sacrament and ointment together.
 Then shortly see ye turn again hither; 710
 We will all abide you here.
FIVE WITS Yea, Everyman, hie you that ye
 ready were.
 There is no emperor, king, duke, ne baron,
 That of God hath commission° *authority*
 As hath the least priest in the world 715
 being;° *living*
 For of the blessed sacraments pure and
 benign
 He beareth the keys, and thereof hath
 the cure° *charge*
 For man's redemption—it is ever sure—
 Which God for our soul's medicine
 Gave us out of his heart with great 720
 pine.° *suffering*
 Here in this transitory life, for thee and me,
 The blessed sacraments seven there be:
 Baptism, confirmation, with priest-
 hood good,
 And the sacrament of God's precious flesh
 and blood,
 Marriage, the holy extreme unction, and
 penance; 725
 These seven be good to have in remembrance,
 Gracious sacraments of high divinity.
EVERYMAN Fain would I receive that holy body,
 and meekly to my ghostly° father I will go. *spiritual*
FIVE WITS Everyman, that is the best that ye
 can do. 730
 God will you to salvation bring,
 To us Holy Scripture they do teach,
 And converteth man from sin heaven to reach;
 God hath to them more power given 735
 Than to any angel that is in heaven.
 With five words he may consecrate,
 God's body in flesh and blood to make,
 And handleth his Maker between his hands.
 The priest bindeth and unbindeth all bands, 740
 Both in earth and in heaven.
 Thou ministers° all the sacraments seven; *administer*
 Though we kissed thy feet, thou were
 worthy;
 Thou art surgeon that cureth sin deadly:
 No remedy we find under God 745
 But all only priesthood.

Everyman, God gave priests that dignity,
And setteth them in his stead among us to be;
Thus be they above angels in degree.

[EVERYMAN *GOES TO THE PRIEST TO RECEIVE*
THE LAST SACRAMENTS]

KNOWLEDGE If priests be good, it is so,
 surely. 750
 But when Jesus hanged on the cross with
 great smart,
 There he gave out of his blessed heart
 The same sacrament in great torment:
 He sold them not to us, that Lord
 omnipotent.
 Therefore Saint Peter the apostle doth say 755
 That Jesu's curse hath all they
 Which God their Saviour do buy or sell,
 Or they for any money do take or tell.° *count out*
 Sinful priests giveth the sinners example bad;
 Their children sitteth by other men's fires, I
 have heard: 760
 And some haunteth women's company
 With unclean life, as lusts of lechery:
 These be with sin made blind.
FIVE WITS I trust to God no such may we find;
 Therefore let us priesthood honour, 765
 And follow their doctrine for our souls' succour.
 We be their sheep, and they shepherds be
 By whom we all be kept in surety.
 Peace, for yonder I see Everyman come,
 Which hath made true satisfaction. 770
GOOD DEEDS Methinks it is he indeed.

[*RE-ENTER* EVERYMAN]

EVERYMAN Now Jesu be your alder speed!
 I have received the sacrament for my
 redemption,
 And then mine extreme unction:
 Blessed be all they that counselled me to
 take it! 775
 And now, friends, let us go without longer
 respite;
 I thank God that ye have tarried so long.
 Now set each of you on this rood° your hand *cross*
 And shortly follow me:
 I go before there I would be; God be our
 guide! 780
STRENGTH Everyman, we will not from you go
 Till ye have done this voyage long.
DISCRETION I, Discretion, will bide by
 you also.
KNOWLEDGE And though this pilgrimage be
 never so strong,° *grievous*
 I will never part you fro.° *from you*
STRENGTH Everyman, I will be as sure
 by thee
 As ever I did by Judas Maccabee.

[EVERYMAN *COMES TO HIS GRAVE*]

EVERYMAN Alas, I am so faint I may not
 stand;
 My limbs under me doth fold.
 Friends, let us not turn again to this land, 790
 Not for all the world's gold;
 For into this cave must I creep
 And turn to earth, and there to sleep.
BEAUTY What, into this grave? Alas!

EVERYMAN Yea, there shall ye consume, more
 and less. 795
BEAUTY And what, should I smother here?
EVERYMAN Yea, by my faith, and never more
 appear.
 In this world live no more we shall,
 But in heaven before the highest Lord of all.
BEAUTY I cross out all this; adieu, by Saint John! 800
 I take my cap in my lap, and am gone.
EVERYMAN What, Beauty, whither will ye?
BEAUTY Peace, I am deaf; I look not be-
 hind me,
 Not and thou wouldest give me all the gold
 in thy chest.

[*EXIT BEAUTY*]

EVERYMAN Alas, whereto may I trust? 805
 Beauty goeth fast away from me;
 She promised with me to live and die.
STRENGTH Everyman, I will thee also forsake
 and deny;
 Thy game liketh° me not at all. *pleases*
EVERYMAN Why, then, ye will forsake me all? 810
 Sweet Strength, tarry a little space.° *while*
STRENGTH Nay, sir, by the rood of grace!
 I will hie me from thee fast,
 Though thou weep till thy heart to-brast.° *break*
EVERYMAN Ye would ever bide by me,
 ye said. 815
STRENGTH Yea, I have you far enough
 conveyed.
 Ye be old enough, I understand,
 Your pilgrimage to take on hand;
 I repent me that I hither came.
EVERYMAN Strength, you to displease I am
 blame; 820
 Yet promise is debt, this ye well wot.
STRENGTH In faith, I care not.
 Thou art but a fool to complain;
 You spend your speech and waste your
 brain.
 Go thrust thee into the ground! 825

[*EXIT STRENGTH*]

EVERYMAN I had wend surer I should you
 have found.
 He that trusteth in his Strength
 She him deceiveth at the length.
 Both Strength and Beauty forsaketh me;
 Yet they promised me fair and lovingly. 830
DISCRETION Everyman, I will after Strength
 be gone;
 As for me, I will leave you alone.
EVERYMAN Why, Discretion, will ye for-
 sake me?
DISCRETION Yea, in faith, I will go from
 thee,
 For when Strength goeth before 835
 I follow after evermore.
EVERYMAN Yet I pray thee, for the love of the
 Trinity,
 Look in my grave once piteously.
DISCRETION Nay, so nigh will I not come;
 Farewell, every one! 840

[*EXIT DISCRETION*]

EVERYMAN O, all thing faileth, save God alone—

Beauty, Strength, and Discretion;
For when Death bloweth his blast,
They all run from me full fast.
FIVE WITS Everyman, my leave now of thee
 I take; 845
I will follow the other, for here I thee forsake.
EVERYMAN Alas, then may I wail and weep,
For I took you for my best friend.
FIVE WITS I will no longer thee keep;
Now farewell, and there an end. 850

<div align="center">[EXIT FIVE WITS]</div>

EVERYMAN O Jesu; help! All hath for-
 saken me.
GOOD DEEDS Nay, Everyman; I will bide
 with thee.
I will not forsake thee indeed;
Thou shalt find me a good friend at need.
EVERYMAN Gramercy, Good Deeds! Now
 may I true friends see. 855
They have forsaken me, every one;
I loved them better than my Good Deeds
 alone.
Knowledge, will ye forsake me also?
KNOWLEDGE Yea, Everyman, when ye to
 Death shall go; 860
But not yet, for no manner of danger.
EVERYMAN Gramercy, Knowledge, with all
 my heart.
KNOWLEDGE Nay, yet I will not from hence
 depart
Till I see where ye shall become.
EVERYMAN Methink, alas, that I must
 be gone 865
To make my reckoning and my debts pay,
For I see my time is nigh spent away.
Take example, all ye that this do hear or see,
How they that I loved best do forsake me,
Except my Good Deeds that bideth truly. 870
GOOD DEEDS All earthly things is but vanity:
Beauty, Strength, and Discretion do man forsake,
Foolish friends, and kinsmen, that fair
 spake—
All fleeth save Good Deeds, and that am I.
EVERYMAN Have mercy on me, God most
 mighty 875
And stand by me, thou mother and maid,
 holy Mary.
GOOD DEEDS Fear not; I will speak for thee.
KNOWLEDGE Here I cry God mercy.
GOOD DEEDS Short our end, and minish
 our pain;
Let us go and never come again. 880
EVERYMAN Into thy hands, Lord, my soul I
 commend;
Receive it, Lord, that it be not lost.
As thou me boughtest, so me defend,
And save me from the fiend's boast,
That I may appear with that blessed host 885
That shall be saved at the day of doom.
In manus tuas, of mights most
For ever, commendo spiritum meum.

<div align="center">[HE SINKS INTO HIS GRAVE.]</div>

KNOWLEDGE Now hath he suffered that we
 all shall endure;
The Good Deeds shall make all sure. 890
Now hath he made ending;

Methinketh that I hear angels sing,
And make great joy and melody
Where Everyman's soul received shall be.
ANGEL Come, excellent elect spouse, to Jesu! 895
Hereabove thou shalt go
Because of thy singular virtue.
Now the soul is taken the body fro,
Thy reckoning is crystal-clear.
Now shalt thou into the heavenly sphere, 900
Unto the which all ye shall come
That liveth well before the day of doom.

<div align="center">[ENTER DOCTOR]</div>

[DOCTOR] This moral men may have in mind
 Ye hearers, take it of worth,° old and young, value it
And forsake Pride, for he deceiveth you in
 the end; 905
And remember Beauty, Five Wits, Strength,
 and Discretion,
They all at the last do every man forsake,
Save his Good Deeds there° doth he take. unless
But beware, for and they be small
Before God, he hath no help at all; 910
None excuse may be there for every man.
Alas, how shall he do then?
For after death amends may no man make,
For then mercy and pity doth him forsake
If his reckoning be not clear when he doth come 915
God will say: "Ite, maledicti, in ignem eternum."
And he that hath his account whole and sound,
High in heaven he shall be crowned;
Unto which place God bring us all thither,
That we may live body and soul together. 920
Thereto help the Trinity!
Amen, say ye, for saint charity.

<div align="center">THUS ENDETH THIS MORAL PLAY OF EVERYMAN</div>

CHAPTER 10

READING 36
SAINT FRANCIS OF ASSISI (1181–1226), "THE CANTICLE OF BROTHER SUN"

Two years before he died, Francis, blind and in ill health, wrote this long poem with the hope that his brothers would sing it when on their preaching journeys. It was one of the earliest poems written in Italian. It reflects the Franciscan love for nature. The lines about peace and forgiveness as well as those about death were additions to the original poem.

The Canticle of Brother Sun

Most High, omnipotent, good Lord
To you alone belong praise and glory,
Honor, and blessing.
No man is worthy to breathe thy name.

Be praised, my Lord, for all your creatures.
In the first place for the blessed Brother Sun,
who gives us the day and enlightens us through you.
He is beautiful and radiant with his great splendor.

Giving witness of thee, Most Omnipotent One.

Be praised, my Lord, for Sister Moon and the stars
Formed by you so bright, precious, and beautiful.

Be praised, my Lord, for Brother Wind
And the airy skies, so cloudy and serene;
For every weather, be praised, for it is life-giving.

Be praised, my Lord, for Sister Water,
So necessary yet so humble, precious, and chaste.

Be praised, my Lord, for Brother Fire,
Who lights up the night.
He is beautiful and carefree, robust, and fierce.
Be praised, my Lord, for our sister, Mother Earth,
Who nourishes and watches us
While bringing forth abundance of fruits with color
And herbs.

Be praised, my Lord, for those who pardon through
And bear weakness and trial.
Blessed are those who endure in peace,
For they will be crowned by you, Most High.

Be praised, my Lord, for our sister, Bodily Death,
Whom no living man can escape.
Woe to those who die in sin.
Blessed are those who discover thy holy will.
The second death will do them no harm.

Praise and bless my Lord.
Render thanks.
Serve him with great humility. Amen.

READING 37
from Saint Thomas Aquinas (c. 1225–1274), Summa Theologica (1267–1273)

These three articles from the first question of the first part of the Summa Theologica *make three points: (1) To know God one needs a revelation beyond what human reason can attain; (2) the proper language of theology includes metaphorical language; and (3) sacred scripture has many levels of meaning. Thomas Aquinas did not consider himself a philosopher; he was a theologian, which in his day meant a commentator on the Bible.*

Question I. on what sort of teaching Christian theology is and what it covers

In order to keep our efforts within definite bounds we must first investigate this holy teaching and find out what it is like and how far it goes. Here there are ten points of inquiry:

1. about the need for this teaching;
2. whether it be science;
3. whether it be single or several;
4. whether it be theoretical or practical;
5. how it compares with other sciences;
6. whether it be wisdom;
7. what is its subject;
8. whether it sets out to prove anything;
9. whether it should employ metaphorical or symbolical language;
10. whether its sacred writings are to be interpreted in several senses.

Article 1. is another teaching required apart from philosophical studies?

THE FIRST POINT: 1. Any other teaching beyond that of science and philosophy seems needless. For man ought not to venture into realms beyond his reason; according to *Ecclesiasticus, Be not curious about things far above thee.* Now the things lying within range of reason yield well enough to scientific and philosophical treatment. Additional teaching, therefore, seems superfluous.

2. Besides, we can be educated only about what is real; for nothing can be known for certain save what is true, and what is true is identical with what really is. Yet the philosophical sciences deal with all parts of reality, even with God; hence Aristotle refers to one department of philosophy as theology or the divine science. That being the case, no need arises for another kind of education to be admitted or entertained.

ON THE OTHER HAND the second epistle to Timothy says, *All Scripture inspired of God is profitable to teach, to reprove, to correct, to instruct in righteousness.* Divinely inspired Scripture, however, is no part of the branches of philosophy traced by reasoning. Accordingly it is expedient to have another body of sure knowledge inspired by God.

REPLY: It should be urged that human well-being called for schooling in what God has revealed, in addition to the philosophical researches pursued by human reasoning.

Above all because God destines us for an end beyond the grasp of reason; according to Isaiah, *Eye hath not seen, O God, without thee what thou hast prepared for them that love thee.* Now we have to recognize an end before we can stretch out and exert ourselves for it. Hence the necessity for our welfare that divine truths surpassing reason should be signified to us through divine revelation.

We also stood in need of being instructed by divine revelation even in religious matters the human reason is able to investigate. For the rational truth about God would have appeared only to few, and even so after a long time and mixed with many mistakes; whereas on knowing this depends our whole welfare, which is in God. In these circumstances, then, it was to prosper the salvation of human beings, and the more widely and less anxiously, that they were provided for by divine revelation about divine things.

These then are the grounds of holding a holy teaching which has come to us through revelation beyond the discoveries of the rational sciences.

Hence: 1. Admittedly the reason should not pry into things too high for human knowledge, nevertheless when they are revealed by God they should be welcomed by faith: indeed the passage in *Ecclesiasticus* goes on, *Many things are shown thee above the understanding of men.* And on them Christian teaching rests.

2. The diversification of the sciences is brought about by the diversity of aspects under which things can be known. Both an astronomer and a physical scientist may demonstrate the same conclusion, for instance that the earth is spherical; the first, however, works in a mathematical medium prescinding from material qualities, while for the second his medium is the observation of material bodies through the senses. Accordingly there is nothing to stop the same things from being treated by the philosophical sciences when they can be looked at in the light of natural reason and by another science when they are looked at in the light of divine revelation. Consequently the theology of holy teaching differs in kind from that theology which is ranked as a part of philosophy.

Article 9. should holy teaching employ metaphorical or symbolical language?

THE NINTH POINT: 1. It seems that holy teaching should not use metaphors. For what is proper to a lowly type of instruction appears ill-suited to this, which, as already observed, stands on the summit. Now to carry on with various similitudes and images is proper to poetry, the most modest of all teaching

methods. Therefore to make use of such similitudes is ill-suited to holy teaching.

2. Moreover, this teaching seems intended to make truth clear; and there is a reward held out to those who do so: *Those who explain me shall have life everlasting*. Such symbolism, however, obscures the truth. Therefore it is not in keeping with this teaching to convey divine things under the symbolic representation of bodily things.

3. Again, the nobler the creatures the closer they approach God's likeness. If then the properties of creatures are to be read into God, then at least they should be chiefly of the more excellent not the baser sort; and this is the way frequently taken by the Scriptures.

ON THE OTHER HAND *it is declared in Hosea, I have multiplied visions and I have used similitudes by the ministry of the prophets*. To put something across under imagery is metaphorical usage. Therefore sacred doctrine avails itself of metaphors.

REPLY: Holy Scripture fittingly delivers divine and spiritual realities under bodily guises. For God provides for all things according to the kind of things they are. Now we are of the kind to reach the world of intelligence through the world of sense, since all our knowledge takes its rise from sensation. Congenially, then, holy Scripture delivers spiritual things to us beneath metaphors taken from bodily things. Dionysius agrees, *The divine rays cannot enlighten us except wrapped up in many sacred veils.*

Then also holy Scripture is intended for all of us in common without distinction of persons, as is said in the epistle to the Romans, *To the wise and the foolish I am a debtor,* and fitly puts forward spiritual things under bodily likenesses; at all events the uneducated may then lay hold of them, those, that is to say, who are not ready to take intellectual truths neat with nothing else.

Hence: 1. Poetry employs metaphors for the sake of representation, in which we are born to take delight. Holy teaching, on the other hand, adopts them for their indispensable usefulness, as just explained.

2. Dionysius teaches in the same place that the beam of divine revelation is not extinguished by the sense imagery that veils it, and its truth does not flicker out, since the minds of those given the revelation are not allowed to remain arrested with the images but are lifted up to their meaning; moreover, they are so enabled to instruct others. In fact truths expressed metaphorically in one passage of Scripture are more expressly explained elsewhere. Yet even the figurative disguising serves a purpose, both as a challenge to those eager to find out the truth and as a defense against unbelievers ready to ridicule; to these the text refers, *Give not that which is holy to the dogs.*

3. Dionysius also tells us that in the Scriptures the figures of base bodies rather than those of fine bodies more happily serve the purpose of conveying divine things to us. And this for three reasons. First, because thereby human thinking is the more exempt from error, for the expressions obviously cannot be taken in the proper sense of their words and be crudely ascribed to divine things; this might be more open to doubt were sublime figures evoked, especially for those people who can summon up nothing more splendid than physical beauty. Secondly, because understatement is more to the point with our present knowledge of God. For in this life what he is not is clearer to us than what he is; and therefore from the likenesses of things farthest removed from him we can more fairly estimate how far above our speech and thought he is. Thirdly, because thereby divine matters are more effectively screened against those unworthy of them.

Article 10. can one passage of holy Scripture bear several senses?

THE TENTH POINT: 1. It would seem that the same text of holy Scripture does not bear several senses, namely the historical or literal, the allegorical, the tropological or moral, and the anagogical. Allow a variety of readings to one passage, and you produce confusion and deception, and sap the foundations of argument; examples of the stock fallacies, not reasoned discourse, follow from the medley of meanings. Holy Scripture, however, should effectively display the truth without fallacy of any sort. One text, therefore, should not offer various meanings.

2. Besides, St. Augustine holds that *Scripture which is entitled the Old Testament has a fourfold meaning, namely according to history, to etiology, to analogy, and to allegory.* Now these four appear inconsistent with the four mentioned above; which therefore appear awkward headings for interpreting a passage of Scripture.

3. Further, there is also a parabolic sense, not included among them.

ON THE OTHER HAND, *St. Gregory declares that holy Scripture transcends all other sciences by its very style of expression, in that one and the same discourse, while narrating an event, transmits a mystery as well.*

REPLY: That God is the author of holy Scripture should be acknowledged, and he has the power, not only of adapting words to convey meanings (which men also can do), but also of adapting things themselves. In every branch of knowledge words have meaning, but what is special here is that the things meant by the words also themselves mean something. That first meaning whereby the words signify things belongs to the sense first-mentioned, namely the historical or literal. That meaning, however, whereby the things signified by the words in their turn also signify other things is called the spiritual sense; it is based on and presupposes the literal sense.

Now this spiritual sense is divided into three. For, as St Paul says, *The Old Law is the figure of the New,* and the New Law itself, as Dionysius says, *is the figure of the glory to come.* Then again, under the New Law the deeds wrought by our Head are signs also of what we ourselves ought to do.

Well then, the allegorical sense is brought into play when the things of the Old Law signify the things of the New Law; the moral sense when the things done in Christ and in those who prefigured him are signs of what we should carry out; and the anagogical sense when the things that lie ahead in eternal glory are signified.

Now because the literal sense is that which the author intends, and the author of holy Scripture is God who comprehends everything all at once in his understanding, it comes not amiss, as St. Augustine observes, if many meanings are present even in the literal sense of one passage of Scripture.

Hence: 1. These various readings do not set up ambiguity or any other kind of mixture of meanings, because, as we have explained, they are many, not because one term may signify many things, but because the things signified by the terms can themselves be the signs of other things. Consequently holy Scripture sets up no confusion, since all meanings are based on one, namely the literal sense. From this alone can arguments be drawn, and not, as St. Augustine remarks in his letter to Vincent the Donatist, from the things said by allegory. Nor does this undo the effect of holy Scripture, for nothing necessary for faith is contained under the spiritual sense that is not openly conveyed through the literal sense elsewhere.

2. These three, history, etiology, and analogy, are grouped under the one general heading of the literal sense. For as St. Augustine explains in the same place, you have history when any matter is straightforwardly recorded; etiology when its cause is indicated, as when our Lord pointed to men's hardness of heart as the reason why Moses allowed them to set aside their wives; analogy when the truth of one Scriptural passage

is shown not to clash with the truth of another. Of the four senses enumerated in the argument, allegory stands alone for the three spiritual senses of our exposition. For instance Hugh of St. Victor included the anagogical sense under the allegorical, and enumerated just three senses, namely the historical, the allegorical, and the tropological.

3. The parabolical sense is contained in the literal sense, for words can signify something properly and something figuratively; in the last case the literal sense is not the figure of speech itself, but the object it figures. When Scripture speaks of the arm of God, the literal sense is not that he has a physical limb, but that he has what it signifies, namely the power of doing and making. This example brings out how nothing false can underlie the literal sense of Scripture.

READING 38

from DANTE ALIGHIERI (1265–1321),
DIVINE COMEDY, INFERNO

This reading and the two that follow reproduce selections from the DIVINE COMEDY and include cantos from all three parts of Dante's poem: the INFERNO, the PURGATORIO, and the PARADISO. They represent a fair sample of Dante's sources and his highly visual imagination. In these cantos there are mythical monsters, demons, angels, saints, heroes from the Classical past, and figures from Dante's Italy. Those figures do not exist in solitude. The figure of Satan only makes sense in juxtaposition with the vision of God, the haughty pride of Farinata in contrast to the figure of Francis of Assisi.

While reading these selections keep in mind Dante's powerful use of language: a single sentence can sketch a scene; one image can set a mood; an individual can stand for a class. While the poem as a whole is immensely long, the thing that most leaps out from these pages is Dante's economy, his ability to say so much in so few words. Coupled with his near-total control of Classical and religious learning Dante makes this poem a veritable encyclopedia of medieval culture.

The commentary, translation, and notes for each canto are by the late American poet John Ciardi.

INFERNO

CANTO I

The Dark Wood of Error

Midway in his allotted threescore years and ten, Dante comes to himself with a start and realizes that he has strayed from the True Way into the Dark Wood of Error (Worldliness). As soon as he has realized his loss, Dante lifts his eyes and sees the first light of the sunrise (the Sun is the symbol of Divine Illumination) lighting the shoulders of a little hill (the Mount of Joy). It is the Easter season, the time of resurrection, and the sun is in its equinoctial rebirth. This juxtaposition of joyous symbols fills Dante with hope and he sets out at once to climb directly up the Mount of Joy, but almost immediately his way is blocked by the Three Beasts of Worldliness: The Leopard of Malice and Fraud, The Lion of Violence and Ambition, and The She-Wolf of Incontinence. These beasts, and especially the She-Wolf, drive him back despairing into the darkness of error. But just as all seems lost, a figure appears to him. It is the shade of Vergil, Dante's symbol of Human Reason.

Vergil explains that he has been sent to lead Dante from error. There can, however, be no direct ascent past the beasts: The man who would escape them must go a longer and harder way. First he must descend through Hell (the Recognition of Sin), then he must ascend through Purgatory (the Renunciation of Sin), and only then may he reach the pinnacle of joy and come to the Light of God. Vergil offers to guide Dante, but only as far as Human Reason can go. Another guide

(Beatrice, symbol of Divine Love) must take over for the final ascent, for Human Reason is self-limited. Dante submits himself joyously to Vergil's guidance and they move off.

Midway in our life's journey, I went astray
from the straight road and woke to find myself
alone in a dark wood. How shall I say 3

what wood that was! I never saw so drear,
so rank, so arduous a wilderness!
Its very memory gives a shape to fear. 6

Death could scarce be more bitter than that place!
But since it came to good, I will recount
all that I found revealed there by God's grace. 9

How I came to it I cannot rightly say,
so drugged and loose with sleep had I become
when I first wandered there from the True Way. 12

But at the far end of that valley of evil
whose maze had sapped my very heart with fear
I found myself before a little hill 15

and lifted up my eyes. Its shoulders glowed
already with the sweet rays of that planet
whose virtue leads men straight on every road, 18

and the shining strengthened me against the fright
whose agony had wracked the lake of my heart
through all the terrors of that piteous night. 21

Just as a swimmer, who with his last breath
flounders ashore from perilous seas, might turn
to memorize the wide water of his death— 24

so did I turn, my soul still fugitive
from death's surviving image, to stare down
that pass that none had ever left alive. 27

And there I lay to rest from my heart's race
till calm and breath returned to me. Then rose
and pushed up that dead slope at such a pace 30

each footfall rose above the last. And lo!
almost at the beginning of the rise
I faced a spotted Leopard, all tremor and flow 33

and gaudy pelt. And it would not pass, but stood
so blocking my every turn that time and again
I was on the verge of turning back to the wood. 36

This fell at the first widening of the dawn
as the sun was climbing Aries with those stars
that rode with him to light the new creation. 39

Thus the holy hour and the sweet season
of commemoration did much to arm my fear
of that bright murderous beast with their good omen. 42

Yet not so much but what I shook with dread
at sight of a great Lion that broke upon me
raging with hunger, its enormous head 45

held high as if to strike a mortal terror
into the very air. And down his track,
a She-Wolf drove upon me, a starved horror 48

ravening and wasted beyond all belief.
She seemed a rack for avarice, gaunt and craving.
Oh many the souls she has brought to endless grief! 51

She brought such heaviness upon my spirit
at sight of her savagery and desperation,
I died from every hope of that high summit. 54

And like a miser—eager in acquisition
but desperate in self-reproach when Fortune's wheel
turns to the hour of his loss—all tears and attrition 57

I wavered back; and still the beast pursued,
forcing herself against me bit by bit
till I slid back into the sunless wood. 60

And as I fell to my soul's ruin, a presence
gathered before me on the discolored air,
the figure of one who seemed hoarse from long silence. 63

At sight of him in that friendless waste I cried:
"Have pity on me, whatever thing you are,
whether shade or living man." And it replied: 66

"Not man, though man I once was, and my blood
was Lombard, both my parents Mantuan.
I was born, though late, *sub Julio,* and bred 69

in Rome under Augustus in the noon
of the false and lying gods. I was a poet
and sang of old Anchises' noble son 72

who came to Rome after the burning of Troy.
But you—why do *you* return to these these distresses
instead of climbing that shining Mount of Joy 75

which is the seat and first cause of man's bliss?"
"And are you then that Virgil and that fountain
of purest speech?" My voice grew tremulous: 78

"Glory and light of poets! now may that zeal
and love's apprenticeship that I poured out
on your heroic verses serve me well! 81

For you are my true master and first author,
the sole maker from whom I drew the breath
of that sweet style whose measures have
brought me honor. 84

See there, immortal sage, the beast I flee.
For my soul's salvation, I beg you, guard me from her,
for she has struck a mortal tremor through me." 87

And he replied, seeing my soul in tears:
"He must go by another way who would escape
this wilderness, for that mad beast that flees 90

before you there, suffers no man to pass.
She tracks down all, kills all, and knows no glut,
but, feeding, she grows hungrier than she was. 93

She mates with any beast, and will mate with more
before the Greyhound comes to hunt her down.
He will not feed on lands nor loot, but honor 96

and love and wisdom will make straight his way.
He will rise between Feltro and Feltro, and in him
shall be the resurrection and new day 99

of that sad Italy for which Nisus died,
and Turnus, and Euryalus, and the maid Camilla.
He shall hunt her through every nation of sick pride 102

till she is driven back forever to Hell
whence Envy first released her on the world.
Therefore, for your own good, I think it well 105

you follow me and I will be your guide
and lead you forth through an eternal place.
There you shall see the ancient spirits tried 108

in endless pain, and hear their lamentation
as each bemoans the second death of souls.
Next you shall see upon a burning mountain 111

souls in fire and yet content in fire,
knowing that whensoever it may be
they yet will mount into the blessed choir. 114

To which, if it is still your wish to climb,
a worthier spirit shall be sent to guide you.
With her shall I leave you, for the King of Time, 117

who reigns on high, forbids me to come there
since, living, I rebelled against his law.
He rules the waters and the land and air 120

and there holds court, his city and his throne.
Oh blessed are they he chooses!" And I to him:
"Poet, by that God to you unknown, 123

lead me this way. Beyond this present ill
and worse to dread, lead me to Peter's gate
and be my guide through the sad halls of Hell." 126

And he then: "Follow." And he moved ahead
in silence, and I followed where he led.

Notes

1. MIDWAY IN OUR LIFE'S JOURNEY: The biblical life span is three-score years and ten. The action opens in Dante's thirty-fifth year, i.e., 1300 C.E.

17. THAT PLANET: The sun. Ptolemaic astronomers considered it a planet. It is also symbolic of God as He who lights man's way.

31. EACH FOOTFALL ROSE ABOVE THE LAST: The literal rendering would be: "So that the fixed foot was ever the lower." *Fixed* has often been translated "right" and an ingenious reasoning can support that reading, but a simpler explanation offers itself and seems more competent: Dante is saying that he climbed with such zeal and haste that every footfall carried him above the last despite the steepness of the climb. At a slow pace, on the other hand, the rear foot might be brought up only as far as the forward foot. This device of selecting a minute but exactly centered detail to convey the whole of a larger action is one of the central characteristics of Dante's style.

THE THREE BEASTS: These three beasts undoubtedly are taken from *Jeremiah* v. 6. Many additional and incidental interpretations have been advanced for them, but the central interpretation must remain as noted. They foreshadow the three divisions of Hell (incontinence, violence, and fraud) which Vergil explains at length in Canto XI, 16–111.

38–39. ARIES . . . THAT RODE WITH HIM TO LIGHT THE NEW CREATION: The medieval tradition had it that the sun was in Aries at the time of Creation. The significance of the astronomical and religious conjunction is an important part of Dante's intended allegory. It is just before dawn of Good Friday 1300 A.D. when he awakens in the Dark Wood. Thus, his new life begins under Aries, the sign of creation, at dawn (rebirth) and in the Easter season (resurrection). Moreover the moon is full and the sun is in the equinox, conditions that did not fall together on any Friday of 1300. Dante is obviously constructing poetically the perfect Easter as a symbol of his new awakening.

69. SUB JULIO: In the reign of Julius Caesar.

95. THE GREYHOUND . . . FELTRO AND FELTRO: Almost certainly refers to Can Grande della Scala (1290–1329), great Italian leader born in Verona, which lies between the towns of Feltre and Montefeltro.

100–101. NISUS, TURNUS, EURYALUS, CAMILLA: All were killed in the war between the Trojans and the Latins when, according to legend, Aeneas led the survivors of Troy into Italy. Nisus and Euryalus (*Aeneid* IX) were Trojan comrades-in-arms who died together. Camilla (*Aeneid* XI) was the daughter of the Latin king and one of the warrior women. She was killed during a horse charge against the Trojans after displaying great gallantry. Turnus (*Aeneid* XII) was killed by Aeneas in a duel.

110. THE SECOND DEATH: Damnation. "This is the second death, even the lake of fire." (*Revelation* xx, 14)

118. FORBIDS ME TO COME THERE SINCE, LIVING, ETC.: Salvation is only through Christ in Dante's theology. Vergil lived and died before the establishment of Christ's teachings in Rome, and cannot therefore enter Heaven.

125. PETER'S GATE: The gate of Purgatory. (See *Purgatorio* IX, 76 ff.) The gate is guarded by an angel with a gleaming sword. The angel is Peter's vicar (Peter, the first Pope, symbolized all Popes; i.e., Christ's vicar on earth) and is entrusted with the two great keys.

Some commentators argue that this is the gate of Paradise, but Dante mentions no gate beyond this one in his ascent to Heaven. It should be remembered, too, that those who pass the gate of Purgatory have effectively entered Heaven.

The three gates that figure in the entire journey are: the gate of Hell (Canto III, 1–11), the gate of Dis (Canto VIII, 79–113, and Canto IX, 86–87), and the gate of Purgatory, as above.

Canto III

The Vestibule of Hell

The Opportunists • *The Poets pass the Gate of Hell and are immediately assailed by cries of anguish. Dante sees the first of the souls in torment. They are The Opportunists, those souls who in life were neither for good nor evil but only for themselves. Mixed with them are those outcasts who took no side in the Rebellion of the Angels. They are neither in Hell nor out of it. Eternally unclassified, they race round and round pursuing a wavering banner that runs forever before them through the dirty air; and as they run they are pursued by swarms of wasps and hornets, who sting them and produce a constant flow of blood and putrid matter which trickles down the bodies of the sinners and is feasted upon by loathsome worms and maggots who coat the ground.*

The law of Dante's Hell is the law of symbolic retribution. As they sinned so are they punished. They took no sides, therefore they are given no place. As they pursued the ever-shifting illusion of their own advantage, changing their courses with every changing wind, so they pursue eternally an elusive, ever-shifting banner. As their sin was a darkness, so they move in darkness. As their own guilty conscience pursued them, so they are pursued by swarms of wasps and hornets. And as their actions were a moral filth, so they run eternally through the filth of worms and maggots which they themselves feed.

Dante recognizes several, among them Pope Celestine V, but without delaying to speak to any of these souls, the Poets move on to Acheron, the first of the rivers of Hell. Here the newly arrived souls of the damned gather and wait for monstrous Charon to ferry them over to punishment. Charon recognizes Dante as a living man and angrily refuses him passage. Vergil forces Charon to serve them, but Dante swoons with terror, and does not reawaken until he is on the other side.

I AM THE WAY INTO THE CITY OF WOE.
I AM THE WAY TO A FORSAKEN PEOPLE.
I AM THE WAY INTO ETERNAL SORROW. 3

SACRED JUSTICE MOVED MY ARCHITECT.
I WAS RAISED HERE BY DIVINE OMNIPOTENCE,
PRIMORDIAL LOVE AND ULTIMATE INTELLECT. 6

ONLY THOSE ELEMENTS TIME CANNOT WEAR
WERE MADE BEFORE ME, AND BEYOND TIME I STAND.
ABANDON ALL HOPE YE WHO ENTER HERE. 9

These mysteries I read cut into stone
above a gate. And turning I said: "Master,
what is the meaning of this harsh inscription?" 12

And he then as initiate to novice:
"Here must you put by all division of spirit
and gather your soul against all cowardice. 15

This is the place I told you to expect.
Here you shall pass among the fallen people,
souls who have lost the good of intellect." 18

So saying, he put forth his hand to me,
and with a gentle and encouraging smile
he led me through the gate of mystery. 21

Here sighs and cries and wails coiled and recoiled
on the starless air, spilling my soul to tears.
A confusion of tongues and monstrous accents toiled 24

in pain and anger. Voices hoarse and shrill
and sounds of blows, all intermingled, raised
tumult and pandemonium that still 27

whirls on the air forever dirty with it
as if a whirlwind sucked at sand. And I,
holding my head in horror, cried: "Sweet Spirit, 30

what souls are these who run through this black haze?"
And he to me: "These are the nearly soulless
whose lives concluded neither blame nor praise. 33

They are mixed here with that despicable corps
of angels who were neither for God nor Satan,
but only for themselves. The High Creator 36

scourged them from Heaven for its perfect beauty,
and Hell will not receive them since the wicked
might feel some glory over them." And I: 39

"Master, what gnaws at them so hideously
their lamentation stuns the very air?"
"They have no hope of death," he answered me, 42

"and in their blind and unattaining state
their miserable lives have sunk so low
that they must envy every other fate. 45

No word of them survives their living season.
Mercy and Justice deny them even a name.
Let us not speak of them: look, and pass on." 48

I saw a banner there upon the mist.
Circling and circling, it seemed to scorn all pause.
So it ran on, and still behind it pressed 51

a never-ending rout of souls in pain.
I had not thought death had undone so many
as passed before me in that mournful train. 54

And some I knew among them; last of all
I recognized the shadow of that soul
who, in his cowardice, made the Great Denial. 57

At once I understood for certain: these
were of that retrograde and faithless crew
hateful to God and to His enemies. 60

These wretches never born and never dead
ran naked in a swarm of wasps and hornets
that goaded them the more the more they fled, 63

and made their faces stream with bloody gouts
of pus and tears that dribbled to their feet
to be swallowed there by loathsome worms and maggots. 66

Then looking onward I made out a throng
assembled on the beach of a wide river,
whereupon I turned to him: "Master, I long 69

to know what souls these are, and what strange usage
makes them as eager to cross as they seem to be
in this infected light." At which the Sage: 72

"All this shall be made known to you when we stand
on the joyless beach of Acheron." And I
cast down my eyes, sensing a reprimand 75

in what he said, and so walked at his side
in silence and ashamed until we came
through the dead cavern to that sunless tide. 78

There, steering toward us in an ancient ferry
came an old man with a white bush of hair,
bellowing: "Woe to you depraved souls! Bury 81

here and forever all hope of Paradise:
I come to lead you to the other shore,
into eternal dark, into fire and ice. 84

And you who are living yet, I say begone
from these who are dead." But when he saw me stand
against his violence he began again: 87

"By other windings and by other steerage
shall you cross to that other shore. Not here! Not here!
A lighter craft than mine must give you passage." 90

And my Guide to him: "Charon, bite back your spleen:
this has been willed where what is willed must be,
and is not yours to ask what it may mean." 93

The steersman of that marsh of ruined souls,
who wore a wheel of flame around each eye,
stifled the rage that shook his woolly jowls. 96

But those unmanned and naked spirits there
turned pale with fear and their teeth began to chatter
at sound of his crude bellow. In despair 99

they blasphemed God, their parents, their time on earth,
the race of Adam, and the day and the hour
and the place and the seed the womb that gave them birth. 102

But all together they drew to that grim shore
where all must come who lose the fear of God.
Weeping and cursing they come for evermore, 105

and demon Charon with eyes like burning coals
herds them in, and with a whistling oar
flails on the stragglers to his wake of souls. 108

As leaves in autumn loosen and stream down
until the branch stands bare above its tatters
spread on the rustling ground, so one by one 111

the evil seed of Adam in its Fall
cast themselves, at his signal, from the shore
and streamed away like birds who hear their call. 114

So they are gone over that shadowy water,
and always before they reach the other shore
a new noise stirs on this, and new throngs gather. 117

"My son," the courteous Master said to me,
"all who die in the shadow of God's wrath
converge to this from every clime and country. 120

And all pass over eagerly, for here
Divine Justice transforms and spurs them so
their dread turns wish: they yearn for what they fear. 123

No soul in Grace comes ever to this crossing;
therefore if Charon rages at your presence
you will understand the reason for his cursing." 126

When he had spoken, all the twilight country
shook so violently, the terror of it
bathes me with sweat even in memory: 129

the tear-soaked ground gave out a sigh of wind
that spewed itself in flame on a red sky,
and all my shattered senses left me. Blind, 132

like one whom sleep comes over in a swoon,
I stumbled into darkness and went down.

Notes

7–8. ONLY THOSE ELEMENTS TIME CANNOT WEAR: The Angels, the Empyrean, and the First Matter are the elements time cannot wear because they will last for all time. Man, however, in his mortal state, is not eternal. The Gate of Hell was therefore created before man. The theological point is worth attention. The doctrine of Original Sin is, of course, one familiar to many creeds. Here, however, it would seem that the preparation for damnation predates Original Sin. True, in one interpretation, Hell was created for the punishment of the Rebellious Angels and not for man. Had man not sinned, he would never have known Hell. But on the other hand, Dante's God was one who knew all, and knew therefore that man would indeed sin. The theological problem is an extremely delicate one.

It is significant, however, that having sinned, man lives out his days on the rind of Hell, and that damnation is forever below his feet. This central concept of man's sinfulness, and, opposed to it, the doctrine of Christ's ever-abounding mercy, are central to all of Dante's theology. Only as man surrenders himself to Divine Love may he hope for salvation, and salvation is open to all who will surrender themselves.

8. AND BEYOND TIME I STAND: So odious is sin to God that there can be no end to its just punishment.

9. ABANDON ALL HOPE YE WHO ENTER HERE: This admonition is, of course, to the damned and not to those who come on Heaven-sent errands. The Harrowing of Hell provided the only exemption from this decree, and that only through the direct intercession of Christ.

57. WHO, IN HIS COWARDICE, MADE THE GREAT DENIAL: This is almost certainly intended to be Celestine V, who became Pope in 1294. He was a man of saintly life, but allowed himself to be convinced by a priest named Benedetto that his soul was in danger since no man could live in the world without being damned. In fear for his soul he withdrew from all worldly affairs and renounced the papacy. Benedetto promptly assumed the mantle himself and became Boniface VIII, a Pope who became for Dante a symbol of all the worst corruption of the church. Dante also blamed Boniface and his intrigues for many of the evils that befell Florence. We shall learn in Canto XIX that the fires of Hell are waiting for Boniface in the pit of the Simoniacs, and we shall be given further evidence of his corruption in Canto XXVII. Celestine's great guilt is that his cowardice (in selfish terror for his own welfare) served as the door through which so much evil entered the church.

80. AN OLD MAN: Charon. He is the ferryman of dead souls across the Acheron in all Classical mythology.

88–90. BY OTHER WINDINGS: Charon recognizes Dante not only as a living man but as a soul in grace, and knows, therefore, that the Infernal Ferry was not intended for him. He is probably referring to the fact that souls destined for Purgatory and Heaven assemble not at his ferry point, but on the banks of the Tiber, from which they are transported by an Angel.

100. THEY BLASPHEMED GOD: The souls of the damned are not permitted to repent, for repentance is a divine grace.

123. THEY YEARN FOR WHAT THEY FEAR: Hell (allegorically Sin) is what the souls of the damned really wish for. Hell is their actual and deliberate choice, for divine grace is denied to none who wish for it in their hearts. The damned must, in fact, deliberately harden their hearts to God in order to become damned. Christ's grace is sufficient to save all who wish for it.

133–34. DANTE'S SWOON: This device (repeated at the end of Canto V) serves a double purpose. The first is technical: Dante uses

it to cover a transition. We are never told how he crossed
Acheron, for that would involve certain narrative matters he
can better deal with when he crosses Styx in Canto VII. The
second is to provide a point of departure for a theme that
is carried through the entire descent: the theme of Dante's
emotional reaction to Hell. These two swoons early in the
descent show him most susceptible to the grief about him.
As he descends, pity leaves him, and he even goes so far as to
add to the torments of one sinner. The allegory is clear: We
must harden ourselves against every sympathy for sin.

Canto V

Circle Two

The Carnal • *The Poets leave Limbo [the dwelling place of the un-
baptized] and enter the Second Circle. Here begin the torments of
Hell proper, and here, blocking the way, sits Minos, the dread and
semi-bestial judge of the damned who assigns to each soul its eternal
torment. He orders the Poets back; but Vergil silences him as he earlier
silenced Charon, and the Poets move on.*

*They find themselves on a dark ledge swept by a great whirlwind,
which spins within it the souls of the Carnal, those who betrayed rea-
son to their appetites. Their sin was to abandon themselves to the tem-
pest of their passions: so they are swept forever in the tempest of Hell,
forever denied the light of reason and of God. Vergil identifies many
among them. Semiramis is there, and Dido, Cleopatra, Helen,
Achilles, Paris, and Tristan. Dante sees Paolo and Francesca swept
together, and in the name of love he calls to them to tell their sad story.
They pause from their eternal flight to come to him, and Francesca tells
their history while Paolo weeps at her side. Dante is so stricken by
compassion at their tragic tale that he swoons once again.*

So we went down to the second ledge alone;
a smaller circle of so much greater pain
the voice of the damned rose in a bestial moan.　　3

There Minos sits, grinning, grotesque, and hale.
He examines each lost soul as it arrives
and delivers his verdict with his coiling tail.　　6

That is to say, when the ill-fated soul
appears before him it confesses all,
and that grim sorter of the dark and foul　　9

decides which place in Hell shall be its end,
then wraps his twitching tail about himself
one coil for each degree it must descend.　　12

The soul descends and others take its place:
each crowds in its turn to judgment, each confesses,
each hears its doom and falls away through space.　　15

"O you who come into this camp of woe,"
cried Minos when he saw me turn away
without awaiting his judgment, "watch where you go　　18

once you have entered here, and to whom you turn!
Do not be misled by that wide and easy passage!"
And my Guide to him: "That is not your concern;　　21

it is his fate to enter every door.
This has been willed where what is willed must be,
and is not yours to question. Say no more."　　24

Now the choir of anguish, like a wound,
strikes through the tortured air. Now I have come
to Hell's full lamentation, sound beyond sound.　　27

I came to a place stripped bare of every light
and roaring on the naked dark like seas
wracked by a war of winds. Their hellish flight　　30

of storm and counterstorm through time foregone,
sweeps the souls of the damned before its charge.
Whirling and battering it drives them on,　　33

and when they pass the ruined gap of Hell
through which we had come, their shrieks begin anew.
There they blaspheme the power of God eternal.　　36

And this, I learned, was the never ending flight
of those who sinned in the flesh, the carnal and lusty
who betrayed reason to their appetite.　　39

As the wings of wintering starlings bear them on
in their great wheeling flights, just so the blast
wherries these evil souls through time foregone.　　42

Here, there, up, down, they whirl and whirling, strain
with never a hope of hope to comfort them,
not of release, but even of less pain.　　45

As cranes go over sounding their harsh cry,
leaving the long streak of their flight in air,
so come these spirits, wailing as they fly.　　48

And watching their shadows lashed by wind, I cried:
"Master, what souls are these the very air
lashes with its black whips from side to side?"　　51

"The first of these whose history you would know,"
he answered me, "was Empress of many tongues.
Mad sensuality corrupted her so　　54

that to hide the guilt of her debauchery
she licensed all depravity alike,
and lust and law were one in her decree.　　57

She is Semiramis of whom the tale is told
how she married Ninus and succeeded him
to the throne of that wide land the Sultans hold.　　60

The other is Dido; faithless to the ashes
of Sichaeus, she killed herself for love.
The next whom the eternal tempest lashes　　63

is sense-drugged Cleopatra. See Helen there,
from whom such ill arose. And great Achilles,
who fought at last with love in the house of prayer.　　66

And Paris. And Tristan." As they whirled above
he pointed out more than a thousand shades
of those torn from the mortal life by love.　　69

I stood there while my Teacher one by one
named the great knights and ladies of dim time;
and I was swept by pity and confusion.　　72

At last I spoke: "Poet, I should be glad
to speak a word with those two swept together
so lightly on the wind and still so sad."　　75

And he to me: "Watch them. When next they pass,
call to them in the name of love that drives
and damns them here. In that name they will pause."　　78

Thus, as soon as the wind in its wild course
brought them around, I called: "O wearied souls!
if none forbid it, pause and speak to us."　　81

As mating doves that love calls to their nest
glide through the air with motionless raised wings,
borne by the sweet desire that fills each breast—　　84

Just so those spirits turned on the torn sky
from the band where Dido whirls across the air;
such was the power of pity in my cry.　　87

"O living creature, gracious, kind, and good,
going this pilgrimage through the sick night,
visiting us who stained the earth with blood, 90

were the King of Time our friend, we would pray His peace
on you who have pitied us. As long as the wind
will let us pause, ask of us what you please. 93

The town where I was born lies by the shore
where the Po descends into its ocean rest
with its attendant streams in one long murmur. 96

Love, which in gentlest hearts will soonest bloom
seized my lover with passion for that sweet body
from which I was torn unshriven to my doom. 99

Love, which permits no loved one not to love,
took me so strongly with delight in him
that we are one in Hell, as we were above. 102

Love led us to one death. In the depths of Hell
Caïna waits for him who took our lives."
This was the piteous tale they stopped to tell. 105

And when I had heard those world-offended lovers
I bowed my head. At last the Poet spoke:
"What painful thoughts are these your lowered brow
covers?" 108

When at length I answered, I began: "Alas!
What sweetest thoughts, what green and young desire
led these two lovers to this sorry pass." 111

Then turning to those spirits once again,
I said: "Francesca, what you suffer here
melts me to tears of pity and of pain. 114

But tell me: in the time of your sweet sighs
by what appearances found love the way
to lure you to his perilous paradise?" 117

And she: "The double grief of a lost bliss
is to recall its happy hour in pain.
Your Guide and Teacher knows the truth of this. 120

But if there is indeed a soul in Hell
to ask of the beginning of our love
out of his pity, I will weep and tell: 123

On a day for dalliance we read the rhyme
of Lancelot, how love had mastered him.
We were alone with innocence and dim time. 126

Pause after pause that high old story drew
our eyes together while we blushed and paled;
but it was one soft passage overthrew 129

our caution and our hearts. For when we read
how her fond smile was kissed by such a lover,
he who is one with me alive and dead 132

breathed on my lips the tremor of his kiss.
That book, and he who wrote it, was a pander.
That day we read no further." As she said this, 135

the other spirit, who stood by her, wept
so piteously, I felt my senses reel
and faint away with anguish. I was swept 138

by such a swoon as death is, and I fell,
as a corpse might fall, to the dead floor of Hell.

Notes

2. A SMALLER CIRCLE: The pit of Hell tapers like a funnel. The
 circles of ledges accordingly grow smaller as they descend.

4. MINOS: Like all the monsters Dante assigns to the various of-
fices of Hell, Minos is drawn from Classical mythology. He
was the son of Europa and of Zeus, who descended to her
in the form of a bull. Minos became a mythological king of
Crete, so famous for his wisdom and justice that after death
his soul was made judge of the dead. Vergil presents him ful-
filling the same office at Aeneas' descent to the underworld.
Dante, however, transforms him into an irate and hideous
monster with a tail. The transformation may have been sug-
gested by the form Zeus assumed for the rape of Europa—the
monster is certainly bullish enough here—but the obvious
purpose of the brutalization is to present a figure symbolic of
the guilty conscience of the wretches who come before it to
make their confessions. Dante freely reshapes his materials to
his own purposes.

8. IT CONFESSES ALL: Just as the souls appeared eager to cross
Acheron, so they are eager to confess even while they dread.
Dante is once again making the point that sinners elect their
Hell by an act of their own will.

27. HELL'S FULL LAMENTATION: It is with the second circle that the
real tortures of Hell begin.

34. THE RUINED GAP OF HELL: See note to Canto II, 53. At the time
of the Harrowing of Hell a great earthquake shook the under-
world shattering rocks and cliffs. Ruins resulting from the same
shock are noted in Canto XII, 34, and Canto XXI, 112 ff. At
the beginning of Canto XXIV, the Poets leave the bolgia of the
Hypocrites by climbing the ruined slabs of a bridge that was
shattered by this earthquake.

THE SINNERS OF THE SECOND CIRCLE (THE CARNAL): Here be-
gin the punishments for the various sins of Incontinence (the
sins of the She-Wolf). Punished in the second circle are those
who sinned by excess of sexual passion. Since this is the most
natural sin and the sin most nearly associated with love, its
punishment is the lightest of all to be found in Hell proper.
The Carnal are whirled and buffeted endlessly through the
murky air (symbolic of the beclouding of their reason by pas-
sion) by a great gale (symbolic of their lust).

53. EMPRESS OF MANY TONGUES: Semiramis, a legendary queen of
Assyria who assumed full power at the death of her husband,
Ninus.

61. DIDO: Queen and founder of Carthage. She had vowed to re-
main faithful to her husband, Sichaeus, but she fell in love with
Aeneas. When Aeneas abandoned her she stabbed herself on a
funeral pyre she had had prepared.

According to Dante's own system of punishments, she
should be in the Seventh Circle (Canto XIII) with the suicides.
The only clue Dante gives to the tempering of her punishment
is his statement that "she killed herself for love." Dante always
seems readiest to forgive in that name.

65. ACHILLES: He is placed among this company because of his pas-
sion of Polyxena, the daughter of Priam. For love of her, he
agreed to desert the Greeks and to join the Trojans, but when
he went to the temple for the wedding (according to the leg-
end Dante has followed) he was killed by Paris.

74. THOSE TWO SWEPT TOGETHER: Paolo and Francesca (PAH-oe-
loe: Frahn-CHAY-ska). Dante's treatment of these two lovers
is certainly the tenderest and most sympathetic accorded any
of the sinners in Hell, and legends immediately began to grow
about this pair.

The facts are these. In 1275 Giovanni Malatesta (Djoe-
VAH-nee Mahl-ah-TEH-stah) of Rimini, called Giovanni the
Lame, a somewhat deformed but brave and powerful warrior,
made a political marriage with Francesca, daughter of Guido
da Polenta of Ravenna. Francesca came to Rimini and there
an amour grew between her and Giovanni's younger brother
Paolo. Despite the fact that Paolo had married in 1269 and had
become the father of two daughters by 1275, his affair with
Francesca continued for many years. It was sometime between
1283 and 1286 that Giovanni surprised them in Francesca's
bedroom and killed both of them.

Around these facts the legend has grown that Paolo was
sent by Giovanni as his proxy to the marriage, that Francesca
thought he was her real bridegroom and accordingly gave him
her heart irrevocably at first sight. The legend obviously in-
creases the pathos, but nothing in Dante gives it support.

102. THAT WE ARE ONE IN HELL, AS WE WERE ABOVE: At many points of the *Inferno* Dante makes clear the principle that the souls of the damned are locked so blindly into their own guilt that none can feel sympathy for another, or find any pleasure in the presence of another. The temptation of many readers is to interpret this line romantically: that is, the love of Paolo and Francesca survives Hell itself. The more Dantean interpretation, however, is that they add to one another's anguish (a) as mutual reminders of their sin, and (b) as insubstantial shades of the bodies for which they once felt such great passion.

104. CAÏNA WAITS FOR HIM: Giovanni Malatesta was still alive at the writing. His fate is already decided, however, and upon his death, his soul will fall to Caïna, the first ring of the last circle (Canto XXXII), where lie those who performed acts of treachery against their kin.

124–5. THE RHYME OF LANCELOT: The story exists in many forms. The details Dante makes use of are from an Old French version.

126. DIM TIME: The original simply reads "We were alone, suspecting nothing." "Dim time" is rhyme-forced, but not wholly outside the legitimate implications of the original, I hope. The old courtly romance may well be thought of as happening in the dim ancient days. The apology, of course, comes after the fact: one does the possible, then argues for justification, and there probably is none.

134. THAT BOOK, AND HE WHO WROTE IT, WAS A PANDER: *Galeotto*, the Italian word for "pander," is also the Italian rendering of the name of Gallehault, who in the French Romance Dante refers to here, urged Lancelot and Guinevere on to love.

CANTO X

Circle Six

The Heretics • *As the Poets pass on, one of the damned hears Dante speaking, recognizes him as a Tuscan, and calls to him from one of the fiery tombs. A moment later he appears. He is* Farinata degli Uberti, *a great war-chief of the Tuscan Ghibellines. The majesty and power of his bearing seem to diminish Hell itself. He asks Dante's lineage and recognizes him as an enemy. They begin to talk politics, but are interrupted by another shade, who rises from the same tomb. This one is* Cavalcante dei Cavalcanti, *father of Guido Cavalcanti, a contemporary poet. If it is genius that leads Dante on his great journey, the shade asks, why is Guido not with him? Can Dante presume to a greater genius than Guido's? Dante replies that he comes this way only with the aid of powers Guido has not sought. His reply is a classic example of many-leveled symbolism as well as an overt criticism of a rival poet. The senior Cavalcanti mistakenly infers from Dante's reply that Guido is dead, and swoons back into the flames.*

Farinata, who has not deigned to notice his fellow-sinner, continues from the exact point at which he had been interrupted. It is as if he refuses to recognize the flames in which he is shrouded. He proceeds to prophesy Dante's banishment from Florence, he defends his part in Florentine politics, and then, in answer to Dante's question, he explains how it is that the damned can foresee the future but have no knowledge of the present. He then names others who share his tomb, and Dante takes his leave with considerable respect for his great enemy, pausing only long enough to leave word for Cavalcanti that Guido is still alive.

We go by a secret path along the rim
of the dark city, between the wall and the torments.
My master leads me and I follow him. 3

"Supreme Virtue, who through this impious land
wheel me at will down these dark gyres," I said,
"speak to me, for I wish to understand. 6

Tell me, Master, is it permitted to see
the souls within these tombs? The lids are raised,
and no one stands on guard." And he to me: 9

"All shall be sealed forever on the day
these souls return here from Jehosaphat
with the bodies they have given once to clay. 12

In this dark corner of the morgue of wrath
lie Epicurus and his followers,
who make the soul share in the body's death. 15

And here you shall be granted presently
not only your spoken wish, but that other as well,
which you had thought perhaps to hide from me." 18

And I: "Except to speak my thoughts in few
and modest words, as I learned from your example,
dear Guide, I do not hide my heart from you." 21

"O Tuscan, who go living through this place
speaking so decorously, may it please you pause
a moment on your way, for by the grace 24

of that high speech in which I hear your birth,
I know you for a son of that noble city
which perhaps I vexed too much in my time on earth." 27

These words broke without warning from inside
one of the burning arks. Caught by surprise,
I turned in fear and drew close to my Guide. 30

And he: "Turn around. What are you doing? Look
 there:
it is Farinata rising from the flames.
From the waist up his shade will be made clear." 33

My eyes were fixed on him already. Erect,
he rose above the flame, great chest, great brow;
he seemed to hold all Hell in disrespect. 36

My Guide's prompt hands urged me among the dim
and smoking sepulchres to that great figure,
and he said to me: "Mind how you speak to him." 39

And when I stood alone at the foot of the tomb,
the great soul stared almost contemptuously,
before he asked: "Of what line do you come?" 42

Because I wished to obey, I did not hide
anything from him: whereupon as he listened,
he raised his brows a little, then replied: 45

"Bitter enemies were they to me,
to my fathers, and to my party, so that twice
I sent them scattering from high Italy." 48

"If they were scattered, still from every part
they formed again and returned both times," I
 answered,
"but yours have not yet wholly learned that art." 51

At this another shade rose gradually,
visible to the chin. It had raised itself,
I think, upon its knees, and it looked around me 54

as if it expected to find through that black air
that blew about me, another traveler.
And weeping when it found no other there, 57

turned back. "And if," it cried, "you travel through
this dungeon of the blind by power of genius,
where is my son? why is he not with you?" 60

And I to him: "Not by myself am I borne
this terrible way. I am led by him who waits there,
and whom perhaps your Guido held in scorn." 63

For by his words and the manner of his torment
I knew his name already, and could, therefore,
answer both what he asked and what he meant. 66

Instantly he rose to his full height:
"He *held?* What is it you say? Is he dead, then?
Do his eyes no longer fill with that sweet light?" 69

And when he saw that I delayed a bit
in answering his question, he fell backwards
into the flame, and rose no more from it. 72

But that majestic spirit at whose call
I had first paused there, did not change expression,
nor so much as turn his face to watch him fall. 75

"And if," going on from his last words, he said,
"men of my line have yet to learn that art,
that burns me deeper than his flaming bed. 78

But the face of her who reigns in Hell shall not
be fifty times rekindled in its course
before you learn what griefs attend that art. 81

And as you hope to find the world again,
tell me: why is that populace so savage
in the edicts they pronounce against my strain?" 84

And I to him: "The havoc and the carnage
that dyed the Arbia red at Montaperti
have caused these angry cries in our assemblage." 87

He sighed and shook his head. "I was not alone
in that affair," he said, "nor certainly
would I have joined the rest without good reason. 90

But I *was* alone at that time when every other
consented to the death of Florence; I
alone with open face defended her." 93

"Ah, so may your soul sometime have rest,"
I begged him, "solve the riddle that pursues me
through this dark place and leaves
 my mind perplexed: 96

you seem to see in advance all time's intent,
if I have heard and understood correctly;
but you seem to lack all knowledge of the present." 99

"We see asquint, like those whose twisted sight
can make out only the far-off," he said,
"for the King of All still grants us that much light. 102

When things draw near, or happen, we perceive
nothing of them. Except what others bring us
we have no news of those who are alive. 105

So may you understand that all we know
will be dead forever from that day and hour
when the portal of the Future is swung to." 108

Then, as if stricken by regret, I said:
"Now, therefore, will you tell that fallen one
who asked about his son, that he is not dead, 111

and that, if I did not reply more quickly,
it was because my mind was occupied
with this confusion you have solved for me." 114

And now my Guide was calling me. In haste,
therefore, I begged that mighty shade to name
the others who lay with him in that chest. 117

And he: "More than a thousand cram this tomb.
The second Frederick is here, and the Cardinal
of the Ubaldini. Of the rest let us be dumb." 120

And he disappeared without more said, and I
turned back and made my way to the ancient Poet,
pondering the words of the dark prophecy. 123

He moved along, and then, when we had started,
he turned and said to me, "What troubles you?
Why do you look so vacant and downhearted?" 126

And I told him. And he replied: "Well may you bear
those words in mind." Then, pausing, raised a finger:
"Now pay attention to what I tell you here: 129

when finally you stand before the ray
of that Sweet Lady whose bright eye sees all,
from her you will learn the turnings of your way." 132

So saying, he bore left, turning his back
on the flaming walls, and we passed deeper yet
into the city of pain, along a track 135

that plunged down like a scar into a sink
which sickened us already with its stink.

Notes

11. JEHOSAPHAT: A valley outside Jerusalem. The popular belief that it would serve as the scene of the Last Judgment was based on *Joel* iii, 2, 12.

14. EPICURUS: The Greek philosopher. The central aim of his philosophy was to achieve happiness, which he defined as the absence of pain. For Dante this doctrine meant the denial of the Eternal life, since the whole aim of the Epicurean was temporal happiness.

17. NOT ONLY YOUR SPOKEN WISH, BUT THAT OTHER AS WELL: "All knowing" Vergil is frequently presented as being able to read Dante's mind. The "other wish" is almost certainly Dante's desire to speak to someone from Florence with whom he could discuss politics. Many prominent Florentines were Epicureans.

22. TUSCAN: Florence lies in the province of Tuscany. Italian, to an extent unknown in America, is a language of dialects, all of which are readily identifiable even when they are not well understood by the hearer. Dante's native Tuscan has become the main source of modern official Italian. Two very common sayings still current in Italy are: *Lingua toscana, lingua di Dio* ("the Tuscan tongue is the language of God") and—to express the perfection of Italian speech—*Lingua toscana in bocca romana* ("the Tuscan tongue in a Roman mouth").

26. THAT NOBLE CITY: Florence.

32–51. FARINATA: Farinata degli Uberti (deh-lyee Oob-ehr-tee) was head of the ancient noble house of the Uberti. He became leader of the Ghibellines of Florence in 1239, and played a large part in expelling the Guelphs in 1248. The Guelphs returned in 1251, but Farinata remained. His arrogant desire to rule single-handed led to difficulties, however, and he was expelled in 1258. With the aid of the Manfredi of Siena, he gathered a large force and defeated the Guelphs at Montaperti on the river Arbia in 1260. Reentering Florence in triumph, he again expelled the Guelphs, but at the Diet of Empoli, held by the victors after the battle of Montaperti, he alone rose in open counsel to resist the general sentiment that Florence should be razed. He died in Florence in 1264. In 1266, the Guelphs once more returned and crushed forever the power of the Uberti, destroying their palaces and issuing special decrees against persons of the Uberti line. In 1283, a decree of heresy was published against Farinata.

39. "MIND HOW YOU SPEAK TO HIM": The surface interpretation is clearly that Vergil means Dante to show proper respect to so majestic a soul. But the allegorical level is more interesting here. Vergil (as Human Reason) is urging Dante to go forward on his own. These final words then would be an admonition to Dante to guide his speech according to the highest principles.

52. ANOTHER SHADE: Cavalcante dei Cavalcanti was a famous Epicurean ("like lies with like"). He was the father of Guido Cavalcanti, a poet and friend of Dante. Guido was also Farinata's son-in-law.

61. NOT BY MYSELF: Cavalcanti assumes that the resources of human genius are all that are necessary for such a journey. (It is an assumption that well fits his character as an Epicurean.)

Dante replies as a man of religion that other aid is necessary.

63. WHOM PERHAPS YOUR GUIDO HELD IN SCORN: This reference has not been satisfactorily explained. Vergil is a symbol on many levels—of Classicism, of Religiosity, of Human Reason. Guido might have scorned him on any of these levels, or on all of them. One interpretation might be that Dante wished to present Guido as an example of how skepticism acts as a limitation upon a man of genius. Guido's skepticism does not permit him to see beyond the temporal. He does not see that Vergil (Human Reason expressed as Poetic Wisdom) exists only to lead one to Divine Love, and therefore he cannot undertake the final journey on which Dante has embarked.

70. AND WHEN HE SAW THAT I DELAYED: Dante's delay is explained in lines 112–114.

79. HER WHO REIGNS IN HELL: Hecate or Proserpine. She is also the moon goddess. The sense of this prophecy, therefore, is that Dante will be exiled within fifty full moons. Dante was banished from Florence in 1302, well within fifty months of the prophecy.

83. THAT POPULACE: The Florentines.

97–108. THE KNOWLEDGE OF THE DAMNED: Dante notes with surprise that Farinata can foresee the future, but that Cavalcanti does not know whether his son is presently dead or alive. Farinata explains by outlining a most ingenious detail of the Divine Plan: The damned can see far into the future, but nothing of what is present or *of what has happened.* Thus, after Judgment, when there is no longer any Future, the intellects of the damned will be void.

119. THE SECOND FREDERICK: Emperor Frederick II. In Canto XIII Dante has Pier delle Vigne speak of him as one worthy of honor, but he was commonly reputed to be an Epicurean.

119–120. THE CARDINAL OF THE UBALDINI: In the original Dante refers to him simply as "il Cardinale." Ottaviano degli Ubaldini (born c. 1209, died 1273) became a cardinal in 1245, but his energies seem to have been directed exclusively to money and political intrigue. When he was refused an important loan by the Ghibellines, he is reported by many historians as having remarked: "I may say that if I have a soul, I have lost it in the cause of the Ghibellines, and no one of them will help me now." The words "If I have a soul" would be enough to make him guilty in Dante's eyes of the charge of heresy.

131. THAT SWEET LADY: Beatrice.

Canto XXXIII

Circle Nine: Cocytus

Compound Fraud *Round Two: Antenora*

The Treacherous to Country *Round Three: Ptolomea*

The Treacherous to Guests and Hosts• *The sinner who is gnawing his companion's head looks up, wipes his bloody mouth on his victim's hair, and tells his harrowing story. He is* Count Ugolino *and the wretch he gnaws is* Archbishop Ruggieri. *Both are in Antenora for treason. In life they had once plotted together. Then Ruggieri betrayed his fellow-plotter and caused his death, by starvation, along with his four "sons." In the most pathetic and dramatic passage of the* Inferno, *Ugolino details how their prison was sealed and how his "sons" dropped dead before him one by one, weeping for food. His terrible tale serves only to renew his grief and hatred, and he has hardly finished it before he begins to gnaw Ruggieri again with renewed fury. In the immutable Law of Hell, the killer-by-starvation becomes the food of his victim.*

The Poets leave Ugolino and enter Ptolomea, *so named for the Ptolomaeus of* Maccabees, *who murdered his father-in-law at a banquet. Here are punished those who were Treacherous Against the Ties of Hospitality. They lie with only half their faces above the ice and their tears freeze in their eye sockets, sealing them with little crystal visors. Thus even the comfort of tears is denied them. Here Dante finds* Friar Alberigo *and* Branca d'Oria, *and discovers the terrible power of*

Ptolomea: So great is its sin that the souls of the guilty fall to its torments even before they die, leaving their bodies still on earth, inhabited by Demons.

The sinner raised his mouth from his grim repast
and wiped it on the hair of the bloody head
whose nape he had all but eaten away. At last 3

he began to speak: "You ask me to renew
a grief so desperate that the very thought
of speaking of it tears my heart in two. 6

But if my words may be a seed that bears
the fruit of infamy for him I gnaw,
I shall weep, but tell my story through my tears. 9

Who you may be, and by what powers you reach
into this underworld, I cannot guess,
but you seem to me a Florentine by your speech. 12

I was Count Ugolino, I must explain;
this reverend grace is the Archbishop Ruggieri:
now I will tell you why I gnaw his brain. 15

That I, who trusted him, had to undergo
imprisonment and death through his treachery,
you will know already. What you cannot know— 18

that is, the lingering inhumanity
of the death I suffered—you shall hear in full:
then judge for yourself if he has injured me. 21

A narrow window in that coop of stone
now called the Tower of Hunger for my sake
(within which others yet must pace alone) 24

had shown me several waning moons already
between its bars, when I slept the evil sleep
in which the veil of the future parted for me. 27

This beast appeared as master of a hunt
chasing the wolf and his whelps across the mountain
that hides Lucca from Pisa. Out in front 30

of the starved and shrewd and avid pack he had placed
Gualandi and Sismondi and Lanfranchi
to point his prey. The father and sons had raced 33

a brief course only when they failed of breath
and seemed to weaken; then I thought I saw
their flanks ripped open by the hounds' fierce teeth. 36

Before the dawn, the dream still in my head,
I woke and heard my sons, who were there with me,
cry from their troubled sleep, asking for bread. 39

You are cruelty itself if you can keep
your tears back at the thought of what foreboding
stirred in my heart; and if you do not weep, 42

at what are you used to weeping?—The hour when food
used to be brought, drew near. They were now awake,
and each was anxious from his dream's dark mood. 45

And from the base of that horrible tower I heard
the sound of hammers nailing up the gates:
I stared at my sons' faces without a word. 48

I did not weep: I had turned stone inside.
They wept. 'What ails you, Father, you look so strange,'
my little Anselm, youngest of them, cried. 51

But I did not speak a word nor shed a tear:
not all that day nor all that endless night,
until I saw another sun appear. 54

When a tiny ray leaked into that dark prison
and I saw staring back from their four faces
the terror and the wasting of my own, 57

I bit my hands in helpless grief. And they,
thinking I chewed myself for hunger, rose
suddenly together. I heard them say: 60

Father, it would give us much less pain
if you ate us: it was you who put upon us
this sorry flesh; now strip it off again.' 63

I calmed myself to spare them. Ah! hard earth,
why did you not yawn open? All that day
and the next we sat in silence. On the fourth, 66

Gaddo, the eldest, fell before me and cried,
stretched at my feet upon that prison floor:
'Father, why don't you help me?' There he died. 69

And just as you see me, I saw them fall
one by one on the fifth day and the sixth.
Then, already blind, I began to crawl 72

from body to body shaking them frantically.
Two days I called their names, and they were dead.
Then fasting overcame my grief and me." 75

His eyes narrowed to slits when he was done,
and he seized the skull again between his teeth
grinding it as a mastiff grinds a bone. 78

Ah, Pisa! foulest blemish on the land
where "si" sound sweet and clear,
since those nearby you are slow to blast
 the ground on which you stand, 81

may Caprara and Gorgona drift from place
and dam the flooding Arno at its mouth
until it drowns the last of your foul race! 84

For if to Ugolino falls the censure
for having betrayed your castles, you for your part
should not have put his sons to such a torture: 87

you modern Thebes! those tender lives you split—
Brigata, Uguccione, and the others
I mentioned earlier—were too young for guilt! 90

We passed on further, where the frozen mine
entombs another crew in greater pain;
these wraiths are not bent over, but lie supine. 93

Their very weeping closes up their eyes;
and the grief that finds no outlet for its tears
turns inward to increase their agonies: 96

for the first tears that they shed knot instantly
in their eye-sockets, and as they freeze they form
a crystal visor above the cavity. 99

And despite the fact that standing in that place
I had become as numb as any callus,
and all sensation had faded from my face, 102

somehow I felt a wind begin to blow,
whereat I said: "Master, what stirs this wind?
Is not all heat extinguished here below?" 105

And the Master said to me: "Soon you will be
where your own eyes will see the source and cause
and give you their own answer to the mystery." 108

And one of those locked in that icy mall
cried out to us as we passed: "O souls so cruel

that you are sent to the last post of all, 111

relieve me for a little from the pain
of this hard veil; let my heart weep a while
before the weeping freeze my eyes again." 114

And I to him: "If you would have my service,
tell me your name; then if I do not help you
may I descend to the last rim of the ice." 117

"I am Friar Alberigo," he answered therefore,
"the same who called for the fruits from the bad garden.
Here I am given dates for figs full store." 120

"What! Are you dead already?" I said to him.
And he then: "How my body stands in the world
I do not know. So privileged is this rim 123

of Ptolomea, that often souls fall to it
before dark Atropos has cut their thread.
And that you may more willingly free my spirit 126

of this glaze of frozen tears that shrouds my face,
I will tell you this: when a soul betrays as I did,
it falls from flesh, and a demon takes its place, 129

ruling the body till its time is spent.
The ruined soul rains down into this cistern.
So, I believe, there is still evident 132

in the world above, all that is fair and mortal
of this black shade who winters here behind me.
If you have only recently crossed the portal 135

from that sweet world, you surely must have known
his body: Branca D'Oria is its name,
and many years have passed since he rained down." 138

"I think you are trying to take me in," I said,
"Ser Branca D'Oria is a living man;
he eats, he drinks, he fills his clothes and his bed." 141

"Michel Zanche had not yet reached the ditch
of the Black Talons," the frozen wraith replied,
"there where the sinners thicken in hot pitch, 144

when this one left his body to a devil,
as did his nephew and second in treachery,
and plumbed like lead through space
 to this dead level. 147

But now reach out your hand, and let me cry."
And I did not keep the promise I had made,
for to be rude to him was courtesy. 150

Ah, men of Genoa! souls of little worth,
corrupted from all custom of righteousness,
why have you not been driven from the earth? 153

For there beside the blackest soul of all
Romagna's evil plain, lies one of yours
bathing his filthy soul in the eternal 156

glacier of Cocytus for his foul crime,
while he seems yet alive in world and time!

Notes

1–90. UGOLINO AND RUGGIERI: (Oog-oh-LEE-noe: ROO-DJAIR-ee)
Ugolino, Count of Donoratico and a member of the Guelph
family della Gherardesca. He and his nephew, Nino de' Vis-
conti, led the two Guelph factions of Pisa. In 1288, Ugolino
intrigued with Archbishop Ruggieri degli Ubaldini, leader
of the Ghibellines, to get rid of Visconti and to take over the

command of all the Pisan Guelphs. The plan worked, but in the consequent weakening of the Guelphs, Ruggieri saw his chance and betrayed Ugolino, throwing him into prison with his sons and his grandsons. In the following year the prison was sealed up and they were left to starve to death. The law of retribution is clearly evident: in life Ruggieri sinned against Ugolino by denying him food; in Hell he himself becomes food for his victim.

18. YOU WILL KNOW ALREADY: News of Ugolino's imprisonment and death would certainly have reached Florence, *what you cannot know:* No living man could know what happened after Ugolino and his sons were sealed in the prison and abandoned.

22. COOP: Dante uses the Italian word *muda,* signifying a stone tower in which falcons were kept in the dark to moult. From the time of Ugolino's death it became known as The Tower of Hunger.

25. SEVERAL WANING MOONS: Ugolino was jailed late in 1288. He was sealed in to starve early in 1289.

28. THIS BEAST: Ruggieri.

29–30. THE MOUNTAIN THAT HIDES LUCCA FROM PISA: These two cities would be in view of one another were it not for Monte San Guiliano.

32. GUALANDI AND SISMONDI AND LANFRANCHI: (Gwah-LAHN-dee . . . Lahn-FRAHN-kee) Three Pisan nobles, Ghibellines and friends of the Archbishop.

51–71. UGOLINO'S "SONS": Actually two of the boys were grandsons and all were considerably older than one would gather from Dante's account. Anselm, the younger grandson, was fifteen. The others were really young men and were certainly old enough for guilt despite Dante's charge in line 90.

75. THEN FASTING OVERCAME MY GRIEF AND ME: That is, he died. Some interpret the line to mean that Ugolino's hunger drove him to cannibalism. Ugolino's present occupation in Hell would certainly support that interpretation but the fact is that cannibalism is the one major sin Dante does not assign a place to in Hell. So monstrous would it have seemed to him that he must certainly have established a special punishment for it. Certainly he could hardly have relegated it to an ambiguity. Moreover, it would be a sin of bestiality rather than of fraud, and as such it would be punished in the Seventh Circle.

79–80. THE LAND WHERE "SI" SOUND SWEET AND CLEAR: Italy.

82. CAPRARA AND GORGONA: These two islands near the mouth of the Arno were Pisan possessions in 1300.

86. BETRAYED YOUR CASTLES: In 1284, Ugolino gave up certain castles to Lucca and Florence. He was at war with Genoa at the time and it is quite likely that he ceded the castles to buy the neutrality of these two cities, for they were technically allied with Genoa. Dante, however, must certainly consider the action as treasonable, for otherwise Ugolino would be in Caïna for his treachery to Visconti.

88. YOU MODERN THEBES: Thebes, as a number of the foregoing notes will already have made clear, was the site of some of the most hideous crimes of antiquity.

91. WE PASSED ON FURTHER: Marks the passage into Ptolomea.

105. IS NOT ALL HEAT EXTINGUISHED: Dante believed (rather accurately, by chance) that all winds resulted from "exhalations of heat." Cocytus, however, is conceived as wholly devoid of heat, a metaphysical absolute zero. The source of the wind, as we discover in the next Canto, is Satan himself.

117. MAY I DESCEND TO THE LAST RIM OF THE ICE: Dante is not taking any chances; he has to go on to the last rim in any case. The sinner, however, believes him to be another damned soul and would interpret the oath quite otherwise than as Dante meant it.

118. FRIAR ALBERIGO: (Ahl-beh-REE-ghoe) Of the Manfredi of Faenza. He was another Jovial Friar. In 1284, his brother Manfred struck him in the course of an argument. Alberigo pretended to let it pass, but in 1285 he invited Manfred and his son to a banquet and had them murdered. The signal to the assassins were the words: "Bring in the fruit." "Friar Alberigo's bad fruit," became a proverbial saying.

125. ATROPOS: The Fate who cuts the thread of life.

137. BRANCA D'ORIA: (DAW-ree-yah) A Genoese Ghibelline. His sin is identical in kind to that of Friar Alberigo. In 1275, he invited his father-in-law, Michel Zanche, to a banquet and had him and his companions cut to pieces. He was assisted in the butchery by his nephew.

Canto XXXIV

Circle Nine: Cocytus

Compound Fraud *Round Four: Judecca*

The Treacherous to Their Masters *The Center*

Satan • "*On march the banners of the King,*" *Vergil begins as the Poets face the last depth. He is quoting a medieval hymn, and to it he adds the distortion and perversion of all that lies about him.* "*On march the banners of the King—of Hell.*" *And there before them, in an infernal parody of Godhead, they see Satan in the distance, his great wings beating like a windmill. It is their beating that is the source of the icy wind of Cocytus, the exhalation of all evil.*

All about him in the ice are strewn the sinners of the last round, Judecca, named for Judas Iscariot. These are the Treacherous to Their Masters. They lie completely sealed in the ice, twisted and distorted into every conceivable posture. It is impossible to speak to them, and the Poets move on to observe Satan.

He is fixed into the ice at the center to which flow all the rivers of guilt; and as he beats his great wings as if to escape, their icy wind only freezes him more surely into the polluted ice. In a grotesque parody of the Trinity, he has three faces, each a different color, and in each mouth he clamps a sinner whom he rips eternally with his teeth. Judas Iscariot in the central mouth: Brutus and Cassius in the mouths on either side.

Having seen all, the Poets now climb through the center, grappling hand over hand down the hairy flank of Satan himself—a last supremely symbolic action—and at last, when they have passed the center of all gravity, they emerge from Hell. A long climb from the earth's center to the Mount of Purgatory awaits them, and they push on without rest, ascending along the sides of the river Lethe, until they emerge once more to see the stars of Heaven, just before dawn on Easter Sunday.

"On march the banners of the King of Hell,"
my Master said. "Toward us. Look straight ahead:
can you make him out at the core of the frozen shell?" 3

Like a whirling windmill seen afar at twilight,
or when a mist has risen from the ground—
just such an engine rose upon my sight 6

stirring up such a wild and bitter wind
I cowered for shelter at my Master's back,
there being no other windbreak I could find. 9

I stood now where the souls of the last class
(with fear my verses tell it) were covered wholly;
they shone below the ice like straws in glass. 12

Some lie stretched out; others are fixed in place
upright, some on their heads, some on their soles;
another, like a bow, bends foot to face. 15

When we had gone so far across the ice
that it pleased my Guide to show me the foul creature
that once had worn the grace of Paradise, 18

he made me stop, and, stepping aside, he said:
"Now see the face of Dis! This is the place
where you must arm your soul against all dread." 21

Do not ask, Reader, how my blood ran cold
and my voice choked up with fear. I cannot write it:
this is a terror that cannot be told. 24

I did not die, and yet I lost life's breath:
imagine for yourself what I became,
deprived at once of both my life and death. 27

The Emperor of the Universe of Pain
jutted his upper chest above the ice;
and I am closer in size to the great mountain 30

the Titans make around the central pit,
than they to his arms. Now, starting from this part,
imagine the whole that corresponds to it! 33

If he was once as beautiful as now
he is hideous, and still turned on his Maker,
well may he be the source of every woe! 36

With what a sense of awe I saw his head
towering above me! for it had three faces:
one was in front, and it was fiery red; 39

the other two, as weirdly wonderful,
merged with it from the middle of each
shoulder to the point where all converged at the top of
 the skull; 42

the right was something between white and bile;
the left was about the color one observes
on those who live along the banks of the Nile. 45

Under each head two wings rose terribly,
their span proportioned to so gross a bird:
I never saw such sails upon the sea. 48

They were not feathers—their texture and their form
were like a bat's wings—and he beat them so
that three winds blew from him in one great storm: 51

it is these winds that freeze all Cocytus.
He swept from his six eyes, and down three chins
the tears ran mixed with bloody froth and pus. 54

In every mouth he worked a broken sinner
between his rake-like teeth. Thus he kept three
in eternal pain at his eternal dinner. 57

For the one in front the biting seemed to play
no part at all compared to the ripping: at times
the whole skin of his back was flayed away. 60

"That soul that suffers most," explained my Guide,
"is Judas Iscariot, he who kicks his legs
on the fiery chin and has his head inside. 63

Of the other two, who have their heads thrust forward,
the one who dangles down from the black face
is Brutus: note how he writhes without a word. 66

And there, with the huge and sinewy arms, is the soul
of Cassius.—But the night is coming on
and we must go, for we have seen the whole." 69

Then as he bade, I clasped his neck, and he,
watching for a moment when the wings
were opened wide, reached over dexterously 72

and seized the shaggy coat of the king demon;
then grappling matted hair and frozen crusts
from one tuft to another, clambered down. 75

When we had reached the joint where the great thigh
merges into the swelling of the haunch,
my Guide and Master, straining terribly, 78

turned his head to where his feet had been
and began to grip the hair as if he were climbing;
so that I thought we moved toward Hell again. 81

"Hold fast!" my Guide said, and his breath came shrill
with labor and exhaustion. "There is no way
but by such stairs to rise above such evil." 84

At last he climbed out through an opening
in the central rock, and he seated me on the rim;
then joined me with a nimble backward spring. 87

I looked up, thinking to see Lucifer
as I had left him, and I saw instead
his legs projecting high into the air. 90

Now let all those whose dull minds are still vexed
by failure to understand what point it was
I had passed through, judge if I was perplexed. 93

"Get up. Up on your feet," my Master said.
"The sun already mounts to middle tierce,
and a long road and hard climbing lie ahead." 96

It was no hall of state we had found there,
but a natural animal pit hollowed from rock
with a broken floor and a close and sunless air. 99

"Before I tear myself from the Abyss,"
I said when I had risen, "O my Master,
explain to me my error in all this: 102

where is the ice? and Lucifer—how has he
been turned from top to bottom: and how can the sun
have gone from night to day so suddenly?" 105

And he to me: "You imagine you are still
on the other side of the center where I grasped
the shaggy flank of the Great Worm of Evil 108

which bores through the world—you *were* while I
 climbed down,
but when I turned myself about, you passed
the point to which all gravities are drawn. 111

You are under the other hemisphere where you stand;
the sky above us is the half opposed
to that which canopies the great dry land. 114

Under the midpoint of that other sky
the Man who was born sinless and who lived
beyond all blemish, came to suffer and die. 117

You have your feet upon a little sphere
which forms the other face of the Judecca.
There it is evening when it is morning here. 120

And this gross Fiend and Image of all Evil
who made a stairway for us with his hide
is pinched and prisoned in the ice-pack still. 123

On this side he plunged down from heaven's height,
and the land that spread here once hid in the sea
and fled North to our hemisphere for fright; 126

and it may be that moved by that same fear,
the one peak that still rises on this side
fled upward leaving this great cavern here." 129

Down there, beginning at the further bound
of Beelzebub's dim tomb, there is a space
not known by sight, but only by the sound 132

of a little stream descending through the hollow
it has eroded from the massive stone
in its endlessly entwining lazy flow. 135

My Guide and I crossed over and began
to mount that little known and lightless road
to ascend into the shining world again. 138

He first, I second, without thought of rest
we climbed the dark until we reached the point
where a round opening brought in sight the blest 141

and beauteous shining of the Heavenly cars.
And we walked out once more beneath the Stars.

Notes

1. ON MARCH THE BANNERS OF THE KING: The hymn *(Vexilla regis prodeunt)* was written in the sixth century by Venantius Fortunatus, Bishop of Poitiers. The original celebrates the Holy Cross, and is part of the service for Good Friday to be sung at the moment of uncovering the cross.
17. THE FOUL CREATURE: Satan.
38. THREE FACES: Numerous interpretations of these three faces exist. What is essential to all explanation is that they be seen as perversions of the qualities of the Trinity.
54. BLOODY FROTH AND PUS: The gore of the sinners he chews which is mixed with his saliva.
62. JUDAS: Note how closely his punishment is patterned on that of the Simoniacs.
67. HUGE AND SINEWY ARMS: The Cassius who betrayed Caesar was more generally described in terms of Shakespeare's "lean and hungry look." Another Cassius is described by Cicero (*Catiline* III) as huge and sinewy. Dante probably confused the two.
68. THE NIGHT IS COMING ON: It is now Saturday evening.
95. MIDDLE TIERCE: In the canonical day tierce is the period from about 6 to 9 A.M. Middle tierce, therefore, is 7:30. In going through the center point, they have gone from night to day. They have moved ahead twelve hours.
128. THE ONE PEAK: The Mount of Purgatory.
129. THIS GREAT CAVERN: The natural animal pit of line 98. It is also "Beelzebub's dim tomb," line 131.
133. A LITTLE STREAM: Lethe. In Classical mythology, the river of forgetfulness, from which souls drank before being born. In Dante's symbolism it flows down from the top of Purgatory, where it washes away the memory of sin from the souls that have achieved purity. That memory it delivers to Hell, which draws all sin to itself.
143. STARS: As part of his total symbolism Dante ends each of the three divisions of the *Commedia* with this word. Every conclusion of the upward soul is toward the stars, God's shining symbols of hope and virtue. It is just before dawn of Easter Sunday that the Poets emerge—a further symbolism.

READING 39

from DANTE ALIGHIERI (1265–1321), DIVINE COMEDY, PURGATORY

PURGATORY

CANTO I

Ante-Purgatory: the Shore of the Island

Cato of Utica • *The Poets emerge from Hell just before dawn of Easter Sunday (April 10, 1300), and Dante revels in the sight of the rediscovered heavens. As he looks eagerly about at the stars, he sees nearby an old man of impressive bearing. The ancient is Cato of Utica, guardian of the shores of Purgatory. Cato challenges the Poets as fugitives from Hell, but Vergil, after first instructing Dante to kneel in reverence, explains Dante's mission and Beatrice's command. Cato then gives them instructions for proceeding.*

The Poets have emerged at a point a short way up the slope of Purgatory. It is essential, therefore, that they descend to the lowest point and begin from there, an allegory of Humility. Cato, accordingly, orders Vergil to lead Dante to the shore, to wet his hands in the dew of the new morning, and to wash the stains of Hell from Dante's face and the film of Hell's vapors from Dante's eyes. Vergil is then to bind about Dante's waist one of the pliant reeds (symbolizing Humility) that grow in the soft mud of the shore.

Having so commanded, Cato disappears. Dante arises in silence and stands waiting, eager to begin. His look is all the communication that is necessary. Vergil leads him to the shore and performs all that Cato has commanded. Dante's first purification is marked by a miracle: when Vergil breaks off a reed, the stalk immediately regenerates a new reed, restoring itself exactly as it had been.

For better waters now the little bark
of my indwelling powers raises her sails,
and leaves behind that sea so cruel and dark. 3

Now shall I sing that second kingdom given
the soul of man wherein to purge its guilt
and so grow worthy to ascend to Heaven. 6

Yours am I, sacred Muses! To you I pray.
Here let dead poetry rise once more to life,
and here let sweet Calliope rise and play 9

some far accompaniment in that high strain
whose power the wretched Pierides once felt
so terribly they dared not hope again. 12

Sweet azure of the sapphire of the east
was gathering on the serene horizon
its pure and perfect radiance—a feast 15

to my glad eyes, reborn to their delight,
as soon as I had passed from the dead air
which had oppressed my soul and dimmed my sight. 18

The planet whose sweet influence strengthens love
was making all the east laugh with her rays,
veiling the Fishes, which she swam above. 21

I turned then to my right and set my mind
on the other pole, and there I saw four stars
unseen by mortals since the first mankind. 24

The heavens seemed to revel in their light.
O widowed Northern Hemisphere, bereft
forever of the glory of that sight! 27

As I broke off my gazing, my eyes veered
a little to the left, to the other pole
from which, by then, the Wain had disappeared. 30

I saw, nearby, an ancient man, alone.
His bearing filled me with such reverence,
no father had had more from any son. 33

His beard was long and touched with strands of white,
as was his hair, of which two tresses fell
over his breast. Rays of the holy light 36

that fell from the four stars made his face glow
with such a radiance that he looked to me
as if he faced the sun. And standing so, 39

he moved his venerable plumes and said:
"Who are you two who climb by the dark stream
to escape the eternal prison of the dead? 42

Who led you? or what served you as a light
in your dark flight from the eternal valley,
which lies forever blind in darkest night? 45

Are the laws of the pit so broken? Or is new counsel
published in Heaven that the damned may wander
onto my rocks from the abyss of Hell?" 48

At that my Master laid his hands upon me,
instructing me by word and touch and gesture
to show my reverence in brow and knee, 51

then answered him: "I do not come this way
of my own will or powers. A Heavenly Lady
sent me to this man's aid in his dark day. 54

But since your will is to know more, my will
cannot deny you; I will tell you truly
why we have come and how. This man has still 57

to see his final hour, though in the burning
of his own madness he had drawn so near it
his time was perilously short for turning. 60

As I have told you, I was sent to show
the way his soul must take for its salvation;
and there is none but this by which I go. 63

I have shown him the guilty people. Now I mean
to lead him through the spirits in your keeping,
to show him those whose suffering makes them clean. 66

By what means I have led him to this strand
to see and hear you, takes too long to tell:
from Heaven is the power and the command. 69

Now may his coming please you, for he goes
to win his freedom; and how dear that is
the man who gives his life for it best knows. 72

You know it, who in that cause found death sweet
in Utica where you put off that flesh
which shall rise radiant at the Judgment Seat. 75

We do not break the Laws: this man lives yet,
and I am of that Round not ruled by Minos,
with your own Marcia, whose chaste eyes seem set 78

in endless prayers to you. O blessed breast
to hold her yet your own! for love of her
grant us permission to pursue our quest 81

across your seven kingdoms. When I go
back to her side I shall bear thanks of you,
if you will let me speak your name below." 84

"Marcia was so pleasing in my eyes
there on the other side," he answered then
"that all she asked, I did. Now that she lies 87

beyond the evil river, no word or prayer
of hers may move me. Such was the Decree
pronounced upon us when I rose from there. 90

But if, as you have said, a Heavenly Dame
orders your way, there is no need to flatter:
you need but ask it of me in her name. 93

Go then, and lead this man, but first see to it
you bind a smooth green reed about his waist
and clean his face of all trace of the pit. 96

For it would not be right that one with eyes
still filmed by mist should go before the angel
who guards the gate: he is from Paradise. 99

All round the wave-wracked shore-line, there below,
reeds grow in the soft mud. Along that edge
no foliate nor woody plant could grow. 102

for what lives in that buffeting must bend.
Do not come back this way: the rising sun
will light an easier way you may ascend." 105

With that he disappeared; and silently
I rose and moved back till I faced my Guide,
my eyes upon him, waiting. He said to me: 108

"Follow my steps and let us turn again:
along this side there is a gentle slope
that leads to the low boundaries of the plain." 111

The dawn, in triumph, made the day-breeze flee
before its coming, so that from afar
I recognized the trembling of the sea. 114

We strode across that lonely plain like men
who seek the road they strayed from and who count
the time lost till they find it once again. 117

When we had reached a place along the way
where the cool morning breeze shielded the dew
against the first heat of the gathering day, 120

with gentle graces my Sweet Master bent
and laid both outspread palms upon the grass.
Then I, being well aware of his intent, 123

lifted my tear-stained cheeks to him, and there
he made me clean, revealing my true color
under the residues of Hell's black air. 126

We moved on then to the deserted strand
which never yet has seen upon its waters
a man who found his way back to dry land. 129

There, as it pleased another, he girded me.
Wonder of wonders! when he plucked a reed
another took its place there instantly, 132

arising from the humble stalk he tore
so that it grew exactly as before.

Notes

4. THAT SECOND KINGDOM: Purgatory.

5. TO PURGE ITS GUILT: (See also line 66: THOSE WHOSE SUFFER-
ING MAKES THEM CLEAN.) There is suffering in Purgatory but no
torment. The torment of the damned is endless, produces no
change in the soul that endures it, and is imposed from without.
The suffering of the souls in Purgatory, on the other hand, is
temporary, is a means of purification, and is eagerly embraced
as an act of the soul's own will. Demons guard the damned to
inflict punishment and to prevent escape. In Purgatory, the sin-
ners are free to leave off their sufferings: nothing but their own
desire to be made clean moves them to accept their pains, and
nothing more is needed. In fact, it is left to the suffering soul
itself (no doubt informed by Divine Illumination) to decide at
what point it has achieved purification and is ready to move on.

8. DEAD POETRY: The verses that sang of Hell. Dante may equally
have meant that poetry as an art has long been surpassed by his-
tory as the medium for great subjects. Here poetry will return
to its Classic state.

7–12. THE INVOCATION: Dante invokes all the Muses, as he did in *In-
ferno*, II, 7, but there the exhortation was to his own powers,
to High Genius, and to Memory. Here he addresses his spe-
cific exhortation to Calliope, who, as the Muse of Epic Poetry,
is foremost of the Nine. In *Paradiso* (I, 13) he exhorts Apollo
himself to come to the aid of the poem.

Dante exhorts Calliope to fill him with the strains of the
music she played in the defeat of the Pierides, the nine daugh-
ters of Pierus, King of Thessaly. They presumed to challenge
the Muses to a contest of song. After their defeat they were
changed into magpies for their presumption. Ovid (*Metamor-
phoses*, V, 294–340 and 662–678) retells the myth in detail.

Note that Dante not only calls upon Calliope to fill him
with the strains of highest song, but that he calls for that very
song that overthrew the arrogant pretensions of the Pierides,
the strains that humbled false pride. The invocation is especially
apt, therefore, as a first sounding of the theme of Humility.

17. THE DEAD AIR: Of Hell.

19–21. THE PLANET WHOSE SWEET INFLUENCE STRENGTHENS LOVE: Ve-
nus. Here, as morning star, Venus is described as rising in Pi-
sces, the Fishes, the zodiacal sign immediately preceding Aries.
In Canto I of the *Inferno* Dante has made it clear that the Sun is
in Aries. Hence it is about to rise.

Allegorically, the fact that Venus represents love is, of
course, indispensable to the mood of the *Purgatory*. At no time
in April of 1300 was Venus the morning star. Rather, it rose
after the sun. Dante's description of the first dawn in Canto I
of the *Inferno* similarly violates the exact detail of things. But
Dante is no bookkeeper of the literal. In the *Inferno* he violated
fact in order to compile a perfect symbol of rebirth. Here, he
similarly violates the literal in order to describe an ideal sun-
rise, and simultaneously to make the allegorical point that Love
(Venus) leads the way and that Divine Illumination (the Sun)
follows upon it.

23. FOUR STARS: Modern readers are always tempted to identify
these four stars as the Southern Cross, but it is almost certain
that Dante did not know about that formation. In VIII, 89,
Dante mentions three other stars as emphatically as he does
these four and no one has been tempted to identify them on
a starchart. Both constellations are best taken allegorically. The
four stars represent the Four Cardinal Virtues: Prudence, Jus-
tice, Fortitude, and Temperance. Dante will encounter them

again in the form of nymphs when he achieves the Earthly Par-
adise.

24. THE FIRST MANKIND: Adam and Eve. In Dante's geography, the
Garden of Eden (the earthly Paradise) was atop the Mount of
Purgatory, which was the only land in the Southern Hemi-
sphere. All of what were called "the southern continents" were
believed to lie north of the equator. When Adam and Eve were
driven from the Garden, therefore, they were driven into the
Northern Hemisphere, and no living soul since had been far
enough south to see those stars.

Ulysses and his men had come within sight of the Mount of
Purgatory, but Ulysses mentioned nothing of having seen these
stars.

29. THE OTHER POLE: The North pole. The Wain (Ursa Major, *i.e.*,
the Big Dipper) is below the horizon.

31. ff. CATO OF UTICA: Marcus Porcius Cato the Younger, 95–46 B.C.
In the name of freedom, Cato opposed the policies of both
Caesar and Pompey, but because he saw Caesar as the greater
evil joined forces with Pompey. After the defeat of his cause at
the Battle of Thapsus, Cato killed himself with his own sword
rather than lose his freedom. Vergil lauds him in the *Aeneid* as a
symbol of perfect devotion to liberty, and all writers of Roman
antiquity have given Cato a similar high place. Dante spends
the highest praises on him both in *de Monarchia* and *Ii Convivio*.

Why Cato should be so signally chosen by God as the spe-
cial guardian of Purgatory has been much disputed. Despite his
suicide (and certainly one could argue that he had less excuse
for it than had Pier delle Vigne—see *Inferno*, XIII—for his)
he was sent to Limbo as a Virtuous Pagan. From Limbo he was
especially summoned to his present office. It is clear, moreover,
that he will find a special triumph on Judgment Day, though he
will probably not be received into Heaven.

The key to Dante's intent seems to lie in the four stars, the
Four Cardinal Virtues, that shine so brightly on Cato's face
when Dante first sees him. Once Cato is forgiven his suicide
(and a partisan could argue that it was a positive act, a death for
freedom), he may certainly be taken as a figure of Prudence,
Justice, Fortitude, and Temperance. He does very well, more-
over, as a symbol of the natural love of freedom; and Purga-
tory, it must be remembered, is the road to Ultimate Freedom.
Cato may therefore be taken as representative of supreme vir-
tue short of godliness. He has accomplished everything but the
purifying total surrender of his will to God. As such he serves as
an apt transitional symbol, being the highest rung on the ladder
of natural virtue, but the lowest on the ladder of those godly
virtues to which Purgatory is the ascent. Above all, the fact that
he took Marcia (see note, line 78) back to his love, makes him
an especially apt symbol of God's forgiveness in allowing the
strayed soul to return to him through Purgatory.

53. A HEAVENLY LADY: Beatrice.

77. MINOS: The Judge of the Damned. The round in Hell not ruled
by Minos is Limbo, the final resting place of the Virtuous Pa-
gans, Minos (see *Inferno*, V) is stationed at the entrance to the
second circle of Hell. The souls in Limbo (the first circle) have
never had to pass before him to be judged.

78. MARCIA: The story of Marcia and of Cato is an extraordinary
one. She was the daughter of the consul Philippus and became
Cato's second wife, bearing his three children. In 56 B.C.E., in
an unusual transaction approved by her father, Cato released
her in order that she might marry his friend Hortensius (hence
line 87: "that all she asked I did"). After the death of Horten-
sius, Cato took her back.

In *Ii Convivio*, IV, 28, Dante presents the newly widowed
Marcia praying to be taken back in order that she may die the
wife of Cato, and that it may be said of her that she was not
cast forth from his love. Dante treats that return as an allegory
of the return of the strayed soul to God (that it may die "mar-
ried" to God, and that God's love for it be made manifest to all
time). Vergil describes Marcia as still praying to Cato.

89. THE DECREE: May be taken as that law which makes an absolute
separation between the damned and the saved. Cato cannot be
referring here to Mark, XII, 25 ("when they shall rise from the
dead, they neither marry, nor are given in marriage") for that
"decree" was not pronounced upon his ascent from Limbo.

98. FILMED BY MIST: Of Hell.

100. ff. THE REED: The pliant reed clearly symbolizes humility, but other allegorical meanings suggest themselves at once. First, the Reed takes the place of the Cord that Dante took from about his waist in order to signal Geryon. The Cord had been intended to snare and defeat the Leopard with the Gaudy Pelt, a direct assault upon sin. It is now superseded by the Reed of submission to God's will. Second, the reeds are eternal and undiminishable. As such they must immediately suggest the redemption purchased by Christ's sufferings (ever-abounding grace), for the quantity of grace available to mankind through Christ's passion is, in Christian creed, also eternal and undiminishable. The importance of the fact that the reeds grow at the lowest point of the island and that the Poets must descend to them before they can begin, has already been mentioned. Curiously, the reed is never again mentioned, though it must remain around Dante's waist. See also Matthew, xxvii, 29.

119. BREEZE SHIELDED THE DEW: The dew is a natural symbol of God's grace. The morning breeze shields it in the sense that, being cool, it retards evaporation.

Even more naturally, being bathed in the dew may be taken to signify baptism. The structure of Purgatory certainly suggests a parable of the soul's stages of sacred development: the dew, baptism; the gate of Purgatory, above, first communion; Vergil's certification of Dante as lord of himself (XXVII, 143), confirmation; and Dante's swoon and awakening as extreme unction and the reception into the company of the blessed.

CANTO IX

The Gate of Purgatory

The Angel Guardian • *Dawn is approaching. Dante has a dream of a golden eagle that descends from the height of Heaven and carries him up to the Sphere of Fire. He wakes to find he has been transported in his sleep, that it was* Lucia *(Divine Light) who bore him, laying him down beside an enormous wall, through an opening in which he and Vergil may approach the gate of purgatory.*

Having explained these matters, Vergil leads Dante to the Gate and its angel guardian. The Angel is seated on the topmost of three steps that symbolize the three parts of a perfect act of confession. *Dante prostrates himself at the feet of the Angel, who cuts* seven p's in Dante's forehead with the point of a blazing sword. *He then allows the Poets to enter. As the Gates open with a sound of thunder, the mountain resounds with a great* hymn of praise.

Now pale upon the balcony of the East
ancient Tithonus' concubine appeared,
but lately from her lover's arms released. 3

Across her brow, their radiance like a veil,
a scroll of gems was set, worked in the shape
of the cold beast whose sting is in his tail. 6

And now already, where we were, the night
had taken two steps upward, while the third
thrust down its wings in the first stroke of flight; 9

when I, by Adam's weight of flesh defeated,
was overcome by sleep, and sank to rest
across the grass on which we five were seated. 12

At that new hour when the first dawn light grows
and the little swallow starts her mournful cry,
perhaps in memory of her former woes; 15

and when the mind, escaped from its submission
to flesh and to the chains of waking thought,
becomes almost prophetic in its vision; 18

in a dream I saw a soaring eagle hold
the shining height of heaven, poised to strike,
yet motionless on widespread wings of gold. 21

He seemed to hover where old history
records that Ganymede rose from his friends,
borne off to the supreme consistory. 24

I thought to myself: "Perhaps his habit is
to strike at this one spot; perhaps he scorns
to take his prey from any place but this." 27

Then from his easy wheel in Heaven's spire,
terrible as a lightning bolt, he struck
and snatched me up high as the Sphere of Fire. 30

It seemed that we were swept in a great blaze,
and the imaginary fire so scorched me
my sleep broke and I wakened in a daze. 33

Achilles must have roused exactly thus—
glancing about with unadjusted eyes,
now here, now there, not knowing where he was— 36

when Thetis stole him sleeping, still a boy,
and fled with him from Chiron's care to Scyros,
whence the Greeks later lured him off to Troy. 39

I sat up with a start; and as sleep fled
out of my face, I turned the deathly white
of one whose blood is turned to ice by dread. 42

There at my side my comfort sat—alone.
The sun stood two hours high, and more. I sat
facing the sea. The flowering glen was gone. 45

"Don't be afraid," he said. "From here our course
leads us to joy, you may be sure. Now, therefore,
hold nothing back, but strive with all your force. 48

You are now at Purgatory. See the great
encircling rampart there ahead. And see
that opening—it contains the Golden Gate. 51

A while back, in the dawn before the day,
while still your soul was locked in sleep inside you,
across the flowers that made the valley gay, 54

a Lady came. 'I am Lucia,' she said.
'Let me take up this sleeping man and bear him
that he may wake to see his hope ahead.' 57

Sordello and the others stayed. She bent
and took you up. And as the light grew full,
she led, I followed, up the sweet ascent. 60

Here she put you down. Then with a sweep
of her sweet eyes she marked that open entrance.
Then she was gone; and with her went your sleep." 63

As one who finds his doubt dispelled, sheds fear
and feels it change into new confidence
as bit by bit he sees the truth shine clear— 66

so did I change; and seeing my face brim
with happiness, my Guide set off at once
to climb the slope, and I moved after him. 69

Reader, you know to what exalted height
I raised my theme. Small wonder if I now
summon still greater art to what I write. 72

As we drew near the height, we reached a place
from which—inside what I had first believed
to be an open breach in the rock face— 75

I saw a great gate fixed in place above
three steps, each its own color; and a guard
who did not say a word and did not move. 78

Slow bit by bit, raising my lids with care,
I made him out seated on the top step,
his face more radiant than my eyes could bear. 81

He held a drawn sword, and the eye of day
beat such a fire back from it, that each time
I tried to look, I had to look away. 84

I heard him call: "What is your business here?
Answer from where you stand. Where is your Guide?
Take care you do not find your coming dear." 87

"A little while ago," my Teacher said,
"A Heavenly Lady, well versed in these matters,
told us 'Go there. That is the Gate ahead.'" 90

"And may she still assist you, once inside,
to your soul's good! Come forward to our three steps,"
the courteous keeper of the gate replied. 93

We came to the first step: white marble gleaming
so polished and so smooth that in its mirror
I saw my true reflection past all seeming. 96

The second was stained darker than blue-black
and of a rough-grained and a fire-flaked stone,
its length and breadth crisscrossed by many a crack. 99

The third and topmost was of porphyry,
or so it seemed, but of a red as flaming
as blood that spurts out of an artery. 102

The Angel of the Lord had both feet on
this final step and sat upon the sill
which seemed made of some adamantine stone. 105

With great good will my Master guided me
up the three steps and whispered in my ear;
"Now beg him humbly that he turn the key." 108

Devoutly prostrate at his holy feet,
I begged in mercy's name to be let in,
but first three times upon my breast I beat. 111

Seven *P*'s, the seven scars of sin,
his sword point cut into my brow. He said:
"Scrub off these wounds when you have passed within." 114

Color of ashes, of parched earth one sees
deep in an excavation, were his vestments,
and from beneath them he drew out two keys. 117

One was of gold, one silver. He applied
the white one to the gate first, then the yellow,
and did with them what left me satisfied. 120

"Whenever either of these keys is put
improperly in the lock and fails to turn it,"
the Angel said to us, "the door stays shut. 123

One is more precious. The other is so wrought
as to require the greater skill and genius,
for it is that one which unties the knot. 126

They are from Peter, and he bade me be
more eager to let in than to keep out
whoever cast himself prostrate before me." 129

Then opening the sacred portals wide:
"Enter. But first be warned: do not look back
or you will find yourself once more outside." 132

The Tarpeian rock-face, in that fatal hour
that robbed it of Metellus, and then the treasure,
did not give off so loud and harsh a roar 135

as did the pivots of the holy gate—
which were of resonant and hard-forged metal—
when they turned under their enormous weight. 138

At the first thunderous roll I turned half-round,
for it seemed to me I heard a chorus singing
Te deum laudamus mixed with that sweet sound. 141

I stood there and the strains that reached my ears
left on my soul exactly that impression
a man receives who goes to church and hears 144

the choir and organ ringing out their chords
and now does, now does not, make out the words.

Notes

1–9. There is no wholly satisfactory explanation of this complex opening description. Dante seems to be saying that the third hour of darkness is beginning (hence, if sunset occurred at 6:00 it is now a bit after 8:00 P.M.) and that the aurora of the rising moon is appearing above the horizon.

He describes the moon as the concubine of Tithonus. Tithonus, however, married the daughter of the sun, Aurora (dawn), and it was she who begged Jove to give her husband immortality while forgetting to ask perpetual youth for him. Thus Tithonus lived but grew older and older beside his ageless bride. (In one legend he was later changed into a grasshopper.) Despite his advanced years, however, he seems here to be philandering with the moon as his concubine. Dante describes the moon as rising from Tithonus' bed and standing on the balcony of the East (the horizon) with the constellation Scorpio gemmed on her forehead, that "cold [blooded] beast whose sting is in his tail" being the scorpion.

Having given Tithonus a double life, Dante now adds a mixed metaphor in which the "steps" of the night have "wings." Two of the steps (hours) have flown, and the third has just completed the first downstroke of its wings (i.e., has just begun its flight).

15. FORMER WOES: Tereus, the husband of Procne, raped her sister Philomela, and cut out her tongue so that she could not accuse him. Philomela managed to communicate the truth to Procne by means of her weaving. The two sisters thereupon took revenge by killing Itys, son of Procne and Tereus, and serving up his flesh to his father. Tereus, learning the truth, was about to kill the sisters when all were turned into birds. Ovid (*Metamorphoses,* VI, 424 ff.) has Tereus changed into a hoopoe, and probably (though the text leaves some doubt) Procne into a swallow and Philomela into a nightingale. Dante clearly takes the swallow to be Philomela.

18. PROPHETIC IN ITS VISION: It was an ancient belief that dreams that came toward dawn were prophetic.

19–33. DANTE'S DREAM: Each of Dante's three nights on the Mount of Purgatory ends with a dream that comes just before dawn. The present dream is relatively simple in its symbolism and, as we learn shortly after Dante's awakening, it parallels his ascent of the mountain in the arms of Lucia. The dream is told, however, with such complexities of allusion that every reference must be carefully weighed.

To summarize the symbolism in the simplest terms, the Golden Eagle may best be rendered in its attributes. It comes from highest Heaven (from God), its feathers are pure gold (Love? God's splendor?), its wings are outspread (the open arms of Divine Love?), and it appears poised to descend in an instant (as is Divine Grace). The Eagle snatches Dante up to the Sphere of Fire (the presence of God? the beginning of Purgatorial purification? both?), and both are so consumed by the fire that Dante, in his unpurified state, cannot bear it.

On another level, of course, the Eagle is Lucia (Divine Light), who has descended from Heaven, and who bears the sleeping Dante from the Flowering Valley to the beginning of the true Purgatory. Note that Lucia is an anagram for *acuila,* ("eagle").

On a third level, the dream simultaneously connects with the earlier reference to Ganymede, also snatched up by the eagle of God, but the two experiences are contrasted as much as they are compared. Ganymede was out hunting in the company of his worldly associates; Dante was laboring for grace, had renounced worldliness, and was in the company of great souls who were themselves awaiting purification. Ganymede was carried to Olympus; Dante to the beginning of a purification which, though he was still too unworthy to endure it, would in time make him a perfect servant of the true God. Thus, his experience is in the same pattern as Ganymede's, but surpasses it as Faith surpasses Human Reason, and as Beatrice surpasses Vergil.

23. GANYMEDE: Son of Tros, the mythical founder of Troy, was reputedly the most beautiful of mortals, so beautiful that Jove sent an eagle (or perhaps went himself in the form of an eagle) to snatch up the boy and bring him to Heaven, where he became cupbearer to the gods. The fact that Dante himself is about to begin the ascent of Purgatory proper (and hence to Heaven) inevitably suggests an allegory of the soul in the history of Ganymede. God calls to Himself what is most beautiful in man.

The fact that Dante always thought of the Trojans as an especially chosen people is also relevant. Ganymede was the son of the founder of Troy; Troy, in Dante's Vergilian view, founded Rome. And through the Church of Rome men's souls were enabled to mount to Heaven.

24. CONSISTORY: Here, the council of the gods on Olympus. Dante uses the same term to describe Paradise.

30. SPHERE OF FIRE: The four elemental substances are earth, water, fire, and air. In Dante's cosmography, the Sphere of Fire was located above the Sphere of Air and just under the Sphere of the Moon. Hence the eagle bore him to the top of the atmosphere. The Sphere of Fire, however, may also be taken as another symbol for God.

34–39. ACHILLES' WAKING: It had been prophesied that Achilles would be killed at Troy. Upon the outbreak of the Trojan War, his mother, Thetis, stole him while he was sleeping, from the care of the centaur Chiron who was his tutor and fled with him to Scyros, where she hid him disguised as a girl. He was found there and lured away by Ulysses and Diomede, who burn for that sin (among others) in Malebolge. Thus Achilles, like Dante, was borne off in his sleep and awoke to find himself in a strange place.

51. THAT OPENING: The Gate, as the Poets will find, is closed and guarded. Dante (here and below in line 62) can only mean "the opening in which the gate was set" and not "an open entrance." At this distance, they do not see the Gate itself but only the gap in the otherwise solid wall.

55. LUCIA (Loo-TCHEE-ya): Symbolizes Divine Light, Divine Grace.

77. THREE STEPS: (See also lines 94–102, below.) The entrance into Purgatory involves the ritual of the Roman Catholic confessional with the Angel serving as the confessor. The three steps are the three acts of the perfect confession: candid confession (mirroring the whole man), mournful contrition, and burning gratitude for God's mercy. The Angel Guardian, as the priestly confessor, does not move or speak as the Poets approach, because he can admit to purification only those who ask for admission.

86. WHERE IS YOUR GUIDE?: It must follow from the Angel's question that souls ready to enter Purgatory are led up the mountain by another Angel. Dante and Vergil are arriving in an irregular way, as they did to the shore below, where they were asked essentially the same question by Cato. Note, too, that Vergil answers for the Poets, as he did to Cato. The allegory may be that right thinking answers for a man, at least to start with, though the actual entrance into the state of Grace requires an act of Faith and of Submission.

90. TOLD US: Lucia spoke only with her eyes, and what Vergil is quoting is her look. What he is quoting is, in essence, correct, but it does seem he could have been a bit more accurate in his first actual conversation with an Angel.

94–96. THE FIRST STEP: Contrition of the heart. White for purity, shining for hope, and flawless for perfection. It is not only the mirror of the soul, but it is that mirror in which the soul sees itself as it truly is and not in its outward seeming.

97–99. THE SECOND: Contrition of the mouth; that is, confession. The color of a bruise for the shame that envelops the soul as it confesses, rough-grained and fire-flaked for the pain the confessant must endure, and cracked for the imperfection (sin) the soul confesses.

100–102. THE THIRD: Satisfaction by works. Red for the ardor that leads to good works. Porphyry is, of course, a purple stone, but Dante does not say the stone was porphyry; only that it resembled it, though red in color.

"Artery" here is, of course, an anachronism, the circulation of the blood having yet to be discovered in Dante's time. Dante uses the word *vena* ("vein"), but it seems to me the anachronism will be less confusing to a modern reader than would be the idea of bright red and spurting venous blood.

103–105. The Angel, as noted, represents the confessor, and, more exactly, the Church Confessant. Thus the church is founded on adamant and rests its feet on Good Works.

112. SEVEN P's: *P* is for the Latin *peccatum*. Thus there is one *P* for each of the Seven Deadly Sins for which the sinners suffer on the seven ledges above: Pride, Envy, Wrath, Acedia (Sloth), Avarice (Hoarding and Prodigality), Gluttony, and Lust.

Dante has just completed the act of confession and the Angel confessor marks him to indicate that even in a shriven soul there remain traces of the seven sins which can be removed only by suffering.

115–117. COLOR OF ASHES, OF PARCHED EARTH: The colors of humility which befit the office of the confessor. two keys: (*Cf.* the Papal Seal, which is a crown above two crossed keys.) The keys symbolize the power of the confessor (the church, and hence the Pope) to grant or to withhold absolution. In the present context they may further be interpreted as the two parts of the confessor's office of admission: the gold key may be taken to represent his ordained authority, the silver key as the learning and reflection with which he must weigh the guilt before assigning penance and offering absolution.

126. UNTIES THE KNOT: Another mixed metaphor. The soul-searched judgment of the confessor (the silver key) decides who may and who may not receive absolution, and in resolving that problem the door is opened, provided that the gold key of ordained authority has already been turned.

133–138. THE TARPEIAN ROCK-FACE: The public treasury of Rome was kept in the great scarp of Tarpeia on the Campidoglio. The tribune Metellus was its custodian when Caesar, returned to Rome after crossing the Rubicon, moved to seize the treasury. Metellus opposed him but was driven away and the great gates were opened. Lucan (*Pharsalia,* III, 154–156 and 165–168) describes the scene and the roar that echoed from the rock face as the gates were forced open.

139–141. The thunder of the opening of the Gates notifies the souls within that a new soul has entered, and they burst into the hymn "We Praise Thee, O God." (Contrast these first sounds of Purgatory with the first sounds of Hell—*Inferno*, III, 22–24.) Despite the thunderous roar right next to him, Dante seems to hear with his "allegorical ear" what certainly could not have registered upon his physical ear.

This seeming incongruity has long troubled me. I owe Professor MacAllister a glad thanks for what is certainly the essential clarification. The whole *Purgatorio*, he points out, is built upon the structure of a Mass. The Mass moreover is happening not on the mountain but in church with Dante devoutly following its well-known steps. I have not yet had time to digest Professor MacAllister's suggestion, but it strikes me immediately as a true insight and promises another illuminating way of reading the *Purgatorio*.

Cantos I, IX from The Purgatorio in *The Divine Comedy* by Dante Alighieri, translated by John Ciardi. Copyright 1954, © 1957, 1959, 1960, 1961, 1965, 1967, 1970 by the Ciardi Family Publishing Trust. Used with permission of W. W. Norton & Co.

READING 40

from DANTE ALIGHIERI (1265–1321),
DIVINE COMEDY, PARADISE

PARADISE

CANTO XI

The Fourth Sphere: The Sun

Doctors of the Church

The First Garland of Souls: Aquinas • Praise of St. Francis • Degeneracy of Dominicans • Aquinas reads Dante's mind and speaks to make clear several points about which Dante was in doubt. He explains that Providence sent two equal princes to guide the church: St. Dominic, the wise law-giver, being one; and St. Francis, the ardent soul, being the other. Aquinas was himself a Dominican. To demonstrate the harmony of Heaven's gift and the unity of the Dominicans and Franciscans, Aquinas proceeds to pronounce a Praise of the Life of St. Francis. His account finished, he returns to the theme of the unity of the Dominicans and Franciscans, and proceeds to illustrate it further by himself lamenting the Degeneracy of the Dominican Order.

O senseless strivings of the mortal round!
how worthless is that exercise of reason
that makes you beat your wings into the ground! 3

One man was giving himself to law, and one
to aphorisms; one sought sinecures,
and one to rule by force or sly persuasion; 6

one planned his business, one his robberies;
one, tangled in the pleasure of the flesh,
wore himself out, and one lounged at his ease; 9

while I, of all such vanities relieved
and high in Heaven with my Beatrice,
arose to glory, gloriously received. 12

—When each had danced his circuit and come back
to the same point of the circle, all stood still,
like votive candles glowing in a rack. 15

And I saw the splendor of the blazing ray
that had already spoken to me, smile,
and smiling, quicken; and I heard it say: 18

"Just as I take my shining from on high,
so, as I look into the Primal Source,
I see which way your thoughts have turned, and why. 21

You are uncertain, and would have me find
open and level words in which to speak
what I expressed too steeply for your mind 24

when I said 'leads to where all plenty is,'
and 'no mortal ever rose to equal this one.'
And it is well to be exact in this. 27

The Providence that governs all mankind
with wisdom so profound that any creature
who seeks to plumb it might as well be blind, 30

in order that the Bride seek her glad good
in the Sweet Groom who, crying from on high,
took her in marriage with His blessed blood, 33

sent her two Princes, one on either side
that she might be secure within herself,
and thereby be more faithfully His Bride. 36

One, in his love, shone like the seraphim.
The other, in his wisdom, walked the earth
bathed in the splendor of the cherubim. 39

I shall speak of only one, though to extol
one or the other is to speak of both
in that their works led to a single goal. 42

Between the Tupino and the little race
sprung from the hill blessed Ubaldo chose,
a fertile slope spreads up the mountain's face. 45

Perugia breathes its heat and cold from there
through Porta Sole, and Nocera and Gualdo
behind it mourn the heavy yoke they bear. 48

From it, at that point where the mountainside
grows least abrupt, a sun rose to the world
as this one does at times from Ganges' tide. 51

Therefore, let no man speaking of that place
call it *Ascesi*— 'I have risen'—but rather,
Oriente—so to speak with proper grace. 54

Nor was he yet far distant from his birth
when the first comfort of his glorious powers
began to make its warmth felt on the earth: 57

a boy yet, for that lady who, like death
knocks on no door that opens to her gladly,
he had to battle his own father's wrath. 60

With all his soul he married her before
the diocesan court *et coram patre*;
and day by day he grew to love her more. 63

Bereft of her First Groom, she had had to stand
more than eleven centuries, scorned, obscure;
and, till he came, no man had asked her hand: 66

none, at the news that she had stood beside
the bed of Amyclas and heard, unruffled,
the voice by which the world was terrified; 69

and none, at word of her fierce constancy,
so great, that even when Mary stayed below,
she climbed the Cross to share Christ's agony 72

But lest I seem obscure, speaking this way,
take Francis and Poverty to be those lovers.
That, in plain words, is what I meant to say. 75

Their harmony and tender exultation
gave rise in love, and awe, and tender glances
to holy thoughts in blissful meditation. 78

The venerable Bernard, seeing them so,
kicked off his shoes, and toward so great a peace
ran, and running, seemed to go too slow. 81

O wealth unknown! O plentitude untried!
Egidius went unshod. Unshod, Sylvester
followed the groom. For so it pleased the bride! 84

Thenceforth this father and this happy lord
moved with his wife and with his family,
already bound round by the humble cord. 87

He did not grieve because he had been born
the son of Bernardone; he did not care
that he went in rags, a figure of passing scorn. 90

He went with regal dignity to reveal
his stern intentions to Pope Innocent,
from whom his order first received the seal. 93

There as more souls began to follow him
in poverty—whose wonder-working life
were better sung among the seraphim— 96

Honorius, moved by the Eternal Breath,
placed on the holy will of this chief shepherd
a second crown and everflowering wreath. 99

Then, with a martyr's passion, he went forth
and in the presence of the haughty Sultan
he preached Christ and his brotherhood on earth; 102

but when he found none there would take Christ's
 pardon,
rather than waste his labors, he turned back
to pick the fruit of the Italian garden. 105

On the crag between Tiber and Arno then, in tears
of love and joy, he took Christ's final seal,
the holy wounds of which he wore two years. 108

When God, whose loving will had sent him forward
to work such good, was pleased to call him back
to where the humble soul has its reward, 111

he, to his brothers, as to rightful heirs
commended his dearest Lady and he bade them
to love her faithfully for all their years. 114

Then from her bosom, that dear soul of grace
willed its return to its own blessed kingdom;
and wished its flesh no other resting place. 117

Think now what manner of man was fit to be
his fellow helmsman, holding Peter's ship
straight to its course across the dangerous sea. 120

Such was our patriarch. Hence, all who rise
and follow his command will fill the hold,
as you can see, with fruits of paradise. 123

But his flock has grown so greedy for the taste
of new food that it cannot help but be
far scattered as it wanders through the waste. 126

The more his vagabond and distant sheep
wander from him, the less milk they bring back
when they return to the fold. A few do keep 129

close to the shepherd, knowing what wolf howls
in the dark around them, but they are so few
it would take little cloth to make their cowls. 132

Now, if my words have not seemed choked and blind,
if you have listened to me and taken heed,
and if you will recall them to your mind, 135

your wish will have been satisfied in part,
for you will see how the good plant is broken,
and what rebuke my words meant to impart 138

when I referred, a while back in our talk,
to 'where all plenty is' and to 'bare rock.'"

Notes

15. RACK: Dante says "candellier," which may be taken to mean candlestick, but equally to mean the candle-racks that hold votive candles in churches. The image of the souls as twelve votive candles in a circular rack is certainly more apt than that of twelve candles in separate candlesticks.

25–26. LEAD TO . . . ALL PLENTY: X, 95. NO MORTAL EVER: X, 114.

28–42. INTRODUCTION TO THE LIFE OF ST. FRANCIS: Compare the words of Bonaventura in introducing the life of St. Dominic, XII, 31–45.

31. THE BRIDE: The Church.

32. CRYING FROM ON HIGH: Matthew, XXVII. 46, 50; Mark, XV, 34, 37; Luke, XXIII, 46; and John, XIX, 26–30; all record Christ's dying cries upon the cross.

34. TWO PRINCES, ONE ON EITHER SIDE: St. Dominic and St. Francis. Dominic, on one side (line 39 equates his wisdom with the cherubic), by his wisdom and doctrinal clarity made the church secure within itself by helping to defend it against error and heresy. Francis, on the other hand (line 37 ascribes to him seraphic ardor or love), set the example that made her more faithfully the bride of Christ.

43–51. ASSISI AND THE BIRTH OF ST. FRANCIS: The passage, in Dante's characteristic topophiliac style, is full of local allusions, not all of which are relevant to St. Francis, but all describing the situation of Assisi, his birthplace. Perugia stands to the east of the upper Tiber. The Tiber at this point runs approximately north to south. Mount Subasio, a long and many spurred crest, runs roughly parallel to the Tiber on the west. Assisi is on the side of Subasio, and it was from Assisi that the sun of St. Francis rose to the world, as "this one" (the actual sun in which Dante and Aquinas are standing) rises from the Ganges. The upper Ganges crosses the Tropic of Cancer, the line of the summer solstice. When the sun rises from the Ganges, therefore, it is at its brightest.

THE TUPINO: Skirts Mt. Subasio on the south and flows roughly west into the Tiber. THE LITTLE RACE: The Chiascio (kyah-show) flows south along the length of Subasio and empties into the Tupino below Assisi. BLESSED UBALDO: St. Ubaldo (1084–1160), Bishop of Gubbio from 1129. He chose a hill near Gubbio as a hermitage in which to end

his days, but died before he could retire there. PORTA SOLE: Perugia's west gate. It faces Mount Subasio. In summer its slopes reflect the sun's ray through Porta Sole; in winter, covered with snow, they send the cold wind. NOCERA (NAW-tcheh-ra), GUALDO (GWAHL-doe): Towns on the other side of (behind) Subasio. Their heavy yoke may be their subjugation by Perugia, or Dante may have meant by it the taxes imposed by Robert of Naples and his Spanish brigands.

51–54. It is such passages that certify the failures of all translation. ASCESI, which can mean "I have risen," was a common name for Assisi in Dante's day. ORIENTE, of course, is the point at which the sun rises. Let no man, therefore, call Assisi "I have risen" (i.e., a man has risen), but let him call it, rather, the dawning east of the world (a sun has risen).

55 ff. YET FAR DISTANT: While he was still young. The phrasing continues the figure of the new-risen sun.

Francis, born Bernardone, was the son of a relatively prosperous merchant and, early in life, assisted his father. In a skirmish between Assisi and Perugia he was taken prisoner and later released. On his return to Assisi (he was then twenty-four) he abandoned all worldly affairs and gave himself entirely to religious works.

A BOY YET: Here, as in line 55, Aquinas is overdoing it a bit: twenty-four is a bit old for being a boy yet. THAT LADY: poverty. HIS OWN FATHER'S WRATH: In 1207 (Francis was then twenty-five) he sold one of his father's horses along with a load of bread and gave the money to a church. In a rage, his father forced the church to return the money, called Francis before the Bishop of Assisi, and there demanded that he renounce his right to inherit. Francis not only agreed gladly but removed his clothes and gave them back to his father saying, "Until this hour I called you my father on earth; from this hour I can say in full truth 'our Father which art in Heaven.'"

HE MARRIED: In his "Hymn to Poverty" Francis himself celebrated his union to Poverty as a marriage. He had married her before the diocesan court of Assisi, *et coram patre* ("before the court"; i.e., in the legal presence of, his father). The marriage was solemnized by his renunciation of all possessions.

64–66. HER FIRST GROOM: Christ. HE: St. Francis.

68. AMYCLAS: Lucan reported (see also *Convivio*, IV, 13) how the fisherman Amyclas lay at his ease on a bed of seaweed before Caesar himself, being so poor that he had nothing to fear from any man. Not even this report of the serenity Mistress Poverty could bring to a man, and not even the fact that she outdid even Mary in constancy, climbing the very cross with Christ, had moved any man to seek her in marriage.

79. BERNARD: Bernard di Quintavalle, a wealthy neighbor, became the first disciple of Francis, kicking off his shoes to go barefoot in imitation of the master.

82–84. UNKNOWN: To men. Holy Poverty is the wealth none recognize, the plentitude none try. EGIDIUS . . . SYLVESTER: The third and fourth disciples of Francis. Peter, the second disciple, seems not to have been known to Dante. THE GROOM: Francis. THE BRIDE: Poverty.

87. THE HUMBLE CORD: Now a symbol of the Franciscans but then in general use by the poor as a makeshift belt.

88. GRIEVE: At his humble origins.

93. HIS ORDER FIRST RECEIVED THE SEAL: In 1210. But Innocent III thought the proposed rule of the order so harsh that he granted only provisional approval.

96. AMONG THE SERAPHIM: In the Empyrean, rather than in this Fourth Heaven.

97–99. HONORIUS . . . SECOND CROWN: In 1223, Pope Honorius III gave his fully solemnized approval of the Franciscan Order.

100–105. In 1219, St. Francis and eleven of his followers made missionary pilgrimage to Greece and Egypt. Dante, whose facts are not entirely accurate, may have meant that pilgrimage; or he may have meant Francis' projected journey to convert the Moors (1214–1215) when Francis fell ill in southern Spain and had to give up his plans.

106–108. In 1224, on a crag of Mount Alverna (on the summit of which the Franciscans have reared a commemorative cha-

pel), St. Francis received the stigmata in a rapturous vision of Christ. He wore the wound two years before his death in 1226, at the age of (probably) forty-four.

109–117. The central reference here is to Dame Poverty. HER BOSOM: The bare ground of Poverty. NO OTHER RESTING PLACE: Than in the bare ground.

119. HIS FELLOW HELMSMAN: St. Dominic. PETER'S SHIP: The Church.

121–132. THE DEGENERACY OF THE DOMINICANS IN DANTE'S TIME: Aquinas was a Dominican. As a master touch to symbolize the harmony of Heaven and the unity of Franciscans and Dominicans, Dante puts into the mouth of a Dominican the praise of the life of St. Francis. That praise ended, he chooses the Dominican to lament the degeneracy of the order. In XII, Dante will have the Franciscan, St. Bonaventure, praise the life of St. Dominic and lament the degeneracy of the Franciscans.

122. HIS COMMAND: The rule of the Dominicans, will fill his hold: With the treasures of Paradise. Dante is carrying forward the helmsman metaphor of lines 118–120, though the ship is now commanded by a patriarch. Typically, the figure changes at once to a shepherd-and-flock metaphor.

136. IN PART: In X, 95–96, in identifying himself as a Dominican, Aquinas said the Dominican rule "leads to where all plenty is" unless the lamb itself stray to "bare rock." In lines 25–26, above, he refers to these words and also to his earlier statements (X, 114) about Solomon's wisdom (that "no mortal ever rose to equal this one"). What he has now finished saying about the degeneracy of the Dominicans will satisfy part of Dante's wish (about "plenty" and "bare rock"). The other part of his wish (about "no mortal ever rose to equal this one") will be satisfied later.

137. THE GOOD PLANT: Of the Dominican rule strictly observed.

CANTO XXXIII

The Empyrean

St. Bernard • Prayer to the Virgin • The Vision of God •
St. Bernard offers a lofty Prayer to the Virgin, asking her to intercede in Dante's behalf, and in answer Dante feels his soul swell with new power and grow calm in rapture as his eyes are permitted the Direct Vision of God.

There can be no measure of how long the vision endures. It passes, and Dante is once more mortal and fallible. Raised by God's presence, he had looked into the Mystery and had begun to understand its power and majesty. Returned to himself, there is no power in him capable of speaking the truth of what he saw. Yet the impress of the truth is stamped upon his soul, which he now knows will return to be one with God's Love.

"Virgin Mother, daughter of thy son;
humble beyond all creatures and more exalted;
predestined turning point to God's intention; 3

thy merit so ennobled human nature
that its divine Creator did not scorn
to make Himself the creature of His creature. 6

The Love that was rekindled in Thy womb
sends forth the warmth of the eternal peace
within whose ray this flower has come to bloom. 9

Here, to us, thou art the noon and scope
of Love revealed; and among mortal men,
the living fountain of eternal hope. 12

Lady, thou art so near God's reckonings
that who seeks grace and does not first seek thee
would have his wish fly upward without wings. 15

Not only does thy sweet benignity
flow out to all who beg, but oftentimes
thy charity arrives before the plea. 18

In thee is pity, in thee munificence,
in thee the tenderest heart, in thee unites
all that creation knows of excellence! 21

Now comes this man who from the final pit
of the universe up to this height has seen,
one by one, the three lives of the spirit. 24

He prays to thee in fervent supplication
for grace and strength, that he may raise his eyes
to the all-healing final revelation. 27

And I, who never more desired to see
the vision myself than I do that he may see It,
add my own prayer, and pray that it may be 30

enough to move you to dispel the trace
of every mortal shadow by thy prayers
and let him see revealed the Sum of Grace. 33

I pray thee further, all-persuading Queen,
keep whole the natural bent of his affections
and of his powers after his eyes have seen. 36

Protect him from the stirrings of man's clay;
see how Beatrice and the blessèd host
clasp reverent hands to join me as I pray." 39

The eyes that God reveres and loves the best
glowed on the speaker, making clear the joy
with which true prayer is heard by the most blest. 42

Those eyes turned then to the Eternal Ray,
through which, we must indeed believe, the eyes
of others do not find such ready way. 45

And I, who neared the goal of all my nature,
felt my soul, at the climax of its yearning,
suddenly, as it ought, grow calm with rapture. 48

Bernard then, smiling sweetly, gestured to me
to look up, but I had already become
within myself all he would have me be. 51

Little by little as my vision grew
it penetrated further through the aura
of the high lamp which in Itself is true 54

What then I saw is more than tongue can say.
One human speech is dark before the vision.
The ravished memory swoons and falls away. 57

As one who sees in dreams and wakes to find
the emotional impression of his vision
still powerful while its parts fade from his mind— 60

just such am I, having lost nearly all
the vision itself, while in my heart I feel
the sweetness of it yet distill and fall. 63

So, in the sun, the footprints fade from snow.
On the wild wind that bore the tumbling leaves
the Sybil's oracles were scattered so. 66

O Light Supreme who doth Thyself withdraw
so far above man's mortal understanding,
lend me again some glimpse of what I saw; 69

make Thou my tongue so eloquent it may
of all Thy glory speak a single clue
to those who follow me in the world's day; 72

for by returning to my memory
somewhat, and somewhat sounding in these verses,
Thou shalt show man more of Thy victory. 75

So dazzling was the splendor of that Ray,
that I must certainly have lost my senses
had I, but for an instant, turned away. 78

And so it was, as I recall, I could
the better bear to look, until at last
my vision made one with the Eternal Good. 81

Oh grace abounding that had made me fit
to fix my eyes on the eternal light
until my vision was consumed in it! 84

I saw within Its depth how It conceives
all things in a single volume bound by Love,
of which the universe is the scattered leaves; 87

substance, accident, and their relation
so fused that all I say could do no more
than yield a glimpse of that bright revelation. 90

I think I saw the universal form
that binds these things, for as I speak these words
I feel my joy swell and my spirits warm. 93

Twenty-five centuries since Neptune saw
the Argo's keel have not moved all mankind,
recalling that adventure, to such awe 96

as I felt in an instant. My tranced being
stared fixed and motionless upon that vision,
ever more fervent to see in the act of seeing. 99

Experiencing that Radiance, the spirit
is so indrawn it is impossible
even to think of ever turning from it. 102

For the good which is the will's ultimate object
is all subsumed in It; and, being removed,
all is defective which in It is perfect. 105

Now in my recollection of the rest
I have less power to speak than any infant
wetting its tongue yet at its mother's breast; 108

and not because that Living Radiance bore
more than one semblance, for It is unchanging
and is forever as it was before; 111

rather, as I grew worthier to see,
the more I looked, the more unchanging semblance
appeared to change with every change in me. 114

Within the depthless deep and clear existence
of that abyss of light three circles shown—
three in color, one in circumference: 117

the second from the first, rainbow from rainbow;
the third, an exhalation of pure fire
equally breathed forth by the other two. 120

But oh how much my words miss my conception,
which is itself so far from what I saw
that to call it feeble would be rank deception! 123

O Light Eternal fixed in Itself alone,
by Itself alone understood, which from Itself
loves and glows, self-knowing and self-known; 126

that second aureole which shone forth in Thee,
conceived as a reflection of the first—
or which appeared so to my scrutiny— 129

seemed in Itself of Its own coloration
to be painted with man's image. I fixed my eyes
on that alone in rapturous contemplation. 132

Like a geometer wholly dedicated
to squaring the circle, but who cannot find,
think as he may, the principle indicated— 135

so did I study the supernal face.
I yearned to know just how our image merges
into that circle, and how it there finds place; 138

but mine were not the wings for such a flight.
Yet, as I wished, the truth I wished for came
cleaving my mind in a great flash of light. 141

Here my powers rest from their high fantasy,
but already I could feel my being turned—
instinct and intellect balanced equally 144

as in a wheel whose motion nothing jars—
by the Love that moves the Sun and the other stars.

Notes

1–39. ST. BERNARD'S PRAYER TO THE VIRGIN MARY: No reader who has come this far will need a lengthy gloss of Bernard's prayer. It can certainly be taken as a summarizing statement of the special place of Mary in Catholic faith. For the rest, only a few turns of phrase need underlining. 3. PREDESTINED TURNING POINT OF GOD'S INTENTION: All-forseeing God built his whole scheme for mankind with Mary as its pivot, for through her He would become man. 7. THE LOVE THAT WAS REKINDLED IN THY WOMB: God. In a sense He withdrew from man when Adam and Eve sinned. In Mary He returned and Himself became man. 35. KEEP WHOLE THE NATURAL BENT OF HIS AFFECTIONS: Bernard is asking Mary to protect Dante lest the intensity of the vision overpower his faculties. 37. PROTECT HIM FROM THE STIRRINGS OF MAN'S CLAY: Protect him from the stirrings of base human impulse, especially from pride, for Dante is about to receive a grace never before granted to any man and the thought of such glory might well move a mere mortal to an hybris [a hubris] that would turn glory to sinfulness.

40. THE EYES: Of Mary.

50. BUT I HAD ALREADY BECOME: That is, "But I had already fixed my entire attention upon the vision of God." But if so, how could Dante have seen Bernard's smile and gesture? Eager students like to believe they catch Dante in a contradiction here. Let them bear in mind that Dante is looking directly at God, as do the souls of Heaven, who thereby acquire—insofar as they are able to contain it—God's own knowledge. As a first stirring of that heavenly power, therefore, Dante is sharing God's knowledge of St. Bernard.

54. WHICH IN ITSELF IS TRUE: The light of God is the one light whose source is Itself. All others are a reflection of this.

65–66. TUMBLING LEAVES . . . ORACLES: The Cumean Sybil (Vergil describes her in *Aeneid,* III, 441 ff.) wrote her oracles on leaves,

one letter to a leaf, then sent her message scattering on the wind. Presumably, the truth was all contained in that strew, could one only gather all the leaves and put the letters in the right order.

76–81. How can a light be so dazzling that the beholder would swoon if he looked away for an instant? Would it not be, rather, in looking at, not away from, the overpowering vision that the viewer's senses would be overcome? So it would be on Earth. But now Dante, with the help of all heaven's prayers, is in the presence of God and strengthened by all he sees. It is by being so strengthened that he can see yet more. So the passage becomes a parable of grace. Stylistically it once more illustrates Dante's genius: Even at this height of concept, the poet can still summon and invent new perceptions, subtlety exfoliating from subtlety.

The simultaneous metaphoric statement is, of course, that no man can lose his good in the vision of God, but only in looking away from it.

85–87. THE IDEA HERE IS PLATONIC: The essence of all things (form) exists in the mind of God. All other things exist as exempla.

88. SUBSTANCE: Matter, all that exists in itself. ACCIDENT: All that exists as a phase of matter.

92. THESE THINGS: Substance and accident.

109–114. In the presence of God the soul grows ever more capable of perceiving God. Thus the worthy soul's experience of God is a constant expansion of awareness. God appears to change as He is better seen. Being perfect, He is changeless within Himself, for any change would be away from perfection.

130–144. The central metaphor of the entire *Comedy* is the image of God and the final triumphant in Godding of the elected soul returning to its Maker. On the mystery of that image, the metaphoric symphony of the *Comedy* comes to rest.

In the second aspect of Trinal-unity, in the circle reflected from the first, Dante thinks he sees the image of mankind woven into the very substance and coloration of God. He turns the entire attention of his soul to that mystery, as a geometer might seek to shut out every other thought and dedicate himself to squaring the circle. In *Il Convivio,* II, 14, Dante asserted that the circle could not be squared, but that impossibility had not yet been firmly demonstrated in Dante's time and mathematicians still worked at the problem. Note, however, that Dante assumes the impossibility of squaring the circle as a weak mortal example of mortal impossibility. How much more impossible, he implies, to resolve the mystery of God, study as man will.

The mystery remains beyond Dante's mortal power. Yet, there in Heaven, in a moment of grace, God revealed the truth to him in a flash of light—revealed it, that is, to the God-enlarged power of Dante's emparadised soul. On Dante's return to the mortal life, the details of that revelation vanished from his mind but the force of the revelation survives in its power on Dante's feelings.

So ends the vision of the *Comedy,* and yet the vision endures, for ever since that revelation, Dante tells us, he feels his soul turning ever as one with the perfect motion of God's love.

CHAPTER 11

READING 41
from GIOVANNI BOCCACCIO (1313–1375), DECAMERON, PREFACE TO THE LADIES (C. 1348–1352)

This selection is the prologue to the hundred tales that make up the DECAMERON. It reflects not only the experience of the writer who lived

through the terrible plague year of 1348 but also his reflections on the effects of this terrible plague on both the minds of the population and the structures of society. Boccaccio senses the tendency of some facing death to seize whatever pleasures are available, while others turn to God for mercy and relief from the scourge of sickness. Furthermore, he details how the very whisper of plague destroyed public order and familial bonds. In our own century the French writer Albert Camus would use a plague setting as a symbol of the Nazi occupation of France to depict the reactions of people faced with extreme social conditions—conditions that call forth both cowardice and heroism and much in between.

from the Preface to the Ladies

How many times, most gracious ladies, have I considered in my innermost thoughts how full of pity you all are by nature. As often as I have thought this, I recognized that this present work will have in your judgment a depressing and unpleasant beginning. For it bears in its initial pages a disheartening remembrance of the past mortal pestilence, which was irksome and painful to all who saw it or otherwise knew it. But I do not wish that this should frighten you from going further, as if your reading will continuously carry you through sighs and tears. Let this horrid beginning be to you not otherwise than a rugged and steep mountain to travelers, next to which lies a lovely and delightful plain. The plain is all the more pleasing to them, in proportion to the great difficulties of climbing and descending. For just as sorrow dims our extreme happiness, so miseries are ended by supervening joy. To this brief unpleasantness (I say brief since it is contained in few words) there shall at once follow sweetness and delight. I have promised it to you in advance; for it might not have been expected from such a beginning, if it hadn't been told you. In truth, if I could have in honesty led you where I want by a way other than a path as rough as this, I would willingly have done so. But without this recollection I could not have shown you the reason why the things took place, of which you soon will be reading. Thus even, strained, as if by necessity, I brought myself to write of them.

I say, then, that it was the year of the bountiful Incarnation of the Son of God, 1348. The mortal pestilence then arrived in the excellent city of Florence, which surpasses every other Italian city in nobility. Whether through the operations of the heavenly bodies, or sent upon us mortals through our wicked deeds by the just wrath of God for our correction, the plague had begun some years before in Eastern countries. It carried off uncounted numbers of inhabitants, and kept moving without cease from place to place. It spread in piteous fashion towards the West. No wisdom of human foresight worked against it. The city had been cleaned of much filth by officials delegated to the task. Sick persons were forbidden entrance, and many laws were passed for the safeguarding of health. Devout persons made to God not just modest supplications and not just once, but many, both in ordered processions and in other ways. Almost at the beginning of the spring of that year, the plague horribly began to reveal, in astounding fashion, its painful effects.

It did not work as it had in the East, where anyone who bled from the nose had a manifest sign of inevitable death. But in its early stages both men, and women too, acquired certain swellings either in the groin or under the armpits. Some of these swellings reached the size of a common apple, and others were as big as an egg, some more and some less. The common people called them plague-boils. From these two parts of the body, the deadly swellings began in a short time to appear and to reach indifferently every part of the body. Then, the appearance of the disease began to change into black or livid blotches, which showed up in many on the arms or thighs and in every other part of the body. On some they were large

and few, on others small and numerous. And just as the swellings had been at first and still were an infallible indication of approaching death, so also were these blotches to whomever they touched. In the cure of these illnesses, neither the advice of a doctor nor the power of any medicine appeared to help and to do any good. Perhaps the nature of the malady did not allow it; perhaps the ignorance of the physicians (of whom, besides those trained, the number had grown very large both of women and of men who were completely without medical instruction) did not know whence it arose, and consequently did not take required action against it. Not only did very few recover, but almost everyone died within the third day from the appearance of these symptoms, some sooner and some later, and most without any fever or other complication. This plague was of greater virulence, because by contact with those sick from it, it infected the healthy, not otherwise than fire does, when it is brought very close to dry or oily material.

The evil was still greater than this. Not only conversation and contact with the sick carried the illness to the healthy and was cause of their common death. But even to handle the clothing or other things touched or used by the sick seemed to carry with it that same disease for those who came into contact with them. You will be amazed to hear what I now must tell you. If the eyes of many, including my own, had not seen it, I would hardly dare to believe it, much less to write it, even if I had heard it from a person worthy of faith. I say that the character of the pestilence we describe was of such virulence in spreading from one person to another, that not only did it go from man to man, but many times it also apparently did the following, which is even more remarkable. If an animal outside the human species contacted the belongings of a man sick or dead of this illness, it not only caught the disease, but within a brief time was killed by it. My own eyes, as I said a little while ago, saw one day (and other times besides) this occurrence. The rags of a poor man dead from this disease had been thrown in a public street. Two pigs came to them and they, in their accustomed manner, first rooted among them with their snouts, and then seized them with their teeth and tossed them about with their jaws. A short hour later, after some staggering, as if the poison was taking effect, both of them fell dead to earth upon the rags which they had unhappily dragged.

Such events and many others similar to them or even worse conjured up in those who remained healthy diverse fears and imaginings. Almost all were inclined to a very cruel purpose, that is, to shun and to flee the sick and their belongings. By so behaving, each believed that he would gain safety for himself. Some persons advised that a moderate manner of living, and the avoidance of all excesses, greatly strengthened resistance to this danger. Seeking out companions, such persons lived apart from other men. They closed and locked themselves in those houses where no sick person was found. To live better, they consumed in modest quantities the most delicate foods and the best wines, and avoided all sexual activity. They did not let themselves speak to anyone, nor did they wish to hear any news from the outside, concerning death or the sick. They lived amid music and those pleasures which they were able to obtain.

Others were of a contrary opinion. They affirmed that heavy drinking and enjoyment, making the rounds with singing and good cheer, the satisfaction of the appetite with everything one could and the laughing and joking which derived from this, were the most effective medicine for this great evil. As they recommended, so they put into practice, according to their ability. Night and day, they went now to that tavern and now to another, drinking without moderation or measure. They did even more in the houses of others; they had only to discern there things which were to their liking or pleasure. This they could easily do, since everyone, as if he was destined to live

no more, had abandoned all care of his possessions and of himself. Thus, most houses had become open to all, and strangers used them as they happened upon them, as their proper owner might have done. With this inhuman intent, they continuously avoided the sick with all their power.

In this great affliction and misery of our city, the revered authority of both divine and human laws was left to fall and decay by those who administered and executed them. They too, just as other men, were all either dead or sick or so destitute of their families, that they were unable to fulfill any office. As a result everyone could do just as he pleased.

Many others held a middle course between the two mentioned above. Not restraining themselves in their diet as much as the first group, nor letting themselves go in drinking and other excesses as the second, they satisfied their appetites sufficiently. They did not go into seclusion but went about carrying flowers, fragrant herbs and various spices which they often held to their noses, believing it good to comfort the brain with such odors since the air was heavy with the stench of dead bodies, illness and pungent medicines. Others had harsher but perhaps safer ideas. They said that against plagues no medicine was better than or even equal to simple flight. Moved by this reasoning and giving heed to nothing but themselves, many men and women abandoned their own city, their houses and homes, their relatives and belongings in search of their own country places or those of others. Just as if the wrath of God, in order to punish the iniquity of men with the plague, could not pursue them, but would only oppress those within city walls! They were apparently convinced that no one should remain in the city, and that its last hour had struck.

Although these people of various opinions did not all die, neither did they all live. In fact many in each group and in every place became ill, but having given example to those who were still well, they in turn were abandoned and left to perish.

We have said enough of these facts: that one townsman shuns another; that almost no one cares for his neighbor; that relatives rarely or never exchange visits, and never do they get too close. The calamity had instilled such terror in the hearts of men and women that brother abandoned brother, uncle nephew, brother sister, and often wives left their husbands. Even more extraordinary, unbelievable even, fathers and mothers shunned their children, neither visiting them nor helping them, as though they were not their very own.

Consequently, for the enormous number of men and women who became ill, there was no aid except the charity of friends, who were few indeed, or the avarice of servants attracted by huge and exorbitant stipends. Even so, there weren't many servants, and those few men and women were of unrefined capabilities, doing little more than to hand the sick the articles they requested and to mark their death. Serving in such a capacity, many perished along with their earnings. From this abandonment of the sick by neighbors, relatives and friends and from the scarcity of servants arose an almost unheard-of custom. Once she became ill, no woman, however attractive, lovely or well-born, minded having as her servant a man, young or old. To him without any shame she exhibited any part of her body as sickness required, as if to another woman. This explains why those who were cured were less modest than formerly. A further consequence is that many died for want of help who might still be living. The fact that the ill could not avail themselves of services as well as the virulence of the plague account for the multitude who died in the city by day and by night. It was dreadful to hear tell of it, and likewise to see it. Out of necessity, therefore, there were born among the survivors customs contrary to the old ways of the townspeople.

It used to be the custom, as it is today, for the female relative and neighbors of the dead man to gather together with those close to him in order to mourn. Outside the house of the dead man his friends, neighbors and many others would assemble. Then, according to the status of the deceased, a priest would come with the funeral pomp of candles and chants, while the dead man was borne on the shoulders of his peers to the church chosen before death. As the ferocity of the plague increased, such customs ceased either totally or in part, and new ones took their place. Instead of dying amidst a crowd of women, many left this life without a single witness. Indeed, few were conceded the mournful wails and bitter tears of loved ones. Instead, quips and merrymaking were common and even normally compassionate women had learned well such habits for the sake of their health. Few bodies had more than ten or twelve neighbors to accompany them to church, and even those were not upright citizens, but a species of vulture sprung from the lowly who called themselves "grave-diggers," and sold their services. They shouldered the bier and with hurried steps went not to the church designated by the deceased, but more often than not to the nearest church. Ahead were four or six clerics with little light or sometimes none, who with the help of the grave-diggers placed the dead in the nearest open grave without straining themselves with too long or solemn a service.

Much more wretched was the condition of the poor people and even perhaps of the middle class in large part. Because of hope or poverty, these people were confined to their houses. Thus keeping to their quarters, thousands fell ill daily and died without aid or help of any kind, almost without exception. Many perished on the public streets by day or by night, and many more ended their days at home, where the stench of their rotting bodies first notified their neighbors of their death. With these and others dying all about, the city was full of corpses. Now a general procedure was followed more out of fear of contagion than because of pity felt for the dead. Alone or with the help of whatever bearers they could find, they dragged the corpses from their houses and piled them in front so, particularly in the morning, anyone abroad could see countless bodies. Biers were sent for and when they were lacking, ordinary planks carried the bodies. It was not an isolated bier which carried two or three together. This happened not just once, but many biers could be counted which held in fact a wife and husband, two or three brothers, or father and son. Countless times, it happened that two priests going forth with a cross to bury someone were joined by three or four biers carried behind by bearers, so that whereas the priests thought they had one corpse to bury, they found themselves with six, eight or even more. Nor were these dead honored with tears, candles or mourners. It had come to such a pass that men who died were shown no more concern than dead goats today.

All of this clearly demonstrated that although the natural course of events with its small and occasional stings had failed to impress the wise to bear such trials with patience, the very magnitude of this now had forced even the simple people to become indifferent to them. Every hour of every day there was such a rush to carry the huge number of corpses that there was not enough blessed burial ground, especially with the usual custom of giving each body its own place. So when the ground was filled, they made huge trenches in every churchyard, in which they stacked hundreds of bodies in layers like goods stowed in the hold of a ship, covering them with a bit of earth until the bodies reached the very top.

And so I won't go on searching out every detail of our city's miseries, but while such hard times prevailed, the surrounding countryside was spared nothing. There, in the scattered villages (not to speak of the castles which were like miniature cities) and across the fields, the wretched and impoverished peasants and their families died without any medical aid or help from servants, not like men but like beasts, on the roads, on their farms,

and about the houses by day and by night. For this reason, just like the townspeople, they became lax in their ways and neglected their chores as if they expected death that very day. They became positively ingenious, not in producing future yields of crops and beasts, but in ways of consuming what they already possessed. Thus, the oxen, the asses, sheep, goats, pigs and fowl and even the dogs so faithful to man, were driven from the houses, and roamed through the fields where the abandoned wheat grew uncut and unharvested. Almost as if they were rational, many animals having eaten well by day returned filled at night to their houses without any shepherding.

To leave the countryside and to return to the city, what more could be said? Such was heaven's cruelty (and perhaps also man's) that between March and the following July, the raging plague and the absence of help given the sick by the fearful healthy ones took from this life more than one hundred thousand human beings within the walls of Florence. Who would have thought before this deadly calamity that the city had held so many inhabitants? Oh, how many great palaces, how many lovely houses, how many rich mansions once filled with families of lords and ladies remained empty even to the lowliest servant! Alas! How many memorable families, how many ample heritages, how many famous fortunes remained without a lawful heir! What number of brave and beautiful ladies, lively youths, whom not only others, but Galen, Hippocrates, and Aesculapius themselves would have pronounced in the best of health, breakfasted in the morning with their relatives, companions and friends, only to dine that very night with their ancestors in the other world!

Excerpt from Boccaccio's "Decameron: Preface to the Ladies" from *Medieval Culture and Society* by David Herlihy. Copyright © 1968 by David Herlihy. Reprinted by permission of HarperCollins Publishers, Inc.

READING 42

from Geoffrey Chaucer (1340–1400), The Canterbury Tales (1385–1400), The General Prologue

Two extensive selections from The Canterbury Tales *appear here and in the next reading. The* General Prologue, *reprinted in its entirety, should be read both for the sheer poetry of Chaucer's characterizations and for its careful descriptions of the various individuals in medieval society who make up the pilgrimage groups. Pay particular attention to the economy with which Chaucer sketches a personality—notice the particulars he gives us that create an image of the person. For example, what physical characteristics of the Pardoner make us say, almost instinctively, that here is a person about whom Chaucer holds very negative feelings?*

General Prologue

Here begins the Book of the Tales of Canterbury
When the sweet showers of April have pierced
The drought of March, and pierced it to the root,
And every vein is bathed in that moisture
Whose quickening force will engender the flower;
And when the west wind too with its sweet breath
Has given life in every wood and field
To tender shoots, and when the stripling sun
Has run his half-course in Aries, the Ram,
And when small birds are making melodies,
That sleep all the night long with open eyes, 10
(Nature so prompts them, and encourages);
Then people long to go on pilgrimages,
And palmers to take ship for foreign shores,
And distant shrines, famous in different lands;
And most especially, from all the shires
Of England, to Canterbury they come,
The holy blessed martyr there to seek,
Who gave his help to them when they were sick.

It happened at this season, that one day
In Southwark at the Tabard where I stayed 20
Ready to set out on my pilgrimage
To Canterbury, and pay devout homage,
There came at nightfall to the hostelry
Some nine-and-twenty in a company,
Folk of all kinds, met in accidental
Companionship, for they were pilgrims all;
It was to Canterbury that they rode.
The bedrooms and the stables were good-sized,
The comforts offered us were of the best.
And by the time the sun had gone to rest 30
I'd talked with everyone, and soon became
One of their company, and promised them
To rise at dawn next day to take the road
For the journey I am telling you about.

But, before I go further with this tale,
And while I can, it seems reasonable
That I should let you have a full description
Of each of them, their sort and condition,
At any rate as they appeared to me;
Tell who they were, their status and profession, 40
What they looked like, what kind of clothes they
 dressed in;
And with a knight, then, I shall first begin.

There was a knight, a reputable man,
Who from the moment that he first began
Campaigning, had cherished the profession
Of arms: he also prized trustworthiness,
Liberality, fame, and courteousness.
In the king's service he'd fought valiantly,
And traveled far; no man as far as he
In Christian and in heathen lands as well, 50
And ever honored for his ability.
He was at Alexandria when it fell,
Often he took the highest place at table
Over the other foreign knights in Prussia;
He'd raided in Lithuania and Russia,
No Christian of his rank fought there more often.
Also he'd been in Granada, at the siege
Of Algeciras; forayed in Benmarin;
At Ayas and Adalia he had been
When they were taken; and with the great hosts 60
Freebooting on the Mediterranean coasts;
Fought fifteen mortal combats; thrice as champion
In tournaments, he at Tramassene
Fought for our faith, and each time killed his man.
This worthy knight had also, for a time,
Taken service in Palatia for the Bey,
Against another heathen in Turkey;
And almost beyond price was his prestige.
Though eminent, he was prudent and sage,
And in his bearing mild as any maid. 70
He'd never been foul-spoken in his life
To any kind of man; he was indeed
The very pattern of a noble knight.
But as for his appearance and outfit,
He had good horses, yet was far from smart.
He wore a tunic made of coarse thick stuff,
Marked by his chainmail, all begrimed with rust,
Having just returned from an expedition,

And on his pilgrimage of thanksgiving.
 With him there was his son, a young squire, 80
A lively knight-apprentice, and a lover,
With hair as curly as if newly waved;
I took him to be twenty years of age.
In stature he was of an average length,
Wonderfully athletic, and of great strength.
He'd taken part in cavalry forays
In Flanders, in Artois, and Picardy,
With credit, though no more than a novice,
Hoping to stand well in his lady's eyes.
His clothes were all embroidered like a field 90
Full of the freshest flowers, white and red.
He sang, or played the flute, the livelong day,
And he was fresher than the month of May.
Short was his gown, with sleeves cut long and wide.
He'd a good seat on horseback, and could ride,
Make music too, and songs to go with it;
Could joust and dance, and also draw and write.
So burningly he loved, that come nightfall
He'd sleep no more than any nightingale.
Polite, modest, willing to serve, and able, 100
He carved before his father at their table.
 The knight had just one servant, a yeoman,
For so he wished to ride, on this occasion.
The man was clad in coat and hood of green.
He carried under his belt, handily,
For he looked to his gear in yeoman fashion,
A sheaf of peacock arrows, sharp and shining,
Not liable to fall short from poor feathering;
And in his hand he bore a mighty bow.
He had a cropped head, and his face was brown; 110
Of woodcraft he knew all there was to know.
He wore a fancy leather guard, a bracer,
And by his side a sword and a rough buckler,
And on the other side a fancy dagger,
Well-mounted, sharper than the point of spear,
And on his breast a medal: St Christopher,
The woodman's patron saint, in polished silver.
He bore a horn slung from a cord of green,
And my guess is, he was a forester.
 There was also a nun, a prioress, 120
Whose smile was unaffected and demure;
Her greatest oath was just, 'By St Eloi!'
And she was known as Madame Eglantine.
She sang the divine service prettily,
And through the nose, becomingly intoned;
And she spoke French well and elegantly
As she'd been taught it at Stratford-at-Bow,
For French of Paris was to her unknown.
Good table manners she had learnt as well:
She never let a crumb from her mouth fall; 130
She never soiled her fingers, dipping deep
Into the sauce: when lifting to her lips
Some morsel, she was careful not to spill
So much as one small drop upon her breast.
Her greatest pleasure was in etiquette.
She used to wipe her upper lip so clean,
No print of grease inside her cup was seen,
Not the least speck, when she had drunk from it.
Most daintily she'd reach for what she ate.
No question, she possessed the greatest charm, 140
Her demeanor was so pleasant, and so warm;
Though at pains to ape the manners of the court,
And be dignified, in order to be thought
A person well deserving of esteem.
But, speaking of her sensibility,

She was so full of charity and pity
That if she saw a mouse caught in a trap,
And it was dead or bleeding, she would weep.
She kept some little dogs, and these she fed
On roast meat, or on milk and fine white bread. 150
But how she'd weep if one of them were dead,
Or if somebody took a stick to it!
She was all sensitivity and tender heart.
Her veil was pleated most becomingly;
Her nose well-shaped; eyes blue-grey, of great beauty;
And her mouth tender, very small, and red.
And there's no doubt she had a fine forehead,
Almost a span in breadth, I'd swear it was,
For certainly she was not undersized.
Her cloak, I noticed, was most elegant. 160
A coral rosary with gauds of green
She carried on her arm; and from it hung
A brooch of shining gold; inscribed thereon
Was, first of all, a crowned 'A,'
And under, *Amor vincit omnia.*
 With her were three priests, and another nun,
Who was her chaplain and companion.
 There was a monk; a nonpareil was he,
Who rode, as steward of his monastery,
The country round; a lover of good sport, 170
A manly man, and fit to be an abbot.
He'd plenty of good horses in his stable,
And when he went out riding, you could hear
His bridle jingle in the wind, as clear
And loud as the monastery chapel-bell.
Inasmuch as he was keeper of the cell,
The rule of St Maurus or St Benedict
Being out of date, and also somewhat strict,
This monk I speak of let old precepts slide,
And took the modern practice as his guide. 180
He didn't give so much as a plucked hen
For the maxim, 'Hunters are not pious men,'
Or 'A monk who's heedless of his regimen
Is much the same as a fish out of water,'
In other words, a monk out of his cloister.
But that's a text he thought not worth an oyster;
And I remarked his opinion was sound.
What use to study, why go round the bend
With poring over some book in a cloister,
Or drudging with his hands, to toil and labor 190
As Augustine bids? How shall the world go on?
You can go keep your labor, Augustine!
So he rode hard—no question about that—
Kept greyhounds swifter than a bird in flight.
Hard riding, and the hunting of the hare,
Were what he loved, and opened his purse for.
I noticed that his sleeves were edged and trimmed
With squirrel fur, the finest in the land.
For fastening his hood beneath his chin,
He wore an elaborate golden pin, 200
Twined with a love-knot at the larger end.
His head was bald and glistening like glass
As if anointed; and likewise his face.
A fine fat patrician, in prime condition,
His bright and restless eyes danced in his head,
And sparkled like the fire beneath a pot;
Boots of soft leather, horse in perfect trim:
No question but he was a fine prelate!
Not pale and wan like some tormented spirit.
A fat roast swan was what he loved the best. 210
His saddle-horse was brown as any berry.
 There was a begging friar, a genial merry

Limiter, and a most imposing person.
In all of the four Orders there was none
So versed in small talk and in flattery:
And many was the marriage in a hurry
He'd had to improvise and even pay for.
He was a noble pillar of his Order,
And was well in and intimate with every
Well-to-do freeman farmer of his area, 220
And with the well-off women in the town;
For he was qualified to hear confession,
And absolve graver sins than a curate,
Or so he said; he was a licentiate.
How sweetly he would hear confession!
How pleasant was his absolution!
He was an easy man in giving shrift,
When sure of getting a substantial gift:
For, as he used to say, generous giving
To a poor Order is a sign you're shriven; 230
For if you gave, then he could vouch for it
That you were conscience-stricken and contrite;
For many are so hardened in their hearts
They cannot weep, though burning with remorse.
Therefore, instead of weeping and prayers,
They should give money to the needy friars.
The pockets of his hood were stuffed with knives
And pins to give away to pretty wives.
He had a pleasant singing voice, for sure,
Could sing and play the fiddle beautifully; 240
He took the biscuit as a ballad-singer,
And though his neck was whiter than a lily,
Yet he was brawny as a prize-fighter.
He knew the taverns well in every town,
And all the barmaids and the innkeepers,
Better than lepers or the street-beggars;
It wouldn't do, for one in his position,
One of his ability and distinction,
To hold acquaintance with diseased lepers.
It isn't seemly, and it gets you nowhere, 250
To have any dealings with that sort of trash,
Stick to provision-merchants and the rich!
And anywhere where profit might arise
He'd crawl with courteous offers of service.
You'd nowhere find an abler man than he,
Or a better beggar in his friary;
He paid a yearly fee for his district,
No brother friar trespassed on his beat.
A widow might not even own a shoe,
But so pleasant was his *In principio* 260
He'd win her farthing in the end, then go.
He made his biggest profits on the side.
He'd frolic like a puppy. He'd give aid
As arbitrator upon settling-days,
For there he was not like some cloisterer
With threadbare cape, like any poor scholar,
But like a Master of Arts, or the Pope!
Of the best double-worsted was his cloak,
And bulging like a bell that's newly cast.
He lisped a little, from affectation, 270
To make his English sweet upon his tongue;
And when he harped, as closing to a song,
His eyes would twinkle in his head just like
The stars upon a sharp and frosty night.
This worthy limiter was called Hubert.
 A merchant was there, on a high-saddled horse:
He'd a forked beard, a many-colored dress,
And on his head a Flanders beaver hat,
Boots with expensive clasps, and buckled neatly.

He gave out his opinions pompously, 280
Kept talking of the profits that he'd made,
How, at all costs, the sea should be policed
From Middleburg in Holland to Harwich.
At money-changing he was an expert;
He dealt in French gold florins on the quiet.
This worthy citizen could use his head:
No one could tell whether he was in debt,
So impressive and dignified his bearing
As he went about his loans and bargaining.
He was a really estimable man, 290
But the fact is I never learnt his name.
There was a scholar from Oxford as well,
Not yet an MA, reading Logic still;
The horse he rode was leaner than a rake,
And he himself, believe me, none too fat,
But hollow-cheeked, and grave and serious.
Threadbare indeed was his short overcoat:
A man too unworldly for lay office,
Yet he'd not got himself a benefice.
For he'd much rather have at his bedside 300
A library, bound in black calf or red,
Of Aristotle and his philosophy,
Than rich apparel, fiddle, or fine psaltery.
And though he was a man of science, yet
He had but little gold in his strongbox;
But upon books and learning he would spend
All he was able to obtain from friends;
He'd pray assiduously for their souls,
Who gave him wherewith to attend the schools.
Learning was all he cared for or would heed. 310
He never spoke a word more than was need,
And that was said in form and decorum,
And brief and terse, and full of deepest meaning.
Moral virtue was reflected in his speech,
And gladly would he learn, and gladly teach.
 There was a wise and wary sergeant-at-law,
A well-known figure in the portico
Where lawyers meet; one of great excellence,
Judicious, worthy of reverence,
Or so he seemed, his sayings were so wise. 320
He'd often acted as Judge of Assize
By the king's letters patent, authorized
To hear all cases. And his great renown
And skill had won him many a fee, or gown
Given in lieu of money. There was none
To touch him as a property-buyer; all
He bought was fee-simple, without entail;
You'd never find a flaw in the conveyance.
And nowhere would you find a busier man;
And yet he seemed much busier than he was. 330
From yearbooks he could quote, chapter and verse,
Each case and judgement since William the First.
And he knew how to draw up and compose
A deed; you couldn't fault a thing he wrote;
And he'd reel all the statutes off by rote.
He was dressed simply, in a colored coat,
Girt by a silk belt with thin metal bands.
I have no more to tell of his appearance.
 A franklin—that's country gentleman
And freeman landowner—was his companion. 340
White was his beard, as white as any daisy;
Sanguine his temperament; his face ruddy.
He loved his morning draught of sops-in-wine,
Since living well was ever his custom,
For he was Epicurus' own true son
And held with him that sensuality

Is where the only happiness is found.
And he kept open house so lavishly
He was St Julian to the country round,
The patron saint of hospitality. 350
His bread and ale were always of the best,
Like his wine-cellar, which was unsurpassed.
Cooked food was never lacking in his house,
Both meat and fish, and that so plenteous
That in his home it snowed with food and drink,
And all the delicacies you could think.
According to the season of the year,
He changed the dishes that were served at dinner.
He'd plenty of fat partridges in coop,
And keep his fishpond full of pike and carp. 360
His cook would catch it if his sauces weren't
Piquant and sharp, and all his equipment
To hand. And all day in his hall there stood
The great fixed table, with the places laid.
When the justices met, he'd take the chair;
He often served as MP for the shire.
A dagger, and a small purse made of silk,
Hung at his girdle, white as morning milk.
He'd been sheriff, and county auditor:
A model squireen, no man worthier. 370

A haberdasher and a carpenter,
A weaver, dyer, tapestry-maker —
And they were in the uniform livery
Of a dignified and rich fraternity,
A parish-guild: their gear all trim and fresh,
Knives silver-mounted, none of your cheap brass;
Their belts and purses neatly stitched as well,
All finely finished to the last detail.
Each of them looked indeed like a burgess,
And fit to sit on any guildhall dais. 380
Each was, in knowledge and ability,
Eligible to be an alderman;
For they'd income enough and property.
What's more, their wives would certainly agree,
Or otherwise they'd surely be to blame —
It's very pleasant to be called 'Madam'
And to take precedence at church processions,
And have one's mantle carried like a queen's.

They had a cook with them for the occasion,
To boil the chickens up with marrowbones, 390
Tart powdered flavouring, spiced with galingale.
No better judge than he of London ale.
And he could roast, and seethe, and boil, and fry,
Make a thick soup, and bake a proper pie;
But to my mind it was the greatest shame
He'd got an open sore upon his shin;
For he made chicken-pudding with the best.

A sea-captain, whose home was in the west,
Was there — a Dartmouth man, for all I know.
He rode a cob as well as he knew how, 400
And was dressed in a knee-length woolen gown.
From a lanyard round his neck, a dagger hung
Under his arm. Summer had tanned him brown.
As rough a diamond as you'd hope to find,
He'd tapped and lifted many a stoup of wine
From Bordeaux, when the merchant wasn't looking.
He hadn't time for scruples or fine feeling,
For if he fought, and got the upper hand,
He'd send his captives home by sea, not land.
But as for seamanship, and calculation 410
Of moon, tides, currents, all hazards at sea,
For harbor-lore, and skill in navigation,
From Hull to Carthage there was none to touch him.

He was shrewd adventurer, tough and hardy.
By many a tempest had his beard been shaken.
And he knew all the harbors that there were
Between the Baltic and Cape Finisterre,
And each inlet of Britanny and Spain.
The ship he sailed was called 'The Magdalen.'
 With us there was a doctor, a physician; 420
Nowhere in all the world was one to match him
Where medicine was concerned, or surgery;
Being well grounded in astrology
He'd watch his patient with the utmost care
Until he'd found a favorable hour,
By means of astrology, to give treatment.
Skilled to pick out the astrologic moment
For charms and talismans to aid the patient,
He knew the cause of every malady,
If it were 'hot' or 'cold' or 'moist' or 'dry,' 430
And where it came from, and from which humor.
He was a really fine practitioner.
Knowing the cause, and having found its root,
He'd soon give the sick man an antidote.
Ever at hand he had apothecaries
To send him syrups, drugs, and remedies,
For each put money in the other's pocket —
Theirs was no newly founded partnership.
Well-read was he in Aesculapius,
In Dioscorides, and in Rufus, 440
Ancient Hippocrates, Hali, and Galen,
Avicenna, Rhazes, and Serapion,
Averroës, Damascenus, Constantine,
Bernard, and Gilbertus, and Gaddesden.
In his own diet he was temperate,
For it was nothing if not moderate,
Though most nutritious and digestible.
He didn't do much reading in the Bible.
He was dressed all in Persian blue and scarlet
Lined with taffeta and fine sarsenet, 450
And yet was very chary of expense.
He put by all he earned from pestilence;
In medicine gold is the best cordial.
So it was gold that he loved best of all.

There was a business woman, from near Bath,
But, more's the pity, she was a bit deaf;
So skilled a clothmaker, that she outdistanced
Even the weavers of Ypres and Ghent.
In the whole parish there was not a woman
Who dared precede her at the almsgiving, 460
And if there did, so furious was she,
That she was put out of all charity.
Her headkerchiefs were of the finest weave,
Ten pounds and more they weighed, I do believe,
Those that she wore on Sundays on her head.
Her stockings were of finest scarlet red,
Very tightly laced; shoes pliable and new.
Bold was her face, and handsome; florid too.
She had been respectable all her life,
And five times married, that's to say in church, 470
Not counting other loves she'd had in youth,
Of whom, just now, there is no need to speak.
And she had thrice been to Jerusalem;
Had wandered over many a foreign stream;
And she had been at Rome, and at Boulogne,
St James of Compostella, and Cologne;
She knew all about wandering — and straying:
For she was gap-toothed, if you take my meaning.
Comfortably on an ambling horse she sat,
Well-wimpled, wearing on her head a hat 480

That might have been a shield in size and shape;
A riding-skirt round her enormous hips,
Also a pair of sharp spurs on her feet.
In company, how she could laugh and joke!
No doubt she knew of all the cures for love,
For at that game she was a past mistress.
　　　And there was a good man, a religious.
He was the needy priest of a village,
But rich enough in saintly thought and work.
And educated, too, for he could read;　　　　490
Would truly preach the word of Jesus Christ,
Devoutly teach the folk in his parish.
Kind was he, wonderfully diligent;
And in adversity most patient,
As many a time had been put to the test.
For unpaid tithes he'd not excommunicate,
For he would rather give, you may be sure,
From his own pocket to the parish poor;
Few were his needs, so frugally he lived.
Wide was his parish, with houses far asunder,　　500
But he would not neglect, come rain or thunder,
Come sickness or adversity, to call
On the furthest of his parish, great or small;
Going on foot, and in his hand a staff.
This was the good example that he set:
He practiced first what later he would teach.
Out of the gospel he took that precept;
And what's more, he would cite this saying too:
'If gold can rust, then what will iron do?'
For if a priest be rotten, whom we trust,　　　510
No wonder if a layman comes to rust.
It's shame to see (let every priest take note)
A shitten shepherd and a cleanly sheep.
It's the plain duty of a priest to give
Example to his sheep; how they should live.
He never let his benefice for hire
And left his sheep to flounder in the mire
While he ran off to London, to St Paul's
To seek some chantry and sing mass for souls,
Or to be kept as chaplain by a guild;　　　520
But stayed at home, and took care of his fold,
So that no wolf might do it injury.
He was a shepherd, not a mercenary.
And although he was saintly and virtuous,
He wasn't haughty or contemptuous
To sinners, speaking to them with disdain,
But in his teaching tactful and humane.
To draw up folk to heaven by goodness
And good example, was his sole business.
But if a person turned out obstinate,　　　530
Whoever he was, of high or low estate,
He'd earn a stinging rebuke then and there.
You'll never find a better priest, I'll swear.
He never looked for pomp or deference,
Nor affected an over-nice conscience,
But taught the gospel of Christ and His twelve
Apostles; but first followed it himself.
　　　With him there was his brother, a ploughman,
Who'd fetched and carried many a load of dung;
A good and faithful laborer was he,　　　540
Living in peace and perfect charity.
God he loved best, and that with all his heart,
At all times, good and bad, no matter what;
And next he loved his neighbor as himself.
He'd thresh, and ditch, and also dig and delve,
And for Christ's love would do as much again
If he could manage it, for all poor men,

And ask no hire. He paid his tithes in full,
On what he earned and on his goods as well.
He wore a smock, and rode upon a mare.　　　550
　　　There was a reeve as well, also a miller,
A pardon-seller and a summoner,
A manciple, and myself—there were no more.
　　　The miller was a burly fellow—brawn
And muscle, big of bones as well as strong,
As was well seen—he always won the ram
At wrestling-matches up and down the land.
He was barrel-chested, rugged and thickset,
And would heave off its hinges any door
Or break it, running at it with his head.　　　560
His beard was red as any fox or sow,
And wide at that, as though it were a spade.
And on his nose, right on its tip, he had
A wart, upon which stood a tuft of hairs
Red as the bristles are in a sow's ears.
Black were his nostrils; black and squat and wide.
He bore a sword and buckler by his side.
His big mouth was as big as a furnace.
A loudmouth and a teller of blue stories
(Most of them vicious or scurrilous),　　　570
Well versed in stealing corn and trebling dues,
He had a golden thumb—by God he had!
A white coat he had on, and a blue hood.
He played the bagpipes well, and blew a tune,
And to its music brought us out of town.
　　　A worthy manciple of the Middle Temple
Was there; he might have served as an example
To all provision-buyers for his thrift
In making purchase, whether on credit
Or for cash down: he kept an eye on prices,　　580
So always got in first and did good business.
Now isn't it an instance of God's grace,
Such an unlettered man should so outpace
The wisdom of a pack of learned men?
He'd more than thirty masters over him,
All of them proficient experts in law,
More than a dozen of them with the power
To manage rents and land for any peer
So that—unless the man were off his head—
He could live honorably, free of debt,　　　590
Or sparingly, if that were his desire;
And able to look after a whole shire
In whatever emergency might befall;
And yet this manciple could hoodwink them all.
　　　There was a reeve, a thin and bilious man;
His beard he shaved as close as a man can;
Around his ears he kept his hair cropped short,
Just like a priest's, docked in front and on top.
His legs were very long, and very lean,
And like a stick; no calf was to be seen.　　600
His granary and bins were ably kept;
There was no auditor could trip him up.
He could foretell, by noting drought and rain,
The likely harvest from his seed and grain.
His master's cattle, dairy, cows, and sheep,
His pigs and horses, poultry and livestock,
Were wholly under this reeve's governance.
And, as was laid down in his covenant,
Of these he'd always rendered an account
Ever since his master reached his twentieth year.　610
No man could ever catch him in arrears.
He was up to every fiddle, every dodge
Of every herdsman, bailiff, or farm-lad.
All of them feared him as they feared the plague.

His dwelling was well placed upon a heath,
Set with green trees that overshadowed it.
At business he was better than his lord:
He'd got his nest well-feathered, on the side,
For he was cunning enough to get round
His lord by lending him what was his own, 620
And so earn thanks, besides a coat and hood.
As a young man he'd learned a useful trade
As a skilled artisan, a carpenter.
The reeve rode on a sturdy farmer's cob
That was called Scot: it was a dapple grey.
He had on a long blue-grey overcoat,
And carried by his side a rusty sword.
A Norfolk man was he of whom I tell,
From near a place that they call Bawdeswell.
Tucked round him like a friar's was his coat: 630
He always rode the hindmost of our troop.
 A summoner was among us at the inn,
Whose face was fire-red, like the cherubim;
All covered with carbuncles; his eyes narrow;
He was as hot and randy as a sparrow.
He'd scabbed black eyebrows, and a scraggy beard,
No wonder if the children were afraid!
There was no mercury, white lead, or sulphur,
No borax, no ceruse, no cream of tartar,
Nor any other salves that cleanse and burn, 640
Could help with the white pustules on his skin,
Or with the knobbed carbuncles on his cheeks.
He'd a great love of garlic, onions, leeks,
Also for drinking strong wine, red as blood,
When he would roar and gabble as if mad.
And once he had got really drunk on wine,
Then he would speak no language but Latin.
He'd picked up a few tags, some two or three,
Which he'd learned from some edict or decree—
No wonder, for he heard them every day. 650
Also, as everybody knows, a jay
Can call our 'Wat' as well as the Pope can.
But if you tried him further with a question,
You'd find his well of learning had run dry;
'Questio quid juris' was all he'd ever say.
A most engaging rascal, and a kind,
As good a fellow as you'd hope to find:
For he'd allow—given a quart of wine—
A scallywag to keep his concubine
A twelvemonth, and excuse him altogether. 660
He'd dip his wick, too, very much sub rosa.
And if he found some fellow with a woman,
He'd tell him not to fear excommunication
If he were caught, or the archdeacon's curse,
Unless the fellow's soul was in his purse,
For it's his purse must pay the penalty.
'Your purse is the archdeacon's Hell,' said he.
Take it from me, the man lied in his teeth:
Let sinners fear, for that curse is damnation,
Just as their souls are saved by absolution. 670
Let them beware, too, of a 'Significavit.'
Under his thumb, to deal with as he pleased,
Were the young people of his diocese;
He was their sole adviser and confidant.
Upon his head he sported a garland
As big as any hung outside a pub,
And, for a shield, he'd a round loaf of bread.
 With him there was a peerless pardon-seller
Of Charing Cross, his friend and his confrère,
Who'd come straight from the Vatican in Rome. 680
Loudly he sang, 'Come to me, love, come hither!'

The summoner sang the bass, a loud refrain;
No trumpet ever made one half the din.
This pardon-seller's hair was yellow as wax,
And sleekly hanging, like a hank of flax.
In meager clusters hung what hair he had;
Over his shoulders a few strands were spread,
But they lay thin, in rat's tails, one by one.
As for a hood, for comfort he wore none,
For it was stowed away in his knapsack. 690
Save for a cap, he rode with a head all bare,
Hair loose; he thought it was the *dernier cri.*
He had big bulging eyes, just like a hare.
He'd sewn a veronica on his cap.
His knapsack lay before him, on his lap,
Chockful of pardons, all come hot from Rome.
His voice was like a goat's, plaintive and thin.
He had no beard, nor was he like to have;
Smooth was his face, as if he had just shaved.
I took him for a gelding or a mare. 700
As for his trade, from Berwick down to Ware
You'd not find such another pardon-seller.
For in his bag he had a pillowcase
Which had been, so he said, Our Lady's veil;
He said he had a snippet of the sail
St Peter had, that time he walked upon
The sea, and Jesus Christ caught hold of him.
And he'd a brass cross, set with pebble-stones,
And a glass reliquary of pigs' bones.
But with these relics, when he came upon 710
Some poor up-country priest or backwoods parson,
In just one day he'd pick up far more money
Than any parish priest was like to see
In two whole months. With double-talk and tricks
He made the people and the priest his dupes.
But to speak truth and do the fellow justice,
In church he made a splendid ecclesiastic.
He'd read a lesson; or saint's history,
But best of all he sang the offertory:
For, knowing well that when that hymn was sung, 720
He'd have to preach and polish smooth his tongue
To raise—as only he knew how—the wind,
The louder and the merrier he would sing.
 And now I've told you truly and concisely
The rank, and dress, and number of us all,
And why we gathered in a company
In Southwark, at that noble hostelry
Known as the Tabard, that's hard by the Bell.
But now the time has come for me to tell
What passed among us, what was said and done 730
The night of our arrival at the inn;
And afterwards I'll tell you how we journeyed,
And all the remainder of our pilgrimage.
But first I beg you, not to put it down
To my ill-breeding if my speech be plain
When telling what they looked like, what they said,
Or if I use the exact words they used.
For, as you all must know as well as I,
To tell a tale told by another man
You must repeat as nearly as you can 740
Each word, if that's the task you've undertaken,
However coarse or broad his language is;
Or, in the telling, you'll have to distort it
Or make things up, or find new words for it.
You can't hold back, even if he's your brother:
Whatever word is used, you must use also.
Christ Himself spoke out plain in Holy Writ,
And well you know there's nothing wrong with that.

Plato, as those who read him know, has said,
'The word must be related to the deed.' 750
Also I beg you to forgive it me
If I overlooked all standing and degree
As regards the order in which people come
Here in this tally, as I set them down:
My wits are none too bright, as you can see.

 Our host gave each and all a warm welcome,
And set us down to supper there and then.
The eatables he served were of the best;
Strong was the wine; we matched it with our thirst.
A handsome man our host, handsome indeed, 760
And a fit master of ceremonies.
He was a big man with protruding eyes
—You'll find no better burgess in Cheapside—
Racy in talk, well-schooled and shrewd was he;
Also a proper man in every way.
And moreover he was a right good sort,
And after supper he began to joke,
And, when we had all paid our reckonings,
He spoke of pleasure, among other things:
'Truly,' said he, 'ladies and gentlemen, 770
Here you are all most heartily welcome.
Upon my word—I'm telling you no lie—
All year I've seen no jollier company
At one time in this inn, than I have now.
I'd make some fun for you, if I knew how.
And, as it happens, I have just now thought
Of something that will please you, at no cost.

 'You're off to Canterbury—so Godspeed!
The blessed martyr give you your reward!
And I'll be bound, that while you're on your way, 780
You'll be telling tales, and making holiday:
It makes no sense, and really it's no fun
To ride along the road dumb as a stone.
And therefore I'll devise a game for you,
To give you pleasure, as I said I'd do.
And if with one accord you all consent
To abide by my decision and judgement,
And if you'll do exactly as I say,
Tomorrow, when you're riding on your way,
Then, by my father's soul—for he is dead— 790
If you don't find it fun, why, here's my head!
Now not another word! Hold up your hands!'

 We were not long in making up our minds.
It seemed not worth deliberating, so
We gave our consent without more ado,
Told him to give us what commands he wished.
'Ladies and gentlemen,' began our host,
'Do yourselves a good turn, and hear me out:
But please don't turn your noses up at it.
I'll put it in a nutshell: here's the nub: 800
It's that you each, to shorten the long journey,
Shall tell two tales *en route* to Canterbury,
And, coming homeward, tell another two,
Stories of things that happened long ago.
Whoever best acquits himself, and tells
The most amusing and instructive tale,
Shall have a dinner, paid for by us all,
Here in this inn, and under this roof-tree,
When we come back again from Canterbury.
To make it the more fun, I'll gladly ride 810
With you at my own cost, and be your guide.
And anyone who disputes what I say
Must pay all our expenses on the way!
And if this plan appeals to all of you,
Tell me at once, and with no more ado,
And I'll make my arrangements here and now.'

 To this we all agreed, and gladly swore
To keep our promises; and furthermore
We asked him if he would consent to do
As he had said, and come and be our leader, 820
And judge our tales, and act as arbiter,
Set up our dinner too, at a fixed price;
And we'd obey whatever he might decide
In everything. And so, with one consent,
We bound ourselves to bow to his judgement.
And thereupon wine was at once brought in.
We drank; and not long after, everyone
Went off to bed, and that without delay.

 Next morning our host rose at break of day:
He was our cockcrow; so we all awoke. 830
He gathered us together in a flock,
And we rode, at little more than walking-pace
Till we had reached St Thomas' watering-place,
Where our host began reining in his horse.
'Ladies and gentlemen, attention please!'
Said he. 'All of you know what we agreed,
And I'm reminding you. If evensong
And matins are in harmony—that's to say,
If you are still of the same mind today—
Let's see who'll tell the first tale, and begin. 840
And whosoever balks at my decision
Must pay for all we spend upon the way,
Or may I never touch a drop again!
And now let's draw lots before going on.
The one who draws the short straw must begin.
Sir Knight, my lord and master,' said our host,
'Now let's draw lots, for such is my request.
Come near,' said he, 'my lady Prioress,
And, Mister Scholar, lay by bashfulness,
Stop dreaming! Hands to drawing, everyone!' 850
To cut the story short, the draw began,
And, whether it was luck, or chance, or fate,
The truth is this: the lot fell to the knight,
Much to the content of the company.
Now, as was only right and proper, he
Must tell his tale, according to the bargain
Which, as you know, he'd made. What more to say?
And when the good man saw it must be so,
Being sensible, and accustomed to obey
And keep a promise he had freely given, 860
He said, 'Well, since I must begin the game,
Then welcome to the short straw, in God's name!
Now let's ride on, and listen to what I say.'

 And at these words we rode off on our way,
And he at once began, with cheerful face,
His tale. The way he told it was like this:

READING 43
from GEOFFREY CHAUCER (1340–1400),
THE CANTERBURY TALES (1385–1400),
PROLOGUE OF THE WIFE OF BATH'S TALE

*This selection is interesting for its lengthy discussion about the place of
women in medieval society. The Wife of Bath mounts a sustained argu-
ment against male chauvinism and the misogyny that pervaded medieval
life.*

Prologue of the Wife of Bath's Tale

'Experience—and no matter what they say
In books—is good enough authority

For me to speak of trouble in marriage.
For ever since I was twelve years of age,
Thanks be to God, I've had no less than five
Husbands at church door—if one may believe
I could be wed so often legally!
And each a man of standing, in his way.
Certainly it was told me, not long since,
That, seeing Christ had never more than once
Gone to a wedding (Cana, in Galilee) 10
He taught me by that very precedent
That I ought not be married more than once.
What's more, I was to bear in mind also
Those bitter words that Jesus, God and Man,
Spoke in reproof to the Samaritan
Beside a well—"Thou hast had," said He,
"Five husbands, and he whom now thou hast
Is not thy husband." He said that, of course,
But what He meant by it I cannot say. 20
All I ask is, why wasn't the fifth man
The lawful spouse of the Samaritan?
How many lawful husbands could she have?
All my born days, I've never heard as yet
Of any given number or limit,
However folk surmise or interpret.
All I know for sure is, God has plainly
Bidden us to increase and multiply—
A noble text, and one I understand!
And, as I'm well aware, He said my husband 30
Must leave father and mother, cleave to me.
But, as to number, did He specify?
He named no figure, neither two nor eight—
Why should folk talk of it as a disgrace?

 'And what about that wise King Solomon:
I take it that he had more wives than one!
Now would to God that I might lawfully
Be solaced half as many times as he!
What a God-given gift that Solomon
Had for his wives! For there's no living man 40
Who has the like; Lord knows how many about
That noble king enjoyed on the first night
With each of them! His was a happy life!
Blessed be God that I have married five!
Here's to the sixth, whenever he turns up.
I won't stay chaste for ever, that's a fact.
For when my husband leaves this mortal life
Some Christian man shall wed me soon enough.
For then, says the Apostle Paul, I'm free
To wed, in God's name, where it pleases me. 50
He says that to be married is no sin,
Better it is to marry than to burn.
What do I care if people execrate
The bigamy of villainous Lamech?
I know that Abraham was a holy man,
And Jacob too, so far as I can tell;
And they had more than two wives, both of them,
And many another holy man as well.
Now can you tell me where, in any age,
Almighty God explicitly forbade 60
All marrying and giving in marriage?
Answer me that! And will you please tell me
Where was it He ordained virginity?
No fear, you know as well as I do, that
The Apostle, where he speaks of maidenhood,
Says he has got no firm precept for it.
You may advise a woman not to wed,
But by no means is advice a command.
To our own private judgement he left it;
Had virginity been the Lord's command, 70

Marriage would at the same time be condemned.
And surely, if no seed were ever sown,
From what, then, could virginity be grown?
Paul did not dare command, at any rate,
A thing for which the Lord gave no edict.
There's a prize set up for virginity:
Let's see who'll make the running, win who may!
 'This teaching's not for all men to receive,
Just those to whom it pleases God to give
The strength to follow it. All I know is, 80
That the Apostle was himself a virgin;
But none the less, though he wished everyone
—Or so he wrote and said—were such as he,
That's only to *advise* virginity.
I have his leave, by way of concession,
To be a wife; and so it is no shame,
My husband dying, if I wed again;
A second marriage can incur no blame.
Though it were good for a man not to touch
A woman—meaning in his bed or couch, 90
For who'd bring fire and tow too close together?
I think you'll understand the metaphor!
Well, by and large, he thought virginity
Better than marrying out of frailty.
I call it frailty, unless he and she
Mean to live all their lives in chastity.
 'I grant all this; I've no hard feelings if
Maidenhood be set above remarriage.
Purity in body and in heart
May please some—as for me, I make no boast. 100
For, as you know, no master of a household
Has all of his utensils made of gold;
Some are of wood, and yet they are of use.
The Lord calls folk to Him in many ways,
And each has his peculiar gift from God,
Some this, some that, even as He thinks good.
 'Virginity is a great excellence,
And so is dedicated continence,
But Christ, of perfection the spring and well,
Did not bid everyone to go and sell 110
All that he had, and give it to the poor,
And thus to follow in His tracks; be sure
He spoke to those who would live perfectly;
And, sirs, if you don't mind, that's not for me.
I mean to give the best years of my life
To the acts and satisfactions of a wife.
 'And tell me also, what was the intention
In creating organs of generation,
When man was made in so perfect a fashion?
They were not made for nothing, you can bet! 120
Twist it how you like and argue up and down
That they were only made for the emission
Of urine; that our little differences
Are there to distinguish between the sexes,
And for no other reason—who said no?
Experience teaches that it is not so.
But not to vex the scholars, I'll say this:
That they were fashioned for both purposes,
That's to say, for a necessary function
As much as for enjoyment in procreation 130
Wherein we do not displease God in heaven.
Why else is it set down in books, that men
Are bound to pay their wives what's due to them?
And with whatever else would he make payment
If he didn't use his little instrument?
It follows, therefore, they must have been given
Both to pass urine, and for procreation.
 'But I'm not saying everyone who's got

The kind of tackle I am talking of
Is bound to go and use it sexually. 140
For then who'd bother about chastity?
Christ was a virgin, though formed like a man,
Like many another saint since time began,
And yet they lived in perfect chastity.
I've no objection to virginity.
Let them be loaves of purest sifted wheat,
And us wives called mere barley-bread, and yet
As St Mark tells us, when our Saviour fed
The multitude, it was with barley-bread.
I'm not particular: I'll continue 150
In the condition God has called us to.
In married life I mean to use my gadget
As generously as my Maker gave it.
If I be grudging, the Lord punish me!
My husband's going to have it night and day,
At any time he likes to pay his dues.
I shan't be difficult! I shan't refuse!
I say again, a husband I must have,
Who shall be both my debtor and my slave,
And he shall have, so long as I'm his wife, 160
His "trouble in the flesh." For during life
I've "power of his body" and not he.
That's just what the Apostle Paul told me;
He told our husbands they must love us too.
Now I approve entirely of this view—'

 Up leapt the pardoner—'Now then, madam,
I swear to you by God and by St John,
You make a splendid preacher on this theme.
I was about to wed a wife—but then
Why should my body pay a price so dear? 170
I'll not wed this nor any other year!'

 'You wait!' said she. 'My tale has not begun.
It is a different cask that you'll drink from
Before I've done; a bitterer brew than ale.
And when I've finished telling you my tale
Of tribulation in matrimony
—And I'm a lifelong expert; that's to say
That I myself have been both scourge and whip—
You can decide then if you want to sip
Out of the barrel that I mean to broach. 180
But you had best take care if you approach
Too near—for I've a dozen object-lessons
And more, that I intend to tell. "The man
Who won't be warned by others, he shall be
Himself a warning to all other men."
These are the very words that Ptolemy
Writes in his *Almagest*: you'll find it there.'

 'Let me beg you, madam,' said the pardoner,
'If you don't mind, go on as you began,
And tell your tale to us and spare no man, 190
And teach all us young fellows your technique.'

 'Gladly,' said she, 'if that's what you would like;
But let no one in this company, I beg,
If I should speak what comes into my head,
Take anything that I may say amiss;
All that I'm trying to do is amuse.

 'And now, sir, now, I will begin my tale.
May I never touch a drop of wine or ale
If this be not the truth! Of those I had,
Three were good husbands, two of them were bad. 200
The three good ones were very rich and old;
But barely able, all the same, to hold
To the terms of our covenant and contract—
Bless me! you'll all know what I mean by that!

It makes me laugh to think, so help me Christ,
How cruelly I made them sweat at night!
And I can tell you it meant nothing to me.
They'd given me their land and property;
I'd no more need to be assiduous
To win their love, or treat them with respect. 210
They all loved me so much that, heavens above!
I set no store whatever by their love.
A wily woman's always out to win
A lover—that is, if she hasn't one.
Since I'd got them in the hollow of my hand,
And they'd made over to me all their land,
What point was there in taking pains to please,
Except for my advantage, or my ease?
Believe you me, I set them so to work
That many a night I made them sing, "Alack!" 220
No flitch of bacon for them, anyhow,
Like some have won in Essex at Dunmow.
I governed them so well in my own way,
And kept them happy, so they'd always buy
Fairings to bring home to me from the fair.
When I was nice to them, how glad they were!
For God knows how I'd nag and give them hell!

 'Now listen how I managed things so well,
You wives that have the wit to understand!
Here's how to talk and keep the upper hand: 230
For no man's half as barefaced as a woman
When it comes to chicanery and gammon.
It's not for knowing wives that I say this,
But for those times when things have gone amiss.
For any astute wife, who knows what's what,
Can make her husband think that black is white,
With her own maid as witness in support.
But listen to the kind of thing I'd say:

 "So this is how things are, old Mister Dotard?
Why does the woman next door look so gay? 240
She can go where she likes, and all respect her,
—I sit at home, I've nothing fit to wear!
Why are you always over at her house?
She's pretty, is she? So you're amorous!
What did I catch you whispering to the maid?
Mister Old Lecher, drop it, for God's sake!
And if I've an acquaintance or a friend,
You rage and carry on just like a fiend
If I pay him some harmless little visit!
And then you come back home pissed as a newt, 250
And preach at me, confound you, from your bench!
What a great shame—just think of the expense—
To marry a poor woman, so you tell me.
And if she's rich, and comes of a good family,
It's hell, you say, to put up with her pride,
And her black moods and fancies. Then, you swine,
Should she be beautiful, you change your line,
And say that every rakehell wants to have her,
That in no time she's bound to lose her honor,
Because it is assailed on every side. 260

 "You say that some folk want us for our riches,
Some for our looks, and others for our figures,
Or for our sex appeal, or our good breeding;
Some want a girl who dances, or can sing,
Else it's our slender hands and arms they want.
So the devil takes the lot, by your account!
None can defend a castle wall, you say,
For long if it's attacked day after day.

 "And if she's plain, why then you say that she's
Setting her cap at every man she sees: 270

She'll jump upon him, fawning like a spaniel,
Till someone buys what she has got to sell.
Never a goose upon the lake so grey
But it will find its gander, so you say.
Says you, it's hard to manage or control
A thing no man would keep of his own will.
That's how you talk, pig, when you go to bed,
Saying that no sane man need ever wed,
Nor any man who hopes to go to heaven.
Wretch, may your withered wrinkled neck be broken 280
In two by thunderblast and fiery lightning!

 "And then, you say, a leaky roof, and smoke,
And nagging wives, are the three things that make
A man flee from his home. Oh, for God's sake!
What ails an old man to go on like that?

 "Then you go on to claim we women hide
Our failings till the knot is safely tied,
And then we show them—A villainous saying,
A scoundrel's proverb, if I ever heard one!

 "You say that oxen, asses, horses, hounds, 290
Can be tried out and proved at different times,
And so can basins, washbowls, stools, and spoons,
And household goods like that, before you buy;
Pots, clothes and dresses too; but who can try
A wife out till he's wed? Old dotard! Pig!
And then, says you, we show the faults we've hid.

 "You also claim that it enrages me
If you forget to compliment my beauty,
If you're not always gazing on my face,
Paying me compliments in every place, 300
If on my birthday you don't throw a party,
Buy a new dress, and make a fuss of me;
Or if you are ungracious to my nurse,
Or to my chambermaid, or even worse,
Rude to my father's kinsfolk and his cronies,—
That's what you say, old barrelful of lies!

 "And about Jankin you've the wrong idea,
Our apprentice with curly golden hair
Who makes himself my escort everywhere—
I wouldn't have him if you died tomorrow! 310
But, damn you, tell me this—God send you sorrow!—
Why do you hide the strongbox keys from me?
It's mine as much as yours—our property!
What! I'm the mistress of the house, and you'll
Make her look like an idiot and a fool?
You'll never be, no matter how you scold,
Master of both my body and my gold,
No, by St James! For you'll have to forgo
One or the other, take or leave it! Now,
What use is all your snooping and your spying? 320
I sometimes think you want to lock me in
That strongbox of yours, when you should be saying
"Dear wife, go where you like, go and have fun,
I shan't believe the tales they tell in malice,
I know you for a faithful wife, Dame Alice."
We love no man who watches carefully
Our coming and going; we want liberty.

 "Blessed above all other men is he,
That astrologer, Mister Ptolemy,
Who set down in his book, the *Almagest* 330
This proverb: "Of all men he is the wisest
Who doesn't care who has the world in hand."
From which proverb you are to understand
That if you have enough, why should you care
A curse how well-off other people are?
Don't worry, you old dotard—it's all right,

You'll have cunt enough and plenty, every night.
What bigger miser than he who'll not let
Another light a candle at his lantern—
He won't have any the less light, I'm thinking! 340
If you've enough, what's there to grumble at?

 "And you say if we make ourselves look smart
With dresses and expensive jewelry,
It only puts at risk our chastity;
And then, confound you, you must quote this text,
And back yourself up with the words of Paul,
As thus: 'In chaste and modest apparel
You women must adorn yourselves,' said he,
'And not with braided hair and jewelry,
Such as pearls and gold; and not in costly dress.' 350
But of your text, and your red-letter rubric,
I'll be taking no more notice than a gnat!

 "And you said this: that I was like a cat,
For you have only got to singe its skin,
And then the cat will never go from home;
But if its coat is looking sleek and gay,
She won't stop in the house, not half a day,
But off she goes the first thing in the morning,
To show her coat off and go caterwauling.
That's to say, if I'm all dressed up, Mister Brute, 360
I'll run out in my rags to show them off!

 "Mister Old Fool, what good is it to spy?
If you begged Argus with his hundred eyes
To be my bodyguard—what better choice?—
There's little he would see unless I let him,
For if it killed me, yet I'd somehow fool him!

 "And you have also said, there are three things,
Three things there are that trouble the whole earth,
And there's no man alive can stand the fourth—
Sweet Mister Brute, Jesus cut short your life! 370
You keep on preaching that an odious wife
Is to be counted one of these misfortunes.
Really, are there no other comparisons
That you can make, and without dragging in
A poor innocent wife as one of them?

 "Then you compare a woman's love to Hell,
To barren lands where rain will never fall.
And you go on to say, it's like Greek fire,
The more it burns, the fiercer its desire
To burn up everything that can be burned. 380
And just as grubs and worms eat up a tree,
Just so a woman will destroy her husband;
All who are chained to wives know this, you say."

 'Ladies and gentlemen, just as you've heard
I'd browbeat them; they really thought they'd said
All these things to be in their drunkenness.
All lies—but I'd get Jankin to stand witness
And bear me out, and my young niece also.
O Lord! the pain I gave them, and the woe,
And they, heaven knows, quite innocent of course. 390
For I could bite and whinny like a horse.
I'd scold them even when I was at fault,
For otherwise I'd often have been dished.
Who comes first to the mill, is first to grind;
I'd get in first, till they'd be glad to find
A quick excuse for things they'd never done
In their whole lives; and so our war was won.
I'd pick on them for wenching; never mind
They were so ill that they could barely stand!

 'And yet it tickled him to the heart, because 400
He thought it showed how fond of him I was.
I swore that all my walking out at night

Was to spy out the women that he tapped;
Under that cover, how much fun I had!
To us at birth such mother-wit is given;
As long as they live God has granted women
Three things by nature: lies, and tears, and spinning.
There's one thing I can boast of: in the end
I'd gain, in every way, the upper hand
By force or fraud, or by some stratagem 410
Like everlasting natter, endless grumbling.
Bed in particular was their misfortune;
That's when I'd scold, and see they got no fun.
I wouldn't stop a moment in the bed
If I felt my husband's arm over my side,
No, not until his ransom had been paid,
And then I'd let him do the thing he liked.
What I say is, everything has its price;
You cannot lure a hawk with empty hand.
If I wanted something, I'd endure his lust. 420
And even feign an appetite for it;
Though I can't say I ever liked old meat—
And that's what made me nag them all the time.
Even though the Pope were sitting next to them
I'd not spare them at table or at board,
But paid them back, I tell you, word for word.
I swear upon my oath, so help me God,
I owe them not a word, all's been paid back.
I set my wits to work till they gave up;
They had to, for they knew it would be best, 430
Or else we never would have been at rest.
For even if he looked fierce as a lion,
Yet he would fail to get his satisfaction.

 'Then I would turn and say, "Come, dearest, come!
How meek you look, like Wilkin, dear old lamb!
Come to me, sweetheart, let me kiss your cheek!
You ought to be all patient and meek,
And have ever such a scrupulous conscience—
Or so you preach of Job and his patience!
Always be patient; practice what you preach, 440
For if you don't, we've got a thing to teach,
Which is: it's good to have one's wife in peace!
One of us has got to knuckle under,
And since man is more rational a creature
Than woman is, it's you who must forbear.
But what's the matter now? Why moan and groan?
You want my quim just for yourself alone?
Why, it's all yours—there now, go take it all!
By Peter, but I swear you love it well!
For if I wished to sell my pretty puss, 450
I'd go about as sweet as any rose;
But no, I'll keep it just for you to taste.
Lord knows you're in the wrong; and that's the truth!"

 'All arguments we had were of that kind.
Now I will speak about my fourth husband.

 'My fourth husband was a libertine;
That is to say, he kept a concubine;
And I was young, and passionate, and gay,
Stubborn and strong, and merry as a magpie.
How I would dance to the harp's tunable 460
Music, and sing like any nightingale,
When I had downed a draught of mellow wine!
Metellius, the dirty dog, that swine
Who with a club beat his own wife to death
Because she drank—if I had been his wife,
Even he would not have daunted me from drink!
And after taking wine I'm bound to think
On Venus—sure as cold induces hail,

A greedy mouth points to a greedy tail.
A woman full of wine has no defense, 470
All lechers know this from experience.

 'But, Lord Christ! when it all comes back to me,
And I recall my youth and gaiety,
It warms the very cockles of my heart.
And to this day it does my spirit good
To think that in my time I've had my fling.
But age, alas, that cankers everything,
Has stripped me of my beauty and spirit.
Let it go then! Goodbye, and devil take it!
The flour's all gone; there is no more to say. 480
Now I must sell the bran as best I may;
But all the same I mean to have my fun.
And now I'll tell about my fourth husband.

 'I tell you that it rankled in my heart
That in another he should take delight.
But he was paid for it in full, by God!
From that same wood I made for him a rod—
Now with my body, and not like a slut,
But certainly I carried on with folk
Until I made him stew in his own juice, 490
With fury, and with purest jealousy.
By God! on earth I was his purgatory,
For which I hope his soul's in Paradise.
God knows he often had to sit and whine
When his shoe pinched him cruelest! And then
How bitterly, and in how many ways,
I wrung his withers, there is none can guess
Or know, save only he and God in heaven!
He died when I came from Jerusalem,
And now lies buried under the rood beam, 500
Although his tomb is not as gorgeous
As is the sepulcher of Darius
That Apelles sculpted so skillfully;
For to have buried him expensively
Would have been waste. So goodbye, and God rest him!
He's in his grave now, shut up in his coffin.

 'Of my fifth husband I have this to tell
—I pray God keep and save his soul from hell!—
And yet he was to me the worst of all:
I feel it on my ribs, on each and all, 510
And always will until my dying day!
But in our bed he was so free and gay
And moreover knew so well how to coax
And cajole when he wanted my *belle chose,*
That, though he'd beaten me on every bone,
How quickly he could win my love again!
I think that I loved him the best, for he
Was ever chary of his love for me.
We women have, I'm telling you no lies,
In this respect the oddest of fancies; 520
If there's a thing we can't get easily,
That's what we're bound to clamor for all day:
Forbid a thing, and that's what we desire;
Press hard upon us, and we run away.
We are not forward to display our ware:
For a great crowd at market makes things dear;
Who values stuff bought at too cheap a price?
And every woman knows this, if she's wise.

 'My fifth husband—may God bless his soul!
Whom I took on for love, and not for gold, 530
Was at one time a scholar at Oxford,
But had left college, and come home to board
With my best friend, then living in our town:
God keep her soul! her name was Alison.

She knew me and the secrets of my heart
As I live, better than the parish priest:
She was my confidant; I told her all—
For had my husband pissed against a wall,
Or done a thing that might have cost his life—
To her, and also to my dearest niece, 540
And to another lady friend as well,
I'd have betrayed his secrets, one and all.
And so I did time and again, dear God!
It often made his face go red and hot
For very shame; he'd kick himself, that he
Had placed so great a confidence in me.
　　'And it so happened that one day in Lent
(For I was ever calling on my friend,
As I was always fond of having fun,
Strolling about from house to house in spring, 550
In March, April, and May, to hear the gossip)
Jankin the scholar, and my friend Dame Alice,
And I myself, went out into the meadows.
My husband was in London all that Lent,
So I was free to follow my own bent,
To see and to be seen by the gay crowd.
How could I know to whom, and in what place.
My favors were destined to be bestowed?
At feast-eves and processions, there I was;
At pilgrimages; I attended sermons, 560
And these miracle-plays; I went to weddings,
Dressed in my best, my long bright scarlet gowns.
No grub, no moth or insect had a chance
To nibble at them, and I'll tell you why:
It was because I wore them constantly.
　　'Now I'll tell you what happened to me then.
We strolled about the fields, as I was saying,
And got on so well together, he and I,
That I began to think ahead, and tell him
That if I were a widow we could marry. 570
For certainly—I speak without conceit—
Till now I've never been without foresight
In marriage matters; other things as well.
I'd say a mouse's life's not worth a leek
Who has but one hole to run to for cover,
For if that fails the mouse, then it's all over!
　　'I let him think that he'd got me bewitched.
It was my mother taught me that device.
I also said I dreamed of him at night,
That he'd come to kill me, lying on my back, 580
And that the entire bed was drenched in blood.
And yet I hoped that he would bring me luck—
In dreams blood stands for gold, so I was taught.
All lies—for I dreamed nothing of the sort.
I was in this, as in most other things,
As usual following my mother's teachings.
　　'But now, sirs, let me see—what was I saying?
Aha! Bless me, I've found the thread again.
　　'When my fourth husband was laid on his bier
I wept for him—what a sad face I wore!— 590
As all wives must, because it's customary;
With my kerchief I covered up my face.
But, since I was provided with a mate,
I wept but little, that I guarantee!
　　'To church they bore my husband in the morning
Followed by the neighbors, all in mourning,
And one among them was the scholar Jankin.
So help me God, when I saw him go past,
Oh what a fine clean pair of legs and feet
Thought I—and so to him I lost my heart. 600

He was, I think, some twenty winters old,
And I was forty, if the truth be told.
But then I always had an itch for it!
I was gap-toothed; but it became me well;
I wore St. Venus' birthmark and her seal.
So help me God, but I was a gay one,
Pretty and fortunate; joyous and young;
And truly, as my husbands always told me,
I had the best what-have-you that might be.
Certainly I am wholly Venerian 610
In feeling; and in courage, Martian.
Venus gave to me lust, lecherousness;
And Mars gave me my sturdy hardiness.
Taurus was my birth-sign, with Mars therein.
Alas, alas, that ever love was sin!
And so I always followed my own bent,
Shaped as it was by my stars' influence,
That made me so that I could not begrudge
My chamber of Venus to a likely lad.
I've still the mark of Mars upon my face, 620
And also in another secret place.
For, sure as God above is my salvation,
I never ever loved in moderation,
But always followed my own appetite,
Whether for short or tall, or black or white;
I didn't care, so long as he pleased me,
If he were poor, or what his rank might be.
　　'There's little more to say: by the month's ending,
This handsome scholar Jankin, gay and dashing,
Had married me with all due ceremony. 630
To him I gave all land and property,
Everything that I had inherited.
But, later, I was very sorry for it—
He wouldn't let me do a thing I wanted!
My God, he once gave my ear such a box
Because I tore a page out of his book,
That from the blow my ear became quite deaf.
I was untamable as a lioness;
My tongue unstoppable and garrulous;
And walk I would, as I had done before, 640
From house to house, no matter how he swore
I shouldn't; and for this he'd lecture me,
And tell old tales from Roman history;
How one Simplicius Gallus left his wife,
Left her for the remainder of his life,
Only because one day he saw her looking
Out of the door with no head-covering.
　　'He said another Roman, Whatsisname
Because his wife went to a summer-game
Without his knowledge, went and left her too. 650
And then he'd get his Bible out to look
In Ecclesiasticus for that text
Which with absolute stringency forbids
A man to let his wife go gad about;
Then, never fear, here's the next thing he'd quote:
"Whoever builds his house out of willows,
And rides a blind horse over the furrows,
And lets his wife trot after saints' altars,
Truly deserves to be hung on the gallows."
But all for nothing; I cared not a bean 660
For all his proverbs, nor for his old rhyme;
And neither would I be reproved by him.
I hate a man who tells me of my vices,
And God knows so do more of us than I.
This made him absolutely furious:
I'd not give in to him, in any case.

'Now, by St Thomas, I'll tell you the truth
About why I ripped a page out of his book,
For which he hit me so that I went deaf.

'He had a book he loved to read, that he 670
Read night and morning for his own delight;
Valerius and Theophrastus, he called it,
Over which book he'd chuckle heartily.
And there was a learned man who lived in Rome,
A cardinal who was called St. Jerome,
Who wrote a book attacking Jovinian;
And there were also books by Tertullian,
Chrysippus, Trotula, and Heloise,
Who was an abbess not far from Paris,
Also the parables of Solomon, 680
Ovid's *Art of Love*, and many another one,
All bound together in the same volume.
And night and morning it was his custom,
Whenever he had leisure and freedom
From any other worldly occupation,
To read in it concerning wicked women:
He knew more lives and legends about them
Than there are of good women in the Bible.
Make no mistake, it is impossible
That any scholar should speak good of women, 690
Unless they're saints in the hagiologies;
Not any other kind of woman, no!
Who drew the picture of the lion? Who?
My God, had women written histories
Like cloistered scholars in oratories,
They'd have set down more of men's wickedness
Than all the sons of Adam could redress.
For women are the children of Venus,
And scholars those of Mercury; the two
Are at cross purposes in all they do; 700
Mercury loves wisdom, knowledge, science,
And Venus, revelry and extravagance.
Because of their contrary disposition
The one sinks when the other's in ascension;
And so, you see, Mercury's powerless
When Venus is ascendant in Pisces,
And Venus sinks where Mercury is raised.
That's why no woman ever has been praised
By any scholar. When they're old, about
As much use making love as an old boot, 710
Then in their dotage they sit down and write:
Women can't keep the marriage vows they make!

'But to the point—why I got beaten up,
As I was telling you, just for a book:
One night Jankin—that's my lord and master—
Read in his book as he sat by the fire,
Of Eva first, who through her wickedness
Brought the whole human race to wretchedness,
For which Jesus Himself was crucified,
He Who redeemed us all with His heart's blood. 720
Look, here's a text wherein we plainly find
That woman was the ruin of mankind.

'He read to me how Samson lost his hair:
He slept; his mistress cut it with her shears,
Through which betrayal he lost both his eyes.

'And then he read to me, if I'm no liar,
Of Hercules and his Dejaneira.
And how she made him set himself on fire.

'He left out nothing of the grief and woe
That the twice-married Socrates went through; 730
How Xantippe poured piss upon his head,
And the poor man sat stock-still as if dead;
He wiped his head, not daring to complain:

"Before the thunder stops, down comes the rain!"

'And out of bloody-mindedness he'd relish
The tale of Pasiphaë, Queen of Crete—
Fie! say no more—it's gruesome to relate
Her abominable likings and her lust!

'Of the lechery of Clytemnestra,
How she betrayed her husband to his death, 740
These things he used to read with great relish.

'He also told me how it came about
That at Thebes Amphiarus lost his life:
My husband had a tale about his wife
Eriphile, who for a golden brooch
Had covertly discovered to the Greeks
Where they might find her husband's hiding-place,
Who thus, at Thebes, met a wretched fate.

'He told of Livia and Lucilia,
Who caused their husbands, both of them, to die; 750
One out of love, the other out of loathing.
Hers, Livia poisoned late one evening.
Because she hated him; ruttish Lucilia
On the contrary, loved her husband so,
That she mixed for him, so that he should think
Only of her, an aphrodisiac drink
So strong that before morning he was dead.
Thus husbands always have the worst of it!

'Then he told me how one Latumius
Once lamented to his friend Arrius 760
That there was a tree growing in his garden
On which, he said, his three wives, out of dudgeon,
Had hanged themselves. "Dear friend," said Arrius,
"Give me a cutting from this marvelous tree,
And I shall go and plant it in my garden."

'Concerning wives of later days, he read
How some had killed their husbands in their bed,
And let their lovers have them while the corpse
Lay all night on its back upon the floor.
And others, while their husbands slept, have driven 770
Nails through their brainpans, and so murdered them.
Yet others have put poison in their drink.
He spoke more evil than the heart can think.
On top of that, he knew of more proverbs
Than there is grass and herbage upon earth.
"Better to live with a lion or dragon,"
Said he, "than take up with a scolding woman.
Better to live high in an attic roof
Than with a brawling woman in the house:
They are so wicked and contrarious 780
That what their husbands love, they always hate."
He also said, "A woman casts off shame
When she casts off her smock," and he'd go on:
"A pretty woman, if she isn't chaste,
Is like a gold ring stuck in a sow's nose."
Now who could imagine, or could suppose,
The grief and torment in my heart, the pain?

'When I realized he'd never make an end
But read away in that damned book all night,
All of a sudden I got up and tore 790
Three pages out of it as he was reading,
And hit him with my fist upon the cheek
So that he tumbled back into our fire,
And up he jumped just like a raging lion.
And punched me with his fist upon the head
Till I fell to the floor and lay for dead.
And when he saw how motionless I lay,
He took alarm, and would have run away,
Had I not burst at last out of my swoon.
"You've murdered me, you dirty thief!" I said, 800

"You've gone and murdered me, just for my land!
But I'll kiss you once more, before I'm dead!"
 'He came close to me and kneeled gently down,
And said, "My dearest sweetheart Alison,
So help me God, I'll not hit you again.
You yourself are to blame for what I've done.
Forgive it me this once, for mercy's sake."
But once again I hit him on the cheek:
"You robber, take that on account!" I said.
"I can't speak any more; I'll soon be dead." 810
After no end of grief and pain, at last
We made it up between the two of us:
He gave the reins to me, and to my hand
Not only management of house and land,
But of his tongue, and also of his fist—
And then and there I made him burn his book!
And when I'd got myself the upper hand
And in this way obtained complete command,
And he had said, "My own true faithful wife,
Do as you please from now on, all your life: 820
Guard your honor and look after my estate."
—From that day on we had no more debate.
So help me God, to him I was as kind
As any wife from here to the world's end,
And true as well—and so was he to me.
I pray to God Who reigns in majesty,
For His dear mercy's sake, to bless his soul.
Now if you'll listen, I will tell my tale.'

Extract from the modern-verse translation of *The Canterbury Tales* by David Wright (Copyright © by David Wright 1985) is reproduced by permission of PFD (www.pfd.co.uk) on behalf of the Estate of David Wright.

READING 44

from CHRISTINE DE PISAN (1365–1428),
THE BOOK OF THE CITY OF LADIES (1404)

Titled to play on Augustine's CITY OF GOD, *this work is an elaborate allegory describing a city with women's accomplishments. Pisan presents an argument against the antifeminist writers of the day who condemned women as the snare of Satan and inferior to men. These excerpts deal with some notable women: Sappho, the goddess Minerva, and various educated women of the Middle Ages.*

30. Here She Speaks of Sappho, that Most Subtle Woman, Poet, and Philosopher

"The wise Sappho, who was from the city of Mytilene, was no less learned than Proba. This Sappho had a beautiful body and face and was agreeable and pleasant in appearance, conduct, and speech. But the charm of her profound understanding surpassed all the other charms with which she was endowed, for she was expert and learned in several arts and sciences, and she was not only well-educated in the works and writings composed by others but also discovered many new things herself and wrote many books and poems. Concerning her, Boccaccio has offered these fair words couched in the sweetness of poetic language: 'Sappho, possessed of sharp wit and burning desire for constant study in the midst of bestial and ignorant men, frequented the heights of Mount Parnassus, that is, of perfect study. Thanks to her fortunate boldness and daring, she kept company with the Muses, that is, the arts and sciences, without being turned away. She entered the forest of laurel trees filled with may boughs, greenery,

and different colored flowers, soft fragrances and various aromatic spices, where Grammar, Logic, noble Rhetoric, Geometry, and Arithmetic live and take their leisure. She went on her way until she came to the deep grotto of Apollo, god of learning, and found the brook and conduit of the fountain of Castalia, and took up the plectrum and quill of the harp and played sweet melodies, with the nymphs all the while leading the dance, that is, following the rules of harmony and musical accord.' From what Boccaccio says about her, it should be inferred that the profundity of both her understanding and of her learned books can only be known and understood by men of great perception and learning, according to the testimony of the ancients. Her writings and poems have survived to this day, most remarkably constructed and composed, and they serve as illumination and models of consummate poetic craft and composition to those who have come afterward. She invented different genres of lyric and poetry, short narratives, tearful laments and strange lamentations about love and other emotions, and these were so well made and so well ordered that they were named 'Sapphic' after her. Horace recounts, concerning her poems, that when Plato, the great philosopher who was Aristotle's teacher, died, a book of Sappho's poems was found under his pillow.

"In brief this lady was so outstanding in learning that in the city where she resided a statue of bronze in her image was dedicated in her name and erected in a prominent place so that she would be honored by all and be remembered forever. This lady was placed and counted among the greatest and most famous poets, and, according to Boccaccio, the honors of the diadems and crowns of kings and the miters of bishops are not any greater, nor are the crowns of laurel and victor's palm.

34. Here She Speaks of Minerva, Who Invented Many Sciences and the Technique of Making Armor from Iron and Steel

"Minerva, just as you have written elsewhere, was a maiden of Greece and surnamed Pallas. This maiden was of such excellence of mind that the foolish people of that time, because they did not know who her parents were and saw her doing things which had never been done before, said she was a goddess descended from Heaven; for the less they knew about her ancestry, the more marvelous her great knowledge seemed to them, when compared to that of the women of her time. She had a subtle mind, of profound understanding, not only in one subject but also generally, in every subject. Through her ingenuity she invented a shorthand Greek script in which a long written narrative could be transcribed with far fewer letters, and which is still used by the Greeks today, a fine invention whose discovery demanded great subtlety. She invented numbers and a means of quickly counting and adding sums. Her mind was so enlightened with general knowledge that she devised various skills and designs which had never before been discovered. She developed the entire technique of gathering wool and making cloth and was the first who ever thought to shear sheep of their wool and then to pick, comb, and card it with iron spindles and finally to spin it with a distaff, and then she invented the tools needed to make the cloth and also the method by which the wool should finally be woven.

"Similarly she initiated the custom of extracting oil from different fruits of the earth, also from olives, and of squeezing and pressing juice from other fruits. At the same time she discovered how to make wagons and carts to transport things easily from one place to another.

"This lady, in a similar manner, did even more, and it seems all the more remarkable because it is far removed from a woman's nature to conceive of such things; for she invented the art and technique of making harnesses and armor from iron and

steel, which knights and armed soldiers employ in battle and with which they cover their bodies, and which she first gave to the Athenians whom she taught how to deploy an army and battalions and how to fight in organized ranks.

"Similarly she was the first to invent flutes and fifes, trumpets and wind instruments. With her considerable force of mind, this lady remained a virgin her entire life. Because of her outstanding chastity, the poets claimed in their fictions that Vulcan, the god of fire, wrestled with her for a long time and that finally she won and overcame him, which is to say that she overcame the ardor and lusts of the flesh which so strongly assail the young. The Athenians held this maiden in such high reverence that they worshiped her as a goddess and called her the goddess of arms and chivalry because she was the first to devise their use, and they also called her the goddess of knowledge because of her learnedness.

"After her death they erected a temple in Athens dedicated to her, and there they placed a statue of her, portraying a maiden, as a representation of wisdom and chivalry. This statue had terrible and cruel eyes because chivalry has been instituted to carry out rigorous justice; they also signified that one seldom knows toward what end the meditation of the wise man tends. She wore a helmet on her head which signified that a knight must have strength, endurance, and constant courage in the deeds of arms, and further signified that the counsels of the wise are concealed, secret, and hidden. She was dressed in a coat of mail which stood for the power of the estate of chivalry and also taught that the wise man is always armed against the whims of Fortune, whether good or bad. She held some kind of spear or very long lance, which meant that the knight must be the rod of justice and also signified that the wise man casts his spears from great distances. A buckler or shield of crystal hung at her neck, which meant that the knight must always be alert and oversee everywhere the defense of his country and people and further signified that things are open and evident to the wise man. She had portrayed in the middle of this shield the head of a serpent called Gorgon, which teaches that the knight must always be wary and watchful over his enemies like the serpent, and furthermore, that the wise man is aware of all the malice which can hurt him. Next to this image they also placed a bird that flies by night, named the owl, as if to watch over her, which signified that the knight must be ready by night as well as by day for civil defense, when necessary, and also that the wise man should take care at all times to do what is profitable and fitting for him. For a long time this lady was held in such high regard and her great fame spread so far that in many places temples were founded to praise her. Even long afterward, when the Romans were at the height of their power, they included her image among their gods."

36. Against those Men Who Claim It Is Not Good for Women to be Educated

Following these remarks, I, Christine, spoke, "My lady, I realize that women have accomplished many good things and that even if evil women have done evil, it seems to me, nevertheless, that the benefits accrued and still accruing because of good women—particularly the wise and literary ones and those educated in the natural sciences whom I mentioned above—outweigh the evil. Therefore, I am amazed by the opinion of some men who claim that they do not want their daughters, wives, or kinswomen to be educated because their mores would be ruined as a result."

She responded, "Here you can clearly see that not all opinions of men are based on reason and that these men are wrong. For it must not be presumed that mores necessarily grow worse from knowing the moral sciences, which teach the vir-

tues, indeed, there is not the slightest doubt that moral education amends and ennobles them. How could anyone think or believe that whoever follows good teaching or doctrine is the worse for it? Such an opinion cannot be expressed or maintained. I do not mean that it would be good for a man or a woman to study the art of divination or those fields of learning which are forbidden—for the holy Church did not remove them from common use without good reason—but it should not be believed that women are the worse for knowing what is good.

"Quintus Hortensius, a great rhetorician and consumately skilled orator in Rome, did not share this opinion. He had a daughter, named Hortensia, whom he greatly loved for the subtlety of her wit. He had her learn letters and study the science of rhetoric, which she mastered so thoroughly that she resembled her father Hortensius not only in wit and lively memory but also in her excellent delivery and order of speech—in fact, he surpassed her in nothing. As for the subject discussed above, concerning the good which comes about through women, the benefits realized by this woman and her learning were, among others, exceptionally remarkable. That is, during the time when Rome was governed by three men, this Hortensia began to support the cause of women and to undertake what no man dared to undertake. There was a question whether certain taxes should be levied on women and on their jewelry during a needy period in Rome. This woman's eloquence was so compelling that she was listened to, no less readily than her father would have been, and she won her case.

"Similarly, to speak of more recent times, without searching for examples in ancient history, Giovanni Andrea, a solemn law professor in Bologna not quite sixty years ago, was not of the opinion that it was bad for women to be educated. He had a fair and good daughter, named Novella, who was educated in the law to such an advanced degree that when he was occupied by some task and not at leisure to present his lectures to his students, he would send Novella, his daughter, in his place to lecture to the students from his chair. And to prevent her beauty from distracting the concentration of her audience, she had a little curtain drawn in front of her. In this manner she could on occasion supplement and lighten her father's occupation. He loved her so much that, to commemorate her name, he wrote a book of remarkable lectures on the law which he titled *Novella super Decretalium,* after his daughter's name.

"Thus, not all men (and especially the wisest) share the opinion that it is bad for women to be educated. But it is very true that many foolish men have claimed this because it displeased them that women knew more than they did. Your father, who was a great scientist and philosopher, did not believe that women were worth less by knowing science; rather, as you know, he took great pleasure from seeing your inclination to learning. The feminine opinion of your mother, however, who wished to keep you busy with spinning and silly girlishness, following the common custom of women, was the major obstacle to your being more involved in the sciences. But just as the proverb already mentioned above says, 'No one can take away what Nature has given,' your mother could not hinder in you the feeling for the sciences which you, through natural inclination, had nevertheless gathered together in little droplets. I am sure that, on account of these things, you do not think you are worth less but rather that you consider it a great treasure for yourself; and you doubtless have reason to."

And I, Christine, replied to all of this, "Indeed, my lady, what you say is as true as the Lord's Prayer."

Selections from *The Book of the City of Ladies* by Christine de Pizan are translated by Earl Jeffrey Richards. Copyright © 1982, 1998 by Persea Books, Inc. Reprinted by permission of Persea Books, Inc. (New York).

CHAPTER 12

READING 45

from PICO DELLA MIRANDOLA (1463–1494), ORATION ON THE DIGNITY OF MAN

These four paragraphs introduce the nine hundred theses Pico wrote to summarize his philosophy—and in many ways they can stand as the position paper on Renaissance ideals. Pico argues that it is humans who stand at the apex of the world. In Pico's formulation humans, as a composite of body and soul, are the meeting point of the physical world (the body) and the spiritual (the soul) and, as a consequence, sum up the glory and potentiality of the created world.

1. I have read in the records of the Arabians, reverend Fathers, that Abdala the Saracen, when questioned as to what on this stage of the world, as it were, could be seen most worthy of wonder, replied: "There is nothing to be seen more wonderful than man." In agreement with this opinion is the saying of Hermes Trismegistus: "A great miracle, Asclepius, is man." But when I weighed the reason for these maxims, the many grounds for the excellence of human nature reported by many men failed to satisfy me—that man is the intermediary between creatures, the intimate of the gods, the king of the lower beings, by the acuteness of his senses, by the discernment of his reason, and by the light of his intelligence the interpreter of nature, the interval between fixed eternity and fleeting time, and (as the Persians say) the bond, nay, rather, the marriage song of the world, on David's testimony but little lower than the angels. Admittedly great though these reasons be, they are not the principal grounds, that is, those which may rightfully claim for themselves the privilege of the highest admiration. For why should we not admire more the angels themselves and the blessed choirs of heaven? At last it seems to me I have come to understand why man is the most fortunate of creatures and consequently worthy of all admiration and what precisely is the rank which is his lot in the universal chain of Being—a rank to be envied not only by brutes but even by the stars and by minds beyond this world. It is a matter past faith and a wondrous one. Why should it not be? For it is on this very account that man is rightly called and judged a great miracle and a wonderful creature indeed.

2. But hear, Fathers, exactly what this rank is and, as friendly auditors, conformably to your kindness, do me this favor. God the Father, the supreme Architect, had already built this cosmic home we behold, the most sacred temple of His godhead, by the laws of His mysterious wisdom. The region above the heavens He had adorned with Intelligences, the heavenly spheres He had quickened with eternal souls, and the excrementary and filthy parts of the lower world He had filled with a multitude of animals of every kind. But, when the work was finished, the Craftsman kept wishing that there were someone to ponder the plan of so great a work, to love its beauty, and to wonder at its vastness. Therefore, when everything was done (as Moses and Timaeus bear witness), He finally took thought concerning the creation of man. But there was not among His archetypes that from which He could fashion a new offspring, nor was there in His treasurehouses anything which He might bestow on His new son as an inheritance, nor was there in the seats of all the world a place where the latter might sit to contemplate the universe. All was now complete; all things had been assigned to the highest, the middle, and the lowest orders. But in its final creation it was not the part of the Father's power to fail as though exhausted. It was not the part of His wisdom to waver in a needful matter through poverty of counsel. It was not the part of His kindly love that he who was to praise God's divine generosity in regard to others should be compelled to condemn it in regard to himself.

3. At last the best of artisans ordained that the creature to whom He had been able to give nothing proper to himself should have joint possession of whatever had been peculiar to each of the different kinds of being. He therefore took man as a creature of indeterminate nature and, assigning him a place in the middle of the world, addressed him thus: "Neither a fixed abode nor a form that is thine alone nor any function peculiar to thyself have we given thee, Adam, to the end that according to thy longing and according to thy judgment thou mayest have and possess what abode, what form, and what functions thou thyself shalt desire. The nature of all other beings is limited and constrained within the bounds of laws prescribed by Us. Thou, constrained by no limits, in accordance with thine own free will, in whose hand We have placed thee, shalt ordain for thyself the limits of thy nature. We have set thee at the world's center that thou mayest from thence more easily observe whatever is in the world. We have made thee neither of heaven nor of earth, neither mortal nor immortal, so that with freedom of choice and with honor, as though the maker and molder of thyself, thou mayest fashion thyself in whatever shape thou shalt prefer. Thou shalt have the power to degenerate into the lower forms of life, which are brutish. Thou shalt have the power, out of thy soul's judgment, to be reborn into the higher forms, which are divine."

4. O supreme generosity of God the Father, O highest and most marvelous felicity of man! To him it is granted to have whatever he chooses, to be whatever he wills. Beasts as soon as they are born (so says Lucilius) being with them from their mother's womb all they will ever possess. Spiritual beings, either from the beginning or soon thereafter, become what they are to be for ever and ever. On man when he came into life the Father conferred the seeds of all kinds and the germs of every way of life. Whatever seeds each man cultivates will grow to maturity and bear in him their own fruit. If they be vegetative, he will be like a plant. If sensitive, he will become brutish. If rational, he will grow into a heavenly being. If intellectual, he will be an angel and the son of God. And if, happy in the lot of no created thing, he withdraws into the center of his own unity, his spirit, made one with God, in the solitary darkness of God, who is set above all things, shall surpass them all. Who would not admire this our chameleon? Or who could more greatly admire aught else whatever? It is man who Asclepius of Athens, arguing from his mutability of character and from his self-transforming nature, on just grounds says was symbolized by Proteus in the mysteries. Hence those metamorphoses renowned among the Hebrews and the Pythagoreans.

READING 46

from LAURA CERETA (1469–1499)

Laura Cereta was an Italian humanist who pursued a scholarly life against a tide of criticism both from her male peers and from women. In keeping with other humanist writers, she wrote in Latin on a variety of themes (marriage and family, fate and fortune, avarice, solitude, and death) in the form of letters that she hoped to publish. But her Latin scholarship was so good that it inspired charges of plagiarism from her male colleagues and publication eluded her. Out of those struggles came two letters that were penned to answer her critics: a defense of learning aimed at male humanists and a defense of her vocation directed toward her female critics. Those two documents testify to the difficulty of her life apart from the roles expected of her in society.

Letter to Bibulus Sempronius: Defense of the Liberal Instruction of Women

Cereta recovered her spirits after her husband's death by immersing herself ever more deeply in her literary studies. These efforts, in turn,

brought forth critics, both male and female, who, jealous of her ac-
complishments, belittled her work. Two principal charges were brought
against her: that a woman could not be learned and that her father had
written the letters for her. She turned against her critics with a feroc-
ity at least equal to theirs. One of her surviving letters is an invective
against two males whom she had known since childhood. But here we
find, addressed to a man, as reasoned and thorough a defense of learned
women as was penned during the Quattrocentro. The letter is particu-
larly interesting for its suggestion that the correspondent was disguising
his contempt for women in singling out Cereta for praise.

The correspondent is unknown to us from other sources and may
well be fictitious. Bibulus, which we have not found elsewhere among
the names of this period, means "drunkard." No other letter is ad-
dressed to such a correspondent.

This translation is based on the Latin text in Tomasini, Laurae
Ceretae epistolae, *pp. 187–195.*

My ears are wearied by your carping. You brashly and pub-
licly not merely wonder but indeed lament that I am said to
possess as fine a mind as nature ever bestowed upon the most
learned man. You seem to think that so learned a woman has
scarcely before been seen in the world. You are wrong on both
counts, Sempronius, and have clearly strayed from the path
of truth and disseminate falsehood. I agree that you should be
grieved; indeed, you should be ashamed, for you have ceased
to be a living man, but have become an animated stone; having
rejected the studies which make men wise, you rot in torpid
leisure. Not nature but your own soul has betrayed you, desert-
ing virtue for the easy path of sin.

You pretend to admire me as a female prodigy, but there
lurks sugared deceit in your adulation. You wait perpetually in
ambush to entrap my lovely sex, and overcome by your hatred
seek to trample me underfoot and dash me to the earth. It is
a crafty ploy, but only a low and vulgar mind would think to
halt Medusa with honey.[1] You would better have crept up on
a mole than on a wolf. For a mole with its dark vision can see
nothing around it, while a wolf's eyes glow in the dark. For the
wise person sees by [force of] mind, and anticipating what lies
ahead, proceeds by the light of reason. For by foreknowledge
the thinker scatters with knowing feet the evils which litter her
path.

I would have been silent, believe me, if that savage old
enmity of yours had attacked me alone. For the light of Phoebus
cannot be befouled even in the mud.[2] But I cannot tolerate your
having attacked my entire sex. For this reason my thirsty soul
seeks revenge, my sleeping pen is aroused to literary struggle,
raging anger stirs mental passions long chained by silence. With
just cause I am moved to demonstrate how great a reputation
for learning and virtue women have won by their inborn excel-
lence, manifested in every age as knowledge, the [purveyor] of
honor. Certain, indeed, and legitimate is our possession of this
inheritance, come to us from a long eternity of ages past.

[To begin], we read how Sabba of Ethiopia, her heart
imbued with divine power, solved the prophetic mysteries of
the Egyptian Salomon.[3] And the earliest writers said that Amal-
thea, gifted in foretelling the future, sang her prophecies around
the banks of Lake Avernus, not far from Baiae. A sibyl worthy
of the pagan gods, she sold books of oracles to Priscus Tar-
quinius.[4] The Babylonian prophetess Eriphila, her divine mind
penetrating the distant future, described the fall and burning
of Troy, the fortunes of the Roman Empire, and the coming
birth of Christ.[5] Nicostrata also, the mother of Evander, learned
both in prophecy and letters, possessed such great genius that
with sixteen symbols she first taught the Latins the art of writ-
ing.[6] The fame of Inachian Isis will also remain eternal who, an
Argive goddess, taught her alphabet to the Egyptians.[7] Zenobia
of Egypt was so nobly learned, not only in Egyptian, but also in
Greek and Latin, that she wrote histories of strange and exotic

places.[8] Manto of Thebes, daughter of Tiresias, although not
learned, was skilled in the arts of divination from the remains
of sacrificed animals or the behavior of fire and other such
Chaldaean techniques. [Examining] the fire's flames, the bird's
flight, the entrails and innards of animals, she spoke with spirits
and foretold future events.[9] What was the source of the great
wisdom of the Tritonian Athena by which she taught so many
arts to the Athenians, if not the secret writings, admired by all,
of the philosopher Apollo?[10] The Greek women Philiasia and
Lasthenia, splendors of learning, excite me, who often tripped
up, with tricky sophistries, Plato's clever disciples.[11] Sappho of
Lesbos sang to her stone-hearted lover doleful verses, echoes,
I believe, of Orpheus' lyre or Apollo's lute.[12] Later, Leontia's
Greek and poetic tongue dared sharply to attack, with a lively
and admired style, the eloquence of Theophrastus.[13] I should
not omit Proba, remarkable for her excellent command of both
Greek and Latin and who, imitating Homer and Vergil, retold
the stories from the Old Testament.[14] The majesty of Rome
exalted the Greek Semiamira, [invited] to lecture in the Senate
on laws and kings.[15] Pregnant with virtue, Rome also gave birth
to Sempronia, who imposingly delivered before an assembly a
fluent poem and swayed the minds of her hearers with her con-
vincing oratory.[16] Celebrated with equal and endless praise for
her eloquence was Hortensia, daughter of Hortensius, an ora-
trix of such power that, weeping womanly and virtuous tears,
she persuaded the Triumvirs not to retaliate against women.[17]
Let me add Cornificia, sister of the poet Cornificius, to whose
love of letters so many skills were added that she was said to
have been nourished by waters from the Castalian spring;
she wrote epigrams always sweet with Heliconian flowers.[18]
I shall quickly pass by Tulliola, daughter of Cicero,[19] Teren-
tia,[20] and Cornelia, all Roman women who attained the heights
of knowledge. I shall also omit Nicolosa [Sanuto] of Bologna,
Isotta Nogarola and Cassandra Fedele of our own day. All of
history is full of these examples. Thus your nasty words are
refuted by these arguments, which compel you to concede that
nature imparts equally to all the same freedom to learn.

Only the question of the rarity of outstanding women
remains to be addressed. The explanation is clear: women have
been able by nature to be exceptional, but have chosen lesser
goals. For some women are concerned with parting their hair
correctly, adorning themselves with lovely dresses, or decorat-
ing their fingers with pearls and other gems. Others delight in
mouthing carefully composed phrases, indulging in dancing,
or managing spoiled puppies. Still others wish to gaze at lav-
ish banquet tables, to rest in sleep, or, standing at mirrors, to
smear their lovely faces. But those in whom a deeper integrity
yearns for virtue, restrain from the start their youthful souls,
reflect on higher things, harden the body with sobriety and
trials, and curb their tongues, open their ears, compose their
thoughts in wakeful hours, their minds in contemplation, to
letters bonded to righteousness. For knowledge is not given as a
gift, but [is gained] with diligence. The free mind, not shirking
effort, always soars zealously toward the good, and the desire to
know grows ever more wide and deep. It is because of no spe-
cial holiness, therefore, that we [women] are rewarded by God
the Giver with the gift of exceptional talent. Nature has gener-
ously lavished its gifts upon all people, opening to all the doors
of choice through which reason sends envoys to the will, from
which they learn and convey its desires. The will must choose
to exercise the gift of reason.

[But] where we [women] should be forceful we are [too
often] devious; where we should be confident we are insecure.
[Even worse], we are content with our condition. But you, a
foolish and angry dog, have gone to earth as though frightened
by wolves. Victory does not come to those who take flight.
Nor does he remain safe who makes peace with the enemy;
rather, when pressed, he should arm himself all the more with

weapons and courage. How nauseating to see strong men pursue a weakling at bay. Hold on! Does my name alone terrify you? As I am not a barbarian in intellect and do not fight like one, what fear drives you? You flee in vain, for traps craftily-laid rout you out of every hiding place. Do you think that by hiding, a deserter [from the field of battle], you can remain undiscovered? A penitent, do you seek the only path of salvation in flight? [If you do] you should be ashamed.

I have been praised too much; showing your contempt for women, you pretend that I alone am admirable because of the good fortune of my intellect. But I, compared to other women who have won splendid renown, am but a little mousling. You disguise your envy in dissimulation, but cloak yourself in apologetic words in vain. The lie buried, the truth, dear to God, always emerges. You stumble half-blind with envy on a wrongful path that leads you from your manhood, from your duty, from God. Who, do you think, will be surprised, Bibulus, if the stricken heart of an angry girl, whom your mindless scorn has painfully wounded, will after this more violently assault your bitter words? Do you suppose, O most contemptible man on earth, that I think myself sprung [like Athena] from the head of Jove? I am a school girl, possessed of the sleeping embers of an ordinary mind. Indeed I am too hurt, and my mind, offended, too swayed by passions, sighs, tormenting itself, conscious of the obligation to defend my sex. For absolutely everything—that which is within us and that which is without—is made weak by association with my sex.

I, therefore, who have always prized virtue, having put my private concerns aside, will polish and weary my pen against chatterboxes swelled with false glory. Trained in the arts, I shall block the paths of ambush. And I shall endeavor, by avenging arms, to sweep away the abusive infamies of noisemakers with which some disreputable and impudent men furiously, violently, and nastily rave against a woman and a republic worthy of reference. January 13 [1488]

Notes

1. Literally the text reads: "blind Medusa by dropping oil [into her eyes]."
2. Phoebus Apollo, i.e., the Sun.
3. We find no reference to an Ethiopian Sabba. But in the Old Testament Saba is Sheba and in this case would mean the Queen of Sheba, who visited the court of the Hebrew King, Solomon, posing to him certain riddles to test his proverbial wisdom (see III Kings 10; II Chronicles 9). She is believed to have come from what is now Arabia, though she is referred to in the New Testament as simply from "the south" (Matthew 12:42; Luke 11:31).
4. See Boccaccio, *Concerning Famous Women,* chap. 24.
5. See ibid., chap. 19.
6. Ibid., chap. 25.
7. Ibid., chap. 8.
8. On her and the qualities mentioned, see ibid., chap. 98.
9. Ibid., chap. 28.
10. Apollo was the god of higher aspects of civilization, among them philosophy. He was said, for example, to be the father of Plato. The reference to secret writings suggests nothing specific, perhaps a tradition associated with the Oracle at Delphi, Apollo's principal sanctuary.
11. Diogenes Laertius twice mentions Lastheneia as a disciple of Plato. Lastheneia of Mantinea is mentioned both times together with Axiothea of Philus. One reference states that they wore men's clothes, the other that they attended Plato's lectures and that Plato was derided for having an "Arcadian girl" as his pupil (3. 46; 4. 2). We find no reference to Philiasia or to the tradition that they tricked the disciples of Plato with clever sophistries.
12. Sappho (b. 612 B.C.) of Lesbos is among the most famous of Greek poets and poetesses. Her poems were collected into seven books. A number of fragments are extant. Many of these have recently been rendered into English by S. Q. Groden, *The Poems of Sappho* (Indi-

anapolis, 1966). Cereta's source was doubtless Boccaccio, *Concerning Famous Women,* chap. 45.
13. Boccaccio, *Concerning Famous Women,* chap. 58.
14. Ibid., chap. 95.
15. Ibid., chap. 2, discusses Semiramis, a Queen of the Assyrians. We find no reference to a Greek Semiamira.
16. Ibid., chap. 74.
17. Ibid., chap. 82.
18. Ibid., chap. 84.
19. Tulliola or Tullia was born in 78 B.C. and died in 45 B.C. Cicero loved her dearly and considered building a temple to her after her death which was a turning point in his mental life. See *The Oxford Classical Dictionary,* p. 928.
20. Terentia, perhaps Cicero's wife and the mother of Tullia (above). She exercised a great influence on her husband on numerous occasions, including that of the Catiline conspiracy. The two were divorced in 46 B.C. after Cicero returned from exile. She is reputed to have lived to the age of 103. See *The Oxford Classical Dictionary,* p. 885.

Letter to Lucilia Vernacula: Against Women Who Disparage Learned Women

Not only did Cereta have to deal with carping men, she also had to contend with other women who attacked her out of envy and perhaps also because her accomplishment, so unusual for a woman, could easily be seen as socially deviant. Her departure from the norm of female existence invited resentment. This is perhaps why her tone is more violent here than in the preceding letter addressed to a man. Whereas in the preceding letter she appears to concentrate more on the issue at hand, here she focuses more on the persons involved. She regards learning as growing out of virtue, the external manifestation of an inward state. In effect she is saying that those who do not love learning have no inner direction of their own but are directed by things outside them. Thus, although virtue and learning are not the same thing, virtue will lead to learning rather than to the kinds of lives led by the women who criticize her.

This is the only letter addressed to this correspondent, who is unknown to us from other sources. Here again, the name may be fictitious. Vernacula can mean "common slave," perhaps "hussy."

This translation is based on the Latin text in Tomasini, Laurae Ceretae epistolae, pp. 122– 125.

I thought their tongues should have been fine-sliced and their hearts hacked to pieces—those men whose perverted minds and inconceivable hostility [fueled by] vulgar envy so flamed that they deny, stupidly ranting, that women are able to attain eloquence in Latin. [But] I might have forgiven those pathetic men, doomed to rascality, whose patent insanity I lash with unleashed tongue. But I cannot bear the babbling and chattering women, glowing with drunkenness and wine, whose impudent words harm not only our sex but even more themselves. Empty-headed, they put their heads together and draw lots from a stockpot to elect each other [number one]; but any women who excel they seek out and destroy with the venom of their envy. A wanton and bold plea indeed for ill-fortune and unkindness! Breathing viciousness, while she strives to besmirch her better, she befouls herself; for she who does not yearn to be sinless desires [in effect] license to sin. Thus these women, lazy with sloth and insouciance, abandon themselves to an unnatural vigilance; like scarecrows hung in gardens to ward off birds, they tackle all those who come into range with a poisonous tongue. Why should it behoove me to find this barking, snorting pack of provocateurs worthy of my forbearance, when important and distinguished gentlewomen always esteem and honor me? I shall not allow the base sallies of arrogance to pass, absolved by silence, lest my silence be taken for approval or lest women leading this shameful life attract to their licentiousness

crowds of fellow-sinners. Nor should anyone fault me for impatience, since even dogs are permitted to claw at pesty flies, and an infected cow must always be isolated from the healthy flock, for the best is often injured by the worst. Who would believe that a [sturdy] tree could be destroyed by tiny ants? Let them fall silent, then, these insolent little women, to whom every norm of decency is foreign; inflamed with hatred, they would noisily chew up others, [except that] mute, they are themselves chewed up within. Their inactivity of mind maddens these raving women, or rather Megaeras, who cannot bear even to hear the name of a learned woman. These are the mushy faces who, in their vehemence, now spit tedious nothings from their tight little mouths, now to the horror of those looking on spew from their lips thunderous trifles. One becomes disgusted with human failings and grows weary of these women who, [trapped in their own mental predicament], despair of attaining possession of human arts, when they could easily do so with the application of skill and virtue. For letters are not bestowed upon us, or assigned to us by chance. Virtue only is acquired by ourselves alone; nor can those women ascend to serious knowledge who, soiled by the filth of pleasures, languidly rot in sloth. For those women the path to true knowledge is plain who see that there is certain honor in exertion, labor, and wakefulness. Farewell. November 1 [1487]

Excerpt by Laura Cereta from *Her Immaculate Hand: Selected Works by and about the Women Humanists of Quattrocento Italy*, by Margaret L. King and Albert Rabil (Eds.), Second Revised Edition. © 1997 Pegasus Press, Asheville, NC 28803. Used with permission.

READING 47

from NICCOLÒ MACHIAVELLI (1469–1527), THE PRINCE (1513)

This selection from Machiavelli's great work on political philosophy is typical of his approach to the subject, the most notable aspect of which is an unswerving pragmatism. Machiavelli never wavers from his basic conviction that the politician (the Prince) should act on one basic principle: Is what I am doing going to work to attain my goals? Questions of morality or popularity are always secondary to the issue of how best to use power to attain one's goals and to maintain one's authority. If the Prince is to be a success, Machiavelli argues, he cannot afford to be moral if morality undermines his capacity to rule.

Chapter 15

Those Things for Which Men and Especially Princes are Praised or Censured

Now it remains to examine the wise prince's methods and conduct in dealing with subjects or with allies. And because I know that many have written about this, I fear that, when I too write about it, I shall be thought conceited, since in discussing this material I depart very far from the methods of the others. But since my purpose is to write something useful to him who comprehends it, I have decided that I must concern myself with the truth of the matter as facts show it rather than with any fanciful notion. Yet many have fancied for themselves republics and principalities that have never been seen or known to exist in reality. For there is such a difference between how men live and how they ought to live that he who abandons what is done for what ought to be done learns his destruction rather than his preservation, because any man who under all conditions insists on making it his business to be good will surely be destroyed among so many who are not good. Hence a prince, in order to hold his

position, must acquire the power to be not good, and understand when to use it and when not to use it, in accord with necessity.

Omitting, then, those things about a prince that are fancied, and discussing those that are true I say that all men, when people speak of them, and especially princes, who are placed so high, are labeled with some of the following qualities that bring them either blame or praise. To wit, one is considered liberal, one stingy (I use a Tuscan word, for the *avaricious* man in our dialect is still one who tries to get property through violence; *stingy* we call him who holds back too much from using his own goods); one is considered a giver, one grasping; one cruel, one merciful; one a promise-breaker, the other truthful; one effeminate and cowardly, the other bold and spirited; one kindly, the other proud; one lascivious, the other chaste; one reliable, the other tricky; one hard, the other tolerant; one serious, the other light-minded; one religious, the other unbelieving; and the like.

I am aware that everyone will admit that it would be most praiseworthy for a prince to exhibit such of the above-mentioned qualities as are considered good. But because no ruler can possess or fully practice them, on account of human conditions that do not permit it, he needs to be so prudent that he escapes ill repute for such vices as might take his position away from him, and that he protects himself from such as will not take it away if he can; if he cannot, with little concern he passes over the latter vices. He does not even worry about incurring reproach for those vices without which he can hardly maintain his position, because when we carefully examine the whole matter, we find some qualities that look like virtues, yet—if the prince practices them—they will be his destruction, and other qualities that look like vices, yet—if he practices them—they will bring him safety and well-being.

Chapter 16

Liberality and Stinginess

Beginning then with the first qualities mentioned above, I say that to be considered liberal is good. Nevertheless, liberality, when so practiced that you get a reputation for it, damages you, because if you exercise that quality wisely and rightfully, it is not recognized, and you do not avoid the reproach of practicing its opposite. Therefore, in order to keep up among men the name of a liberal man, you cannot neglect any kind of lavishness. Hence, invariably a prince of that sort uses up in lavish actions all his resources, and is forced in the end, if he wishes to keep up the name of a liberal man, to burden his people excessively and to be a tax-shark and to do everything he can to get money. This makes him hateful to his subjects and not much esteemed by anybody, as one who is growing poor. Hence, with such liberality having injured the many and rewarded the few, he is early affected by all troubles and is ruined early in any danger. Seeing this and trying to pull back from it, he rapidly incurs reproach as stingy.

Since, then, a prince cannot, without harming himself, make use of this virtue of liberality in such a way that it will be recognized, he does not worry, if he is prudent, about being called stingy; because in the course of time he will be thought more and more liberal, since his economy makes his income adequate; he can defend himself against anyone who makes war on him; he can carry through enterprises without burdening his people. Hence, in the end, he practices liberality toward all from whom he takes nothing, who are countless, and stinginess toward all whom he gives nothing, who are few. In our times we have not seen great things done except by those reputed stingy; the others are wiped out. Pope Julius II, although he made use of the name of a liberal man in order to gain the

papacy, afterward paid no attention to keeping it up, in order to be able to make war. The present King of France carries on so many wars, without laying an excessive tax on his people, solely because his long stinginess helps pay his enormous expenses. The present King of Spain, if he were reputed liberal, would not engage in or complete so many undertakings.

Therefore, in order not to rob his subjects, in order to defend himself, in order not to grow poor and contemptible, in order not to be forced to become extortionate, a wise prince judges it of little importance to incur the name of a stingy man, for this is one of those vices that make him reign. And if somebody says: "Caesar through his liberality attained supreme power, and many others through being and being reputed liberal have come to the highest positions," I answer: "Either you are already prince or you are on the road to gaining that position. In the first case, the kind of liberality I mean is damaging; in the second, it is very necessary to be thought liberal. Now Caesar was one of those who were trying to attain sovereignty over Rome. But if, when he had got there, he had lived on and on and had not restrained himself from such expenses, he would have destroyed his supremacy." If somebody replies: "Many have been princes and with their armies have done great things, who have been reputed exceedingly liberal," I answer you: "The prince spends either his own money and that of his subjects, or that of others. In the first case the wise prince is economical; in the second he does not omit any sort of liberality. For that prince who goes out with his armies, who lives on plunder, on booty, and on ransom, has his hands on the property of others; for him this liberality is necessary; otherwise he would not be followed by his soldiers. Of wealth that is not yours or your subjects', you can be a very lavish giver, as were Cyrus, Caesar, and Alexander, because to spend what belongs to others does not lessen your reputation but adds to it. Nothing hurts you except to spend your own money."

Moreover, nothing uses itself up as fast as does liberality; as you practice it, you lose the power to practice it, and grow either poor and despised or, to escape poverty, grasping and hated. Yet the most important danger a wise prince guards himself against is being despised and hated; and liberality brings you to both of them. So it is wiser to accept the name of a niggard, which produces reproach without hatred, than by trying for the name of freespender to incur the name of extortioner, which produces reproach with hatred.

Chapter 17

Cruelty and Mercy: Is It Better to Be Loved Than Feared, or the Reverse?

Passing on to the second of the above-mentioned qualities, I say that every sensible prince wishes to be considered merciful and not cruel. Nevertheless, he takes care not to make a bad use of such mercy. Cesare Borgia was thought cruel; nevertheless that well-known cruelty of his reorganized the Romagna, united it, brought it to peace and loyalty. If we look at this closely, we see that he was much more merciful than the Florentine people, who, to escape being called cruel, allowed the ruin of Pistoia. A wise prince, then, is not troubled about a reproach for cruelty by which he keeps his subjects united and loyal because, giving a very few examples of cruelty, he is more merciful than those who, through too much mercy, let evils continue, from which result murders or plunder, because the latter commonly harm a whole group, but those executions that come from the prince harm individuals only. The new prince—above all other princes—cannot escape being called cruel, since new governments abound in dangers. As Vergil says by the mouth of Dido, "My hard condition and the newness of my sovereignty force

me to do such things, and to set guards over my boundaries far and wide."

Nevertheless, he is judicious in believing and in acting, and does not concoct fear for himself, and proceeds in such a way, moderated by prudence and kindness, that too much trust does not make him reckless and too much distrust does not make him unbearable.

This leads to a debate: Is it better to be loved than feared, or the reverse? The answer is that it is desirable to be both, but because it is difficult to join them together, it is much safer for a prince to be feared than loved, if he is to fail in one of the two. Because we can say this about men in general: they are ungrateful, changeable, simulators and dissimulators, runaways in danger, eager for gain; while you do well by them they are all yours; they offer you their blood, their property, their lives, their children, as was said above, when need is far off; but when it comes near you, they turn about. A prince who bases himself entirely on their words, if he is lacking in other preparations, falls; because friendships gained with money, not with greatness and nobility of spirit, are purchased but not possessed, and at the right times cannot be turned to account. Men have less hesitation in injuring one who makes himself loved than one who makes himself feared, for love is held by a chain of duty which, since men are bad, they break at every chance of their own profit; but fear is held by a dread of punishment that never fails you.

Nevertheless, the wise prince makes himself feared in such a way that, if he does not gain love, he escapes hatred; because to be feared and not to be hated can well be combined; this he will always achieve if he refrains from the property of his citizens and his subjects and from their women. And if he does need to take anyone's life, he does so when there is proper justification and a clear case. But above all, he refrains from the property of others, because men forget more quickly the death of a father than the loss of a father's estate. Besides, reasons for seizing property never fail, for he who is living on plunder continually finds chances for appropriating other men's goods; but on the contrary, reasons for taking life are rarer and cease sooner.

But when the prince is with his armies and has in his charge a multitude of soldiers, then it is altogether essential not to worry about being called cruel, for without such a reputation he never keeps an army united or fit for any action. Among the most striking of Hannibal's achievements is reckoned this: though he had a very large army, a mixture of countless sorts of men, led to service in foreign lands, no discord ever appeared in it, either among themselves or with their chief, whether in bad or in good fortune. This could not have resulted from anything else than his well-known inhuman cruelty, which, together with his numberless abilities, made him always respected and terrible in the soldiers' eyes; without it, his other abilities would not have been enough to get him that result. Yet historians, in this matter not very discerning, on one side admire this achievement of his and on the other condemn its main cause.

And that it is true that Hannibal's other abilities would not have been enough, can be inferred from Scipio (a man unusual indeed not merely in his own days but in all the record of known events) against whom his armies in Spain rebelled—an action that resulted from nothing else than his too great mercy, which gave his soldiers more freedom than befits military discipline. For this, he was rebuked in the Senate by Fabius Maximus, who called him the destroyer of the Roman soldiery. The Locrians, who had been ruined by a legate of his, Scipio did not avenge nor did he punish the legate's arrogance—all a result of his tolerant nature. Hence, someone who tried to apologize for him in the Senate said there were many men who knew better how not to err than

how to punish errors. This tolerant nature would in time have damaged Scipio's fame and glory, if, having it, he had kept on in supreme command; but since he lived under the Senate's control, this harmful trait of his not merely was concealed but brought him fame.

I conclude, then, reverting to being feared and loved, that since men love at their own choice and fear at the prince's choice, a wise prince takes care to base himself on what is his own, not on what is another's; he strives only to avoid hatred; as I have said.

Chapter 18

How Princes Should Keep Their Promises

How praiseworthy a prince is who keeps his promises and lives with sincerity and not with trickery everybody realizes. Nevertheless, experience in our time shows that those princes have done great things who have valued their promises little, and who have understood how to addle the brains of men with trickery; and in the end they have vanquished those who have stood upon their honesty.

You need to know, then, that there are two ways of fighting: one according to the laws, the other with force. The first is suited to man, the second to the animals; but because the first is often not sufficient, a prince must resort to the second. Therefore he needs to know well how to put to use the traits of animal and of man. This conduct is taught to princes in allegory by ancient authors, who write that Achilles and many other well-known ancient princes were given for upbringing to Chiron the Centaur, who was to guard and educate them. This does not mean anything else (this having as teacher one who is half animal and half man) than that a prince needs to know how to adopt the nature of either animal or man, for one without the other does not secure him permanence.

Since, then, a prince is necessitated to play the animal well, he chooses among the beasts the fox and the lion, because the lion does not protect himself from traps; the fox does not protect himself from the wolves. The prince must be a fox, therefore, to recognize the traps and a lion to frighten the wolves. Those who rely on the lion alone are not perceptive. By no means can a prudent ruler keep his word—and he does not—when to keep it works against himself and when the reasons that made him promise are annulled. If all men were good, this maxim would not be good, but because they are bad and do not keep their promises to you, you likewise do not have to keep yours to them. Never has a shrewd prince lacked justifying reasons to make his promise-breaking appear honorable. Of this I can give countless modern examples, showing how many treaties of peace and how many promises have been made null and empty through the dishonesty of princes. The one who knows best how to play the fox comes out best, but he must understand well how to disguise the animal's nature and must be a great simulator and dissimulator. So simple-minded are men and so controlled by immediate necessities that a prince who deceives always finds men who let themselves be deceived.

I am not willing, among fresh instances, to keep silent about one of them. Alexander VI never did anything else and never dreamed of anything else than deceiving men, yet he always found a subject to work on. Never was there a man more effective in swearing and who with stronger oaths confirmed a promise, but yet honored it less. Nonetheless, his deceptions always prospered as he hoped, because he understood well this aspect of the world.

For a prince, then, it is not necessary actually to have all the above-mentioned qualities, but it is very necessary to appear to have them. Further, I shall be so bold as to say this: that if he has them and always practices them, they are harmful; and if he appears to have them, they are useful; for example, to appear merciful, trustworthy, humane, blameless, religious—and to be so—yet to be in such measure prepared in mind that if you need to be not so, you can and do change to the contrary. And it is essential to realize this: that a prince, and above all a prince who is new, cannot practice all those things for which men are considered good, being often forced, in order to keep his position, to act contrary to truth, contrary to charity, contrary to humanity, contrary to religion. Therefore he must have a mind ready to turn in any direction as Fortune's winds and the variability of affairs require, yet, as I said above, he holds to what is right when he can but knows how to do wrong when he must.

A wise prince, then, is very careful never to let out of his mouth a single word not weighty with the above-mentioned five qualities; he appears to those who see him and hear him talk, all mercy, all faith, all integrity, all humanity, all religion. No quality does a prince more need to possess—in appearance—than this last one, because in general men judge more with their eyes than with their hands, since everybody can see but few can perceive. Everybody sees what you appear to be; few perceive what you are, and those few dare not contradict the belief of the many, who have the majesty of the government to support them. As to the actions of all men and especially those of princes, against whom charges cannot be brought in court, everybody looks at their result. So if a prince succeeds in conquering and holding this state, his means are always judged honorable and everywhere praised, because the mob is always fascinated by appearances and by the outcome of an affair; and in the world the mob is everything; the few find no room there when the many crowd together. A certain prince of the present time, whom I refrain from naming, never preaches anything except peace and truth, and to both of them he is utterly opposed. Either one, if he had practiced it, would many times have taken from him either his reputation or his power.

READING 48

from Desiderius Erasmus (1466–1536), The Praise of Folly (1509)

It may be tempting to read this portion of Erasmus's satire on all manner of human follies as plain and bitter criticism. But, as in the work of all great satirists, there is a deep vein of moral outrage in these pages. Erasmus was a teacher and a reformer. He uses his biting wit not only to score against stupidity but also to improve the way people live in society.

In the same realm are those who are authors of books. All of them are highly indebted to me ["me" = the goddess Folly], especially those who blacken their pages with sheer triviality. For those who write learnedly to be criticized by a few scholars, not even ruling out a Persius or a Laelius as a judge, seem to be more pitiable than happy to men, simply because they are continuously torturing themselves. They add, they alter, they cross something out, they reinsert it, they recopy their work, they rearrange it, they show it to friends, and they keep it for nine years; yet they still are not satisfied with it. At such a price, they buy an empty reward, namely praise—and the praise of only a handful, at that. They buy this at the great expense of long hours, no sleep, so much sweat, and so many vexations.

Add also the loss of health, the deterioration of their physical appearance, the possibility of blindness or partial loss of their sight, poverty, malice, premature old age, an early death, and if you can think of more, add them to this list. The scholar feels that he has been compensated for such ills when he wins the sanction of one or two other weak-eyed scholars. But my author is crazy in a far happier way for he, without any hesitation, rapidly writes down anything that comes to his mind, his pen, or even his dreams. There is a little or no waste of paper, since he knows that if the trifles are trivial enough the majority of the readers, that is, the fools and ignoramuses, will approve of them. What is the difference if one should ignore two or three scholars, even though he may have read them? Or what weight will the censure of a few scholars carry, so long as the multitudes give it acclaim?

Actually, the wiser writers are those who put out the work of someone else as their own. By a few alterations they transfer someone else's glory to themselves, disregarding the other person's long labor and comforting themselves with the thought that even though they might be publicly convicted of plagiarism, meanwhile they shall have enjoyed the fruits and glory of authorship. It is worth one's while to observe how pleased authors are with their own works when they are popular and pointed out in a crowd—as celebrities! Their work is on display in bookstores, with three cryptic words in large type on the title page, something like a magician's spell. Ye gods! After all, what are they but words? Few people will ever hear of them, compared to the total world population, and far fewer will admire them, since people's tastes vary so, even among the common people. And why is it that the very names of the authors are often false, or stolen from the books of the ancients? One calls himself Telemachus, another Stelenus or Laertes, still another Polycrates, and another Thrasymachus. As a result, nowadays it does not matter whether you dedicate your book to a chameleon or a gourd, or simply to alpha or beta, as the philosophers do.

The most touching event is when they compliment each other and turn around in an exchange of letters, verses, and superfluities. They are fools praising fools and dunces praising dunces. The first, in the opinion of the second, is an Alcaeus, and the second, in the opinion of the first, is a Callimachus. One holds another in higher esteem than Cicero, the other finds the one more learned than Plato. Or sometimes they will choose a competitor and increase their reputation by rivaling themselves with him. As a result the public is split with opposing viewpoints, until finally, when the dispute is over, each reigns as victor and has a triumphal parade. Wise men deride this as being absolute nonsense, which is just what it is. Who will deny it? Meanwhile, our authors are leading a luxurious life because of my excellence, and they would not exchange their accomplishments for even those of Scipius. And while the scholars most certainly derive a great deal of pleasure from laughing at them, relishing to the utmost the madness of others, they themselves owe me a great deal, which they cannot deny without being most ungrateful men.

Among men of the learned professions, a most self-satisfied group of men, the lawyers may hold themselves in the highest esteem. For while they laboriously roll up the stone of Sisyphus by the force of weaving six hundred laws together at the same time, by the stacking of commentary upon commentary and opinion upon opinion regardless of how far removed from the purpose, they contrive to make their profession seem to be most difficult of all. What is actually tedious they consider brilliant. Let us include with them the logicians and sophists, a breed of men more loquacious than the famed brass kettles of Dodona. Any one of them can outtalk any twenty women. They would be happier, though, if they were just talkative and not quarrelsome as well. In fact, they are so quarrelsome that they will argue and fight over a lock of a goat's wool, absurdly losing sight of the truth in the furor of their dispute. Their egotistical love keeps them happy, and manned with but three syllogisms, they will unflinchingly argue on any subject with any man. Their mere obstinacy affords them victory, even though you place Stentor against them.

Next in line are the scientists, revered for their beards and the fur on their gowns. They feel that they are the only men with any wisdom, and all other men float about as shadows. How senilely they daydream, while they construct their countless worlds and shoot the distance to the sun, the moon, the stars, and spheres, as with a thumb and line. They postulate causes for lightning, winds, eclipses, and other inexplicable things, never hesitating for a moment, as if they had exclusive knowledge about the secrets of nature, designer of elements, or as if they visited us directly from the council of the gods. Yet all this time nature is heartily laughing at them and their conjectures. It is a sufficient argument just proving that they have good intelligence for nothing. They can never explain why they always disagree with each other on every subject. In summation, knowing nothing in general they profess to know everything in particular. They are ignorant even to themselves, and at times they do not see the ditch or stone lying across their path, because many of them are day-dreamers and are absent-minded. Yet they proclaim that they perceive ideas, universals, forms without matter, primary substances, quiddities, entities, and things so tenuous that I'm afraid that Lynceus could not see them himself. The common people are especially disdained when they bring out their triangles, quadrangles, circles, and mathematical figures of the like. They place one on top of the other and arrange them into a maze. Then they deploy some letters precisely, as if in a battle formation, and finally they reverse them. And all of this is done only to confuse those who are ignorant of their field. These scientists do not like those who predict the future from the stars, and promise even more fantastic miracles. And these fortunate men find people who believe them.

Perhaps it would be better to pass silently over the theologians. Dealing with them, since they are hot-tempered, is like crossing Lake Camarina or eating poisonous beans. They may attack me with six hundred arguments and force me to retract what I hold; for if I refuse, they will immediately declare me a heretic. By this blitz action they show a desire to terrify anyone to whom they are ill-diagnosed. No other people are so adverse to acknowledge my favors to them, yet the divines are bound to me by extraordinary obligations. These theologians are happy in their self-love, and as if they were presently inhabiting a third heaven, they look down on all men as though they were animals that crawled along the ground, coming near to pity them. They are protected by a wall of scholastic definitions, arguments, corollaries, and implicit and explicit propositions. They have so many hideouts that not even the net of Vulcan would be able to catch them; for they back down from their distinctions, by which they also cut through the knots of an argument, as if with a double-blade ax from Tenedos; and they come forth with newly invented terms and monstrous-sounding words. Furthermore, they explain the most mysterious matters to suit themselves, for instance, the method by which the world was set in order and began, through what channels original sin has come down to us through generations, by what means, in what measure, and how long the Omnipotent Christ was in the Virgin's womb, and how accidents subsist in the Eucharist without their substance.

But those have been beaten to death down through the ages. Here are some questions that are worthy of great (and some call them) illuminated theologians, questions that will really make them think, if they should ever encounter them.

Did divine generation take place at a particular time? Are there several sonships in Christ? Whether this is a possible proposition: Does God the Father hate the Son? Could God the Father have taken upon Himself the likeness of a woman, a devil, an ass, a gourd, or a piece of flint? Then how would that gourd have preached, performed miracles, or been crucified? Also, what would Peter have consecrated, if he had administered the Eucharist, while Christ's body hung on the cross? Another thought: could Christ have been said to be a man at that very moment? Will we be forbidden to eat and drink after the resurrection? (Now, while there is time, they are providing against hunger and thirst!) These intricate subtleties are infinite, and there are others that are even more subtle, concerning instances of time, notions, relations, accidents, quiddities, and entities, which no one can perceive unless, like Lynceus, he can see in the blackest darkness things that aren't there.

We must insert those maxims, rather contradictions, that, compared to the Stoic paradoxes, appear to be the most common simplicity. For instance: it is a lesser crime to cut the throats of a thousand men than to sew a stitch on a poor man's shoe on the Sabbath; it is better to want the earth to perish, body, boots, and breeches (as the saying goes), than to tell a single lie, however inconsequential. The methods that our scholastics follow only render more subtle the subtlest of subtleties; for you will more easily escape from a labyrinth than from the snares of the Realists, Nominalists, Thomists, Albertists, Occamists, and Scotists. I have not named them all, only a few of the major ones. But there is so much learning and difficulty in all of these sects that I should think the apostles themselves must have the need of some help from some other's spirit if they were to try to argue these topics with our new generation of theologians.

Paul could present faith. But when he said, "Faith is the substance of things hoped for, the evidence of things not seen," he did not define it doctorally. The same apostle, though he exemplified charity to its utmost, divided and defined it with very little logical skill in the first epistle to the Corinthians, Chapter 13. And there is no doubt that the apostles consecrated the Eucharist devoutly enough, but suppose you had questioned them about the "terminus a quo" and the "terminus ad quem," or about transubstantiation—how the body is in many places at once, and the difference between the body of Christ in heaven, on the cross, in the Eucharist at the point when transubstantiation occurs (taking note that the prayer effecting it is a discrete quantity having extension in time)—I say that they would not have answered with the same accuracy with which the pupils of Scotus distinguish and define these matters. The apostles knew the mother of Jesus, but who among them has demonstrated philosophically just how she was preserved from the stain of original sin, as our theologians have done? Peter received the keys from One who did not commit them to an unworthy person, and yet I doubt that he ever understood—for Peter never did have a profound knowledge for the subtle—that a person who did not have knowledge could have the key to knowledge. They went everywhere baptizing people, and yet they never taught what the formal, material, efficient, and final causes of baptism were, nor did they mention that it has both a delible and indelible character. They worshiped, this is certain, but in spirit, following no other teaching than that of the gospel, "God is a spirit, and those that worship Him must do so in spirit and in truth." They seem never to have known that a picture drawn in charcoal on a wall ought to be worshiped as though it was Christ Himself, at least if it is drawn with two outstretched fingers and the hair uncombed, and has three sets of rays in the nimbus fastened to the back of the head. For

who would comprehend these things had they not spent all the thirty-six years on the Physics and Metaphysics of Aristotle and the Scotists?

In the same way the apostles teach grace, and yet they never determined the difference between a grace freely given and one that makes one deserving. They urge us to do good works, but they don't separate work in general, work being done, and work that is already finished. At all times they inculcate charity, but they don't distinguish infused charity from that which is acquired, or state whether charity is an accident or a substance, created or uncreated. They abhor sin, but may I be shot if they could define sin scientifically as we know it, unless they were fortunate enough to have been instructed by the Scotists.

You could never persuade me to believe that Paul, upon whose learning others can be judged, would have condemned so many questions, disputes, genealogies, and what he called "strifes for words," if he had really been a master of those subtle topics, especially since all of the controversies at that time were merely little informal discussions. Actually, when compared with the Chrysippean subtleties of our masters, they appeared quite amateurish. And yet these masters are extremely modest; for if by chance the apostles were to have written a document carelessly or without proper knowledge of the subject, the masters would have properly interpreted what they wrote, they would not have condemned it. Therefore, they greatly respect what the apostles wrote, both because of the antiquity of the passage and their apostolic authority. And good heavens, it would almost be unjust to expect scholarly work from the apostles, for they had been told nothing about which they were writing by their Master. But if a mistake of the same kind appears in Chrysostom, Basil, or Jerome, our scholars would unhesitatingly say: "It is not accepted."

The apostles also defeated the pagan philosophers and the Jews in debates, and they are, by nature, the stubbornest of all. But they did this by using their lives as examples and by performing miracles. And, of course, they dealt with people who were not even smart enough to comprehend the most basic ideas of Scotus. Nowadays, what heathen or heretic does not immediately submit when faced with one of these cob-webbed subtleties? Unless, of course, he is either so stupid that he cannot follow them, or so impudent that he hisses them in defiance, or, possibly, so well instructed in the same ambiguities that the contest is a draw. Then it would appear that you had matched one magician against another, or two men fighting each other with magic swords. It would amount to nothing more than reweaving Penelope's tapestry. In my humble opinion it would be much wiser for the Christians to fight off the Turks and Saracens with these brawling Scotists, stubborn Occamists, invincible Albertists, and a whole band of Sophists, rather than with the undisciplined and unwieldy battalions of soldiers with whom they have been fighting for quite some time, and without any particular favor from Mars. Then I daresay they would witness the most one sided battle that they had ever seen, and one of the greatest victories ever achieved. Who is so impassive that the shrewdness of these fighters would not excite him? And who could be so stupid that these sophistries would not quicken him? And finally, who could be so alert that they would not cloud his vision?

But you think that I say all these things as a joke. Certainly, it is no wonder, since there are some even among the divines, instructed in aural learning, who are nauseated by what they consider the petty subtleties of the theologians. There are those who abhor speaking about holy things with a smutty mouth as a kind of sacrilege and the greatest impiety. These things are to be worshiped and not expounded upon. I am speaking of the

heathen's profane methods of arguing, this arrogant way that they define things, and this defiance of the majesty of sacred theology by silly and sordid terms and sentiments. And yet, for all that, the others revel and even applaud themselves in their happiness, and they are so attentive about their precious trifles, both night and day, that they don't even have enough time to read a gospel or epistle from St. Paul. And while they waste their time away in school, they think that they are upholding the universal church, which is otherwise about to crumble to ruins, by the influence of their syllogisms, in the same way that Atlas supports the heavens on his shoulders, according to the poets. You can imagine how much pleasure they derive from shaping and reshaping the Holy Scriptures, as if they were made of wax. And they insist that their own conclusions, subscribed to by a few students, are more valid than Solon's laws and preferred before a pope's decrees; and as world censors they will force a retraction of any statement that does not completely adhere both to their explicit and implicit conclusions. And they announce these conclusions as if they were oracles. "This proposition is scandalous." "This one lacks reverence." "This one tends toward heresy." "This one does not have the right ring." The inference is that neither baptism nor the gospel, Peter and Paul, St. Jerome and Augustine, no, not even the great Aristotelian Thomas, himself, can convert a Christian, unless these scholarly men give their approval. And how kind it is of them to pass judgment! Who would ever have thought, unless these wise men had instructed us, that a man who approves of both "matula putes" and "matula putet," or "ollae fervere" and "ollam fervere," as good Latin, is not a Christian? Who else would have purged the Church from treacherous errors of this sort, which no one would have ever had the occasion to read if these wise men had not published them under the great seals of their universities? Henceforth, aren't they happy while they do these things?

And furthermore, they draw exact pictures of every part of hell, as though they had spent many years in that region. They also fabricate new heavenly regions as imagination dictates, adding the biggest of all and the finest, for there must be a suitable place for the blessed souls to take their walks, to entertain at dinner, or even to play a game of ball. Their heads are so stuffed and stretched with these and two thousand other trivialities of the same sort that I am certain Jupiter's brain was no more pregnant when he yelled for Vulcan's help to bring forth Pallas. Therefore, do not be astonished when you see one of their heads all wrapped up in swathes at a public debate, for if it wasn't it would certainly fly to pieces. I often derive much pleasure myself when these theologians, who, holding themselves in such great esteem, begin speaking in their slovenly and barbarous tongues and jabber so that no one except a jabberer can understand them, reaching a high pitch—"highest acumen," they call it. This the common man cannot attain. It is their claim that it is beyond the station of sacred discourse to be obliged to adhere to the rules of grammarians. What an amazing attribute for theologians that incorrect speech be allowed them alone! As a matter of fact they share this honor with most intellectuals. When they are addressed as "Our Masters," they feel that they are in the proximity of the gods. They feel that the term has the same religious vigor as the unspeakable four letters of the Hebrews. They say it is sacrilegious to even write MAGISTER NOSTER in small letters, and should one mistakenly utter the term, he destroys in one stroke the sublimity of the theological order.

Those who are the closest to these in happiness are generally called "the religious" or "monks," both of which are deceiving names, since for the most part they stay as far away from religion as possible and frequent every sort of place. I cannot, however, see how any life could be more gloomy than the life of these monks if I did not assist them in many ways. Though most people detest these men so much that accidentally meeting one is considered to be bad luck, the monks themselves believe that they are magnificent creatures. One of the chief benefits is that to be illiterate is to be of a high state of sanctity, and so they make sure that they are not able to read. Another is that when braying out their gospels in church they are making themselves very pleasing and satisfying to God, when in fact they are uttering these psalms as a matter of repetition rather than from their hearts. Indeed, some of these men make a good living through their uncleanliness and beggary by bellowing their petitions for food from door to door; there is not an inn, an announcement board, or a ship into which they are not accessible, here having a great advantage over other common beggars. According to them, though, they are setting an apostolic example for us by their filthiness, their ignorance, their bawdiness, and their insolence.

Moreover, it is amusing to find that they insist that everything be done in fastidious detail, as if employing the orderliness of mathematics, a small mistake in which would be a great crime. Just so many knots must be on each shoe and the shoelace may be of only one specified color; just so much lace is allowed on each habit; the girdle must be of just the right material and width; the hood of a certain shape and capacity; their hair of just so many fingers' length; and finally they can sleep only the specified number of hours per day. Can they not understand that, because of a variety of bodies and temperaments, all this equality of restrictions is in fact very unequal? Nevertheless, because of all this detail that they employ they think that they are superior to all other people. And what is more, amid all their pretense of Apostolic charity, the members of one order will denounce the members of another order clamorously because of the way in which the habit has been belted or the slightly darker color of it. You will find some among the monks who are so strictly religious and pious that they will wear no outer clothes other than those made of Cilician goat's hair or inner garments other than the ones made of Milesian wool; some others, however, will permit linen outer garments, but they again insist on wool underneath. Members of other orders shrink from the mere touch of money as if it were poison. They do not, however, retreat from the touch of wine or of women. All derive a great deal of joy in choosing the name of their order; some prefer to call themselves Cordeliers, who are subdivided into the Coletes, the Minors, the Minims, and the Crutched; others prefer to be called Benedictines or Bernardines; while still others prefer the names Bridgetines, Augustinians, Williamists, or Jacobines—as if it were not enough to be called Christians. In short, all the different orders make sure that nothing in their lives will be uniform; nor is it so much their concern to be like Christ as it is to be unlike one another.

Many of them work so hard at protocol and at traditional fastidiousness that they think one heaven hardly a suitable reward for their labors; never recalling, however, that the time will come when Christ will demand a reckoning of that which he has prescribed, namely charity, and that he will hold their deeds of little account. One monk will then exhibit his belly filled with every kind of fish; another will profess a knowledge of over a hundred hymns. Still another will reveal a countless number of fasts that he has made, and will account for his large belly by explaining that his fasts have always been broken by a single large meal. Another will show a list of church ceremonies over which he has officiated so large that it would fill seven ships, while still another will brag that he hasn't touched any money in over sixty years unless

he wore two pairs of gloves to protect his fingers. Another will take pride in the fact that he has lived a beggarly life as exampled by the filthiness and dirtiness of his hood, which even a sailor would not see fit to wear. Another will take glory in the fact that he has parasitically lived in the same spot for over fifty-five years. Another will exhibit his hoarse voice, which is a result of his diligent chanting; another, a lethargy contracted from his reclusive living; and still another, muteness as a result of his vow of silence. But Christ, interrupting their otherwise unending pleas will ask to himself, "Where does this new race of Jews come from? I recognize only one commandment that is truly mine and yet I hear nothing of it. Many years ago in the sight of all men I promised, in clear language, not through the use of parables, the inheritance of My Father to those who perform works of mercy and charity—not to those who merely wear hoods, chant prayers, or perform fasts. Nor do I reward those who acknowledge their own good works too much. Let those who think themselves holier than I, dwell in those six hundred heavens of Basilides, if they wish, or let them command those whose fastidious customs they have followed in the place of my commandments to build them a new heaven." Having heard these words and seeing that even sailors and teamsters are considered better company than they are, it should be interesting to see what looks they give each other! Yet they are, in the meantime, with my assistance, contented with their present hopes of happiness.

No one, however, even though isolated from public life, will dare to rebuke one of these monks, because through the confessional these men acquire the secrets of everyone. To be sure, they believe it a crime to publish these secrets, but they may accidentally divulge them when drinking heavily or when wishing to promote amusement by relating funny stories. The names, of course, are not revealed, because the stories are told by means of implications in most cases. In other words, if anyone offends the monks, the monks in turn will take revenge against the offender. They will reveal their enemies in public sermons by direct implications, so that everyone will know of whom they speak. And they will continue this malicious chatter until bribed to stop.

Show me any actor or charlatan you would rather watch than these monks as they drone through their sermons, trying to exemplify all the art of rhetoric that has been handed down through the ages. Good Lord! How wonderfully they gesture with their hands; how skillfully they pitch their voice; how cleverly they intone their sermons, throwing themselves about, changing facial expressions, and in the end leaving their audience in a complete state of confusion by their contradictory arguments. Yet this "art of rhetoric" is handed down with much ceremony from monk to monk, as if it required the greatest skill, craft, and ingenuity. It is forbidden for me to know this art, but I shall relate what I think are a few of its foundations. First, each oration is begun with an invocation, a device they have borrowed from the poets. Next, if charity is to be their topic, they commence their sermon with a dissertation on the Nile River in Egypt. Or they are contented to begin with Baal, the Babylonian snake god, if they intend to speak on the mystery of the cross. If fasting is their subject, they open with the twelve signs of the Zodiac; if they wish to expound faith, they initiate their sermon with the problem of squaring the circle.

I know of one notable fool—there I go again! I meant to say scholar—who was ready to expound the mystery of the Holy Trinity to a very distinguished assembly. Wishing to exhibit exceptional scholarship and to please the Divine in a special way, he embarked upon his lecture in an unheard-of manner—that is, he began by showing the relation of letters, syllables, and words; from there, he explained the agreement between nouns and verbs and nouns and adjectives. At once everyone became lost in amazement at this new approach and began to ask among themselves the question that Horace had once asked, "What is all this stink about?" As his oration progressed, however, he drew out this observation, that through the foregoing elements of grammar he could demonstrate the Holy Trinity so clearly that no mathematician could demonstrate it more understandably through his use of symbols in the sand. This fastidious monk had worked so hard on this one sermon for the previous eight months that he became blind as a mole afterward, all the keenness of his sight having given way to the sharpness of his mind. This man, to this day, however, does not regret the loss of his sight to any degree, because he believes it to have been a small price, indeed, to pay for so much glory.

I know of another monk of eighty years of age who was so scholarly that it was often said that Scotus, himself, was reborn in him. He expounded the mystery of the name of Jesus, showing with admirable subtlety that the letters of the name served to explain all that could be understood about Him. The fact that the name can be declined in three different cases—Jesus, Jesum, and Jesu—clearly illustrates the threefold nature of God. In one case the name ends with "s," this showing that He is the sum; in the second case it ends with "m," illustrating that He is the middle; and finally, in the third case we find the ending "u," this symbolizing that He is the ultimate. He amazed his audience even more when he treated the letters of the name mathematically. The name Jesus was equally divided into two parts with an s left in the middle. He then proceeded to point out that this lone letter was ש in the Hebrew language and was pronounced Schin, or Sin, and that furthermore this Hebrew letter was a word in the Scottish dialect that means *peccatum* (Latin for sin). From the above premises he declared to his audience that this connection showed that Jesus takes away the sins of the world. His listeners, especially the theologians, were so amazed at this new approach that some of them came near to being overtaken by the same mysterious force that transformed Niobe to stone; as for my reaction, I was more inclined to imitate shoddy Priapus, who upon witnessing the nocturnal rites of Canidia and Sagona fled from the spot. And I had reason to flee, too, for when did the Greek Demosthenes or Roman Cicero ever cook up such a rhetorical insinuation as that?

These great rhetoricians insisted that any introduction that had no explicit connection with the matter of the oration was faulty, and was used only by swineherds, who had mere nature as their guide. Nevertheless, these eminent preachers hold that their preamble, as they have named it, contains its rhetorical values only insofar as it has nothing to do with the matter of the discourse, so that the listener will be asking himself, "Now what is he getting at?"

As a third step, instead of a narration they substitute the hasty explanation of some verse from a gospel, when in fact this above all other things is the part that needs to be dwelt upon. As a fourth rule, they interpret some questions of divinity through references to things that are neither in earth or in heaven. Here is where they reach the height of their theological and rhetorical ability in that they astound their audience by flowering their speech, when referring to other preachers, with such illustrious titles as Renowned Doctor, Subtle Doctor, Very Subtle Doctor, Seraphic Doctor, Holy Doctor, and Invincible Doctor. Next, they mystify their uneducated audience by their use of syllogisms, majors, minors, conclusions, corollaries, conversions, and other scholarly devices, playing on the ignorance of the crowd. And they consider all these things necessary and unique to their art.

CHAPTER 13

READING 49
from BALDASSARE CASTIGLIONE (1478–1529), THE COURTIER (1528)

In THE COURTIER, *cast in the form of an extended dialogue, Castiglione has his learned friends discuss a range of topics: the ideals of chivalry, classical virtues, the character of the true courtier. Castiglione insistently pleaded that the true* **courtier** *should be a person of humanist learning, impeccable ethics, refined courtesy, physical and martial skills, and fascinating conversation. He should not possess any of these qualities to the detriment of any other. The* uomo universale *("well-rounded person") should do all things with what Castiglione calls* sprezzatura, *meaning something like "effortless mastery." The courtier does everything equally well but with an air of unhurried and graceful effortlessness.*

We reproduce here a portion of the third book, which deals with the position of women in the courtly life of Renaissance Italy. Remember that this was an aristocratic setting in which the discussion of women reflects none of the popular prejudice or social conservatism of ordinary sixteenth-century life. One strikingly modern note sounds in this selection when the Magnifico argues that women imitate men not because of masculine superiority but because they desire to "gain their freedom and shake off the tyranny that men have imposed on them by their one-sided authority."

from The Third Book, *The Perfect Lady* (5–18)

"Leaving aside, therefore, those virtues of the mind which she must have in common with the courtier, such as prudence, magnanimity, continence and many others besides, and also the qualities that are common to all kinds of women, such as goodness and discretion, the ability to take good care, if she is married, of her husband's belongings and house and children, and the virtues belonging to a good mother, I say that the lady who is at Court should properly have, before all else, a certain pleasing affability whereby she will know how to entertain graciously every kind of man with charming and honest conversation, suited to the time and the place and the rank of the person with whom she is talking. And her serene and modest behavior, and the candor that ought to inform all her actions, should be accompanied by a quick and vivacious spirit by which she shows her freedom from boorishness; but with such a virtuous manner that she makes herself thought no less chaste, prudent and benign than she is pleasing, witty and discreet. Thus she must observe a certain difficult mean, composed as it were of contrasting qualities, and take care not to stray beyond certain fixed limits. Nor in her desire to be thought chaste and virtuous, should she appear withdrawn or run off if she dislikes the company she finds herself in or thinks the conversation improper. For it might easily be thought that she was pretending to be straitlaced simply to hide something she feared others could find out about her; and in any case, unsociable manners are always deplorable. Nor again, in order to prove herself free and easy, should she talk immodestly or practice a certain unrestrained and excessive familiarity or the kind of behavior that leads people to suppose of her what is perhaps untrue. If she happens to find herself present at such talk, she should listen to it with a slight blush of shame. Moreover, she should avoid an error into which I have seen many women fall, namely, eagerly talking and listening to someone speaking evil of others. For those women who when they hear of the immodest behavior of other women grow hot and bothered and pretend it is unbelievable and that to them an unchaste woman is simply a mon-

ster, in showing that they think this is such an enormous crime, suggest that they might be committing it themselves. And those who go about continually prying into the love affairs of other women, relating them in such detail and with such pleasure, appear to be envious and anxious that everyone should know how the matter stands lest by mistake the same thing should be imputed to them; and so they laugh in a certain way, with various mannerisms which betray the pleasure they feel. As a result, although men seem ready enough to listen, they nearly always form a bad opinion of them and hold them in very little respect, and they imagine that the mannerisms they affect are meant to lead them on; and then often they do go so far that the women concerned deservedly fall into ill repute, and finally they come to esteem them so little that they do not care to be with them and in fact regard them with distaste. On the other hand, there is no man so profligate and brash that he does not respect those women who are considered to be chaste and virtuous; for in a woman a serious disposition enhanced by virtue and discernment acts as a shield against insolence and beastliness of arrogant men; and thus we see that a word, a laugh or an act of kindness, however small, coming from an honest woman is more universally appreciated than all the blandishments and caresses of those who without reserve display their lack of shame, and who, if they are not unchaste, with their wanton laughter, loquacity, brashness and scurrilous behavior of this sort, certainly appear to be.

"And then, since words are idle and childish unless they are concerned with some subject of importance, the lady at Court as well as being able to recognize the rank of the person with whom she is talking should possess a knowledge of many subjects; and when she is speaking she should know how to choose topics suitable for the kind of person she is addressing, and she should be careful about sometimes saying something unwittingly that may give offense. She ought to be on her guard lest she arouse distaste by praising herself indiscreetly or being too tedious. She should not introduce serious subjects into light-hearted conversation, or jests and jokes into a discussion about serious things. She should not be inept in pretending to know what she does not know, but should seek modestly to win credit for knowing what she does, and, as was said, she should always avoid affectation. In this way she will be adorned with good manners; she will take part in the recreations suitable for a woman with supreme grace; and her conversation will be fluent, and extremely reserved, decent and charming. Thus she will be not only loved but also revered by all and perhaps worthy to stand comparison with our courtier as regards qualities both of mind and body."

Having said this, the Magnifico fell silent and seemed to be sunk in reflection, as if he had finished what he had to say. And then signor Gaspare said:

"You have indeed, signor Magnifico, beautifully adorned his lady and made her of excellent character. Nevertheless, it seems to me that you have been speaking largely in generalities and have mentioned qualities so impressive that I think you were ashamed to spell them out; and, in the way people sometimes hanker after things that are impossible and miraculous, rather than explain them you have simply wished them into existence. So I should like you to explain what kind of recreations are suitable for a lady at Court, and in what way she ought to converse, and what are the many subjects you say it is fitting for her to know about; and also whether you mean that the prudence, magnanimity, purity and so many other qualities you mentioned are to help her merely in managing her home, and her family and children (though this was not to be her chief occupation) or rather in her conversation and in the graceful practice of those various activities. And now for heaven's sake be careful not to set those poor virtues such degraded tasks that they come to feel ashamed!"

The Magnifico laughed and said:

"You still cannot help displaying your ill-will towards women, signor Gaspare. But I was truly convinced that I had said enough, and especially to an audience such as this; for I hardly think there is anyone here who does not know, as far as recreation is concerned, that it is not becoming for women to handle weapons, ride, play the game of tennis, wrestle or take part in other sports that are suitable for men."

Then the Unico Aretino remarked: "Among the ancients women used to wrestle naked with men; but we have lost that excellent practice, along with many others."

Cesare Gonzaga added: "And in my time I have seen women play tennis, handle weapons, ride, hunt and take part in nearly all the sports that a knight can enjoy."

The Magnifico replied: "Since I may fashion this lady my own way, I do not want her to indulge in these robust and manly exertions, and, moreover, even those that are suited to a woman I should like her to practice very circumspectly and with the gentle delicacy we have said is appropriate to her. For example, when she is dancing I should not wish to see her use movements that are too forceful and energetic, nor, when she is singing or playing a musical instrument, to use those abrupt and frequent diminuendos that are ingenious but not beautiful. And I suggest that she should choose instruments suited to her purpose. Imagine what an ungainly sight it would be to have a woman playing drums, fifes, trumpets or other instruments of that sort; and this is simply because their stridency buries and destroys the sweet gentleness which embellishes everything a woman does. So when she is about to dance or make music of any kind, she should first have to be coaxed a little, and should begin with a certain shyness, suggesting the dignified modesty that brazen women cannot understand. She should always dress herself correctly, and wear clothes that do not make her seem vain and frivolous. But since women are permitted to pay more attention to beauty than men, as indeed they should, and since there are various kinds of beauty, this lady of ours ought to be able to judge what kind of garments enhance her grace and are most appropriate for whatever she intends to undertake, and then make her choice. When she knows that her looks are bright and gay, she should enhance them by letting her movements, words and dress incline towards gaiety; and another woman who feels that her nature is gentle and serious should match it in appearance. Likewise she should modify the way she dresses depending on whether she is a little stouter or thinner than normal, or fair or dark, though in as subtle a way as possible; and keeping herself all the while dainty and pretty, she should avoid giving the impression that she is going to great pains.

"Now since signor Gaspare also asks what are the many things a lady at Court should know about, how she ought to converse, and whether her virtues should be such as to contribute to her conversation, I declare that I want her to understand what these gentlemen have said the courtier himself ought to know; and as for the activities we have said are unbecoming to her, I want her at least to have the understanding that people can have of things they do not practice themselves; and this so that she may know how to value and praise the gentlemen concerned in all fairness, according to their merits. And, to repeat in just a few words something of what has already been said, I want this lady to be knowledgeable about literature and painting, to know how to dance and play games, adding a discreet modesty and the ability to give a good impression of herself to the other principles that have been taught the courtier. And so when she is talking or laughing, playing or jesting, no matter what, she will always be most graceful, and she will converse in a suitable manner with whomever she happens to meet, making use of agreeable witticisms and jokes. And although continence, magnanimity, temperance, fortitude of spirit, prudence

and the other virtues may not appear to be relevant in her social encounters with others, I want her to be adorned with these as well, not so much for the sake of good company, though they play a part in this too, as to make her truly virtuous, and so that her virtues, shining through everything she does, may make her worthy of honor."

"I am quite surprised," said signor Gaspare with a laugh, "that since you endow women with letters, continence, magnanimity and temperance, you do not want them to govern cities as well, and to make laws and lead armies, while the men stay at home to cook and spin."

The Magnifico replied, also laughing: "Perhaps that would not be so bad, either."

Then he added: "Do you not know that Plato, who was certainly no great friend of women, put them in charge of the city and gave all the military duties to the men? Don't you think that we might find many women just as capable of governing cities and armies as men? But I have not imposed these duties on them, since I am fashioning a Court lady and not a queen. I'm fully aware that you would like by implication to repeat the slander that signor Ottaviano made against women yesterday, namely, that they are most imperfect creatures, incapable of any virtuous act, worth very little and quite without dignity compared with men. But truly both you and he would be very much in error if you really thought this."

Then signor Gaspare said: "I don't want to repeat things that have been said already; but you are trying hard to make me say something that would hurt the feelings of these ladies, in order to make them my enemies, just as you are seeking to win their favor by deceitful flattery. However, they are so much more sensible than other women that they love the truth, even if it is not all that much to their credit, more than false praises; nor are they aggrieved if anyone maintains that men are of greater dignity, and they will admit that you have made some fantastic claims and attributed to the Court lady ridiculous and impossible qualities and so many virtues that Socrates and Cato and all the philosophers in the world are as nothing in comparison. And to tell the truth I wonder that you haven't been ashamed to go to such exaggerated lengths. For it should have been quite enough for you to make this lady beautiful, discreet, pure and affable, and able to entertain in an innocent manner with dancing, music, games, laughter, witticisms and the other things that are in daily evidence at Court. But to wish to give her an understanding of everything in the world and to attribute to her qualities that have rarely been seen in men, even throughout the centuries, is something one can neither tolerate nor bear listening to. That women are imperfect creatures and therefore of less dignity than men and incapable of practicing the virtues practiced by men, I would certainly not claim now, for the worthiness of these ladies here would be enough to give me the lie; however, I do say that very learned men have written that since Nature always plans and aims at absolute perfection she would, if possible, constantly bring forth men; and when a woman is born this is a mistake or defect, and contrary to Nature's wishes. This is also the case when someone is both blind, or lame, or with some other defect, as again with trees, when so many fruits fail to ripen. Nevertheless, since the blame for the defects of women must be attributed to Nature, who has made them what they are, we ought not to despise them or to fail to give them the respect which is their due. But to esteem them to be more than they are seems to me to be manifestly wrong."

The Magnifico Giuliano waited for signor Gaspare to continue, but seeing that he remained silent he remarked:

"It appears to me that you have advanced a very feeble argument for the imperfection of women. And, although this is not perhaps the right time to go into subtleties, my answer, based both on a reliable authority and on the simple truth, is that the

substance of anything whatsoever cannot receive of itself either more or less; thus just as one stone cannot, as far as its essence is concerned, be more perfectly stone than another stone, nor one piece of wood more perfectly wood than another piece, so one man cannot be more perfectly man than another; and so, as far as their formal substance is concerned, the male cannot be more perfect than the female, since both the one and the other are included under the species man, and they differ in their accidents and not their essence. You may then say that man is more perfect than woman if not as regards essence then at least as regards accidents; and to this I reply that these accidents must be the properties either of the body or of the mind. Now if you mean the body, because man is more robust, more quick and agile, and more able to endure toil, I say that this is an argument of very little validity since among men themselves those who possess these qualities more than others are not more highly regarded on that account; and even in warfare, when for the most part the work to be done demands exertion and strength, the strongest are not the most highly esteemed. If you mean the mind, I say that everything men can understand, women can too; and where a man's intellect can penetrate, so along with it can a woman's."

After pausing for a moment, the Magnifico then added with a laugh:

"Do you not know that this proposition is held in philosophy: namely, that those who are weak in body are able in mind? So there can be no doubt that being weaker in body women are abler in mind and more capable of speculative thought than men."

Then he continued: "But apart from this, since you have said that I should argue from their acts as to the perfection of the one and the other, I say that if you will consider the operations of Nature, you will find that she produces women the way they are not by chance but adapted to the necessary end; for although she makes them gentle in body and placid in spirit, and with many other qualities opposite to those of men, yet the attributes of the one and the other tend towards the same beneficial end. For just as their gentle frailty makes women less courageous, so it makes them more cautious; and thus the mother nourishes her children, whereas the father instructs them and with his strength wins outside the home what his wife, no less commendably, conserves with diligence and care. Therefore if you study ancient and modern history (although men have always been very sparing in their praises of women) you will find that women as well as men have constantly given proof of their worth; and also that there have been some women who have waged wars and won glorious victories, governed kingdoms with the greatest prudence and justice, and done all that men have done. As for learning, cannot you recall reading of many women who knew philosophy, of others who have been consummate poets, others who prosecuted, accused and defended before judges with great eloquence? It would take too long to talk of the work they have done with their hands, nor is there any need for me to provide examples of it. So if in essential substance men are no more perfect than women, neither are they as regards accidents; and apart from theory this is quite clear in practice. And so I cannot see how you define this perfection of theirs.

"Now you said that Nature's intention is always to produce the most perfect things, and therefore she would if possible always produce men, and that women are the result of some mistake or defect rather than of intention. But I can only say that I deny this completely. You cannot possibly argue that Nature does not intend to produce the women without whom the human race cannot be preserved, which is something that Nature desires above everything else. For by means of the union of male and female, she produces children, who then return the benefits received in childhood by supporting their parents when they are old; then they renew them when they themselves have children, from whom they expect to receive in their old age what they bestowed on their own parents when they were young. In this way Nature, as if moving in a circle, fills out eternity and confers immortality on mortals. And since woman is as necessary to this process as man, I do not see how it can be that one is more the fruit of mere chance than the other. It is certainly true that Nature always intends to produce the most perfect things, and therefore always intends to produce the species man, though not male rather than female; and indeed, if Nature always produced males this would be imperfection: for just as there results from body and soul a composite nobler than its parts, namely, man himself, so from the union of male and female there results a composite that preserves the human species, and without which its parts would perish. Thus male and female always go naturally together, and one cannot exist without the other. So by very definition we cannot call anything male unless it has its female counterpart, or anything female if it has no male counterpart. And since one sex alone shows imperfection, the ancient theologians attribute both sexes to God. For this reason, Orpheus said that Jove was both male and female in His own likeness; and very often when the poets speak of the gods they confuse the sex."

Then signor Gaspare said: "I do not wish us to go into such subtleties because these ladies would not understand them; and though I were to refute you with excellent arguments, they would still think that I was wrong, or pretend to at least; and they would at once give a verdict in their own favor. However, since we have made a beginning, I shall say only that, as you know, it is the opinion of very learned men that man is as the form and woman as the matter, and therefore just as the form is more perfect than matter, and indeed it gives it its being, so man is far more perfect than woman. And I recall having once heard that a great philosopher in certain of his *Problems* asks: Why is it that a woman always naturally loves the man to whom she first gave herself in love? And on the contrary, why is it that a man detests the woman who first coupled with him in that way? And in giving his explanation he affirms that this is because in the sexual act the woman is perfected by the man, whereas the man is made imperfect, and that everyone naturally loves what makes him perfect and detests what makes him imperfect. Moreover, another convincing argument for the perfection of man and the imperfection of woman is that without exception every woman wants to be a man, by reason of a certain instinct that teaches her to desire her own perfection."

The Magnifico Giuliano at once replied:

"The poor creatures do not wish to become men in order to make themselves more perfect but to gain their freedom and shake off the tyranny that men have imposed on them by their one-sided authority. Besides the analogy you give of matter and form is not always applicable; for woman is not perfected by man in the way that matter is perfected by form. To be sure, matter receives its being from form, and cannot exist without it; and indeed the more material a form is, the more imperfect it is, and it is most perfect when separated from matter. On the other hand, woman does not receive her being from man but rather perfects him just as she is perfected by him, and thus both join together for the purpose of procreation which neither can ensure alone. Moreover, I shall attribute woman's enduring love for the man with whom she has first been, and man's detestation for the first woman he possesses, not to what is alleged by your philosopher in his *Problems* but to the resolution and constancy of women and the inconstancy of men. And for this, there are natural reasons: for because of its hot nature, the male sex possesses the qualities of lightness, movement and inconstancy, whereas from its coldness, the female sex derives its steadfast gravity and calm and is therefore more susceptible."

At this point, signora Emilia turned to the Magnifico to say:

"In heaven's name, leave all this business of matter and form and male and female for once, and speak in a way that you can be understood. We heard and understood quite well all the evil said about us by signor Ottaviano and signor Gaspare, but now we can't at all understand your way of defending us. So it seems to me that what you are saying is beside the point and merely leaves in everyone's mind the bad impression of us given by these enemies of ours."

"Do not call us that," said signor Gaspare, "for your real enemy is the Magnifico who, by praising women falsely, suggests they cannot be praised honestly."

Then the Magnifico Giuliano continued: "Do not doubt, madam, that an answer will be found for everything. But I don't want to abuse men as gratuitously as they have abused women; and if there were anyone here who happened to write these discussions down, I should not wish it to be thought later on, in some place where the concepts of matter and form might be understood, that the arguments and criticisms of signor Gaspare had not been refuted."

"I don't see," said signor Gaspare, "how on this point you can deny that man's natural qualities make him more perfect than woman, since women are cold in temperament and men are hot. For warmth is far nobler and more perfect than cold, since it is active and productive; and, as you know, the heavens shed warmth on the earth rather than coldness, which plays no part in the work of Nature. And so I believe that the coldness of women is the reason why they are cowardly and timid."

"So you still want to pursue these sophistries," replied the Magnifico Giuliano, "though I warn you that you get the worst of it every time. Just listen to this, and you'll understand why. I concede that in itself warmth is more perfect than cold; but this is not therefore the case with things that are mixed and composite, since if it were so the warmer any particular substance was the more perfect it would be, whereas in fact temperate bodies are the most perfect. Let me inform you also that women are cold in temperament only in comparison with men. In themselves, because of their excessive warmth, men are far from temperate; but in themselves women are temperate, or at least more nearly temperate than men, since they possess, in proportion to their natural warmth, a degree of moisture which in men, because of their excessive aridity, soon evaporates without trace. The coldness which women possess also counters and moderates their natural warmth, and brings it far nearer to a temperate condition; whereas in men excessive warmth soon brings their natural heat to the highest point where for lack of sustenance it dies away. And thus since men dry out more than women in the act of procreation they invariably do not live so long; and therefore we can attribute another perfection to women, namely, that enjoying longer life than men they fulfill far better than men the intention of Nature. As for the warmth that is shed on us from the heavens, I have nothing to say, since it has only its name in common with what we are talking about and preserving as it does all things beneath the orb of the moon, both warm and cold, it cannot be opposed to coldness. But the timidity of women, though it betrays a degree of imperfection, has a noble origin in the subtlety and readiness of their senses which convey images very speedily to the mind, because of which they are easily moved by external things. Very often you will find men who have no fear of death or anything else and yet cannot be called courageous, since they fail to recognize danger and rush headlong without another thought along the path they have chosen. This is the result of a certain obtuse insensitivity; and a fool cannot be called brave. Indeed, true greatness of soul springs from a deliberate choice and free resolve to act in a certain way and to set honor and duty above every possible risk, and from being so stout-hearted

even in the face of death, that one's faculties do not fail or falter but perform their functions in speech and thought as if they were completely untroubled. We have seen and heard of great men of this sort, and also of many women, both in recent centuries and in the ancient world, who no less than men have shown greatness in spirit and have performed deeds worthy of infinite praise."

"On Women" from *The Book of the Courtier* by Baldesar Castiglione, translated by George Bull (Penguin Classics, 1967). Copyright © George Bull, 1967. Reprinted by permission of the publisher, Penguin Books, Ltd.

READING 50
from BENVENUTO CELLINI (1500–1571), THE AUTOBIOGRAPHY

In this portion of his autobiography Cellini recalls his casting of the bronze statue of Perseus that now stands in the Piazza della Signoria in Florence. The reader quickly hears a common note Cellini strikes throughout this work: his own powerful ego. If there ever was a story of the self—an autobiography—this work is it. Cellini has no doubts about either his talent or his genius and, in this case—as the finished work clearly demonstrates—he has reason for his self-assurance.

Casting Perseus

Then one morning when I was preparing some little chisels for my work a very fine steel splinter flew into my right eye and buried itself so deeply in the pupil that I found it impossible to get out. I thought for certain that I would lose the sight of that eye. After a few days I sent for the surgeon, Raffaello dé Pilli, who took two live pigeons, made me lie on my back on a table, and then holding the pigeons opened with a small knife one of the large veins they have in the wings. As a result the blood poured out into my eye: I felt immediate relief, and in under two days the steel splinter came out and my sight was unimpeded and improved.

As the feast of St. Lucy fell three days later, I made a golden eye out of a French crown piece and had it offered to the saint by one of my six nieces, the daughter of my sister Liperata, who was about ten years old. I gave thanks with her to God and to St. Lucy. For a while I was reluctant to work on the Narcissus. But, in the difficult circumstances I mentioned, I continued with the Perseus, with the idea of finishing it and then clearing off out of Florence.

I had cast the Medusa—and it came out very well—and then very hopefully I brought the Perseus towards completion. I had already covered it in wax, and I promised myself that it would succeed in bronze as well as the Medusa had. The wax Perseus made a very impressive sight, and the Duke thought it extremely beautiful. It may be that someone had given him to believe that it could not come out so well in bronze, or perhaps that was his own opinion, but anyhow he came along to my house more frequently than he used to, and on one of his visits he said:

"Benvenuto, this figure can't succeed in bronze, because the rules of art don't permit it."

I strongly resented what his Excellency said.

"My lord," I replied, "I'm aware that your Most Illustrious Excellency has little faith in me, and I imagine this comes of your putting too much trust in those who say so much evil of me, or perhaps it's because you don't understand the matter."

He hardly let me finish before exclaiming: "I claim to understand and I do understand, only too well."

"Yes," I answered, "like a patron, but not like an artist. If your Excellency understood the matter as you believe you do, you'd trust in me on the evidence of the fine bronze bust I made of you: that large bust of your Excellency that has been sent to Elba. And you'd trust me because of my having restored the beautiful Ganymede in marble; a thing I did with extreme difficulty and which called for much more exertion than if I had made it myself from scratch: and because of my having cast the Medusa, which is here now in your Excellency's presence; and casting that was extraordinarily difficult, seeing that I have done what no other master of this devilish art has ever done before. Look, my lord, I have rebuilt the furnace and made it very different from any other. Besides the many variations and clever refinements that it has, I've constructed two outlets for the bronze: that was the only possible way of ensuring the success of this difficult, twisted figure. It only succeeded so well because of my inventiveness and shrewdness, and no other artist ever thought it possible.

"Be certain of this, my lord, that the only reason for my succeeding so well with all the important and difficult work I did in France for that marvelous King Francis was because of the great encouragement I drew from his generous allowances and from the way that he met my request for workmen—there were times when I made use of more than forty, all of my own choice. That was why I made so much in so short a time. Now, my lord, believe what I say, and let me have the assistance I need, since I have every hope of finishing a work that will please you. But if your Excellency discourages me and refuses the assistance I need, I can't produce good results, and neither could anyone else no matter who."

The Duke had to force himself to stay and listen to my arguments; he was turning now one way and now another, and, as for me, I was sunk in despair, and I was suffering agonies as I began to recall the fine circumstances I had been in [when] in France.

All at once the Duke said: "Now tell me, Benvenuto, how can you possibly succeed with this beautiful head of Medusa, way up there in the hand of the Perseus?"

Straight away I replied: "Now see, my lord: if your Excellency understood this art as you claim to then you wouldn't be worried about that head not succeeding; but you'd be right to be anxious about the right foot, which is so far down."

At this, half in anger, the Duke suddenly turned to some noblemen who were with him and said:

"I believe the man does it from self-conceit, contradicting everything."

Then all at once he turned toward me with an almost mocking expression that was imitated by the others, and he said:

"I'm ready to wait patiently and listen to the arguments you can think up to convince me."

"I shall give such convincing ones," I said, "that your Excellency will understand only too well."

Then I began: "You know, my lord, the nature of fire is such that it tends upwards, and because this is so I promise you that the head of Medusa will come out very well. But seeing that fire does not descend I shall have to force it down six cubits by artificial means: and for that very cogent reason I tell your Excellency that the foot can't possibly succeed, though it will be easy for me to do it again."

"Well then," said the Duke, "why didn't you take precautions to make sure the foot comes out in the way you say the head will?"

"I would have had to make the furnace much bigger," I replied, "and build in it a conduit as wide as my leg, and then the weight of the hot metal would have enabled me to bring it down. As it is, the conduit now descends those six cubits I mentioned before down to the feet, but it's no thicker than two fingers. It was not worth the expense of changing it, because I

can easily repair the fault. But when my mould has filled up more than halfway, as I hope it will, then the fire will mount upwards, according to its nature, and the head of the Perseus, as well as that of Medusa, will come out perfectly. You may be sure of that."

After I had expounded these cogent arguments and endless others which it would take me too long to write down here, the Duke moved off shaking his head.

Left to myself in this way, I regained my self-confidence and rid myself of all those troublesome thoughts that used to torment me from time to time, often driving me to bitterly tearful regret that I had ever quit France, even though it had been to go on a charitable mission to Florence, my beloved birthplace, to help out my six nieces. I now fully realized that it was this that had been at the root of all my misfortunes, but all the same I told myself that when my Perseus that I had already begun was finished, all my hardships would give way to tremendous happiness and prosperity.

So with renewed strength and all the resources I had both in my limbs and in my pocket (though I had very little money left) I made a start by ordering several loads of wood from the pine forest at Serristori, near Monte Lupo. While waiting for them to arrive I clothed my Perseus with the clays I had prepared some months previously in order to ensure that they would be properly seasoned. When I had made its clay tunic, as it is called, I carefully armed it, enclosed it with iron supports, and began to draw off the wax by means of a slow fire. It came out through the air vents I had made—the more of which there are, the better a mould fills. After I had finished drawing off the wax, I built round my Perseus a funnel-shaped furnace. It was built, that is, round the mould itself, and was made of bricks piled on top of the other, with a great many gaps for the fire to escape more easily. Then I began to lay on wood, in fairly small amounts, keeping the fire going for two days and nights.

When all the wax was gone and the mould well baked, I at once began to dig the pit in which to bury it, observing all the rules that my art demands. That done, I took the mould and carefully raised it up by pulleys and strong ropes, finally suspending it an arm's length above the furnace, so that it hung down just as I wanted it above the middle of the pit. Very, very slowly I lowered it to the bottom of the furnace and set it in exact position with the utmost care: and then, having finished that delicate operation, I began to bank it up with the earth I had dug out. As I built this up, layer by layer, I left a number of air holes by means of little tubes of terracotta of the kind used for drawing off water and similar purposes. When I saw that it was perfectly set up, that all was well as far as covering it and putting those tubes in position was concerned, and that the workmen had grasped what my method was—very different from those used by all the others in my profession—I felt confident that I could rely on them, and I turned my attention to the furnace.

I had had it filled with a great many blocks of copper and other bronze scraps, which were placed according to the rules of our art, that is, so piled up that the flames would be able to play through them, heat the metal more quickly, and melt it down. Then, very excitedly, I ordered the furnace to be set alight.

The pine logs were heaped on, and what with the greasy resin from the wood and the excellence of my furnace, everything went so merrily that I was soon rushing from one side to another, exerting myself so much that I became worn out. But I forced myself to carry on.

To add to the difficulties, the workshop caught fire and we were terrified that the roof might fall in on us, and at the same time the furnace began to cool off because of the rain and wind that swept in at me from the garden.

I struggled against these infuriating accidents for several hours, but the strain was more than even my strong constitution

could bear, and I was suddenly attacked by a bout of fever—the fiercest you can possibly imagine—and was forced to throw myself on to my bed.

Very upset, forcing myself away from the work, I gave instructions to my assistants, of whom there were ten or more, including bronze-founders, craftsmen, ordinary laborers, and the men from my own workshop. Among the last was Bernardino Mannellini of Mugello, whom I had trained for a number of years; and I gave him special orders.

"Now look, my dear Bernardino," I said, "do exactly as I've shown you, and be very quick about it as the metal will soon be ready. You can't make any mistakes—these fine fellows will hurry up with the channels and you yourself will easily be able to drive in the two plugs with these iron hooks. Then the mould will certainly fill beautifully. As for myself, I've never felt so ill in my life. I'm sure it will make an end of me in a few hours."

And then, very miserably, I left them and went to bed.

As soon as I was settled, I told my housemaids to bring into the workshop enough food and drink for everyone, and I added that I myself would certainly be dead by the next day. They tried to cheer me up, insisting that my grave illness would soon pass and was only the result of excessive tiredness. Then I spent two hours fighting off the fever, which all the time increased in violence, and I kept shouting out: "I'm dying!"

Although my housekeeper, the best in the world, an extraordinarily worthy and lovable woman called Fiore of Castel del Reio, continually scolded me for being so miserable, she tended to all my wants with tremendous devotion. But when she realized how very ill I was, and how low my spirits had fallen, for all her unflagging courage she could not keep back her tears, though even then she did her best to prevent my noticing them.

In the middle of this dreadful suffering I caught sight of someone making his way into my room. His body was all twisted, just like a capital *S*, and he began to moan in a voice full of gloom, like a priest consoling a prisoner about to be executed.

"Poor Benvenuto! Your work is all ruined—there's no hope left!"

On hearing the wretch talk like that I let out a howl that could have been heard echoing from the farthest planet, sprang out of bed, seized my clothes, and began to dress. My servants, my boy, and everyone else who rushed up to help me found themselves treated to kicks and blows, and I grumbled furiously at them:

"The jealous traitors! This is deliberate treachery—but I swear by God I'll get to the root of it. Before I die I'll leave such an account of myself that the whole world will be dumbfounded!"

As soon as I was dressed, I set out for the workshop in a very nasty frame of mind, and there I found the men I had left in such high spirits all standing round with an air of astonished dejection.

"Come along now," I said, "listen to me. As you either couldn't or wouldn't follow the instructions I left you, obey me now that I'm here with you to direct my work in person. I don't want any objections—we need work now, not advice."

At this, a certain Alessandro Lastricati cried out:

"Look here, Benvenuto, what you want done is beyond the powers of art. It's simply impossible."

When I heard him say that I turned on him so furiously and with such a murderous glint in my eye that he and all the others shouted out together:

"All right then, let's have your orders. We'll obey you in everything while there's still life in us."

And I think they showed this devotion because they expected me to fall down dead at any minute.

I went at once to inspect the furnace, and I found that the metal had all curdled, had caked as they say. I ordered two of the hands to go over to Capretta, who kept a butcher's shop, for a load of young oak that had been dried out a year or more before and had been offered me by his wife, Ginevra. When they carried in the first armfuls I began to stuff them under the grate. The oak that I used, by the way, burns much more fiercely than any other kind of wood, and so alder or pinewood, which are slower burning, is generally preferred for work such as casting artillery. Then, when it was licked by those terrible flames, you should have seen how that curdled metal began to glow and sparkle!

Meanwhile I hurried on with the channels and also sent some men up to the roof to fight the fire that had begun to rage more fiercely because of the greater heat from the furnace down below. Finally I had some boards and carpets and other hangings set up to keep out the rain that was blowing in from the garden.

As soon as all that terrible confusion was straightened out, I began roaring: "Bring it here! Take it there!" And when they saw the metal beginning to melt my whole band of assistants were so keen to help that each one of them was as good as three men put together.

Then I had someone bring me a lump of pewter, weighing about sixty pounds, which I threw inside the furnace on to the caked metal. By this means, and by piling on the fuel and stirring with pokers and iron bars, the metal soon became molten. And when I saw that despite the despair of all my ignorant assistants that I had brought a corpse back to life, I was so reinvigorated that I quite forgot the fever that had put the fear of death into me.

At this point there was a sudden explosion and a tremendous flash of fire, as if a thunderbolt had been hurled in our midst. Everyone, not least myself, was struck with unexpected terror. When the glare and noise had died away, we stared at each other, and then realized that the cover of the furnace had cracked open and that the bronze was pouring out. I hastily opened the mouths of the mould and at the same time drove in the two plugs.

Then, seeing that the metal was not running as easily as it should, I realized that the alloy must have been consumed in that terrific heat. So I sent for all my pewter plates, bowls, and salvers, which numbered about two hundred, and put them one by one in front of the channels, throwing some straight into the furnace. When they saw how beautifully the bronze was melting and the mould filling up, everyone grew excited. They all ran up smiling to help me, and fell over themselves to answer my calls, while I—now in one place, now another—issued instructions, gave a hand with the work, and cried out loud: "O God, who by infinite power raised Yourself from the dead and ascended into heaven!" And then in an instant my mould was filled. So I knelt down and thanked God with all my heart.

Then I turned to a plate of salad that was there on some bench or other, and with a good appetite ate and drank with all my band of helpers. Afterwards I went to bed, healthy and happy, since it was two hours off dawn, and so sweetly did I sleep that it was as if I hadn't a thing wrong with me. Without a word from me that good servant of mine had prepared a fat capon, and so when I got up—near dinner time—she came to me smiling and said:

"Now then, is this the man who thought he was going to die? I believe the blows and kicks you gave us last night, with you so enraged and in such a devilish temper, made your nasty fever frightened that it would come in for a beating as well, and so it ran away."

Then all my poor servants, no longer burdened by anxiety and toil, immediately went out to replace those pewter vessels

and plates with the same number of earthenware pots, and we all dined happily. I never remember in my life having dined in better spirits or with a keener appetite.

After dinner all those who had assisted came to visit me; they rejoiced with me, thanking God for what had happened and saying that they had learnt and seen how to do things that other masters held to be impossible. I was a little boastful and inclined to show off about it, and so I preened myself a little. Then I put my hand in my purse and paid them all to their satisfaction.

My mortal enemy, that bad man Pier Francesco Riccio, the Duke's majordomo, was very diligent in trying to find out how everything had gone: those two whom I strongly suspected of being responsible for the metal's curdling told him that I obviously wasn't human but rather some powerful fiend, since I had done the impossible, and some things which even a devil would have found baffling.

They greatly exaggerated what had happened—perhaps to excuse themselves—and without delay, the majordomo wrote repeating it all to the Duke who was at Pisa, making the story even more dramatic and marvelous than he had heard it.

I left the cast to cool off for two days and then very, very slowly, I began to uncover it. The first thing that I found was the head of Medusa, which had come out beautifully because of the air vents, just as I had said to the Duke that the nature of fire was to ascend. Then I began uncovering the rest, and came to the other head—that is the head of the Perseus—which had also succeeded beautifully. This came as much more of a surprise because, as can be seen, it's a good deal lower than the Medusa.

The mouths of the mould were placed above the head of the Perseus, and by the shoulders, and I found that all the bronze there was in my furnace had been used up in completing the head of the Perseus. It was astonishing to find that there was not the slightest trace of metal left in the channels, nor on the other hand was the statue incomplete. This was so amazing that it seemed a certain miracle, with everything controlled and arranged by God.

I carried on happily with the uncovering, and without exception I found everything perfect until I reached the foot of the right leg on which it rests. There I discovered that the heel was perfectly formed, and continuing farther I found it all complete: on the one hand, I rejoiced very much, but on the other I was half disgruntled if only because I had told the Duke that it could not come out. But then on finishing the uncovering I found that the toes of the foot had not come out: and not only the toes, because there was missing a small part above the toes as well, so that just under a half was missing. Although this meant a little more work I was very glad of it, merely because I could show the Duke that I knew my business. Although much more of the foot had come out than I had expected, the reason for this was that—with all that had taken place—the metal had been hotter than it would have been, and at the same time I had had to help it out with the alloy in the way I described, and with those pewter vessels—something no one else had ever done before.

Seeing that the work was so successful I immediately went to Pisa to find my Duke. He welcomed me as graciously as you can imagine, and the Duchess did the same. Although their majordomo had sent them news about everything, it seemed to their Excellencies far more of a stupendous and marvelous experience to hear me tell of it in person. When I came to the foot of the Perseus which had not come out—just as I had predicted to his Excellency—he was filled with astonishment and he described to the Duchess how I had told him this beforehand. Seeing how pleasantly my patrons were treating me I begged the Duke's permission to go to Rome. He gave me leave, with great kindness, and told me to return quickly and

finish his Perseus; and he also gave me letters recommending me to his ambassador, who was Averardo Serristori: these were the first years of Pope Julius dé Monti.

CHAPTER 14

READING 51

MICHEL EYQUEM DE MONTAIGNE (1533–1593), OF CANNIBALS (1580)

During the period of this essay, reports of native peoples were pouring into Europe from explorers who wrote of their adventures in the New World. As Montaigne contrasts so-called primitive people to the so-called civilized people of his own time and place, he reflects his horror at the lack of civility in a European culture incessantly warring over religion. Montaigne's somewhat Romantic view of the "cannibals" reminds us of the tendency of European culture—especially in the following century—to praise the "noble savage" as a vehicle for social and political criticism.

When King Pyrrhus passed over into Italy, after studying the formation of the army that the Romans sent to meet him, he said: "I do not know what barbarians these are" (for so the Greeks called all foreign nations), "but the formation of this army that I see is not at all barbarous." The Greeks said as much of the army that Flaminius brought into their country, and so did Philip, seeing from a knoll the order and distribution of the Roman camp, in his kingdom, under Publius Sulpicius Galba. That is how we should beware of clinging to common opinions, and judge things by reason's way, not by popular say.

I had with me for a long time a man who had lived for ten or twelve years in that other world which was discovered in our century, in the place where Villegaignon landed, and which he called Antarctic France.[1] This discovery of a boundless country seems worthy of consideration. I don't know if I can guarantee that some other such discovery will not be made in the future, so many personages greater than ourselves having been mistaken about this one. I am afraid we have eyes bigger than our stomachs, and more curiosity than capacity. We embrace everything, but we clasp only wind.

Plato brings in Solon, telling how he had learned from the priests of the city of Saïs in Egypt that in days of old, before the Flood, there was a great island named Atlantis, right at the mouth of the Straits of Gibraltar, which contained more countries than Africa and Asia put together, and that the kings of that country, who not only possessed that island but had stretched out so far on the mainland that they held the breadth of Africa as far as Egypt, and the length of Europe as far as Tuscany, attempted to step over into Asia and subjugate all the nations that border on the Mediterranean, as far as the gulf of the Black Sea; and to accomplish this, crossed the Spains, Gaul, Italy, as far as Greece, where the Athenians checked them; but that some time after, both the Athenians and themselves and their island were swallowed up by the Flood.

It is quite likely that that phenomenal havoc of waters made amazing changes in the habitations of the earth, as people maintain that the sea cut off Sicily from Italy—

'Tis said an earthquake once asunder tore
These lands with dreadful havoc, which before
Formed but one land, one shore,

[Virgil]

—Cyprus from Syria, the island of Euboea from the mainland of Boeotia; and elsewhere joined lands that were divided, filling the channels between them with sand and mud:

> A sterile marsh, long fit for rowing, now
> Feeds neighbor towns, and feels the heavy plow.
>
> [Horace]

But there appears little likelihood that that island was the new world which we have just discovered; for it almost touched Spain, and it would be an incredible result of a flood to have forced it away as far as it is, more than twelve hundred leagues; besides, the travels of the moderns have already almost revealed that it is not an island, but a mainland connected with the East Indies on one side, and elsewhere with the lands under the two poles; or, if it is separated from them, it is by so narrow a strait and interval that it does not deserve to be called an island on that account.

It seems that there are movements, some natural, others feverish, in these great bodies, just as in our own. When I consider the inroads that my river, the Dordogne, is making in my lifetime into the right bank in its descent, and that in twenty years it has gained so much ground and stolen away the foundations of several buildings, I clearly see that this is an extraordinary disturbance; for if it had always gone at this rate, or was to do so in the future, the face of the world would be turned topsy-turvy. But rivers are subject to changes: now they overflow in one direction, now in another, now they keep to their course. I do not speak of the sudden inundations whose causes are manifest. In Médoc, along the seashore, my brother, the Sieur d'Arsac, can see an estate of his buried under the sands that the sea vomits in front of it; the tops of some buildings are still visible; his rents and domains have changed into very thin pasturage. The inhabitants say that for some time the sea has been pushing toward them so hard that they have lost four leagues of land. These sands are its harbingers; and we see great dunes of moving sand that march half a league ahead of it and gain territory.

The other testimony of antiquity with which some would connect this discovery is in Aristotle, at least if that little book *Of Unheard-of Wonders* is by him. He there relates that certain Carthaginians, having set out upon the Atlantic Ocean from the Straits of Gibraltar, and sailed a long time, had at last discovered a great fertile island, all clothed in woods and watered by great deep rivers, far remote from any mainland; and that they, and others since, attracted by the goodness and fertility of the soil, went there with their wives and children, and began to settle there. The lords of Carthage, seeing that their country was gradually becoming depopulated, expressly forbade anyone to go there any more, on pain of death, and drove out these new inhabitants, fearing, it is said, that in course of time they might come to multiply so greatly as to supplant themselves and ruin their state. This story of Aristotle does not fit our new lands any better than the other.

This man I had was a simple crude fellow[2]—a character fit to bear true witness; for clever people observe more things and more curiously, but they interpret them; and to lend weight and conviction to their interpretation, they cannot help altering history a little. They never show you the things as they are, but bend and disguise them according to the way they have seen them; and to give credence to their judgment and attract you to it, they are prone to add something to their matter to stretch it out and amplify it. We need a man either very honest, or so simple that he has not the stuff to build up false inventions and give them plausibility; and wedded to no theory. Such was my man; and besides this, he has at various times brought sailors and merchants, whom he had known on that trip, to see me. So I content myself with his information, without inquiring what the cosmographers say about it.

We ought to have topographers who would give us an exact account of the places where they have been. But because they have this advantage over us that they have seen Palestine, they want to enjoy the privilege of telling us news about all the rest of the world. I would like everyone to write what he knows, and as much as he knows, not only in this, but in all other subjects; for a man may have some special knowledge and experience of the nature of a river or a fountain, who in other matters knows only what everybody knows. However, to circulate this little scrap of knowledge, he will undertake to write down the whole of physics. From this vice spring many great abuses.

Now, to return to my subject, I think there is nothing barbarous and savage in this nation, from what I have been told, except that each man calls barbarism whatever is not his own practice; for indeed it seems we have no other test of truth and reason than the example and pattern of the opinions and customs of the country we live in. *There* is always the perfect religion, the perfect government, the perfect and accomplished usage in all things. Those people are wild, just as we call wild the fruits that Nature has produced by herself and in her normal course; whereas really it is those that we have changed artificially and led astray from the common order, that we should rather call wild. In the former the genuine, most useful and natural virtues and properties are alive and vigorous, which we have debased in the latter, and have only adapted to the pleasure of our corrupted taste. And yet for all that, the savor and delicacy of some uncultivated fruits of those countries is quite as excellent, even to our taste, as that of our own. It is not reasonable that art should win the place of honor over our great and powerful mother Nature. We have so overloaded the beauty and richness of her works by our inventions that we have quite smothered her. Yet wherever she shines forth in her purity, she wonderfully puts to shame our vain and frivolous attempts:

> Ivy comes readier without our care;
> In lonely caves the arbutus grows more fair;
> No art with artless bird-song can compare.
>
> [Propertius]

All our efforts cannot even succeed in reproducing the nest of the tiniest little bird, its contexture, its beauty and convenience; nor even the web of the puny spider. All things, says Plato, are produced by nature, by chance, or by art; the greatest and most beautiful by one or the other of the first two, the least and most imperfect by the last.

These nations, then, seem to me barbarous in this sense, that they have been fashioned very little by the human mind, and are still very close to their original naturalness. The laws of nature still rule them, very little corrupted by ours; but they are in such a state of purity that I sometimes am vexed that knowledge of them did not come earlier, in the days when there were men able to judge them better than we. I am sorry that Lycurgus and Plato did not have this knowledge; for it seems to me that what we actually see in these nations surpasses not only all the pictures in which poets have embellished the golden age, and all their ingenuity in imagining a happy state of man, but also the conceptions and the very desire of philosophy. They could not imagine a naturalness so pure and simple as that which we see by experience; nor could they believe that our society can be maintained with so little artifice and human solder. This is a nation, I should say to Plato, in which there is no sort of traffic, no knowledge of letters, no science of numbers, no name for a magistrate or for political superiority, no custom of servitude, no riches or poverty, no contracts, no successions, no partitions, no occupations but leisure ones, no care for any but common kinship, no clothes, no agriculture, no metal, no use of wine or corn. The very words that signify lying, treach-

ery, dissimulation, avarice, envy, belittling, pardon, unheard of. How far from this perfection would he find the republic that he imagined: *Men fresh sprung from the gods* [Seneca].

These manners nature first ordained.

[Virgil]

For the rest, they live in a country with a very pleasant and temperate climate, so that according to my witnesses you rarely see a sick man there; and they have assured me that they never saw one palsied, bleary-eyed, toothless, or bent with age. They are settled along the sea and shut in on the land side by great high mountains, with a stretch about a hundred leagues wide in between. They have a great abundance of fish and flesh which bear no resemblance to ours, and they eat them with no other artifice than cooking. The first man who rode a horse there, though he had had dealings with them on several other trips, so horrified them in this posture that they shot him dead with arrows before they could recognize him.

Their buildings are very long, with a capacity of two or three hundred souls, covered with the bark of great trees, the strips fastened to the ground at one end and supporting and leaning on one another at the top, in the manner of some of our barns, whose covering hangs down to the ground and acts as a side. They have wood so hard that they cut with it and make of it their swords and grills to cook their food. Their beds are of a cotton weave, hung from the roof like those in our ships, each man having his own; for the wives sleep apart from their husbands.

They get up with the sun, and eat right after they get up, for the whole day, having no other meal than that one. They do not drink then, as Suidas tells us of some other Eastern peoples, who drank apart from meals; but they drink several times a day, and to capacity. Their drink is made of some root, and is of the color of our claret wines. They only drink it lukewarm. This beverage keeps only two or three days; it has a slightly sharp taste, is not at all heady, good for the stomach, and laxative for those who are not used to it; it is a very pleasant drink for anyone who is accustomed to it. In place of bread they use a certain white substance like preserved coriander. I have tried it; it tastes sweet and a little flat.

The whole day is spent in dancing. The younger men go to hunt animals with bows. Some of the women busy themselves meanwhile in warming their drink, which is their chief duty. Some one of the old men, in the morning before they begin to eat, preaches to the whole barnful in common, walking from one end to the other, and repeating one single sentence several times until he has completed the circuit (for the buildings are fully a hundred paces long). He recommends to them only two things: valor against the enemy and love for their wives. And they never fail to point out this obligation, as their refrain, that it is their wives who keep their drink warm and seasoned.

There may be seen in several places, including my own house, the shape of their beds, of their ropes, of their wooden swords and the bracelets with which they cover their wrists in combats, and of the big canes, open at one end, by whose sound they keep time in their dances. They are close shaven all over, and shave themselves much more cleanly than we, with nothing but a wooden or stone razor. They believe that souls are immortal, and that those who have deserved well of the gods are lodged in that part of heaven where the sun rises, and the damned in the west.

They have some sort of priests and prophets, who very rarely appear before the people, having their home in the mountains. On their arrival there is a great feast and solemn assembly of several villages—each barn, as I have described it, makes up a village, and they are about one French league from each other. This prophet speaks to them in public, exhorting them to virtue and their duty; but their whole ethical science contains only these two articles: resoluteness in war and affection for their wives. This man prophesies to them things to come and the results they are to expect from their undertakings, and urges them to war or holds them back from it; but this is on the condition that when he fails to prophesy correctly, and if things turn out otherwise than he has predicted, he is cut into a thousand pieces if they catch him, and condemned as a false prophet. For this reason, the prophet who has once been mistaken is never seen again.

Divination is a gift of God; that is why it should be a punishable imposture to abuse it. Among the Scythians, when the soothsayers failed to hit the mark, they were laid, chained hand and foot, on carts full of heather and drawn by oxen, on which they were burned. Those who handle matters subject to the conduct of human capacity are excusable if they do the best they can. But these others, who come and trick us with assurances of an extraordinary faculty that is beyond our ken, should they not be punished for not making good their promise, and for the temerity of their imposture?

They have their wars with the nations beyond the mountains, further inland, to which they go quite naked, with no other arms than bows or wooden swords pointed at one end, in the manner of the tongues of our boar spears. It is marvelous what firmness they show in their combats, which never end but in slaughter and bloodshed; for as for routs and terror, they do not know what that means.

Each man brings back as his trophy the head of the enemy he has killed, and sets it up at the entrance to his dwelling. After treating their prisoners well for a long time with all the hospitality they can think of, the captor of each one calls a great assembly of his acquaintances. He ties a rope to one of the prisoner's arms, by the end of which he holds him, a few steps away, for fear of being hurt, and gives his dearest friend the other arm to hold in the same way; and these two, in the presence of the whole assembly, dispatch him with their swords. This done, they roast him and eat him in common and send some pieces to their absent friends. This is not, as people think, for nourishment, as of old the Scythians used to do; it is to betoken an extreme revenge. And the proof of this is that having perceived that the Portuguese, who had joined forces with their adversaries, inflicted a different kind of death on them when they took them prisoner, which was to bury them up to the waist, shoot the rest of their bodies full of arrows, and afterwards hang them; they thought that these people from the other world, being men who had sown the knowledge of many vices among their neighbors and were much greater masters than themselves in every sort of wickedness, did not adopt this sort of vengeance without some reason, and that it must be more painful than their own; so they began to give up their old method and follow this one.

I am not sorry that we notice the barbarous horror of such acts, but I am heartily sorry that, judging their faults rightly, we should be so blind to our own. I think there is more barbarity in eating a man alive than in eating him dead, in tearing by tortures and the rack a body still full of feeling, in roasting him bit by bit, having him bitten and mangled by dogs and swine (as we have not only read but seen within fresh memory, not among ancient enemies, but among neighbors and fellow citizens, and what is worse, on the pretext of piety and religion) than in roasting and eating him after he is dead.

Indeed, Chrysippus and Zeno, heads of the Stoic sect, thought that there was nothing wrong in using our carcasses for any purpose in case of need, and getting nourishment from them; just as our ancestors, being besieged by Caesar in the city of Alésia, resolved to relieve the famine of this siege with the bodies of the old men, women, and other people useless for fighting.

The Gascons once, 'tis said, their life renewed
By eating of such food.

[Juvenal]

And physicians do not fear to use human flesh in all sorts of ways for our health, applying it either inwardly or outwardly. But there never was any opinion so diseased as to excuse treachery, disloyalty, tyranny, and cruelty, which are our common vices.

Then we may well call these people barbarians, in respect to the rules of reason, but not in respect to ourselves, who surpass them in every kind of barbarity.

Their warfare is wholly noble and generous, and as excusable and beautiful as this human disease can be; its only basis among them is the jealousy of valor. They are not fighting for the conquest of new lands, for they still enjoy that natural abundance that provides them without toil and trouble with all necessary things in such profusion that they have no wish to enlarge their boundaries. They are still in that happy state of desiring only as much as their natural needs demand; anything beyond that is superfluous to them.

They generally call each other thus: those of the same age, brothers; those who are younger, children; and the old men are fathers to all the others. These leave to their heirs in common the full possession of their property, without division or any other title at all than just the one that Nature gives to her creatures in bringing them into the world.

If their neighbors cross the mountains to come and attack them, and win victory over them, the gain of the victor is glory, and the advantage of having proven the master in valor and virtue; for otherwise they have no use for the goods of the vanquished, and they return to their own country, where they have no lack of anything necessary, nor yet lack of that great thing, the knowledge of how to enjoy their condition happily and be content with it. These do the same in their turn. They demand of their prisoners no other ransom than their confession and acknowledgment of being vanquished. But there is not one in a whole century who does not choose to die rather than to relax a single bit, by word or look, from the grandeur of an invincible courage; you do not see one who does not choose to be killed and eaten rather than so much as ask not to be. They treat them very freely, so that life may be all the dearer to them, and usually talk to them of the threats of their coming death, the torments they will have to suffer, the preparations that are being made for that purpose, the cutting up of their limbs, and the feast that will be made at their expense. All this is done for the sole purpose of extorting from their lips some weak or base word, or making them want to flee, so as to gain the advantage of having terrified them and broken down their firmness. For indeed, if you take it the right way, it is in this point alone that true victory lies:

It is no victory
Unless the vanquished foe admits your mastery.

[Claudian]

The Hungarians, very bellicose fighters, did not in olden times pursue their advantage beyond putting the enemy at their mercy. For having wrung this confession from him, they let him go unharmed, unransomed, except, at most, for making him give his word never again to take arms against them.

We win quite enough advantages over our enemies that are borrowed advantages, not really our own. It is the quality of a porter, not of valor, to have sturdier arms and legs; agility is a dead and corporal quality; it is a stroke of luck to make our enemy stumble, or dazzle his eyes by the light of the sun; it is a trick of art and science, which may be found in a worthless coward, to be an able fencer. The worth and value of a man is in his heart and his will; there lies his real honor. Valor is the strength, not of legs and arms, but of heart and soul; it does not consist in the worth of our horse, or our weapons, but in our own. He who falls obstinate in his courage, *if he has fallen, he fights on his knees* [Seneca]. He who relaxes none of his assurance for any danger of imminent death; who, giving up his soul, still looks firmly and scornfully at his enemy, he is beaten not by us, but by fortune; he is killed, not conquered.

The most valiant are sometimes the most unfortunate. Thus there are triumphant defeats that rival victories. Nor did those four sister victories, the fairest that the sun ever beheld with his eyes—Salamis, Plataea, Mycale, and Sicily—ever dare match all their combined glory against the glory of the annihilation of King Leonidas and his men at the pass of Thermopylae.

Who ever hastened with more glorious and ambitious desire to win a battle than Captain Ischolas to lose one? Who ever secured his safety more ingeniously and painstakingly than he did his destruction? He was charged to defend a certain pass in the Peloponnesus against the Arcadians. In order to do so, finding himself quite powerless in view of the nature of the place and the inequality of the forces, and making up his mind that all who confronted the enemy would necessarily have to remain on the field; on the other hand, deeming it unworthy both of his own virtue and magnanimity and of the name of a Lacedaemonian to fail in his charge, he took a middle course between these two extremes, in this way. The youngest and fittest of his band he preserved for the defense and service of their country, and sent them home; and with those whose loss was less vital, he determined to hold this pass, and by their death to make the enemy buy their entry as dearly as he could. And so it turned out. For being presently surrounded on all sides by the Arcadians, after slaughtering a larger number of them, he and his men were all put to the sword. Is there a trophy dedicated to victors that would not be more due to these vanquished? The role of true victory is in fighting, not in coming off safely; and the honor of valor consists in combating, not in beating.

To return to our story. These prisoners are so far from giving in, in spite of all that is done to them, that on the contrary, during the two or three months that they are kept, they wear a gay expression; they urge their captors to hurry and put them to the test; they defy them, insult them, reproach them with their cowardice and the number of battles lost to their men.

I have a song composed by a prisoner which contains this challenge, that they should all come boldly and gather to dine off him, for they will be eating at the same time their own fathers and grandfathers, who have served to feed and nourish his body. "These muscles," he says, "this flesh and these veins are your own, poor fools that you are. You do not recognize that the substance of your ancestors' limbs is still contained in them? Savor them well; you will find in them the taste of your own flesh." An idea that certainly does not smack of barbarity. Those that paint these people dying, and who show the execution, portray the prisoner spitting in the face of his slayers and making faces at them. Indeed, to the last gasp they never stop braving and defying them by word and look. Truly here are real savages by our standards; for either they must be thoroughly so, or we must be; there is an amazing distance between their character and ours.

The men there have several wives, and the higher their reputation for valor, the more wives they have. It is a remarkably beautiful thing about their marriages that the same jealousy our wives have to keep us from the affection and favors of other women, theirs have to win this for them. Being more concerned for their husbands' honor than for anything else, they strive and worry to have as many companions as they can, since that is a sign of their husband's valor.

Our wives will cry "Miracle!"; but it is not. It is a properly matrimonial virtue, but one of the highest order. And in the

Chapter 14 ◆ **179**

Bible, Leah, Rachel, Sarah, and Jacob's wives gave their beautiful handmaids to their husbands; and Livia seconded the appetites of Augustus, to her own disadvantage; and Stratonice, the wife of King Deiotarus, not only lent her husband for his use a very beautiful young chambermaid in her service, but carefully brought up her children, and backed them up to succeed to their father's estates.

And lest it be thought that all this is done through a simple and servile bondage to usage and through the pressure of the authority of their ancient customs, without reasoning or judgment, and because their minds are so stupid that they cannot take any other course, I must cite some examples of their capacity. Besides the warlike song I have just quoted, I have another, a love song, which begins in this vein: "Adder, stay; stay, adder, that from the pattern of your coloring my sister may draw the model and the workmanship of a rich girdle that I may give to my love; so may your beauty and your disposition be forever preferred to all other serpents." This first couplet is the refrain of the song. Now I am familiar enough with poetry to be a judge of this: that not only is there nothing barbarous in this fancy, but that it is altogether Anacreontic. Their language, moreover, is a soft language, with an agreeable sound, somewhat like Greek in its endings.

Three of these men, not knowing how much their repose and happiness will pay some day for the knowledge of the corruptions of this side of the ocean, and that of this intercourse will come their ruin, which I suppose is already well advanced—poor wretches, to have let themselves be tricked by the desire for new things, and to have left the serenity of their own sky to come and see ours—were at Rouen, at the time when the late King Charles the Ninth[3] was there. The King talked to them for a long time; they were shown our ways, our pomp, the form of a fine city. After that someone asked their opinion, and wanted to know what they had found most amazing. They replied that there were three things, of which I have forgotten the third, and I am very sorry for it; but I still remember two of them. They said that in the first place they thought it very strange that so many grown men, bearded, strong, and armed, who were around the King (it is likely that they were talking about the Swiss of his guard) should submit to obey a child, and that one of them was not chosen to command instead; secondly (they have a way in their language of speaking of men as halves of one another), that they had noticed that there were among us men full and gorged with all sorts of good things, and that their other halves were beggars at their doors, emaciated with hunger and poverty; and they thought it strange that these needy halves could suffer such an injustice, and did not take the others by the throat, or set fire to their houses.

I had a long talk with one of them; but I had an interpreter who followed my meaning so badly, and who was so hindered by his stupidity in taking in my ideas, that I could get hardly any satisfaction from the man. When I asked him what profit he gained from his superior position among his people (for he was a captain, and our sailors called him king), he told me that it was to march foremost in war. How many men followed him? He pointed to a piece of ground, to signify as many as such a space could hold; it might have been four or five thousand men. Did all this authority expire with the war? He said that this much remained, that when he visited the villages dependent on him, they made paths for him through the underbrush by which he might pass quite comfortably.

All this is not too bad. But wait! They don't wear trousers.

Notes

1 In Brazil, in 1557.
2 The traveler Montaigne spoke of at the beginning of the chapter.
3 In 1562.

READING 52
Martin Luther (1483–1546), The Small Catechism (Enchiridion[1]) (1528–1531)

In 1528, with the Reformation in progress, Luther toured villages in Saxony (Germany) and came away appalled at the people's lack of knowledge about their religion. In response he wrote THE SMALL CATECHISM intended for ordinary people to read as a brief handbook of the tenets and rituals of their faith.

Preface

Grace, mercy, and peace in Jesus Christ, our Lord, from Martin Luther to all faithful, godly pastors and preachers.

The deplorable conditions which I recently encountered when I was a visitor[2] constrained me to prepare this brief and simple catechism or statement of Christian teaching. Good God, what wretchedness I beheld! The common people, especially those who live in the country, have no knowledge whatever of Christian teaching, and unfortunately many pastors are quite incompetent and unfitted for teaching. Although the people are supposed to be Christian, are baptized, and receive the holy sacrament, they do not know the Lord's Prayer, the Creed, or the Ten Commandments,[3] they live as if they were pigs and irrational beasts, and now that the Gospel has been restored they have mastered the fine art of abusing liberty.

How will you bishops answer for it before Christ that you have so shamefully neglected the people and paid no attention at all to the duties of your office? May you escape punishment for this! You withhold the cup in the Lord's Supper and insist on the observance of human laws, yet you do not take the slightest interest in teaching the people the Lord's Prayer, the Creed, the Ten Commandments, or a single part of the Word of God. Woe to you forever!

I therefore beg of you for God's sake, my beloved brethren who are pastors and preachers, that you take the duties of your office seriously, that you have pity on the people who are entrusted to your care, and that you help me to teach the catechism to the people, especially those who are young. Let those who lack the qualifications to do better at least take this booklet and these forms and read them to the people word for word in this manner:

In the first place, the preacher should take the utmost care to avoid changes or variations in the text and wording of the Ten Commandments, the Creed, the Lord's Prayer, the sacraments, etc. On the contrary, he should adopt one form, adhere to it, and use it repeatedly year after year. Young and inexperienced people must be instructed on the basis of a uniform, fixed text and form. They are easily confused if a teacher employs one form now and another form—perhaps with the intention of making improvements—later on. In this way all the time and labor will be lost.

This was well understood by our good fathers, who were accustomed to use the same form in teaching the Lord's Prayer, the Creed, and the Ten Commandments. We, too, should teach these things to the young and unlearned in such a way that we do not alter a single syllable or recite the catechism differently from year to year. Choose the form that pleases you, therefore, and adhere to it henceforth. When you preach to intelligent and educated people, you are at liberty to exhibit your learning and

to discuss these topics from different angles and in such a variety of ways as you may be capable of. But when you are teaching the young, adhere to a fixed and unchanging form and method. Begin by teaching them the Ten Commandments, the Creed, the Lord's Prayer, etc., following the text word for word so that the young may repeat these things after you and retain them in their memory.

If any refuse to receive your instruction, tell them that they deny Christ and are no Christians. They should not be admitted to the sacrament, be accepted as sponsors in Baptism, or be allowed to participate in any Christian privileges.[4] On the contrary, they should be turned over to the pope and his officials,[5] and even to the devil himself. In addition, parents and employers should refuse to furnish them with food and drink and should notify them that the prince is disposed to banish such rude people from his land.

Although we cannot and should not compel anyone to believe, we should nevertheless insist that the people learn to know how to distinguish between right and wrong according to the standards of those among whom they live and make their living.[6] For anyone who desires to reside in a city is bound to know and observe the laws under whose protection he lives, no matter whether he is a believer or, at heart, a scoundrel or knave.

In the second place, after the people have become familiar with the text, teach them what it means. For this purpose, take the explanations in this booklet, or choose any other brief and fixed explanations which you may prefer, and adhere to them without changing a single syllable, as stated above with reference to the text. Moreover, allow yourself ample time, for it is not necessary to take up all the parts at once. They can be presented one at a time. When the learners have a proper understanding of the First Commandment, proceed to the Second Commandment, and so on. Otherwise they will be so overwhelmed that they will hardly remember anything at all.

In the third place, after you have thus taught this brief catechism, take up a large catechism[7] so that the people may have a richer and fuller understanding. Expound every commandment, petition, and part, pointing out their respective obligations, benefits, dangers, advantages, and disadvantages, as you will find all of this treated at length in the many books written for this purpose. Lay the greatest weight on those commandments or other parts which seem to require special attention among the people where you are. For example, the Seventh Commandment, which treats of stealing, must be emphasized when instructing laborers and shopkeepers, and even farmers and servants, for many of these are guilty of dishonesty and thievery.[8] So, too, the Fourth Commandment must be stressed when instructing children and the common people in order that they may be encouraged to be orderly, faithful, obedient, and peaceful. Always adduce many examples from the Scriptures to show how God punished and blessed.

You should also take pains to urge governing authorities and parents to rule wisely and educate their children. They must be shown that they are obliged to do so, and that they are guilty of damnable sin if they do not do so, for by such neglect they undermine and lay waste both the kingdom of God and the kingdom of the world and are the worst enemies of God and man. Make very plain to them the shocking evils they introduce when they refuse their aid in the training of children to become pastors, preachers, notaries, etc., and tell them that God will inflict awful punishments on them for these sins. It is necessary to preach about such things. The extent to which parents and governing authorities sin in this respect is beyond telling. The devil also has a horrible purpose in mind.

Finally, now that the people are freed from the tyranny of the pope, they are unwilling to receive the sacrament and they treat it with contempt. Here, too, there is need of exhortation, but with this understanding: No one is to be compelled to believe or to receive the sacrament, no law is to be made concerning it, and no time or place should be appointed for it. We should so preach that, of their own accord and without any law, the people will desire the sacrament and, as it were, compel us pastors to administer it to them. This can be done by telling them: It is to be feared that anyone who does not desire to receive the sacrament at least three or four times a year despises the sacrament and is no Christian, just as he is no Christian who does not hear and believe the Gospel. Christ did not say, "Omit this," or "Despise this," but he said, "Do this, as often as you drink it," etc.[9] Surely he wishes that this be done and not that it be omitted and despised. "*Do* this," he said.

He who does not highly esteem the sacrament suggests thereby that he has no sin, no flesh, no devil, no world, no death, no hell. That is to say, he believes in none of these, although he is deeply immersed in them and is held captive by the devil. On the other hand, he suggests that he needs no grace, no life, no paradise, no heaven, no Christ, no God, nothing good at all. For if he believed that he was involved in so much that is evil and was in need of so much that is good, he would not neglect the sacrament in which aid is afforded against such evil and in which such good is bestowed. It is not necessary to compel him by any law to receive the sacrament, for he will hasten to it of his own accord, he will feel constrained to receive it, he will insist that you administer it to him.

Accordingly you are not to make a law of this, as the pope has done. All you need to do is clearly to set forth the advantage and disadvantage, the benefit and loss, the blessing and danger connected with this sacrament. Then the people will come of their own accord without compulsion on your part. But if they refuse to come, let them be, and tell them that those who do not feel and acknowledge their great need and God's gracious help belong to the devil. If you do not give such admonitions, or if you adopt odious laws on the subject, it is your own fault if the people treat the sacrament with contempt. How can they be other than negligent if you fail to do your duty and remain silent. So it is up to you, dear pastor and preacher! Our office has become something different from what it was under the pope. It is now a ministry of grace and salvation. It subjects us to greater burdens and labors, dangers and temptations, with little reward or gratitude from the world. But Christ himself will be our reward if we labor faithfully. The Father of all grace grant it! To him be praise and thanks forever, through Christ, our Lord. Amen.

Notes

[1] Greek: manual or handbook.

[2] Luther visited congregations in Electoral Saxony and Meissen between Oct. 22, 1528, and Jan. 9, 1529.

[3] This is the order in which these materials appeared in late medieval manuals.

[4] Cf. *Large Catechism,* Short Preface, 1–5.

[5] Diocesan judges who decided disciplinary and other cases; now often called vicar-generals.

[6] Cf. *Large Catechism,* Short Preface, 2.

[7] Luther here refers not only to his own *Large Catechism* but also to other treatments of the traditional parts of the catechism. See the reference to "many books" in the next sentence.

[8] Cf. *Large Catechism,* Ten Commandments, 225, 226.

[9] I Cor. 11:25.

I The Ten Commandments

In the Plain Form in Which the Head of the Family Shall Teach Them to His Household[1]

The First

"You shall have no other gods." [2]
 What does this mean?
 Answer: We should fear,[3] love, and trust in God above all things.

The Second

"You shall not take the name of the Lord your God in vain." [4]
 What does this mean?
 Answer: We should fear and love God, and so[5] we should not use his name to curse, swear,[6] practice magic, lie, or deceive, but in every time of need call upon him, pray to him, praise him, and give him thanks.

The Third

"Remember the Sabbath day,[7] to keep it holy."
 What does this mean?
 Answer: We should fear and love God, and so we should not despise his Word and the preaching of the same, but deem it holy and gladly hear and learn it.

The Fourth

"Honor your father and your mother."
 What does this mean?
 Answer: We should fear and love God, and so we should not despise our parents and superiors, nor provoke them to anger, but honor, serve, obey, love, and esteem them.

The Fifth

"You shall not kill."
 What does this mean?
 Answer: We should fear and love God, and we should not endanger our neighbor's life, nor cause him any harm, but help and befriend him in every necessity of life.

The Sixth

"You shall not commit adultery."
 What does this mean?
 Answer: We should fear and love God, and so we should lead a chaste and pure life in word and deed, each one loving and honoring his wife or her husband.

The Seventh

"You shall not steal."
 What does this mean?
 Answer: We should fear and love God, and so we should not rob our neighbor of his money or property, nor bring them into our possession by dishonest trade or by dealing in shoddy wares, but help him to improve and protect his income and property.

The Eighth

"You shall not bear false witness against your neighbor."
 What does this mean?
 Answer: We should fear and love God, and so we should not tell lies about our neighbor, nor betray, slander, or defame him, but should apologize for him, speak well of him, and interpret charitably all that he does.

The Ninth

"You shall not covet your neighbor's house."
 What does this mean?
 Answer: We should fear and love God, and so we should not seek by craftiness to gain possession of our neighbor's inheritance or home, nor to obtain them under pretext of legal right, but be of service and help to him so that he may keep what is his.

The Tenth

"You shall not covet your neighbor's wife, or his manservant, or his maidservant, or his ox, or his ass,[8] or anything that is your neighbor's."
 What does this mean?
 Answer: We should fear and love God, and so we should not abduct, estrange, or entice away our neighbor's wife, servants, or cattle, but encourage them to remain and discharge their duty to him.

Conclusion

What does God declare concerning all these commandments?
 Answer: He says, "I the Lord your God am a jealous God, visiting the iniquity of the fathers upon the children to the third and the fourth generation of those who hate me, but showing steadfast love to thousands of those who love me and keep my commandments."
 What does this mean?
 Answer: God threatens to punish all who transgress these commandments. We should therefore fear his wrath and not disobey these commandments. On the other hand, he promises grace and every blessing to all who keep them. We should therefore love him, trust in him, and cheerfully do what he has commanded.

Notes

[1] Latin title: *Small Catechism for the Use of Children in School. How, in a very Plain Form, Schoolmasters Should Teach the Ten Commandments to their Pupils.*
[2] The Nuremberg editions of 1531 and 1558 read: "I am the Lord your God. You shall have no other gods before me." In some editions since the sixteenth century "I am the Lord your God" was printed separately as an introduction to the entire Decalogue. The Ten Commandments are from Exod. 20:2–17 and Deut. 5:6–21.
[3] On filial and servile fear see Apology, XII, 38.
[4] The Nuremberg editions of 1531 and 1558 add: "for the Lord will not hold him guiltless who takes his name in vain."
[5] On the translation of *dass* see M. Reu in *Kirchliche Zeitschrift*, L (1926), pp. 626–689.
[6] For the meaning of "swear" see *Large Catechism*, Ten Commandments, 66.
[7] Luther's German word *Feiertag* means day of rest, and this is the original Hebrew meaning of Sabbath, the term employed in the Latin text. The Jewish observance of Saturday is not enjoined here, nor a Sabbatarian observance of Sunday; cf. Augsburg Confession, XXVIII, 57–60; *Large Catechism*, Ten Commandments, 79–82.
[8] For "or his ox, or his ass" Luther's German text reads "or his cattle." The Latin text employs the fuller expression.

II The Creed

In the Plain Form in Which the Head of the Family Shall Teach It to His Household[1]

The First Article: Creation

"I believe in God, the Father almighty, maker of heaven and earth."
 What does this mean?

Answer: I believe that God has created me and all that exists; that he has given me and still sustains my body and soul, all my limbs and senses, my reason and all the faculties of my mind, together with food and clothing, house and home, family and property; that he provides me daily and abundantly with all the necessities of life, protects me from all danger, and preserves me from all evil. All this he does out of his pure, fatherly, and divine goodness and mercy, without any merit or worthiness on my part. For all of this I am bound to thank, praise, serve, and obey him. This is most certainly true.

The Second Article: Redemption

"And in Jesus Christ, his only son, our Lord: who was conceived by the Holy Spirit, born of the virgin Mary, suffered under Pontius Pilate, was crucified, dead, and buried: he descended into hell, the third day he rose from the dead, he ascended into heaven, and is seated on the right hand of God, the Father almighty, whence he shall come to judge the living and the dead."

What does this mean?

Answer: I believe that Jesus Christ, true God, begotten of the Father from eternity, and also true man, born of the virgin Mary, is my Lord, who has redeemed me, a lost and condemned creature, delivered me and freed me from all sins, from death, and from the power of the devil, not with silver and gold but with his holy and precious blood and with his innocent sufferings and death, in order that I may be his, live under him in his kingdom, and serve him in everlasting righteousness, innocence, and blessedness, even as he is risen from the dead and lives and reigns to all eternity. This is most certainly true.

The Third Article: Sanctification

"I believe in the Holy Spirit, the holy Christian church, the communion of saints, the forgiveness of sins, the resurrection of the body, and the life everlasting. Amen."

What does this mean?

Answer: I believe that by my own reason or strength I cannot believe in Jesus Christ, my Lord, or come to him. But the Holy Spirit has called me through the Gospel, enlightened me with his gifts, and sanctified and preserved me in true faith, just as he calls, gathers, enlightens, and sanctifies the whole Christian church on earth and preserves it in union with Jesus Christ in the one true faith. In this Christian church he daily and abundantly forgives all my sins, and the sins of all believers, and on the last day he will raise me and all the dead and will grant eternal life to me and to all who believe in Christ. This is most certainly true.

Note

[1] Latin text: *How, in a very Plain Form, Schoolmasters Should Teach the Apostles' Creed to their Pupils.*

III The Lord's Prayer

In the Plain Form in Which the Head of the Family Shall Teach It to His Household[1]

Introduction

"Our Father who art in heaven." [2]

What does this mean?

Answer: Here God would encourage us to believe that he is truly our Father and we are truly his children in order that we may approach him boldly and confidently in prayer, even as beloved children approach their dear father.

The First Petition

"Hallowed be thy name."

What does this mean?

Answer: To be sure, God's name is holy in itself, but we pray in this petition that it may also be holy for us.

How is this done?

Answer: When the Word of God is taught clearly and purely and we, as children of God, lead holy lives in accordance with it. Help us to do this, dear Father in heaven! But whoever teaches and lives otherwise than as the Word of God teaches, profanes the name of God among us. From this preserve us, heavenly Father!

The Second Petition

"Thy kingdom come."

What does this mean?

Answer: To be sure, the kingdom of God comes of itself, without our prayer, but we pray in this petition that it may also come to us.

How is this done?

Answer: When the heavenly Father gives us his Holy Spirit so that by his grace we may believe in his holy Word and live a godly life, both here in time and hereafter forever.

The Third Petition

"Thy will be done, on earth as it is in heaven."

What does this mean?

Answer: To be sure, the good and gracious will of God is done without our prayer, but we pray in this petition that it may also be done by us.

How is this done?

Answer: When God curbs and destroys every evil counsel and purpose of the devil, of this world, and of our flesh which would hinder us from hallowing his name and prevent the coming of his kingdom, and when he strengthens us and keeps us steadfast in his Word and in faith even to the end. This is his good and gracious will.

The Fourth Petition

"Give us this day our daily bread."

What does this mean?

Answer: To be sure, God provides daily bread, even to the wicked, without our prayer, but we pray in this petition that God may make us aware of his gifts and enable us to receive our daily bread with thanksgiving.

What is meant by daily bread?

Answer: Everything required to satisfy our bodily needs, such as food and clothing, house and home, fields and flocks, money and property; a pious spouse and good children, trustworthy servants, godly and faithful rulers, good government; seasonal weather, peace and health, order and honor; true friends, faithful neighbors, and the like.

The Fifth Petition

"And forgive us our debts, as we have also forgiven our debtors."

What does this mean?

Answer: We pray in this petition that our heavenly Father may not look upon our sins, and on their account deny our prayers, for we neither merit nor deserve those things for which we pray. Although we sin daily and deserve nothing but punishment, we nevertheless pray that God may grant us all things by his grace. And assuredly we on our part will heartily forgive and cheerfully do good to those who may sin against us.

The Sixth Petition

"And lead us not into temptation."

What does this mean?

Answer: God tempts no one to sin, but we pray in this petition that God may so guard and preserve us that the devil, the world, and our flesh may not deceive us or mislead us into unbelief, despair, and other great and shameful sins, but that, although we may be so tempted, we may finally prevail and gain the victory.

The Seventh Petition

"But deliver us from evil."

What does this mean?

Answer: We pray in this petition, as in a summary, that our Father in heaven may deliver us from all manner of evil, whether it affect body or soul, property or reputation, and that at last, when the hour of death comes, he may grant us a blessed end and graciously take us from this world of sorrow to himself in heaven.

Conclusion

"Amen." [3]

What does this mean?

Answer: It means that I should be assured that such petitions are acceptable to our heavenly Father and are heard by him, for he himself commanded us to pray like this and promised to hear us. "Amen, amen" means "Yes, yes, it shall be so."

Notes

[1] Latin title: *How, in a very Plain Form, Schoolmasters Should Teach the Lord's Prayer to their Pupils.*

[2] The "introduction" to the Lord's Prayer was not prepared by Luther until 1531. It does not appear in the Latin text, which begins with the First Petition. The text of the Prayer is from Matt. 6:9–13.

[3] The Nuremberg edition of 1558, and many later editions, inserted "For thine is the kingdom, and the power, and the glory, for ever and ever" before "Amen."

IV The Sacrament of Holy Communion

In the Plain Form in Which the Head of the Family Shall Teach It to His Household[1]

First

What is Baptism?

Answer: Baptism is not merely water, but it is water used according to God's command and connected with God's Word.

What is this Word of God?

Answer: As recorded in Matthew 28:19, our Lord Christ said, "Go therefore and make disciples of all nations, baptizing them in the name of the Father and of the Son and of the Holy Spirit."

Second

What gifts or benefits does Baptism bestow?

Answer: It effects forgiveness of sins, delivers from death and the devil, and grants eternal salvation to all who believe, as the Word and promise of God declare.

What is this Word and promise of God?

Answer: As recorded in Mark 16:16, our Lord Christ said, "He who believes and is baptized will be saved; but he who does not believe will be condemned."

Third

How can water produce such great effects?

Answer: It is not the water that produces these effects, but the Word of God connected with the water, and our faith which relies on the Word of God connected with the water. For without the Word of God that water is merely water and no Baptism. But when connected with the Word of God it is a Baptism, that is, a gracious water of life and a washing of regeneration in the Holy Spirit, as St. Paul wrote to Titus (3:5–8), "He saved us by the washing of regeneration and renewal in the Holy Spirit, which he poured out upon us richly through Jesus Christ our Saviour, so that we might be justified by his grace and become heirs in hope of eternal life. The saying is sure."

Fourth

What does such baptizing with water signify?

Answer: It signifies that the old Adam in us, together with all sins and evil lusts, should be drowned by daily sorrow and repentance and be put to death, and that the new man should come forth daily and rise up, cleansed and righteous, to live forever in God's presence.

Where is this written?

Answer: In Romans 6:4, St. Paul wrote, "We were buried therefore with him by baptism into death, so that as Christ was raised from the dead by the glory of the Father, we too might walk in newness of life."

Note

[1] Latin title: *How, in a very Plain Form, Schoolmasters Should Teach the Sacrament of Baptism to their Pupils.*

V Confession and Absolution

How Plain People Are to Be Taught to Confess[1]

What is confession?

Answer: Confession consists of two parts. One is that we confess our sins. The other is that we receive absolution or forgiveness from the confessor as from God himself, by no means doubting but firmly believing that our sins are thereby forgiven before God in heaven.

What sins should we confess?

Answer: Before God we should acknowledge that we are guilty of all manner of sins, even those of which we are not aware, as we do in the Lord's Prayer. Before the confessor, however, we should confess only those sins of which we have knowledge and which trouble us.

What are such sins?

Answer: Reflect on your condition in the light of the Ten Commandments: whether you are a father or mother, a son or daughter, a master or servant; whether you have been disobedient, unfaithful, lazy, ill-tempered, or quarrelsome; whether you have harmed anyone by word or deed; and whether you have stolen, neglected, or wasted anything, or done other evil.

Please give me a brief form of confession.

Answer: You should say to the confessor: "Dear Pastor, please hear my confession and declare that my sins are forgiven for God's sake."

"Proceed."

"I, a poor sinner, confess before God that I am guilty of all sins. In particular I confess in your presence that, as a manservant or maidservant, etc., I am unfaithful to my master, for here

and there I have not done what I was told. I have made my master angry, caused him to curse, neglected to do my duty, and caused him to suffer loss. I have also been immodest in word and deed. I have quarreled with my equals. I have grumbled and sworn at my mistress, etc. For all this I am sorry and pray for grace. I mean to do better."

A master or mistress may say: "In particular I confess in your presence that I have not been faithful in training my children, servants, and wife to the glory of God. I have cursed. I have set a bad example by my immodest language and actions. I have injured my neighbor by speaking evil of him, overcharging him, giving him inferior goods and short measure." Masters and mistresses should add whatever else they have done contrary to God's commandments and to their action in life, etc.

If, however, anyone does not feel that his conscience is burdened by such or by greater sins, he should not worry, nor should he search for and invent other sins, for this would turn confession into torture;[2] he should simply mention one or two sins of which he is aware. For example, "In particular I confess that I once cursed. On one occasion I also spoke indecently. And I neglected this or that," etc. Let this suffice.

If you have knowledge of no sin at all (which is quite unlikely), you should mention none in particular, but receive forgiveness upon the general confession[3] which you make to God in the presence of the confessor.

Then the confessor shall say: "God be merciful to you and strengthen your faith. Amen."

Again he shall say: "Do you believe that this forgiveness is the forgiveness of God?"

Answer: "Yes, I do."

Then he shall say: "Be it done for you as you have believed."[4] According to the command of our Lord Jesus Christ, I forgive you your sins in the name of the Father and of the Son and of the Holy Spirit. Amen. Go in peace."[5]

A confessor will know additional passages of the Scriptures with which to comfort and to strengthen the faith of those whose consciences are heavily burdened or who are distressed and sorely tried. This is intended simply as an ordinary form of confession for plain people.

Notes

[1] In 1531 this section replaced the earlier "A Short Method of Confessing" (1529), *WA,* 30I: 343–45. Luther intended confession especially for those who were about to receive Communion.

[2] Luther was here alluding to the medieval practice of confession; see also Smalcald Articles, Pt. II, Art. III, 19.

[3] See article "General Confession" in *New Schaff-Herzog Encyclopedia of Religious Knowledge,* IV, 449. Cf. Smalcald Articles, Pt. III, Art. III, 13.

[4] Matt. 8:13.

[5] Mark 5:34; Luke 7:50; 8:48.

VI The Sacrament of the Altar

In the Plain Form in Which the Head of the Family Shall Teach It to His Household[1]

What is the Sacrament of the Altar?

Answer: Instituted by Christ himself, it is the true body and blood of our Lord Jesus Christ, under the bread and wine, given to us Christians to eat and drink.

Where is this written?

Answer: The holy evangelists Matthew, Mark, and Luke, and also St. Paul, write thus: "Our Lord Jesus Christ, on the night when he was betrayed, took bread, and when he had given thanks, he broke it, and gave it to the disciples and said, 'Take, eat; this is my body which is given for you. Do this in remembrance of me.' In the same way also he took the cup,

after supper, and when he had given thanks he gave it to them, saying, 'Drink of it, all of you. This cup is the new covenant in my blood, which is poured out for many for the forgiveness of sins. Do this, as often as you drink it, in remembrance of me.'"[2]

What is the benefit of such eating and drinking?

Answer: We are told in the words "for you" and "for the forgiveness of sins." By these words the forgiveness of sins, life, and salvation are given to us in the sacrament, for where there is forgiveness of sins, there are also life and salvation.

How can bodily eating and drinking produce such great effects?

Answer: The eating and drinking do not in themselves produce them, but the words "for you" and "for the forgiveness of sins." These words, when accompanied by the bodily eating and drinking, are the chief thing in the sacrament, and he who believes these words has what they say and declare: the forgiveness of sins.

Who, then, receives this sacrament worthily?

Answer: Fasting and bodily preparation are a good external discipline, but he is truly worthy and well prepared who believes these words: "for you" and "for the forgiveness of sins." On the other hand, he who does not believe these words, or doubts them, is unworthy and unprepared, for the words "for you" require truly believing hearts.

Notes

[1] Latin title: *How, in a very Plain Form, Schoolmasters Should Teach the Sacrament of the Altar to their Pupils.*

[2] A conflation of texts from I Cor. 11:23–25; Matt. 26:26–28; Mark 14:22–24; Luke 22:19, 20. Cf. *Large Catechism,* Sacrament of the Altar, 3.

VII Morning and Evening Prayers

How the Head of the Family Shall Teach His Household to Say Morning and Evening Prayers[1]

In the morning, when you rise, make the sign of the cross and say, "In the name of God, the Father, the Son, and the Holy Spirit. Amen."

Then, kneeling or standing, say the Apostles' Creed and the Lord's Prayer. Then you may say this prayer:

"I give Thee thanks, heavenly Father, through thy dear Son Jesus Christ, that Thou hast protected me through the night from all harm and danger. I beseech Thee to keep me this day, too, from all sin and evil, that in all my thoughts, words, and deeds I may please Thee. Into thy hands I commend my body and soul and all that is mine. Let the holy angel have charge of me, that the wicked one may have no power over me. Amen."

After singing a hymn (possibly a hymn on the Ten Commandments)[2] or whatever your devotion may suggest, you should go to your work joyfully.

In the evening, when you retire, make the sign of the cross and say, "In the name of God, the Father, the Son, and the Holy Spirit. Amen."

Then, kneeling or standing, say the Apostles' Creed and the Lord's Prayer. Then you may say this prayer:

"I give Thee thanks, heavenly Father, through thy dear Son Jesus Christ, that Thou hast this day graciously protected me. I beseech Thee to forgive all my sin and the wrong which I have done. Graciously protect me during the coming night. Into thy hands I commend my body and soul and all that is mine. Let thy holy angels have charge of me, that the wicked one may have no power over me. Amen."

Then quickly lie down and sleep in peace.

Notes

[1] Latin title: *How, in a very Plain Form, Schoolmasters Should Teach their Pupils to Say their Prayers in the Morning and in the Evening.* (The material in this section was adapted from the Roman Breviary.)

[2] See *Large Catechism*, Short Preface, 25.

VIII Grace at Table

How the Head of the Family Shall Teach His Household to Offer Blessing and Thanksgiving at Table[1]

Blessing before Eating

When children and the whole household gather at the table, they should reverently fold their hands and say:

"The eyes of all look to Thee, O Lord, and Thou givest them their food in due season. Thou openest thy hand; Thou satisfiest the desire of every living thing." [2]

(It is to be observed that "satisfying the desire of every living thing" means that all creatures receive enough to eat to make them joyful and of good cheer. Greed and anxiety about food prevent such satisfaction.)

Then the Lord's Prayer should be said, and afterwards this prayer:

"Lord God, heavenly Father, bless us, and these thy gifts which of thy bountiful goodness Thou hast bestowed on us, through Jesus Christ our Lord. Amen."

Thanksgiving after Eating

After eating, likewise, they should fold their hands reverently and say:

"O give thanks to the Lord, for he is good; for his steadfast love endures forever. He gives to the beasts their food, and to the young ravens which cry. His delight is not in the strength of the horse, nor his pleasure in the legs of a man; but the Lord takes pleasure in those who fear him, in those who hope in his steadfast love." [3]

Then the Lord's Prayer should be said, and afterwards this prayer:

"We give Thee thanks, Lord God, our Father, for all thy benefits, through Jesus Christ our Lord, who lives and reigns forever. Amen."

Notes

[1] Latin title: *How, in Plain Form, Schoolmasters Should Teach their Pupils to Offer Blessing and Thanksgiving at Table.* (The material in this section was adapted from the Roman Breviary.)

[2] Ps. 145:15, 16. The gloss which follows, here given in parentheses, was intended to explain the meaning of *Wohlgefallen* or *benedictio* in the German and Latin translations of the Psalm.

[3] Ps. 106:1, 136:26; 147:9–11.

IX Table of Duties

Consisting of Certain Passages of the Scriptures, Selected for Various Estates and Conditions of Men, by Which They May Be Admonished to Do Their Respective Duties[1]

Bishops, Pastors, and Preachers

"A bishop must be above reproach, married only once, temperate, sensible, dignified, hospitable, an apt teacher, no drunkard, not violent but gentle, not quarrelsome, and no lover of money. He must manage his own household well, keeping his children submissive and respectful in every way. He must not be a recent convert," etc. (I Tim. 3:2–6).

Duties Christians Owe Their Teachers and Pastors[2]

"Remain in the same house, eating and drinking what they provide, for the laborer deserves his wages" (Luke 10:7). "The Lord commanded that those who proclaim the gospel should get their living by the gospel" (I Cor. 9:14). "Let him who is taught the word share all good things with him who teaches. Do not be deceived; God is not mocked" (Gal. 6:6, 7). "Let the elders who rule well be considered worthy of double honor, especially those who labor in preaching and teaching; for the scripture says, 'You shall not muzzle an ox when it is treading out the grain,' and 'The laborer deserves his wages,'" (I Tim. 5:17, 18). "We beseech you, brethren, to respect those who labor among you and are over you in the Lord and admonish you, and to esteem them very highly in love because of their work. Be at peace among yourselves" (I Thess. 5:12, 13). "Obey your leaders and submit to them; for they are keeping watch over your souls, as men who will have to give account. Let them do this joyfully, and not sadly, for that would be of no advantage to you" (Heb. 13:17).

Governing Authorities[3]

"Let every person be subject to the governing authorities. For there is no authority except from God, and those that exist have been instituted by God. Therefore he who resists the authorities resists what God has appointed, and those who resist will incur judgment. He who is in authority does not bear the sword in vain; he is the servant of God to execute his wrath on the wrongdoer" (Rom. 13:1–4).

Duties Subjects Owe Governing Authorities

"Render therefore to Caesar the things that are Caesar's, and to God the things that are God's" (Matt. 22:21). "Let every person be subject to the governing authorities. Therefore one must be subject, not only to avoid God's wrath but also for the sake of conscience. For the same reason you also pay taxes, for the authorities are ministers of God, attending to this very thing. Pay all of them their dues, taxes to whom taxes are due, revenue to whom revenue is due, respect to whom respect is due, honor to whom honor is due" (Rom. 13:1, 5–7). "I urge that supplications, prayers, intercessions, and thanksgivings be made for all men, for kings and all who are in high positions, that we may lead a quiet and peaceable life, godly and respectful in every way" (I Tim. 2:1, 2). "Remind them to be submissive to rulers and authorities, to be obedient, to be ready for any honest work" (Tit. 3:1). "Be subject for the Lord's sake to every human institution, whether it be to the emperor as supreme, or to governors as sent by him to punish those who do wrong and to praise those who do right" (I Pet. 2:13, 14).

Husbands

"You husbands, live considerately with your wives, bestowing honor on the woman as the weaker sex, since you are joint heirs of the grace of life, in order that your prayers not be hindered" (I Pet. 3:7). "Husbands, love your wives, and do not be harsh with them" (Col. 3:19).

Wives

"You wives, be submissive to your husbands, as Sarah obeyed Abraham, calling him lord. And you are now her children if you do right and let nothing terrify you" (I Pet. 3:1, 6).

Parents

"Fathers, do not provoke your children to anger, lest they become discouraged, but bring them up in the discipline and instruction of the Lord" (Eph. 6:4; Col. 3:21).

Children

"Children, obey your parents in the Lord, for this is right. 'Honor your father and mother' (this is the first commandment with a promise) 'that it may be well with you and that you may live long on the earth'" (Eph. 6:1–3).

Laborers and Servants, Male and Female

"Be obedient to those who are your earthly masters, with fear and trembling, with singleness of heart, as to Christ; not in the way of eye-service, as men-pleasers, but as servants of Christ, doing the will of God from the heart, rendering service with a good will as to the Lord and not to men, knowing that whatever good anyone does, he will receive the same again from the Lord, whether he is a slave or free" (Eph. 6:5–8).

Masters and Mistresses

"Masters, do the same to them, and forbear threatening, knowing that he who is both their Master and yours is in heaven, and that there is no partiality with him" (Eph. 6:9).

Young Persons in General

"You that are younger, be subject to the elders. Clothe yourselves, all of you, with humility toward one another, for 'God opposes the proud, but gives grace to the humble.' Humble yourselves therefore under the mighty hand of God, that in due time he may exalt you" (I Pet. 5:5, 6).

Widows

"She who is a real widow, and is left all alone, has set her hope on God and continues in supplication and prayers night and day; whereas she who is self-indulgent is dead even while she lives" (I Tim. 5:5, 6).

Christians in General

"The commandments are summed up in this sentence, 'You shall love your neighbor as yourself'" (Rom. 13:9). "I urge that supplications, prayers, intercessions, and thanksgivings be made for all men" (I Tim. 2:1).

Let each his lesson learn with care
And all the household well will fare.[4]

From *Martin Luther's Basic Theological Writings*, edited by Timothy L. Lull, copyright © 1989 Augsburg Fortress. Used by permission of Augsburg Fortress.

Notes

[1] This table of duties was probably suggested to Luther by John Gerson's *Tractatus de modo vivendi omnium fidelium*.

[2] This section was not prepared by Luther, but was later taken up into the *Small Catechism*, probably with Luther's consent. The passages from Luke 10 and I Thess. 5 are not included in the Latin text.

[3] This section was not prepared by Luther, but was later taken up into the *Small Catechism*, probably with Luther's consent.

[4] On this rhyme by Luther see WA, 35:580.

READING 53

WILLIAM SHAKESPEARE (1564–1616), HAMLET, PRINCE OF DENMARK (1600)

Probably none of Shakespeare's works has been discussed more than HAMLET. It would be possible to make a case for KING LEAR or even OTHELLO as a greater work of art, but HAMLET presents problems that intrigue at so many different levels that it justifies its reputation as the most famous play ever written. To the scholar, the critic, the psychiatrist, the actor, the lover of the theater, every performance of HAMLET represents a challenge to their powers of interpretation, and every reading presents the possibility of coming to grips with its central question: why is Hamlet unable to make up his mind and do something?

The theme of the play was familiar to Elizabethan audiences. It belongs to a category known as revenge tragedy, in which the hero discovers that a close relative has been murdered, experiences considerable trouble in identifying the murderer, and, after overcoming numerous obstacles, finally succeeds in avenging the death by killing the murderer. Other violent elements were usually thrown in, including mad scenes and ghosts. The plays generally ended in a welter of blood. A good example of a revenge tragedy is THE SPANISH TRAGEDY of Thomas Kyd (1558–1594), who also wrote a now lost version of the Hamlet story that may have influenced Shakespeare's.

HAMLET is a revenge tragedy with a number of important differences, however. Hamlet has no need to investigate the cause of his father's death, since his father's ghost communicates directly to him both the fact and method of his murder. Nor does he need to search for the identity of the murderer, his uncle, whom he has in any case already suspected. The only obstacles in the way of his revenge are ones he creates himself. Although Hamlet does indeed eventually avenge his father's death, he does so at the price of the lives of his mother, the girl he loves, her father and brother, and himself. If Hamlet had only taken action at the time he first learned the truth, as any other hero might have done, all the agony of the closing scenes would have been avoided.

A partial explanation of HAMLET's fascination for the modern reader lies precisely in the fact that Hamlet is not a conventional hero, but represents instead a type sometimes called antiheroic. Certainly it is true that throughout the play Hamlet is aware of the difficulties of existence rather than the possibilities it presents. His mood is not so much of melancholy as of disillusionment. The disgust he feels at his mother's unseemly haste to remarry within two months of her husband's death gives him a newly pessimistic perspective on human relationships, which he extends to all aspects of life.

The pessimism with which Hamlet contemplates existence extends to nonexistence as well, both in the great soliloquy "To be, or not to be" (see Act III) and in the graveyard scene at the beginning of Act V. At the side of the grave destined for Ophelia, who has been driven to madness and suicide by Hamlet's callous treatment of her love for him, the fact of death, hitherto veiled beneath layers of poetic and philosophical reflection, suddenly becomes real and neither Hamlet nor Shakespeare hesitates to stare it in the face. The bleakness of the vision, coupled with the down-to-earth reactions of the gravediggers, is reminiscent of Bruegel's painting THE TRIUMPH OF DEATH with its skeletons and peasant folk.

Hamlet is by no means the only character of interest in the play or his vengeance the only issue. His relationships with his mother Gertrude and Ophelia provide further insights into human behavior. Gertrude is shown as good-natured but weak, led astray by her inability to resist temptation (especially sexual temptation). In the gentle Ophelia, destroyed by her own innocence, Shakespeare produced one of his most touching creations. Her father Polonius stands alongside the great comic figures of Shakespearean drama while retaining a curious dignity. Even the courtiers Rosencrantz and Guildenstern and the odious Osric are given personalities of their own.

Nonetheless it is Hamlet himself who continues to attract our interest and curiosity. The reasons for his indecisiveness have been discussed again and again. External circumstances, religious or moral scruples, simple lack

of nerve, excessive tendency to intellectualize, and psychological instability have all been suggested. All can be defended, but none is by itself totally convincing. It has even been said that most analyses of HAMLET are inappropriate because they look at the play from a modern rather than an Elizabethan point of view and try to find subtleties of which Shakespeare never dreamed. Why can we not, some critics argue, see HAMLET as an exceptional revenge tragedy given a pessimistic twist and expressed in superb poetic language?

Such a position would seem to underrate both Shakespeare and his audience, but we can agree at least about the language. To a viewer or reader coming to the play for the first time, or returning to it after a long absence, perhaps nothing is more astonishing than the way in which so many of the lines are already familiar. They seem to have become part of the way in which we think and speak. It is difficult to remember the first time we heard the words "To be, or not to be," so much are they a part of our cultural heritage. The familiarity of phrase after phrase— "Fraility, thy name is woman"; "to thine own self be true"; "though this be madness, yet there is method in it"—illustrates that no play of Shakespeare has had a more universal appeal than the one which, paradoxically, presents the greatest enigmas.

PERSONS REPRESENTED

CLAUDIUS, *King of Denmark*

HAMLET, *son to the late, and nephew to the present, King*

FORTINBRAS, *Prince of Norway*

POLONIUS, *Lord Chamberlain*

HORATIO, *friend to Hamlet*

LAERTES, *son to Polonius*

VOLTIMAND

CORNELIUS

ROSENCRANTZ *courtiers*

GUILDENSTERN

OSRIC

A GENTLEMAN

A PRIEST

MARCELLUS *officers*

BERNARDO

FRANCISCO, *a solider*

REYNALDO, *servant to Polonius*

PLAYERS

TWO CLOWNS, *grave-diggers*

A CAPTAIN

ENGLISH AMBASSADORS

GHOST *of Hamlet's father*

GERTRUDE, *Queen of Denmark and mother to Hamlet*

OPHELIA, *daughter of Polonius*

LORDS, LADIES, OFFICERS, SOLDIERS, SAILORS, MESSENGERS, AND OTHER ATTENDANTS

SCENE: ELSINORE

Act I

Scene I. *A platform before the castle.*

FRANCISCO AT HIS POST. ENTER TO HIM BERNARDO.

BERNARDO Who's there?

FRANCISCO Nay, answer me: stand, and unfold[1] yourself.

BERNARDO Long live the king!

FRANCISCO Bernardo?

BERNARDO He.

FRANCISCO You come most carefully upon your hour.

BERNARDO 'Tis now struck twelve: get thee to bed, Francisco.

FRANCISCO For this relief much thanks: 'tis bitter cold, And I am sick at heart.

BERNARDO Have you had quiet guard?

FRANCISCO Not a mouse stirring.

BERNARDO Well, good night. If you do meet Horatio and Marcellus, The rivals[2] of my watch, bid them make haste.

FRANCISCO I think I hear them.— Stand, ho! who is there? 11

ENTER HORATIO AND MARCELLUS.

HORATIO Friends to this ground.

MARCELLUS And liegemen to the Dane.[3]

FRANCISCO Give you good night.

MARCELLUS O, farewell, honest soldier: Who hath relieved you?

FRANCISCO Bernardo hath my place. Give you good night.

EXIT FRANCISCO.

MARCELLUS Holla! Bernardo!

BERNARDO Say,— What, is Horatio there?

HORATIO A piece of him.

BERNARDO Welcome, Horatio; welcome, good Marcellus.

MARCELLUS What, has this thing appeared again tonight?

BERNARDO I have seen nothing.

MARCELLUS Horatio says, 'tis but our fantasy; 20
And will not let belief take hold of him,
Touching this dreaded sight, twice seen of us:
Therefore I have entreated him along
With us to watch the minutes of this night;
That if again this apparition come,
He may approve[4] our eyes and speak to it.

HORATIO Tush, tush, 'twill not appear.

BERNARDO Sit down a while;
And let us once again assail your ears,
That are so fortified against our story,
What we have two nights seen.

HORATIO Well, sit we down,
And let us hear Bernardo speak of this.

BERNARDO — Last night of all, 32
When yon same star that's westward from the pole,
Had made his course to illume that part of heaven
Where now it burns, Marcellus and myself,
The bell then beating one,—

ENTER GHOST.

MARCELLUS Peace, break thee off; look, where it comes again!

BERNARDO In the same figure, like the king that's dead.

MARCELLUS Thou art a scholar, speak to it, Horatio.

BERNARDO Looks 'a[5] not like the king? mark it, Horatio. 40

HORATIO Most like: it harrows me with fear and wonder.

BERNARDO It would be spoke to.

MARCELLUS Speak to it, Horatio.

HORATIO What art thou, that usurp'st this time of night,
Together with that fair and warlike form
In which the majesty of buried Denmark
Did sometimes march? by heaven I charge thee, speak!

MARCELLUS It is offended.

BERNARDO See, it stalks away!

HORATIO Stay! speak, speak! I charge thee, speak!

EXIT GHOST.

MARCELLUS 'Tis gone, and will not answer.

BERNARDO How now, Horatio! you tremble and look pale: 50
Is not this something more than fantasy?
What think you on't?

HORATIO Before my God, I might not this believe,
 Without the sensible and true avouch
 Of mine own eyes.
MARCELLUS Is it not like the king?
HORATIO As thou art to thyself:
 Such was the very armour he had on
 When he the ambitious Norway[6] combated;
 So frowned he once, when, in an angry parle,[7]
 He smote the sledded pole-axe on the ice. 60
 'Tis strange.
MARCELLUS Thus twice before, and jump[8] at this
 dead hour,
 With martial stalk hath he gone by our watch.
HORATIO In what particular thought to work I know not;
 But, in the gross and scope of mine opinion,
 This bodes some strange eruption to our state.
MARCELLUS Good now, sit down, and tell me, he
 that knows,
 Why this same strict and most observant watch
 So nightly toils the subject of the land?
 And why such daily cast of brazen cannon, 70
 And foreign mart for implements of war:
 Why such impress of shipwrights, whose sore task
 Does not divide the Sunday from the week:
 What might be toward that this sweaty haste
 Doth make the night joint-labourer with the day;
 Who is't that can inform me?
HORATIO That can I;
 At least the whisper goes so. Our last king,
 Whose image even but now appeared to us,
 Was, as you know, by Fortinbras of Norway,
 Thereto pricked on by a most emulate pride, 80
 Dared to the combat; in which our valiant Hamlet—
 For so this side of our known world esteemed him—
 Did slay this Fortinbras; who, by a sealed compact,
 Well ratified by law and heraldry,
 Did forfeit, with his life, all those his lands,
 Which he stood seized of, to the conqueror:
 Against the which a moiety competent
 Was gaged[9] by our king; which had returned
 To the inheritance of Fortinbras,
 Had he been vanquisher; as, by the same comart[10] 90
 And carriage of the article designed,
 His fell to Hamlet. Now, sir, young Fortinbras,
 Of unapproved mettle hot and full,
 Hath in the skirts[11] of Norway here and there
 Sharked up a list of lawless resolutes,
 For food and diet, to some enterprise
 That hath a stomach in't: which is no other—
 As it doth well appear unto our state,—
 But to recover of us, by strong hand,
 And terms compulsatory, those foresaid lands 100
 So by his father lost: and this, I take it,
 Is the main motive of our preparations;
 The source of this our watch; and the chief head
 Of this post-haste and romage[12] in the land.
BERNARDO I think it be no other but e'en so.
 Well may it sort, that this portentous figure
 Comes armed through our watch, so like the king
 That was and is the question of these wars.
HORATIO A mote it is to trouble the mind's eye.
 In the most high and palmy state of Rome, 110
 A little ere the mightiest Julius fell,
 The graves stood tenantless, and the sheeted dead
 Did squeak and gibber in the Roman streets:
 As stars with trains of fire and dews of blood,
 Disasters in the sun; and the moist star,
 Upon whose influence Neptune's empire stands,

Was sick almost to doomsday with eclipse:
And even the like precurse of fierce events,
As harbingers preceding still the fates,
And prologue to the omen coming on, 120
Have heaven and earth together demonstrated
Unto our climatures[13] and countrymen. —

 RE-ENTER GHOST.

But soft; behold! lo, where it comes again!
I'll cross it, though it blast me. — Stay, illusion!
If thou hast any sound, or use of voice,
Speak to me:
If there be any good thing to be done,
That may to thee do ease and grace to me,
Speak to me:
If thou art privy to thy country's fate, 130
Which, happily, foreknowing may avoid,
O, speak!
Or if thou hast uphoarded in thy life
Extorted treasure in the womb of earth,
For which, they say, you spirits oft walk in death,

 THE COCK CROWS.

Speak of it: stay, and speak. — Stop it, Marcellus.
MARCELLUS Shall I strike at it with my partizan?[14]
HORATIO Do, if it will not stand.
BERNARDO 'Tis here!
HORATIO 'Tis here!
MARCELLUS 'Tis gone!

 EXIT GHOST.

We do it wrong, being so majestical, 140
To offer it the show of violence;
For it is, as the air, invulnerable,
And our vain blows malicious mockery.
BERNARDO It was about to speak, when the cock crew.
HORATIO And then it started like a guilty thing
Upon a fearful summons. I have heard,
The cock, that is the trumpet to the morn,
Doth with his lofty and shrill-sounding throat
Awake the god of day, and at his warning,
Whether in sea or fire, in earth or air, 150
The extravagant and erring spirit hies
To his confine: and of the truth herein
This present object made probation.
MARCELLUS It faded on the crowing of the cock.
Some say that ever 'gainst that season comes
Wherein our Saviour's birth is celebrated,
The bird of dawning singeth all night long:
And then, they say, no spirit dare stir abroad,
The nights are wholesome, then no planets strike,
No fairy takes, nor witch hath power to charm, 160
So hallowed and so gracious is the time.
HORATIO So have I heard, and do in part believe it.
But, look, the morn, in russet mantle clad,
Walks o'er the dew of yon high eastward hill.
Break we our watch up; and by my advice,
Let us impart what we have seen to-night
Unto young Hamlet: for, upon my life,
This spirit, dumb to us, will speak to him:
Do you consent we shall acquaint him with it,
As needful in our loves, fitting our duty? 170
MARCELLUS Let's do't, I pray: and I this morning know
Where we shall find him most convenient.

 EXEUNT.

Notes

[1] reveal
[2] partners
[3] loyal subjects of the Danish king
[4] confirm
[5] he
[6] king of Norway
[7] parley
[8] just
[9] pledged
[10] agreement
[11] borders
[12] bustle
[13] regions
[14] pike (a type of spear)

Scene II. *A room of state in the castle.*

FLOURISH. ENTER THE KING, QUEEN, HAMLET, POLONIUS,
LAERTES, VOLTIMAND, CORNELIUS, LORDS, AND ATTENDANTS.

KING Though yet of Hamlet our dear brother's death
 The memory be green, and that it us befitted
 To bear our hearts in grief and our whole kingdom
 To be contracted in one brow of woe;
 Yet so far hath discretion fought with nature,
 That we with wisest sorrow think on him,
 Together with remembrance of ourselves.
 Therefore our sometime sister, now our queen,
 The imperial jointress[1] to this warlike state,
 Have we, as 'twere, with a defeated joy, 10
 With an auspicious and a dropping eye;
 With mirth in funeral and with dirge in marriage
 In equal scale weighing delight and dole,
 Taken to wife: nor have we herein barred
 Your better wisdoms, which have freely gone
 With this affair along. For all, our thanks.
 Now follows, that you know, young Fortinbras,
 Holding a weak supposal of our worth;
 Or thinking by our late dear brother's death,
 Our state to be disjoint and out of frame, 20
 Colleagued with this dream of his advantage,
 He hath not failed to pester us with message,
 Importing the surrender of those lands
 Lost by his father, with all bands of law,
 To our most valiant brother. So much for him.
 Now for ourself, and for this time of meeting;
 Thus much the business is: we have here writ
 To Norway, uncle of young Fortinbras,—
 Who, impotent and bed-rid, scarcely hears
 Of this his nephew's purpose,—to suppress 30
 His further gait herein; in that the levies,
 The lists and full proportions,[2] are all made
 Out of his subject: and we here dispatch
 You, good Cornelius, and you, Voltimand,
 For bearers of this greeting to old Norway;
 Giving to you no further personal power
 To business with the king more than the scope
 Of these delated articles[3] allow.
 Farewell, and let your haste commend your duty.
CORNELIUS, VOLTIMAND In that, and all things, will we
 show our duty. 40
KING We doubt it nothing; heartily farewell.

 EXEUNT VOLTIMAND AND CORNELIUS.

 And now, Laertes, what's the news with you?
 You told us of some suit; what is't, Laertes?
 You cannot speak of reason to the Dane,
 And lose your voice: what wouldst thou beg, Laertes,
 That shall not be my offer, not thy asking?

 The head is not more native to the heart,
 The hand more instrumental to the mouth,
 Than is the throne of Denmark to thy father.
 What wouldst thou have, Laertes? 50
LAERTES My dread lord,
 Your leave and favour to return to France;
 From whence though willingly I came to Denmark,
 To show my duty in your coronation;
 Yet now, I must confess, that duty done,
 My thoughts and wishes bend again toward France,
 And bow them to your gracious leave and pardon.
KING Have you your father's leave? What says Polonius?
POLONIUS He hath, my lord, wrung from me my slow
 leave,
 By laboursome petition; and at last,
 Upon his will I sealed my hard consent: 60
 I do beseech you, give him leave to go.
KING Take thy fair hour, Laertes; time be thine,
 And thy best graces spend it at thy will!
 But now, my cousin Hamlet, and my son,—
HAMLET *[Aside]* A little more than kin, and less than kind.
KING How is it that the clouds still hang on you?
HAMLET Not so, my lord, I am too much i' the sun.
QUEEN Good Hamlet, cast thy nighted colour off,
 And let thine eye look like a friend on Denmark,
 Do not, for ever, with thy vailed[4] lids 70
 Seek for thy noble father in the dust.
 Thou know'st, 'tis common; all that lives must die,
 Passing through nature to eternity.
HAMLET Ay, madam, it is common.
QUEEN If it be,
 Why seems it so particular with thee?
HAMLET "Seems," madam! nay, it is; I know not seems."
 'Tis not alone my inky cloak, good mother,
 Nor customary suits of solemn black,
 Nor windy suspiration of forced breath,
 No, nor the fruitful river in the eye, 80
 Nor the dejected haviour of the visage,
 Together with all forms, moods, shows of grief,
 That can denote me truly: these indeed seem,
 For they are actions that a man might play:
 But I have that within which passes show;
 These, but the trappings and the suits of woe.
KING 'Tis sweet and commendable in your nature, Hamlet,
 To give these mourning duties to your father:
 But, you must know, your father lost a father;
 That father lost his; and the survivor bound 90
 In filial obligation for some term
 To do obsequious sorrow: but to persever
 In obstinate condolement[5] is a course
 Of impious stubbornness; 'tis unmanly grief:
 It shows a will most incorrect to heaven;
 A heart unfortified, a mind impatient,
 An understanding simple and unschooled:
 For what we know must be and is as common
 As any the most vulgar thing to sense,
 Why should we, in our peevish opposition, 100
 Take it to heart? Fie! 'tis a fault to heaven,
 A fault against the dead, a fault to nature,
 To reason most absurd, whose common theme
 Is death of fathers, and who still hath cried,
 From the first corse[6] till he that died to-day,
 "This must be so." We pray you, throw to earth
 This unprevailing woe, and think of us
 As of a father: for let the world take note,
 You are the most immediate to our throne,
 And with no less nobility of love, 110
 Than that which dearest father bears his son,

Do I impart toward you. For your intent
In going back to school in Wittenberg,
It is most retrograde to our desire:
And we beseech you, bend you to remain
Here, in the cheer and comfort of our eye,
Our chiefest courtier, cousin, and our son.
QUEEN Let not thy mother lose her prayers, Hamlet;
 I pray thee, stay with us; go not to Wittenberg.
HAMLET I shall in all my best obey you, madam. 120
KING Why, 'tis a loving and a fair reply;
 Be as ourself in Denmark. Madam, come;
 This gentle and unforced accord of Hamlet
 Sits smiling to my heart: in grace whereof,
 No jocund health that Denmark drinks to-day,
 But the great cannon to the clouds shall tell;
 And the king's rouse the heaven shall bruit[7] again,
 Re-speaking earthly thunder. Come away.

 EXEUNT ALL BUT HAMLET.

HAMLET O, that this too too solid flesh would melt,
 Thaw and resolve itself into a dew! 130
 Or that the Everlasting had not fixed
 His canon[8] 'gainst self-slaughter! O God! O God!
 How weary, stale, flat, and unprofitable
 Seem to me all the uses of this world!
 Fie on't! ah, fie! 'tis an unweeded garden,
 That grows to seed; things rank and gross in nature,
 Possess it merely. That it should come to this!
 But two months dead! nay, not so much, not two;
 So excellent a king; that was, to this,
 Hyperion[9] to a satyr: so loving to my mother, 140
 That he might not beteem[10] the winds of heaven
 Visit her face too roughly. Heaven and earth!
 Must I remember? why, she would hang on him,
 As if increase of appetite had grown
 By what it fed on: and yet, within a month,—
 Let me not think on't;—frailty, thy name is woman! —
 A little month; or ere those shoes were old,
 With which she followed my poor father's body,
 Like Niobe,[11] all tears;—why she, even she,—
 O God! a beast, that wants discourse of reason, 150
 Would have mourned longer,—married with my uncle,
 My father's brother, but no more like my father,
 Than I to Hercules. Within a month?
 Ere yet the salt of most unrighteous tears
 Had left the flushing in her galled eyes,
 She married. O, most wicked speed, to post[12]
 With such dexterity to incestuous sheets!
 It is not, nor it cannot come to, good;—
 But break, my heart: for I must hold my tongue!

 ENTER HORATIO, MARCELLUS, BERNARDO.

HORATIO Hail to your lordship!
HAMLET I am glad to see you well: 160
 Horatio,—or I do forget myself.
HORATIO The same, my lord, and your poor servant ever.
HAMLET Sir, my good friend; I'll change that name
 with you.
 And what makes you from Wittenberg,
 Horatio?—
 Marcellus?
MARCELLUS My good lord,—
HAMLET I am very glad to see you; good even, sir,—
 But what, in faith, make you from Wittenberg?
HORATIO A truant disposition, good my lord.
HAMLET I would not hear your enemy say so,
 Nor shall you do mine ear that violence, 170
 To make it truster of your own report

Against yourself: I know you are no truant.
 But what is your affair in Elsinore?
 We'll teach you to drink deep, ere you depart.
HORATIO My lord, I came to see your father's funeral.
HAMLET I pray thee, do not mock me, fellow-student;
 I think it was to see my mother's wedding.
HORATIO Indeed, my lord, it followed hard upon.
HAMLET Thrift, thrift, Horatio! the funeral baked meats
 Did coldly furnish forth the marriage tables. 180
 Would I had met my dearest foe in heaven
 Or ever I had ever seen that day, Horatio! —
 My father,—methinks I see my father.
HORATIO Where, my lord?
HAMLET In my mind's eye, Horatio.
HORATIO I saw him once, 'a was a goodly king.
HAMLET 'A was a man, take him for all in all,
 I shall not look upon his like again.
HORATIO My lord, I think I saw him yesternight.
HAMLET Saw! who?
HORATIO My lord, the king your father. 190
HAMLET The king my father!
HORATIO Season your admiration for a while
 With an attent ear, till I may deliver,
 Upon the witness of these gentlemen,
 This marvel to you.
HAMLET For God's love; let me hear.
HORATIO Two nights together had these gentlemen,
 Marcellus and Bernardo, on their watch,
 In the dead waste and middle of the night,
 Been thus encountered. A figure like your father,
 Armed at point, exactly, cap-a-pe,[13]
 Appears before them, and with solemn march, 200
 Goes slow and stately by them; thrice he walked,
 By their oppressed and fear-surprised eyes,
 Within his truncheon's length; whilst they, distilled
 Almost to jelly with the act of fear,
 Stand dumb, and speak not to him. This to me
 In dreadful[14] secrecy impart they did;
 And I with them the third night kept the watch:
 Where, as they had delivered, both in time,
 Form of the thing, each word made true and good,
 The apparition comes. I knew your father; 210
 These hands are not more like.
HAMLET But where was this?
MARCELLUS My lord, upon the platform where we
 watched.
HAMLET Did you not speak to it?
HORATIO My lord, I did;
 But answer made it none: yet once, methought,
 It lifted up its head and did address
 Itself to motion, like as it would speak:
 But even then the morning cock crew loud,
 And at the sound it shrank in haste away,
 And vanished from our sight.
HAMLET 'Tis very strange.
HORATIO As I do live, my honoured lord, 'tis true; 220
 And we did think it writ down in our duty,
 To let you know of it.
HAMLET Indeed, indeed, sirs, but this troubles me.
 Hold you the watch to-night?
MARCELLUS, BERNARDO We do, my lord.
HAMLET Armed, say you?
ALL Armed, my lord.
HAMLET From top to toe?
ALL My lord, from head to foot.
HAMLET Then saw you not his face?
HORATIO O, yes, my lord; he wore his beaver[15] up.
HAMLET What, looked he frowningly?

HORATIO A countenance more in sorrow than in anger. 230
HAMLET Pale or red?
HORATIO Nay, very pale.
HAMLET And fixed his eyes upon you?
HORATIO Most constantly.
HAMLET I would I had been there.
HORATIO It would have much amazed you.
HAMLET Very like, very like. Stayed it long?
HORATIO While one with moderate haste might tell a
 hundred.
MARCELLUS, BERNARDO Longer, longer.
HORATIO Not when I saw't.
HAMLET His beard was grizzled, no?
HORATIO It was, as I have seen it in his life,
 A sable silvered.
HAMLET I will watch to-night; 240
 Perchance, 'twill walk again.
HORATIO I warrant it will.
HAMLET If it assume my noble father's person,
 I'll speak to it, though hell itself should gape
 And bid me hold my peace. I pray you all,
 If you have hitherto concealed this sight,
 Let it be tenable in your silence still,
 And whatsoever else shall hap to-night,
 Give it an understanding, but no tongue;
 I will requite your loves. So, fare you well:
 Upon the platform, 'twixt eleven and twelve, 250
 I'll visit you.
ALL Our duty to your honour.
HAMLET Your loves, as mine to you: farewell.

EXEUNT ALL BUT HAMLET.

My father's spirit in arms! all is not well;
I doubt some foul play: would the night were come!
Till then sit still, my soul; foul deeds will rise,
Though all the earth o'erwhelm them, to men's eyes.

EXIT.

Notes

[1] partner
[2] provisions
[3] detailed documents
[4] lowered
[5] mourning
[6] corpse
[7] noisily proclaim
[8] law
[9] the sun god, a symbol of ideal beauty
[10] allow
[11] a mother who, according to the Greek myth, wept so profusely at the death of her children that she was turned to stone by the gods
[12] hasten
[13] head to foot
[14] fearful
[15] visor, face guard

Scene III. *A room in* POLONIUS' *house.*

ENTER LAERTES AND OPHELIA.

LAERTES My necessaries are embarked; farewell:
 And, sister, as the winds give benefit,
 And convoy is assistant, do not sleep,
 But let me hear from you.
OPHELIA Do you doubt that?
LAERTES For Hamlet, and the trifling of his favour,
 Hold it a fashion, and a toy in blood,
 A violet in the youth of primy[1] nature,

Forward, not permanent, sweet, not lasting,
The perfume and suppliance[2] of a minute;
No more.
OPHELIA No more but so?
LAERTES Think it no more: 10
 For nature crescent[3] does not grow alone
 In thews and bulk; but, as this temple waxes,
 The inward service of the mind and soul
 Grows wide withal. Perhaps he loves you now;
 And now no soil nor cautel[4] doth besmirch
 The virtue of his will: but, you must fear,
 His greatness weighed, his will is not his own;
 For he himself is subject to his birth:
 He may not, as unvalued persons do,
 Carve for himself, for on his choice depends, 20
 The safety and health of this whole state,
 And therefore must his choice be circumscribed
 Unto the voice and yielding of that body
 Whereof he is the head. Then if he says he loves you,
 It fits your wisdom so far to believe it
 As he in his particular act and place
 May give his saying deed; which is not further,
 Than the main voice of Denmark goes withal.
 Then weigh what loss your honour may sustain,
 If with too credent ear you list his songs, 30
 Or lose your heart, or your chaste treasure open
 To his unmastered importunity.
 Fear it, Ophelia, fear it, my dear sister,
 And keep you in the rear of your affection,
 Out of the shot and danger of desire.
 The chariest maid is prodigal enough,
 If she unmask her beauty to the moon:
 Virtue itself 'scapes not calumnious strokes:
 The canker galls the infants of the spring
 Too oft before their buttons[5] be disclosed, 40
 And in the morn and liquid dew of youth
 Contagious blastments are most imminent.
 Be wary then: best safety lies in fear;
 Youth to itself rebels, though none else near.
OPHELIA I shall the effect of this good lesson keep,
 As watchman to my heart. But, good my brother,
 Do not, as some ungracious pastors do,
 Show me the steep and thorny way to heaven,
 Whiles, like a puffed and reckless libertine,
 Himself the primrose path of dalliance treads 50
 And recks not his own rede.[6]
LAERTES O, fear me not.
 I stay too long; but here my father comes.

ENTER POLONIUS.

A double blessing is a double grace;
Occasion smiles upon a second leave.
POLONIUS Yet here, Laertes! aboard, aboard, for shame!
 The wind sits in the shoulder of your sail,
 And you are stayed for. There; my blessing with thee!

LAYING HIS HAND ON LAERTES' HEAD.

And these few precepts in thy memory
Look thou character.[7] Give thy thoughts no tongue,
Nor any unproportioned thought his act. 60
Be thou familiar, but by no means vulgar.
The friends thou hast, and their adoption tried,
Grapple them to thy soul with hoops of steel;
But do not dull thy palm with entertainment
Of each new-hatched, unfledged comrade.
Beware
Of entrance to a quarrel: but, being in,
Bear't that the opposed may beware of thee.

Give every man thine ear, but few thy voice:
Take each man's censure, but reserve thy judgement.
Costly thy habit as thy purse can buy, 70
But not expressed in fancy; rich, not gaudy:
For the apparel oft proclaims the man;
And they in France of the best rank and station
Are most select and generous, chief in that.
Neither a borrower nor a lender be:
For loan oft loses both itself and friend,
And borrowing dulls the edge of husbandry.
This above all: to thine ownself be true,
And it must follow, as the night the day,
Thou canst not then be false to any man. 80
Farewell; my blessing season this in thee!
LAERTES Most humbly do I take my leave, my lord.
POLONIUS The time invites you; go, your servants tend.
LAERTES Farewell, Ophelia, and remember well
 What I have said to you.
OPHELIA 'Tis in my memory locked,
 And you yourself shall keep the key of it.
LAERTES Farewell.

EXIT LAERTES.

POLONIUS What is't, Ophelia, he hath said to you?
OPHELIA So please you, something touching the Lord
 Hamlet.
POLONIUS Marry, well bethought: 90
 'Tis told me, he hath very oft of late
 Given private time to you, and you yourself
 Have of your audience been most free and bounteous;
 If it be so,—as so 'tis put on me,
 And that in way of caution,—I must tell you,
 You do not understand yourself so clearly,
 As it behoves my daughter and your honour.
 What is between you? give me up the truth.
OPHELIA He hath, my lord, of late, made many tenders
 Of his affection to me. 100
POLONIUS Affection! pooh! you speak like a green girl,
 Unsifted in such perilous circumstance.
 Do you believe his "tenders," as you call them?
OPHELIA I do not know, my lord, what I should think.
POLONIUS Marry, I'll teach you: think yourself a baby;
 That you have ta'en his tenders for true pay,
 Which are not sterling. Tender yourself more dearly;
 Or,—not to crack the wind of the poor phrase,
 Running it thus,—you'll tender me a fool.
OPHELIA My lord, he hath importuned me with love 110
 In honourable fashion.
POLONIUS Ay, "fashion" you may call it; go to, go to.
OPHELIA And hath given countenance to his speech,
 my lord,
 With almost all the vows of heaven.
POLONIUS Ay, springes to catch woodcocks.[8] I do know,
 When the blood burns, how prodigal the soul
 Lends the tongue vows: these blazes, daughter,
 Giving more light than heat, extinct in both,
 Even in their promise, as it is a-making,
 You must not take for fire. From this time 120
 Be something scanter of your maiden presence;
 Set your entreatments at a higher rate,
 Than a command to parley. For Lord Hamlet,
 Believe so much in him, that he is young;
 And with a larger tether may he walk,
 Than may be given you; in few, Ophelia,
 Do not believe his vows; for they are brokers,
 Not of that dye which their investments show,
 But mere implorators of unholy suits,
 Breathing like sanctified and pious bawds, 130

The better to beguile. This is for all;
I would not, in plain terms, from this time forth,
Have you so slander any moment's leisure,
As to give words or talk with the Lord Hamlet.
Look to't, I charge you; come your ways.
OPHELIA I shall obey, my lord.

EXEUNT.

Notes

[1] springlike
[2] occupation
[3] growing
[4] deceit
[5] buds
[6] does not heed his own advice
[7] inscribe
[8] traps to catch stupid birds

Scene IV. *The platform.*

ENTER HAMLET, HORATIO, AND MARCELLUS.

HAMLET The air bites shrewdly; it is very cold.
HORATIO It is a nipping and an eager air.
HAMLET What hour now?
HORATIO I think it lacks of twelve.
MARCELLUS No, it is struck.
HORATIO Indeed? I heard it not; it then draws near the
 season,
 Wherein the spirit held his wont to walk.

A FLOURISH OF TRUMPETS, AND ORDNANCE SHOT OFF,
WITHIN.

 What does this mean, my lord?
HAMLET The king doth wake to-night and takes his rouse,
 Keeps wassail and the swaggering up-spring reels;
 And as he drains his draughts of Rhenish down, 10
 The kettle-drum and trumpet thus bray out
 The triumph of his pledge.
HORATIO Is it a custom?
HAMLET Ay, marry, is't:
 But to my mind, though I am native here,
 And to the manner born, it is a custom
 More honoured in the breach than the observance.
 This heavy-headed revel east and west
 Makes us traduced and taxed of other nations:
 They clepe[1] us drunkards, and with swinish phrase
 Soil our addition;[2] and indeed it takes 20
 From our achievements, though performed at height,
 The pith and marrow of our attribute.
 So, oft it chances in particular men,
 That for some vicious mole of nature in them,
 As, in their birth,—wherein they are not guilty
 Since nature cannot choose his origin,—
 By the o'ergrowth of some complexion,
 Oft breaking down the pales[3] and forts of reason;
 Or by some habit that too much o'erleavens
 The form of plausive[4] manners; that these men,— 30
 Carrying, I say, the stamp of one defect;
 Being nature's livery, or fortune's star,—
 His virtues else—be they as pure as grace,
 As infinite as man may undergo,—
 Shall in the general censure take corruption
 From that particular fault: the dram of eale
 Doth all the noble substance of a doubt,
 To his own scandal.

ENTER GHOST.

HORATIO Look, my lord, it comes!
HAMLET Angels and ministers of grace defend us!
 Be thou a spirit of health or goblin damned, 40
 Bring with thee airs from heaven or blasts from hell,
 Be thy intents wicked or charitable,
 Thou com'st in such a questionable shape,
 That I will speak to thee; I'll call thee Hamlet,
 King, father; royal Dane, O, answer me!
 Let me not burst in ignorance; but tell
 Why thy canonized bones, hearsed in death
 Have burst their cerements;[5] why the sepulchre,
 Wherein we saw thee quietly in-urned,
 Hath oped his ponderous and marble jaws, 50
 To cast thee up again. What may this mean,
 That thou, dead corse, again, in complete steel,
 Revisit'st thus the glimpses of the moon,
 Making night hideous; and we fools of nature
 So horridly to shake our disposition,
 With thoughts beyond the reaches of our souls?
 Say, why is this? wherefore? what should we do?

 GHOST BECKONS HAMLET.

HORATIO It beckons you to go away with it,
 As if it some impartments[6] did desire
 To you alone.
MARCELLUS Look, with what courteous action 60
 It waves you to a more removed ground:
 But do not go with it.
HORATIO No, by no means.
HAMLET It will not speak; then I will follow it.
HORATIO Do not, my lord.
HAMLET Why, what should be the fear?
 I do not set my life at a pin's fee;
 And for my soul, what can it do to that,
 Being a thing immortal as itself?
 It waves me forth again: I'll follow it.
HORATIO What if it tempt you toward the flood, my lord,
 Or to the dreadful summit of the cliff 70
 That beetles o'er his base into the sea,
 And there assume some other horrible form,
 Which might deprive your sovereignty of reason,
 And draw you into madness? think of it:
 The very place puts toys of desperation,
 Without more motive, into every brain,
 That looks so many fathoms to the sea
 And hears it roar beneath.
HAMLET It waves me still.
 Go on; I'll follow thee. 79
MARCELLUS You shall not go, my lord.
HAMLET Hold off your hands!
HORATIO Be ruled; you shall not go.
HAMLET My fate cries out,
 And makes each petty artery in this body
 As hardy as the Nemean lion's[7] nerve.

 GHOST BECKONS.

Still am I called:—unhand me, gentlemen;

 BREAKING FROM THEM.

By heaven, I'll make a ghost of him that lets me:
I say, away!—Go on, I'll follow thee.

 EXEUNT GHOST AND HAMLET.

HORATIO He waxes desperate with imagination.
MARCELLUS Let's follow; 'tis not fit thus to obey him.
HORATIO Have after.—To what issue will this come?
MARCELLUS Something is rotten in the state of Denmark. 90

HORATIO Heaven will direct it.
MARCELLUS Nay, let's follow him.

 EXEUNT.

Notes

[1] call
[2] reputation
[3] enclosures
[4] pleasing
[5] shroud
[6] communication
[7] mythical lion killed by the Greek hero Hercules

Scene V. *Another part of the platform.*

 ENTER GHOST AND HAMLET.

HAMLET Where wilt thou lead me? speak,
 I'll go no further.
GHOST Mark me.
HAMLET I will.
GHOST My hour is almost come,
 When I to sulphurous and tormenting flames
 Must render up myself.
HAMLET Alas, poor ghost!
GHOST Pity me not, but lend thy serious hearing
 To what I shall unfold.
HAMLET Speak; I am bound to hear.
GHOST So art thou to revenge, when thou shalt hear.
HAMLET What?
GHOST I am thy father's spirit;
 Doomed for a certain term to walk the night;
 And for the day confined to fast in fires, 10
 Till the foul crimes done in my days of nature
 Are burnt and purged away. But that I am forbid
 To tell the secrets of my prison-house,
 I could a tale unfold whose lightest word
 Would harrow up thy soul, freeze thy young blood,
 Make thy two eyes, like stars, start from their spheres,
 Thy knotted and combined locks to part,
 And each particular hair to stand on end,
 Like quills upon the fretful porpentine,[1]
 But this eternal blazon must not be 20
 To ears of flesh and blood. List, list, O list!
 If thou didst ever thy dear father love—
HAMLET O God!
GHOST Revenge his foul and most unnatural murder.
HAMLET Murder?
GHOST Murder, most foul, as in the best it is,
 But this most foul, strange, and unnatural.
HAMLET Haste me to know't; that I, with wings as swift
 As meditation or the thoughts of love,
 May sweep to my revenge.
GHOST I find thee apt;
 And duller shouldst thou be than the fat weed
 That roots itself in ease on Lethe[2] wharf, 30
 Wouldst thou not stir in this. Now Hamlet, hear:
 'Tis given out, that, sleeping in mine orchard,
 A serpent stung me; so the whole ear of Denmark
 Is by a forged process of my death
 Rankly abused: but know, thou noble youth,
 The serpent that did sting thy father's life,
 Now wears his crown.
HAMLET O my prophetic soul! my uncle!
GHOST Ay, that incestuous, that adulterate beast,
 With witchcraft of his wit, with traitorous gifts,—
 O wicked wit and gifts, that have the power 40
 So to seduce!—won to his shameful lust

The will of my most seeming-virtuous queen:
O Hamlet, what a falling-off was there!
From me, whose love was of that dignity,
That it went hand in hand even with the vow
I made to her in marriage; and to decline
Upon a wretch, whose natural gifts were poor
To those of mine!
But virtue, as it never will be moved,
Though lewdness court it in a shape of heaven; 50
So lust, though to a radiant angel linked,
Will sort itself in a celestial bed,
And prey on garbage.
But, soft! methinks I scent the morning air;
Brief let me be. Sleeping within my orchard
My custom always in the afternoon,
Upon my secure hour thy uncle stole,
With juice of cursed hebenon[3] in a vial,
And in the porches of mine ears did pour
The leperous distilment; whose effect
Holds such an enmity with blood of man, 60
That swift as quicksilver it courses through
The natural gates and alleys of the body;
And with a sudden vigour it doth posset[4]
And curd, like eager[5] droppings into milk,
The thin and wholesome blood: so did it mine;
And a most instant tetter[6] barked about,
Most lazar-like,[7] with vile and loathsome crust,
All my smooth body.
Thus was I, sleeping, by a brother's hand, 70
Of life, of crown, and queen, at once dispatched;
Cut off even in the blossoms of my sin,
Unhouseled, disappointed, unaneled;[8]
No reckoning made, but sent to my account
With all my imperfections on my head:
O, horrible! O, horrible! most horrible!
If thou hast nature in thee, bear it not;
Let not the royal bed of Denmark be
A couch for luxury and damned incest,
But, howsoever thou pursuest this act, 80
Taint not thy mind, nor let thy soul contrive
Against thy mother aught; leave her to heaven,
And to those thorns that in her bosom lodge,
To prick and sting her. Fare thee well at once!
The glow-worm shows the matin[9] to be near,
And 'gins to pale his uneffectual fire:
Adieu, adieu, adieu! remember me.

EXIT.

HAMLET O all you host of heaven! O earth! What else?
And shall I couple hell? O fie! Hold, hold, my heart;
And you, my sinews, grow not instant old, 90
But bear me stiffly up.—Remember thee?
Ay, thou poor ghost, whiles memory holds a seat
In this distracted globe. Remember thee?
Yea, from the table of my memory
I'll wipe away all trivial fond records,
All saws of books, all forms, all pressures past,
That youth and observation copied there;
And thy commandment all alone shall live
Within the book and volume of my brain,
Unmixed with baser matter: yes, by heaven! 100
O most pernicious woman!
O villain, villain, smiling, damned villain!
My tables, meet it is I set it down,
That one may smile, and smile, and be a villain;
At least I'm sure it may be so in Denmark;

WRITING.

So, uncle, there you are. Now to my word;
It is, "Adieu, adieu! remember me."
I have sworn't.
HORATIO [Within] My lord, my lord—
MARCELLUS [Within] Lord Hamlet—
HORATIO [Within] Heaven secure him!
MARCELLUS [Within] So be it!
HORATIO [Within] Illo, ho, ho, my lord! 109
HAMLET Hillo, ho, ho, boy! come, bird, come.

ENTER HORATIO AND MARCELLUS.

MARCELLUS How is't, my noble lord?
HORATIO What news, my lord?
HAMLET O, wonderful!
HORATIO Good my lord, tell it.
HAMLET No, you will reveal it.
HORATIO Not I, my lord, by heaven.
MARCELLUS Nor I, my lord.
HAMLET How say you then; would heart of man once
think it?
But you'll be secret—
HORATIO, MARCELLUS Ay, by heaven, my lord.
HAMLET There's ne'er a villain dwelling in all Denmark
But he's an arrant knave.
HORATIO There needs no ghost, my lord, come from
the grave
To tell us this.
HAMLET Why, right; you are i' the right;
And so, without more circumstance at all, 121
I hold it fit that we shake hands and part;
You, as your business and desire shall point you;
For every man hath business and desire,
Such as it is; and for my own poor part,
Look you, I'll go pray.
HORATIO These are but wild and whirling words, my lord.
HAMLET I'm sorry they offend you, heartily;
Yes, faith, heartily.
HORATIO There's no offence, my lord.
HAMLET Yes, by Saint Patrick, but there is, Horatio, 130
And much offence too. Touching this vision here,
It is an honest ghost, that let me tell you;
For your desire to know what is between us,
O'ermaster it as you may. And now, good friends,
As you are friends, scholars, and soldiers,
Give me one poor request.
HORATIO What is't my lord? we will.
HAMLET Never make known what you have seen tonight.
HORATIO, MARCELLUS My lord, we will not.
HAMLET Nay, but swear't.
HORATIO In faith, My lord, not I.
MARCELLUS Nor I, my lord, in faith. 140
HAMLET Upon my sword.
MARCELLUS We have sworn, my lord, already.
HAMLET Indeed, upon my sword, indeed.
GHOST [Beneath] Swear.
HAMLET Ha, ha, boy! say'st thou so? art thou there, true-penny?[10]
Come on; you hear this fellow in the cellarage;
Consent to swear.
HORATIO Propose the oath, my lord.
HAMLET Never to speak of this that you have seen.
Swear by my sword.
GHOST [Beneath] Swear.
HAMLET *Hic et ubique?*[11] then we'll shift our ground—
Come hither, gentlemen, 150
And lay your hands again upon my sword:
Never to speak of this that you have heard,
Swear by my sword.
GHOST [Beneath] Swear.

HAMLET Well said, old mole! canst work i' the ground
 so fast?
 A worthy pioneer![12] Once more remove, good friends.
HORATIO O day and night, but this is wondrous strange!
HAMLET And therefore as a stranger give it welcome.
 There are more things in heaven and earth, Horatio, 160
 Than are dreamt of in your philosophy. But come;
 Here, as before, never, so help you mercy,
 How strange or odd soe'er I bear myself,
 As I perchance hereafter shall think meet
 To put an antic disposition on,
 That you, at such times seeing me, never shall
 With arms encumbered thus, or this head-shake,
 Or by pronouncing of some doubtful phrase,
 As, "Well, well, we know," or "We could, and if we
 would,"
 Or, "If we list to speak," or, "There be, and if they might," 170
 Or such ambiguous giving out, to note
 That you know aught of me: this not to do,
 So grace and mercy at your most need help you.
 Swear!
GHOST *[Beneath]* Swear!
HAMLET Rest, rest, perturbed spirit! So, gentlemen,
 With all my love I do commend me to you:
 And what so poor a man as Hamlet is
 May do, to express his love and friending to you,
 God willing, shall not lack. Let us go in together;
 And still your fingers on your lips, I pray. 180
 The time is out of joint;—O cursed spite,
 That ever I was born to set it right!—
 Nay, come, let's go together.

<div align="center">EXEUNT.</div>

Notes

[1] timid porcupine
[2] river of forgetfulness in Hades
[3] a poisonous plant
[4] curdle
[5] acid
[6] scab
[7] leperlike
[8] without taking communion, unabsolved, without extreme unction
[9] morning
[10] honest fellow
[11] here and everywhere
[12] miner

Aᴄᴛ II

Scene I. *A room in* POLONIUS' *house.*

<div align="center">ENTER POLONIUS AND REYNALDO.</div>

POLONIUS Give him this money and these notes,
 Reynaldo.
REYNALDO I will, my lord.
POLONIUS You shall do marvellous wisely, good Reynaldo,
 Before you visit him, to make inquire
 Of his behaviour.
REYNALDO My lord, I did intend it.
POLONIUS Marry, well said, very well said. Look you, sir.
 Inquire me first what Danskers[1] are in Paris,
 And how, and who; what means, and where they keep;
 What company, at what expense; and finding
 By this encompassment and drift of question, 10
 That they do know my son, come you more nearer
 Than your particular demands will touch it:
 Take you, as 'twere, some distant knowledge of him,

 As thus, "I know his father and his friends,
 And in part him." Do you mark this, Reynaldo?
REYNALDO Ay, very well, my lord.
POLONIUS "And in part, him; but," you may say,
 "not well:
 But if't be he I mean, he's very wild,
 Addicted" so and so; and there put on him
 What forgeries you please; marry, none so rank 20
 As may dishonour him; take heed of that;
 But, sir, such wanton, wild, and usual slips,
 As are companions noted and most known
 To youth and liberty.
REYNALDO As gaming, my lord.
POLONIUS Ay, or drinking, fencing, swearing,
 Quarrelling, drabbing:[2] you may go so far.
REYNALDO My lord, that would dishonour him.
POLONIUS Faith, no; as you may season it in the charge.
 You must not put another scandal on him,
 That he is open to incontinency; 30
 That's not my meaning: but breathe his faults so quaintly
 That they may seem the taints of liberty:
 The flash and outbreak of a fiery mind;
 A savageness in unreclaimed blood,
 Of general assault.[3]
REYNALDO But, my good lord,—
POLONIUS Wherefore should you do this?
REYNALDO Ay, my lord, I would know that.
POLONIUS Marry, sir, here's my drift;
 And, I believe, it is a fetch of warrant:
 You laying these slight sullies on my son,
 As 'twere a thing a little soiled i' the working, 40
 Mark you, your party in converse, him you would sound,
 Having ever seen in the prenominate crimes,
 The youth you breathe of guilty, be assured,
 He closes with you in this consequence:
 "Good sir," or so; or, "friend," or "gentleman,"—
 According to the phrase or the addition,
 Of man and country.
REYNALDO Very good, my lord.
POLONIUS And then, sir, does 'a[4] this,—'a does—
 what was
 I about to say? By the mass, I was about to say
 something: where did I leave? 50
REYNALDO At "closes in the consequence," at "friend
 or so," and "gentleman."
POLONIUS At "closes in the consequence," ay, marry;
 He closes thus: "I know the gentleman;
 I saw him yesterday, or t' other day,
 Or then, or then, with such, or such, and, as you say,
 There was a-gaming, there o'ertook in's rouse:
 There falling out at tennis;" or perchance,
 "I saw him enter such a house of sale"
 Videlicet,[5] a brothel, or so forth. See you now; 60
 Your bait of falsehood takes this carp of truth:
 And thus do we of wisdom and of reach,
 With windlasses and with assays of bias,
 By indirections find direction out;
 So, by my former lecture and advice,
 Shall you my son. You have me, have you not?
REYNALDO My lord, I have.
POLONIUS God b'uy ye; fare ye well.
REYNALDO Good, my lord!
POLONIUS Observe his inclination in yourself.
REYNALDO I shall, my lord. 70
POLONIUS And let him ply his music.
REYNALDO Well, my lord.
POLONIUS Farewell!

<div align="center">EXIT.</div>

ENTER OPHELIA.

How now, Ophelia? what's the matter?

OPHELIA O, my lord, my lord, I have been so affrighted!

POLONIUS With what, i' the name of God?

OPHELIA My lord, as I was sewing in my closet,
Lord Hamlet, with his doublet all unbraced:[6]
No hat upon his head: his stockings fouled,
Ungartered, and down-gyved[7] to his ankle;
Pale as his shirt; his knees knocking each other;
And with a look so piteous in purport, 80
As if he had been loosed out of hell,
To speak of horrors, he comes before me.

POLONIUS Mad for thy love?

OPHELIA My lord, I do not know,
But truly I do fear it.

POLONIUS What said he?

OPHELIA He took me by the wrist, and held me hard;
Then goes he to the length of all his arm,
And with his other hand thus o'er his brow,
He falls to such perusal of my face,
As he would draw it. Long stayed he so;
At last, a little shaking of mine arm, 90
And thrice his head thus waving up and down,
He raised a sigh so piteous and profound,
As it did seem to shatter all his bulk,
And end his being: that done, he lets me go:
And with his head over his shoulder turned
He seemed to find his way without his eyes;
For out o' doors he went without their help,
And to the last bended their light on me.

POLONIUS Come, go with me; I will go seek the king.
This is the very ecstasy of love; 100
Whose violent property fordoes itself,
And leads the will to desperate undertakings,
As oft as any passion under heaven,
That does afflict our natures. I am sorry,—
What, have you given him any hard words of late?

OPHELIA No, my good lord, but, as you did command,
I did repel his letters, and denied
His access to me.

POLONIUS That hath made him mad.
I am sorry that with better heed and judgment,
I had not quoted him: I feared he did but trifle 110
And meant to wrack thee; but, beshrew my jealousy!
By heaven, it is as proper to our age
To cast beyond ourselves in our opinions
As it is common for the younger sort
To lack discretion. Come, go we to the king:
This must be known; which, being kept close,
 might move
More grief to hide than hate to utter love.
Come!

EXEUNT.

Notes

[1] Danes
[2] womanizing
[3] common to all
[4] he
[5] namely
[6] jacket completely unfastened
[7] hanging down like fetters

Scene II. *A room in the castle.*

FLOURISH. ENTER KING, QUEEN, ROSENCRANTZ,
GUILDENSTERN, AND ATTENDANTS.

KING Welcome, dear Rosencrantz and Guildenstern!
Moreover that we much did long to see you,
The need we have to use you did provoke
Our hasty sending. Something have you heard
Of Hamlet's transformation: so I call it,
Sith[1] nor the exterior nor the inward man
Resembles that it was. What it should be,
More than his father's death, that thus hath put him
So much from the understanding of himself,
I cannot dream of. I entreat you both, 10
That, being of so young days brought up with him,
And sith so neighboured to his youth and humour,[2]
That you vouchsafe your rest here in our court
Some little time; so by your companies
To draw him on to pleasures, and to gather,
So much as from occasion you may glean,
Whether aught to us unknown afflicts him thus,
That, opened, lies within our remedy.

QUEEN Good gentlemen, he hath much talked of you;
And sure I am two men there are not living 20
To whom he more adheres. If it will please you
To show us so much gentry[3] and good will,
As to expend your time with us a while,
For the supply and profit of our hope,
Your visitation shall receive such thanks
As fits a king's remembrance.

ROSENCRANTZ Both your majesties
Might, by the sovereign power you have of us,
Put your dread pleasures more into command
Than to entreaty.

GUILDENSTERN But we both obey,
And here give up ourselves, in the full bent, 30
To lay our service freely at your feet,
To be commanded.

KING Thanks, Rosencrantz and gentle Guildenstern.

QUEEN Thanks, Guildenstern and gentle Rosencrantz:
And I beseech you instantly to visit
My too much changed son. Go, some of you,
And bring these gentlemen where Hamlet is.

GUILDENSTERN Heavens make our presence and our
 practices,
Pleasant and helpful to him!

QUEEN Ay, amen!

EXEUNT ROSENCRANTZ, GUILDENSTERN,
AND SOME ATTENDANTS.

ENTER POLONIUS.

POLONIUS The ambassadors from Norway, my good lord,
 are joyfully returned. 40

KING Thou still hast been the father of good news.

POLONIUS Have I, my lord? Assure you, my good
liege, I hold my duty, as I hold my soul,
Both to my God and to my gracious king:
And I do think, or else this brain of mine
Hunts not the trail of policy so sure
As I have used to do, that I have found
The very cause of Hamlet's lunacy.

KING O, speak of that; that I do long to hear. 50

POLONIUS Give first admittance to the ambassadors;
My news shall be the fruit to that great feast.

KING Thyself do grace to them, and bring them in.

EXIT POLONIUS.

He tells me, my dear Gertrude, that he hath found
The head and source of all your son's distemper.

QUEEN I doubt it is no other but the main;
His father's death, and our o'erhasty marriage.

KING Well, we shall sift him.—

RE-ENTER POLONIUS, WITH VOLTIMAND AND CORNELIUS.

 Welcome, my good friends!
 Say, Voltimand, what from our brother Norway?
VOLTIMAND Most fair return of greetings and desires. 60
 Upon our first, he sent out to suppress
 His nephew's levies, which to him appeared
 To be a preparation 'gainst the Polack;
 But better looked into, he truly found
 It was against your highness: whereat, grieved
 That so his sickness, age, and impotence,
 Was falsely borne in hand, sends out arrests
 On Fortinbras, which he, in brief, obeys,
 Receives rebuke from Norway, and, in fine,[4]
 Makes vow before his uncle never more 70
 To give the assay of arms against your majesty.
 Whereon old Norway, overcome with joy,
 Gives him three thousand crowns in annual fee
 And his commission to employ those soldiers,
 So levied as before, against the Polack:
 With an entreaty, herein further shown,

GIVES A PAPER.

 That it might please you to give quiet pass
 Through your dominions for this enterprise;
 On such regards of safety and allowance,
 As therein are set down.
KING It likes us well; 80
 And at our more considered time, we'll read,
 Answer, and think upon this business.
 Meantime we thank you for your well-took labour:
 Go to your rest; at night we'll feast together:
 Most welcome home!

EXEUNT VOLTIMAND AND CORNELIUS.

POLONIUS This business is well ended.
 My liege, and madam, to expostulate
 What majesty should be, what duty is,
 Why day is day, night night, and time is time,
 Were nothing but to waste night, day, and time.
 Therefore, since brevity is the soul of wit, 90
 And tediousness the limbs and outward flourishes,
 I will be brief. Your noble son is mad:
 Mad call I it: for, to define true madness,
 What is't but to be nothing else but mad?
 But let that go.
QUEEN More matter, with less art.
POLONIUS Madam, I swear, I use no art at all.
 That he is mad, 'tis true; 'tis true 'tis pity;
 And pity 'tis 'tis true: a foolish figure;[5]
 But farewell it, for I will use no art.
 Mad let us grant him then: and now remains, 100
 That we find out the cause of this effect,
 Or rather say, the cause of this defect,
 For this effect defective comes by cause:
 Thus it remains and the remainder thus.
 Perpend.[6]
 I have a daughter; have, while she is mine;
 Who in her duty and obedience, mark,
 Hath given me this: now gather and surmise.

READS.

—To the celestial, and my soul's idol, the most
 beautified Ophelia,"— 110
That's an ill phrase, a vile phrase; "beautified" is
a vile phrase, but you shall hear. Thus:
[Reads] "These. In her excellent white bosom, these."

QUEEN Came this from Hamlet to her?
POLONIUS Good madam, stay awhile; I will be faithful.
 [Reads] "Doubt thou, the stars are fire;
 Doubt that the sun doth move;
 Doubt truth to be a liar;
 But never doubt, I love.
 "O dear Ophelia, I am ill at these numbers; I have 120
 not heart to reckon my groans: but that I love thee best, O most
 best, believe it. Adieu.
 "Thine evermore, most dear lady, whilst
 this machine is to him, Hamlet."
 This in obedience hath my daughter shown me:
 And more above, hath his solicitings,
 As they fell out by time, by means, and place,
 All given to mine ear.
KING But how hath she
 Received his love?
POLONIUS What do you think of me?
KING As of a man faithful and honourable. 130
POLONIUS I would fain prove so. But what might you
 think,
 When I had seen this hot love on the wing,
 As I perceived it, I must tell you that,
 Before my daughter told me, what might you,
 Or my dear majesty your queen here, think,
 If I had played the desk or table-book,[7]
 Or given my heart a working, mute and dumb;
 Or looked upon this love with idle sight;
 What might you think? No, I went round to work,
 And my young mistress thus I did bespeak; 140
 "Lord Hamlet is a prince out of thy star;[8]
 This must not be:" and then I prescripts gave her,
 That she should lock herself from his resort,
 Admit no messengers, receive no tokens
 Which done, she took the fruits of my advice;
 And he repelled, a short tale to make,
 Fell into a sadness, then into a fast,
 Thence to a watch, thence into a weakness,
 Thence to a lightness, and by this declension
 Into the madness wherein now he raves 150
 And all we mourn for.
KING Do you think 'tis this?
QUEEN It may be, very like.
POLONIUS Hath there been such a time, I'd fain know that,
 That I have positively said "'tis so,"
 When it proved otherwise?
KING Not that I know.
POLONIUS [Pointing to his head, and shoulder] Take
 this from this, if this be otherwise.
 of circumstances lead me, I will find
 Where truth is hid, though it were hid indeed
 Within the centre.
KING How may we try it further?
POLONIUS You know, sometimes he walks four hours
 together, 160
 Here in the lobby.
QUEEN So he does, indeed.
POLONIUS At such time I'll loose my daughter to him;
 Be you and I behind an arras[9] then;
 Mark the encounter: if he love her not,
 And be not from his reason fallen thereon,
 Let me be no assistant for a state,
 But keep a farm and carters.
KING We will try it.
QUEEN But, look, where sadly the poor wretch comes
 reading.
POLONIUS Away, I do beseech you, both away;
 I'll board him presently:—O, give me leave.— 170

EXEUNT KING, QUEEN, AND ATTENDANTS.

ENTER HAMLET, READING.

How does my good Lord Hamlet?

HAMLET Well, God-a-mercy.

POLONIUS Do you know me, my lord?

HAMLET Excellent well; you are a fishmonger.[10]

POLONIUS Not I, my lord.

HAMLET Then I would you were so honest a man.

POLONIUS Honest, my lord?

HAMLET Ay, sir; to be honest, as this world goes, is to be
 one man picked out of ten thousand.

POLONIUS That's very true, my lord. 180

HAMLET For if the sun breed maggots in a dead dog, being a
 good kissing carrion,——Have you a daughter?

POLONIUS I have, my lord.

HAMLET Let her not walk i' the sun: conception is a
 blessing; but not as your daughter may conceive,——
 friend, look to't.

POLONIUS How say you by that? *[Aside]* Still harping on
 my daughter: yet he knew me not at first; 'a said I was
 a fishmonger: 'a is far gone, far gone: and truly in my
 youth I suffered much extremity for love; very near
 this. I'll speak to him again.——What do you read,
 my lord? 192

HAMLET Words, words, words!

POLONIUS What is the matter, my lord?

HAMLET Between who?

POLONIUS I mean the matter that you read, my lord?

HAMLET Slanders, sir: For the satirical rogue says here
 that old men have grey beards, that their faces are
 wrinkled, their eyes purging thick amber and plum-
 tree gum, and that they have a plentiful lack of wit,
 together with most weak hams: all which, sir, though I
 most powerfully and potently believe, yet I hold it
 not honesty to have it thus set down; for you yourself,
 sir, should be old as I am, if like a crab you could go
 backward. 205

POLONIUS Though this be madness, yet there is method
 in't. *[Aside]* Will you walk out of the air, my lord?

HAMLET Into my grave?

POLONIUS Indeed, that is out of the air.——How pregnant[11]
 sometimes his replies are! a happiness that often
 madness hits on, which reason and sanity could not so
 prosperously be delivered of. I will leave him, and
 suddenly contrive the means of meeting between him
 and my daughter.——My honourable lord, I will most
 humbly take my leave of you.

HAMLET You cannot, sir, take from me any thing that I will
 more willingly part withal; except my life, except my
 life, except my life. 220

POLONIUS Fare you well, my lord.

HAMLET These tedious old fools!

ENTER ROSENCRANTZ AND GUILDENSTERN.

POLONIUS You go to seek the Lord Hamlet; there he is.

ROSENCRANTZ *[To* POLONIUS*]* God save you, sir!

EXIT POLONIUS.

GUILDENSTERN My honoured lord!——

ROSENCRANTZ My most dear lord!

HAMLET My excellent good friends! How dost thou,
 Guildenstern? Ah, Rosencrantz! Good lads, how do
 ye both? 230

ROSENCRANTZ As the indifferent children of the earth.

GUILDENSTERN Happy, in that we are not overhappy; on
 fortune's cap we are not the very button.

HAMLET Nor the soles of her shoe?

ROSENCRANTZ Neither, my lord.

HAMLET Then you live about her waist, or in the middle of
 her favours?

GUILDENSTERN Faith, her privates we. 240

HAMLET In the secret parts of fortune? O, most true; she is
 a strumpet. What's the news?

ROSENCRANTZ None, my lord; but that the world's
 grown honest.

HAMLET Then is dooms-day near: but your news is not
 true. Let me question more in particular: what have
 you, my good friends, deserved at the hands of
 fortune, that she sends you to prison hither?

GUILDENSTERN Prison, my lord?

HAMLET Denmark's a prison. 250

ROSENCRANTZ Then is the world one.

HAMLET A goodly one; in which there are many confines,
 wards,[12] and dungeons; Denmark being one o' the
 worst.

ROSENCRANTZ We think not so, my lord.

HAMLET Why, then 'tis none to you: for there is nothing
 either good or bad but thinking makes it so: to me it is
 a prison.

ROSENCRANTZ Why, then your ambition makes it one; 'tis
 too narrow for your mind. 260

HAMLET O God, I could be bounded in a nutshell, and
 count myself a king of infinite space; were it not that I
 have bad dreams.

GUILDENSTERN Which dreams, indeed, are ambition; for
 the very substance of the ambitious is merely the
 shadow of a dream.

HAMLET A dream itself is but a shadow.

ROSENCRANTZ Truly, and I hold ambition of so airy and
 light a quality that it is but a shadow's shadow. 270

HAMLET Then are our beggars bodies; and our monarchs
 and outstretched heroes the beggars' shadows. Shall
 we to the court? for, by my fay,[13] I cannot reason.

ROSENCRANTZ, GUILDENSTERN We'll wait upon you.

HAMLET No such matter: I will not sort you with the rest
 of my servants; for, to speak to you like an honest
 man, I am most dreadfully attended. But, in the beaten
 way of friendship, what make you at Elsinore? 280

ROSENCRANTZ To visit you, my lord; no other occasion.

HAMLET Beggar that I am, I am even poor in thanks; but I
 thank you: and sure, dear friends, my thanks are too
 dear a halfpenny. Were you not sent for? Is it your
 own inclining? Is it a free visitation? Come, deal justly
 with me: come, come; nay, speak.

GUILDENSTERN What should we say, my lord?

HAMLET Why anything, but to the purpose. You were sent
 for; and there is a kind of confession in your looks,
 which your modesties have not craft enough to colour.
 I know, the good king and queen have sent for you. 293

ROSENCRANTZ To what end, my lord?

HAMLET That you must teach me. But let me conjure you,
 by the rights of our fellowship, by the consonancy of
 our youth, by the obligation of our ever-preserved
 love, and by what more dear a better proposer could
 charge you withal, be even and direct with me,
 whether you were sent for, or no. 301

ROSENCRANTZ *[To* GUILDENSTERN*]* What say you?

HAMLET *[Aside]* Nay, then I have an eye of you,——If you
 love me, hold not off.

GUILDENSTERN My lord, we were sent for.

HAMLET I will tell you why; so shall my anticipation pre-
 vent your discovery, and your secrecy to the king and
 queen moult no feather. I have of late, but wherefore, I
 know not, lost all my mirth, forgone all custom of
 exercises: and indeed, it goes so heavily with my dis-

position that this goodly frame, the earth, seems to me
a sterile promontory; this most excellent canopy, the
air, look you, this brave o'erhanging firmament, this
majestical roof fretted with golden fire, why, it appears
no other thing to me than a foul and pestilent con-
gregation of vapours. What a piece of work is a man!
how noble in reason! how infinite in faculty! in form
and moving, how express[14] and admirable! in action,
how like an angel! in apprehension, how like a god!
the beauty of the world! the paragon of animals! And
yet, to me, what is this quintessence of dust? man de-
lights not me; no, nor woman neither, though by your
smiling you seem to say so. 325

ROSENCRANTZ My lord, there was no such stuff in my
thoughts.

HAMLET Why did you laugh then, when I said, "Man de-
lights not me"?

ROSENCRANTZ To think, my lord, if you delight not in
man, what lenten[15] entertainment the players shall re-
ceive from you: we coted[16] them on the way; and
hither are they coming, to offer you service.

HAMLET He that plays the king shall be welcome; his
majesty shall have tribute of me: the adventurous
knight shall use his foil and target: the lover shall not
sigh gratis; the humorous man shall end his part in
peace: the clown shall make those laugh whose lungs
are tickle o' the sere,[17] and the lady shall say her mind
freely, or the blank verse shall halt for't. What players
are they? 342

ROSENCRANTZ Even those you were wont to take such
delight in, the tragedians of the city.

HAMLET How chances it they travel? their residence, both
in reputation and profit, was better both ways.

ROSENCRANTZ I think their inhibition comes by the
means of the late innovation.

HAMLET Do they hold the same estimation they did when
I was in the city? Are they so followed?

ROSENCRANTZ No indeed, they are not.

HAMLET How comes it? Do they grow rusty?

ROSENCRANTZ Nay, their endeavour keeps in the wonted
pace: but there is, sir, an aerie[18] of children, little
eyases, that cry out on the top of question and are
most tyrannically clapped for't: these are now the
fashion, and so berattle the common stages,—so they
call them,—that many wearing rapiers are afraid of
goose quills, and dare scarce come thither. 361

HAMLET What, are they children? who maintains 'em?
how are they escoted?[19] Will they pursue the quality[20]
no longer than they can sing? will they not say after-
wards, if they should grow themselves to common
players,—as it is most like, if their means are not
better,—their writers do them wrong, to make them
exclaim against their own succession?

ROSENCRANTZ Faith, there has been much to-do on both
sides; and the nation holds it no sin to tarre[21] them to
controversy; there was for a while no money bid for
argument, unless the poet and the player went to cuffs
in the question. 374

HAMLET Is't possible?

GUILDENSTERN O, there has been much throwing about
of brains.

HAMLET Do the boys carry it away?

ROSENCRANTZ Ay, that they do, my lord; Hercules and
his load too. 380

HAMLET It is not very strange; for my uncle is king of
Denmark; and those that would make mows at him while
my father lived, give twenty, forty, fifty, an hundred
ducats a-piece, for his picture in little. 'Sblood, there is

something in this more than natural, if philosophy
could find it out.

FLOURISH OF TRUMPETS WITHIN.

GUILDENSTERN There are the players.

HAMLET Gentlemen, you are welcome to Elsinore. Your
hands, come: the appurtenance of welcome is fashion
and ceremony: let me comply with you in this garb,
lest my extent[22] to the players, which, I tell you, must
show fairly outwards, should more appear like enter-
tainment than yours. You are welcome: but my uncle-
father and aunt-mother are deceived. 395

GUILDENSTERN In what, my dear lord?

HAMLET I am but mad north-north-west: when the wind is
southerly, I know a hawk from a handsaw.

ENTER POLONIUS.

POLONIUS Well be with you, gentlemen!

HAMLET Hark you, Guildenstern,—and you too;—at each
ear a hearer; that great baby you see there is not yet
out of his swaddling clouts.

ROSENCRANTZ Happily, he's the second time come to
them; for, they say, an old man is twice a child.

HAMLET I will prophesy he comes to tell me of the players;
mark it.—You say right, sir: o' Monday morning;
'twas so, indeed.

POLONIUS My lord, I have news to tell you.

HAMLET My lord, I have news to tell you. When Roscius[23]
was an actor in Rome,— 410

POLONIUS The actors are come hither, my lord.

HAMLET Buz, buz!

POLONIUS Upon mine honour,—

HAMLET Then came each actor on his ass,—

POLONIUS The best actors in the world, either for tragedy,
comedy, history, pastoral, pastoral-comical, historical-
pastoral, tragical-historical, tragical-comical-
historical-pastoral, scene individable, or poem un-
limited: Seneca[24] cannot be too heavy, nor Plautus[25]
too light. For the law of writ and the liberty, these are
the only men. 421

HAMLET O Jephthah, judge of Israel, what a treasure
hadst thou!

POLONIUS What a treasure had he, my lord?

HAMLET Why—
"One fair daughter, and no more,
The which he loved passing well."

POLONIUS *[Aside]* Still on my daughter.

HAMLET Am I not i' the right, old Jephthah?

POLONIUS If you call me Jephthah, my lord, I have a
daughter, that I love passing well. 431

HAMLET Nay, that follows not.

POLONIUS What follows then, my lord?

HAMLET Why,
"As by lot, God wot," and then you know,
"It came to pass, as most like it was,"—the first row of
the pious chanson will show you more: for look,
where my abridgments come.

ENTER FOUR OR FIVE PLAYERS.

You are welcome, masters; welcome all. I am glad to see
thee well. Welcome, good friends.—O, my old friend!
Thy face is valanced[26] since I saw thee last: com'st
thou to beard me in Denmark?—What! my young
lady and mistress! By'r lady, your ladyship is nearer to
heaven, than when I saw you last, by the altitude of a
chopine.[27] Pray God, your voice, like a piece of
uncurrent gold, be not cracked within the ring.—
Masters, you are all welcome. We'll e'en to't like

French falconers, fly at any thing we see: we'll have a
speech straight: come, give us a taste of your quality;
come, a passionate speech. 452

FIRST PLAYER What speech, my good lord?

HAMLET I heard thee speak me a speech once, but it was
never acted; or, if it was, not above once; for the play,
I remember, pleased not the million; 'twas caviare to
the general: but it was, as I received it, and others,
whose judgments, in such matters, cried in the top of
mine, an excellent play, well digested in the scenes, set
down with as much modesty as cunning. I remember,
one said, there were no sallets[28] in the lines to make
the matter savoury, nor no matter in the phrase that
might indict the author of affection; but called it an
honest method, as wholesome as sweet, and by very
much more handsome than fine. One speech in it I
chiefly loved: 'twas Æneas' tale to Dido; and there-
about of it especially, where he speaks of Priam's
slaughter. If it live in your memory, begin at this line;
let me see, let me see;— 470
"The rugged Pyrrhus, like the Hyrcanian beast,"[29]—
'tis not so; it begins with "Pyrrhus."
"The rugged Pyrrhus, he, whose sable arms,
Black as his purpose, did the night resemble
When he lay couched in the ominous horse,
Hath now this dread and black complexion smeared
With heraldry more dismal; head to foot
Now is he total gules; horridly tricked[30]
With blood of fathers, mothers, daughters, sons,
Baked and impasted with the parching streets,
That lend a tyrannous and damned light 481
To their lords' murther: roasted in wrath and fire,
And thus o'er-sized with coagulate gore,
With eyes like carbuncles, the hellish Pyrrhus
Old grandsire Priam seeks."
So, proceed you.

POLONIUS 'Fore God, my lord, well spoken; with good
accent and good discretion.

FIRST PLAYER "Anon he finds him
Striking too short at Greeks; his antique sword,
Rebellious to his arm, lies where it falls, 491
Repugnant to command: unequal matched,
Pyrrhus at Priam drives; in rage strikes wide;
But with the whiff and wind of his fell sword
The unnerved father falls. Then senseless Ilium,
Seeming to feel this blow, with flaming top
Stoops to his base; and with a hideous crash
Takes prisoner Pyrrhus' ear: for, lo! his sword,
Which was declining on the milky head
Of reverend Priam, seemed i' the air to stick:
So, as a painted tyrant, Pyrrhus stood, 501
And, like a neutral to his will and matter,
Did nothing.
But as we often see, against some storm,
A silence in the heavens, the rack[31] stand still,
The bold winds speechless and the orb below
As hush as death, anon the dreadful thunder
Doth rend the region: so after Pyrrhus' pause
Aroused vengeance sets him new a-work;
And never did the cyclops hammer fall 510
On Mars's armour, forged for proof eterne,
with less remorse than Pyrrhus' bleeding sword
Now falls on Priam.—
Out, out, thou strumpet, Fortune! All you gods,
In general synod[32] take away her power;
Break all the spokes and fellies[33] from her wheel,
And bowl the round nave[34] down the hill of heaven,
As low as to the fiends."

POLONIUS This is too long.

HAMLET It shall to the barber's with your beard.—Prithee,
say on: he's for a jig, or a tale of bawdry, or he sleeps:
say on: come to Hecuba.

FIRST PLAYER "But who, O who, had seen the mobled[35]
queen—" 524

HAMLET "The mobled queen?"

POLONIUS That's good: "mobled queen" is good.

FIRST PLAYER "Run barefoot up and down, threatening
the flames
With bisson rheum;[36] a clout[37] about that head,
Where late the diadem stood; and for a robe,
About her lank and all o'er-teemed loins,
A blanket, in the alarm of fear caught up;
Who this had seen, with tongue in venom steeped,
'Gainst Fortune's state would treason have pronounced;
But if the gods themselves did see her then,
When she saw Pyrrhus make malicious sport
In mincing with his sword her husband's limbs,
The instant burst of clamour that she made,—
Unless things mortal move them not at all,—
Would have made milch the burning eyes of heaven,
And passion in the gods." 540

POLONIUS Look, whether he has not turned his colour and
has tears in's eyes.—Pray you, no more.

HAMLET 'Tis well; I'll have thee speak out the rest soon.—
Good my lord, will you see the players well
bestowed?[38] Do you hear, let them be well used; for
they are the abstract and brief chronicles of the time:
after your death you were better have a bad epitaph
than their ill report while you live.

POLONIUS My lord, I will use them according to their
desert. 551

HAMLET God's bodikins, man, much better! Use every
man after his desert, and who should scape whip-
ping? Use them after your own honour and dignity:
the less they deserve, the more merit is in your bounty.
Take them in.

POLONIUS Come, sirs.

HAMLET Follow him, friends: we'll hear a play tomorrow.
[Exit POLONIUS with all the PLAYERS but the FIRST.] Dost
thou hear me, old friend; can you play "The Murder
of Gonzago"? 561

FIRST PLAYER Ay, my lord.

HAMLET We'll ha't to-morrow night. You could, for a need,
study a speech of some dozen or sixteen lines, which I
would set down, and insert in't?, could you not?

FIRST PLAYER Ay, my lord.

HAMLET Very well. Follow that lord; and look you mock
him not. [Exit PLAYER] My good friends,
[To ROSENCRANTZ and GUILDENSTERN] I'll leave you till
night; you are welcome to Elsinore. 571

ROSENCRANTZ Good my lord!

HAMLET Ay, so, God b'uy ye. [Exeunt ROSENCRANTZ and
GUILDENSTERN.] Now I am alone.
O what a rogue and peasant slave am I!
Is it not monstrous that this player here,
But in a fiction, in a dream of passion,
Could force his soul so to his own conceit[39]
That from her working, all his visage wanned;
Tears in his eyes, distraction in's aspect, 580
A broken voice, and his whole function suiting
With forms to his conceit? And all for nothing!
For Hecuba!
What's Hecuba to him, or he to Hecuba,
That he should weep for her? What would he do,
Had he the motive and the cue for passion
That I have? He would drown the stage with tears,

And cleave the general ear with horrid speech,
Make mad the guilty and appal the free,
Confound the ignorant, and amaze indeed 590
The very faculties of eyes and ears. Yet I,
A dull and muddy-mettled rascal, peak,
Like John-a-dreams, unpregnant of my cause,
And can say nothing; no, not for a king,
Upon whose property, and most dear life,
A damned defeat was made. Am I a coward?
Who calls me villain? breaks my pate across?
Plucks off my beard, and blows it in my face?
Tweaks me by the nose? gives me the lie i' the throat,
As deep as to the lungs? Who does me this? 600
Ha! 'swounds, I should take it: for it cannot be,
But I am pigeon-livered, and lack gall
To make oppression bitter; or, ere this,
I should ha' fatted all the region kites⁴⁰
With this slave's offal: bloody, bawdy villain!
Remorseless, treacherous, lecherous, kindless villain!
O vengeance!
Why, what an ass am I! This is most brave;
That I, the son of the dear father murdered,
Prompted to my revenge by heaven and hell,
Must, like a whore, unpack my heart with words,
And fall a-cursing, like a very drab,⁴¹
A scullion!
Fie upon't! foh! About, my brain! Hum, I have heard
That guilty creatures, sitting at a play,
Have by the very cunning of the scene,
Been struck so to the soul that presently
They have proclaimed their malefactions;
For murder, though it have no tongue, will speak
With most miraculous organ. I'll have these players 620
Play something like the murder of my father
Before mine uncle: I'll observe his looks;
I'll tent⁴² him to the quick; if he but blench,
I know my course. The spirit that I have seen
May be the devil: and the devil hath power
To assume a pleasing shape; yea, and perhaps
Out of my weakness and my melancholy,
As he is very potent with such spirits,
Abuses me to damn me. I'll have grounds
More relative than this. The play's the thing 630
Wherein I'll catch the conscience of the king.

<p style="text-align:center">EXIT.</p>

Notes

¹ since
² behavior
³ courtesy
⁴ finally
⁵ rhetorical device
⁶ consider carefully
⁷ had kept secrets
⁸ sphere
⁹ tapestry hanging in front of a wall
¹⁰ dealer in fish (slang for a procurer)
¹¹ meaningful
¹² cells
¹³ faith
¹⁴ exact
¹⁵ scanty
¹⁶ overtook
¹⁷ on hair trigger
¹⁸ nest
¹⁹ financially supported
²⁰ acting profession
²¹ incite
²² behavior

²³ famous comic actor in ancient Rome
²⁴ Roman tragic dramatist
²⁵ Roman comic dramatist
²⁶ fringed with a beard
²⁷ thick-soled shoe
²⁸ salads, spicy jests
²⁹ tiger (Hyrcania was in Asia and notorious for its wild animals)
³⁰ all red, horridly adorned
³¹ clouds
³² council
³³ rims
³⁴ hub
³⁵ muffled
³⁶ blinding tears
³⁷ rag
³⁸ housed
³⁹ imagination
⁴⁰ scavenger birds
⁴¹ prostitute
⁴² probe

ACT III

Scene I. *A room in the castle.* 609

<p style="text-align:center">ENTER KING, QUEEN, POLONIUS, OPHELIA,
ROSENCRANTZ, AND GUILDENSTERN.</p>

KING And can you, by no drift of conference,
 Get from him why he puts on this confusion,
 Grating so harshly all his days of quiet
 With turbulent and dangerous lunacy?
ROSENCRANTZ He does confess he feels himself
 distracted,
 But from what cause 'a will by no means speak.
GUILDENSTERN Nor do we find him forward to be
 sounded,
 But, with a crafty madness, keeps aloof,
 When we would bring him on to some confession
 Of his true state.
QUEEN Did he receive you well? 10
ROSENCRANTZ Most like a gentleman.
GUILDENSTERN But with much forcing of his disposition.
ROSENCRANTZ Niggard of question, but of our demands.
 Most free in his reply.
QUEEN Did you assay¹ him to any pastime?
ROSENCRANTZ Madam, it so fell out that certain players
 We o'er-raught² on the way: of these we told him,
 And there did seem in him a kind of joy
 To hear of it: they are here about the court
 And, as I think, they have already order 20
 This night to play before him.
POLONIUS 'Tis most true;
 And he beseeched me to entreat your majesties
 To hear and see the matter.
KING With all my heart;
 And it doth much content me to hear him so inclined.—
 Good gentlemen, give him a further edge,
 And drive his purpose on to these delights.
ROSENCRANTZ We shall, my lord.

<p style="text-align:center">EXEUNT ROSENCRANTZ AND GUILDENSTERN.</p>

KING Sweet Gertrude, leave us too:
 For we have closely sent for Hamlet hither,
 That he, as 'twere by accident, may here
 Affront Ophelia. Her father, and myself, 30
 Will so bestow ourselves that, seeing unseen,
 We may of their encounter frankly judge,
 And gather by him, as he is behaved,
 If't be the affliction of his love or no
 That thus he suffers for.

QUEEN I shall obey you.—
 And for your part, Ophelia, I do wish
 That your good beauties be the happy cause
 Of Hamlet's wildness; so shall I hope your virtues
 Will bring him to his wonted way again,
 To both your honours.
OPHELIA Madam, I wish it may. 40
POLONIUS Ophelia, walk you here.—Gracious, so
 please you,
 We will bestow ourselves. *[To* OPHELIA*]* Read on this book;
 That show of such an exercise may colour
 Your loneliness. We are oft to blame in this,—
 'Tis too much proved,—that with devotion's visage,
 And pious action we do sugar o'er
 The devil himself.
KING *[Aside]* O, 'tis too true!
 How smart a lash that speech doth give my conscience!
 The harlot's cheek, beautied with plastering art,
 Is not more ugly to the thing that helps it, 50
 Than is my deed to my most painted word.
 O heavy burthen!
POLONIUS I hear him coming; let's withdraw, my lord.

 EXEUNT KING AND POLONIUS.

 ENTER HAMLET.

HAMLET To be; or not to be,—that is the question:
 Whether 'tis nobler in the mind to suffer
 The slings and arrows of outrageous fortune,
 Or to take arms against a sea of troubles,
 And by opposing end them? To die,—to sleep,—
 No more; and by a sleep to say we end
 The heartache, and the thousand natural shocks 60
 That flesh is heir to,—'tis a consummation
 Devoutly to be wished. To die;—to sleep;—
 To sleep! perchance to dream;—ay, there's the rub;
 For in that sleep of death what dreams may come,
 When we have shuffled off this mortal coil,
 Must give us pause: there's the respect,
 That makes calamity of so long life:
 For who would bear the whips and scorns of time,
 The oppressor's wrong, the proud man's contumely,
 The pangs of disprized love, the law's delay, 70
 The insolence of office, and the spurns
 That patient merit of the unworthy takes,
 When he himself might his quietus[3] make
 With a bare bodkin?[4] Who would fardels[5] bear,
 To grunt and sweat under a weary life,
 But that the dread of something after death,
 The undiscovered country, from whose bourne[6]
 No traveller returns, puzzles the will,
 And makes us rather bear those ills we have
 Than fly to others that we know not of? 80
 Thus conscience does make cowards of us all;
 And thus the native hue of resolution
 Is sicklied o'er with the pale cast[7] of thought;
 And enterprises of great pitch[8] and moment,
 With this regard their currents turn awry
 And lose the name of action. Soft you now!
 The fair Ophelia?—Nymph, in thy orisons[9]
 Be all my sins remembered.
OPHELIA Good my lord,
 How does your honour for this many a day?
HAMLET I humbly thank you; well, well, well. 90
OPHELIA My lord, I have remembrances of yours,
 That I have longed long to re-deliver;
 I pray you, now receive them.
 HAMLET No, not I; I never gave you aught.

OPHELIA My honoured lord, you know right well you did;
 And with them words of so sweet breath composed
 As made these things more rich: their perfume lost,
 Take these again; for to the noble mind,
 Rich gifts wax poor, when givers prove unkind.
 There, my lord. 100
HAMLET Ha, ah! are you honest?
OPHELIA My lord?
HAMLET Are you fair?
OPHELIA What means your lordship?
HAMLET That if you be honest and fair, your honesty
 should admit no discourse to your beauty.
OPHELIA Could beauty, my lord, have better commerce
 than with honesty?
HAMLET Ay, truly; for the power of beauty will sooner
 transform honesty from what it is to a bawd,[10] than
 the force of honesty can translate beauty into his like-
 ness: this was sometime a paradox, but now the time
 gives it proof. I did love you once. 114
OPHELIA Indeed, my lord, you made me believe so.
HAMLET You should not have believed me: for virtue can-
 not so inoculate our old stock, but we shall relish of it;
 I loved you not.
OPHELIA I was the more deceived.
HAMLET Get thee to a nunnery; why wouldst thou be a
 breeder of sinners? I am myself indifferent honest; but
 yet I could accuse me of such things that it were better
 my mother had not borne me: I am very proud, re-
 vengeful, ambitious; with more offences at my beck
 than I have thoughts to put them in, imagination to
 give them shape, or time to act them in. What should
 such fellows as I do crawling between heaven and
 earth? We are arrant knaves all; believe none of us. Go
 thy ways to a nunnery. Where's your father? 130
OPHELIA At home, my lord.
HAMLET Let the doors be shut upon him, that he may play
 the fool no where but in's own house. Farewell.
OPHELIA O, help him, you sweet heavens!
HAMLET If thou dost marry, I'll give thee this plague for
 thy dowry: be thou as chaste as ice, as pure as snow,
 thou shalt not escape calumny. Get thee to a nunnery,
 go; farewell. Or, if thou wilt needs marry, marry a fool;
 for wise men know well enough what monsters you
 make of them. To a nunnery, go; and quickly too.
 Farewell. 142
OPHELIA O heavenly powers, restore him!
HAMLET I have heard of your paintings too, well enough.
 God hath given you one face, and you make your-
 selves another; you jig, you amble, and you lisp, and
 nickname God's creatures, and make your wanton-
 ness your ignorance. Go to, I'll no more on't; it hath
 made me mad. I say, we will have no moe[11] marriage:
 those that are married already, all but one, shall live;
 the rest shall keep as they are. To a nunnery, go.

 EXIT HAMLET.

OPHELIA O, what a noble mind is here o'erthrown! 153
 The courtier's, soldier's, scholar's, eye, tongue, sword:
 The expectancy and rose of the fair state,
 The glass of fashion, and the mould of form,
 The observed of all observers, quite, quite down!
 And I, of ladies most deject and wretched,
 That sucked the honey of his music-vows,
 Now see that noble and most sovereign reason,
 Like sweet bells jangled, out of time and harsh;
 That unmatched form and stature of blown youth, 162
 Blasted with ecstasy:[12] O, woe is me!
 To have seen what I have seen, see what I see!

RE-ENTER KING AND POLONIUS.

KING Love! his affections do not that way tend;
 Nor what he spake, though it lacked form a little,
 Was not like madness. There's something in his soul,
 O'er which his melancholy sits on brood;
 And I do doubt the hatch and the disclose,
 Will be some danger: which for to prevent, 170
 I have in quick determination
 Thus set it down: he shall with speed to England,
 For the demand of our neglected tribute:
 Haply the seas and countries different
 With variable objects shall expel
 This something-settled matter in his heart,
 Whereon his brains still beating puts him thus
 From fashion of himself. What think you on't?

POLONIUS It shall do well; but yet do I believe,
 The origin and commencement of his grief
 Sprung from neglected love.—How now, Ophelia? 181
 You need not tell us what Lord Hamlet said;
 We heard it all.—My Lord, do as you please;
 But, if you hold it fit, after the play,
 Let his queen mother all alone entreat him
 To show his grief; let her be round with him;
 And I'll be placed, so please you, in the ear
 Of all their conference. If she find him not, 188
 To England send him, or confine him where
 Your wisdom best shall think.

KING It shall be so;
 Madness in great ones must not unwatched go.

EXEUNT.

Notes

[1] tempt
[2] overtook
[3] full discharge (a legal term)
[4] dagger
[5] burdens
[6] regions
[7] color
[8] height
[9] prayers
[10] procurer
[11] more
[12] madness

Scene II. *A hall in the same.*

ENTER HAMLET AND PLAYERS.

HAMLET Speak the speech, I pray you, as I pronounced it
 to you, trippingly on the tongue: but if you mouth it,
 as many of our players do, I had as lief the town-crier
 spoke my lines. Nor do not saw the air too much with
 your hand, thus: but use all gently: for in the very tor-
 rent, tempest, and, as I may say, whirlwind of your
 passion, you must acquire and beget a temperance
 that may give it smoothness. O, it offends me to the
 soul, to hear a robustious periwig-pated fellow tear a
 passion to tatters, to very rags, to split the ears of the
 groundlings;[1] who, for the most part, are capable of
 nothing but inexplicable dumb-shows and noise: I
 would have such a fellow whipped for o'erdoing
 Termagant; it out-herods Herod:[2] pray you, avoid it.

FIRST PLAYER I warrant your honour.

HAMLET Be not too tame neither, but let your own discre-
 tion be your tutor: suit the action to the word, the
 word to the action; with this special observance, that
 you o'er-step not the modesty of nature; for anything

so overdone is from the purpose of playing, whose
end, both at the first and now, was and is, to hold, as
'twere, the mirror up to nature; to show virtue her
own feature, scorn her own image, and the very age
and body of the time his form and pressure. Now this
overdone, or come tardy off, though it make the un-
skilful laugh, cannot but make the judicious grieve;
the censure of the which one must in your allowance
o'er-weigh a whole theatre of others. O, there be play-
ers that I have seen play, and heard others praise, and
that highly, not to speak it profanely, that neither
having the accent of Christians nor the gait of Chris-
tian, pagan, nor man, have so strutted and bellowed,
that I have thought some of nature's journeymen had
made them, and not made them well, they imitated
humanity so abominably. 39

FIRST PLAYER I hope we have reformed that indifferently[3]
 with us, sir.

HAMLET O, reform it altogether. And let those that play
 your clowns speak no more than is set down for them;
 for there be of them that will themselves laugh, to set
 on some quantity of barren spectators to laugh too,
 though in the mean time some necessary question of
 the play be then to be considered: that's villainous;
 and shows a most pitiful ambition in the fool that uses
 it. Go, make you ready.—

EXEUNT PLAYERS.

ENTER POLONIUS, ROSENCRANTZ, AND GUILDENSTERN.

How now, my lord? will the king hear this piece of work? 51

POLONIUS And the queen too, and that presently.

HAMLET Bid the players make haste.

EXIT POLONIUS.

Will you two help to hasten them?

BOTH We will, my lord.

EXEUNT ROSENCRANTZ AND GUILDENSTERN.

HAMLET What, ho! Horatio!

ENTER HORATIO.

HORATIO Here, sweet lord, at your service.

HAMLET Horatio, thou art e'en as just a man
 As e'er my conversation coped withal.

HORATIO O, my dear lord,—

HAMLET Nay, do not think I flatter: 60
 For what advancement may I hope from thee,
 That no revenue hast but thy good spirits,
 To feed and clothe thee? Why should the poor be
 flattered?
 No, let the candied[4] tongue lick absurd pomp,
 And crook the pregnant hinges of the knee
 Where thrift may follow fawning. Dost thou hear?
 Since my dear soul was mistress of her choice,
 And could of men distinguish, her election
 Hath sealed thee for herself: for thou hast been
 As one, in suffering all, that suffers nothing; 70
 A man that fortune's buffets and rewards
 Hath ta'en with equal thanks: and blest are those,
 Whose blood and judgment are so well commingled,
 That they are not a pipe for fortune's finger
 To sound what stop she please. Give me that man
 That is not passion's slave, and I will wear him
 In my heart's core, ay, in my heart of heart,
 As I do thee. Something too much of this.
 There is a play to-night before the king;
 One scene of it comes near the circumstance 80
 Which I have told thee of my father's death.

I prithee, when thou seest that act a-foot,
Even with the very comment of my soul
Observe my uncle: if his occulted[5] guilt
Do not itself unkennel in one speech,
It is a damned ghost that we have seen;
And my imaginations are as foul
As Vulcan's stithy.[6] Give him heedful note:
For I mine eyes will rivet to his face;
And after we will both our judgments join 90
To censure of his seeming.

HORATIO Well, my lord:
 If he steal aught the whilst this play is playing,
 And scape detecting, I will pay the theft.

HAMLET They are coming to the play; I must be idle:
 Get you a place.

DANISH MARCH. FLOURISH. ENTER KING, QUEEN, POLONIUS,
OPHELIA, ROSENCRANTZ, GUILDENSTERN, AND OTHER
LORDS.

ATTENDANT, WITH THE GUARD, CARRYING TORCHES.

KING How fares our cousin Hamlet?

HAMLET Excellent, i' faith; of the chameleon's dish:[7] I eat
 the air, promise-crammed: you cannot feed capons so.

KING I have nothing with this answer, Hamlet; these words
 are not mine. 101

HAMLET No, nor mine now. [To POLONIUS]
 My lord, you played once i' the university, you say?

POLONIUS That I did, my lord, and was accounted a good
 actor.

HAMLET And what did you enact?

POLONIUS I did enact Julius Caesar: I was killed i' the
 Capitol: Brutus killed me.

HAMLET It was a brute part of him to kill so capital a calf
 there.—Be the players ready? 111

ROSENCRANTZ Ay, my lord; they stay upon your patience.

QUEEN Come hither, my dear Hamlet, sit by me.

HAMLET No, good mother, here's metal more attractive.

POLONIUS [To the KING] O ho! do you mark that?

HAMLET Lady, shall I lie in your lap?

LYING DOWN AT OPHELIA'S FEET.

OPHELIA No, my lord.

HAMLET I mean, my head upon your lap? 120

OPHELIA Ay, my lord.

HAMLET Do you think I meant country matters?

OPHELIA I think nothing, my lord.

HAMLET That's a fair thought to lie between maids' legs.

OPHELIA What is, my lord?

HAMLET Nothing.

OPHELIA You are merry, my lord.

HAMLET Who, I?

OPHELIA Ay, my lord. 130

HAMLET O God! your only jig-maker. What should a man
 do but be merry? for, look you, how cheerfully my
 mother looks, and my father died within's two hours.

OPHELIA Nay, 'tis twice two months, my lord.

HAMLET So long? Nay, then let the devil wear black, for I'll
 have a suit of sables. O heavens! die two months ago,
 and not forgotten yet? Then there's hope a great man's
 memory may outlive his life half a year: but, by'r lady,
 'a must build churches then: or else shall 'a suffer not
 thinking on, with the hobby-horse; whose epitaph is,
 "For, O, for, O, the hobby-horse is forgot." 143

HAUTBOYS PLAY. THE DUMB SHOW ENTERS.

ENTER A KING AND A QUEEN, VERY LOVINGLY; THE QUEEN
EMBRACING HIM, AND HE HER. SHE KNEELS, AND MAKES SHOW
OF PROTESTATION UNTO HIM. HE TAKES HER UP, AND DECLINES

HIS HEAD UPON HER NECK: LAYS HIM DOWN UPON A BANK OF
FLOWERS; SHE, SEEING HIM ASLEEP, LEAVES HIM. ANON COMES
IN A FELLOW, TAKES OFF HIS CROWN, KISSES IT, AND POURS
POISON IN THE KING'S EARS, AND EXIT. THE QUEEN RETURNS;
FINDS THE KING DEAD, AND MAKES PASSIONATE ACTION. THE
POISONER, WITH SOME TWO OR THREE MUTES, COMES IN AGAIN,
SEEMING TO LAMENT WITH HER. THE DEAD BODY IS CARRIED
AWAY. THE POISONER WOOS THE QUEEN WITH GIFTS; SHE
SEEMS LOTH AND UNWILLING A WHILE, BUT, IN THE END
ACCEPTS HIS LOVE.

EXEUNT.

OPHELIA What means this, my lord?

HAMLET Marry, this is miching mallecho;[8] it means mis-
 chief.

OPHELIA Belike this show imports the argument of
 the play?

ENTER PROLOGUE.

HAMLET We shall know by this fellow: the players cannot
 keep counsel; they'll tell all. 150

OPHELIA Will he tell us what this show meant?

HAMLET Ay, or any show that you'll show him: be not you
 ashamed to show, he'll not shame to tell you what it
 means.

OPHELIA You are naught, you are naught; I'll mark
 the play.

PROLOGUE For us, and for our tragedy
 Here stooping to your clemency,
 We beg your hearing patiently.

HAMLET Is this a prologue, or the posy of a ring?

OPHELIA 'Tis brief, my lord. 161

HAMLET As woman's love.

ENTER TWO PLAYERS, KING AND QUEEN.

PLAYER KING Full thirty times hath Phœbus' cart[9]
 gone round
 Neptune's salt wash[10] and Tellus'[11] orbed ground,
 And thirty dozen moons with borrowed sheen,
 About the world have times twelve thirties been,
 Since love our hearts and Hymen did our hands,
 Unite commutual in most sacred bands.

PLAYER QUEEN So many journeys may the sun and moon
 Make us again count o'er ere love be done! 170
 But, woe is me, you are so sick of late,
 So far from cheer and from your former state,
 That I distrust you. Yet, though I distrust,
 Discomfort you, my lord, it nothing must;
 For women's fear and love hold quantity,
 In neither aught, or in extremity.
 Now, what my love is, proof hath made you know;
 And as my love is sized, my fear is so.
 Where love is great, the littlest doubts are fear;
 Where little fears grow great, great love grows there. 180

PLAYER KING 'Faith, I must leave thee, love, and
 shortly too;
 My operant[12] powers my functions leave to do:
 And thou shalt live in this fair world behind,
 Honoured, beloved; and haply one as kind
 For husband shalt thou—

PLAYER QUEEN O, confound the rest!
 Such love must needs be treason in my breast:
 In second husband let me be accurst!
 None wed the second but who killed the first.

HAMLET [Aside] Wormwood,[13] wormwood.

PLAYER QUEEN The instances that second marriage move, 190
 Are base respects of thrift, but none of love;
 A second time I kill my husband dead,
 When second husband kisses me in bed.

PLAYER KING I do believe you think what now you speak;
 But what we do determine oft we break.
 Purpose is but the slave to memory,
 Of violent birth but poor validity:
 Which now, like fruit unripe, sticks on the tree,
 But fall unshaken when they mellow be.
 Most necessary 'tis that we forget 200
 To pay ourselves what to ourselves is debt:
 What to ourselves in passion we propose,
 The passion ending, doth the purpose lose.
 The violence of either grief or joy
 Their own enactures[14] with themselves destroy:
 Where joy most revels, grief doth most lament;
 Grief joys, joy grieves, on slender accident.
 This world is not for aye, nor 'tis not strange,
 That even our loves should with our fortunes change,
 For 'tis a question left us yet to prove, 210
 Whether love lead fortune or else fortune love.
 The great man down, you mark his favourite flies;
 The poor advanced makes friends of enemies;
 And hitherto doth love on fortune tend:
 For who not needs shall never lack a friend,
 And who in want a hollow friend doth try
 Directly seasons him his enemy.
 But, orderly to end where I begun,
 Our wills and fates do so contrary run,
 That our devices still are overthrown, 220
 Our thoughts are ours, their ends none of our own;
 So think thou wilt no second husband wed;
 But die thy thoughts when thy first lord is dead.
PLAYER QUEEN Nor earth to me give food nor heaven
 light!
 Sport and repose lock from me, day and night!
 To desperation turn my trust and hope!
 And anchor's[15] cheer in prison be my scope!
 Each opposite, that blanks the face of joy,
 Meet what I would have well and it destroy!
 Both here and hence pursue me lasting strife,
 If, once a widow, ever I be wife! 231
HAMLET *[To* OPHELIA*]* If she should break it now!
PLAYER KING 'Tis deeply sworn. Sweet, leave me here
 awhile;
 My spirits grow dull, and fain I would beguile
 The tedious day with sleep.

SLEEPS.

PLAYER QUEEN Sleep rock thy brain
 And never come mischance between us twain!

EXIT.

HAMLET Madam, how like you this play?
QUEEN The lady doth protest too much, methinks.
HAMLET O, but she'll keep her word.
KING Have you heard the argument? Is there no
 offence in't? 240
HAMLET No, no, they do but jest, poison in jest; no offence
 i' the world.
KING What do you call the play?
HAMLET "The Mouse-trap." Marry, how? Tropically. This
 play is the image of a murder done in Vienna: Gon-
 zago is the Duke's name; his wife, Baptista: you shall
 see anon; 'tis a knavish piece of work: but what o'
 that? your majesty, and we that have free souls, it
 touches us not: let the galled jade wince,[16] our withers
 are unwrung.—

ENTER LUCIANUS.

This is one Lucianus, nephew to the king. 251

OPHELIA You are as good as a chorus, my lord.
HAMLET I could interpret between you and your love, if I
 could see the puppets dallying.
OPHELIA You are keen, my lord, you are keen.
HAMLET It would cost you a groaning, to take off my edge.
OPHELIA Still better and worse.
HAMLET So you mistake your husbands.—Begin,
 murderer. Pox, leave thy damnable faces, and
 begin. Come; 261
 "the croaking raven
 Doth bellow for revenge."
LUCIANUS Thoughts black, hands apt, drugs fit, and time
 agreeing;
 Confederate season, else no creature seeing;
 Thou mixture rank, of midnight weeds collected,
 With Hecate's[17] ban thrice blasted, thrice infected,
 Thy natural magic and dire property,
 On wholesome life usurp immediately.

POURS THE POISON IN THE SLEEPER'S EAR.

HAMLET 'A poisons him i' the garden for his estate. His
 name's Gonzago; the story is extant, and writ in very
 choice Italian: you shall see anon, how the murderer
 gets the love of Gonzago's wife. 273
OPHELIA The king rises.
HAMLET What, frighted with false fire!
QUEEN How fares my lord?
POLONIUS Give o'er the play.
KING Give me some light.—Away!
ALL Lights, lights, lights!

EXEUNT ALL BUT HAMLET AND HORATIO.

HAMLET Why, let the strucken deer go weep, 280
 The hart ungalled play:
 For some must watch, while some must sleep;
 Thus runs the world away.
 Would not this, sir, and a forest of feathers,—if the rest of
 my fortunes turn Turk with me,— with two Provincial
 roses on my razed[18] shoes, get me a fellowship in a
 cry[19] of players, sir?
HORATIO Half a share.
HAMLET A whole one, I.
 For thou dost know, O Damon dear, 290
 This realm dismantled was
 Of Jove himself; and now reigns here
 A very, very—pajock.[20]
HORATIO You might have rhymed.
HAMLET O good Horatio, I'll take the ghost's word for a
 thousand pound. Didst perceive?
HORATIO Very well, my lord.
HAMLET Upon the talk of the poisoning,—
HORATIO I did very well note him.
HAMLET Ah, ha! Come, some music! come, the
 recorders!— 301
 For if the king like not the comedy,
 Why then, belike,—he likes it not, perdy.[21]

ENTER ROSENCRANTZ AND GUILDENSTERN.

Come, some music.
GUILDENSTERN Good my lord, vouchsafe me a word
 with you.
HAMLET Sir, a whole history.
GUILDENSTERN The king, sir,—
HAMLET Ay, sir, what of him?
GUILDENSTERN Is, in his retirement marvellous
 distempered. 311
HAMLET With drink, sir?
GUILDENSTERN No, my lord, rather with choler.

HAMLET Your wisdom should show itself more richer to
 signify this to the doctor; for, for me to put him to his
 purgation would perhaps plunge him into far more
 choler.

GUILDENSTERN Good my lord, put your discourse into
 some frame, and start not so wildly from my affair. 320

HAMLET I am tame, sir; pronounce.

GUILDENSTERN The queen, your mother, in most great
 affliction of spirit, hath sent me to you.

HAMLET You are welcome.

GUILDENSTERN Nay, good my lord, this courtesy is not of
 the right breed. If it shall please you to make me a
 wholesome answer, I will do your mother's com-
 mandment: if not, your pardon and my return shall be
 the end of my business.

HAMLET Sir, I cannot. 330

GUILDENSTERN What, my lord?

HAMLET Make you a wholesome answer; my wit's
 diseased: but, sir, such answers as I can make, you
 shall command; or rather, as you say, my mother:
 therefore no more but to the matter; my mother,
 you say,—

ROSENCRANTZ Then thus she says: your behaviour hath
 struck her into amazement and admiration.[22]

HAMLET O wonderful son, that can so 'stonish a mother!
 But is there no sequel at the heels of this mother's
 admiration? Impart. 341

ROSENCRANTZ She desires to speak with you in her
 closet, ere you go to bed.

HAMLET We shall obey, were she ten times our mother.
 Have you any further trade with us?

ROSENCRANTZ My lord, you once did love me.

HAMLET And do still, by these pickers and stealers.[23]

ROSENCRANTZ Good my lord, what is your cause of dis-
 temper? you do surely bar the door upon your own
 liberty, if you deny your griefs to your friend. 351

HAMLET Sir, I lack advancement.

ROSENCRANTZ How can that be, when you have the
 voice of the king himself for your succession in
 Denmark?

HAMLET Ay, sir, but "while the grass grows,"— the
 proverb is something musty.

RE-ENTER PLAYERS, WITH RECORDERS.

O, the recorders! let me see one.—To withdraw with
 you:—why do you go about to recover the wind of
 me, as if you would drive me into a toil?[24]

GUILDENSTERN O, my lord, if my duty be too bold, my
 love is too unmannerly. 362

HAMLET I do not well understand that. Will you play upon
 this pipe?

GUILDENSTERN My lord, I cannot.

HAMLET I pray you.

GUILDENSTERN Believe me, I cannot.

HAMLET I do beseech you.

GUILDENSTERN I know no touch of it, my lord.

HAMLET It is as easy as lying: govern these ventages[25] with your
 fingers and thumb, give it breath with your
 mouth, and it will discourse most eloquent music.
 Look you, these are the stops. 373

GUILDENSTERN But these cannot I command to any
 utterance of harmony; I have not the skill.

HAMLET Why, look you now, how unworthy a thing you
 make of me! You would play upon me: you would
 seem to know my stops; you would pluck out the
 heart of my mystery; you would sound me from my
 lowest note to the top of my compass: and there is
 much music, excellent voice, in this little organ; yet

cannot you make it speak.—'Sblood, do you think I
 am easier to be played on than a pipe? Call me what
 instrument you will, though you can fret me, you
 cannot play upon me.— 386

RE-ENTER POLONIUS.

God bless you, sir!

POLONIUS My lord, the queen would speak with you, and
 presently.

HAMLET Do you see yonder cloud that's almost in shape
 of a camel?

POLONIUS By the mass, and 'tis like a camel, indeed.

HAMLET Methinks it is like a weasel.

POLONIUS It is backed like a weasel.

HAMLET Or like a whale?

POLONIUS Very like a whale.

HAMLET Then will I come to my mother by and by.—They
 fool me to the top of my bent.— I will come by and by.

POLONIUS I will say so.

EXIT POLONIUS.

HAMLET "By and by" is easily said.—Leave me, friends. 402

EXEUNT ALL BUT HAMLET.

'Tis now the very witching time of night;
When churchyards yawn, and hell itself breathes out
Contagion to this world: now could I drink hot blood,
And do such bitter business as the day
Would quake to look on. Soft! now to my mother.—
O, heart, lose not thy nature; let not ever
The soul of Nero[26] enter this form bosom:
Let me be cruel, not unnatural: 410
I will speak daggers to her, but use none;
My tongue and soul in this be hypocrites:
How in my words soever she be shent,[27]
To give them seals never, my soul, consent!

EXIT.

Notes

[1] those who stood in the pit of the theater
[2] characters in the old mystery plays
[3] tolerably
[4] flattering
[5] hidden
[6] smithy
[7] air, on which chameleons were believed to live
[8] sneaking mischief
[9] the sun's chariot
[10] the sea
[11] Roman goddess of the earth
[12] active
[13] a bitter herb
[14] acts
[15] anchorite's, hermit's
[16] chapped horse wince
[17] the goddess of witchcraft
[18] ornamented with slashes
[19] company
[20] peacock
[21] by God (French: *par dieu*)
[22] wonder
[23] hands
[24] trap
[25] vents, stops on a recorder
[26] Roman emperor who murdered his mother
[27] rebuked

Scene III. *A room in the castle.*

ENTER KING, ROSENCRANTZ, AND GUILDENSTERN.

KING I like him not, nor stands it safe with us
　To let his madness range. Therefore prepare you;
　I your commission will forthwith dispatch,
　And he to England shall along with you;
　The terms of our estate may not endure
　Hazard so near us as doth hourly grow
　Out of his brows.
GUILDENSTERN We will ourselves provide:
　Most holy and religious fear it is,
　To keep those many many bodies safe,
　That live and feed upon your majesty.　　　　　　10
ROSENCRANTZ The single and peculiar life is bound
　With all the strength and armour of the mind
　To keep itself from noyance; but much more
　That spirit upon whose weal depends and rests
　The lives of many. The cease of majesty¹
　Dies not alone, but like a gulf² doth draw
　What's near it with it: it is a massy wheel,
　Fixed on the summit of the highest mount,
　To whose huge spokes ten thousand lesser things
　Are mortised and adjoined; which, when it falls,　　20
　Each small annexment, petty consequence,
　Attends the boisterous ruin. Never alone
　Did the king sigh, but with a general groan.
KING Arm you, I pray you, to this speedy voyage;
　For we will fetters put upon this fear,
　Which now goes too free-footed.
ROSENCRANTZ, GUILDENSTERN We will haste us.

　　EXEUNT ROSENCRANTZ AND GUILDENSTERN.

　　　ENTER POLONIUS.

POLONIUS My lord, he's going to his mother's closet:
　Behind the arras I'll convey myself,
　To hear the process; I'll warrant she'll tax him home;
　And, as you said, and wisely was it said,　　　　　30
　'Tis meet that some more audience than a mother,
　Since nature makes them partial, should o'erhear
　The speech of vantage. Fare you well, my liege:
　I'll call upon you ere you go to bed,
　And tell you what I know.
KING Thanks, dear my lord.

　　　EXIT POLONIUS.

O, my offence is rank, it smells to heaven;
It hath the primal eldest curse³ upon't,
A brother's murder!—Pray can I not,　　　　　　39
Though inclination be as sharp as will;
My stronger guilt defeats my strong intent,
And, like a man to double business bound,
I stand in pause where I shall first begin,
And both neglect. What if this cursed hand
Were thicker than itself with brother's blood?
Is there not rain enough in the sweet heavens,
To wash it white as snow? Whereto serves mercy
But to confront the visage of offence?
And what's in prayer but this two-fold force,
To be forestalled ere we come to fall,　　　　　　49
Or pardoned being down? Then I'll look up;
My fault is past. But, O, what form of prayer
Can serve my turn? "Forgive me my foul murder!"—
That cannot be, since I am still possessed
Of those effects for which I did the murder,
My crown, mine own ambition and my queen.
May one be pardoned and retain the offence?
In the corrupted currents of this world,
Offence's gilded hand may shove by justice;
And oft 'tis seen the wicked prize itself

Buys out the law: but 'tis not so above:　　　　　60
There is no shuffling, there the action lies
In his true nature; and we ourselves compelled,
Even to the teeth and forehead of our faults,
To give in evidence. What then? what rests?
Try what repentance can. What can it not?
Yet what can it, when one can not repent?
O wretched state! O bosom, black as death!
O limed⁴ soul, that struggling to be free,
Art more engaged! Help, angels! make assay!
Bow, stubborn knees, and, heart with strings of steel,　70
Be soft as sinews of the new-born babe!
All may be well.

　　RETIRES AND KNEELS.

　　　ENTER HAMLET.

HAMLET How might I do it pat, now he is praying;
　And now I'll do't; and so he goes to heaven:
　And so am I revenged? That would be, scanned:
　A villain kills my father; and for that,
　I, his sole son, do this same villain send
　To heaven.
　O, this is hire and salary, not revenge.
　He took my father grossly, full of bread,　　　　80
　With all his crimes broad blown, as flush⁵ as May;
　And how his audit stands who knows save heaven?
　But in our circumstance and course of thought,
　'Tis heavy with him: and am I then revenged,
　To take him in the purging of his soul,
　When he is fit and seasoned for his passage?
　No!
　Up, sword, and know thou a more horrid hent;⁶
　When he is drunk asleep, or in his rage,
　Or in the incestuous pleasure of his bed;　　　　90
　At gaming, swearing; or about some act
　That has no relish of salvation in't:
　Then trip him, that his heels may kick at heaven;
　And that his soul may be damned and black
　As hell, whereto it goes. My mother stays:—
　This physic but prolongs thy sickly days.

　　　EXIT.

KING [*Rising*] My words fly up, my thoughts remain below;
　Words without thoughts never to heaven go.

　　　EXIT.

Notes

¹ end (death) of a king
² whirlpool
³ curse of Cain, who killed Abel
⁴ trapped (birdlime is a sticky substance spread on boughs to snare birds)
⁵ vigorous
⁶ grasp (here, time for seizing)

Scene IV. *The queen's closet.*

　　ENTER QUEEN AND POLONIUS.

POLONIUS 'A will come straight. Look you lay home
　　to him:
　Tell him his pranks have been too broad to bear with,
　And that your grace hath screened and stood between
　Much heat and him. I'll silence me e'en here.
　Pray you, be round with him.
HAMLET [*Within*] Mother! mother! mother!
QUEEN I'll warrant you;
　Fear me not. Withdraw, I hear him coming.

　　POLONIUS HIDES HIMSELF.

ENTER HAMLET.

HAMLET Now, mother; what's the matter?
QUEEN Hamlet, thou hast thy father much offended.
HAMLET Mother, you have my father much offended. 10
QUEEN Come, come, you answer with an idle tongue.
HAMLET Go, go, you question with a wicked tongue.
QUEEN Why, how now, Hamlet?
HAMLET What's the matter now?
QUEEN Have you forgot me?
HAMLET No, by the rood,[1] no so:
 You are the queen, your husband's brother's wife;
 And would it were not so!—you are my mother.
QUEEN Nay, then I'll set those to you that can speak.
HAMLET Come, come, and sit you down; you shall not
 budge;
 You go not till I set you up a glass[2]
 Where you may see the inmost part of you. 20
QUEEN What wilt thou do? thou wilt not murder me? Help,
 help, oh!
POLONIUS [Behind] What, ho! help, help, help!
HAMLET How now! a rat? Dead, for a ducat, dead.

DRAWS. HAMLET MAKES A PASS THROUGH THE ARRAS.

POLONIUS [Behind] O, I am slain!

FALLS AND DIES.

QUEEN O me, what hast thou done?
HAMLET Nay, I know not: is it the king?

LIFTS UP THE ARRAS, AND DRAWS FORTH POLONIUS.

QUEEN O, what a rash and bloody deed is this!
HAMLET A bloody deed! almost as bad, good mother,
 As kill a king, and marry with his brother.
QUEEN As kill a king!
HAMLET Ay, lady, 'twas my word.—
 [To POLONIUS]
 Thou wretched, rash, intruding fool, farewell! 30
 I took thee for thy better; take thy fortune;
 Thou find'st, to be too busy is some danger.—
 Leave wringing of your hands. Peace! sit you down,
 And let me wring your heart: for so I shall,
 If it be made of penetrable stuff;
 If damned custom have not brazed it so,
 That it is proof and bulwark against sense.
QUEEN What have I done, that thou darest wag thy tongue
 In noise so rude against me?
HAMLET Such an act,
 That blurs the grace and blush of modesty, 40
 Calls virtue hypocrite, takes off the rose
 From the fair forehead of an innocent love,
 And sets a blister there; makes marriage vows
 As false as dicers' oaths; O, such a deed
 As from the body of contraction[3] plucks
 The very soul, and sweet religion makes
 A rhapsody of words: heaven's face doth glow;
 Yea, this solidity and compound mass,
 With heated visage, as against the doom,
 Is thought-sick at the act.
QUEEN Ay me, what act, 50
 That roars so loud and thunders in the index?[4]
HAMLET Look here, upon this picture, and on this,
 The counterfeit presentment of two brothers.
 See what a grace was seated on this brow:
 Hyperion's curls; the front of Jove himself;
 An eye like Mars, to threaten and command;
 A station, like the herald Mercury,
 New-lighted on a heaven-kissing hill;

A combination and a form indeed,
Where every god did seem to set his seal 60
To give the world assurance of a man:
This was your husband. Look you now, what follows:
Here is your husband; like a mildewed ear,
Blasting his wholesome brother. Have you eyes?
Could you on this fair mountain leave to feed,
And batten on this moor? Ha! have you eyes?
You cannot call it love, for at your age
The hey-day in the blood is tame, it's humble,
And waits upon the judgment: and what judgment
Would step from this to this? Sense sure you have, 70
Else could you not have motion: but sure that sense
Is apoplexed: for madness would not err,
Nor sense to ecstasy was ne'er so thralled,
But it reserved some quantity of choice,
To serve in such a difference. What devil was't,
That thus hath cozened you at hoodman-blind?[5]
Eyes without feeling, feeling without sight,
Ears without hands or eyes, smelling sans[6] all,
Or but a sickly part of one true sense
Could not so mope. 80
O shame! where is thy blush? Rebellious hell,
If thou canst mutine in a matron's bones,
To flaming youth let virtue be as wax,
And melt in her own fire: proclaim no shame,
When the compulsive ardour gives the charge,
Since frost itself as actively doth burn,
And reason panders will.
QUEEN O Hamlet, speak no more:
 Thou turn'st my very eyes into my soul;
 And there I see such black and grained spots,
 As will not leave their tinct.[7]
HAMLET Nay, but to live 90
 In the rank of sweat of an enseamed bed,
 Stewed in corruption, honeying and making love
 Over the nasty sty;—
QUEEN O, speak to me no more;
 These words like daggers enter in mine ears.
 No more, sweet Hamlet!
HAMLET A murderer and a villain:
 A slave that is not twentieth part the tithe[8]
 Of your precedent lord: a vice of kings:
 A cutpurse of the empire and the rule;
 that from a shelf the precious diadem stole,
 And put it in his pocket!
QUEEN No more! 100
HAMLET A king of shreds and patches:—

ENTER GHOST.

 Save me, and hover o'er me with your wings,
 You heavenly guards!—What would you, gracious
 figure?
QUEEN Alas! he's mad!
HAMLET Do you not come your tardy son to chide,
 That, lapsed in time and passion, lets go by
 The important acting of your dread command?
 O, say!
GHOST Do not forget. This visitation
 Is but to whet thy almost blunted purpose.
 But, look, amazement on thy mother sits: 110
 O, step between her and her fighting soul;
 Conceit in weakest bodies strongest works:
 Speak to her, Hamlet.
HAMLET How is it with you, lady?
QUEEN Alas, how is't with you,
 That you do bend your eye on vacancy,
 And with the incorporal air do hold discourse?

Forth at your eyes your spirits wildly peep;
And as the sleeping soldiers in the alarm,
Your bedded hair,[9] like life in excrements,
Starts up and stands on end. O gentle son, 120
Upon the heat and flame of thy distemper
Sprinkle cool patience. Whereon do you look?

HAMLET On him, on him! Look you, how pale he glares!
His form and cause conjoined, preaching to stones,
Would make them capable.—Do not look upon me;
Lest, with this piteous action you convert
My stern effects: then what I have to do
Will want true colour! tears perchance for blood.

QUEEN To whom do you speak this?

HAMLET Do you see nothing there?

QUEEN Nothing at all; yet all that is I see. 130

HAMLET Nor did you nothing hear?

QUEEN No, nothing but ourselves.

HAMLET Why, look you there! look, how it steals away!
My father, in his habit as he lived!
Look, where he goes, even now, out at the portal!

EXIT GHOST.

QUEEN This is the very coinage of your brain:
This bodiless creation ecstasy
Is very cunning in.

HAMLET "Ecstasy!"
My pulse, as yours, doth temperately keep time,
And makes as healthful music: it is not madness
That I have uttered: bring me to the test, 140
And I the matter will re-word, which madness
Would gambol from. Mother, for love of grace,
Lay not that flattering unction to your soul,
That not your trespass but my madness speaks:
It will but skin and film the ulcerous place,
Whiles rank corruption, mining[10] all within,
Infects unseen. Confess yourself to heaven;
Repent what's past, avoid what is to come;
And do not spread the compost on the weeds,
To make them ranker. Forgive me this my virtue, 150
For in the fatness of these pursy[11] times,
Virtue itself of vice must pardon beg,
Yea, courb and woo for leave to do him good.

QUEEN O Hamlet, thou hast cleft my heart in twain.

HAMLET O, throw away the worser part of it,
And live the purer with the other half.
Good night: but go not to mine uncle's bed;
Assume a virtue, if you have it not.
That monster, custom, who all sense doth eat,
Of habits devil, is angel yet in this, 160
That to the use of actions fair and good
He likewise gives a frock or livery,
That aptly is put on. Refrain to-night,
And that shall lend a kind of easiness
To the next abstinence: the next more easy;
For use almost can change the stamp of nature,
And either master the devil, or throw him out
With wondrous potency. Once more, good night:
And when you are desirous to be blessed, 169
I'll blessing beg of you.—For this same lord,

[POINTING TO POLONIUS]

I do repent: but heaven hath pleased it so,
To punish me with this, and this with me,
That I must be their scourge and minister.
I will bestow him, and will answer well
The death I gave him. So again, good night!
I must be cruel, only to be kind:
Thus bad begins and worse remains behind.

One word more, good lady.

QUEEN What shall I do?

HAMLET Not this, by no means, that I bid you do:
Let the bloat king tempt you again to bed; 180
Pinch wanton on your cheek; call you his mouse;
And let him, for a pair of reechy[12] kisses,
Or paddling in your neck with his damned fingers,
Make you to ravel all this matter out,
That I essentially am not in madness,
But mad in craft. 'Twere good you let him know:
For who, that's but a queen, fair, sober, wise,
Would from a paddock,[13] from a bat, a gib,[14]
Such dear concernings hide? who would do so?
No, in despite of sense and secrecy, 190
Unpeg the basket on the house's top,
Let the birds fly, and like the famous ape,
To try conclusions, in the basket creep,
And break your own neck down.

QUEEN Be thou assured, if words be made of breath,
And breath of life, I have no life to breathe
What thou hast said to me.

HAMLET I must to England; you know that?

QUEEN Alack, I had forgot; 'tis so concluded on.

HAMLET There's letters sealed: and my two school-fellows, 200
Whom I will trust as I will adders fanged,
They bear the mandate; they must sweep my way,
And marshal me to knavery. Let it work;
For 'tis the sport to have the engineer
Hoist with his own petard:[15] and't shall go hard
But I will delve one yard below their mines,
And blow them at the moon: O, 'tis most sweet,
When in one line two crafts directly meet.
This man shall set me packing:
I'll lug the guts into the neighbour room. 210
Mother, good night. Indeed, this counsellor
Is now most still, most secret, and most grave
Who was in life a foolish prating knave.
Come, sir, to draw toward an end with you:
Good night, mother.

EXEUNT SEVERALLY; HAMLET
DRAGGING IN THE BODY OF POLONIUS.

Notes

[1] cross
[2] mirror
[3] marriage contract
[4] prologue
[5] blindman's buff
[6] without
[7] color
[8] tenth part
[9] flattened hairs
[10] undermining
[11] bloated
[12] foul
[13] toad
[14] tomcat
[15] bomb

Act IV

Scene I. *A room in the castle*.

ENTER KING, QUEEN, ROSENCRANTZ, AND GUILDENSTERN.

KING There's matter in these sighs: these profound heaves
You must translate: 'tis fit we understand them.
Where is your son?

QUEEN Bestow this place on us a little while.—

EXEUNT ROSENCRANTZ AND GUILDENSTERN.

Ah, my good lord, what have I seen to-night!
KING What, Gertrude? How does Hamlet?
QUEEN Mad as the sea and wind, when both contend
 Which is the mightier: in his lawless fit,
 Behind the arras hearing something stir,
 Whips out his rapier, cries "A rat! a rat!" 10
 And in his brainish apprehension kills
 The unseen good old man.
KING O heavy deed!
 It had been so with us, had we been there:
 His liberty is full of threats to all,
 To you yourself, to us, to every one.
 Alas, how shall this bloody deed be answered?
 It will be laid to us, whose providence
 Should have kept short, restrained, and out of haunt,
 This mad young man: but, so much was our love,
 We would not understand what was most fit, 20
 But, like the owner of a foul disease,
 To keep it from divulging, let it feed
 Even on the pith of life. Where is he gone?
QUEEN To draw apart the body he hath killed:
 O'er whom his very madness, like some ore
 Among a mineral of metals base,
 Shows itself pure. 'A weeps for what is done.
KING O, Gertrude, come away!
 The sun no sooner shall the mountains touch,
 But we will ship him hence: and this vile deed
 We must, with all our majesty and skill, 31
 Both countenance and excuse.—Ho!
 Guildenstern!

RE-ENTER ROSENCRANTZ AND GUILDENSTERN.

Friends both, go join you with some further aid:
Hamlet in madness hath Polonius slain,
And from his mother's closet hath he dragged him.
Go seek him out; speak fair, and bring the body
Into the chapel. I pray you haste in this.

EXEUNT ROSENCRANTZ AND GUILDENSTERN.

Come, Gertrude, we'll call up our wisest friends;
And let them know, both what we mean to do,
And what's untimely done: so, haply, slander, 40
Whose whisper o'er the world's diameter,
As level as the cannon to his blank[1]
Transports his poisoned shot, may miss our name,
And hit the woundless air. O, come away!
My soul is full of discord and dismay.

EXEUNT.

Note

[1] center of a target

Scene II. *Another room in the castle.*

ENTER HAMLET.

HAMLET Safely stowed,—
ROSENCRANTZ, GUILDENSTERN [*Within*] Hamlet! Lord
 Hamlet!
HAMLET But soft, what noise? who calls on Hamlet?
 O, here they come.

ENTER ROSENCRANTZ AND GUILDENSTERN.

ROSENCRANTZ What have you done, my lord, with the
 dead body?
HAMLET Compound it with dust, whereto 'tis kin.

ROSENCRANTZ Tell us where 'tis, that we may take it
 thence, 10
 And bear it to the chapel.
HAMLET Do not believe it.
ROSENCRANTZ Believe what?
HAMLET That I can keep your counsel, and not mine own.
 Besides, to be demanded of a sponge, what replica-
 tion[1] should be made by the son of a king?
ROSENCRANTZ Take you me for a sponge, my lord?
HAMLET Ay, sir; that soaks up the king's countenance, his
 rewards, his authorities. But such officers do the king
 best service in the end: he keeps them, like an ape, in
 the corner of his jaw; first mouthed, to be last swal-
 lowed: when he needs what you have gleaned, it is
 but squeezing you, and, sponge, you shall be dry
 again. 24
ROSENCRANTZ I understand you not, my lord.
HAMLET I am glad of it: a knavish speech sleeps in a
 foolish ear.
ROSENCRANTZ My lord, you must tell us where the body
 is, and go with us to the king.
HAMLET The body is with the king, but the king is not
 with the body. The king is a thing—
GUILDENSTERN "A thing," my lord?
HAMLET Of nothing: bring me to him. Hide fox, and all
 after. 34

EXEUNT.

Note

[1] reply

Scene III. *Another room in the castle.*

ENTER KING, ATTENDED.

KING I have sent to seek him, and to find the body.
 How dangerous is it that this man goes loose!
 Yet must not we put the strong law on him:
 He's loved of the distracted multitude,
 Who like not in their judgment, but their eyes;
 And where 'tis so, the offender's scourge is weighed,
 But never the offence. To bear all smooth and even,
 This sudden sending him away must seem
 Deliberate pause: diseases desperate grown
 By desperate appliance are relieved, 10
 Or not at all.—

ENTER ROSENCRANTZ.

 How now! what hath befallen?
ROSENCRANTZ Where the dead body is bestowed, my lord,
 We cannot get from him.
KING But where is he?
ROSENCRANTZ Without, my lord; guarded, to know your
 pleasure.
KING Bring him before us.
ROSENCRANTZ Ho, Guildenstern! bring in my lord.

ENTER HAMLET AND GUILDENSTERN.

KING Now, Hamlet, where's Polonius?
HAMLET At supper. 20
KING "At supper"? where?
HAMLET Not where he eats, but where 'a is eaten: a certain
 convocation of politic[1] worms are e'en at him. Your
 worm is your only emperor for diet. We fat all
 creatures else to fat us, and we fat ourselves for mag-
 gots. Your fat king, and your lean beggar, is but
 variable service, two dishes, but to one table; that's
 the end.

KING Alas, alas!

HAMLET A man may fish with the worm that hath eat of a
 king, and eat of the fish that hath fed of that worm. 32

KING What dost thou mean by this?

HAMLET Nothing but to show you how a king may go a
 progress[2] through the guts of a beggar.

KING Where is Polonius?

HAMLET In heaven; send thither to see: if your messenger
 find him not there, seek him i' the other place your-
 self. But if, indeed, you find him not within this
 month, you shall nose him as you go up the stairs into
 the lobby. 41

KING [To some ATTENDANTS] Go seek him there.

HAMLET 'A will stay till you come.

EXEUNT ATTENDANTS.

KING Hamlet, this deed of thine, for thine especial safety,
 Which we do tender,[3] as we dearly grieve
 For that which thou hast done, must send thee hence
 With fiery quickness: therefore prepare thyself;
 The bark is ready and the wind at help,
 The associates tend,[4] and everything is bent
 For England.

HAMLET For England?

KING Ay, Hamlet.

HAMLET Good.

KING So is it, if thou knew'st our purposes.

HAMLET I see a cherub that sees them.—But, come; for
 England!—Farewell, dear mother.

KING Thy loving father, Hamlet.

HAMLET My mother: father and mother is man and wife;
 man and wife is one flesh, and so, my mother.—
 Come, for England.

EXIT.

KING Follow him at foot; tempt him with speed aboard;
 Delay it not; I'll have him hence to-night:
 Away! for everything is sealed and done 60
 That else leans on the affair: pray you, make haste.

EXEUNT ROSENCRANTZ AND GUILDENSTERN.

And England, if my love thou hold'st at aught,—
As my great power thereof may give thee sense;
Since yet thy cicatrice,[5] looks raw and red
After the Danish sword, and thy free awe
Pays homage to us,—thou mayst not coldly set
Our sovereign process; which imports at full,
By letters conguring to that effect,
The present death of Hamlet. Do it, England;
for like the hectic[6] in my blood he rages, 70
And thou must cure me: till I know 'tis done,
Howe'er my haps,[7] my joys were ne'er begun.

EXIT.

Notes

[1] statesmanlike
[2] royal journey
[3] hold dear
[4] wait
[5] scar
[6] fever
[7] fortune

Scene IV. *A plain in Denmark.*

ENTER FORTINBRAS, A CAPTAIN AND SOLDIERS, MARCHING.

FORTINBRAS Go, captain, from me greet the Danish king;
 Tell him that, by his licence, Fortinbras

Claims the conveyance of a promised march
Over his kingdom. You know the rendezvous.
If that his majesty would aught with us,
We shall express our duty in his eye;
And let him know so.

CAPTAIN I will do't, my lord.

FORTINBRAS Go softly on.

EXEUNT FORTINBRAS AND SOLDIERS.

ENTER HAMLET, ROSENCRANTZ, GUILDENSTERN, ETC.

HAMLET Good sir, whose powers are these?

CAPTAIN They are of Norway, sir. 10

HAMLET How purposed, sir, I pray you?

CAPTAIN Against some part of Poland.

HAMLET Who commands them, sir?

CAPTAIN The nephew to old Norway, Fortinbras.

HAMLET Goes it against the main of Poland, sir,
 Or for some frontier?

CAPTAIN Truly to speak, and with no addition,
 We go to gain a little patch of ground,
 That hath in it no profit but the name.
 To pay five ducats, five, I would not farm it; 20
 Nor will it yield to Norway, or the Pole,
 A ranker[1] rate, should it be sold in fee.[2]

HAMLET Why, then the Polack never will defend it.

CAPTAIN Yes, 'tis already garrisoned.

HAMLET Two thousand souls and twenty thousand ducats
 Will not debate the question of this straw:
 This is the imposthume[3] of much wealth and peace;
 That inward breaks, and shows no cause without 28
 Why the man dies.—I humbly thank you, sir.

CAPTAIN God b'uy you, sir.

EXIT.

ROSENCRANTZ Will't please you go, my lord?

HAMLET I will be with you straight. Go a little before.

EXEUNT ALL EXCEPT HAMLET.

How all occasions do inform against me,
And spur my dull revenge! What is a man,
If his chief good and market of his time
Be but to sleep and feed? a beast, no more.
Sure, he that made us with such large discourse,
Looking before and after, gave us not
That capability and godlike reason
To fust[4] in us unused. Now, whether it be
Bestial oblivion, or some craven scruple 40
Of thinking too precisely on the event,—
A thought which, quartered, hath but one part wisdom
And ever three parts coward,—I do not know
Why yet I live to say, "This thing's to do;"
Sith I have cause, and will, and strength, and means,
To do't. Examples, gross as earth, exhort me:
Witness this army, of such mass and charge,
Led by a delicate and tender prince,
Whose spirit, with divine ambition puffed,
Makes mouths at the invisible event; 50
Exposing what is mortal and unsure
To all that fortune, death, and danger dare,
Even for an egg-shell. Rightly to be great,
Is not to stir without great argument,
But greatly to find quarrel in a straw
When honour's at the stake. How stand I then,
That have a father killed, a mother stained,
Excitements of my reason and my blood,
And let all sleep while to my shame I see,
The imminent death of twenty thousand men, 60

That for a fantasy and trick of fame,
Go to their graves like beds, fight for a plot
Whereon the numbers cannot try the cause,
Which is not tomb enough and continent,[5]
To hide the slain? O, from this time forth,
My thoughts be bloody, or be nothing worth?

EXIT.

Notes

[1] higher
[2] outright
[3] abscess, ulcer
[4] grow moldy
[5] container

Scene V. *A room in the castle.*

ENTER QUEEN, HORATIO, AND A GENTLEMAN.

QUEEN I will not speak with her.
GENTLEMAN She is importunate, indeed, distract;
 Her mood will needs be pitied.
QUEEN What would she have?
GENTLEMAN She speaks much of her father; says
 she hears,
 There's tricks i' the world; and hems and beats her heart;
 Spurns enviously at straws; speaks things in doubt,
 That carry but half sense: her speech is nothing,
 Yet the unshaped use of it doth move
 The hearers to collection; they aim at it,
 And botch the words up fit to their own thoughts; 10
 Which, as her winks and nods and gestures yield them,
 Indeed would make one think there might be thought,
 Though nothing sure, yet much unhappily.
HORATIO 'Twere good she were spoken with, for she
 may strew
 Dangerous conjectures in ill-breeding minds.
QUEEN Let her come in.

EXIT HORATIO.

To my sick soul, as sin's true nature is,
Each toy seems prologue to some great amiss:
So full of artless jealousy is guilt,
It spills itself in fearing to be spilt. 20

RE-ENTER HORATIO WITH OPHELIA.

OPHELIA Where is the beauteous majesty of Denmark?
QUEEN How now, Ophelia?
OPHELIA [Sings] *How should I your true love know*
 From another
 By his cockle hat
 And his sandal shoon.[1]
QUEEN Alas, sweet lady, what imports this song?
OPHELIA Say you? nay, pray you, mark.
 He is dead and gone, lady,
 He is dead and gone; 30
 At his head a grass-green turf,
 At his heels a stone.
 O, ho!
QUEEN Nay, but Ophelia,—
OPHELIA Pray you, mark.
 [Sings] White his shroud as the mountain snow.

ENTER KING.

QUEEN Alas, look here, my lord.
OPHELIA [Sings] *Larded*[2] *with sweet flowers:*
 Which bewept to the grave did not go,
 With true-love showers.

KING How do you, pretty lady?
OPHELIA Well, God dild[3] you! They say the owl was a
 baker's daughter. Lord, we know what we are, but
 know not what we may be. God be at your table! 43
KING [Aside] Conceit[4] upon her father.
OPHELIA Pray you, let us have no words of this; but when
 they ask you what it means, say you this:
 [Sings] To-morrow is Saint Valentine's day,
 All in the morning bedtime,
 And I a maid at your window,
 To be your Valentine: 50
 Then up he rose, and donned his clothes
 And dupped[5] *the chamber-door;*
 Let in the maid, that out a maid
 Never departed more.
KING Pretty Ophelia!
OPHELIA Indeed, la, without an oath, I'll make an end on't:
 [Sings] By Gis,[6] *and by Saint Charity,*
 Alack, and fie for shame!
 Young men will do't, if they come to't; 60
 By cock, they are to blame.
 Quoth she, before you tumbled me,
 You promised me to wed:
 [He answers:] So would I ha' done, by yonder sun,
 And thou hadst not come to my bed.
KING How long hath she been thus?
OPHELIA I hope, all will be well. We must be patient: but I
 cannot choose but weep, to think they should lay him
 i' the cold ground. My brother shall know of it; and so
 I thank you for your good counsel.—Come, my
 coach!—
 Good night, ladies; good night, sweet ladies; good night,
 good night.

EXIT.

KING Follow her close; give her good watch, I pray you.

EXIT HORATIO.

O, this is the poison of deep grief; it springs
All from her father's death. O Gertrude,
Gertrude, 75
When sorrows come, they come not single spies,
But in battalions! First, her father slain;
Next, your son gone; and he most violent author
Of this own just remove: the people muddied,
Thick and unwholesome in thoughts and whispers, 80
For good Polonius' death; and we have done
but greenly,[7]
In hugger-mugger[8] to inter him; poor Ophelia
Divided from herself and her fair judgment
Without the which we are pictures, or mere beasts;
Last, and as much containing as all these,
Her brother is in secret come from France:
Feeds on his wonder, keeps himself in clouds,
And wants not buzzers to infect his ear
With pestilent speeches of his father's death;
Wherein necessity, of matter beggared, 90
Will nothing stick our person to arraign
In ear and ear. O my dear Gertrude, this,
Like to a murdering-piece, in many places
Gives me superfluous death.

A NOISE WITHIN.

QUEEN Alack! what noise is this?
KING Where are my Switzers?[9] Let them guard the door.

ENTER A GENTLEMAN.

What is the matter?

GENTLEMAN Save yourself, my lord;
 The ocean, overpeering of his list,[10]
 Eats not the flats with more impetuous haste,
 Than young Laertes, in a riotous head,
 O'erbears your officers. The rabble call him lord; 100
 And, as the world were now but to begin,
 Antiquity forgot, custom not known,
 The ratifiers and props of every word,
 They cry, "Choose we; Laertes shall be king!"
 Caps, hands, and tongues, applaud it to the clouds,
 "Laertes shall be king, Laertes king!"
QUEEN How cheerfully on the false trail they cry!
 O, this is counter, you false Danish dogs!

NOISE WITHIN.

KING The doors are broke.

ENTER LAERTES, ARMED; DANES FOLLOWING.

LAERTES Where is the king?—Sirs, stand you all without. 110
DANES No, let's come in.
LAERTES I pray you, give me leave.
DANES We will, we will.

THEY RETIRE WITHOUT THE DOOR.

LAERTES I thank you. Keep the door.—O thou vile king,
 Give me my father!
QUEEN Calmly, good Laertes.
LAERTES That drop of blood that's calm, proclaims me
 bastard;
 Cries cuckold to may father; brands the harlot
 Even here, between the chaste unsmirched brow
 Of my true mother.
KING What is the cause, Laertes,
 That thy rebellion looks so giant-like?
 Let him go, Gertrude; do not fear our person; 120
 There's such divinity doth hedge a king,
 That treason can but peep to what it would,
 Acts little of his will. Tell me, Laertes,
 Why thou art thus incensed.—Let him go,
 Gertrude.—
 Speak, man.
LAERTES Where's my father?
KING Dead.
QUEEN But not by him.
KING Let him demand his fill.
LAERTES How came he dead? I'll not be juggled with.
 To hell, allegiance! vows, to the blackest devil!
 Conscience and grace, to the profoundest pit!
 I dare damnation. To this point I stand: 130
 That both the worlds I give to negligence,
 Let come what comes; only I'll be revenged
 Most throughly for my father.
KING Who shall stay you?
LAERTES My will, not all the world:
 And for my means, I'll husband them so well,
 They shall go far with little.
KING Good Laertes,
 If you desire to know the certainty
 Of your dear father's death, is't writ in your revenge,
 That, swoopstake,[11] you will draw both friend and foe,
 Winner and loser? 140
LAERTES None but his enemies.
KING Will you know them then?
LAERTES To his good friends thus wide I'll ope my arms;
 And, like the kind life-rendering pelican,[12]
 Repast[13] them with my blood.
KING Why, now you speak

Like a good child and a true gentleman.
 That I am guiltless of your father's death,
 And am most sensibly in grief for it,
 It shall as level to your judgment pierce,
 As day does to your eye.
DANES [*Within*] Let her come in.
LAERTES How now! what noise is that? 150

ENTER OPHELIA.

O heat, dry up my brains! tears, seven times salt,
 Burn out the sense and virtue of mine eye!—
 By heaven, thy madness shall be paid with weight,
 Till our scale turn the beam. O rose of May!
 Dear maid, kind sister, sweet Ophelia!—
 O heavens! is't possible a young maid's wits
 Should be as mortal as an old man's life?
 Nature is fine in love, and where 'tis fine,
 It sends some precious instance of itself
 After the thing it loves. 160
OPHELIA [*Sings*] *They bore him barefaced on the bier;*
 Hey non nonny, nonny, hey nonny;
 And on his grave rains many a tear.—
 Fare you well, my dove!
LAERTES Hadst thou thy wits, and didst persuade revenge,
 It could not move thus.
OPHELIA You must sing, *Down-a-down, and you call him a-*
 down-a. O, how the wheel becomes it!
 It is the false steward, that stole his master's daughter.
LAERTES This nothing's more than matter. 170
OPHELIA There's rosemary, that's for remembrance; pray
 you, love, remember: and there is pansies, that's for
 thoughts.
LAERTES A document in madness; thoughts and remem-
 brance fitted.
OPHELIA There's fennel for you, and columbines: there's
 rue for you; and here's some for me: we may call it
 herb of grace o'Sundays: oh, you must wear your rue
 with a difference. There's a daisy: I would give you
 some violets; but they withered all, when my father
 died: they say 'a made a good end,— 182
 [*Sings*] *For bonny sweet Robin is all my joy.*
LAERTES Thought and affliction, passion, hell itself,
 She turns to favour and to prettiness.
OPHELIA [*Sings*] *And will 'a not come again?*
 And will 'a not come again?
 No, no, he is dead,
 Go to thy death-bed,
 He never will come again. 190
 His beard was as white as snow,
 All flaxen was his poll:
 He is gone, he is gone,
 And we cast away moan;
 God ha' mercy on his soul!
 And of all Christian souls, I pray God.—God b'uy you!

EXIT OPHELIA.

LAERTES Do you see this, O God?
KING Laertes, I must commune with your grief,
 Or you deny me right. Go but apart,
 Make choice of whom your wisest friends you will, 200
 And they shall hear and judge 'twixt you and me.
 If by direct or by collateral hand
 They find us touched,[14] we will our kingdom give,
 Our crown, our life, and all that we call ours,
 To you in satisfaction. But if not,
 Be you content to lend your patience to us,
 And we shall jointly labour with your soul
 To give it due content.

LAERTES Let this be so;
 His means of death, his obscure burial —
 No trophy, sword, not hatchment[15] o'er his bones, 210
 No noble rite nor formal ostentation, —
 Cry to be heard, as 'twere from heaven to earth,
 That I must call't in question.
KING So you shall;
 And where the offence is let the great axe fall.
 I pray you, go with me.

 EXEUNT.

Notes

[1] shoes
[2] decorated
[3] yield, i.e., reward
[4] brooding
[5] opened
[6] contraction of "Jesus"
[7] foolishly
[8] secret haste
[9] Swiss guards
[10] shore
[11] in a clean sweep
[12] the pelican was thought to feed its young with its own blood
[13] feed
[14] implicated
[15] tablet bearing the coat of arms of the dead

Scene VI. *Another room in the castle.*

 ENTER HORATIO AND A SERVANT.

HORATIO What are they that would speak with me?
SERVANT Sea-faring men, sir; they say, they have letters for you.
HORATIO Let them come in. —

 EXIT SERVANT.

 I do not know from what part of the world
 I should be greeted, if not from Lord Hamlet.

 ENTER SAILORS.

1 SAILOR God bless you, sir.
HORATIO Let him bless thee too.
1 SAILOR 'A shall, sir, and't please him. There's a letter for
 you, sir; it comes from the ambassador that was
 bound for England; if your name be Horatio, as I am
 let to know it is. 13
HORATIO *[Reads]* *Horatio, when thou shalt have overlooked*
 this, give these fellows some means to the king; they have
 letters for him. Ere we were two days old at sea, a pirate of
 very warlike appointment gave us chase. Finding ourselves
 too slow of sail, we put on a compelled valour; in the grap-
 ple I boarded them: on the instant, they got clear of our ship;
 so I alone became their prisoner. They have dealt with me
 like thieves of mercy; but they knewwhat they did; I am to
 do a good turn for them. Let the king have the letters I have
 sent; and repair thou to me with as much speed as thou
 wouldst fly death. I have words to speak in thine ear will
 make thee dumb; yet are they much too light for the bore of
 the matter. These good fellows will bring thee where I am.
 Rosencrantz and Guildenstern hold their course for En-
 gland; of them I have much to tell thee. Farewell. 30
 He that thou knowest thine, Hamlet.
 Come, I will give you way for these your letters;
 And do't the speedier, that you may direct me
 To him from whom you brought them.

 EXEUNT.

Scene VII. *Another room in the castle.*

 ENTER KING AND LAERTES.

KING Now must your conscience my acquittance seal,
 And you must put me in your heart for friend;
 Sith you have heard, and with a knowing ear,
 That he which hath your noble father slain,
 Pursued my life.
LAERTES It well appears: but tell me
 Why you proceeded not against these feats,
 So crimeful and so capital in nature,
 As by your safety, greatness, wisdom, all things else,
 You mainly were stirred up.
KING O, for two special reasons;
 Which may to you, perhaps, seem much unsinewed, 10
 And yet to me they are strong. The queen, his mother,
 Lives almost by his looks; and for myself, —
 My virtue or my plague, be it either which, —
 She's so conjunctive to my life and soul,
 That, as the star moves not but in his sphere,
 I could not but by her. The other motive,
 Why to a public count I might not go,
 Is the great love the general gender[1] bear him:
 Who, dipping all his faults in their affection,
 Would, like the spring that turneth wood to stone, 20
 Convert his gyves[2] to graces; so that my arrows,
 Too slightly timbered for so loud a wind,
 Would have reverted to my bow again,
 And not where I had aimed them.
LAERTES And so have I a noble father lost;
 A sister driven into desperate terms,
 Whose worth, if praises may go back again,
 Stood challenger on mount of all the age
 For her perfections. But my revenge will come.
KING Break not your sleeps for that: you must not think 30
 That we are made of stuff so flat and dull
 That we can let our beard be shook with danger
 And think it pastime. You shortly shall hear more:
 I loved your father, and we love ourself;
 And that, I hope, will teach you to imagine, —
 How now? what news?

 ENTER A MESSENGER.

MESSENGER Letters, my lord, from Hamlet:
 These to your majesty; this to the queen.
KING From Hamlet! who brought them?
MESSENGER Sailors, my lord, they say: I saw them not.
 They were given me by Claudio; he received them 40
 Of him that brought them.
KING Laertes, you shall hear them.
 Leave us.

 EXIT MESSENGER.

 [Reads] *High and mighty, You shall know, I am set naked on*
 your kingdom. To-morrow shall I beg leave to see your
 kingly eyes: when I shall, first asking your pardon there-
 unto, recount the occasion of my sudden and more strange
 return. Hamlet.
 What should this mean? Are all the rest come back?
 Or is it some abuse, and no such thing?
LAERTES Know you the hand?
KING 'Tis Hamlet's character.[3] "Naked," —
 And, in a postscript here, he says, "alone":
 Can you advise me? 52
LAERTES I'm lost in it, my lord. But let him come:
 It warms the very sickness in my heart,
 That I shall live and tell him to his teeth,

"Thus didest thou."
KING If it be so, Laertes,—
 As how should it be so? how otherwise?—
 Will you be ruled by me?
LAERTES Ay, my lord:
 So you will not o'er-rule me to a peace.
KING To thine own peace. If he be now returned, 60
 As checking at his voyage, and that he means
 No more to undertake it, I will work him
 To an exploit now ripe in my device,
 Under the which he shall not choose but fall;
 And for his death no wind of blame shall breathe;
 But even his mother shall uncharge the practice,
 And call it accident.
LAERTES My lord, I will be ruled:
 The rather, if you could devise it so,
 That I might be the organ.
KING It falls right.
 You have been talked of since your travel much, 70
 And that in Hamlet's hearing, for a quality
 Wherein, they say, you shine: your sum of parts
 Did not together pluck such envy from him,
 As did that one, and that, in my regard,
 Of the unworthiest siege.[4]
LAERTES What part is that, my lord?
KING A very riband in the cap of youth,
 Yet needful too; for youth no less becomes
 The light and careless livery that it wears,
 Than settled age his sables and his weeds,
 Importing health and graveness. Two months since, 80
 Here was a gentleman of Normandy;—
 I have seen myself, and served against the French,
 And they can well on horseback: but this gallant
 Had witchcraft in't; he grew unto his seat,
 And to such wondrous doing brought his horse,
 As he had been incorpsed and demi-natured
 With the brave beast. So far he topped my thought
 That I, in forgery of shapes and tricks,
 Come short of what he did.
LAERTES A Norman, was't?
KING A Norman.
LAERTES Upon my life, Lamord.
KING The very same.
LAERTES I know him well: he is the brooch indeed, 91
 And gem of all the nation.
KING He made confession of you,
 And gave you such a masterly report,
 For art and exercise in your defence,
 And for your rapier most especially,
 That he cried out, 'twould be a sight indeed,
 If one could match you: the scrimers[5] of their nation,
 He swore, had neither motion, guard, nor eye,
 If you opposed them. Sir, this report of his 100
 Did Hamlet so envenom with his envy,
 That he could nothing do, but wish and beg
 Your sudden coming o'er, to play with him.
 Now, out of this,—
LAERTES What out of this, my lord?
KING Laertes, was your father dear to you?
 Or are you like the painting of a sorrow,
 A face without a heart?
LAERTES Why ask you this?
KING Not that I think you did not love your father;
 But that I know love is begun by time;
 And that I see, in passages of proof, 110
 Time qualifies the spark and fire of it.
 There lives within the very flame of love
 A kind of wick or snuff that will abate it;

And nothing is at a like goodness still;
For goodness, growing to a plurisy,[6]
Dies in his own too-much: that we would do,
We should do when we would; for this "would" changes
And hath abatements and delays as many,
As there are tongues, are hands, are accidents,
And then this "should" is like a spendthrift sigh, 120
That hurts by easing. But, to the quick[7] o' the ulcer:
Hamlet comes back: what would you undertake,
To show yourself your father's son in deed
More than in words?
LAERTES To cut his throat i' the church.
KING No place, indeed, should murder sanctuarize;
 Revenge should have no bounds. But, good Laertes,
 Will you do this, keep close within your chamber?
 Hamlet returned shall know you are come home:
 We'll put on those shall praise your excellence,
 And set a double varnish on the fame 130
 The Frenchman gave you, bring you, in fine,[8] together,
 And wager on your heads: he, being remiss,
 Most generous and free from all contriving,
 Will not peruse the foils, so that with ease,
 Or with a little shuffling, you may choose
 A sword unbated,[9] and in a pass of practice,
 Requite him for your father.
LAERTES I will do't:
 And for that purpose I'll anoint my sword.
 I bought an unction of a mountebank,[10]
 So mortal that but dip a knife in it, 140
 Where it draws blood no cataplasm[11] so rare,
 Collected from all simples[12] that have virtue
 Under the moon, can save the thing from death
 That is but scratched withal: I'll touch my point
 With this contagion, that if I gall him slightly
 It may be death.
KING Let's further think of this;
 Weigh what convenience both of time and means,
 May fit us to our shape. If this should fail,
 And that our drift look through our bad performance,
 'Twere better not assayed; therefore this project 150
 Should have a back or second, that might hold
 If this should blast in proof. Soft!—let me see!—
 We'll make a solemn wager on your cunnings;
 I ha't: when in your motion you are hot and dry,—
 As make your bouts more violent to that end,—
 And that he calls for drink, I'll have prepared him
 A chalice for the nonce;[13] whereon but sipping,
 If he by chance escape your venomed stuck,[14]
 Our purpose may hold there. But stay, what noise?—

ENTER QUEEN.

How now, sweet queen? 160
QUEEN One woe doth tread upon another's heel,
 So fast they follow. Your sister's drowned,
 Laertes.
LAERTES "Drowned"! O, where?
QUEEN There is a willow grows aslant a brook,
 That shows his hoar leaves in the glassy stream;
 There with fantastic garlands did she come
 Of crow-flowers, nettles, daisies, and long purples,
 That liberal shepherds give a grosser name,
 But our cold maids do dead men's fingers call them:
 There, on the pendent boughs her coronet weeds 170
 Clambering to hang, an envious sliver broke;
 When down the weedy trophies and herself
 Fell in the weeping brook. Her clothes spread wide,
 And, mermaid-like, a while they bore her up:
 Which time she chanted snatches of old tunes,

As one incapable of her own distress,
Or like a creature native and indued[15]
Unto that element: but long it could not be,
Till that her garments, heavy with their drink,
Pulled the poor wretch from her melodious lay 180
To muddy death.
LAERTES Alas then, she is drowned?
QUEEN Drowned, drowned.
LAERTES Too much of water hast thou, poor Ophelia,
And therefore I forbid my tears: but yet
It is our trick, nature her custom holds,
Let shame say what it will: when these are gone,
The woman will be out.—Adieu, my lord;
I have a speech of fire that fain would blaze,
But that this folly douts it.

EXIT.

KING Let's follow, Gertrude;
How much I had to do to calm his rage! 190
Now fear I this will give it start again;
Therefore let's follow.

EXEUNT.

Notes

[1] common people
[2] letters
[3] handwriting
[4] rank
[5] fencers
[6] excess
[7] sensitive flesh
[8] finally
[9] not blunted
[10] quack
[11] poultice
[12] medicinal herbs
[13] occasion
[14] thrust
[15] in harmony with

ACT V

Scene I. *A churchyard.*

ENTER TWO CLOWNS, WITH SPADES, ETC.

1 CLOWN Is she to be buried in Christian burial when she
wilfully seeks her own salvation?
2 CLOWN I tell thee she is; and therefore make her grave
straight: the crowner[1] hath sate on her, and finds it
Christian burial.
1 CLOWN How can that be, unless she drowned herself in
her own defence?
2 CLOWN Why, 'tis found so.
1 CLOWN It must be *se offendendo;*[2] it cannot be else. For
here lies the point: if I drown myself wittingly, it
argues an act, and an act hath three branches; it is, to
act, to do, and to perform: argal,[3] she drowned herself
wittingly. 13
2 CLOWN Nay, but hear you, goodman delver,—
1 CLOWN Give me leave. Here lies the water; good: here
stands the man; good: if the man go to this water and
drown himself, it is, will he, nill he, he goes; mark you
that; but if the water come to him and drown him, he
drowns not himself: argal, he that is not guilty of his
own death shortens not his own life. 21
2 CLOWN But is this law?
1 CLOWN Ay, marry is't; crowner's quest[4] law.
2 CLOWN Will you ha' the truth on't? If this had not been a
gentlewoman, she should have been buried out o'
Christian burial.
1 CLOWN Why, there thou say'st: and the more pity, that
great folk should have countenance in this world to
drown or hang themselves more than their even
Christen. Come, my spade. There is no ancient gentle-
men but gardeners, ditchers, and grave-makers; they
hold up Adam's profession.
2 CLOWN Was he a gentleman? 33
1 CLOWN 'A was the first that ever bore arms.
2 CLOWN Why, he had none.
1 CLOWN What, art a heathen? How dost thou understand
the scripture? The scripture says "Adam digged";
could he dig without arms? I'll put another question
to thee: if thou answerest me not to the purpose, con-
fess thyself— 40
2 CLOWN Go to.
1 CLOWN What is he, that builds stronger than either the
mason, the shipwright, or the carpenter?
2 CLOWN The gallows-maker; for that frame outlives a
thousand tenants.
1 CLOWN I like thy wit well, in good faith; the gallows
does well: but how does it well? it does well to those
that do ill: now thou dost ill to say, the gallows is built
stronger than the church; argal, the gallows may do
well to thee. To't again; come.
2 CLOWN "Who builds stronger than a mason, a ship-
wright, or a carpenter?" 52
1 CLOWN Ay, tell me that, and unyoke.
2 CLOWN Marry, now I can tell.
1 CLOWN To't.
2 CLOWN Mass,[5] I cannot tell.

ENTER HAMLET AND HORATIO AT A DISTANCE.

1 CLOWN Cudgel thy brains no more about it, for your dull
ass will not mend his pace with beating, and when
you are asked this question next, say "a grave-maker;"
the house that he makes lasts till doomsday. Go, get
thee to Yaughan; fetch me a stoup[6] of liquor. 62

EXIT 2 CLOWN. 1 CLOWN DIGS, AND SINGS.

In youth, when I did love, did love,
Methought it was very sweet,
To contract, O, the time, for, ah, my behove[7]
O, methought, there was nothing meet.
HAMLET Has this fellow no feeling of his business, that he
sings at grave-making?
HORATIO Custom hath made it in him a property of easiness. 70
HAMLET 'Tis e'en so: the hand of little employment hath
the daintier sense.
1 CLOWN *But age with his stealing steps,*
Hath clawed me in his clutch,
And hath shipped me intil the land,
As if I had never been such.

THROWS UP A SKULL.

HAMLET That skull had a tongue in it, and could sing
once: how the knave jowls[8] it to the ground as if
'twere Cain's jaw-bone, that did the first murder! This
might be the pate of a politician, which this ass now
o'er-reaches; one that could circumvent God, might
it not? 82
HORATIO It might, my lord.
HAMLET Or of a courtier, which could say, "Good-morrow,
sweet lord! How dost thou, good Lord?" This might
be my lord Such-a-one, that praised my lord Such-a-
one's horse, when he meant to beg it; might it not?
HORATIO Ay, my lord.

HAMLET Why, e'en so: and now my Lady Worm's; chap-
less,[9] and knocked about the mazzard[10] with a sex-
ton's spade: here's fine revolution, and we had the
trick to see't. Did these bones cost no more the breed-
ing, but to play at loggats[11] with 'em? mine ache to
think on't.

1 CLOWN [Sings.] *A pick-axe, and a spade, a spade,* 95
 For and a shrouding sheet:
 O, a pit of clay for to be made
 For such a guest is meet.

THROWS UP A SKULL.

HAMLET There's another; why may not that be the skull of
a lawyer? Where be his quiddits[12] now, his quillets,[13]
his cases, his tenures,[14] and his tricks? why does he
suffer this rude knave now to knock him about the
sconce[15] with a dirty shovel, and will not tell him of
his action of battery? Hum! This fellow might be in's
time a great buyer of land, with his statutes, his recogniz-
ances, his fines, his double vouchers, his recoveries:
is this the fine[16] of his fines and the recovery of his re-
coveries, to have his fine pate full of fine dirt? will his
vouchers vouch him no more of his purchases, and
double ones too, than the length and breadth of a pair
of indentures? The very conveyances of his lands will
hardly lie in this box; and must the inheritor himself
have no more, ha? 115

HORATIO Not a jot more, my lord.

HAMLET Is not parchment made of sheep-skins?

HORATIO Ay, my lord, and of calf-skins.

HAMLET They are sheep and calves which seek out
assurance in that. I will speak to this fellow.—Whose
grave's this, sirrah? 121

1 CLOWN Mine, sir.—
 [Sings] *O, a pit of clay for to be made*
 For such a guest is meet.

HAMLET I think it be thine, indeed, for thou liest in't.

1 CLOWN You lie out on't, sir, and therefore it is not yours:
for my part, I do not lie in't, and yet it is mine.

HAMLET Thou dost lie in't, to be in't, and say it is thine: 'tis
for the dead, not for the quick;[17] therefore thou liest. 131

1 CLOWN 'Tis a quick lie, sir; 'twill away again, from me
to you.

HAMLET What man dost thou dig it for?

1 CLOWN For no man, sir.

HAMLET What woman then?

1 CLOWN For none neither.

HAMLET Who is to be buried in't?

1 CLOWN One that was a woman, sir; but, rest her soul,
she's dead. 140

HAMLET How absolute the knave is! we must speak by the
card or equivocation will undo us. By the lord,
Horatio, these three years I have taken note of it; the
age is grown so picked[18] that the toe of the peasant
comes so near the heel of the courtier, he galls his
kibe.[19]—How long hast thou been grave-maker?

1 CLOWN Of all the days i' the year, I came to't that day
that our last king Hamlet o'ercame Fortinbras.

HAMLET How long is that since? 150

1 CLOWN Cannot you tell that? every fool can tell that: it
was the very day that young Hamlet was born: he that
is mad, and sent into England.

HAMLET Ay, marry; why was he sent into England?

1 CLOWN Why, because 'a was mad: 'a shall recover his
wits there; or, if 'a do not, 'tis no great matter there!

HAMLET Why?

1 CLOWN 'Twill not be seen in him; there the men are as
mad as he. 160

HAMLET How came he mad?

1 CLOWN Very strangely, they say.

HAMLET How "strangely"?

1 CLOWN Faith, e'en with losing his wits.

HAMLET Upon what ground?

1 CLOWN Why, here in Denmark. I have been sexton here,
man and boy, thirty years.

HAMLET How long will a man lie i' the earth ere he rot?

1 CLOWN Faith, if 'a be not rotten before 'a die,—as we
have many pocky corses[20] now-a-days, that will scarce hold
the laying in,—'a will last you some eight year or nine year:
a tanner will last you nine year. 174

HAMLET Why he more than another?

1 CLOWN Why, sir, his hide is so tanned with his trade, that
'a will keep out water a great while; and your water is
a sore decayer of your whoreson dead body. Here's a
skull now: this skull has lain in the earth three-and-
twenty years. 180

HAMLET Whose was it?

1 CLOWN A whoreson mad fellow's it was; whose do you
think it was?

HAMLET Nay, I know not.

1 CLOWN A pestilence on him for a mad rogue! 'a poured a
flagon of Rhenish on my head once. This same skull,
sir, was Yorick's skull, the king's jester.

HAMLET This?

1 CLOWN E'en that. 190

HAMLET Let me see. Alas, poor Yorick!—I knew him,
Horatio; a fellow of infinite jest, of most excellent
fancy: he hath borne me on his back a thousand times;
and now how abhorred in my imagination it is! my
gorge rises at it. Here hung those lips that I have
kissed I know not how oft. Where be your gibes now?
your gambols? your songs? your flashes of merriment,
that were wont to set the table on a roar? Not one now,
to mock your own grinning? quite chapfallen? Now
get you to my lady's chamber, and tell her, let her
paint an inch thick, to this favour she must come; make
her laugh at that.—Prithee, Horatio, tell me one thing. 204

HORATIO What's that, my lord?

HAMLET Dost thou think Alexander looked o' this fashion
i' the earth?

HORATIO E'en so.

HAMLET And smelt so? puh!

THROWS DOWN THE SKULL.

HORATIO E'en so, my lord. 210

HAMLET To what base uses we may return, Horatio!
 Why may not imagination trace the noble dust of
 Alexander, till he find it stopping a bung-hole?

HORATIO 'Twere to consider too curiously, to consider so.

HAMLET No, faith, not a jot; but to follow him thither with mod-
esty enough and likelihood to lead it; as thus;
Alexander died, Alexander was buried, Alexander
returneth to dust; the dust is earth; of earth we make
loam: and why of that loam, whereto he was
converted, might they not stop a beer-barrel? 222
 Imperious Caesar, dead, and turned to clay,
 Might stop a hole to keep the wind away:
 O that that earth, which kept the world in awe,
 Should patch a wall to expel the winter's flaw.[21]
 But soft! but soft! aside! here comes the king.

ENTER PRIESTS, ETC. IN PROCESSION; THE CORPSE OF
OPHELIA, LAERTES, AND MOURNERS FOLLOWING IT; KING,
QUEEN, THEIR TRAINS, ETC.

 The queen, the courtiers: who is this they follow?
 And with such maimed rites? This doth betoken

The corse they follow did with desperate hand
Fordo it own life; 'twas of some estate.²²
Couch²³ we a while, and mark.

RETIRING WITH HORATIO.

LAERTES What ceremony else?
HAMLET This is Laertes, a very noble youth: mark.
LAERTES What ceremony else?
1 PRIEST Her obsequies have been as far enlarged
 As we have warrantise: her death was doubtful;
 And, but that great command o'ersways the order,
 She should in ground unsanctified have lodged
 Till the last trumpet; for charitable prayers,
 Shards,²⁴ flints, and pebbles should be thrown on her, 242
 Yet here she is allowed her virgin crants,²⁵
 Her maiden strewments, and the bringing home
 Of bell and burial.
LAERTES Must there no more be done?
1 PRIEST No more be done;
 We should profane the service of the dead,
 To sing a *requiem* and such rest to her,
 As to peace-parted souls.
LAERTES Lay her i' the earth;—
 And from her fair and unpolluted flesh
 May violets spring! I tell thee, churlish priest, 250
 A ministering angel shall my sister be,
 When thou liest howling.
HAMLET What, the fair Ophelia?
QUEEN Sweets to the sweet: farewell!

SCATTERING FLOWERS.

I hoped thou shouldst have been my Hamlet's wife.
I thought thy bride-bed to have decked, sweet maid,
And not t' have strewed thy grave.
LAERTES O, treble woe
 Fall ten times treble on that cursed head,
 Whose wicked deed thy most ingenious sense
 Deprived thee of!—Hold off the earth a while,
 Till I have caught her once more in mine arms.

LEAPS INTO THE GRAVE.

Now pile your dust upon the quick and dead,
Till of this flat a mountain you have made
To o'er-top old Pelion²⁶ or the skyish head
Of blue Olympus. 264
HAMLET [Advancing] What is he whose grief
 Bears such an emphasis? whose phrase of sorrow
 Conjures the wandering stars, and makes them stand
 Like wonder-wounded hearers? This is I,
 Hamlet the Dane!

LEAPS INTO THE GRAVE.

LAERTES The devil take thy soul! 270

GRAPPLING WITH HIM.

HAMLET Thou pray'st not well.
 I prithee, take thy fingers from my throat;
 For, though I am not splenetive²⁷ and rash,
 Yet have I something in me dangerous,
 Which let thy wisdom fear. Hold off thy hand.
KING Pluck them asunder.
QUEEN Hamlet, Hamlet!
ALL Gentlemen,—
HORATIO Good my lord, be quiet.

THE ATTENDANTS PART THEM, AND
THEY COME OUT OF THE GRAVE.

HAMLET Why, I will fight with him upon this theme, 280

Until my eyelids will no longer wag.
QUEEN O my son, what theme?
HAMLET I loved Ophelia; forty thousand brothers 232
 Could not, with all their quantity of love,
 Make up my sum.—What wilt thou do for her?
KING O, he is mad, Laertes.
QUEEN For love of God, forbear him.
HAMLET 'Swounds show me what thou'lt do:
 Woo't weep? woo't fight? woo't fast? woo't tear thyself?
 Woo't drink up eisil?²⁸ eat a crocodile? 290
 I'll do't. Dost thou come here to whine?
 To outface me with leaping in her grave?
 Be buried quick with her, and so will I.
 And, if thou prate of mountains, let them throw
 Millions of acres on us, till our ground,
 Singeing his pate against the burning zone,
 Make Ossa like a wart! Nay, an thou'lt mouth,
 I'll rant as well as thou.
QUEEN This is mere madness:
 And thus a while the fit will work on him;
 Anon, as patient as the female dove, 300
 When that her golden couplets are disclosed,
 His silence will sit drooping.
HAMLET Hear you, sir;
 What is the reason that you use me thus?
 I loved you ever.—But it is no matter;
 Let Hercules himself do what he may,
 The cat will mew, and dog will have his day.

EXIT.

KING I pray thee, good Horatio, wait upon him.—

EXIT HORATIO.

[To LAERTES] Strengthen your patience in our last night's speech;
We'll put the matter to the present push.—
Good Gertrude, set some watch over your son.— 310
This grave shall have a living monument:
An hour of quiet shortly shall we see;
Till then, in patience our proceeding be.

EXEUNT.

Notes

¹ coroner
² offending herself (parody of *se defendendo,* a legal term meaning "in self-defense")
³ parody of Latin *ergo,* "therefore"
⁴ inquest
⁵ by the mass
⁶ tankard
⁷ advantage
⁸ hurls
⁹ lacking the lower jaw
¹⁰ head
¹¹ a game in which small pieces of wood were thrown at an object
¹² subtle distinctions
¹³ time arguments
¹⁴ legal means of holding land
¹⁵ head
¹⁶ end
¹⁷ living
¹⁸ refined
¹⁹ sore on the back of the heel
²⁰ pock-marked corpses
²¹ gust
²² high rank
²³ hide
²⁴ broken pieces of pottery
²⁵ garlands
²⁶ one of two mountains (the other is Ossa, 1. 297) which, according to

Greek mythology, the giants piled on top of one another in order to reach heaven and fight the gods

[27] fiery

[28] vinegar

Scene II. *A hall in the castle.*

ENTER HAMLET AND HORATIO.

HAMLET So much for this, sir: now shall you see the other;
 You do remember all the circumstance?
HORATIO Remember it, my lord!
HAMLET Sir, in my heart there was a kind of fighting,
 That would not let me sleep: methought I lay
 Worse than the mutines in the bilboes.[1]
 Rashly,—
 And praised be rashness for it, let us know,
 Our indiscretion sometimes serves us well
 When our deep plots do pall; and that should learn us
 There's divinity that shapes our ends, 10
 Rough-hew them how we will.
HORATIO That is most certain.
HAMLET —Up from my cabin,
 My sea-gown scarfed about me, in the dark
 Groped I to find out them: had my desire,
 Fingered their packet, and in fine withdrew
 To mine own room again; making so bold,
 My fears forgetting manners, to unfold
 Their grand commission; where I found, Horatio,—
 O royal knavery! an exact command,
 Larded[2] with many several sorts of reasons, 20
 Importing Denmark's health and England's too,
 With, ho! such bugs and goblins in my life,
 That, on the supervise, no leisure bated,
 No, not to stay the grinding of the axe,
 My head should be strook off.
HORATIO Is't possible?
HAMLET Here's the commission; read it at more leisure.
 But wilt thou hear me how I did proceed?
HORATIO I beseech you.
HAMLET Being thus benetted round with villanies,—
 Ere I could make a prologue to my brains, 30
 They had begun the play, I sat me down;
 Devised a new commission; wrote it fair:
 I once did hold it, as our statists[3] do,
 A baseness to write fair, and laboured much
 How to forget that learning; but, sir, now
 It did me yeoman's service. Wilt thou know
 The effect of what I wrote?
HORATIO Ay, good my lord.
HAMLET An earnest conjuration from the king,
 As England was his faithful tributary;
 As love between them like the palm might flourish, 40
 As peace should still her wheaten garland wear
 And stand a comma[4] 'tween their amities,
 And many such like "Ases" of great charge
 That on the view and knowing of these contents,
 Without debatement further, more, or less,
 He should the bearers put to sudden death,
 Not shriving[5]-time allowed.
HORATIO How was this sealed?
HAMLET Why, even in that was heaven ordinant;
 I had my father's signet in my purse,
 Which was the model of that Danish seal:
 Folded the writ up in form of the other; 50
 Subscribed it; gave't the impression; placed it safely,
 The changeling never known. Now, the next day
 Was our sea-fight: and what to this was sequent
 Thou know'st already.

HORATIO So Guildenstern and Rosencrantz go to't.
HAMLET Why, man, they did make love to this
 employment;
 They are not near my conscience; their defeat
 Does by their own insinuation grow:
 'Tis dangerous when the baser nature comes 60
 Between the pass and fell incensed points
 Of mighty opposites.
HORATIO Why, what a king is this!
HAMLET Does it not, think'st thee, stand me now upon—
 he that hath killed my king, and whored my mother;
 Popped in between the election and my hopes;
 Thrown out his angle[6] for my proper life,
 And with such cozenage[7]—isn't not perfect conscience
 To quit him with this arm? and is't not to be damned,
 To let this canker of our nature come
 In further evil? 70
HORATIO It must be shortly known to him from England
 What is the issue of the business there.
HAMLET It will be short: the interim is mine;
 And a man's life no more than to say "One."
 But I am very sorry, good Horatio,
 That to Laertes I forgot myself;
 For by the image of my cause, I see
 The portraiture of his: I'll court his favours:
 But, sure, the bravery of his grief did put me
 Into a towering passion.
HORATIO Peace! who comes here?

ENTER OSRIC.

OSRIC Your lordship is right welcome back to Denmark. 82
HAMLET I humbly thank you, sir.—Dost know this
 water-fly?
HORATIO No, my good lord.
HAMLET Thy state is the more gracious: for 'tis a vice to
 know him. He hath much land, and fertile; let a beast
 be lord of beasts, and his crib shall stand at the king's
 mess:[8] 'tis a chough,[9] but, as I say, spacious in the
 possession of dirt. 90
OSRIC Sweet lord, if your lordship were at leisure, I should
 impart a thing to you from his majesty.
HAMLET I will receive it with all diligence of spirit. Put
 your bonnet to his right use; 'tis for the head.
OSRIC I thank your lordship, it is very hot.
HAMLET No, believe me, 'tis very cold; the wind is
 northerly.
OSRIC It is indifferent cold, my lord, indeed.
HAMLET But yet methinks it is very sultry and hot for my
 complexion. 100
OSRIC Exceedingly, my lord; it is very sultry,—as 'twere,—I
 cannot tell how. But, my lord, his majesty bade me
 signify to you, that 'a has laid a great wager on your
 head. Sir, this is the matter.
HAMLET I beseech you, remember—

HAMLET MOVES HIM TO PUT ON HIS HAT.

OSRIC Nay, in good faith; for mine ease, in good faith. Sir,
 here is newly come to court Laertes: believe me, an
 absolute gentleman, full of most excellent differences,
 of very soft society, and great showing: indeed, to
 speak feelingly of him, he is the card or calendar of
 gentry, for you shall find in him the continent of what
 part a gentleman would see. 113
HAMLET Sir, his definement suffers no perdition in you;
 though, I know, to divide him inventorially would
 dizzy the arithmetic of memory, and yet but yaw
 neither, in respect of his quick sail. But, in the verity of
 extolment, I take him to be a soul of great article, and

his infusion of such dearth and rareness, as, to make
true diction of him, his semblable is his mirror, and,
who else would trace him, his umbrage,[10] noth-
ing more. 122

OSRIC Your lordship speaks most infallibly of him.

HAMLET The concernancy,[11] sir? why do we wrap the gen-
tleman in our more rawer breath?

OSRIC Sir?

HORATIO Is't not possible to understand in another
tongue? You will do't, sir, really.

HAMLET What imports the nomination of this gentleman? 130

OSRIC Of Laertes?

HORATIO His purse is empty already; all's golden words
are spent.

HAMLET Of him, sir.

OSRIC I know you are not ignorant—

HAMLET I would you did, sir; yet, in faith, if you did, it
would not much approve me. Well, sir.

OSRIC You are not ignorant of what excellence Laertes is. 139

HAMLET I dare not confess that, lest I should compare with
him in excellence; but, to know a man well, were to
know himself.

OSRIC I mean, sir, for his weapon; but in the imputation
laid on him by them, in his meed[12] he's unfellowed.

HAMLET What's his weapon?

OSRIC Rapier and dagger.

HAMLET That's two of his weapons: but, well.

OSRIC The king, sir, hath wagered with him six Barbary
horses: against the which he has imponed, as I take it,
six French rapiers and poniards, with their assigns, as
girdle, hangers,[13] and so: three of the carriages, in
faith, are very dear to fancy, very responsive to the
hilts, most delicate carriages, and of very liberal
conceit. 155

HAMLET What call you the carriages?

HORATIO I knew you must be edified by the margent, ere
you had done.

OSRIC The carriages, sir, are the hangers.

HAMLET The phrase would be more germane to the matter
if we could carry cannon by our sides: I would it
might be hangers till then.
But, on: six Barbary horses against six French swords,
their assigns, and three liberal-conceited carriages;
that's the French bet against the Danish. Why is this
"imponed," as you call it? 166

OSRIC The king, sir, hath laid, sir, that in a dozen passes
between yourself and him, he shall not exceed you three
hits; he hath laid on twelve for nine; and it would
come to immediate trial, if your lordship would
vouchsafe the answer.

HAMLET How, if I answer "no"?

OSRIC I mean, my lord, the opposition of your person in
trial.

HAMLET Sir, I will walk here in the hall; if it please his
majesty, 'tis the breathing time of day with me: let the
foils be brought; the gentleman willing, and the king
hold his purpose, I will win for him if I can; if not, I
will gain nothing but my shame and the odd hits. 180

OSRIC Shall I re-deliver you e'en so?

HAMLET To this effect, sir, after what flourish your
nature will.

OSRIC I commend my duty to your lordship.

<div align="center">EXIT.</div>

HAMLET Yours, yours. He does well to commend it him-
self; there are no tongues else for's turn.

HORATIO This lapwing runs away with the shell on
his head.

HAMLET He did comply with his dug, before he sucked it.
Thus has he, and many more of the same bevy that I
know the drossy age dotes on, only got the tune of the time
and outward habit of encounter; a kind of yesty[14]
collection, which carries them through and through
the most fond and winnowed opinions; and do but
blow them to their trial, the bubbles are out. 196

<div align="center">ENTER A LORD.</div>

LORD My lord, his majesty commended him to you by
young Osric, who brings back to him, that you attend
him in the hall: he sends to know if your pleasure hold
to play with Laertes, or that you will take longer time. 201

HAMLET I am constant to my purposes; they follow the
king's pleasure; if his fitness speaks, mine is ready:
now or whensoever, provided I be so able as now.

LORD The king, and queen, and all are coming down.

HAMLET In happy time.

LORD The queen desires you to use some gentle entertain-
ment to Laertes, before you fall to play.

HAMLET She well instructs me.

<div align="center">EXIT LORD.</div>

HORATIO You will lose this wager, my lord. 212

HAMLET I do not think so; since he went into France, I
have been in continual practice; I shall win at the
odds. But thou wouldst not think, how ill all's here
about my heart: but it is no matter.

HORATIO Nay, good my lord,—

HAMLET It is but foolery; but it is such a kind of gain-
giving[15] as would perhaps trouble a woman.

HORATIO If your mind dislike anything, obey it. I will
forestal their repair hither, and say you are not fit. 222

HAMLET Not a whit; we defy augury; there's a special
providence in the fall of a sparrow. If it be now, 'tis not
to come; if it be not to come, it will be now; if it be not
now, yet it will come: the readiness is all. Since no
man of aught he leaves, knows, what is't to leave
betimes? Let be.

<div align="center">ENTER KING, QUEEN, LAERTES, AND LORDS, OSRIC,
AND OTHER ATTENDANTS WITH FOILS AND GAUNTLETS:
A TABLE AND FLAGONS OF WINE ON IT.</div>

KING Come, Hamlet, come, and take this hand from me. 230

<div align="center">THE KING PUTS THE HAND OF LAERTES INTO THAT
OF HAMLET.</div>

HAMLET Give me your pardon, sir: I have done you
wrong;
But pardon't, as you are a gentleman.
—This presence[16] knows,
And you must needs have heard, how I am punished
With a sore distraction. What I have done,
That might your nature, honour, and exception
Roughly awake, I here proclaim was madness.
Was't Hamlet wronged Laertes? Never, Hamlet:
If Hamlet from himself be ta'en away,
And, when he's not himself, does wrong Laertes, 240
Then Hamlet does it not; Hamlet denies it.
Who does it then? His madness: if't be so,
Hamlet is of the faction that is wronged;
His madness is poor Hamlet's enemy.
—Sir, in this audience,
Let my disclaiming from a purposed evil
Free me so far in your most generous thoughts,
That I have shot mine arrow o'er the house,
And hurt my brother.

LAERTES I am satisfied in nature,

Whose motive, in this case, should stir me most
To my revenge; but in my terms of honour,
I stand aloof, and will no reconcilement,
Till by some elder masters of known honour
I have a voice and precedent of peace,
To keep my name ungored. But till that time
I do receive your offered love like love,
And will not wrong it.

HAMLET I embrace it freely,
And will this brother's wager frankly play.—
Give us the foils. Come on.

LAERTES Come, one for me.

HAMLET I'll be your foil, Laertes; in mine ignorance 260
Your skill shall, like a star i' the darkest night,
Stick fiery off indeed.

LAERTES You mock me, sir.

HAMLET No, by this hand.

KING Give them the foils, young Osric.—Cousin Hamlet,
You know the wager?

HAMLET Very well, my lord;
Your grace hath laid the odds o' the weaker side.

KING I do not fear it: I have seen you both.
But since he is bettered, we have therefore odds.

LAERTES This is too heavy, let me see another.

HAMLET This likes me well. These foils have all a length? 270

OSRIC Ay, my good lord.

THEY PREPARE TO PLAY.

KING Set me the stoups of wine upon that table.—
If Hamlet give the first or second hit,
Or quit[17] in answer of the third exchange,
Let all the battlements their ordnance fire;
The king shall drink to Hamlet's better breath;
And in the cup an union[18] shall he throw,
Richer than that which four successive kings
In Denmark's crown have worn. Give me the cups;
And let the kettle[19] to the trumpet speak,
The trumpet to the cannoneer without,
The cannons to the heavens, the heaven to earth,
"Now the king drinks to Hamlet."—Come, begin;—
And you, the judges, bear a wary eye.

HAMLET Come on, sir.

LAERTES Come, my lord.

THEY PLAY.

HAMLET One.

LAERTES No.

HAMLET Judgment.

OSRIC A hit, a very palpable hit.

LAERTES Well; again.

KING Stay, give me drink: Hamlet, this pearl is thine;
Here's to thy health. Give him the cup.

TRUMPETS SOUND; AND CANNON SHOT OFF WITHIN.

HAMLET I'll play this bout first, set it by awhile.—
Come.—[They play] Another hit. What say you?

LAERTES A touch, a touch, I do confess. 291

KING Our son shall win.

QUEEN He's fat, and scant of breath.—
Here, Hamlet, take my napkin, rub thy brows:
The queen carouses to thy fortune, Hamlet.

HAMLET Good, madam.

KING Gertrude, do not drink.

QUEEN I will, my lord; I pray you, pardon me.

KING [Aside] It is the poisoned cup! it is too late!

HAMLET I dare not drink yet, madam; by and by.

QUEEN Come, let me wipe thy face. 299

LAERTES My lord, I'll hit him now.

KING I do not think't.

LAERTES [Aside] And yet 'tis almost against my conscience. 252

HAMLET Come, for the third, Laertes: you but dally;
I pray you, pass with your best violence;
I am afeard you make a wanton of me.

LAERTES Say you so? come on.

THEY PLAY.

OSRIC Nothing neither way.

LAERTES Have at you now!

LAERTES WOUNDS HAMLET; THEN, IN SCUFFLING, 260
THEY CHANGE RAPIERS, AND HAMLET WOUNDS LAERTES.

KING Part them, they are incensed.

HAMLET Nay, come again.

THE QUEEN FALLS.

OSRIC Look to the queen there, ho!

HORATIO They bleed on both sides,—How is it, my lord? 311

OSRIC How is't, Laertes?

LAERTES Why, as a woodcock to mine own springe,[20]
Osric;
I am justly killed with mine own treachery.

HAMLET How does the queen?

KING She swounds[21] to see them bleed.

QUEEN No, no, the drink, the drink,—O my dear Ham-
let,—
The drink, the drink;—I am poisoned!

DIES.

HAMLET O villainy! Ho! Let the door be locked:
Treachery! seek it out.

LAERTES FALLS.

LAERTES It is here, Hamlet, Hamlet, thou art slain; 280
No medicine in the world can do thee good,
In thee there is not half an hour of life; 322
The treacherous instrument is in thy hand,
Unbated and envenomed: the foul practice
Hath turned itself on me; lo, here I lie,
Never to rise again; thy mother's poisoned;
I can no more, the king—the king's to blame.

HAMLET The point envenomed too! then, venom, to
thy work.

STABS THE KING.

ALL Treason! treason!

KING O, yet defend me, friends; I am but hurt.

HAMLET Here, thou incestuous, murderous, damned Dane, 331
Drink off this potion. Is thy union here?
Follow my mother!

KING DIES.

LAERTES He is justly served;
It is a poison tempered by himself.—
Exchange forgiveness with me, noble Hamlet:
Mine and my father's death come not upon thee,
Nor thine on me!

DIES.

HAMLET Heaven make thee free of it! I follow thee.— 338
I am dead, Horatio.—Wretched queen, adieu!—
You that look pale and tremble at this chance,
That are but mutes[22] or audience to this act,
Had I but time, as this fell sergeant, death,

Is strict in his arrest, O, I could tell you—
But let it be.—Horatio, I am dead;
Thou livest; report me and my cause aright
To the unsatisfied.
HORATIO Never believe it;
I am more an antique Roman[23] than a Dane;
Here's yet some liquor left.
HAMLET As thou'rt a man,
Give me the cup; let go; by heaven I'll have't.
O, good Horatio, what a wounded name,
Things standing thus unknown, shall live behind me! 351
If thou didst ever hold me in thy heart,
Absent thee from felicity a while,
And in this harsh world draw thy breath in pain,
To tell my story.—

 MARCH AFAR OFF, AND SHOT WITHIN.

What warlike noise is this?
OSRIC Young Fortinbras, with conquest come from Poland,
To the ambassadors of England gives
This warlike volley.
HAMLET O, I die, Horatio;
The potent poison quite o'er-crows my spirit;
I cannot live to hear the news from England.
But I do prophesy the election lights 361
On Fortinbras; he has my dying voice;
So tell him, with the occurrents,[24] more and less,
Which have solicited—the rest is silence.

 DIES.

HORATIO Now cracks a noble heart.—Good night, sweet
 prince,
And flights of angels sing thee to thy rest!
Why does the drum come hither?

 MARCH WITHIN.

 ENTER FORTINBRAS, THE ENGLISH AMBASSADORS,
 WITH DRUM, COLOURS, AND ATTENDANTS.

FORTINBRAS Where is this sight?
HORATIO What is it ye would see?
If aught of woe or wonder, cease your search.
FORTINBRAS This quarry[25] cries on havoc.—O proud
 death! 370
What feast is toward in thine eternal cell,
That thou so many princes, at a shot,
So bloodily hast strook?
1 AMBASSADOR The sight is dismal;
And our affairs from England come too late:
The ears are senseless that should give us hearing,
To tell him his commandment is fulfilled,
That Rosencrantz and Guildenstern are dead.
Where should we have our thanks?
HORATIO Not from his mouth,
Had it the ability of life to thank you; 379
He never gave commandment for their death.
But since, so jump[26] upon this bloody question,
You from the Polack wars, and you from England
Are here arrived, give order that these bodies
High on a stage be placed to the view;
And let me speak to the yet unknowing world,
How these things came about: so shall you hear
Of carnal, bloody, and unnatural acts,
Of accidental judgments, casual slaughters,
Of deaths put on by cunning, and forced cause;
And, in this upshot, purposes mistook 390
Fallen on the inventors' heads. All this can I
Truly deliver.

FORTINBRAS Let us haste to hear it,
And call the noblest to the audience.
For me, with sorrow I embrace my fortune;
I have some rights of memory in this kingdom,
Which now to claim my vantage doth invite me.
HORATIO Of that I shall have always cause to speak,
And from his mouth whose voice will draw on more:
But let this same be presently performed,
E'en while men's minds are wild; lest more mischance, 400
On plots and errors, happen.
FORTINBRAS Let four captains
Bear Hamlet, like a soldier, to the stage;
For he was likely, had he been put on,
To have proved most royally: and, for his passage,
The soldiers' music and the rites of war
Speak loudly for him.—
Take up the bodies.—Such a sight as this
Becomes the field, but here shows much amiss.
Go, bid the soldiers shoot.

 A DEAD MARCH.

 EXEUNT, BEARING OFF THE BODIES; AFTER WHICH
 A PEAL OF ORDNANCE IS SHOT OFF.

Notes

[1] mutineers in fetters
[2] enriched
[3] statesmen
[4] link
[5] absolution
[6] fishing line
[7] trickery
[8] table
[9] jackdaw, chatterer
[10] shadow
[11] meaning
[12] merit
[13] straps hanging the sword to the belt
[14] frothy
[15] misgiving
[16] royal assembly
[17] hit back
[18] pearl
[19] kettledrum
[20] snare
[21] swoons
[22] performers who have no lines to speak
[23] reference to the old Roman fashion of suicide
[24] occurrences
[25] heap of slain bodies
[26] precisely

CHAPTER 15

READING 54

from FRANCIS BACON (1561–1626), NOVUM ORGANUM ("THE NEW ORGANON") (1620)

Medieval thinkers, relying on the examples of Aristotle (author of the ORGANON) and Ptolemy, had devised general theories and then looked for specific examples to confirm them. Scientists like Francis Bacon, one of the leading figures in the scientific revolution, sought to reason in the opposite way: start from specific examples and use then to build a general theory. This emphasis on learning based on experience and drawing

general conclusions from particular observations is known as induction. Like all the new scientists of his age, Bacon took nothing for granted and regarded no opinion as "settled and immovable."

NOVUM ORGANUM ("THE NEW ORGANON"), which we excerpt here, laid out a new method for acquiring knowledge about the natural world—a method aimed specifically at establishing scientific truth. Here, Bacon sets out the first step in his method: freeing the mind of false Idols, that is, fixations or errors of thinking that impede objective investigation. He names four: Idols of the Tribe that arise from placing humanity at the center of the natural world and imposing a human order on it (for example, believing that the sun revolves around the earth); Idols of the Cave that arise from using individual experience to interpret all other experience (the student who sees the world entirely from the perspective of being young); Idols of the Marketplace that arise not only from using words inaccurately to describe the natural world (to call a whale a fish) but as substitutes for thought; and Idols of the Theatre that arise from relying on philosophical systems that, like dramas, are fictional.

Part II, Book I—from Aphorisms Concerning the Interpretation of Nature and the Kingdom of Man

XXXVI. One method of delivery alone remains to us which is simply this: we must lead men to the particulars themselves, and their series and order; while men on their side must force themselves for a while to lay their notions by and begin to familiarize themselves with facts.

XXXVIII. The idols and false notions which are now in possession of the human understanding, and have taken deep root therein, not only so beset men's minds that truth can hardly find entrance, but even after entrance is obtained, they will again in the very instauration of the sciences meet and trouble us, unless men being forewarned of the danger fortify themselves as far as may be against their assaults.

XXXIX. There are four classes of Idols which beset men's minds. To these for distinction's sake I have assigned names, calling the first class *Idols of the Tribe*; the second, *Idols of the Cave*; the third, *Idols of the Market Place*; the fourth, *Idols of the Theater*.

XLI. The Idols of the Tribe have their foundation in human nature itself, and in the tribe or race of men. For it is a false assertion that the sense of man is the measure of things. On the contrary, all perceptions as well of the sense as of the mind are according to the measure of the individual and not according to the measure of the universe. And the human understanding is like a false mirror, which, receiving rays irregularly, distorts and discolors the nature of things by mingling its own nature with it.

XLII. The Idols of the Cave are the idols of the individual man. For everyone (besides the errors common to human nature in general) has a cave or den of his own, which refracts and discolors the light of nature, owing either to his own proper and peculiar nature; or to his education and conversation with others; or to the reading of books, and the authority of those whom he esteems and admires; or to the differences of impressions, accordingly as they take place in a mind preoccupied and predisposed or in a mind indifferent and settled; or the like. So that the spirit of man (according as it is meted out to different individuals) is in fact a thing variable and full of perturbation, and governed as it were by chance. Whence it was well observed by Heraclitus that men look for sciences in their own lesser worlds, and not in the greater or common world.

XLIII. There are also Idols formed by the intercourse and association of men with each other, which I call Idols of the Market Place, on account of the commerce and consort of men there. For it is by discourse that men associate, and words are imposed according to the apprehension of the vulgar. And there-

fore the ill and unfit choice of words wonderfully obstructs the understanding. Nor do the definitions or explanations wherewith in some things learned men are wont to guard and defend themselves, by any means set the matter right. But words plainly force and overrule the understanding, and throw all into confusion, and lead men away into numberless empty controversies and idle fancies.

XLIV. Lastly, there are Idols which have immigrated into men's minds from the various dogmas of philosophies, and also from wrong laws of demonstration. These I call Idols of the Theater, because in my judgment all the received systems are but so many stage plays, representing worlds of their own creation after an unreal and scenic fashion. Nor is it only of the systems now in vogue, or only of the ancient sects and philosophies, that I speak; for many more plays of the same kind may yet be composed and in like artificial manner set forth; seeing that errors the most widely different have nevertheless causes for the most part alike. Neither again do I mean this only of entire systems, but also of many principles and axioms in science, which by tradition, credulity, and negligence have come to be received.

READING 55
from RENÉ DESCARTES (1596–1650),
DISCOURSE ON THE METHOD OF RIGHTLY CONDUCTING THE REASON AND SEEKING THE TRUTH IN THE SCIENCES (1637) PART IV

René Descartes, often called the Father of Modern Philosophy, is considered the founder of modern rational thought. Attacking philosophical problems, René Descartes's prime concern was to establish criteria for defining reality. The work from which we quote here contains a step-by-step account of how he arrived at his conclusions.

The essential first step lay in refusing to believe anything that he could not decisively prove to be true. This required that he doubt all of his previously held beliefs, including the evidence of his own senses. By stripping away all uncertainties he reached a basis of absolute certainty, a central truth on which he could build: that he existed. The very act of doubting proved that he was a thinking being. As he put it in the famous phrase contained below, "Cogito, ergo sum" ("I think, therefore I am").

From this foundation Descartes concluded that "[he] was a substance whose whole essence or nature consists only in thinking" and proceeded to consider the nature of material objects (including his own body) as he reconstructed the world he had taken to pieces. Guided by the principle that "all the things which we very clearly and distinctly conceive are true," he nevertheless acknowledged that our perceptions of the exact natures of material objects were likely to be incorrect and misleading. When, for example, we look at the sun, instead of an immense globe we see a very small disk. We must be careful, therefore, not to assume the accuracy of our perceptions; they demonstrate only that an object in question exists. Descartes concludes that the power to perceive the physical universe, to the best of our flawed abilities, comes from God.

from Book IV

I had long before remarked that, in (relation to) practice, it is sometimes necessary to adopt, as if above doubt, opinions which we discern to be highly uncertain, as has been already said; but as I then desired to give my attention solely to the search after truth, I thought that a procedure exactly the opposite was called for, and that I ought to reject as absolutely false all opinions in regard to which I could suppose the least ground for doubt, in order to ascertain whether after that there remained aught in my belief that was wholly indubitable. Accordingly, seeing that our

senses sometimes deceive us, I was willing to suppose that there existed nothing really such as they presented to us; and because some men err in reasoning, and fall into paralogisms, even on the simplest matters of Geometry, I, convinced that I was as open to error as any other, rejected as false all the reasonings I had hitherto taken for demonstrations; and finally, when I considered that the very same thoughts (presentations) which we experience when awake may also be experienced when we are asleep, while there is at that time not one of them true, I supposed that all the objects (presentations) that had ever entered into my mind when awake, had in them no more truth than the illusions of my dreams. But immediately upon this I observed that, whilst I thus wished to think that all was false, it was absolutely necessary that I, who thus thought, should be somewhat; and as I observed that this truth, I think, therefore I am, was so certain and of such evidence, that no ground of doubt, however extravagant, could be alleged by the Sceptics capable of shaking it, I concluded that I might, without scruple, accept it as the first principle of the Philosophy of which I was in search.

In the next place, I attentively examined what I was, and as I observed that I could suppose that I had no body, and that there was no world nor any place in which I might be; but that I could not therefore suppose that I was not; and that, on the contrary, from the very circumstance that I thought to doubt of the truth of other things, it most clearly and certainly followed that I was; while, on the other hand, if I had only ceased to think, although all the other objects which I had ever imagined had been in reality existent, I would have had no reason to believe that I existed; I thence concluded that I was a substance whose whole essence or nature consists only in thinking, and which, that it may exist, has need of no place, nor is dependent on any material thing; so that "I," that is to say, the mind by which I am what I am, is wholly distinct from the body, and is even more easily known that the latter, and is such, that although the latter were not, it would still continue to be all that it is.

After this I inquired in general into what is essential to the truth and certainty of a proposition; for since I had discovered one which I knew to be true, I thought that I must likewise be able to discover the ground of this certitude. And as I observed that in the words I think, therefore I am, there is nothing at all which gives me assurance of their truth beyond this, that I see very clearly that in order to think it is necessary to exist, I concluded that I might take, as a general rule, the principle, that all the things which we very clearly and distinctly conceive are true, only observing, however, that there is some difficulty in rightly determining the objects which we distinctly conceive.

In the next place, from reflecting on the circumstance that I doubted, and that consequently my being was not wholly perfect, (for I clearly saw that it was a greater perfection to know than to doubt,) I was led to inquire whence I had learned to think of something more perfect than myself; and I clearly recognised that I must hold this notion from some Nature which in reality was more perfect. As for the thoughts of many other objects external to me, as of the sky, the earth, light, heat, and a thousand more, I was less at a loss to know whence these came; for since I remarked in them nothing which seemed to render them superior to myself, I could believe that, if these were true, they were dependencies on my own nature, in so far as it possessed a certain perfection, and, if they were false, that I held them from nothing, that is to say, that they were in me because of a certain imperfection of my nature. But this could not be the case with the idea of a Nature more perfect than myself; for to receive it from nothing was a thing manifestly impossible; and, because it is not less repugnant that the more perfect should be an effect of, and dependence on the less perfect, than that something should proceed from nothing, it was equally impossible that I could hold it from myself: accordingly, it but remained that it had been placed in me by a Nature which was in reality more perfect than

mine, and which even possessed within itself all the perfections of which I could form any idea; that is to say, in a single word, which was God.

READING 56

from Thomas Hobbes (1588–1679), Leviathan (1651), Part I, Chapter XIII

Hobbes's philosophical masterpiece describes the life of humans in their natural state as "solitary, poor, nasty, brutish, and short." The only remedy lies in the imposition of social order, if possible in the form of an absolute monarchy. In this chapter, Hobbes's cynical view of human motivation is expressed in a tone of cool irony, which blends wit and detachment.

Part I, Chapter XIII

Of the Natural Condition of Mankind, As Concerning Their Felicity and Misery

Nature hath made men so equal in the faculties of body and mind as that though there be found one man sometimes manifestly stronger in body, or of quicker mind than another, yet when all is reckoned together, the difference between man and man is not so considerable as that one man can thereupon claim to himself any benefit to which another may not pretend as well as he. For as to the strength of body, the weakest has strength enough to kill the strongest, either by secret machination, or by confederacy with others that are in the same danger with himself.

And as to the faculties of the mind, setting aside the arts grounded upon words, and especially that skill of proceeding upon general and infallible rules, called science, which very few have, and but in few things as being not a native faculty, born with us, nor attained, as prudence, while we look after somewhat else, I find yet a greater equality amongst men than that of strength. For prudence is but experience; which equal time equally bestows on all men, in those things they equally apply themselves unto. That which may perhaps make such equality incredible is but a vain conceit of one's own wisdom, which almost all men think they have in a greater degree than the vulgar; that is, than all men but themselves and a few others, whom by fame or for concurring with themselves they approve. For such is the nature of men, that howsoever they may acknowledge many others to be more witty or more eloquent or more learned, yet they will hardly believe there be many so wise as themselves. For they see their own wit at hand, and other men's at a distance. But this proveth rather that men are in that point equal, than unequal. For there is not ordinarily a greater sign of the equal distribution of anything than that every man is contented with his share.

From this equality of ability ariseth equality of hope in the attaining of our ends. And therefore if any two men desire the same thing, which nevertheless they cannot both enjoy, they become enemies; and in the way to their end (which is principally their own conservation, and sometimes their delectation only), endeavor to destroy or subdue one another. And from hence it comes to pass, that where an invader hath no more to fear than another man's single power, if one plant, sow, build or possess a convenient seat, others may probably be expected to come prepared with forces united to dispossess and deprive him, not only of the fruit of his labor, but also of his life or liberty. And the invader again is in the like danger of another.

And from this diffidence of one another, there is no way for any man to secure himself so reasonable as anticipation; that is, by force or wiles to master the persons of all men he can, so

long till he see no other power great enough to endanger him; and this is no more than his own conservation requireth, and is generally allowed. Also because there be some, that taking pleasure in contemplating their own power in the acts of conquest, which they pursue farther than their security requires; if others, that otherwise would be glad to be at ease within modest bounds, should not by invasion increase their power, they would not be able, long time, by standing only on their defense, to subsist. And by consequence, such augmentation of dominion over men, being necessary to a man's conservation, it ought to be allowed him.

Again, men have no pleasure, but on the contrary a great deal of grief, in keeping company, where there is no power able to overawe them all: For every man looketh that his companion should value him at the same rate he sets upon himself; and upon all signs of contempt or undervaluing, naturally endeavors, as far as he dares (which amongst them that have no common power to keep them in quiet, is far enough to make them destroy each other), to extort a greater value from his contemners, by damage; and from others, by the example.

So that in the nature of man, we find three principal causes of quarrel. First, competition; second, diffidence; third, glory.

The first maketh men invade for gain; the second, for safety; and the third, for reputation. The first use violence, to make themselves masters of other men's persons, wives, children, and cattle; the second, to defend them; the third, for trifles, as a word, a smile, a different opinion, and any other sign of undervalue, either direct in their persons, or by reflection in their kindred, their friends, their nation, their profession, or their name.

Hereby it is manifest, that during the time men live without a common power to keep them all in awe, they are in that condition which is called war; and such a war as is of every man, against every man. For war consisteth not in battle only or the act of fighting; but in a tract of time, wherein the will to contend by battle is sufficiently known; and therefore the notion of time is to be considered in the nature of war, as it is in the nature of weather. For as the nature of foul weather lieth not in a shower or two of rain, but in an inclination thereto of many days together; so the nature of war consisteth not in actual fighting, but in the known disposition thereto during all the time there is no assurance to the contrary. All other time is peace.

Whatsoever therefore is consequent to a time of war, where every man is enemy to every man, the same is consequent to the time wherein men live without other security than what their own strength and their own invention shall furnish them withal. In such condition there is no place for industry, because the fruit thereof is uncertain; and consequently no culture of the earth; no navigation, nor use of the commodities that may be imported by sea; no commodious building; no instruments of moving and removing such things as require much force; no knowledge of the face of the earth; no account of time; no arts; no letters; no society; and, which is worst of all, continual fear, and danger of violent death; and the life of man, solitary, poor, nasty, brutish, and short.

It may seem strange to some man that has not well weighed these things, that nature should thus dissociate and render men apt to invade and destroy one another; and he may therefore, not trusting to this inference made from the passions, desire perhaps to have the same confirmed by experience. Let him therefore consider with himself; when taking a journey, he arms himself, and seeks to go well accompanied; when going to sleep, he locks his doors; when even in his house he locks his chests; and then when he knows there be laws and public officers, armed, to revenge all injuries shall be done him; what opinion he has of his fellow-subjects, when he rides armed; of his fellow-citizens, when he locks his doors; and of his children and servants, when he locks his chests. Does he not there as much accuse mankind by his actions as I do by my words? But neither of us accuse man's nature in it. The desires and other passions of man are in themselves no sin. No more are the actions that proceed from those passions, till they know a law that forbids them; which till laws be made they cannot know; nor can any law be made till they have agreed upon the person that shall make it.

It may peradventure [perhaps; perchance] be thought there was never such a time nor condition of war as this; and I believe it was never generally so over all the world; but there are many places where they live so now. For the savage people in many places of America, except the government of small families, the concord whereof dependeth on natural lust, have no government at all, and live at this day in that brutish manner, as I said before. Howsoever, it may be perceived what manner of life there would be, where there were no common power to fear, by the manner of life which men that have formerly lived under a peaceful government use to degenerate into in a civil war.

But though there had never been any time wherein particular men were in a condition of war one against another, yet in all times, kings and persons of sovereign authority, because of their independence, are in continual jealousies, and in the state and posture of gladiators; having their weapons pointing, and their eyes fixed on one another; that is, their forts, garrisons, and guns, upon the frontiers of their kingdoms; and continual spies upon their neighbors; which is a posture of war. But because they uphold thereby the industry of their subjects, there does not follow from it that misery which accompanies the liberty of particular men.

To this war of every man against every man, this also is consequent, that nothing can be unjust. The notions of right and wrong, justice and injustice, have there no place. Where there is no common power, there is no law; where no law, no injustice. Force and fraud are in war the two cardinal virtues. Justice and injustice are none of the faculties neither of the body nor mind. If they were, they might be in a man that were alone in the world, as well as his senses and passions. They are qualities that relate to men in society, not in solitude. It is consequent also to the same condition that there be no propriety, no dominion, no "mine" and "thine" distinct; but only that to be every man's that he can get; and for so long as he can keep it. And thus much for the ill condition which every man by mere nature is actually placed in; though with a possibility to come out of it, consisting partly in the passions, partly in his reason.

The passions that incline men to peace are fear of death, desire of such things as are necessary to commodious living, and a hope by their industry to obtain them. And reason suggesteth convenient articles of peace, upon which men may be drawn to agreement. These articles are they which otherwise are called the laws of nature. . . .

READING 57
from JOHN LOCKE (1632–1704), AN ESSAY CONCERNING HUMAN UNDERSTANDING (1690), BOOK I, OF INNATE NOTIONS

Book I of Locke's most important work deals with the nature of ideas. Arguing against the notion of innate ideas, Locke propounds the theory that knowledge depends on perception. In later sections, he discusses the nature of language and argues that it consists of a series of counters put in motion by associative ideas. By the end of his essay, he claims that the knowledge of each of us is limited to the sense impressions we have accumulated, and to our interpretation of them. Thus we should not believe ourselves inescapably trapped by divine preordination or the accidents of birth.

Chapter I Introduction

1. Since it is the *understanding* that sets man above the rest of sensible beings, and gives him all the advantage and dominion which he has over them; it is certainly a subject, even for its nobleness, worth our labor to inquire into. The understanding, like the eye, whilst it makes us see and perceive all other things, takes no notice of itself; and it requires art and pains to set it at a distance and make it its own object. But whatever be the difficulties that lie in the way of this inquiry; whatever it be that keeps us so much in the dark to ourselves; sure I am that all the light we can let in upon our minds, all the acquaintance we can make with our own understandings, will not only be very pleasant, but bring us great advantage, in directing our thoughts in the search of other things.

2. This, therefore, being my purpose—to inquire into the original, certainty, and extent of human knowledge, together with grounds and degrees of belief, opinion, and assent—I shall not at present meddle with the physical consideration of the mind; or trouble myself to examine wherein its essence consists; or by what motions of our spirits or alterations of our bodies we come to have any sensation by our organs, or any *ideas* in our understandings; and whether those *ideas* do in their formation, any or all of them, depend on matter or not. These are speculations which, however curious and entertaining, I shall decline, as lying out of my way in the design I am now upon. It shall suffice to my present purpose, to consider the discerning faculties of a man, as they are employed about the objects which they have to do with. And I shall imagine I have not wholly misemployed myself in the thoughts I shall have on this occasion, if, in this historical, plain method, I can give any account of the ways whereby our understandings come to attain those notions of things we have, and can set down any measures of the certainty of our knowledge; or the grounds of those persuasions which are to be found amongst men, so various, different, and wholly contradictory; and yet asserted somewhere or other with such assurance and confidence that he that shall take a view of the opinions of mankind, observe their opposition, and at the same time consider the fondness and devotion wherewith they are embraced, the resolution and eagerness wherewith they are maintained, may perhaps have reason to suspect, that either there is no such thing as truth at all, or that mankind hath no sufficient means to attain a certain knowledge of it . . .

5. For though the comprehension of our understandings comes exceeding short of the vast extent of things, yet we shall have cause enough to magnify the bountiful Author of our being, for that proportion and degree of knowledge he has bestowed on us, so far above all the rest of the inhabitants of this our mansion. Men have reason to be well satisfied with what God hath thought fit for them, since he hath given them (as St. Peter says) πάντα πρὸς ζωὴν καὶ εὐσέβειαν, whatsoever is necessary for the conveniences of life and information of virtue; and has put within the reach of their discovery, the comfortable provision for this life, and the way that leads to a better. How short soever their knowledge may come of an universal or perfect comprehension of whatsoever is, yet it secures their great concernments, that they have light enough to lead them to the knowledge of their Maker, and the sight of their own duties. Men may find matter sufficient to busy their heads and employ their hands with variety, delight and satisfaction, if they will not boldly quarrel with their own constitution, and throw away the blessings their hands are filled with, because they are not big enough to grasp everything. We shall not have much reason to complain of the narrowness of our minds, if we will but employ them about what may be of use to us; for of that they are very capable. And it will be an unpardonable as well as childish peevishness, if we undervalue the advantages of our knowledge, and neglect to improve it to the ends for which it was given us, because there are some

things that are set out of the reach of it. It will be no excuse to an idle and untoward servant, who would not attend his business by candlelight, to plead that he had not broad sunshine. The Candle that is set up in us shines bright enough for all our purposes. The discoveries we can make with this ought to satisfy us; and we shall then use our understandings right, when we entertain all objects in that way and proportion that they are suited to our faculties, and upon those grounds they are capable of being proposed to us; and not peremptorily or intemperately require demonstration, and demand certainty, where probability only is to be had, and which is sufficient to govern all our concernments. If we will disbelieve everything, because we cannot certainly know all things, we shall do much-what as wisely as he who would not use his legs, but sit still and perish because he had no wings to fly.

Chapter II No Innate Principles in the Mind

1. It is an established opinion amongst some men, that there are in the understanding certain *innate principles;* some primary notions, κοιναὶ ἔννοιαι, characters, as it were stamped upon the mind of man; which the soul receives in its very first being, and brings into the world with it.

It would be sufficient to convince unprejudiced readers of the falseness of this supposition, if I should only show (as I hope I shall in the following parts of this Discourse) how men, barely by the use of their natural faculties, may attain to all the knowledge they have, without the help of any innate impressions; and may arrive at certainty, without any such original notions or principles. For I imagine any one will easily grant that it would be impertinent to suppose the ideas of colors innate in a creature to whom God hath given sight, and a power to receive them by the eyes from external objects; and no less unreasonable would it be to attribute several truths to the impressions of nature, and innate characters, when we may observe in ourselves faculties fit to attain as easy and certain knowledge of them as if they were originally imprinted on the mind.

2. There is nothing more commonly taken for granted than that there are certain principles, both speculative and practical (for they speak of both), universally agreed upon by all mankind: which therefore, they argue, must needs be the constant impressions which the souls of men receive in their first beings, and which they bring into the world with them, as necessarily and really as they do any of their inherent faculties. . . .

4. But, which is worse, this argument of universal consent, which is made use of to prove innate principles, seems to me a demonstration that there are none such: because, there are none to which all mankind give an universal assent. I shall begin with the speculative, and instance in those magnified principles of demonstration, "Whatsoever is, is," and "It is impossible for the same thing to be and not to be"; which of all others, I think have the most allowed title to innate. But yet I take liberty to say, that these propositions are so far from having an universal assent, that there are a great part of mankind to whom they are not so much as known. . . .

6. To avoid this it is usually answered, that all men know and assent to them, *when they come to the use of reason;* and this is enough to prove them innate. I answer:

7. Doubtful expressions, that have scarce any signification, go for clear reasons to those who, being prepossessed, take not the pains to examine even what they themselves say. For, to apply this answer with any tolerable sense to our present purpose, it must signify one of these two things: either that as soon as men come to the use of reason these supposed native inscriptions come to be known and observed by them; or else, that the use and exercise of men's reason assists them in the discovery of these principles, and certainly makes them known to them.

Chapter III No Innate Practical Principles

1. If those speculative Maxims, whereof we discoursed in the foregoing chapter, have not an actual universal assent from all mankind, as we there proved, it is much more visible concerning *practical* Principles, that they come short of an universal reception: and I think it will be hard to instance any one moral rule which can pretend to so general and ready an assent as, "What is, is," or to be so manifest a truth as this, that "It is impossible for the same thing to be and not to be." Whereby it is evident that they are further removed from a title to be innate; and the doubt of their being native impressions on the mind is stronger against those moral principles than the others. Not that it brings their truth at all in question. They are equally true, though not equally evident. Those speculative maxims carry their own evidence with them: but moral principles require reasoning and discourse, and some exercise of the mind, to discover the certainty of their truth. They lie not open as natural characters engraved on the mind; which, if any such were, they must needs be visible b themselves, and by their own light be certain and known to everybody. But this is no derogation to their truth and certainty; no more than it is to the truth or certainty of the three angles of a triangle being equal to two right ones: because it is not so evident as "The whole is bigger than a part," nor so apt to be assented to at first hearing. It may suffice that these moral rules are capable of demonstration; and therefore it is our own fault if we come not to a certain knowledge of them. But the ignorance wherein many men are of them, and the slowness of assent wherewith others receive them, are manifest proofs that they are not innate, and such as offer themselves to their view without searching.

2. Whether there be any such moral principles, wherein all men do agree, I appeal to any who have been but moderately conversant in the history of mankind and looked abroad beyond the smoke of their own chimneys. Where is that practical truth that is universally received, without doubt or question as it must be if innate? *Justice,* and keeping of contracts, is that which most men seem to agree in. This is a principle which is thought to extend itself to the dens of thieves, and the confederacies of the greatest villains; and they who have gone furthest towards the putting off of humanity itself, keep faith and rules of justice one with another. I grant that outlaws themselves do this one amongst another: but it is without receiving these as the innate laws of nature. They practice them as rules of convenience within their own communities: but it is impossible to conceive that he embraces justice as a practical principle, who acts fairly with his fellow highwayman, and at the same time plunders or kills the next honest man he meets with. Justice and truth are the common ties of society; and therefore even outlaws and robbers, who break with all the world besides, must keep faith and rules of equity amongst themselves; or else they cannot hold together. But will any one say, that those that live by fraud or rapine have innate principles of truth and justice which they allow and assent to?

READING 58
RICHARD CRASHAW (1613–1649), "ON THE WOUNDS OF OUR CRUCIFIED LORD"

Crashaw's religious poetry, intense even by baroque standards, often fuses fervor and eroticism. In this poem, composed as if spoken by a weeping Mary Magdalen, the image of Christ's wounds as mouths blends with the image of Mary's tears and kisses, just as the wounds and kisses themselves literally blend.

O these wakeful wounds of thine!
 Are they Mouthes? or are they eyes?
Be they Mouthes, or be they eyne,
 Each bleeding part some one supplies.

Lo! a mouth, whose full-bloom'd lips
 At too deare a rate are roscs.
Lo! a blood-shot eye! that weepes
 And many a cruell teare discloses.

O thou that on this foot hast laid
 Many a kisse, and many a Teare. 10
Now thou shal't have all repaid.
 Whatsoe're thy charges were.

This foot hath got a Mouth and lippes,
 To pay the sweet summe of thy kisses:
To pay thy Teares, and Eye that weeps
 In stead of Teares such Gems as this is.

The difference onely this appeares.
 (Nor can the change offend)
The debt is paid in Ruby-Teares,
 Which thou in Pearles did'st lend. 20

READING 59
JOHN DONNE (1572–1631), "THE CANONIZATION"

Donne's poetry, like Crashaw's, contains both religious and erotic elements. In THE CANONIZATION the first three verses express with mounting passion the intensity of the poet's love. The climactic image of the phoenix, the mythological bird that died only to rise from its own ashes, is especially powerful, since in the sixteenth and seventeenth centuries to die often connoted the consummation of the physical act of love. Yet when Donne wants to cap even this image he turns to the language of religion, in the picture of the two lovers canonized.

For Godsake, hold your tongue, and let me
 love,
 Or chide my palsy, or my gout,
My five gray hairs, or ruined fortune flout.
 With wealth your state, your mind with
 arts improve.
 Take you a course, get you a place,
 Observe his honor, or his grace,
Or the King's real, or his stamped face
 Contemplate; what you will, approve,
 So you will let me love.

Alas, alas, who's injured by my love? 10
 What merchant's ships have my sighs
 drowned?
Who says my tears have overflowed his
 ground?
 When did my colds a forward spring
 remove?
 When did the heats which my veins fill
 Add one more to the plaguy bill?
Soldiers find wars, and lawyers find out still
 Litigious men, which quarrels move,
 Though she and I do love.

Call us what you will, we are made such
 by love;
 Call her one, me another fly, 20
We're tapers too, and at our own cost die,
 And we in us find the eagle and the dove.
 The phoenix riddle hath more wit
 By us; we two being one, are it.
So, to one neutral thing both sexes fit.
 We die and rise the same, and prove
 Mysterious by this love.

We can die by it, if not live by love,
 And if unfit for tombs and hearse
Our legend be, it will be fit for verse; 30
 And if no piece of chronicle we prove,
 We'll build in sonnets pretty rooms;
 As well a well-wrought urn becomes
The greatest ashes, as half-acre tombs.

 And by these hymns, all shall approve
 Us *canonized* for Love.
And thus invoke us: "You, whom reverend
 love
 Made one another's hermitage;
You, to whom love was peace, that now is
 rage;
Who did the whole world's soul extract, 40
 and drove
 Into the glasses of your eyes
 (So made such mirrors, and such spies,
That they did all to you epitomize)
 Countries, towns, courts: beg from above
 A pattern of your love!"

READING 60

from Molière (Jean Baptiste Poquelin) (1622–1673), Tartuffe (1664)

Tartuffe, the central character of Molière's play, is a sensual man who hypocritically pretends to be a religious ascetic. Although most people see through his deceit, he manages to fool Orgon, a wealthy Parisian, who is so taken in by Tartuffe's pose that he decides to leave his fortune to him. In order to open Orgon's eyes to the truth—and to protect their own interests—his wife, Elmire, and his son, Damis, decide to expose Tartuffe as a fraud. Dorine, the maid, hides Damis in a cupboard from which he can watch Elmire and Tartuffe together. As Damis and Elmire suspected he would, Tartuffe proceeds to try to seduce Elmire. Damis bursts out of hiding and, when Orgon enters, denounces Tartuffe to his father. Yet even this is not sufficient to convince the stubborn old man, and Tartuffe's clever protestations of guilt turn Orgon's anger against his son. The scene ends with Tartuffe triumphant, about to be adopted as Orgon's son.

As the play continues, Tartuffe returns to the assault of Elmire's honor, only to be caught by Orgon himself. Not only does he show no regret for his actions, he also takes immediate possession of Orgon's property and tries to have him evicted from his own house. At the very last moment Tartuffe is arrested and Orgon saved, but only by a sudden and completely unexpected royal decree. If this were real life and not a comedy, Molière seems to be saying, Tartuffe would probably get away with his diabolical scheme.

In Act III of the play we see Tartuffe in all his poses, as well as in his revelation of his true nature to Elmire. Molière brilliantly conveys the reactions of the various characters to Tartuffe while making the situation only too believable. Tartuffe's fake piety would have had a particular significance for an age in which religion was taken very seriously.

Act III

Scene 1. DAMIS, DORINE

DAMIS May lightning strike me even as I speak,
 May all men call me cowardly and weak,
 If any fear or scruple holds me back
 From settling things, at once, with that great quack!
DORINE Now, don't give way to violent emotion. 5
 Your father's merely talked about this notion,
 And words and deeds are far from being one.
 Much that is talked about is never done.
DAMIS No, I must stop that scoundrel's machinations;

 I'll go and tell him off; I'm out of patience. 10
DORINE Do calm down and be practical. I had rather
 My mistress dealt with him—and with your father.
 She has some influence with Tartuffe, I've noted.
 He hangs upon her words, seems most devoted,
 And may, indeed, be smitten by her charm. 15
 Pray Heaven it's true! 'Twould do our cause no harm.
 She sent for him, just now, to sound him out
 On this affair you're so incensed about;
 She'll find out where he stands, and tell him, too,
 What dreadful strife and trouble will ensue 20
 If he lends countenance to your father's plan.
 I couldn't get in to see him, but his man
 Says that he's almost finished with his prayers.
 Go, now. I'll catch him when he comes downstairs.
DAMIS I want to hear this conference, and I will. 25
DORINE No, they must be alone.
DAMIS Oh, I'll keep still.
DORINE Not you. I know your temper. You'd start a brawl,
 And shout and stamp your foot and spoil it all.
 Go on.
DAMIS I won't; I have a perfect right . . . 30
DORINE Lord, you're a nuisance! He's coming; get out of
 sight.

[DAMIS CONCEALS HIMSELF IN A CLOSET
AT THE REAR OF THE STAGE.]

Scene 2. TARTUFF, DORINE

TARTUFFE *[Observing* DORINE, *and calling to his manservant offstage]* Hang up my hair-shirt, put my scourge in
 place,
 And pray, Laurent, for Heaven's perpetual grace.
 I'm going to the prison now, to share
 My last few coins with the poor wretches there.
DORINE *[Aside]* Dear God, what affectation! What a fake! 5
TARTUFFE You wished to see me?
DORINE Yes . . .
TARTUFFE *[Taking a handkerchief from his pocket]* For
 mercy's sake,
 Please take this handkerchief, before you speak.
DORINE What?
TARTUFFE Cover that bosom, girl, The flesh is weak,
 And unclean thoughts are difficult to control.
 Such sights as that can undermine the soul. 10
DORINE Your soul, it seems, has very poor defenses,
 And flesh makes quite an impact on your senses.
 It's strange that you're so easily excited;
 My own desires are not so soon ignited,
 And if I saw you naked as a beast, 15
 Not all your hide would tempt me in the least.
TARTUFFE Girl, speak more modestly; unless you do,
 I shall be forced to take my leave of you.
DORINE Oh, no, it's I who must be on my way;
 I've just one little message to convey.
 Madame is coming down, and begs you, Sir, 20
 To wait and have a word or two with her.
TARTUFFE Gladly.
DORINE *[Aside]* That had a softening effect!
 I think my guess about him was correct.
TARTUFFE Will she be long?
DORINE No: that's her step I hear. 25
 Ah, here she is, and I shall disappear.

Scene 3. ELMIRE, TARTUFFE

TARTUFFE May Heaven, whose infinite goodness we
 adore,

Preserve your body and soul forevermore,
And bless your days, and answer thus the plea
Of one who is its humblest votary.
ELMIRE I thank you for that pious wish. But please,　　5
　　Do take a chair and let's be more at ease.

[THEY SIT DOWN.]

TARTUFFE I trust that you are once more well and strong?
ELMIRE Oh, yes: the fever didn't last for long.
TARTUFFE My prayers are too unworthy, I am sure,
　　To have gained from Heaven this most gracious cure;　　10
　　But lately, Madam, my every supplication
　　Has had for object your recuperation.
ELMIRE You shouldn't have troubled so. I don't deserve it.
TARTUFFE Your health is priceless, Madam, and to pre-
　　serve it
　　I'd gladly give my own, in all sincerity.　　15
ELMIRE Sir, you outdo us all in Christian charity.
　　You've been most kind. I count myself your debtor.
TARTUFFE 'Twas nothing, Madam. I long to serve you
　　better.
ELMIRE There's a private matter I'm anxious to discuss.
　　I'm glad there's no one here to hinder us.　　20
TARTUFFE I too am glad; it floods my heart with bliss
　　To find myself alone with you like this.
　　For just this chance I've prayed with all my power
　　But prayed in vain, until this happy hour.
ELMIRE This won't take long, Sir, and I hope you'll be　　25
　　Entirely frank and unconstrained with me.
TARTUFFE Indeed, there's nothing I had rather do
　　Than bare my inmost heart and soul to you.
　　First, let me say that what remarks I've made
　　About the constant visits you are paid　　30
　　Were prompted not by any mean emotion,
　　But rather by a pure and deep devotion,
　　A fervent zeal . . .
ELMIRE No need for explanation.
　　Your sole concern, I'm sure, was my salvation.
TARTUFFE [Taking ELMIRE's hand and pressing her
　　　fingertips]
　　Quite so; and such great fervor do I feel . . .　　35
ELMIRE Ooh! Please! You're pinching.
TARTUFFE 'Twas from excess of zeal.
　　I never meant to cause you pain, I swear.
　　I'd rather . . .

[HE PLACES HIS HAND ON ELMIRE'S KNEE.]

ELMIRE What can your hand be doing there?
TARTUFFE Feeling your gown: what soft, fine-woven stuff!
ELMIRE Please, I'm extremely ticklish. That's enough.　　40

[SHE DRAWS HER CHAIR AWAY; TARTUFFE PULLS
HIS AFTER HER.]

TARTUFFE [Fondling the lace collar of her gown]
　　My, my, what lovely lacework on your dress!
　　The workmanship's miraculous, no less.
　　I've not seen anything to equal it.
ELMIRE Yes, quite. But let's talk business for a bit.
　　They say my husband means to break his word　　45
　　And give his daughter to you, Sir. Had you heard?
TARTUFFE He did once mention it. But I confess
　　I dream of quite a different happiness.
　　It's elsewhere, Madam, that my eyes discern
　　The promise of that bliss for which I yearn.　　50
ELMIRE I see: you care for nothing here below.
TARTUFFE Ah, well my heart's not made of stone,
　　you know.
ELMIRE All your desires mount heavenward, I'm sure,
　　In scorn of all that's earthly and impure.

TARTUFFE A love of heavenly beauty does not preclude　　55
　　A proper love for earthly pulchritude;
　　Our senses are quite rightly captivated
　　By perfect works our Maker has created.
　　Some glory clings to all that Heaven has made;
　　In you, all Heaven's marvels are displayed.　　60
　　On that fair face, such beauties have been lavished,
　　The eyes are dazzled and the heart is ravished;
　　How could I look on you, O flawless creature,
　　And not adore the Author of all Nature,
　　Feeling a love both passionate and pure　　65
　　For you, his triumph of self-portraiture?
　　At first, I trembled lest that love should be
　　A subtle snare that Hell had laid for me;
　　I vowed to flee the sight of you, eschewing
　　A rapture that might prove my soul's undoing;　　70
　　But soon, fair being, I became aware
　　That my deep passion could be made to square
　　With rectitude, and with my bounden duty,
　　I thereupon surrendered to your beauty.
　　It is, I know, presumptuous on my part　　75
　　To bring you this poor offering of my heart,
　　And it is not my merit, Heaven knows,
　　But your compassion on which my hopes repose.
　　You are my peace, my solace, my salvation;
　　On you depends my bliss or desolation;　　80
　　I bide your judgment and, as you think best,
　　I shall be either miserable or blest.
ELMIRE Your declaration is most gallant, Sir,
　　But don't you think it's out of character?
　　You'd have done better to restrain your passion　　85
　　And think before you spoke in such a fashion.
　　It ill becomes a pious man like you . . .
TARTUFFE I may be pious, but I'm human too:
　　With your celestial charms before his eyes,
　　A man has not the power to be wise.　　90
　　I know such words sound strangely, coming from me,
　　But I'm no angel, nor was meant to be,
　　And if you blame my passion, you must needs
　　Reproach as well the charms on which it feeds.
　　Your loveliness I had no sooner seen　　95
　　Than you became my soul's unrivalled queen;
　　Before your seraph glance, divinely sweet,
　　My heart's defenses crumbled in defeat,
　　And nothing fasting, prayer, or tears might do
　　Could stay my spirit from adoring you.　　100
　　My eyes, my sighs have told you in the past
　　What now my lips make bold to say at last,
　　And if, in your great goodness, you will deign
　　To look upon your slave, and ease his pain,
　　If, in compassion for my soul's distress,　　105
　　You'll stoop to comfort my unworthiness,
　　I'll raise to you, in thanks for that sweet manna,
　　An endless hymn, an infinite hosanna.
　　With me, of course, there need be no anxiety,
　　No fear of scandal or of notoriety.　　110
　　These young court gallants, whom all the ladies fancy,
　　Are vain in speech, in action rash and chancy;
　　When they succeed in love, the world soon knows it;
　　No favor's granted them but they disclose it
　　And by the looseness of their tongues profane　　115
　　The very altar where their hearts have lain.
　　Men of my sort, however, love discreetly,
　　And one may trust our reticence completely.
　　My keen concern for my good name insures
　　The absolute security of yours;　　120
　　In short, I offer you, my dear Elmire,
　　Love without scandal, pleasure without fear.
ELMIRE I've heard your well-turned speeches to the end,

And what you urge I clearly apprehend.
Aren't you afraid that I may take a notion 125
To tell my husband of your warm devotion,
And that, supposing he were duly told,
His feelings toward you might grow rather cold?

TARTUFFE I know, dear lady, that your exceeding charity
Will lead your heart to pardon my temerity; 130
That you'll excuse my violent affection
As human weakness, human imperfection;
And that O fairest! you will bear in mind
That I'm but flesh and blood, and am not blind.

ELMIRE Some women might do otherwise, perhaps, 135
But I shall be discreet about your lapse;
I'll tell my husband nothing of what's occurred
If, in return, you'll give your solemn word
To advocate as forcefully as you can
The marriage of Valère and Mariane, 140
Renouncing all desire to dispossess
Another of his rightful happiness.
And . . .

Scene 4. DAMIS, ELMIRE, TARTUFFE

DAMIS *[Emerging from the closet where he has been hiding]*
No! We'll not hush up this vile affair;
I heard it all inside that closet there,
Where Heaven, in order to confound the pride
Of this great rascal, prompted me to hide.
Ah, now I have my long-awaited chance 5
To punish his deceit and arrogance,
And give my father clear and shocking proof
Of the black character of his dear Tartuffe.

ELMIRE As no, Damis; I'll be content if he
Will study to deserve my leniency. 10
I've promised silence don't make me break my word;
To make a scandal would be too absurd.
Good wives laugh off such trifles, and forget them;
Why should they tell their husbands, and upset them?

DAMIS You have your reasons for taking such a course, 15
And I have reasons, too, of equal force.
To spare him now would be insanely wrong.
I've swallowed my just wrath for far too long
And watched this insolent bigot bringing strife
And bitterness into our family life. 20
Too long he's meddled in my father's affairs,
Thwarting my marriage-hopes, and poor Valère's.
It's high time that my father was undeceived,
And now I've proof that can't be disbelieved
Proof that was furnished me by Heaven above. 25
It's too good not to take advantage of.
This is my chance, and I deserve to lose it
If, for one moment, I hesitate to use it.

ELMIRE Damis . . .

DAMIS No, I must do what I think right.
Madam, my heart is bursting with delight, 30
And, say whatever you will, I'll not consent
To lose the sweet revenge on which I'm bent.
I'll settle matters without more ado;
And here, most opportunely, is my cue.

Scene 5. ORGON, DAMIS, TARTUFFE, ELMIRE

DAMIS Father, I'm glad you've joined us. Let us advise you
Of some fresh news which doubtless will surprise you.
You've just now been repaid with interest
For all your loving-kindness to our guest.
He's proved his warm and grateful feelings toward you; 5
It's with a pair of horns he would reward you.
Yes, I surprised him with your wife, and heard

His whole adulterous offer, every word.
She, with her all too gentle disposition,
Would not have told you of his proposition; 10
But I shall not make terms with brazen lechery,
And feel that not to tell you would be treachery.

ELMIRE And I hold that one's husband's peace of mind
Should not be spoilt by tattle of this kind.
One's honor doesn't require it: to be proficient 15
In keeping men at bay is quite sufficient.
These are my sentiments, and I wish, Damis,
That you had heeded me and held your peace.

Scene 6. ORGON, DAMIS, TARTUFFE

ORGON Can it be true, this dreadful thing I hear?

TARTUFFE Yes, Brother, I'm a wicked man, I fear:
A wretched sinner, all depraved and twisted,
The greatest villain that has ever existed.
My life's one heap of crimes, which grows each minute; 5
There's naught but foulness and corruption in it;
And I perceive that Heaven, outraged by me,
Has chosen this occasion to mortify me.
Charge me with any deed you wish to name;
I'll not defend myself, but take the blame. 10
Believe what you are told, and drive Tartuffe
Like some base criminal from beneath your roof;
Yes, drive me hence, and with a parting curse:
I shan't protest, for I deserve far worse.

ORGON *[To* DAMIS*]* Ah, you deceitful boy, how dare you try 15
To stain his purity with so foul a lie?

DAMIS What! Are you taken in by such a bluff?
Did you not hear . . . ?

ORGON Enough, you rogue, enough!

TARTUFFE Ah, Brother, let him speak: you're being unjust.
Believe his story; the boy deserves your trust. 20
Why, after all, should you have faith in me?
How can you know what I might do, or be?
Is it on my good actions that you base
Your favor? Do you trust my pious face?
Ah, no, don't be deceived by hollow shows; 25
I'm far, alas, from being what men suppose;
Though the world takes me for a man of worth,
I'm truly the most worthless man on earth.
[To DAMIS*]*
Yes, my dear son, speak out now: call me the chief
Of sinners, a wretch, a murderer, a thief; 30
Load me with all the names men most abhor;
I'll not complain, I've earned them all, and more;
I'll kneel here while you pour them on my head
As a just punishment for the life I've led.

ORGON *[To* TARTUFFE*]* This is too much, dear Brother.
[To DAMIS*]* Have you no heart?

DAMIS Are you so hoodwinked by this rascal's art . . . ? 35

ORGON Be still, you monster.
[To TARTUFFE*]* Brother, I pray you, rise.
[To DAMIS*]* Villain!

DAMIS But . . .

ORGON Silence!

DAMIS Can't you realize . . . ?

ORGON Just one word more, and I'll tear you limb from limb.

TARTUFFE In God's name, Brother, don't be harsh with him. 40
I'd rather far be tortured at the stake
Than see him bear one scratch for my poor sake.

ORGON *[To* DAMIS*]* Ingrate!

TARTUFFE If I must beg you, on bended knee,

To pardon him . . .

ORGON [*Falling to his knees, addressing* TARTUFFE]

 Such goodness cannot be!

 [*To* DAMIS] Now, there's true charity!

DAMIS What, you . . . ?

ORGON Villain, be still! 45

 I know your motives; I know you wish him ill:

 Yes, all of you wife, children, servants, all

 Conspire against him and desire his fall,

 Employing every shameful trick you can

 To alienate me from this saintly man. 50

 Ah, but the more you seek to drive him away,

 The more I'll do to keep him. Without delay,

 I'll spite this household and confound its pride

 By giving him my daughter as his bride.

DAMIS You're going to force her to accept his hand? 55

ORGON Yes, and this very night, d'you understand?

 I shall defy you all, and make it clear

 That I'm the one who gives the orders here.

 Come, wretch, kneel down and clasp his blessed feet,

 And ask his pardon for your black deceit. 60

DAMIS I ask that swindler's pardon? Why, I'd rather . . .

ORGON So! You insult him, and defy your father!

 A stick! A stick! [*To* TARTUFFE] No, no release me, do.

 [*To* DAMIS] Out of my house this minute! Be off with you,

 And never dare set foot in it again. 65

DAMIS Well, I shall go, but . . .

ORGON Well, go quickly, then.

 I disinherit you; an empty purse

 Is all you'll get from me except my curse!

Scene 7. ORGON, TARTUFFE

ORGON How he blasphemed your goodness!

 What a son!

TARTUFFE Forgive him, Lord, as I've already done.

 [*To* ORGON] You can't know how it hurts when some-

 one tries

 To blacken me in my dear Brother's eyes.

ORGON Ahh!

TARTUFFE The mere thought of such ingratitude 5

 Plunges my soul into so dark a mood . . .

 Such horror grips my heart . . . I gasp for breath,

 And cannot speak, and feel myself near death.

ORGON [*He runs, in tears, to the door through which he has

 just driven his son.*]

 You blackguard! Why did I spare you? Why did I not

 Break you in little pieces on the spot? 10

 Compose yourself, and don't be hurt, dear friend.

TARTUFFE These scenes, these dreadful quarrels, have got

 to end.

 I've much upset your household, and I perceive

 That the best thing will be for me to leave.

ORGON What are you saying!

TARTUFFE They're all against me here;

 They'd have you think me false and insincere. 15

ORGON Ah, what of that? Have I ceased believing in you?

TARTUFFE Their adverse talk will certainly continue,

 And charges which you now repudiate

 You may find credible at a later date. 20

ORGON No, Brother, never.

TARTUFFE Brother, a wife can sway

 Her husband's mind in many a subtle way.

ORGON No, no.

TARTUFFE To leave at once is the solution;

 Thus only can I end their persecution.

ORGON No, no, I'll not allow it; you shall remain. 25

TARTUFFE Ah, well; 'twill mean much martyrdom

 and pain,

But if you wish it . . .

ORGON Ah!

TARTUFFE Enough; so be it.

 But one thing must be settled, as I see it.

 For your dear honor, and for our friendship's sake,

 There's one precaution I feel bound to take. 30

 I shall avoid your wife, and keep away . . .

ORGON No, you shall not, 'whatever they may say.

 It pleases me to vex them, and for spite

 I'd have them see you with her day and night.

 What's more, I'm going to drive them to despair 35

 By making you my only son and heir;

 This very day, I'll give to you alone

 Clear deed and title to everything I own.

 A dear, good friend and son-in-law-to-be

 Is more than wife, or child, or kin to me. 40

 Will you accept my offer, dearest son?

TARTUFFE In all things, let the will of Heaven be done.

ORGON Poor fellow! Come, we'll go draw up the deed.

 Then let them burst with disappointed greed!

Tartuffe by Molière, English translation copyright © 1963, 1962, 1961, and renewed 1991, 1990, and 1989 by Richard Wilbur. Reprinted by permission of Harcourt, Inc.

READING 61

from MIGUEL DE CERVANTES SAAVEDRA (1547–1616), THE ADVENTURES OF DON QUIXOTE (1605–1615), PART II

These two chapters, from the beginning of the second half of the story, illustrate some of the many layers of meaning in Cervantes's novel. The two heroes are hidden outside the town of El Toboso, where they have come in search of Don Quixote's ideal (and imaginary) mistress, Dulcinea. Sancho, who realizes the absurdity of the quest, pretends to recognize a passing peasant girl as the beloved Dulcinea. Don Quixote can see immediately that the girl is plain, poorly dressed, and riding on a donkey, yet Sancho's conviction—as well as his own need to be convinced—persuades him to greet her as his beautiful mistress. But how to reconcile her appearance with her noble identity? The Don rushes to the conclusion that some malign, persecuting enchanter has bewitched him; as a result he cannot see the real Dulcinea on her magnificent horse, but only a rough girl on an ass. Thus he sees the truth yet invents his own interpretation of it.

The two travelers then meet up with a band of actors dressed as the characters they play: Death, Cupid, the Emperor, and so on. The resulting confusion between reality and illusion, with its implicit questioning of the nature of role-playing, has significance far beyond the man of la Mancha and his delusions.

In both of these episodes, Cervantes touches on profound questions of identity and truth, yet his style is always easy, even conversational. The narrator's apparent detachment adds to the touching effect of the Don's madness.

Chapter X. In which is related the device Sancho adopted to enchant the Lady Dulcinea, and other incidents as comical as they are true.

When the author of this great history comes to recount the contents of this chapter, he says that he would have liked to pass it over in silence, through fear of disbelief. For Don Quixote's delusions here reach the greatest imaginable bounds and limits, and even exceed them, great as they are, by two bowshots. But finally he wrote the deeds down, although with fear and misgivings, just as our knight performed them, without

adding or subtracting one atom of truth from the history, or taking into account any accusations of lying that might be laid against him. And he was right, for truth, though it may run thin, never breaks, and always flows over the lie like oil over water. So, continuing his history, he says that as soon as Don Quixote had hidden himself in the thicket, or oak wood, or forest, beside great El Toboso, he ordered Sancho to go back to the city, and not return to his presence without first speaking to his lady on his behalf, and begging her to be so good as to allow herself to be seen by her captive knight, and to deign to bestow her blessing on him, so that he might hope thereby to meet with the highest success in all his encounters and arduous enterprises. Sancho undertook to do as he was commanded, and to bring his master as favorable a reply as he had brought the first time.

"Go, my son," said Don Quixote, "and do not be confused when you find yourself before the light of the sun of beauty you are going to seek. How much more fortunate you are than all other squires in the world! Bear in your mind, and let it not escape you, the manner of your reception; whether she changes color whilst you are delivering her my message; whether she is stirred or troubled on hearing my name; whether she shifts from her cushion, should you, by chance, find her seated on the rich dais of her authority. If she is standing, watch whether she rests first on one foot and then on the other; whether she repeats her reply to you two or three times; whether she changes from mild to harsh, from cruel to amorous; whether she raises her hand to her hair to smooth it, although it is not untidy. In fact, my son, watch all her actions and movements; because, if you relate them to me as they were, I shall deduce what she keeps concealed in the secret places of her heart as far as concerns the matter of my love. For you must know, Sancho, if you do not know already, that between lovers the outward actions and movements they reveal when their loves are under discussion are most certain messengers, bearing news of what is going on in their innermost souls. Go, friend, and may better fortune than mine guide you, and send you better success than I expect, waiting between fear and hope in this bitter solitude where you leave me."

"I'll go, and come back quickly," said Sancho. "Cheer up that little heart of yours, dear master, for it must be no bigger now than a hazel nut.

Remember the saying that a stout heart breaks bad luck; and where there are no flitches there are no hooks; and they say, too, where you least expect it, out jumps the hare. This I say because now that it's day I hope to find my lady's palaces or castles where I least expect them, even though we didn't find them last night: and once found, leave me to deal with her alone."

"Indeed, Sancho," said Don Quixote, "you always bring in your proverbs very much to the purpose of our business. May God give me as good luck in my ventures as you have in your sayings."

At these words Sancho turned away and gave Dapple the stick; and Don Quixote stayed on horseback, resting in his stirrups and leaning on his lance, full of sad and troubled fancies, with which we will leave him and go with Sancho Panza, who parted from his master no less troubled and thoughtful than he. So much so that scarcely had he come out of the wood than he turned round and, seeing that Don Quixote was out of sight, dismounted from his ass. Then, sitting down at the foot of a tree, he began to commune with himself to this effect:

"Now, let us learn, brother Sancho, where your worship is going. Are you going after some ass you have lost? No, certainly not. Then what are you going to look for? I am going to look, as you might say, for nothing, for a Princess, and in her the sun of beauty and all heaven besides.

And where do you expect to find this thing you speak of, Sancho? Where? In the great city of El Toboso. Very well, and

on whose behalf are you going to see her? On behalf of the famous knight Don Quixote de la Mancha, who rights wrongs, gives meat to the thirsty, and drink to the hungry. All this is right enough. Now, do you know her house? My master says it will be some royal palace or proud castle. And have you by any chance ever seen her? No, neither I nor my master have ever seen her. And, if the people of El Toboso knew that you are here for the purpose of enticing away their Princesses and disturbing their ladies, do you think it would be right and proper for them to come and give you such a basting as would grind your ribs to powder and not leave you a whole bone in your body? Yes, they would be absolutely in the right, if they did not consider that I am under orders, and that

You are a messenger, my friend
And so deserve no blame.

"Don't rely on that, Sancho, for the Manchegans are honest people and very hot-tempered, and they won't stand tickling from anyone. God's truth, if they smell you, you're in for bad luck. Chuck it up, you son of a bitch, and let someone else catch it. No, you won't find me searching for a cat with three legs for someone else's pleasure. What's more, looking for Dulcinea up and down El Toboso will be like looking for little Maria in Ravenna, or the Bachelor in Salamanca. It's the Devil, the Devil himself who has put me into this business. The Devil and no other!"

This colloquy Sancho held with himself, and it led him to the following conclusion: "Well, now, there's a remedy for everything except death, beneath whose yoke we must all pass, willy-nilly, at the end of our lives. I have seen from countless signs that this master of mine is a raving lunatic who ought to be tied up—and me, I can't be much better, for since I follow him and serve him, I'm more of a fool than he—if the proverb is true that says: tell me what company you keep and I will tell you what you are; and that other one too: not with whom you are born but with whom you feed. Well, he's mad—that he is—and it's the kind of madness that generally mistakes one thing for another, and thinks white black and black white, as was clear when he said that the windmills were giants and the friars' mules dromedaries, and the flocks of sheep hostile armies, and many other things to this tune. So it won't be very difficult to make him believe that the first peasant girl I run across about here is the lady Dulcinea. If he doesn't believe it I'll swear, and if he swears I'll outswear him, and if he sticks to it I shall stick to it harder, so that, come what may, my word shall always stand up to his. Perhaps if I hold out I shall put an end to his sending me on any more of these errands, seeing what poor answers I bring back. Or perhaps he'll think, as I fancy he will, that one of those wicked enchanters who, he says, have a grudge against him, has changed her shape to vex and spite him."

With these thoughts Sancho quieted his conscience, reckoning the business as good as settled. And there he waited till afternoon, to convince Don Quixote that he had had time to go to El Toboso and back. And so well did everything turn out that when he got up to mount Dapple he saw three peasant girls coming in his direction, riding on three young asses or fillies—our author does not tell us which—though it is more credible that they were she-asses, as these are the ordinary mounts of village women; but as nothing much hangs on it, there is no reason to stop and clear up the point. To continue—as soon as Sancho saw the girls, he went back at a canter to look for his master and found him, sighing and uttering countless amorous lamentations. But as soon as Don Quixote saw him, he cried: "What luck, Sancho? Shall I mark this day with a white stone or with a black?"

"It'll be better," replied Sancho, "for your worship to mark it in red chalk, like college lists, to be plainly seen by all who look."

"At that rate," said Don Quixote, "you bring good news."

"So good," answered Sancho, "that your worship has nothing more to do than to spur Rocinante and go out into the

open to see the lady Dulcinea del Toboso, who is coming to meet your worship with two of her damsels."

"Holy Father! What is that you say, Sancho my friend?" cried Don Quixote. "See that you do not deceive me, or seek to cheer my real sadness with false joys."

"What could I gain by deceiving your worship?" replied Sancho. "Especially as you are so near to discovering the truth of my report. Spur on, sir, come, and you'll see the Princess, our mistress, coming dressed and adorned—to be brief, as befits her. Her maidens and she are one blaze of gold, all ropes of pearls, all diamonds, all rubies, all brocade of more than ten gold strands; their hair loose on their shoulders, like so many sunrays sporting in the wind and what's more, they are riding on three piebald nackneys, the finest to be seen."

"Hackneys you mean, Sancho."

"There is very little difference," replied Sancho, "between nackneys and hackneys. But let them come on whatever they may, they are the bravest ladies you could wish for, especially the Princess Dulcinea, my lady, who dazzles the senses."

"Let us go, Sancho my son," replied Don Quixote, "and as a reward for this news, as unexpected as it is welcome, I grant you the best spoil I shall gain in the first adventure that befalls me; and, if that does not content you, I grant you the fillies that my three mares will bear me this year, for you know that I left them to foal on our village common."

"The fillies for me," cried Sancho, "for it's not too certain that the spoils of the first adventure will be good ones."

At this point they came out of the wood and discovered the three village girls close at hand. Don Quixote cast his eye all along the El Toboso road, and seeing nothing but the three peasant girls, asked Sancho in great perplexity whether he had left the ladies outside the city.

"How outside the city?" he answered. "Can it be that your worship's eyes are in the back of your head that you don't see that these are they, coming along shining like the very sun at noon?"

"I can see nothing, Sancho," said Don Quixote, "but three village girls on three donkeys."

"Now God deliver me from the Devil," replied Sancho. "It is possible that three hackneys or whatever they're called, as white as driven snow, look to your worship like asses? Good Lord, if that's the truth, may my beard be plucked out."

"But I tell you, Sancho my friend," said Don Quixote, "that it is as true that they are asses, or she-asses, as that I am Don Quixote and you Sancho Panza. At least, they look so to me."

"Hush, sir!" said Sancho. "Don't say such a thing, but wipe those eyes of yours, and come and do homage to the mistress of your thoughts, who is drawing near."

As he spoke he rode forward to receive the three village girls, and dismounting from Dapple, took one of the girls' asses by the bridle and sank on both knees to the ground, saying: "Queen and Princess and Duchess of beauty, may your Highness and Mightiness deign to receive into your grace and good liking your captive knight, who stands here, turned to marble stone, all troubled and unnerved at finding himself in your magnificent presence. I am Sancho Panza, his squire, and he is the travel-weary knight, Don Quixote de la Mancha, called also by the name of the Knight of the Sad Countenance."

By this time Don Quixote had fallen on his knees beside Sancho, and was staring, with his eyes starting out of his head and a puzzled look on his face, at the person whom Sancho called Queen and Lady. And as he could see nothing in her but a country girl, and not a very handsome one at that, she being round-faced and flat-nosed, he was bewildered and amazed, and did not dare to open his lips. The village girls were equally astonished at seeing these two men, so different in appearance, down on their knees and preventing their companion from going forward. But the girl they had stopped broke the silence by crying roughly and angrily: "Get out of the way, confound you, and let us pass.

We're in a hurry."

To which Sancho replied: "O Princess and world-famous Lady of El Toboso! How is it that your magnanimous heart is not softened when you see the column and prop of knight errantry kneeling before your sublimated presence?"

On hearing this, one of the two others exclaimed: "Wait till I get my hands on you, you great ass! See how these petty gentry come and make fun of us village girls, as if we couldn't give them as good as they bring! Get on your way, and let us get on ours. You had better!"

"Rise, Sancho," said Don Quixote at this; "for I see that Fortune, unsatisfied with the ill already done me, has closed all roads by which any comfort may come to this wretched soul I bear in my body. And you, O perfection of all desire! Pinnacle of human gentleness! Sole remedy of this afflicted heart, that adores you! Now that the malignant enchanter persecutes me, and has put clouds and cataracts into my eyes, and for them alone, and for no others, has changed and transformed the peerless beauty of your countenance into the semblance of a poor peasant girl, if he has not at the same time turned mine into the appearance of some specter to make it abominable to your sight, do not refuse to look at me softly and amorously, perceiving in this submission and prostration, which I make before your deformed beauty, the humility with which my soul adores you."

"Tell that to my grandmother!" replied the girl. "Do you think I want to listen to that nonsense? Get out of the way and let us go on, and we'll thank you."

Sancho moved off and let her pass, delighted at having got well out of his fix. And no sooner did the girl who had played the part of Dulcinea find herself free than she prodded her nackney with the point of a stick she carried, and set off at a trot across the field. But when the she-ass felt the point of the stick, which pained her more than usual, she began to plunge so wildly that my lady Dulcinea came off upon the ground. When Don Quixote saw this accident he rushed to pick her up, and Sancho to adjust and strap on the packsaddle, which had slipped under the ass's belly. But when the saddle was adjusted and Don Quixote was about to lift his enchanted mistress in his arms and place her on her ass, the lady picked herself up from the ground and spared him the trouble. For, stepping back a little, she took a short run, and resting both her hands on the ass's rump, swung her body into the saddle, lighter than a hawk, and sat astride like a man.

At which Sancho exclaimed: "By St. Roque, the lady, our mistress, is lighter than a falcon, and she could train the nimblest Cordovan or Mexican to mount like a jockey. She was over the crupper of the saddle in one jump, and now without spurs she's making that hackney gallop like a zebra. And her maidens are not much behind her. They're all going like the wind."

And so they were, for once Dulcinea was mounted, they all spurred after her and dashed away at full speed, without once looking behind them till they had gone almost two miles. Don Quixote followed them with his eyes, and, when he saw that they had disappeared, turned to Sancho and said:

"Do you see now what a spite the enchanters have against me, Sancho? See to what extremes the malice and hatred they bear me extend, for they have sought to deprive me of the happiness I should have enjoyed in seeing my mistress in her true person. In truth, I was born a very pattern for the unfortunate, and to be a target and mark for the arrows of adversity. You must observe also, Sancho, that these traitors were not satisfied with changing and transforming my Dulcinea, but transformed her and changed her into a figure as low and ugly as that peasant girl's. And they have deprived her too of something most proper to great ladies, which is the sweet smell they have from always moving among ambergris and flowers. For I must tell you, Sancho, that when I went to help my Dulcinea on to her hackney—as you say it was, though it seemed a she-ass to

me—I got such a whiff of raw garlic as stank me out and poisoned me to the heart."

"Oh, the curs!" cried Sancho at this. "Oh, wretched and spiteful enchanters! I should like to see you strung up by the gills like pilchards on a reed. Wise you are and powerful and much evil you do! It should be enough for you, ruffians, to have changed the pearls of my lady's eyes into corktree galls, and her hair of purest gold into red ox tail bristles, and all her features, in fact, from good to bad, without meddling with her smell. For from that at least we have gathered what lay concealed beneath that ugly crust. Though, to tell you the truth, I never saw her ugliness, but only her beauty, which was enhanced and perfected by a mole she had on her right lip, like a moustache, with seven or eight red hairs like threads of gold more than nine inches long."

"To judge from the mole," said Don Quixote, "by the correspondence there is between those on the face and those on the body, Dulcinea must have another on the fleshy part of her thigh, on the same side as the one on her face. But hairs of the length you indicate are very long for moles."

"But I can assure your worship," replied Sancho, "that there they were, as if they had been born with her."

"I believe it, friend," said Don Quixote, "for nature has put nothing on Dulcinea which is not perfect and well-finished. And so, if she had a hundred moles like the one you speak of on her, they would not be moles, but moons and shining stars. But tell me, Sancho, that which appeared to me to be a pack-saddle and which you set straight—was it a plain saddle or a side-saddle?"

"It was just a lady's saddle," replied Sancho, "with an outdoor covering so rich that it was worth half a kingdom."

"And to think that I did not see all this, Sancho!" cried Don Quixote, "Now I say once more—and I will repeat it a thousand times—I am the most unfortunate of men."

And that rascal Sancho had all he could do to hide his amusement on hearing this crazy talk from his master, whom he had so beautifully deceived. In the end, after much further conversation between the pair, they mounted their beasts once more, and followed the road to Saragossa, where they expected to arrive in time to be present at a solemn festival which is held every year in that illustrious city. But before they got there certain things happened to them, so many, so important, and so novel that they deserve to be written down and read, as will be seen hereafter.

Chapter XI. Of the strange Adventure which befell the valorous Don Quixote with the Car or Wagon of the Parliament of Death.

Very much downcast Don Quixote went on his way, pondering on the evil trick the enchanters had played on him in turning his lady Dulcinea into the foul shape of a village girl, and he could think of no remedy he could take to restore her to her original state. These thoughts took him so much out of himself that he gave Rocinante the reins without noticing it. And his horse, feeling the liberty he was given, lingered at each step to browse the green grass, which grew thickly in those fields. But Sancho roused his master from his musing by saying:

"Sir, griefs were not made for beasts but for men. Yet if men feel them too deeply they turn to beasts. Pull yourself together, your worship, and come to your senses and pick up Rocinante's reins. Cheer up and wake up, and show that gay spirit knights errant should have. What the devil is it? What despondency is this? Are we here or in France? Let all the Dul-

cineas in the world go to Old Nick, for the wellbeing of a single knight errant is worth more than all the enchantments and transformations on earth."

"Hush, Sancho," replied Don Quixote with more spirit than might have been expected. "Hush, I say, and speak no more blasphemies against that enchanted lady. For I alone am to blame for her misfortune and disaster. From the envy the wicked bear me springs her sad plight."

"And so say I," answered Sancho, "who saw her and can still see her now. What heart is there that would not weep?"

"You may well say that, Sancho," replied Don Quixote, "since you saw her in the perfect fullness of her beauty, for the enchantment did not go so far as to disturb your vision or conceal her beauty from you. Against me alone, against my eyes, was directed the power of their venom.

But for all that, Sancho, one thing occurs to me: you described her beauty to me badly. For, if I remember rightly, you said that she had eyes like pearls, and eyes like pearls suit a sea-bream better than a lady. According to my belief, Dulcinea's eyes must be green emeralds, full and large, with twin rainbows to serve them for eyebrows. So take these pearls from her eyes and transfer them to her teeth, for no doubt you got mixed up, Sancho, taking her teeth for her eyes."

"Anything's possible," replied Sancho, "for her beauty confused me, as her ugliness did your worship. But let's leave it all in God's hands.

For He knows all things that happen in this vale of tears, in this wicked world of ours, where there's hardly anything to be found without a tincture of evil, deceit and roguery in it. But one thing troubles me, dear master, more than all the rest: I can't think what we're to do when your worship conquers a giant or another knight and commands him to go and present himself before the beauteous Dulcinea. Where is he to find her, that poor giant or that poor miserable conquered knight? I seem to see them wandering about El Toboso, gaping like dummies, in search of my lady Dulcinea; and even if they meet her in the middle of the street they won't know her any more than they would my father."

"Perhaps, Sancho," answered Don Quixote, "the enchantment will not extend so far as to deprive vanquished and presented giants and knights of the power to recognize Dulcinea. But we will make the experiment with one or two of the first I conquer. We will send them with orders to return and give me an account of their fortunes in this respect, and so discover whether they can see her or not."

"Yes, sir," said Sancho; "that seems a good idea to me. By that trick we shall find out what we want to, and if it proves that she is only disguised from your worship, the misfortunes will be more yours than hers. But so long as the lady Dulcinea has her health and happiness, we in these parts will make shift to put up with it as best we can. We'll seek our adventures and leave Time to look after hers; for Time's the best doctor for such ailments and for worse."

Don Quixote was about to reply to Sancho, but he was interrupted by a wagon, which came out across the road loaded with some of the strangest shapes imaginable. Driving the mules and acting as carter was an ugly demon, and the wagon itself was open to the sky, without tilt or hurdle roof. The first figure which presented itself before Don Quixote's eyes was Death himself with a human face. Beside him stood an angel with large painted wings. On one side was an Emperor with a crown on his head, apparently of gold. At the feet of Death was the God they call Cupid, without his bandage over his eyes, but with his bow, his quiver and his arrows. There was also a knight in complete armor, except that he wore no helmet or headpiece, but a hat instead adorned with multi-colored plumes. And there were other personages differing in dress and appearance. The sudden vision of this assembly threw Don Quixote into some

degree of alarm, and struck fear into Sancho's heart. But soon the knight's spirits mounted with the belief that there was some new and perilous adventure presenting itself; and with this idea in his head, and his heart ready to encounter any sort of danger, he took up his position in front of the cart, and cried in a loud and threatening voice:

"Carter, coachman, devil, or whatever you may be, tell me instantly who you are, where you are going, and who are the people you are driving in your coach, which looks more like Charon's bark than an ordinary cart."

To which the Devil, stopping the cart, politely replied: "Sir, we're players of Angulo El Malo's company. We've been acting this morning in a village which lies behind that hill for it's Corpus Christi week. Our piece is called *The Parliament of Death;* and we have to perform this evening, in that village which you can see over there. So because it's quite near, and to spare ourselves the trouble of taking off our clothes and dressing again, we are travelling in the costumes we act in. That young man there plays Death. The other fellow's the Angel. That lady, who is the manager's wife, is the Queen. This man plays the Soldier. That man's the Emperor. And I'm the Devil and one of the chief characters in the piece, for I play the principal parts in this company. If your worship wants to know anything more about us, ask me. I can tell you every detail, for being the Devil I'm up to everything."

"On the faith of a knight errant," answered Don Quixote, "when I saw this cart I imagined that some great adventure was presenting itself to me. But now I declare that appearances are not always to be trusted. Go, in God's name, good people, and hold your festival; and think whether you have any request to make of me. If I can do you any service I gladly and willingly will do so, for from my boyhood I have been a lover of pantomimes, and in my youth I was always a glutton for comedies."

Now, whilst they were engaged in this conversation, as Fate would have it, one of the company caught them up, dressed in motley with a lot of bells about him, and carrying three full blown ox-bladders on the end of a stick. When this clown came up to Don Quixote, he began to fence with his stick, to beat the ground with his bladders, and leap into the air to the sound of his bells; and this evil apparition so scared Rocinante that he took the bit between his teeth, and started to gallop across the field with more speed than the bones of his anatomy promised; nor was Don Quixote strong enough to stop him. Then, realizing that his master was in danger of being thrown off, Sancho jumped down from Dapple and ran in all haste to his assistance. But when he got up to him he was already on the ground, and beside him lay Rocinante, who had fallen with his master for such was the usual upshot of the knight's exploits and Rocinante's high spirits.

But no sooner had Sancho left his own mount to help Don Quixote than the dancing devil jumped on to Dapple, and dealt him a slap with the bladders, whereat, startled by the noise rather than by the pain of the blows, the ass went flying off across country towards the village where the festival was to take place. Sancho watched Dapple's flight and his master's fall, undecided which of the two calls to attend to first. But finally, good squire and good servant that he was, love of his master prevailed over affection for his ass, though each time he saw the bladders rise in the air and fall on his Dapple's rump, he felt the pains and terrors of death, for he would rather have had those blows fall on his own eyeballs than on the least hair of his ass's tail. In this sad state of perplexity he arrived where Don Quixote lay in a great deal worse plight than he cared to see him in and, helping him on to Rocinante, he said: "Sir, the Devil's carried Dapple off."

"What Devil?" asked Don Quixote.

"The one with the bladders," replied Sancho.

"Then I shall get him back," said Don Quixote, "even if he were to lock him up in the deepest and darkest dungeons of Hell. Follow me, Sancho. For the waggon goes slowly, and I will take its mules to make up for the loss of Dapple."

"There's no need to go to that trouble, sir," said Sancho. "Cool your anger, your worship, for it looks to me, as if the Devil has let Dapple go and is off to his own haunts again."

And so indeed he was. For when the Devil had given an imitation of Don Quixote and Rocinante by tumbling off Dapple he set off to the village on foot, and the ass came back to his master.

"All the same," said Don Quixote, "it will be as well to visit that demon's impoliteness on one of those in the wagon, perhaps on the Emperor himself."

"Put that thought out of your head, your worship," answered Sancho. "Take my advice and never meddle with play-actors, for they're a favored race. I've seen an actor taken up for a couple of murders and get off scot-free. As they're a merry lot and give pleasure, I would have your worship know that everybody sides with them and protects them, aids them, and esteems them, particularly if they belong to the King's companies and have a charter. And all of them, or most of them, look like princes when they have their costumes and make-up on."

"For all that," answered Don Quixote, "that player devil shall not go away applauding himself, even if the whole human race favors him."

And as he spoke, he turned toward the wagon, which was now very close to the village, calling out loudly, as he rode: "Halt! Stop, merry and festive crew! For I would teach you how to treat asses and animals which serve as mounts to the squires of knights errant."

So loudly did Don Quixote shout that those in the wagon heard and understood him; and judging from his words the purpose of their speaker, Death promptly jumped out of the wagon, and after him the Emperor, the Demon-driver, and the Angel; nor did the Queen or the god Cupid stay behind. Then they all loaded themselves with stones and took up their positions in a row, waiting to receive Don Quixote with the edges of their pebbles. But when he saw them drawn up in so gallant a squadron, with their arms raised in the act of discharging this powerful volley of stones, he reined Rocinante in, and began to consider how to set upon them with least peril to his person. While he was thus checked Sancho came up and, seeing him drawn up to attack that well-ordered squadron, said:

"It would be the height of madness to attempt such an enterprise. Consider, your worship, that there is no defensive armor in the world against the rain of these fellows' bullets, unless you could ram yourself into a brass bell and hide. And you must consider too, master, that it is rashness and not valor for a single man to attack an army with Death in its ranks, Emperors in person fighting in it, and assisted by good and bad angels. What's more, if this isn't reason enough to persuade you to stay quiet, consider that it's a positive fact that although they look like Kings, Princes and Emperors, there isn't a single knight errant among the whole lot of them there."

"Now, Sancho," said Don Quixote, "you have certainly hit on a consideration which should deflect me from my determination. I cannot and must not draw my sword, as I have told you on many occasions before now, against anyone who is not a knight. It rests with you therefore, Sancho, if you wish to take revenge for the injury done to your Dapple; and I will help you from here with words of salutary counsel."

"There's no reason, sir, to take revenge on anyone," replied Sancho, "for it's not right for a good Christian to avenge his injuries. What's more I shall persuade Dapple to leave his cause in my hands, and it's my intention to live peacefully all the days of life that Heaven grants me."

"Since that is your decision," answered Don Quixote, "good Sancho, wise Sancho, Christian Sancho, honest Sancho, let us leave these phantoms and return to our quest for better and more substantial adventures. For I'm sure that this is the sort of country that can't fail to provide us with many and most miraculous ones."

Then he turned Rocinante, Sancho went to catch his Dapple, and Death and all his flying squadron returned to their wagon and continued their journey. And this was the happy ending of the encounter with the waggon of Death, thanks to the healthy advice which Sancho Panza gave his master.

From *The Adventures of Don Quixote* by Miguel de Cervantes Saavedra, translated by J. M. Cohen, © 1950 by J. M. Cohen. Published by Penguin Books, Ltd. Reproduced by permission of Penguin Books, Ltd.

READING 62
from JOHN MILTON (1608–1674), PARADISE LOST (1667), BOOK I

The reader who approaches Book I by itself must bear in mind the perhaps obvious but important fact that it represents only the introduction to a cosmic struggle on a massive scale. The events of the book prefigure the eventual fall of Adam and Eve and are dominated by the figure of Satan, who is depicted in language so powerful as to seem almost heroic. His defiance of God's punishment in lines 94 to 111 has been compared by some critics to Prometheus's defiance in the face of the threats of Zeus and subsequent punishment at the hands of the father of the Greek gods. The description of his kingdom in lines 670 to 798 is of epic grandeur. Yet Milton leaves no doubt that the grandeur is fatally flawed. In lines 158 to 165 Satan himself reminds us that in Hell "ever to do ill [is] our sole delight." To see Satan as the hero of the epic, a kind of underdog, victim of the divine tyranny, is to misinterpret Milton. Satan is a courageous and formidable opponent, but neither quality is inconsistent with the utmost evil.

Milton's language and imagery present an almost inexhaustible combination of biblical and Classical reference. From the very first lines of Book I, where the poet calls upon a Classical Muse to help him tell the tale of The Fall, the two great Western cultural traditions are inextricably linked. Toward the end of the book, for example, we learn that the chief architect of both Heaven and Hell was none other than the Greek god Hephaistos, the Roman Vulcan (lines 732–751). Much of the poetic effect is gained by Milton's love of exotic or romantic names from ancient sources, many of them obscure. He would, of course, have hoped that his readers could identify them all and understand the references; but the modern reader may be somewhat comforted to find that the sheer musical value of lines like 406 to 411, or 582 to 587 is considerable without regard to their detailed significance. The richness of effect is in keeping with the lavishness of much of baroque art.

Book I of PARADISE LOST therefore provides an introduction to many aspects of the entire epic. It partially conceals the true nature of the conflict between good and evil and fails to introduce us to Adam and Eve. Yet a reading of even this small part of the whole work makes it absolutely clear why Milton so profoundly affected successive generations of poets. After Milton, English literature was never the same again.

The Argument

This First Book proposes, first in brief, the whole subject Man's disobedience, and the loss thereupon of Paradise, wherein he was placed; then touches the prime cause of his fall the Serpent, or rather Satan in the Serpent; who, revolting from God, and drawing to his side many legions of Angels, was, by the command of God, driven out of Heaven, with all his crew, into the great Deep. Which action passed over, the Poem hastens into the midst of things; presenting Satan, with his Angels, now fallen into Hell—described here not in the Center (for heaven and earth may be supposed as yet not made, certainly not yet accursed), but in a place of utter darkness, [most fitly] called Chaos. Here Satan, with his Angels lying on the burning lake, thunderstruck and astonished, after a certain space recovers, as from confusion; calls up him who, next in order and dignity, lay by him: they confer of their miserable fall. Satan awakens all his legions, who lay till then in the same manner confounded. They rise: their numbers; array of battle: their chief leaders named, according to the idols known afterwards in Canaan and the countries adjoining. To these Satan directs his speech; comforts them with hope yet of regaining Heaven; but tells them, lastly, of a new world and new kind of creature to be created, according to an ancient prophecy, or report, in Heaven—for that Angels were long before this visible creation was the opinion of many ancient Fathers. To find out the truth of this prophecy, and what to determine thereon, he refers to a full council. What his associates thence attempt. Pandemonium, the palace of Satan, rises, suddenly built out of the Deep: The infernal Peers there sit in council.

Of Man's first disobedience, and the fruit
Of that forbidden tree whose mortal taste
Brought death into the World, and all our woe,
With loss of Eden, till one greater Man
Restore us, and regain the blissful seat,
Sing, Heavenly Muse, that, on the secret top
Of Oreb, or of Sinai, didst inspire
That shepherd who first taught the chosen seed
In the beginning how the heavens and earth
Rose out of Chaos: or, if Sion hill 10
Delight thee more, and Siloa's brook that flowed
Fast by the oracle of God, I thence
Invoke thy aid to my adventurous song,
That with no middle flight intends to soar
Above the Aonian mount, while it pursues
Things unattempted yet in prose or rhyme.
And chiefly Thou, O Spirit, that dost prefer
Before all temples the upright heart and pure.
Instruct me, for Thou know'st; Thou from the first
Wast present, and, with mighty wings outspread, 20
Dove-like sat'st brooding on the vast Abyss,
And mad'st it pregnant: what in me is dark
Illumine, what is low raise and support;
That, to the height of this great argument,
I may assert Eternal Providence,
And justify the ways of God to men.
Say first—for heaven hides nothing from thy view,
Nor the deep tract of Hell—say first what cause
Favored of Heaven so highly, to fall off 30
From their Creator, and transgress his will
For one restraint, lords of the World besides.
Who first seduced them to that foul revolt?
The infernal Serpent; he it was whose guile,
Stirred up with envy and revenge, deceived
The mother of mankind, what time his pride
Had cast him out from Heaven, with all his host
Of rebel Angels, by whose aid, aspiring
To set himself in glory above his peers,
He trusted to have equaled the Most High, 40
If he opposed, and, with ambitious aim
Against the throne and monarchy of God,
Raised impious war in Heaven and battle proud,
With vain attempt. Him the Almighty Power
Hurled headlong flaming from the ethereal sky,

With hideous ruin and combustion, down
To bottomless perdition, there to dwell
In adamantine chains and penal fire,
Who durst defy the Omnipotent to arms.
Nine times the space that measures day and night 50
To mortal men, he, with his horrid crew,
Lay vanquished, rolling in the fiery gulf,
Confounded, though immortal. But his doom
Reserved him to more wrath; for now the thought
Both of lost happiness and lasting pain
Torments him: round he throws his baleful eyes,
That witnessed huge affliction and dismay,
Mixed with obdurate pride and steadfast hate.
At once, as far as Angel's ken, he views
The dismal situation waste and wild. 60
A dungeon horrible, on all sides round,
As one great furnace flamed; yet from those flames
No light; but rather darkness visible
Served only to discover sights of woe,
Regions of sorrow, doleful shades, where peace
And rest can never dwell, hope never comes
That comes to all, but torture without end
Still urges, and a fiery deluge, fed
With ever-burning sulfur unconsumed.
Such place Eternal Justice had prepared 70
For those rebellious; here their prison ordained
In utter darkness, and their portion set,
As far removed from God and light of Heaven
As from the center thrice to the utmost pole.
Oh how unlike the place from whence they fell!
There the companions of his fall, o'erwhelmed
With floods and whirlwinds of tempestuous fire,
He soon discerns; and, weltering by his side.
next himself in power, and next in crime,
Long after known in Palestine, and named 80
BEELZEBUB. To whom the Arch-Enemy,
And thence in Heaven called SATAN, with bold words
Breaking the horrid silence, thus began:—
"If thou beest he but Oh how fallen! how changed
From him!—who, in the happy realms of light,
Clothed with transcendent brightness, didst outshine
Myriads, though bright if he whom mutual league,
United thoughts and counsels, equal hope
And hazard in the glorious enterprise,
Joined with me once, now misery hath joined 90
In equal ruin; into what pit thou seest
From what height fallen: so much the stronger proved
He with his thunder: and till then who knew
The force of those dire arms? Yet not for those,
Nor what the potent Victor in his rage
Can else inflict, do I repent, or change,
Though changed in outward luster, that fixt mind,
And high disdain from sense of injured merit,
That with the Mightiest raised me to contend,
And to the fierce contention brought along 100
Innumerable force of Spirits armed,
That durst dislike his reign, and, me preferring,
His utmost power with adverse power opposed
In dubious battle on the plains of heaven,
And shook his throne. What though the field be lost?
All is not lost—the unconquerable will,
And study of revenge, immortal hate,
And courage never to submit or yield:
And what is else not to be overcome.
That glory never shall his wrath or might 110
Extort from me. To bow and sue for grace
With suppliant knee, and deify his power

Who, from the terror of this arm, so late
Doubted his empire that were low indeed;
That were an ignominy and shame beneath
This downfall; since, by fate, the strength of Gods,
And this empyreal substance, cannot fail;
Since, through experience of this great event,
In arms not worse, in foresight much advanced,
We may with more successful hope resolve 120
To wage by force or guile eternal war,
Irreconcilable to our grand Foe,
Who now triumphs, and in the excess of joy
Sole reigning holds the tyranny of Heaven."
So spake the apostate Angel, though in pain,
Vaunting aloud, but racked with deep despair;
And him thus answered soon his bold compeer:—
"O Prince, O Chief of many thronèd Powers
That led the embattled Seraphim to war
Under thy conduct, and, in dreadful deeds 130
Fearless, endangered Heaven's perpetual King,
And put to proof his high supremacy,
Whether upheld by strength, or chance, or fate!
Too well I see and rue the dire event
That, with sad overthrow and foul defeat,
Hath lost us Heaven, and all this mighty host
In horrible destruction laid thus low,
As far as Gods and heavenly Essences
Can perish: for the mind and spirit remains
Invincible, and vigor soon returns, 140
Though all our glory extinct, and happy state
Here swallowed up in endless misery.
But what if He our Conqueror (whom I now
Of force believe almighty, since no less
Than such could have o'erpowered such force as ours)
Have left us this our spirit and strength entire,
Strongly to suffer and support our pains,
That we may so suffice his vengeful ire
Or do him mightier service as his thralls
By right of war, whate'er his business be, 150
Here in the heart of Hell to work in fire,
Or do his errands in the gloomy Deep?
What can it then avail though yet we feel
Strength undiminished, or eternal being
To undergo eternal punishment?"
Whereto with speedy words the Arch-Fiend replied:—
"Fallen Cherub, to be weak is miserable,
Doing or suffering: but of this be sure—
To do aught good never will be our task,
But ever to do ill our sole delight, 160
As being the contrary to His high will
Whom we resist. If then his providence
Out of our evil seek to bring forth good,
Our labor must be to pervert that end,
And out of good still to find means of evil;
Which ofttimes may succeed so as perhaps
Shall grieve him, if I fail not, and disturb
His inmost counsels from their destined aim.
But see? the angry Victor hath recalled
His ministers of vengeance and pursuit 170
Back to the gates of Heaven: the sulphurous hail,
Shot after us in storm, o'erblown hath laid
The fiery surge that from the precipice
Of Heaven received us falling; and the thunder,
Winged with red lightning and impetuous rage,
Perhaps hath spent his shafts, and ceases now
To bellow through the vast and boundless Deep.
Let us not slip the occasion, whether scorn
Or satiate fury yield it from our Foe.

Seest thou yon dreary plain, forlorn and wild, 180
The seat of desolation, void of light,
Save what the glimmering of these livid flames
Casts pale and dreadful? Thither let us tend
From off the tossing of these fiery waves;
There rest, if any rest can harbor there;
And, reassembling our afflicted powers,
Consult how we may henceforth most offend
Our enemy, our own loss how repair,
How overcome this dire calamity,
What reinforcement we may gain from hope, 190
If not what resolution from despair."
Thus Satan, talking to his nearest mate,
With head uplift above the wave, and eyes
That sparkling blazed; his other parts besides
Prone on the flood, extended long and large
Lay floating many a rood, in bulk as huge
As whom the fables name of monstrous size,
Titanian or Earth-born, that warred on Jove,
Briareos or Typhon, whom the den
By ancient Tarsus held, or that sea-beast 200
Leviathan, which God of all his works
Created hugest that swim the ocean-stream.
Him, haply slumbering on the Norway foam,
The pilot of some small night-foundered skiff,
Deeming some island, oft, as seamen tell,
With fixed anchor in his scaly rind,
Moors by his side under the lee, while night
Invests the sea, and wished morn delays.
So stretched out huge in length the Arch-Fiend lay,
Chained on the burning lake; nor ever thence 210
Had risen, or heaved his head, but that the will
And high permission of all-ruling Heaven
Left him at large to his own dark designs,
That with reiterated crimes he might
Heap on himself damnation, while he sought
Evil to others, and enraged might see
How all his malice served but to bring forth
Infinite goodness, grace, and mercy, shown
On Man by him seduced, but on himself
Treble confusion, wrath, and vengeance poured, 220
Forthwith upright he rears from off the pool
His mighty stature; on each hand the flames
Driven backward slope their pointing spires, and, rolled
In billows, leave i' the midst a horrid vale.
Then with expanded wings he steers his flight
Aloft, incumbent on the dusky air,
That felt unusual weight; till on dry land
He lights—if it were land that ever burned
With solid, as the lake with liquid fire,
And such appeared in hue as when the force 230
Of subterranean wind transports a hill
Torn from Pelorus, or the shattered side
Of thundering Ætna, whose combustible
And fuelled entrails, thence conceiving fire,
Sublimed with mineral fury, aid the winds,
And leave a singed bottom all involved
With stench and smoke. Such resting found the sole
Of unblest feet. Him followed his next mate;
Both glorying to have scaped the Stygian flood
As gods, and by their own recovered strength, 240
Not by the sufferance of supernal power.
"Is this the region, this the soil, the clime,"
Said then the lost Archangel, "this the seat
That we must change for Heaven?—this mourn-
 ful gloom
For that celestial light? Be it so, since He
Who now is sovereign can dispose and bid

What shall be right: farthest from Him is best,
Whom reason hath equaled; force hath made supreme
Above his equals. Farewell, happy fields,
Where joy for ever dwells! Hail, horrors! hail, 250
Infernal World! and thou, profoundest Hell,
Receive thy new possessor—one who brings
A mind not to be changed by place or time.
The mind is its own place, and in itself
Can make a Heaven of Hell, a Hell of Heaven.
What matter where, if I be still the same,
And what I should be, all but less than he
Whom thunder hath made greater? Here at least
We shall be free; the Almighty hath not built
Here for his envy, will not drive us hence: 260
Here we may reign secure; and, in my choice,
To reign is worth ambition, though in Hell:
Better to reign in Hell than serve in Heaven.
But wherefore let we then our faithful friends,
The associates and co-partners of our loss,
Lie thus astonished on the oblivious pool,
And call them not to share with us their part
In this unhappy mansion, or once more
With rallied arms to try what may be yet
Regained in Heaven, or what more lost in Hell?" 270
So Satan spoke; and him Beëlzebub
Thus answered:—"Leader of those armies bright
Which, but the Omnipotent, none could have foiled!
If once they hear that voice, their liveliest pledge
Of hope in fears and dangers—heard so oft
In worst extremes, and on the perilous edge
Of battle, when it raged, in all assaults
Their surest signal—they will soon resume
New courage and revive, though now they lie
Groveling and prostrate on yon lake of fire, 280
As we erewhile, astounded and amazed;
No wonder, fallen such a pernicious height!"
He scarce had ceased when the superior Fiend
Was moving toward the shore; his ponderous shield,
Ethereal temper, massy, large, and round,
Behind him cast. The broad circumference
Hung on his shoulders like the moon, whose orb
Through optic glass the Tuscan artist views
At evening, from the top of Fiesolé,
Or in Valdarno, to descry new lands, 290
Rivers, or mountains, in her spotty globe.
His spear—to equal which the tallest pine
Hewn on Norwegian hills, to be the mast
Of some great ammiral, were but a wand—
He walked with, to support uneasy steps
Over the burning marle, not like those steps
On Heaven's azure; and the torrid clime
Smote on him sore besides, vaulted with fire.
Nathless he so endured, till on the beach
Of that inflamèd sea he stood, and called 300
His legions—Angel Forms, who lay entranced
Thick as autumnal leaves that strow the brooks
In Vallombrosa, where the Etrurian shades
High over-arched embower; or scattered sedge
Afloat, when with fierce winds Orion armed
Hath vexed the Red-Sea coast, whose waves o'erthrew
Busiris and his Memphian chivalry,
While with perfidious hatred they pursued
The sojourners of Goshen, who beheld
From the safe shore their floating carcasses 310
And broken chariot-wheels. So thick bestrown,
Abject and lost, lay these, covering the flood,
Under amazement of their hideous change.
He called so loud that all the hollow deep

Of Hell resounded: — "Princes, Potentates,
Warriors, the Flower of heaven — once yours; now lost,
If such astonishment as this can seize
Eternal Spirits! Or have ye chosen this place
After the toil of battle to repose
Your wearied virtue, for the ease you find 320
To slumber here, as in the vales of Heaven?
Or in this abject posture have ye sworn
To adore the Conqueror, who now beholds
Cherub and Seraph rolling in the flood
With scattered arms and ensigns, till anon
His swift pursuers from Heaven-gates discern
The advantage, and, descending, tread us down
Thus drooping, or with linked thunderbolts
transfix us to the bottom of this gulf? —
Awake, arise, or be for ever fallen!" 330
They heard, and were abashed, and up they sprung
Upon the wing, as when men wont to watch,
On duty sleeping found by whom they dread,
Rouse and bestir themselves ere well awake.
Nor did they not perceive the evil plight
In which they were, or the fierce pains not feel;
Yet to their General's voice they soon obeyed
Innumerable. As when the potent rod
Of Amram's son, in Egypt's evil day,
Waved round the coast, up-called a pitchy cloud 340
Of locusts, warping on the eastern wind,
That o'er the realm of impious Pharaoh hung
Like Night, and darkened all the land of Nile;
So numberless were those bad Angels seen
Hovering on wing under the cope of Hell,
'Twixt upper, nether, and surrounding fires;
Till, as a signal given, the uplifted spear
Of their great Sultan waving to direct
Their course, in even balance down they light
On the firm brimstone, and fill all the plain: 350
A multitude like which the populous North
Poured never from her frozen loins to pass
Rhene or the Danaw, when her barbarous sons
Came like a deluge on the South, and spread
Beneath Gibraltar to the Libyan sands.
Forthwith, from every squadron and each band,
The heads and leaders thither haste where stood
Their great Commander — godlike Shapes, and Forms
Excelling human; princely Dignities;
And Powers that erst in Heaven sat on thrones, 360
Though of their names in Heavenly records now
Be no memorial, blotted out and razed
By their rebellion from the Books of Life.
Nor had they yet among the sons of Eve
Got them new names, till, wandering o'er the earth,
Through God's high sufferance for the trial of man.
By falsities and lies the greatest part
Of mankind they corrupted to forsake
God their Creator, and the invisible
Glory of Him that made them to transform 370
Oft to the image of a brute, adorned
With gay religions full of pomp and gold,
And devils to adore for deities:
Then were they known to men by various names,
And various idols through the Heathen World.
Say, Muse, their names then known, who first, who last,
Roused from the slumber on that fiery couch,
At their great Emperor's call, as next in worth
Came singly where he stood on the bare strand,
While the promiscuous crowd stood yet aloof. 380
The chief were those who, from the pit of Hell
Roaming to seek their prey on Earth, durst fix

Their seats, long after, next the seat of God,
Their altars by His altar, gods adored
Among the nations round, and durst abide
Jehovah thundering out of Sion, throned
Between the Cherubim; yea, often placed
Within His sanctuary itself their shrines,
Abomination; and with cursed things
His holy rites and solemn feasts profaned, 390
And with their darkness durst affront His light.
First, *Moloch,* horrid king, besmeared with blood
Of human sacrifice, and parents' tears;
Though, for the noise of drums and timbrels loud,
Their children's cries unheard that passed through fire
To his grim idol. Him the Ammonite
Worshiped in Rabba and her watery plain,
In Argob and in Basan, to the stream
Of utmost Arnon. Nor content with such
Audacious neighborhood, the wisest heart 400
Of Solomon he led by fraud to build
His temple right against the temple of God
On that opprobrious hill, and made his grove
The pleasant valley of Hinnom, Tophet thence
And black Gehenna called, the type of Hell.
Next *Chemos,* the obscene dread of Moab's sons,
From Aroar to Nebo and the wild
Of southmost Abarim; in Hesebon
And Horonaim, Seon's realm, beyond
The flowery dale of Sibma clad with vines, 410
And Elealé — to the Asphaltic Pool:
Peor his other name, when he enticed
Israel in Sittim, on their march from Nile,
To do him wanton rites, which cost them woe.
Yet thence his lustful orgies he enlarged
Even to that hill of scandal, by the grove
Of Moloch homicide, lust hard by hate,
Till good Josiah drove them hence to Hell.
With these came they who, from the bordering flood
Of old Euphrates to the brook that parts 420
Egypt from Syrian ground, had general names
Of *Baalim* and *Ashtaroth* — those male,
These feminine. For Spirits, when they please,
Can either sex assume, or both; so soft
And uncompounded is their essence pure,
Not tied or manacled with joint or limb,
Nor founded on the brittle strength of bones,
Like cumbrous flesh; but, in what shape they choose,
Dilated or condensed, bright or obscure,
Can execute their aery purposes, 430
And works of love or enmity fulfil.
For those the race of Israel oft forsook
Their Living Strength, and unfrequented left
His righteous altar, bowing lowly down
To bestial gods; for which their heads, as low
Bowed down in battle, sunk before the spear
Of despicable foes. With these in troop
Came *Astoreth,* whom the Phoenicians called
Astarte, queen of heaven, with crescent horns;
To whose bright image nightly by the moon 440
Sidonian virgins paid their vows and songs;
In Sion also not unsung, where stood
Her temple on the offensive mountain, built
By that uxorious king whose heart, though large,
Beguiled by fair idolatresses, fell
To idols foul. *Thammuz* came next behind,
Whose annual wound in Lebanon allured
The Syrian damsels to lament his fate
In amorous ditties all a summer's day,
While smooth Adonis from his native rock 450

Ran purple to the sea, supposed with blood
Of Thammuz yearly wounded: the love-tale
Infected Sion's daughters with like heat,
Whose wanton passions in the sacred porch
Ezekiel saw, when, by the vision led,
His eye surveyed the dark idolatries
Of alienated Judah. Next came one
Who mourned in earnest, when the captive ark
Maimed his brute image, head and hands lopt off,
In his own temple, on the grunsel-edge, 460
Where he fell flat and shamed his worshipers:
Dagon his name, sea-monster, upward man
And downward fish; yet had his temple high
Reared in Azotus, dreaded through the coast
Of Palestine, in Gath and Ascalon,
And Accaron and Gaza's frontier bounds.
Him followed *Rimmon*, whose delightful seat
Was fair Damascus, on the fertile banks
Of Abbana and Pharphar, lucid streams.
He also against the house of God was bold: 470
A leper once he lost, and gained a king—
Ahaz, his sottish conqueror, whom he drew
God's altar to disparage and displace
For one of Syrian mode, whereon to burn
His odious offerings, and adore the gods
Whom he had vanquished. After these appeared
A crew who, under names of old renown—
Osiris, Isis, Orus, and their train—
With monstrous shapes and sorceries abused
Fanatic Egypt and her priests to seek 480
Their wandering gods disguised in brutish forms
Rather than human. Nor did Israel scape
The infection, when their borrowed gold composed
The calf in Oreb; and the rebel king
Doubled that sin in Bethel and in Dan,
Likening his Maker to the grazed ox—
Jehovah, who, in one night, when he passed
From Egypt marching, equaled with one stroke
Both her first-born and all her bleating gods.
Belial came last; than whom a spirit more lewd
Fell not from Heaven, or more gross to love 491
Vice for itself. To him no temple stood
Or altar smoked; yet who more oft than he
In temples and at altars, when the priest
Turns atheist, as did Eli's sons, who filled
With lust and violence the house of God?
In courts and palaces he also reigns,
And in luxurious cities, where the noise
Of riot ascends above their loftiest towers,
And injury and outrage; and, when night 500
Darkens the streets, then wander forth the sons
Of Belial, flown with insolence and wine.
Witness the streets of Sodom, and that night
In Gibeah, when the hospitable door
Exposed a matron, to avoid worse rape.
These were the prime in order and in might:
The rest were long to tell; though far renowned
The Ionian gods—of Javan's issue held
Gods, yet confessed later than Heaven and Earth,
Their boasted parents;—*Titan,* Heaven's first-born 510
With his enormous brood, and birthright seized
By younger *Saturn:* he from mightier Jove,
His own and Rhea's son, like measure found;
So *Jove* usurping reigned. These, first in Crete
And Ida known, thence on the snowy top
Of cold Olympus ruled the middle air,
Their highest heaven; or on the Delphian cliff,

Or in Dodona, and through all the bounds
Of Doric land; or who with Saturn old
Fled over Adria to the Hesperian fields, 520
And o'er the Celtic roamed the utmost Isles.
All these and more came flocking; but with looks
Downcast and damp; yet such wherein appeared
Obscure some glimpse of joy to have found their Chief
Not in despair, to have found themselves not lost
In loss itself; which on his countenance cast
Like doubtful hue. But he, his wonted pride
Soon recollecting, with high words, that bore
Semblance of worth, not substance, gently raised
Their fainting courage, and dispelled their fears; 530
Then straight commands that, at the warlike sound
Of trumpets loud and clarions, be upreared
His mighty standard. That proud honor claimed
Azazel as his right, a Cherub tall:
Who forthwith from the glittering staff unfurled
The imperial ensign; which, full high advanced,
Shone like a meteor streaming to the wind,
With gems and golden luster rich emblazed,
Seraphic arms and trophies; all the while
Sonorous metal blowing martial sounds: 540
At which the universal host up-sent
A shout that tore Hell's concave, and beyond
Frighted the reign of Chaos and old Night.
All in a moment through the gloom were seen
Ten thousand banners rise into the air,
With orient colors waving: with them rose
A forest huge of spears; and thronging helms
Appeared, and serried shields in thick array
Of depth immeasurable. Anon they move
In perfect phalanx to the Dorian mood 550
Of flutes and soft recorders—such as raised
To height of noblest temper heroes old
Arming to battle, and instead of rage
Deliberate valor breathed, firm, and unmoved
With dread of death to flight or foul retreat;
Nor wanting power to mitigate and swage
With solemn touches troubled thoughts, and chase
Anguish and doubt and fear and sorrow and pain
From mortal or immortal minds. Thus they,
Breathing united force with fixed thought, 560
Moved on in silence to soft pipes that charmed
Their painful steps o'er the burnt soil. And now
Advanced in view they stand—a horrid front
Of dreadful length and dazzling arms, in guise
Of warriors old, with ordered spear and shield,
Awaiting what command their mighty Chief
Had to impose. He through the armed files
Darts his experienced eye, and soon traverse
The whole battalion views—their order due,
Their visages and stature as of gods; 570
Their number last he sums. And now his heart
Distends with pride, and, hardening in his strength,
Glories: for never, since created Man,
Met such embodied force as, named with these,
Could merit more than that small infantry
Warred on by cranes—though all the giant brood
Of Phlegra with the heroic race were joined
That fought at Thebes and Ilium, on each side
Mixed with auxiliar gods; and what resounds
In fable or romance of Uther's son, 580
Begirt with British and Armoric knights;
And all who since, baptized or infidel,
Jousted in Aspramont, or Montalban,
Damasco, or Marocco, or Trebisond,

Or whom Biserta sent from Afric shore
When Charlemagne with all his peerage fell
By Fontarabia. Thus far these beyond
Compare of mortal prowess, yet observed
Their dread Commander. He, above the rest
In shape and gesture proudly eminent, 590
Stood like a tower. His form had yet not lost
All her original brightness, nor appeared
Less than Archangel ruined, and the excess
Of glory obscured: as when the sun new-risen
Looks through the horizontal misty air
Shorn of his beams, or, from behind the moon.
In dim eclipse, disastrous twilight sheds
On half the nations, and with fear of change
Perplexes monarchs. Darkened so, yet shone
Above them all the Archangel: but his face 600
Deep scars of thunder had entrenched, and care
Sat on his faded cheek, but under brows
Of dauntless courage, and considerate pride
Waiting revenge. Cruel his eye, but cast
Signs of remorse and passion, to behold
The fellows of his crime, the follower's rather
(Far other once beheld in bliss), condemned
For ever now to have their lot in pain—
Millions of Spirits for his fault amerced
Of Heaven, and from eternal splendors flung 610
For his revolt—yet faithful how they stood,
Their glory withered; as, when heaven's fire
Hath scathed the forest oaks or mountain pines,
With singed top their stately growth, though bare,
Stands on the blasted heath. He now prepared
To speak; whereat their doubled ranks they bend
From wing to wing, and half enclose him round
With all his peers: Attention held them mute.
Thrice he assayed, and thrice, in spite of scorn,
Tears, such as Angels weep, burst forth: at last 620
Words interwove with sighs found out their way:—
"O myriads of immortal Spirits! O Powers
Matchless, but with the Almighty!—and that strife
Was not inglorious, though the event was dire,
As this place testifies, and this dire change,
Hateful to utter. But what power of mind,
Foreseeing or presaging, from the depth
Of knowledge past or present, could have feared
How such united force of gods, how such
As stood like these, could ever know repulse? 630
For who can yet believe, though after loss,
That all these puissant legions, whose exile
Hath emptied Heaven, shall fail to re-ascend,
Self-raised, and re-possess their native seat?
For me, be witness all the host of heaven,
If counsels different, or danger shunned
By me, have lost our hopes. But he who reigns
Monarch in Heaven till then as one secure
Sat on his throne, upheld by old repute,
Consent or custom, and his regal state 640
Put forth at full, but still his strength concealed—
Which tempted our attempt, and wrought our fall.
Henceforth his might we know, and know our own.
So as not either to provoke, or dread
New war provoked: our better part remains
To work in close design, by fraud or guile,
What force effected not; that he no less
At length from us may find, Who overcomes
By forth hath overcome but half his foe.
Space may produce new Worlds; whereof so rife 650
There went a fame in Heaven that He ere long

Intended to create, and therein plant
A generation whom his choice regard
Should favor equal to the Sons of Heaven.
Thither, if but to pry, shall be perhaps
Our first eruption—thither, or elsewhere;
For this infernal pit shall never hold
Celestial Spirits in bondage, nor the Abyss
Long under darkness cover. But these thoughts
Full counsel must mature. Peace is despaired; 660
For who can think submission? War, then, war
Open or understood, must be resolved."
He spake; and, to confirm his words, out-flew
Millions of flaming swords, drawn from the thighs
Of mighty Cherubim; the sudden blaze
Far round illumined Hell. Highly they raged
Against the Highest, and fierce with grasped arms
Clashed on their sounding shields the din of war,
Hurling defiance toward the vault of Heaven.
There stood a hill not far, whose grisly top 670
Belched fire and rolling smoke; the rest entire
Shone with a glossy scurf—undoubted sign
That in his womb was hid metallic ore,
The work of sulfur. Thither, winged with speed.
A numerous brigade hastened: as when bands
Of pioneers, with spade and pickaxe armed,
Forerun the royal camp, to trench a field,
Or cast a rampart. Mammon led them on—
Mammon, the least erected Spirit that fell
From Heaven; for even in Heaven his looks and thoughts 680
Were always downward bent, admiring more
The riches of Heaven's pavement, trodden gold,
Than aught divine or holy else enjoyed
In vision beatific. By him first
Men also, and by his suggestion taught,
Ransacked the Center, and with impious hands
Rifled the bowels of their mother Earth
For treasures better hid. Soon had his crew
Opened into the hill a spacious wound,
And digged out ribs of gold. Let none admire 690
That riches grow in Hell; that soil may best
Deserve the precious bane. And here let those
Who boast in mortal things, and wondering tell
Of Babel, and the works of Memphian kings,
Learn how their greatest monuments of fame,
And strength, and art, are easily outdone
By Spirits reprobate, and in an hour
What in an age they, with incessant toil
And hands innumerable, scarce perform.
Nigh on the plain, in many cells prepared, 700
That underneath had veins of liquid fire
Sluiced from the lake, a second multitude
With wondrous art founded the massy ore,
Severing each kind, and scummed the bullion-dross.
A third as soon had formed within the ground
A various mould, and from the boiling cells
By strange conveyance filled each hollow nook;
As in an organ, from one blast of wind,
To many a row of pipes the sound-board breathes.
Anon out of the earth a fabric huge 710
Rose like an exhalation, with the sound
Of dulcet symphonies and voices sweet—
Built like a temple, where pilasters round
Were set, and Doric pillars overlaid
With golden architrave; nor did there want
Cornice or frieze, with bossy sculptures graven:
The roof was fretted gold. Not Babylon
Nor great Alcairo such magnificence

Equaled in all their glories, to enshrine
Belus or Serapis their gods, or seat 720
Their kings, when Egypt with Assyria strove
In wealth and luxury. The ascending pile
Stood fixed her stately height; and straight the doors,
Opening their brazen folds, discover, wide
Within, her ample spaces o'er the smooth
And level pavement: from the archèd roof,
Pendent by subtle magic, many a row
Of starry lamps and blazing cressets, fed
With naphtha and asphaltus, yielded light
As from a sky. The hasty multitude 730
Admiring entered; and the work some praise,
And some the architect. His hand was known
In Heaven by many a towered structure high,
Where scepterd Angels held their residence,
And sat as Princes, whom the supreme King
Exalted to such power, and gave to rule,
Each in his hierarchy, the Orders bright.
Nor was his name unheard or unadored
In ancient Greece; and in Ausonian land
Men called him Mulciber; and how he fell 740
From Heaven they fabled, thrown by angry Jove
Sheer o'er the crystal battlements: from morn
To noon he fell, from noon to dewy eve,
A summer's day, and with the setting sun
Dropt from the zenith like a falling star,
On Lemnos, the Ægæan isle. Thus they relate,
Erring; for he with this rebellious rout
Fell long before; nor aught availed him now
To have built in Heaven high towers; nor did he scape
By all his engines, but was headlong sent, 750
With his industrious crew, to build in Hell.
Meanwhile the wingèd Heralds, by command
Of sovereign power, with awful ceremony
And trumpet's sound, throughout the host proclaim
A solemn council forthwith to be held
At Pandemonium, the high capital
Of Satan and his peers. Their summons called
From every band and squarèd regiment
By place or choice the worthiest: they anon
With hundreds and with thousands trooping came 760
Attended. All access was thronged; the gates
And porches wide, but chief the spacious hall
(Though like a covered field, where champions bold
Wont ride in armed, and at the Soldan's chair
Defied the best of Panim chivalry
To mortal combat, or career with lance),
Thick swarmed, both on the ground and in the air,
Brushed with the hiss of rustling wings. As bees
In spring-time, when the Sun with Taurus rides,
Pour forth their populous youth about the hive 770
In clusters; they among fresh dews and flowers
Fly to and fro, or on the smoothèd plank,
The suburb of their straw-built citadel,
New rubbed with balm, expatiate, and confer
Their state affairs: so thick the aery crowd
Swarmed and were straitened; till, the signal given,
Behold a wonder! They but now who seemed
In bigness to surpass Earth's giant sons,
Now less than smallest dwarfs, in narrow room
Throng numberless—like that pygmean race 780
Beyond the Indian mount; or faery elves,
Whose midnight revels, by a forest-side
Or fountain, some belated peasant sees,
Or dreams he sees, while overhead the Moon
Sits arbitress, and nearer to the Earth

Wheels her pale course: they, on their mirth and dance
Intent, with jocund music charm his ear;
At once with joy and fear his heart rebounds.
Thus incorporeal Spirits to smallest forms
Reduced their shapes immense, and were at large, 790
Though without number still, amidst the hall
Of that infernal court. But far within.
And in their own dimensions like themselves,
The great Seraphic Lords and Cherubim
In close recess and secret conclave sat,
A thousand demi-gods on golden seats,
Frequent and full. After short silence then,
And summons read, the great consult began.

"The Argument" from *John Milton: Paradise Lost* by Roy Flannagan, © 1993
by Roy Flannagan.

CHAPTER 16

READING 63
from Alexander Pope (1688–1744), Essay
on Man (1733–1734)

The following epigram illustrates the delicacy and precision of Pope's wit. "Engraved on the collar of a dog which I gave to his Royal Highness: I am his Highness' dog at Kew; / Pray tell me, sir, whose dog are you?" Far more serious in its intent is Pope's ESSAY ON MAN, which takes the form of four verse letters (or epistles) to his friend Henry Bolingbroke. The first of these, reproduced below, discusses the part that evil plays in a world created by God, and tries to describe the divinely appointed social order. Pope expresses his conclusions in the epistle's last words: "Whatever is, is right." Later sections of the poem are concerned with how humans should act in a world where evil exists.

Epistle I

Awake, my St. John! leave all meaner things
To low ambition, and the pride of Kings.
Let us (since Life can little more supply
Than just to look about us and to die)
Expatiate free o'er all this scene of Man; 5
A mighty maze! but not without a plan;
A Wild, where weeds and flow'rs promiscuous shoot,
Or Garden, tempting with forbidden fruit.
Together let us beat this ample field,
Try what the open, what the covert yield; 10
The latent tracts, the giddy heights explore
Of all who blindly creep, or sightless soar;
Eye Nature's walks, shoot Folly as it flies,
And catch the Manners living as they rise;
Laugh where we must, be candid where we can; 15
'But vindicate the ways of God to Man.
 I. Say first, of God above, or Man below,
What can we reason, but from what we know?
Of Man what see we, but his station here,
From which to reason, or to which refer? 20
Thro' worlds unnumber'd tho' the God be known,
'Tis ours to trace him only in our own.
He, who thro' vast immensity can pierce,
See worlds on worlds compose one universe,
Observe how system into system runs, 25
What other planets circle other suns,

What vary'd being peoples ev'ry star,
May tell why Heav'n has made us as we are.
But of this frame the bearings, and the ties,
The strong connections, nice dependencies, 30
Gradations just, has thy pervading soul
Look'd thro'? or can a part contain the whole?
 Is the great chain, that draws all to agree,
And drawn supports, upheld by God, or thee? 34
 II. Presumptuous Man! the reason wouldst thou find,
Why form'd so weak, so little, and so blind!
First, if thou canst, the harder reason guess,
Why form'd no weaker, blinder, and no less!
Ask of thy mother earth, why oaks are made
Taller or stronger than the weeds they shade? 40
Or ask of yonder argent fields above,
Why JOVE's Satellites are less than JOVE?
 Of Systems possible, if 'tis confest
That Wisdom infinite must form the best,
Where all must full or not coherent be, 45
And all that rises, rise in due degree;
Then, in the scale of reas'ning life, 'tis plain
There must be, somewhere, such a rank as Man;
And all the question (wrangle e'er so long)
Is only this, if God has plac'd him wrong? 50
 Respecting Man, whatever wrong we call,
May, must be right, as relative to all.
In human works, tho' labour'd on with pain,
A thousand movements scarce one purpose gain;
In God's, one single can its end produce; 55
Yet serves to second too some other use.
So Man, who here seems principal alone,
Perhaps acts second to some sphere unknown,
Touches some wheel, or verges to some goal;
'Tis but a part we see, and not a whole. 60
 When the proud steed shall know why Man restrains
His fiery course, or drives him o'er the plains;
When the dull Ox, why now he breaks the clod,
Is now a victim, and now Ægypt's God:
Then shall Man's pride and dullness comprehend 65
His actions', passions', being's, use and end;
Why doing, suff'ring, check'd, impell'd; and why
This hour a slave, the next a deity.
 Then say not Man's imperfect, Heav'n in fault;
Say rather, Man's as perfect as he ought; 70
His knowledge measur'd to his state and place,
His time a moment, and a point his space.
If to be perfect in a certain sphere,
What matter, soon or late, or here or there?
The blest today is as completely so, 75
As who began a thousand years ago.
 III. Heav'n from all creatures hides the book of Fate,
All but the page prescrib'd, their present state;
From brutes what men, from men what spirits know:
Or who could suffer Being here below? 80
The lamb thy riot dooms to bleed to-day,
Had he thy Reason, would he skip and play?
Pleas'd to the last, he crops the flow'ry food,
And licks the hand just rais'd to shed his blood.
Oh blindness to the future! kindly giv'n, 85
That each may fill the circle mark'd by Heav'n;
Who sees with equal eye, as God of all,
A hero perish, or a sparrow fall,
Atoms or systems into ruin hurl'd,
And now a bubble burst, and now a world. 90
 Hope humbly then; with trembling pinions soar;
Wait the great teacher Death, and God adore!
What future bliss, he gives not thee to know,

But gives that Hope to be thy blessing now.
Hope springs eternal in the human breast: 95
Man never Is, but always To be blest:
The soul, uneasy and confin'd from home,
Rests and expatiates in a life to come.
 Lo! the poor Indian, whose untutor'd mind
Sees God in clouds, or hears him in the wind; 100
His soul proud Science never taught to stray
Far as the solar walk, or milky way;
Yet simple Nature to his hope has giv'n,
Behind the cloud-topt hill, an humbler heav'n;
Some safer world in depth of woods embrac'd, 105
Some happier island in the watry waste,
Where slaves once more their native land behold,
No fiends torment, no Christians thirst for gold!
To Be, contents his natural desire,
He asks no Angel's wing, no Seraph's fire; 110
But thinks, admitted to that equal sky,
His faithful dog shall bear him company.
 IV. Go, wiser thou! and in thy scale of sense
Weigh thy Opinion against Providence;
Call Imperfection what thou fancy'st such, 115
Say, here he gives too little, there too much;
Destroy all creatures for thy sport or gust,
Yet cry, If Man's unhappy, God's unjust;
If Man alone ingross not Heav'n's high care,
Alone made perfect here, immortal there: 120
Snatch from his hand the balance and the rod,
Rejudge his justice, be the GOD of GOD!
 In Pride, in reas'ning Pride, our error lies;
All quit their sphere, and rush into the skies.
Pride still is aiming at the blest abodes, 125
Men would be Angels, Angels would be Gods.
Aspiring to be Gods, if Angels fell,
Aspiring to be Angels, Men rebel;
And who but wishes to invert the laws
Of ORDER, sins against th' Eternal Cause. 130
 V. Ask for what end the heav'nly bodies shine,
Earth for whose use? Pride answers, 'Tis for mine:
For me kind Nature wakes her genial pow'r,
Suckles each herb, and spreads out ev'ry flow'r;
Annual for me, the grape, the rose renew 135
The juice nectareous, and the balmy dew;
For me, the mine a thousand treasures brings;
For me, health gushes from a thousand springs;
Seas roll to waft me, suns to light me rise;
My foot-stool earth, my canopy the skies.' 140
 But errs not Nature from this gracious end,
From burning suns when livid deaths descend,
When earthquakes swallow, or when tempests
 sweep
Towns to one grave, whole nations to the deep?
'No ('tis reply'd) the first Almighty Cause 145
Acts not by partial, but by gen'ral laws;
Th' exceptions few; some change since all began,
And what created perfect?'—Why then Man?
If the great end be human Happiness,
Then Nature deviates; and can Man do less? 150
As much that end a constant course requires
Of show'rs and sunshine, as of Man's desires;
As much eternal springs and cloudless skies,
As Men for ever temp'rate, calm, and wise.
If plagues or earthquakes break not Heav'n's design, 155
Why then a Borgia, or a Catiline?
Who knows but he, whose hand the light'ning forms,
Who heaves old Ocean, and who wings the storms,
Pours fierce Ambition in a Caesar's mind,

Or turns young Ammon loose to scourge mankind? 160
From pride, from pride, our very reas'ning springs;
Account for moral as for nat'ral things:
Why charge we Heav'n in those, in these acquit?
In both, to reason right is to submit.
 Better for Us, perhaps, it might appear, 165
Were there all harmony, all virtue here;
That never air or ocean felt the wind;
That never passion discompos'd the mind:
But all subsists by elemental strife;
And Passions are the elements of Life. 170
The gen'ral ORDER, since the whole began,
Is kept in Nature, and is kept in Man.
 VI. What would this Man? Now upward will
 he soar,
And little less than Angel, would be more;
Now looking downwards, just as griev'd appears 175
To want the strength of bulls, the fur of bears.
Made for his use all creatures if he call,
Say what their use, had he the pow'rs of all?
Nature to these, without profusion kind,
The proper organs, proper pow'rs assign'd; 180
Each seeming want compensated of course,
Here with degrees of swiftness, there of force;
All in exact proportion to the state;
Nothing to add, and nothing to abate.
Each beast, each insect, happy in its own; 185
Is Heav'n unkind to Man, and Man alone?
Shall he alone, whom rational we call,
Be pleas'd with nothing, if not bless'd with all?
 The bliss of Man (could Pride that blessing find)
Is not to act or think beyond mankind; 190
No pow'rs of body or of soul to share,
But what his nature and his state can bear.
Why has not Man a microscopic eye?
For this plain reason, Man is not a Fly.
Say what the use, were finer optics giv'n, 195
T' inspect a mite, not comprehend the heav'n?
Or touch, if trembling alive all o'er,
To smart and agonize at ev'ry pore?
Or quick effluvia darting thro' the brain,
Die of a rose in aromatic pain? 200
If nature thunder'd in his op'ning ears,
And stunn'd him with the music of the spheres,
How would he wish that Heav'n had left him still
The whisp'ring Zephyr, and the purling rill?
Who finds not Providence all good and wise, 205
Alike in what it gives, and what denies?
 VII. Far as Creation's ample range extends,
The scale of sensual, mental pow'rs ascends:
Mark how it mounts, to Man's imperial race,
From the green myriads in the peopled grass: 210
What modes of sight betwixt each wide extreme,
The mole's dim curtain, and the lynx's beam:
Of smell, the headlong lioness between,
And hound sagacious on the tainted green:
Of hearing, from the life that fills the flood, 215
To that which warbles thro' the vernal wood:
The spider's touch, how exquisitely fine!
Feels at each thread, and lives along the line:
In the nice bee, what sense so subtly true
From pois'nous herbs extracts the healing dew: 220
How Instinct varies in the grov'ling swine,
Compar'd, half-reas'ning elephant, with thine:
'Twixt that, and Reason, what a nice barrier;
For ever sep'rate, yet for ever near!
Remembrance and Reflection how ally'd; 225
What thin partitions Sense from Thought divide:

And Middle natures, how they long to join,
Yet never pass th' insuperable line!
Without this just gradation, could they be
Subjected these to those, or all to thee? 230
The pow'rs of all subdu'd by thee alone,
Is not thy Reason all these pow'rs in one?
 VIII. See, thro' this air, this ocean, and this earth,
All matter quick, and bursting into birth.
Above, how high progressive life may go! 235
Around, how wide! how deep extend below!
Vast chain of being, which from God began,
Natures æthereal, human, angel, man,
Beast, bird, fish, insect! what no eye can see,
No glass can reach! from Infinite to thee, 240
From thee to Nothing!—On superior pow'rs
Were we to press, inferior might on ours:
Or in the full creation leave a void,
Where, one step broken, the great scale's destroy'd:
From Nature's chain whatever link you strike, 245
Tenth or ten thousandth, breaks the chain alike.
 And if each system in gradation roll,
Alike essential to th' amazing whole;
The least confusion but in one, not all
That system only, but the whole must fall. 250
Let Earth unbalanc'd from her orbit fly,
Planets and Suns run lawless thro' the sky,
Let ruling Angels from their spheres be hurl'd,
Being on being wreck'd, and world on world,
Heav'n's whole foundations to their center nod, 255
And Nature tremble to the throne of God:
All this dread ORDER break—for whom? for thee?
Vile worm!—oh Madness, Pride, Impiety!
 IX. What if the foot, ordain'd the dust to tread,
Or hand to toil, aspir'd to be the head? 260
What if the head, the eye, or ear repin'd
To serve mere engines to the ruling Mind?
Just as absurd for any part to claim
To be another, in this gen'ral frame:
Just as absurd, to mourn the tasks or pains 265
The great directing MIND OF ALL ordains.
All are but parts of one stupendous whole,
Whose body, Nature is, and God the soul;
That, chang'd thro' all, and yet in all the same,
Great in the earth, as in th' æthereal frame, 270
Warms in the sun, refreshes in the breeze,
Glows in the stars, and blossoms in the trees,
Lives thro' all life, extends thro' all extent,
Spreads undivided, operates unspent,
Breathes in our soul, informs our mortal part, 275
As full, as perfect, in a hair as heart;
As full, as perfect, in vile Man that mourns,
As the rapt Seraph that adores and burns;
To him no high, no low, no great, no small;
He fills, he bounds, connects, and equals all. 280
 X. Cease then, nor Order Imperfection name:
Our proper bliss depends on what we blame.
Know thy own point: This kind, this due degree
Of blindness, weakness, Heav'n bestows on thee.
Submit—In this, or any other sphere, 285
Secure to be as blest as thou canst bear:
Safe in the hand of one disposing Pow'r,
Or in the natal, or the mortal hour.
All Nature is but Art, unknown to thee;
All Chance, Direction, which thou canst not see; 290
All Discord, Harmony, not understood;
All partial Evil, universal Good:
And, spite of Pride, in erring Reason's spite,
One truth is clear, 'Whatever is, is RIGHT.'

READING 64

Jonathan Swift (1667–1745), A Modest Proposal … (1729)

In frustration at the widespread starvation of the poor in Ireland and the general indifference on the part of those better off, Swift wrote a savage masterpiece. His proposed final solution to the problem of overpopulation and undernourishment is simple: the rich should eat the poor. In relentlessly working out the implications of his ironic proposal, Swift identifies human cruelties and weaknesses with deadly truth. The essay has been described as a "lucid nightmare." Swift would certainly not have been surprised to learn that the conditions of abject poverty he describes are still present in large areas of the world.

A Modest Proposal For Preventing The Children of Poor People in Ireland From Being A Burden to Their Parents or Country, and For Making Them Beneficial to The Public

It is a melancholy object to those who walk through this great town or travel in the country, when they see the streets, the roads, and cabin doors, crowded with beggars of the female-sex, followed by three, four, or six children, all in rags and importuning every passenger for an alms. These mothers, instead of being able to work for their honest livelihood, are forced to employ all their time in strolling to beg sustenance for their helpless infants, who, as they grow up, either turn thieves for want of work, or leave their dear native country to fight for the Pretender in Spain, or sell themselves to the Barbadoes.

I think it is agreed by all parties that this prodigious number of children in the arms, or on the backs, or at the heels of their mothers, and frequently of their fathers, is in the present deplorable state of the kingdom a very great additional grievance; and therefore whoever could find out a fair, cheap, and easy method of making these children sound, useful members of the commonwealth would deserve so well of the public as to have his statue set up for a preserver of the nation.

But my intention is very far from being confined to provide only for the children of professed beggars; it is of a much greater extent, and shall take in the whole number of infants at a certain age who are born of parents in effect as little able to support them as those who demand our charity in the streets.

As to my own part, having turned my thoughts for many years upon this important subject, and maturely weighed the several schemes of other projectors, I have always found them grossly mistaken in their computation. It is true, a child just dropped from its dam may be supported by her milk for a solar year, with little other nourishment; at most not above the value of two shillings, which the mother may certainly get, or the value in scraps, by her lawful occupation of begging; and it is exactly at one year old that I propose to provide for them in such a manner as instead of being a charge upon their parents or the parish, or wanting food and raiment for the rest of their lives, they shall on the contrary contribute to the feeding, and partly to the clothing, of many thousands.

There is likewise another great advantage in my scheme, that it will prevent those voluntary abortions, and that horrid practice of women murdering their bastard children, alas, too frequent among us, sacrificing the poor innocent babes, I doubt, more to avoid the expense than the shame, which would move tears and pity in the most savage and inhuman breast.

The number of souls in this kingdom being usually reckoned one million and a half, of these I calculate there may be about two hundred thousand couples whose wives are breeders; from which number I subtract thirty thousand couples who are able to maintain their own children, although I apprehend there cannot be so many under the present distresses of the kingdom; but this being granted, there will remain an hundred and seventy thousand breeders. I again subtract fifty thousand for those women who miscarry, or whose children die by accident or disease within the year. There only remain an hundred and twenty thousand children of poor parents annually born. The question therefore is, how this number shall be reared and provided for, which, as I have already said, under the present situation of affairs, is utterly impossible by all the methods hitherto proposed. For we can neither employ them in handicraft or agriculture; we neither build houses (I mean in the country) nor cultivate land. They can very seldom pick up a livelihood by stealing till they arrive at six years old, except where they are of towardly parts: although I confess they learn the rudiments much earlier, during which time they can however be looked upon only as probationers, as I have been informed by a principal gentleman in the county of Cavan, who protested to me that he never knew above one or two instances under the age of six, even in a part of the kingdom so renowned for the quickest proficiency in that art.

I am assured by our merchants that a boy or a girl before twelve years old is no salable commodity; and even when they come to this age they will not yield above three pounds, or three pounds and half a crown at most on the Exchange; which cannot turn to account either to the parents or the kingdom, the charge of nutriment and rags having been at least four times that value.

I shall now therefore humbly propose my own thoughts, which I hope will not be liable to the least objection.

I have been assured by a very knowing American of my acquaintance in London, that a young healthy child well nursed is at a year old a most delicious, nourishing, and wholesome food, whether stewed, roasted, baked, or boiled; and I make no doubt that it will equally serve in a fricasse or a ragout.

I do therefore humbly offer it to public consideration that of the hundred and twenty thousand children, already computed, twenty thousand may be reserved for breed, whereof only one fourth part to be males, which is more than we allow to sheep, black cattle, or swine; and my reason is that these children are seldom the fruits of marriage, a circumstance not much regarded by our savages, therefore one male will be sufficient to serve four females. That the remaining hundred thousand may at a year old be offered in sale to the persons of quality and fortune through the kingdom, always advising the mother to let them suck plentifully in the last month, so as to render them plump and fat for a good table. A child will make two dishes at an entertainment for friends; and when the family dines alone, the fore or hind quarter will make a reasonable dish, and seasoned with a little pepper or salt will be very good boiled on the fourth day, especially in winter.

I have reckoned upon a medium that a child just born will weigh twelve pounds, and in a solar year if tolerably nursed increaseth to twenty-eight pounds.

I grant this food will be somewhat dear, and therefore very proper for landlords, who, as they have already devoured most of the parents, seem to have the best title to the children.

Infant's flesh will be in season throughout the year, but more plentiful in March, and a little before and after. For we are told by a grave author, an eminent French physician [Rabelais], that fish being a prolific diet, there are more children born in Roman Catholic countries about nine months after Lent than at any other season; therefore, reckoning a year after Lent, the markets will be more glutted than usual, because the number of popish infants is at least three to one in this kingdom; and therefore it will have one other collateral advantage, by lessening the number of Papists among us.

I have already computed the charge of nursing a beggar's child (in which list I reckon all cottagers, laborers, and four fifths of the farmers) to be about two shillings per annum, rags included; and I believe no gentleman would repine to give ten shillings for the carcass of a good fat child, which, as I have said, will make four dishes of excellent nutritive meat, when he hath only some particular friend or his own family to dine with him. Thus the squire will learn to be a good landlord, and grow popular among the tenants; the mother will have eight shillings net profit, and be fit for work till she produces another child.

Those who are more thrifty (as I must confess the times require) may flay the carcass; the skin of which artificially dressed will make admirable gloves for ladies and summer boots for fine gentlemen.

As to our city of Dublin, shambles may be appointed for this purpose in the most convenient parts of it, and butchers we may be assured will not be wanting; although I rather recommend buying the children alive, and dressing them hot from the knife as we do roasting pigs.

A very worthy person, a true lover of his country, and whose virtues I highly esteem, was lately pleased in discoursing on this matter to offer a refinement upon my scheme. He said that many gentlemen of this kingdom, having of late destroyed their deer, he conceived that the want of venison might be well supplied by the bodies of young lads and maidens, not exceeding fourteen years of age nor under twelve, so great a number of both sexes in every county being now ready to starve for want of work and service; and these to be disposed of by their parents, if alive, or otherwise by their nearest relations. But with due deference to so excellent a friend and so deserving a patriot, I cannot be altogether in his sentiments; for as to the males, my American acquaintance assured me from frequent experience that their flesh was generally tough and lean, like that of our schoolboys, by continual exercise, and their taste disagreeable; and to fatten them, would not answer the charge. Then as to the females, it would, I think with humble submission, be a loss to the public, because they soon would become breeders themselves: and besides, it is not improbable that some scrupulous people might be apt to censure such a practice (although indeed very unjustly) as little bordering upon cruelty; which, I confess, hath always been with me the strongest objection against any project, how well soever intended.

But in order to justify my friend, he confessed that this expedient was put into his head by the famous Psalmanazar, a native of the island Formosa, who came from thence to London above twenty years ago, and in conversation told my friend that in his country when any young person happened to be put to death, the executioner sold the carcass to persons of quality as a prime dainty; and that in his time the body of a plump girl of fifteen, who was crucified for an attempt to poison the emperor, was sold to his Imperial Majesty's prime minister of state, and other great mandarins of the court, in joints from the gibbet, at four hundred crowns. Neither indeed can I deny that if the same use were made of several plump young girls in this town, who without one single groat to their fortunes cannot stir abroad without a chair, and appear at the playhouse and assemblies in foreign fineries which they never will pay for, the kingdom would not be the worse.

Some persons of a desponding spirit are in great concern about that vast number of poor people who are aged, diseased, or maimed, and I have been desired to employ my thoughts what course may be taken to ease the nation of so grievous an encumbrance. But I am not in the least pain upon that matter, because it is very well known that they are every day dying and rotting by cold and famine, and filth and vermin, as fast as can be reasonably expected. And as to the younger laborers, they are now in almost as hopeful a condition. They cannot get work, and consequently pine away for want of nourishment to a degree that if at any time they are accidentally hired to com-

mon labor, they have not strength to perform it; and thus the country and themselves are happily delivered from the evils to come.

I have too long digressed, and therefore shall return to my subject. I think the advantages by the proposal which I have made are obvious and many, as well as of the highest importance.

For first, as I have already observed, it would greatly lessen the number of Papists, with whom we are yearly overrun, being the principal breeders of the nation as well as our most dangerous enemies; and who stay at home on purpose to deliver the kingdom to the Pretender, hoping to take their advantage by the absence of so many good Protestants, who have chosen rather to leave their country than to stay at home and pay tithes against their conscience to an Episcopal curate.

Secondly, the poorer tenants will have something valuable of their own, which by law may be made liable to distress, and help to pay their landlord's rent, their corn and cattle being already seized and money a thing unknown.

Thirdly, whereas the maintenance of an hundred thousand children, from two years old and upwards, cannot be computed at less than ten shillings a piece per annum, the nation's stock will be thereby increased fifty thousand pounds per annum, besides the profit of a new dish introduced to the tables of all gentlemen of fortune in the kingdom who have any refinement in taste. And the money will circulate among ourselves, the goods being entirely of our own growth and manufacture.

Fourthly, the constant breeders, besides the gain of eight shillings sterling per annum by the sale of their children, will be rid of the charge of maintaining them after the first year.

Fifthly, this food would likewise bring great custom to taverns, where the vintners will certainly be so prudent as to procure the best receipts for dressing it to perfection, and consequently have their houses frequented by all the fine gentlemen, who justly value themselves upon their knowledge in good eating; and a skillful cook, who understands how to oblige his guests, will contrive to make it as expensive as they please.

Sixthly, this would be a great inducement to marriage, which all wise nations have either encouraged by rewards or enforced by laws and penalties. It would increase the care and tenderness of mothers toward their children, when they were sure of a settlement for life to the poor babes, provided in some sort by the public, to their annual profit instead of expense. We should see an honest emulation among the married women, which of them could bring the fattest child to the market. Men would become as fond of their wives during the time of their pregnancy as they are now of their mares in foal, their cows in calf, or sows when they are ready to farrow; nor offer to beat or kick them (as is too frequent a practice) for fear of a miscarriage.

Many other advantages might be enumerated. For instance, the addition of some thousand carcasses in our exportation of barreled beef, the propagation of swine's flesh, and improvement in the art of making good bacon, so much wanted among us by the great destruction of pigs, too frequent at our tables, which are no way comparable in taste of magnificence to a well-grown, fat, yearling child, which roasted whole will make a considerable figure at a lord mayor's feast or any other public entertainment. But this and many others I omit, being studious of brevity.

Supposing that one thousand families in this city would be constant customers for infants' flesh, besides others who might have it at merry meetings, particularly weddings and christenings, I compute that Dublin would take off annually about twenty thousands carcasses, and the rest of the kingdom (where probably they will be sold somewhat cheaper) the remaining eighty thousand.

I can think of no one objection that will possibly be raised against this proposal, unless it should be urged that the number of people will be thereby much lessened in the kingdom. This

I freely own, and it was indeed one principal design in offering it to the world. I desire the reader will observe, that I calculate my remedy for this one individual kingdom of Ireland and for no other that ever was, is, or I think ever can be upon earth. Therefore let no man talk to me of other expedients: of taxing our absentees at five shillings a pound: of using neither clothes nor household furniture except what is of our own growth and manufacture: of utterly rejecting the materials and instruments that promote foreign luxury: of curing the expensiveness of pride, vanity, idleness, and gaming in our women: of introducing a vein of parsimony, prudence, and temperance: of learning to love our country, in the want of which we differ even from Laplanders and the inhabitants of Topinamboo: of quitting our animosities and factions, nor acting any longer like the Jews, who were murdering one another at the very moment their city was taken: of being a little cautious not to sell our country and conscience for nothing: of teaching landlords to have at least one degree of mercy toward their tenants: lastly: of putting a spirit of honesty, industry, and skill into our shopkeepers; who, if a resolution could now be taken to buy only our native goods, would immediately unite to cheat and exact upon us in the price, the measure, and the goodness, nor could ever yet be brought to make one fair proposal of just dealing, though often and earnestly invited to it.

Therefore I repeat, let no man talk to me of these and the like expedients, till he hath at least some glimpse of hope that there will ever be some hearty and sincere attempt to put them in practice.

But as to myself, having been wearied out for many years with offering vain, idle, visionary thoughts, and at length utterly despairing of success, I fortunately fell upon this proposal, which, as it is wholly new, so it hath something solid and real, of no expense and little trouble, full in our own power and whereby we can incur no danger in disobliging England. For this kind of commodity will not bear exportation, the flesh being of too tender a consistence to admit a long continuance in salt, although perhaps I could name a country which would be glad to eat up our whole nation without it.

After all, I am not so violently bent upon my own opinion as to reject any offer proposed by wise men, which shall be found equally innocent, cheap, easy, and effectual. But before something of that kind shall be advanced in contradiction to my scheme, and offering a better, I desire the author or authors will be pleased maturely to consider two points. First, as things now stand, how they will be able to find food and raiment for an hundred thousands useless mouths and backs. And secondly, there being a round million of creatures in human figure throughout this kingdom, whose sole subsistence put into a common stock would leave them in debt two millions of pounds sterling, adding those who are beggars by profession to the bulk of farmers, cottagers, and laborers, with their wives and children who are beggars in effect; I desire those politicians who dislike my overture, and may perhaps be so bold to attempt an answer, that they will first ask the parents of these mortals whether they would not at this day think it a great happiness to have been sold for food at a year old in the manner I prescribe, and thereby have avoided such a perpetual scene of misfortunes as they have since gone through by the oppression of landlords, the impossibility of paying rent without money or trade, the want of common sustenance, with neither house nor clothes to cover them from the inclemencies of the weather, and the most inevitable prospect of entailing the like or greater miseries upon their breed forever.

I profess, in the sincerity of my heart, that I have not the least personal interest in endeavoring to promote this necessary work, having no other motive than the public good of my country, by advancing our trade, providing for infants, relieving the poor, and giving some pleasure to the rich. I have no children by which I can propose to get a single penny; the youngest being nine years old, and my wife past childbearing.

READING 65

from JEAN JACQUES ROUSSEAU (1712–1778), EMILE (1762), BOOK IV

Rousseau's didactic novel EMILE *first appeared in 1762. A landmark in the history of educational thought, the book's criticism of traditional educational methods earned its author the disapproval of the French parliament. In the following passage, Rousseau analyzes the nature of his own existence and sensations, and sets out his view of religion.*

Profession of Faith of a Savoyard Vicar

My child, do not look to me for learned speeches or profound arguments. I am no great philosopher, nor do I desire to be one. I have, however, a certain amount of common-sense and a constant devotion to truth. I have no wish to argue with you nor even to convince you; it is enough for me to show you, in all simplicity of heart, what I really think. Consult your own heart while I speak; that is all I ask. If I am mistaken, I am honestly mistaken, and therefore my error will not be counted to me as a crime; if you, too, are honestly mistaken, there is no great harm done. If I am right, we are both endowed with reason, we have both the same motive for listening to the voice of reason. Why should not you think as I do?

By birth I was a peasant and poor; to till the ground was my portion; but my parents thought it a finer thing that I should learn to get my living as a priest and they found means to send me to college. . . . I learned what was taught me, I said what I was told to say, I promised all that was required, and I became a priest. But I soon discovered that when I promised not to be a man, I had promised more than I could perform.

Conscience, they tell us, is the creature of prejudice, but I know from experience that conscience persists in following the order of nature in spite of all the laws of man. . . . My good youth, nature has not yet appealed to your senses; may you long remain in this happy state when her voice is the voice of innocence. Remember that to anticipate her teaching is to offend more deeply against her than to resist her teaching; you must first learn to resist, that you may know when to yield without wrong-doing.

From my youth up I had reverenced the married state as the first and most sacred institution of nature. . . .

This very resolution proved my ruin. My respect for marriage led to the discovery of my misconduct. . . . The scandal must be expiated; I was arrested, suspended, and dismissed; I was the victim of my scruples rather than of my incontinence, and I had reason to believe, from the reproaches which accompanied my disgrace, that one can often escape punishment by being guilty of a worse fault.

A thoughtful mind soon learns from such experiences. I found my former ideas of justice, honesty, and every duty of man overturned by these painful events, and day by day I was losing my hold on one or another of the opinions I had accepted.

I was in the state of doubt and uncertainty which Descartes considers essential to the search for truth. It is a state which cannot continue, it is disquieting and painful; only vicious tendencies and an idle heart can keep us in that state. . . .

I pondered, therefore, on the sad fate of mortals, adrift upon this sea of human opinions, without compass or rudder, and abandoned to their stormy passions with no guide but an inexperienced pilot who does not know whence he comes or whither he is going. I said to myself, "I love truth, I seek her, and cannot find her. Show me truth and I will hold her fast; why does she hide her face from the eager heart that would fain worship her?"

My perplexity was increased by the fact that I had been brought up in a church which decides everything and permits

no doubts, so that having rejected one article of faith I was forced to reject the rest; . . .

I consulted the philosophers, I searched their books and examined their various theories; I found them all alike proud, assertive, dogmatic, professing, even in their so-called skepticism, to know everything, proving nothing, scoffing at each other, . . .

I suppose this prodigious diversity of opinion is caused, in the first place, by the weakness of the human intellect; and, in the second, by pride. . . . The one thing we do not know is the limit of the knowable. We prefer to trust to chance and to believe what is not true, rather than to own that not one of us can see what really is. A fragment of some vast whole whose bounds are beyond our gaze, a fragment abandoned by its Creator to our foolish quarrels, we are vain enough to want to determine the nature of that whole and our own relations with regard to it.

The first thing I learned from these considerations was to restrict my inquiries to what directly concerned myself, to rest in profound ignorance of everything else, and not even to trouble myself to doubt anything beyond what I required to know.

I also realized that the philosophers, far from ridding me of my vain doubts, only multiplied the doubts that tormented me and failed to remove any one of them. So I chose another guide and said, "Let me follow the Inner Light; it will not lead me so far astray as others have done, or if it does it will be my own fault, and I shall not go so far wrong if I follow my own illusions as if I trusted to their deceits."

But who am I? What right have I to decide? What is it that determines my judgments? If they are inevitable, if they are the results of the impressions I receive, I am wasting my strength in such inquiries; they would be made or not without any interference of mine. I must therefore first turn my eyes upon myself to acquaint myself with the instrument I desire to use, and to discover how far it is reliable.

I exist, and I have senses through which I receive impressions. This is the first truth that strikes me and I am forced to accept it. Have I any independent knowledge of my existence, or am I only aware of it through my sensations? This is my first difficulty, and so far I cannot solve it. For I continually experience sensations, either directly or indirectly through memory, so how can I know if the feeling of self is something beyond these sensations or if it can exist independently of them?

My sensations take place in myself, for they make me aware of my own existence; but their cause is outside me, for they affect me whether I have any reason for them or not, and they are produced or destroyed independently of me. So I clearly perceive that my sensation, which is within me, and its cause or its object, which is outside me, are different things.

Thus, not only do I exist, but other entities exist also, that is to say, the objects of my sensations; and even if these objects are merely ideas, still these ideas are not me.

But everything outside myself, everything which acts upon my senses, I call matter, and all the particles of matter which I suppose to be united into separate entities I call bodies. Thus all the disputes of the idealists and the realists have no meaning for me; their distinctions between the appearance and the reality of bodies are wholly fanciful.

I am now as convinced of the existence of the universe as of my own. I next consider the objects of my sensations, and I find that I have the power of comparing them, so I perceive that I am endowed with an active force of which I was not previously aware.

To perceive is to feel; to compare is to judge; to judge and to feel are not the same. Through sensation objects present themselves to me separately and singly as they are in nature; by comparing them I rearrange them, I shift them so to speak, I place one upon another to decide whether they are alike or different, or more generally to find out their relations. To my mind, the distinctive faculty of an active or intelligent being is the power of understanding this word *is*. I seek in vain in the merely sensitive entity that intelligent force which compares and judges; I can find no trace of it in its nature. This passive entity will be aware of each object separately, it will even be aware of the whole formed by the two together, but having no power to place them side by side it can never compare them, it can never form a judgment with regard to them.

To see two things at once is not to see their relations nor to judge of their differences; to perceive several objects, one beyond the other, is not to relate them. I may have at the same moment an idea of a big stick and a little stick without comparing them, without judging that one is less than the other, just as I can see my whole hand without counting my fingers. These comparative ideas, greater, smaller, together with number ideas of one, two, etc., are certainly not sensations, although my mind only produces them when my sensations occur.

We are told that a sensitive being distinguishes sensations from each other by the inherent differences in the sensations; this requires explanation. When the sensations are different, the sensitive being distinguishes them by their differences; when they are alike, he distinguishes them because he is aware of them one beyond the other. Otherwise, how could he distinguish between two equal objects simultaneously experienced? He would necessarily confound the two objects and take them for one object, especially under a system which professed that the representative sensations of space have no extension.

When we become aware of the two sensations to be compared, their impression is made, each object is perceived, both are perceived, but for all that their relation is not perceived. If the judgment of this relation were merely a sensation, and came to me solely from the object itself, my judgments would never be mistaken, for it is never untrue that I feel what I feel.

Why then am I mistaken as to the relation between these two sticks, especially when they are not parallel? Why, for example, do I say the small stick is a third of the large, when it is only a quarter? Why is the picture, which is the sensation, unlike its model which is the object? It is because I am active when I judge, because the operation of comparison is at fault; because my understanding, which judges of relations, mingles its errors with the truth of sensations, which only reveal to me things.

Add to this a consideration which will, I feel sure, appeal to you when you have thought about it: it is this—If we were purely passive in the use of our senses, there would be no communication between them; it would be impossible to know that the body we are touching and the touch we are looking at is the same. Either we should never perceive anything outside ourselves, or there would be for us five substances perceptible by the senses, whose identity we should have no means of perceiving.

This power of my mind which brings my sensations together and compares them may be called by any name; let it be called attention, meditation, reflection, or what you will; it is still true that it is in me and not in things, that it is I alone who produce it, though I only produce it when I receive an impression from things. Though I am compelled to feel or not to feel, I am free to examine more or less what I feel.

Being now, so to speak, sure of myself, I begin to look at things outside myself, and I behold myself with a sort of shudder flung at random into this vast universe, plunged as it were into the vast number of entities, knowing nothing of what they are in themselves or in relation to me. I study them, I observe them; . . .

I believe, therefore, that there is a will which sets the universe in motion and gives life to nature. This is my first dogma, or the first article of my creed. . . .

Let us compare the special ends, the means, the ordered relations of every kind, then let us listen to the inner voice of

feeling; what healthy mind can reject its evidence? Unless the eyes are blinded by prejudices, can they fail to see that the visible order of the universe proclaims a supreme intelligence? What sophisms must be brought together before we fail to understand the harmony of existence and the wonderful cooperation of every part for the maintenance of the rest? . . .

In vain do those who deny the unity of intention manifested in the relations of all the parts of this great whole, in vain do they conceal their nonsense under abstractions, coordinations, general principles, symbolic expressions; whatever they do I find it impossible to conceive of a system of entities so firmly ordered unless I believe in an intelligence that orders them. It is not in my power to believe that passive and dead matter can have brought forth living and feeling beings, that blind chance has brought forth intelligent beings, that that which does not think has brought forth thinking beings.

I believe, therefore, that the world is governed by a wise and powerful will; I see it or rather I feel it, and it is a great thing to know this. But has this same world always existed, or has it been created? Is there one source of all things? Are there two or many? What is their nature? I know not; and what concern is it of mine? When these things become of importance to me I will try to learn them; till then I abjure these idle speculations, which may trouble my peace, but cannot affect my conduct nor be comprehended by my reason.

Recollect that I am not preaching my own opinion but explaining it. Whether matter is eternal or created, whether its origin is passive or not, it is still certain that the whole is one, and that it proclaims a single intelligence; for I see nothing that is not part of the same ordered system, nothing which does not cooperate to the same end, namely, the conservation of all within the established order. This being who wills and can perform his will, this being active through his own power, this being, whoever he may be, who moves the universe and orders all things, is what I call God. To this name I add the ideas of intelligence, power, will, which I have brought together, and that of kindness which is their necessary consequence; but for all this I know no more of the being to which I ascribe them. He hides himself alike from my senses and my understanding; the more I think of him, the more perplexed I am; I know full well that he exists, and that he exists of himself alone; I know that my existence depends on his, and that every thing I know depends upon him also. I see God everywhere in his works; I feel him within myself; I behold him all around me; but if I try to ponder him himself, if I try to find out where he is, what he is, what is his substance, he escapes me and my troubled spirit finds nothing.

"Emile" by Jean Jacques Rousseau from *Introduction to Contemporary Civilization in the West, Vol. 1*, Third Edition, translated by Barbara Foxley. Copyright 1960 Columbia University Press. Reprinted by permission.

READING 66

from Jean Jacques Rousseau (1712–1778), The Social Contract or Principles of Political Right (1762)

Rousseau's contempt for the superficial and the artificial, and his praise for simple and direct relationships between individuals, did a great deal to inspire believers in human equality and opposed to the principles of aristocracy. Briefly stated, Rousseau believed that the growth of civilization had corrupted the natural goodness of the human race and that the growth of society had destroyed the freedom of the individual. With this in mind, Rousseau strove to create a new social order. In THE SOCIAL CONTRACT (1762), he tried to describe the basis of his ideal state in terms of the General Will of the people, which would delegate authority to individual organs of government. In our excerpt here, Rousseau addresses the question of whether any person can be the slave of another.

from Book I, Section 4, "Slavery"

Since no man has a natural authority over his fellow, and force creates no right, we must conclude that conventions form the basis of all legitimate authority among men.

If an individual, says Grotius, can alienate his liberty and make himself the slave of a master, why could not a whole people do the same and make itself subject to a king? There are in this passage plenty of ambiguous words which would need explaining; but let us confine ourselves to the word *alienate*. To alienate is to give or to sell. Now, a man who becomes the slave of another does not give himself; he sells himself, at the least for his subsistence: but for what does a people sell itself? A king is so far from furnishing his subjects with their subsistence that he gets his own only from them; and, according to Rabelais, kings do not live on nothing. Do subjects then give their persons on condition that the king takes their goods also? I fail to see what they have left to preserve.

It will be said that the despot assures his subjects civil tranquillity. Granted; but what do they gain, if the wars his ambition brings down upon them, his insatiable avidity, and the vexatious conduct of his ministers press harder on them than their own dissensions would have done? What do they gain, if the very tranquillity they enjoy is one of their miseries? Tranquillity is found also in dungeons; but is that enough to make them desirable places to live in? The Greeks imprisoned in the cave of the Cyclops lived there very tranquilly, while they were awaiting their turn to be devoured.

To say that a man gives himself gratuitously, is to say what is absurd and inconceivable; such an act is null and illegitimate, from the mere fact that he who does it is out of his mind. To say the same of a whole people is to suppose a people of madmen; and madness creates no right.

Even if each man could alienate himself, he could not alienate his children: they are born men and free; their liberty belongs to them, and no one but they has the right to dispose of it. Before they come to years of discretion, the father can, in their name, lay down conditions for their preservation and well-being, but he cannot give them irrevocably and without conditions: such a gift is contrary to the ends of nature, and exceeds the rights of paternity. It would therefore be necessary, in order to legitimise an arbitrary government, that in every generation the people should be in a position to accept or reject it; but, were this so, the government would be no longer arbitrary.

To renounce liberty is to renounce being a man, to surrender the rights of humanity and even its duties. . . . from whatever aspect we regard the question, the right of slavery is null and void, not only as being illegitimate, but also because it is absurd and meaningless. The words slave and right contradict each other, and are mutually exclusive. It will always be equally foolish for a man to say to a man or to a people: "I make with you a convention wholly at your expense and wholly to my advantage; I shall keep it as long as I like, and you will keep it as long as I like."

READING 67

from Voltaire (François Marie-Arouet, 1694–1778), Candide or Optimism (1759)

Candide is a simple young man of charm and courage who at an early age has been subjected to the opinions of his tutor, Dr. Pangloss. According to Dr. Pangloss, who is a parody of the rational philosophers of the day, everything that happens is bound to happen for the best, be it rape, murder, or earthquake. In a famous scene in Chapter 5, Candide and Pangloss become involved in an actual historical event, the disastrous earthquake that destroyed most of Lisbon in 1755. When called upon to help the injured, the learned doctor meditates instead on the causes and effects of the earthquake and duly comes to the conclusion that if Lisbon

and its inhabitants were destroyed, it had to be so, and therefore was all for the best.

It is, incidentally, typical of the breadth of Voltaire's satire that in the very first sentence of the next chapter he turns from philosophical optimism to an attack on religious superstition and fanaticism, when he describes the decision taken to find some victims injured in the earthquake and burn them alive as a means of averting further disasters. That this decision is made by the University of Coimbra—supposedly an establishment of reason—is of course an extra twist of the knife on Voltaire's part.

Among the chosen victims is Candide himself; by the time he has escaped even he, innocent follower of his tutor's precepts, is beginning to have serious doubts. When he hears of the disasters that have befallen his childhood sweetheart Cunegonde and the old lady who is her companion, the absurdity of philosophical optimism becomes clear. Much of the rest of the book is devoted to underlining precisely how absurd it is and exploring alternative schools of thought. Candide travels from Spain to the New World and back to Europe, and wherever he goes finds nothing but evil, stupidity, and ignorance.

The reader who expects to find fully developed characters and a convincing plot in CANDIDE *is likely to be severely disappointed. Voltaire's aim is to teach, and to this end he manipulates the narrative to make his points as powerfully as possible. This does not mean that he does not write entertainingly; indeed,* CANDIDE *is probably one of the most enjoyable of the great literary works. With inexhaustible imagination and dry wit, Voltaire even succeeds in making us laugh at the impossible disasters he invents and the absurd reactions of his characters to them, since, given the choice of laughter or tears at the injustices of life, he chooses the former. Nonetheless, the message of the work is far from comforting. It is a measure of Voltaire's courage that his final advice to "cultivate our gardens" manages to extract something positive from the despair masked by his humor and irony. The world is a cruel place where human life is of little account, but to give way to total pessimism is fruitless. Instead, we should try to find some limited activity we can perform well.*

The two long selections that follow are not intended to present every twist and turn of the plot but to convey something of the flavor and spirit of the whole.

Chapters 1–13

The first selection (Chapters 1–13) sees the story well on its way, with Candide separated from Cunegonde, reunited with her and separated yet again, while Voltaire takes on an assortment of targets that includes the aristocracy, the law, war, religious intolerance and hypocrisy, and, of course, Dr. Pangloss. The episode of the old woman and her story, furthermore, contains some of Voltaire's most bizarre inventions. The note of suspense on which Chapter 13 closes is typical of much of the rest of the book, where characters are placed in an impossible situation from which they find a highly unlikely means of escape.

Chapter 1. How Candide was brought up in a noble castle and how he was expelled from the same

In the castle of Baron Thunder-ten-tronckh in Westphalia there lived a youth, endowed by Nature with the most gentle character. His face was the expression of his soul. His judgment was quite honest and he was extremely simpleminded; and this was the reason, I think, that he was named Candide. Old servants in the house suspected that he was the son of the Baron's sister and a decent honest gentleman of the neighborhood, whom this young lady would never marry because he could only prove seventy-one quarterings, and the rest of his genealogical tree was lost, owing to the injuries of time. The Baron was one of the most powerful lords in Westphalia, for his castle possessed a door and windows. His Great Hall was even decorated with a piece of tapestry. The dogs in his stable-yards formed a pack of hounds when necessary; his grooms were his huntsmen; the village curate was his Grand Almoner. They all called him "My Lord," and laughed heartily at his stories. The Baroness weighed about three hundred and fifty pounds, was therefore greatly respected, and did the honors of the house with a dignity which rendered her still more respectable. Her daughter Cunegonde, age seventeen, was rosy-cheeked, fresh, plump and tempting. The Baron's son appeared in every respect worthy of his father. The tutor Pangloss was the oracle of the house, and little Candide followed his lessons with all the candor of his age and character. Pangloss taught metaphysico-theologo-cosmo-lonigology. He proved admirably that there is no effect without a cause and that in this best of all possible worlds, My Lord the Baron's castle was the best of castles and his wife the best of all possible Baronesses. "'Tis demonstrated," said he, "that things cannot be otherwise; for, since everything is made for an end, everything is necessarily for the best end. Observe that noses were made to wear spectacles; and so we have spectacles. Legs were visibly instituted to be breeched, and we have breeches. Stones were formed to be quarried and to build castles; and My Lord has a very noble castle; the greatest Baron in the province should have the best house; and as pigs were made to be eaten, we eat pork all the year round; consequently, those who have asserted that all is well talk nonsense; they ought to have said that all is for the best." Candide listened attentively and believed innocently; for he thought Mademoiselle Cunegonde extremely beautiful, although he was never bold enough to tell her so. He decided that after the happiness of being born Baron of Thunder-ten-tronckh, the second degree of happiness was to be Mademoiselle Cunegonde; the third to see her every day; and the fourth to listen to Doctor Pangloss, the greatest philosopher of the province and therefore of the whole world. One day when Cunegonde was walking near the castle, in a little wood which was called The Park, she observed Doctor Pangloss in the bushes, giving a lesson in experimental physics to her mother's waiting-maid, a very pretty and docile brunette. Mademoiselle Cunegonde had a great inclination for science and watched breathlessly the reiterated experiments she witnessed; she observed clearly the Doctor's sufficient reason, the effects and the causes, and returned home very much excited, pensive, filled with the desire of learning, reflecting that she might be the sufficient reason of young Candide and that he might be hers. On her way back to the castle she met Candide and blushed; Candide also blushed. She bade him good-morning in a hesitating voice; Candide replied without knowing what he was saying. Next day, when they left the table after dinner, Cunegonde and Candide found themselves behind a screen; Cunegonde dropped her handkerchief, Candide picked it up; she innocently held his hand; the young man innocently kissed the young lady's hand with remarkable vivacity, tenderness and grace; their lips met, their eyes sparkled, their knees trembled, their hands wandered. Baron Thunder-ten-tronckh passed near the screen, and, observing this cause and effect, expelled Candide from the castle by kicking him in the backside frequently and hard. Cunegonde swooned; when she recovered her senses, the Baroness slapped her in the face; and all was in consternation in the noblest and most agreeable of all possible castles.

Chapter 2. What happened to Candide among the Bulgarians

Candide, expelled from the earthly paradise, wandered for a long time without knowing where he was going, turning up his eyes to Heaven, gazing back frequently at the noblest of castles which held the most beautiful of young Baronesses; he lay down to sleep supperless between two furrows in the open fields; it snowed heavily in large flakes. The next morning the shivering Candide, penniless, dying of cold and exhaustion, dragged

himself towards the neighboring town, which was called Wald-berghoff-trarbk-dikdorff. He halted sadly at the door of an inn. Two men dressed in blue noticed him. "Comrade," said one, "there's a well-built young man of the right height." They went up to Candide and very civilly invited him to dinner. "Gentle-men," said Candide with charming modesty, "you do me a great honor, but I have no money to pay my share." "Ah, sir," said one of the men in blue, "persons of your figure and merit never pay anything; are you not five feet five tall?" "Yes, gentlemen," said he, bowing, "that is my height." "Ah, sir, come to table; we will not only pay your expenses, we will never allow a man like you to be short of money; men were only made to help each other." "You are in the right," said Candide, "that is what Doc-tor Pangloss was always telling me, and I see that everything is for the best." They begged him to accept a few crowns, he took them and wished to give them an I O U; they refused to take it and all sat down to table. "Do you not love tenderly. . . ." "Oh, yes," said he. "I love Mademoiselle Cunegonde tenderly." "No," said one of the gentlemen. "We were asking if you do not tenderly love the King of the Bulgarians." "Not a bit," said he, "for I have never seen him." "What! He is the most charming of Kings, and you must drink his health." "Oh, gladly, gentlemen." And he drank. "That is sufficient," he was told. "You are now the support, the aid, the defender, the hero of the Bulgarians; your fortune is made and your glory assured." They immediately put irons on his legs and took him to a regiment. He was made to turn to the right and left, to raise the ramrod and return the ramrod, to take aim, to fire, to march double time, and he was given thirty strokes with a stick; the next day he drilled not quite so badly, and received only twenty strokes; the day after, he only had ten and was looked on as a prodigy by his comrades. Can-dide was completely mystified and could not make out how he was a hero. One fine spring day he thought he would take a walk, going straight ahead, in the belief that to use his legs as he pleased was a privilege of the human species as well as of animals. He had not gone two leagues when four other heroes, each six feet tall, fell upon him, bound him and dragged him back to a cell. He was asked by his judges whether he would rather be thrashed thirty-six times by the whole regiment or receive a dozen lead bullets at once in his brain. Although he protested that men's wills are free and that he wanted neither one nor the other, he had to make a choice; by virtue of that gift of God which is called *liberty*, he determined to run the gauntlet thirty-six times and actually did so twice. There were two thousand men in the regiment. That made four thousand strokes which laid bare the muscles and nerves from his neck to his backside. As they were about to proceed to a third turn, Candide, utterly exhausted, begged as a favor that they would be so kind as to smash his head; he obtained this favor; they bound his eyes and he was made to kneel down. At that moment the King of the Bulgarians came by and inquired the victim's crime; and as this King was possessed of a vast genius, he perceived from what he learned about Candide that he was a young metaphysician very ignorant in worldly matters, and therefore pardoned him with a clemency which will be praised in all newspapers and all ages. An honest surgeon healed Candide in three weeks with the oint-ments recommended by Dioscorides. He had already regained a little skin and could walk when the King of the Bulgarians went to war with the King of the Abares.

Chapter 3. How Candide escaped from the Bulgarians and what became of him

Nothing could be smarter, more splendid, more brilliant, bet-ter drawn up than the two armies. Trumpets, fifes, hautboys, drums, cannons, formed a harmony such as has never been heard even in hell. The cannons first of all laid flat about six thousand men on each side; then the musketry removed from the best of worlds some nine or ten thousand blackguards who infested its surface. The bayonet also was the sufficient reason for the death of some thousands of men. The whole might amount to thirty thousand souls. Candide, who trembled like a philosopher, hid himself as well as he could during this heroic butchery. At last, while the two Kings each commanded a Te Deum in his camp, Candide decided to go elsewhere to rea-son about effects and causes. He clambered over heaps of dead and dying men and reached a neighboring village, which was in ashes; it was an Abare village which the Bulgarians had burned in accordance with international law. Here, old men dazed with blows watched the dying agonies of their murdered wives who clutched their children to their bleeding breasts; there, disem-boweled girls who had been made to satisfy the natural appetites of heroes gasped their last sighs; others, half-burned, begged to be put to death. Brains were scattered on the ground among dis-membered arms and legs. Candide fled to another village as fast as he could; it belonged to the Bulgarians, and Abarian heroes had treated it in the same way. Candide, stumbling over quiv-ering limbs or across ruins, at last escaped from the theatre of war, carrying a little food in his knapsack, and never forgetting Mademoiselle Cunegonde. His provisions were all gone when he reached Holland; but, having heard that everyone in that country was rich and a Christian, he had no doubt at all but that he would be as well treated as he had been in the Baron's castle before he had been expelled on account of Mademoiselle Cune-gonde's pretty eyes. He asked alms of several grave persons, who all replied that if he continued in that way he would be shut up in a house of correction to teach him how to live. He then addressed himself to a man who had been discoursing on charity in a large assembly for an hour on end. This orator, glancing at him askance, said: "What are you doing here? Are you for the good cause?" "There is no effect without a cause," said Can-dide modestly. "Everything is necessarily linked up and arranged for the best. It was necessary that I should be expelled from the company of Mademoiselle Cunegonde, that I ran the gauntlet, and that I beg my bread until I can earn it; all this could not have happened differently." "My friend," said the orator, "do you believe that the Pope is anti-Christ?" "I had never heard so before," said Candide, "but whether he is or isn't, I am starv-ing." "You don't deserve to eat," said the other. "Hence, rascal; hence, you wretch; and never come near me again." The ora-tor's wife thrust her head out of the window and seeing a man who did not believe that the Pope was anti-Christ, she poured on his head a full . . . O Heavens! To what excess religious zeal is carried by ladies! A man who had not been baptized, an honest Anabaptist named Jacques, saw the cruel and ignomini-ous treatment of one of his brothers, a featherless two-legged creature with a soul; he took him home, cleaned him up, gave him bread and beer, presented him with two florins, and even offered to teach him to work at the manufacture of Persian stuffs which are made in Holland. Candide threw himself at the man's feet, exclaiming: "Doctor Pangloss was right in telling me that all is for the best in this world, for I am vastly more touched by your extreme generosity than by the harshness of the gentlemen in the black cloak, and his good lady." The next day when he walked out he met a beggar covered with sores, dull-eyed, with the end of his nose fallen away, his mouth awry, his teeth black, who talked huskily, was tormented with a violent cough and spat out a tooth at every cough.

Chapter 4. How Candide met his old master in philosophy, Doctor Pangloss, and what happened

Candide, moved even more by compassion than by horror, gave this horrible beggar the two florins he had received from

the honest Anabaptist, Jacques. The phantom gazed fixedly at him, shed tears and threw its arms round his neck. Candide recoiled in terror. "Alas!" said the wretch to the other wretch, "don't you recognize your dear Pangloss?" "What do I hear? You, my dear master! You, in this horrible state! What misfortune has happened to you! Why are you no longer in the noblest of castles? What has become of Mademoiselle Cunegonde, the pearl of young ladies, the masterpiece of Nature?" "I am exhausted," said Pangloss. Candide immediately took him to the Anabaptist's stable where he gave him a little bread to eat; and when Pangloss had recovered: "Well!" said he, "Cunegonde?" "Dead," replied the other. At this word Candide swooned; his friend restored him to his senses with a little bad vinegar which happened to be in the stable. Candide opened his eyes. "Cunegonde dead! Ah! best of worlds, where are you? But what illness did she die of? Was it because she saw me kicked out of her father's noble castle?" "No," said Pangloss. "She was disemboweled by Bulgarian soldiers, after having been raped to the limit of possibility; they broke the Baron's head when he tried to defend her; the Baroness was cut to pieces; my poor pupil was treated exactly like his sister; and as to the castle, there is not one stone standing on another, not a barn, not a sheep, not a duck, not a tree; but we were well avenged, for the Abares did exactly the same to a neighboring barony which belonged to a Bulgarian Lord." At this, Candide swooned again; but, having recovered and having said all that he ought to say, he inquired the cause and effect, the sufficient reason which had reduced Pangloss to so piteous a state. "Alas!" said Pangloss, "'tis love; love, the consoler of the human race, the preserver of the universe, the soul of all tender creatures, gentle love." "Alas!" said Candide. "I am acquainted with this love, this sovereign of hearts, this soul of our soul; it has never brought me anything but one kiss and twenty kicks in the backside. How could this beautiful cause produce in you so abominable an effect?" Pangloss replied as follows: "My dear Candide! You remember Paquette, the maid-servant of our august Baroness; in her arms I enjoyed the delights of Paradise which have produced the tortures of Hell by which you see I am devoured; she was infected and perhaps is dead. Paquette received this present from a most learned monk, who had it from the source; for he received it from an old countess, who had it from a cavalry captain, who owed it to a marchioness, who derived it from a page, who had received it from a Jesuit, who, when a novice, had it in a direct line from one of the companions of Christopher Columbus. For my part, I shall not give it to anyone, for I am dying." "O Pangloss!" exclaimed Candide, "this is a strange genealogy! Wasn't the devil at the root of it?" "Not at all," replied that great man. "It was something indispensable in this best of worlds, a necessary ingredient; for, if Columbus in an island of America had not caught this disease, which poisons the source of generation, and often indeed prevents generation, we should not have chocolate and cochineal; it must also be noticed that hitherto in our continent this disease is peculiar to us, like theological disputes. The Turks, the Indians, the Persians, the Chinese, the Siamese and the Japanese are not yet familiar with it; but there is a sufficient reason why they in their turn should become familiar with it in a few centuries. Meanwhile, it has made marvelous progress among us, and especially in those large armies composed of honest, well-bred stipendiaries who decide the destiny of States; it may be asserted that when thirty thousand men fight a pitched battle against an equal number of troops, there are about twenty thousand with the pox on either side." "Admirable!" said Candide. "But you must get cured." "How can I?" said Pangloss. "I haven't a sou, my friend, and in the whole extent of this globe, you cannot be bled or receive an enema without paying or without someone paying for you." This last speech determined Candide; he went and threw himself at the

feet of his charitable Anabaptist, Jacques, and drew so touching a picture of the state to which his friend was reduced that the good easy man did not hesitate to succor Pangloss; he had him cured at his own expense. In this cure Pangloss only lost one eye and one ear. He could write well and knew arithmetic perfectly. The Anabaptist made him his book-keeper. At the end of two months he was compelled to go to Lisbon on business and took his two philosophers on the boat with him. Pangloss explained to him how everything was for the best. Jacques was not of this opinion. "Men," said he, "must have corrupted nature a little, for they were not born wolves, and they have become wolves. God did not give them twenty-four-pounder cannons or bayonets, and they have made bayonets and cannons to destroy each other. I might bring bankruptcies into the account and Justice which seizes the goods of bankrupts in order to deprive the creditors of them." "It was all indispensable," replied the one-eyed doctor, "and private misfortunes make the public good, so that the more private misfortunes there are, the more everything is well." While he was reasoning, the air grew dark, the winds blew from the four quarters of the globe and the ship was attacked by the most horrible tempest in sight of the port of Lisbon.

Chapter 5. Storm, shipwreck, earthquake, and what happened to Doctor Pangloss, to Candide and the Anabaptist Jacques

Half the enfeebled passengers, suffering from that inconceivable anguish which the rolling of a ship causes in the nerves and in all the humors of bodies shaken in contrary directions, did not retain strength enough even to trouble about the danger. The other half screamed and prayed; the sails were torn, the masts broken, the vessel leaking. Those worked who could, no one cooperated, no one commanded. The Anabaptist tried to help the crew a little; he was on the main-deck; a furious sailor struck him violently and stretched him on the deck; but the blow he delivered gave the sailor so violent a shock that he fell head-first out of the ship. He remained hanging and clinging to part of the broken mast. The good Jacques ran to his aid, helped him to climb back, and from the effort he made was flung into the sea in full view of the sailor, who allowed him to drown without condescending even to look at him. Candide came up, saw his benefactor reappear for a moment and then be engulfed for ever. He tried to throw himself after him into the sea; he was prevented by the philosopher Pangloss, who proved to him that the Bay of Lisbon had been expressly created for the Anabaptist to be drowned in it. While he was proving this a priori, the vessel sank, and every one perished except Pangloss, Candide and the brutal sailor who had drowned the virtuous Anabaptist; the blackguard swam successfully to the shore and Pangloss and Candide were carried there on a plank. When they had recovered a little, they walked toward Lisbon; they had a little money by the help of which they hoped to be saved from hunger after having escaped the storm. Weeping the death of their benefactor, they had scarcely set foot in the town when they felt the earth tremble under their feet; the sea rose in foaming masses in the port and smashed the ships which rode at anchor. Whirlwinds of flame and ashes covered the streets and squares; the houses collapsed, the roofs were thrown upon the foundations, and the foundations were scattered; thirty thousand inhabitants of every age and both sexes were crushed under the ruins. Whistling and swearing, the sailor said: "There'll be something to pick up here." "What can be the sufficient reason for this phenomenon?" said Pangloss. "It is the last day!" cried Candide. The sailor immediately ran among the debris, dared death to find money, found it, seized it, got drunk, and having slept off his wine, purchased the favors of the first woman of good-will he

met on the ruins of the houses and among the dead and dying. Pangloss, however, pulled him by the sleeve. "My friend," said he, "this is not well, you are disregarding universal reason, you choose the wrong time." "Blood and 'ounds!" he retorted. "I am a sailor and I was born in Batavia; four times have I stamped on the crucifix during four voyages to Japan; you have found the right man for your universal reason!" Candide had been hurt by some falling stones; he lay in the street covered with debris. He said to Pangloss: "Alas! Get me a little wine and oil; I am dying." "This earthquake is not a new thing," replied Pangloss. "The town of Lima felt the same shocks in America last year; similar causes produce similar effects; there must certainly be a train of sulphur underground from Lima to Lisbon." "Nothing is more probable," replied Candide; "but, for God's sake, a little oil and wine." "What do you mean, probable?" replied the philosopher; "I maintain that it is proved." Candide lost consciousness, and Pangloss brought him a little water from a neighboring fountain. Next day they found a little food as they wandered among the ruins and regained a little strength. Afterwards they worked like others to help the inhabitants who had escaped death. Some citizens they had assisted gave them as good a dinner as could be expected in such a disaster; true, it was a dreary meal; the hosts watered their bread with their tears, but Pangloss consoled them by assuring them that things could not be otherwise. "For," said he, "all this is for the best; for, if there is a volcano at Lisbon, it cannot be anywhere else; for it is impossible that things should not be where they are; for all is well." A little, dark man, a familiar of the Inquisition, who sat beside him, politely took up the conversation, and said: "Apparently, you do not believe in original sin; for, if everything is for the best, there was neither fall nor punishment." "I most humbly beg your excellency's pardon," replied Pangloss still more politely, "for the fall of man and the curse necessarily entered into the best of all possible worlds." "Then you do not believe in free-will?" said the familiar. "Your excellency will pardon me," said Pangloss; "free-will can exist with absolute necessity; for it was necessary that we should be free; for in short, limited will . . ." Pangloss was in the middle of his phrase when the familiar nodded to his armed attendant who was pouring out port or Oporto wine for him.

Chapter 6. How a splendid audo-da-fé was held to prevent earthquakes and how Candide was flogged

After the earthquake which destroyed three-quarters of Lisbon, the wise men of that country could discover no more efficacious way of preventing a total ruin than by giving the people a splendid *auto-da-fé*. It was decided by the university of Coimbra that the sight of several persons being slowly burned in great ceremony is an infallible secret for preventing earthquakes. Consequently they had arrested a Biscayan convicted of having married his fellow-godmother, and two Portuguese who, when eating a chicken, had thrown away the fat; after dinner they came and bound Doctor Pangloss and his disciple Candide, one because he had spoken and the other because he had listened with an air of approbation; they were both carried separately to extremely cool apartments, where there was never any discomfort from the sun; a week afterwards each was dressed in a sanbenito and their heads were ornamented with paper mitres. Candide's mitre and sanbenito were painted with flames upside down and with devils who had neither tails nor claws; but Pangloss's devils had claws and tails, and his flames were upright. Dressed in this manner they marched in procession and listened to a most pathetic sermon, followed by lovely plain-song music. Candide was flogged in time to the music, while the singing went on; the Biscayan and the two men who had not wanted to eat fat were burned,

and Pangloss was hanged, although this is not the custom. The very same day, the earth shook again with a terrible clamor. Candide, terrified, dumbfounded, bewildered, covered with blood, quivered from head to foot, said to himself: "If this is the best of all possible worlds, what are the others? Let it pass that I was flogged, for I was flogged by the Bulgarians, but, O my dear Pangloss! The greatest of philosophers! Must I see you hanged without knowing why! O my dear Anabaptist! The best of men! Was it necessary that you should be drowned in port! O Mademoiselle Cunegonde! The pearl of women! Was it necessary that your belly should be slit!" He was returning, scarcely able to support himself, preached at, flogged, absolved and blessed, when an old woman accosted him and said: "Courage, my son, follow me."

Chapter 7. How an old woman took care of Candide and how he regained that which he loved

Candide did not take courage, but he followed the old woman to a hovel; she gave him a pot of ointment to rub on, and left him food and drink; she pointed out a fairly clean bed; near the bed there was a suit of clothes. "Eat, drink, sleep," she said, "and may our Lady of Atocha, my Lord Saint Anthony of Padua and my Lord Saint James of Compostella take care of you; I shall come back tomorrow." Candide, still amazed by all he had seen, by all he had suffered, and still more by the old woman's charity, tried to kiss her hand. "'Tis not my hand you should kiss," said the old woman, "I shall come back tomorrow. Rub on the ointment, eat and sleep." In spite of all his misfortune, Candide ate and went to sleep. Next day the old woman brought him breakfast, examined his back and smeared him with another ointment; later she brought him dinner, and returned in the evening with supper. The next day she went through the same ceremony. "Who are you?" Candide kept asking her. "Who has inspired you with so much kindness? How can I thank you?" The good woman never made any reply; she returned in the evening but without any supper. "Come with me," said she, "and do not speak a word." She took him by the arm and walked into the country with him for about a quarter of a mile; they came to an isolated house, surrounded with gardens and canals. The old woman knocked at a little door. It was opened; she led Candide up a back stairway into a gilded apartment, left him on a brocaded sofa, shut the door and went away. Candide thought he was dreaming, and felt that his whole life was a bad dream and the present moment an agreeable dream. The old woman soon reappeared; she was supporting with some difficulty a trembling woman of majestic stature, glittering with precious stones and covered with a veil. "Remove the veil," said the old woman to Candide. The young man advanced and lifted the veil with a timid hand. What a moment! What a surprise! He thought he saw Mademoiselle Cunegonde, in fact he was looking at her, it was she herself. His strength failed him, he could not utter a word and fell at her feet. Cunegonde fell on the sofa. The old woman dosed them with distilled waters; they recovered their senses and began to speak: at first they uttered only broken words, questions and answers at cross purposes, sighs, tears, exclamations. The old woman advised them to make less noise and left them alone. "What! Is it you?" said Candide. "You are alive, and I find you here in Portugal! Then you were not raped? Your belly was not slit, as the philosopher Pangloss assured me?" "Yes, indeed," said the fair Cunegonde; "but those two accidents are not always fatal." "But your father and mother were killed?" "'Tis only too true," said Cunegonde, weeping. "And your brother?" "My brother was killed too." "And why are you in Portugal? And how did you know I was here? And by what strange adventure have you

brought me to this house?" "I will tell you everything," replied the lady, "but first of all you must tell me everything that has happened to you since the innocent kiss you gave me and the kicks you received." Candide obeyed with profound respect; and, although he was bewildered, although his voice was weak and trembling, although his back was still a little painful, he related in the most natural manner all he had endured since the moment of their separation. Cunegonde raised her eyes to heaven; she shed tears at the death of the good Anabaptist and Pangloss, after which she spoke as follows to Candide, who did not miss a word and devoured her with his eyes.

Chapter 8. Cunegonde's story

"I was fast asleep in bed when it pleased Heaven to send the Bulgarians to our noble castle of Thunder-ten-tronckh; they murdered my father and brother and cut my mother to pieces. A large Bulgarian six feet tall, seeing that I had swooned at the spectacle, began to rape me; this brought me to, I recovered my senses, I screamed, I struggled, I bit, I scratched, I tried to tear out the big Bulgarian's eyes, not knowing that what was happening in my father's castle was a matter of custom; the brute stabbed me with a knife in the left side where I still have the scar." "Alas! I hope I shall see it," said the naive Candide. "You shall see it," said Cunegonde, "but let me go on." "Go on," said Candide. She took up the thread of her story as follows: "A Bulgarian captain came in, saw me covered with blood, and the soldier did not disturb himself. The captain was angry at the brute's lack of respect to him, and killed him on my body. Afterwards, he had me bandaged and took me to his billet as a prisoner of war. I washed the few shirts he had and did the cooking; I must admit he thought me very pretty; and I will not deny that he was very well built and that his skin was white and soft; otherwise he had little wit and little philosophy; it was plain that he had not been brought up by Dr. Pangloss. At the end of three months he lost all his money and got tired of me; he sold me to a Jew named Don Issachar, who traded in Holland and Portugal and had a passion for women. This Jew devoted himself to my person but he could not triumph over it; I resisted him better than the Bulgarian soldier; a lady of honor may be raped once, but it strengthens her virtue. In order to subdue me, the Jew brought me to this country house. Up till then I believed that there was nothing on earth so splendid as the castle of Thunder-ten-tronckh; I was undeceived. One day the Grand Inquisitor noticed me at Mass; he ogled me continually and sent a message that he wished to speak to me on secret affairs. I was taken to his palace; I informed him of my birth; he pointed out how much it was beneath my rank to belong to an Israelite. A proposition was made on his behalf to Don Issachar to give me up to His Lordship. Don Issachar, who is the court banker and a man of influence, would not agree. The Inquisitor threatened him with an *auto-da-fé*. At last the Jew was frightened and made a bargain whereby the house and I belong to both in common. The Jew has Mondays, Wednesdays and the Sabbath day, and the Inquisitor has the other days of the week. This arrangement has lasted for six months. It has not been without quarrels; for it has often been debated whether the night between Saturday and Sunday belonged to the old law or the new. For my part, I have hitherto resisted them both; and I think that is the reason why they still love me. At last My Lord the Inquisitor was pleased to arrange an *auto-da-fé* to remove the scourge of earthquakes and to intimidate Don Issachar. He honored me with an invitation. I had an excellent seat; and refreshments were served to the ladies between the Mass and the execution. I was indeed horror-stricken when I saw the burning of the two Jews and the honest Biscayan who had married his fellow-godmother; but what was my surprise, my terror, my anguish, when I saw in a sanbenito and under a mitre a face which resembled Pangloss's! I rubbed my eyes, I looked carefully, I saw him hanged; and I fainted. I had scarcely recovered my senses when I saw you stripped naked; that was the height of horror, of consternation, of grief and despair. I will frankly tell you that your skin is even whiter and of a more perfect tint than that of my Bulgarian captain. This spectacle redoubled all the feelings which crushed and devoured me. I exclaimed, I tried to say: 'Stop, Barbarians!' but my voice failed and my cries would have been useless. When you had been well flogged, I said to myself: 'How does it happen that the charming Candide and the wise Pangloss are in Lisbon, the one to receive a hundred lashes, and the other to be hanged, by order of My Lord the Inquisitor, whose darling I am? Pangloss deceived me cruelly when he said that all is for the best in the world.' I was agitated, distracted, sometimes beside myself and sometimes ready to die of faintness, and my head was filled with the massacre of my father, of my mother, of my brother, the insolence of my horrid Bulgarian soldier, the gash he gave me, my slavery, my life as a kitchen-wench, my Bulgarian captain, my horrid Don Issachar, my abominable Inquisitor, the hanging of Dr. Pangloss, that long *miserere* in counterpoint during which you were flogged, and above all the kiss I gave you behind the screen that day when I saw you for the last time. I praised God for bringing you back to me through so many trials, I ordered my old woman to take care of you and to bring you here as soon as she could. She has carried out my commission very well; I have enjoyed the inexpressible pleasure of seeing you again, of listening to you, and of speaking to you. You must be very hungry; I have a good appetite; let us begin by having supper." Both sat down to supper; and after supper they returned to the handsome sofa we have already mentioned; they were still there when Signor Don Issachar, one of the masters of the house, arrived. It was the day of the Sabbath. He came to enjoy his rights and to express his tender love.

Chapter 9. What happened to Cunegonde, to Candide, to the Grand Inquisitor and to a Jew

This Issachar was the most choleric Hebrew who had been seen in Israel since the Babylonian captivity. "What!" said he. "Bitch of a Galilean, isn't it enough to have the Inquisitor? Must this scoundrel share with me too?" So saying, he drew a long dagger which he always carried and, thinking that his adversary was unarmed, threw himself upon Candide; but our good Westphalian had received an excellent sword from the old woman along with his suit of clothes. He drew his sword, and although he had a most gentle character, laid the Israelite stone-dead on the floor at the feet of the fair Cunegonde. "Holy Virgin!" she exclaimed, "what will become of us? A man killed in my house! If the police come we are lost." "If Pangloss had not been hanged," said Candide, "he would have given us good advice in this extremity, for he was a great philosopher. In default of him, let us consult the old woman." She was extremely prudent and was beginning to give her advice when another little door opened. It was an hour after midnight, and Sunday was beginning. This day belonged to My Lord the Inquisitor. He came in and saw the flogged Candide sword in hand, a corpse lying on the ground, Cunegonde in terror, and the old woman giving advice. At this moment, here is what happened in Candide's soul and the manner of his reasoning: "If this holy man calls for help, he will infallibly have me burned; he might do as much to Cunegonde; he had me pitilessly lashed; he is my rival; I am in the mood to kill, there is no room for hesitation." His reasoning was clear and swift; and, without giving the Inquisitor time to recover from his surprise, he pierced him through and through and cast him beside the Jew. "Here's another," said Cunegonde.

"There is no chance of mercy; we are excommunicated, our last hour has come. How does it happen that you, who were born so mild, should kill a Jew and a prelate in two minutes?" "My dear young lady," replied Candide, "when a man is in love, jealous, and has been flogged by the Inquisition, he is beside himself." The old woman then spoke up and said: "In the stable are three Andalusian horses, with their saddles and bridles; let the brave Candide prepare them; mademoiselle has moidores [Portuguese gold coins] and diamonds; let us mount quickly, although I can only sit on one buttock, and go to Cadiz; the weather is beautifully fine, and it is most pleasant to travel in the coolness of the night." Candide immediately saddled the three horses. Cunegonde, the old woman and he rode thirty miles without stopping. While they were riding away, the Holy Hermandad arrived at the house; My Lord was buried in a splendid church and Issachar was thrown into a sewer. Candide, Cunegonde and the old woman had already reached the little town of Avacena in the midst of the mountains of the Sierra Morena; and they talked in their inn as follows.

Chapter 10. How Candide, Cunegonde, and the old woman arrived at Cadiz in great distress, and how they embarked

"Who can have stolen my pistoles and my diamonds?" said Cunegonde, weeping. "How shall we live? What shall we do? Where shall we find Inquisitors and Jews to give me others?" "Alas!" said the old woman, "I strongly suspect a reverend Franciscan father who slept in the same inn at Badajoz with us: Heaven forbid that I should judge rashly! But he twice came into our room and left long before we did." "Alas!" said Candide, "the good Pangloss often proved to me that this world's goods are common to all men and that every one has an equal right to them. According to these principles the monk should have left us enough to continue our journey. Have you nothing left then, my fair Cunegonde?" "Not a maravedi," said she. "What are we to do?" said Candide. "Sell one of the horses," said the old woman. "I will ride postilion behind Mademoiselle Cunegonde, although I can only sit on one buttock, and we will get to Cadiz." In the same hotel there was a Benedictine friar. He bought the horse very cheap. Candide, Cunegonde and the old woman passed through Lucena. Chillas, Lebrixa, and at last reached Cadiz. A fleet was there being equipped and troops were being raised to bring to reason the reverend Jesuit fathers of Paraguay, who were accused of causing the revolt of one of their tribes against the kings of Spain and Portugal near the town of Sacramento. Candide, having served with the Bulgarians, went through the Bulgarian drill before the general of the little army with so much grace, celerity, skill, pride and agility, that he was given the command of an infantry company. He was now a captain; he embarked with Mademoiselle Cunegonde, the old woman, two servants, and the two Andalusian horses which had belonged to the Grand Inquisitor of Portugal. During the voyage they had many discussions about the philosophy of poor Pangloss. "We are going to a new world," said Candide, "and no doubt it is there that everything is for the best; for it must be admitted that one might lament a little over the physical and moral happenings in our own world." "I love you with all my heart," said Cunegonde, "but my soul is still shocked by what I have seen and undergone." "All will be well," replied Candide, "the sea in this new world already is better than the seas of our Europe; it is calmer and the winds are more constant. It is certainly the new world which is the best of all possible worlds." "God grant it!" said Cunegonde, "but I have been so horribly unhappy in mine that my heart is nearly closed to hope." "You complain," said the old woman to them. "Alas! you have not

endured such misfortunes as mine." Cunegonde almost laughed and thought it most amusing of the old woman to assert that she was more unfortunate. "Alas! my dear," said she, "unless you have been raped by two Bulgarians, stabbed twice in the belly, have had two castles destroyed, two fathers and mothers murdered before your eyes, and have seen two of your lovers flogged in an *auto-da-fé*, I do not see how you can surpass me; moreover, I was born a Baroness with seventy-two quarterings and I have been a kitchen wench." "You do not know my birth," said the old woman, "and if I showed you my backside you would not talk as you do and you would suspend your judgment." This speech aroused intense curiosity in the minds of Cunegonde and Candide. And the old woman spoke as follows.

Chapter 11. The old woman's story

"My eyes were not always bloodshot and red-rimmed; my nose did not always touch my chin and I was not always a servant. I am the daughter of Pope Urban X and the Princess of Palestrina. Until I was fourteen I was brought up in a palace to which all the castles of your German Barons would not have served as stables; and one of my dresses cost more than all the magnificence of Westphalia. I increased in beauty, in grace, in talents, among pleasures, respect and hopes; already I inspired love, my breasts were forming; and what breasts! White, firm, carved like those of the Venus de´ Medici. And what eyes! What eyelids! What black eyebrows! What fire shone from my two eye-balls, and dimmed the glitter of the stars, as the local poets pointed out to me. The women who dressed and undressed me fell into ecstasy when they beheld me in front and behind; and all the men would have liked to be in their place. I was betrothed to a ruling prince of Massa-Carrara. What a prince! As beautiful as I was, formed of gentleness and charms, brilliantly witty and burning with love; I loved him with a first love, idolatrously and extravagantly. The marriage ceremonies were arranged with unheard-of pomp and magnificence; there were continual fêtes, revels and comic operas; all Italy wrote sonnets for me and not a good one among them. I reached the moment of my happiness when an old marchioness who had been my prince's mistress invited him to take chocolate with her; less than two hours afterwards he died in horrible convulsions; but that is only a trifle. My mother was in despair, though less distressed than I, and wished to absent herself for a time from a place so disastrous. She had a most beautiful estate near Gaeta; we embarked on a galley, gilded like the altar of St. Peter's at Rome. A Salle pirate swooped down and boarded us; our soldiers defended us like soldiers of the Pope; they threw down their arms, fell on their knees and asked the pirates for absolution in *articulo mortis*. They were immediately stripped as naked as monkeys and my mother, our ladies of honor and myself as well. The diligence with which these gentlemen strip people is truly admirable; but I was still more surprised by their inserting a finger in a place belonging to all of us where women usually only allow the end of a syringe. This appeared to me a very strange ceremony; but that is how we judge everything when we leave our own country. I soon learned that it was to find out if we had hidden any diamonds there; 'tis a custom established from time immemorial among the civilized nations who roam the seas.

"I have learned that the religious Knights of Malta never fail in it when they capture Turks and Turkish women; this is an international law which has never been broken. I will not tell you how hard it is for a young princess to be taken with her mother as a slave to Morocco; you will also guess all we had to endure in the pirates' ship. My mother was still very beautiful; our ladies of honor, even our waiting-maids possessed more charms than could be found in all Africa; and I was ravishing,

I was beauty, grace itself, and I was a virgin; I did not remain so long; the flower which had been reserved for the handsome prince of Massa-Carrara was ravished from me by a pirate captain; he was an abominable Negro who thought he was doing me a great honor. The Princess of Palestrina and I must indeed have been strong to bear up against all we endured before our arrival in Morocco! But let that pass; these things are so common that they are not worth mentioning. Morocco was swimming in blood when we arrived. The fifty sons of the Emperor Muley Ismael had each a faction; and this produced fifty civil wars, of blacks against blacks, browns against browns, mulatoes against mulatoes. There was continual carnage throughout the whole extent of the empire. Scarcely had we landed when the blacks of a party hostile to that of my pirate arrived with the purpose of depriving him of his booty. After the diamonds and the gold, we were the most valuable possessions. I witnessed a fight such as is never seen in your European climates. The blood of the northern peoples is not sufficiently ardent; their madness for women does not reach the point which is common in Africa. The Europeans seem to have milk in their veins; but vitriol and fire flow in the veins of the inhabitants of Mount Atlas and the neighboring countries. They fought with the fury of the lions, tigers and serpents of the country to determine who should have us. A Moor grasped my mother by the right arm, my captain's lieutenant held her by the left arm; a Moorish soldier held one leg and one of our pirates seized the other. In a moment nearly all our women were seized in the same way by four soldiers. My captain kept me hidden behind him; he had a scimitar in his hand and killed everybody who opposed his fury. I saw my mother and all our Italian women torn to pieces, gashed, massacred by the monsters who disputed them. The prisoners, my companions, those who had captured them, soldiers, sailors, blacks, browns, whites, mulatoes and finally my captain were all killed and I remained expiring on a heap of corpses. As everyone knows, such scenes go on in an area of more than three hundred square leagues and yet no one ever fails to recite the five daily prayers ordered by Mahomet. With great difficulty I extricated myself from the bloody heaps of corpses and dragged myself to the foot of a large orange-tree on the bank of a stream; there I fell down with terror, weariness, horror, despair and hunger. Soon afterwards, my exhausted senses fell into a sleep which was more like a swoon than repose. I was in this state of weakness and insensibility between life and death when I felt myself oppressed by something which moved on my body. I opened my eyes and saw a white man of good appearance who was sighing and muttering between his teeth: *O che sciagura d'essere senza coglioni!*

Chapter 12. Continuation of the old woman's misfortunes

"Amazed and delighted to hear my native language, and not less surprised at the words spoken by this man, I replied that there were greater misfortunes than that of which he complained. In a few words I informed him of the horrors I had undergone and then swooned again. He carried me to a neighboring house, had me put to bed, gave me food, waited on me, consoled me, flattered me, told me he had never seen anyone so beautiful as I, and that he had never so much regretted that which no one could give back to him. 'I was born at Naples,' he said, 'and every year they make two or three thousand children there into capons; some die of it, others acquire voices more beautiful than women's, and others become the governors of States. This operation was performed upon me with very great success and I was a musician in the chapel of the Princess of Palestrina.' 'Of my mother,' I exclaimed. 'Of your mother!' cried he, weeping 'What! Are you that young princess I brought up to the age of

six and who even then gave promise of being as beautiful as you are?' 'I am! my mother is four hundred yards from here, cut into quarters under a heap of corpses . . .' I related all that had happened to me; he also told me his adventures and informed me how he had been sent to the King of Morocco by a Christian power to make a treaty with that monarch whereby he was supplied with powder, cannons and ships to help to exterminate the commerce of other Christians. 'My mission is accomplished,' said this honest eunuch, 'I am about to embark at Ceuta and I will take you back to Italy. *Ma che sciagura d'essere senza coglioni!*' I thanked him with tears of gratitude; and instead of taking me back to Italy he conducted me to Algiers and sold me to the Dey. I had scarcely been sold when the plague which had gone through Africa, Asia and Europe, broke out furiously in Algiers. You have seen earthquakes; but have you ever seen the plague?" "Never," replied the Baroness. "If you had," replied the old woman, "you would admit that it is much worse than an earthquake. It is very common in Africa; I caught it. Imagine the situation of a Pope's daughter age fifteen, who in three months had undergone poverty and slavery, had been raped nearly every day, had seen her mother cut into four pieces, had undergone hunger and war, and was now dying of the plague in Algiers. However, I did not die; but my eunuch and the Dey and almost all the seraglio of Algiers perished. When the first ravages of this frightful plague were over, the Dey's slaves went sold. A merchant bought me and carried me to Tunis; he sold me to another merchant who resold me at Tripoli; from Tripoli I was resold to Alexandria, from Alexandria re-sold to Smyrna; from Smyrna to Constantinople. I was finally bought by an Aga of the Janizaries, who was soon ordered to defend Azov against the Russians who were besieging it. The Aga, who was a man of great gallantry, took his whole seraglio with him, and lodged us in a little fort on the Islands of Palus-Maeotis, guarded by two black eunuchs and twenty soldiers. He killed a prodigious number of Russians but they returned the compliment as well. Azov was given up to fire and blood, neither sex nor age was pardoned; only our little fort remained; and the enemy tried to reduce it by starving us. The twenty Janizaries had sworn never to surrender us. The extremities of hunger to which they were reduced forced them to eat our two eunuchs for fear of breaking their oath. Some days later they resolved to eat the women. We had with us a most pious and compassionate Imam who delivered a fine sermon to them by which he persuaded them not to kill us altogether. 'Cut,' said he, 'only one buttock from each of these ladies and you will have an excellent meal; if you have to return, there will still be as much left in a few days; Heaven will be pleased at so charitable action and you will be saved.' He was very eloquent and persuaded them. This horrible operation was performed upon us; the Imam anointed us with the same balm that is used for children who have just been circumcised; we were all at the point of death. Scarcely had the Janizaries finished the meal we had supplied when the Russians arrived in flat-bottomed boats; not a Janizary escaped. The Russians paid no attention to the state we were in. There are French doctors everywhere; one of them who was very skillful, took care of us; he healed us and I shall remember all my life that, when my wounds were cured, he made propositions to me. For the rest, he told us all to cheer up; he told us that the same thing had happened in several sieges and that it was a law of war. As soon as my companions could walk they were sent to Moscow. I fell to the lot of a Boyar who made me his gardener and gave me twenty lashes a day. But at the end of two years the lord was broken on the wheel with thirty other Boyars owing to some court disturbance, and I profited by this adventure; I fled; I crossed all Russia; for a long time I was servant in an inn at Riga, then at Rostock, at Wismar, at Leipzig, at Cassel, at Utrecht, at Leyden, at the Hague, at Rotterdam; I have grown

old in misery and in shame, with only half a backside, always remembering that I was the daughter of a Pope; a hundred times I wanted to kill myself but I still loved life. This ridiculous weakness is perhaps the most disastrous of our inclinations; for is there anything sillier than to desire to bear continually a burden one always wishes to throw on the ground; to look upon oneself with horror and yet to cling to oneself; in short, to caress the serpent which devours us until he has eaten our heart? In the countries it has been my fate to traverse and in the inns where I have served I have seen a prodigious number of people who hated their lives; but I have only seen twelve who voluntarily put an end to their misery: three Negroes, four Englishmen, four Genevans and a German professor named Robeck. I ended up as servant to the Jew, Don Issachar; he placed me in your service, my fair young lady; I attached myself to your fate and have been more occupied with your adventures than with my own. I should never even have spoken of my misfortunes, if you had not piqued me a little and if it had not been the custom on board ship to tell stories to pass the time. In short, Mademoiselle, I have had experience, I know the world; provide yourself with an entertainment, make each passenger tell you his story; and if there is one who has not often cursed his life, who has not often said to himself that he was the most unfortunate of men, throw me headfirst into the sea."

Chapter 13. How Candide was obliged to separate from the fair Cunegonde and the old woman

The fair Cunegonde, having heard the old woman's story, treated her with all the politeness due to a person of her rank and merit. She accepted the proposition and persuaded all the passengers one after the other to tell her their adventures. She and Candide admitted that the old woman was right. "It was most unfortunate," said Candide, "that the wise Pangloss was hanged contrary to custom at an *auto-da-fé*, he would have said admirable things about the physical and moral evils which cover the earth and the sea, and I should feel myself strong enough to urge a few objections with all due respect." While each of the passengers was telling his story the ship proceeded on its way. They arrived at Buenos Ayres. Cunegonde, Captain Candide and the old woman went to call on the governor, Don Fernando d'Ibaraa y Figueora y Mascarenes y Lampourdos y Souza. This gentleman had the pride befitting a man who owned so many names. He talked to men with a most noble disdain, turning his nose up so far, raising his voice so pitilessly, assuming so imposing a tone, affecting so lofty a carriage, that all who addressed him were tempted to give him a thrashing. He had a furious passion for women. Cunegonde seemed to him the most beautiful woman he had ever seen. The first thing he did was to ask if she were the Captain's wife. The air with which he asked this question alarmed Candide; he did not dare say that she was his wife, because as a matter of fact she was not; he dared not say she was his sister, because she was not that either; and though this official lie was formerly extremely fashionable among the ancients, and might be useful to the moderns, his soul was too pure to depart from truth. "Mademoiselle Cunegonde," said he, "is about to do me the honor of marrying me, and we beg your excellency to be present at the wedding." Don Fernando d'Ibaraa y Figuerora y Mascarenes y Lampourdos y Souza twisted his moustache, smiled bitterly and ordered Captain Candide to go and inspect his company. Candide obeyed; the governor remained with Mademoiselle Cunegonde. He declared his passion, vowed that the next day he would marry her publicly, or otherwise, as it might please her charms. Cunegonde asked for a quarter of an hour to collect herself, to consult the old woman and to make up her mind.

The old woman said to Cunegonde: "You have seventy-two quarterings and you haven't a shilling; it is in your power to be the wife of the greatest Lord in South America, who has an exceedingly fine moustache; is it for you to pride yourself on a rigid fidelity? You have been raped by Bulgarians, a Jew and an Inquisitor have enjoyed your good graces; misfortunes confer certain rights. If I were in your place, I confess I should not have the least scruple in marrying the governor and making Captain Candide's fortune." While the old woman was speaking with all that prudence which comes from age and experience, they saw a small ship come into the harbor; an Alcayde and some Alguazils were on board, and this is what had happened. The old woman had guessed correctly that it was a long-sleeved monk who stole Cunegonde's money and jewels at Badajoz, when she was flying in all haste with Candide. The monk tried to sell some of the gems to a jeweler. The merchant recognized them as the property of the Grand Inquisitor. Before the monk was hanged he confessed that he had stolen them; he described the persons and the direction they were taking. The flight of Cunegonde and Candide was already known. They were followed to Cadiz; without any waste of time a vessel was sent in pursuit of them. The vessel was already in the harbor at Buenos Ayres. The rumor spread that an Alcayde was about to land and that he was in pursuit of the murderers of His Lordship the Grand Inquisitor. The prudent old woman saw in a moment what was about to be done. "You cannot escape," she said to Cunegonde, "and you have nothing to fear; you did not kill His Lordship; moreover, the governor is in love with you and will not allow you to be maltreated; stay here." She ran to Candide at once. "Fly," said she, "or in an hour's time you will be burned." There was not a moment to lose; but how could he leave Cunegonde and where could he take refuge?

Chapters 26–30 (Conclusion)

By the beginning of Chapter 26, where our second selection opens, Candide has lost both Cunegonde and his personal servant Cacambo but, having decided to find a companion, joined up with Martin, an old scholar who represents the opposite philosophical viewpoint from that of Dr. Pangloss: total pessimism. The two travel to Venice. After his reunion with Cacambo and their extraordinary experience at the inn he sets out for Constantinople and his once-beloved Cunegonde, while Voltaire begins to pull the threads of his narrative together. Both Dr. Pangloss and Cunegonde's brother turn up yet again, the doctor still refusing to budge from his philosophical position. The lovers' meeting in Chapter 29 is handled with typical cynicism, while the last chapter reassesses the views on life we have heard.

By the end of his journeys Candide has had a chance to think about the optimism of Dr. Pangloss and the pessimism of his friend Martin and to compare them both to real life. The conclusion he reaches is expressed in the book's final words, "we must cultivate our gardens." By succeeding in this small task we can construct a little island of peace and sanity in a hostile world.

Chapter 26. How Candide and Martin supped with six strangers and who they were

One evening when Candide and Martin were going to sit down to table with the strangers who lodged in the same hotel, a man with a face the color of soot came up to him from behind and, taking him by the arm, said: "Get ready to come with us, and do not fail." He turned round and saw Cacambo. Only the sight of Cunegonde could have surprised and pleased him more. He was almost wild with joy. He embraced his dear friend. "Cunegonde is here, of course? Where is she? Take me

to her, let me die of joy with her." "Cunegonde is not here," said Cacambo. "She is in Constantinople." "Heavens! In Constantinople! But were she in China, I would fly to her; let us start at once." "We will start after supper," replied Cacambo. "I cannot tell you any more; I am a slave, and my master is waiting for me; I must go and serve him at table! Do not say anything; eat your supper and be in readiness." Candide, torn between joy and grief, charmed to see his faithful agent again, amazed to see him a slave, filled with the idea of seeing his mistress again, with turmoil in his heart, agitation in his mind, sat down to table with Martin (who met every strange occurrence with the same calmness), and with six strangers, who had come to spend the Carnival at Venice. Cacambo, who acted as butler to one of the strangers, bent down to his master's head towards the end of the meal and said: "Sire, your Majesty can leave when you wish, the ship is ready." After saying this, Cacambo withdrew. The guests looked at each other with surprise without saying a word, when another servant came up to his master and said: "Sire, your Majesty's post-chaise is at Padua, and the boat is ready." The master made a sign and the servant departed. Once more all the guests looked at each other, and the general surprise doubled. A third servant went up to the third stranger and said: "Sire, believe me, your Majesty cannot remain here any longer; I will prepare everything." And he immediately disappeared. Candide and Martin had no doubt that this was a Carnival masquerade. A fourth servant said to the fourth master: "Your Majesty can leave when you wish." And he went out like the others. The fifth servant spoke similarly to the fifth master. But the sixth servant spoke differently to the sixth stranger who was next to Candide, and said: "Faith, sire, they will not give your Majesty any more credit nor me either, and we may very likely be jailed to-night, both of us; I am going to look to my own affairs, good-bye." When the servants had all gone, the six strangers, Candide and Martin remained in profound silence. At last it was broken by Candide. "Gentlemen," said he, "this is a curious jest. How is it you are all kings? I confess that neither Martin nor I are kings." Cacambo's master then gravely spoke and said in Italian: "I am not jesting, my name is Achmet III. For several years I was Sultan; I dethroned my brother; my nephew dethroned me; they cut off the heads of my viziers; I am ending my days in the old seraglio; my nephew, Sultan Mahmoud, sometimes allows me to travel for my health, and I have come to spend the Carnival at Venice." A young man who sat next to Achmet spoke after him and said: "My name is Ivan; I was Emperor of all the Russias; I was dethroned in my cradle; my father and mother were imprisoned and I was brought up in prison; I sometimes have permission to travel, accompanied by those who guard me, and I have come to spend the Carnival at Venice." The third said: "I am Charles Edward, King of England; my father gave up his rights to the throne to me and I fought a war to assert them; the hearts of eight hundred of my adherents were torn out and dashed in their faces. I have been in prison; I am going to Rome to visit the King, my father, who is dethroned like my grandfather and me; and I have come to spend the Carnival at Venice." The fourth then spoke and said: "I am the King of Poland; the chance of war deprived me of my hereditary states; my father endured the same reverse of fortune; I am resigned to Providence like the Sultan Achmet, the Emperor Ivan and King Charles Edward, to whom God grant long life; and I have come to spend the Carnival at Venice." The fifth said: "I also am the King of Poland: I have lost my kingdom twice; but Providence has given me another state in which I have been able to do more good than all the kings of the Sarmatians together have ever been able to do on the banks of the Vistula; I also am resigned to Providence and I have come to spend the Carnival at Venice." It was now for the sixth monarch to speak. "Gentlemen," said he, "I am not so eminent as you; but I have been a king like anyone else. I am Theodore; I was elected King of Corsica; I

have been called Your Majesty and now I am barely called Sir. I have coined money and do not own a farthing; I have had two Secretaries of State and now have scarcely a valet; I have occupied a throne and for a long time lay on straw in a London prison. I am much afraid I shall be treated in the same way here, although I have come, like your Majesties, to spend the Carnival at Venice." The five other kings listened to this speech with a noble compassion. Each of them gave King Theodore twenty sequins to buy clothes and shirts; Candide presented him with a diamond worth two thousand sequins. "Who is this man," said the five kings, "who is able to give a hundred times as much as any of us, and who gives it?" As they were leaving the table, there came to the same hotel four serene highnesses who had also lost their states in the chance of war, and who had come to spend the rest of the Carnival at Venice; but Candide did not even notice these newcomers. He could think of nothing but of going to Constantinople to find his dear Cunegonde.

Chapter 27. Candide's voyage to Constantinople

The faithful Cacambo had already spoken to the Turkish captain who was to take Sultan Achmet back to Constantinople and had obtained permission for Candide and Martin to come on board. They both entered this ship after having prostrated themselves before his miserable Highness. On the way, Candide said to Martin: "So we have just supped with six dethroned kings! And among those six kings there was one to whom I gave charity. Perhaps there are many other princes still more unfortunate. Now, I have only lost a hundred sheep and I am hastening to Cunegonde's arms. My dear Martin, once more, Pangloss was right, all is well." "I hope so," said Martin. "But," said Candide, "this is a very singular experience we have just had at Venice. Nobody has ever seen or heard of six dethroned kings supping together in a tavern." "'Tis no more extraordinary," said Martin, "than most of the things which have happened to us. It is very common for kings to be dethroned; and as to the honor we have had of supping with them, 'tis a trifle not deserving our attention." Scarcely had Candide entered the ship when he threw his arms round the neck of the old valet, of his friend Cacambo. "Well!" said he, "what is Cunegonde doing? Is she still a marvel of beauty? Does she still love me? How is she? Of course you have bought her a palace in Constantinople?" "My dear master," replied Cacambo, "Cunegonde is washing dishes on the banks of Propontis for a prince who possesses very few dishes; she is a slave in the house of a former sovereign named Ragotsky, who receives in his refuge three crowns a day from the Grand Turk; but what is even sadder is that she has lost her beauty and has become horribly ugly." "Ah! beautiful or ugly," said Candide, "I am a man of honor and my duty is to love her always. But how can she be reduced to so abject a condition with the five or six millions you carried off?" "Ah!" said Cacambo, "did I not have to give two millions to Senor Don Fernando d'Ibaraa y Figueora y Mascarenes y Lampourdos y Souza, Governor of Buenos Ayres, for permission to bring away Mademoiselle Cunegonde? And did not a pirate bravely strip us of all the rest? And did not this pirate take us to Cape Matapan, to Milo, to Nicaria, to Samos, to Petra, to the Dardanelles, to Marmora, to Scutari? Cunegonde and the old woman are servants to the prince I mentioned, and I am slave to the dethroned Sultan." "What a chain of terrible calamities!" said Candide. "But after all, I still have a few diamonds; I shall easily deliver Cunegonde. What a pity she has become so ugly." Then turning to Martin, he said: "Who do you think is the most to be pitied, the Sultan Achmet, the Emperor Ivan, King Charles Edward, or me?" "I do not know at all," said Martin. "I should have to be in your hearts to know." "Ah!" said Candide, "if Pangloss were here he would know and would tell us." "I do not know," said Martin,

"what scales your Pangloss would use to weigh the misfortunes of men and to estimate their sufferings. All I presume is that there are millions of men on the earth a hundred times more to be pitied than King Charles Edward, the Emperor Ivan and the Sultan Achmet." "That may very well be," said Candide. In a few days they reached the Black Sea channel. Candide began by paying a high ransom for Cacambo and, without wasting time, he went on board a galley with his companions bound for the shores of Propontis, in order to find Cunegonde however ugly she might be. Among the galley slaves were two convicts who rowed very badly and from time to time the Levantine captain applied several strokes of a bull's pizzle to their naked shoulders. From a natural feeling of pity Candide watched them more attentively than the other galley slaves and went up to them. Some features of their disfigured faces appeared to him to have some resemblance to Pangloss and the wretched Jesuit, the Baron, Mademoiselle Cunegonde's brother. This idea disturbed and saddened him. He looked at them still more carefully. "Truly," said he to Cacambo, "if I had not seen Doctor Pangloss hanged, and if I had not been so unfortunate as to kill the Baron, I should think they were rowing in this galley." At the words Baron and Pangloss, the two convicts gave a loud cry, stopped on their seats and dropped their oars. The Levantine captain ran up to them and the lashes with the bull's pizzle were redoubled. "Stop! Stop, sir!" cried Candide. "I will give you as much money as you want." "What! Is it Candide?" said one of the convicts. "What! Is it Candide?" said the other. "Is it a dream?" said Candide. "Am I awake? Am I in this galley? Is that my Lord the Baron whom I killed? Is that Doctor Pangloss whom I saw hanged?" "It is, it is," they replied. "What! Is that the great philosopher?" said Martin. "Ah! sir," said Candide to the Levantine captain, "how much money do you want for My Lord Thunder-ten-tronckh, one of the first Barons of the empire, and for Dr. Pangloss, the most profound metaphysician of Germany?" "Dog of a Christian," replied the Levantine captain, "since these two dogs of Christian convicts are Barons and metaphysicians, which no doubt is a high rank in their country, you shall pay me fifty thousand sequins." "You shall have them, sir. Row back to Constantinople like lightning and you shall be paid at once. But, no, take me to Mademoiselle Cunegonde." The captain, at Candide's first offer had already turned the bow towards the town, and rowed there more swiftly than a bird cleaves the air. Candide embraced the Baron and Pangloss a hundred times. "How was it I did not kill you, my dear Baron? And, my dear Pangloss, how do you happen to be alive after having been hanged? And why are you both in a Turkish galley?" "Is it really true that my dear sister is in this country?" said the Baron. "Yes," replied Cacambo. "So once more I see my dear Candide!" cried Pangloss. Candide introduced Martin and Cacambo. They all embraced and all talked at the same time. The galley flew; already they were in the harbor. They sent for a Jew, and Candide sold him for fifty thousand sequins a diamond worth a hundred thousand, for which he swore by Abraham he could not give any more. The ransom of the Baron and Pangloss was immediately paid. Pangloss threw himself at the feet of his liberator and bathed them with tears; the other thanked him with a nod and promised to repay the money at the first opportunity. "But is it possible that my sister is in Turkey?" said he. "Nothing is so possible," replied Cacambo, "since she washes the dishes of a prince of Transylvania." They immediately sent for two Jews: Candide sold some more diamonds; and they all set out in another galley to rescue Cunegonde.

Chapter 28. What happened to Candide, to Cunegonde, to Pangloss, to Martin, etc.

"Pardon once more," said Candide to the Baron, "pardon me, reverend father, for having thrust my sword through your body." "Let us say no more about it," said the Baron. "I admit I was a little too sharp; but since you wish to know how it was you saw me in a galley, I must tell you that after my wound was healed by the brother apothecary of the college, I was attacked and carried off by a Spanish raiding party; I was imprisoned in Buenos Ayres at the time when my sister had just left. I asked to return to the Vicar-General in Rome. I was ordered to Constantinople to act as almoner to the Ambassador of France. A week after I had taken up my office I met towards evening a very handsome young page of the Sultan. It was very hot; the young man wished to bathe; I took the opportunity to bathe also. I did not know that it was a most serious crime for a Christian to be found naked with a young Mahometan. A cadi sentenced me to a hundred strokes on the soles of my feet and condemned me to the galley. I do not think a more horrible injustice has ever been committed. But I should very much like to know why my sister is in the kitchen of a Transylvanian sovereign living in exile among the Turks." "But, my dear Pangloss," said Candide, "how does it happen that I see you once more?" "It is true," said Pangloss, "that you saw me hanged; and in the natural course of events I should have been burned. But you remember, it poured with rain when they were going to roast me; the storm was so violent that they despaired of lighting the fire; I was hanged because they could do nothing better; a surgeon bought my body, carried me home and dissected me. He first made a crucial incision in me from the navel to the collarbone. Nobody could have been worse hanged than I was. The executioner of the holy Inquisition, who was a subdeacon, was marvelously skillful in burning people, but he was not used to hanging them; the rope was wet and did not slide easily and it was knotted; in short, I still breathed. The crucial incision caused me to utter so loud a scream that the surgeon fell over backwards and, thinking he was dissecting the devil, fled away in terror and fell down the staircase in his flight. His wife ran in from another room at the noise; she saw me stretched out on the table with my crucial incision; she was still more frightened than her husband, fled, and fell on top of him. When they had recovered a little, I heard the surgeon's wife say to the surgeon: 'My dear, what were you thinking of, to dissect a heretic? Don't you know the devil always possesses them? I will go and get a priest at once to exorcise him.' At this I shuddered and collected the little strength I had left to shout: 'Have pity on me!' At last the Portuguese barber grew bolder; he sewed up my skin; his wife even took care of me, and at the end of a fortnight I was able to walk again. The barber found me a situation and made me lackey to a Knight of Malta who was going to Venice; but, as my master had no money to pay me wages, I entered the service of a Venetian merchant and followed him to Constantinople. One day I took it into my head to enter a mosque: there was nobody there except an old Imam and a very pretty young devotee who was reciting her prayers; her breasts were entirely uncovered; between them she wore a bunch of tulips, roses, anemones, ranunculus, hyacinths and auriculas; she dropped her bunch of flowers; I picked it up and returned it to her with a most respectful alacrity. I was so long putting them back that the Imam grew angry and, seeing I was a Christian, called for help. I was taken to the cadi, who sentenced me to receive a hundred strokes on the soles of my feet and sent me to the galleys. I was chained on the same seat and in the same galley as My Lord the Baron. In this galley there were four young men from Marseilles, five Neapolitan priests and two monks from Corfu, who assured us that similar accidents occurred every day. His Lordship the Baron claimed that he had suffered a greater injustice than I; and I claimed that it was much more permissible to replace a bunch of flowers between a woman's breasts than to be naked with one of the Sultan's pages. We argued continually, and every day received twenty strokes of the bull's pizzle, when the chain of events of this universe led you to our galley and you ransomed us." "Well! my dear Pangloss," said Candide, "when you were

hanged, dissected, stunned with blows and made to row in the galleys, did you always think that everything was for the best in this world?" "I am still of my first opinion," replied Pangloss, "for after all I am a philosopher; and it would be unbecoming for me to recant, since Leibnitz could not be in the wrong and preestablished harmony is the finest thing imaginable like the plenum and subtle matter."

Chapter 29. How Candide found Cunegonde and the old woman again

While Candide, the Baron, Pangloss, Martin and Cacambo were relating their adventures, reasoning upon contingent or noncontingent events of the universe, arguing about effects and causes, moral and physical evil, free will and necessity, and the consolations to be found in the Turkish galleys, they came to the house of the Transylvanian prince on the shores of Propontis. The first objects which met their sight were Cunegonde and the old woman hanging out towels to dry on the line. At this sight the Baron grew pale. Candide, that tender lover, seeing his fair Cunegonde sunburned, blear-eyed, flat-breasted, with wrinkles round her eyes and red, chapped arms, recoiled three paces in horror, and then advanced from mere politeness. She embraced Candide and her brother. They embraced the old woman; Candide bought them both. In the neighborhood was a little farm; the old woman suggested that Candide should buy it, until some better fate befell the group. Cunegonde did not know that she had become ugly, for nobody had told her so; she reminded Candide of his promises in so peremptory a tone that the good Candide dared not refuse her. He therefore informed the Baron that he was about to marry his sister. "Never," said the Baron, "will I endure such baseness on her part and such insolence on yours; nobody shall ever reproach me with this infamy; my sister's children could never enter the noble assemblies of Germany. No, my sister shall never marry anyone but a Baron of the Empire." Cunegonde threw herself at his feet and bathed him in tears; but he was inflexible. "Madman," said Candide, "I rescued you from the galleys, I paid your ransom and your sister's; she was washing dishes here, she is ugly, I am so kind as to make her my wife, and you pretend to oppose me! I should kill you again if I listened to my anger." "You may kill me again," said the Baron, "but you shall never marry my sister while I am alive."

Chapter 30. Conclusion

At the bottom of his heart Candide had not the least wish to marry Cunegonde. But the Baron's extreme impertinence determined him to complete the marriage, and Cunegonde urged it so warmly that he could not retract. He consulted Pangloss, Martin and the faithful Cacambo. Pangloss wrote an excellent memorandum by which he proved that the Baron had no rights over his sister and that by all the laws of the empire she could make a left-handed marriage with Candide. Martin advised that the Baron should be thrown into the sea; Cacambo decided that he should be returned to the Levantine captain and sent back to the galleys, after which he could be returned by the first ship to the Vicar-General at Rome. This was thought to be very good advice; the old woman approved it; they said nothing to the sister; the plan was carried out with the aid of a little money and they had the pleasure of duping a Jesuit and punishing the pride of a German Baron.

It would be natural to suppose that when, after so many disasters, Candide was married to his mistress, and living with the philosopher Pangloss, the philosopher Martin, the prudent Cacambo and the old woman, having brought back so many diamonds from the country of the ancient Incas, he would lead the most pleasant life imaginable. But he was so cheated by the Jews that he had nothing left but his little farm; his wife, growing uglier every day, became shrewish and unendurable; the old woman was ailing and even more bad-tempered than Cunegonde. Cacambo, who worked in the garden and then went to Constantinople to sell vegetables, was overworked and cursed his fate. Pangloss was in despair because he did not shine in some German university. As for Martin, he was firmly convinced that people are equally uncomfortable everywhere; he accepted things patiently. Candide, Martin and Pangloss sometimes argued about metaphysics and morals. From the windows of the farm they often watched the ships going by, filled with effendis, pashas, and cadis, who were being exiled to Lemnos, to Mitylene and Erzerum. They saw other cadis, other pashas and other effendis coming back to take the place of the exiles and to be exiled in their turn. They saw the neatly impaled heads which were taken to the Sublime Porte. These sights redoubled their discussions; and when they were not arguing, the boredom was so excessive that one day the old woman dared to say to them: "I should like to know which is worse, to be raped a hundred times by Negro pirates, to have a buttock cut off, to run the gauntlet among the Bulgarians, to be whipped and flogged in an *auto-da-fé*, to be dissected, to row in a galley, in short, to endure all the miseries through which we have passed, or to remain here doing nothing?" "'Tis a great question," said Candide.

These remarks led to new reflections, and Martin especially concluded that man was born to live in the convulsions of distress or in the lethargy of boredom. Candide did not agree, but he asserted nothing. Pangloss confessed that he had always suffered horribly; but, having once maintained that everything was for the best, he had continued to maintain it without believing it.

One thing confirmed Martin in his detestable principles, made Candide hesitate more than ever, and embarrassed Pangloss. And it was this. One day there came to their farm Paquette and Friar Giroflée, who were in the most extreme misery; they had soon wasted their three thousand piastres, had left each other, made up, quarreled again, been put in prison, escaped, and finally Friar Giroflée had turned Turk. Paquette continued her occupation everywhere and now earned nothing by it. "I foresaw," said Martin to Candide, "that your gifts would soon be wasted and would only make them the more miserable. You and Cacambo were once bloated with millions of piastres and you are no happier than Friar Giroflée and Paquette." "Ah! Ha!" said Pangloss to Paquette, "so Heaven brings you back to us, my dear child? Do you know that you cost me the end of my nose, an eye and an ear! What a plight you are in! Ah! What a world this is!" This new occurrence caused them to philosophize more than ever.

In the neighborhood there lived a very famous Dervish, who was supposed to be the best philosopher in Turkey; they went to consult him; Pangloss was the spokesman and said: "Master, we have come to beg you to tell us why so strange an animal as man was ever created." "What has it to do with you?" said the Dervish, "Is it your business?" "But, reverend father," said Candide, "there is a horrible amount of evil in the world." "What does it matter," said the Dervish, "whether there is evil or good? When his highness sends a ship to Egypt, does he worry about the comfort or discomfort of the rats in the ship?" "Then what should we do?" said Pangloss. "Hold your tongue," said the Dervish. "I flattered myself," said Pangloss, "that I should discuss with you effects and causes, this best of all possible worlds, the origin of evil, the nature of the soul and preestablished harmony." At these words the Dervish slammed the door in their faces.

During this conversation the news went round that at Constantinople two viziers and the mufti had been strangled and

several of their friends impaled. This catastrophe made a prodigious noise everywhere for several hours. As Pangloss, Candide and Martin were returning to their little farm, they came upon an old man who was taking the air under a bower of orange-trees at his door. Pangloss, who was as curious as he was argumentative, asked him what was the name of the mufti who had just been strangled. "I do not know," replied the old man. "I have never known the name of any mufti or of any vizier. I am entirely ignorant of the occurrence you mention; I presume that in general those who meddle with public affairs sometimes perish miserably and that they deserve it; but I never inquire what is going on in Constantinople; I content myself with sending there for sale the produce of the garden I cultivate." Having spoken thus, he took the strangers into his house. His two daughters and his two sons presented them with several kinds of sherbet which they made themselves, caymac flavored with candied citron peel, oranges, lemons, limes, pineapples, dates, pistachios and Mocha coffee which had not been mixed with the bad coffee of Batavia and the Isles. After which this good Mussulman's two daughters perfumed the beards of Candide, Pangloss and Martin. "You must have a vast and magnificent estate?" said Candide to the Turk. "I have only twenty acres," replied the Turk. "I cultivate them with my children; and work keeps at bay three great evils: boredom, vice and need."

As Candide returned to his farm he reflected deeply on the Turk's remarks. He said to Pangloss and Martin: "That good old man seems to me to have chosen an existence preferable by far to that of the six kings with whom we had the honor to sup." "Exalted rank," said Pangloss, "is very dangerous, according to the testimony of all philosophers; for Eglon, King of the Moabites, was murdered by Ehud; Absolom was hanged by the hair and pierced by three darts; King Nadab, son of Jeroboam, was killed by Baasha; King Elah by Zimri; Ahaziah by Jehu; Athaliah by Jehoiada; the Kings Jehoiakim, Jeconiah and Zedekiah were made slaves. You know in what manner died Croesus, Astyages, Darius, Denys of Syracuse, Pyrrhus, Perseus, Hannibal, Jugurtha, Ariovistus, Caesar, Pompey, Nero, Otho, Vitellius, Domitian, Richard II of England, Edward II, Henry VI, Richard III, Mary Stuart, Charles I, the three Henrys of France, the Emperor Henry IV. You know . . ." "I also know," said Candide, "that we should cultivate our garden." "You are right," said Pangloss, "for, when man was placed in the Garden of Eden, he was placed there *ut operaretur eum,* to dress it and to keep it; which proves that man was not born for idleness." "Let us work without theorizing," said Martin, "'tis the only way to make life endurable."

The whole small fraternity entered into this praiseworthy plan, and each started to make use of his talents. The little farm yielded well. Cunegonde was indeed very ugly, but she became an excellent pastry-cook; Paquette embroidered; the old woman took care of the linen. Even Friar Giroflée performed some service; he was a very good carpenter and even became a man of honor; and Pangloss sometimes said to Candide: "All events are linked up in this best of all possible worlds; for, if you had not been expelled from the noble castle, by hard kicks in your backside for love of Mademoiselle Cunegonde, if you had not been clapped into the Inquisition, if you had not wandered about America on foot, if you had not stuck your sword in the Baron, if you had not lost all your sheep from the land of Eldorado, you would not be eating candied citrons and pistachios here." "That's well said," replied Candide, "but we must cultivate our garden."

CHAPTER 17

READING 68
from KARL MARX (1818–1883)
AND FRIEDRICH ENGELS (1820–1895),
THE COMMUNIST MANIFESTO (1848)

THE COMMUNIST MANIFESTO, from which we reproduce here the famous preface and Part II with its ringing final exhortation, was written jointly by Marx and Engels in 1848, to serve as a program for a secret workingmen's society, the Communist League, but subsequently became the core of all Communist doctrine. The translation that appears below was done by Samuel F. Moore under the supervision of Engels. "The bourgeois" defines the class of modern capitalists, owners of the means of social production and employers of wage labor. In a note to the 1888 English edition, Engels defined the proletariat as the "class of modern wage laborers who, having no means of production of their own, are reduced to selling their labor power in order to live."

Preface

A spectre is haunting Europe—the spectre of communism. All the powers of old Europe have entered into a holy alliance to exorcise this spectre: Pope [Vatican] and Tsar [Russia], Metternich [Austria] and Guizot [France], French Radicals, and German police-spies.

Where is the party in opposition that has not been decried as communistic by its opponents in power? Where is the opposition that has not hurled back the branding reproach of communism, against the more advanced opposition parties, as well as against its reactionary adversaries?

Two things result from this fact:

1. Communism is already acknowledged by all European powers to be itself a power.

2. It is high time that Communists should openly, in the face of the whole world, publish their views, their aims, their tendencies, and meet this nursery tale of the spectre of communism with a manifesto of the party itself.

To this end, Communists of various nationalities have assembled in London and sketched the following manifesto, to be published in the English, French, German, Italian, Flemish and Danish languages.

II. Proletarians and Communists

In what relation do the Communists stand to the proletarians as a whole?

The Communists do not form a separate party opposed to other working-class parties.

They have no interests separate and apart from those of the proletariat as a whole.

They do not set up any sectarian principles of their own, by which to shape and mould the proletarian movement.

The Communists are distinguished from the other working-class parties by this only: 1. In the national struggles of the proletarians of the different countries, they point out and bring to the front the common interests of the entire proletariat independently of all nationality. 2. In the various stages of development which the struggle of the working class against the bourgeoisie has to pass through, they always and everywhere represent the interests of the movement as a whole.

The Communists, therefore, are on the one hand, practically, the most advanced and resolute section of the working-class parties of every country, that section which pushes forward

all others; on the other hand, theoretically, they have over the great mass of the proletariat the advantage of clearly understanding the line of march, the conditions, and the ultimate general results of the proletarian movement.

The immediate aim of the Communists is the same as that of all the other proletarian parties; formation of the proletariat into a class, overthrow of the bourgeois supremacy, conquest of political power by the proletariat.

The theoretical conclusions of the Communists are in no way based on ideas or principles that have been invented, or discovered, by this or that would-be universal reformer.

They merely express, in general terms, actual relations springing from an existing class struggle, from a historical movement going on under our very eyes. The abolition of existing property relations is not at all a distinctive feature of Communism.

All property relations in the past have continually been subject to historical change consequent upon the change in historical conditions.

The French Revolution, for example, abolished feudal property in favor of bourgeois property.

The distinguishing feature of Communism is not the abolition of property generally, but the abolition of bourgeois property. But modern bourgeois private property is the final and most complete expression of the system of producing and appropriating products, that is based on class antagonism, on the exploitation of the many by the few.

In this sense, the theory of the Communists may be summed up in the single sentence: Abolition of private property.

We Communists have been reproached with the desire of abolishing the right of personally acquiring property as the fruit of a man's own labor, which property is alleged to be the groundwork of all personal freedom, activity and independence.

Hard-won, self-acquired, self-earned property! Do you mean the property of the petty artisan and of the small peasant, a form of property that preceded the bourgeois form? There is no need to abolish that; the development of industry has to a great extent already destroyed it, and is still destroying it daily.

Or do you mean modern bourgeois private property?

But does wage-labor create any property for the laborer? Not a bit. It creates capital, i.e., that kind of property which exploits wage-labor, and which cannot increase except upon condition of getting a new supply of wage-labor for fresh exploitation. Property, in its present form, is based on the antagonism of capital and wage-labor. Let us examine both sides of this antagonism.

To be a capitalist, is to have not only a purely personal, but a social status in production. Capital is a collective product, and only by the united action of many members, nay, in the last resort, only by the united action of all members of society, can it be set in motion.

Capital is therefore not a personal, it is a social power.

When, therefore, capital is converted into common property, into the property of all members of society, personal property is not thereby transformed into social property. It is only the social character of the property that is changed. It loses its class–character. . . .

Abolition of the family! Even the most radical flare up at this infamous proposal of the Communists.

On what foundation is the present family, the bourgeois family, based? On capital, on private gain. In its completely developed form this family exists only among the bourgeoisie. But this state of things finds its complement in the practical absence of the family among the proletarians, and in public prostitution.

The bourgeois family will vanish as a matter of course when its complement vanishes, and both will vanish with the vanishing of capital.

Do you charge us with wanting to stop the exploitation of children by their parents? To this crime we plead guilty.

But, you will say, we destroy the most hallowed of relations, when we replace home education by social.

And your education! Is not that also social, and determined by the social conditions under which you educate, by the intervention, direct or indirect, of society by means of schools, etc.? The Communists have not invented the intervention of society in education; they do but seek to alter the character of that intervention, and to rescue education from the influence of the ruling class.

The bourgeois clap-trap about the family and education, about the hallowed co-relation of parent and child, becomes all the more disgusting, the more, by the action of Modern Industry, all family ties among the proletarians are torn asunder, and their children transformed into simple articles of commerce and instruments of labor.

But you Communists would introduce community of women, screams the whole bourgeoisie in chorus.

The bourgeois sees in his wife a mere instrument of production. He hears that the instruments of production are to be exploited in common, and, naturally, can come to no other conclusion, than that the lot of being common to all will likewise fall to the women.

He has not even a suspicion that the real point aimed at is to do away with the status of women as mere instruments of production.

For the rest, nothing is more ridiculous than the virtuous indignation of our bourgeois at the community of women which, they pretend, is to be openly and officially established by the Communists. The Communists have no need to introduce community of women; it has existed almost from time immemorial.

Our bourgeois, not content with having the wives and daughters of their proletarians at their disposal, not to speak of common prostitutes, take the greatest pleasure in seducing each other's wives.

Bourgeois marriage is in reality a system of wives in common and thus, at the most, what the Communists might possibly be reproached with, is that they desire to introduce, in substitution for a hypocritically concealed, an openly legalized community of women. For the rest, it is self-evident, that the abolition of the present system of production must bring with it the abolition of the community of women springing from that system, i.e., of prostitution both public and private.

The Communists are further reproached with desiring to abolish countries and nationalities.

The working men have no country. We cannot take from them what they have not got. Since the proletariat must first of all acquire political supremacy, must rise to be the leading class of the nation, must constitute itself the nation, it is, so far, itself national, though not in the bourgeois sense of the word.

National differences, and antagonisms between peoples, are daily more and more vanishing, owing to the development of the bourgeoisie, to freedom of commerce, to the world-market, to uniformity in the mode of production and in the conditions of life corresponding thereto.

The supremacy of the proletariat will cause them to vanish still faster. United action, of the leading civilized countries at least, is one of the first conditions for the emancipation of the proletariat.

In proportion as the exploitation of one individual by another is put an end to, the exploitation of one nation by another will also be put an end to. In proportion as the antagonism between classes within the nation vanishes, the hostility of one nation to another will come to an end.

The charges against Communism made from a religious, a philosophical, and generally, from an ideological standpoint, are not deserving of serious examination.

Does it require deep intuition to comprehend that man's ideas, views, and conceptions, in one word, man's consciousness, changes with every change in the conditions of his material existence, in his social relations and in his social life?

What else does the history of ideas prove, than that intellectual production changes in character in proportion as material production is changed? The ruling ideas of each age have ever been the ideas of its ruling class.

When people speak of ideas that revolutionize society, they do but express the fact, that within the old society, the elements of a new one have been created, and that the dissolution of the old ideas keeps even pace with the dissolution of the old conditions of existence. . . .

The Communists turn their attention chiefly to Germany, because that country is on the eve of a bourgeois revolution, that is bound to be carried out under more advanced conditions of European civilization, and with a more developed proletariat, than that of England was in the seventeenth, and of France in the eighteenth century, and because the bourgeois revolution in Germany will be but the prelude to an immediately following proletarian revolution.

In short, the Communists everywhere support every revolutionary movement against the existing social and political order of things.

In all these movements they bring to the front, as the leading question in each, the property question, no matter what its degree of development at the time.

Finally, they labor everywhere for the union and agreement of the democratic parties of all countries.

The Communists disdain to conceal their views and aims. They openly declare that their ends can be attained only by the forcible overthrow of all existing social conditions. Let the ruling classes tremble at a Communistic revolution. The proletarians have nothing to lose but their chains. They have a world to win.

Working men of all countries, unite!

READING 69
WILLIAM WORDSWORTH (1770–1850), "TINTERN ABBEY" (1798)

The principal theme of Wordsworth's poetry—the relation between humans and nature—emerges in "Lines Composed a Few Miles Above Tintern Abbey on Revisiting the Banks of the Wye During a Tour," which describes the poet's reactions in his return to the place he had visited five years earlier. After describing the scene, he recalls the joy its memory has brought to him in the intervening years (lines 23–49). This in turn brings to mind the passage of time in his own life (lines 65–88) and the importance that the beauty of nature has always had for him (lines 88–111). The last part of the poem shows how his love of nature has illuminated his relationships with other human beings; in this case, his beloved sister. The complete thought processes are expressed in the simplest language. In contrast to such eighteenth-century poets as Alexander Pope, the words are straightforward with no learned biblical, classical, or even literary references.

Five years have past: five summers, with the length
Of five long winters! and again I hear
These waters, rolling from their mountain-springs
With a soft inland murmur.—Once again
Do I behold these steep and lofty cliffs,
That on a wild secluded scene impress
Thoughts of more deep seclusion: and connect
The landscape with the quiet of the sky.
The day is come when I again repose
Here, under this dark sycamore, and view　　　　10

These plots of cottage-ground, these orchard-tufts,
Which at this season, with their unripe fruits,
Are clad in one green hue, and lose themselves
'Mid groves and copses. Once again I see
These hedge-rows, hardly hedge-rows, little lines
Of sportive wood run wild: these pastoral farms,
Green to the very door; and wreaths of smoke
Sent up, in silence, from among the trees!
With some uncertain notice, as might seem
Of vagrant dwellers in the houseless woods,　　　20
Or of some Hermit's cave, where by his fire
The Hermit sits alone.
　　　These beauteous forms,
Through a long absence, have not been to me
As is a landscape to a blind man's eye:
But oft, in lonely rooms, and 'mid the din
Of towns and cities, I have owed to them.
In hours of weariness, sensations sweet,
Felt in the blood, and felt along the heart;
And passing even into my purer mind,　　　30
With tranquil restoration:—feelings too
Of unremembered pleasure: such, perhaps,
As have no slight or trivial influence
On that best portion of a good man's life,
His little, nameless, unremembered, acts
Of kindness and of love. Nor less, I trust,
To them I may have owed another gift,
Of aspect more sublime; that blessed mood,
In which the burthen [burden] of the mystery,
In which the heavy and the weary weight　　　40
Of all this unintelligible world,
Is lightened:—that serene and blessed mood,
In which the affections gently lead us on,—
Until, the breath of this corporeal frame
And even the motion of our human blood
Almost suspended, we are laid asleep
In body, and become a living soul:
While with an eye made quiet by the power
Of harmony, and the deep power of joy,
We see into the life of things.　　　50
　　　If this
Be but a vain belief, yet, oh! how oft—
In darkness and amid the many shapes
Of joyless daylight; when the fretful stir
Unprofitable, and the fever of the world,
Have hung upon the beatings of my heart—
How oft, in spirit, have I turned to thee,
O sylvan Wye! thou wanderer thro' the woods,
How often has my spirit turned to thee!
And now, with gleams of half-extinguished thought,
With many recognitions dim and faint,　　　60
And somewhat of a sad perplexity,
The picture of the mind revives again:
While here I stand, not only with the sense
Of present pleasure, but with pleasing thoughts
That in this moment there is life and food
For future years. And so I dare to hope,
Though changed, no doubt, from what I was when first
I came among these hills; when like a roe
I bounded o'er the mountains, by the sides
Of the deep rivers, and the lonely streams,
Wherever nature led: more like a man　　　70
Flying from something that he dreads than one
Who sought the thing he loved. For nature then
(The coarser pleasures of my boyish days,
And their glad animal movements all gone by)
To me was all in all.—I cannot paint
What then I was. The sounding cataract

Haunted me like a passion: the tall rock.
The mountain, and the deep and gloomy wood,
Their colors and their forms, were then to me
An appetite; a feeling and a love, 80
That had no need of a remoter charm,
By thought supplied, nor any interest
Unborrowed from the eye.—That time is past,
And all its aching joys are now no more,
And all its dizzy raptures. Not for this
Faint I, nor mourn nor murmur; other gifts
Have followed; for such loss, I would believe,
Abundant recompense. For I have learned
To look on nature, not as in the hour
Of thoughtless youth; but hearing oftentimes 90
The still, sad music of humanity,
Nor harsh nor grating, though of ample power
To chasten and subdue. And I have felt
A presence that disturbs me with the joy
Of elevated thoughts; a sense sublime
Of something far more deeply interfused,
Whose dwelling is the light of setting suns,
And the round ocean and the living air,
And the blue sky, and in the mind of man:
A motion and a spirit, that impels 100
All thinking things, all objects of all thought,
And rolls through all things. Therefore am I still
A lover of the meadows and the woods,
And mountains; and of all that we behold
From this green earth; of all the mighty world
Of eye, and ear,—both what they half create,
And what perceive; well pleased to recognize
In nature and the language of the sense
The anchor of my purest thoughts, the nurse,
The guide, the guardian of my heart, and soul 110
Of all my moral being.
 Nor perchance,
If I were not thus taught, should I the more
Suffer my genial spirits to decay:
For thou art with me here upon the banks
Of this fair river; thou my dearest Friend,
My dear, dear Friend; and in thy voice I catch
The language of my former heart, and read
My former pleasures in the shooting lights
Of thy wild eyes. Oh! yet a little while
May I behold in thee what I was once, 120
My dear, dear Sister! and this prayer I make,
Knowing that Nature never did betray
The heart that loved her; 'tis her privilege,
Through all the years of this our life, to lead
From joy to joy: for she can so inform
The mind that is within us, so impress
With quietness and beauty, and so feed
With lofty thoughts, that neither evil tongues,
Rash judgments, nor the sneers of selfish men,
Nor greetings where no kindness is, nor all 130
The dreary intercourse of daily life,
Shall e'er prevail against us, or disturb
Our cheerful faith, that all which we behold
Is full of blessings. Therefore let the moon
Shine on thee in thy solitary walk;
And let the misty mountain-winds be free
To blow against thee; and, in after years.
When these wild ecstasies shall be matured
Into a sober pleasure; when thy mind
Shall be a mansion for all lovely forms, 140
Thy memory be as a dwelling-place
For all sweet sounds and harmonies; oh! then,
If solitude, or fear, or pain, or grief,

Should be thy portion, with what healing thoughts
Of tender joy wilt thou remember me,
And these my exhortations! Nor, perchance—
If I should be where I no more can hear
Thy voice, nor catch from thy wild eyes these gleams
Of past existence—wilt thou then forget
That on the banks of this delightful stream 150
We stood together; and that I, so long
A worshipper of Nature, hither came
Unwearied in that service: rather say
With warmer love—oh! with far deeper zeal
Of holier love. Nor wilt thou then forget
That after many wanderings, many years
Of absence, these steep woods and lofty cliffs,
And this green pastoral landscape, were to me
More dear, both for themselves and for thy sake!

READING 70
from Percy Bysshe Shelley (1792–1822)

The first of these two poems, "To——" illustrates Shelley's ability to capture intense emotions by the use of the simplest of language. Without any overstatement and with direct, uncomplicated images the poem makes an impression out of all proportion to its length.

In the second poem, Shelley sounds deeper and more resonant chords. Ozymandias was the Greek name for the mighty Egyptian Pharaoh Ramses II, and Shelley uses the image of his shattered statue to symbolize the impermanence of human achievement.

"To——"

Music, when soft voices die,
Vibrates in the memory;
Odors, when sweet violets sicken,
Live within the sense they quicken.
Rose leaves, when the rose is dead,
Are heaped for the beloved's bed;
And so thy thoughts, when thou art gone,
Love itself shall slumber on.

"Ozymandias"

I met a traveler from an antique land
Who said: Two vast and trunkless legs of stone
Stand in the desert . . . Near them, on the sand,
Half sunk, a shattered visage lies, whose frown,
And wrinkled lip, and sneer of cold command,
Tell that its sculptor well those passions read
Which yet survive, stamped on these lifeless things
The hand that mocked them and the heart that fed:
And on the pedestal these words appear:
"My name is Ozymandias, king of kings: 10
Look on my works, ye Mighty, and despair!"
Nothing beside remains. Round the decay
Of that colossal wreck, boundless and bare
The lone and level sands stretch far away.

READING 71
John Keats (1795–1821), "Ode to a Nightingale" (1819)

Keats wrote this poem while living in Hampstead (London), and his companion, Charles Brown, left an account of the circumstances of its composition: "In the spring of 1819 a nightingale had built her nest near my house. Keats felt a tranquil and continual joy in her song; and one

morning he took his chair from the breakfast table to the grass plot under a plum-tree where he sat for two or three hours. When he came into the house, I perceived he had some scraps of paper in his hand. . . ."

The song of the bird serves as inspiration for a meditation on the nature of human experience. The poem begins in despondency as Keats (only age twenty-four, but already stricken by tuberculosis) broods on life's sorrows. As he muses, the immortal song and the beauty of nature that it represents console him, bringing comfort and release, and he accepts his tragic fate. He died less than two years later.

I

My heart aches, and a drowsy numbness pains
My sense, as though of hemlock I had drunk,
Or emptied some dull opiate to the drains
One minute past, and Lethe-wards had sunk:
'Tis not through envy of thy happy lot,
But being too happy in thine happiness,—
That thou, light-winged Dryad of the trees,
In some melodious plot
Of beechen green, and shadows numberless,
Singest of summer in full-throated ease. 10

II

O, for a draught of vintage! that hath been
Cool'd a long age in the deep-delved earth,

Tasting of Flora and the country green,
Dance, and Provençal song, and sunburnt mirth!
O for a beaker full of the warm South,
Full of the true, the blushful Hippocrene,
With beaded bubbles winking at the brim,
And purple-stainèd mouth;
That I might drink, and leave the world unseen,
And with thee fade away into the forest dim: 20

III

Fade far away, dissolve, and quite forget
What thou among the leaves hast never known,
The weariness, the fever, and the fret
Here, where men sit and hear each other groan;
Where palsy shakes a few, sad, last gray hairs,
Where youth grows pale, and spectre-thin, and dies;
Where but to think is to be full of sorrow
And leaden-eyed despairs,
Where Beauty cannot keep her lustrous eyes,
Or new Love pine at them beyond tomorrow. 30

IV

Away! away! for I will fly to thee,
Not charioted by Bacchus and his pards [leopards],
But on the viewless wings of Poesy,
Though the dull brain perplexes and retards:
Already with thee! tender is the night,
And haply the Queen-Moon is on her throne,
Cluster'd around by all her starry Fays;
But here there is no light,
Save what from heaven is with the breezes blown
Through verdurous glooms and winding mossy ways. 40

V

I cannot see what flowers are at my feet,
Nor what soft incense hangs upon the boughs,
But, in embalmed darkness, guess each sweet
Wherewith the seasonable month endows
The grass, the thicket, and the fruit-tree wild;
White hawthorn, and the pastoral eglantine;
Fast fading violets cover'd up in leaves;

And mid-May's eldest child,
The coming musk-rose, full of dewy wine,
The murmurous haunt of flies on summer eves. 50

VI

Darkling I listen; and, for many a time
I have been half in love with easeful Death,
Call'd him soft names in many a musèd rhyme,
To take into the air my quiet breath;
Now more than ever seems it rich to die,
To cease upon the midnight with no pain,
While thou art pouring forth thy soul abroad
In such an ecstasy!
Still wouldst thou sing, and I have ears in vain—
To thy high requiem become a sod. 60

VII

Thou wast not born for death, immortal Bird!
No hungry generations tread thee down;
The voice I hear this passing night was heard
In ancient days by emperor and clown:
Perhaps the self-same song that found a path
Through the sad heart of Ruth, when, sick for home,
She stood in tears amid the alien corn;
The same that oft-times hath
Charm'd magic casements, opening on the foam
Of perilous seas, in faery lands forlorn. 70

VIII

Forlorn! the very word is like a bell
To toll me back from thee to my sole self!
Adieu! the fancy cannot cheat so well
As she is fam'd to do, deceiving elf.
Adieu! adieu! thy plaintive anthem fades
Past the near meadows, over the still stream,
Up the hill-side; and now 'tis buried deep
In the next valley-glades.
Was it a vision, or a waking dream?
Fled is that music:—Do I wake or sleep? 80

READING 72

from CHARLES DICKENS (1812–1870), OLIVER TWIST (1837–1839)

Although Dickens also wrote short stories, he needed the large canvas of the novel to do justice to his genius. The opening chapters of OLIVER TWIST, *which appeared in serial form in a British literary magazine, reveal the author's passionate anger at the conditions of the poor and underprivileged. The publication of this and other novels by Dickens played a significant part in arousing public indignation, and led to reform of institutions like the workhouse. The last scene in this extract, in which Oliver asks for more, provides a powerful instance of Dickens' ability to find an unforgettable image, while the blend of comedy and anger is also characteristically Dickensian.*

Chapter 1 Treats of the Place where Oliver Twist was Born; and of the Circumstances attending his Birth

Among other public buildings in a certain town, which for many reasons it will be prudent to refrain from mentioning, and to which I will assign no fictitious name, there is one anciently common to most towns, great or small; to wit, a workhouse: and in this workhouse was born: on a day and date which I

need not trouble myself to repeat, inasmuch as it can be of no possible consequence to the reader, in this stage of the business at all events: the item of mortality whose name is prefixed to the head of this chapter.

For a long time after it was ushered into this world of sorrow and trouble, by the parish surgeon, it remained a matter of considerable doubt whether the child would survive to bear any name at all, in which case it is somewhat more than probable that these memoirs would never have appeared; or, if they had, that being comprised within a couple of pages, they would have possessed the inestimable merit of being the most concise and faithful specimen of biography, extant in the literature of any age or country.

Although I am not disposed to maintain that the being born in a workhouse, is in itself the most fortunate and enviable circumstance that can possibly befall a human being, I do mean to say that in this particular instance, it was the best thing for Oliver Twist that could by possibility have occurred. The fact is, that there was considerable difficulty in inducing Oliver to take upon himself the office of respiration—a troublesome practice, but one which custom has rendered necessary to our easy existence; and for some time he lay gasping on a little flock mattress, rather unequally poised between this world and the next: the balance being decidedly in favor of the latter. Now, if, during this brief period, Oliver had been surrounded by careful grandmothers, anxious aunts, experienced nurses, and doctors of profound wisdom, he would most inevitably and indubitably have been killed in no time. There being nobody by, however, but a pauper old woman, who was rendered rather misty by an unwonted allowance of beer; and a parish surgeon who did such matters by contract; Oliver and Nature fought out the point between them. The result was, that, after a few struggles, Oliver breathed, sneezed, and proceeded to advertise to the inmates of the workhouse the fact of a new burden having been imposed upon the parish, by setting up as loud a cry as could reasonably have been expected from a male infant who had not been possessed of that very useful appendage, a voice, for a much longer space of time than three minutes and a quarter.

As Oliver gave this first proof of the free and proper action of his lungs, the patchwork coverlet which was carelessly flung over the iron bedstead, rustled; the pale face of a young woman was raised feebly from the pillow; and a faint voice imperfectly articulated the words, "Let me see the child, and die."

The surgeon had been sitting with his face turned towards the fire: giving the palms of his hands a warm and a rub alternately. As the young woman spoke, he rose, and advancing to the bed's head, said, with more kindness than might have been expected of him:

"Oh, you must not talk about dying yet."

"Lor' bless her dear heart, no!" interposed the nurse, hastily depositing in her pocket a green glass bottle, the contents of which she had been tasting in a corner with evident satisfaction. "Lor' bless her dear heart, when she has lived as long as I have, sir, and had thirteen children of her own, and all on 'em dead except two, and them in the wurkus with me, she'll know better than to take on in that way, bless her dear heart!

Think what it is to be a mother, there's a dear young lamb, do."

Apparently this consolatory perspective of a mother's prospect failed in producing its due effect. The patient shook her head, and stretched out her hand towards the child.

The surgeon deposited it in her arms. She imprinted her cold white lips passionately on its forehead; passed her hands over her face; gazed wildly round; shuddered; fell back and died. They chafed her breast, hands, and temples; but the blood had stopped for ever. They talked of hope and comfort. They had been strangers too long.

"It's all over, Mrs. Thingummy!" said the surgeon at last.

"Ah, poor dear, so it is!" said the nurse, picking up the cork of the green bottle, which had fallen out on the pillow, as she stooped to take up the child. "Poor dear!"

"You needn't mind sending up to me, if the child cries, nurse," said the surgeon, putting on his gloves with great deliberation. "It's very likely it *will* be troublesome. Give it a little gruel if it is." He put on his hat, and, pausing by the bedside on his way to the door, added "She was a good-looking girl, too; where did she come from?"

"She was brought here last night," replied the old woman, "by the overseer's order. She was found lying in the street. She had walked some distance, for her shoes were worn to pieces; but where she came from, or where she was going to, nobody knows."

The surgeon leaned over the body, and raised the left hand. "The old story," he said, shaking his head; "no wedding-ring, I see. Ah! Good night!"

The medical gentleman walked away to dinner; and the nurse, having once more applied herself to the green bottle, sat down on a low chair before the fire, and proceeded to dress the infant.

What an excellent example of the power of dress, young Oliver Twist was! Wrapped in the blanket which had hitherto formed his only covering, he might have been the child of a nobleman or a beggar; it would have been hard for the haughtiest stranger to have assigned him his proper station in society. But now that he was enveloped in the old calico robes which had grown yellow in the same service, he was badged and ticketed, and fell into his place at once—a parish child—the orphan of a workhouse—the humble, half-starved drudge—to be cuffed and buffeted through the world—despised by all, and pitied by none.

Oliver cried lustily. If he could have known that he was an orphan, left to the tender mercies of church wardens and overseers, perhaps he would have cried the louder.

Chapter 2 Treats of Oliver Twist's Growth, Education, and Board

For the next eight or ten months, Oliver was the victim of a systematic course of treachery and deception. He was brought up by hand. The hungry and destitute situation of the infant orphan was duly reported by the workhouse authorities to the parish authorities. The parish authorities inquired with dignity of the workhouse authorities whether there was no female then domiciled "in the house" who was in a situation to impart to Oliver Twist the consolation and nourishment of which he stood in need. The workhouse authorities replied with humility, that there was not. Upon this, the parish authorities magnanimously and humanely resolved, that Oliver should be "farmed," or, in other words, that he should be dispatched to a branch-workhouse some three miles off, where twenty or thirty other juvenile offenders against the poor-laws, rolled about the floor all day, without the inconvenience of too much food or too much clothing, under the parental superintendence of an elderly female, who received the culprits at and for the consideration of sevenpence-halfpenny per small head per week. Sevenpence-halfpenny's worth per week is a good round diet for a child; a great deal may be got for sevenpence-halfpenny, quite enough to overload its stomach, and make it uncomfortable. The elderly female was a woman of wisdom and experience; she knew what was good for children; and she had a very accurate perception of what was good for herself. So, she appropriated the greater part of the weekly stipend to her own use, and consigned the rising parochial generation to even a shorter allowance than was originally provided for them. Thereby finding in the lowest depth a deeper still; and proving herself a very great experimental philosopher.

Everybody knows the story of another experimental philosopher who had a great theory about a horse being able to live without eating, and who demonstrated it so well, that he got his own horse down to a straw a day, and would unquestionably have rendered him a very spirited and rampageous animal on nothing at all, if he had not died, just four-and-twenty hours before he was to have had his first comfortable bait of air. Unfortunately for the experimental philosophy of the female to whose protecting care Oliver Twist was delivered over, a similar result usually attended the operation of *her* system; for at the very moment when a child had contrived to exist upon the smallest possible portion of the weakest possible food, it did perversely happen in eight and a half cases out of ten, either that it sickened from want and cold, or fell into the fire from neglect, or got half-smothered by accident; in any one of which cases, the miserable little being was usually summoned into another world, and there gathered to the fathers it had never known in this.

Occasionally, when there was some more than usually interesting inquest upon a parish child, who had been overlooked in turning up a bedstead, or inadvertently scalded to death when there happened to be a washing—though the latter accident was very scarce, anything approaching to a washing being of rare occurrence in the farm—the jury would take it into their heads to ask troublesome questions, or the parishioners would rebelliously affix their signatures to a remonstrance. But these impertinences were speedily checked by the evidence of the surgeon, and the testimony of the beadle; the former of whom had always opened the body and found nothing inside (which was very probable indeed), and the latter of whom invariably swore whatever the parish wanted; which was very self-devotional. Besides, the board made periodical pilgrimages to the farm, and always sent the beadle the day before, to say they were going. The children were neat and clean to behold, when *they* went; and what more would the people have!

It cannot be expected that this system of farming would produce any very extraordinary or luxuriant crop. Oliver Twist's ninth birthday found him a pale thin child, somewhat diminutive in stature, and decidedly small in circumference. But nature or inheritance had implanted a good sturdy spirit in Oliver's breast. It had had plenty of room to expand, thanks to the spare diet of the establishment; and perhaps to the circumstance may be attributed his having any ninth birthday at all. Be this as it may, however, it *was* his ninth birthday; and he was keeping it in the coal-cellar with a select party of two other young gentlemen, who, after participating with him in a sound thrashing, had been locked up therein for atrociously presuming to be hungry, when Mrs. Mann, the good lady of the house, was unexpectedly startled by the apparition of Mr. Bumble, the beadle, striving to undo the wicket of the garden-gate.

"Goodness gracious! Is that you, Mr. Bumble, Sir?" said Mrs. Mann, thrusting her head out of the window in well-affected ecstasies of joy.

"(Susan, take Oliver and them two brats up stairs and wash 'em directly.)—My heart alive! Mr. Bumble, how glad I am to see you, surely!"

Now, Mr. Bumble was a fat man, and a choleric; so, instead of responding to this open-hearted salutation in a kindred spirit, he gave the little wicket a tremendous shake, and then bestowed upon it a kick which could have emanated from no leg but a beadle's.

"Lor', only think," said Mrs. Mann, running out—for the three boys had been removed by this time—"only think of that! That I should have forgotten that the gate was bolted on the inside, on account of them dear children! Walk in, Sir; walk in, pray, Mr. Bumble, do, Sir."

Although this invitation was accompanied with a curtsey that might have softened the heart of a churchwarden, it by no means mollified the beadle.

"Do you think this respectful or proper conduct, Mrs. Mann," inquired Mr. Bumble, grasping his cane, "to keep the parish officers a waiting at your garden-gate, when they come here upon parochial business connected with the parochial orphans? Are you aweer, Mrs. Mann, that you are, as I may say, a parochial delegate, and a stipendiary?"

"I'm sure, Mr. Bumble, that I was only a telling one or two of the dear children as is so fond of you, that it was you a coming," replied Mrs. Mann with great humility.

Mr. Bumble had a great idea of his oratorical powers and his importance. He had displayed the one, and vindicated the other. He relaxed.

"Well, well, Mrs. Mann," he replied in a calmer tone; "it may be as you say; it may be. Lead the way in, Mrs. Mann, for I come on business, and have something to say."

Mrs. Mann ushered the beadle into a small parlor with a brick floor; placed a seat for him; and officiously deposited his cocked hat and cane on the table before him. Mr. Bumble wiped from his forehead the perspiration which his walk had engendered, glanced complacently at the cocked hat, and smiled. Yes, he smiled. Beadles are but men; and Mr. Bumble smiled.

"Now don't you be offended at what I'm a going to say," observed Mrs. Mann, with captivating sweetness. "You've had a long walk, you know, or I wouldn't mention it. Now, will you take a little drop of somethink, Mr. Bumble?"

"Not a drop. Not a drop," said Mr. Bumble, waving his right hand in a dignified, but placid manner.

"I think you will," said Mrs. Mann, who had noticed the tone of the refusal, and the gesture that had accompanied it. "Just a leetle drop, with a little cold water, and a lump of sugar."

Mr. Bumble coughed.

"Now, just a leetle," said Mrs. Mann persuasively.

"What is it?" inquired the beadle.

"Why, it's what I'm obliged to keep a little of in the house, to put into the blessed infants' Daffy, when they ain't well, Mr. Bumble," replied Mrs. Mann as she opened a corner cupboard, and took down a bottle and glass. "It's gin. I'll not deceive you, Mr. B. It's gin."

"Do you give the children Daffy, Mrs. Mann?" inquired Bumble, following with his eyes the interesting process of mixing.

"Ah, bless 'em, that I do, dear as it is," replied the nurse. "I couldn't see 'em suffer before my very eyes, you know, Sir."

"No," said Mr. Bumble approvingly; "no, you could not. You are a humane woman, Mrs. Mann." (Here she set down the glass.) "I shall take a early opportunity of mentioning it to the board, Mrs. Mann." (He drew it towards him.) "You feel as a mother, Mrs. Mann." (He stirred the gin-and-water.) "I—I drink your health with cheerfulness, Mrs. Mann;" and he swallowed half of it.

"And now about business," said the beadle, taking out a leathern pocket-book. "The child that was half-baptized Oliver Twist, is nine year old today."

"Bless him!" interposed Mrs. Mann, inflaming her left eye with the corner of her apron.

"And notwithstanding a offered reward of ten pound, which was afterwards increased to twenty pound. Notwithstanding the most superlative, and, I may say, supernat'ral exertions on the part of this parish," said Bumble, "we have never been able to discover who is his father, or what was his mother's settlement, name, or condition."

Mrs. Mann raised her hands in astonishment; but added, after a moment's reflection, "How comes he to have any name at all, then?"

The beadle drew himself up with great pride, and said, "I inwented it."

"You, Mr. Bumble!"

"I, Mrs. Mann. We name our fondlins in alphabetical order. The last was a S,—Swubble, I named him. This was a T,—

Twist, I named *him*. The next one as comes will be Unwin; and the next Vilkins. I have got names ready made to the end of the alphabet, and all the way through it again, when we come to Z."

"Why, you are quite a literary character, Sir!" said Mrs. Mann.

"Well, well," said the beadle, evidently gratified with the compliment; "perhaps I may be. Perhaps I may be, Mrs. Mann." He finished the gin-and-water, and added, "Oliver being now too old to remain here, the board have determined to have him back into the house. I have come out myself to take him there. So let me see him at once."

"I'll fetch him directly," said Mrs. Mann, leaving the room for that purpose. Oliver, having had by this time as much of the outer coat of dirt which encrusted his face and hands, removed, as could be scrubbed off in one washing, was led into the room by his benevolent protectress.

"Make a bow to the gentleman, Oliver," said Mrs. Mann.

Oliver made a bow, which was divided between the beadle on the chair, and the cocked-hat on the table.

"Will you go along with me, Oliver?" said Mr. Bumble, in a majestic voice.

Oliver was about to say that he would go along with any-body with great readiness, when, glancing upwards, he caught sight of Mrs. Mann, who had got behind the beadle's chair, and was shaking her fist at him with a furious countenance. He took the hint at once, for the first had been too often impressed upon his body not to be deeply impressed upon his recollection.

"Will *she* go with me?" inquired poor Oliver.

"No, she can't," replied Mr. Bumble. "But she'll come and see you sometimes."

This was no very great consolation to the child. Young as he was, however, he had sense enough to make a feint of feeling great regret at going away. It was no very difficult matter for the boy to call the tears into his eyes. Hunger and recent ill-usage are great assistants if you want to cry; and Oliver cried very naturally indeed. Mrs. Mann gave him a thousand embraces, and, what Oliver wanted a great deal more, a piece of bread and butter, lest he should seem too hungry when he got to the workhouse. With the slice of bread in his hand, and the little brown-cloth parish cap on his head, Oliver was then led away by Mr. Bumble from the wretched home where one kind word or look had never lighted the gloom of his infant years. And yet he burst into an agony of childish grief, as the cottage-gate closed after him. Wretched as were the little companions in misery he was leaving behind, they were the only friends he had ever known; and a sense of his loneliness in the great wide world, sank into the child's heart for the first time.

Mr. Bumble walked on with long strides; little Oliver, firmly grasping his gold-laced cuff, trotted beside him, inquiring at the end of every quarter of a mile whether they were "nearly there." To these interrogations, Mr. Bumble returned very brief and snappish replies; for the temporary blandness which gin-and-water awakens in some bosoms had by this time evaporated; and he was once again a beadle.

Oliver had not been within the walls of the workhouse a quarter of an hour, and had scarcely completed the demolition of a second slice of bread, when Mr. Bumble, who had handed him over to the care of an old woman, returned; and, telling him it was a board night, informed him that the board had said he was to appear before it forthwith.

Not having a very clearly defined notion of what a live board was, Oliver was rather astounded by this intelligence, and was not quite certain whether he ought to laugh or cry. He had no time to think about the matter, however; for Mr. Bumble gave him a tap on the head, with his cane, to wake him up: and another on the back to make him lively: and bidding him follow, conducted him into a large whitewashed room, where eight or ten fat gentlemen were sitting round a table. At the top of the table, seated in an arm-chair rather higher than the rest, was a particularly fat gentleman with a very round, red face.

"Bow to the board," said Bumble. Oliver brushed away two or three tears that were lingering in his eyes; and seeing no board but the table, fortunately bowed to that.

"What's your name, boy?" said the gentleman in the high chair.

Oliver was frightened at the sight of so many gentlemen, which made him tremble: and the beadle gave him another tap behind, which made him cry. These two causes made him answer in a very low and hesitating voice; whereupon a gentle-man in a white waistcoat said he was a fool. Which was a capi-tal way of raising his spirits, and putting him quite at his ease.

"Boy," said the gentleman in the high chair, "listen to me. You know you're an orphan, I suppose?"

"What's that, Sir?" inquired poor Oliver.

"The boy *is* a fool—I thought he was," said the gentleman in the white waistcoat.

"Hush!" said the gentleman who had spoken first. "You know you've got no father or mother, and that you were brought here by the parish, don't you?"

"Yes, Sir," replied Oliver, weeping bitterly.

"What are you crying for?" inquired the gentleman in the white waistcoat? And to be sure, it was very extraordinary. What *could* the boy be crying for?

"I hope you say your prayers every night," said another gentleman in a gruff voice; "and pray for the people who feed you, and take care of you—like a Christian."

"Yes, Sir," stammered the boy. The gentleman who spoke last was unconsciously right. It would have been very like a Christian, and a marvelously good Christian too, if Oliver had prayed for the people who fed and took care of *him*. But he hadn't, because nobody had taught him.

"Well! You have come here to be educated, and taught a useful trade," said the red-faced gentleman in the high chair.

"So you'll begin to pick oakum tomorrow morning at six o'clock," added the surly one in the white waistcoat.

For the combination of both these blessings in the one sim-ple process of picking oakum, Oliver bowed low by the direc-tion of the beadle, and was then hurried away to a large ward: where, on a rough hard bed, he sobbed himself to sleep. What a noble illustration of the tender laws of England! They let the paupers go to sleep!

Poor Oliver! He little thought, as he lay sleeping in happy unconsciousness of all around him, that the board had that very day arrived at a decision which would exercise the most mate-rial influence over all his future fortunes. But they had. And this was it:—

The members of this board were very sage, deep, philo-sophical men; and when they came to turn their attention to the workhouse, they found out at once, what ordinary folks would never have discovered—the poor people liked it! It was a regular place of public entertainment for the poorer classes; a tavern where there was nothing to pay; a public breakfast, dinner, tea, and supper all the year round; a brick and mortar elysium, where it was all play and no work. "Oho!" said the board, looking very knowing; "we are the fellows to set this to rights; we'll stop it all, in no time." So, they established the rule, that all poor people should have the alternative (for they would compel nobody, not they), of being starved by a gradual process in the house, or by a quick one out of it. With this view, they contracted with the works to lay on an unlimited supply of water; and with a corn-factor to supply periodically small quantities of oatmeal; and issued three meals of thin gruel a day, with an onion twice a week, and half a roll on Sun-days. They made a great many other wise and humane regula-tions, having reference to the ladies, which it is not necessary to repeat; kindly undertook to divorce poor married people, in consequence of the great expense of a suit in Doctors' Com-

mons; and, instead of compelling a man to support his family, as they theretofore had done, took his family away from him, and made him a bachelor! There is no saying how many applicants for relief under these last two heads, might have started up in all classes of society, if it had not been coupled with the workhouse; but the board were long-headed men, and had provided for this difficulty. The relief was inseparable from the workhouse and the gruel; and that frightened people.

For the first six months after Oliver Twist was removed, the system was in full operation. It was rather expensive at first, in consequence of the increase in the undertaker's bill, and the necessity of taking in the clothes of all the paupers, which fluttered loosely on their wasted, shrunken forms, after a week or two's gruel. But the number of workhouse inmates got thin as well as the paupers; and the board were in ecstasies.

The room in which the boys were fed, was a large stone hall, with a copper at one end: out of which the master, dressed in an apron for the purpose, and assisted by one or two women, ladled the gruel at mealtimes. Of this festive composition each boy had one porringer, and no more—except on occasions of great public rejoicing, when he had two ounces and a quarter of bread besides. The bowls never wanted washing. The boys polished them with their spoons till they shown again; and when they had performed this operation (which never took very long, the spoons being nearly as large as the bowls), they would sit staring at the copper, with such eager eyes, as if they could have devoured the very bricks of which it was composed; employing themselves, meanwhile, in sucking their fingers most assiduously, with the view of catching up any stray splashes of gruel that might have been cast thereon. Boys have generally excellent appetites. Oliver Twist and his companions suffered the tortures of slow starvation for three months; at last they got so voracious and wild with hunger, that one boy, who was tall for his age, and hadn't been used to that sort of thing (for his father had kept a small cookshop), hinted darkly to his companions, that unless he had another basin of gruel *per diem,* he was afraid he might some night happen to eat the boy who slept next him, who happened to be a weakly youth of tender age. He had a wild, hungry eye; and they implicitly believed him. A council was held; lots were cast who should walk up to the master after supper that evening, and ask for more; and it fell to Oliver Twist.

The evening arrived; the boys took their places. The master, in his cook's uniform, stationed himself at the copper; his pauper assistants ranged themselves behind him; the gruel was served out; and a long grace was said over the short commons. The gruel disappeared; the boys whispered each other, and winked at Oliver; while his next neighbors nudged him. Child as he was, he was desperate with hunger, and reckless with misery. He rose from the table; and advancing to the master, basin and spoon in hand, said: somewhat alarmed at his own temerity:

"Please, Sir, I want some more."

The master was a fat, healthy man; but he turned very pale. He gazed in stupefied astonishment on the small rebel for some seconds, and then clung for support to the copper. The assistants were paralyzed with wonder; the boys with fear.

"What!" said the master at length, in a faint voice.

"Please, Sir," replied Oliver, "I want some more."

The master aimed a blow at Oliver's head with the ladle; pinioned him in his arms; and shrieked aloud for the beadle.

The board were sitting in solemn conclave, when Mr. Bumble rushed into the room in great excitement, and addressing the gentleman in the high chair, said,

"Mr. Limbkins, I beg your pardon, Sir! Oliver Twist has asked for more!"

There was a general start. Horror was depicted on every countenance.

"For *more!*" said Mr. Limbkins. "Compose yourself, Bumble, and answer me distinctly. Do I understand that he asked for more, after he had eaten the supper allotted by the dietary?"

"He did, Sir," replied Bumble.

"That boy will be hung," said the gentleman in the white waistcoat. "I know that boy will be hung."

Nobody controverted the prophetic gentleman's opinion. An animated discussion took place. Oliver was ordered into instant confinement; and a bill was next morning pasted on the outside of the gate, offering a reward of five pounds to anybody who would take Oliver Twist off the hands of the parish. In other words, five pounds and Oliver Twist were offered to any man or woman who wanted an apprentice to any trade, business or calling.

"I never was more convinced of anything in my life," said the gentleman in the white waistcoat, as he knocked at the gate and read the bill next morning: "I never was more convinced of anything in my life, than I am, that that boy will come to be hung."

As I purpose to show in the sequel whether the white-waistcoated gentleman was right or not, I should perhaps mar the interest of this narrative (supposing it to possess any at all), if I ventured to hint, just yet, whether the life of Oliver Twist had this violent termination or no.

READING 73
Leo Tolstoy (1828–1910), The Three Hermits (1886)

Tolstoy is best known for his vast historical novel, War and Peace, but throughout his life he also wrote short stories. The following story, which dates toward the end of his career, shows Tolstoy's interest in the spiritual, represented by the three hermits who transcend conventional religion. Tolstoy himself spent his last years in a mystical search for enlightenment, "leaving this worldly life in order to live out my days in peace and solitude."

An Old Legend Current in the Volga District

And in praying use not vain repetitions, as the Gentiles do: for they think that they shall be heard for their much speaking. Be not therefore like them; for your Father knoweth what things ye have need of, before ye ask Him.

Matthew vi: 7,8.

A Bishop was sailing from Archangel to the Solovétsk Monastery, and on the same vessel were a number of pilgrims on their way to visit the shrines at that place. The voyage was a smooth one. The wind favorable and the weather fair. The pilgrims lay on deck, eating, or sat in groups talking to one another. The Bishop, too, came on deck, and as he was pacing up and down he noticed a group of men standing near the prow and listening to a fisherman, who was pointing to the sea and telling them something. The Bishop stopped, and looked in the direction in which the man was pointing. He could see nothing, however, but the sea glistening in the sunshine. He drew nearer to listen, but when the man saw him, he took off his cap and was silent. The rest of the people also took off their caps and bowed.

"Do not let me disturb you, friends," said the Bishop. "I came to hear what this good man was saying."

"The fisherman was telling us about the hermits," replied one, a tradesman, rather bolder than the rest.

"What hermits?" asked the Bishop, going to the side of the vessel and seating himself on a box. "Tell me about them. I should like to hear. What were you pointing at?"

"Why, that little island you can just see over there," answered the man, pointing to a spot ahead and a little to the right. "That is the island where the hermits live for the salvation of their souls."

"Where is the island?" asked the Bishop. "I see nothing."

"There, in the distance, if you will please look along my hand. Do you see that little cloud? Below it, and a bit to the left, there is just a faint streak. That is the island."

The Bishop looked carefully, but his unaccustomed eyes could make out nothing but the water shimmering in the sun.

"I cannot see it," he said. "But who are the hermits that live there?"

"They are holy men," answered the fisherman. "I had long heard tell of them, but never chanced to see them myself till the year before last."

And the fisherman related how once, when he was out fishing, he had been stranded at night upon that island, not knowing where he was.

In the morning, as he wandered about the island, he came across an earth hut, and met an old man standing near it. Presently two others came out, and after having fed him and dried his things, they helped him mend his boat.

"And what are they like?" asked the Bishop.

"One is a small man and his back is bent. He wears a priest's cassock and is very old; he must be more than a hundred, I should say. He is so old that the white of his beard is taking a greenish tinge, but he is always smiling, and his face is as bright as an angel's from heaven. The second is taller, but he also is very old. He wears a tattered peasant coat. His beard is broad, and of a yellowish gray color. He is a strong man. Before I had time to help him, he turned my boat over as if it were only a pail. He too is kindly and cheerful. The third is tall, and has a beard as white as snow and reaching to his knees. He is stern, with overhanging eyebrows; and he wears nothing but a piece of matting tied round his waist."

"And did they speak to you?" asked the Bishop.

"For the most part they did everything in silence, and spoke but little even to one another. One of them would just give a glance, and the others would understand him. I asked the tallest whether they had lived there long. He frowned, and muttered something as if he were angry; but the oldest one took his hand and smiled, and then the tall one was quiet. The oldest one only said: 'Have mercy upon us,' and smiled."

While the fisherman was talking, the ship had drawn nearer to the island.

"There, now you can see it plainly, if your Lordship will please to look," said the tradesman, pointing with his hand.

The Bishop looked, and now he really saw a dark streak—which was the island. Having looked at it a while, he left the prow of the vessel, and going to the stern, asked the helmsman:

"What island is that?"

"That one," replied the man, "has no name. There are many such in this sea."

"Is it true that there are hermits who live there for the salvation of their souls?"

"So it is said, your Lordship, but I don't know if it's true. Fishermen say they have seen them; but of course they may only be spinning yarns."

"I should like to land on the island and see these men," said the Bishop. "How could I manage it?"

"The ship cannot get close to the island," replied the helmsman, "but you might be rowed there in a boat. You had better speak to the captain."

The captain was sent for and came.

"I should like to see these hermits," said the Bishop. "Could I not be rowed ashore?"

The captain tried to dissuade him.

"Of course it could be done," said he, "but we should lose much time. And if I might venture to say so to your Lordship, the old men are not worth your pains. I have heard say that they are foolish old fellows, who understand nothing, and never speak a word, any more than the fish in the sea."

"I wish to see them," said the Bishop, "and I will pay you for your trouble and loss of time. Please let me have a boat."

There was no help for it; so the order was given. The sailors trimmed the sails, the steersman put up the helm, and the ship's course was set for the island. A chair was placed at the prow for the Bishop, and he sat there, looking ahead. The passengers all collected at the prow, and gazed at the island. Those who had the sharpest eyes could presently make out the rocks on it, and then a mud hut was seen. At last one man saw the hermits themselves. The captain brought a telescope and, after looking through it, handed it to the Bishop.

"It's right enough. There are three men standing on the shore. There, a little to the right of that big rock."

The Bishop took the telescope, got it into position, and he saw the three men: a tall one, a shorter one, and one very small and bent, standing on the shore and holding each other by the hand.

The captain turned to the Bishop.

"The vessel can get no nearer in than this, your Lordship. If you wish to go ashore, we must ask you to go in the boat, while we anchor here."

The cable was quickly let out; the anchor cast, and the sails furled. There was a jerk, and the vessel shook. Then, a boat having been lowered, the oarsmen jumped in, and the Bishop descended the ladder and took his seat. The men pulled at their oars and the boat moved rapidly towards the island. When they came within a stone's throw, they saw three old men: a tall one with only a piece of matting tied round his waist: a shorter one in a tattered peasant coat, and a very old one bent with age and wearing an old cassock—all three standing hand in hand.

The oarsmen pulled in to the shore, and held on with the boathook while the Bishop got out.

The old men bowed to him, and he gave them his blessing, at which they bowed still lower. Then the Bishop began to speak to them.

"I have heard," he said, "that you, godly men, live here saving your own souls and praying to our Lord Christ for your fellow men. I, an unworthy servant of Christ, am called, by God's mercy, to keep and teach His flock. I wished to see you, servants of God, and to do what I can to teach you, also."

The old men looked at each other smiling, but remained silent.

"Tell me," said the Bishop, "what you are doing to save your souls, and how you serve God on this island."

The second hermit sighed, and looked at the oldest, the very ancient one. The latter smiled, and said:

"We do not know how to serve God. We only serve and support ourselves, servant of God."

"But how do you pray to God?" asked the Bishop.

"We pray in this way," replied the hermit. "Three are ye, three are we, have mercy upon us."

And when the old man said this, all three raised their eyes to heaven, and repeated:

"Three are ye, three are we, have mercy upon us!"

The Bishop smiled.

"You have evidently heard something about the Holy Trinity," said he. "But you do not pray aright. You have won my affection, godly men. I see you wish to please the Lord, but you do not know how to serve Him. That is not the way to pray; but listen to me, and I will teach you. I will teach you, not a way of my own, but the way in which God in the Holy Scriptures has commanded all men to pray to Him."

And the Bishop began explaining to the hermits how God had revealed Himself to men; telling them of God the Father, and God the Son, and God the Holy Ghost.

"God the Son came down to the earth," said he, "to save men, and this is how He taught us all to pray. Listen, and repeat after me: 'Our Father.'"

And the first old man repeated after him, "Our Father," and the second said, "Our Father," and the third said, "Our Father."

"Which art in heaven," continued the Bishop.

The first hermit repeated, "Which art in heaven," but the second blundered over the words, and the tall hermit could not say them properly.

His hair had grown over his mouth so that he could not speak plainly. The very old hermit, having no teeth, also mumbled indistinctly.

The Bishop repeated the words again, and the old men repeated them after him. The Bishop sat down on a stone, and the old men stood before him, watching his mouth, and repeating the words as he uttered them. And all day long the Bishop labored, saying a word twenty, thirty, a hundred times over, and the old men repeated it after him. They blundered, and he corrected them, and made them begin again.

The Bishop did not leave off till he had taught them the whole of the Lord's Prayer so that they could not only repeat it after him, but could say it by themselves. The middle one was the first to know it, and to repeat the whole of it alone. The Bishop made him say it again and again, and at last the others could say it too.

It was getting dark and the moon was appearing over the water, before the Bishop rose to return to the vessel. When he took leave of the old men they all bowed down to the ground before him. He raised them, and kissed each of them, telling them to pray as he had taught them.

Then he got into the boat and returned to the ship.

And as he sat in the boat and was rowed to the ship he could hear the three voices of the hermits loudly repeating the Lord's Prayer. As the boat drew near the vessel their voices could no longer be heard, but they could still be seen in the moonlight, standing as he had left them on the shore, the shortest in the middle, the tallest on the right, the middle one on the left. As soon as the Bishop had reached the vessel and got on board, the anchor was weighed and the sails unfurled. The wind filled them and the ship sailed away, and the Bishop took a seat in the stern and watched the island they had left. For a time he could still see the hermits, but presently they disappeared from sight, though the island was still visible. At last it too vanished, and only the sea was to be seen, rippling in the moonlight.

The pilgrims lay down to sleep, and all was quiet on deck. The Bishop did not wish to sleep, but sat alone at the stern, gazing at the sea where the island was no longer visible, and thinking of the good old men. He thought how pleased they had been to learn the Lord's Prayer; and he thanked God for having sent him to teach and help such godly men.

So the Bishop sat, thinking, and gazing at the sea where the island had disappeared. And the moonlight flickered before his eyes, sparkling, now here, now there, upon the waves. Suddenly he saw something white and shining, on the bright path which the moon cast across the sea.

Was it a seagull, or the little gleaming sail of some small boat? The Bishop fixed his eyes on it, wondering.

"It must be a boat sailing after us," thought he, "but it is overtaking us very rapidly. It was far, far away a minute ago, but now it is much nearer. It cannot be a boat, for I can see no sail; but whatever it may be, it is following us and catching us up."

And he could not make out what it was. Not a boat, nor a bird, nor a fish! It was too large for a man, and besides a man could not be out there in the midst of the sea. The Bishop rose, and said to the helmsman:

"Look there, what is that, my friend? What is it?" the Bishop repeated, though he could now see plainly what it was—the three hermits running upon the water, all gleaming white, their gray beards shining, and approaching the ship as quickly as though it were not moving.

The steersman looked, and let go the helm in terror.

"Oh, Lord! The hermits are running after us on the water as though it were dry land!"

The passengers, hearing him, jumped up and crowded to the stern. They saw the hermits coming along hand in hand, and the two outer ones beckoning the ship to stop. All three were gliding along upon the water without moving their feet. Before the ship could be stopped, the hermits had reached it, and raising their heads, all three as with one voice, began to say:

"We have forgotten your teaching, servant of God. As long as we kept repeating it we remembered, but when we stopped saying it for a time, a word dropped out, and now it has all gone to pieces. We can remember nothing of it. Teach us again."

The Bishop crossed himself, and leaning over the ship's side, said:

"Your own prayer will reach the Lord, men of God. It is not for me to teach you. Pray for us sinners."

And the Bishop bowed low before the old men; and they turned and went back across the sea. And a light shone until daybreak on the spot where they were lost to sight.

READING 74
Edgar Allan Poe (1809–1849), The Oval Portrait (1845)

Poe's first short stories, full of the macabre and mystery, were written as parodies—or so he claimed. Certainly the following short story compresses an astonishing number of Romantic elements into a couple of pages: the gloomy castle, the mysterious picture seen by candlelight, the "vague and quaint" words of explanation, and the dramatic revelation of the story's last words. Yet if there is an element of self-consciousness in Poe's technique—every phrase adds another touch of mystery—few readers can resist the compelling atmosphere he creates.

The chateau in which my valet had ventured to make forcible entrance, rather than permit me, in my desperately wounded condition, to pass a night in the open air, was one of those piles of commingled gloom and grandeur which have so long frowned among the Apennines, not less in fact than in the fancy of Mrs. Radcliffe. To all appearance it had been temporarily and very lately abandoned. We established ourselves in one of the smallest and least sumptuously furnished apartments. It lay in a remote turret of the building. Its decorations were rich, yet tattered and antique. Its walls were hung with tapestry and bedecked with manifold and multiform armorial trophies, together with an unusually great number of very spirited modern paintings in frames of rich golden arabesque. In these paintings, which depended from the walls not only in their main surfaces, but in very many nooks which the bizarre architecture of the chateau rendered necessary—in these paintings my incipient delirium, perhaps, had caused me to take deep interest; so that I bade Pedro to close the heavy shutters of the room, since it was already night, to light the tongues of a tall candelabrum which stood by the head of the bed, and to throw open far and wide the fringed curtains of black velvet which enveloped the bed itself. I wished all this done that I might resign myself, if

not to sleep, at least alternately to the contemplation of these pictures, and the perusal of a small volume which had been found upon the pillow, and which purported to criticize and explain them.

Long, long I read—and devoutly, devotedly I gazed. Rapidly and gloriously the hours flew by and the deep midnight came. The position of the candelabrum displeased me, and outreaching my hand with difficulty, rather than disturb my slumbering valet, I placed it so as to throw its rays more fully upon the book.

But the action produced an effect altogether unanticipated. The rays of the numerous candles (for there were many) now fell within a niche of the room which had hitherto been thrown into deep shade by one of the bed-posts. I thus saw in vivid light a picture all unnoticed before. It was the portrait of a young girl just ripening into womanhood. I glanced at the painting hurriedly, and then closed my eyes. Why I did this was not at first apparent even to my own perception. But while my lids remained thus shut, I ran over in my mind my reason for so shutting them.

It was an impulsive movement to gain time for thought, to make sure that my vision had not deceived me, to calm and subdue my fancy for a more sober and more certain gaze. In a very few moments I again looked fixedly at the painting.

That I now saw aright I could not and would not doubt; for the first flashing of the candles upon that canvas had seemed to dissipate the dreamy stupor which was stealing over my senses, and to startle me at once into waking life.

The portrait, as I have already said, was that of a young girl. It was a mere head and shoulders, done in what is technically termed a vignette manner, much in the style of the favorite heads of Sully. The arms, the bosom, and even the ends of the radiant hair melted imperceptibly into the vague yet deep shadow which formed the background of the whole. The frame was oval, richly gilded and filagreed in Moresque. As a thing of art nothing could be more admirable than the painting itself. But it could have been neither the execution of the work, nor the immortal beauty of the countenance, which had so suddenly and so vehemently moved me. Least of all, could it have been that my fancy, shaken from its half slumber, had mistaken the head for that of a living person. I saw at once that the peculiarities of the design, of the vignetting, and of the frame, must have instantly dispelled such idea—must have prevented even its momentary entertainment. Thinking earnestly upon these points, I remained, for an hour perhaps, half sitting, half reclining, with my vision riveted upon the portrait. At length, satisfied with the true secret of its effect, I fell back within the bed. I had found the spell of the picture in an absolute *life-likeness* of expression, which, at first startling, finally confounded, subdued, and appalled me. With deep and reverent awe I replaced the candelabrum in its former position. The cause of my deep agitation being thus shut from view, I sought eagerly the volume which discussed the paintings and their histories. Turning to the number which designated the oval portrait, I there read the vague and quaint words which follow:

She was a maiden of rarest beauty, and not more lovely than full of glee. And evil was the hour when she saw, and loved, and wedded the painter. He, passionate, studious, austere, and having already a bride in his Art: she a maiden of rarest beauty and not more lovely than full of glee; all light and smiles, and frolicsome as the young fawn; loving and cherishing all things; hating only the Art which was her rival; dreading only the palette and brushes and other untoward instruments which deprived her of the countenance of her lover. It was thus a terrible thing for this lady to hear the painter speak of his desire to portray even his young bride. But she was humble and obedient, and sat meekly for many weeks in the dark high turret-chamber where the light dripped upon the pale canvas only from overhead. But he, the painter, took glory in his work, which went on from hour to hour, and from day to day. And he was a passionate and wild, and moody man, who became lost in reveries; so that he *would* not see the light which fell so ghastly in that lone turret withered the health and the spirits of his bride, who pined visibly to all but him. Yet she smiled on and still on, uncomplainingly, because she saw that the painter (who has high renown) took a fervid and burning pleasure in his task, and wrought day and night to depict her who so loved him, yet who grew daily more dispirited and weak. And in sooth some who beheld the portrait spoke of its resemblance in low words, as of a mighty marvel, and a proof not less of the power of the painter than of his deep love for her whom he depicted so surpassingly well. But at length, as the labor drew nearer to its conclusion, there were admitted none into the turret; for the painter had grown wild with the ardor of his work, and turned his eyes from the canvas rarely, even to regard the countenance of his wife. And he *would* not see that the tints which he spread upon the canvas were drawn from the cheeks of her who sat beside him. And when many weeks had passed, and but little remained to do, save one brush upon the mouth and one tint upon the eye, the spirit of the lady again flickered up as the flame within the socket of the lamp. And then the brush was given, and then the tint was placed; and for one moment, the painter stood entranced before the work which he had wrought; but in the next, while he yet gazed, he grew tremulous and very pallid, and aghast, and crying with a loud voice, "This is indeed *Life* itself!" turned suddenly to regard his beloved—*She was dead.*

READING 75

from Walt Whitman (1819–1892), Leaves of Grass, "Song of Myself" (1855)

"Song of Myself" first appeared as the untitled lead poem in Whitman's first important collection of poems, Leaves of Grass, published in 1855. From then until his death he produced edition after edition of verse, gradually adding new poems and revising the old ones. Whitman was defiantly, even aggressively, an American poet. Yet the central theme of most of his work was the importance of the individual—as can be seen in the transition of this poem's title, from "Poem of Walt Whitman, an American" in the 1856 edition to "Song of Myself" in the 1881–1882 edition. The American perspective on freedom, tolerance, and spiritual unity reached its most complete poetic expression in Whitman's works, but by describing the details of his own feelings and reactions, he hoped to communicate the essential oneness of the human condition. Although many of his earlier readers were horrified at the explicit sexual descriptions in some of his poems, the sheer vitality and flow of his language helps make his experiences our own. In the 1881–1882 edition of Leaves of Grass, Whitman divided "Song of Myself" into fifty-two numbered sections, several of which we reproduce here.

1

I celebrate myself, and sing myself,
And what I assume you shall assume,
For every atom belonging to me as good belongs to you.

I loafe and invite my soul,
I lean and loafe at my ease observing a spear of summer grass.

My tongue, every atom of my blood, form'd from this soil,
 this air,
Born here of parents born here from parents the same, and
 their parents the same,
I, now thirty-seven years old in perfect health begin,
 Hoping to cease not till death.
Creeds and schools in abeyance,
Retiring back a while sufficed at what they are, but never
 forgotten,

I harbor for good or bad, I permit to speak at every hazard,
Nature without check with original energy.

2

Houses and rooms are full of perfumes, the shelves are
crowded with perfumes,
I breathe the fragrance myself and know it and like it,
The distillation would intoxicate me also, but I shall not let it.

The atmosphere is not a perfume, it has no taste of the
distillation, it is odorless,
It is for my mouth forever, I am in love with it,
I will go to the bank by the wood and become undisguised
and naked,
I am mad for it to be in contact with me.

The smoke of my own breath,
Echoes, ripples, buzz'd whispers, love-root, silk-thread,
crotch and vine,
My respiration and inspiration, the beating of my heart, the
passing of blood and air through my lungs,
The sniff of green leaves and dry leaves, and of the shore
and dark-color'd sea-rocks, and of hay in the barn,
The sound of the belch'd words of my voice loos'd to the
eddies of the wind,
A few light kisses, a few embraces, a reaching around of arms,
The play of shine and shade on the trees as the supple
boughs wag,
The delight alone or in the rush of the streets, or along the
fields and hill-sides,
The feeling of health, the full-noon trill, the song of me
rising from bed and meeting the sun.

Have you reckon'd a thousand acres much? have you
reckon'd the earth much?
Have you practis'd so long to learn to read? Have you felt
so proud to get at the meaning of poems?

Stop this day and night with me and you shall possess the
origin of all poems,
You shall possess the good of the earth and sun, (there are
millions of suns left,)
You shall no longer take things at second or third hand,
nor look through the eyes of the dead, nor feed on the
spectres in books,
You shall not look through my eyes either, nor take things
from me,
You shall listen to all sides and filter them from your self.

6

A child said What is the grass? fetching it to me with full
hands;
How could I answer the child? I do not know what it is
any more than he.

I guess it must be the flag of my disposition, out of hopeful
green stuff woven.

Or I guess it is the handkerchief of the Lord,
A scented gift and remembrancer designedly dropt,
Bearing the owner's name someway in the corners, that we
may see and remark, and say Whose?

Or I guess the grass is itself a child, the produced babe of
the vegetation.
Or I guess it is a uniform hieroglyphic,
And it means, Sprouting alike in broad zones and narrow
zones,
Growing among black folks as among white,
Kanuck, Tuckahoe, Congressman, Cuff, I give them the

same, I receive them the same.

And now it seems to me the beautiful uncut hair of graves.

Tenderly will I use you curling grass,
It may be you transpire from the breasts of young men,
It may be if I had known them I would have loved them,
It may be you are from old people, or from offspring taken
soon out of their mothers' laps,
And here you are the mothers' laps.

This grass is very dark to be from the white heads of old
mothers,
Darker than the colorless beards of old men,
Dark to come from under the faint red roofs of mouths.

O I perceive after all so many uttering tongues,
And I perceive they do not come from the roofs of mouths
for nothing.

I wish I could translate the hints about the dead young men
and women,
And the hints about old men and mothers, and the
offspring taken soon out of their laps.

What do you think has become of the young and old men?
And what do you think has become of the women and
children?
They are alive and well somewhere,
The smallest sprout shows there is really no death,
And if ever there was it led forward life, and does not wait
at the end to arrest it,
And ceas'd the moment life appear'd.

All goes onward and outward, nothing collapses,
And to die is different from what any one supposed, and
luckier.

15

The pure contralto sings in the organ loft,
The carpenter dresses his plank, the tongue of his foreplane
whistles its wild ascending lisp,
The married and unmarried children ride home to their
Thanksgiving dinner,
The pilot seizes the king-pin, he heaves down with a strong
arm,
The mate stands braced in the whale-boat, lance and
harpoon are ready,
The duck-shooter walks by silent and cautious stretches,
The deacons are ordain'd with cross'd hands at the altar,
The spinning-girl retreats and advances to the hum of the
big wheel,
The farmer stops by the bars as he walks on a First-day
loafe and looks at the oats and rye,
The lunatic is carried at last to the asylum a confirm'd case,
(He will never sleep any more as he did in the cot in his
mother's bed-room;)
The jour printer with gray head and gaunt jaws works at
his case,
He turns his quid of tobacco while his eyes blurr with the
manuscript;
The malform'd limbs are tied to the surgeon's table,
What is removed drops horribly in a pail;
The quadroon girl is sold at the auction-stand, the drunkard
nods by the bar-room stove,
The machinist rolls up his sleeves, the policeman travels his
beat, the gate-keeper marks who pass,
The young fellow drives the express-wagon, (I love him,
though I do not know him;)
The half-breed straps on his light boots to compete in the
race,
The western turkey-shooting draws old and young, some

lean on their rifles, some sit on logs,

Out from the crowd steps the marksman, takes his position,
levels his piece;

The groups of newly-come immigrants cover the wharf or
levee,

As the woolly-pates hoe in the sugar-field, the overseer
views them from his saddle,

The bugle calls in the ball-room, the gentlemen run for
their partners, the dancers bow to each other,

The youth lies awake in the cedar-roof'd garret and harks
to the musical rain,

The Wolverine sets traps on the creek that helps fill the
Huron,

The squaw wrapt in her yellow-hemm'd cloth is offering
moccasins and bead-bags for sale,

The connoisseur peers along the exhibition-gallery with
half-shut eyes bent sideways,

As the deck-hands make fast the steamboat the plank is
thrown for the shore-going passengers,

The young sister holds out the skein while the elder sister
winds it off in a ball, and stops now and then for the
knots,

The one-year wife is recovering and happy having a week
ago borne her first child,

The clean-hair'd Yankee girl works with her sewing-
machine or in the factory or mill,

The paving-man leans on his two-handed rammer, the
reporter's lead flies swiftly over the note-book, the sign-
painter is lettering with blue and gold,

The canal boy trots on the tow-path, the book-keeper
counts at his desk, the shoemaker waxes his thread,

The conductor beats time for the band and all the
performers follow him,

The child is baptized, the convert is making his first
professions,

The regatta is spread on the bay, the race is begun, (how the
white sails sparkle!)

The drover watching his drove sings out to them that
would stray,

The pedler sweats with his pack on his back, (the purchaser
higgling about the odd cent;)

The bride unrumples her white dress, the minute-hand of
the clock moves slowly,

The opium-eater reclines with rigid head and just-open'd
lips,

The prostitute draggles her shawl, her bonnet bobs on her
tipsy and pimpled neck,

The crowd laugh at her blackguard oaths, the men jeer and
wink to each other,

(Miserable! I do not laugh at your oaths nor jeer you;)

The President holding a cabinet council is surrounded by
the great Secretaries,

On the piazza walk three matrons stately and friendly with
twined arms,

The crew of the fish-smack pack repeated layers of halibut
in the hold,

The Missourian crosses the plains toting his wares and his
cattle,

As the fare-collector goes through the train he gives notice
by the jingling of loose change,

The floor-men are laying the floor, the tinners are tinning
the roof, the masons are calling for mortar,

In single file each shouldering his hod pass onward the
laborers;

Seasons pursuing each other the indescribable crowd is
gather'd, it is the fourth of Seventh-month, (what salutes
of cannon and small arms!)

Seasons pursuing each other the plougher ploughs, the

mower mows, and the winter-grain falls in the ground;

Off on the lakes the pike-fisher watches and waits by the
hole in the frozen surface,

The stumps stand thick round the clearing, the squatter
strikes deep with his axe,

Flatboatmen make fast towards dusk near the cotton-wood
or pecan-trees,

Coon-seekers go through the regions of the Red river or
through those drain'd by the Tennessee, or through those
of the Arkansas,

Torches shine in the dark that hangs on the Chattahooche
or Altamahaw,

Patriarchs sit at supper with sons and grandsons and great-
grandsons around them,

In walls of adobie, in canvas tents, rest hunters and trappers
after their day's sport,

The city sleeps and the country sleeps,

The living sleep for their time, the dead sleep for their time,

The old husband sleeps by his wife and the young husband
sleeps by his wife;

And these tend inward to me, and I tend outward to them,

And such as it is to be of these more or less I am,

And of these one and all I weave the song of myself.

READING 76
from Walt Whitman (1819–1892), Leaves of Grass, Songs of Parting

*The second and third of these poems date to 1865, the others to the
1860 edition of Leaves of Grass. Between them they illustrate many
of the characteristics of Whitman's poetry. The mood is optimistic, even
when the poet contemplates his own end. America, with its Manifest
Destiny, symbolizes hope for the world. Even the tragedy of the Civil
War can teach a positive lesson.*

*The style is rhetorical, and Whitman uses the device of repetition
to hammer home his message. Place names are given a magic ring. We
are reminded again and again that these are songs, while always in the
forefront is the poet himself, the ever-present I.*

As the Time Draws Nigh

As the time draws nigh glooming a cloud,
A dread beyond of I know not what darkens me.

I shall go forth,
I shall traverse the States awhile, but I cannot tell whither
or how long,
Perhaps soon some day or night while I am singing my
voice will suddenly cease.

O book, O chants! must all then amount to but this?
Must we barely arrive at this beginning of us?—and yet
it is enough, O soul;
O soul, we have positively appear'd—that is enough.

Years of the Modern

Years of the modern! years of the unperform'd!
Your horizon rises, I see it parting away for more august
dramas,
I see not America only, not only Liberty's nation but other
nations preparing,
I see tremendous entrances and exits, new combinations,
the solidarity of races,
I see that force advancing with irresistible power on the
world's stage,

(Have the old forces, the old wars, played their parts? are
 the acts suitable to them closed?)
I see Freedom, completely arm'd and victorious and very
 haughty, with Law on one side and Peace on the
 other,
A stupendous trio all issuing forth against the idea of
 caste;
What historic denouements are these we so rapidly approach?
I see men marching and countermarching by swift
 millions, 10
I see the frontiers and boundaries of the old aristocracies
 broken,
I see the landmarks of European kings removed,
I see this day the People beginning their landmarks, (all
 others give way;)
Never were such sharp questions ask'd as this day,
Never was average man, his soul, more energetic, more
 like a God,

Lo, how he urges and urges, leaving the masses no rest!
His daring foot is on land and sea everywhere, he
 colonizes the Pacific, the archipelagoes,
With the steamship, the electric telegraph, the newspaper,
 the wholesale engines of war,
With these and the world-spreading factories he inter-
 links all geography, all lands;
What whispers are these O lands, running ahead of you,
 passing under the seas? 20
Are all nations communing? is there going to be but one
 heart to the globe?
Is humanity forming en-masse? for lo, tyrants tremble,
 crowns grow dim,
The earth, restive, confronts a new era, perhaps a general
 divine war,
No one knows what will happen next, such portents fill
 the days and nights;
Years prophetical! the space ahead as I walk, as I vainly
 try to pierce it, is full of phantoms,
Unborn deeds, things soon to be, project their shapes
 around me,
This incredible rush and heat, this strange ecstatic fever
 of dreams O years!
Your dreams O years, how they penetrate through me!
 (I know not whether I sleep or wake;)
The perform'd America and Europe grow dim, retiring in
 shadow behind me,
The unperform'd, more gigantic than ever, advance,
 advance upon me. 30

Ashes of Soldiers

Ashes of soldiers South or North,
As I muse retrospective murmuring a chant in thought,
The war resumes, again to my sense your shapes,
And again the advance of the armies.

Noiseless as mists and vapors,
From their graves in the trenches ascending,
From cemeteries all through Virginia and Tennessee,
From every point of the compass out of the countless
 graves,
In wafted clouds, in myriads large, or squads of twos or
 threes or single ones they come,
And silently gather round me. 10

Now sound no note O trumpeters,
Not at the head of my cavalry parading on spirited horses,
With sabers drawn and glistening, and carbines by their
 thighs, (ah my brave horsemen!

My handsome tan-faced horsemen! what life, what joy
 and pride,
With all the perils were yours.)

Nor you drummers, neither at reveillé at dawn,
Nor the long roll alarming the camp, nor even the
 muffled beat for a burial,
Nothing from you this time O drummers bearing my
 warlike drums.

But aside from these and the marts of wealth and the
 crowded promenade,
Admitting around me comrades close unseen by the rest
 and voiceless, 20
The slain elate and alive again, the dust and debris alive,
I chant this chant of my silent soul in the name of all dead
 soldiers.
Faces so pale with wondrous eyes, very dear, gather
 closer yet,
Draw close, but speak not.

Phantoms of countless lost,
Invisible to the rest henceforth become my companions,
Follow me ever—desert me not while I live.
Sweet are the blooming cheeks of the living— sweet are
 the musical voices sounding,
But sweet, ah sweet, are the dead with their silent eyes.

Dearest comrades, all is over and long gone, 30
But love is not over—and what love, O comrades
Perfume from battle-fields rising, up from the foetor
 arising.
Perfume therefore my chant, O love, immortal love,
Give me to bathe the memories of all dead soldiers,
Shroud them, embalm them, cover them all over with
 tender pride.
Perfume all—make all wholesome,
Make these ashes to nourish and blossom,
O love, solve all, fructify all with the last chemistry.
Give me exhaustless, make me a fountain,
That I exhale love from me wherever I go like a moist
 perennial dew, 40
For the ashes of all dead soldiers South or North.

Thoughts

1

Of these years I sing,
How they pass and how pass'd through convuls'd pains,
 as through parturitions,
How America illustrates birth, muscular youth, the
 promise, the sure fulfilment, the absolute success,
 despite of people—illustrates evil as well as good,
The vehement struggle so fierce for unity in one's-self;
How many hold despairingly yet to the models departed,
 caste, myths, obedience, compulsion, and to
 infidelity,
How few see the arrived models, the athletes, the Western
 States, or see freedom or spirituality, or hold any
 faith in results,
(But I see the athletes, and I see the results of the war
 glorious and inevitable, and they again leading to
 other results.)

How the great cities appear—how the Democratic
 masses, turbulent, willful, as I love them,
How the whirl, the context, the wrestle of evil with good,
 the sounding and resounding, keep on and on,
How society waits unform'd, and is for a while 10

between things ended and things begun,
How America is the continent of glories, and of the
 triumph of freedom and of the Democracies, and
 of the fruits of society, and of all that is begun,
And how the States are complete in themselves— and
 how all triumphs and glories are complete in themselves,
 to lead onward,
And how these of mine and of the States will in their turn
 be convuls'd, and serve other parturitions and
 transitions,
And how all people, sights, combinations, the democratic
 masses too, serve—and how every fact, and war
 itself, with all its horrors, serves,
And how now or at any time each serves the exquisite
 transition of death.

2

Of seeds dropping into the ground, of births,
Of the steady concentration of America, inland, upward,
 to impregnable and swarming places,
Of what Indiana, Kentucky, Arkansas, and the rest, are
 to be,
Of what a few years will show there in Nebraska,
 Colorado, Nevada, and the rest,
(Or afar, mounting the Northern Pacific to Sitka or
 Alaska,)
Of what the feuilage of America is the preparation for—
 and of what all sights, North, South, East and
 West are,
Of this Union welded in blood, of the solemn price paid,
 of the unnamed lost ever present in my mind;
Of the temporary use of materials for identity's sake,
Of the present, passing, departing—of the growth of
 completer men than any yet,
Of all sloping down there where the fresh free giver the
 mother, the Mississippi flows, 10
Of mighty inland cities yet unsurvey'd and
 unsuspected,
Of the new and good names, of the modern develop-
 ments, of inalienable homesteads,
Of a free and original life there, of simple diet and clean
 and sweet blood,
Of litheness, majestic faces, clear eyes, and perfect
 physique there,
Of immense spiritual results future years far West, each
 side of the Anahuacs,
Of these songs, well understood there, (being made for
 that area,)
Of the native scorn of grossness and gain there,
(O it lurks in me night and day what is gain after all to
 savageness and freedom?)

Song at Sunset

Splendor of ended day floating and filling me,
Hour prophetic, hour resuming the past,
Inflating my throat, you divine average,
You earth and life till the last ray gleams I sing.

Open mouth of my soul uttering gladness,
Eyes of my soul seeing perfection,
Natural life of me faithfully praising things,
Corroborating forever the triumph of things.

Illustrious every one!
Illustrious what we name space, sphere of unnumber'd
 spirits, 10
Illustrious the mystery of motion in all beings, even the
 tiniest insect,

Illustrious the attribute of speech, the senses, the body,
Illustrious the passing light—illustrious the pale reflec-
 tion on the new moon in the western sky,
Illustrious whatever I see or hear or touch, to the last.

Good in all,
In the satisfaction and aplomb of animals,
In the annual return of the seasons,
In the hilarity of youth,
In the strength and flush of manhood,
In the grandeur and exquisiteness of old age, 20
In the superb vistas of death.

Wonderful to depart!
Wonderful to be here!
The heart, to jet the all-alike and innocent blood!
To breathe the air, how delicious!
To speak—to walk—to seize something by the hand!
To prepare for sleep, for bed, to look on my rose-color'd
 flesh!
To be conscious of my body, so satisfied, so large!
To be this incredible God I am!
To have gone forth among other Gods, these men and
 women I love. 30

Wonderful how I celebrate you and myself!
How my thoughts play subtly at the spectacles around!
How the clouds pass silently overhead!
How the earth darts on and on! and how the sun, moon,
 stars, dart on and on!
How the water sports and sings! (surely it is alive!)
How the trees rise and stand up, with strong trunks, with
 branches and leaves!
(Surely there is something more in each of the trees, some
 living soul.)
O amazement of things—even the least particle!
O spirituality of things!
O strain musical flowing through ages and continents,
 now reaching me and America! 40
I take your strong chords, intersperse them, and cheer-
 fully pass them forward.

I too carol the sun, usher'd or at noon, or as now, setting,
I too throb to the brain and beauty of the earth and of all
 the growths of the earth,
I too have felt the resistless call of myself.

As I steam'd down the Mississippi,
As I wander'd over the prairies,
As I have lived, as I have look'd through my windows
 my eyes,
As I went forth in the morning, as I beheld the light
 breaking in the east,
As I bathed on the beach of the Eastern Sea, and again on
 the beach of Western Sea,
As I roam'd the streets of inland Chicago, whatever
 streets I have roam'd, 50
Or cities or silent woods, or even amid the sights of war,
Wherever I have been I have charged myself with con-
 tentment and triumph.

I sing to the last the equalities modern or old,
I sing the endless finalés of things,
I say Nature continues, glory continues,
I praise with electric voice,
For I do not see one imperfection in the universe,
And I do not see one cause or result lamentable at last in
 the universe.

O setting sun! though the time has come,
I still warble under you, if none else does, unmitigated
 adoration. 60

READING 77
from EMILY DICKINSON (1830–1886)

Feeling no pressure to publish her nearly 1800 poems, Dickinson developed a personal style that was remarkably free, intense, and idiomatic. Among her sources of inspiration were hymns and popular jingles. The following poems, typically untitled, are short and easy to grasp, but have a power and emotional force out of all proportion to their simple form. Dickinson had the ability to find an image and make it vivid—the jewel in the second poem, the slanting light in the third. Yet her recurring theme is complex: the effect that our awareness of death has on our lives. For all the moments of happiness or hope, her vision is essentially a bleak one.

(125)

For each ecstatic
We must an anguish pay
In keen and quivering ratio
To the ecstasy.

For each beloved hour
Sharp pittances of years—
Bitter contested farthings
And Coffers heaped with Tears!
(c. 1859)

(245)

I held a Jewel in my fingers—
And went to sleep—
The day was warm, and winds were prosy—
I said "'Twill keep"

I woke—and chid my honest fingers,
The Gem was gone—
And now, an Amethyst remembrance
Is all I own.
(c. 1861)

(258)

There's a certain Slant of light,
Winter Afternoons—
That oppresses, like the Heft
Of Cathedral Tunes—

Heavenly Hurt, it gives us—
We can find no scar,
But internal difference,
Where the Meanings are—

None may teach it—Any— 10
'Tis the Seal Despair
An imperial Affliction
Sent us of the Air—

When it comes, the Landscape listens—
Shadows—hold their breath—
When it goes, 'tis like the Distance
On the look of Death—
(c. 1861)

(529)

I'm sorry for the Dead—Today—
It's such congenial times
Old Neighbors have at fences—
It's time o' year for Hay.

And Broad—Sunburned Acquaintance
Discourse between the Toil—
And laugh, a homely species
That makes the Fences smile—

It seems so straight to lie away
From all the noise of Fields— 10
The busy Carts—the fragrant Cocks—
The Mower's Metre—Steals

A Trouble lest they're homesick—
Those Farmers—and their Wives
Set Separate from the Farming—
And all the Neighbors' lives—

A Wonder if the Sepulchre
Don't feel a lonesome way—
When Men—and Boys—and Carts—and June,
Go down the Fields to "Hay"— 20
(c. 1862)

(712)

Because I could not stop for Death—
He kindly stopped for me—
The Carriage held but just Ourselves—
And Immortality.

We slowly drove—He knew no haste
And I had put away
My labor and my leisure too,
For His Civility—

We passed the School, where Children strove
At Recess—in the Ring— 10
We passed the Fields of Gazing Grain—
We passed the Setting Sun—

Or rather—He passed Us—
The Dews drew quivering and chill—
For only Gossamer, my Gown—
My Tippet—only Tulle—

We paused before a House that seemed
A Swelling of the Ground—
The Roof was scarcely visible—
The Cornice—in the Ground— 20

Since then—'tis Centuries—and yet
Feels shorter than the Day
I first surmised the Horses' Heads
Were toward Eternity—
(c. 1863)

(760)

Elysium is as far as to
The very nearest Room
If in that Room a Friend await
Felicity or Doom—

What fortitude the Soul contains,
That it can so endure
The accent of a coming Foot—
The opening of a Door—
(c. 1882)

CHAPTER 18

READING 78

ANTON CHEKHOV (1860–1904),

THE BET (1889)

Many readers of this famous story have asked about the wager it describes: "Who won?" Whichever of the two suffers the most, their plight underlines Chekhov's concern for the human condition and the isolation and sense of futility that have become part of the modern condition. The last sentence adds a final note of typical Chekhovian irony.

I

It was a dark autumn night. The old banker was pacing from corner to corner of his study, recalling to his mind the party he gave in the autumn fifteen years before. There were many clever people at the party and much interesting conversation. They talked among other things of capital punishment. The guests, among them not a few scholars and journalists, for the most part disapproved of capital punishment. They found it obsolete as a means of punishment, unfitted to a Christian State and immoral. Some of them thought that capital punishment should be replaced universally by life imprisonment.

"I don't agree with you," said the host. "I myself have experienced neither capital punishment nor life imprisonment, but if one may judge *a priori*, then in my opinion capital punishment is more moral and more humane than imprisonment. Execution kills instantly, life imprisonment kills by degrees. Who is the more humane executioner, one who kills you in a few seconds or one who draws the life out of you incessantly, for years?"

"They're both equally immoral," remarked one of the guests, "because their purpose is the same, to take away life. The State is not God. It has no right to take away that which it cannot give back, if it should so desire."

Among the company was a lawyer, a young man of about twenty-five. On being asked his opinion, he said:

"Capital punishment and life imprisonment are equally immoral; but if I were offered the choice between them, I would certainly choose the second. It's better to live somehow than not to live at all."

There ensued a lively discussion. The banker, who was then younger and more nervous, suddenly lost his temper, banged his fist on the table, and turning to the young lawyer, cried out:

"It's a lie. I bet you two million you wouldn't stick in a cell even for five years."

"If you mean it seriously," replied the lawyer, "then I bet I'll stay not five but fifteen."

"Fifteen! Done!" cried the banker. "Gentlemen, I stake two million."

"Agreed. You stake two million, I my freedom," said the lawyer.

So this wild, ridiculous bet came to pass. The banker, who at that time had too many millions to count, spoiled and capricious, was beside himself with rapture. During supper he said to the lawyer jokingly:

"Come to your senses, young man, before it's too late. Two million are nothing to me, but you stand to lose three or four of the best years of your life. I say three or four, because you'll never stick it out any longer. Don't forget either, you unhappy man, that voluntary is much heavier enforced imprisonment. The idea that you have the right to free yourself at any moment will poison the whole of your life in the cell. I pity you."

And now the banker, pacing from corner to corner, recalled all this and asked himself:

"Why did I make this bet? What's the good? The lawyer loses fifteen years of his life and I throw away two million. Will it convince people that capital punishment is worse or better than imprisonment for life? No, no! All stuff and rubbish. On my part, it was the caprice of a well-fed man; on the lawyer's pure greed of gold."

He recollected further what happened after the evening party. It was decided that the lawyer must undergo his imprisonment under the strictest observation, in a garden wing of the banker's house. It was agreed that during the period he would be deprived of the right to cross the threshold, to see living people, to hear human voices, and to receive letters and newspapers. He was permitted to have a musical instrument, to read books, to write letters, to drink wine and smoke tobacco. By the agreement he could communicate, but only in silence, with the outside world through a little window specially constructed for this purpose. Everything necessary, books, music, wine, he could receive in any quantity by sending a note through the window. The agreement provided for all the minutest details, which made the confinement strictly solitary, and it obliged the lawyer to remain exactly fifteen years from twelve o'clock of November 14th, 1870, to twelve o'clock of November 14th, 1885. The least attempt on his part to violate the conditions, to escape if only for two minutes before the time, freed the banker from the obligation to pay him the two million.

During the first year of imprisonment, the lawyer, as far as it was possible to judge from his short notes, suffered terribly from loneliness and boredom. From his wing day and night came the sound of the piano. He rejected wine and tobacco. "Wine," he wrote, "excites desires, and desires are the chief foes of a prisoner; besides, nothing is more boring than to drink good wine alone, and tobacco spoils the air in his room."

During the first year the lawyer was sent books of a light character; novels with a complicated love interest, stories of crime and fantasy, comedies, and so on.

In the second year the piano was heard no longer and the lawyer asked only for classics. In the fifth year, music was heard again, and the prisoner asked for wine. Those who watched him said that during the whole of that year he was only eating, drinking, and lying on his bed.

He yawned often and talked angrily to himself. Books he did not read. Sometimes at night he would sit down to write. He would write for a long time and tear it all up in the morning. More than once he was heard to weep.

In the second half of the sixth year, the prisoner began zealously to study languages, philosophy, and history. He fell on these subjects so hungrily that the banker hardly had time to get books enough for him. In the space of four years about six hundred volumes were bought at his request. It was while that passion lasted that the banker received the following letter from the prisoner: "My dear gaoler, I am writing these lines in six languages. Show them to experts. Let them read them. If they do not find one single mistake, I beg you to give orders to have a gun fired off in the garden. By the noise I shall know that my efforts have not been in vain. The geniuses of all ages and countries speak in different languages; but in them all burns the same flame. Oh, if you knew my heavenly happiness now that I can understand them!" The prisoner's desire was fulfilled. Two shots were fired in the garden by the banker's order.

Later on, after the tenth year, the lawyer sat immovable before his table and read only the New Testament. The banker found it strange that a man who in four years had mastered six hundred erudite volumes, should have spent nearly a year in reading one book, easy to understand and by no means thick. The New Testament was then replaced by the history of religions and theology.

During the last two years of his confinement the prisoner read an extraordinary amount, quite haphazard. Now he would apply himself to the natural sciences, then he would read Byron or Shakespeare. Notes used to come from him in which he

asked to be sent at the same time a book on chemistry, a text-book of medicine, a novel, and some treatise on philosophy or theology. He read as though he were swimming in the sea among broken pieces of wreckage, and in his desire to save his life was eagerly grasping one piece after another.

II

The banker recalled all this, and thought:

"Tomorrow at twelve o'clock he receives his freedom. Under the agreement, I shall have to pay him two million. If I pay, it's all over with me. I am ruined forever . . ."

Fifteen years before he had too many millions to count, but now he was afraid to ask himself which he had more of, money or debts.

Gambling on the Stock Exchange, risky speculation, and the recklessness of which he could not rid himself even in old age, had gradually brought his business to decay; and the fearless, self-confident, proud man of business had become an ordinary banker, trembling at every rise and fall in the market.

"That cursed bet," murmured the old man clutching his head in despair. . . . "Why didn't the man die? He's only forty years old. He will take away my last farthing, marry, enjoy life, gamble on the exchange, and I will look on like an envious beggar and hear the same words from him every day: 'I'm obliged to you for the happiness of my life. Let me help you.' No. it's too much! The only escape from bankruptcy and disgrace—is that the man should die."

The clock had just struck three. The banker was listening. In the house every one was asleep, and one could hear only the frozen trees whining outside the windows. Trying to make no sound, he took out of his safe the key of the door which had not been opened for fifteen years, put on his overcoat, and went out of the house. The garden was dark and cold. It was raining. A damp, penetrating wind howled in the garden and gave the trees no rest. Though he strained his eyes, the banker could see neither the ground, nor the white statues, nor the garden wing, nor the trees. Approaching the garden wing, he called the watchman twice. There was no answer. Evidently the watchman had taken shelter from the bad weather and was now asleep somewhere in the kitchen or the greenhouse.

"If I have the courage to fulfill my intention," thought the old man, "the suspicion will fall on the watchman first of all."

In the darkness he groped for the steps and the door and entered the hall of the garden wing, then poked his way into a narrow passage and struck a match. Not a soul was there. Someone's bed, with no bedclothes on it, stood there, and an iron stove loomed dark in the corner. The seals on the door that led into the prisoner's room were unbroken.

When the match went out, the old man, trembling from agitation, peeped into the little window.

In the prisoner's room a candle was burning dimly. The prisoner himself sat by the table. Only his back, the hair on his head and his hands were visible. Open books were strewn about on the table, the two chairs, and on the carpet near the table.

Five minutes passed and the prisoner never once stirred. Fifteen years' confinement had taught him to sit motionless. The banker tapped on the window with his finger, but the prisoner made no movement in reply. Then the banker cautiously tore the seals from the door and put the key into the lock. The rusty lock gave a hoarse groan and the door creaked. The banker expected instantly to hear a cry of surprise and the sound of steps. Three minutes passed and it was as quiet as it had been before. He made up his mind to enter.

Before the table sat a man, unlike an ordinary human being. It was a skeleton, with tight-drawn skin, with long curly hair like a woman's, and a shaggy beard. The color of his face was yellow, of an earthy shade; the cheeks were sunken, the back long and narrow, and the hand upon which he leaned his hairy head was so lean and skinny that is was painful to look upon. His hair was already silvering with gray, and no one who glanced at the senile emaciation of the face would have believed that he was only forty years old. On the table, before his bent head, lay a sheet of paper on which something was written in a tiny hand.

"Poor devil," thought the banker, "he's asleep and probably seeing millions in his dreams. I have only to take and throw this half-dead thing on the bed, smother him a moment with the pillow, and the most careful examination will find no trace of unnatural death. But, first, let us read what he has written here."

The banker took the sheet from the table and read:

"Tomorrow at twelve o'clock midnight, I shall obtain my freedom and the right to mix with people. But before I leave this room and see the sun I think it necessary to say a few words to you. On my own clear conscience and before God who sees me I declare to you that I despise freedom, life, health, and all that your books call the blessings of the world.

"For fifteen years I have diligently studied earthly life. True, I saw neither the earth nor the people, but in your books I drank fragrant wine, sang songs, hunted deer and wild boar in the forests, loved women. . . . And beautiful women, like clouds ethereal, created by the magic of your poets' genius, visited me by night and whispered to me wonderful tales, which made my head drunken. In your books I climbed the summits of Elburz and Mont Blanc and saw from there how the sun rose in the morning, and in the evening suffused the sky, the ocean, and the mountain ridges with a purple gold. I saw from there how above me lightning glimmered cleaving the clouds; I saw green forests, fields, rivers, lakes, cities; I heard sirens singing, and the playing of the pipes of Pan; I touched the wings of beautiful devils who came flying to me to speak of God. . . . In your books I cast myself into bottomless abysses, worked miracles, burned cities to the ground, preached new religions, conquered whole countries. . . .

"Your books gave me wisdom. All that unwearying human thought created in the centuries is compressed to a little lump in my skull. I know that I am cleverer than you all.

"And I despise your books, despise all worldly blessings and wisdom. Everything is void, frail, visionary and delusive as a mirage. Though you be proud and wise and beautiful, yet will death wipe you from the face of the earth like the mice underground; and your posterity, your history, and the immortality of your men of genius will be as frozen slag, burnt down together with the terrestrial globe.

"You are mad, and gone the wrong way. You take falsehood for truth and ugliness for beauty. You would marvel if suddenly apple and orange trees should bear frogs and lizards instead of fruit, and if roses should begin to breathe the odor of a sweating horse. So do I marvel at you, who have bartered heaven for earth. I do not want to understand you.

"That I may show you in deed my contempt for that by which you live, I waive the two million of which I once dreamed as of paradise, and which I now despise. That I may deprive myself of my right to it, I shall come out from here five minutes before the stipulated term, and thus shall violate the agreement."

When he had read, the banker put the sheet on the table, kissed the head of the strange man, and began to weep. He went out of the wing.

Never at any other time, not even after his terrible losses on the exchange, had he felt such contempt for himself as now. Coming home, he lay down on his bed, but agitation and tears kept him a long time from sleeping. . . .

The next morning the poor watchman came running to him and told him that they had seen the man who lived in the wing climb through the window into the garden. He had gone to the gate and disappeared. The banker instantly went with his servants to the wing and established the escape of his prisoner. To avoid unnecessary rumors he took the paper with the renunciation from the table and, on his return, locked it in his safe.

READING 79

from HENRIK IBSEN (1828–1906),
A DOLL'S HOUSE (1879)

In this famous scene Ibsen, through the words of his character Nora, challenges many of the nineteenth century's most cherished illusions about marriage and the family. The insights Nora has gained into her husband's nature and the quality of their relationship mean nothing to Helmer when she tries to explain them to him. In the course of the dialogue the two struggle in mutual incomprehension as Nora describes her feelings of alienation and Helmer continues to respond with astonishment to the idea of his wife being concerned with "serious thoughts." By the end she leaves because she "can't spend the night in a strange man's house."

Ibsen has sometimes been accused of writing "problem plays" in which the ideas are more important than the characters. It is certainly true that Nora and Helmer are chiefly concerned with articulating their points of view. Yet amid the heated arguments both of them emerge as individuals. With great difficulty Helmer gradually begins to understand something of Nora's anguish. As for Nora, the whole of her past life is unforgettably described in the metaphor she uses to sum it up, which gives the play its name: a doll's house.

Act III, final scene

[THE ACTION TAKES PLACE LATE AT NIGHT, IN THE HELMERS' LIVING ROOM. NORA, INSTEAD OF GOING TO BED, HAS SUDDENLY REAPPEARED IN EVERYDAY CLOTHES.]

HELMER . . . What's all this? I thought you were going to bed. You've changed your dress?

NORA Yes, Torvald; I've changed my dress.

HELMER But what for? At this hour?

NORA I shan't sleep tonight.

HELMER But, Nora dear—

NORA [*looking at her watch*] It's not so very late—Sit down. Torvald; we have a lot to talk about.

[SHE SITS AT ONE SIDE OF THE TABLE.]

HELMER Nora—what does this mean? Why that stern expression? 10

NORA Sit down. It'll take some time. I have a lot to say to you.

[HELMER SITS AT THE OTHER SIDE OF THE TABLE.]

HELMER You frighten me, Nora. I don't understand you.

NORA No, that's just it. You don't understand me; and I have never understood you either—until tonight. No, don't interrupt me. Just listen to what I have to say. This is to be a final settlement, Torvald.

HELMER How do you mean?

NORA [*after a short silence*] Doesn't anything special strike you as we sit here like this? 20

HELMER I don't think so—why?

NORA It doesn't occur to you, does it, that though we've been married for eight years, this is the first time that we two—man and wife—have sat down for a serious talk?

HELMER What do you mean by serious?

NORA During eight whole years, no—more than that—ever since the first day we met—we have never exchanged so much as one serious word about serious things. 30

HELMER Why should I perpetually burden you with all my cares and problems? How could you possibly help me to solve them?

NORA I'm not talking about cares and problems. I'm simply saying we've never once sat down seriously and tried to get to the bottom of anything.

HELMER But, Nora, darling—why should you be concerned with serious thoughts?

NORA That's the whole point! You've never understood me—A great injustice has been done me, Torvald; first by Father, and then by you. 40

HELMER What a thing to say! No two people on earth could ever have loved you more than we have!

NORA [*shaking her head*] You never loved me. You just thought it was fun to be in love with me.

HELMER This is fantastic!

NORA Perhaps. But it's true all the same. While I was still at home I used to hear Father airing his opinions and they became my opinions; or if I didn't happen to agree, I kept it to myself—he 50 would have been displeased otherwise. He used to call me his doll-baby, and played with me as I played with my dolls. Then I came to live in your house—

HELMER What an expression to use about our marriage!

NORA [*undisturbed*] I mean—from Father's hands I passed into yours. You arranged everything according to your tastes, and I acquired the same tastes, or I pretended to—I'm not sure which—a little of both, perhaps. Looking back on it all, it seems to me I've lived here like a beg- 60 gar, from hand to mouth. I've lived by performing tricks for you, Torvald. But that's the way you wanted it. You and Father have done me a great wrong. You've prevented me from becoming a real person.

HELMER Nora, how can you be so ungrateful and unreasonable! Haven't you been happy here?

NORA No, never. I thought I was; but I wasn't really.

HELMER Not—not happy! 70

NORA No, only merry. You've always been so kind to me. But our home has never been anything but a play-room. I've been your doll-wife, just as at home I was Papa's doll-child. And the children in turn, have been my dolls. I thought it fun when you played games with me, just as they thought it fun when I played games with them. And that's been our marriage, Torvald.

HELMER There may be a grain of truth in what you say, even though it is distorted and exaggerated. From now on things will be different. Play- 80 time is over now; tomorrow lessons begin!

NORA Whose lessons? Mine, or the children's?

HELMER Both, if you wish it, Nora, dear.

NORA Torvald, I'm afraid you're not the man to teach me to be a real wife to you.

HELMER How can you say that?

NORA And I'm certainly not fit to teach the children.

HELMER Nora!

NORA Didn't you just say, a moment ago, you
 didn't dare trust them to me?

HELMER That was in the excitement of the mo-
 ment! You mustn't take it so seriously!

NORA But you were quite right, Torvald. That job
 is beyond me; there's another job I must do first:
 I must try and educate myself. You could never
 help me to do that; I must do it quite alone. So,
 you see that's why I'm going to leave you.

HELMER *[jumping up]* What did you say—?

NORA I shall never get to know myself—I shall
 never learn to face reality—unless I stand alone.
 So I can't stay with you any longer.

HELMER Nora! Nora!

NORA I am going at once. I'm sure Kristine will
 let me stay with her tonight—

HELMER But, Nora—this is madness! I shan't al-
 low you to do this. I shall forbid it!

NORA You no longer have the power to forbid me
 anything. I'll only take a few things with me—
 those that belong to me. I shall never again ac-
 cept anything from you.

HELMER Have you lost your senses?

NORA Tomorrow I'll go home—to what was
 my home, I mean. It might be easier for me
 there, to find something to do.

HELMER You talk like an ignorant child, Nora—!

NORA Yes. That's just why I must educate myself.

HELMER To leave hour home—to leave your hus-
 band, and your children! What do you suppose
 people would say to that?

NORA It makes no difference. This is something I
 must do.

HELMER It's inconceivable? Don't you realize
 you'd be betraying your most sacred duty?

NORA What do you consider that to be?

HELMER Your duty toward your husband and
 your children—I surely don't have to tell
 you that!

NORA I've another duty just as sacred.

HELMER Nonsense! What duty do you mean?

NORA My duty toward myself.

HELMER Remember—before all else you are a
 wife and mother.

NORA I don't believe that anymore. I believe that
 before all else I am a human being, just as you
 are—or at least that I should try and become
 one. I know that most people would agree with
 you, Torvald—and that's what they say in
 books. But I can no longer be satisfied with what
 most people say or what they write in books. I
 must think things out for myself—get clear
 about them.

HELMER Surely your position in your home is
 clear enough? Have you no sense of religion?
 Isn't that an infallible guide to you?

NORA But don't you see, Torvald—I don't really
 know what religion is.

HELMER Nora! How *can* you!

NORA All I know about it is what Pastor Hansen
 told me when I was confirmed. He taught me
 what he thought religion was—said it was *this*
 and *that*. As soon as I get away by myself, I shall
 have to look into that matter too, try and de-
 cide whether what he taught me was right—or
 whether it's right for *me,* at least.

HELMER A nice way for a young woman to talk!

It's unheard of! If religion means nothing to you,
 I'll appeal to your conscience; you must have
 some sense of ethics, I suppose? Answer me! Or
 have you none?

NORA It's hard for me to answer you, Torvald. I
 don't think I know—all these things bewilder
 me. But I do know that I think quite different-
 ly from you about them. I've discovered that the
 law, for instance, is quite different from what I
 had imagined; but I find it hard to believe it can
 be right. It seems it's criminal for a woman to try
 and spare her old, sick, father, or save her hus-
 band's life! I can't agree with that.

HELMER You talk like a child. You have no under-
 standing of the society we live in.

NORA No, I haven't. But I'm going to try and
 learn. I want to find out which of us is right—
 society or I.

HELMER You are ill, Nora; you have a touch of
 fever; you're quite beside yourself.

NORA I've never felt so sure—so clear-headed—
 as I do tonight.

HELMER "Sure and clear-headed" enough to leave
 your husband and your children?

NORA Yes.

HELMER Then there is only one explanation possible.

NORA What?

HELMER You don't love me any more.

NORA No; that is just it.

HELMER Nora!—What are you saying!

NORA It makes me so unhappy, Torvald; for
 you've always been so kind to me. But I can't
 help it. I don't love you anymore.

HELMER *[mastering himself with difficulty]* You feel
 "sure and clear-headed" about this too?

NORA Yes, utterly sure. That's why I can't stay
 here any longer.

HELMER And can you tell me how I lost your love?

NORA Yes, I can tell you. It was tonight—when
 the wonderful thing didn't happen; I knew then
 you weren't the man I always thought you were.

HELMER I don't understand.

NORA For eight years I've been waiting patiently;
 I knew, of course, that such things don't happen
 every day. Then, when this trouble came to
 me—I thought to myself: Now! Now the
 wonderful thing will happen! All the time
 Krogstad's letter was out there in the box, it
 never occurred to me for a single moment that
 you'd think of submitting to his conditions. I
 was absolutely convinced that you'd defy him—
 that you'd tell him to publish the thing to all the
 world; and that then—

HELMER You mean you thought I'd let my wife be
 publicly dishonored and disgraced?

NORA No. What I thought you'd do, was to take
 the blame upon yourself.

HELMER Nora—!

NORA I know! You think I never would have accep-
 ted such a sacrifice. Of course I wouldn't! But
 my word would have meant nothing against
 yours. That was the wonderful thing I hoped for,
 Torvald, hoped for with such terror. And it was
 to prevent that, that I chose to kill myself.

HELMER I'd gladly work for you day and night,
 Nora—go through suffering and want, if
 need be—but one doesn't sacrifice one's honor
 for love's sake.

NORA Millions of women have done so.

HELMER You think and talk like a silly child.

NORA Perhaps. But you neither think nor talk like
the man I want to share my life with. When
you'd recovered from your fright—and you
never thought of me, only of yourself—when
you had nothing more to fear—you behaved
as though none of this had happened. I was your
little lark again, your little doll—whom you
would have to guard more carefully than ever,
because she was so weak and frail. *[stands up]* At
that moment it suddenly dawned on me that I
had been living here for eight years with a stranger 230
and that I'd borne him three children. I can't bear
to think about it! I could tear myself to pieces!

HELMER *[sadly]* I see, Nora—I understand;
there's suddenly a great void between us—Is
there no way to bridge it?

NORA Feeling as I do now, Torvald—I could
never be a wife to you.

HELMER But, if I were to change? Don't you think
I'm capable of that?

NORA Perhaps—when you no longer have your 240
doll to play with.

HELMER It's inconceivable! I can't part with you,
Nora. I can't endure the thought.

NORA *[going into room on the right]* All the more rea-
son it should happen.

*[SHE COMES BACK WITH OUTDOOR THINGS AND A SMALL
TRAVELING BAG, WHICH SHE PLACES ON A CHAIR.]*

HELMER But not at once, Nora—not now! At least
wait till tomorrow.

NORA *[putting on cloak]* I can't spend the night in a
strange man's house.

HELMER Couldn't we go on living here together? 250
As brother and sister, if you like—as friends.

NORA *[fastening her hat]* You know very well that
wouldn't last, Torvald. *[puts on the shawl]*
Goodbye. I won't go in and see the children.
I know they're in better hands than mine. Being
what I am—how can I be of any use to them?

HELMER But surely, some day, Nora—?

NORA How can I tell? How do I know what sort
of person I'll become?

HELMER You are my wife, Nora, now and always! 260

NORA Listen to me, Torvald—I've always heard
that when a wife deliberately leaves her hus-
band as I am leaving you, he is legally freed
from all responsibility toward her. At any rate, I
release you now from all responsibility. You
mustn't feel yourself bound, any more than I
shall. There must be complete freedom on both
sides. Here is your ring. Now give me mine.

HELMER That too?

NORA That too. 270

HELMER Here it is.

NORA So—it's all over now. Here are the keys.
The servants know how to run the house—
better than I do. I'll ask Kristine to come
by tomorrow, after I've left town; there are a
few things I brought with me from home; she'll
pack them up and send them on to me.

HELMER You really mean it's over, Nora? *Really*
over? You'll never think of me again?

NORA I expect I shall often think of you; of you— 280
and the children, and this house.

HELMER May I write to you?

NORA No—never. You mustn't! Please! 220

HELMER At least, let me send you—

NORA Nothing!

HELMER But, you'll let me help you, Nora—

NORA No, I say! I can't accept anything from strangers.

HELMER Must I always be a stranger to you,
Nora?

NORA *[taking her traveling bag]* Yes. Unless it were to
happen—the most wonderful thing of all— 290

HELMER What?

NORA Unless we both could change so that—Oh,
Torvald! I no longer believe in miracles, you see!

HELMER Tell me! Let me believe! Unless we both
could change so that—?

NORA So that our life together might truly be a
marriage. Good-bye.

[SHE GOES OUT BY THE HALL DOOR.]

HELMER *[sinks into a chair by the door with his face in his
hands]* Nora! Nora! *[he looks around the room and
rises]* She is gone! How empty it all seems! *[a hope
springs up in him]* The most wonderful thing
of all—? 300

*[FROM BELOW IS HEARD THE REVERBERATION
OF A HEAVY DOOR CLOSING.]*

CURTAIN

From Act III of A Doll's House by Henrik Ibsen, translated by Eva Le Gal-
lienne in *Six Plays by Henrik Ibsen*, © 1957 Eva Le Gallienne. Reprinted by
permission of International Creative Management, Inc.

READING 80
KATE CHOPIN (1851–1904), THE STORY
OF AN HOUR (1894)

*This story illustrates several aspects of Chopin's narrative art. Most of it
consists of a stream-of-consciousness account of Mrs. Mallard's thoughts,
but at the very end there is a sudden switch to objective observation—
except, of course, that we know that the observation is wrong. The ability
to think the unthinkable is characteristically bold. The ironies in the tale
are many-layered. Finally the proportions are perfect, and brevity serves
to reinforce the story's considerable impact.*

Knowing that Mrs. Mallard was afflicted with a heart trouble,
great care was taken to break to her as gently as possible the
news of her husband's death.

It was her sister Josephine who told her, in broken sen-
tences; veiled hints that revealed in half concealing. Her hus-
band's friend Richards was there, too, near her. It was he who
had been in the newspaper office when intelligence of the rail-
road disaster was received, with Brently Mallard's name leading
the list of "killed." He had only taken the time to assure himself
of its truth by a second telegram, and had hastened to forestall
any less careful, less tender friend in bearing the sad message.

She did not hear the story as many women have heard the
same, with a paralyzed inability to accept its significance. She
wept at once, with sudden, wild abandonment, in her sister's
arms. When the storm of grief had spent itself she went away to
her room alone. She would have no one follow her.

There stood, facing the open window, a comfortable, roomy
armchair. Into this she sank, pressed down by a physical exhaus-
tion that haunted her body and seemed to reach into her soul.

She could see in the open square before her house the tops
of trees that were all aquiver with the new spring life. The deli-

cious breath of rain was in the air. In the street below a peddler was crying his wares. The notes of a distant song which some one was singing reached her faintly, and countless sparrows were twittering in the eaves.

There were patches of blue sky showing here and there through the clouds that had met and piled one above the other in the west facing her window.

She sat with her head thrown back upon the cushion of the chair, quite motionless, except when a sob came up into her throat and shook her, as a child who has cried itself to sleep continues to sob in its dreams.

She was young, with a fair, calm face, whose lines bespoke repression and even a certain strength. But now there was a dull stare in her eyes, whose gaze was fixed away off yonder on one of those patches of blue sky. It was not a glance of reflection, but rather indicated a suspension of intelligent thought.

There was something coming to her and she was waiting for it, fearfully. What was it? She did not know; it was too subtle and elusive to name. But she felt it, creeping out of the sky, reaching toward her through the sounds, the scents, the color that filled the air.

Now her bosom rose and fell tumultuously. She was beginning to recognize this thing that was approaching to possess her, and she was striving to beat it back with her will—as powerless as her two white slender hands would have been.

When she abandoned herself a little whispered word escaped her slightly parted lips. She said it over and over under her breath: "free, free, free!" The vacant stare and the look of terror that had followed it went from her eyes. They stayed keen and bright. Her pulses beat fast, and the coursing blood warmed and relaxed every inch of her body.

She did not stop to ask if it were or were not a monstrous joy that held her. A clear and exalted perception enabled her to dismiss the suggestion as trivial.

She knew that she would weep again when she saw the kind, tender hands folded in death; the face that had never looked save with love upon her, fixed and gray and dead. But she saw beyond that bitter moment a long procession of years to come that would belong to her absolutely. And she opened and spread her arms out to them in welcome.

There would be no one to live for her during those coming years; she would live for herself. There would be no powerful will bending hers in that blind persistence with which men and women believe they have a right to impose a private will upon a fellow-creature. A kind intention or a cruel intention made the act seem no less a crime as she looked upon it in that brief moment of illumination.

And yet she had loved him—sometimes. Often she had not. What did it matter! What could love, the unsolved mystery, count for in face of this possession of self-assertion which she suddenly recognized as the strongest impulse of her being!

"Free! Body and soul free!" she kept whispering.

Josephine was kneeling before the closed door with her lips to the keyhole, imploring for admission. "Louise, open the door! I beg; open the door—you will make yourself ill. What are you doing, Louise? For heaven's sake open the door."

"Go away. I am not making myself ill." No; she was drinking in a very elixir of life through that open window.

Her fancy was running riot along those days ahead of her. Spring days, and summer days, and all sorts of days that would be her own. She breathed a quick prayer that life might be long. It was only yesterday she had thought with a shudder that life might be long.

She arose at length and opened the door to her sister's importunities. There was a feverish triumph in her eyes, and she carried herself unwittingly like a goddess of Victory. She clasped her sister's waist, and together they descended the stairs. Richards stood waiting for them at the bottom.

Someone was opening the front door with a latchkey. It was Brently Mallard who entered, a little travel-stained, composedly carrying his grip-sack and umbrella. He had been far from the scene of the accident, and did not even know there had been one. He stood amazed at Josephine's piercing cry; at Richards' quick motion to screen him from the view of his wife.

But Richards was too late.

When the doctors came they said she had died of heart disease—of joy that kills.

READING 81
from KATE CHOPIN (1851–1904),
THE AWAKENING (1899)

These passages from Kate Chopin's novelette trace the short adult life of Edna Pontellier, who "apprehended instinctively the dual life—that outward existence which conforms, the inward life which questions." A member of upper-class Creole society in the New Orleans of the late 1800s, Edna is vacationing with her family on Grand Isle when she begins to awaken to herself as an indvidual, a self ultimately at odds with conventional obligations to society and family. In the end, she weighs the cost of sacrificing that individual self to her outward existence.

Mr. Pontellier ... fixed his gaze upon a white sunshade that was advancing at snail's pace from the beach. He could see it plainly between the gaunt trunks of the water-oaks and across the stretch of yellow camomile. . . . Beneath its pink-lined shelter were his wife, Mrs. Pontellier, and young Robert Lebrun. When they reached the cottage, the two seated themselves with some appearance of fatigue upon the upper step of the porch, facing each other, each leaning against a supporting post.

"What folly! to bathe at such an hour in such heat!" exclaimed Mr. Pontellier. He himself had taken a plunge at daylight. . . .

"You are burnt beyond recognition," he added, looking at his wife as one looks at a valuable piece of personal property which has suffered some damage.

She held up her hands, strong, shapely hands, and surveyed them critically, drawing up her lawn sleeves above the wrists. Looking at them reminded her of her rings, which she had given to her husband before leaving for the beach. She silently reached out to him, and he, understanding, took the rings from his vest pocket and dropped them into her open palm. (4–5)

. . .

It would have been a difficult matter for Mr. Pontellier to define to his own satisfaction or any one else's wherein his wife failed in her duty toward their children. It was something which he felt rather than perceived, and he never voiced the feeling without subsequent regret and ample atonement.

If one of the little Pontellier boys took a tumble whilst at play, he was not apt to rush crying to his mother's arms for comfort; he would more likely pick himself up, wipe the water out of his eyes and the sand out of his mouth, and go on playing. . . .

In short, Mrs. Pontellier was not a mother-woman. The mother-women seemed to prevail that summer at Grand Isle. It was easy to know them, fluttering about with extended, protecting wings when any harm, real or imaginary, threatened their precious brood. They were women who idolized their children, worshiped their husbands, and esteemed it a holy privilege to efface themselves as individuals and grow wings as ministering angels. (18–19)

. . .

Edna Pontellier could not have told why, wishing to go to the beach with Robert, she should in the first place have declined,

and in the second place have followed in obedience to one of the two contradictory impulses which impelled her.

A certain light was beginning to dawn dimly within her,— the light which, showing the way, forbids it.

At that early period it served but to bewilder her. It moved her to dreams, to thoughtfulness, to the shadowy anguish which had overcome her the midnight when she had abandoned herself to tears.

In short, Mrs. Pontellier was beginning to realize her position in the universe as a human being, and to recognize her relations as an individual to the world within and about her. This may seem like a ponderous weight of wisdom to descend upon the soul of a young woman of twenty-eight—perhaps more wisdom than the Holy Ghost is usually pleased to vouchsafe to any woman.

But the beginning of things, of a world especially, is necessarily vague, tangled, chaotic, and exceedingly disturbing. How few of us ever emerge from such beginning! How many souls perish in its tumult!

The voice of the sea is seductive; never ceasing, whispering, clamoring, murmuring, inviting the soul to wander for a spell in abysses of solitude; to lose itself in mazes of inward contemplation.

The voice of the sea speaks to the soul. The touch of the sea is sensuous, enfolding the body in its soft, close embrace. (33–34)

. . .

Her marriage to Léonce Pontellier was purely an accident, in this respect resembling many other marriages which masquerade as the decrees of Fate. . . . He fell in love, as men are in the habit of doing, and pressed his suit with an earnestness and an ardor which left nothing to be desired. He pleased her; his absolute devotion flattered her. She fancied there was a sympathy of thought and taste between them, in which fancy she was mistaken. . . . As the devoted wife of a man who worshiped her, she felt she would take her place with a certain dignity in the world of reality, closing the portals forever behind her upon the realm of romance and dreams. . . . She grew fond of her husband, realizing with some unaccountable satisfaction that no trace of passion or excessive and fictitious warmth colored her affection, thereby threatening its dissolution. (35, 46–47)

. . .

Edna had attempted all summer to learn to swim. She had received instructions from both the men and women; in some instances from the children. . . . A certain ungovernable dread hung about her when in the water, unless there was a hand near by that might reach out and reassure her.

But that night she was like the little tottering, stumbling, clutching child, who of a sudden realizes its powers, and walks for the first time alone, boldly and with over-confidence. She could have shouted for joy. She did shout for joy, as with a sweeping stroke or two she lifted her body to the surface of the water.

A feeling of exultation overtook her, as if some power of significant import had been given her to control the working of her body and her soul. She grew daring and reckless, overestimating her strength. She wanted to swim far out, where no woman had swum before. . . .

"How easy it is!" she thought. "It is nothing," she said aloud; "why did I not discover before that it was nothing. Think of the time I have lost splashing about like a baby!" She would not join the groups in their sports and bouts, but intoxicated with her newly conquered power, she swam out alone.

She turned face seaward to gather in an impression of space and solitude, which the vast expanse of water, meeting and melting with the moonlit sky, conveyed to her excited fancy. As she swam she seemed to be reaching out for the unlimited in which to lose herself. (70–71)

. . .

"What are you doing out here, Edna? I thought I should find you in bed," said her husband, when he discovered her lying there [after her swim]. He had walked up with Madame Lebrun and left her at the house. His wife did not reply.

"Are you asleep?" he asked, bending down close to look at her.

"No." Her eyes gleamed bright and intense, with no sleepy shadows, as they looked into his.

"Do you know it is past one o'clock? Come on," and he mounted the steps and went into their room.

"Edna!" called Mr. Pontellier from within, after a few moments had gone by.

"Don't wait for me," she answered. He thrust his head through the door.

"You will take cold out there," he said, irritably. "What folly is this? Why don't you come in?"

"It isn't cold; I have my shawl."

"The mosquitoes will devour you."

"There are no mosquitoes."

She heard him moving about the room; every sound indicating impatience and irritation. Another time she would have gone in at his request. She would, through habit, have yielded to his desire; not with any sense of submission or obedience to his compelling wishes, but unthinkingly, as we walk, move, sit, stand, go through the daily treadmill of the life which has been portioned out to us.

"Edna, dear, are you not coming in soon?" he asked again, this time fondly, with a note of entreaty.

"No; I am going to stay out here."

"This is more than folly," he blurted out. "I can't permit you to stay out there all night. You must come in the house instantly."

With a writhing motion she settled herself more securely in the hammock. She perceived that her will had blazed up, stubborn and resistant. She could not at that moment have done other than denied and resisted. She wondered if her husband had ever spoken to her like that before, and if she had submitted to his command. Of course she had; she remembered that she had. But she could not realize why or how she should have yielded, feeling as she then did.

"Léonce, go to bed," she said. "I mean to stay out here. I don't wish to go in, and I don't intend to. Don't speak to me like that again; I shall not answer you." (78–80)

. . .

She let her mind wander back over her stay at Grand Isle; and she tried to discover wherein this summer had been different from any and every other summer of her life. She could only realize that she herself—her present self—was in some way different from the other self. That she was seeing with different eyes and making the acquaintance of new conditions in herself that colored and changed her environment, she did not yet suspect. (102)

. . .

Edna had once told Madame Ratignolle that she would never sacrifice herself for her children, or for any one.

Then had followed a rather heated argument; the two women did not appear to understand each other or to be talking the same language. Edna tried to appease her friend, to explain.

"I would give up the unessential; I would give my money, I would give my life for my children; but I wouldn't give myself. I can't make it more clear; it's only something which I am beginning to comprehend, which is revealing itself to me."

"I don't know what you would call the essential, or what you mean by the unessential," said Madame Ratignolle, cheerfully; "but a woman who would give her life for her children could do no more than that—your Bible tells you so. I'm sure I couldn't do more than that."

"Oh, yes you could!" laughed Edna. (121–122)

. . .

She began to do as she liked and to feel as she liked.... Mr. Pontellier had been a rather courteous husband so long as he met a certain tacit submissiveness in his wife. But her new and unexpected line of conduct completely bewildered him. It shocked him. Then her absolute disregard for her duties as a wife angered him. When Mr. Pontellier became rude, Edna grew insolent. She had resolved never to take another step backward.

"It seems to me the utmost folly for a woman at the head of a household, and the mother of children, to spend in an atelier days which would be better employed contriving for the comfort of her family."

"I feel like painting," answered Edna. "Perhaps I shan't always feel like it."

"Then in God's name paint! but don't let the family go to the devil." . . .

It sometimes entered Mr. Pontellier's mind to wonder if his wife were not growing a little unbalanced mentally. He could see plainly that she was not herself. That is, he could not see that she was becoming herself and daily casting aside that fictitious self which we assume like a garment with which to appear before the world....

Her husband let her alone as she requested, and went away to his office. Edna went up to her atelier—a bright room in the top of the house. She was working with great energy and interest . . . For a time she had the whole household enrolled in the service of art. The boys posed for her. They thought it amusing at first, but the occupation soon lost its attractiveness when they discovered that it was not a game arranged especially for their entertainment. The quadroon sat for hours before Edna's palette, patient as a savage, while the housemaid took charge of the children, and the drawing-room went undusted. But the housemaid, too, served her term as model when Edna perceived that the young woman's back and shoulders were molded on classic lines, and that her hair, loosened from its confining cap, became an inspiration.

While Edna worked she sometimes sang low the little air, "Ah! si tu savais!" [Ah! if you knew!] (147–149)

. . .

One morning on his way into town Mr. Pontellier stopped at the house of his old friend and family physician, Doctor Mandelet.... "I came to consult—no, not precisely to consult—to talk to you about Edna. I don't know what ails her . . . she seems quite well . . . but she doesn't act well. She's odd, she's not like herself. I can't make her out, and I thought perhaps you'd help me.... Her whole attitude—toward me and everybody and everything—has changed."

"Has she," asked the Doctor, with a smile, "has she been associating of late with a circle of pseudo-intellectual women—super-spiritual superior beings? My wife has been telling me about them."

"That's the trouble," broke in Mr. Pontellier," she hasn't been associating with any one. She has abandoned her Tuesdays at home, has thrown over all her acquaintances, and goes tramping about by herself, moping in the street-cars, getting in after dark. I tell you she's peculiar. I don't like it; I feel a little worried over it." . . .

"I'll drop in to dinner some evening . . ."

"Do! by all means," urged Mr. Pontellier. "What evening will you come? Say Thursday." . . .

When Doctor Mandelet dined with the Pontelliers on Thursday he could discern in Mrs. Pontellier no trace of that morbid condition which her husband had reported to him. She was excited and in a manner radiant.... He observed his hostess attentively from under his shaggy brows, and noted a subtle change which had transformed her from the listless woman he had known into a being who, for the moment, seemed palpitant with the forces of life. Her speech was warm and energetic. There was no repression in her glance or gesture. She reminded him of some beautiful, sleek animal waking up in the sun. (168–173, 181)

. . .

There was with her a feeling of having descended in the social scale, with a corresponding sense of having risen in the spiritual. Every step which she took toward relieving herself from obligations added to her strength and expansion as an individual. She began to look with her own eyes; to see and to apprehend the deeper undercurrents of life. No longer was she content to "feed upon opinion" when her own soul had invited her. (246)

. . .

The water of the Gulf stretched out before her, gleaming with the million lights of the sun. The voice of the sea is seductive, never ceasing, whispering, clamoring, murmuring, inviting the soul to wander in abysses of solitude. All along the white beach, up and down, there was no living thing in sight. A bird with a broken wing was beating the air above, reeling, fluttering, circling disabled down, down to the water.

Edna had found her old bathing suit still hanging, faded, upon its accustomed peg.

She put it on, leaving her clothing in the bath-house. But when she was there beside the sea, absolutely alone, she cast the unpleasant, pricking garments from her, and for the first time in her life she stood naked in the open air, at the mercy of the sun, the breeze that beat upon her, and the waves that invited her.

How strange and awful it seemed to stand naked under the sky! how delicious! She felt like some new-born creature, opening its eyes in a familiar world that it had never known.

The foamy wavelets curled up to her white feet, and coiled like serpents about her ankles. She walked out. The water was chill, but she walked on. The water was deep, but she lifted her white body and reached out with a long, sweeping stroke. The touch of the sea is sensuous, enfolding the body in its soft, close embrace.

She went on and on.... Her arms and legs were growing tired. She thought of Léonce and the children. They were a part of her life. But they need not have thought that they could possess her, body and soul.... Exhaustion was pressing upon and overpowering her.... the shore was far behind her, and her strength was gone. (300–302)

CHAPTER 19

READING 82
Prem Chand (Dhanpat Ray Srivastav, 1880–1936), The Shroud (1936)

Prem Chand was one of India's leading writers, in both Hindi and Urdu, during the first part of the twentieth century. He worked for many years as a schoolteacher and schools inspector, but in 1921, on the advice of Gandhi, Chand withdrew from government service to devote himself to Gandhi's Non-Cooperation Movement. In short stories and novels, he tried to describe to the outside world the grim life that so many of India's poorest villagers led. His story, The Shroud depicts the all-but-hopeless conditions that existed for millions of Indians over countless generations,

and that, of course, still afflict many today. The fate of Madhava's wife shows that even in a society almost utterly bereft of material goods, the women suffer most. In a poignant touch, the author does not even give her a name.

I

Father and son were sitting silently at the door of their hut beside the embers of a fire. Inside, the son's young wife, Bud-hiya, was suffering the pangs of childbirth. Every now and then she gave such piercing cries that the hearts of both men seemed to stop beating. It was a winter night; all was silent and the whole village was plunged in darkness.

Gheesu said, "She may be dying. We've been out chasing around all day. You ought to go in now and see how she is."

Madhava answered peevishly, "If she has to die, then the sooner the better. What's there to see?"

"You're heartless. Such lack of consideration for the wife with whom you lived so pleasantly for a whole year!"

"I can't bear to watch her in pain and torment."

Theirs was a family of cobblers notorious throughout the village. Gheesu worked for a day, then rested for three days. His son, Madhava, tired so quickly that he needed an hour for a smoke after every half hour of work. Therefore they could find little work anywhere. If they had no more than a handful of grain in the house, they refused to stir themselves. After a couple of days' fasting, Gheesu would climb a tree and break off some branches for firewood. Madhava would take it to the bazaar and sell it. As long as they had any of the proceeds in their pockets, both of them lazed about. When it came to the fasting point once more, they again collected firewood or looked for work.

There was no dearth of work in their peasant village; in fact, there were a hundred jobs for a hard-working man. But these two were called only in emergencies, when an employer had to be content with two people doing the work of one. If they had been ascetics, they would not have needed restraint or discipline to cultivate contentment and patience. It was part of their nature.

Their life was strange. They had no property at all in the house except a few mud pots. They covered their nakedness with a few tattered rags. With no worldly cares and anxieties, in spite of their burden of debts, they suffered abuse and beatings, but they were never sad. They were so destitute that people always lent them something or other, though there was never any hope of the debt being repaid. During the season for peas and potatoes, they habitually plundered somebody's field. Sometimes they uprooted sugar cane and made a meal out of it. Gheesu had passed his sixty years in this bohemian fashion, and Madhava, as became a good son, was treading in his father's footsteps. He was even adding to the glories of the ancestral name.

Gheesu's wife had died long ago; Madhava had married only a year ago. Since his wife had come to their house, she had tried to introduce some sort of order in the family. She managed to earn a handful of flour either by grinding corn for somebody or by mowing grass, and this filled the bellies of these two shameless creatures. Since she had come, they had grown even more indolent. They had even begun putting on airs. If somebody called them to work, they coolly asked for double wages. Now she was suffering the agony of a difficult birth, and the two seemed to be only waiting for her to die so that they could sleep undisturbed.

Gheesu dug out a stolen potato from the ashes, and proceeding to peel it, he said, "Just go and see how she is. Some ghost must have got hold of her; what else can it be? Perhaps a doctor could help, but here even the healer wants nothing less than a rupee."

Madhava was afraid that Gheesu would polish off most of the potatoes if he were to go inside. He said, "I'm afraid to go inside."

"What are you afraid of? I'm right here."

"Why don't you go in yourself, then, and see how things are?"

"When my wife died, I never left her side for three whole days. Your wife will feel shy of me. I've never even seen her face, and now you want me to see her naked body! Her clothes are probably all in disorder. If she were to see me, even the little relief of thrashing her arms and legs about would be denied her."

"I'm thinking what will happen if a child is born. We've nothing at all in the house—oil, candy, and the rest."

"We'll have everything, God willing! The same people who refuse us even a crust of bread today will send for us and offer us money tomorrow. Nine sons were born to me, and we never had anything in the house. But God helped us to pull through, anyhow."

In a society in which to condition of those who toiled honestly day and night was hardly better than theirs, while those who knew how to take advantage of the weaknesses of the peasants were flourishing and prosperous, the growth of an attitude of mind like this was nothing very strange. We may even conclude that Gheesu was far wiser than the honest people were, having cast lot with the ignoble tribe of idlers instead of joining the bunch of unthinking peasants. True, he had no finesse in observing the rules and policies that enrich nonproducers. Therefore, while the other members of this class ruled the roost in the village as its leaders and chief men, he was merely the object of the entire village's scorn. Still, he at least did not have to indulge in back-breaking toil day and night. Moreover, other people did not get rich at the expense of his innocence.

Both men dug the potatoes out of the ashes and consumed them while they were still scorching hot. As they had eaten nothing since the day before, they didn't have the patience to let them cool. They each burned their tongues several times. They gobbled at top speed, though their eyes watered at the effort.

Gheesu recalled at this moment the landowner's wedding party which he had attended twenty years ago. The satisfaction he had found in that feast was something worth remembering all his life, and the memory was still fresh in his mind. He said, "I can't forget that landowner's feast. I have never since had food to equal it. The bride's party had ordered enough wheat cakes to satisfy everyone. Every single person, small or great, was fed on those cakes, fried in the best butter. Every delicacy was provided—pickles, curds, four varieties of curry, chutney, sweets! How can I describe to you how wonderful that meal was? There were no limits. You could ask for anything you liked and have as much of it as you pleased. We ate so much that there was hardly any room left for a drop of water. Those who were serving went on supplying the guests with hot, round, and fragrant cakes. You said you didn't want them, you covered your leaf plate with your hands, but still they put them down before you. When everybody had rinsed his mouth and wiped his hands, they offered betel nut, too. But I had no thought of betel nut that day. I could hardly stand up. I went and collapsed on my blanket. Ah, but that landowner was generous that day!"

Madhava savored the wonder of these delicacies in his imagination and said, "These days we never have a feast like that."

"Who can afford such a feast now? That was a different age. Now everyone wants to economize. They don't spend either at weddings or funerals. Then what are they going to do with all the money plundered from the poor? There's a limit to piling up of money! They ought to go as easy on grabbing as they do on spending."

"You must have eaten at least twenty cakes?"

"More than twenty!"

"I would have eaten at least fifty!"

"I couldn't have eaten less than fifty. I was strong then. You aren't even half the size I was."

They drank some water after finishing the potatoes and lay down by the fire, their knees pulled up to their bellies, covering themselves with their loincloths. They were like two huge pythons curled up.

And Madhava's wife, Budhiya, was still moaning.

II

When Madhava entered the hut in the morning, his wife lay dead and cold. Flies swarmed over her face. Her eyes were fixed in a glassy stare. Her whole body was covered with dust. The child had died in the womb.

Madhava came rushing out to Gheesu. Each started wailing loudly and beating his breast. When the neighbors heard this uproar, they came running and tried to console the bereaved in the time-honored fashion.

But there was not much time for weeping and wailing. They had to buy a shroud and wood for the funeral pyre. Money was as scarce in their house as meat in the nest of a kite!

Father and son went weeping to the landowner's house. He hated the very sight of these two, both of whom he had beaten on several occasions with his own hands for thieving and for failing to come to work after promising to. He asked, "What is it, Gheesu? Why are you weeping, you rogue? I never even see you now. It seems you do not wish to live in this village any more."

Gheesu touched the ground with his forehead; his eyes were filled with tears. He said, "Master, I am in very great trouble. Madhava's wife passed away last night. She was in agony the whole night long. We sat by her side through it all. We arranged for medicine and did all we could. But she has departed. Now there is no one to feed us even a crust of bread, sir! We are ruined. Our home has been devastated. I am your slave, master. Who is there except you to help us in arranging her last rites? We have spent all we had on her treatment. Her body can be removed only if you take pity on us. There is no one else I can turn to."

The landowner was a kindhearted person. But he knew that to show pity to Gheesu was wasted effort. He wanted to say, "Get out! You don't come at all when we send for you; but now that you're in trouble, you come bowing and scraping. Scoundrel!"

But this was no occasion for anger or reprimands. Annoyed as he was, he threw down two rupees. He uttered not a word of solace, however. He did not even glance in Gheesu's direction.

When the landowner had given two rupees, how could the shopkeepers and moneylenders of the village refuse to give anything? Gheesu knew well how to use the landowner's name in his favor. One man offered two annas; another gave four. Within an hour Gheesu had collected the respectable sum of five rupees. He got grain from one place and wood from another. At midday Gheesu and Madhava went to fetch cloth for a shroud from the bazaar. Neighbors began to cut bamboo and make other preparations.

The tenderhearted ones among the village women came to view the dead body and shed a few tears over Budhiya's unhappy fate.

III

When they reached the bazaar, Gheesu said, "We've got enough wood to burn her body; isn't that right, Madhava?"

Madhava said, "Yes, we have enough wood. Now we need a shroud."

"Then come, let us buy a cheap shroud."

"Yes, of course. It'll be dark before the body is removed. Who's going to see at night what sort of a shroud it is?"

"What a bad custom it is that one who gets hardly a stitch of cloth while living must have a new cloth for a shroud when dead."

"The shroud is, after all, burned with the body."

"Of course. Does anyone think it survives? Had we got these five rupees earlier, we could have given her some medicines and looked after her properly."

Each guessed the other's secret thoughts. They wandered about in the bazaar. They went to this cloth shop and that. They examined various kinds of cloth, silk and cotton, but approved of none. Gradually it became evening. Then, by some sort of heavenly guidance, they reached a liquor shop and went in, as though according to a prearranged plan. They stood there for a while, hesitating; then Gheesu approached the counter and said, "Sir, please give us a bottle, too."

They got something to nibble at and some fried fish, and then both sat down on the veranda of the liquor shop to drink peacefully.

After several tumblefuls downed in a great hurry, the liquor began taking effect.

Gheesu said, "A shroud would have been useless. It would have just got burned. It couldn't possibly go to heaven with her."

Madhava looked at the sky as though calling upon the gods to be witnesses to his innocence, and said, "It's just the custom. But why should people give thousands of rupees to Brahmans? Who can know whether it ever reaches our loved ones in heaven or not?"

"The rich have wealth to squander. They are welcome to do so. We haven't got anything to waste."

"But what will you say to people who ask where the shroud is?"

Gheesu laughed. "We'll tell them we lost the money somewhere. We looked for it everywhere, but found no trace of it. They won't believe us, but they'll have to give us money a second time."

Madhava also laughed at this unexpected good fortune. He said, "She was a good wife. She provides for us even after her death!"

More than half the bottle had been consumed. Gheesu sent for several pounds of cakes. Also pickles, liver, and chutney. There was a meat shop right in front of the liquor shop. Madhava rushed over and brought everything back in two leaf-covered bundles. He spent a whole rupee and a half on it. Now they had only a few small coins left.

The two were eating cakes with great righteousness, like lions feeding on game in the jungle. They feared neither explanations nor ill fame. They had got over such feelings years ago.

Gheesu spoke philosophically. "Our hearts are blessing her for this feast. That would be a virtuous deed in her favor."

Madhava bowed his head reverently and said, "Certainly that would be. O God, All-knowing One! Take her to heaven. We both bless her from our hearts. We are eating today as never before in our lives."

After a while a certain curiosity arose in Madhava's heart. "Father, will we also go to heaven someday?"

Gheesu gave no reply to this innocent query. He did not wish to spoil the joy of the present moment by thinking about the other world.

"If she asks us there why we gave her no shroud, then what will you say?"

"Nonsense!"

"She will certainly ask us."

"How do you know that she'll have not shroud? Do you think I'm such a fool? Have I learned nothing in all my sixty years on earth? She'll have a shroud and a better one than we could have given her."

Madhava was skeptical. He asked, "Who will give it to her? You spent the money, but it's me she'll call to account. It was I who took on the responsibility, when I married her."

Gheesu got angry and said, "I tell you she'll have her shroud. Why don't you listen to me?"

"Then tell me who will give it?"

"The same people who gave it last time. Only this time, we won't be given any cash."

As darkness grew and the splendor of the stars increased, the liquor shop, too, hummed with greater gaiety. One customer sang, another talked big, a third embraced his companions, and another put his cup to the lips of a friend.

There was intoxication in the very spirit of the place and in the air surrounding it. Many grew drunk here just on a couple of drops. They found the atmosphere even more intoxicating than the liquor. The vicissitudes of life drew them here where they forgot for a time whether they were alive or dead, or didn't care which.

And these two—father and son—continued to sip happily. All eyes were focused on them. How lucky they were! They had a whole bottle between them.

After they had eaten their fill, Madhava gave the remaining cakes to a beggar who stood looking hungrily at them. He experienced for the first time in his life the joy, pride, and glory of giving something.

Gheesu said, "Take it, eat your fill, and bless us! She whose earnings these are has died. But your blessings will certainly reach her. Let each hair on your body bless her. This money she earned the hard way."

Madhava again looked up at the sky and said, "She will go to heaven, Father! She will be the queen of heaven."

Gheesu stood up, and as though swimming on waves of elation, said, "Yes, son! She will go to heaven. She never troubled or oppressed anyone. Even in dying, she fulfilled the most heartfelt desire of our lives. If she is not to go to heaven, who then should go there? The fat ones who plunder the poor, then bathe in the Ganges and offer incense in temples to wash away their sins?"

This mood of reverence soon passed. Fickleness is the special virtue of intoxication. They now struck a note of grief and despair.

Madhava: "But Father, the poor thing suffered hell in this life. How painfully she died!"

He began to weep again, covering his eyes with his hands. Gheesu consoled him. "Why do you weep, son? You should be happy that she has found her release from this mortal bondage. She has been liberated from her sorrows. She was very fortunate in breaking through the bonds of Maya so early."

Then they both stood up and started singing:

O Maya, deceitful one, Goddess of Illusion,
Cast not your beguiling eyes at us.

The eyes of all the other drunkards were focused on this pair as they sang merrily, full of their own joy of intoxication. Then they began to dance. They jumped and leaped; they fell down and rolled their eyes. They gesticulated and dramatized their emotions. And in the end they sank down dead drunk.

READING 83
from WU CH'ENG-EN (C. 1501–1580), MONKEY

In this episode from Wu Ch'eng-en's long novel, describing the journey of the Buddhist priest Tripitaka and his companion Monkey to India, Tripitaka loses his horse to a greedy dragon. When the priest, in tearful despair, turns for help to various deities (who symbolize administrators in China's labyrinthine bureaucracy), they only make things more complicated, and it is left to Monkey—who has little patience or respect for the various Bodhisattvas and other spirits—to remedy the situation.

Chapter XV

It was mid-winter, a fierce north wind was blowing and icicles hung everywhere. Their way took them up precipitous cliffs and across ridge after ridge of jagged mountain. Presently Tripitaka heard the roaring of a torrent and asked Monkey what this river might be. 'I remember,' said Monkey, 'that there is a river near here called the Eagle Grief Stream.' A moment later they came suddenly to the river side, and Tripitaka reined in his horse. They were looking down at the river, when suddenly there was a swirling sound and a dragon appeared in midstream. Churning the waters, it made straight for the shore, clambered up the bank and had almost reached them, when Monkey dragged Tripitaka down from the horse and turning his back to the river, hastily threw down the luggage and carried the Master up the bank. The dragon did not pursue them, but swallowed the horse, harness and all, and then plunged once more into the stream. Meanwhile Monkey had set down Tripitaka upon a high mound, and gone back to recover the horse and luggage. The luggage was there, but the horse had disappeared. He brought up the luggage to where Tripitaka was sitting.

'The dragon has made off,' he said. 'The only trouble is that the horse has taken fright and bolted.'

'How are we to find it?' asked Tripitaka.

'Just wait while I go and have a look,' said Monkey. He sprang straight up into the sky, and shading his fiery eyes with his hand he peered down in every direction. But nowhere was the least sign of the horse. He lowered his cloud-trapeze.

'I can't see it anywhere,' he said. 'There is only one thing that can have happened to it. It has been eaten by the dragon.'

'Now Monkey, what can you be thinking of?' said Tripitaka. 'It would have to have a big mouth indeed to swallow a large horse, harness and all. It is much more likely that it bolted and is hidden by a fold of the hill. You had better have another look.'

'Master, you underrate my power,' said Monkey. 'My sight is so good that in daylight I can see everything that happens a thousand leagues around. Within a thousand leagues a gnat cannot move its wings without my seeing it. How could I fail to see a horse?'

'Well, suppose it has been eaten,' said Tripitaka, 'how am I to travel? It's a great deal too far to walk.' And as he spoke his tears began to fall like rain.

'Don't make such an object of yourself,' shouted Monkey, infuriated by this exhibition of despair. 'Just sit here, while I go and look for the wretch and make him give us back the horse.'

'You can't do anything unless he comes out of the water,' said Tripitaka, 'and if he does it will be me that he will eat this time.'

'You're impossible, impossible,' thundered Monkey, angrier than ever. 'You say you need the horse to ride, and yet you won't let me go and recover it. At this rate, you'll sit here staring at the luggage forever.'

He was still storming, when a voice spoke out of the sky, saying, 'Monkey, do not be angry. Priest of T'ang, do not weep. We divinities have been sent by Kuan-yin to protect you in your quest.' Tripitaka at once did obeisance.

'Which divinities are you?' cried Monkey. 'Tell me your names, and I'll tick you off on the roll.'

'Here present are Lu Ting and Lu Chia,' they said, 'the Guardians of the Five Points, the Four Sentinels, and the Eighteen Protectors of Monasteries. We attend upon you in rotation.'

'And which of you are on duty this morning?' asked Monkey.

'Lu Chia, one Sentinel and the Protectors are on duty,' they said, 'and the Golden-headed Guardian is always somewhere about, night and day.'

'Those who aren't on duty can retire,' said Monkey. 'But Lu Ting, the Sentinel of the day, and all the Guardians had better stay and look after the Master, while I go to the river and look for that dragon, and see if I can get him to return the horse.'

Tripitaka, feeling somewhat reassured, sat down on the bank, begging Monkey to be careful. 'Don't you worry about me!' said Monkey.

Dear Monkey! He tightened the belt of his brocade jacket, hitched up his tiger-skin, grasped his iron cudgel, and going straight down to the water's edge called in a loud voice, 'Cursed fish, give me back my horse!' The dragon way lying quietly at the bottom of the river, digesting the white horse. But hearing someone cursing him and demanding his prey, he fell into a great rage, and leapt up through the waves crying, 'Who is it that dares make such a hullabaloo outside my premises?'

'Stand your ground,' hissed Monkey, 'and give me back my horse.' He brandished hid cudgel and struck at the dragon's head. The dragon advanced upon him with open jaws and threatening claws. It was a valiant fight that those two had on the banks of the river. To and fro they went, fighting for a long while, hither and thither, round and round. At last the dragon's strength began to fail, he could hold out no longer, and with a rapid twist of the tail he fled from the encounter and disappeared in the river. Monkey, standing on the bank, cursed and taunted him unceasingly, but he turned a deaf ear. Monkey saw nothing for it but to go back and report to Tripitaka.

'Master,' he said, 'I taunted him till he came out and fought many bouts, and in the end he took fright and ran away. He is now at the bottom of the river and won't come out.'

'We are still not sure whether he did swallow the horse,' said Tripitaka.

'How can you say such a thing?' said Monkey. 'If he hadn't eaten it, why should he have come out and answered my challenge?'

'The other day when you dealt with that tiger,' said Tripitaka, 'you mentioned that you could also subdue dragons. I don't understand why you are having such difficulties with this dragon today.'

To such a taunt as this no one could be more sensitive than Monkey. 'Not another word!' he cried, stung to the quick. 'I'll soon show you which is master!'

He strode to the stream-side, and used a magic which stirred up the clear waters of the river till they became as turbulent as the waves of the Yellow River. The dragon soon became very uncomfortable as he lay at the bottom of the stream. 'Misfortunes never come singly,' he thought to himself. 'Hardly a year has passed since I barely escaped with my life from the Tribunal of Heaven and was condemned to this exile; and now I have fallen foul of this cursed monster, who seems determined to do me injury.' The more he thought, the angrier he became. At last, determined not to give in, he leapt up through the waves and gnashing his teeth he snarled, 'What monster are you, and where do you come from, that you dare affront me in this fashion?'

'Never mind where I come from or don't come from,' said Monkey. 'Just give me back my horse, or you shall pay for it with your life.'

'Your horse,' said the dragon, 'is inside me. How am I to give it back to you? And anyhow, if I don't, what can you do to me?'

'Have a look at this cudgel,' said Monkey. 'If you don't give me back the horse you shall pay for it with your life.'

Again they fought upon the bank, and after several rounds the dragon could hold out no longer, made one great wriggle, and changing itself into a water-snake, disappeared into the long grass. Beating the grass with his cudgel, Monkey pranced wildly about, trying to track it down, but all in vain. At last, fuming with impatience, he uttered a loud Om, as a secret summons to the spirits of the locality. In a moment they were kneeling before him.

'Hold out your shanks,' said Monkey, 'and I'll give you each five strokes with the cudgel just to relieve my feelings.'

'Great Sage,' they besought him, 'pray give us a chance to put our case to you. We had no idea that you had been released from your penance, or we should have come to meet you before. We humbly beg you to forgive us.'

'Very well then,' said Monkey. 'You shan't be beaten. But answer me this. Where does this dragon come from, who lives in the Eagle Grief River? Why did he swallow my Master's white horse?'

'Great Sage,' they said, 'in old days you had no Master, and indeed refused obedience to any power in Heaven or Earth. What do you mean by your Master's horse?'

'After I got into trouble about that affair in Heaven,' said Monkey, 'I had to do penance for five hundred years. But now I have been taken in hand by the Bodhisattva Kuan-yin and put in charge of a priest who is going to India to fetch Scriptures. I was travelling with him as a disciple, when we lost my Master's horse.'

'If you want to catch this dragon, surely your best plan would be to get the Bodhisattva to come to deal with it,' they said. 'There used not to be any dragon here, and it is she who sent it.'

They all went and told Tripitaka of this plan. 'How long shall you be?' he asked. 'Shan't I be dead of cold or starvation before you come back?' While he spoke, the voice of the Golden-headed Guardian was heard saying from the sky, 'None of you need move a step. *I* will go and ask the Bodhisattva.'

'Much obliged,' said Monkey. 'Pray go at once.'

The Guardian soared up through the clouds and made straight for the Southern Ocean. Monkey told the local deities to look after the Master, and the Sentinels to supply food. Then he went back to the banks of the river.

'What have you come for?' asked the Bodhisattva, when the Golden-headed Guardian was brought to her where she sat in her bamboo-grove.

'The priest of T'ang,' said he, 'has lost his horse at the Eagle Grief River. It was swallowed by a dragon, and the Great Sage sent me for your help.'

'That dragon,' said Kuan-yin, 'is a son of the Dragon King of the Western Ocean. By his carelessness he set fire to the magic pearls in the palace and they were destroyed. His father accused him of subversive intents, and the Tribunal of Heaven condemned him to death. I saw the Jade Emperor about it, and asked that the sentence might be commuted if the dragon consented to carry the priest of T'ang on his journey to India. I cannot understand how he came to swallow the horse. I'll come and look into it.' She got down from her lotus seat, left her fairy cave, and riding on a beam of magic light crossed the Southern Sea. When she came near the River of Eagle Grief, she looked down and saw Monkey on the bank uttering ferocious curses. She sent the Guardian to announce her arrival. Monkey at once sprang into the air and shouted at her, 'A fine "Teacher of the Seven Buddhas", a fine "Founder of the Faith of Mercy" you are, to plot in this way against us!'

'You impudent stableman, you half-witted red-bottom,' said the Bodhisattva. 'After all the trouble I have taken to find someone to fetch scriptures, and tell him to redeem you, instead of thanking me you make a scene like this!'

'You've played a fine trick on me,' said Monkey. 'You might in decency, when you let me out, have allowed me to go round and amuse myself as I pleased. But you gave me a dressing down and told me I was to spend all my time and energy

in looking after this T'ang priest. Very well! But why did you give him a cap that he coaxed me into putting on, and now I can't get it off, and whenever he says some spell or other I have frightful pains in the head?'

'Oh Monkey,' laughed Kuan-yin, 'if you were not controlled in some such way as this, there would be no doing anything with you. Before long we should have you at all your old tricks again.'

'It's no good trying to put the blame on me,' said Monkey. 'How comes it that you put this dragon here, after he had been condemned by the Courts, and let him eat my Master's horse? It was you who put it in his way to continue his villainies here below. You ought to be ashamed of yourself!'

'I specially asked the Jade Emperor,' said Kuan-yin, 'to let this dragon be stationed here, so that he might be used to carry the master on his way to India. No ordinary Chinese horse would be able to carry him all that way.'

'Well, now he is frightened of me and is hiding,' said Monkey, 'so what is to be done?'

Kuan-yin called the Golden-headed Guardian and said to him, 'Go to the edge of the river and cry "Third son of the Dragon King, come out! The Bodhisattva is here." He'll come out all right.' The dragon leapt up through the waves and immediately assumed human form.

'Don't you know that this is the Scripture-seeker's disciple?' Kuan-yin said, pointing at Monkey.

'Bodhisattva,' said the young dragon, 'I've been having a fight with him. I was hungry yesterday and ate his horse. He never once mentioned anything about "Scripture-seeking".'

'You never asked my name,' said Monkey, 'so why should I tell you?'

'Didn't I ask you what monster you were and where you came from?' asked the dragon. 'And didn't you shout at me "Never mind where I came from or didn't come from, but just give me back my horse"? You never so much as mentioned the word T'ang.'

'Monkey is fonder of showing off his own powers than mentioning his connection with other people,' said Kuan-yin. 'But in future if anyone questions him, he must be sure to say that he is seeking Scriptures. Then there will be no more trouble.'

The Bodhisattva then went to the dragon and removed the jewel of wisdom from under his chin. Then she took her willow-spray and sprinkled him all over with sweet dew, and blowing upon him with magic breath cried 'Change!' Whereupon the dragon immediately changed into the exact image of the lost horse. She then solemnly called upon the once-dragon to turn from his evil ways, and promised that when his task was ended he should be given a golden body and gain illumination. The young dragon humbled himself and promised faithfully to do as he was bid. Then she turned to go, but Monkey grabbed at her, crying, 'This is not good enough! The way to the west is very bad going, and it would be difficult enough in any case to get an earthly priest over all those precipices and crags. But if we are going to have encounters like this all the time, I shall have hard work keeping alive at all, let alone any thought of achieving salvation. I'm not going on!'

'That's odd,' said the Bodhisattva, 'because in the old days you used to be very keen on obtaining illumination. I am surprised that, having escaped from the punishment imposed upon you by Heaven, you should be so unwilling to take a little trouble. When you get into difficulties you have only to call upon Earth, and Earth will perform its miracles. If need be, I will come myself to succour you. And, by the way, come here! I am going to endow you with one more power.' She took the willow leaves from her willow-spray, and dropping them down Monkey's back cried 'Change.' At once they changed into three magic hairs. 'These,' she said, 'will get you out of any trouble, however menacing.'

Monkey thanked the Bodhisattva, who now set out for the Southern Heaven, and taking the horse by the forelock he led it to Tripitaka, saying, 'Master, here's a horse anyway!'

'It's in much better condition than the old one,' said Tripitaka. 'However did you manage to find it?'

'What have you been doing all the while? Dreaming?' said Monkey. 'The Golden-headed Guardian sent for Kuan-yin, who changed the dragon into the exact image of our white horse. The only thing it lacks is harness.'

'Where is the Bodhisattva?' asked Tripitaka, very much surprised. 'I should like to thank her.'

'You're too late,' said Monkey. 'By this time she is already crossing the Southern Ocean.'

However Tripitaka burned incense and bowed towards the south. Then he helped Monkey to put together the luggage, and they set out. 'It's not going to be easy to ride a horse without saddle and reins,' said Tripitaka. 'I'd better find a boat to get across the river, and see if I can't get some harness on the other side.'

'That's not a very practical suggestion,' said Monkey. 'What chance is there of finding a boat in this wild, desolate place? The horse has lived here for some time and must know his way through the waters. Just sit tight on his back and let him carry you across.' They had got to the river bank, Tripitaka astride the horse and Monkey carrying the luggage, when an old fisherman appeared upstream, punting a crazy old raft. Monkey waved to him, crying, 'We have come from the east to fetch scriptures. My Master does not know how to get across, and would like you to ferry him.' The old man punted rapidly towards them, and Monkey told Tripitaka to dismount. He then helped him on board, and embarked the horse and luggage. The old man punted them swiftly across to the far side, where Tripitaka told Monkey to look in the pack for some Chinese money to give to the old fisherman. But the old man pushed off again at once, saying he did not want money. Tripitaka felt very uncomfortable and could only press together his palms in token of gratitude. 'Don't you worry about him,' said Monkey. 'Didn't you see who he really is? This is the river divinity who failed to come and meet us. I was on the point of giving him a good hiding, which he richly deserved. The fact that I let him off is payment enough. No wonder he hadn't the face to take your cash.' Tripitaka was not at all sure whether to believe this story or not. He got astride the horse once more, and followed Monkey along the road to the west. And if you do not know where they got to, you must listen to what is told in the next chapter.

Excerpt from *Monkey* by Wu Cheng-En, translated by Arthur Waley, Chapter XV, pp. 158–166, Allen & Unwin, © 1942 by permission of The Arthur Waley Estate.

READING 84
from BASHO (1644–1694)

Basho, the greatest master of the three-line haiku, was born in Kyoto, and spent much of his youth in the local aristocratic circles. In 1667, at age twenty-three, Basho moved to Tokyo, and later left that city to settle in a recluse's hut in the countryside. Outside the hut there grew a banana tree (basho in Japanese), and he took the word as his name. His haiku chiefly date from the final years of his life, during which he followed the example of Chinese poets like Li Po, and traveled widely in order to experience the wonders of nature. His aim was karumi (lightness of touch), and the concise quality of his verses reflects the influence of Zen Buddhism.

The order in which the following haiku appear is random; Basho expected each haiku to be self-sufficient.

In my new robe
this morning—
someone else

Spring rain—
under trees
a crystal stream.

Now cat's done
Mewing, bedroom's
touched by moonlight.

Do not forget the plum,
blooming
in the thicket.

Drizzly June—
long hair, face
sickly white.

Wake, butterfly—
it's late, we've miles
to go together.

Violets—
how precious on
a mountain path.

Bright moon: I
stroll around the pond—
hey, dawn has come.

Noon doze,
wall cool against
my feet.

Snowy morning—
one crow
after another.

Come, see real
flowers
of this painful world.

Friends part
forever—wild geese
lost in cloud.

Year's end, all
corners of this
floating world, swept.

From *On Love and Barley: Haiku of Bashō*, translated by Lucien Stryk (Penguin Classics, 1985). Copyright © Lucien Stryk, 1985. Reproduced by permission of Penguin Books, Ltd.

CHAPTER 20

READING 85
from CHINUA ACHEBE (B. 1930),
NO LONGER AT EASE (1958)

Chinua Achebe's novel NO LONGER AT EASE takes its title from a verse by T. S. Eliot in his poem "The Journey of the Magi"—

We returned to our places, these Kingdoms,
But no longer at ease here, in the old dispensation,
With an alien people clutching their gods.
I should be glad of another death.

The hero of the story, Obi Okonkwo, returns from his schooling in England, having been chosen by his village for education abroad, to find himself very far from at ease. No longer able to relate to the society in which he grew up and out of place in the alien and corrupt world of the colonial rulers for whom he works, he finds himself out of place wherever he turns. The first chapter of the novel, reproduced here, describes the consequences of this alienation: he is arrested and tried for accepting a small bribe. The rest of the book explores the forces that led to his apparently self-destructive act, including an affair with Clara, an African young woman whom he meets in London. In his sympathetic depiction of Obi, Achebe spares neither the petty world of the colonialists nor the African society from which Obi comes. Chapter One includes a particularly ironic depiction of the collision between African traditional religion and Christianity, lending additional dimension to Achebe's choice of quotation from T. S. Eliot.

Chapter One

For three or four weeks Obi Okonkwo had been steeling himself against this moment. And when he walked into the dock that morning he thought he was fully prepared. He wore a smart palm-beach suit and appeared unruffled and indifferent. The proceeding seemed to be of little interest to him. Except for one brief moment at the very beginning when one of the counsel had got in to trouble with the judge.

"This court begins at nine o'clock. Why are you late?"

Whenever Mr. Justice William Galloway, Judge of the High Court of Lagos and the Southern Cameroons, looked at a victim he fixed him with his gaze as a collector fixes his insect with formalin. He lowered his head like a charging ram and looked over his gold-rimmed spectacles at the lawyer.

"I am sorry, Your Honor," the man stammered. "My car broke down on the way."

The judge continued to look at him for a long time. Then he said very abruptly:

"All right, Mr. Adeyemi. I accept your excuse. But I must say I'm getting sick and tired of these constant excuses about the problems of locomotion."

There was suppressed laughter at the bar. Obi Okonkwo smiled a wan and ashy smile and lost interest again.

Every available space in the courtroom was taken up. There were almost as many people standing as sitting. The case had been the talk of Lagos for a number of weeks and on this last day anyone who could possibly leave his job was there to hear the judgment. Some civil servants paid as much as ten shillings and sixpence to obtain a doctor's certificate of illness for the day.

Obi's listlessness did not show any signs of decreasing even when the judge began to sum up. It was only when he said: "I cannot comprehend how a young man of your education and brilliant promise could have done this" that a sudden and marked change occurred. Treacherous tears came into Obi's eyes. He brought out a white handkerchief and rubbed his face. But he did it as people do when they wipe sweat. He even tried to smile and belie the tears. A smile would have been quite logical. All that stuff about education and promise and betrayal had not taken him unawares. He had expected it and rehearsed this very scene a hundred times until it had become as familiar as a friend.

In fact, some weeks ago when the trial first began, Mr. Green, his boss, who was one of the Crown witnesses, had also said something about a young man of great promise. And Obi had remained completely unmoved. Mercifully he had recently

lost his mother, and Clara had gone out of his life. The two events following closely on each other had dulled his sensibility and left him a different man, able to look words like *education* and *promise* squarely in the face. But now when the supreme moment came he was betrayed by treacherous tears.

Mr. Green had been playing tennis since five o'clock. It was most unusual. As a rule his work took up so much of his time that he rarely played. His normal exercise was a short walk in the evenings. But today he had played with a friend who worked for the British Council. After the game they retired to the club bar. Mr. Green had a light-yellow sweater over his white shirt, and a white towel hung from his neck. There were many other Europeans in the bar, some half-sitting on the high stools and some standing in groups of twos and threes drinking cold beer, orange squash or gin and tonic.

"I cannot understand why he did it," said the British Council man thoughtfully. He was drawing lines of water with his finger on the back of his mist-covered glass of ice-cold beer.

"I can," said Mr. Green simply. "What I can't understand is why people like you refuse to face facts." Mr. Green was famous for speaking his mind. He wiped his red face with the white towel on his neck. "The African is corrupt through and through." The British Council man looked about him furtively, more from instinct than necessity, for although the club was now open to them technically, few Africans went to it. On this particular occasion there was none, except of course the stewards who served unobtrusively. It was quite possible to go in, drink, sign a check, talk to friends and leave again without noticing these stewards in their white uniforms. If everything went right you did not see them.

"They are all corrupt," repeated Mr. Green. "I'm all for equality and all that. I for one would hate to live in South Africa. But equality won't alter facts."

"What facts?" asked the British Council man, who was relatively new to the country. There was a lull in the general conversation, as many people were now listening to Mr. Green without appearing to do so.

"The fact that over countless centuries the African has been the victim of the worst climate in the world and of every imaginable disease. Hardly his fault. But he has been sapped mentally and physically. We have brought him Western education. But what use is it to him? He is . . ." He was interrupted by the arrival of another friend.

"Hello, Peter. Hello, Bill."

"Hello."

"Hello."

"May I join you?"

"Certainly."

"Most certainly. What are you drinking? Beer? Right. Steward. One beer for this master."

"What kind, sir?"

"Heineken."

"Yes, sir."

"We were talking about this young man who took a bribe."

"Oh, yes."

Somewhere on the Lagos mainland the Umuofia Progressive Union was holding an emergency meeting. Umuofia is an Ibo village in Eastern Nigeria and the hometown of Obi Okonkwo. It is not a particularly big village, but its inhabitants call it a town. They are very proud of its past when it was the terror of their neighbors, before the white man came and leveled everybody down. Those Umuofians (that is the name they call themselves) who leave their home town to find work in towns all over Nigeria regard themselves as sojourners. They return to Umuofia every two years or so to spend their leave. When they have saved up enough money they ask their rela-

tions at home to find them a wife, or they build a "zinc" house on their family land. No matter where they are in Nigeria, they start a local branch of the Umuofia Progressive Union.

In recent weeks the Union had met several times over Obi Okonkwo's case. At the first meeting, a handful of people had expressed the view that there was no reason why the Union should worry itself over the troubles of a prodigal son who had shown great disrespect to it only a little while ago.

"We paid eight hundred pounds to train him in England," said one of them. "But instead of being grateful he insults us because of a useless girl. And now we are being called together again to find more money for him. What does he do with his big salary? My own opinion is that we have already done too much for him."

This view, although accepted as largely true, was not taken very seriously. For, as the President pointed out, a kinsman in trouble had to be saved, not blamed; anger against a brother was felt in the flesh, not in the bone. And so the Union decided to pay for the services of a lawyer from their funds.

But this morning the case was lost. That was why another emergency meeting had been convened. Many people had already arrived at the house of the President on Moloney Street, and were talking excitedly about the judgment.

"I knew it was a bad case," said the man who had opposed the Union's intervention from the start. "We are just throwing money away. What do our people say? He that fights a ne'er-do-well has nothing to show for it except a head covered in earth and grime."

But this man had no following. The men of Umuofia were prepared to fight to the last. They had no illusions about Obi. He was, without doubt, a very foolish and self-willed young man. But this was not the time to go into that. The fox must be chased away first, after that the hen might be warned against wandering into the bush.

When the time for warning came the men of Umuofia could be trusted to give it in full measure, pressed down and flowing over. The President said it was a thing of shame for a man in the senior service to go to prison for twenty pounds. He repeated twenty pounds, spitting it out: "I am against people reaping where they have not sown. But we have a saying that if you want to eat a toad you should look for a fat and juicy one."

"It is all lack of experience," said another man. "He should not have accepted the money himself. What others do is tell you to go and hand it to their houseboy. Obi tried to do what everyone does without finding out how it was done." He told the proverb of the house rat who went swimming with his friend the lizard and died from cold, for while the lizard's scales kept him dry the rat's hairy body remained wet.

The President, in due course, looked at his pocket watch and announced that it was time to declare the meeting open. Everybody stood up and he said a short prayer. Then he presented three kola nuts to the meeting. The oldest man present broke one of them, saying another kind of prayer while he did it. "He that brings kola nuts brings life," he said. "We do not seek to hurt any man, but if any man seeks to hurt us may he break his neck." The congregation answered *Amen*. "We are strangers in this land. If good comes to it may we have our share." *Amen*. "But if bad comes let it go to the owners of the land who know what gods should be appeased." *Amen*. "Many towns have four or five or even ten of their sons in European posts in this city. Umuofia has only one. And now our enemies say that even that one is too many for us. But our ancestors will not agree to such a thing." *Amen*. "An only palm fruit does not get lost in the fire." *Amen*.

Obi Okonkwo was indeed an only palm-fruit. His full name was Obiajulu—"the mind at last is at rest"; the mind being his father's of course, who his wife having borne him four daughters before Obi, was naturally becoming a little anxious. Being

a Christian convert—in fact a catechist—he could not marry a second wife. But he was not the kind of man who carried his sorrow on his face. In particular, he would not let the heathen know that he was unhappy. He had called his fourth daughter Nwanyidinma—"a girl is also good." But his voice did not carry conviction.

The old man who broke the kola nuts in Lagos and called Obi Okonkwo an only palm-fruit was not, however, thinking of Okonkwo's family. He was thinking of the ancient and warlike village of Umuofia. Six or seven years ago Umuofians abroad had formed their Union with the aim of collecting money to send some of their brighter young men to study in England. They taxed themselves mercilessly. The first scholarship under this scheme was awarded to Obi Okonkwo five years ago, almost to the day. Although they called it a scholarship it was to be repaid. In Obi's case it was worth eight hundred pounds, to be repaid within four years of his return. They wanted him to read law so that when he returned he would handle all their land cases against their neighbors. But when he got to England he read English, his self-will was not new. The Union was angry but in the end they left him alone. Although he would not be a lawyer, he would get a "European post" in the civil service.

The selection of the first candidate had not presented any difficulty to the Union. Obi was an obvious choice. At the age of twelve or thirteen he had passed his Standard Six examination at the top of the whole province. Then he had won a scholarship to one of the best secondary schools in Eastern Nigeria. At the end of five years he passed the Cambridge School Certificate with distinction in all eight subjects. He was in fact a village celebrity, and his name was regularly invoked at the mission school where he had once been a pupil. (No one mentioned nowadays that he once brought shame to the school by writing a letter to Adolf Hitler during the war. The headmaster at the time had pointed out, almost in tears, that he was a disgrace to the British Empire, and that if he had been older he would surely have been sent to jail for the rest of his miserable life. He was only eleven then, and so got off with six strokes of the cane on his buttocks.)

Obi's going to England caused a big stir in Umuofia. A few days before his departure to Lagos his parents called a prayer meeting at their home. The Reverend Samuel Ikedi of St. Mark's Anglican Church, Umuofia, was chairman. He said the occasion was the fulfillment of the prophecy:

The people which sat in darkness
Saw a great light,
And to them which sat in the region and shadow of death
To them did light spring up.

He spoke for over half an hour. Then he asked that someone should lead them in prayer. Mary at once took up the challenge before most people had had time to stand up, let alone shut their eyes. Mary was one of the most zealous Christians in Umuofia and a good friend of Obi's mother, Hannah Okonkwo. Although Mary lived a long way from the church—three miles or more—she never missed the early morning prayer which the pastor conducted at cockcrow. In the heart of the wet season, or the cold harmattan, Mary was sure to be there. Sometimes she came as much as an hour before time. She would blow out her hurricane lamp to save kerosene and go to sleep on the long mud seats.

"Oh, God of Abraham, God of Isaac and God of Jacob," she burst forth, "the Beginning and the End. Without you we can do nothing. The great river is not big enough for you to wash your hands in. You have the yam and you have the knife; we cannot eat unless you cut us a piece. We are like ants in your sight. We are like little children who only wash their stomach when they bathe, leaving their back dry . . ." She went on and on reeling off proverb after proverb and painting picture after picture. Finally, she got round to the subject of the gathering and dealt with it as fully as it deserved, giving among other things, the life history of her friend's son who was about to go to the place where learning finally came to an end. When she was done, people blinked and rubbed their eyes to get used to the evening light once more.

They sat on long wooden forms which had been borrowed from the school. The chairman had a little table before him. On one side sat Obi in his school blazer and white trousers.

Two stalwarts emerged from the kitchen area, half bent with the gigantic iron pot of rice which they carried between them. Another pot followed. Two young women then brought in a simmering pot of stew hot from the fire. Kegs of palm wine followed, and a pile of plates and spoons which the church stocked for the use of its members at marriages, births, deaths, and other occasions such as this.

Mr. Isaac Okonkwo made a short speech placing "this small kola" before his guests. By Umuofia standards he was well-to-do. He had been a catechist of the Church Missionary Society for twenty-five years and then retired on a pension of twenty-five pounds a year. He had been the very first man to build a "zinc" house in Umuofia. It was therefore not unexpected that he would prepare a feast. But no one had imagined anything on this scale, not even from Okonkwo, who was famous for his openhandedness which sometimes bordered on improvidence. Whenever his wife remonstrated against his thriftlessness he replied that a man who lived on the banks of the Niger should not wash his hands with spittle—a favorite saying of his father's. It was odd that he should have rejected everything about his father except this one proverb. Perhaps he had long forgotten that his father often used it.

At the end of the feast the pastor made another long speech. He thanked Okonkwo for giving them a feast greater than many a wedding feast these days.

Mr. Ikedi had come to Umuofia from a township, and was able to tell the gathering how wedding feasts had been steadily declining in the towns since the invention of invitation cards. Many of his hearers whistled in unbelief when he told them that a man could not go to his neighbor's wedding unless he was given one of these papers on which they wrote R.S.V.P.—Rice and Stew Very Plenty—which was invariably an overstatement.

Then he turned to the young man on his right. "In times past," he told him, "Umuofia would have required of you to fight in her wars and bring home human heads. But those were days of darkness from which we have been delivered by the blood of the Lamb of God. Today we send you to bring knowledge. Remember that the fear of the Lord is the beginning of wisdom. I have heard of young men from other towns who went to the white man's country, but instead of facing their studies they went after the sweet things of the flesh. Some of them even married white women." The crowd murmured its strong disapproval of such behavior. "A man who does that is lost to his people. He is like rain wasted in the forest. I would have suggested getting you a wife before you leave. But the time is too short now. Anyway, I know that we have no fear where you are concerned. We are sending you to learn book. Enjoyment can wait. Do not be in a hurry to rush into the pleasures of the world like the young antelope who danced herself lame when the main dance was yet to come."

He thanked Okonkwo again, and the guests for answering his call. "If you had not answered his call, our brother would have become like the king in the Holy Book who called a wedding feast."

As soon as he had finished speaking, Mary raised a song which the women had learnt at their prayer meeting.

Leave me not behind Jesus, wait for me
When I am going to the farm.
Leave me not behind Jesus, wait for me
When I am going to the market.
Leave me not behind Jesus, wait for me
When I am eating my food.
Leave me not behind Jesus, wait for me
When I am having my bath.
Leave me not behind Jesus, wait for me
When he is going to the White Man's Country.
Leave him not behind Jesus, wait for him.

The gathering ended with the singing of "Praise God from whom all blessings flow." The guests then said their farewells to Obi, many of them repeating all the advice that he had already been given. They shook hands with him and as they did so they pressed their presents into his palm, to buy a pencil with, or an exercise book or a loaf of bread for the journey, a shilling there and a penny there—substantial presents in a village where money was so rare, where men and women toiled from year to year, to wrest a meager living from an unwilling and exhausted soil.

Excerpt from "The Journey of the Magi" in *Collected Poems 1909–1962* by T. S. Eliot, copyright 1936 by Harcourt, Inc., copyright © 1964, 1963 by T. S. Eliot, reprinted by permission of the publisher and Faber & Faber, Ltd.

From *No Longer at Ease* by Chinua Achebe, pp. 1–13. Reprinted by permission of Harcourt Education.

CHAPTER 21

READING 86
T. S. Eliot (1888–1965), "The Hollow Men" (1925)

This poem tracks two basic themes that run through all of Eliot's poetry: the alienation of modern people as a result of a loss of traditional values and the response of faith as an affirmation of some deep center that anchors human life in a time of cultural decay.

"Mistah Kurtz—he dead."
"A penny for the Old Guy."

I

We are the hollow men
We are the stuffed men
Leaning together
Headpiece filled with straw. Alas!
Our dried voices, when
We whisper together
Are quiet and meaningless
As wind in dry grass
Or rats' feet over broken glass
In our dry cellar 10

Shape without form, shade without color,
Paralyzed force, gesture without motion;

Those who have crossed
With direct eyes, to death's other Kingdom
Remember us—if at all—not as lost
Violent souls, but only
As the hollow men
The stuffed men.

II

Eyes I dare not meet in dreams
In death's dream kingdom 20
These do not appear:
There, the eyes are
Sunlight on a broken column
There, is a tree swinging
And voices are
In the wind's singing
More distant and more solemn
Than a fading star.

Let me be no nearer
In death's dream kingdom 30
Let me also wear
Such deliberate disguises
Rat's coat, crowskin, crossed staves
In a field
Behaving as the wind behaves
No nearer—

Not that final meeting
In the twilight kingdom.

III

This is the dead land
This is cactus land
Here the stone images
Are raised, here they receive
The supplication of a dead man's hand
Under the twinkle of a fading star. 40

Is it like this
In death's other kingdom
Waking alone
At the hour when we are
Trembling with tenderness
Lips that would kiss
Form prayers to broken stone.

IV 50

The eyes are not here
There are no eyes here
In this valley of dying stars
In this hollow valley
This broken jaw of our lost kingdoms.

In this last of meeting places
We grope together
And avoid speech
Gathered on this beach of the tumid river.

Sightless, unless
The eyes reappear 60
As the perpetual star
Multifoliate rose
Of death's twilight kingdom
The hope only
Of empty men.

V

Here we go round the prickly pear
Prickly pear prickly pear
Here we go round the prickly pear
At five o'clock in the morning.

Between the idea 70
And the reality
Between the motion
And the act
Falls the shadow
 For Thine is the Kingdom

Between the conception
And the creation
Between the emotion
And the response
Falls the Shadow
 Life is very long

Between the desire
And the spasm
Between the potency
And the existence
Between the essence
And the descent
Falls the Shadow 90
 For Thine is the Kingdom

For Thine is
Life is
For Thine is the
This is the way the world ends
This is the way the world ends
This is the way the world ends
Not with a bang but a whimper.

READING 87
from T. S. Eliot (1888–1965), The Waste Land (1922), "The Fire Sermon"

In this excerpt from The Waste Land *Eliot conveys his sense of the human condition following the exhaustion and trauma of World War I. Here the poet describes a loveless evening encounter between a typist and a clerk who are unwilling or unable to connect with each other emotionally. Eliot drew his title for this section from one of the Buddha's sermons in which he urges his disciples to free themselves from their attachments to earthly passions and material goods. In Greek mythology, Tiresias was the blind prophet of Zeus; here, according to Eliot, "the two sexes meet in Tiresias. What Tiresias sees, in fact, is the substance of the poem."*

from Part III, "The Fire Sermon"

At the violet hour, when the eyes and back 215
Turn upward from the desk, when the human engine waits
Like a taxi throbbing waiting,
I Tiresias, though blind, throbbing between two lives,
Old man with wrinkled female breasts, can see
At the violet hour, the evening hour that strives 220
Homeward, and brings the sailor home from sea,
The typist home at teatime, clears her breakfast, lights
Her stove, and lays out food in tins.
Out of the window perilously spread
Her drying combinations touched by the sun's last rays,
On the divan are piled (at night her bed)
Stockings, slippers, camisoles, and stays.
I Tiresias, old man with wrinkled dugs
Perceived the scene, and foretold the rest –
I too awaited the expected guest. 230
He, the young man carbuncular, arrives,
A small house agent's clerk, with one bold stare,
One of the low on whom assurance sits
As a silk hat on a Bradford millionaire.
The time is now propitious, as he guesses,
The meal is ended, she is bored and tired,
Endeavours to engage her in caresses

Which still are unreproved, if undesired.
Flushed and decided, he assaults at once;
Exploring hands encounter no defence; 240
His vanity requires no response,
And makes a welcome of indifference.
(And I Tiresias have foresuffered all
Enacted on this same divan or bed;
I who have sat by Thebes below the wall
And walked among the lowest of the dead.)
Bestows one final patronising kiss,
And gropes his way, finding the stairs unlit . . .

She turns and looks a moment in the glass,
Hardly aware of her departed lover; 250
Her brain allows one half-formed thought to pass:
"Well now that's done: and I'm glad it's over."
When lovely woman stoops to folly and
Paces about her room again, alone,
She smoothes her hair with automatic hand,
And puts a record on the gramophone.

READING 88
Countee Cullen (1903–1946), "Heritage" (1925)

Countee Cullen was a strong voice cut off by an early death. His poem "Heritage" is a powerful blend of African roots and American experience.

Heritage

What is Africa to me:
Copper sun or scarlet sea,
Jungle star or jungle track,
Strong bronzed men, or regal black
Women from whose loins I sprang
When the birds of Eden sang?
One three centuries removed
From the scenes his fathers loved,
Spicy grove, cinnamon tree,
What is Africa to me?

So I lie, who all day long
Want no sound except the song
Sung by wild barbaric birds
Goading massive jungle herds,
Juggernauts of flesh that pass
Trampling tall defiant grass
Where young forest lovers lie,
Plighting troth beneath the sky.
So I lie, who always hear,
Though I cram against my ear
Both my thumbs, and keep them there,
Great drums throbbing through the air.
So I lie, whose fount of pride,
Dear distress, and joy allied,
Is my somber flesh and skin,
With the dark blood dammed within
Like great pulsing tides of wine
That, I fear, must burst the fine
Channels of the chafing net
Where they surge and foam and fret.
Africa? A book one thumbs
Listlessly, till slumber comes.
Unremembered are her bats

Circling through the night, her cats
Crouching in the river reeds,
Stalking gentle flesh that feeds
By the river brink; no more
Does the bugle-throated roar
Cry that monarch claws have leapt
From the scabbards where they slept.

Silver snakes that once a year
Doff the lovely coats you wear,
Seek no covert in your fear
Lest a mortal eye should see;
What's your nakedness to me?
Here no leprous flowers rear
Fierce corollas in the air;
Here no bodies sleek and wet,
Dripping mingled rain and sweat,
Tread the savage measures of
Jungle boys and girls in love.
What is last year's snow to me,
Last year's anything? The tree
Budding yearly must forget
How its past arose or set—
Bough and blossom, flower, fruit,
Even what shy bird with mute
Wonder at her travail there,
Meekly labored in its hair.
One three centuries removed
From the scenes his fathers loved,
Spice grove, cinnamon tree,
What is Africa to me?

So I lie, who find no peace
Night or day, no slight release
From the unremittant beat
Made by cruel padded feet
Walking through my body's street.
Up and down they go, and back,
Treading out a jungle track.
So I lie, who never quite
Safely sleep from rain at night—
I can never rest at all
When the rain begins to fall;
Like a soul gone mad with pain
I must match its weird refrain;
Ever must I twist and squirm,
Writhing like a baited worm,
While its primal measures drip
Through my body, crying, "Strip!
Doff this new exuberance.
Come and dance the Lover's Dance!"
In an old remembered way
Rain works on me night and day.

Quaint, outlandish heathen gods
Black men fashion out of rods,
Clay, and brittle bits of stone,
In a likeness like their own,
My conversion came high-priced;
I belong to Jesus Christ,
Preacher of humility;
Heathen gods are naught to me.

Father, Son, and Holy Ghost,
So I make an idle boast;
Jesus of the twice-turned cheek,
Lamb of God, although I speak
With my mouth thus, in my heart
Do I play a double part.

Ever at Thy glowing altar
Must my heart grow sick and falter,
Wishing He I served were black,
Thinking then it would not lack
Precedent of pain to guide it,
Let who would or might deride it;
Surely then this flesh would know
Yours had borne a kindred woe.
Lord, I fashion dark gods, too,
Daring even to give You
Dark despairing features where,
Crowned with dark rebellious hair,
Patience wavers just so much as
Mortal grief compels, while touches
Quick and hot, of anger, rise
To smitten cheek and weary eyes.
Lord, forgive me if my need
Sometimes shapes a human creed.
All day long and all night through,
One thing only must I do:
Quench my pride and cool my blood,
Lest I perish in the flood.
Lest a hidden ember set
Timber that I thought was wet
Burning like the driest flax,
Melting like the merest wax,
Lest the grave restore its dead.
Not yet has my heart or head
In the least way realized
They and I are civilized.

READING 89
from LANGSTON HUGHES (1902–1967)

Langston Hughes was the premier poet of the Harlem Renaissance. His poem "I, Too, Sing America" is a cry against racial discrimination and, at the same time, an affirmation of Black Pride. By contrast, "The Negro Speaks of Rivers" is a poem filled with memories both racial and historical.

"I, Too, Sing America"

I, too, sing America
I am the darker brother.
They send me to eat in the kitchen
When company comes,
But I laugh,
And eat well,
And grow strong.

Tomorrow,
I'll be at the table
When company comes.
Nobody'll dare
Say to me,
"Eat in the kitchen,"
Then.

Besides,
They'll see how beautiful I am
And be ashamed—

I, too, am America.

"The Negro Speaks of Rivers"

I've known rivers:
I've known rivers ancient as the world and older than the
 flow of human blood in human veins.
My soul has grown deep like the rivers.

I bathed in the Euphrates when dawns were young.
I built my hut near the Congo and it lulled me to sleep.
I looked upon the Nile and raised the pyramids above it.
I heard the singing of the Mississippi when Abe Lincoln went
 down to New Orleans, and I've seen its muddy bosom
 turn all golden in the sunset.

I've known rivers:
Ancient, dusky rivers.

My soul has grown deep like rivers.

READING 90
HELENE JOHNSON (1906–1995), "BOTTLED" (1907)

Published in the classic CAROLING DUSK, AN ANTHOLOGY OF VERSE BY NEGRO POETS, edited by Countee Cullen in 1927, this bitter poem against stereotyping uses racial epithets like "darky" and "shine" to drive home its point.

Upstairs on the third floor
Of the 135th Street library
In Harlem, I saw a little
Bottle of sand, brown sand
Just like the kids make pies
Out of down at the beach.
But the label said: "This Sand was taken from the
 Sahara desert."
Imagine that! The Sahara desert!
Some bozo's been all the way to Africa to get some sand.

And yesterday on Seventh Avenue
I saw a darky dressed fit to kill
In yellow gloves and swallow tail coat
And swirling a cane. And everyone
Was laughing at him. Me too,
At first, till I saw his face
When he stopped to hear a
Organ grinder grind out some jazz.
Boy! You should a seen that darky's face!
It just shone. Gee, he was happy!
And he began to dance. No
Charleston or Black Bottom for him.
No sir. He danced just as dignified
And slow. No, not slow either.
Dignified and *proud!* You couldn't
Call it slow, not with all the
Cuttin' up he did. You would a died to see him.

The crowd kept yellin' but he didn't hear,
Just kept on dancin' and twirlin' that cane
And yellin' out loud every once in a while.
I know the crowd thought he was coo-coo,
But say, I was where I could see his face,
And somehow, I could see him dancin' in a jungle,
A real honest-to-cripe-jungle, and he wouldn't have on them

Trick clothes—those yaller shoes and yaller gloves
And swallow tail coat. He wouldn't have on nothing.
And he wouldn't be carrying no cane.
He'd be carrying a spear with a sharp fine point
Like the bayonets we had "over there."
And the end of it would be dipped in some kind of
Hoo-doo poison. And he'd be dancin' black and naked and
 gleaming.
And he's have rings in his ears and on his nose
And bracelets and necklaces of elephants' teeth.
Gee, I bet he'd be beautiful then all right.
No one could laugh at him then, I bet.
Say! that man that took that sand from the Sahara desert
And put it in a little bottle on a shelf in the library,
That's what they done to this shine, ain't it? Bottled him.
Trick shoes, trick coat, trick cane, trick everything—all
 glass—
But inside—
Gee, that poor shine!

READING 91
from FRANZ KAFKA (1883–1924), THE TRIAL (1925)

This parable, told to Joseph K. in a cathedral, is meant to be an enigma and a puzzle. As a parable it mirrors the confusion of the hero, who is pursued by the Court for crimes he cannot identify, a guilt he recognizes, but whose source he cannot name.

Chapter 9 In the Cathedral
Before the Law

Before the Law stands a doorkeeper. To this doorkeeper there comes a man from the country who begs for admittance to the Law. But the doorkeeper says that he cannot admit the man at the moment. The man, on reflection, asks if he will be allowed, then, to enter later. 'It is possible,' answers the doorkeeper, 'but not at this moment.' Since the door leading into the Law stands open as usual and the doorkeeper steps to one side, the man bends down to peer through the entrance. When the doorkeeper sees that, he laughs and says: 'If you are so strongly tempted, try to get in without my permission. But note that I am powerful. And I am only the lowest doorkeeper. From hall to hall, keepers stand at every door, one more powerful than the other. And the sight of the third man is already more than even I can stand.' These are difficulties which the man from the country has not expected to meet, the Law, he thinks, should be accessible to every man and at all times, but when he looks more closely at the doorkeeper in his furred robe, with his huge pointed nose and long thin Tartar beard, he decides that he had better wait until he gets permission to enter. The doorkeeper gives him a stool and lets him sit down at the side of the door. There he sits waiting for days and years. He makes many attempts to be allowed in and wearies the doorkeeper with his importunity. The doorkeeper often engages him in brief conversation, asking him about his home and about other matters, but the questions are put quite impersonally, as great men put questions, and always conclude with the statement that the man cannot be allowed to enter yet. The man, who has equipped himself with many things

for his journey, parts with all he has, however valuable, in the hope of bribing the doorkeeper. The doorkeeper accepts it all, saying, however, as he takes each gift: 'I take this only to keep you from feeling that you have left something undone.' During all these long years the man watches the doorkeeper almost incessantly. He forgets about the other doorkeepers, and this one seems to him the only barrier between himself and the Law. In the first years he curses his evil fate aloud; later, as he grows old, he only mutters to himself. He grows childish, and since in his prolonged study of the doorkeeper he has learned to know even the fleas in his fur collar, he begs the very fleas to help him and to persuade the doorkeeper to change his mind. Finally his eyes grow dim and he does not know whether the world is really darkening around him or whether his eyes are only deceiving him. But in the darkness he can now perceive a radiance that streams inextinguishably from the door of the Law. Now his life is drawing to a close. Before he dies, all that he has experienced during the whole time of his sojourn condenses in his mind into one question, which he has never yet put to the doorkeeper. He beckons the doorkeeper, since he can no longer raise his stiffening body. The doorkeeper has to bend far down to hear him, for the difference in size between them has increased very much to the man's disadvantage. 'What do you want to know now?' asks the doorkeeper, 'you are insatiable.' 'Everyone strives to attain the Law,' answers the man, 'how does it come about, then, that in all these years no one has come seeking admittance but me?' The doorkeeper perceives that the man is nearing his end and his hearing is failing, so he bellows in his ear: 'No one but you could gain admittance through this door, since this door was intended for you. I am now going to shut it.'"

"Before the Law" translated by Willa & Edwin Muir, from *Franz Kafka: The Complete Stories* by Franz Kafka, edited by Nahum N. Glatzer, copyright 1946, 1947, 1948, 1949, 1954, 1958, 1971 by Schocken Books. Used by permission of Schocken Books, a division of Random House, Inc.

READING 92
from Aldous Huxley (1894–1963),
Brave New World (1932)

Written at a time when totalitarian powers were gaining strength in Europe, this selection is an incisive meditation on the power of language and art to undermine the authority of the state. Art, the totalitarian mind argues, provides an alternative way of seeing things and that, in a totalitarian society, is an unthinkable danger.

Chapter 16

The room into which the three were ushered was the Controller's study.

"His fordship will be down in a moment." The Gamma butler left them to themselves.

Helmholtz laughed aloud.

"It's more like a caffeine-solution party than a trial," he said, and let himself fall into the most luxurious of the pneumatic armchairs. "Cheer up, Bernard," he added, catching sight of his friend's green unhappy face. But Bernard would not be cheered; without answering, without even looking at Helmholtz, he went and sat down on the most uncomfortable chair in the room, carefully chosen in the obscure hope of somehow deprecating the wrath of the higher powers.

The Savage meanwhile wandered restlessly round the room, peering with a vague superficial inquisitiveness at the books in the shelves, at the soundtrack rolls and the reading machine bobbins in their numbered pigeon-holes. On the table under the window lay a massive volume bound in limp black leather-surrogate, and stamped with large golden T's. He picked it up and opened it. MY LIFE AND WORK, BY OUR FORD. The book had been published at Detroit by the Society for the Propagation of Fordian Knowledge. Idly he turned the pages, read a sentence here, a paragraph there, and had just come to the conclusion that the book didn't interest him, when the door opened, and the Resident World Controller for Western Europe walked briskly into the room.

Mustapha Mond shook hands with all three of them; but it was to the Savage that he addressed himself. "So you don't much like civilization, Mr. Savage," he said.

The Savage looked at him. He had been prepared to lie, to bluster, to remain sullenly unresponsive; but, reassured by the good-humored intelligence of the Controller's face, he decided to tell the truth, straightforwardly. "No." He shook his head.

Bernard started and looked horrified. What would the Controller think? To be labeled as the friend of a man who said that he didn't like civilization—said it openly and, of all people, to the Controller—it was terrible. "But, John," he began. A look from Mustapha Mond reduced him to an abject silence.

"Of course," the Savage went on to admit, "there are some very nice things. All that music in the air, for instance . . ."

"Sometimes a thousand twangling instruments will hum about my ears and sometimes voices."

The Savage's face lit up with a sudden pleasure. "Have you read it too?" he asked. "I thought nobody knew about that book here, in England."

"Almost nobody. I'm one of the very few. It's prohibited, you see. But as I make the laws here, I can also break them. With impunity, Mr. Marx," he added, turning to Bernard. "Which I'm afraid you *can't* do."

Bernard sank into a yet more hopeless misery.

"But why is it prohibited?" asked the Savage. In the excitement of meeting a man who had read Shakespeare he had momentarily forgotten everything else.

The Controller shrugged his shoulders. "Because it's old; that's the chief reason. We haven't any use for old things here."

"Even when they're beautiful?"

"Particularly when they're beautiful. Beauty's attractive, and we don't want people to be attracted by old things. We want them to like the new ones."

"But the new ones are so stupid and horrible. Those plays, where there's nothing but helicopters flying about and you *feel* the people kissing." He made a grimace. "Goats and monkeys!" Only in Othello's words could he find an adequate vehicle for his contempt and hatred.

"Nice tame animals, anyhow," the Controller murmured parenthetically.

"Why don't you let them see *Othello* instead?"

"I've told you; it's old. Besides, they couldn't understand it."

Yes, that was true. He remembered how Helmholtz had laughed at *Romeo and Juliet*. "Well then," he said, after a pause, "something new that's like *Othello,* and that they could understand."

"That's what we've all been wanting to write," said Helmholtz, breaking a long silence.

"And it's what you never will write," said the Controller. "Because, if it were really like *Othello* nobody could understand it, however new it might be. And if it were new, it couldn't possibly be like *Othello.*"

"Why not?"

"Yes, why not?" Helmholtz repeated. He too was forgetting the unpleasant realities of the situation. Green with anxiety and apprehension, only Bernard remembered them; the others ignored him. "Why not?"

"Because our world is not the same as Othello's world. You can't make flivvers without steel—and you can't make tragedies without social instability. The world's stable now. People are happy; they get what they want, and they never want what they can't get. They're well off; they're safe; they're never ill; they're not afraid of death; they're blissfully ignorant of passion and old age; they're plagued with no mothers or fathers; they've got no wives, or children, or lovers to feel strongly about; they're so conditioned that they practically can't help behaving as they ought to behave. And if anything should go wrong, there's *soma*. Which you go and chuck out of the window in the name of liberty, Mr. Savage. *Liberty!*" He laughed. "Expecting Deltas to know what liberty is! And now expecting them to understand *Othello!* My good boy!"

The Savage was silent for a little. "All the same," he insisted obstinately, *"Othello's* good, *Othello's* better than those feelies."

"Of course it is," the Controller agreed. "But that's the price we have to pay for stability. You've got to choose between happiness and what people used to call high art. We've sacrificed the high art. We have the feelies and the scent organ instead."

"But they don't mean anything."

"They mean themselves; they mean a lot of agreeable sensations to the audience."

"But they're . . . they're told by an idiot."

The Controller laughed. "You're not being very polite to your friend, Mr. Watson. One of our most distinguished Emotional Engineers . . ."

"But he's right," said Helmholtz gloomily. "Because it *is* idiotic. Writing when there's nothing to say . . ."

"Precisely. But that requires the most enormous ingenuity. You're making flivvers out of the absolute minimum of steel—works of art out of practically nothing but pure sensation."

The Savage shook his head. "It all seems to me quite horrible."

"Of course it does. Actual happiness always looks pretty squalid in comparison with the over-compensations for misery. And, of course, stability isn't nearly so spectacular as instability. And being contented has none of the glamour of a good fight against misfortune, none of the picturesqueness of a struggle with temptation, or a fatal overthrow by passion or doubt. Happiness is never grand."

"I suppose not," said the Savage after a silence. "But need it be quite so bad as those twins?" He passed his hand over his eyes as though he were trying to wipe away the remembered image of those long rows of identical midgets at the assembling tables, those queued-up twin-herds at the entrance to the Brentford monorail station, those human maggots swarming round Linda's bed of death, the endlessly repeated face of his assailants. He looked at his bandaged left hand and shuddered. "Horrible!"

"But how useful! I see you don't like our Bokanovsky Groups; but, I assure you, they're the foundation on which everything else is built. They're the gyroscope that stabilizes the rocket plane of state on its unswerving course." The deep voice thrillingly vibrated; the gesticulating hand implied all space and the onrush of the irresistible machine. Mustapha Mond's oratory was almost up to synthetic standards.

"I was wondering," said the Savage, "why you had them at all—seeing that you can get whatever you want out of those bottles. Why don't you make everybody an Alpha Double Plus while you're about it?"

Mustapha Mond laughed. "Because we have no wish to have our throats cut," he answered. "We believe in happiness and stability. A society of Alphas couldn't fail to be unstable and miserable. Imagine a factory staffed by Alphas—that is to say by separate and unrelated individuals of good heredity and conditioned so as to be capable (within limits) of making a free choice and assuming responsibilities. Imagine it!" he repeated.

The Savage tried to imagine it, not very successfully.

"It's an absurdity. An Alpha-decanted, Alpha-conditioned man would go mad if he had to do Epsilon Semi-Moron work—go mad, or start smashing things up. Alphas can be completely socialized—but only on condition that you make them do Alpha work. Only an Epsilon can be expected to make Epsilon sacrifices, for the good reason that for him they aren't sacrifices; they're the line of least resistance. His conditioning has laid down rails along which he's got to run. He can't help himself; he's foredoomed. Even after decanting, he's still inside a bottle—an invisible bottle of infantile and embryonic fixations. Each one of us, of course," the Controller meditatively continued, "goes through life inside a bottle. But if we happen to be Alphas, our bottles are, relatively speaking, enormous. We should suffer acutely if we were confined in a narrower space."

"You cannot pour upper-caste champagne-surrogate into lower-caste bottles. It's obvious theoretically. But it has also been proved in actual practice. The result of the Cyprus experiment was convincing."

"What was that?" asked the Savage.

Mustapha Mond smiled. "Well, you can call it an experiment in rebottling if you like. It began in A.F. 473. The Controllers had the island of Cyprus cleared of all its existing inhabitants and recolonized with a specially prepared batch of twenty-two thousand Alphas. All agricultural and industrial equipment was handed over to them and they were left to manage their own affairs. The result exactly fulfilled all the theoretical predictions. The land wasn't properly worked; there were strikes in all the factories; the laws were set at naught, orders disobeyed; all the people detailed for a spell of low-grade work were perpetually intriguing for high-grade jobs, and all the people with high-grade jobs were counter-intriguing at all costs to stay where they were. Within six years they were having a first class civil war. When nineteen out of the twenty-two thousand had been killed, the survivors unanimously petitioned the World Controllers to resume the government of the island. Which they did. And that was the end of the only society of Alphas that the world has ever seen."

The Savage sighed, profoundly.

"The optimum population," said Mustapha Mond, "is modeled on the iceberg—eight-ninths below the water line, one-ninth above."

"And they're happy below the water line?"

"Happier than above it. Happier than your friend here, for example." He pointed.

"In spite of that awful work?"

"Awful? *They* don't find it so. On the contrary, they like it. It's light, it's childishly simple. No strain on the mind or the muscles. Seven and a half hours of mild, unexhausting labor, and then the *soma* ration and games and unrestricted copulation and the feelies. What more can they ask for? True," he added, "they might ask for shorter hours. And of course we could give them shorter hours. Technically, it would be perfectly simple to reduce all lower-caste working hours to three or four a day. But would they be any happier for that? No, they wouldn't. The experiment was tried, more than a century and a half ago. The whole of Ireland was put on to the four-hour day. What was the result? Unrest and a large increase in the consumption of *soma*; that was all. Those three and a half hours of extra leisure were so far from being a source of happiness, that people felt constrained to take a holiday from them. The Inventions Office is stuffed with plans for labor-saving processes. Thousands of them." Mustapha Mond made a lavish gesture. "And why don't we put them into execution? For the sake of the laborers; it would be sheer cruelty to afflict them with excessive leisure. It's the same with agriculture. We could synthesize every morsel of food, if we wanted to. But we don't. We prefer to keep a third of the population on the land. For their

own sakes—because it takes *longer* to get food out of the land than out of a factory. Besides, we have our stability to think of. We don't want to change. Every change is a menace to stability. That's another reason why we're so chary of applying new inventions. Every discovery in pure science is potentially subversive; even science must sometimes be treated as a possible enemy. Yes, even science."

Science? The Savage frowned. He knew the word. But what it exactly signified he could not say. Shakespeare and the old men of the pueblo had never mentioned science, and from Linda he had only gathered the vaguest hints: science was something you made helicopters with, something that caused you to laugh at the Corn Dances, something that prevented you from being wrinkled and losing your teeth. He made a desperate effort to take the Controller's meaning.

"Yes," Mustapha Mond was saying, "that's another item in the cost of stability. It isn't only art that's incompatible with happiness; it's also science. Science is dangerous; we have to keep it most carefully chained and muzzled."

"What?" said Helmholtz, in astonishment. "But we're always saying that science is everything. It's a hypnopædic platitude."

"Three times a week between thirteen and seventeen," put in Bernard.

"And all the science propaganda we do at the College . . ."

"Yes, but what sort of science?" asked Mustapha Mond sarcastically. "You've had no scientific training, so you can't judge. I was a pretty good physicist in my time. Too good—good enough to realize that all our science is just a cookery book, with an orthodox theory of cooking that nobody's allowed to question, and a list of recipes that mustn't be added to except by special permission from the head cook. I'm the head cook now. But I was an inquisitive young scullion once. I started doing a bit of cooking on my own. Unorthodox cooking, illicit cooking. A bit of real science, in fact." He was silent.

"What happened?" asked Helmholtz Watson.

The Controller sighed. "Very nearly what's going to happen to you young men. I was on the point of being sent to an island."

The words galvanized Bernard into a violent and unseemly activity. "Send *me* to an island?" He jumped up, ran across the room, and stood gesticulating in front of the Controller. "You can't send *me*. I haven't done anything. It was the others, I swear it was the others." He pointed accusingly to Helmholtz and the Savage. "Oh, please don't send me to Iceland. I promise I'll do what I ought to do. Give me another chance. Please give me another chance." The tears began to flow. "I tell you, it's their fault," he sobbed. "And not to Iceland. Oh please, your fordship, please . . ." And in a paroxysm of abjection he threw himself on his knees before the Controller. Mustapha Mond tried to make him get up; but Bernard persisted in his groveling; the stream of words poured out inexhaustibly. In the end the Controller had to ring for his fourth secretary.

"Bring three men," he ordered, "and take Mr. Marx into a bedroom. Give him a good *soma* vaporization and then put him to bed and leave him."

The fourth secretary went out and returned with three green-uniformed twin footmen. Still shouting and sobbing, Bernard was carried out.

"One would think he was going to have his throat cut," said the Controller, as the door closed. "Whereas, if he had the smallest sense, he'd understand that his punishment is really a reward. He's being sent to an island. That's to say, he's being sent to a place where he'll meet the most interesting set of men and women to be found anywhere in the world. All the people who, for one reason or another, have got too self-consciously individual to fit into community-life. All the people who aren't satisfied with orthodoxy, who've got independent ideas of their own. Every one, in a word, who's any one. I almost envy you, Mr. Watson."

Helmholtz laughed. "Then why aren't you on an island yourself?"

"Because, finally, I preferred this," the Controller answered. "I was given the choice: to be sent to an island, where I could have got on with my pure science, or to be taken on to the Controllers' Council with the prospect of succeeding in due course to an actual Controllership. I chose this and let the science go." After a little silence, "Sometimes," he added, "I rather regret the science. Happiness is a hard master—particularly other people's happiness. A much harder master, if one isn't conditioned to accept it unquestioningly, than truth." He sighed, fell silent again, then continued in a brisker tone. "Well, duty's duty. One can't consult one's own preferences. I'm interested in truth, I like science. But truth's a menace, science is a public danger. As dangerous as it's been beneficent. It has given us the stablest equilibrium in history. China's was hopelessly insecure by comparison; even the primitive matriarchies weren't steadier than we are. Thanks, I repeat, to science. But we can't allow science to undo its own good work. That's why we so carefully limit the scope of its researches—that's why I almost got sent to an island. We don't allow it to deal with any but the most immediate problems of the moment. All other inquiries are most sedulously discouraged. It's curious," he went on after a little pause, "to read what people in the time of Our Ford used to write about scientific progress. They seemed to have imagined that it could be allowed to go on indefinitely, regardless of everything else. Knowledge was the highest good, truth the supreme value; all the rest was secondary and subordinate. True, ideas were beginning to change even then. Our Ford himself did a great deal to shift the emphasis from truth and beauty to comfort and happiness. Mass production demanded the shift. Universal happiness keeps the wheels steadily turning; truth and beauty can't. And, of course, whenever the masses seized political power, then it was happiness rather than truth and beauty that mattered. Still, in spite of everything, unrestricted scientific research was still permitted. People still went on talking about truth and beauty as though they were the sovereign goods. Right up to the time of the Nine Years' War. *That* made them change their tune all right. What's the point of truth or beauty or knowledge when the anthrax bombs are popping all around you? That was when science first began to be controlled—after the Nine Years' War. People were ready to have even their appetites controlled then. Anything for a quiet life. We've gone on controlling ever since. It hasn't been very good for truth, of course. But it's been very good for happiness. One can't have something for nothing. Happiness has got to be paid for. You're paying for it, Mr. Watson—paying because you happen to be too much interested in beauty. I was too much interested in truth; I paid too."

"But *you* didn't go to an island," said the Savage, breaking a long silence.

The Controller smiled. "That's how I paid. By choosing to serve happiness. Other people's—not mine. It's lucky," he added, after a pause, "that there are such a lot of islands in the world. I don't know what we should do without them. Put you all in the lethal chamber, I suppose. By the way, Mr. Watson, would you like a tropical climate? The Marquesas, for example; or Samoa? Or something rather more bracing?"

Helmholtz rose from his pneumatic chair. "I should like a thoroughly bad climate," he answered. "I believe one would write better if the climate were bad. If there were a lot of wind and storms, for example . . ."

The Controller nodded his approbation. "I like your spirit, Mr. Watson. I like it very much indeed. As much as I offi-

cially disapprove of it." He smiled. "What about the Falkland Islands?"

"Yes, I think that will do," Helmholtz answered. "And now, if you don't mind, I'll go and see how poor Bernard's getting on."

Chapter 17

"Art, science—you seem to have paid a fairly high price for your happiness," said the Savage, when they were alone. "Anything else?"

"Well, religion, of course," replied the Controller. "There used to be something called God—before the Nine Years' War. But I was forgetting; you know all about God, I suppose."

"Well . . ." The Savage hesitated. He would have liked to say something about solitude, about night, about the mesa lying pale under the moon, about the precipice, the plunge into shadowy darkness, about death. He would have liked to speak; but there were no words. Not even in Shakespeare.

The Controller, meanwhile, had crossed to the other side of the room and was unlocking a large safe let into the wall between the bookshelves. The heavy door swung open. Rummaging in the darkness within, "It's a subject," he said, "that has always had a great interest for me." He pulled out a thick black volume. "You've never read this, for example."

The Savage took it. *"The Holy Bible, containing the Old and New Testaments,"* he read aloud from the title-page.

"Nor this." It was a small book and had lost its cover. *"The Imitation of Christ."*

"Nor this." He handed out another volume. *"The Varieties of Religious Experience.* By William James."

"And I've got plenty more," Mustapha Mond continued, resuming his seat. "A whole collection of pornographic old books. God in the safe and Ford on the shelves." He pointed with a laugh to his avowed library—to the shelves of books, the racks full of reading-machine bobbins and sound-track rolls.

"But if you know about God, why don't you tell them?" asked the Savage indignantly. "Why don't you give them these books about God?"

"For the same reason as we don't give them *Othello:* they're old; they're about God hundreds of years ago. Not about God now."

"But God doesn't change."

"Men do, though."

"What difference does that make?"

"All the difference in the world," said Mustapha Mond. He got up again and walked to the safe. "There was a man called Cardinal Newman," he said. "A cardinal," he exclaimed parenthetically, "was a kind of Arch-Community-Songster."

"'I Pandulph, of fair Milan, cardinal.' I've read about them in Shakespeare."

"Of course you have. Well, as I was saying, there was a man called Cardinal Newman. Ah, here's the book." He pulled it out. "And while I'm about it I'll take this one too. It's by a man called Maine de Biran. He was a philosopher, if you know what that was."

"A man who dreams of fewer things than there are in heaven and earth," said the Savage promptly.

"Quite so. I'll read you one of the things he *did* dream of in a moment. Meanwhile, listen to what this old Arch-Community-Songster said." He opened the book at the place marked by a slip of paper and began to read. "We are not our own any more than what we possess is our own. We did not make ourselves, we cannot be supreme over ourselves. We are not our own masters. We are God's property. Is it not our happiness thus to view the matter? Is it any happiness or any com-

fort, to consider that we *are* our own? It may be thought so by the young and prosperous. These may think it a great thing to have everything, as they suppose, their own way—to depend on no one—to have to think of nothing out of sight, to be without the irksomeness of continual acknowledgment, continual prayer, continual reference of what they do to the will of another. But as time goes on, they, as all men, will find that independence was not made for man—that it is an unnatural state—will do for a while, but will not carry us on safely to the end . . .'" Mustapha Mond paused, put down the first book and, picking up the other, turned over the pages. "Take this, for example," he said, and in his deep voice once more began to read: "'A man grows old; he feels in himself that radical sense of weakness, of listlessness, of discomfort, which accompanies the advance of age; and, feeling thus, imagines himself merely sick, lulling his fears with the notion that this distressing condition is due to some particular cause, from which, as from an illness, he hopes to recover. Vain imaginings! That sickness is old age; and a horrible disease it is. They say that it is the fear of death and of what comes after death that makes men turn to religion as they advance in years. But my own experience has given me the conviction that, quite apart from any such terrors or imaginings, the religious sentiment tends to develop as we grow older; to develop because, as the passions grow calm, as the fancy and sensibilities are less excited and less excitable, our reason becomes less troubled in its working, less obscured by the images, desires and distractions, in which it used to be absorbed; whereupon God emerges as from behind a cloud; our soul feels, sees, turns towards the source of all light; turns naturally and inevitably; for now that all that gave to the world of sensations its life and charm has begun to leak away from us, now that phenomenal existence is no more bolstered up by impressions from within or from without, we feel the need to lean on something that abides, something that will never play us false—a reality, an absolute and everlasting truth. Yes, we inevitably turn to God; for this religious sentiment is of its nature so pure, so delightful to the soul that experiences it, that it makes up to us for all our other losses.'" Mustapha Mond shut the book and leaned back in his chair. "One of the numerous things in heaven and earth that these philosophers didn't dream about was this" (he waved his hand), "us, the modern world. 'You can only be independent of God while you've got youth and prosperity; independence won't take you safely to the end.' Well, we've now got youth and prosperity right up to the end. What follows? Evidently, that we can be independent of God. 'The religious sentiment will compensate us for all our losses.' But there aren't any losses for us to compensate; religious sentiment is superfluous. And why should we go hunting for a substitute for youthful desires, when youthful desires never fail? A substitute for distractions, when we go on enjoying all the old fooleries to the very last? What need have we of repose when our minds and bodies continue to delight in activity? of consolation, when we have *soma?* of something immovable, when there is the social order?"

"Then you think there is no God?"

"No, I think there quite probably is one."

"Then why? . . ."

Mustapha Mond checked him. "But he manifests himself in different ways to different men. In premodern times he manifested himself as the being that's described in these books. Now . . ."

"How does he manifest himself now?" asked the Savage.

"Well, he manifests himself as an absence; as though he weren't there at all."

"That's your fault."

"Call it the fault of civilization. God isn't compatible with machinery and scientific medicine and universal happiness. You

must make your choice. Our civilization has chosen machinery and medicine and happiness. That's why I have to keep these books locked up in the safe. They're smut. People would be shocked if . . ."

The Savage interrupted him. "But isn't it *natural* to feel there's a God?"

"You might as well ask if it's natural to do up one's trousers with zippers," said the Controller sarcastically. "You remind me of another of those old fellows called Bradley. He defined philosophy as the finding of bad reason for what one believes by instinct. As if one believed anything by instinct! One believes things because one has been conditioned to believe them. Finding bad reasons for what one believes for other bad reasons—that's philosophy. People believe in God because they've been conditioned to believe in God."

"But all the same," insisted the Savage, "it is natural to believe in God when you're alone—quite alone, in the night, thinking about death . . ."

"But people never are alone now," said Mustapha Mond. "We make them hate solitude; and we arrange their lives so that it's almost impossible for them ever to have it."

The Savage nodded gloomily. At Malpais he had suffered because they had shut him out from the communal activities of the pueblo, in civilized London he was suffering because he could never escape from those communal activities, never be quietly alone.

"Do you remember that bit in *King Lear*?" said the Savage at last. "'The gods are just and of our pleasant vices make instruments to plague us; the dark and vicious place where thee he got cost him his eyes,' and Edmund answers—you remember, he's wounded, he's dying—'Thou hast spoken right; 'tis true. The wheel has come full circle; I am here.' What about that now? Doesn't there seem to be a God managing things, punishing, rewarding?"

"Well, does there?" questioned the Controller in his turn. "You can indulge in any number of pleasant vices with a freemartin and run no risks of having your eyes put out by your son's mistress. 'The wheel has come full circle; I am here.' But where would Edmund be nowadays? Sitting in a pneumatic chair, with his arm around a girl's waist, sucking away at his sex-hormone chewing-gum and looking at the feelies. The gods are just. No doubt. But their code of law is dictated, in the last resort, by the people who organize society; Providence takes its cue from men."

"Are you sure?" asked the Savage. "Are you quite sure that the Edmund in that pneumatic chair hasn't been just as heavily punished as the Edmund who's wounded and bleeding to death? The gods are just. Haven't they used his pleasant vices as an instrument to degrade him?"

"Degrade him from what position? As a happy, hard-working, goods-consuming citizen he's perfect. Of course, if you choose some other standard than ours, then perhaps you might say he was degraded. But you've got to stick to one set of postulates. You can't play Electro-magnetic Golf according to the rules of Centrifugal Bumble-puppy."

"But value dwells not in particular will," said the Savage. "It holds his estimate and dignity as well wherein 'tis precious of itself as in the prizer."

"Come, come," protested Mustapha Mond, "that's going rather far isn't it?"

"If you allowed yourselves to think of God, you wouldn't allow yourselves to be degraded by pleasant vices. You'd have reason for bearing things patiently, for doing things with courage. I've seen it with the Indians."

"I'm sure you have," said Mustapha Mond. "But then we aren't Indians. There isn't any need for a civilized man to bear anything that's seriously unpleasant. And as for doing things—Ford forbid that he should get the idea into his head. It would

upset the whole social order if men started doing things on their own."

"What about self-denial, then? If you had a God, you'd have a reason for self-denial."

"But industrial civilization is only possible when there's no self-denial. Self-indulgence up to the very limits imposed by hygiene and economics. Otherwise the wheels stop turning."

"You'd have a reason for chastity!" said the Savage, blushing a little as he spoke the words.

"But chastity means passion, chastity means neurasthenia. And passion and neurasthenia mean instability. And instability means the end of civilization. You can't have a lasting civilization without plenty of pleasant vices."

"But God's the reason for everything noble and fine and heroic. If you had a God . . ."

"My dear young friend," said Mustapha Mond, "civilization has absolutely no need of nobility or heroism. These things are symptoms of political inefficiency. In a properly organized society like ours, nobody has any opportunities for being noble or heroic. Conditions have got to be thoroughly unstable before the occasion can arise. Where there are wars, where there are divided allegiances, where there are temptations to be resisted, objects of love to be fought for or defended—there, obviously, nobility and heroism have some sense. But there aren't any wars nowadays. The greatest care is taken to prevent you from loving any one too much. There's no such thing as a divided allegiance; you're so conditioned that you can't help doing what you ought to do. And what you ought to do is on the whole so pleasant, so many of the natural impulses are allowed free play, that there really aren't any temptations to resist. And if ever, by some unlucky chance, anything unpleasant should somehow happen, why, there's always *soma* to give you a holiday from the facts. And there's always *soma* to calm your anger, to reconcile you to your enemies, to make you patient and long-suffering. In the past you could only accomplish these things by making a great effort and after years of hard moral training. Now, you swallow two or three half-gram tablets, and there you are. Anybody can be virtuous now. You can carry at least half your morality about in a bottle. Christianity without tears—that's what *soma* is."

"But the tears are necessary. Don't you remember what Othello said? 'If after every tempest came such calms, may the winds blow till they have wakened death.' There's a story one of the old Indians used to tell us, about the Girl of Mátaski. The young men who wanted to marry her had to do a morning's hoeing in her garden. It seemed easy; but there were flies and mosquitoes, magic ones. Most of the young men simply couldn't stand the biting and stinging. But the one that could—he got the girl."

"Charming! But in civilized countries," said the Controller, "you can have girls without hoeing for them; and there aren't any flies or mosquitoes to sting you. We got rid of them centuries ago."

The Savage nodded, frowning. "You got rid of them. Yes, that's just like you. Getting rid of everything unpleasant instead of learning to put up with it. Whether 'tis better in the mind to suffer the slings and arrows of outrageous fortune, or to take arms against a sea of troubles and by opposing end them . . . But you don't do either. Neither suffer nor oppose. You just abolish the slings and arrows. It's too easy."

He was suddenly silent, thinking of his mother. In her room on the thirty-seventh floor, Linda had floated in a sea of singing lights and perfumed caresses—floated away, out of space, out of time, out of the prison of her memories, her habits, her aged and bloated body. And Tomakin, ex-director of Hatcheries and Conditioning, Tomakin was still on holiday—from humiliation and pain, in a world where he could not hear those words, that derisive laughter, could not see that hideous face,

feel those moist and flabby arms round his neck, in a beautiful world . . .

"What you need," the Savage went on, "is something *with* tears for a change. Nothing costs enough here."

("Twelve and a half million dollars." Henry Foster had protested when the Savage told him that. "Twelve and a half million—that's what the new Conditioning Center cost. Not a cent less.")

"Exposing what is mortal and unsure to all that fortune, death and danger dare, even for an egg-shell. Isn't there something in that?" he asked, looking up at Mustapha Mond. "Quite apart from God—though of course God would be a reason for it. Isn't there something in living dangerously?"

"There's a great deal in it," the Controller replied. "Men and women must have their adrenals stimulated from time to time."

"What?" questioned the Savage, uncomprehending.

"It's one of the conditions of perfect health. That's why we've made the V.P.S. treatments compulsory."

"V.P.S.?"

"Violent Passion Surrogate. Regularly once a month. We flood the whole system with adrenin. It's the complete physiological equivalent of fear and rage. All the tonic effects of murdering Desdemona and being murdered by Othello, without any of the inconveniences."

"But I like the inconveniences."

"We don't," said the Controller. "We prefer to do things comfortably."

"But I don't want comfort. I want God, I want poetry, I want real danger, I want freedom, I want goodness. I want sin."

"In fact," said Mustapha Mond, "you're claiming the right to be unhappy."

"All right then," said the Savage defiantly, "I'm claiming the right to be unhappy."

"Not to mention the right to grow old and ugly and impotent; the right to have syphilis and cancer; the right to have too little to eat; the right to be lousy; the right to live in constant apprehension of what may happen tomorrow; the right to catch typhoid; the right to be tortured by unspeakable pains of every kind."

There was a long silence.

"I claim them all," said the Savage at last.

Mustapha Mond shrugged his shoulders. "You're welcome," he said.

CHAPTER 22

READING 93

from JEAN-PAUL SARTRE (1905–1980), EXISTENTIALISM IS A HUMANISM (1946)

Existentialism was an attempt to help people understand their existence (hence the term "Existentialism") and their place in an absurd world. John-Paul Sartre, one of the leading proponents of Existentialism, believed that God did not exist. Consequently, he insisted, there is no blueprint for what a person should be and no ultimate significance to the universe. People are thrown into life and are free to behave as they choose. Their very aloneness forces people to face up to their freedom and make decisions about who they are and what they shall become. This excerpt from a lecture that Sartre delivered at the club Maintenant in Paris, October 29, 1945 (at the end of World War II) lays out the main theses of Sartre's analysis. Later published, it would becoming a defining text of the Existentialist movement.

Atheistic existentialism, of which I am a representative, declares with greater consistency that if God does not exist there is at least one being whose existence comes before its essence, a being which exists before it can be defined by any conception of it. That being is man or, as Heidegger [German philosopher] has it, the human reality. What do we mean by saying that existence precedes essence? We mean that man first of all exists, encounters himself, surges up in the world—and defines himself afterwards. If man as the existentialist sees him is not definable, it is because to begin with he is nothing. He will not be anything until later, and then he will be what he makes of himself. Thus, there is no human nature, because there is no God to have a conception of it. Man simply is. Not that he is simply what he conceives himself to be, but he is what he wills, and as he conceives himself after already existing—as he wills to be after that leap towards existence.

Man is nothing else but that which he makes of himself. That is the first principle of existentialism. And this is what people call its "subjectivity," using the word as a reproach against us. But what do we mean to say by this, but that man is of a greater dignity than a stone or a table? For we mean to say that man primarily exists—that man is, before all else, something which propels itself towards a future and is aware that it is doing so. Man is, indeed, a project which possesses a subjective life, instead of being a kind of moss, or a fungus or a cauliflower. Before that projection of the self nothing exists; not even in the heaven of intelligence: man will only attain existence when he is what he purposes to be. Not, however, what he may wish to be. For what we usually understand by wishing or willing is a conscious decision taken—much more often than not—after we have made ourselves what we are. I may wish to join a party, to write a book or to marry—but in such a case what is usually called my will is probably a manifestation of a prior and more spontaneous decision. If, however, it is true that existence is prior to essence, man is responsible for what he is. Thus, the first effect of existentialism is that it puts every man in possession of himself as he is, and places the entire responsibility for his existence squarely upon his own shoulders. And, when we say that man is responsible for himself, we do not mean that he is responsible only for his own individuality, but that he is responsible for all men.

The word "subjectivism" is to be understood in two senses, and our adversaries play upon only one of them. Subjectivism means, on the one hand, the freedom of the individual subject and, on the other, that man cannot pass beyond human subjectivity. It is the latter which is the deeper meaning of existentialism. When we say that man chooses himself, we do mean that every one of us must choose himself; but by that we also mean that in choosing for himself he chooses for all men. For in effect, of all the actions a man may take in order to create himself as he wills to be, there is not one which is not creative, at the same time, of an image of man such as he believes he ought to be. To choose between this or that is at the same time to affirm the value of that which is chosen; for we are unable ever to choose the worse. What we choose is always the better; and nothing can be better for us unless it is better for all.

If, moreover, existence precedes essence and we will to exist at the same time as we fashion our image, that image is valid for all and for the entire epoch in which we find ourselves. Our responsibility is thus much greater than we had supposed, for it concerns mankind as a whole. If I am a worker, for instance, I may choose to join a Christian rather than a Communist trade union. And if, by that membership, I choose to signify that resignation is, after all, the attitude that best becomes a man, that

man's kingdom is not upon this earth, I do not commit myself alone to that view. Resignation is my will for everyone, and my action is, in consequence, a commitment on behalf of all mankind. Or if, to take a more personal case, I decide to marry and to have children, even though this decision proceeds simply from my situation, from my passion or my desire, I am thereby committing not only myself, but humanity as a whole, to the practice of monogamy. I am thus responsible for myself and for all men, and I am creating a certain image of man as I would have him to be. In fashioning myself I fashion man.

This may enable us to understand what is meant by such terms—perhaps a little grandiloquent—as anguish, abandonment, and despair. As you will soon see, it is very simple.

First, what do we mean by anguish? The existentialist frankly states that man is in anguish. His meaning is as follows: When a man commits himself to anything, fully realising that he is not only choosing what he will be, but is thereby at the same time a legislator deciding for the whole of mankind—in such a moment a man cannot escape from the sense of complete and profound responsibility. There are many, indeed, who show no such anxiety. But we affirm that they are merely disguising their anguish or are in flight from it. Certainly, many people think that in what they are doing they commit no one but themselves to anything: and if you ask them, "What would happen if everyone did so?" they shrug their shoulders and reply, "Everyone does not do so." But in truth, one ought always to ask oneself what would happen if everyone did as one is doing; nor can one escape from that disturbing thought except by a kind of self-deception. The man who lies in self-excuse, by saying "Everyone will not do it" must be ill at ease in his conscience, for the act of lying implies the universal value which it denies. By its very disguise his anguish reveals itself.

The existentialist, on the contrary, finds it extremely embarrassing that God does not exist, for there disappears with Him all possibility of finding values in an intelligible heaven. There can no longer be any good *a priori*, since there is no infinite and perfect consciousness to think it. It is nowhere written that "the good" exists, that one must be honest or must not lie, since we are now upon the plane where there are only men. Dostoevsky once wrote: "If God did not exist, everything would be permitted"; and that, for existentialism, is the starting point. Everything is indeed permitted if God does not exist, and man is in consequence forlorn, for he cannot find anything to depend upon either within or outside himself. He discovers forthwith, that he is without excuse.

For if indeed existence precedes essence, one will never be able to explain one's action by reference to a given and specific human nature; in other words, there is no determinism—man is free, man *is* freedom. Nor, on the other hand, if God does not exist, are we provided with any values or commands that could legitimise our behaviour. Thus we have neither behind us, nor before us in a luminous realm of values, any means of justification or excuse.—We are left alone, without excuse.

That is what I mean when I say that man is condemned to be free. Condemned, because he did not create himself, yet is nevertheless at liberty, and from the moment that he is thrown into this world he is responsible for everything he does. The existentialist does not believe in the power of passion. He will never regard a grand passion as a destructive torrent upon which a man is swept into certain actions as by fate, and which, therefore, is an excuse for them. He thinks that man is responsible for his passion.

Neither will an existentialist think that a man can find help through some sign being vouchsafed upon earth for his orientation: for he thinks that the man himself interprets the sign as he chooses. He thinks that every man, without any support or help whatever, is condemned at every instant to invent man. As Ponge [French poet and essayist] has written in a very fine article, "Man

is the future of man." That is exactly true. Only, if one took this to mean that the future is laid up in Heaven, that God knows what it is, it would be false, for then it would no longer even be a future. If, however, it means that, whatever man may now appear to be, there is a future to be fashioned, a virgin future that awaits him—then it is a true saying. But in the present one is forsaken.

But in reality and for the existentialist, there is no love apart from the deeds of love; no potentiality of love other than that which is manifested in loving; there is no genius other than that which is expressed in works of art. The genius of Proust is the totality of the works of Proust; the genius of Racine is the series of his tragedies, outside of which there is nothing. Why should we attribute to Racine the capacity to write yet another tragedy when that is precisely what he did not write? In life, a man commits himself, draws his own portrait and there is nothing but that portrait. No doubt this thought may seem comfortless to one who has not made a success of his life. On the other hand, it puts everyone in a position to understand that reality alone is reliable; that dreams, expectations and hopes serve to define a man only as deceptive dreams, abortive hopes, expectations unfulfilled; that is to say, they define him negatively, not positively. Nevertheless, when one says, "You are nothing else but what you live," it does not imply that an artist is to be judged solely by his works of art, for a thousand other things contribute no less to his definition as a man. What we mean to say is that a man is no other than a series of undertakings, that he is the sum, the organization, the set of relations that constitute these undertakings.

But there is another sense of the word, of which the fundamental meaning is this: Man is all the time outside of himself: it is in projecting and losing himself beyond himself that he makes man to exist; and, on the other hand, it is by pursuing transcendent aims that he himself is able to exist. Since man is thus self-surpassing, and can grasp objects only in relation to his self-surpassing, he is himself the heart and center of his transcendence. There is no other universe except the human universe, the universe of human subjectivity. This relation of transcendence as constitutive of man (not in the sense that God is transcendent, but in the sense of self-surpassing) with subjectivity (in such a sense that man is not shut up in himself but forever present in a human universe)—it is this that we call existential humanism. This is humanism, because we remind man that there is no legislator but himself; that he himself, thus abandoned, must decide for himself; also because we show that it is not by turning back upon himself, but always by seeking, beyond himself, an aim which is one of liberation or of some particular realization, that man can realize himself as truly human.

Existentialism and Humanism by Jean-Paul Sartre. Translated by Philip Mairet. Methuen, 1952.

READING 94
from Elie Wiesel (b. 1928), Night (1960)

This selection, based on Wiesel's own personal experiences, recounts life in a concentration camp as seen by a teenage boy. Reading, one begins to see why Wiesel calls camp life the "Kingdom of the Night."

Chapter 5

The summer was coming to an end. The Jewish year was nearly over.

On the eve of Rosh Hashanah, the last day of that accursed year, the whole camp was electric with the tension which was in all our hearts. In spite of everything, this day was different

from any other. The last day of the year. The word *last* rang very strangely. What if it were indeed the last day?

They gave us our evening meal, a very thick soup, but no one touched it. We wanted to wait until after the prayers. At the place of assembly, surrounded by the electrified barbed wire, thousands of silent Jews gathered, their faces stricken.

Night was falling. Other prisoners continued to crowd in, from every block, able suddenly to conquer time and space and submit both to their will.

"What are You, my God," I thought angrily, "compared to this afflicted crowd, proclaiming to You their faith, their anger, their revolt? What does Your greatness mean, Lord of the Universe, in the face of all this weakness, this decomposition, and this decay? Why do You still trouble their sick minds, their crippled bodies?"

Ten thousand men had come to attend the solemn service, heads of the blocks, Kapos, functionaries of death.

"Bless the Eternal. . . ."

The voice of the officiant [one who officiates at a religious ceremony] had just made itself heard. I thought at first it was the wind.

"Blessed be the Name of the Eternal!"

Thousands of voices repeated the benediction; thousands of men prostrated themselves like trees before a tempest.

"Blessed be the Name of the Eternal!"

Why, but why should I bless Him? In every fiber I rebelled. Because He had had thousands of children burned in His pits? Because He kept six crematories working night and day, on Sundays and feast days? Because in His great might He had created Auschwitz, Birkenau, Buna, and so many factories of death? How could I say to Him: "Blessed art Thou, Eternal, Master of the Universe, Who chose us from among the races to be tortured day and night, to see our fathers, our mothers, our brothers, end in the crematory? Praised be Thy Holy Name, Thou Who hast chosen us to be butchered on Thine altar?"

I heard the voice of the officiant rising up, powerful yet at the same time broken, amid the tears, the sobs, the sighs of the whole congregation:

"All the earth and the Universe are God's!"

He kept stopping every moment, as though he did not have the strength to find the meaning beneath the words. The melody choked in his throat.

And I, mystic that I had been, I thought:

"Yes, man is very strong, greater than God. When You were deceived by Adam and Eve, You drove them out of Paradise. When Noah's generation displeased You, You brought down the Flood. When Sodom no longer found favor in Your eyes, You made the sky rain down fire and sulfur. But these men here, whom You have betrayed, whom You have allowed to be tortured, butchered, gassed, burned, what do they do? They pray before You! They praise Your name!"

"All creation bears witness to the Greatness of God!"

Once, New Year's Day had dominated my life. I knew that my sins grieved the Eternal; I implored his forgiveness. Once, I had believed profoundly that upon one solitary deed of mine, one solitary prayer, depended the salvation of the world.

This day I had ceased to plead. I was no longer capable of lamentation. On the contrary, I felt very strong. I was the accuser, God the accused. My eyes were open and I was alone—terribly alone in a world without God and without man. Without love or mercy. I had ceased to be anything but ashes, yet I felt myself to be stronger than the Almighty, to whom my life had been tied for so long. I stood amid that praying congregation, observing it like a stranger.

The service ended with the Kaddish [prayer for the dead]. Everyone recited the Kaddish over his parents, over his children, over his brothers, and over himself.

We stayed for a long time at the assembly place. No one dared to drag himself away from this mirage. Then it was time to go to bed and slowly the prisoners made their way over to their blocks. I heard people wishing one another a Happy New Year!

I ran off to look for my father. And at the same time I was afraid of having to wish him a Happy New Year when I no longer believed in it.

He was standing near the wall, bowed down, his shoulders sagging as though beneath a heavy burden. I went up to him, took his hand and kissed it. A tear fell upon it. Whose was that tear? Mine? His? I said nothing. Nor did he. We had never understood one another so clearly.

The sound of the bell jolted us back to reality. We must go to bed. We came back from far away. I raised my eyes to look at my father's face leaning over mine, to try to discover a smile or something resembling one upon the aged, dried-up countenance. Nothing. Not the shadow of an expression. Beaten.

Yom Kippur. The Day of Atonement.

Should we fast? The question was hotly debated. To fast would mean a surer, swifter death. We fasted here the whole year round. The whole year was Yom Kippur. But others said that we should fast simply because it was dangerous to do so. We should show God that even here, in this enclosed hell, we were capable of singing His praises.

I did not fast, mainly to please my father, who had forbidden me to do so. But further, there was no longer any reason why I should fast. I no longer accepted God's silence. As I swallowed my bowl of soup, I saw in the gesture an act of rebellion and protest against Him.

And I nibbled my crust of bread.

In the depths of my heart, I felt a great void.

The SS gave us a fine New Year's gift.

We had just come back from work. As soon as we had passed through the door of the camp, we sensed something different in the air. Roll call did not take so long as usual. The evening soup was given out with great speed and swallowed down at once in anguish.

I was no longer in the same block as my father. I had been transferred to another unit, the building one, where, twelve hours a day, I had to drag heavy blocks of stone about. The head of my new block was a German Jew, small of stature, with piercing eyes. He told us that evening that no one would be allowed to go out after the evening soup. And soon a terrible word was circulating—selection.

We knew what that meant. An SS man would examine us. Whenever he found a weak one, a *musulman* as we called them, he would write his number down: good for the crematory.

After soup, we gathered together between the beds. The veterans said:

"You're lucky to have been brought here so late. This camp is paradise today, compared with what is was like two years ago. Buna was a real hell then. There was no water, no blankets, less soup and bread. At night we slept almost naked, and it was below thirty degrees. The corpses were collected in hundreds every day. The work was hard. Today, this is a little paradise. The Kapos had orders to kill a certain number of prisoners every day. And every week—selection. A merciless selection.

. . . Yes, you're lucky."

"Stop it! Be quiet!" I begged. "You can tell your stories tomorrow or on some other day."

They burst out laughing. They were not veterans for nothing.

"Are you scared? So were we scared. And there was plenty to be scared of in those days."

The old men stayed in their corner, dumb, motionless, hunted. Some were praying.

An hour's delay. In an hour, we should know the verdict—death or a reprieve.

And my father. Suddenly I remembered him. How would he pass the selection? He had aged so much. . . .

The head of our block had never been outside concentration camps since 1933. He had already been through all the slaughterhouses, all the factories of death. At about nine o'clock, he took up his position in our midst:

"Achtung!"

There was instant silence.

"Listen carefully to what I am going to say." (For the first time, I heard his voice quiver.) "In a few moments the selection will begin. You must get completely undressed. Then one by one you go before the SS doctors. I hope you will all succeed in getting through. But you must help your own chances. Before you go into the next room, move about in some way so that you give yourselves a little color. Don't walk slowly, run! Run as if the devil were after you! Don't look at the SS. Run, straight in front of you!"

He broke off for a moment, then added:

"And, the essential thing, don't be afraid!"

Here was a piece of advice we should have liked very much to be able to follow.

I got undressed, leaving my clothes on the bed. There was no danger of anyone stealing them this evening.

Tibi and Yossi, who had changed their unit at the same time I had, came up to me and said:

"Let's keep together. We shall be stronger."

Yossi was murmuring something between his teeth. He must have been praying. I had never realized that Yossi was a believer. I had even always thought the reverse. Tibi was silent, very pale. All the prisoners in the block stood naked between the beds. This must be how one stands at the last judgment.

"They're coming!"

There were three SS officers standing round the notorious Dr. Mengele, who had received us at Birkenau. The head of the block, with an attempt at a smile, asked us:

"Ready?"

Yes, we were ready. So were the SS doctors. Dr. Mengele was holding a list in his hand: our numbers. He made a sign to the head of the block: "We can begin!" As if this were a game!

The first to go by were the "officials" of the block: *Stubenaelteste,* Kapos, foreman, all in perfect physical condition of course! Then came the ordinary prisoners' turn. Dr. Mengele took stock of them from head to foot. Every now and then, he wrote a number down. One single thought filled my mind: not to let my number be taken; not to show my left arm.

There were only Tibi and Yossi in front of me. They passed. I had time to notice that Mengele had not written their numbers down. Someone pushed me. It was my turn. I ran without looking back. My head was spinning: you're too thin, you're weak, you're too thin, you're good for the furnace. . . . The race seemed interminable. I thought I had been running for years. . . . You're too thin, you're too weak. . . . At last I had arrived exhausted. When I regained my breath, I questioned Yossi and Tibi:

"Was I written down?"

"No," said Yossi. He added, smiling: "In any case, he couldn't have written you down, you were running too fast. . . ."

I began to laugh. I was glad. I would have liked to kiss him: At that moment, what did the others matter! I hadn't been written down.

Those whose number had been noted stood apart, abandoned by the whole world. Some were weeping in silence. The SS officers went away. The head of the block appeared, his face reflecting the general weariness.

"Everything went off all right. Don't worry. Nothing is going to happen to anyone. To anyone."

Again he tried to smile. A poor, emaciated, dried-up Jew questioned him avidly in a trembling voice:

"But . . . but, *Blockaelteste,* they did write me down!"

The head of the block let his anger break out. What! Did someone refuse to believe him!

"What's the matter now? Am I telling lies then? I tell you once and for all, nothing's going to happen to you! To anyone! You're wallowing in your own despair, you fool!"

The bell rang, a signal that the selection had been completed throughout the camp.

With all my might I began to run to Block 36. I met my father on the way. He came up to me:

"Well? So you passed?"

"Yes. And you?"

"Me too."

How we breathed again, now! My father had brought me a present—half a ration of bread obtained in exchange for a piece of rubber, found at the warehouse, which would do to sole a shoe.

The bell. Already we must separate, go to bed. Everything was regulated by the bell. It gave me orders, and I automatically obeyed them. I hated it. Whenever I dreamed of a better world, I could only imagine a universe with no bells.

Several days had elapsed. We no longer thought about the selection. We went to work as usual, loading heavy stones into railway wagons. Rations had become more meager: this was the only change.

We had risen before dawn, as on every day. We had received black coffee, the ration of bread. We were about to set out for the yard as usual. The head of the block arrived, running.

"Silence for a moment. I have a list of numbers here. I'm going to read them to you. Those whose numbers I call won't be going to work this morning; they'll stay behind in the camp."

And, in a soft voice, he read out about ten numbers. We had understood. These were numbers chosen at the selection. Dr. Mengele had not forgotten.

The head of the block went toward his room. Ten prisoners surrounded him, hanging onto his clothes:

"Save us! You promised. . . ! We want to go to the yard. We're strong enough to work. We're good workers. We can . . . we will. . . ."

He tried to calm them, to reassure them about their fate, to explain to them that the fact that they were staying behind in the camp did not mean much, had no tragic significance.

"After all, I stay here myself every day," he added.

It was a somewhat feeble argument. He realized it, and without another word went and shut himself up in his room.

The bell had just rung.

"Form up!"

It scarcely mattered now that the work was hard. The essential thing was to be as far away as possible from the block, from the crucible of death, from the center of hell.

I saw my father running toward me. I became frightened all of a sudden.

"What's the matter?"

Out of breath, he could hardly open his mouth.

"Me, too . . . me, too . . . ! They told me to stay behind in the camp."

They had written down his number without his being aware of it.

"What will happen?" I asked in anguish.

But it was he who tried to reassure me.

"It isn't certain yet. There's still a chance of escape. They're going to do another selection today . . . a decisive selection."

I was silent.

He felt that his time was short. He spoke quickly. He would have liked to say so many things. His speech grew confused; his voice choked. He knew that I would have to go in a few moments. He would have to stay behind alone, so very alone.

"Look, take this knife," he said to me. "I don't need it any longer. It might be useful to you. And take this spoon as well. Don't sell them. Quickly! Go on. Take what I'm giving you!"

The inheritance.

"Don't talk like that, father." (I felt that I would break into sobs.) "I don't want you to say that. Keep the spoon and knife. You need them as much as I do. We shall see each other again this evening, after work."

He looked at me with his tired eyes, veiled with despair. He went on:

"I'm asking this of you. . . . Take them. Do as I ask, my son. We have no time. . . . Do as your father asks."

Our Kapo yelled that we should start.

The unit set out toward the camp gate. Left, right! I bit my lips. My father had stayed by the block, leaning against the wall. Then he began to run, to catch up with us. Perhaps he had forgotten something he wanted to say to me. . . . But we were marching too quickly. . . . Left, right!

We were already at the gate. They counted us, to the din of military music. We were outside.

The whole day, I wandered about as if sleepwalking. Now and then Tibi and Yossi would throw me a brotherly word. The Kapo, too, tried to reassure me. He had given me easier work today. I felt sick at heart. How well they were treating me! Like an orphan! I thought: even now, my father is still helping me.

I did not know myself what I wanted—for the day to pass quickly or not. I was afraid of finding myself alone that night. How good it would be to die here!

At last we began the return journey. How I longed for orders to run!

The military march. The gate. The camp.

I ran to Block 36.

Were there still miracles on this earth? He was alive. He had escaped the second selection. He had been able to prove that he was still useful. . . . I gave him back his knife and spoon.

READING 95
FLANNERY O'CONNOR (1925–1964),
REVELATION (1965)

This short story by Flannery O'Connor has its deepest meaning in the title itself. The reader might well ask: What is revealed to Mrs. Turpin? Who is the agent of that revelation? How will she be different as she grasps the revelation? Pay particular attention to the closing paragraphs of the story.

The doctor's waiting room, which was very small, was almost full when the Turpins entered and Mrs. Turpin, who was very large, made it look even smaller by her presence. She stood looming at the head of the magazine table set in the center of it, a living demonstration that the room was inadequate and ridiculous. Her little bright black eyes took in all the patients as she sized up the seating situation. There was one vacant chair and a place on the sofa occupied by a blond child in a dirty blue romper who should have been told to move over and make room for the lady. He was five or six, but Mrs. Turpin saw at once that no one was going to tell him to move over. He was slumped down in the seat, his arms idle at his sides and his eyes idle in his head; his nose ran unchecked.

Mrs. Turpin put a firm hand on Claud's shoulder and said in a voice that included anyone who wanted to listen, "Claud, you sit in that chair there," and gave him a push down into the vacant one. Claud was florid and bald and sturdy, somewhat shorter than Mrs. Turpin, but he sat down as if he were accustomed to doing what she told him to.

Mrs. Turpin remained standing. The only man in the room besides Claud was a lean stringy old fellow with a rusty hand spread out on each knee, whose eyes were closed as if he were asleep or dead or pretending to be so as not to get up and offer her his seat. Her gaze settled agreeably on a well-dressed gray-haired lady whose eyes met hers and whose expression said: if that child belonged to me, he would have some manners and move over—there's plenty of room there for you and him too.

Claud looked up with a sigh and made as if to rise.

"Sit down," Mrs. Turpin said. "You know you're not supposed to stand on that leg. He has an ulcer on his leg," she explained.

Claud lifted his foot onto the magazine table and rolled his trouser leg up to reveal a purple swelling on a plump marble-white calf.

"My!" the pleasant lady said. "How did you do that?"

"A cow kicked him," Mrs. Turpin said.

"Goodness!" said the lady.

Claud rolled his trouser leg down.

"Maybe the little boy would move over," the lady suggested, but the child did not stir.

"Somebody will be leaving in a minute," Mrs. Turpin said. She could not understand why a doctor—with as much money as they made charging five dollars a day to just stick their head in the hospital door and look at you—couldn't afford a decent-sized waiting room. This one was hardly bigger than a garage. The table was cluttered with limp-looking magazines and at one end of it there was a big green glass ash tray full of cigarette butts and cotton wads with little blood spots on them. If she had had anything to do with the running of the place, that would have been emptied every so often. There were no chairs against the wall at the head of the room. It had a rectangular-shaped panel in it that permitted a view of the office where the nurse came and went and the secretary listened to the radio. A plastic fern in a gold pot sat in the opening and trailed its fronds down almost to the floor. The radio was softly playing gospel music.

Just then the inner door opened and a nurse with the highest stack of yellow hair Mrs. Turpin had ever seen put her face in the crack and called for the next patient. The woman sitting beside Claud grasped the two arms of her chair and hoisted herself up; she pulled her dress free from her legs and lumbered through the door where the nurse had disappeared.

Mrs. Turpin eased into the vacant chair, which held her tight as a corset. "I wish I could reduce," she said, and rolled her eyes and gave a comic sigh.

"Oh, *you* aren't fat," the stylish lady said.

"Ooooo I am too," Mrs. Turpin said. "Claud he eats all he wants to and never weighs over one hundred and seventy-five pounds, but me I just look at something good to eat and I gain some weight," and her stomach and shoulders shook with laughter. "You can eat all you want to, can't you, Claud?" she asked, turning to him.

Claud only grinned.

"Well, as long as you have such a good disposition," the stylish lady said, "I don't think it makes a bit of difference what size you are. You just can't beat a good disposition."

Next to her was a fat girl of eighteen or nineteen, scowling into a thick blue book which Mrs. Turpin saw was [titled] *Human Development.* The girl raised her head and directed her scowl at Mrs. Turpin as if she did not like her looks. She appeared annoyed that anyone should speak while she tried to read. The poor girl's face was blue with acne and Mrs. Turpin thought how pitiful it was to have a face like that at that age. She gave the girl a friendly smile but the girl only scowled the harder. Mrs. Turpin herself was fat but she had always had good skin, and, though she was forty-seven years old, there was not a wrinkle in her face except around her eyes from laughing too much.

Next to the ugly girl was the child, still in exactly the same position, and next to him was a thin leathery old woman in a cotton print dress. She and Claud had three sacks of chicken feed in their pump house that was in the same print. She had seen from the first that the child belonged with the old woman. She could tell by the way they sat—kind of vacant and white-trashy, as if they would sit there until Doomsday if nobody called and told them to get up. And at right angles but next to the well-dressed pleasant lady was a lank-faced woman who was certainly the child's mother. She had on a yellow sweat shirt and wine-colored slacks, both gritty-looking, and the rims of her lips were stained with snuff. Her dirty yellow hair was tied behind with a little piece of red paper ribbon. Worse than niggers any day, Mrs. Turpin thought.

The gospel hymn playing was, "When I looked up and He looked down," and Mrs. Turpin, who knew it, supplied the last line mentally, "And wona these days I know I'll we-eara crown."

Without appearing to, Mrs. Turpin always noticed people's feet. The well-dressed lady had on red and gray suede shoes to match her dress. Mrs. Turpin had on her good black patent leather pumps. The ugly girl had on Girl Scout shoes and heavy socks. The old woman had on tennis shoes and the white-trashy mother had on what appeared to be bedroom slippers, black straw with gold braid threaded through them—exactly what you would have expected her to have on.

Sometimes at night when she couldn't go to sleep, Mrs. Turpin would occupy herself with the question of who she would have chosen to be if she couldn't have been herself. If Jesus had said to her before he made her, "There's only two places available for you. You can either be a nigger or white-trash," what would she have said? "Please, Jesus, please," she would have said, "just let me wait until there's another place available," and he would have said, "No, you have to go right now and I have only those two places so make up your mind." She would have wiggled and squirmed and begged and pleaded but it would have been no use and finally she would have said, "All right, make me a nigger then—but that don't mean a trashy one." And he would have made her a neat clean respectable Negro woman, herself but black.

Next to the child's mother was a red-headed youngish woman, reading one of the magazines and working a piece of chewing gum, hell for leather, as Claud would say. Mrs. Turpin could not see the woman's feet. She was not white-trash, just common. Sometimes Mrs. Turpin occupied herself at night naming the classes of people. On the bottom of the heap were most colored people, not the kind she would have been if she had been one, but most of them; then next to them—not above, just away from—were the white-trash; then above them were the home-owners, and above them the home-and-land owners, to which she and Claud belonged. Above she and Claud were people with a lot of money and much bigger houses and much more land. But here the complexity of it would begin to bear in on her, for some of the people with a lot of money were common and ought to be below she and Claud and some of the people who had good blood had lost

their money and had to rent and then there were colored people who owned their homes and land as well. There was a colored dentist in town who had two red Lincolns and a swimming pool and a farm with registered white-face cattle on it. Usually by the time she had fallen asleep all the classes of people were moiling and roiling around in her head, and she would dream they were all crammed in together in a box car, being ridden off to be put in a gas oven.

"That's a beautiful clock," she said and nodded to her right. It was a big wall clock, the face encased in a brass sunburst.

"Yes, it's very pretty," the stylish lady said agreeably. "And right on the dot too," she added, glancing at her watch.

The ugly girl beside her cast an eye upward at the clock, smirked, then looked directly at Mrs. Turpin and smirked again. Then she returned her eyes to her book. She was obviously the lady's daughter because, although they didn't look anything alike as to disposition, they both had the same shape of face and the same blue eyes. On the lady they sparkled pleasantly but in the girl's seared face they appeared alternately to smolder and to blaze.

What if Jesus had said, "All right, you can be white-trash or a nigger or ugly"!

Mrs. Turpin felt an awful pity for the girl, though she thought it was one thing to be ugly and another to act ugly.

The woman with the snuff-stained lips turned around in her chair and looked up at the clock. Then she turned back and appeared to look a little to the side of Mrs. Turpin. There was a cast in one of her eyes. "You want to know wher you can get you one of themther clocks?" she asked in a loud voice.

"No, I already have a nice clock," Mrs. Turpin said. Once somebody like her got a leg in the conversation, she would be all over it.

"You can get you one with green stamps," the woman said. "That's most likely wher he got hisn. Save you up enough, you can get you most anythang. I got me some joo'ry."

Ought to have got you a wash rag and some soap, Mrs. Turpin thought.

"I get contour sheets with mine," the pleasant lady said.

The daughter slammed her book shut. She looked straight in front of her, directly through Mrs. Turpin and on through the yellow curtain and the plate glass window which made the wall behind her. The girl's eyes seemed lit all of a sudden with a peculiar light, an unnatural light like night road signs give. Mrs. Turpin turned her head to see if there was anything going on outside that she should see, but she could not see anything. Figures passing cast only a pale shadow through the curtain. There was no reason the girl should single her out for her ugly looks.

"Miss Finley," the nurse said, cracking the door. The gum-chewing woman got up and passed in front of her and Claud and went into the office. She had on red high-heeled shoes.

Directly across the table, the ugly girl's eyes were fixed on Mrs. Turpin as if she had some very special reason for disliking her.

"This is wonderful weather, isn't it?" the girl's mother said.

"It's good weather for cotton if you can get the niggers to pick it," Mrs. Turpin said, "but niggers don't want to pick cotton any more. You can't get the white folks to pick it and now you can't get the niggers—because they got to be right up there with the white folks."

"They gonna *try* anyways," the white-trash woman said, leaning forward.

"Do you have one of the cotton-picking machines?" the pleasant lady asked.

"No," Mrs. Turpin said, "they leave half the cotton in the field. We don't have much cotton anyway. If you want to make it farming now, you have to have a little of everything. We got a couple of acres of cotton and a few hogs and chick-

ens and just enough white-face that Claud can look after them himself."

"One thang I don't want," the white-trash woman said, wiping her mouth with the back of her hand. "Hogs. Nasty stinking things, a-gruntin and a-rootin all over the place."

Mrs. Turpin gave her the merest edge of her attention. "Our hogs are not dirty and they don't stink," she said. "They're cleaner than some children I've seen. Their feet never touch the ground. We have a pig-parlor—that's where you raise them on concrete," she explained to the pleasant lady, "and Claud scoots them down with the hose every afternoon and washes off the floor." Cleaner by far than that child right there, she thought. Poor nasty little thing. He had not moved except to put the thumb of his dirty hand into his mouth.

The woman turned her face away from Mrs. Turpin. "I know I wouldn't scoot down no hog with no hose," she said to the wall.

You wouldn't have no hog to scoot down, Mrs. Turpin said to herself.

"A-gruntin and a-rootin and a-groanin," the woman muttered.

"We got a little of everything," Mrs. Turpin said to the pleasant lady. "It's no use in having more than you can handle yourself with help like it is. We found enough niggers to pick our cotton this year but Claud he has to go after them and take them home again in the evening. They can't walk that half a mile. No they can't. I tell you," she said and laughed merrily, "I sure am tired of buttering up niggers, but you got to love em if you want em to work for you. When they come in the morning, I run out and I say, 'Hi yawl this morning?' and when Claud drives them off to the field I just wave to beat the band and they just wave back." And she waved her hand rapidly to illustrate.

"Like you read out of the same book," the lady said, showing she understood perfectly.

"Child, yes," Mrs. Turpin said. "And when they come in from the field, I run out with a bucket of icewater. That's the way it's going to be from now on," she said. "You may as well face it."

"One thang I know," the white-trash woman said. "Two thangs I ain't going to do: love no niggers or scoot down no hog with no hose." And she let out a bark of contempt.

The look that Mrs. Turpin and the pleasant lady exchanged indicated they both understood that you had to *have* certain things before you could *know* certain things. But every time Mrs. Turpin exchanged a look with the lady, she was aware that the ugly girl's peculiar eyes were still on her, and she had trouble bringing her attention back to the conversation.

"When you got something," she said, "you got to look after it." And when you ain't got a thing but breath and britches, she added to herself, you can afford to come to town every morning and just sit on the Court House coping and spit.

A grotesque revolving shadow passed across the curtain behind her and was thrown palely on the opposite wall. Then a bicycle clattered down against the outside of the building. The door opened and a colored boy glided in with a tray from the drugstore. It had two large red and white paper cups on it with tops on them. He was a tall, very black boy in discolored white pants and a green nylon shirt. He was chewing gum slowly, as if to music. He set the tray down in the office opening next to the fern and stuck his head through to look for the secretary. She was not in there. He rested his arms on the ledge and waited, his narrow bottom stuck out, swaying to the left and right. He raised a hand over his head and scratched the base of his skull.

"You see that button there, boy?" Mrs. Turpin said. "You can punch that and she'll come. She's probably in the back somewhere."

"Is that right?" the boy said agreeably, as if he had never seen the button before. He leaned to the right and put his finger on it. "She sometime out," he said and twisted around to face his audience, his elbows behind him on the counter. The nurse appeared and he twisted back again. She handed him a dollar and he rooted in his pocket and made the change and counted it out to her. She gave him fifteen cents for a tip and he went out with the empty tray. The heavy door swung to slowly and closed at length with the sound of suction. For a moment no one spoke.

"They ought to send all them niggers back to Africa," the white-trash woman said. "That's wher they come from in the first place."

"Oh, I couldn't do without my good colored friends," the pleasant lady said.

"There's a heap of things worse than a nigger," Mrs. Turpin agreed. "It's all kinds of them just like it's all kinds of us."

"Yes, and it takes all kinds to make the world go round," the lady said in her musical voice.

As she said it, the raw-complexioned girl snapped her teeth together. Her lower lip turned downwards and inside out, revealing the pale pink inside of her mouth. After a second it rolled back up. It was the ugliest face Mrs. Turpin had ever seen anyone make and for a moment she was certain that the girl had made it at her. She was looking at her as if she had known and disliked her all her life—all of Mrs. Turpin's life, it seemed too, not just all the girl's life. Why, girl, I don't even know you, Mrs. Turpin said silently.

She forced her attention back to the discussion. "It wouldn't be practical to send them back to Africa," she said. "They wouldn't want to go. They got it too good here."

"Wouldn't be what they wanted—if I had anythang to do with it," the woman said.

"It wouldn't be a way in the world you could get all the niggers back over there," Mrs. Turpin said. "They'd be hiding out and lying down and turning sick on you and wailing and hollering and raring and pitching. It wouldn't be a way in the world to get them over there."

"They got over here," the trashy woman said. "Get back like they got over."

"It wasn't so many of them then," Mrs. Turpin explained.

The woman looked at Mrs. Turpin as if here was an idiot indeed but Mrs. Turpin was not bothered by the look, considering where it came from.

"Nooo," she said, "they're going to stay here where they can go to New York and marry white folks and improve their color. That's what they all want to do, every one of them, improve their color."

"You know what comes of that, don't you?" Claud asked.

"No, Claud, what?" Mrs. Turpin said.

Claud's eyes twinkled. "White-faced niggers," he said with never a smile.

Everybody in the office laughed except the white-trash and the ugly girl. The girl gripped the book in her lap with white fingers. The trashy woman looked around her from face to face as if she thought they were all idiots. The old woman in the feed sack dress continued to gaze expressionless across the floor at the high-top shoes of the man opposite her, the one who had been pretending to be asleep when the Turpins came in. He was laughing heartily, his hands still spread out on his knees. The child had fallen to the side and was lying now almost face down in the old woman's lap.

While they recovered from their laughter, the nasal chorus on the radio kept the room from silence.

"You go to blank blank
and I'll go to mine
But we'll all blank along

To-geth-ther,
And wall along the blank
We'll hep eachother out
Smile-ling in any kind of
Weath-ther!"

Mrs. Turpin didn't catch every word but she caught enough to agree with the spirit of the song and it turned her thoughts sober. To help anybody out that needed it was her philosophy of life. She never spared herself when she found somebody in need, whether they were white or black, trash or decent. And of all she had to be thankful for, she was most thankful that this was so. If Jesus had said, "You can be high society and have all the money you want and be thin and svelte-like, but you can't be a good woman with it," she would have had to say, "Well don't make me that then. Make me a good woman and it don't matter what else, how fat or how ugly or how poor!" Her heart rose. He had not made her a nigger or white-trash or ugly! He had made her herself and given her a little of everything. Jesus, thank you! she said. Thank you thank you thank you! Whenever she counted her blessings she felt as buoyant as if she weighed one hundred and twenty-five pounds instead of one hundred and eighty.

"What's wrong with your little boy?" the pleasant lady asked the white-trashy woman.

"He has a ulcer," the woman said proudly. "He ain't give me a minute's peace since he was born. Him and her are just alike," she said, nodding at the old woman, who was running her leathery fingers through the child's pale hair. "Look like I can't get nothing down them two but Co' Cola and candy."

That's all you try to get down em, Mrs. Turpin said to herself. Too lazy to light the fire. There was nothing you could tell her about people like them that she didn't know already. And it was not just that they didn't have anything. Because if you gave them everything, in two weeks it would all be broken or filthy or they would have chopped it up for lightwood. She knew all this from her own experience. Help them you must, but help them you couldn't.

All at once the ugly girl turned her lips inside out again. Her eyes fixed like two drills on Mrs. Turpin. This time there was no mistaking that there was something urgent behind them.

Girl, Mrs. Turpin exclaimed silently, I haven't done a thing to you! The girl might be confusing her with somebody else. There was no need to sit by and let herself be intimidated. "You must be in college," she said boldly, looking directly at the girl. "I see you reading a book there."

The girl continued to stare and pointedly did not answer.

Her mother blushed at this rudeness. "The lady asked you a question, Mary Grace," she said under her breath.

"I have ears," Mary Grace said.

The poor mother blushed again. "Mary Grace goes to Wellesley College," she explained. She twisted one of the buttons on her dress. "In Massachusetts," she added with a grimace. "And in the summer she just keeps right on studying. Just reads all the time, a real book worm. She's done real well at Wellesley; she's taking English and Math and History and Psychology and Social Studies," she rattled on, "and I think it's too much. I think she ought to get out and have fun."

The girl looked as if she would like to hurl them all through the plate glass window.

"Way up north," Mrs. Turpin murmured and thought, well, it hasn't done much for her manners.

"I'd almost rather to have him sick," the white-trash woman said, wrenching the attention back to herself. "He's so mean when he ain't. Look like some children just take natural to meanness. It's some gets bad when they get sick but he was the opposite. Took sick and turned good. He don't give me no trouble now. It's me waitin to see the doctor," she said.

If I was going to send anybody back to Africa, Mrs. Turpin thought, it would be your kind, woman. "Yes, indeed," she said aloud, but looking up at the ceiling, "it's a heap of things worse than a nigger." And dirtier than a hog, she added to herself.

"I think people with bad dispositions are more to be pitied than anyone on earth," the pleasant lady said in a voice that was decidedly thin.

"I thank the Lord he has blessed me with a good one," Mrs. Turpin said. "The day has never dawned that I couldn't find something to laugh at."

"Not since she married me anyways," Claud said with a comical straight face.

Everybody laughed except the girl and the white-trash.

Mrs. Turpin's stomach shook. "He's such a caution," she said, "that I can't help but laugh at him."

The girl made a loud ugly noise through her teeth.

Her mother's mouth grew thin and tight. "I think the worst thing in the world," she said, "is an ungrateful person. To have everything and not appreciate it. I know a girl," she said, "who has parents who would give her anything, a little brother who loves her dearly, who is getting a good education, who wears the best clothes, but who can never say a kind word to anyone, who never smiles, who just criticizes and complains all day long."

"Is she too old to paddle?" Claud asked.

The girl's face was almost purple.

"Yes," the lady said, "I'm afraid there's nothing to do but leave her to her folly. Some day she'll wake up and it'll be too late."

"It never hurt anyone to smile," Mrs. Turpin said. "It just makes you feel better all over."

"Of course," the lady said sadly, "but there are just some people you can't tell anything to. They can't take criticism."

"If it's one thing I am," Mrs. Turpin said with feeling, "it's grateful. When I think who all I could have been besides myself and what all I got, a little of everything, and a good disposition besides, I just feel like shouting, 'Thank you, Jesus, for making everything the way it is!' It could have been different!" For one thing, somebody else could have got Claud. At the thought of this, she was flooded with gratitude and a terrible pang of joy ran through her. "Oh thank you, Jesus, Jesus, thank you!" she cried aloud.

The book struck her directly over her left eye. It struck almost at the same instant that she realized the girl was about to hurl it. Before she could utter a sound, the raw face came crashing across the table toward her, howling. The girl's fingers sank like clamps into the soft flesh of her neck. She heard the mother cry out and Claud shout, "Whoa!" There was an instant when she was certain that she was about to be in an earthquake.

All at once her vision narrowed and she saw everything as if it were happening in a small room far away, or as if she were looking at it through the wrong end of a telescope. Claud's face crumpled and fell out of sight. The nurse ran in, then out, then in again. Then the gangling figure of the doctor rushed out of the inner door. Magazines flew this way and that as the table turned over. The girl fell with a thud and Mrs. Turpin's vision suddenly reversed itself and she saw everything large instead of small. The eyes of the white-trashy woman were staring hugely at the floor. There the girl, held down on one side by the nurse and on the other by her mother, was wrenching and turning in their grasp. The doctor was kneeling astride her, trying to hold her arm down. He managed after a second to sink a long needle into it.

Mrs. Turpin felt entirely hollow except for her heart which swung from side to side as if it were agitated in a great empty drum of flesh.

"Somebody that's not busy call for the ambulance," the doctor said in the off-hand voice young doctors adopt for terrible occasions.

Mrs. Turpin could not have moved a finger. The old man who had been sitting next to her skipped nimbly into the office and made the call, for the secretary still seemed to be gone.

"Claud!" Mrs. Turpin called.

He was not in his chair. She knew she must jump up and find him but she felt like some one trying to catch a train in a dream, when everything moves in slow motion and the faster you try to run the slower you go.

"Here I am," a suffocated voice, very unlike Claud's, said.

He was doubled up in the corner on the floor, pale as paper, holding his leg. She wanted to get up and go to him but she could not move. Instead, her gaze was drawn slowly downward to the churning face on the floor, which she could see over the doctor's shoulder.

The girl's eyes stopped rolling and focused on her. They seemed a much lighter blue than before, as if a door that had been tightly closed behind them was now open to admit light and air.

Mrs. Turpin's head cleared and her power of motion returned. She leaned forward until she was looking directly into the fierce brilliant eyes. There was no doubt in her mind that the girl did know her, knew her in some intense and personal way, beyond the time and place and condition. "What you got to say to me?" she asked hoarsely and held her breath, waiting, as for a revelation.

The girl raised her head. Her gaze locked with Mrs. Turpin's. "Go back to hell where you came from, you old wart hog," she whispered. Her voice was low but clear. Her eyes burned for a moment as if she saw with pleasure that her message had struck its target.

Mrs. Turpin sank back in her chair.

After a moment the girl's eyes closed and she turned her head wearily to the side.

The doctor rose and handed the nurse the empty syringe. He leaned over and put both hands for a moment on the mother's shoulders, which were shaking. She was sitting on the floor, her lips pressed together, holding Mary Grace's hand in her lap. The girl's fingers were gripped like a baby's around her thumb. "Go on to the hospital," he said, "I'll call and make the arrangements."

"Now let's see that neck," he said in a jovial voice to Mrs. Turpin. He began to inspect her neck with his first two fingers. Two little moon-shaped lines like pink fish bones were indented over her windpipe. There was the beginning of an angry red swelling above her eye. His fingers passed over this also.

"Lea' me be," she said thickly and shook him off. "See about Claud. She kicked him."

"I'll see about him in a minute," he said and felt her pulse. He was a thin gray-haired man, given to pleasantries. "Go home and have yourself a vacation the rest of the day," he said and patted her on the shoulder.

Quit your pattin me, Mrs. Turpin growled to herself.

"And put an ice pack over that eye," he said. Then he went and squatted down beside Claud and looked at his leg. After a moment he pulled him up and Claud limped after him into the office.

Until the ambulance came, the only sounds in the room were the tremulous moans of the girl's mother, who continued to sit on the floor. The white-trash woman did not take her eyes off the girl. Mrs. Turpin looked straight ahead at nothing. Presently the ambulance drew up, a long dark shadow, behind the curtain. The attendants came in and set the stretcher down beside the girl and lifted her expertly onto it and carried her out. The nurse helped the mother gather up her things. The shadow of the ambulance moved silently away and the nurse came back in the office.

"That ther girl is going to be a lunatic, ain't she?" the white-trash woman asked the nurse, but the nurse kept on to the back and never answered her.

"Yes, she's going to be a lunatic," the white-trash woman said to the rest of them.

"Po' critter," the old woman murmured. The child's face was still in her lap. His eyes looked idly out over her knees. He had not moved during the disturbance except to draw one leg up under him.

"I thank Gawd," the white-trash woman said fervently, "I ain't a lunatic."

Claud came limping out and the Turpins went home.

As their pick-up truck turned into their own dirt road and made the crest of the hill, Mrs. Turpin gripped the window ledge and looked out suspiciously. The land sloped gracefully down through a field dotted with lavender weeds and at the start of the rise their small yellow frame house, with its little flower beds spread out around it like a fancy apron, sat primly in its accustomed place between two giant hickory trees. She would not have been startled to see a burnt wound between two blackened chimneys.

Neither of them felt like eating so they put on their house clothes and lowered the shade in the bedroom and lay down, Claud with his leg on a pillow and herself with a damp washcloth over her eye. The instant she was flat on her back, the image of a razor-backed hog with warts on its face and horns coming out behind its ears snorted into her head. She moaned, a low quiet moan.

"I am not," she said tearfully, "a wart hog. From hell." But the denial had no force. The girl's eyes and her words, even the tone of her voice, low but clear, directed only to her, brooked no repudiation. She had been singled out for the message, though there was trash in the room to whom it might justly have been applied. The full force of this fact struck her only now. There was a woman there who was neglecting her own child but she had been overlooked. The message had been given to Ruby Turpin, a respectable, hard-working, church-going woman. The tears dried. Her eyes began to burn instead with wrath.

She rose on her elbow and the washcloth fell into her hand. Claud was lying on his back, snoring. She wanted to tell him what the girl had said. At the same time, she did not wish to put the image of herself as a wart hog from hell into his mind.

"Hey, Claud," she muttered and pushed his shoulder.

Claud opened one pale baby blue eye.

She looked into it warily. He did not think about anything. He just went his way.

"Wha, whasit?" he said and closed the eye again.

"Nothing," she said. "Does your leg pain you?"

"Hurts like hell," Claud said.

"It'll quit derreckly," she said and lay back down. In a moment Claud was snoring again. For the rest of the afternoon they lay there. Claud slept. She scowled at the ceiling. Occasionally she raised her fist and made a small stabbing motion over her chest as if she was defending her innocence to invisible guests who were like the comforters of Job, reasonable-seeming but wrong.

About five-thirty Claud stirred. "Got to go after those niggers," he sighed, not moving.

She was looking straight up as if there were unintelligible handwriting on the ceiling. The protuberance over her eye had turned a greenish-blue. "Listen here," she said.

"What?"

"Kiss me."

Claud leaned over and kissed her loudly on the mouth. He pinched her side and their hands interlocked. Her expression of ferocious concentration did not change. Claud got up, groaning and growling, and limped off. She continued to study the ceiling.

She did not get up until she heard the pick-up truck coming back with the Negroes. Then she rose and thrust her feet in her brown oxfords, which she did not bother to lace, and stumped out onto the back porch and got her red plastic bucket. She emptied a tray of ice cubes into it and filled it half full of water and went out into the back yard. Every afternoon after Claud brought the hands in, one of the boys helped him put out hay and the rest waited in the back of the truck until he was ready to take them home. The truck was parked in the shade under one of the hickory trees.

"Hi yawl this evening?" Mrs. Turpin asked grimly, appearing with the bucket and the dipper. There were three women and a boy in the truck.

"Us doin nicely," the oldest woman said. "Hi you doin?" and her gaze stuck immediately on the dark lump on Mrs. Turpin's forehead. "You done fell down, ain't you?" she asked in a solicitous voice. The old woman was dark and almost toothless. She had an old felt hat of Claud's set back on her head. The other two women were younger and lighter and they both had new bright green sunhats. One of them had hers on her head; the other had taken hers off and the boy was grinning beneath it.

Mrs. Turpin set the bucket down on the floor of the truck. "Yawl hep yourselves," she said. She looked around to make sure Claud had gone. "No, I didn't fall down," she said, folding her arms. "It was something worse than that."

"Ain't nothin bad happen to you!" the old woman said. She said it as if they all knew that Mrs. Turpin was protected in some special way by Divine Providence. "You just had you a little fall."

"We were in town at the doctor's office for where the cow kicked Mr. Turpin," Mrs. Turpin said in a flat tone that indicated they could leave off their foolishness. "And there was this girl there. A big fat girl with her face all broke out. I could look at that girl and tell she was peculiar but I couldn't tell how. And me and her mama was just talking and going along and all of a sudden WHAM! She throws this big book she was reading at me and . . ."

"Naw!" the old woman cried out.

"And then she jumps over the table and commences to choke me."

"Naw!" they all exclaimed, "naw!"

"Hi come she do that?" the old woman asked. "What ail her?"

Mrs. Turpin only glared in front of her.

"Somethin ail her," the old woman said.

"They carried her off in an ambulance," Mrs. Turpin continued, "but before she went she was rolling on the floor and they were trying to hold her down to give her a shot and she said something to me." She paused. "You know what she said to me?"

"What she say?" they asked.

"She said," Mrs. Turpin began, and stopped, her face very dark and heavy. The sun was getting whiter and whiter, blanching the sky overhead so that the leaves of the hickory tree were black in the face of it. She could not bring forth the words. "Something real ugly," she muttered.

"She sho shouldn't said nothin ugly to you," the old woman said. "You so sweet. You the sweetest lady I know."

"She pretty too," the one with the hat on said.

"And stout," the other one said. "I never knowed no sweeter white lady."

"That's the truth befo' Jesus," the old woman said. "Amen! You des as sweet and pretty as you can be."

Mrs. Turpin knew exactly how much Negro flattery was worth and it added to her rage. "She said," she began again and finished this time with a fierce rush of breath, "that I was an old wart hog from hell."

There was an astounded silence.

"Where she at?" the youngest woman cried in a piercing voice.

"Lemme see her. I'll kill her!"

"I'll kill her with you!" the other one cried.

"She b'long in the sylum," the old woman said emphatically. "You the sweetest white lady I know."

"She pretty too," the other two said. "Stout as she can be and sweet. Jesus satisfied with her!"

"Deed he is," the old woman declared.

Idiots! Mrs. Turpin growled to herself. You could never say anything intelligent to a nigger. You could talk at them but not with them. "Yawl ain't drunk your water," she said shortly. "Leave the bucket in the truck when you're finished with it. I got more to do than just stand around and pass the time of day," and she moved off and into the house.

She stood for a moment in the middle of the kitchen. The dark protuberance over her eye looked like a miniature tornado cloud which might any moment sweep across the horizon of her brow. Her lower lip protruded dangerously. She squared her massive shoulders. Then she marched into the front of the house and out the side door and started down the road to the pig parlor. She had the look of a woman going single-handed, weaponless, into battle.

The sun was a deep yellow now like a harvest moon and was riding westward very fast over the far tree line as if it meant to reach the hogs before she did. The road was rutted and she kicked several good-sized stones out of her path as she strode along. The pig parlor was on a little knoll at the end of a lane that ran off from the side of the barn. It was a square of concrete as large as a small room, with a board fence about four feet high around it. The concrete floor sloped slightly so that the hog wash could drain off into a trench where it was carried to the field for fertilizer. Claud was standing on the outside, on the edge of the concrete, hanging onto the top board, hosing down the floor inside. The hose was connected to the faucet of a water trough nearby.

Mrs. Turpin climbed up beside him and glowered down at the hogs inside. There were seven long-snouted bristly shoats in it—tan with liver-colored spots—and an old sow a few weeks off from farrowing. She was lying on her side grunting. The shoats were running about shaking themselves like idiot children, their little slit pig eyes searching the floor for anything left. She had read that pigs were the most intelligent animal. She doubted it. They were supposed to be smarter than dogs. There had even been a pig astronaut. He had performed his assignment perfectly but died of a heart attack afterwards because they left him in his electric suit, sitting upright throughout his examination when naturally a hog should be on all fours.

A-gruntin and a-rootin and a-groanin.

"Gimme that hose," she said, yanking it away from Claud. "Go on and carry them niggers home and then get off that leg."

"You look like you might have swallowed a mad dog," Claud observed, but he got down and limped off. He paid no attention to her humors.

Until he was out of earshot, Mrs. Turpin stood on the side of the pen, holding the hose and pointing the stream of water at the hind quarters of any shoat that looked as if it might try to lie down. When he had had time to get over the hill, she turned her head slightly and her wrathful eyes scanned the path. He was nowhere in sight. She turned back again and seemed to gather herself up. Her shoulders rose and she drew in her breath.

"What do you send me a message like that for?" she said in a low fierce voice, barely above a whisper but with the force of a shout in its concentrated fury. "How am I a hog and me both? How am I saved and from hell too?" Her free fist was knotted and with the other she gripped the hose, blindly pointing the stream of water in and out of the eye of the old sow whose outraged squeal she did not hear.

The pig parlor commanded a view of the back pasture where their twenty beef cows were gathered around the hay-bales Claud and the boy had put out. The freshly cut pasture sloped down to the highway. Across it was their cotton field and beyond that a dark green dusty wood which they owned as well. The sun was behind the wood, very red, looking over the paling of trees like a farmer inspecting his own hogs.

"Why me?" she rumbled. "It's no trash around here, black or white, that I haven't given to. And break my back to the bone every day working. And do for the church."

She appeared to be the right size woman to command the arena before her. "How am I a hog?" she demanded. "Exactly how am I like them?" and she jabbed the stream of water at the shoats. "There was plenty of trash there. It didn't have to be me.

"If you like trash better, go get yourself some trash then," she railed. "You could have made me trash. Or a nigger. If trash is what you wanted why didn't you make me trash?" She shook her fist with the hose in it and a watery snake appeared momentarily in the air. "I could quit working and take it easy and be filthy," she growled. "Lounge about the sidewalks all day drinking root beer. Dip snuff and spit in every puddle and have it all over my face. I could be nasty.

"Or you could have made me a nigger. It's too late for me to be a nigger," she said with deep sarcasm, "but I could act like one. Lay down in the middle of the road and stop traffic. Roll on the ground."

In the deepening light everything was taking on a mysterious hue. The pasture was growing a peculiar glassy green and the streak of highway had turned lavender. She braced herself for a final assault and this time her voice rolled out over the pasture. "Go on," she yelled, "call me a hog! Call me a hog again. From hell. Call me a wart hog from hell. Put that bottom rail on top. There'll still be a top and bottom!"

A garbled echo returned to her.

A final surge of fury shook her and she roared, "Who do you think you are?"

The color of everything, field and crimson sky, burned for a moment with a transparent intensity. The question carried over the pasture and across the highway and the cotton field and returned to her clearly like an answer from beyond the wood.

She opened her mouth but no sound came out of it.

A tiny truck, Claud's, appeared on the highway, heading rapidly out of sight. Its gears scraped thinly. It looked like a child's toy. At any moment a bigger truck might smash into it and scatter Claud's and the niggers' brains all over the road.

Mrs. Turpin stood there, her gaze fixed on the highway, all her muscles rigid, until in five or six minutes the truck reappeared, returning. She waited until it had had time to turn into their own road. Then like a monumental statue coming to life, she bent her head slowly and gazed, as if through the very heart of mystery, down into the pig parlor at the hogs. They had set-

tled all in one corner around the old sow who was grunting softly. A red glow suffused them. They appeared to pant with a secret life.

Until the sun slipped finally behind the tree line, Mrs. Turpin remained there with her gaze bent to them as if she were absorbing some abysmal life-giving knowledge. At last she lifted her head. There was only a purple streak in the sky, cutting through a field of crimson and leading, like an extension of the highway, into the descending dusk. She raised her hands from the side of the pen in a gesture hieratic and profound. A visionary light settled in her eyes. She saw the streak as a vast swinging bridge extending upward from the earth through a field of living fire. Upon it a vast horde of souls were rumbling toward heaven. There were whole companies of white-trash, clean for the first time in their lives, and bands of black niggers in white robes, and battalions of freaks and lunatics shouting and clapping and leaping like frogs. And bringing up the end of the procession was a tribe of people whom she recognized at once as those who, like herself and Claud, had always had a little of everything and the God-given wit to use it right. She leaned forward to observe them closer. They were marching behind the others with great dignity, accountable as they had always been for good order and common sense and respectable behavior. They alone were on key. Yet she could see by their shocked and altered faces that even their virtues were being burned away. She lowered her hands and gripped the rail of the hog pen, her eyes small but fixed unblinkingly on what lay ahead. In a moment the vision faded but she remained where she was, immobile.

At length she got down and turned off the faucet and made her slow way on the darkening path to the house. In the woods around her the invisible cricket choruses had struck up, but what she heard were the voices of the souls climbing upward into the starry field and shouting hallelujah.

READING 96
Gwendolyn Brooks (b. 1917),
"The Last Quatrain of the Ballad of Emmett Till" (1978)

The first African-American woman to win a Pulitzer Prize (in 1949), Brooks' poetry has focused on black pride and the concerns of oppression. The Emmett Till of the poem was a black child murdered in Mississippi in the early 1960s.

> after the murder,
> after the burial
> Emmett's mother is a pretty-faced thing;
> the tint of pulled taffy.
> She sits in a red room,
> drinking black coffee.
> She kisses her killed boy.
> And she is sorry.
> Chaos in windy grays
> through a red prairie.
> 1960

10

READING 97
SYLVIA PLATH (1932–1963), "LADY LAZARUS" (1963)

From one of the finest of the "confessional" poets, the poem "LADY LAZARUS" reflects themes that would eventually drive Plath to suicide: a sense of loss; a haunting fascination with death; and strangely mixed feelings about men in her life.

I have done it again.
One year in every ten
I manage it——

A sort of walking miracle, my skin
Bright as a Nazi lampshade,
My right foot

A paperweight,
My face a featureless, fine
Jew linen.

Peel off the napkin 10
O my enemy.
Do I terrify?——

The nose, the eye pits, the full set of teeth?
The sour breath
Will vanish in a day.

Soon, soon the flesh
The grave cave ate will be
At home on me.

And I a smiling woman.
I am only thirty. 20
And like the cat I have nine times to die.

This is Number Three.
What a trash
To annihilate each decade.

What a million filaments.
The peanut-crunching crowd
Shoves in to see

Them unwrap me hand and foot——
The big strip tease.
Gentlemen, ladies, 30

These are my hands,
My knees.
I may be skin and bone,

Nevertheless, I am the same, identical woman.
The first time it happened I was ten.
It was an accident.

The second time I meant
To last it out and not come back at all.
I rocked shut

As a seashell. 40
They had to call and call
And pick the worms off me like sticky pearls.

Dying
Is an art, like everything else.
I do it exceptionally well.

I do it so it feels like hell.
I do it so it feels real.
I guess you could say I've a call.

It's easy enough to do it in a cell
It's easy enough to do it and stay put. 50
It's the theatrical

Comeback in broad day
To the same place, the same face, the same brute
Amused shout:

"A miracle!"
That knocks me out.
There is a charge

For the eyeing of my scars, there is a charge
For the hearing of my heart——
It really goes. 60

And there is a charge, a very large charge,
For a word or a touch
Or a bit of blood

Or a piece of my hair or my clothes.
So, so, Herr Doktor.
So, Herr Enemy.

I am your opus,
I am your valuable,
The pure gold baby

That melts to a shriek. 70
I turn and burn.
Do not think I underestimate your great concern.

Ash, ash——
You poke and stir.
Flesh, bone, there is nothing there——

A cake of soap,
A wedding ring,
A gold filling.

Herr God, Herr Lucifer,
Beware
Beware. 80

Out of the ash
I rise with my red hair
And I eat men like air.

READING 98
ADRIENNE RICH (B. 1929), "DIVING INTO THE WRECK" (1972)

Rich is one of the most accomplished poets of our time. Her recent concerns have been with feminism. "DIVING INTO THE WRECK" shows Rich at her greatest powers as a skin-diving expedition takes on a mystical and mythical dimension.

First having read the book of myths,
and loaded the camera,
and checked the edge of the knife-blade,
I put on
the body-armor of black rubber
the absurd flippers
the grave and awkward mask.
I am having to do this
not like Cousteau with his
assiduous team 10

aboard the sun-flooded schooner
but here alone.

There is a ladder.
The ladder is always there
hanging innocently
close to the side of the schooner.
We know what it is for,
we who have used it.
Otherwise
it's a piece of maritime floss 20
some sundry equipment.

I go down.
Rung after rung and still
the oxygen immerses me
the blue light
the clear atoms
of our human air.
I go down.
My flippers cripple me,
I crawl like an insect down the ladder 30
and there is no one
to tell me when the ocean
will begin.

First the air is blue and then
it is bluer and then green and then
black I am blacking out and yet
my mask is powerful
it pumps my blood with power
the sea is another story
the sea is not a question of power 40
I have to learn alone
to turn my body without force
in the deep element.

And now: it is easy to forget
what I came for
among so many who have always
lived here
swaying their crenellated fans
between the reefs
and besides 50
you breathe differently down here.

I came to explore the wreck.
The words are purposes.
The words are maps.
I came to see the damage that was done
and the treasures that prevail.
I stroke the beam of my lamp
slowly along the flank
of something more permanent
than fish or weed 60

the thing I came for:
the wreck and not the story of the wreck
the thing itself and not the myth
the drowned face always staring
toward the sun
the evidence of damage
worn by salt and sway into this threadbare beauty
the ribs of the disaster
curving their assertion
among the tentative haunters. 70

This is the place.
And I am here, the mermaid whose dark hair
streams black, the merman in his armored body
We circle silently
about the wreck

we dive into the hold.
I am she: I am he

whose drowned face sleeps with open eyes
whose breasts still bear the stress
whose silver, copper, vermeil cargo lies 80
obscurely inside barrels
half-wedged and left to rot
we are the half-destroyed instruments
that once held to a course
the water-eaten log
the fouled compass

We are, I am, you are
by cowardice or courage
the one who find our way
back to this scene 90
carrying a knife, a camera
a book of myths
in which
our names do not appear.

READING 99
TONI MORRISON (B. 1931), NOBEL PRIZE ACCEPTANCE SPEECH, STOCKHOLM, DECEMBER 7, 1993

The first African-American woman to receive the Nobel Prize for Literature, Morrison stresses the universal value of literature in her address.

MEMBERS OF THE SWEDISH ACADEMY, LADIES AND GENTLEMEN: Narrative has never been merely entertainment for me. It is, I believe, one of the principal ways in which we absorb knowledge. I hope you will understand, then, why I begin these remarks with the opening phrase of what must be the oldest sentence in the world, and the earliest one we remember from childhood: "Once upon a time . . ."

"Once upon a time there was an old woman. Blind but wise." Or was it an old man? A guru, perhaps. Or a *griot* soothing restless children. I have heard this story, or one exactly like it, in the lore of several cultures.

"Once upon a time there was an old woman. Blind. Wise."

In the version I know the woman is the daughter of slaves, black, American, and lives alone in a small house outside of town. Her reputation for wisdom is without peer and without question. Among her people she is both the law and its transgression. The honor she is paid and the awe in which she is held reach beyond her neighborhood to places far away; to the city where the intelligence of rural prophets is the source of much amusement.

One day the woman is visited by some young people who seem to be bent on disproving her clairvoyance and showing her up for the fraud they believe she is. Their plan is simple: they enter her house and ask the one question the answer to which rides solely on her difference from them, a difference they regard as a profound disability: her blindness. They stand before her, and one of them says, "Old woman, I hold in my hand a bird. Tell me whether it is living or dead."

She does not answer, and the question is repeated. "Is the bird I am holding living or dead?"

Still she does not answer. She is blind and cannot see her visitors, let alone what is in their hands. She does not know their color, gender or homeland. She only knows their motive.

The old woman's silence is so long, the young people have trouble holding their laughter.

Finally she speaks, and her voice is soft but stern. "I don't know," she says. "I don't know whether the bird you are holding is dead or alive, but what I do know is that it is in your hands. It is in your hands."

Her answer can be taken to mean: if it is dead, you have either found it that way or you have killed it. If it is alive, you can still kill it. Whether it is to stay alive is your decision. Whatever the case, it is your responsibility.

For parading their power and her helplessness, the young visitors are reprimanded, told they are responsible not only for the act of mockery but also for the small bundle of life sacrificed to achieve its aims. The blind woman shifts attention away from assertions of power to the instrument through which that power is exercised.

Speculation on what (other than its own frail body) that bird in the hand might signify has always been attractive to me, but especially so now, thinking as I have been about the work I do that has brought me to this company. So I choose to read the bird as language and the woman as a practiced writer. She is worried about how the language she dreams in, given to her at birth, is handled, put into service, even withheld from her for certain nefarious purposes. Being a writer, she thinks of language partly as a system, partly as a living thing over which one has control, but mostly as agency—as an act with consequences. So the question the children put to her, "Is it living or dead?," is not unreal, because she thinks of language as susceptible to death, erasure; certainly imperiled and salvageable only by an effort of the will. She believes that if the bird in the hands of her visitors is dead, the custodians are responsible for the corpse. For her a dead language is not only one no longer spoken or written, it is unyielding language content to admire its own paralysis. Like statist language, censored and censoring. Ruthless in its policing duties, it has no desire or purpose other than to maintain the free range of its own narcotic narcissism, its own exclusivity and dominance. However, moribund, it is not without effect, for it actively thwarts the intellect, stalls conscience, suppresses human potential. Unreceptive to interrogation, it cannot form or tolerate new ideas, shape other thoughts, tell another story, fill baffling silences. Official language smithered to sanction ignorance and preserve privilege is a suit of armor, polished to shocking glitter, a husk from which the knight departed long ago. Yet there it is; dumb, predatory, sentimental. Exciting reverence in schoolchildren, providing shelter for despots, summoning false memories of stability, harmony among the public.

She is convinced that when language dies, out of carelessness, disuse, indifference, and absence of esteem, or killed by fiat, not only she herself but all users and makers are accountable for its demise. In her country children have bitten their tongues off and use bullets instead to iterate the void of speechlessness, of disabled and disabling language, or language adults have abandoned altogether as a device for grappling with meaning, providing guidance, or expressing love. But she knows tongue-suicide is not only the choice of children. It is common among the infantile heads of state and power merchants whose evacuated language leaves them with no access to what is left of their human instincts, for they speak only to those who obey, or in order to force obedience.

The systematic looting of language can be recognized by the tendency of its users to forgo its nuanced, complex, midwifery properties, replacing them with menace and subjugation. Oppressive language does more than represent violence; it is violence, does more than represent the limits of knowledge; it limits knowledge. Whether it is obscuring state language or the faux language of mindless media; whether it is the proud but calcified language of the academy or the commodity-driven language of science; whether it is the malign language of law-without-ethics, or language designed for the estrangement of minorities, hiding its racist plunder in its literary cheek—it must be rejected, altered and exposed. It is the language that drinks blood, laps vulnerabilities, tucks its fascist boots under crinolines of respectability and patriotism as it moves relentlessly toward the bottom line and the bottomed-out mind. Sexist language, racist language, theistic language—all are typical of the policing languages of mastery, and cannot, do not, permit new knowledge or encourage the mutual exchange of ideas.

The old woman is keenly aware that no intellectual mercenary or insatiable dictator, no paid-for politician or demagogue, no counterfeit journalist would be persuaded by her thoughts. There is and will be rousing language to keep citizens armed and arming; slaughtered and slaughtering in the malls, courthouses, post offices, playgrounds, bedrooms and boulevards; stirring, memorializing language to mask the pity and waste of needless death. There will be more diplomatic language to countenance rape, torture, assassination. There is and will be more seductive, mutant language designed to throttle women, to pack their throats like pâté-producing geese with their own unsayable, transgressive words; there will be more of the language of surveillance disguised as research; of politics and history calculated to render the suffering of millions mute; language glamorized to thrill the dissatisfied and bereft into assaulting their neighbors; arrogant pseudo-empirical language crafted to lock creative people into cages of inferiority and hopelessness.

Underneath the eloquence, the glamour, the scholarly associations, however stirring or seductive, the heart of such language is languishing, or perhaps not beating at all—if the bird is already dead.

She has thought about what could have been the intellectual history of any discipline if it had not insisted upon, or been forced into, the waste of time and life that rationalizations for and representations of dominance required—lethal discourses of exclusion blocking access to cognition for both the excluder and the excluded.

The conventional wisdom of the Tower of Babel story is that the collapse was a misfortune. That it was the distraction or the weight of many languages that precipitated the tower's failed architecture. That one monolithic language would have expedited the building, and heaven would have been reached. Whose heaven, she wonders? And what kind? Perhaps the achievement of Paradise was premature, a little hasty if no one could take the time to understand other languages, other views, other narratives. Had they, the heaven they imagined might have been found at their feet. Complicated, demanding, yes, but a view of heaven as life; not heaven as post-life.

She would not want to leave her young visitors with the impression that language should be forced to stay alive merely to be. The vitality of language lies in its ability to limn the actual, imagined and possible lives of its speakers, readers, writers. Although its poise is sometimes in displacing experience, it is not a substitute for it. It arcs toward the place where meaning may lie. When a President of the United States thought about the graveyard his country had become, and said, "The world will little note nor long remember what we say here. But it will never forget what they did here," his simple words were exhilarating in their life-sustaining properties because they refused to encapsulate the reality of 600, dead men in a cataclysmic race war. Refusing to monumentalize, disdaining the "final word," the precise "summing up," acknowledging their "poor power to add or detract," his words signal deference to the uncapturability of the life it mourns. It is the deference that moves her, that recognition that language can never live up to life once and for all. Nor should it. Language can never "pin down" slavery, genocide, war. Nor should it yearn for the arrogance to be able to do so. Its force, its felicity, is in its reach toward the ineffable.

Be it grand or slender, burrowing, blasting or refusing to sanctify; whether it laughs out loud or is a cry without an alphabet, the choice word or the chosen silence, unmolested language surges toward knowledge, not its destruction. But who does not know of literature banned because it is interrogative; discredited because it is critical; erased because alternate? And how many are outraged by the thought of a self-ravaged tongue?

Word-work is sublime, she thinks, because it is generative; it makes meaning that secures our difference, our human difference—the way in which we are like no other life.

We die. That may be the meaning of life. But we *do* language. That may be the measure of our lives.

"Once upon a time . . ." Visitors ask an old woman a question. Who are they, these children? What did they make of that encounter? What did they hear in those final words: "The bird is in your hands"? A sentence that gestures toward possibility, or one that drops a latch? Perhaps what the children heard was, "It is not my problem. I am old, female, black, blind. What wisdom I have now is in knowing I cannot help you. The future of language is yours."

They stand there. Suppose nothing was in their hands. Suppose the visit was only a ruse, a trick to get to be spoken to, taken seriously as they have not been before. A chance to interrupt, to violate the adult world, its miasma of discourse about them. Urgent questions are at stake, including the one they have asked: "Is the bird we hold living or dead?" Perhaps the question meant: "Could someone tell us what is life? What is death?" No trick at all; no silliness. A straightforward question worthy of the attention of a wise one. An old one. And if the old and wise who have lived life and faced death cannot describe either, who can?

But she does not; she keeps her secret, her good opinion of herself, her gnomic pronouncements, her art without commitment. She keeps her distance, enforces it and retreats into the singularity of isolation, in sophisticated, privileged space.

Nothing, no word follows her declaration of transfer. That silence is deep, deeper than the meaning available in the words she has spoken. It shivers, this silence, and the children, annoyed, fill it with language invented on the spot.

"Is there no speech," they ask her, "no words you can give us that help us break through your dossier of failures? through the education you have just given us that is no education at all because we are paying close attention to what you have done as well as to what you have said? to the barrier you have erected between generosity and wisdom?

"We have no bird in our hands, living or dead. We have only you and our important question. Is the nothing in our hands something you could not bear to contemplate, to even guess? Don't you remember being young, when language was magic without meaning? When what you could say, could not mean? When the invisible was what imagination strove to see? When questions and demands for answers burned so brightly you trembled with fury at not knowing?

"Do we have to begin consciousness with battle, heroes and heroines, like you have already fought and lost, leaving us with nothing in our hands except what you have imagined is there? Your answer is artful, but its artfulness embarrasses us and ought to embarrass you.° Your answer is indecent in its self-congratulation. A made-for-television script that makes no sense if there is nothing in our hands.

"Why didn't you reach out, touch us with your soft fingers, delay the sound bite, the lesson, until you knew who we were? Did you so despise our trick, our modus operandi, that you could not see that we were baffled about how to get your attention? We are young. Unripe. We have heard all our short lives that we have to be responsible. What could that possibly mean in the catastrophe this world has become; where, as a poet said, 'nothing needs to be exposed since it is already barefaced'? Our inheritance is an affront. You want us to have your old, blank eyes and see only cruelty and mediocrity. Do you think we are stupid enough to perjure ourselves again and again with the fiction of nationhood? How dare you talk to us of duty when we stand waist deep in the toxin of your past?

"You trivialize us and trivialize the bird that is not in our hands. Is there no context for our lives? No song, no literature, no poem full of vitamins, no history connected to experience that you can pass along to help us start strong? You are an adult. The old one, the wise one. Stop thinking about saving face. Think of our lives and tell us your particularized world. Make up a story. Narrative is radical, creating us at the very moment it is being created. We will not blame you if your reach exceeds your grasp; if love so ignites your words that they go down in flames and nothing is left but their scald. Or if, with the reticence of a surgeon's hands, your words suture only the places where blood might flow. We know you can never do it properly—once and for all. Passion is never enough; neither is skill. But try. For our sake and yours forget your name in the street; tell us what the world has been to you in the dark places and in the light. Don't tell us what to believe, what to fear. Show us belief's wide skirt and the stitch that unravels fear's caul. You, old woman, blessed with blindness, can speak the language that tells us what only language can: how to see without pictures. Language alone protects us from the scariness of things with no names. Language alone is meditation.

"Tell us what it is to be a woman so that we may know what it is to be a man. What moves at the margin. What it is to have no home in this place. To be set adrift from the one you knew. What it is to live at the edge of towns that cannot bear your company.

"Tell us about ships turned away from shorelines at Easter, placenta in a field. Tell us about a wagonload of slaves, how they sang so softly their breath was indistinguishable from the falling snow. How they knew from the hunch of the nearest shoulder that the next stop would be their last. How, with hands prayered in their sex, they thought of heat, then sun. Lifting their faces as though it was there for the taking. Turning as though there for the taking. They stop at an inn. The driver and his mate go in with the lamp, leaving them humming in the dark. The horse's void steams into the snow beneath its hooves and the hiss and melt are the envy of the freezing slaves.

"The inn door opens: a girl and a boy step away from its light. They climb into the wagon bed. The boy will have a gun in three years, but now he carries a lamp and a jug of warm cider. They pass it from mouth to mouth. The girl offers bread, pieces of meat and something more: a glance into the eyes of the one she serves. One helping for each man, two for each woman. And a look. They look back. The next stop will be their last. But not this one. This one is warmed."

It's quiet again when the children finish speaking, until the woman breaks into the silence.

"Finally," she says. "I trust you now. I trust you with the bird that is not in your hands because you have truly caught it. Look. How lovely it is, this thing we have done—together."

Nobel Prize acceptance speech given by Toni Morrison in Stockholm on December 7, 1993. Reprinted by permission of International Creative Management, Inc. Copyright © 1993 Toni Morrison.

LITERARY CREDITS

CHAPTER 1—Page 1, Reading 1: From *The Epic of Gilgamesh*, translated with an introduction by N. K. Sandars (Penguin Classics 1960, Third Edition 1972), copyright © N. K. Sandars, 1960, 1964, 1972. Reproduced by permission of Penguin Books, Ltd.

CHAPTER 2—Page 3, Reading 2: Excerpt from *The Iliad* by Homer, translated by Richard Lattimore, copyright 1951 from Books XVIII, XXIII, XV, XXIV. Copyright 1951 University of Chicago Press. Reprinted by permission. **Page 11, Reading 3:** Excerpt from *Sappho and the Greek Lyric Poets*, translated by Willis Barnstone, copyright © 1962, 1967, 1988 by Willis Barnstone. Used by permission of Schocken Books, a division of Random House, Inc. **Page 11, Readings 4 and 5:** Excerpt from *The Classics in Translation*, Volume I, edited by Paul L. MacKendrick and Herbert M. Howe, copyright 1952. Reprinted by permission of The University of Wisconsin Press. **Page 12, Reading 6:** From *The Histories* by Herodotus, translated by Aubrey de Selicourt, revised with introduction and notes by A. R. Burn (Penguin Classics 1954, Revised edition 1972). Translation copyright 1954 by Aubrey de Selicourt. This revised edition copyright © A. R. Burn, 1972. Reproduced by permission of Penguin Books, Ltd.

CHAPTER 3—Page 27, Reading 8: Excerpt from *The Classics in Translation*, Volume I, edited by Paul L. MacKendrick and Herbert M. Howe, copyright 1952. Reprinted by permission of The University of Wisconsin Press. **Page 29, Reading 8:** "Phaedo" from *The Great Dialogues of Plato* by Plato, translated by W. H. D. Rouse. Copyright © 1956, renewed 1984 by J. C. G. Rouse. Used by permission of Dutton Signet, a division of Penguin Group (USA), Inc. **Page 32, Reading 9:** "Book VII of *The Republic*: Allegory of the Cave" from *The Great Dialogues of Plato* by Plato, translated by W. H. D. Rouse. Copyright © 1956 and renewed 1984 by J. C. G. Rouse. Used by permission of Dutton Signet, a division of Penguin Group (USA), Inc.

CHAPTER 4—Page 38, Reading 13: From Book I, Book IV, and Book VI of "The Georgics of Vergil" translated by C. Day Lewis. Copyright 1953 by C. Day Lewis. Reprinted by permission of SLL/Sterling Lord Literistic, Inc. **Page 47, Reading 14:** "Book I, Ode IX", "Book I, Ode XX", "Book II, Ode III", "Book II, Ode XIV", "Book III, Ode XXX", from *The Odes of Horace* by Horace, translated by James Michie. Translation copyright © 1965 by James Michie. Used by permission of Viking Penguin, a division of Penguin Group (USA), Inc. **Page 48, Reading 15:** Juvenal. Translated by Rolfe Humphries. *The Satires of Juvenal*, pp. 33–45. Copyright © 1958 Indiana University Press. Reprinted with permission of Indiana University Press. **Page 49, Reading 16:** Book II from *Marcus Aurelius: Meditations*, translated by G. M. A. Grube. Copyright © 1963. All rights reserved. Reproduced by permission of Holt, Rinehart & Winston.

CHAPTER 5—Page 51, Reading 17: From *The Rig Veda*, translated and annotated by Wendy Doniger O'Flaherty (Penguin Classics, 1981). Copyright © Wendy Doniger O'Flaherty, 1981. Reprinted by permission of Penguin Books, Ltd. **Page 53, Reading 18:** From *The Upanishad*, translated with an introduction by Juan Mascaro (Penguin Classics, 1965). Copyright © Juan Mascaro, 1965. Reprinted by permission of Penguin Books, Ltd. **Page 56, Reading 19:** From *The Wisdom of Buddhism*, translated by Christmas Humphreys, p. 36–37, 42–45. Copyright (c) 1961 by Random House Group Limited. All rights reserved. Reproduced by permission. **Page 57, Reading 20:** From *The Columbia Book of Chinese Poetry: From Early Times to the Thirteenth Century*, translated and edited by Burton Watson, p. 207–210, 212, © 1984 Columbia University Press. Reprinted by permission.

CHAPTER 6—Page 67, Reading 23: From "The First Apology" by Justin Martyr from *Writings of Saint Justin Martyr*, translated by Thomas Falls. Copyright © Catholic University Press of America. Reprinted by permission of Catholic University of America Press, Washington, DC.

CHAPTER 7—Page 72, Reading 25: From Book VIII and Book IX of *Confessions by Saint Augustine*, translated with an introduction by R. S. Pine-Coffin (Penguin Classics, 1961). Copyright © R. S. Pine-Coffin, 1961. Reprinted by permission of Penguin Books, Ltd. **Page 75, Reading 26:** From Book XIX of *Concerning the City of God: Against the Pagans* by Saint Augustine, translated by Henry Bettenson, introduction by G R Evans (First published in Pelican Books 1972, Reprinted in Penguin Classics, 1984, Reissued Penguin Classics 2003). Translation copyright © Henry Bettenson, 1972. Chronology, Introduction, Further Reading copyright © G R Evans, 2003. Reprinted by permission of Penguin Books, Ltd.

CHAPTER 8—Page 81, Reading 27: From "The Opening," "The Table Spread," "The Children of Israel," "The Coursers," "The Unity" from *The Meaning of Glorious Koran*, translated by Mohammed Marmaduke Pickthall, 1930, George Allen & Unwin, an imprint of HarperCollins Publishers, Ltd., 1930. **Page 88, Reading 28:** From *Readings from the Mystics of Islam*, translated by Margaret Smith, 1950. Copyright Pir Press. All rights reserved. Reproduced by permission.

CHAPTER 9—Page 92, Reading 31: "Causae et Curae" from *Women Writers of the Middle Ages: A Critical Study of Texts from Perpetua to Marguerite* by Peter Dronke. Copyright © Cambridge University Press. Reprinted with the permission of Cambridge University Press. **Page 98, Reading 33:** Jo Ann McNamara and John E. Halborg, Gordon Whatley, "Saint Bertilla, Abbess of Chelles" in *Sainted Women of the Dark Ages*, pp. 279–289. Copyright © 1992, Duke University Press. All rights reserved. Used by permission of the publisher. **Page 101, Reading 34:** From *Song of Roland* translated by Robert Harrison. Copyright © 1970 by Robert Harrison. Used by permission of Dutton Signet, a division of Penguin Group (USA), Inc.

CHAPTER 10—Page 119, Reading 38–40: Cantos I, III, V, X, XXXIII, XXXIV from *The Divine Comedy* by Dante Alighiere, translated by John Ciardi. Copyright © 1954, 1957, 1959, 1960, 1961, 1965, 1967, 1970 by the Ciardi Family Publishing Trust. Used by permission of W. W. Norton & Co.

CHAPTER 11—Page 141, Reading 41: Excerpt from Boccaccio's "Decameron: Preface to the Ladies" from *Medieval Culture and Society* by David Herlihy. Copyright © 1968 by David Herlihy. Reprinted by permission of HarperCollins Publishers, Inc. **Page 157, Reading 44:** Selections from *The Book of the City of Ladies* by Christine de Pizan, translated by Earl Jeffrey Richards. Copyright © 1982, 1998 by Persea Books, Inc. Reprinted by permission of Persea Books, Inc.

CHAPTER 12—Page 159, Reading 46: Excerpt by Laura Cereta from *Her Immaculate Hand: Selected Works by and about the Women Humanists of Quattrocento Italy*, by Margaret L. King and Albert Rabil (Eds.), Second Revised Edition. © 1997 Pegasus Press, Asheville, NC 28803. Used with permission. **Page 162, Reading 47:** Niccolo Machiavelli, "The Prince" in *The Chief Works and Others, Vol. 1*, Allan Gilbert, trans., pp. 5–97. Copyright © 1965, Duke University Press. All rights reserved. Reprinted by permission of publisher. **Page 164, Reading 48:** "The Praise of Folly," from *The Essential Erasmus* by Erasmus, translated by John P. Dolan. Copyright © 1964 by John P. Dolan. Used by permission of Dutton Signet, a division of Penguin Putnam, Inc.

CHAPTER 13—Page 169, Reading 49: "On Women" from *The Book of the Courtier* by Baldesar Castiglione, translated by George Bull (Penguin Classics, 1967). Copyright © George Bull, 1967. Reprinted by permission of the publisher Penguin Books, Ltd. **Page 172, Reading 50:** From *The Autobiography of Benvenuto Cellini*, translated by George Bull (Penguin Classics, 1956). Copyright © George Bull, 1956. Reprinted by permission of Penguin Books, Ltd.

CHAPTER 14—Page 175, Reading 51: From Frame, Donald M., *The Complete Works of Montaigne: Essays, Travel Journal, Letters*. Copyright © 1958 by the Board of Trustees of the Leland Stanford Junior University. All rights reserved. Used with permission of Stanford University Press, www.sup.org **Page 179, Reading 52:** From *Martin Luther's Basic Theological Writings*, edited by Timothy L. Lull, copyright © 1989 Augsburg Fortress. Reproduced by permission of Augsburg Fortress.

CHAPTER 15—Page 228, Reading 60: Tartuffe by Moliere, English translation copyright © 1963, 1962, 1961 and renewed 1991, 1990 and 1989 by Richard Wilbur, reprinted by permission of Houghton Mifflin Harcourt Publishing Company. **Page 231, Reading 61:** From *The Adventures of Don Quixote* by Miguel de Cervantes Saavedra, translated by J. M. Cohen, © 1950 by J. M. Cohen. Published by Penguin Books, Ltd. Reproduced by permission of Penguin Books, Ltd.

CHAPTER 16—Page 247, Reading 65: "Emile" by Jean Jacques Rousseau from *Introduction to Contemporary Civilization in the West, Vol. 1*, Third Edition, translated by Barbara Foxley. Copyright 1960 Columbia University Press. Reprinted by permission. **Page 249, Reading 67:** From *Candide and Other Writings* by Voltaire, edited by Haskell M. Block, copyright © 1956 and renewed 1984 by Random House, Inc. Used by permission of Random House, Inc.

CHAPTER 17—Page 277, Reading 77: Reprinted by permission of the publishers and the Trustees of Amherst College from *The Poems of Emily Dickinson*, Thomas H. Johnson, editor,